THE STAFFORDSHIRE HOARD

STAFFORDSHIRE HOARD

AN ANGLO-SAXON TREASURE

EDITED BY **CHRIS FERN, TANIA DICKINSON** & **LESLIE WEBSTER**

SCIENTIFIC ADVISORY EDITOR: MARCOS MARTINÓN-TORRES

Research Report of the Society of Antiquaries of London No. 80

CONTRIBUTORS

Janet Ambers[†], Eamonn Baldwin, Eleanor Blakelock, Jenni Butterworth, H E M Cool, Alison Deegan, Tania Dickinson, Chris Fern, Svante Fischer, Kayleigh Fuller, Richard Gameson, Pieta Greaves, Peter Guest, Matthias Hardt, Catherine Higgitt, John Hines, Alex Jones, Marcos Martinón-Torres, Peter Mc Elhinney, Andrew Meek, Lizzie Miller, George Speake, Alan Thacker, Leslie Webster, Niamh Whitfield, Barbara Yorke

SOCIETY OF ANTIQUARIES OF LONDON

The Staffordshire Hoard collection is jointly owned by Birmingham City Council and Stoke-on-Trent City Council on behalf of the nation, and is cared for by Birmingham Museums Trust and The Potteries Museum and Art Gallery, Stoke-on-Trent. The Staffordshire Hoard research project was conducted by Barbican Research Associates Ltd and funded by Historic England and the owners.

First edition published 2019 by the Society of Antiquaries of London
Burlington House, Piccadilly, London W1J 0BE

www.sal.org.uk

© 2019 Society of Antiquaries of London

All rights reserved. No part of this publication may be reproduced, distributed, or transmitted in any form or by any means, including photocopying, recording, or other electronic or mechanical methods, without the prior written permission of the publisher, except in the case of brief quotations embodied in critical reviews and certain other noncommercial uses permitted by copyright law. For permission requests, write to the publisher at the address below.

Society of Antiquaries of London, Burlington House, Piccadilly, London W1J 0BE.

British Library Cataloguing in Publication Data

A catalogue record for this book is available from the British Library

Library of Congress Cataloging in Publication Data
A catalogue record for this book is available from the Library of Congress

ISBN: 978-1-5272-3350-8 (hbk)

2 3 4 5 6 7 8 9 10

Frontispiece: Reconstruction of the great gold cross (**539**). The placement of the oval garnet (**692**) at the centre in rock crystal surround is conjecture. The round garnets at the ends of the three short arms are proposed from the single surviving example (H. 300mm). *Drawing*: C. Fern.

Book cover, book design, typography and pre-press production by
Sunita J. Gahir | Bigmetalfish Design Services, London. | sunita@bigmetalfish.com

Typeset in Garamond Pro & Mundo Sans

Printed in Poland by Interak Services Ltd.

CONTENTS

List of figures ... xii

List of tables ... xxii

List of online tables ... xxiii

Abbreviated Catalogue listing ... xxiv

Foreword ... xxv

Acknowledgements ... xxvi

Résumé ... xxvii

Zusammenfassung ... xxix

Introduction

Leslie Webster, Tania Dickinson and Chris Fern ... xxxi

Setting the agenda: aims, questions and challenges ... xxxi

The structure of the publication ... xxxiii

Map 1. The major kingdoms of mainland Britain in the seventh century and battles mentioned in the text ... xxxiv

Map 2. Main places mentioned in the text ... xxxv

PART ONE: THE HOARD ... 1

CHAPTER 1. From Discovery to Conservation

Discovery *H E M Cool* ... 3

Fieldwork of 2009 and 2010 *Alex Jones, Eamonn Baldwin and Alison Deegan* ... 4

 Fieldwork methodology ... 8

 Fieldwork results ... 11

 Geophysical (magnetometer) survey, 2009 *Eamonn Baldwin* ... 11

 Recovery excavation, 2009 ... 11

 Trenching, 2010 ... 11

 Aerial photography assessment *Alison Deegan* ... 12

 Discussion ... 12

Fieldwork in 2012 *H E M Cool* ... 13

Acquisition, funding and project organisation *Jenni Butterworth* ... 13

The conservation programme *Pieta Greaves, Kayleigh Fuller and Lizzie Miller* ... 16

 Investigative conservation methodology ... 17

 Garnet cloisonné objects ... 18

 Filigree decorated objects ... 20

 Rejoining and reconstruction ... 22

Die-impressed silver sheet ... 24

Conclusion ... 24

The reliability of the finds context *Chris Fern* ... 24

Chapter 2. Characterising the Objects
Chris Fern ... 29

Fittings from weaponry ... 33

 Pommels and sword-rings (cat. **1–84**) ... 34

 Hilt-collars and hilt-rings (cat. **85–242**) ... 41

 Hilt-plates and hilt-guards (cat. **243–409** and **696–7**) ... 44

 Hilt-mounts and other small mounts (cat. **410–537**) ... 50

 Fittings from weapon-harness (cat. **572–87**) ... 56

 The typological and functional significance of the weapon-fittings ... 58

 Conclusion ... 70

Helmet parts, decorated silver sheet, reeded strip and edge binding
Chris Fern and George Speake ... 70

 Cast helmet parts with animal ornament (cat. **589–92**) ... 71

 Silver helmet-band and decorated silver sheet (cat. **593–604** and **606**) ... 74

 Reeded strip (cat. **609–13**) ... 78

 Edge binding (cat. **614–5**) *Chris Fern* ... 79

The social context, form and date of the helmet *George Speake* ... 79

 The helmet and its Anglo-Saxon context ... 80

 Helmet: form and reconstruction ... 80

 Origin, social significance and date ... 84

 Conclusion ... 84

Large mounts not from weaponry and harness-mount (cat. **698**) ... 85

 Sets of mounts in garnet cloisonné (cat. **542–66**) ... 85

 Mount with fish and birds (cat. **538**) ... 93

 Set of silver mounts with niello (cat. **567–71**) ... 93

 Harness-mount with interlace (cat. **698**) ... 93

 Discussion of the large mounts and harness-mount (cat. **698**) ... 94

Christian objects ... 99

 Great gold cross (cat. **539**) ... 100

 Socketed-base and pins (cat. **607/8** and **676**) ... 102

 Inscribed strip (cat. **540**) ... 102

 The palaeography of the inscriptions *Richard Gameson* 103

Head-dress mount (cat. **541**) 109

Cross-pendant (cat. **588**) 110

The Christian objects: function and significance *Leslie Webster* 110

 Objects associated with Christian ceremony and worship 111

 Crosses worn on the body or on equipment 116

 Objects of uncertain, but possibly religious, purpose 117

 Conclusion 118

Miscellanea 119

Chapter 3. Workshop Practice
Eleanor Blakelock and Chris Fern 123

Analysing the resource 124

Materials 125

 Gold 125

 Silver, copper alloy and other metals 127

 Garnets *Janet Ambers† and Catherine Higgitt* 129

 Glass *Chris Fern and Andrew Meek* 133

 'Unidentified' inlay *Chris Fern and Marcos Martinón-Torres* 134

 Organics and pastes *Peter Mc Elhinney and Chris Fern* 136

 Other materials 138

Manufacture 138

 Casting 138

 Sheet and foil 138

 Soldering 141

 Surface-enrichment of gold 144

 Gilding 145

 Die-impressing on sheet and foil *George Speake* 146

 Reeded strip *George Speake* 148

 Incising and punching 149

 Niello 151

 Filigree *Chris Fern and Niamh Whitfield* 155

 Wires, granules and patterns 156

 Back-sheets 163

 Conclusion 165

Cloisonné and other lapidary work *Chris Fern* .. 166

 Stones and manufacture .. 168

 Cell-forms and patterns .. 172

 Backing foils .. 179

 Conclusion .. 181

'Assembly' marks and other marks *Chris Fern* .. 183

CHAPTER 4. Life of Objects: Wear, Modification, Repair and Damage
Chris Fern .. 187

Wear .. 188

Modification and repair .. 194

Damage .. 195

Conclusion .. 205

CHAPTER 5. Styles of Display and Revelation
Chris Fern .. 207

Style and substance .. 208

Animal ornament in the Hoard .. 213

Ornament of the helmet and die-impressed sheet *George Speake* 232

 Animal ornament .. 232

 Figural ornament .. 239

Interlace and knots .. 245

Scrollwork .. 249

Early Insular style .. 250

Geometric ornament and symbols .. 253

Conclusion .. 255

CHAPTER 6. Date and Origin
Chris Fern .. 257

Dating the Hoard .. 258

 Hoard Phase 1: sixth-century silver fittings from weapons 263

 Hoard Phase 2 (gold): Anglo-Saxon early Style II and contemporaneous styles and objects,
 c 570–*c* 630 .. 264

 Hoard Phase 3 (gold): Anglo-Saxon late Style II and contemporaneous objects,
 c 610–*c* 650 .. 266

 Hoard Phase 4 (silver objects with gold mounts): Early Insular style objects,
 c 630–*c* 660 .. 269

Summary..270
Origins..271
 Mercia..273
 Kent, East Anglia or Greater Northumbria..276
Conclusion..279

PART TWO: THE BROADER CONTEXT..283

Chapter 7. The Historical Context: Local, Regional and National
Historical background *Barbara Yorke*..286
 Early medieval Britain in the seventh century..286
 The early Mercian kings..287
 Religion in early Mercia..289
 The findspot of the Staffordshire assemblage and the history of Mercia..................291
 Conclusion..292

The Church and warfare: the religious and cultural background to the Hoard
Alan Thacker..293
 The contemporary context..293
 Christian and pagan culture in the early seventh century..296
 Anglian connections..298
 Conclusion..299

Chapter 8. The Archaeological Context: Matters of Material and Social Significance
John Hines..301
The Early Anglo-Saxon period: graves and grave goods..302
Social hierarchy and its visibility..306
Resources and their use: the contemporary value of the Hoard......................................312
The archaeology of early Mercia..315

Chapter 9. Hoards and Hoarding
Introduction *Leslie Webster and Tania Dickinson*..321
Hoarding in later Roman Britain and beyond *Peter Guest*..325
 The hoarding of Roman objects in Britain in the fourth and fifth centuries............325
 The status of gold and silver in the later Roman world (and beyond)......................329
 Dating hoards of late Roman objects..330
 Fragmentation of Roman gold and silver objects..331

The hoarding of late Roman objects in post-Roman Britain	332
Hoarding in continental Germanic Europe *Matthias Hardt*	334
Royal treasure, gift exchange and tribute	335
Precious metal of provincial Roman origin	336
Gold and silver: coins, ingots and rings in Migration period hoards in eastern central Europe	336
Brooches from deposits in the Carpathian Basin	337
Tableware in hoards from the Danubian area	338
Hoard finds in Italy, Burgundia and Visigothic Spain	340
Hidden treasure in texts from the early medieval period	343
Conclusion	344
Scandinavian hoarding *Svante Fischer*	344
Imagining Scandinavia	344
Ways of hoarding	346
War booty sacrifices	346
Precious metal hoards and central places	347
Conclusion	349

Chapter 10. What Does it Mean?

Tania Dickinson, Chris Fern and Leslie Webster	352
The exceptionality of the Hoard	352
Key characteristics	352
Comparable assemblages?	353
Towards a biography of the Staffordshire Hoard	354
Assembly	354
A 'last gathering'	356
Final selection and disassembly	347
Burial	359
Conclusion: multiple explanations and narratives	360

Afterword

The impact of the Hoard *Tania Dickinson, Leslie Webster and Chris Fern*	364
Impact on our knowledge of the Anglo-Saxon world	364
Future research	366
Impact on public engagement with the past *Jenni Butterworth*	366

PART THREE: THE ABBREVIATED CATALOGUE ... 373

Catalogue images .. 375
Catalogue entries *Chris Fern* .. 423
Select sets of hilt-fittings ... 463

Guide to the digital component of the publication *H E M Cool* 472
Glossary ... 474
Endnotes .. 478
Bibliography .. 528
Index ... 562
Picture credits ... 586

LIST OF FIGURES

Frontispiece Reconstruction of the great gold cross (**539**). The placement of the oval garnet (**692**) at the centre in rock crystal surround is conjecture. The round garnets at the ends of the three short arms are proposed from the single surviving example.

Map 1 The major kingdoms of mainland Britain in the seventh century and battles mentioned in the text.

Map 2 Main places mentioned in the text.

1.1 View of the field where the Hoard was found.

1.2 The Hoard in its local Midlands setting

1.3 Detailed location map of the Hoard site.

1.4 Areas investigated at the Hoard site.

1.5 General view of the recovery excavation.

1.6 Hand-excavation in grid squares.

1.7 Find with bag showing small find and grid square numbers.

1.8 Scanning hand-dug soil with a metal-detector.

1.9 Simplified plan of the main features identified by fieldwork and aerial photography.

1.10 Excavating ice wedge [*4104*].

1.11 Gully [*4203*].

1.12 The queue to see the Hoard exhibition at Birmingham Museum & Art Gallery.

1.13 A conservator removing loose soil from a metal fragment.

1.14 Parts from mount **541**.

1.15 Half of mount **558**.

1.16 Mount **565** with its bone inlay.

1.17 Part of filigree hilt-collar **100** during conservation.

1.18 Pommel **25** after conservation showing variations in the tarnish layers.

1.19 A selection of the fragments used to reconstruct pommel **77**.

1.20 Some of the many silver-gilt fragments.

1.21 Silver-gilt sheet covering **607/8** with trims of reeded strip from a socketed base.

1.22 The best preserved of the die-impressed sheet panels of **597**.

1.23 Metal wire supports on the reverse of die-impressed panel **595**.

1.24 X-radiographs of soil blocks.

1.25 Updated distribution of finds and simplified site plan.

LIST OF FIGURES

2.1 The Hoard by weight and fragment count.

2.2 X-radiographs showing nails and bosses inside gold pommels.

2.3 Broad object categories within the Hoard by weight.

2.4 Sword-, seax- and scabbard-fittings by object count.

2.5 The long sword typical of the period.

2.6 Pommel **2**.

2.7 The two pommel forms in the collection.

2.8 Pommels **36** and **46**.

2.9 Pommels **63** and **64**.

2.10 Pommel **57**.

2.11 Pommel **73**.

2.12 Ring-pommel **76**.

2.13 Silver sword-rings **79–84**.

2.14 Gold hilt-collars **87–8** and pommel **1**.

2.15 Gold hilt-collars **125–6** and **157–8**.

2.16 Silver pommel **69**, hilt-collars **186–7**, and mounts **534–6**.

2.17 Examples of the different types of hilt-ring.

2.18 Quantities and characteristics of the hilt-plates.

2.19 The best-preserved set of gold hilt-plates (**243–4**).

2.20 Side view of hilt-plate pair **243** from the upper guard.

2.21 Schematic drawing of possible positions for hilt-plates suggested by the collection.

2.22 Pair of silver hilt-plates (**372–3**) from the upper guard.

2.23 Pair of bent gold hilt-plates (**361–2**) with garnet cloisonné trims.

2.24 Silver hilt-guards **409** with gold mounts.

2.25 Small mounts of various form and ornament.

2.26 The preserved horn 'Cumberland' hilt.

2.27 X-radiograph of the 'Cumberland' hilt, with a drawn section.

2.28 Guard-tip **412**.

2.29 Interpretation for hilt-fittings **499–502**, with pommel **49**.

2.30 Interpretation for hilt-fitting **512**.

2.31 Interpretation for hilt-fitting **519**.

2.32 Interpretation for hilt-fitting **536**.

2.33 Interpretation for hilt-fittings **533–5**, with pommel **69** and hilt-collars **186–7**.

2.34 Gold and garnet cloisonné mounts **521–2** and gold serpent mounts **529–30**.

2.35 Selected small mounts of zoomorphic form or with animal ornament.

2.36 Pyramid-fittings **578–9** and button-fittings **582–3**.

2.37 Gold buckles **585–6** and silver buckle **587**.

2.38 Schematic representations of the function of button- and pyramid-fittings.

2.39 Grave 16 at Alton and its sword.

2.40 The zoomorphic filigree style of sixth-century Scandinavia on hilt-fittings.

2.41 Gold hilt-fittings from a sword-hilt from Market Rasen.

2.42 Pommel **50** and a pommel from Hög Edsten.

2.43 Reconstruction of the Hoard seax and related examples.

2.44 Pyramid-fittings **574–5** and a similar pyramid from Dalmeny.

2.45 Helmet-crest parts **589–90**.

2.46 Cheek-pieces **591–2**.

2.47 The surviving structural parts of the helmet (**589–93**).

2.48 Proposed arrangement of the decorative sheet panels and bands of the helmet cap.

2.49 Silver-gilt band **593** with its sheet band decorated with warriors.

2.50 Silver-gilt zoomorphic band **594**.

2.51 Silver sheet **595, 598–9, 601–3** and select fragments of **604** and **606**.

2.52 Panels with warriors marching right (**596**).

2.53 Panels with warriors marching left (**597**).

2.54 Fragments of sheet **600** with animal ornament.

2.55 Reconstruction of the neck-guard.

2.56 Reconstruction of the helmet.

2.57 The parts of silver-gilt edging **614**.

2.58 Garnet cloisonné mounts **542–7**.

2.59 Schematic section showing how the cloisonné mounts were fixed.

2.60 One possible arrangement of cloisonné mounts **542–7**.

2.61 Mounts **548–9**.

2.62 The angled join between cloisonné mounts **550** (**551**) and **552** (**553**).

2.63 Cloisonné mounts **558–9**.

2.64 Cloisonné mounts **562–4**.

2.65 Wing-shaped cloisonné mounts **565–6**.

2.66 Mount **538**.

2.67 Silver mount **569** with a reconstruction.

2.68 Harness-mount **698**.

2.69 The Chelles Chalice.

2.70 Reconstruction of cloisonné mounts **556–61** as fittings for a saddle.

2.71 Reconstruction of mount **538** as a saddle fitting.

2.72 Reconstruction of silver mounts **567–71** as fittings from a bridle.

2.73 Great gold cross **539** with its gem-settings and loose garnet.

2.74 The 'unfolded' cross mount.

2.75 The equal arm and Latin cross forms combined in the great cross, and the original locations of the gem-settings.

2.76 Reconstruction of object **607/8** with pins **676**.

2.77 Socket **607/8** interpreted as the base of an altar cross.

2.78 Inscribed strip **540** 'unfolded'.

2.79 Head-dress mount **541**.

2.80 Exploded illustration of head-dress mount **541**.

2.81 Cross-pendant **588**.

2.82 Drawing of a CT-section taken of the centre of cross **588**.

2.83 A silver processional or altar cross from Kurin.

2.84 The *crux gemmata* from the apse mosaic of Santa Pudenziana.

2.85 Sea-creatures and serpent interlace from the mausoleum of Hypogée de Dunes.

2.86 The gold and garnet cloisonné pommel from Dinham.

2.87 The Codex Amiatinus showing the prophet Ezra.

2.88 Object **684**.

2.89 Selection of loose bosses, rivets, nails and washers, and 'locking' pin **676**.

3.1 Ternary diagram showing the range of gold-alloy compositions.

3.2 Results from the sub-surface analysis of the great gold cross **539**.

3.3 Binary plots showing the range of silver-alloy compositions.

3.4 Binary plot comparing the alloys of different silver objects.

3.5 Hoard copper alloys compared to data for early Anglo-Saxon and middle Saxon alloys.

3.6 Plot of CaO vs MgO for the Staffordshire Hoard garnets.

3.7 Garnet types identified for pommel **52** and seax collar **167**.

3.8 Glass *millefiori* inlay on pommel **53**.

3.9 Glass *millefiori* inlay on pyramid-fitting **578**.

3.10 Tiny red glass sphere for the eye of bird mount **512**.

3.11 Triangular blue glass inlays in the cloisonné on pyramid-fitting **572**.

3.12 Yellow-green glass in the gem-setting of hilt-plate **260**.

3.13 'Unidentified' inlay in the cloisonné of pommel **54**.

3.14 Very small patch of red substance, possibly molten spillage, on pommel **54**.

3.15 Very small red fragment of inlay in a cell on pommel **44**.

3.16 BSE image of the textile fragment from hilt-collar **126**.

3.17 Surviving ash dowel used to align and secure part of pommel **75**.

3.18 Wood and calcite core inside pommel **51**.

3.19 Wax and glue paste remains on helmet-band **593**.

3.20 Hilt-plate **370** showing evidence that a wax model was probably used.

3.21 Sheet joins in the interior of pommel **11**.

3.22 Sheet joins in the interior and on the edge of hilt-collar **166**.

3.23 The reverse of hilt-plate **292** showing fine incised lines.

3.24 Mount **447** showing solder around the beaded wire of a filigree scroll.

3.25 Hilt-collar **133** showing filigree scrollwork flooded by solder.

3.26 Hilt-ring **218** showing filigree wire flooded by solder.

3.27 Hilt-plate **288** showing solder scarring.

3.28 Cloisonné strip-mount **547** showing solder scarring.

3.29 Hilt-ring **191** showing solder join in thick beaded wire.

3.30 Chemical analysis of components of hilt-collars plotted on a liquidus diagram showing melting points for different alloys.

3.31 BSE elemental map for hilt-collar **106**.

3.32 Frequency graph showing percentage decrease and increase of silver at the surface of objects.

3.33 Plots of gold versus silver for the different components of pommel **31**.

3.34 Cheek-piece **591** showing the bonded layer of gilding.

3.35 Fragment of zoomorphic band **594**.

3.36 Both sides of one fragment from panel **596**.

3.37 Silver-gilt 5mm reeded strip **611**.

3.38 Silver-gilt 8mm reeded strip **613** with a deliberately flattened butt-end.

3.39 Silver-gilt 8mm reeded strip **613** with ends deliberately cut at angles.

3.40 Broken edge of eye-shaped mount **567**, showing channels carved for niello inlay.

3.41 Three-dimensional image of mount **568**.

3.42 Incised and punched ornament of the great gold cross **539**.

3.43 Carved serpent head on one filigree mount from strip-mount **556**.

3.44 Hilt-collar **184** showing worn punch ornament and a reconstruction.

3.45 Zig-zag punched and inlaid band on cheek-piece **592**.

3.46 Geometric inlay on mount **570**, showing overlapping niello stripwork.

3.47 Detail of the niello inscription on strip **540**.

3.48 Niello remains on hilt-collar **187**.

3.49 One of the boar heads on pommel **68**, showing the remnants of the niello inlay.

3.50 Detail of one of the nielloed triangles with teardrops on pommel **75**.

3.51 'Serpent' triquetra in silver against a triangular niello field on pommel **76**.

3.52 Hilt-collar **110** with Style II animal ornament in filigree.

3.53 Bar chart showing the number of objects with filigree per category.

3.54 Pie chart showing the incidence of filigree patterns.

3.55 Poorly formed filigree and notches on pommel **24**.

3.56 Filigree on hilt-collar **111**.

3.57 SEM image of one end of pommel **42**.

3.58 The rivet-housings at one end of pommel **54**.

3.59 Hilt-collar **124** showing an 'unfinished' wire.

3.60 Hilt-ring **207** formed from a thick beaded wire.

3.61 Cabochon garnet boss with a filigree collar on hilt-plate **245**.

3.62 SEM image of mount **474** showing spiral-beaded wires.

3.63 Pommel **56** showing flat-beaded wire.

3.64 Pommel **8** showing a rare triple-strand pattern.

3.65 Mount **447** with S-scrolls in fine beaded wire.

3.66 Hilt-collar **130** with volute scrolls and annulets.

3.67 Pyramid-fitting **580** with conical spirals of beaded wire.

3.68 Hilt-collar **128** showing plaited wire.

3.69 Detail of hilt-ring **211** formed from three strands of beaded wire twisted together.

3.70 Detail of hilt-ring **224** formed from wrapped-beaded wire.

3.71 Hilt-collar **114** showing herringbone decoration.

3.72 Gem-setting from the centre of great gold cross **539**.

3.73 Collared granules on pommel **21**.

3.74 Clutch of granules forming one animal shoulder on hilt-collar **110**.

3.75 Back and front views of mount **456**.

3.76 Pommel **2** with a lattice backing.

3.77 'Horse' head of mount **460**.

3.78 Hilt-collar **125** showing the reverse of the pierced back-sheet.

3.79 Layout marks on the back-sheet of hilt-collar **107**.

3.80 Gold and garnet cloisonné fittings from the hilt of a seax or knife.

3.81 Damaged edge of mount **551** showing the cloisonné in section.

3.82 Triform garnet cut in three planes at the corner of pyramid-fitting **573**.

3.83 Garnets cut with a beaded surface on hilt-collar **158**.

3.84 Damaged cloisonné on mount **546**.

3.85 Cloisonné of pommel **47**.

3.86 Pattern of garnet crosses and gold stepped rhomboids on pommel **49**.

3.87 Style II cloisonné design on one side of pommel **53**.

3.88 Detailed comparison of hilt-collar **168** and one Sutton Hoo shoulder-clasp.

3.89 Hilt-collar **165** showing fragments of sheet set vertically to infill between cells and 'unidentified' inlay.

3.90 Exposed gold foils of standard type and stepped rhomboid cells on mount **499**.

3.91 Cloisonné on edge-mount **564** showing mushroom and arrow cellwork.

3.92 Cloisonné pattern on mount **543** and the derivative version on pommel **47**.

3.93 Similar cloisonné patterns on mount **565**, pommels **36** and **50**.

3.94 Fish mount **513** with fish-scale cloisonné.

3.95 Style II animal ornament on seax hilt-collars **167–8**.

3.96 Inexpert cloisonné on pommel **39** filled with 'unidentified' inlay.

3.97 Honeycomb and round cellwork.

3.98 Boxed 3×3 foil on mount **542**.

3.99 Mount **552** showing the use of standard and boxed foils.

3.100 Loose foil **694** of special boxed type.

3.101 Standard foil on small mount **506** showing line errors.

3.102 Two standard foils of different fineness on hilt-plate **363**.

3.103 Unusual boxed-lozenge foil on mount **474**.

3.104 Pommel **72** with possible ᚴ rune.

3.105 Grid and rune-like markings on hilt-collar **174**.

3.106 Marks on the reverse of filigree panels from strip-mounts **558–9** and other objects.

4.1 Repaired garnet boss from great gold cross **539**.

4.2 Heavy wear and damage to the apex of pommel **14**.

4.3 Comparison of wear on pommels **5** and **2**.

4.4 Heavy wear on one side of pommel **3**.

4.5 Heavy wear to pommel **68**.

4.6 Schematic drawing showing points of most wear.

4.7 Hilt-plate **293** showing longitudinal scratches probably caused by polishing.

4.8 Hilt-collar **168** showing polishing scratches

4.9 Hilt-plate **370** showing polishing scratches.

4.10 Hilt-plate **289** showing a mark around the rivet-holes left by a pommel.

4.11 Hole drilled at one end of hilt-plate **373**.

4.12 Two glass inlays on pommel **49**.

4.13 Angled cut marks on hilt-collar **85**.

4.14 Angled cut mark on hilt-collar **86**.

4.15 Vertical cut mark on mount **456**.

4.16 Cut end of hilt-ring **222**.

4.17 Torn-open underside of pommel **55**.

4.18 Cut mark and burr of metal on the edge of hilt-plate **387**.

4.19 Cut marks from the point and edge of a blade inserted under hilt-plate **328**.

4.20 Cut marks on hilt-plate **373**.

4.21 Blade scratches on hilt-plate **287**.

4.22 Mark from the point of a knife on hilt-plate **314**.

4.23 Blade scratches around rivet holes on hilt-plate **320**.

4.24 Cut marks on one side of mount **489**.

4.25 Stretched fixing-holes on the reverse of guard-tip mount **510**.

4.26 Iron smithing tongs from the Tattershall Thorpe grave.

4.27 Pommel **2** demonstrating wear and damage.

4.28 Pommels **14** and **56** showing horizontal dents from a tool.

4.29 Hilt-ring **221**, pinched on one edge by a tool.

4.30 Hilt-plate **347** with tool 'teeth' marks.

4.31 Hilt-plate **355** with tool 'teeth' marks.

4.32 Hilt-plate **325**, neatly folded and with torn rivet-holes.

4.33 Nicks from a blade along the edge of helmet-band **593**.

5.1 Decoding Style II.

5.2 Gold and garnet pommel **52** with syncretic art.

5.3 Style I animal ornament on hilt-collars **182–3**.

5.4 Pommels **68–9** and hilt-collars **186–7** with *comparanda*.

5.5 Style II filigree on pommel **1** and hilt-collars **85** and **88** with *comparanda*.

5.6 Pairs of zoomorphs on filigree pommels.

5.7 Quartets of zoomorphs on filigree pommels.

5.8 Pairs of zoomorphs and quadrupeds on pommels.

5.9 Zoomorphs and quadrupeds on pommels, hilt-collars and mounts.

5.10 Serpents on Hoard objects with *comparanda*.

5.11 Birds, fish and masks in the Hoard with *comparanda*.

5.12 The art of the great gold cross with *comparanda*.

5.13 Quadrupeds from the Hoard and the Book of Durrow compared.

5.14 Animal and cross ornament on head-dress mount **541**.

5.15 Serpent interlace on one side of helmet-crest **589–90**.

5.16 Serpent interlace and quadrupeds on the other side of helmet-crest **589–90**.

5.17 Animal ornament on cheek-piece **591**.

5.18 Animal and warrior ornament on die-impressed sheet **593–7** with *comparanda*.

5.19 Animal and warrior ornament on die-impressed sheet **598–603** with *comparanda*.

5.20 Warrior ornament *comparanda* from Vendel and Bradwell.

5.21 Interlace in the Hoard with *comparanda*.

5.22 Early Insular style with *comparanda*.

5.23 Symbols of belief on Hoard objects with *comparanda*.

6.1 Anglo-Saxon early Style II (*c* 570–*c* 600).

6.2 Gold filigree pommels from Wellingore and Middleham.

6.3 Anglo-Saxon late Style II (*c* 610–*c* 650).

6.4 Wilton cross with mounts **562–4**.

6.5 Proportions of metalwork allocated to *Hoard Phases 1–4*.

6.6 Styles of hilt-furniture in the Hoard.

6.7 Map showing the distribution of Hoard-related gold and silver pommels.

6.8 Elite objects from Mercia.

6.9 Composite disc-brooch from Kingston Down and disc-pendant from Loftus.

6.10 One of the Sutton Hoo mound 1 shoulder-clasps.

7.1 Local context of the Hoard in the seventh century.

7.2 Reliquary cross given by Justin II to St Peter's, Rome.

7.3 Helmet from Benty Grange.

8.1 Sword-related finds from the East Anglian centre of Rendlesham.

8.2 Pommel **47**.

8.3 Weapon-graves of the seventh century in England.

8.4 Schematic plan of development of the Anglo-Saxon royal vill at Yeavering.

8.5 Schematic plan of development of the Anglo-Saxon settlement at Cowdery's Down.

8.6 The Middle Trent, Derwent and Tame region.

9.1 Late Roman coin and treasure hoards from Britain.

9.2 Mildenhall and Water Newton treasures.

9.3 Selection of objects from the Hoxne hoard.

9.4 *Missorium* of Theodosius.

9.5 Selection of objects from the Patching hoard.

9.6 Selection of objects from the Traprain treasure.

9.7 Clipped *siliquae* from the Hoxne hoard.

9.8 Map of hoards on the Continent.

9.9 Gold brooch from the Szilágysomlyó II hoard.

9.10 Gold neck-collar from the Pietroasa treasure.

9.11 Gold bowl from the Pietroasa treasure.

9.12 Gold cloisonné mount depicting a helmeted head from the Domagno treasure.

9.13 Miniature chalice and paten set from Gourdon.

9.14 Map showing the distribution of different types of hoards and deposits in Scandinavia.

9.15 Neck-collar and weapon-fittings from the Tureholm hoard.

Endpiece Reconstruction of a sword-hilt in Early Insular style, from the proposed set of pommel **76**, hilt-collar pair **188** and hilt-guard pair **409**. The silver objects with gold and garnet mounts were reassembled from a combined total of seventy-three fragments (scale 1/1). *Image*: I. Dennis.

LIST OF TABLES

1.1 Summary of objects/fragments by finder.

2.1 Quantities in the Hoard.
2.2 Typological characteristics of the pommels.
2.3 Typological characteristics of the hilt-collars and hilt-rings.
2.4 Typological characteristics of the small mounts.
2.5 Typological characteristics of the pyramid- and button-fittings.
2.6 Dimensional data for blade and hilt parts from swords and seaxes.
2.7 Cast helmet-parts and associated fittings.
2.8 Large mounts of non-weapon-related function.
2.9 Christian objects.
2.10 Boss-types, rivets, nails, washers and related fixings.

3.1 Details of the garnets from the Staffordshire Hoard.
3.2 Punch-mark types.
3.3 Incidence of filigree types.
3.4 Incidence of filigree patterns.
3.5 Frequency per pommel or hilt-collar of different filigree types and patterns.
3.6 Quantities of cloisonné, gem-settings and inlays.
3.7 Selected cell-forms recorded for the cloisonné.
3.8 Selected patterns recorded for the cloisonné.
3.9 Incidence of 'assembly' and other marks on objects.

4.1 Criteria for judging wear.
4.2 Wear on weapon- and scabbard-fittings.
4.3 Interpretation of damage on weapon- and scabbard-fittings.

5.1 Styles in the Hoard.
5.2 Incidence of Style II creatures and anthropomorphic imagery.
5.3 Concordance of figural designs on Scandinavian-type helmets and related material.
5.4 Incidence of symbols.

6.1 Summary of *Hoard Phases 1–4*.

LIST OF ONLINE TABLES

The following tables may be found online via the Archaeology Data Service (ADS):

https://doi.org/10.5284/1041576

Online Table 1
Spreadsheet of objects/fragments by *K*-number, finder and catalogue.

Online Table 2
Spreadsheets showing contents of 'soil blocks' 1–21, *K438*, *K512*, *K795*, *K824*, *K826*, *K832*, *K960* and *K998*.

Online Table 3
Spreadsheets showing find associations not shown in online Table 2.

Online Table 4
Summary of sets of objects identified in the Hoard.

Online Table 5
Measurements for metal sheet and filigree.

Online Table 6
Measurements from weapon-parts and marks.

ABBREVIATED CATALOGUE LISTING

1 Catalogue nos. **1–26**.
2 Catalogue nos. **27–48**.
3 Catalogue nos. **44–75**.
4 Catalogue nos. **76–99**.
5 Catalogue nos. **100–18**.
6 Catalogue nos. **119–46**.
7 Catalogue nos. **147–73**.
8 Catalogue nos. **174–203**.
9 Catalogue nos. **204–25**.
10 Catalogue nos. **226–54**.
11 Catalogue nos. **255–78**.
12 Catalogue nos. **279–94**.
13 Catalogue nos. **295–322**.
14 Catalogue nos. **323–37**.
15 Catalogue nos. **338–64**.
16 Catalogue nos. **365–83**.
17 Catalogue nos. **385–439**.
18 Catalogue nos. **440–80**.
19 Catalogue nos. **481–526**.
20 Catalogue nos. **527–38**.
21 Catalogue nos. **539–41**.
22 Catalogue nos. **542–7**.
23 Catalogue nos. **548–57**.
24 Catalogue nos. **558–64**.
25 Catalogue nos. **565–84**.
26 Catalogue nos. **585–93**.
27 Catalogue nos. **594–605**.
28 Catalogue nos. **607/8**, **611–7**, **621**, **676**, **667–8**, **684–5**, **692**, **698**.
29 Pommel and hilt-collar sets in gold filigree.
30 Pommel, hilt-collar, hilt-ring, hilt-plate and mount sets in gold cloisonné.
31 Pommel, hilt-collar, hilt-guard and mount sets in silver.

Endpiece Reconstruction of a sword-hilt in Early Insular style.

FOREWORD

From the moment of its discovery, the Staffordshire Hoard has engaged almost unprecedented levels of public interest, combining as it does three crucial elements of popular appeal: warriors, precious materials, and a mystery. As the owners of this unique public asset, the cities of Birmingham and Stoke-on-Trent, and their respective museum services working with other venues in Staffordshire, have done their best to meet public interest through a wide range of displays, touring exhibitions, publications, and other events and activities, including fundraising and support for the research reported in this volume. Nine years on, the Hoard continues to attract high levels of interest, and its presence in the West Midlands is a source of considerable local pride. The audiences for the Hoard reflect the diversity of the region's population, suggesting that it has become a shared symbol of local identity. It continues to draw an international audience establishing the Hoard as a lead tourism asset, raising profile and benefiting the region's economy.

This volume marks both an end and a beginning. It is the culmination of a long, painstaking programme of conservation, scientific analysis and scholarly research that has revealed a great deal about the Hoard and the society in which it was shaped. One of the revelations for the owners – and a source of constant speculation since the Hoard was discovered – has been the presence of the helmet, now replicated by a team of expert makers. But the mass of information represented by this research volume will undoubtedly be mined by our curators for many years to come, supporting new and exciting interpretation and programming for fresh audiences. The find continues to provide opportunities to connect with other collections, stimulate new exhibitions and loans and further develop a wider understanding of the archaeology of the area already present in the region's leading museums.

Museums do not exist only to display objects. All museums of any size hold many more collection items in store than can be displayed at any one time. The stored collection exists to provide the breadth and depth of knowledge that supports public programming, and to form a resource for academic research. It is the hope of the owners of the collection that this extremely comprehensive and well-researched monograph, like all the best research volumes, will have raised questions that stimulate further interest and research into all the circumstances of the Hoard's manufacture, use and deposition in the future, and we look forward to working with our partners to facilitate this.

Dr Ellen McAdam
Director, Birmingham Museums Trust

Keith Bloor
Museums Manager, Stoke-on-Trent Museums

Historic England is able, in exceptional circumstances, to provide grant aid and specialist advice and expertise to ensure that extraordinary discoveries at imminent risk of loss can be recorded, interpreted and their stories told to everyone. The discovery of the Staffordshire Hoard in 2009 (when we were called English Heritage) was just such an exception, but one that proved exceptional in so very many ways as its story unfolded.

Such a research project, involving dozens of specialists, ground-breaking techniques, and deep expertise from across Europe – and taking place at multiple locations while museum displays were being planned and opened – was hugely complex and not without significant challenge. Its results are an enormous credit to the finders who reported it, to the museums and research institutions who enabled the research, and to the experts who very often gave much more of their time than expected in unlocking the fascinating narratives of the Hoard. It is also a great credit to those who managed this intricate and occasionally very difficult programme of work.

Our past helps us to understand who we are and where we came from. Ancient treasures such as those described and explored in the following pages speak to all of us, young and old, local and visitor alike, and Historic England is therefore extremely proud to have supported this project.

Barney Sloane
National Specialist Services Director, Historic England

ACKNOWLEDGEMENTS

The academic editors would like to thank all the contributors to this publication, for their expert studies and time given in consultation, and the many others who contributed to bringing it to fruition. A full list of all these can be found at *Cool 2017a. We would especially like to thank the Project Managers from Barbican Research Associates: Hilary Cool, who skilfully steered this project through its complex first two stages with clear-sighted determination; and Peter Guest, who, with constant good humour, guided and encouraged us through the final editing stage. Our thanks are also due to Barney Sloane of Historic England for his support. We are also extremely grateful to Jenni Butterworth, the project coordinator, for harmonising the many strands and facilitating the work in progress; a special debt is also owed to the curators and conservators of the two owning institutions, notably Deb Klemperer, David Symons, Deborah Cane and Pieta Greaves, who with unfailing good grace organised access to the material despite many concurrent demands. We should also like to thank the two advisory panels for their expert input and support throughout the preparation of this volume, with particular thanks to Sam Lucy, the final Chair of RPAP, for organising and raising funding for a valuable seminar on current work in the field of garnet analysis in February 2016. Throughout the duration of the Project, and indeed before its inception, we have benefited from discussion not only with fellow contributors, but with many other specialists, and from their insightful advice; in particular, Noel Adams, Sue Brunning, Thomas Calligaro, Martin Carver, David Ganz, Colin Haselgrove, Alexandra Hilgner, Catherine Hills, Elisabeth Okasha, Patrick Périn, Chris Scull and Sarah Semple. We thank them all for their support, their questions, and the challenges that they have presented. Lastly, we are most grateful for the constructive comments and suggestions for improvement made by the two anonymous referees. The final manuscript of this book was delivered to the publisher in June 2018.

Chris Fern would also like to thank the following individuals for answering enquiries, for their generous lending of expertise, or for providing access to collections or unpublished research: Kirsty Beecham, Alice Blackwell, David Bowsher, Sue Brunning, Esther Cameron, Joanna Caruth, Andy Chapman, Alexandra Hilgner, Sue Hirst, Fraser Hunter, Michelle Johns, Sam Lucy, Aude Mongiatti, Paul Mortimer, Susan La Niece, Chris Scull, Fleur Shearman, Jo Storey, Gabor Thomas, Robert White and Henry Yallop.

Barbican Research Associates would like to thank Barney Sloane and Tim Cromack of Historic England for their unfailing support and advice throughout the life of the project. They also thank Richard Abdy, Peter Reavill, James Sainsbury and numerous others for their help in sourcing some of the images used, and the 'Crisis or Continuity: hoarding in Iron Age and Roman Britain with special reference to the 3rd century AD' project, (University of Leicester and The British Museum) for the data used in Figure 9.1i in advance of their own publication.

Excavation, analysis and publication of the Hoard has been made possible by the continuous support and generous grant-aid of Historic England through the project *Contextualising Metal-Detected Discoveries: the Staffordshire Anglo-Saxon Hoard* (HE Project 5892).

Birmingham Archaeology was commissioned to undertake an emergency excavation of the Hoard site in 2009, and a short follow-up in 2010. In 2012, Archaeology Warwickshire co-ordinated further supervised metal-detecting and field walking surveys.

The helmet reconstructions were created by a team of specialist makers including The School of Jewellery at Birmingham City University (BCU), Royal Oak Armoury, Gallybagger Leather, Drakon Heritage and Conservation, and metalsmith Samantha Chilton, who worked collaboratively to bring the helmet to life, advised by the archaeologists.

RÉSUMÉ

Le Dépôt du Staffordshire est un trésor anglo-saxon exceptionnel qui date des 6e et 7e siècles. Il se compose essentiellement de pièces et de fragments, environ 4 kg d'or et 1,7 kg d'argent, propres à l'équipement des guerriers et d'un petit nombre d'objets clairement chrétiens. Ce trésor, qui fut découvert en 2009 par un détectoriste dans la paroisse civile de Hammerwich (west Midlands), fut acquis conjointement par les villes de Birmingham et Stoke-on-Trent, et repose au Birmingham Museums Trust et au Potteries Museum and Art Gallery. De 2012 à 2018, les propriétaires et Historic England ont financé un programme de recherche majeur afin de pouvoir présenter ce trésor au public aussi rapidement et de manière aussi complète que possible. En résultent ce volume et les ressources numériques associées (https://doi.org/10.5284/1041576) qui comprennent un catalogue complet et les documents de référence.

Avec leurs superbes filigranes, les grenats et le décor de style animalier, les objets du trésor reflètent la condition des élites de l'époque, alors que les premiers royaumes anglo-saxons naissaient de conflits pour la suprématie et par la conversion au christianisme. Cependant, le mauvais état des objets, la variété inégalée de types et le manque d'éléments relatifs au contexte funéraire rendent toute interprétation très difficile. Les arguments avancés ici ne sont pas définitifs, mais reposent toutefois sur un travail de conservation et une analyse archéologique (*chapitres 2–6*) très fouillés, et sont confrontés à nos connaissances archéologiques et historiques de l'Antiquité tardive et du haut Moyen Age (*chapitres 7–9*).

Le gros du matériel comprend des pièces métalliques de poignées d'épées (mais aucune lame en fer). On a relevé 74 pommeaux, mais la totalité des éléments de poignées pourrait bien renvoyer à 100 épées ou plus. Deux scramasaxes furent également identifiés, l'un avec un jeu complet de garnitures de poignée en or et grenats, tandis que seules quelques pièces proviennent de fourreaux ou de harnais. La reconstitution d'un casque recouvert de feuilles d'argent, partiellement dorées, et décoré d'animaux et de figures humaines est peut-être l'un des plus beaux exemplaires connus, fabriqués sans aucun doute pour un roi. Il y a de grandes garnitures en or, souvent par set et incrustées de grenats, et aussi quelques garnitures en argent. On ne connaît pas la fonction de toutes les pièces, mais certaines proviendraient de harnachements de prestige, tandis que d'autres pourraient faire partie d'ustensiles ecclésiastiques. Les objets chrétiens sont tout aussi remarquables : il s'agit d'une grande croix d'or et de grenats, d'une éventuelle branche de croix portant une inscription en latin et provenant peut-être d'un reliquaire conçu pour être emporté sur les champs de bataille, et d'une pièce complexe d'or et de grenats qui faisait certainement partie de la coiffe d'un des premiers évêques anglo-saxons.

Chacun de ces objets a sa propre « histoire ». L'étude des matériaux et des méthodes utilisés dans leur fabrication exige d'importantes analyses des alliages d'or, des types et sources de grenats, des rares vestiges organiques, ainsi que des techniques de fabrication des filigranes et des cloisonnés. On examine et illustre ici en détail le décor des objets et son importance iconographique. Ce trésor a notamment doublé le nombre d'objets anglo-saxons décorés dans le style animalier II, qui joue un rôle déterminant non seulement dans la datation du trésor, mais aussi dans la révision de notre façon d'appréhender l'évolution stylistique en Angleterre. Les objets révèlent aussi la façon dont furent utilisés les artefacts originaux et surtout comment ils furent systématiquement démontés avant leur enfouissement. Tous ces chapitres jettent un nouvel éclairage sur l'artisanat anglo-saxon, l'esthétique, l'iconographie et le comportement social, et étayent l'étude critique de la datation et de l'origine du trésor.

Le trésor révèle quatre phases qui se chevauchent : quelques objets en argent semblent vraiment être des objets de famille du 6e siècle ; la plus grande partie du matériel, caractérisée par un filigrane d'or, date de 570 à env. 630, ou alors, caractérisée par un cloisonné d'or

et de grenats, d'environ 610-650 ; une phase finale datée d'environ 630-660 comprend essentiellement des pièces en argent rehaussées de garnitures en or et de décors du style insulaire précoce, dont trois pommeaux exceptionnels à doubles « anneaux d'épée ». On propose de dater le dépôt du matériel entre env. 650 et env. 675. Il est fort vraisemblable que ces objets venaient de régions différentes, surtout des aires culturelles anglaises de l'Angleterre orientale, avec l'East Anglia et la Northumbrie peut-être. Les parallèles avec le Kent et le Sud de l'Angleterre sont rares; on relève une seule importation (scandinave) et il n'y a aucun objet de fabrication mercienne locale.

Les chapitres 7–9 présentent une série d'études de contextualisation pour mieux comprendre le type de dépôt que représente l'ensemble de Staffordshire, comment il fut réuni et pour quelle raison il fut enterré. La première d'entre elles vise le contexte historique, particulièrement de la Mercie, où fut déposé le trésor, et les règnes de ses rois du 7e siècle, Penda (626/632–655) et ses fils. La lutte de la Mercie contre d'autres royaumes anglais pour la suprématie et le rôle joué dans les conflits par les nouvelles convictions chrétiennes fournissent de précieuses informations sur le milieu politique et religieux à l'origine de ce trésor. La connaissance archéologique des pratiques funéraires anglo-saxonnes contemporaines, des systèmes de hiérarchisation sociale et de valorisation des ressources, ainsi que de l'histoire locale de l'occupation des terres offrent un outil supplémentaire pour évaluer le trésor. Il en va de même pour trois autres études de cas – centrées sur la Bretagne de la fin du 4e et du 5e siècles, l'Europe continentale germanique et la Scandinavie – qui investiguent des pratiques de dépôt quasi contemporaines. Elles offrent un large éventail d'exemples, mais pas vraiment de parallèles proches, soulignant ainsi le caractère exceptionnel du trésor.

Finalement, on considère que le dépôt de Staffordshire est un ensemble constituant pour l'essentiel un trésor royal. Bien que l'on ne puisse cerner le timing exact et les circonstances de l'arrivée de chaque objet en Mercie, une grande partie d'entre eux circulaient déjà depuis des décades sous forme de cadeaux offerts par des rois à leurs égaux ou leurs vassaux, et acquis au cours d'opérations guerrières (raids, butins de guerre, paiements compensatoires ou tributs). La plupart de ces objets fut probablement démontés peu de temps avant leur dépôt, mais on débat toujours de la question si ce fut pour recycler la matière première ou pour détruire leur pouvoir. Leur caractère sélectif et hautement symbolique favoriserait la deuxième option, mais il y a aussi la valeur économique que ce magot a dû représenter, surtout dans le royaume frontalier de Mercie. Malheureusement, les campagnes très courtes entreprises après la découverte du dépôt n'ont guère livré d'informations sur le contexte immédiat, et ainsi la motivation, de l'enterrement. Le site se trouve sur une crête dominant une route principale (Roman Watling Street) dans une zone périphérique, tant au point de vue culturel qu'environnemental : un contexte ambigu permettant plusieurs explications pour l'enterrement du dépôt.

Translation from the English by Yves Gautier.

ZUSAMMENFASSUNG

Der Hortfund von Staffordshire ist ein außergewöhnlicher angelsächsischer Schatzfund des sechsten und siebten nachchristlichen Jahrhunderts. Er besteht fast ausschließlich aus Beschlägen und Fragmenten, ca. 4 kg in Gold und ca. 1,7 kg in Silber, die aus Kriegsausrüstungen und einer kleinen Anzahl von eindeutig christlichen Objekten stammen. Im Jahr 2009 von einem Sondengänger in der Gemeinde Hammerwich in den West Midlands entdeckt, wurde er anschließend gemeinsam von Birmingham und Stoke-on-Trent City Councils erworben und vom Birmingham Museums Trust und The Potteries Museum and Art Gallery verwaltet. In den Jahren von 2012 bis 2018 finanzierten die Eigentümer und Historic England ein umfangreiches Forschungsprogramm, um die Details des Hortfundes schnellstmöglich und vollständig öffentlich zugänglich zu machen. Der vorliegende Band und die zugehörige digitale Ressource (https://doi.org/10.5284/1041576), die einen vollständigen Katalog und begleitende Auswertungen enthalten, stellen die Ergebnisse dar.

Die im Hort enthaltenen Artefakte mit ihren großartigen Filigran-, Granat- und Tierkunstdekorationen, widerspiegeln eindeutig die höchste Schicht der Gesellschaft zu einer Zeit, in der die ersten angelsächsischen Königreiche durch kompetitive Kriegsführung und Konvertierung zum Christentum gegründet wurden. Der beschädigte Zustand der Objekte, ihr beispielloser Artenreichtum und die spärlichen Hinweise bezüglich des Niederlegungskontextes machen seine Interpretation indessen zu einer Herausforderung. Die in diesem Band vorgelegten Argumente sind nicht endgültig, aber sie beruhen auf sorgfältigen investigativen Konservierungsarbeiten und archäologischer Analyse (*Kapitel 2–6*), die dem archäologischen und historischen Wissen über die weitere spätrömische und frühmittelalterliche Welt gegenübergestellt werden (*Kapitel 7–9*).

Nachgewiesen sind 74 Schwertknäufe, allerdings könnte es sich anhand der Basis aller aufgefundenen Griffbeschlagfragmente um die Reste von 100 oder mehr Schwertern handeln. Darüber hinaus sind zwei Saxe nachgewiesen, einer durch einen vollständigen Satz an Gold- und Granat-Hefthalterungen; dahingegen sind nur wenige Teile von Scheiden oder Trageriemen für Schwerter repräsentiert. Die Rekonstruktion eines mit Silber überzogenen, teilweise vergoldeten Helms mit Tier- und Figurenverzierung etabliert sich als das wohl feinste bekannte Exemplar, welches möglicherweise für einen König hergestellt wurde. Darüber hinaus gibt es auch eine große Zahl an Goldbeschlägen, oftmals als Satz mit Granateinlegearbeiten, sowie einige aus Silber. Nicht von allen Gegenständen lässt sich die Funktion klar erschließen, aber einige werden als Pferdegeschirr mit Prestigecharakter interpretiert, während andere von kirchlichen Gegenständen stammen könnten. Ebenso aufschlussreich sind die explizit christlichen Objekte: Dazu gehören ein großes Kreuz aus Gold und mit Granat, ein möglicher Arm eines Kreuzes mit lateinischer Inschrift, der aus einem für den Einsatz auf dem Schlachtfeld bestimmten Reliquiar stammen könnte, sowie eine komplexe Armierung aus Gold und Granat, welche zu einer frühen angelsächsischen Kopfbedeckung eines Bischofs gehört haben könnte.

Ein jedes dieser Objekte hat eine „Lebensgeschichte". Die Untersuchung der Materialien wie deren Herstellungsmethoden umfasst eine wichtige Analyse der Goldlegierungen, der Granatarten wie deren Herkunft genauso wie die der spärlichen organischen Überreste und der Herstellungstechniken der Filigran- und Cloisonnéarbeiten. Die auf den Objekten angebrachte Dekoration und ihre ikonographische Bedeutung werden im Detail erforscht und illustriert. Insbesondere hat sich durch diesen Hortfund die Anzahl der bisher bekannten angelsächsischen Objekte im Tierverzierungsstil II verdoppelt, was nicht nur eine wesentliche Rolle bei der Datierung des Hortes spielt, sondern auch bei der Überprüfung des gegenwärtigen Verständnisses für die Entwicklung dieses Stils in England. Auch liefern die Artefakte Hinweise zu ihrer ursprünglichen Verwendung und vor allem dazu, wie sie vor der Niederlegung systematisch demontiert wurden. Gemeinsam werfen die Kapitel 2–6 ein neues Licht auf das angelsächsische Kunsthandwerk, Ästhetik, Ikonographie und soziales Verhalten und untermauern die kritische Auseinandersetzung mit Datierung und Herkunft dieses Hortfundes.

Insgesamt konnten vier sich überlappende „Hortfund-Phasen" identifiziert werden: Einige Objekte in Silber scheinen tatsächlich Erbstücke des sechsten Jahrhunderts zu sein; der Großteil des Materials stammt aus der Zeit von etwa 570–630 n. Chr.,

was hauptsächlich durch die Goldfiligranarbeit belegt wird; insbesondere die Gold- und Granatcloisonnéarbeiten kennzeichnen Objekte aus der Zeit von ungefähr 610–650. Eine letzte Phase, die von ca. 630–660 reichte, wird hauptsächlich durch silberne und goldene Beschläge repräsentiert, die im „Early Insular"-Stil verziert sind, darunter befinden sich drei außergewöhnliche Schwertknäufe mit doppelten, integralen „Schwertringen". Aufgrund dessen wird eine Datierung der Niederlegung dieses Hortfundes zwischen ca. 650 und 675 vorgeschlagen. Es ist sehr wahrscheinlich, dass das Material aus unterschiedlichen Regionen stammt, vor allem aus den anglischen Kulturgebieten des östlichen Englands einschließlich East Anglia, und möglicherweise Northumbria. Parallelen zu Fundstücken aus Kent und Südengland sind jedoch rar. Bisher ist nur ein (skandinavischer) Import bekannt, und Nachweise lokaler Manufaktur aus Mercia liegen nicht vor.

Um zu verstehen, um welche Art von Hortfund es sich bei dem Staffordshire-Komplex handelt, wie er zusammengetragen und weshalb er niedergelegt wurde, wird in *Kapitel 7–9* in einer Reihe kontextualisierender Beiträge erläutert. Der erste Beitrag konzentriert sich auf den historischen Kontext, insbesondere auf Mercia, wo der Hort deponiert wurde, sowie auf die Regentschaft seiner Könige des 7. Jahrhunderts, wie die Pendas (ca. 626 / 32–655) und seiner Söhne. Die Konkurrenz von Mercia zu anderen englischen Königreichen und die Rolle der damaligen christlichen Einstellungen bei der Kriegsführung liefern wichtige Einblicke in das politische und religiöse Milieu, das zur Entstehung des Hortes führte. Archäologische Kenntnisse der angelsächsischen Bestattungspraxis, Systeme der sozialen Schichtung und Ressourcenbewertung sowie die lokale Siedlungsgeschichte bieten ein ergänzendes Mittel zur Beurteilung des Hortfundes. Dazu kommen noch drei Fallstudien – mit Schwerpunkt auf Britannien im späten vierten und fünften Jahrhundert, dem Kontinentalgermanischen Europa und Skandinavien – welche die ungefähr zeitgenössische Praktiken des Hortens erkunden. Diese bieten eine umfassende Reihe von Beispielen, aber keine wirklich engen Parallelen, wodurch der außergewöhnliche Charakter dieses Hortes unterstrichen wird.

Schließlich wird argumentiert, dass der Staffordshire-Hort größtenteils eine Anhäufung von im Wesentlichen königlichen Schätzen darstellt. Obwohl der genaue Zeitpunkt sowie die Wege, auf denen jedes dieser Stücke Mercia erreichte, unklar bleiben müssen, waren viele der Objekte schon mehrere Jahrzehnte alt. Sie zirkulierten durch Schenkungen von Königen an ihre Gleichgestellten und Untergebenen und stellen die Früchte der Kriegsführung (durch Überfälle, Beute von Schlachtfeldern, Entschädigungszahlungen oder Tribute) dar. Vermutlich wurden die meisten Objekte erst kurz vor ihrer Vergrabung zerkleinert, die Frage, ob sie jedoch einfach als Rohstoff recycelt oder ihre Macht zerstört werden sollte, bleibt offen. Ihr außergewöhnlicher und wahrscheinlich höchst symbolischer Charakter könnte Letzteres untermauern; allerdings ist der damalige wirtschaftliche Wert, den das Gold als solches vor allem im Grenzkönigreich Mercia dargestellt haben muss, unbestreitbar. Unglücklicherweise lieferten die kurzen Zeitfenster der Feldforschung, die nach der Auffindung vor Ort durchgeführt wurden, wenig Information über den unmittelbaren Kontext und damit die Motivation für die Vergrabung. Der Fundplatz befindet sich jedoch auf einem Bergrücken, oberhalb einer wichtigen römischen Hauptverbindungsachse (Watling Street) und in einer sowohl kulturellen wie ökologischen Randzone: Eine ambivalente Umgebung, die mehr als eine Erklärung für die Vergrabung des Hortes zulässt.

Translation from the English by Christine Leitschuh-Weber.

INTRODUCTION

LESLIE WEBSTER, TANIA DICKINSON AND CHRIS FERN

From the moment of its discovery in 2009, the extraordinary character of the Staffordshire Hoard has been clear. It was not simply its precious-metal content – the largest Anglo-Saxon gold treasure yet found – that caught attention, but its unparalleled composition, which held out possibilities for radical new understandings of a formative period of national and international history. The Hoard is dominated by fittings from sword-hilts, most obviously pommels, but early on parts of a helmet were recognisable and also explicitly Christian objects, including a gold cross and a Latin-inscribed gold strip. Superbly crafted with filigree, garnet cloisonné and animal-art decoration, there was no doubting that the objects dated from the sixth to seventh century AD and that they represented the highest levels of society, secular and religious. In many ways, they exemplified the established picture of the seventh century, which can be drawn from narrative histories,[1] hagiography,[2] poetry[3] and archaeology,[4] as the transformative period when the first Anglo-Saxon kingdoms were established through competitive warfare and consolidated through conversion to Christianity (Map 1 and 2).[5] Yet as much as individual objects in the Hoard can be related to other finds from this milieu, most notably 'princely' burials such as those at Sutton Hoo (Suffolk) and Prittlewell (Essex), the singularity of their quantity, deliberately damaged condition and context had not been encountered before, whether in burials, which until now have always provided the scaffolding of early Anglo-Saxon archaeology, or in hoards from Britain or Europe. The Staffordshire Hoard thus presented scholarship with a fundamental challenge: what sort of an assemblage was it, and how could it be explained?

At the same time, the fact that so many and such diverse items, some of them yet to be fully identified, were found together in an apparently novel context created a special richness of data. There was much potential to discover quite new relationships between different sources and types of information, including artefacts, burials, manuscripts and literary texts, and so to reveal new perspectives on the world, both physical and mental, that had produced them. Embodying both elite military culture and the practices of the early church, the Hoard constituted a precious gift from the past and a very specific lens through which to glimpse Anglo-Saxon England at a time of radical transformations – political, economic, social and religious. Such wide expectations added to the challenge that the archaeologists, conservators, scientists and historians involved in publication of the Hoard had to face.

One particular problem that had to be addressed was whether using the word 'hoard' for the material would prejudice interpretation. Sometimes in the discussions to follow an impartial term – collection or assemblage – has been used as an alternative, but on the whole it has proved simpler to refer to the find as the 'Hoard', the capital letter indicating the entity rather than its nature.

SETTING THE AGENDA: AIMS, QUESTIONS AND CHALLENGES

The research agenda embodied in the publication has evolved progressively. The issues were first presented and publicly debated in March 2010 at the Staffordshire Hoard Symposium, held in the British Museum and organised by the Portable Antiquities Scheme (PAS). Twenty-seven specialists, drawn from a wide span of relevant fields, gave short papers.[6] Ideas and insights gained from them and participants on the day were fed into a set of research and publication objectives, drawn up by the Research Advisory Panel appointed in 2010 to aid investigation.[7] These proposals were succinctly incorporated into the main questions and objectives that structured the Project Designs commissioned by Historic England.[8] The overarching aim was set out in those documents: to make the details of the find available to both the scholarly community and the general public as promptly as possible, within the bounds of good scholarship. Necessarily, Stage 1 of the Project (March 2012 to May 2014) focused on primary objectives, the fundamental tasks of conserving, identifying and reconstructing the fragmented contents of the Hoard, though towards the end of this stage (March 2014) a seminar for the project team and invited specialists allowed additional refinements to be made to the research agenda. Stage 2 of the Project ran from February 2015 to June 2017; it concentrated on completion of a full catalogue and turned the focus onto the wider research questions. Following academic peer review, a four-month 'Edit Stage' brought the Project to a conclusion at the start of July 2018.

The research questions divided into three orders, each containing a range of subsidiary questions. Of these, the most essential was that which addressed the intrinsic nature of the Hoard itself. It started with the simple but essential issue of the Hoard's composition: what

types, quantities and groupings of object are present? The answers have changed progressively throughout the course of the research.⁹ From this, developed questions about how the objects were made and decorated, when and where, and crucially at what date was the Hoard deposited. Various methodological approaches, apart from standard typology and style analysis, needed to be investigated here: for example, whether dating on the basis of gold-alloy analysis or radiocarbon assay using surviving organic material might be possible (in the event, neither was). More successful was examination of the life-histories of individual objects, as revealed through evidence of their stages of manufacture, use (wear, repair and modification) and damage or disassembly.

Allied to these questions were those that addressed the Hoard's context, both its immediate physical context and its location in the local archaeological and historical landscape. Was it buried in a container? Could it be determined whether it had been a single, complete deposit, or part of a larger treasure? Was it associated with any contemporary landscape feature or features? Taking the answers to these two lines of enquiry together, and invoking external evidence drawn from what was already known about the late Roman and early medieval worlds that produced the Hoard, only then was it possible to explore the difficult questions of why it had been assembled and finally buried.

A second order of questions addressed the wider context, turning the focus round from the interpretation of the Hoard itself, to asking what it could tell us about seventh-century life. For example, what does the collection reveal about craft and manufacturing practices? What does it tell us about the changing role and significance of Germanic animal art in this period? What are the implications arising from assessment of the date of the Hoard for the context and dating of other classes of artefact, such as the earliest Insular manuscripts? What did the Hoard represent in terms of contemporary value, and in particular how might it shed light on the gold and silver economy of the seventh century? Finally, how might it extend understanding of the exercise of power and the interactions of seventh-century polities – the roles of warfare, elite military culture and the beliefs and practices of the nascent Anglo-Saxon church? There was no expectation that such a legion of complex questions could be fully or equally addressed in this publication, but it was important that they provided a contextual framework for evaluation of the Hoard, and guided presentation of the data that would be necessary to those seeking answers in the future.

These days research projects also need to reflect on the benefits (and drawbacks) that have accrued from their work, and the impact that these might have on life in the present day. So a third order of questions addressed how the Hoard had affected the management of cultural heritage and its presentation to the public, especially within the West Midlands, and asked what lessons might be learnt from this particular experience to guide policies and practices in the future.

There is no doubt that this was an ambitious agenda overall, especially given the primary aim of accomplishing it within a tight time-frame. Although the Project was very fortunate in receiving an exceptional degree of financial support from Historic England, as well as significant funding and support from other sources, meeting its goal did not come without some serious challenges. Some were intrinsic; the circumstances of the discovery meant that there was no intact stratigraphic evidence for the nature of the deposit, while the extremely small and fragile condition of many fragments, especially the die-impressed sheets, required painstaking and time-consuming conservation, reconstruction and research before their function and decorative schemes could begin to be understood.¹⁰ Other potentially limiting factors were externally driven; in particular, the exceptional interest generated by the discovery of the Hoard had to be satisfied by programmes of public engagement, particularly permanent and temporary exhibitions of the material, in the United Kingdom and in the United States. This meant that, unlike most post-excavation projects, the work had to accommodate the need for objects to be publicly visible, which posed significant logistical demands on the curators, conservators and specialists in order to ensure that the conservation and research programme could keep to schedule.¹¹ In addition, a programme of selective analysis and conservation, funded by National Geographic and already in progress when the Project began, had to be factored into the schedule.

From the beginning, it was also acknowledged that some of the research questions which had been identified could not be covered by the available funding, or were not achievable within the allotted timescale. Chief among these is the survey of the wider landscape context, which, though clearly desirable, would be in itself a major research project, involving fieldwork, place-name and documentary research. The publication has drawn, however, on a survey of data held in the existing unpublished literature for a 10km radial zone around the Hoard site, and on the work of Della Hooke and David Parsons in characterising the immediate landscape and some place-name evidence.¹²

In the same vein, while the primary aim was to place interpretation of the Hoard on a firm foundation, on which future researchers could build, it was always recognised that this publication could

not be definitive or for all time. We did not expect that the many contributors to this volume, coming from a range of disciplines and backgrounds, should speak with a single voice, and indeed not all do, though we have endeavoured to draw attention in endnotes to any points of disagreement. We expect that the discussions and interpretations offered here will be challenged as intellectual fashions change, new questions are asked and new analytical techniques are developed that can provide more information about the objects. Some possibilities are suggested in the *Afterword* at the end of the book.

THE STRUCTURE OF THE PUBLICATION

The format of the final publication was planned to consist of three integrated strands, to ensure that future researchers could easily access all the data resulting from the Project's work. This book forms one strand; it is divided into three parts. The *first part* focuses on the Hoard itself. *Chapter 1* takes the story of the Hoard from its initial discovery, through descriptions of the archaeological fieldwork that ensued and the processes of acquisition and setting up of the research project, to an overview of the conservation programme; it concludes with an updated assessment of the finds-context of the fragmentary objects that constitute the Hoard. *Chapter 2* presents the objects themselves, characterising and interpreting their forms and functions. *Chapter 3* considers the workshop practices that lay behind the objects, the materials from which they were made and the methods used in their manufacture. *Chapter 4* explores the evidence of wear, modification, repair and damage on the objects, which are the key to their life-histories and particularly to the ultimate fate of the Hoard. In *Chapter 5* the wealth of decoration displayed by the objects is presented, and the artistic styles and iconography of the motifs and designs are considered. *Chapter 6* brings together and reviews the evidence and arguments for dating the objects in the Hoard, and the places where they were possibly made, concluding with a suggested date of deposition for the Hoard.

The *second part* of this book presents a series of contextualising essays that describe the world which produced the objects in the Hoard and what could have motivated people at the time to consign such wealth to the ground. *Chapter 7* considers these problems from the perspective of Anglo-Saxon political and religious history, while *Chapter 8* examines them from the point of view of archaeology and material culture. *Chapter 9* turns to the nature of hoarding practice more generally, through the medium of three case studies at closely comparable times and in closely comparable regions – late fourth- and fifth-century Britain, mainland Germanic Europe and Scandinavia – against which the Hoard can be judged. All the research findings are drawn together in the concluding *Chapter 10* to provide an overview of current understanding of the Hoard and its meaning. The *Afterword* reviews the impact that the Hoard and its study has had on the understanding of Anglo-Saxon culture and society in the seventh century, and suggests some possible avenues for further research. It concludes by exploring the impact that the recovery of the Hoard has had on public engagement with the past, especially in the local region.

The *third part* of the book contains the abbreviated catalogue, which comprises images of the majority of the Hoard objects, detailed entries of the objects listed by type, and select sets of hilt-fittings.

Finally, at the end of the book can be found supporting apparatus, including a brief guide to the digital component of the publication, a glossary of technical terms, endnotes, and the bibliography.

The second and third strands of the integrated publication are available digitally through the Archaeological Data Service.[13] Within the body of this text references preceded by an asterisk (*) are digital parts of this publication. The second strand consists of thirty detailed specialist reports and surveys. These underpin the findings and conclusions presented in the first part of this book. They include, among other things, the full report on the excavations on the Hoard site and all the detailed accounts of the many scientific analyses that have been carried out.

The third strand is the full catalogue. In any finds-based study it is the catalogue that will have the longest life, as researchers ask new questions. Here the catalogue is available digitally in two forms.[14] A database online provides the full catalogue entry, multiple photographic views of every object and selected drawings, together with detailed analytical results and conservation records; these allow any individual item or fragment to be closely inspected. Also online and available to download is a more traditional illustrated catalogue presented as a series of pdf files.

The Hoard itself is jointly curated by the Potteries Museum & Art Gallery in Stoke-on-Trent[15] and the Birmingham Museums Trust.[16] The main permanent exhibitions of the objects are in the Potteries Museum and the Birmingham Museum & Art Gallery. Smaller displays are normally also to be found at Lichfield Cathedral & Tamworth Castle.

Map 1. The major kingdoms of mainland Britain in the seventh century and battles mentioned in the text. *Drawing*: C. Fern.

MAP 2 xxxv

★ Hoard

● 'Princely' burial

1. Sutton Hoo (Suffolk)
2. Broomfield (Essex)
3. Prittlewell (Essex)
4. Taplow (Bucks.)
5. Asthall (Oxon)
6. Caenby (Lincs)

⌒ Other burial or cemetery

7. Swallowcliffe Down (Wilts)
8. Wollaston (Northants)
9. Benty Grange (Derbs)
10. Chessell Down (IoW)
11. Faversham (Kent)
12. Sarre (Kent)
13. Crundale (Kent)
14. Lyminge (Kent)
15. Dover Buckland (Kent)
16. Trumpington (Cambs)
17. Wilton (Suffolk)
18. Harford Farm (Norfolk)
19. Tattershall Thorpe (Lincs)
20. Barlaston (Staffs)
21. Loftus (N. Yorks)
22. Acklam Wold (N. Yorks)

▲ Settlement

23. *Hamwic* (Southampton, Hants)
24. Sutton Courtenay (Oxon)
25. London
26. Ipswich (Suffolk)
27. Rendlesham (Suffolk)
28. Tamworth (Staffs)
29. Catholme (Staffs)
30. Droitwich (Worcs)
31. Bamburgh (Northumb)
32. Yeavering (Northumb)
33. Dunadd (Argyll and Bute)
34. Mote of Mark (Dumfries and Galloway)
35. Dinas Powys (V. of Glamorgan)

■ Monastic or church centre

36. Canterbury (Kent)
37. Rochester (Kent)
38. Lichfield (Staffs)
39. Hanbury (Staffs)
40. Repton (Derbs)
41. Bardney (Lincs)
42. York (Yorks)
43. Ripon (N. Yorks)
44. Hexham (Northumb)
45. Monkwearmouth (Tyne and Wear)
46. Jarrow (Tyne and Wear)
47. Lindisfarne (Northumb)
48. Bangor (Gwynedd)

● Isolated find

49. Market Rasen (Lincs)
50. Forsbrook (Staffs)
51. Dinham (Shrops)

Map 2. Main places mentioned in the text. *Drawing*: C. Fern.

PART I

THE
HOARD

CHAPTER ONE

CHAPTER ONE
FROM DISCOVERY TO CONSERVATION

DISCOVERY

H E M Cool

On Sunday 5 July 2009 Terry Herbert was metal-detecting in a field in Staffordshire, in the parish of Hammerwich.[1] The field (figs 1.1–1.3) lies to the south of the modern A5(T), to the west of the M6 Toll and to the east of Hanney Hay Road. The part of the A5(T) that borders it follows the line of the Roman Watling Street, which was the main diagonal artery of the Roman province running from Dover through London to Wroxeter. The land forms part of Semi Bungalow Farm, owned by Fred Johnson, and Herbert was detecting with Johnson's written permission. On that Sunday he started to find gold objects. Over the following days he was to recover hundreds more gold and silver pieces from the plough-soil, some even lying on the surface, together with twenty-one blocks of soil that gave a positive response to the metal detector.[2]

In England and Wales metal-detecting is a legal pursuit, provided that the detectorist has the permission of the landowner. In 1997, in order to aid the voluntary recording of archaeological artefacts found by detectorists and other members of the public, the UK Government's Department of Culture, Media and Sport set up the Portable Antiquities Scheme (PAS).[3] The Department allocates monies to organisations, usually museums, which then provide top-up funds to employ finds liaison officers (FLOs). The FLOs are the natural point of contact for any detectorist making archaeological finds. In 2009, the FLO for Staffordshire and West Midlands County was Duncan Slarke. This post is jointly match-funded by The Potteries Museum & Art Gallery, Stoke-on-Trent (PMAG), which is the designated repository for archaeological material from Staffordshire, and Birmingham Museum and Art Gallery (BMAG) and is employed through the latter museum. Herbert duly informed Slarke of the find. As is explained in the section about acquisition below,[4] special circumstances surround finds of gold and silver as they are subject to the Treasure Act 1996. Acting on the legal requirements of the Act, Slarke notified Andrew Haigh, HM Coroner for Staffordshire South. He also alerted officers of Staffordshire County Council, the Treasure Registrar and other PAS representatives based in the British Museum, and the curators of archaeology at BMAG and PMAG.

The extraordinary and unexpected find obviously called for emergency excavations to try to establish its context and to recover any additional items that might still be undiscovered. At a meeting on 21 July 2009 it was decided that Staffordshire County Council archaeologists would make a small trial excavation in the area from which the material had come. Historic England (HE) was notified the same day and agreed to fund an emergency excavation, which Birmingham Archaeology was commissioned to carry out.[5] During the excavations Herbert continued to provide assistance by metal-detecting.

Fig 1.1. View of the field where the Hoard was found, looking north-west along the ridge to Watling Street (A5). *Photograph* © Birmingham Archaeology.

Fig 1.2. The Hoard in its local Midlands setting with overlaid data on Roman and Anglo-Saxon finds and sites. (The red circle is the boundary of the survey reported by Goodwin; the PAS and treasure finds are broadly contemporary with the Hoard; the map includes data from the Staffordshire Historic Environment Record, © Staffordshire County Council. See *Goodwin 2016.) *Drawing*: N. Dodds; © AJ Archaeology.

The excavations took place under conditions of considerable secrecy to avoid looting. Each evening all new finds were taken to Birmingham where a preliminary catalogue was being prepared by Kevin Leahy, the National Finds Adviser for early medieval metalwork within the PAS. This catalogue dealt with both the original finds and those recovered during the excavations. By the time Birmingham Archaeology completed their work, it consisted of 1,381 records of material thought likely to be treasure, including soil blocks whose contents were unknown, with a further thirty-seven records of other material.

Fig 1.3. Detailed location map of the Hoard site. *Drawing*: N. Dodds; © AJ Archaeology.

In 2010 Birmingham Archaeology undertook a short follow-up phase of fieldwork; and, in 2012, after the field had been ploughed for the first time since the 2009 discoveries, Archaeology Warwickshire co-ordinated further supervised metal-detecting and field-walking surveys, which recovered another eighty-six fragments and pieces from the Hoard. Summaries of the fieldwork carried out in 2009–10 and in 2012 are presented in the next two sections, with more detailed reports available digitally.[6]

FIELDWORK OF 2009 AND 2010

Alex Jones, Eamonn Baldwin and Alison Deegan

The Hoard was located (fig 1.1) on the south-western facing shoulder of a north-west to south-east aligned ridge at approximately the 130m contour. The northern edge of this ridge was truncated by successive widening of the adjoining A5 road between 1959 and 2003. The underlying geology of the findspot is Wildmoor sandstone.[7] The soils in the west and south of the field, including the findspot, comprise free-draining, slightly acid sandy soils, with low fertility (Soilscape 10);[8] slightly acid, loamy and clayey soils with impeded drainage and moderate to high fertility characterise the remainder of the field (Soilscape 8). The field had been intermittently ploughed in the past, most notably in the autumn of the year prior to the Hoard's discovery. A variety of crops including carrots and potatoes had previously been cultivated, but at the time of discovery the field was under pasture.

No previous archaeological work has been undertaken within the field in which the Hoard was discovered, although extensive excavations were conducted in connection with the nearby M6 Toll.[9] In 2009, following the initial discovery, a programme of field investigation was devised, that concentrated resources on the safe, systematic and timely recovery of the Hoard (fig 1.4). It included a geophysical survey of the entire field in which the Hoard was found to provide a broader understanding of the archaeological context. Little was previously known about Anglo-Saxon activity in the surrounding area, although a few stray finds of possibly Roman or Anglo-Saxon copper-alloy or lead objects had been recovered, mostly by detectorists (fig 1.2). In 2010 a further geophysical survey was undertaken and the area surrounding the discovery was trenched to provide more detailed information on the Hoard's context. Later, an assessment of aerial photographs within an area of 135ha centred on the Hoard was undertaken to help understanding of its landscape context. The following sections provide a summary of the methodology and results. A more detailed version is available digitally.[10]

Fig 1.4. Areas investigated at the Hoard site. *Drawing*: N. Dodds; © AJ Archaeology (aerial photography data courtesy of A. Deegan).

Fig 1.5. General view of the recovery excavation (view: north-east). *Image:* © Birmingham Archaeology.

Fieldwork methodology

The first stage of archaeological fieldwork involved the hand-excavation of a 1m² test-pit, begun on 22 July and completed on 29 July, centred on the original discovery (fig 1.4). It confirmed that the Hoard derived from the plough-soil, as initially suggested by Herbert. Many further items of gold were recovered from the test-pit. No evidence was found of any archaeological, or possibly archaeological, features (such as pits or ditches) during the careful hand-excavation of the test-pit, despite the identification and hand-cleaning of the underlying subsoil surface, into which any features (if there were any) would have been cut.

While test-pitting was underway, Herbert carefully scanned the area surrounding the original discovery with a metal detector to establish the possible extent of the Hoard, so that a strategy could be devised for its full and safe recovery. This scanning suggested that the Hoard was scattered within a zone approximately 20m² around the original findspot.

The information from test-pitting and scanning allowed a strategy to be developed for the recovery of the Hoard, which was suggested to comprise an extensive scatter confined within the plough-soil. Because the location was highly visible from the A5 road, the Hoard was judged to be at extreme risk from illicit metal-detecting.[11] For this reason, 24-hour security was maintained throughout the recovery excavation, which began on 30 July and was completed on 10 August.

The excavation grid was laid out in 1m grid squares within an area 20m², centred on the original discovery, using a GPS in Ordnance Survey (OS) National Grid co-ordinates (fig 1.5). During the

▲ **Fig 1.6.** Hand-excavation in grid squares. *Photograph:* © Birmingham Archaeology.

▲ **Fig 1.7.** Find with bag showing small find (**500**) and grid-square number (Q10). *Photograph:* © Birmingham Archaeology.

▶ **Fig 1.8.** Scanning hand-dug soil with a metal-detector. *Photograph:* © Birmingham Archaeology.

recovery excavation, each field archaeologist excavated one 1m grid square at a time to ensure that the finds were kept separate (fig 1.6). Each find was allocated a unique small find number and grid square number (fig 1.7), so that the spatial distribution of the material could be plotted later. Within each metre square the plough-soil was carefully hand-excavated in spits of 0.1m in depth down to the natural subsoil, with collection of all finds or possible finds. The soil from each spit, including the turf, was visually searched for finds and re-checked with a metal detector operated by Herbert.

Initially, all the spoil was bagged by grid square and wet-sieved through a 5mm sieve using a York flotation tank, with collection of all finds from the flots,[12] in order to maximise finds recovery, including the smallest items. Wet sieving operated for two days only, however, because flotation was very slow, and illicit metal-detecting continued to be a severe threat. A new strategy was therefore devised to expedite recovery of the Hoard. This involved continued hand-excavation in 0.1m spits within one metre squares, but no wet sieving. To maximise finds recovery, the soil from each grid square was spread over plywood sheets. The soil was sorted by hand and re-checked for finds visually and by using a metal detector operated by Herbert (fig 1.8). The finds thus continued to be recorded by 0.1m spits within metre squares. A team of six archaeologists systematically excavated the plough-soil, working outwards from the initial discovery, until no more than one find was recovered from each grid square. An area measuring a maximum of 12m by 15m was excavated, a total of 152m².

While the hand-excavation was proceeding, a magnetometer survey of the entire field was undertaken to provide an initial understanding of the immediate context. Following completion of the hand-excavation, an area measuring approximately 50m² in the north-western corner of the field was gridded out in 5m squares, which were systematically scanned with a metal detector by Herbert to establish if further items associated with the Hoard were located outside the area excavated (fig 1.4). Possible signals were marked and hand-excavated, but only post-medieval artefacts were found. Herbert also scanned the excavated topsoil during the mechanical backfilling of the excavated area, and a number of gold or silver objects were recovered. This survey was begun on 10 August and was completed on 14 August.

The final stage of fieldwork in 2009 comprised archaeological monitoring during scanning of the area surrounding the Hoard by a team from the Home Office Scientific Investigation Branch (fig 1.4). This was completed on 21 August; no finds associated with the Hoard were recovered from this deployment.

A second phase of fieldwork was undertaken in early 2010 to provide further information on the archaeological context. A resistivity survey within an area of 1ha including the Hoard findspot (fig 1.3) was followed by the excavation of five trial-trenches to ground-truth a selection of the anomalies identified by the 2009 magnetometer and 2010 resistivity survey outside the area hand-excavated in 2009 (fig 1.4). In each trench the plough-soil was removed by a JCB excavator working under continuous archaeological supervision. The surface of the natural subsoil exposed by machining was hand-cleaned to define any archaeological features or possible features, which were tested by hand-excavation. Eleven test-pits were also dug to profile deposits across the natural ridge. Spoil from mechanical or hand-excavation was carefully scanned with a metal detector.

PART I | THE HOARD

2 [4104]

9 [3903] [3905]

4 [4404] **5** [4406]

[1007]

[4203] **3**

[1000]

[1001]

1

[4005]

▬ 2010 trenches

▭ Geophysical anomaly

0 20m

Fieldwork results

Geophysical (magnetometer) survey, 2009

Eamonn Baldwin

A number of features of possible archaeological interest was identified.[13] A weakly magnetic curvilinear anomaly [1000] was recorded for a distance of 55m to the south-west of the Hoard findspot. It appeared to measure 0.8–1.8m in width. A further weakly magnetic anomaly [1001] runs south-west to north-east. It coincides with the line of a former field boundary. Other anomalies were pit-like [1002, not illustrated] or linear, aligned east–west [1003, not illustrated]. Although the latter do not conform to the current direction of ploughing, they are the result of earlier ploughing. Strongly magnetic responses [1005, not illustrated] were probably caused by the localised burning of crops.

Recovery excavation, 2009

A total of 1,381 finds associated with the Hoard, mostly comprising gold items and exhibiting little plough damage, were recovered by hand-excavation from the plough-soil within one metre squares.[14] In addition, a total of thirty-seven items of later date were recovered.

No features or possible features associated with the Hoard were identified by careful hand-cleaning of the subsoil surface. The natural subsoil comprised a red-brown silt-clay [1021] and an area of weathered sandstone [1008]. The main feature identified [1007] was slightly curvilinear in plan, mainly aligned north-west to south-east (fig 1.9). Approximately coincident with magnetometer anomaly [1000], it measured a maximum of 1.5m in width and 0.4m in depth and had a very irregular profile. It is interpreted as an ice wedge, a feature caused by the freezing and thawing of ice. The other excavated features (not illustrated), including a gully [1013]/[1015] and a post-hole [1012], were modern in origin. A number of plough scars were recorded cutting the natural subsoil. The natural subsoil was overlain by dark brown silt-sand [1000] plough-soil. Three test-pits were dug beyond the area excavated to test possible pit-like magnetometer anomalies, but no features or possible features could be identified.

Fig 1.9. Simplified plan of the main features identified by fieldwork and aerial photography (plotting of the air-photograph features is approximate only). *Drawing:* N. Dodds. © AJ Archaeology (trench and geophysical data courtesy of Birmingham Archaeology).

Trenching, 2010

No features or possible features associated with the Hoard were identified, and no associated finds were recovered. In Trench 1 an east–west aligned gully [4005] contained a single prehistoric worked flint. In Trench 2 was an east–west aligned feature [4104], interpreted as another ice wedge (fig 1.10). In Trench 3 was an east–west aligned gully [4203] (fig 1.11), which was probably also recorded in Trench 5 following a north-west–south-east alignment [4406]. Also in Trench 5 was a broad ditch [4404] following the same alignment, which is a former field boundary. Two undated post-holes [3903] and [3905] were recorded in test-pit 9.

Fig 1.10. Excavating ice-wedge [4104] in Trench 2. *Photograph:* © Birmingham Archaeology.

Fig 1.11. Gully [4203] in Trench 4 (view: south). *Photograph:* © Birmingham Archaeology.

Aerial photography assessment
Alison Deegan

The field in which the Hoard was found was divided by a north-west–south-east field boundary (AP O) which survived as a hedgerow on post-war aerial photographs, but had been removed by 1971 (see fig 1.4). Thereafter it appeared as a diffuse cropmark and soilmark. On the 1968 air photo there is a perceptible difference in ground level between the west and east sides of the boundary (with the former higher than the latter), but this appears to have been reduced by ploughing once the field boundary was removed. This feature corresponds with field boundary [*4404*] in Trench 5.

Several air photographs show a curvilinear cropmark close to the Hoard findspot (AP N) (see fig 1.4). This feature lies on one of the highest points of the natural ridge and just 50m to the south of the modern A5(T) road. The appearance of the cropmarks varies between the photographs, but the consistency of their position indicates that they are caused by the same underlying feature. Taken together these features are oval in plan, measuring approximately 50m by 40m. The resistivity survey identified a curvilinear anomaly which appeared to approximately correspond with the southern side of the curvilinear cropmark. Trenching identified an ice wedge [*4104*] in this location (Trench 2).

Other undated cropmarks could be of medieval or post-medieval origin. The cropmarks at AP Q (not illustrated) to the south-east of the Hoard findspot suggest a pair of conjoined enclosures, although it is not certain that the marks are of archaeological origin. However, they lie close to the site of an excavated Romano-British aisled building.[15]

A detailed version of this report is available digitally,[16] including the sources consulted and methodology.

Discussion

Excavation of the 1m test-pit confirmed that the Hoard finds were confined to the plough-soil, as first suggested by Herbert. No features or possible features associated with the Hoard were found by the 2009 and 2010 fieldwork. The absence of any associated features cut into the subsoil would suggest that any feature, such as a pit, into which the Hoard had originally been placed, had been scoured-out entirely by plough truncation. From at least 1948 (the date of the earliest aerial photograph) the field had been sown with grass or cereals, root or leaf crops. The recovery excavation demonstrated that ploughing had spread the Hoard over an area of 152m². Including the material recovered by metal-detecting outside the excavated area, the Hoard extended over an area of 210m². A plot of the object distributions may suggest that the material could have derived from a single source, such as a pit.[17] It is notable that the site was deep ploughed in late 2008.

Notwithstanding that no features or possible features associated with the Hoard were found, it is nevertheless important to reconstruct the site history in order to appreciate why the Hoard had survived. The earliest datable feature may have been the east–west aligned gully [*4005*] in Trench 1, which contained a single prehistoric flint flake with traces of re-working. The broader Roman context of the site is well established, including Watling Street and the complex of Roman first-century forts and later civilian settlement at Wall (*Letocetum*), located approximately 4km to the east of the findspot. Approximately 550m to the south-east of the Hoard findspot a Romano-British aisled building has been excavated,[18] but the site itself was notable for the complete absence of Roman pottery, despite the proximity of Watling Street. A watching brief undertaken during the excavation of a nearby length of the A5, in advance of the M6 Toll construction, has suggested that Watling Street may have continued in use into the Saxon and medieval periods.[19]

There is no clear Anglo-Saxon context for the Hoard. According to Della Hooke, in this period the area surrounding the findspot may have been located close to a significant Anglo-Saxon boundary, between the *Pencersǣte* to the west and the *Tomsǣte* to the east (fig 7.1).[20] This area may have been particularly infertile and only used as seasonal pasture. The site may have been located within a triangle of roads described in the tenth-century Wolverhampton Minster 'foundation charter',[21] so that the Hoard could have been located near a crossroads, if the roads were in contemporary use. The suggested line of part of the road from Wolverhampton to Ogley Hay is shown as a dotted line on fig 1.2.

Jon Goodwin has undertaken a review of Historic Environment Record data for the Anglo-Saxon period within a radius of 10km of the findspot (see fig 1.2).[22] Few sites or possible sites of this date have been excavated within this area. Most notable are the Anglo-Saxon cemetery and possible shrine of St Chad within later Lichfield Cathedral.[23] A number of churches in this study area may contain traces of Anglo-Saxon fabric. At the Cross Keys site in Lichfield, a sub-Roman building was succeeded by two phases of sunken-featured buildings occupied from the seventh to the twelfth centuries.[24] A boundary ditch to the rear of Sandford Street, Lichfield, may be Anglo-Saxon in date.[25] Metal-detectorists have recovered a number of stray finds of Roman to Anglo-Saxon date, most notably from Wall and Hammerwich.

Following the Norman Conquest, the region became Royal Forest, although the earliest named references date to the 1140s.[26] At the time of the Domesday Book, Ogley Hay, the historic parish in which the Hoard was located, was described as waste land. By the twelfth century it was known as *Oggeleye*, the latter part of the name implying an open wooded landscape used as wood pasture.[27] In the later eighteenth century the site, as mapped by Yates, continued to be within an area of waste land, which extended to the north and south of Watling Street.[28] The undated gullies [*4203*] and [*4406*] in Trenches 3 and 5 could have represented part of an animal pen, in the absence of evidence to the contrary. The common rights to the heathland, including the site, were only extinguished by an Act of Enclosure in 1819.[29]

In conclusion, the Hoard was located in a marginal area, with the sole exception of the nearby Romano-British aisled building. Until the early nineteenth century it lay within waste land. After enclosure, the Hoard could have been fortuitously protected from earlier plough disturbance by the accumulation of soil on the western side of the disused field boundary, although later ploughing will have entirely removed this build-up.

FIELDWORK IN 2012

H E M Cool

Staffordshire County Council, grant-aided by Historic England, commissioned Archaeology Warwickshire to conduct surveys of the site after ploughing was renewed in 2012. The aims were to recover any further archaeological evidence associated with the Hoard, any evidence of other historic activity and to mitigate the effects of any illicit metal-detecting. An account of this work and of the subsequent Treasure process is available in the digital section,[30] and only a summary is provided here. The impact which the recovery of the additional fragments had on the overall timetable of the research project is also discussed elsewhere.[31]

The first part of the project was a systematic metal-detecting survey between 19 and 23 November. The whole field was detected along transects 2.5m apart running approximately north-northwest–south-southeast. The western (Hoard) end of the field was then detected with transects at 90 degrees to the original ones. On the final afternoon, the area of the 2009 excavation trench was intensively detected without a grid. The metal-detecting survey was followed by a field-walking survey along transects 10m apart.

Eventually, eighty-one of the items found during the 2012 work were declared to be treasure and part of the Hoard.[32] In their initial cataloguing they had been given find numbers in the 5,000 range to distinguish them from the pieces recovered in 2009. Many were small fragments of silver sheet, but they also included one of the cheek-pieces from the helmet (**592**), and fragments that were found to be parts of objects recovered in 2009, such as gold and garnet strip-mount **544** and fantail silver mount **569**. Additional fragments of a copper-alloy horse-harness mount (**698**), which had been deemed not to be treasure, were also found and joined a fragment found in 2009.

The Hoard fragments were found within the area occupied by the 2009 excavation trench and in its vicinity. Naturally, because their precise locations were the result of both backfill in 2009 and then subsequent ploughing in 2012, there is no meaningful relationship between the locations of the 2009 and 2012 fragments. Archaeology Warwickshire had questioned whether the location of the 2009 trench had been accurately plotted.[33] The research project commissioned a report comparing the surveying of 2009 and 2012.[34] This established that the plans of the 2009 trenches were accurate, but that those of 2012 were between one and two metres too far to the north. This would explain why a proportion of the 2012 finds were consistently planned as being within a one- to two-metre wide band north of the 2009 trench.[35]

The 2012 work recovered not only additional pieces of the Hoard, but also nearly a thousand pottery sherds. Most of the pottery belonged to the nineteenth and early twentieth centuries and could be explained by the practice of spreading the contents of ash-pit privies from the neighbouring towns onto fields to enrich the soil. The previous section has shown that this area was marginal wasteland up to the early nineteenth century, and none of the material found during the field walking alters that picture.

ACQUISITION, FUNDING AND PROJECT ORGANISATION

Jenni Butterworth

The Treasure Act 1996 provides the legal framework that governs treasure finds in England, Wales and Northern Ireland. Gold and silver objects, as well as groups of coins over 300 years old and some other assemblages qualify as treasure, and the Crown may claim title to such finds.[36] Treasure procedures, which are currently administered by the PAS and Treasure Section at the British Museum in England, enable the Secretary of State on behalf of the Crown to decide whether a find merits public acquisition, and if any reward is payable to the finder or landowner in such a case.[37] All finders have a legal obligation to declare the discovery of

potential treasure to the relevant district coroner[38] and a treasure case (2009 T394) was opened for the Staffordshire Hoard once it had been reported. The PAS National Finds Adviser Kevin Leahy submitted an initial hand-list of the collection to the Staffordshire Coroner, which contained 1,381 entries summarising the items recovered by the finder and by the subsequent archaeological investigations by Staffordshire County Council and Birmingham Archaeology.[39]

At this stage, the progress of a treasure case is dependent on whether a museum wishes to acquire the find for public benefit or not. In over 50 per cent of treasure cases, no institutional interest is forthcoming and the artefact is returned to the finder or landowner, depending on the individual circumstances.[40] However, it was clear that the Staffordshire Hoard was a significant find that merited public acquisition and accordingly an inquest was held on 24 September 2009, at which Staffordshire Coroner Andrew Haigh formally declared the items on Leahy's hand-list as treasure.[41]

Discussions about the future of the collection had commenced soon after the discovery. A large group of potential stakeholders was involved. This included national organisations such as the British Museum and the Museums, Libraries and Archives Council, along with an informal consortium of local authorities – Staffordshire County Council, Lichfield District Council, Tamworth Borough Council, and Birmingham and Stoke-on-Trent City Councils through their institutions BMAG and PMAG – supported by the Government Office for the West Midlands. This reflected the multiple modern administrative units that equated to the historic area of Anglo-Saxon Mercia to which the discovery belonged. Within the broader West Midlands region, the findspot itself lay in Staffordshire, at the extreme south of the county on the boundary with the metropolitan county of the West Midlands.[42]

The potential impact of this internationally important collection on the modern region was keenly felt by those involved, and a strong commitment to work towards securing it for the region emerged. The Staffordshire Hoard represented a distinctive heritage opportunity with the potential to generate educational, community and economic benefits and to provide a focus for positive regional identity based on renewed interest in a shared historic past. However, it was also recognised that ownership would involve significant challenges, particularly achieving the purchase price, which was likely to be extremely high, and investing in the subsequent programme of research, conservation and exhibition that would be required to realise the potential benefits.

Joint acquisition of the collection by more than one museum was considered an appropriate solution and a relevant precedent for this was the acquisition in 2005 of a Roman bronze vessel known as the Staffordshire Moorlands Pan by the British Museum, PMAG and Tullie House Museum and Art Gallery, Carlisle. As well as enabling increased accessibility and public benefit, and fostering the concept of a 'nationally distributed collection',[43] the collaboration had allowed the broader 'meaning' of the item, which is a souvenir from Hadrian's Wall, to be explored in the combined contexts of the findspot in Staffordshire, the Wall itself and the national collections of the British Museum, thus providing an appealing model for the Staffordshire Hoard acquisition.[44]

The Vale of York Viking silver hoard, discovered in 2007 and subsequently valued at £1,082,800, provided another recent treasure parallel. This hoard was purchased by the British Museum and York Museums Trust in July 2009, both partners also having committed to displaying the hoard in Harrogate near the findspot, in an arrangement felt to be 'the best way to recognise the significance of the hoard, from local to international level' and one supported by a number of fundraising organisations, including the Art Fund and the National Heritage Memorial Fund.[45]

As the national museum, the British Museum has the right to acquire treasure finds from England, either solely or in partnership, but for the Staffordshire Hoard the institution declined in favour of supporting regional acquisition.[46] It was agreed that Birmingham and Stoke-on-Trent City Councils, through their accredited museums, would seek to acquire the collection with the support of the other stakeholders. Joint acquisition would thus bring together PMAG, as the collecting museum for archaeology in Staffordshire,[47] and BMAG, which leads the West Midlands PAS and which has a collecting policy embracing British and regional archaeology. The ownership would benefit from the former's experience of archaeological material and research and the latter's established conservation department, while the partnership of two museums at the north and south of the West Midlands region would reflect the Mercian origin of the collection and provide a broad base for public access and interpretative context.

The Treasure Valuation Committee was tasked with valuing the large, unconserved collection, which by now numbered 1,662 records following the addition of items from the soil blocks, which had been unpicked by conservators after the inquest.[48] The Committee, which met on 25 November 2009 in a special session convened to deal solely with this case, valued 160 objects individually and used four provisional valuations supplied by expert advisers to calculate a valuation for the entire collection of £3,285,000 – the largest sum attached to a UK treasure find at that date.[49] All of the interested parties – the two museums, the landowner and the finder – agreed the figure and it was made public.

The speed at which such a large treasure case was processed was a considerable achievement on the part of the Treasure authorities. From the initial reporting through to the final valuation was under five months, compared with twenty-six months for the Vale of York hoard, or twelve months for the Roman Hoxne hoard discovered in Suffolk in 1992; although it should be noted that in both of these cases a considerable amount of conservation and some scientific analysis was undertaken before the valuation was undertaken, whereas for the Staffordshire Hoard the only such work undertaken,[50] was to unpick the soil blocks.

Institutions hopeful of acquiring treasure have four months to raise the necessary funds.[51] The Art Fund offered to lead the fundraising campaign for the Staffordshire Hoard on behalf of the two museums and their respective city councils, but there was still considerable doubt among all parties as to whether such a large sum could be achieved in such a short period of time, especially given a backdrop of significant economic decline at the time.[52] The extended treasure process for the Vale of York hoard[53] had effectively given the acquiring museums additional time to plan to raise a purchase price one-third of the value of the Staffordshire Hoard, and this remained a remarkable fundraising achievement.

However, from the outset, the Staffordshire Hoard fundraising campaign benefited from a worldwide community of interest and significant public support, particularly locally. The discovery had been announced at the time of the coroner's inquest and intense interest in the case had been generated at both national and international level, with media engagement sufficiently high for the Department of Culture, Media and Sport to formulate communication guidelines specifically for the case.[54] The scale and valuable nature of the find, as well as the strong visual appeal of the artefacts, was the primary point of interest, reflected in the wealth of images published and headlines such as 'UK's largest haul of Anglo-Saxon treasure' or 'Huge gold discovery is unprecedented', but the mystery presented by the burial circumstances and academic excitement about the discovery also caught public attention.[55]

Most significantly, the sense of 'ownership' of the discovery as an expression of regional pride and identity was incredibly strong; the public articulated 'overwhelming' support for the campaign to retain the collection within the West Midlands[56] and many high-profile political, academic and popular figures also supported the public appeal co-ordinated by the Art Fund.[57] The museums and regional stakeholders ran a wide range of fundraising activities to solicit private and corporate support, and with commendable speed the British Museum published a popular booklet *The Staffordshire Hoard*, with £1 from each purchase going to the acquisition and research appeal fund.[58]

Treasure finds are not customarily exhibited before acquisition but, in order to capitalise on public interest, permission was sought from the Secretary of State to do so.[59] Three temporary displays were staged: at BMAG after the coroner's inquest (25 September–13 October 2009); at the British Museum, to coincide with the valuation announcement and launch of the fundraising campaign on 13 January 2010 (3 November 2009–17 April 2010); and finally at PMAG (13 February–7 March 2010). The public response was extremely positive, with 40,063 visitors at Birmingham in nineteen days (fig 1.12) and 55,000 at Stoke-on-Trent in twenty-three days.[60] Compared to planned events, the Birmingham display would have rated in the top ten Antiquities exhibitions for 2009,[61] while the impact of the British Museum display was such that cases are now retained specifically for the temporary display of treasure finds.[62]

The generous public response to the campaign meant that the museums were able to announce that the full purchase price had been achieved on 23 March 2010, three weeks before the deadline.

Fig 1.12. The queue to see the Hoard exhibition in Birmingham Museum & Art Gallery in the autumn of 2009. A collection box for funds to purchase the Hoard can be seen at the front. *Photograph*: © Birmingham Museums Trust.

Major grant contributions had been made by the National Heritage Memorial Fund (£1,285,000) and the Art Fund with the assistance of the Wolfson Foundation (£300,000), augmented by donations from Birmingham and Stoke-on-Trent City Councils (£100,000 each), Staffordshire County Council (£80,000), Lichfield District Council and Tamworth Borough Council (£20,000 each) and £600,000 gifted by trusts and foundations. Perhaps of greatest significance was the fact that donations from members of the public raised nearly £900,000, or over one-quarter of the total, a considerably higher proportion than is usual for campaigns like this and a strong endorsement for the acquisition, which encouraged other institutional donors.[63] The Staffordshire Hoard campaign,

which constituted the largest ever public-giving to a heritage appeal, was the first to be led by the Art Fund for an archaeological treasure and remains a benchmark for such cases.[64] The collection was acquired on 2 June 2010, and a legal agreement was put in place between Birmingham and Stoke-on-Trent City Councils to govern the joint ownership.

When a second group of finds was discovered in the field in 2012,[65] a treasure case (2012 T860) was opened once again. The ninety-one finds recovered during archaeological fieldwork were catalogued by Kevin Leahy, and on 4 January 2013 eighty-one of these were declared treasure by the Staffordshire Coroner and valued at £57,395 by the Treasure Valuation Committee two months later.[66] Although recovered in the course of planned archaeological fieldwork, these finds were judged to be part of the same treasure as the previous discovery and on that basis the original finder as well as the landowner was eligible for the reward.[67] A second public fundraising campaign was anticipated by the museums, but jewellery firm Wartski generously donated the entire sum, which enabled Birmingham and Stoke-on-Trent City Councils to acquire the finds and absorb them into the Staffordshire Hoard. The ten finds recovered in 2012 that were not declared treasure, as well as a copper-alloy object of similar date discovered in the same field in 2009, were donated to PMAG by the landowner and form part of the Stoke-on-Trent City Council collections.[68]

The Staffordshire Hoard acquisition was, and remains, a high-profile and significant achievement for heritage-sector organisations working in partnership. It represents a key example of an internationally significant collection being acquired by regional museums in collaboration and on behalf of the nation. Throughout the fundraising, the high level of public interest, particularly at regional level, had been a defining feature, with the decision to exhibit the collection in its unconserved, pre-acquisition state undoubtedly contributing to this; what might be termed 'archaeological transparency' was an important draw for audiences and it was instrumental in generating interest. In similar cases, such as the Hoxne or Vale of York hoards, the time period between discovery and formal fundraising was significantly longer, allowing the collection to disappear from view, and for initial conservation and planning stages to be undertaken in a less public context. For the Staffordshire Hoard, the short timescale and the temporary exhibitions sustained public interest. This delivered significant advantages for the fundraising campaign, but also generated an expectation on the part of stakeholders and the public that the collection would continue to be similarly accessible after its acquisition. The subsequent research, conservation and engagement programmes would be profoundly influenced by this.

The owners wished to put in place a research project that would benefit from expert advice. They appointed two advisory panels, one for the conservation and one for the research, which were subsequently amalgamated. These helped to develop the research strategy. As the excavations at the Hoard site had been grant-aided by Historic England, the research was eligible for funding from that body as part of its normal post-excavation commitment. Barbican Research Associates Ltd was invited to develop and manage the research following the normal HE project cycle of assessment and analysis.

The assessment stage ran from June to December 2011, and it was estimated that the full cost of analysis would be in the vicinity of two-thirds of a million pounds. Given the cost, it was decided to conduct the analysis in two stages. Stage 1 ran from March 2012 to May 2014, and Stage 2 from February 2015 to June 2017. A more detailed consideration of the development of the project is available in the digital part of this publication.[69]

THE CONSERVATION PROGRAMME

Pieta Greaves, Kayleigh Fuller and Lizzie Miller

As well as being tasked with ensuring the continued survival of the collection, the conservation programme contributed significant evidence for object manufacture, use and ultimately disposal, thus helping to inform the insights and conclusions of *Chapters 2–4* below. In addition, working in close collaboration with the finds specialist (Chris Fern), previously unrecognised objects were pieced together and rebuilt. The results highlight the benefit of the early and continuous engagement between conservators and finds specialists.

Encouraging public interest was identified as a priority at the outset, with the conservation programme recognised as a key way to deliver a broad range of outreach and educational objectives. These activities helped to increase the profile of both the Hoard and the conservation discipline.[70]

This section discusses specifically the processes and methodologies employed during the investigative conservation of the Hoard between 2010 and 2016. Examples are used to highlight the strengths of these methods, as well as the challenges provided by certain types of material and ornament, such as the items with intricate garnet cloisonné or filigree decoration, or the highly-fragmented silver objects.

Investigative conservation methodology

Prior to the acquisition of the collection and the implementation of the conservation strategy, the Treasure Valuation Committee required that soil blocks, containing material collected by the finder and during the subsequent excavations, be dismantled to facilitate the valuation process.[71] After X-radiography at National Museums Liverpool, the blocks were disaggregated at the BMAG conservation studio, using the X-radiograph images as a guide, and the sediments were wet-sieved to recover the smallest fragments. However, relationships between objects within each block were not recorded. Fern notes below that there is a possibility that these blocks could have been the final evidence of a ploughed-out pit.[72] It is possible that further evidence to contribute to this question might have been identified, therefore, if micromorphological assessment of the sediments had been conducted to look, for example, for mineral-preserved organic (MPO) remains, and had the exact relationship of the material been studied. This oversight is worth noting, because it illustrates the complexities inherent in balancing archaeological and treasure priorities during the valuation process.

To manage the conservation programme within a controlled framework, a formal Conservation Plan was developed and agreed by the owners in 2010.[73] This strategy was written in conjunction with staff of the British Museum's Department of Conservation and Scientific Research, who have extensive experience of Anglo-Saxon material. It outlined the order of work, the techniques and procedures to be used and how the process would be documented. The overarching aim of the conservation work was to 'produce objects which [sic] are physically and chemically stable and will reveal and preserve all the surviving surface detail and any related information, such as organic material, by means which will not be prejudicial to the wider study of the Hoard'.[74] It was also recognised as important to maintain any distortion of the objects, since it could represent original damage relating to their disposal, as discussed in Chapter 4. In addition to this guidance, a Conservation Advisory Panel was established, composed of specialists in archaeological science and conservation, metals conservation and conservation ethics, to advise and support the conservation process.[75]

After acquisition of the Hoard, the conservation programme was carried out in two main phases.[76] The conservation documentation was designed in line with the professional guidelines of The Institute of Conservation (ICON) and the European Confederation of Conservator-Restorers' Organisations (ECCO).[77] During Stage 1 of the project (2010–14) the objects were sorted into related material types, followed by the controlled removal of the sediment that covered the finds. In close collaboration with the finds specialist, many joins and associations between fragments were quickly established. The phase culminated in a 'grouping exercise', with the whole Hoard brought together in Birmingham for two weeks from the various venues where it was being exhibited and studied. During this time hundreds of further physical and stylistic relationships were identified that suggested new objects and sets. Stage 2 (2015–16) concentrated on consolidating the work of the first phase to achieve the aims of the research project. The fine cleaning of the objects was completed to enable their physical reconstruction and study, and they were packed and stored according to their sets and typology. Towards the end of this stage there was another brief opportunity to examine the whole Hoard at one venue.[78]

The conservation of every fragment started with a thorough, documented examination to record the condition and weight as accessioned (fig 1.13). Visual examination and photomicroscopy were carried out using a Keyence VHX-1000 digital microscope and/or a Meiji EMX-8TRD trinocular stereo microscope, with all subsequent cleaning to remove sediments carried out under the latter. Examples of images taken with the Keyence microscope can be seen especially in Chapters 3 and 4. X-radiography of the finds was undertaken at the Lincolnshire Archives, Lincolnshire County Council, to help reveal details of the objects' condition and construction prior to the removal of soil.

The finds are largely of gold, silver and garnet, materials that are chemically relatively stable, but damage sustained prior to burial and post-burial had created issues of physical instability. As well as

▲ **Fig 1.13**, A conservator removing loose soil from a metal fragment at Birmingham Museum & Art Gallery. *Photograph*: © Birmingham Museums Trust.

distortions of form, many pieces had detached or loose components, while others were greatly fragmented. A small number of objects had fragile remains of organic materials, such as wood, and even textile was recorded. As the standard of conservation needed to be consistent, this variability in condition was the initial challenge: within the context of the overall Conservation Plan, a strategy was developed for each type of material and ornament (e.g. filigree, cloisonné), but which was also adaptable to meet the unique needs of each individual item, taking into consideration the methods of construction, the nature and level of any physical damage and the level of corrosion.

The objects were initially cleaned mechanically under low magnification (×20–40) to remove sufficient soil to reveal their form and condition, in order to enable the finds specialist to make preliminary identifications of the find types. Scalpels and metal pins in hand-held pin-vices are typically used to clean copper-alloy and iron objects, but these are not suitable for silver or gold, since even under good lighting and magnification there is the potential for accidentally damaging the surface of the metal. After experimentation, it was decided instead to use natural *Berberis* sp. thorns mounted in pin-vices to remove compacted soil, after softening with industrial denatured alcohol (IDA: formerly known as industrial methylated spirits). The thorns have fine-pointed but rounded tips and are strong but flexible, making them ideal for the task, allowing the soil to be eased away without scratching. Soft brushes were used to remove any powdery soil, with a gentle sweeping or lifting action, in order to avoid polishing or abrading the soft-metal surfaces. No attempt was made to remove tarnishing, as this layer offered potential evidence for tool marks and wear. Furthermore, in cases where soil provided essential physical stability to *in situ* fragments, it was retained. Small fragments that became detached during conservation, such as the garnets and gold foils used in cloisonné, were transferred into plastic vials, gel capsules or small polythene bags, and were retained with the object for future study. Even the removed sediment was collected, as a record of the original burial environment, and in case of physical or chemical traces of organic remains. It quickly became clear, however, that the soil remains were heavily contaminated with small rootlets and other components from the topsoil.[79]

Adding modern conservation materials to the objects was avoided as much as possible, although it was clearly necessary for reconstruction purposes, and to adhere loose components, such as garnets, to prevent their disassociation. Paraloid™ B72 resin (a co-polymer of methyl acrylate and ethyl methacrylate) was the adhesive used, diluted in acetone to a suitable viscosity.

At the end of Stage 1, it was clear from discussions between conservators and the finds researcher that the ornamental nature of the prestigious metalwork meant that full laboratory micro-excavation was necessary for virtually the entire collection, while at the same time meticulous care was necessary to fully realise the potential of the rare organics. In Stage 2, these were revealed to include, for example, previously unseen wooden cores inside pommels, as well as a fragment of textile with hilt-collar **126**.[80] These remains were left *in situ* on the objects, where possible, as removal threatened their survival. This evidence, and that of other components (such as pastes, fillers and organic adhesives), justified the decision to use only mechanical techniques in the investigative conservation. That any organic-based material had survived at all in the humid and aerated sediments of the burial environment was probably largely due to contact with the corroding silver or rarer copper-alloy elements of the Hoard. The corrosion solutions of these metals have biocidal properties that inhibit biodeterioration of organic matter, and in some cases precipitation of the solutions can take place within the actual physical microstructure of the organic material, resulting in a mineralised cast of it.[81]

Garnet cloisonné objects

The conservation and reconstruction of the objects with garnet inlays was particularly complicated, due to their cellular construction and multiple small parts, which, as well as the garnets, typically included gold backing foils and filigree additions. It was often simple enough to reattach loose and detached parts, though many elements were typically missing.

In many cases it was only the soil surrounding the garnets that held the stones in place, so the decision was made to keep the cleaning to a minimum, leaving any soil in the minute gaps between the stones and the cell walls *in situ*. *Berberis* thorns were used with denatured alcohol solution applied sparingly to avoid any migration of the fine sediment under the garnets, which could obscure the gold foils set behind them.[82] Once loosened, the soil was removed using an air puffer, in preference to a brush, to avoid applying excessive pressure directly to the garnets or any exposed foils.

In some cases, the damage to the objects provided insights into the processes of their manufacture and construction that could not have been gained if the object had been complete. Damage to the large round mount [*K130*] of object **541** had resulted in the loss of garnets, foils and gold panel inlays. Removal of the soil from the area of one detached inlay revealed an incised 'X', as well as lines around the edges of the cell that possibly relate to the original planning of the ornamental scheme (fig 1.14).[83] A match was subsequently

identified in panel [*K54*] and it was confirmed that this piece would have fitted perfectly onto [*K130*] prior to the distortion of the parts.

Many loose garnets and foils were recovered during the excavation, but matching these to their empty settings was often impossible: although individually cut and crafted, the forms and sizes of the stones are repetitious, as are the patterns they were used in, and in many cases the gold cell walling of the objects was damaged.

Strip-mount **558** with filigree panels demonstrates further the complexities of conserving the garnet cloisonné material (fig 1.15). Due to the distortion and folding of the object, some of the cell walls were bent out of shape and many garnets were missing or dislodged. Great care had to be taken, therefore, during examination and handling to avoid any further loss. To secure the loose parts, a minimal amount of 20 per cent w/v Paraloid B-72 in acetone was applied with a fine paintbrush. This high viscosity solution was used to avoid the adhesive flooding any of the ornament, and the exact locations of its application were noted in the object's conservation record.

Removal of the soil revealed the impressive cloisonné cell structure and detail of the die-impressed patterns on the exposed gold backing foils. Cleaning also revealed fixing-holes on the mount, providing information about how the object had been attached. Finally, recognition of an assembly programme by the finds specialist allowed virtually the full reconstruction of cloisonné mounts **558** and **559** from a total of twenty-three parts, including nineteen small filigree panels decorated with serpents and interlace (see fig 2.63).

▲ **Fig 1.14.** Mount [*K130*] from **541** with a possible assembly mark in its empty recess, in which loose panel [*K54*] once fitted (scale 1/1). *Photograph*: A. Osinska/Cotswold Archaeology, © Barbican Research Associates.

▲ **Fig 1.15.** Half of mount **558** with some of its gold filigree panels (scale 1/1). *Photograph*: A. Osinska/Cotswold Archaeology, © Barbican Research Associates.

Fig 1.16. Mount **565** with its bone inlay, which was only minimally cleaned (scale 1/1). *Photograph*: A. Osinska/Cotswold Archaeology, © Barbican Research Associates.

On mount **565** the removal of the surface soil revealed a large area of bone inlay (fig 1.16). Although the bone was greatly deteriorated, being darkly stained, with a slight green tinge, and cracked and crumbling, some thin surface areas had survived. Bone is naturally cream in colour and when degreased it can appear quite white, but it also stains easily and so excavated bone can be dark brown or even black. The green hue of the inlay in this instance could be the result of deliberate dyeing with a copper solution, but it may be due to accidental staining transferred from corroding copper-alloy objects in the burial environment. The decision was made not to consolidate the loose bone inlay, as this might inhibit any future scientific analysis.

The cleaning of cloisonné pommel **49** provided another surprise. Once cleaned, it became apparent that the opaque, weathered stones in two cells were not garnet but glass (see fig 4.12). Analysis carried out in Paris showed these to be red glass.[84]

Filigree decorated objects

The gold filigree objects presented different challenges (fig 1.17). The fine wires and thin gold backing sheets were physically weaker than the typically more robust gold components of the cloisonné, and the damage to these presented joins that were more difficult to make without the addition of supporting materials. Also, different gold alloys were used in their construction,[85] resulting in different working properties, colours, intergranular corrosion and surface tarnish.

The intricate wire designs were originally attached to their gold backing sheets with solder,[86] but by only a small area of contact, so gentle cleaning was required. The *Berberis* thorns proved excellent for cleaning the small spaces around the filigree. However, soil close to the solder joins was often left *in situ*.

The overall guidance strategy for the Hoard, which aimed at achieving the greatest degree of preservation of the objects, resulted quite deliberately in the slight under-cleaning of the objects. The judgement of the individual conservator also played a role in determining the exact degree to which soils were removed. Where there was a risk of abrading any tarnish, for instance, cleaning ceased before corrosion products were removed from the surface. In historic collections, gold and silver alloys were often cleaned to remove all surface corrosion, to produce bright, polished, metallic

Fig 1.17. Part of filigree hilt-collar **100** during conservation (not to scale). *Photograph*: © Birmingham Museums Trust.

Fig 1.18. Pommel **25** after conservation, showing variations in the tarnish layers that reflects differences in the gold alloys used for the different filigree and backing-sheet parts (not to scale). *Photograph*: D. Rowan. © Birmingham Museums Trust.

surfaces. Such cleaning was done for cosmetic reasons, but can leave objects more vulnerable to further surface corrosion: repeated cycles of tarnishing and cleaning eventually result in the loss of surface detail. With archaeological material it may be necessary to remove corrosion crusts that are obscuring surfaces necessary for study; however, the compact surface patinas or tarnish beneath are usually left in place as they represent the object's original surface and preserve its surviving details. It was particularly important to retain the tarnish on the Hoard's gold objects, because this could change subtly between parts, reflecting colour differences that might have been deliberate and dependent upon the different gold alloys chosen and how they were manipulated in manufacture (fig 1.18).[87] As well as safeguarding potential research information, leaving the tarnish intact was desirable, furthermore, where multiple fragments from the same object were rejoined: under-cleaning of individual fragments allowed for further cleaning of the object after reconstruction, ensuring an even appearance across surfaces.

The cleaning process also exposed some interesting details on the gold filigree objects. For example, during cleaning of pommel **8**, intriguing surface details in the form of incised marks on the sheet backing under the filigree were discovered. Although the purpose of these lines is currently unknown, the conservation process documented them fully for future study.

Rejoining and reconstruction

The processes of rejoining and reconstruction were essential to achieving the aims of the research project. Fragments that required rejoining were identified by both the conservators and finds specialist. The complexity of the task for each object depended on the quantity of it surviving, the level of fragmentation, the size and thickness of the fragments, and the amount of distortion and abrasion. Where rejoining was not possible, fragments were instead boxed together.

Many joins were identified when the fragments were first sorted by object-type – for example, as pommels or hilt-collars, but the process remained ongoing, especially for the highly fragmented silver material, tarnished to a dark, matt grey, which was broken both by deliberate action (e.g. cutting and tearing) and due to embrittlement in the burial environment. In some cases, the process of reconstruction revealed new objects not identified in the original assessment.

Fig 1.19. A selection of the fragments (above; not to scale) used to reconstruct pommel **77** (below) (scale 1/1). *Photographs*: fragments © Birmingham Museums Trust; pommel **77** by L. Martin/Cotswold Archaeology, © Barbican Research Associates.

One was pommel **77**, a composite object that was rebuilt in stages from 'fragment groups' of silver and gold material, which were not initially identified as belonging together (fig 1.19). Joins were first examined under a microscope, and the weights of the individual fragments were recorded before joining, so that the final total weight for the object would not include the adhesive and additional support materials. Only gradually did it become apparent that the fragment groups were part of a large, distorted sword pommel. However, due to distortion, many joins could not be made and this meant the broken object was unstable. To complicate matters further, there were organic and inorganic materials inside the pommel parts. The reconstruction process had to ensure that these remained stable *in situ* and uncontaminated by adhesive.

Distorted joins were held together by supports made from Reemay™, a non-woven synthetic fabric, which, in the case of the pommel, were stuck across breaks on the object's interior so they would not be visible. A Plastazote™ (expanded polyethylene foam) support was then inserted into the hollow interior of the pommel to provide rigidity. This allowed the object to be displayed in an upright position in association with its 'floating' parts: the fragments identified as belonging to it, but which could not be physically joined.

CHAPTER ONE | FROM DISCOVERY TO CONSERVATION

Custom-made Plastazote™ supports also played a major role in the reconstruction of other complex objects, including silver pommel **76**, hilt-guards **409** and silver mount **569**. In all cases the sculptured supports have enabled the object's form to be better understood and displayed, as well as providing stabilisation to help prevent further damage and allow careful handling for study.

One further notable discovery occurred in the final stages of the conservation programme in 2016. From among the numerous fragments of silver sheet, a group of around sixty fragments was identified of similar thickness and gilded on one side (fig 1.20). After three weeks of joining work, these were rebuilt into two silver-gilt coverings (**607/8**) of unusual form (fig 1.21), together with associated trims of reeded sheet. Originally thought to be several different items, these parts are now interpreted as remains from a base for the great cross:[88] they might have remained unknown but for the thoroughness of the conservation process and its close integration with the overall research project.

▲ **Fig 1.20.** Some of the many silver-gilt fragments. *Photograph:* © Birmingham Museums Trust.

▶ **Fig 1.21.** Silver-gilt sheet covering **607/8** with trims of reeded strip from a socketed-base (scale 1/1). For a reconstruction see Fig 2.76. *Image composite of photographs:* courtesy of C. Fern © Birmingham Museums Trust.

607/8

Die-impressed silver sheet

The die-impressed silver sheet received perhaps the most attention of all the material groups. Decorated with human and animal forms, the thin sheet was identified early in the project as possibly pertaining to an Anglo-Saxon helmet or helmets, and therefore its reconstruction and study was given high priority. Due to previous experience with similar highly fragmented finds, particularly the helmet from Sutton Hoo, the initial assessment and partial assembly was carried out by a team at the British Museum.[89] In Stage 2 of the project, further work was carried out at BMAG by a multi-disciplinary team.[90]

Examination resulted in the identification of the die patterns used to create the repeating designs, meaning the position of fragments could be accurately located and the original form of the bands and panels reconstructed (e.g. see figs 2.48–2.49). Where possible the material was joined with Paraloid B72 with joins reinforced on the reverse with strips of Reemay™ (figs 1.22–1.23). The resulting fragile structures were then secured on Plastazote™ mounts, in some cases tied on with metal wire, and any non-joining fragments were packed with them.

Conclusion

The policy of integrating the two disciplines of investigative conservation and academic research was crucial to the success of the Staffordshire Hoard Project. Its prevailing ethos of sharing discoveries and insights has allowed the fragmented pieces of the puzzle to be brought together both physically and conceptually. What follows in the ensuing chapters is the result of the labours of many individuals: volunteer and professional conservators, materials scientists and finds experts.

THE RELIABILITY OF THE FINDS CONTEXT
Chris Fern

For all its significance, the Staffordshire Hoard has a problematic context. Following the conservation phases and a revised count, it is now possible to show more accurately what proportions were found by the different finders, and the quantity of the total that has a known location within the 16m × 14m area over which the collection was spread by the plough. In addition, there is the record of what objects and fragments were found together. These data are given in full online (online tables 1–3), while a summary by finder is given in table 1.1.

It can now be shown that in the days between making his discovery and the start of any archaeological involvement, Terry Herbert found and excavated around 70 per cent of the collection, some 3,200 fragments and objects, corresponding to about half of the total weight (table 1.1). This includes approximately 1,800 fragments since revealed during conservation that came from multiple 'soil blocks' (fig 1.24), as well as further small debris released from soil on objects. Herbert also found many of the larger, more complete and arresting objects. For example, by weight, three-quarters of the gold pommels were recovered from the plough-soil before the PAS was made aware of the find. In the archive, the finds originally attributed to him are prefixed 'TH' ('Terry Herbert').[91] For all this material we have no precise location information, beyond the general corner of the field, a fact that imposes considerable limits on what can ever be concluded for certain about the nature of the deposit as a whole. What must be certain, however, is that the generally good condition of the fragile finds (except for damage done prior

Fig 1.22. The best-preserved of the die-impressed sheet panels of **597** (scale 1/1). *Photograph*: A. Osinska/Cotswold Archaeology, © Barbican Research Associates.

Fig 1.23. Metal wire supports on the reverse of die-impressed panel **595** (scale 1/1). *Photograph*: © Birmingham Museums Trust.

CHAPTER ONE | FROM DISCOVERY TO CONSERVATION

| Catalogue | Object | Sub-total objs/frags | Finder by quantity and percentage ||||||| |
|---|---|---|---|---|---|---|---|---|---|
| | | | MD ('TH') | SB1–21 | MD('TH')+ SB1–21 | BA/SCC/US | Grid location (BA/SCC) | Arch Works (redeposited) | MD (TH) % Au (not incl. SB1–21) |
| 1–84 | pommels/sword-rings | 167 | 82/49% | 21/13% | | 60/36% | 37/22% | 4/2% | 47/61% |
| 85–190 | hilt-collars | 212 | 88/42% | 25/12% | | 96/45% | 69/33% | 3/1% | 58/45% |
| 191–242 | hilt-rings | 67 | 21/31% | 11/16% | | 35/52% | 24/36% | - | 10/27% |
| 243–409, 696–7 | hilt-plates/-guards | 278 | 83/30% | 38/14% | 510/49% | 149/54% | 88/32% | 8/3% | 58/38% |
| 410–537 | small mounts | 141 | 43/30% | 16/11% | | 77/55% | 58/41% | 5/4% | 42/32% |
| 538–71 | large mounts | 160 | 56/35% | 13/8% | | 84/53% | 52/33% | 7/4% | 41/50% |
| 572–84 | pyramid/button-fittings | 17 | 9/53% | 1/6% | | 7/41% | 4/24% | - | 6/60% |
| 585–8 | buckles, cross-pendant | 6 | 3/50% | - | | 3/50% | 2/33% | - | 3/50% |
| 589–606 | helmet and patterned sheet | 987* | 250/25% | 484/49% | | 214/22% | 77/8% | 20/2% | 1/50% |
| 607/8 | socketed-base with reeded strip | 112 | 17/15% | 44/39% | 2732/77% | 47/42% | 15/13% | 4/4% | - |
| 609–13 | reeded strip | 697 | 227/33% | 335/48% | | 120/17 | 41/6% | 15/2% | - |
| 614–5 | U-section edging | 68 | 22/32% | 8/12% | | 37/54% | 22/32% | 1/1% | - |
| 616–76 | bosses, nails, rivets etc | 265 | 93/35% | 129/49% | | 40/15% | 5/2% | 3/1% | 47/45% |
| 677–95 | fragments | 1421 | 434/31% | 689/48% | | 282/20% | 107/8% | 16/1% | 40/36% |
| 1–697 | **Total** (not incl. glass eye): | **4598** | 1428/31% | 1814/39% | 3242/71% | 1251/27% | 601/13% | 86/2% | 353/42% |

▲ Table 1.1. Summary of objects/fragments by finder. In total, 71 per cent (objects/fragments: 3,242) of the collection was found by Terry Herbert (MD('TH')+SB1–21); just 13 per cent of the finds found afterwards by archaeological excavation (BA/SCC) have a grid location. The final column (% Au) shows the percentage of the gold objects/fragments in each object category found by Herbert. 'MD': finds made by Herbert by metal-detecting (before archaeological excavation); 'SB1–21': soil blocks found by Herbert (13 July); 'BA/SCC/US': finds from archaeological excavation, including those recovered by metal-detecting during backfilling or from spoil (US); '*': nineteen fragments have no record of finder (i.e. 4,579 fragments have a 'finder' context).

to deposition) shows they cannot have been long in the plough-soil, and that in some way they had escaped previous detection and ploughing.

The test-pit and emergency excavation that followed Herbert's declaration of his find added around 1,200 further fragments or objects. These are prefixed 'SCC' ('Staffordshire County Council'), 'BA' ('Birmingham Archaeology'), and 'US' ('unstratified') for finds recovered from the spoil heap and trench backfill. Of these, 601 have a recorded location within the grid system that was established on site (13 per cent by the total fragment/object count). The plot of these finds (fig 1.25) suggests a central concentration of roughly three to four metres square.[92] While this possibly indicates the focus of a ploughed-out pit, the limit of the record prevents certainty that this was the case. The location data can be further manipulated, by object-type and material,[93] which in some instances reinforce the argument for dispersal from a single centre, but ultimately it cannot be ruled out that the finds might have come from more than one deposit.

The soil blocks (1–21) found by Herbert contained roughly 40 per cent of all the objects/fragments (fig 1.24). They mainly contained small fragments of silver, for example, decorated sheet and reeded strip, but a small number of gold objects was also incorporated (online table 2). Several further 'soil blocks' retrieved in the excavation appear to be related by their contents.[94] Herbert later recalled that he had found the soil lumps (probably on 13 July) 'as a concentration' in a two-metre square area and the soil appeared compact.[95] It is possible that this debris came from the base of a pit. Although silver material predominates, the gold finds show that there was no division by metal into different pits, and this conclusion is also supported by the many other find relationships (online table 3). Nevertheless, the largely silver character of the soil blocks might indicate that the gold and silver were originally separated within the same deposit, perhaps in different containers, with later mixing due to decay and bioturbation. Packed together, the whole collection could have fitted into a relatively small space, the size of a 'shoe box' perhaps, as was first suggested.[96] However, that a cloth bag might have been used, at least for some objects, is suggested by a single small textile fragment [*K1821*] found within the soil-filled centre of a gold hilt-collar.[97]

The small number of finds that was added in 2012 by the survey undertaken by Archaeology Warwickshire, was located using a Total Station instrument, but, since these items appear to have been re-deposited from the earlier excavation and exposed to further ploughing, their use for determining any original distribution is negligible.[98] Additionally, two further fragments were located of an incomplete gilded mount (**698**) found in 2009, the only other Anglo-Saxon object from the field (see figs 1.25 and 2.68).

▲ **Fig 1.24.** X-radiographs of soil blocks 1, 4 and 20, showing mixed gold and silver fragments. *Image*: courtesy of National Museums Liverpool (World Museum).

▲ **Fig 1.25.** i) Updated distribution of finds within the grid system established by the Birmingham Archaeology (BA) excavation; ii) simplified plan showing the approximate area detected by Terry Herbert, the location of the excavation and the fragments of mount **698** found by Archaeology Warwickshire. *Drawing*: C. Fern, after figures produced by Birmingham Archaeology (2010: see *Jones and Baldwin 2017) and Archaeology Warwickshire (Palmer 2013: see *Cool 2017b).

CHAPTER TWO

CHAPTER TWO
CHARACTERISING THE OBJECTS

CHRIS FERN

Great treasures like the Hoard capture the imagination. However, the validity of any interpretation of when and why the collection was assembled, and perhaps even who might have owned it, must first take account of the full complexity of its quantities and character. As will be shown, our understanding has been refined very considerably in the years since the find's discovery by the cooperative processes of investigative conservation and academic analysis.

The Hoard is defined most of all by its hundreds of gold and silver fittings from the hilts of prestige weapons. Yet not a single iron sword- or knife-blade was included, and there is little other base metal. Only a few gilded copper-alloy objects are present, perhaps having been mistaken for gold, while other small fragments probably came from the base-metal interiors of the precious-metal finds. It very much represents a sorted collection, therefore. The small number of artefacts that are not weapon related are nevertheless some of the most arresting: a great gold cross mount (**539**), Latin inscribed strip (**540**) and the personal items of early churchmen in the form of a head-dress mount (**541**) and cross-pendant (**588**). Different objects from the battlefield are the remains of at least one magnificent helmet, the most ornate yet found but also one of the most fragmented, and a large gold plaque of a fish between eagles (**538**) that may be from a grand saddle. A number of sets of large mounts with garnet cloisonné (**542–66**) undoubtedly also come from other high-status objects, but their interpretation is uncertain, and other finds are equally problematic for identification (e.g. **567–71**).

Almost immediately upon discovery attention was drawn to what appeared to be missing or might have been expected in such a grand assemblage.[1] There are few scabbard-fittings to represent weapon-harness and just three buckles (**572–87**), which is surprising given the abundance of other weapon fittings. The fact that there are no coins is perhaps not so surprising, as coinage was adopted late in the Midlands regions, though a few gold coins from other territories would not have been unexpected.[2] However, most striking is the total absence of typical articles of female jewellery, particularly brooches, given their frequency in the contemporary burial record from eastern England, and this serves to reinforce the clearly 'masculine' martial character of the assemblage overall.

There are several ways of quantifying the material: by weight, fragment count and by estimating the original number of 'objects' (table 2.1; fig 2.1). All these values have altered substantially from those given soon after discovery in 2009.[3] Then the finds were still covered in soil, which stuck fragments together, and many objects remained to be identified. At the end of conservation, a total of almost 4,600 fragments had been recorded,[4] including around eighty added by the second phase of fieldwork in 2012.[5] It is now certain that the finds from both the 2009 and 2012 episodes of recovery originated from the same deposit, since many fragments have been joined or the objects form sets.

▲ **Fig 2.1.** The Hoard by weight and fragment count (quantifications are based on 'primary material'; garnet is loose stones only).

	Catalogue	Object-type	No. objects*	Objects by primary material				Fragments by primary material						Weight by primary material (g)				
				Gold	Silver	Copper alloy	Garnet	Gold	Silver	Copper alloy	Garnet	Glass	Stone	Gold	Silver	Copper alloy	Garnet	Stone
FITTINGS FROM WEAPONRY	1–78	Pommels	74	58	16	-	-	76	84	1‡	-	-	-	784.65	254.16	9.59‡	-	-
	79–84	Sword-rings	3	-	3	-	-	-	6	-	-	-	-	-	30.60	-	-	-
	85–190	Hilt-collars	107	97	9	1	-	129	51	32	-	-	-	725.34	75.19	0.84	-	-
	191–242	Hilt-rings	52	35	16	1	-	37	26	4	-	-	-	141.55	22.22	0.12	-	-
	243–409, 696-7	Hilt-plates/ guards	171	131	40	-	-	158	120	-	-	-	-	591.11	132.23	-	-	-
	410–526, 533-7	Small mounts (mostly hilt-fittings)	122	117	5	-	-	127	6	-	-	-	-	248.05	7.64	-	-	-
	527–32	Serpent mounts	6	6	-	-	-	8	-	-	-	-	-	70.31	-	-	-	-
	572–84	Pyramid/button-fittings	12	10	2	-	-	10	6	-	-	-	1	114.62	29.31	-	-	5.30
	585–7	Buckles	3	2	1	-	-	2	2	-	-	-	-	7.43	6.06	-	-	-
HELMET PARTS	589–92	Crest and cheek-pieces	4	-	4	-	-	2	35	-	-	-	-	48.29	319.82	-	-	-
	593	Helmet-band with sheet inlay	1	-	1	-	-	-	112	-	-	-	-	-	55.32	-	-	-
	594–604, 606	Die-impressed bands/panels	21	-	21	-	-	-	835	-	-	-	-	-	72.77	-	-	-
	612–13	Reeded strip and clips	3	-	3	-	-	-	677	-	-	-	-	-	134.95	-	-	-
	615	U-section edging	1	-	1	-	-	-	25	-	-	-	-	-	29.33	-	-	-
LARGE MOUNTS	538	Bird-fish mount	1	1	-	-	-	2	-	-	-	-	-	62.20	-	-	-	-
	542–66	Cloisonné mounts	25	25	-	-	-	63	-	-	-	-	-	750.93	-	-	-	-
	567–71	Niello mounts	6	-	6	-	-	-	78	-	-	-	-	-	158.44	-	-	-
CHRISTIAN OBJECTS	539	Great cross	1	1	-	-	-	4	-	-	3	-	-	140.35	-	-	34.90	-
	540	Inscribed strip	1	1†	-	-	-	1	-	-	-	-	-	79.69	-	-	-	-
	541	Head-dress mount	1	1	-	-	-	9	-	-	-	-	-	70.66	-	-	-	-
	588	Cross-pendant	1	1	-	-	-	2	-	-	-	-	-	24.38	-	-	-	-
	607/08	Base with reeded strip	1	-	1	-	-	-	112	-	-	-	-	-	90.38	-	-	-
MISCELLANEA	676	Locking pins	2	-	2	-	-	-	2	-	-	-	-	-	1.68	-	-	-
	609–11	Reeded strip	3	-	3	-	-	-	20	-	-	-	-	-	15.69	-	-	-
	614	U-section edging	1	-	1	-	-	-	43	-	-	-	-	-	104.93	-	-	-
	616–75	Bosses, nails, rivets and washers	-	-	-	-	-	105	157	1	-	-	-	59.81	24.89	0.50	-	-
	605, 677–91	Misc. objects and fragments	9	4	5	-	-	70	1132	107	-	-	-	20.24	130.08	5.41	-	-
	692–5	Loose garnets and foils	1	-	-	-	1	41	-	-	74	-	-	0.33	-	-	8.54	-
	[K580]	Glass ('eye')	-	-	-	-	-	-	-	-	-	1	-	-	-	-	-	-
		Total:	c 633*	c 490*	c 140*	c 2*	1	846	3529	145	77	1	1	3939.94	1695.69	16.46	43.44	5.30

▲ Table 2.1. Quantities in the Hoard. '*': figures are estimates only, as quantities are uncertain for many object categories (and some heavily fragmented material has not been included); '†': strip may be silver-gilt; '‡': copper-alloy core loose from pommel 4.

Fig 2.2. X-radiographs showing nails and bosses inside gold pommels. *Image*: courtesy of Lincolnshire Archives, Lincolnshire County Council.

In all, over 1,000 new 'finds' were added during conservation, though most were small silver fragments found in soil with other objects (fig 2.2). These relationships, and the numerous others between objects and fragments (online table 3), confirm the mixed nature of the collection in the ground. New archive numbers were generated for these new finds, following the original K-number system of Kevin Leahy.[6] However, for the final catalogue a new numbering system was adopted, to take account of the many rebuilt objects (with multiple K-numbers) and that followed more closely the consolidated object categories.[7] The catalogue runs from **1–697**, with the additional Anglo-Saxon mount (**698**) found apart but in the same field. The full catalogue is available online, but summaries by object class are presented in the *Abbreviated Catalogue*. All the significant finds have at least one photographic reproduction.

Because of the composite nature of so many of the objects, it is not possible to arrive at absolute 'bullion' weights for the gold and silver. Some objects were made in both gold and silver, a number have cores of copper alloy or include organic materials, and thousands of tiny garnets remain in the ornament of many. A further stage of disassembly by a smith would have been necessary to yield only the precious metal. Therefore, the weight has been calculated on the basis of the primary material of each object.[8] This gives 3,939.94g of gold and 1,695.69g of silver (fig 2.1).[9] The figure for the gold weight has considerably reduced (by almost 1kg) from that quoted for the uncleaned assemblage in 2009, but the silver weight has increased. This is partly due to the many new fragments identified in conservation and partly due to the correction of some material wrongly identified initially as copper alloy.[10] Because of the fragmentary nature of much of the silver, the dominance of gold by weight is reversed for the fragment count (fig 2.1).

Almost 2,000 silver fragments were of thin sheet metal and over 700 were pieces of silver reeded strip, from which multiple objects have been reassembled, including decorated panels and bands (**593–604**) that are largely helmet related and a gilded socketed-base (**607/8**) that was possibly a stand for the great cross. However, a considerable amount of the silver sheet remains unattributed (**606** and **690**). Much of this fragile material was probably considerably more complete when it entered the ground. Some of the cast silver objects had also become very fragmented. In both cases, the condition of the material was probably due to post-depositional decay, since silver alloys can embrittle and fracture after burial.[11] From among the cast silver material new and significant objects were also recognised during conservation, including pommels (**75–7**), a hilt-guard set (**409**), silver mounts (**567–71**) and the second part of the helmet-crest (**590**). Nevertheless, despite these instances of deterioration, the observed good condition of break-edges and of the objects in general (allowing for the original damage many had suffered) supports the view that the collection was probably discovered not long after it had been spread by the plough.

It is unclear exactly how many parts the assemblage originally comprised prior to the processes of pre-depositional dismantling and post-depositional fragmentation, but around 600 significant 'objects' seems likely (table 2.1; fig 2.3). However, it must be remembered that, with the sole exception of the cross-pendant (**588**), all are fittings or coverings removed from an array of larger equipment: swords, helmet(s), ecclesiastical objects and others. These actual entities of iron, wood, leather and horn are lost to us, except in a reconstructed sense. Particularly important, therefore, to understanding the 'structure' of the Hoard has been the identification of almost 150 sets of fittings: pairs and higher multiples of objects that have been matched on the basis of their style, form and manufacture, and in a small number of cases from physical marks left by contact between the parts (online table 4). The sets are suggested with varying degrees of confidence (as 'possible', 'probable' and 'certain'), and for a few objects more than one association has been suggested. One of the first sets to be recognised, of five parts, and representing the only definite full weapon-hilt, is the exquisite suite in garnet cloisonné from a seax (fig 3.80). Other sets, it seems, were incomplete at the time of deposition, raising the question of what happened to this 'missing' material.

Object category	Weight (g)
Weapon and scabbard-fittings	3172.52
Christian objects	442.04
Large cloisonné mounts	750.93
Helmet	660.48
Other mounts, buckles, and miscellanea	674.86
Total:	5700.83

☐ Weapon- and scabbard-fittings
Cat: 1–526, 533–7, 572–84 and 696–7

■ Christian objects
Cat: 539–41, 588, 607/8 and 676

■ Large cloisonné mounts
Cat: 542–66

■ Helmet
(cast parts, all decorated sheet, and select reeded strip and edging) Cat: 589–604, 606, 612–3 and 615

■ Other mounts, buckles and miscellanea
Cat: 527–32, 538, 567–71, 586–7, 605, 609–11, 614, 616–75 and 677–95

▲ **Fig 2.3.** Broad object categories within the Hoard by weight.

FITTINGS FROM WEAPONRY

Around 80 per cent of the objects, equivalent to just over half of the total weight, are fittings from weapons, including a small number of fittings from scabbards (fig 2.3). All major types of hilt-fitting of the period are represented (fig 2.4) – pommels, hilt-collars, hilt-rings, hilt-plates and sword-rings, as well as rarer types of small mounts from grips and guards.[12] The vast majority very probably came from swords with the tripartite hilt-form then common to England and Europe (fig 2.5).[13] Typically the grip and two guards of the hilt were made of horn that fitted around the iron tang of the blade.[14] This was probably true too for most of the absent weapons represented by the Hoard, though there is also one set of all metal hilt-guards (**409**).

Only a small number of fittings are from seaxes (knives for fighting and hunting), the only certain instances being the garnet cloisonné set (fig 3.80) and a hilt-plate (**370**).

The gold fittings outnumber the silver by a ratio of more than 4:1 (by object count and weight), but the proportion of gold to silver is not constant across the range of objects. For instance, hilt-collars and small mounts are less common in silver, while sword-rings occur exclusively in that metal. Hilt-plates show the lowest ratio, approximately 3:1 (gold:silver), but the fragmented state of the plates in both metals makes this uncertain. Nonetheless, it may be significant to note that this ratio is similar to that of the pommels, which could suggest a close relationship between these fittings.

◀ **Fig 2.4.** Sword-, seax- and scabbard-fittings by object count.

Fig 2.5. The long sword typical of the period. It has a tripartite hilt, formed of a grip with two guards. The combination of hilt-fittings shown are those most common in the collection. *Drawing*: C. Fern.

Pommels and sword-rings (cat. 1–84)

The pommel was often the most ornate part of a sword in the period, but the fitting was also functional, capping the upper guard at the tang end of the blade and thereby securing the whole hilt assembly (fig 2.5). There are at least seventy-four in the collection (**1–58** and **63–78**), and several detached end-fragments might represent additional pommels (**59–62**), making a maximum possible total of seventy-eight. These figures are lower than the total originally identified due to the joining of parts.[15] There are only three silver sword-rings (**79/84**, **80/1/3** and **82**), fittings that could be added to pommels as a further marker of status,[16] although a small group of silver pommels (**75–7**) has fixed ring-knobs incorporated into their form. The key characteristics of the pommels are summarised in table 2.2.

The majority are gold (**1–62**), with sixteen in silver (**63–78**), but no examples are of copper alloy as first reported.[17] Up to ten pommels form potential suites with hilt-collars (**1–2**, **5**, **27**, **47**, **50**, **54–5**, **69** and **71**), although only one could be matched with its set of hilt-plates (**46** and **280–1**), and another is possibly a match with a group of guard-tip fittings (**49** and **499–502**). The most elaborate pommel in silver (**76**) is probably to be associated with an equally extraordinary pair of collars (**188**) and set of guards (**409**). In addition, one silver pommel (**68**) might have fitted one of the three loose sword-rings (**82**), but the match is not certain (see below).

Most take the 'cocked-hat' form common in north-west Europe in the sixth to seventh centuries, with over forty examples in gold with filigree decoration (fig 2.6). The pommels were attached by rivets, though variation is seen in the manner of their fixing across the full range of types. A pair of rivets in housings each end was most common. Exceptions include pommel **1** that has three housings each end, pommel **68** with odd numbers of housings, and others with single housings (**15** and **63**). A further small number has housings of enclosed type (**52**, **57** and **78**), and the small group (**75–7**) with fixed ring-knobs shows yet another form.

CHAPTER TWO | CHARACTERISING THE OBJECTS

	Catalogue	No.	FORM				TECHNOLOGY					STYLE					
			Rivet-housings only	Cocked-hat	Round-back	Double sword-rings	Sheet-metal	Part-cast	Cast	Core: metal	Core: calcite/organic	All-over filigree	Filigree with cloisonné/gem-setting	All-over cloisonné	Incised/cast ornament	Gold mounts	Style II
GOLD	1–35	35	-	33	2	-	X	-	-	5	6	X	-	-	-	-	25
	36–42	7	-	6	1	-	X	-	-	1	2	-	X	-	-	2	3
	43–55	13	-	X	-	-	4	6+?3	-	-	2	-	-	X	-	-	4
	56–7	2	-	1	1	-	1	-	1	-	-	-	-	-	X	1	X
	58–62	1	4	-	-	-	X	-	-	-	-	-	-	-	-	-	-
SILVER	63	1	-	X	-	-	X	-	-	1	-	X	-	-	-	-	-
	64–70	7	-	X	-	-	-	-	X	-	-	-	-	-	6	-	3
	71–4	4	-	-	X	-	-	-	X	-	-	-	1	-	3	2	2
	75–7	3	-	X	-	X	-	-	X	1	3	-	2	-	X	2	1
	78	1	(1)†	-	-	-	-	-	X	-	-	-	-	-	X	-	X
Total:		74	4	64	8	3	49	8	16	8	13	36	10	13	15	7	41

▲ **Table 2.2.** Typological characteristics of the pommels. 'X': all objects have the feature; '?': uncertain identification/quantity; '†': end-fragment 78 as a unique object contributes to the minimum total of seventy-four pommels.

◀ **Fig 2.6.** i) Pommel **2** is one of over forty pommels in gold with all-over filigree decoration. The pommel retains its copper-alloy core, in which is lodged a fragment of iron tang; ii) X-ray of the core (the tang fragment does not show); iii) Style II motif of a pair of zoomorphs one side; iv) quartet of serpents the other side, forming a quatrefoil knot centrally; v) terms used for the parts of a pommel. *Photographs and drawing*: C. Fern.

The pommels suggest how the cocked-hat form might have developed over time (fig 2.7), in accordance with the Hoard chronology suggested in *Chapter 6*. The majority (*c* 80 per cent) of the undistorted pommels are under 20mm in height, of squat form and with flat shoulders (H. 15–18mm), including several with early Style II animal ornament (**1–2**, **4** and **68–9**). These can be compared with taller examples with slightly concave shoulders (H. 21–26mm) and decoration that is arguably later (**32–3**, **38–9** and **52**). Especially large are gold pommel **57** (L. 60mm; H. 27mm) and silver pommels **75–7** (L. reconstructed *c* 80mm; H. 27–30mm), which are certainly among the latest. However, as so many pommels cannot be closely dated, it is uncertain how real this trend from low to tall forms was, and there are exceptions, such as the less squat pommels **5** and **14** (H. 20–20.5mm) with early Style II.

Eight pommels are round-back forms (fig 2.7): four gold (**34–5**, **37** and **56**) and four silver (**71–4**). Most are flat-sided, of varying height, but one in silver is hemispherical (**71**). The other three silver examples share the feature of low rivet-housings (**72–4**), although they have contrasting levels of decoration. In gold, pommels **35** and **56** can also be compared for their similar form, as well as for their animal ornament (fig 5.8).

Of those pommels sufficiently intact to provide measurements, most are in the range of 39–46mm in length (the full range is 30–60mm). The small seax pommel (**55**) can be considered a miniature, and notably it also had a different method of attachment, via a pin housed in its width (fig 3.80).

▲ **Fig 2.7.** The two pommel forms in the collection, *cocked-hat* and *round-back* (scale 1/2). *Drawing*: C. Fern.

The large cohort of gold pommels with all-over filigree ornament (**1–35**) is remarkable for the similarity of style and manufacture that is demonstrated (fig 2.6). A smaller subgroup (fig 2.8) combines the ornament with cloisonné (**36–41**) or in one case an empty gem-setting (**42**). There is also one filigree example (**63**) in silver, which notably had not been gilded (fig 2.9). All were made with an outer 'skin' of thin sheet metal (*c* 0.2–0.4mm), formed of one or more pieces that were cut to shape and soldered together. The seams are visible in some interiors. The rivet-housings at the ends were either formed out of the same sheet or were made and attached separately, and usually an additional plain cap of sheet was soldered over the apex, probably to protect against wear. In most cases, the filigree wires and granules were directly applied to the flat sheet areas of the sides and shoulders, but on a small number of pommels a variety of back-sheet enhancements is seen.[18]

The pommels of fragile gold or silver sheet were provided with solid interiors of cast metal or other material. Seven have cores of copper alloy (**1**, **2**, **14**, **27** and **40**) or silver (**19** and **63**). Silver pommel **63** is missing much of its filigree decoration and the remaining sheet body seems stuck to its silver core; possibly the damage to it was the result of an attempt to separate the two (fig 2.9). By comparison, the core of pommel **40** is loose and was possibly never fixed inside the sheet cap; but the structure would have been held together once the pommel was fixed by its rivets to the guard. Other cores still *in situ* in pommels show on X-radiographs, as in the case of pommel **2** (fig 2.6). There is also considerable evidence for the use of non-metal cores and fillers, of wood, horn, calcite and wax.[19] In addition, the badly damaged pommel **26** is of note, as uniquely it was formed in gold sheet together with its hilt-plate, one tip of which remains at one end.

▲ **Fig 2.8.** Pommels **36** and **46**. Pommel **36** has combined filigree and garnet cloisonné and pommel **46** has all-over cloisonné. Note the abstract face-mask design on pommel **46** (scale 1/1). *Photographs: Cotswold Archaeology, © Barbican Research Associates.*

▲ **Fig 2.9.** Pommels **63** and **64**. Pommel **63** has silver filigree over a silver core and pommel **64** has a cast frame line with a central triangular garnet setting one side. *Photographs: Cotswold Archaeology, © Barbican Research Associates.*

Interlace patterns dominate on the forty-three pommels with filigree (**1–42** and **63**) applied to the sides and in many cases the shoulder panels. In fact, only pommel **23** is entirely without interlace. Mostly the designs were executed in triple-strand beaded wire and, though at first glance they may appear meaningless, many in fact conceal ingenious arrangements of zoomorphs or serpents of Style II type, as well as other symbols (fig 2.6).[20] Only occasionally are any of these patterns identical, for example on pommel **4**, which has the same complex design both sides. In addition, silver pommel **63** stands out for its equal-arm cross in filigree on one side (fig 2.9). The rivet-housings are mostly covered with filigree herringbone pattern (fig 3.57), though beaded wire could also be used to similar effect (e.g. **1** and **2**). Plain housings (**16**, **23**, **38** and **41**) and in one case housings of reeded sheet (**30**) are rare on the filigree pommels, and five pommels with all-over cloisonné ornament also have undecorated housings. Herringbone filigree was also used as a fill for the shoulders of some filigree pommels, as were rows of collared granules and, more rarely, scrollwork and figure-of-eights (**8**, **13**, **15**, **17–21**, **24–5**, **29**, **34**, **39** and **56**).

The weights for complete gold filigree pommels that include metal cores have a range of 15.33–32.74g (**1**, **2**, **14**, **19**, **27** and **40**). However, examples without cores are more informative for the actual measure of gold used. Eleven give a range of 8.14–15.90g,

and within this sample a number demonstrate similar weights: pommels **3** and **8** (8.14–8.57g); pommels **9**, **18** and **20** (11.33–11.91g); pommels **16** and **30** (15.36–15.90g). But, of these, only pommel **16** retains its gold rivets, parts that would have contributed along with any other gold fittings to the total amount of the valuable metal employed overall.

Twenty-five pommels have cloisonné ornament or some other form of gem-setting, but only fifteen of these have garnet inlays (figs 2.8–2.9, 2.11–2.12 and 8.2).[21] As already stated, some combine the ornament with filigree (**36–40**), and notably these have cellwork that appears inexpert within the assemblage as a whole.[22] Three are also without garnets, instead having an inlay that is 'unidentified' (**38–40**), and three other pommels with all-over cloisonné have the same inlay (**43–4** and **54**).[23] Nine of the total had all-over garnet ornament (**46–53** and **55**), together with glass inlays in two cases (**49** and **53**). A number (**43–55**) share particular traits of manufacture and style, including apices and rivet-housings that were cast (**45–7**, **50** and **53–4**), or probably cast (**48** and **51–2**). This manufacture contrasts with the exclusively sheet-metal construction of the filigree pommels. Pommel **54** possibly also had a cast frame, into which its sheet cellwork was inserted.

Distinctive 'mushroom' cellwork occurs on all the gold pommels with full cloisonné, except for the incomplete pommel **45**.[24] Four (**48–51**) are linked by shared patterns, with designs on pommels **50–1** connecting them further with cloisonné mounts **565–6** (fig 3.93). Similarly, the pattern on pommel **47** is a version of that seen on mounts **542–3** (figs 3.92 and 8.2).[25] Four (**52–5**) have Style II animal ornament, while geometric motifs featuring quatrefoil, saltires and crosses are also formed in the cellwork of some.[26]

▼ **Fig 2.10.** Pommel **57** and its extraordinary Style II animal ornament. *Photographs*: G. Evans. *Drawing*: C. Fern.

Fig 2.11. Pommel **73** with cast and gilded interlace one side, and the other side a mount with gold filigree and garnet cloisonné. *Photograph*: Cotswold Archaeology, © Barbican Research Associates.

Two gold pommels are more singular creations. Round-back pommel **56** has identical versions of the same Style II motif on its sides, executed by incising into gold sheet, with details added in black niello inlay (fig 4.28). Pommel **57** has exceptional three-dimensional cast animal ornament juxtaposed with panels that also employ niello, in the form of bold lines, all framed by thick imitation filigree wire (fig 2.10). Its rare character is matched by its large size, and it is by some way the most gold-rich of the pommels, both in its weight (44.23g) and the fineness of its alloy.[27]

Although smaller in number, the silver pommels too present a variety of forms (figs 2.9 and figs 2.11 and fig 2.12). All were cast, except filigree pommel **63**. The three cocked-hat forms (**64–6**) with simple line framing are so similar that they suggest products of the same workshop. One (**64**) is set with a garnet (fig 2.9).

A number have Style II animal ornament. This was originally gilded and niello-inlaid on pommels **68–9** (fig 5.4), with pommel **69** possibly a suite with collars **186–7** and mounts **533–5** (figs 2.16 and 2.33). Hemispherical pommel **71** has incised Style II, as well as a cast band with boar-head terminals surmounting its top, which is related to that on a fragmentary set of collars (**189**) and other remains (**605**) (fig 5.9). Enough of pommel **70** survives to show it also had Style II animal ornament on both sides (fig 5.8). Fragment **78** is an enclosed rivet-housing decorated with bird-beaks, its form and decoration being unrelated to any other pommel in the collection (fig 5.11).

Two of the silver round-back pommels (**73–4**) have applied gold mounts fitted to one side only (and on pommel **74** mounts decorated the shoulders also), with ornament of filigree and in one case cloisonné (fig 2.11). The other side of pommel **73** has cast and gilded interlace, while pommel **74** has an incised quatrefoil knot. Round-back pommel **72** is plain, except for, significantly, a possible rune mark.[28]

The three large ring-pommels (**75–7**) were all highly fragmented, so were only identified and rebuilt during conservation (fig 2.12). On the evidence of their form, manufacture and style, a related origin seems beyond doubt. A pair of 'ring-knobs' was original to each, set on the shoulders, but cast separately. From each hollow knob extended a rivet, which provided the main means of attachment. On pommels **75–6** these fitted into cylindrical rivet-housings at each end. Some of the cast parts are relatively thin, with evidence that they were filled by metal and non-metal core materials. Pommel **76** presents a medley of ornament that is unmatched (figs 2.12 and 5.22). Of its three gold mounts that remain, the large central mount displays a cloisonné roundel of garnet and glass, flanked by filigree interlace. Filigree annulets and scrollwork decorate the mounts on the remaining ring-knob. Cast and gilded interlace and other ornament, some with niello inlay, cover the other surfaces, together with further filigree herringbone strips and a garnet at the apex.

Pommel **75** has cast and gilded interlace on both its sides in sunken panels that are interspersed with triangular elements in relief. On one side the raised equilaterals were decorated with silver tear-drops set against black niello backgrounds (fig 5.22). The composition on the more incomplete other side appears to have been similar, with one large central triangle and smaller triangles at the vertices, but was possibly formed instead entirely of glass inlays (only a single flat green glass inlay remains). The pommel is notable also for a band of thick silver filigree in a channel that runs over its top and ring-knobs.

The two gold mounts on the ring-knobs of pommel **77** are eye-shaped and the large central gold mount also suggests an eye with its central cabochon rock crystal (figs 5.22 and 6.6). It is possible in this case, as for all the pommels with gold mounts set on just

one side, that the mounts indicate the intended 'display' side, which would have faced outwards when the swords were worn scabbarded. The use of the mounts, as well as similar cast interlace, links pommels **73–7**, while plain pommel **72** may be considered also related on account of its shared form.

Sword-ring **82** is a cast skeuomorph of two linked rings, and each side has an incised bird-head (fig 2.13); unusually, the heads do not conform to either Style I or Style II animal ornament. Although the sword-ring fits approximately to the shoulder of pommel **68**, the two fittings were certainly not conceived together, given their contrasting decoration and different silver alloys.[29] Also there is no mark or wear pattern on either pommel shoulder to suggest their prolonged contact. Ring-rivet **83** is a fit with collar **80–1**, and ring-rivet **84** is a fit with collar **79** (fig 2.13); the parts are to an extent interchangeable, but together suggest sword-rings of the same form.

▲ **Fig 2.12.** Ring-pommel **76** with a ring-knob on each shoulder and mounts with gold filigree and garnet cloisonné. *Photograph*: Cotswold Archaeology, © Barbican Research Associates. *Drawing*: C. Fern.

▲ **Fig 2.13.** Silver sword-rings **79–84**. *Photograph*: Cotswold Archaeology, © Barbican Research Associates.

Hilt-collars and hilt-rings (cat. 85–242)

There are at least ninety-seven hilt-collars and thirty-five hilt-rings in gold,[30] and additionally there is one hilt-plate (**359**) with a fitted collar.[31] Both hilt-collars and hilt-rings come from the grip, and a pair seems to have been standard, based on the number of sets in the collection (figs 2.14–2.17). Though principally decorative, they would also have hidden the joins between the grip and guards. Remarkably, from both types of fitting combined, forty-nine pairs are possible (table 2.3): the collar pairs are mostly identified with a good degree of confidence, but the ring pairs are less certain due to their fewer differentiated forms. There are a further four pairs of hilt-collars in silver (**182–8**). Up to sixteen individual silver hilt-rings are suggested, though all are incomplete and some are small fragments, so the actual number of original rings could be lower. In addition, there are fragments of at least one hilt-collar (**190**) and one hilt-ring (**242**) in gilded copper alloy. The large number of hilt-collar pairs, in particular, including some that have been matched with pommels and other objects (see online table 4), now prove beyond doubt that swords and seaxes at the period could be made with sets of hilt-fittings in distinctive styles.

▲ **Fig 2.14.** Gold hilt-collars **87–8** and pommel **1**. They probably are a set with Style II filigree. The collars are high forms and some of the most gold-rich objects in the collection. *Photograph*: Cotswold Archaeology, © Barbican Research Associates.

▲ **Fig 2.15.** Gold hilt-collars **125–6** and **157–8**. They are examples of low form. *Photographs*: Cotswold Archaeology, © Barbican Research Associates (**125–6**); C. Fern (**157–8**).

Just one silver collar (**184**) retains an inner liner of copper alloy, but it is possible that many others had such strengthening linings originally. This is suggested by the fact that the intact gold filigree hilt-collars found at Market Rasen (fig 2.41), which are closely similar to examples in the collection, also have copper-alloy liners.[32] With the addition of an inner liner it would have been necessary to recess the collars into the grip, so that they were flush, as is suggested was done for many of the collection's small mounts.[33]

The gold filigree collars (**85–158**) that make up the majority can be separated into two groups according to the height of the band (figs 2.14–2.15; table 2.3). Thirty-two (**85–116**) are of 'high' form (H. >12mm). Pair **87–8** are the largest examples (H. 20.5–22mm), and they are also by some margin the greatest by weight of the filigree collars (48.41g): with pommel **1** they form a sumptuous set with early Style II that must be near the start of the gold-object

Fig 2.16. Silver pommel **69**, hilt-collars **186–7** and mounts **534–6**. They are possibly a set with gilded Style II and interlace. *Photograph*: Cotswold Archaeology, © Barbican Research Associates.

Fig 2.17. Examples of the different types of hilt-ring: gold beaded (**197**); gold twisted-beaded wire (**213**); gold wrapped-beaded wire (**221**); cast silver beaded (**228**). *Photograph*: Cotswold Archaeology, © Barbican Research Associates.

sequence.³⁴ Forty-two are of 'low' form (H. <12mm). Those with bands less than *c* 3mm are visually little different from hilt-rings, though the manufacture of their filigree on sheet backings is shared with the other hilt-collars. The smaller collection of twenty-three gold collars with cloisonné ornament comprises again high forms (**159–68**; H.>11.5mm) and low forms (**169–81**; H.<9.5mm).

The bulk of the filigree hilt-collars was manufactured from strips of metal (Th. 0.2–0.4mm) joined to form a continuous band, though some have fixing-holes for nails.³⁵ Unusually, on pair **101–2** seams from the joining of the metal sheet are visible beneath the filigree, marking a somewhat inexpert finish; but in most cases the joins were hidden and are only visible on the reverse, often at each end. As with the filigree pommels, the ornamental wires and granules were largely soldered directly onto the sheet body of the object, but a small number show related back-sheet treatments,³⁶ which helped to identify sets with the pommels (online table 4). The collars in cloisonné similarly started as a sheet band onto which the cellwork was built, but sometimes the sheet is slightly thicker (Th. 0.3–0.6mm).

Filigree interlace and Style II animal ornament dominate on the high collars (**85–113**), but also feature on some low collars (**117–29** and **151**), giving the impression of a distinctive style matching that of the filigree pommels. Examples with earlier Style II include collars **85–8**, **90** and **118**. Quite different are the quadruped creatures on collars **109–10**, which are characteristic of late Style II in England (fig 3.52).³⁷ The rare use of concertinaed filigree wire on one of these collars links the pair with several others (**111–3**), and possibly they represent a workshop group. Singular is the plaited filigree interlace on pair **128–9**.³⁸

The low gold filigree collars mainly have herringbone (**135–52**) or herringbone-with-spine ornament (**153–8**).³⁹ On one low collar pair (**149–50**) the herringbone pattern is interposed with sections of gold reeded sheet. In contrast, herringbone decoration is dominant on only a few of the filigree collars of high form (**97** and **114–5**). Also, the collar(s) of gilded copper alloy (**190**) was cast to imitate filigree herringbone-with-spine.

Low collars **157–8** (fig 2.15) are unusual in comprising bands of filigree herringbone-with-spine married with bands of cloisonné. They are also the only objects in the collection that have garnets cut with beaded surfaces, which were arranged so that they imitate the beading of a hilt-ring (cf fig 2.17: 197). Their skeuomorphic form would appear to suggest that hilt-rings and hilt-collars were

	Catalogue	No.	Pairs/set	HILT-COLLAR FORM		HILT-RING FORM			TECHNOLOGY		HILT-COLLAR STYLE						
				High	Low	Beaded	Twisted-beaded	Wrapped-beaded	Sheet-metal	Cast	All-over filigree	Filigree with cloisonné/gem-setting	All-over cloisonné	Incised/cast ornament	Gold mounts	Style I	Style II
Hilt-collars — GOLD	**85–116**	32	14	X	-	-	-	-	X	-	X	1	-	-	-	-	13
	117–58	42	17	-	X	-	-	-	X	-	X	2	-	-	-	-	5
	159–68	10	5‡	X	-	-	-	-	X	-	-	-	X	-	-	-	5
	169–81	13	4‡	-	X	-	-	-	-	1†	-	-	X	-	-	-	-
Hilt-collars — SILVER & COPPER ALLOY	182–90	10	4+?1	6	4	-	-	-	-	X	-	-	-	X	2	2	5
Hilt-rings — GOLD	191–210	20	3	-	-	X	-	-	-	-	-	-	-	-	-	-	-
	211–8	8	3	-	-	-	X	-	-	-	-	-	-	-	-	-	-
	219–24	6	3	-	-	-	-	X	-	-	-	-	-	-	-	-	-
	225	1	(‡)	-	-	-	-	-	-	X	-	-	-	-	-	-	-
Hilt-rings — SILVER & COPPER ALLOY	226–42	?17	3	-	-	X	-	-	-	X	-	-	-	-	-	-	-
Total:		159	57	48	59	37	8	6	84	29	74	3	23	10	2	2	28

▲ **Table 2.3.** Typological characteristics of the hilt-collars and hilt-rings. 'X': all objects have the feature; '?': uncertain identification/quantity; '†': fitting **169** has a cast cap; '‡': fittings **167–9** and **225** are a set with pommel **55**.

sometimes used together on grips, as is similarly suggested by the combination of hilt-rings and grip-mounts on the sword from Sutton Hoo mound 1.[40] However, the thick filigree trims of many of the hilt-collars in the collection would have negated the need for additional hilt-rings.

Filigree scrollwork features on only a small number of collars: on two pairs of low form (**130–1** and **132–3**) and on two of high form (**116** and **359**). This is notable in comparison with the much greater application of the ornament on other types of hilt-fitting.[41]

Some hilt-collars in gold with all-over cloisonné (**159–60** and **163–9**) also form sets with pommels, based on similarities of manufacture and style. A number have 'mushroom' and 'arrow' patterns (**160–6** and **171–3**) and cross cells (**165–6** and **178**). Five collars have animal ornament in Style II (**163** and **165–8**), which in four cases is of late form.[42] Collars **165–6** have an 'unidentified' inlay instead of garnet, and collar **177** has the same inlay combined with garnet cloisonné.[43]

The five fittings (**55**, **167–9** and **225**) from a seax or large knife are consummate creations in gold and garnet (fig 3.80). The parts (total Wt 83.66g) were mainly formed out of thick sheet, except for the cap of the uppermost fitting (**169**) and the cast hilt-ring (**225**): the cap of fitting **169** was possibly cast as a slab with a slot cut for the tang. The cap-fitting, ring and one hilt-collar (**167**) join neatly together and were mounted at the top of the grip. The parts show clearly that the weapon grip was ovoid in section. The small pommel (**55**) fitted over the knife-tang and was set on top of the cap-fitting (**169**). This arrangement is confirmed by a scratched outline of the pommel on the cap-fitting, and there is also a dent left by its forced removal. The ripped-open underside of the pommel shows it housed a pin (now lost) in its broadened width (fig 4.17). The pin presumably would have been fastened through a hole at the top of the tang to secure the whole grip assembly, and possibly it was removable to allow the hilt to be disassembled should the blade or grip need repair. The second hilt-collar (**168**) fitted at the bottom of the grip: it has a slot for the tang of the single-edged knife, along with a contact mark left by the back of the actual blade.

Silver fragments **189** may also be remains of one or more collars from a seax hilt, forming a set possibly with pommel **71** and fragments **605**, but their fragmentary condition makes this uncertain. One fragment may be part of a cap-fitting (like **169**) on which the pommel was mounted.

Another pair of silver collars (**188**) rebuilt from fragments can also be related to other silver fittings.[44] Each collar had a trapezoidal gold filigree mount on one side, with cast and gilded ornament on the other side. The writhing interlace patterns on the filigree mounts are like those on the gold mounts of pommel **76** and hilt-guards **409**, with which the collars possibly formed a grand suite (*endpiece*).

The three other pairs of hilt-collars in silver have decoration that indicates they are some of the earliest objects.[45] A pair of high form has animal ornament of Style I (**182–3**); a second pair of high form is decorated with horizontal lines and punchwork (**184–5**); and a third pair (fig 2.16) of low form has early Style II animal ornament (**186–7**).

The hilt-rings show a smaller range of types (fig 2.17). Most of those in gold (**191–210**) were made from a length of thick beaded wire that was formed into a continuous band with the join visible in some cases (fig 3.29). A few possible sets are identified (**191–6**). All the silver examples (**226–41**) and that in copper alloy (**242**) are cast imitations of this type. A number of these retain gilding, but scientific XRF analysis has indicated that some were probably ungilded.[46] Two further gold hilt-ring types were formed of composite filigree wires: eight are of twisted-beaded wire (**211–8**), in some cases with the join covered by a patch of sheet, and six were formed of wrapped-beaded wire (**219–24**).[47]

Hilt-plates and hilt-guards (cat. 243–409 and 696–7)[48]

The collection's numerous hilt-plates very probably come mainly from the guards of swords (figs 2.5 and 2.18), with the certain exception of plate **370** that is from a seax. While they were no doubt decorative, some in gold were reinforced with metal liners and, like the mostly thicker silver plates, appear robust enough to have strengthened the guards that protected the hand. In total, there are 100 plates that are over half complete (>50 per cent) and seventy-one less complete fragments (<50 per cent). The majority of the entire assemblage (131) is gold (77 per cent).[49] Given the extent of fragmentation, it is not possible to quantify exactly the number of plates originally present, though almost twenty possible sets have been identified (online table 4).[50] Organic remains of guards were found with the plates in just two cases (**243** and **258**). In addition, there are the fragmentary remains of the unique pair of silver hilt-guards (**409**).

Although damage has distorted many, all the more complete plates and the hilt-guards appear to take the long-oval form common to swords in the sixth to seventh centuries in northwest Europe (figs 2.18–2.19).[51] Finds from burials show that a hilt could have a full

CHAPTER TWO | CHARACTERISING THE OBJECTS

Gold Plates	No.	Total
upper guard *tp*	13	
upper guard *bp*	18	
upper guard	18	50
?upper guard	1	
lower guard *tp*	22	
lower guard *bp*	34	
lower guard	1	64
?lower guard	7	
unknown	17	17
Total		**131**

Silver Plates	No.	Total
upper guard *tp*	1	
upper guard *bp*	2	8
upper guard	5	
lower guard *tp*	0	
lower guard *bp*	5	13
?lower guard	8	
unknown	19	19
Total		**40**

▲ **Fig 2.18.** Quantities and characteristics of the hilt-plates from the two guards of the hilt. *Drawing*: C. Fern.

complement of four plates, a pair to sandwich each of the lower and upper guards, though this is by no means true of all the swords known. Possibly plates might be lost or removed with use, but some weapons may never have had full sets. Only a small number of full sets are identified in the collection, with just three pairs still fixed together (figs 2.19–2.20; **243–4** and **265**). Nevertheless, it is the case that the remaining loose plates represent well all four locations on the hilt (fig 2.18).

The plates vary in their size and attributes, meaning that in many cases it has been possible to establish their original location on the upper or lower guard (fig 2.18). All have evidence of a slot, to allow them to be fitted around the tang or blade of the weapon.

The plates of the *upper guard* typically have three fixing-holes in a triangular arrangement at each end: a single hole at each tip secured the plates and these were decorated with bosses; the pair of holes set behind them at each end was for fixing the pommel (with the rivets secured on the bottom plate by double-washers). Telling the two plates of the upper guard

▶ **Fig 2.19.** The best-preserved set of gold hilt-plates (**243–4**). All four plates are almost intact and still riveted together, but only 243 retains the cabochon garnet bosses of its top plate. *Photograph*: Cotswold Archaeology, © Barbican Research Associates.

Fig 2.20. Side view of hilt-plate pair **243** from the upper guard. Part of the horn guard survives between the fixed plates, preserved probably by contact with the corroded copper-alloy liner of the bottom plate. *Photograph*: Cotswold Archaeology, © Barbican Research Associates. *Drawing*: C. Fern.

Fig 2.21. Pair of silver hilt-plates (**372–3**) from the upper guard. The larger hole one end was possibly for a sword-ring. *Photograph*: Cotswold Archaeology, © Barbican Research Associates.

apart relies on the presence of marks left by other fittings, but these are common. On *top plates* a patinated outline or impression was often left by the base of the pommel (figs 2.18–2.19; e.g. **243**); on *bottom plates* an oval mark surrounding the tang-slot could be made by a hilt-collar, hilt-ring or possibly by the top of the grip. Some of these show indentations from filigree beaded wire, indicating that they had been fitted with a hilt-collar or hilt-ring with this ornament. However, only a few of these impressions could be matched with the outlines of actual fittings. One set suggested is pommel **46**, hilt-plates **280–1** and bosses **629**: the pommel outline is unusual and matches the mark on the top plate from the upper guard; and the bosses fit the marks at the ends of the plates around the rivet holes. Just one double-washer (cf fig 2.18) remains with its plate (**243**), but it is the same form as other loose examples (**660**), and many bottom plates demonstrate marks left by such washers.

The plates of the *lower guard* are larger and typically have only single rivet holes at their tips, which were again decorated with bosses (fig 2.18). The *bottom plate* surrounded the weapon blade at its junction with the hilt, and hence it is easily identified by the blade-slot. The slots that survive sufficiently intact indicate the double-edged sword of the period,[52] with the exception of plate **370** with its single-edged slot for a seax (fig 5.1). The *top plate* has a rectangular or oval slot for the tang and bears markings from the fittings of the grip.

The number of plates and fragments identified to each guard is shown in fig 2.18. Most of the silver hilt-plates survive as half-

Fig 2.22. Schematic drawing of possible positions for hilt-plates suggested by the collection: i) full set of four plates; ii) bottom plates for both guards; iii) bottom plate for the lower guard only. *Drawing*: C. Fern.

fragments or smaller: only a single plate (fig 2.21; **373**) was complete and only three are close to whole after rejoining (**371–2** and **375**). In total, forty plates in silver could be represented, though the original figure might have been closer to around two dozen, indicating at least enough plates for the eight pommels in silver of cocked-hat form (**63–70**).

The plates identified to the different parts of the guards are unequal in quantity. Bottom plates are better represented, with the plate that surrounded the blade from the lower guard most numerous. This might suggest that while some hilts certainly had all four plates, others had only pairs of bottom plates (e.g. **263–4** and **361–4**), or even only a single plate around the blade-slot (fig 2.22 ii–iii). However, the following must be acknowledged: many fragments could not be assigned to a specific position, and the blade-slot feature of the bottom plate of the lower guard is most distinctive, even on small fragments, almost certainly favouring its identification.

Most of the gold plates were formed out of a single thickness of sheet metal, with only a few manufactured with a double-sheet thickness (**262**, **289**, **294**, **316** and **365**). The sheet used has a typical thickness of 0.2–0.4mm (online table 5),[53] though some is up to 0.7mm thick, including that of a set of four plates (**306–9**). Plate **264** is the greatest by gold weight (23.68g): it has strips of gold added on its underside around its edges, making it appear unusually thick. The same is true of its pair (**263**) and one other plate (**327**). Seax plate **370** is the only gold plate that was cast. In contrast, almost all the silver plates were cast, with only a few made of sheet (**404–7** and **696–7**).

Many plates have a flange around their outer edge, though these are more common on the bottom plates of both guards. Silver plates **372–3** are an example of a pair from the upper guard that both have flanges (fig 2.21). Also, these plates were possibly adapted to fit the ring-rivet of a sword-ring (cf fig 2.13; **79/84**, **80–1/83**), as each has an enlarged hole at one end (and the same may be true of plates **381–2**). Flanges also occur around some blade-slots: some are down-turned (e.g. **244**); others are upright (e.g. **264**).

Linings on the reverse of copper alloy (fig 2.20) were used to reinforce the thin sheet of some gold plates (**243–5**, **331** and **335**), while a liner of iron was used in one case (**259**), and a plate of shaped horn in another (**258**). Small fragments of copper alloy or copper corrosion are present on other plates (**273**, **283**, **318–9**, **336** and **342**), showing they too were strengthened, and other plates demonstrate characteristic lipped edges that would have held and gripped a liner (**291**, **300**, **303**, **320**, **330**, **333** and **351**).

The majority of the plates have lost their bosses, although these are indicated in some cases by remaining filigree collars or circular marks left by the fittings. A small number of potential matches with loose fittings have been made: boss-headed rivet set **629** with plates **280–1**; boss-headed rivet pair **666** with plates **381–2** (if the holes are not for a sword-ring); and boss pair **638** with plate **328**.

Those bosses that are *in situ* and those found loose present a range of types. Most common are bosses with beaded wire collars,[54] but there is considerable variation in their exact manufacture (fig 2.89): some are boss-headed rivets, with either the rivet soldered into a hemispherical boss of gold sheet or part of a cast solid head;[55] other gold bosses were soldered to their plates, over but not fixed to the rivet;[56] and many were pierced to allow the passage of the rivet.[57] It is possible that some hilts combined these forms: for example, pierced bosses with boss-headed rivets. The decorative filigree collars could be soldered either to the boss or to the plate, and there are also boss-washers, upon which bosses were mounted.[58]

▲ **Fig 2.23.** Pair of bent gold hilt-plates (**361–2**) with garnet cloisonné trims. Both are bottom plates, one from each guard, so they might have been mounted as in Fig 2.22ii. *Photographs*: G. Evans (**361**) and Cotswold Archaeology © Barbican Research Associates (**362**).

In addition, plates **263–4** have plain, pierced bosses without filigree collars. A less common type are the cabochon garnet bosses with gold filigree collars (figs 2.19–2.20),[59] and a single plate fragment has a boss with a green glass inlay (fig 3.12). To prevent the hollow metal bosses from collapsing, some were filled with paste,[60] while others had cores of base metal. A metal core without its gold boss is on gold hilt-plate **283**, and other examples with cores are silver bosses **669** and **671**. In sum, these permutations, together with the variations seen in the manufacture of the plates themselves, suggest that smiths in different workshops adopted varying approaches to the production of the otherwise relatively uniform fittings.

Some of the silver plates were gilded, but metal analysis has shown that a number were probably left plain (like the silver hilt-rings).[61] Other forms of decoration, besides filigree trims, are rare. Remains from one probable set (**374–8**) have simple line ornament on the side-flanges. Likewise, only a few gold plates have decoration: seax plate **370** has cast Style II animal ornament (fig 5.1); the attached hilt-collar of plate **359** has panels of filigree scrollwork; fragmentary plate (or set) **360** bears filigree crosses; and gold plates **361–9** have cloisonné trims (fig 2.23).

Most elaborate are the pair of silver hilt-guards (**409**) rebuilt from thirty-two fragments, including five surviving gold mounts (fig 2.24). Each guard has a cast, hollow structure, which probably had been filled with a paste for solidity. Originally there were eight gold mounts, four for each guard, which were set on the sides together with panels of cast and gilded interlace, within borders of alternating silver and niello leaf and zig-zag patterns. The gold mounts have filigree decoration and one is set with a cabochon garnet: they have been assigned to their positions on the basis of fit and the alignment of fixing-holes. The guards may be a set with pommel **76** and hilt-collar **188**: one of the collars has a shaped base that is a reasonable fit with the oval slot on the lower guard (*endpiece*).

◀ **Fig 2.24.** Silver hilt-guards **409** with gold mounts. *Photograph*: Cotswold Archaeology, © Barbican Research Associates. *Drawing*: C. Fern.

CHAPTER TWO | **CHARACTERISING THE OBJECTS**

▼ **Fig 2.25.** Small mounts of various form and ornament: with animal ornament, filigree scrollwork and garnet cloisonné. *Photographs*: C. Fern and Cotswold Archaeology, © Barbican Research Associates.

Hilt-mounts and other small mounts (cat. 410–537)

There are 128 small fittings that probably come mostly from the grips and guards of swords. The majority are gold, with just five in silver (**534–7**). They demonstrate considerable variation in their form and decoration, as summarised in table 2.4 and shown in figs 2.25 and 2.34–2.35. Overall there are around thirty pairs or sets (online table 4). There is also one fragment in gilded copper alloy with interlace (**691**: [*K1284*]), although it is not certainly a mount. The identification of many as hilt-fittings is based on their resemblance to small gold mounts on a single exemplar, the 'Cumberland' hilt, a remarkably well-preserved find of the nineteenth century, now in the British Museum, which has a grip, guard and pommel of horn (fig 2.26). A new examination of this object and its study by X-radiography has shown how the mounts were set in shallow recesses and fixed by small gold nails (fig 2.27).[62] However, the range of forms in the Hoard considerably exceeds the parallels on the Cumberland hilt, including rare and previously unknown types. Figures 2.28–2.33 show how some of these might have been mounted, although others remain perplexing, such as the wonderful writhing serpents (**527–32**).

Four mounts take the form of the tip of a hilt-guard (fig 2.28). Gold guard-tip pair **410–1** has filigree ornament. The two others are non-matching (**412–13**), but both are of gold sheet, in each case with inner linings of copper alloy that surround organic remains of the guards.[63] Guard-tip **413** is plain, while **412** has Style II serpent decoration against a black niello background; both may have had pairs originally.

Several sets of gold mounts were probably wrapped around the ends of guards (fig 2.25; e.g. **439–41** and **503–6**). They are of strip or rectangular form, with filigree (**439–53** and **471–2**) or cloisonné decoration (**496–7** and **498–510**).[64] The Cumberland hilt has only a single example of a similar filigree fitting (fig 2.26), but the full sets in the collection suggest that the fittings could be mounted at all four points of the upper and lower guards. Some retain curvatures and there are impressions on reverses left by the guard-tip in some cases. Four (**499–502**) may be a suite with pommel **49** (fig 2.29) based on their shared use of a rare cloisonné cell-form.[65] The fittings in the sets tend to be slightly different sizes, with those from the lower guard slightly bigger. It is possible that the cloisonné mounts in particular were combined with hilt-plates, as some are quite low in form (e.g. **503–4**), though none was found in any relationship with a plate. In some cases, the damage to the fittings suggests how they were levered off the hilt (fig 2.29).

Fig 2.26. The preserved horn 'Cumberland' hilt with small gold mounts that are like many in the collection (not to scale). *Image*: © Trustees of the British Museum.

Thirteen gold mounts with filigree ornament (**414–26**) are of triangular or sub-triangular form, and one rectangular filigree mount (**427**) has a triangular projection (fig 2.25). Mount **427** and the other small rectangular mounts (**428–31**) are especially like examples on the hilt in the British Museum (fig 2.26).[66]

The multiple small triangular fittings with cloisonné (**489–93**) also have a parallel on the Cumberland hilt (figs 2.25–2.26). The X-radiograph and drawn section of the hilt show how its single garnet cloisonné fitting was set in a deeper recess to make it flush with the grip (fig 2.27). The collection's small cloisonné mounts are of a similar depth and it is common for them to have a slight curvature to their width, presumably to match the surface of the grip.

CHAPTER TWO | CHARACTERISING THE OBJECTS

			FORM & TECHNOLOGY			STYLE						
	Catalogue	No.	Pairs/sets	Form	Cast	Copper-alloy lining/backing	Filigree	Incised ornament	Cloisonné/gem-setting	Scrollwork	Herringbone (band/fill)	Zoomorphic form/Style II
GOLD	410–3	4	1	guard-tip	-	2	2	1	-	2	-	1
	414–26	13	1+?1	triangular/sub-triangular	-	-	-	-	-	10	-	2
	427–38, 454–8	17	3†	rectangular/sub-rectangular/trapezoidal	-	1	16	-	1	6	3	1
	439–53, 471–2	17	5	guard-tip (rectangular/strip)	-	-	X	-	-	11	2	6
	459–70	12	2	zoomorphic	-	-	11	1	5	6	1	X
	473–5, 480, 488	5	1	unclassified	-	-	4	-	2	3	-	3
	476–7	2	1	pelta	-	-	X	-	-	-	-	-
	478–9	2	(‡)	eye-shaped	-	-	X	-	-	X	-	-
	481–2	2	-	cross	-	-	X	-	1	1	-	-
	483–7	5	2	tongue-shaped	-	-	2	3	-	-	-	3
	527–32	6	3	serpent	6	-	-	-	-	-	-	X
GOLD & GARNET	489–93	5	1	triangular	-	-	1	-	X	1	-	-
	494–5	2	?1	rectangular	-	?1	-	-	X	-	-	-
	496–510	15	5	guard-tip (rectangular/strip)	-	-	-	-	X	-	-	-
	511–7	7	3	zoomorphic	-	-	-	-	X	-	-	X
	518–23	6	2	tongue-shaped (animal heads)	5 (part)	-	-	-	X	-	-	5
	524–5	2	-	oval	-	-	-	-	X	-	-	-
	526	1	-	cross	-	-	-	-	X	-	-	-
SILVER	533–5	3	?1*	tongue-shaped	X	-	-	-	-	-	-	-
	536–7	2	1	zoomorphic	X	-	-	-	-	-	-	X
	Total:	128	34		16	4	72	5	47	42	6	48

▲ **Table 2.4.** Typological characteristics of the small mounts. 'X': all objects have the feature; '?': uncertain identification/quantity; '†': **458** is a possible set with **494–5**; '‡': **478–9** are possibly a set with **417–9**, **420** or **421**; '*': **533–5** are possibly a set with pommel **69** and collars **186–7**.

Fig 2.27. X-radiograph of the 'Cumberland' hilt, with a drawn section showing how the gold mounts were recessed and fastened with small nails (scale 1/1). *X-radiograph*: © Trustees of the British Museum. *Drawing*: C. Fern.

In addition, some of the triangular and other cloisonné mounts have the feature of a neat flange of gold sheet at their basal edge (**491–2** and **511–23**). This includes bird mounts **511–2** and fish mount **513** (fig 2.35), which were possibly a set of four originally (i.e. one fish is missing), for arrangement on a grip as in fig 2.30. All have a single pin on the reverse, and another pair of bird-headed mounts (**514–5**) is similarly furnished. It is proposed that these mounts and the others with base-flanges were fitted in a similar manner: by anchoring the flange in a joint formed with a hilt-collar (fig 2.30), or in that between the grip and guards (fig 2.31). The single backing pins on some were perhaps pushed through drilled holes, being made fast in the tight space behind the grip casing by the insertion of the tang, since it would have bent over the soft metal of the pin to prevent it being withdrawn (fig 2.30). For those tongue-shaped mounts (**518–23**) and one triangular mount (**492**) without pins or holes for nails, an alternative means of engaging the mount was provided in each case by a point or lip of gold projecting from the tip or animal head (fig 2.31).

The majority of the mounts have fixing-holes like on the Cumberland hilt (cf fig 2.27), some with small nails remaining. This includes silver bird-headed pair **536–7**, which were again shaped to fit a gentle curvature, and are of different sizes to suit the narrower top and wider bottom of the grip (fig 2.32). This is also true for several other pairs of fittings (**467–8**, **473–4** and **516–7**). Mounts **536–7** can be compared with certain gold mounts that have rounded bird-heads (**463–5** and **467–8**), with in each case the eye of the head formed by a nail-head or small cabochon gem. The hatched fill of the beaks in cast silver on mounts **536–7**, furthermore, imitates that in filigree on mount **464**, while small collared granules fill the beaks on mounts **465** and **467–8**. Altogether the stylistic relationship of these silver and gold bird-headed mounts suggests a discrete regional and chronological group.

Silver tongue-shaped mount **535** is a known form that would have been fitted to the edge of a grip, as in fig 2.33, following examples from continental and Scandinavian swords.[67] On the evidence of its ornament, very possibly it was part of a set with flat mounts **533–4**, pommel **69** and collars **186–7** (fig 2.16). A number of gold mounts (**483–7**) in the collection are also tongue-shaped.

A small number of the gold mounts (**438**, **454–7** and **473–5**) are akin to hilt-collars in their size and filigree decoration, but, unlike them, they would not have fully encompassed the grip (fig 2.25). Other fittings are less convincingly explained as from hilts, such as swastika mount **464**, since its closest known relations are pendants.[68] Similarly, crosses **481–2** and **526** seem less well suited as hilt-fittings and might have had different applications,[69] though it cannot be ruled out that they furnished weaponry. Further unusual forms are two long ovoid mounts with garnet cloisonné (**524–5**), two eye-shaped filigree mounts (**478–9**) and one of L-shape (**480**), but all have slight curvatures in keeping with those already discussed as from hilts. The pelta shape of mounts **476–7** is also uncommon in Anglo-Saxon ornament.[70] However, the pair exhibit basal flanges like others in the collection. Three rectangular mounts in filigree (**458**) and cloisonné (**494–5**) with copper alloy remains on their reverses were made to be inserted into a flat surface. The filigree example can be compared with mounts from Krassum (Netherlands).[71] Fork-ended mount **488** is one of the most curious objects in the whole collection and is entirely without parallel. Nevertheless, it was made from high-purity gold (Au c 98wt%), which may suggest it came from a significant object.[72]

Fig 2.28. Guard-tip **412** (and its missing pair), constructed of gold sheet over a copper-alloy liner, fitted on the organic guard. *Drawing*: C. Fern.

The delightful serpent mounts form three pairs with different heads (fig 2.34). As a group they appear ostentatious in their use of gold, in terms of their alloy fineness and in their combined weight (70.31g),[73] which accounts for approximately 20 per cent of the total weight of all the gold small mounts. Two pairs are largely complete (**527–30**), but the heads of the remaining pair (**531–2**) are separated, probably at original joins. These separated heads have pin-prick, black niello eyes and duck-like jaws, with the lower jaw in each case formed of a small, shaped piece of sheet.

In comparison, the heads of pair **527–8** are flat and round with pitchfork jaws, while the last pair (**529–30**) has more naturalistic heads with tiny punched eyes. These are very close to the heads of cloisonné mounts **518–22**, suggesting possibly a related origin (fig 2.34), and like them also they have a projecting lip for fitting (cf fig 2.31). The serpent mounts have been damaged by twisting, increasing the impression of a writhing energy, but originally each pair was probably attached to a flat or slightly curved surface since they have planar undersides with integral pins (as on mounts **511–5**). It is possible the smallest pair (**529–30**) was recessed into a weapon grip, but the other two pairs of larger serpents would perhaps have been better suited to some other purpose: there are

Fig 2.29. Interpretation for hilt-fittings **499–502**, possibly a set with pommel **49**. *Drawing*: C. Fern.

▲ **Fig 2.30.** Interpretation for hilt-fitting **512** (a set with **511** and **513**). *Drawing*: C. Fern.

▲ **Fig 2.31.** Interpretation for hilt-fitting **519** (like **518** and **520–3**). *Drawing*: C. Fern.

▲ **Fig 2.32.** Interpretation for hilt-fitting **536** (a pair with **537**). *Drawing*: C. Fern.

▲ **Fig 2.33.** Interpretation for hilt-fittings **533–5**, reconstructed as a set with pommel **69** and collars **186–7** (hilt-plates conjectured). *Drawing*: C. Fern.

CHAPTER TWO | CHARACTERISING THE OBJECTS

Fig 2.34. Gold and garnet cloisonné mounts **521–2** and gold serpent mounts **529–30**. Note the similar heads with punched eyes. *Photographs*: Cotswold Archaeology, © Barbican Research Associates and G. Evans.

myriad possibilities, given the popularity of serpent symbolism in the period, ranging from decoration for a leather scabbard to the cover of a Christian manuscript.[74]

Over seventy of the gold mounts – the majority – are decorated with filigree. More than forty exhibit a dominant scrollwork style, just as on the Cumberland hilt (fig 2.25). Herringbone pattern was combined with the scrollwork typically as framing, but in a small number of cases it is the main ornament (e.g. **432–4** and **448–9**). Forty-three gold mounts are decorated with garnets. Mostly these were used in cloisonné, but five filigree objects have small cabochon garnet bosses (**436**, **465**, **473–4** and **482**) and one triangular mount (**493**) has a single setting.

Forty-eight mounts are in some way zoomorphic (fig 2.35), and thirty-five of these take animal form or are animal-headed. Mount **459**, showing a bird preying on a fish, can be considered a miniature version of the large bird-fish mount (**538**; fig 2.66), with both objects formed out of gold sheet by cutting and incising. Two filigree mounts take fish form (**461–2**), and there is the single example in cloisonné (**513**). Fish-scale pattern is displayed on several (**459**, **461** and **513**), and it is seen too in the cloisonné of other mounts (**496–7** and **521–3**). Other fittings have Style II animal ornament: serpent or zoomorphic interlace is most popular (**412**, **425–6**, **450–3**, **455** and **480**), but quadrupeds appear on one set (**485–7**). Interlace without animal content decorates seven gold mounts (**454**, **456–8**, **475** and **483–4**) and three silver mounts (**533–7**).

Fig 2.35. Selected small mounts of zoomorphic form or with animal ornament, including sets **473–4**, **511–3** and **516–7**. *Photographs*: G. Evans and Cotswold Archaeology, © Barbican Research Associates.

Fig 2.36. Gold and garnet pyramid-fitting pair **578–9** with Style II animal ornament and button-fitting pair **582–3**. Button **582** is shown in its stone 'bead' (**584**). *Photographs: Cotswold Archaeology, © Barbican Research Associates.*

Fittings from weapon-harness (cat. 572–87)

Five pairs of pyramid-fittings (**572–81**) and one pair of button-fittings (**582–4**) are objects associated with weapon-harness, and three buckles (**585–7**) possibly also relate to scabbards or to the wearing of weapons (figs 2.36–2.37). The features of the button- and pyramid-fittings are summarised in table 2.5.

Button- and pyramid-fittings were probably primarily used to attach the scabbard to a belt or other harness (fig 2.38i–ii). The exact way they worked is unknown, but *in situ* finds from burials confirm their association with the upper scabbard.[75] In addition, the use of button-fittings with sword-scabbards is illustrated on a helmet panel from Vendel XIV (Sweden) (fig 5.20v).[76] While the Hoard examples and other instances suggest a pair was perhaps standard, the two pairs found with the sword in mound 1 at Sutton Hoo show that this was not always the case: a pair of buttons was on the scabbard and a pair of pyramids may have served as pendants (fig 2.38iii).[77] Single instances of buttons and pyramids are also known from graves in England and on the Continent, though these may represent survivals from originally functional pairs.[78] In addition, there is now a substantial record of stray examples, mainly found by metal-detecting, and this further suggests that the fittings were susceptible to becoming detached.[79]

Each of the buttons (**582–3**) has a long loop on its reverse, a manner of attachment paralleled on multiple examples from England and the Continent.[80] Those at Sutton Hoo, termed 'scabbard-buttons'

Fig 2.37. Gold buckles **585–6** and silver buckle **587**. *Photographs: Cotswold Archaeology, © Barbican Research Associates.*

by Bruce-Mitford, sat on the corroded blade in remains of collars of bone or ivory, and further examples have been found with similar collars.[81] Button-fitting **582** demonstrates a precise fit with the collection's single stone 'bead' (**584**), which is undoubtedly its original collar (fig 2.36).

The pyramids were fitted by means of a bar on the reverse, as is well paralleled by examples outside the collection. The four gold pairs (**572–9**) possibly have cast bases with solid attachment bars, but the upper part of each pyramid was built of sheet metal. They take different forms and are not all of one cloisonné school. The pair in

CHAPTER TWO | CHARACTERISING THE OBJECTS

		Catalogue	No.	Pair/set	Form		Cast	Part-cast	Cast copper-alloy core	Filigree	Cloisonné/gem-settings	Gold mounts	Glass	Style II
GOLD	GARNET	572–3	2	X	pyramid	low	-	X	-	-	X	-	X	-
		574–5	2	X	pyramid	tall	-	-	X	X	X	-	-	-
	&	576–7	2	X	pyramid	tall	-	?X	-	-	X	-	1	-
		578–9	2	X	pyramid	tall	-	?X	-	-	X	-	X	X
		582–3	2	X	button		-	-	-	X	X	-	-	-
		584	1	-	stone bead		-	-	-	-	-	-	-	-
SILVER		580–1	2	X	pyramid	tall	X	-	-	X	X	X	-	-
		Total:	13	13			2	6	2	6	12	2	5	2

▲ Table 2.5. Typological characteristics of the pyramid- and button-fittings. 'X': all objects have the feature; '?': uncertain identification/quantity.

garnet and blue glass (**572–3**) is of low form (H. 13.5mm), while the others (**574–9**) are tall examples (H. >18mm), a formal variance that may indicate a different dating.[82] Five have glass inlays, three of *millefiori* type.[83] Only pair **578–9** has Style II animal ornament (fig 2.36), which contains remains of an 'unidentified' inlay, similar to that recorded for a number of pommels and hilt-collars.[84]

Pyramids **574–5** are different from the others, as they combine shallow garnet cloisonné with gold filigree over cores of copper alloy, which suggests manufacturing affinities with certain pommels (**36–41**). Also, pyramid **575** has a small gold loop on one edge, and its pair probably had one originally where a tear is now evident. These may have functioned as an extra attachment point for each pyramid that was intended to help avoid their loss. The last pair of pyramids (**580–1**) in cast silver has gold mounts with scrollwork filigree and limited garnet inlay akin with ring-pommels **75–7** and others.[85]

The two small gold buckles (**585–6**) and one in silver (**587**) are fittings commonly found in burials as objects of personal costume, but examples in precious metal are rare,[86] so it is plausible that they also had some association with high-status weaponry, given the predominantly martial character of the assemblage. Gold buckles **585–6** are similar in form, with oval loops and rectangular back-plates (fig 2.37). Buckle **586** is the more elaborate and slightly larger, having three bossed rivets with filigree collars on its plate and a lightly incised band. Silver buckle **587** has gold herringbone filigree decoration inlaid on its oval loop. Its tongue was found separately and has a flat and oval 'tongue-shield' with a silver filigree frame, which is possibly missing its original inlay. Also associated with the loop were remains of a sheet silver back-plate, possibly rectangular in form originally, and punch decorated on one side.

▲ **Fig 2.38.** Schematic representations of the function of: i) button-fittings (**582-4**); ii) pyramid-fittings (**572-81**); iii) the fittings with the Sutton Hoo mound 1 sword (adapted after Bruce-Mitford 1978). *Drawing*: C. Fern.

The typological and functional significance of the weapon-fittings

The Hoard's more than 500 gold and silver fittings from weapons (around 80 per cent of all the objects) have radically transformed our understanding of the sword, in particular, as the principal instrument and symbol of the warrior aristocracy of early medieval Europe. While the long-bladed (*spatha*) form of the sword of the period remained largely unaltered over centuries, the fittings made for hilts and scabbards have long been studied for their changing styles and ornament, and in terms of what they meant as a material statement of elite culture. In quantity and quality, the ostentatious character of the collection's objects can be contrasted, above all, with the state of the record presented in Menghin's (1983) *Das Schwert*, which remains the most comprehensive survey of early medieval sword-fittings from across north-west Europe. The hundreds of hilt-fittings catalogued by Menghin, mainly recorded with weapons from continental graves, are by contrast predominantly of silver or copper alloy. However, they were often gilded to imitate the gold-hilted weapons which, we now know, must have circulated in seventh-century society in much greater quantities than had hitherto been suspected. In the British Isles, prior to discovery of the Hoard, just thirteen gold pommels of contemporary date were known. By comparison, the numbers of, mainly gold, weapon-fittings in the Hoard are truly astounding (summarised in fig 2.4), as are the many sets identified among them. There are: no less than seventy-four pommels; a possible total of 159 hilt-collars and hilt-rings; around 170 plates and fragments from the hilts of guards, as well as two actual silver guards; 128 small mounts, most probably from hilts; and twelve button- and pyramid-fittings from sword-harness.

The importance of the sword in early Anglo-Saxon culture is shown through the lens of poetry in *Beowulf*. The surviving text of the heroic epic is of *c* AD 1000, but it is considered to have been copied from versions that were as early as the eighth century in date, and that these memorialised yet earlier oral traditions that described the material culture of the fifth to seventh centuries.[87] In the poem several swords are recounted, but one sword-hilt is most significant, for it appears to recall the filigree style of hilt-furniture that is dominant in the Hoard. In the poem, after slaying Grendel's monstrous mother, Beowulf presents King Hrothgar with the golden hilt remaining from the weapon used, the blade having disintegrated on contact with the monster.[88] The hilt ornament comprised sheets (*scennum*) of bright gold and was *wreopenhilt ond wyrmfáh*. *Wreopenhilt* can be translated as something 'bound', 'wrapped' or 'twisted' on the grip,[89] which in this context would seem especially apt to describe hilt-collars manufactured of gold sheet. Rosemary Cramp, in her seminal study of the material culture of the poem, believed *wyrmfáh* best described the serpentine markings of a pattern-welded blade.[90]

In the case of the hilt of the 'Grendel' sword, however, this cannot be the case, as the blade was dissolved and no longer present. Therefore, the *wyrm*- element must indicate serpentine ornament on the hilt, and -*fáh* can be understood as the glittering 'play' of that decoration.[91] Indeed, *wyrmfáh* appears a very convincing epithet for the Style II serpentine filigree that is so characteristic of the collection's hilt-collars and pommels.[92] In sum, the array of filigree fittings in the Hoard, which establish the existence of a popular tradition, now allow a new interpretation of what was intended in the original oral verse, and the description should be recognised as yet another memory of elite material culture of the fifth to seventh centuries.

The role of the sword as a status symbol in sixth- to seventh-century Anglo-Saxon society is evidenced in the archaeological record by weapons placed in burials. A study by Heinrich Härke found that only around 10 per cent of male graves contained a sword,[93] but the weapons from these 'warrior' graves stand in marked contrast with the metalwork of the Hoard, since most have only simple fittings of base metal or none at all (fig 2.39). One of the few exceptions is the sword from Sutton Hoo mound 1 with its gold and garnet hilt-fittings.[94] In the context of what was surely a royal burial, it once appeared to represent a sword 'fit for a king', but the Hoard establishes that such arms must have existed in considerable numbers: it is most plausible that they represent the arms of the ruling warrior aristocracy, the *gesiþcund* of England.[95] The few seax-fittings, representing just two or three large single-edged knives (for fighting or hunting), likewise do not conform to the pattern of weapons from burials. In the seventh century there was an increase in the frequency with which seaxes were deposited in graves, and it is possible that they were increasingly used in the place of the sword as a status symbol.[96] The collection strongly suggests, nevertheless, that beyond the funerary context the sword remained at this time the key article of elite costume. In the general absence of parallels from secure archaeological contexts, important *comparanda* for the fittings of the collection are offered by finds made by metal-detecting, as well as by antiquarian finds like the Cumberland hilt (fig 2.26).[97] These will be considered further below, although unfortunately, in contrast to finds from graves, all of this material has poor information on provenance.

Typologically, the majority of the 'cocked-hat' pommels in the Hoard fit best with just one of Menghin's pommel-types, his *Typ Beckum – Vallstenarum*, a form that developed during the second half of the sixth century and remained popular well into the seventh century.[98] Style II animal ornament is strongly associated with the form, as is the case in the collection. Some of the pommels are less convincing adherents to the strict shape (with slightly concave sloping shoulders and a rounded apex),[99] as they are squatter with flatter shoulders,

while damage makes other identifications uncertain. Nevertheless, the strong manufacturing and stylistic affinities of the pommels outweigh these formal differences, to give the impression overall of typologically related yet distinctive pommel traditions in filigree and cloisonné. When Menghin produced his study, *Typ Beckum – Vallstenarum* pommels had been found mainly in east Scandinavia, with outliers in England, Germany and Italy.[100] This distribution is now radically altered by the major contribution of the collection, as well as by other finds from England made recently by metal-detecting. However, an origin in Scandinavia may still be correct.

Pommel **68** is possibly the oldest pommel in the assemblage and its Style II ornament indicates it is probably a Scandinavian import.[101] Its form and ornament fits best with *Typ Beckum – Vallstenarum*, except that its odd number of rivet-housings and their low form are more characteristic of earlier *Typ Bifrons – Gilton* pommels, and it should probably be considered, therefore, an inchoate specimen of *Typ Beckum – Vallstenarum*.[102] Silver pommel **67** can also be compared with a Scandinavian example, the slightly larger pommel on a sword from grave XII at Vendel (Sweden),[103] while pommel **69** can be compared with the continental exemplar of *Typ Beckum – Vallstenarum* from Beckum II (fig 5.4iii).[104] Additionally, another relation of pommel **69** was recently found at Scalford (Leicestershire), a silver-gilt pommel with Style II animal ornament and niello inlay.[105] Apart from the hybridity of pommel **68**, the absence of pommels in the collection of *Typ Bifrons – Gilton*, which was mainly popular in Kent in the sixth century, is important to note, since in particular it weakens the case for the Kentish kingdom as a source of the metalwork.[106]

The rivet-housings of enclosed form on pommels **52**, **57** and **78** are paralleled on several other Menghin types, such as the pommel with bird-head ends from Italy of *Typ Orsoy – Niederstotzingen*.[107] The closest relation for fragment **78** is an Anglo-Saxon pommel from Sarre (Kent), grave 104, which has similarly rounded ends decorated with bird-heads.[108] The bird-beaks at the ends of pommel **52** may echo this fashion. An intriguing parallel for the structural form of the 'princely' pommel **57** is presented by a pommel from Norway, at Snartemo, grave 5.[109] It is older by a century, as is shown by its animal ornament of Style I, but it has the same trapezoidal centre filled by a pair of creatures and wolf-head ends. Ultimately, perhaps pommel **57** might be considered a descendant, therefore, copied from a pommel of Snartemo-type, and thus another example of the influence of Scandinavian fashions.[110]

Round-back pommels like those in the collection are rare in England, but were popular on the Merovingian Continent in the seventh century around the middle and upper Rhine regions.[111] From England, parallels for the hemispherical pommel **71** are a stray small

▲ **Fig 2.39.** Grave 16 at Alton (Hampshire) and the sword found with a copper-alloy pommel and collars. The majority of swords of the period are finds from 'warrior' burials. Adapted after Evison 1988.

silver pommel from Mileham (Norfolk), which is decorated with bands of Style II interlace,[112] and another in iron fixed to a seax from a grave at Lechlade (Gloucestershire).[113] The flat-sided silver (**72–74**) and gold (**34–35**, **37**, and **56**) pommels have no close relations, but other rounded Anglo-Saxon forms include a U-shaped seax pommel from Sibertswold (Kent) and one in gold from Rippingale (Lincolnshire).[114] In addition, iron pommels on a number of Anglo-Saxon swords take a low 'boat-shaped' form, most of which are from graves of the seventh century.[115]

Only a small number of pommels and hilt-collars in gold filigree are known outside England, the earliest being Scandinavian finds of the sixth-century date. A pommel from Skurup (Sweden) has filigree animal ornament of Style I set in relief over a gold-sheet structure (figs 2.40 and 5.5ii).[116] Other examples with Style I filigree are a fragment of a pommel of the same type found at Ödeberg (Norway), a cast silver pommel from Hodneland (Norway) with gold panels[117] and two gold hilt-collars from the Swedish Tureholm hoard (fig 2.40). Additionally, in the same tradition with filigree

animal ornament are a number of scabbard mouth-pieces from across Denmark, Sweden and Norway.[118] George Speake long ago pointed out that this Scandinavian metalworking tradition was probably a key influence on the development of Anglo-Saxon zoomorphic filigree,[119] and fig 2.40 aptly shows how such Scandinavian weapon-fittings could have provided the inspiration for the filigree hilt-furniture of the Hoard. The only other gold filigree pommels and collars known from continental Europe are those on swords from graves 1 and 32 at the Lombardic cemetery of Nocera Umbra (Italy).[120] These are nearer in date to the Hoard fittings and one of the two filigree pommels has cloisonné on one side, making it a parallel for pommels **36–41**.

Given the dominance of filigree pommels and hilt-collars in the collection, it is remarkable that the style was unknown in Anglo-Saxon archaeology prior to the discovery in the early 1990s of a gold pommel with all-over filigree from Earl Shilton (Leicestershire).[121] In total, ten filigree pommels are now known outside the Hoard, all found by metal detectorists (fig 6.7). Other gold examples come from the counties of Essex (Ardleigh),[122] Northamptonshire (Canons Ashby),[123] Lincolnshire (Market Rasen and Wellingore),[124] Suffolk (Hacheston),[125] Wiltshire (Cricklade)[126] and Yorkshire (Aldbrough and Middleham),[127] with a sole example in silver coming from north Wales (Gresford).[128] All share with the pommels of the Hoard a sheet-metal construction, with over half retaining copper-alloy or silver cores. The Hacheston pommel is decorated with filigree scrolls only and may not be of the same type, but some of the others are very similar to the Staffordshire pommels, including that from Market Rasen (fig 2.41). Further comparisons are that the Gresford and Aldbrough pommels, have cloisonné ornament on one side, making them akin with pommels **36–41**; the pattern of filigree interlace with annulets on the Aldbrough pommel is like that on pommel **25**; the herringbone shoulder ornament on the Earl Shilton, Market Rasen and Gresford pommels corresponds with that on pommels **17–19** and **21**; and the strip ornament on the Ardleigh pommel is the only parallel for the decoration on pommel **23**, and its serpent interlace can be compared with that on pommel **38**. However, perhaps most striking is the remarkable resemblance of the filigree designs on the Earl Shilton pommel and pommel **18** (cf figs 5.5v and 5.6: **18**).[129]

◀ **Fig 2.40.** The zoomorphic filigree style of sixth-century Scandinavia, demonstrated by the pommel from Skurup and two hilt-collars from Tureholm (Sweden); though the objects are not an actual set, it is likely such suites existed (not to scale). *Photographs:* U. Bruxe, © Statens Historiska Museum (SHM 29.2; SHM 3671).

Fig 2.41. Gold fittings from a sword-hilt from Market Rasen (Lincolnshire), comprising a filigree-ornamented pommel and hilt-collars, and hilt-plates with garnet bosses. Style II animal ornament on the fittings conceals multiple creatures and symbols. *Photograph*: © Trustees of the British Museum. *Drawing*: C. Fern.

The Market Rasen find comprises a pommel, matching hilt-collars and two hilt-plates with garnet bosses (fig 2.41),[130] which show strong affinities with the style, form and manufacture of many fittings in the collection. These hilt parts were found without the sword blade, but examination at the British Museum of mineral-preserved remains has revealed fragments of the iron tang from the blade, and it also showed that the grip was of *Quercus* sp. (oak) and the guards were of *Prunus* sp. (plum, cherry, blackthorn, etc.).[131] The remains were found beside a river, but it is uncertain if the weapon had been buried near the bank or was originally deposited in the waterway.[132] In fact, of all the stray filigree fittings listed above, the pommel from Middleham is the only example that was actually found with its sword, as well as other objects, all of which probably came from a grave.[133]

Just three gold pommels in full garnet cloisonné (fig 6.7) were known from England before the Hoard (that is excluding pommels that combine the ornament with filigree). They are the pommel from Sutton Hoo mound 1, and more recent stray finds from Maxstoke Priory (Warwickshire) and Dinham (Shropshire) (figs 6.8iv and 2.86, respectively).[134] That from Sutton Hoo is very similar to examples from Sweden, found at Sturkö and Väsby, and Bruce-Mitford reasoned all were made in Scandinavia in the sixth century.[135] Arrhenius has disputed this, arguing all were imports from the Merovingian Continent, based on the use of a sand-putty paste in the garnet cloisonné.[136] However, new evidence from Gamla Uppsala (Sweden) has shown that garnet workshops were operating in Scandinavia in the sixth to seventh centuries.[137] The style, technology and pastes of the collection's cloisonné pommels

all suggest Anglo-Saxon manufacture,[138] but it is the case that their closest stylistic affinities remain with examples from Sweden, including those from Hög Edsten (fig 2.42), Skrävsta, Vallstenarum and Valsgärde.[139]

A Scandinavian connection can also be argued from the form of the hilt demonstrated by the gold and garnet seax-fittings (**55**, **167–9** and **225**) that form a set from another 'princely' weapon (figs 2.43 and 3.80).[140] The hilt-type has its most extensive parallels in Sweden, even if the Scandinavian fittings are by comparison only in copper alloy (fig 2.43i–ii). Examples are especially well-evidenced on Gotland, but occur also on the mainland and on the Danish island of Bornholm.[141] Very possibly, therefore, the Hoard's seax hilt represents an enriched borrowing from this source. Only a small number of Anglo-Saxon seaxes have any fittings, with those on a seax from Ford (Wiltshire) most like the Hoard example (fig 2.43iii). It has a small, silver cocked-hat pommel with a garnet boss and scratched Style II, which was set upon a silver cap-fitting, and at the base of its grip was a collar-fitting.[142] The grip and blade of the Hoard seax reconstructed in fig 2.43 are copied from Gotlandic narrow seaxes.[143]

The tradition of adding 'sword-rings' to pommels became widespread in Europe during the sixth century with fixed, skeuomorphic forms like those in the Hoard eventually replacing free-moving versions formed of two linked rings.[144] The custom was probably a Merovingian invention, with the linked rings argued to symbolise the bond between a warrior (the receiver) and his lord (the giver).[145] In southern England the practice is known from contexts of the fifth to early seventh centuries, so the relatively small number of sword-rings in the Hoard and the absence of any in gold are notable.[146] Nor do any of the gold fittings, pommels or hilt-plates show any evidence of ever having been furnished with them (and only a few silver fittings have been possibly linked with the custom).[147] This could be interpreted as indicating a change in sword customs in some Anglo-Saxon kingdoms from the late sixth century: with ring-giving perhaps replaced by a different tradition, such as the bestowal of weapons with sets of matching fittings. Or it could be that the origin of much of the Hoard's gold was a region where the tradition never took hold. Cast sword-ring **82** is an example of Montelius's Type 3. The two others (**79/84** and **80/1/3**) are his Type 2, each formed of a separate ring-rivet and collar.[148] They are most like the sword-rings with pommels from Sarre (Kent), grave 88, and Grenay (France).[149]

Nevertheless, that the sword-ring custom did survive or was later revived in at least one part of Britain is shown by ring-pommels **75–7**. With their integral ring-knobs, one on each shoulder, they are versions of the final expression of the tradition (Montelius Type 4),[150] although their humped forms are barely reconcilable to the original model of linked rings. Only a small number of ring-pommels are known, and all come from northern Europe, including from Vendel 1 and Valsgärde 7 (Sweden), Kyndby (Denmark) and Pappilanmäki (Finland).[151] These Nordic pommels are further characterised by fine-cast, gilded Style II animal ornament and interlace, decoration that is not entirely dissimilar in effect to the cast ornament on the Hoard pommels. However, the Hoard pommels are unique in having double 'rings'; no other sword in Europe has been found with more than one ring.

The application of gold mounts to cast silver weapon-fittings (**73–4**, **76–7**, **188**, **409** and **580–1**) is also a style almost without precedent. An exception may be a gold mount that was found in 2011 during excavation of Anglo-Saxon layers at Bamburgh Castle, an important political centre of Northumbria. The small, gold semi-circular mount with herringbone and scrollwork filigree is similar in its form and ornament to the mount on pommel **74**, although it is closer in size to those on the ring-knobs of pommels **76–7**.[152]

Given the quantity of hilt-collars and hilt-rings in the Hoard, it is surprising that these have proved so rare with swords from graves.[153] The weapon from Alton (fig 2.39) and swords from burials at Coombe and Dover (both Kent) have pairs of cast collars, in copper alloy or silver, which present matches for the three pairs in silver in the assemblage (**182–7**).[154] The low collars from Coombe can

◀ **Fig 2.42.** Pommel **50** is in the same garnet cloisonné style as the Swedish pommel from Hög Edsten (i) with Style II animal ornament (ii). *Photograph*: C. Hedenstierna-Jonson, © Statens Historiska Museum (SHM 3163). *Drawing*: C. Fern.

▶ **Fig 2.43.** Reconstruction of the Hoard seax, represented by hilt-fittings **55**, **167–9** and **225** (cf fig 3.80), and related examples (scale 1/4): i) Knife from Vendel grave XIV (Sweden); ii) Seax from Gotland (Sweden) (Nerman 1969/1975, no. 1688); iii) Seax from Ford. *Drawing*: C. Fern.

be compared in particular to pair **186–7**, but the form also has an earlier example of fifth-century date in the collars with spiral ornament on a sword from a grave at Högom (Sweden).[155]

The Alton and Dover collars are higher forms that are oval in plan like pair **184–5**. Menghin, in his study of sword-fittings, identified similar collars (*Typ Snartemo – Roes*) as having a mainly Scandinavian distribution.[156] The Swedish collars in filigree from Tureholm (fig 2.40) show the high form in use as early as the first half of the sixth century, and an example from the same country of the late sixth or early seventh century is the cast pair with a sword from Valsgärde 8.[157] The Hoard now shows the popularity of the fittings in England well into the seventh century, with pair **188** possibly the latest.

Gold filigree hilt-collars are rare finds outside the collection. Besides those of high form from Market Rasen (fig 2.41), there is a gold fragment found by a metal-detectorist at Tuxford (Nottinghamshire).[158] It has remains of a Style II design that is to an extent comparable with those on collars **109–10** and it might have come from a similar collar of high form. A sword from Acklam Wold (North Yorkshire) has a pair of gold filigree collars that are a parallel for the collection's low forms with herringbone-with-spine (**153–6**).[159] Collars **128–9** with filigree interlace can be compared with the cast collars in silver-gilt with interlace on the well-known Crundale sword.[160] Both these weapons are of the seventh century, and since no examples of similar low collars are known elsewhere in Europe, it is possible that they represent an Anglo-Saxon fashion.

Hilt-rings are also unknown on the Continent and in Scandinavia.[161] Other Anglo-Saxon examples include hilt-rings of beaded type in silver (cf **226–41**) on several Kentish swords, from Dover, Bifrons and Faversham.[162] However, there is only one parallel for the Hoard's gold beaded type (**191–210**): a pair decorate the grip of a sword from the 'princely' Prittlewell chamber-grave (Essex). The wire used has a diameter of *c* 2.0–2.1mm, close to a number of the Hoard examples.[163] Notably, the weapon-hilt from the grave was otherwise unadorned, including having a non-metal pommel. The 'royal' sword from Sutton Hoo features a pair of gold filigree rings that are the only parallels for those of twisted-beaded wire (cf **211–18**).[164]

The hilt-plates in the assemblage are almost all examples of Menghin's *Typ Faversham – Endrebacke*, the long-oval form applied to the guards of swords across north-west Europe during the sixth and seventh centuries.[165] In England the only gold sets known previously were from Sutton Hoo and Market Rasen (fig 2.41), but a number in gilded silver or copper alloy come from other Anglo-Saxon weapons.[166] The gold plates with garnet cloisonné trims (**361–9**) are without parallel. Nor does hilt-guard pair **409** have any match from England, although some contemporary Scandinavian swords have metal guards.[167] Due to damage, only a single plate could be matched with a pommel (**46** and **280–1**). Nevertheless, it seems very likely on the evidence of the ratios of the fittings (fig 2.4), and from the physical impressions left on plates (fig 2.18), that most did form sets with the collection's pommels, hilt-collars and hilt-rings.

The strong comparison of many of the small gold mounts with those on the Cumberland hilt (fig 2.26) shows another style of decoration that was probably popular.[168] It is also important to note on the exemplar from Cumberland the absence of a metal pommel (and hilt-plates), since this shows that the number of swords represented by the Hoard material cannot simply be equated with the number of pommels. However, that small mounts could also be combined with metal pommels and plates is shown by other swords. One from Chessell Down (Isle of Wight) has a heavily worn parallelogram of gold with filigree annulets stuck to its corroded tang, while the sword from Sutton Hoo mound 1 has filigree mounts at the top and bottom of its grip.[169] On the Continent, a mount of Sutton Hoo type comes from the sword in grave 32 at Nocera Umbra (Italy), and there is a single filigree mount from the terp site of Wijnaldum (Netherlands).[170]

▲ **Fig 2.44.** Pyramid-fittings **574–5** and a similar pyramid from Dalmeny (Scotland). *Photographs*: Cotswold Archaeology, © Barbican Research Associates (**574–5**); Dalmeny © National Museums Scotland.

These examples aside, however, there are few parallels for most of the small mounts. The guard-tip mounts in cloisonné (**496–510**) have just one relation outside the Hoard, in a single fitting on the upper guard of a sword from Stora Sandviken (Sweden), associated with a pommel also in garnet cloisonné.[171] The collection now suggests their use in sets (fig 2.29). The general form shared by bird-headed mounts **465–6** and **536–7** has a single, somewhat puzzling, analogy in filigree on a pair of gold knife-grips from grave 1782 at Krefeld-Gellep (Germany), but this example pre-dates the Hoard by at least a century.[172] Cloisonné bird mounts **511–7** and serpent mounts **527–32** are entirely novel forms.

Pyramid-fittings are the most common class of Anglo-Saxon weapon paraphernalia found by metal-detecting, with a growing distribution mainly across eastern England.[173] By comparison, the fittings seem underrepresented in the collection. The fashion represented by the objects is also seen on the Merovingian Continent and a few examples are known from Scandinavia, but the gold and garnet quality of those in the Hoard is matched only by the best Anglo-Saxon finds.[174] A development in the pyramid form can be traced from the few finds known from graves and on stylistic grounds. The collection's pair of low form (**572–3**) shares its use of blue glass and garnets with the low pyramids from Sutton Hoo mound 1.[175] The fashion for blue glass with garnets is a feature of earlier cloisonné in England, for example, as seen on the Kingston Down brooch (Kent), which also has early Style II (cf fig 6.9i).[176] Another low pair was found in mound 17 at Sutton Hoo, with both graves at the cemetery, therefore, confirming the form's currency around the start of the seventh century.[177] The Hoard's other pairs are all tall forms, one set having rounded bases (**578–9**). Examples of tall pyramid-fittings are unknown from graves, but certain stray finds may be compared. A tall pyramid in gold from Fincham (Norfolk) has small triangular garnets at its four corners,[178] like pair **576–7**, and the same feature is seen on a Scottish find of the nineteenth century from Dalmeny (fig 2.44).[179] This pyramid is an especially close parallel for pair **574–5**, not only in its decoration, but also because originally it had a copper-alloy core and a tear at one edge might indicate it had a loop like pyramid **575**.

Bruce-Mitford believed that the Dalmeny pyramid represented 'a late phase in the evolution' of the object-type.[180] Certainly late is a tall pyramid in silver-gilt and niello with interlace and animal ornament from Bawtry (Nottinghamshire), now in the British Museum, its decoration indicating an eighth-century date.[181] It shares with pair **578–9** the feature of a round base. Probably the latest in the collection is the pair of silver fittings **580–1** with gold mounts. A similar trapezoidal gold panel, with a central cross-shaped garnet surrounded by filigree scrollwork, was found at Maidstone (Kent).[182] Lastly, although most of the Hoard examples are in garnet cloisonné, that swords with gold filigree pommels and hilt-collars might have had scabbards with matching gold filigree pyramid-fittings is suggested by examples with Style II filigree from Selsey (Sussex) and Bury St Edmunds (Suffolk).[183]

Button-fittings are rarer finds across Europe, perhaps because they were popular for a shorter period of time.[184] Pair **582–3** and single stone bead **584** can be compared with a singleton with its white bead from a grave at Wickhambreaux (Kent),[185] and with the pair in bone or ivory collars on the sword from Sutton Hoo mound 1.[186] Recent stray finds that have lost their bead-collars come from 'Anglian' regions: from Griston (Norfolk),[187] Cotgrave (Nottinghamshire)[188] and Wibtoft (Leicestershire).[189] In addition, one from East Linton takes the distribution into lowland Scotland, at the limit of greater Northumbria in the period.[190] All are made in gold with garnet cloisonné, and those from Cotgrave, Griston and East Linton appear very similar to buttons **582–3** and the Sutton Hoo examples, though

the latter are unsurpassed in quality. All share the feature of dog-tooth edging, with resulting unusual serrated cellwork, and it is possible they represent a single workshop output.

The three buckles (**585**–**7**) might all have been items of costume. The majority of buckles from early Anglo-Saxon graves are found in the waist region, where it is assumed they served to fasten belts.[191] However, buckles are also found with other forms of strapwork and harness, including with sword and seax scabbards.[192] For example, two small silver buckles were fixed to the scabbard of the seax from Ford, to suspend the weapon from a belt.[193] Gold buckles **585**–**6** are examples of Type II.24 in Marzinzik's typology, with a distribution of the form mainly in south-east England, although very few examples are of precious metal.[194] The three bossed rivets on buckle **586** are a feature of her subgroup II.24a, the form also taken by the Ford buckles. The form of silver buckle-loop **587** and specifically its gold filigree inlay can be compared with the loop of a buckle with a triangular plate from Alton grave 16.[195] It is possible that buckle **587** had a decorated plate originally, too, but there are no matches for the unusual form of its tongue-shield.

The dimensions of a small number of the better-preserved fittings give information about the grips and guards they were attached to, while marks left from contact between different parts provide another source of data. So, it is in fact possible to say something about the missing iron blades and organic hilts (table 2.6 and online table 6). The mark left by the back of the single-edged blade on the lowermost collar (**168**) of the cloisonné seax-suite measures 28mm (fig 3.80). This suggests either a large knife or 'narrow' seax, according to the most recently published typology,[196] although the latter is surely more likely (fig 2.43). Seax hilt-plate **370** has a blade-slot of 36mm, indicating the same narrow-bladed class, and is similar to the blade width of the seax from Ford (fig 2.43iii). However, without knowing the original lengths of the blades, it is not possible to state whether the Hoard examples were short or long seaxes.[197]

Sword-blade width at the junction with the lower guard could be determined from the blade-slots of eight hilt-plates.[198] These give a range of 49–62.5mm, though four were between 52–7mm. These measurements agree generally with those recorded for actual surviving swords; however, the two examples (**244** and **264**) with blade-slots of 62–62.5mm are above average.[199] For comparison, the two largest blade widths known are from the weapons of Prittlewell (60–62mm) and Sutton Hoo (c 64mm).[200] These parallels, both from 'princely' graves, taken with the fact that hilt-plate **264** is also the most gold-rich plate, suggest a possible correlation between blade-size and social status.

Across north-west Europe during this period, swords and finds of hilt-fittings indicate a common form of grip that was wider at the bottom than at the top (fig 2.5).[201] The collection's numerous pairs of hilt-collars suggest that this was also the case for many of the Hoard weapons, since most comprise a smaller fitting and a larger fitting, and the same is true of some pairs of mounts and probably hilt-rings. They provide, together with the information from impressions from collars and rings left on hilt-plates, ranges for the size of the narrow top of the grip (24.5–42mm × 12–24mm) and its wide bottom (36–56mm × 13–24mm). The best-preserved hilt-plates also suggest minimum and maximum lengths and widths for the guards: lower guard (75.5–91.5mm × 21–5mm) and upper guard (51–73mm × 19–24mm). Those collars and rings that preserve sufficiently their original form mostly indicate an oval section to the grip,[202] although a few pairs suggest hexagonal sections, at least at the junction of the grip and guard.[203] In most cases it cannot be known whether the grip had a tubular waist or was moulded to fit the fingers (e.g. fig 2.26), but the splayed edges of collars **182**–**3** do suggest a grip with an expanded waist, as do some other fittings (e.g. fig 2.33), and hilt-collar pair **130**–**1** may have been shaped to fit a grip with moulded bands at each end.

At the 2010 Hoard symposium at the British Museum in London, Guy Halsall considered two of the 'big' questions that first strike any student of the collection.[204] How many swords, and hence warriors, might be represented by the weapon-fittings of the assemblage? And what are the implications for considering the size and make-up of Anglo-Saxon armies? The number of pommels (now revised to a minimum of seventy-four) was critical to Halsall's calculations. However, as previously stated, this figure cannot be regarded as truly reflecting the potential number of swords or warrior aristocrats represented, since it disregards the existence of weapons with hilts like the Cumberland and Prittlewell examples, with precious-metal mounts but non-metal pommels of horn or other organic material.[205] Swords might also have iron pommels (formed with the tang), as has the Acklam Wold sword.[206] It is very possible, if not probable, that such weapons contributed ornamental parts to the Hoard. Furthermore, the number of fittings a hilt might have could vary greatly: from just a single gold pommel (i.e. Middleham), a pair of hilt-collars (i.e. Acklam Wold), hilt-rings (i.e. Prittlewell) or hilt-mounts only (i.e. Cumberland), to a full array of plates, collars and a pommel (i.e. Sutton Hoo and Market Rasen). Calculating exactly the number of arms represented by the Hoard fittings is thus ultimately impossible. Nevertheless, even a conservative estimate would suggest that the dismantled weapon-fittings and other elite material account for in excess of 100 aristocrats. Princes and kings were very possibly among their number, which, significantly, is at least three times the thirty *duces regii* ('royal leaders') that Bede tells us fought and sub-commanded in the great Mercian army of Penda in 655.[207]

◀ Silver pyramid-fitting **580** with gold mounts with filigree and garnets (not to scale). *Photograph*: D. Rowan; © Birmingham Museums Trust.

Object-type	No.	Blade slot W.(mm) x Th.(mm)	Approximate minimum–maximum (L. (mm) x W. (mm) mo. = mode me. = mean)				Th. (mm) upper guard	Th. (mm) lower guard
			Upper grip (top)	Lower grip (base)	Upper guard	Lower guard		
			(data combined from hilt-collars/rings/plates)					
Hilt-collars	33	-	24.5–42 x 12–24 mo. 26 x 16 me. 31 x 17.5	36–56 x 13–24 mo. 46 x 22 me. 47.5 x 19.5	-	-	-	-
Hilt-rings	10	-			-	-	-	-
Hilt-plates	19	49–62.5 x 3–5			51–73 x 19–24	75.5–91.5 x 21–25	16 (1 sample)	14 (1 sample)
Hilt-guard 409	1	-	-	c 36 x c.14	-	c 105 x 25	13	14.5
Seax hilt-collars 167–8	1	28 x 5	30 x 18	31 x 16.5	-	-	-	-
Seax hilt-plate 370	1	36 x 4	-	-	-	-	-	-

▲ **Table 2.6.** Dimensional data and estimates for blade and hilt parts from swords and seaxes, based on sixty-five fittings. The full data is available in online table 6.

Catalogue	No.	Fragments	Form	Cast	Die-impressed sheet	Gilded	Style II	Figural
589–90	2	28	crest sections	X	-	X	X	-
591–2	2	9	cheek-pieces	X	-	X	X	-
593	1	112	helmet-band with sheet band	X	X	X	-	X
594	1	118	sheet band	-	X	X	X	-
595	1	22	sheet panel	-	X	X	-	X
596	6	82	sheet panels	-	X	X	X	X
597	6	74	sheet panels	-	X	X	-	X
598	1	9	sheet panel	-	X	X	-	X
599	1	3	sheet panel	-	X	†	X	-
600	1	96	sheet panel	-	X	X	X	-
601	1	4	sheet panel	-	X	X	X	-
602	?1	19	sheet	-	X	X	-	-
603	1	9	sheet panel	-	X	X	-	-
604	?1	9	sheet	-	X	-	-	-
606	1	390	sheet	-	X	‡	‡	‡
612–3	3	677	reeded strip	-	-	-	-	-
615	1	25	U-section edging	X	-	-	-	-
Total:	30	1686		5	22	24	9	16

▼ **Table 2.7.** Cast helmet parts and associated fittings (decorated sheet, reeded strip and U-section edging). 'X': all objects have the feature; '?': uncertain identification/quantity; '†': gilding restricted to framing; '‡': fragments from assemblage 606 are not included in totals (both gilded and ungilded sheet is present).

▼**Fig 2.45.** Helmet-crest parts **589–90**. *Photographs*: G. Evans and Cotswold Archaeology, © Barbican Research Associates.

589

head

590

▼**Fig 2.46.** Cheek-pieces **591–2**.
Photograph: Cotswold Archaeology, © Barbican Research Associates.

591

592

The 'war booty sacrifices' of northern Europe, of the late Roman and Migration periods, offer good evidence for the size and structure of armies immediately prior to the time of the Hoard, but they are different in many respects, not least in their earlier date and regional restriction.[208] Nevertheless, a brief comparison is informative for helping to understand further the character of the Staffordshire assemblage. At sites including Nydam and Illerup Ådal (Denmark), Skedemosse (Sweden) and Thorsberg (Germany), it is thought that the weapons came from defeated armies numbering from the hundreds to low thousands.[209] Unlike in the Hoard, whole weapons were deposited, ritually broken: mainly they comprise the spears and shields of rank-and-file warriors, with smaller numbers of swords and horse-gear that are thought to represent mounted leaders.[210] By contrast, the collection's precious-metal fittings from swords, a helmet and possibly horse-gear[211] cannot be considered at all representative of an early medieval army, a point made by Halsall since the spears and shields of the rank-and-file are entirely absent.[212] The ornate parts, as stated, indicate only aristocratic arms. Additionally, as the analysis in *Chapters 5* and *6* will show, the various ornamental styles in the Hoard can suggest swords and hence warriors from multiple territories, and as the material is not all of the same date, it is further possible that its accumulation took decades, rather than being from a single battle.[213]

Conclusion

The Hoard's many precious-metal fittings from swords and seaxes have revealed a remarkable bias in the archaeological record: contrary to the extreme rarity of ornate weapons in graves, it now appears that such arms were in widespread use among the warrior elite of Anglo-Saxon England during the late sixth to seventh centuries. Many of the best parallels for the collection's fittings come instead from single finds with poorly understood contexts, like the hilts from Market Rasen and Cumberland. Furthermore, while swords from graves show that weapons could have their hilts modified with fittings added over time, forming non-matching sets,[214] the many pommels, hilt-collars and other mounts in the collection indicate that swords were also regularly made with suites of decorative parts. The fittings show an awareness of forms and styles current across northwest Europe, but particularly close affinities with Scandinavian types of weapon-fitting are suggested, both for the objects manufactured in zoomorphic filigree and in garnet cloisonné. The take-up of these styles in the emerging kingdoms of England is unlikely to have been random, but rather, as will be argued in *Chapter 6*, their adoption could reflect the conscious development of distinctive fashions of hilt-furniture in different regions.

HELMET PARTS, DECORATED SILVER SHEET, REEDED STRIP AND EDGE BINDING

Chris Fern and George Speake

The remains of at least one ornate helmet are indicated in the first instance by a cast crest (**589–90**) and two cheek-pieces (**591–2**) that appear to be a suite with coverings of gilded Style II animal ornament. The only other structural element from a helmet is a rigid curved silver band (**593**), which held a patterned sheet band decorated with running or kneeling warriors, rebuilt from over 100 fragments. A reconstruction of how these parts might have fitted together is shown in fig 2.47. However, while we can envisage a single 'Hoard helmet', it must be accepted from the outset that the remains as a whole allow for the possibility that more than one helmet is represented.

A total of 557 fragments (116.35g) of decorated silver sheet and plate were allocated to multiple panels and bands (**593–604**). The thin metal sheet has figural or zoomorphic patterns impressed from

▲ **Fig 2.47.** The surviving structural parts of the helmet (**589-93**). Note the alignment of the tab-slots of cheek-piece **591** with the fixing-holes of silver band **593** (scale 1/4). *Drawing*: C. Fern.

the reverse with dies.²¹⁵ The majority are argued to have covered the cap and neck-guard of a single helmet, with their possible placement suggested in fig 2.48. However, some could be from other helmets, and such patterned sheet could also have other applications, including as decoration for drinking-vessels, scabbards and shields.²¹⁶ In addition, almost 400 small fragments of decorated sheet are unattributed (**606**). Not a scrap of copper-alloy decorated sheet was recorded in the collection, however, which contrasts most notably with the helmet from Sutton Hoo mound 1 that had its figural and zoomorphic coverings of copper alloy tinned to give a silver appearance.²¹⁷

The collection's reeded strip (**609–13**) and U-section edging (**614–15**) could also have wide-ranging uses, including in jewellery, vessel and weapon manufacture.²¹⁸ None was found in any definite relationship with the patterned sheet, apart from as debris within 'soil-blocks' (fig 1.24). Nevertheless, it is considered likely that some at least relates to a helmet. In particular, the large quantity of the reeded strip of 8mm width (**613**) evokes the latticework that held in place the decorated plates of the Sutton Hoo helmet, while some of the edge binding (**615**) is also comparable.²¹⁹ The material is summarised in table 2.7.

In sum, there are few certain relationships between the highly-fragmented and incomplete remains thought to come from a helmet, though perhaps most problematic for establishing its original form is the absence of any of the helmet cap, whether of iron or other material. The full colour reconstruction (fig 2.56) that shows how the golden helmet might have appeared is based, therefore, on arguments made below for the relationship of the surviving parts to more complete examples of the Roman and early medieval periods.²²⁰

Cast helmet parts with animal ornament (cat. 589–92)

The metal crest (**589–90**) is our best evidence for the profile of the helmet. It was formed from two curving U-section channels with animal-head terminals at each end, and arranged nose-to-nape suggests a span of *c* 220mm (figs 2.45 and 2.47). Style II animal ornament decorates each side. As found, part **589** was bent, but complete except for its detached animal-head terminal; part **590** had broken into twenty-five fragments during its time in the ground and has been rejoined (fig 2.45). Each channel is slightly tapered, being narrower and lower at the end that received the animal head. The heads were riveted to the crest ends by means of a tang at the rear of each. The wider ends of the two crest parts were never fixed and they are slightly angled, so they do not join flush (fig 2.47). The channel formed by the side walls has remains of paste and wood fragments. It is argued that these remains probably relate in some way to a foundation for a crest of hair or feathers that was set in the channel.²²¹ Nineteen holes for nails or rivets run along the channel, with the flat heads of some remaining, covered by paste, by which means the crest must have been attached.

The preservation of the cheek-pieces (**591–2**) also differs (fig 2.46). Originally each had a curved surface with a right-angled front edge covered with identical, but mirrored, Style II ornament. A pair of tabs projected from the top edge of each, around which were fitted gold collars of thick beaded wire, the only actual gold parts of the helmet. All four of the thick metal tabs were broken off before deposition. The D-shaped slots cut through them are similar in their size and spacing to the square fixing-holes at each end of silver band **593** (cf fig 2.49). Therefore, it is proposed that the cheek-pieces were aligned and riveted with the band on each side of the helmet cap, as shown in fig 2.47. This would have made them inflexible, in contrast with the free-moving function of cheek-pieces on other helmets.²²²

▲ **Fig 2.48.** Proposed arrangement of the decorative sheet panels and bands of the helmet cap, attached by reeded strip and U-section edging. *Drawing*: C. Fern and G. Speake.

72 PART I | THE HOARD

593

▲ **Fig 2.49.** Silver-gilt band **593** with its sheet band decorated with warriors, rebuilt from 112 fragments. *Photograph:* Cotswold Archaeology, © Barbican Research Associates. *Drawing:* C. Fern.

594

▲ **Fig 2.50.** Silver-gilt zoomorphic band **594**, rebuilt from 118 fragments. *Photograph:* Cotswold Archaeology, © Barbican Research Associates.

CHAPTER TWO | **CHARACTERISING THE OBJECTS** 73

▲ **Fig 2.51.** Silver sheet **595**, **598–9** and **601–3**, and select fragments of **604** and **606**. *Photographs*: Cotswold Archaeology, © Barbican Research Associates and E. G. Fregni, © Birmingham Museums Trust (**606**).

Silver helmet-band and decorated silver sheet (cat. 593–604 and 606)

Helmet-band **593** was formed of two curving, rigid sections, with rolled top and bottom edges, forming a tray into which was set the patterned silver-gilt sheet band showing a procession of warriors (fig 2.49). It is argued that it was positioned around the bottom edge of the absent helmet cap, fixed through the large square holes spaced along its length (fig 2.47). The remains are distorted and incomplete, but suggest a reconstructed length (480–500mm) that could not have fully circumscribed the cap; so it is concluded that it terminated at a facial opening.

Two small fragments of the silver-gilt sheet with warriors were found *in situ* in the band, with subsequent joins allowing a larger part to be accurately positioned (fig 2.49). A wax-glue paste underlay the sheet inlay as a foundation and probably as an adhesive (fig 3.19). This may have been thicker than it now appears, having shrunk, so that the sheet band was perhaps originally raised flush with the curved edges of the tray. A number of small fixing-holes are spaced the length of the sheet band (no actual fixings remain), but since these interrupt the pattern they possibly indicate a repair, and were not part of the helmet's first manufacture.

The sheet strip was reconstructed on the basis of several factors: the *in situ* portion of the band; the understanding of the die pattern; and the alignment of the repair holes with corresponding holes in the rigid band. Nonetheless, the arrangement of much of it remains speculation (fig 2.49). This includes the placement at the front of a single fragment that has a cut edge, the only such piece, and on

▲ **Fig 2.52.** Panels with warriors marching right (**596**). *Photograph*: Cotswold Archaeology, © Barbican Research Associates; *Drawing*: C. Fern.

Fig 2.53. Panels with warriors marching left (**597**). *Photograph*: Cotswold Archaeology, © Barbican Research Associates. *Drawing*: C. Fern.

which evidence alone rests the possibility that the sheet band was one continuous strip of metal. A die (*c* L. 55mm; *c* W. 15mm) of five figures framed by a beaded border (fig 5.18: **593**) was used to impress the pattern, perhaps a total of nine times.

A second sheet band in silver-gilt has a zoomorphic procession (**594**) and was again possibly made from a single strip (fig 2.50). Its minimum length has been estimated at *c* 550mm, close to that of band **593**, and for this reason, it is suggested that it ran above it (fig 2.48). Arranged in this way, the two bands may suggest the approximate depth of the proposed facial opening of the cap.

Slight differences between the individual creatures in the procession have indicated another die (L. 70mm; W. 20mm) of five figures (fig 5.18: **594**), which was possibly used a total of eight times to form the band (fig 2.50). Unlike the die used to impress the warriors (**593**), the beaded borders are on the top and bottom edges only, so the procession appears uninterrupted. In addition, it appears that the band was trimmed to the correct length after manufacture, since the leading creature at the front edge has been truncated. Variation in the depth and clarity of the die-impressions is detectable, and a naked flange of sheet was left above and below the beaded border. To hold the band in position, the bottom flange could have been pushed under the edge of helmet-band **593**, while the top flange could have been secured with riveted reeded strip.

The rectangular form and design of a warrior on horseback on silver-gilt panel **595** (fig 2.51) has its best parallels on helmets.[223] Just enough survives to suggest the panel (*c* 60mm × *c* 55mm) in this case tapered slightly to its top edge, possibly so that it could more easily be set on the hemispherical helmet cap (figs 2.48 and 2.56). The dotted circle between the head of the horse and rider, possibly a sun disc, is significant as it is seen again on a single small fragment among the unattributed sheet material (**606**: [*542*]). Possibly this is all that remains from a second panel, a duplicate or mirrored design, which would have been set on the opposite side of the cap.

Around a quarter of all the allocated fragments come from a series of duplicate rectangular panels, each showing three aristocratic

▲ **Fig 2.54.** Fragments of sheet **600** with animal ornament. *Photograph:* Cotswold Archaeology, © Barbican Research Associates.

marching warriors, helmeted and sword-bearing (figs 2.52–2.53). This decoration is also well paralleled on other helmets.[224] A minimum of six panels have figures processing right (**596**), and the same number have figures processing left (**597**). The 150-plus fragments that survive account for only a small proportion of the twelve panels, with some represented by only small pieces. Nevertheless, the overall fragment coverage allows almost the full reconstruction of each die design. The two dies were slightly different sizes (*c* 50mm × *c* 50mm) and after manufacture some of the panels were cut; this could have been done to fit them into smaller spaces on the cap or might relate to damage caused by the removal of the precious-metal plates.

It has not been possible to establish the full dimensions of the die used for band **598** from the small surviving portion of it, but the limited remains perhaps suggest that it was not of any great length originally (figs 2.51 and 5.19). Its design of linked, moustachioed heads is not known on helmets, so possibly it is from a different type of object.

The few fragments of **599** are argued below to have probably been struck from a die showing 'dancing' warriors with elaborate head-dresses (figs 2.51 and 5.19). None shows any gilding, in contrast to the other warrior sheets, however, and it is uncertain if the fragments are from one panel or a pair.

The remains of panel **600** are not straightforward to interpret, but it is suggested they come from a complex arrangement of zones of Style II animal ornament in silver, which were set within a gilded framework (figs 2.54–2.55). Possibly the whole design was rendered on a single large piece of sheet, with the overall form argued as a covering for a neck-guard.[225] Each zone of animal ornament was probably impressed with a different die, while separate dies may also have been used for the beaded and herringbone edging. The other fragments of herringbone border (**604**) in the collection may have been related in some way too, but no joins could be made.

In addition, further gilded panels with Style II animal designs are indicated by gilded sheet fragments **602–3** (figs 2.51 and 5.19). Possibly one or both were associated with panel **600**, as suggested in fig 2.55, or they might have been fitted elsewhere on the helmet cap.

Fig 2.55. Reconstruction of sheet panel **600** and edge-binding **615** as a neck-guard (scale 2/3). A symmetrical composition is conjectured in bichrome with gilded framing around silver zones of animal ornament (colour inset: scale 1/2). *Photograph*: Cotswold Archaeology, © Barbican Research Associates. *Drawing*: G. Speake and C. Fern.

Fragment **601** with gilded animal ornament was possibly originally leaf-shaped (L. 34mm; W. 14mm), but must have been struck from a die manufactured for a different purpose, since the ornament extends beyond its trimmed limits (figs 2.51 and 5.19). The shape is suggestive of a nasal, a feature of other helmets of the period.[226] Most alike in size and form is the nasal on the Wollaston helmet (Northamptonshire).[227]

A few unattributed fragments (**606**) have decoration that may indicate other panels or bands not otherwise surviving, or some could be fragments from those already described (fig 2.51). Two fragments suggest mailed figures: one is part of a figure holding two spears [*K7*]; on the other the mail pattern is overlaid by small lozenges [*K866*]. Possibly both could be further fragments from panel **595**.[228] Another fragment [*K1016*] shows part of a bird-

headed helmet, but it does not fit with panels **596–7**. Two other joined fragments [*K762, K1342*] show a beaded border with possibly zoomorphic elements, while many other fragments are also parts of beaded border, some with fixing-holes, which may account for the underrepresentation generally of both these features on the surviving panels.

Reeded strip (cat. 609–13)

Around 700 fragments of reeded strip (also termed 'fluted strip') were recovered, all in silver and mostly gilded.[229] The strip was originally riveted, but few fixings have remained *in situ*. Two widths of strip (11mm and 14mm) were found to come from a silver socketed object (**607/8**).[230]

Most fragments are approximately 8mm wide (**613**), with a pattern composed of eight parallel reeds in two bands of four separated by a central channel, along which fixing-holes were drilled. Allowing for the bending and twisting of the remains, a total surviving length of *c* 3,100–3,400mm is estimated for this strip, a measure that is in general agreement with the suggestion that it had secured the patterned panel and band coverings of a helmet in the fashion of

▲ **Fig 2.56.** Reconstruction of the helmet. *Image*: G. Speake.

◀ **Fig 2.57.** The parts of silver-gilt edging **614**. Piece (i) includes preserved wood; curved piece (iv) possibly formed the chape on a scabbard. *Drawing*: C. Fern.

known examples (figs 2.48 and 2.56).[231] The spacing of the holes varies: most are 14–17mm apart, but some are spaced 9–13mm, and a few are closer. The majority of the fragments are straight, but a small number are curved. The latter may be noted with regard to the semi-circle cut out of the back-edge of the reconstructed neck-guard (fig 2.55).[232] The rivets that remain mostly have small domed heads, gilded like the strip.[233] Only one rivet is certainly complete (L. 15mm) and two others have bent ends.[234] This bending was possibly done deliberately, as a means of fastening, and suggests an approximate depth of 3–4mm for the material to which the strip was attached.[235] Some of the strip fragments are butt-ended, at ninety degrees, others are angled at forty-five degrees or at twenty degrees (figs 3.38–3.39).[236] The cut ends appear deliberately flattened, which was perhaps done to enable them to be hidden beneath other pieces at junctions within a latticework. One sizeable piece is attached to a crumpled piece of plain silver-gilt sheet. This is an important relationship (not present for the patterned sheet), since it suggests plain coverings may have also featured on the helmet cap.[237]

A smaller quantity of strip is 4–7mm wide with most fragments having a four-reed pattern (**610–2**). One fragment has a pattern of two reeds (**609**). The majority measures 5mm wide and is gilded both sides (**611**); it is possibly all from one object (fig 3.37). It includes several sections of *c* 100mm in length, with fixing-holes spaced 9–12mm, as well as two shorter curved pieces and a possible clip. It is notably similar to the reeded strip used on the maplewood cups from Sutton Hoo mound 1, though its general lack of curvature arguably suggests another purpose.[238]

In addition, there are two clips formed of strip (**612**) that could have fastened some form of edge binding.[239] They do not fit the U-section edging in the collection (**614–5**); but even so it is tempting to associate them with a helmet, on the basis of the similar clips used on the Sutton Hoo helmet.[240]

Edge binding (cat. 614–15)
Chris Fern

Two different gauges of silver edging with a U-section have been partly reassembled from sixty-eight fragments. Both assemblages are incomplete to an unknown extent.

A heavier edging (**614**) of 7mm width was made in sections, probably by casting and has a gilded finish (fig 2.57). Six parts survive, but it is unlikely that they were all fitted to the same object. Only one part is complete (i), with ends at ninety degrees: the only evidence for what it was fitted to is a fragment of wood in its interior (species unidentified), 4–5mm in width, in which is lodged a small iron nail that does not penetrate the metal edging. The two tightly curved parts (iv–v) are not a pair as they have their recesses on opposite sides: that with its recess on the inside of the curvature (iv) also has rivets at its mid-point with a strip of metal between. Potentially it might have formed the chape to a scabbard, though its sides are splayed out somewhat.[241] The upturned ends of two of the other lengths (ii–iii) are original.

The other edging is a narrower 5–6mm gauge in plain silver (**615**). It is entirely without fixing-holes and was fitted to a material of *c* 4mm thickness. Following re-assembly, it is now in nine main parts with two finished ends, and, though these have a surviving length of *c* 400mm, they do not all join. Nevertheless, at least some of the remaining curvature is real and the edging can be compared, in particular, with the trim of a similar gauge used around the helmet from Sutton Hoo.[242] Possibly this was its function, to bind exposed edges on the Hoard helmet, around the facial opening, nasal and neck-guard.

THE SOCIAL CONTEXT, FORM AND DATE OF THE HELMET
George Speake

The silver-gilt cheek-pieces and crest with vibrant Style II animal ornament, alongside the intriguing figural and zoomorphic die-impressed sheets, would indicate that what survives derived from a helmet of the highest order. However, any notional reconstruction of the helmet is fraught with difficulties as all the fittings and impressed panels and friezes had been forcibly removed from the helmet's structural support, which may have been of iron, horn, leather or a combination of these materials, the size, dimensions and constructional details of which can only be inferred. Any appraisal must acknowledge the partial nature of the surviving evidence; it remains uncertain how much has been lost or not recovered from the ground.

In spite of the difficulties and uncertainties, an attempt has been made to understand the original form of the helmet and to suggest a possible reconstruction and placement of the die-impressed panels and bands of decoration (figs 2.47 and 2.48). Much of the evidence for the formal features of the helmet, its scale and dimensions, and the positioning and sequencing of the decorative elements is indirect, but based on reasoned deductions and observations. Some guidance has been dependent on analogies with late Roman, Anglo-Saxon and contemporary Scandinavian helmets, both in terms of their construction and iconographic parallels.

It is clear that the Hoard helmet can be classified as being a 'crested helmet', as distinct from the form and construction of continental *Spangenhelm* or *Lamellenhelm* that have been found in graves in France, Germany, Italy and the Balkans, many of which are decorated with Christian symbols.[243] The structural feature of a longitudinal metal crest or ridge distinguishes the former from the other two types: the *Spangenhelm* had a pointed or bowl-shaped metal cap formed of a metal framework (*Spangen*), comprising a brow-band and vertical strips, which held in place the curved plates of the cap; the *Lamellenhelm* had a conical cap with registers of overlapping metal scales (*Lamellen*) and a brow-plate.[244] All these types could include a nasal and cheek-pieces. Crested helmets are only distributed in England and Scandinavia, where they were made and used up to the beginning of the eleventh century based on depictions of them in illuminated manuscripts, on sculpture and on coins.[245] Nonetheless, the Hoard helmet stands apart from other extant examples in the quality of its silver-gilt fittings and the impressed panels and bands. We can confidently state that in terms of what has survived and been retrieved, the quality of the ornament on the cast silver-gilt cheek-pieces, crest and the die-impressed panels and bands make it the most magnificent of all the known crested helmets.

The helmet and its Anglo-Saxon context

The archaeological evidence would suggest that helmets were rare, high-status items. In addition to the helmet remains in the Staffordshire Hoard, five certain examples are known from Anglo-Saxon contexts, though there are structural and decorative differences between them all, and apart from the iconic helmet from Sutton Hoo mound 1 (Suffolk), none of the other helmets has decoration of die-impressed panels or bands of figural and zoomorphic ornament.

The earliest is that from Shorwell (Isle of Wight),[246] from a grave of the early to mid-sixth century, but it is a simple Frankish style *Bandhelm*, a skull-cap formed of iron bands and plates, not a crested helmet. The helmets from Sutton Hoo,[247] Benty Grange[248] and Wollaston[249] belong to seventh-century grave contexts, while the fifth extant example is from the second half of the eighth century, found in a pit during excavations at Coppergate, York.[250] Both the Benty Grange and Coppergate helmets belonged to Christian warriors. The Benty Grange helmet has a boar crest in conjunction with a Christian cross on the nasal guard (figs 2.75a and 7.3). The Coppergate helmet has a protective prayer in the form of a brass-framed inscription, which crosses the iron crown.

Parts of probable further helmets only survive now in the form of tantalising mounts and fragments, all from Anglian territories. From the barrow-burial at Caenby (Lincolnshire), a fragment of die-impressed silver sheet has been identified, showing a warrior in a horned head-dress, with bird-head terminals, which may derive from a helmet panel.[251] What may be a boar's head terminal to a helmet-crest was found at Horncastle (Lincolnshire), echoing the boar crests on the helmets from Benty Grange (fig 7.3) and Wollaston; as do two further boar-figure mounts, from Guilden Morden (Cambridgeshire) and Icklingham (Suffolk); and lastly there is a zoomorphic crest terminal from Rempstone (Nottinghamshire).[252]

Helmet: form and reconstruction

The design and other aspects of Anglo-Saxon and Scandinavian helmets appear to derive from Roman Imperial examples. The second reconstruction of the Sutton Hoo helmet certainly acknowledges features linking its form to Constantinian helmets.[253] Likewise, the case for late Roman helmets being the inspiration for the East Scandinavian helmets in the Vendel and Valsgärde ship-burials has been strongly made by Lindqvist,[254] Almgren,[255] and Arwidsson.[256]

In attempting to establish the form and dimensions of the Hoard helmet the longitudinal profile of the helmet cap was determined at *c* 220mm by the nose-to-nape curvature of the two channelled sections of the silver-gilt crest with animal-head terminals (**589–90**). This provides a remarkably close correspondence with the rim length of the helmet from Coppergate.[257] The fact that the two crest sections have angled ends that do not neatly abut might have been a deliberate design feature,[258] perhaps to allow the crest to be adjusted to the curvature of the cap, which would have been difficult to predict with exactness prior to manufacture. There is no direct evidence that any lateral bands crossed the helmet, as was the case with the all-iron Wollaston helmet.[259] None of the East Scandinavian helmets, which have die-impressed panels on the helmet cap, has overlying lateral bands other than the reeded strips that anchored the panels. Some guidance was also provided by comparison with the Sutton Hoo helmet and by the dimensions of the replica made by the Tower of London Royal Armouries. Comparisons were noted in relation to the possible size of the helmet cap with the evidence from the reconstruction of the Sutton Hoo helmet, which has a longer length at rim level of 255mm and a width of 215mm.[260]

There is no evidence for a protective face-mask on the front of the Hoard helmet, unlike the Sutton Hoo helmet, with its elaborate

face-mask showing a 'flying bird' (created by the nose, garnet-inlaid eyebrows and the reptilian-head above the nose). Indeed, the depictions of helmeted warriors on the die-impressed panels (**596–7**) show helmets without face-masks and no obvious neck-guards (figs 2.52–2.53). Consideration, however, should be given to gilded sheet fragment **601**, which, given its clipped form, may once have been attached to a nasal guard.

Mindful of the complications and assumptions made by the conservation team at the British Museum in making the first reconstruction of the Sutton Hoo helmet, and its dramatic metamorphosis in the 1970s when a second re-assemblage was made, a cautious and considered approach has been taken to the placement of the die-impressed helmet panels on the cap and the two bands around the rim. Although the iron body of the Sutton Hoo helmet had completely oxidised and shattered into many fragments, clean fractures made possible its restoration to shape.[261] The difficulties that have been posed, however, in presenting a notional reconstruction of the Hoard helmet are more challenging given that the impressed sheets are disassociated from any underlying structural support. Confirmation in identifying the substrate beneath the impressed panels and bands has not been revealed by an examination of their undersides.

The iconography of the Hoard's figural panels clearly shows affinities with the designs on the Sutton Hoo helmet and those from Vendel and Valsgärde (Sweden),[262] but there are significant discrepancies between the forms of these actual helmets and the depictions of helmets on the die-impressed panels.[263] On the Vendel and Valsgärde panels, helmets are shown with fixed neck-guards and cheek-pieces, whereas most of the actual surviving examples have no cheek-pieces and have neck-guards made from hinged iron bands or mail. There is one exception to this, the helmet from Vendel xiv, a grave dated by Arrhenius to *c* 560/570 and considered one of the oldest of the ship-burials.[264] This is the only surviving Scandinavian helmet with cheek-pieces, which have incurved frontal edges and are linked at the chin.[265]

Depictions of crested helmets from Anglo-Saxon contexts are rare. A singular example occurs on a fly-leaf sketch showing David and Goliath in an Insular manuscript of Paulinus of Nola, now in St Petersburg National Library (Cod.Q.v.XIV.I. fol.1).[266] Goliath's high-domed helmet has a splendid crest, a beaked, long-tailed quadruped, which David is grasping firmly as he cuts off the giant's head. The sketch, the origin of which is considered by Lowe to have been in Ireland or Northumbria, is dated to the eighth to ninth century. The type of sword-hilt that David holds, with its domed pommel and curving pommel bar and lower guard, along with the helmet, evokes eighth-century Anglo-Saxon examples, although the style of the figures looks more Irish. Apart from the marching warriors with their eagle-crested helmets impressed on the Hoard panels (figs 2.52–2.53 and 5.18: 596–7), there are no known depictions from the seventh century or earlier. Contemporary parallels only exist on a die (C) from Torslunda (Sweden),[267] and on the Vendel and Valsgärde helmets.[268] Crested helmets are worn by warriors carved on the whalebone panels of the eighth-century Northumbrian Franks Casket, but they bear little semblance to the helmets of the warrior panels of the Hoard helmet, having a high cap, an enveloping neck-guard and a nasal.[269] Evidence that crested helmets existed in the Pictish north, beyond the Anglo-Saxon kingdoms, can be seen on the sculptured stone in Aberlemno churchyard, where a battle scene is shown with warriors wearing crested helmets, which appear to have neck-guards and some form of nasal protection.[270] The majority of Anglo-Saxon warriors depicted on the Bayeux Tapestry are shown wearing helmets, but these are of conical form and not crested.

There are no parallels for the exact form of the Hoard crest on the other Anglo-Saxon helmets, but it undoubtedly relates in function to the *wala* referred to in the Anglo-Saxon poem *Beowulf* (lines 1020–34):

> An embossed ridge, a band lapped with wire, arched over the helmet: head-protection to keep the keen-ground cutting edge from damaging it when danger threatened and the man was battling behind his shield[271]

The crest, in its form and decoration, differs markedly from the flat vestigial crest of the Coppergate helmet or the iron crest with its silver wire inlay from Sutton Hoo, which more closely relates to the description of the helmet *wala* in the *Beowulf* poem. Similarly, nothing comparable exists on the Scandinavian helmets from Vendel and Valsgärde.

The inspiration for its form can be traced ultimately back to crests on Roman Imperial helmets and to Attic helmets, yet the cast and punched decoration on the external walls of the crest is unmistakably Anglo-Saxon. The surviving traces of wood, calcite and beeswax within the crest sections may have secured organic material, such as plumes of horsehair or feathers, a feature that would be a signifier of rank in line with Roman custom. Roman centurions were distinguished by having different crests on their helmets, some crests being worn transversely, to aid identification by their soldiers. Sculptural reliefs also show legionaries and auxiliaries wearing tall feather crests. The depictions clearly show the low box containing the plumes as being mounted flush with the helmet cap.[272] Certainly such crests, of horsehair or feathers, would significantly have increased the

perceived height of the wearer and aid intimidation. Yet none of the depictions of helmeted warriors on the die-impressed panels of the Hoard helmet are recognisable as having feathered crests or ones of horsehair (figs 2.52–2.53).[273] All appear to show a crest terminating with the profiled predatory beak of an eagle. It can be argued that such depictions on Germanic helmets ultimately derive from the high-arched eagle-headed crest seen on certain Roman cavalry helmets, as on the example from Heddernheim (Germany), dated to the late second or early third century.[274]

The longitudinal profile of the helmet cap, as indicated by the crest sections and slightly inward-curved animal-head terminals, would suggest that the cap was rounded. Certainly, this is at variance with the crest profile of the Coppergate helmet with its deep, straight-sided brow-band, where the front animal-head terminal slopes forward as it overlies the nasal.[275] Earlier precedents are clearly suggested by the archaic feature of the boxed-crest form of the Hoard helmet. Parallels can be found in the shape and rich decoration of several late Roman helmets, including that from Deurne (Netherlands).[276] It was clearly an expensive, high-status object of personal equipment. Its deposition in a peat bog, along with other items, had made the iron substructure corrode away completely, leaving intact the form of the outer silver-gilt coverings and preserving parts of its leather lining. This crested helmet has embossed bands of diaper ornament enhancing the cap, brow-band, cheek-guards and neck-guard, but there is no figural or zoomorphic ornament.

The scale and dimensions of the gilded cheek-pieces (**591–2**) contrast with those on other Anglo-Saxon helmets. They would have provided some protection to the cheek and jaw, but they are relatively small in comparison with the reconstructed cheek-pieces of the Sutton Hoo helmet, which are 156mm in length and 135mm wide.[277] Firmer evidence is provided by the complete iron cheek-pieces of the Coppergate helmet and the damaged left cheek-piece of the Wollaston helmet, which have lengths of 129mm and 110mm, respectively. Their widths are closer in scale, being 87.2mm and 86mm at their upper edges.

There are marked constructional differences too in how the cheek-pieces were attached to the cap of each helmet.[278] In contrast to the single iron hinges of the cheek-pieces of the Coppergate and Wollaston helmets, or the suggested leather hinges on the Sutton Hoo helmet, the Hoard helmet has two attachment tabs cast with each cheek-piece. The proposed method of attachment, by riveting to the lower helmet-band,[279] would have made the cheek-pieces rigid, in contrast to the flexibility provided by hinging.[280]

What also remains uncertain is the form and structure of the cap beneath the crest. The Coppergate, Wollaston and Sutton Hoo helmets had caps of iron, but all differ in their construction. The Sutton Hoo cap was apparently made from a single iron sheet, with no trace of riveting to show it had been made in sections or strips. In contrast, the East Scandinavian helmets were of iron openwork-frame construction. The iron cap of the Coppergate helmet was made from eight separate components. The Benty Grange helmet, beneath covering plates of horn, also had an iron openwork construction, comprising a brow-band, c 650mm long and 25mm wide, to which was attached a nose-to-nape band 25mm wide (fig 7.3). There was a projection at the back, which was curved to fit the nape of the neck. A lateral band 25mm wide was curved to cross the helmet cap from ear to ear, crossing the nose-to-nape band at the apex and extending down at each side below the brow-band to provide limited ear protection. Some subsidiary iron bands are in evidence, positioned diagonally, to provide further support to the framework. The helmet did not have cheek-pieces or a substantial neck-guard. While there are some constructional similarities with the Coppergate and Wollaston helmets, the iron bands of the Benty Grange helmet are much broader, and the brow-band and cap were without any secondary enhancement. The horn plates of the Benty Grange helmet, which had been secured to the underlying iron framework with ornamental silver rivets,[281] indicate that not all Anglo-Saxon helmets were totally of iron sheet construction, like the Wollaston and Coppergate helmets.

It is conjectured that a light-weight iron framework provided an armature for the Hoard helmet, as possible traces of iron staining were noticed on the reverse of the silver helmet-band with its die-impressed band of kneeling warriors (**593**), but there is no evidence to suggest that horn panels were used as a protective covering over the iron.[282] Consideration should be given to the possibility that, as in the later medieval period, helmets could have been made from hardened leather, *cuir bouilli*. This technique of immersing leather in boiling water or very hot beeswax, to make it hard and stiff, has been suggested as a process for making non-metallic helmets. In addition, hardened leather could also be fabricated for body armour.[283] Hardened leather riveted to an iron framework could have been a light-weight substitute for iron plates on the Hoard helmet, capable of deflecting glancing blows, although liable to be penetrated by direct thrusts.[284] Indeed, the use of leather headgear protection may have been more widespread among the Germanic peoples than the limited archaeological evidence might suggest.[285] Just as leather was used as a shield covering,[286] its use as a protective cushion both on the inner and outer surfaces of a helmet should not be surprising. The scientific examination of the Sutton Hoo helmet took analytical samples from the tinned sheet plates to determine the exact composition of their copper alloy, but it was not determined what had lain immediately underneath them. It was noted, however, that the corrosion on the inside of the helmet

cap was very black and different from that on the outside; but under the microscope no structure reminiscent of leather or textile was visible.[287]

However, the evidence for leather as a covering for a helmet cap, lying beneath a metallic surface of impressed panels, did survive as mineralised traces on the Swedish helmet from Valsgärde 7.[288] Further indirect evidence comes from an examination of four helmet dies from Torslunda (Öland, Sweden). Axboe in a very perceptive analysis makes a convincing case that a craftsman created two of the dies (C and D) from casts of existing die-impressed helmet panels.[289] Close scrutiny of the rough, reverse surfaces led Axboe to observe that the casts could not have been made directly from the thin, impressed bronze sheets, however, as they were too thick and they did not show the motifs in negative relief on the reverse. Also, there were traces of holes and fastening strips. These details together suggested that the copied panels had originally been fastened to an outer cap of thin leather.

It is proposed, therefore, that for the Hoard helmet a partial framework of iron banding may have existed that provided the support for a leather covering, on to which the die-impressed panels, reeded strips, bands and crest were secured, presumably largely with silver rivets (of which there are many in the collection). Nineteen small holes, some in pairs, had been drilled through the base of the two sections of the crest to secure them to a substrate. Technically, since it would have been easier to drill holes only through the leather covering, it is possible that most of the helmet's parts and coverings were secured only to this substrate, with few fixings actually perforating the iron parts of the cap.

A helmet should not be close-fitting, to allow for some form of cushioning or padding for comfort, held possibly by leather strapping, thus preventing the transmission of the shock of a weapon blow to the head of the wearer. Internal padding would also aid the distribution of weight. A soft leather lining for the helmet cheek-pieces may account for the distinctive patina visible on their inner surfaces. The reconstructed Sutton Hoo helmet, with its lining, weighs 3.74kg, but it is estimated that the original would have been lighter.[290] Even heavier was probably the helmet from Valsgärde 7, which has been calculated with its die-impressed bronze sheets and neck-guard of mail as originally weighing more than 4.5kg.[291]

There has been much deliberation as to whether the helmet had a neck-guard, and, if it did, how it might have been attached to the helmet cap. Appraisal of the configuration of the die-impressed silver zoomorphic fragments with gilded borders (**600**) has led to the proposed neck-guard reconstruction (figs 2.54–2.55). The varied character of the animal ornament, contained within bead edging, initially suggested that the remains belonged to separate panels of differing size, but the subsequent joining of gilded border fragments prompted an alternative arrangement. Little survives overall, but possibly the design originally had a compositional symmetry, with the panels of zoomorphic ornament involving the use of multiple dies. It is argued that the base support for the decorated sheet of the neck-guard could also have been hardened leather. Possibly the neck-guard was finished with the collection's U-sectioned silver edging (**615**), which had been crimped to a material of 4mm thick, paralleling the function of the brass edging on the Sutton Hoo[292] and Coppergate helmets.[293] It is unclear whether the 8mm wide reeded strips (**613**) were used on the neck-guard. Furthermore, it is not possible to determine whether the neck-guard was hinged to the helmet cap or attached by some other method.

While the helmets worn by the warriors on the Hoard panels do not have neck-guards, depictions of helmet-wearing warriors on Swedish helmets do show this protection. Two warriors on one of the Torslunda dies (C) wear boar-crested helmets with neck-guards that appear to fold and drape over the shoulders.[294] Care and attention has been taken to detail a bordered edging to the neck-guard and cheek-pieces (fig 5.18iii). It is clear from the panels of vertical and horizontal bands that the intention was not to portray a guard of mail. Tweddle, however, was of the opinion that the helmet panels on Vendel xiv and Valsgärde 8 show warriors with neck-protection that bends where it falls on to the shoulders and so may represent mail as on the Coppergate helmet.[295] The Sutton Hoo helmet has a flared neck-guard, which is decorated with impressed panels of Style ii zoomorphic interlace. On the reconstructed version, above the neck-guard, there is a five-panelled collar, which was attached to the cap by two flexible leather hinges, secured by rivets.[296]

The evidence is ambiguous, but it is possible that a neck-guard of leather was attached on the boar-crested iron helmet from Wollaston.[297] Although the rear edge of its brow-band had been badly damaged through ploughing, a short section did survive which, when X-rayed, appeared to have part of at least two possible perforations on its damaged edge. It was deduced that the purpose of perforations in this position could only be to fix a neck-guard of some type. No traces of mail were associated with the helmet, but there was uncertainty as to the function of a series of short rods, some of hollow section, some solid, and some with flattened ends. These were suggested as possibly having been attached to the surface of an organic neck-guard as strengtheners, but, as no contemporary parallels are known, it was considered more likely that they derived from a belt.[298]

Origin, social significance and date

To what extent the differences of form, manufacture and decoration of the surviving Anglo-Saxon helmets reflect the status of their owners is open to question. The Hoard helmet, as already stated, was clearly a magnificent prestige item, more gilded and gleaming even than the tinned-bronze panels of the Sutton Hoo helmet, possibly worn by King Rædwald.[299] In the hierarchy of helmets, there is every justification for considering it an item of regalia, but to which 'princely' or even 'royal' person it belonged we can only guess. As Chaney has noted: 'the crown is another badge of kingship, but it cannot be dissociated from the helmet which itself was the early Germanic crown.'[300] He continued: 'The older Germanic tradition for the king was the gold helmet, the sign of his leadership as the war-chief. Thus kennings often refer to the prince as the helmet of his people – he is the *aedelinga helm*, *heriga helm*, *lidmanna helm*, *weoruda helm*, *helm Scyldinga*, and *Wedra helm* – but I know of no kenning which makes of him the 'crown' of his folk.'[301] There are chronological uncertainties, but the implications of Chaney's observations are that it is after the seventh century that the crown came to replace the helmet as symbol of the Germanic warrior-king.[302]

While we might consider that the Staffordshire helmet was fit for a seventh-century Anglian king, we cannot prove that it belonged to a king. A royal association for the Coppergate helmet has been argued by Tweddle, who suggested that it was fabricated between *c* 750 and *c* 775 for 'a member of the Northumbrian royal house, or one of the greater nobles of Northumbria'.[303] Typologically, he views it as being placed between the helmets of the early Anglo-Saxon and Scandinavian Vendel periods, and those of the Viking Age.[304] The art-historical evidence of the animal ornament and the use of Northumbrian script on the crest convinced Tweddle of its Northumbrian origin. In his appraisal, made before the discovery of the Wollaston helmet, he suggests that helmets in the earlier period of the sixth and seventh centuries were confined to kings and their immediate nobles, but by the eleventh century had become more common. With regard to the comparative Swedish helmets from the Vendel and Valsgärde ship-burials and the occurrence of helmet fragments in Gotlandic burials, it is considered that these were not the graves of royals, but belonged to a secondary stratum, being the graves of magnates.[305]

Certainly, the scarcity of helmets in the archaeological record of the sixth and seventh centuries, both in England and Scandinavia, would suggest that they were exclusive items, and this is supported by the literary and historical evidence. But variation in their form and ornament, or lack of ornament, undoubtedly reflects different values for the helmets, and by implication variation in status. What a helmet was worth, relative to other items, is given some indication in the Frankish *Lex Ribuaria* of the eighth century where the prices of weapons and domesticated animals are valued in terms of gold *solidi* (1 *solidus* = *c* 4.5g of gold):

1 helmet (6 *solidi*); 1 shield and 1 spear (2 *solidi*); 1 mail coat (12 *solidi*); 1 two-edged sword and scabbard (7 *solidi*); 1 two-edged sword without a scabbard (3 *solidi*); 1 steed (a warhorse) (7 *solidi*).[306]

The most costly item is the mail coat, being twice as expensive as a helmet, reflecting the labour of making the individually riveted and linked iron rings. We may assume that the helmet of 6 *solidi* was a simple *Bandhelm* form, and not a more-elaborate crested helmet, *Spangenhelm* or *Lamellenhelm*.

The literary records also suggest that helmets were not exclusively royal or only worn by the elite. In the *Beowulf* poem, possession of a helmet and coat of mail seems to be fairly widespread among the warriors described by the poet, though this does not rule them out as symbols of royal power in a society where the king was also the leader of the war-band. By the late Anglo-Saxon period personal armour is recorded as more widespread in use, in comparison with what seems to have been happening in the seventh century. In the Florence of Worcester *Chronicon*, compiled in the early twelfth century, it is mentioned that Godwine gave King Harthacnut a ship that had eighty picked soldiers on board, each of whom had a partly gilded helmet, a sword with a gilded hilt, a battle axe rimmed with gold and silver, and a shield with a gilded boss and studs.[307] It is also recorded that Aelfric, Archbishop of Canterbury, in his will, dated 1003/4, left the king sixty helmets and sixty coats of mail and his best ship, the deduction being that the armour belonged to the ship's crew.[308]

We can conclude from the known distribution of crested helmets that the origin of the Hoard helmet must be in Anglo-Saxon England or Scandinavia.[309] In form and decoration it is so unlike the *Spangen* and *Lamellen* helmets that a continental origin can be ruled out. Ultimately, the appraisal given in *Chapter 5* of its wealth of ornament strongly suggests that its fabrication took place in an accomplished Anglo-Saxon workshop. In particular, the iconographic and stylistic links of the ornament suggest close affinities with East Anglia and perhaps a royal workshop there, but until a site is discovered with convincing evidence, such as figural dies for making helmet panels, we can only speculate as to its place of manufacture.

The questions of when the helmet may have been made, and who may have worn it before its disassembly and deposition, are equally tantalising. Such questions have been more confidently answered in relation to the royal Coppergate helmet of a century later.[310] The Benty Grange helmet (fig 7.3), made no earlier than *c* 650,[311] most likely belonged to a Christian Mercian. The helmet from Wollaston was buried with a man of twenty-five years or older.[312] He is viewed as having been an elite seventh-century Anglian warrior; however, initial publicity in 1997 stating that his was a royal grave can be discounted. A royal association for the Sutton Hoo helmet from the mound 1 ship-burial seems more certain. Rædwald remains the most favoured candidate for mound 1, but other East Anglian kings offer alternatives, and, as Marzinzik has argued, 'we cannot be sure who was buried with the helmet in mound 1'.[313]

Conclusion

It remains conjecture, but the view that the Hoard helmet was 'fit for a king' is a reasonable claim, based on the quality of the craftsmanship and ornament. The close iconographic links of the figural art with designs on the Sutton Hoo and Swedish helmets imply a shared cultural background,[314] signalling a possible link to the East Anglian royal house of the Wuffingas, whose dynastic origins lay most plausibly in Sweden.[315] It was concluded with regard to the Sutton Hoo helmet that it 'was no doubt of some age when buried, particularly if it is of East Scandinavian manufacture, and so quite likely to have been brought to this country long before its burial in AD 624–5'.[316] The fragmented state of the Hoard helmet and its medley of zoomorphic and figural schemes complicate any assessment of age. Certain aspects of the animal art look both backwards and forwards in stylistic development, from the sixth century into the seventh.[317] A minor element of the decoration on the cheek-pieces, the zig-zag niello borders, relates them to silver metalwork of the sixth century, such as the Taplow horn mounts.[318] Its use on seventh-century metalwork is comparatively rare.[319] The figural art is quite singular. Anglo-Saxon parallels for the figural motifs on the helmet are few and far between, apart from some panels on the Sutton Hoo helmet and several mounts from East Anglia.[320] The evidence is hardly conclusive, but the helmet appears to lie within a chronological horizon shared with the Sutton Hoo helmet. If the view is accepted that the Sutton Hoo helmet was old when buried,[321] then the Hoard helmet too, or parts of it, could have been made before 600.[322] Like the Sutton Hoo helmet, its purpose would have been for parade and display, but its dismemberment and destruction would suggest that its owner's final encounter was defeat in battle.

LARGE MOUNTS NOT FROM WEAPONRY AND HARNESS-MOUNT (CAT. 698)

Twenty-five large mounts in gold with garnet cloisonné (**542–66**) that are related in style and manufacture form an impressive group that accounts for 13 per cent of the total weight of the Hoard (fig 2.3). The range of possible interpretations for them includes book-fittings and saddle mounts. The equally extraordinary, large, gold, bird-fish mount **538** and silver mounts **567–71** might also have come from horse-equipment, another saddle and a bridle respectively. There was a close link between equestrianism and warrior society in early Anglo-Saxon England,[323] so the identification of such fittings within the Hoard is not surprising. Nevertheless, with few if any parallels for all of these mounts, the interpretations offered here must ultimately be tested by future scholarship and discoveries. Only mount **698** of gilded copper alloy can be stated with relative certainty to be a fitting from horse-harness, but it was found some distance from the rest of the assemblage, so, for this reason and because it is of base metal, it is considered unlikely to have been part of the same original deposit (fig 1.25). A summary of the objects is provided in table 2.8.

A small number of other large mounts that are confidently identified as deriving from Christian objects are considered separately below.

Sets of mounts in garnet cloisonné (cat. 542–66)

Six sets are suggested from the twenty-five mounts (table 2.8). These have been principally grouped on the basis of their form and style, though the analysis undertaken of their garnet inlays and pastes gives additional cause to think they are a closely related assemblage.[324] The suites mostly comprise two, four or six parts, implying a degree of completeness: strip-mounts dominate, but also present are more unusual 'eye' and 'wing' forms (figs 2.58 and 2.65). Some sets might have been combined on the same object, but it was not possible to confirm this by arranging the fittings together, a process hindered by their damaged state; however, equally it seems unlikely that they all furnished a single large entity, though what they decorated remains to a large extent uncertain.

All the mounts share details of manufacture, beyond their cloisonné and form, which are important for understanding how they were fitted, and which further cement the impression that they have a single provenance. Beaded wire trims were added to the edges in most cases, usually above flanges of thin sheet (exceptions are mounts **556–7** and **562–4**). It varies whether the trim was formed from a single wire or two wires, but importantly this additional decoration indicates that the mounts were not recessed, but would

86 PART I | THE HOARD

break in trim/flange

542

543

break in trim/flange

544

545

546

547

0 10 20 30 40mm

▲ **Fig 2.58.** Garnet cloisonné mounts **542-7**. *Photographs:* G. Evans and Cotswold Archaeology, © Barbican Research Associates.

CHAPTER TWO | CHARACTERISING THE OBJECTS

	Catalogue	No.	Pair/set	Form	Interpretation	Cloisonné	Filigree trim/framing	Gold mounts	Niello	Cast/Incised ornament	Style II
GOLD	538	1	-	Zoomorphic	saddle mount	-	-	-	-	X	X
	542–7	6	X	Eye-shaped x2; strip-mounts x4	flat object, unknown	X	X	-	-	-	-
	548–9	2	X	Curved strip-mounts	curved object, unknown	X	X	-	-	-	-
	550–5	6	X	Strip-mounts	multi-faceted object	X	X	-	-	-	-
	556–61	6	X	Strip-mounts x4; curved strip-mounts x2;	saddle mounts	X	X	X	-	-	X
	562–4	3	X	Edge-mounts: L-shaped x2; straight x1	book mounts	X	X	-	-	-	-
	565–6	2	X	Wing-shaped	slightly curved object, unknown	X	X	-	-	-	-
SILVER & COPPER-ALLOY	567–71	6	X	Eye-shaped x2; fantail mount x1; strip-mounts x?3	horse-bridle	-	1	-	X	-	-
	698	1	-	Disc-mount	horse-harness	-	-	-	-	X	-
	Total:	**33**	**7**			**26**	**29**	**6**	**7**	**2**	**7**

▲ **Table 2.8.** Large mounts of non-weapon related function: gold (**538**); gold with garnet cloisonné (**542–66**); silver with niello (**567–71**); harness-mount **698**. 'X': all objects have the feature.

Fig 2.59. Schematic section showing how the cloisonné mounts were fixed (scale 2/1). *Drawing*: C. Fern.

have stood proud of the surfaces on which they were fixed. It is unlikely that the flanges were meant to be visible, as some (**544–7**) were pierced with fixing-holes (some of which are ragged from tearing). Possibly they were hidden by coverings, perhaps of leather, as suggested in fig 2.59. A further feature on most of the mounts is deliberately short breaks in the filigree trim and flange: these are points where the mounts adjoined one another or possibly some part of the object on which they were fixed.

Fig 2.60. One possible arrangement of cloisonné mounts **542–7**. *Drawing*: C. Fern.

Fig 2.61. Mounts **548–9**. *Photographs*: Cotswold Archaeology, © Barbican Research Associates.

Eye-shaped gold and garnet mount **542** (not to scale). *Photograph*: D. Rowan; © Birmingham Museums Trust.

A set of six parts is formed by the two eye-shaped mounts (**542–3**) and four strip-mounts (**544–7**), which share a cloisonné pattern of hidden crosses (fig 2.58; cf fig 3.92). It is likely all were flat or flattish originally and one possible arrangement for them is presented in fig 2.60. The strip-mounts further form two pairs: mounts **544–5** have ends angled at 45 degrees, with the same orientation at each end; mounts **546–7** have ends angled at less than 45 degrees, with a different orientation at each end, and they are somewhat longer. The eye-shaped mounts (**542–3**) have breaks at one end only, while the strip-mounts (**544–7**) have breaks at each end but not along their sides. The large central 'eye' cells of mounts **542–3** are unlikely to have held garnets, given their size (c 25mm × c 10mm), and instead perhaps had settings of translucent glass in a contrasting colour, surrounded by bone or paste inlays in the curved zones adjacent.

The curvature of strip-mounts **548–9** is original and possibly they were designed to abut, end-to-end (fig 2.61). There is a break in the trim and flange one side at both ends. However, none of the other mounts appears to fit neatly into these breaks, and so the pair cannot certainly be associated with any of the other sets.

Pair **550–1** very probably form a suite of strip-mounts with **552–5**, which have points with inward curving edges at one end. How mounts **550** and **552** could have fitted together is shown in fig 2.62. The mounts were constructed with angled ends and angled junction points and must have been fitted, therefore, to an object which was not flat but of multi-faceted form. This relationship was presumably repeated for the more damaged mounts **551** and **553**, but it is unclear how these related to the shorter mounts of the suite (**554–5**). Also, a small notch at one end of the intact mount **550** is too narrow to have allowed a join with any of the surviving mounts.

The fourth suite, also of six mounts (**556–61**), has its cloisonné ornament combined with small gold filigree mounts set in regularly spaced recesses. Originally, there were thirty-six small mounts; three are missing; seven were *in situ*; and twenty-six were found loose. For this reason, the suite was one of the most complicated of all the collection's parts to reassemble. Of the thirty-three filigree panels remaining, thirty-one are decorated with interlaced serpents and two have filigree non-animal interlace.[325] The *ex situ* small filigree mounts were reassigned to their slots based on several criteria: a few are curved and only fitted in their original recess; most are rectangular, but those from mounts **556–7** are slightly larger; subtly different serpent interlace ornament appears to have been used for mounts **556–7**;[326] and many of the small panels have marks on the reverse that are believed to be from an original 'assembly' programme.[327] This served as a guide, especially for the large crook-shaped mounts (**558–9**). Each of these was made in two parts with thirteen filigree inserts (two are missing), with one panel apiece designed to fit in a recess that bridged the join (figs 1.15 and 2.63). Also, a few of the serpents on mounts **558–9** have different head forms, indicating that some of the small gold panels are likely replacements.[328] Mounts **556–7** are narrower and curved along their length. Each had three serpent panels originally, of which five remain. The two others in the suite are short sections (**560–1**) with two serpent panels apiece. As the fixing-holes on all the mounts are behind the filigree panels, the cloisonné parts must have been secured first to the host object they decorated. Paste remains are in one recess of mount **556**, showing how the panels were stuck in place and raised flush with the cloisonné.

The set of three edge-mounts (**562–4**) with garnet cloisonné on all their outer surfaces may have been arranged end-to-end, with a total length of c 235–50mm, though other configurations are possible, and the set may not be complete (fig 2.64). Of course, if the mounts were more widely spaced (i.e. not abutting), then a larger length could be allowed for. Two are L-shaped and one is straight, and together they have a continuous niche on the inside edge. This contained fragments of wood (species unidentified), and so it is possible they were fitted to the edge of a board of 2–2.5mm thickness. The mounts do not have fixing-holes, but some have remains of gold-sheet tabs, which project from the niche, and on one mount there is a nail similarly located. These would presumably have been hidden by a covering once the mounts were fixed.

▲ **Fig 2.62.** The angled join between cloisonné mounts **550** (**551**) and **552** (**553**). *Drawing*: C. Fern.

CHAPTER TWO | **CHARACTERISING THE OBJECTS**

▲ **Fig 2.63.** Cloisonné mounts **558–9** showing their reconstructed form and allocation of filigree panels. For larger drawings of the assembly programme see fig 3.106. *Drawing*: C. Fern.

▶ **Fig 2.64.** Cloisonné mounts **562–4** arranged as they might have been fitted, possibly to a book-cover of wood and leather. *Drawing*: C. Fern.

92　PART I | **THE HOARD**

▶ **Fig 2.65.** Wing-shaped cloisonné mounts **565–6**. *Photographs*: Cotswold Archaeology, © Barbican Research Associates.

565

566

538　i

ii　approx. scale 4/1

iv　scale 2/1

◀ **Fig 2.66.** Mount **538**. i) Torn and twisted with its detached fish head; ii) a deep scratch caused during use; iii) the mount reconstructed; iv) one of the pair of creatures at the tail; v) the design is a 'split representation' of a bird of prey landing on a fish. *Photographs*: © Birmingham Museums Trust (i), and Nicky Harratt / courtesy of The Potteries Museum & Art Gallery, Stoke-on-Trent (ii); *Drawing*: C. Fern (iii–v).

iii

v　scale 1/2

0　10　20　30　40mm

The wing-shaped mounts (**565–6**) are some of the most enigmatic objects in the whole collection (fig 2.65). Both have breaks in their flange and trim on two sides, and they were possibly set on a slightly curved surface originally. Bands of garnet cloisonné form a border surrounding the divided centre of each. Remaining on one side of the divide of mount **565** is a bone inlay, but the other large cell is empty on both mounts and possibly was never filled. One possible arrangement for them, placed back-to-back, is as a large pelta (or axe-shape).

Mount with fish and birds (cat. 538)

Despite its torn and twisted state, the gold mount depicting a fish flanked by eagles is instantly striking for its extravagant size, using 62.20g of gold, with feather and scale detail, which stands in contrast with the typically miniature animal ornament seen on most objects (fig 2.66). The details were incised and the reeding of the curled wings is especially deeply chased. It was formed out of a double thickness of gold sheet with the outlines of the creatures cut out. This would have created open spaces either side of the fish, but these too were given gold sheet backgrounds. On the reverse these pieces show rough unfinished edges, while in other places on the mount the layers of sheet have lifted or separated due to damage. Probably it was fitted to a flattish surface originally, with four holes in total, one at the eye of each bird and at the centre of each wing-coil.[329]

Set of silver mounts with niello (cat. 567–71)

The six mounts of thick silver plate were reassembled from eighty-two fragments. Their geometric ornament in niello is a rare Anglo-Saxon fashion that imitates cloisonné cellwork.[330] They were given a bichrome finish, with golden edges or trims, and the similarity of their metal alloys further underpins their association.[331]

There were two eye-shaped mounts originally (**567–8**), but only one survives largely intact. The 'eye' at its centre was probably always open, without a stone; surrounding it is a trim of gold beaded wire (**567**). They are an intriguing parallel for the large cloisonné eye-shaped mounts (**542–3**), though in an altogether different style (cf fig 2.58). The large tapered mount (**569**) with a fantail is another unusual form (fig 2.67), and it is of further note for the prominent use of mushroom forms along its length.[332] A notch at its narrow end suggests that it might have joined another fitting. The remaining parts are more fragmentary, with possibly a pair of strip-mounts (**570**), and probably one other fitting with pointed ends that were curved originally and separately attached (**571**). The mounts have a relatively large number of fixing-holes, some retaining silver rivets. These are typically bent, folded deliberately against the reverse of some material which does not survive, perhaps leather, with an implied thickness of *c* 3–5mm.

▶ **Fig 2.67.** Silver mount **569** with a reconstruction. Prominent in the geometric niello decoration is the line of mushroom cells of decreasing size. The mount can be compared with nose-plates from horse-bridles of the late Roman period found in Germany and Denmark, as the example (i) from Thorsberg (Germany). *Drawing*: C. Fern; Thorsberg mount PG05 adapted after Lau 2014.

Harness-mount with interlace (cat. 698)

The disc-mount with interlace was found in the same field as the Hoard, but in three fragments 40–50m away, which were recovered separately in the 2009 and 2012 phases of fieldwork (fig 1.25). The abraded edges of the fragments suggest the parts were longer in the plough soil than the Hoard, and so perhaps the find represents a casual surface loss. The parts join to form a mount in copper alloy with a low saucer rim. It has a central blue glass setting and cast non-animal interlace that was gilded (fig 2.68). On the reverse is one cast rivet: it may have had four originally in a cardinal arrangement. The find was not declared officially as treasure with the Hoard, but it is a contemporary and stylistically related object, and it represents important evidence, therefore, for activity at the site around the time of the main collection's deposition.[333]

▶ **Fig 2.68.** Harness-mount **698** of gilded copper alloy with interlace. *Image*: courtesy of The Potteries Museum & Art Gallery, Stoke-on-Trent.

▲ **Fig 2.69.** The Chelles Chalice, purportedly made by St Eligius. It survives only as an engraving in a seventeenth-century manuscript, *Panoplia Sacerdotalis* (fol 200), and the coloured version was made later (de Linas 1864) (not to scale). *Photograph*: G. Blot, © RMN-Grand Palais (Institut de France).

Discussion of the large mounts and harness-mount (cat. 698)

Grand works in cloisonné had a long tradition on the Continent. In the seventh century, a large cross in gold cloisonné, the height of a man, stood in the royal basilica of Saint-Denis, Paris. It was said to have been made by the Merovingian master goldsmith and bishop, St Eligius, at the command of the Merovingian king, Dagobert (r. 629–39).[334] The Hoard's sets of large cloisonné mounts give a similar impression of prodigious creations, but from an Anglo-Saxon workshop, and they are superior in workmanship to the single surviving panel from the Saint-Denis cross. Remarkably, the two eye-shaped mounts (fig 2.58; **542–3**) have a striking similarity to motifs on another object attributed to St Eligius, the Chelles chalice (fig 2.69). The chalice is now known only from a seventeenth-century manuscript, which shows it had a cloisonné band around its rim of miniature 'eyes'. It was lost at the French Revolution, as was also the fate of the rest of the Saint-Denis cross.[335] Other objects known to have had rich coverings include saddles and other religious trappings, such as book-covers and reliquaries.

Hardly any European book-covers with decorative metal fittings survive from the sixth to eighth centuries, though prestige manuscripts would certainly have had them, such as the early eighth-century Lindisfarne Gospels, recorded as having a costly jewelled binding made by Bilfrith the anchorite.[336] The late sixth century gold and garnet Gospel-book covers of the Lombard queen Theodelinda, now in the cathedral treasury at Monza, near Milan,

are a unique example of a royal treasure binding from this period made in the Byzantine tradition. The wider use of such ornamental panels is also implied by illuminations in manuscripts. One example is the border art on folio 31v in the Gospels of St Médard de Soissons, produced *c* 800 at the court of Charlemagne.³³⁷ It suggests the copying of gold and garnet strip-mounts with stepped garnet cloisonné, fittings which must have been over 150 years old when the illumination was done. It is possible that the object copied was a book-cover, but such strip-mounts may well have been used on a variety of different equipment, as is suggested below.³³⁸

The arrangement of mounts **542–7** suggested in fig 2.60 would have covered a surface *c* 300mm × 350mm. The different lengths and angled ends of the strip-mounts (**544–7**) may indicate the fittings were set on a flat board of trapezoidal form, which perhaps served a religious function.³³⁹ Edge-mounts **562–4** are perhaps the most likely of all the fittings to have come from a book-cover, though other interpretations are possible.³⁴⁰ Assuming they were fitted as in fig 2.64, the size of cover they indicate is small, and similar to that of the eighth-century St Cuthbert Gospel (L. 135mm), which was probably made of birch-wood and covered by embossed leather.³⁴¹ Mounts **550–5** were not fitted to a flat cover or board (cf fig 2.62), but understanding of them is currently insufficient to identify what they did decorate.

The shape of mounts **558–9** can be compared with mounts in garnet cloisonné from saddles with high front boards, like the pair from an early sixth-century grave at Krefeld-Gellep (Germany),³⁴² albeit they are not an especially close match. A reconstruction of set **556–61** as saddle mounts is offered in fig 2.70. The crook-shaped mounts (**558–9**) frame the front board; the narrower and curved strip-mounts (**556–7**) are placed along the top edge of the cantle; and the short mounts (**560–1**) are set on the saddle's flat sides. The *Beowulf* poem includes a description of a 'royal' saddle that was *searwum fah since gewurpad* (skilfully and richly wrought), which had been the property of King Hrothgar: the *hildesetl heahcyninges* (high king's war saddle).³⁴³ The Hoard fittings, if they are from a war saddle, would most likely also indicate the presence of a 'princely' commander.

The use of filigree serpent panels on mounts **556–61** can be compared with the application of panels with filigree zoomorphic ornament on the brooch from Kingston Down (fig 6.9i) and shoulder-clasps from Sutton Hoo (fig 6.10), objects that date to the decades around *c* 600.³⁴⁴ In the late seventh and eighth centuries, similar gold panels with filigree can be seen in Irish metalworking, as is shown on the brooches of Hunterston (Ayrshire) and Tara (Co Meath), and on the chalice from Derrynaflan (Co Tipperary).³⁴⁵ The dating of mounts **556–61** bridges the chronological divide between these Anglo-Saxon and Irish *comparanda*.³⁴⁶

▲ **Fig 2.70.** Reconstruction of cloisonné mounts **556–61** as fittings for a saddle. *Drawing*: C. Fern.

Mount **538** might also have emblazoned the high front of a saddle. Its predatory-bird motif can be compared to similar fittings from shields, and in particular with the bird from Sutton Hoo mound 1.³⁴⁷ However, its symmetrical composition of a fish between birds is not like the mounts of birds in profile that dominated on shields, and which represent in the main an Anglo-Saxon fashion of the sixth century.³⁴⁸ It can instead be likened to mounts on saddles from continental Merovingian and Lombardic graves, like those on a saddle from grave 446 at Wesel Bislich (Germany), which are similar in their scale and mirrored ornament (fig 2.71).³⁴⁹ No examples of this saddle-form with a high front are preserved from England, although the form had certainly reached Ireland by the seventh century, and it was long-lived in Europe and Scandinavia, so it seems most likely that the Anglo-Saxons shared the tradition.³⁵⁰

Mount **569** with its fantail can also be compared with mounts from shields, but the other parts of the set (**567–71**) cannot be accommodated within this interpretation.³⁵¹ An important clue

Fig 2.71. (i) Reconstruction of mount **538** as a saddle-fitting. (ii) It can be compared with the mounts on the high-front board of a saddle from grave **446** at Wesel Bislich (Germany. *Drawing*: C. Fern (i); after Oexle 1992 (Taf. 172) (ii).

Fig 2.72. Reconstruction of silver mounts **567–71** as fittings from a bridle (scale 1/6). *Drawing*: C. Fern.

to their function may be the mounts' fixing-holes and bent silver rivets: these are far more numerous than would be necessary if the set had decorated a wooden object, but are explicable if they had been attached to a flexible material, such as leather. Indeed, the thickness of the material indicated by the rivets (c 3–5mm) is comparable to that suggested for leather harness of the period.[352] Nonetheless, it is necessary to go back to the late Roman period to find a tentative parallel, and then only for mount **569**. It can be compared with the long nasal-plates of bridles from northern Europe, which are approximate in size, and some were similarly secured with rivets along their edges (fig 2.67i).[353] On this basis it is proposed that the fittings might have decorated a horse head-bridle (fig 2.72). The strip-mounts (**570–1**) could have been mounted on the strapwork, along the cheek-straps (**570**) and brow-band (**571**). How the eye-shaped mounts (**567–8**) were incorporated is speculative: it is tempting to hazard that they were mounted on a pair of blinkers, except that this item of horse-gear is not known from early medieval Europe, though eye-guards were part of Roman cavalry equipment.[354]

Mount **698** takes the disc-form typical of decorative horse-harness fittings of the late sixth to seventh centuries. The role of such fittings has been shown by the examples that were found *in situ* with remains of a head-bridle in the 'warrior' burial under mound 17 at Sutton Hoo.[355] Mount **698** would accordingly have secured the junction of two crossing straps, and so would have been part of a set of two or more mounts originally fastened over the points of intersection of the straps of the cheeks, nose and brow.[356]

CHAPTER TWO | CHARACTERISING THE OBJECTS

Catalogue	Object-type	No.	Fragments	Pair/ sets	Interpretation	Incised ornament/text	Cloisonné	Gem-settings	Garnet	Filigree	Niello	Style II
539	Cross	1	7	-	processional/altar cross	X	-	X	X	X	-	X
540	Inscribed strip – ?cross	1	1	-	reliquary mount	X	-	X	-	X	X	?
541	Sub-conical mount with columned disc	1	9	-	head-dress ornament	X	X	X	X	X	-	X
588	Cross-pendant	1	2	-	pectoral cross	-	-	X	X	X	-	-
607/8	Silver-gilt sheet and reeded strip	1	112	-	covering for base of cross	-	-	-	-	-	-	-
676	Pin and rings	2	2	X	locking pins for base	-	-	-	-	-	-	-
Total:		**7**	**133**	**1**		**3**	**1**	**4**	**3**	**4**	**1**	**2**

▲ **Table 2.9.** Christian objects. 'X': all objects have the feature; '?': uncertain identification/quantity.

98 | PART I | THE HOARD

539

reverse

i

◀ **Fig 2.73.** Great gold cross **539** with its gem-settings and loose garnet. For their original assembly see fig 2.75. *Photographs*: G. Evans and C. Fern, © Barbican Research Associates.

ii [K658]

iii [K657]

iv

[K656]

v

[K659]

vi [K1314]

vii [K308]

CHRISTIAN OBJECTS

The objects that can confidently be assigned to an ecclesiastical role are few, but they are among the most significant to survive from the beginnings of Christianity in early Anglo-Saxon England. The cross-pendant (**588**) is a fine example that fits generally with a small group known from the period, but without parallel are the great cross (**539**), inscribed strip (**540**) and a gold and garnet sub-conical mount of curious form (**541**). The last is argued by Webster to be a priestly head-dress decoration.[357] The remains of silver-gilt coverings (**607/8** and **676**) are proposed as coming from a stand for the great cross. The objects are summarised in table 2.9.

Several smaller crosses (**481–2** and **526**), as well as other small (e.g. **458** and **494–5**) and large fittings (**542–66**), might have come from Christian equipment also, but these have been included above in the categories of small mounts and large mounts respectively, since ultimately their functions are uncertain.[358]

▶ **Fig 2.74.** The 'unfolded' cross mount (scale 2/3); i) seams in the gold sheet at the centre. *Drawing*: C. Fern.

▲ **Fig 2.75.** The equal arm and Latin cross forms combined in the great cross, and the original locations of the gem-settings (i–vi) and loose garnet (vii) (scale 1/4). The same two cross forms are combined in the small silver cross from the nasal of the helmet from Benty Grange (a) and in the Rupertus cross (b). *Drawing*: C. Fern: (a) adapted after Bruce-Mitford (1974).

Great gold cross (cat. 539)

The cross, including all its detached parts, is the largest item by weight (175.25g) in the collection (fig 2.73). The finder recalled he found some of the parts together, with a few of the gem-settings still parcelled within the folded arms.[359] 'Unfolded' it would have stood around 300mm tall with six set stones (figs 2.74–2.75). A reconstruction is presented as the *frontispiece*.

Only one setting remains fixed to the cross mount at the end of one of the transecting arms, so the other surviving loose gem-settings, stones and complete garnet bosses have been reassigned to their original positions on the basis of their form and fit (figs 2.73 and 2.75). The setting *in situ* is without its stone (i); loose garnet (vii) fits approximately in it, but the stone might equally belong to the loose round setting (ii) from the opposing transecting arm; larger round setting (iii) is from the top arm; the largest setting (iv) that is also empty is from the oval centre; the smaller oval boss with its large garnet (v) is from the mid-point of the elongated lower arm, and it was repaired in antiquity (fig 4.1); and the D-shaped garnet boss (vi) fits the bottom of the same arm, the stubs on its reverse aligning with the holes on the cross. One other sizeable garnet (**692**) might come from the cross, but this is not certain (*frontispiece*).[360] The flat heads of silver nails/rivets are visible in some of the empty gem-settings (these would have been covered by the stones and any gold foils).

The mount combines two cross forms, a trait of other Anglo-Saxon crosses, as shown in fig 2.75. An equal-arm cross with arms slightly expanded at their ends formed the top of the cross, but with the elongated lower arm giving the cross overall the processional form of a Latin cross. Parallels for this combined form include the small silver cross from the nasal of the contemporary helmet from Benty Grange (Derbyshire) and the much larger Rupertus cross (Bischofshofen, Austria) of the eighth century (figs 7.3 and 2.75a–b).[361] In addition, the cross's outline was influenced by zoomorphic features (fig 2.74). Most prominent are the pointed projections that complete the three short arms, which in their outline and moulding suggest animal ears. These are unprecedented in their zoomorphic character, though they surely mirror in their positioning the rounded lobes that commonly terminated the arms of broadly contemporary Byzantine processional crosses (fig 2.83).[362] In sum, the combined cross forms, the inventive application of the ears, and the covering Style II animal ornament complete a confidently Anglo-Saxon re-imagining of the Roman tradition of the *crux gemmata* (jewelled cross).[363]

The originally flat cross mount was made from a double thickness of sheet, each layer being *c* 0.5mm thick (i.e. *c* 1mm in total), the same method of manufacture that was used for mount **538** and the panels on head-dress mount **541**. The pieces for the transecting arms were added separately to the trunk, with the joins clearly visible both sides of the oval centre (these would have been hidden by the central boss) (fig 2.74). The animal ornament was carved into the top layer of sheet, with eye and hair detail added with punches.

The gem-settings are not all the same. The five oval and round bosses (i–v) have bezels with dog-tooth edging (fig 3.72), while the D-shaped garnet boss (vi) has a plain bezel. All have filigree

collars, but these also differ. The same combination of filigree wires decorates the collars of the three gem-settings from the ends of the short arms (i–iii), comprising a central three-ply twisted-beaded wire, flanked by thinner spiral-beaded wires; settings (v) and (vi) have instead a central wire of two-ply twisted-beaded type, flanked by beaded or spiral-beaded wires; and the large central setting (iv) has a different arrangement again for its collar, a band of herringbone-with-spine formed of a pair of two-ply twisted-beaded wires with a central plain wire and flanking beaded wires (fig 3.72).

In addition, damage to the bottom edge of the D-shaped boss (vi), in the form of flattening of the filigree with discolouration, was examined by XRF analysis. It showed the darkening relates to ferrous deposits (3wt%),[364] suggestive of prolonged contact with an object or fitting of iron, perhaps part of the base in which the cross had stood.

A crushed setting at one end of the gold inscribed strip (**540**) is almost identical to the D-shaped garnet boss (vi) of the cross: it has the same shape, size, plain bezel and filigree collar. This is of considerable significance, suggesting their close contemporaneity and a shared provenance.[365] It cannot have been the case, however, despite their correspondence of form, that the cross mount and inscribed strip were set on opposite sides of one wooden cross, since the strip with its Latin invocation was fastened by gold nails or rivets, not with silver fixings like the cross mount.

▶ **Fig 2.76.** Reconstruction of object **607/8** with pins **676** securing a wooden locking peg. *Drawing*: C. Fern.

Socketed-base and pins (cat. 607/8 and 676)

A reconstruction of object **607/8** as a socketed-base is proposed in fig 2.76. Its significance was revealed late in the conservation programme, as it had to be rebuilt from a mass of small fragments which were found to form the remains of two coverings in silver-gilt (fig 1.21).[366] Fitted back-to-back, the coverings had encased a stand, presumably of some perishable material, being held together with trims of silver-gilt reeded strip that were riveted around the top of the stand (W. 11mm) and around its base (W. 14mm). Less of the sheet from the base survives and it is crumpled, probably from removal, but its original low-domed form is confirmed by the wide band of reeded strip. The 11mm strip has a pattern of two bands of four reeds; the 14mm strip has a central band of four reeds with further top and bottom bands of three reeds. The encased base and standing rectangular socket were possibly of wood, though no organics were preserved.

▶ **Fig 2.77.** Socket **607/8** interpreted as the base of an altar cross (scale 1/4). *Drawing*: C. Fern.

The gilded socketed-base could have been an altar stand for the great cross (**539**), and possibly it was designed to allow the cross to be removed as required (fig 2.77). The jewelled and silver crosses of the Roman east that were the model for the cross were used in both secular and religious ceremonies, and frequently as processional standards.[367] So perhaps the Hoard cross was also designed so that it could be easily converted from an altar to a processional cross. The socket has small rectangular slots on both its front and back faces that align, and it is proposed that these mark the location of a retaining peg (fig 2.76). This peg might have been secured with the pair of metal pins from the collection: only one pin actually survives, which was gilded originally, but there is the wire ring from a second (**676**).

Inscribed strip (cat. 540)

The strip with its biblical inscriptions in Latin (fig 2.78) might have been the arm of another cross, which perhaps graced a reliquary.[368] Before it was folded it would have been *c* 170mm in length, similar to the lower arm of the great gold cross (cf fig 2.74). A D-shaped gem-setting is at one end, while the other is finished with a straight edge, which shows no sign that it ever abutted anything (though equally this is not conclusive evidence that it did not). The strip is thick (2mm) and appears solid, but it may have a core of silver with a sheet-gold wrapping.[369] However, the D-shaped gem-setting is certainly gold, and it is flanked by serpents with twisted bodies that were cast and set on sheet backings. Three fixing-holes were spaced the length of the strip; at the centre of the gem-setting, is an *in situ* gold nail or rivet (L. 10mm) with a rectangular sheet washer. A further two gold rivets secure the corners of the gem-setting and hold in place the gold serpents.

Both sides have similar inscriptions but only one was finished (fig 2.78): on the obverse *Text 1* and its beast head were inlaid with black niello; *Text 2* on the reverse was not inlaid, possibly because it was a first attempt that was abandoned (see below). On the reverse at one end there is also a sketched outline that mirrors the position of the gem-setting on the obverse. It is feasible that the object represents the co-operation of different specialists. As Gameson argues below, clerics could have prepared parchment exemplars to be copied, and perhaps these too were the origin of the unusual serpent heads; but the incising that betrays unfamiliarity with letter forms, the niello inlay and gem-setting are undoubtedly the work of a smith. As already noted, the gem-setting can be closely compared with that of D-shaped form from the lower arm of cross **539**.[370]

The palaeography of the inscriptions

Richard Gameson

The most striking aspect of the now-folded strip (**540**) is the writing that dominates both its long sides (fig 2.78). The two texts read as follows.

Obverse:
 surge. dne. disepentur inimici tui et
 fugent qui oderu[371]ntteafacie tua

Reverse:
 surge d[omi[372]] ne disepintur [i[373]] nimict[374]
 iui et fugiu[n[375]]*[376] quio de
 runete afac-[377] ie tua a diuv[378]e e nos d[eu]s[379]

With normalised word separation, these would become: *Surge, domine, disepentur inimici tui et fugent qui oderunt te a facie tua* (obverse), and *Surge domine disepintur inimictiui et fugiun* qui oderunt te a facie tua adiuve nos deus* (reverse). The substance of these texts and their translation is discussed below.[380]

In principle, the letter forms in which these texts are written might be hoped to shed light on the contexts – geographical, temporal and cultural – in which the object was produced and, perhaps, used. In practice, however, a paucity of relevant *comparanda* severely limits what their evidence can reveal. The near-dearth of Latin alphabet inscriptions on metalwork produced during the Anglo-Saxon conversion period means that one must, perforce, turn to other media for comparisons; however, as the techniques for writing in books or chiselling into stone are quite distinct from those of metalworking, one is not comparing like with like. Moreover, while the small numbers of monuments and manuscripts that are, for one reason or another, dated or datable have permitted the construction of approximate chronologies for the evolution and diffusion of script in their respective media, these are nevertheless fragile structures characterised by many hypothetical attributions strung between a few unevenly spaced points of relative certainty. Nevertheless, as the paucity of direct *comparanda* is a reflection of the (currently) unique nature of this artefact, it is all the more important to offer a preliminary assessment of its script.[381] We shall first examine the nature of the lettering itself; we shall then note such palaeographical comparisons as are relevant; finally, we shall pass in review some of the broader issues that the material raises.

▼ **Fig 2.78.** Inscribed strip **540** 'unfolded'.
Photograph: G. Evans. *Drawing*: C. Fern.

Notwithstanding the obvious similarity of their content, the two inscriptions on the strip do in fact differ in many respects, ranging from the length of the written phrase and the spelling of individual words, through the details of individual letter forms and the use or otherwise of abbreviation marks and punctuation, to their size, spacing and general balance (fig 2.78). The lettering on the reverse is smaller, simpler and slightly cruder than the more monumental and ornate work on the obverse; and while the letters on the reverse are aligned more regularly with the straight edges of the strip, those on the obverse are better conceived to fill the available space in a relatively even manner. The fact that the latter were filled with niello while the letters on the reverse were not, allied to the circumstance that the latter have very clearly been struck through with diagonal lines, strongly suggests that the lettering on the reverse represented a first attempt that was found wanting. (The notion that the strip may have been deliberately designed to have an inward- as well as an outward-facing version of the inscription seems highly improbable,[382] given that the former has manifestly been cancelled.)

The writing on the reverse may have been rejected on account of orthographical errors. The most obtrusive are 'inimictiui' for 'inimici tui', the uncertain final letter of 'fugiun*' (the previous letters lead one to expect a 't', but the drawn form is highly unorthodox and it would be unrecognisable as this in the abstract) and 'oderune' for 'oderunt'. There is also the infelicitous disposition of this last word in relation to its neighbours ('… quio de | runete …') which, even in a context of non-standard word division, is likely to have seemed unsatisfactory to the literate eye.

The first line of text on the reverse is set very close to the top of the strip. This appears to have caused problems for the engraver when he came to the first letter with an ascender (i.e. a rising, tall stroke) – the 'd' of 'domine'. The bowl of the letter having been placed too close to the edge of the strip, its stem had to be truncated at the top and (perhaps to compensate) was extended at the bottom: the resulting shape bears as much resemblance to a 'q' as to a 'd'. Subsequent 'd's have excessively open bowls – that of the third and final example in line 1 was so distant from the stem of the letter that an extra stroke had to be inserted to join them together. Further uncertainty appears within the word 'facie' in the form of the curious line that hovers between its 'c' and 'i': whether this was supposed to be a serif for the 'i', a bogus tongue for the 'c' (implying that it had been confused with an 'e'), or an unnecessary tilde, the actual result is an ambiguous and confusing mark. Subsidiary lines beside the 'c' in line 1 and the first stroke of the first 'a' in line 2 imply either that the engraver had two attempts at forming these letters or that a lightly engraved 'draft' version preceded the definitive engraving and here the latter ended up departing slightly from the former.

That incising lightly was part of the production process is shown by the last three words ('*adiuve nos deus*') which were only executed in this preparatory manner. Further, more general infelicities appear in the crowding of the letters in the second half of line 1 and the overgenerous spacing of them – disrupting the integrity of individual words – towards the end of line 2.

The lettering on the obverse, by contrast, is better conceived to fill the space, and the characters themselves are, on the whole, more competently formed. The complication of the tilde that was used on the reverse has been dispensed with, while pointing (punctuation) was introduced on either side of 'domine', clarifying its grammatical role as a vocative form ('O Lord') in apposition to the rest of the sentence. The script on the obverse is ornamented with pronounced serifs in the form of open triangles, giving it a calligraphic, as opposed to an epigraphic, 'feel'.[383] The actual text on the obverse differs from that on the reverse in several ways: in addition to avoiding the above-noted errors, it has 'disepentur' as opposed to 'disepintur' for the second verb, 'fugent' rather than 'fugiunt' for the third verb, and dispenses with the invocation 'adiuve nos deus' at the end.

Though calligraphically superior to the reverse, the writing on the obverse nevertheless displays its own idiosyncrasies and imperfections. Less anchored to the edges of the strip and without separate ruled lines to guide them, its letters are more varied in height and less consistently aligned than are those on the reverse. The resulting impression of irregularity was then extended into three dimensions, and hence exacerbated, by the uneven application of niello. The most divergent letter-form is the 'u' of the final 'tua' which is more akin to 'ui' than to 'u', suggesting either that the engraver was unfamiliar with the Latin alphabet or that he mistakenly thought that what was needed here was 'tui' (as in the line above), or both.

There is a greater variety of letter forms on the obverse than on the reverse. This is not just because more alternative types were deployed for particular letters – 'N's both of Half-Uncial and Square Capital type, for instance (broadly equivalent to modern lower-case, and modern upper-case respectively), whereas only the latter appears on the reverse – but also because these forms could themselves be treated differently. Thus, the first two Square Capital 'N's (in 'dne' and 'inimici') incorporate a serif at the top of the second upright, whereas the third (in 'oderunt') does not. Comparably varied are the 'u's, which may be: a simple continuous line; a curve with a separate upright; a curve with an upright sporting a serif at its bottom; two uprights, the first topped by a serif, with a curious further serif (or adjustment) under its bowl; not to mention the awkward 'ui' form noted earlier (fig 2.78).[384]

Even the 'a's, though all of superficially identical Half-Uncial 'cc' type (i.e. resembling two abutting 'c's), are in fact differently formed: in the first example, the first 'c' is larger than the second; in the second example, they are equal in size; while in the third example, the second 'c' is larger than the first.[385]

Collectively, the many points of contrast between the letter forms on the obverse and those on the reverse are too great to be explained in terms of the same literate overseer taking more care on a second attempt to delineate the guide text exactly as it was to be reproduced by an engraver and avoiding the complexity of the tilde. On the contrary, they strongly suggest that the two inscriptions were drafted by different hands. When the rendering on the reverse was rejected and cancelled – be it for the reasons suggested above or on account of other factors – the task of drafting a new version was evidently entrusted to a different hand. The question of whether the revised version was undertaken immediately or only after an elapse of time is impossible to resolve conclusively (the script types themselves could be contemporary or a generation or more apart); however, common sense and the likelihood that the finished artefact will have been wanted sooner rather than later suggest that the two interpretations are probably very close in time. Assuming, as the fixture holes imply, that the strip was then attached to a support of some sort, the reverse will have been concealed and only the obverse exposed to view.

Whether the two versions were also engraved by different craftsmen is very difficult to say, given the undoubted disparities of the models and the contrasting degrees of finish. Yet whatever the truth, the incised forms do not suggest an engraver or engravers comfortable with the Latin language or even with its alphabet. This is most obviously the case on the reverse, which includes forms incompatible with even an elementary knowledge of them,[386] but even the obverse, which has no such obvious errors, displays telling uncertainties of approach. Here, as much as on the reverse, the engraver seems to have been creating each letter individually 'by eye' rather than replicating them from any familiarity – even a generalised one – with the relevant shapes themselves. One should not make too much of this since the elementary quality of the beast-heads on both sides of the strip indicates that the craftsman or craftsmen were not outstandingly skilful when dealing with other motifs. Nonetheless, the graphic evidence is most compatible with an engraver or engravers who perceived letters as abstract forms rather than as recurring elements within an intelligible system of writing. Assuming that to be so, literate overseers must have provided him or them with exemplars to copy, probably drawn out on parchment (the uncertainty of the engraved forms themselves argues against guide lettering done directly on the strip itself in charcoal or pigment).

The basic script-type used on both sides was Half-Uncial (the inclusion of certain forms that are technically Square Capitals – some of the 'N's and 'R's – is a common feature of such writing). The more austere version on the reverse echoes a broad range of Half-Uncial from the sixth century onwards, principally continental but also Irish and English.[387] The more ornamental interpretation on the obverse, by contrast, with its pronounced serifs and greater range of letter-types, is unmistakably Insular Half-Uncial, the sub-branch of the script developed by the Irish that spread to the many areas that they influenced. If isolated epigraphic analogues for individual letter forms found on both sides of the strip are scattered chronologically from the sixth century onwards and geographically from Cornwall and Wales to Northumbria,[388] it is difficult to point to any particularly telling parallels for the collocations of letters on either side as a whole within a century of the likely date of the deposit of the Staffordshire Hoard. More obvious matches, particularly for the obverse, appear in manuscripts.

In the context of Anglo-Saxon book script (the early manuscript survival from Wales is too exiguous to support comparable analysis), one can distinguish two basic types of Insular Half-Uncial, characterised respectively by lesser and greater regularity, the former predominantly earlier than the latter.[389] While it is debatable how far this typology is relevant to work in other media, it is worth noting that both the particular forms and the general aspect of the lettering on the strip pertain to those of the earlier type. A reasonable general comparison from the Anglo-Saxon manuscript corpus for the lettering on the reverse is provided by the rather continental-seeming Half-Uncial of a copy of Primasius's *In Apocalypsin*, now in Oxford.[390] The best parallel for the more elaborate script on the obverse is that of a fragmentary Gospel-book, New Testament, or Bible in Durham; one might note, in addition, that there is a certain affinity between the elementary animal ornament that frames the end of the lettering on both sides of the strip and forms used for the one surviving decorated initial in the Durham fragment.[391] This manuscript was either made in Ireland and brought to Northumbria or was written in Northumbria by Irish missionaries or their Anglo-Saxon followers and is plausibly ascribed, albeit on circumstantial grounds, to before – or not long after – the Synod of Whitby in 664. Of Southumbrian provenance, the Primasius was still in England in the tenth century; as it was annotated by Boniface (Wynfrith) of Nursling who left England for good in 718, it was demonstrably produced before that date, perhaps well before. Thus, while the limited material at our disposal is of little help for localising the scripts on the strip, it further underlines the contrast between the letter forms on the two sides and favours a date in the seventh century. The paucity of manuscript material itself from this period and the accident that the first securely datable examples cluster around the end of the seventh century and the

beginning of the eighth rather than earlier mean that one should be wary of seeking further precision – above all in relation to work in a different medium by hands that appear to have been replicating rather than writing the characters in question.

Given that the guide texts for the two inscriptions were almost certainly drafted by different hands and are likely to have been broadly contemporary (as was noted above), this would seem to imply production in a centre where different versions of Half-Uncial, one closer to continental forms, the other to Insular ones, were practised concurrently. The phenomenon may be compared with certain eighth-century manuscripts, which reveal scribes who practised different script types working side by side.[392] We shall return to the implications of this shortly.

While the strip was patently made in a Christian context, it is debatable whether the centre in question was an ecclesiastical one or a secular one. Even if the complete artefact from which the strip comes was a cross (as its shape and the parallels between its design and that of the arms of the better-preserved folded cross from the Staffordshire Hoard itself, **539**, suggest), this does not mandate manufacture for, and use in, a monastery as opposed to at a Christian court.[393] Nor does the presence of the inscriptions, for the St Ninian's Isle scabbard chape and the Coppergate helmet, both ascribed to the eighth century, provide examples of overtly Christian Latin inscriptions on metalwork that was unquestionably secular.[394] Moreover, it might be supposed that, in an ecclesiastical centre, collaboration between scribe(s) and metalworker(s) would have been – or could more easily have been made – sufficiently close to avoid the need for the two attempts at the inscription. The fact that the overwhelming majority of items in the Staffordshire Hoard were of a military nature could be held to favour a secular context, at least at the point when the artefact joined the rest of the material. Yet, to pose the question solely in terms of a dichotomy between the ecclesiastical and the secular is a distortion, for this is an issue that admits a 'both … and' answer as well as an 'either … or' one. There were churches within, as well as beyond, centres of political power. Furthermore, every Christian court will have had attendant clerics, some of whom may have been capable of selecting and transcribing such a text. If a secular potentate might not have worried over orthographical infelicities in an inscription that he could probably not read for himself, he would surely still have preferred, purely on aesthetic grounds, the better-filled space of the obverse to the less elegantly realised version on the reverse.

◀ Inscribed strip **540** (not to scale). *Photograph*: D. Rowan; © Birmingham Museums Trust.

It has often been observed that the engraved texts themselves are, in effect, citations from Numbers 10.35 ('Surge domine et dissipentur inimici tui et fugiant qui oderunt te a facie tua': 'Arise O Lord, and may your enemies be scattered and may those who hate you flee from your face').[395] It has also been noted that the second part of the phrase was used in the Life of St Guthlac of Crowland that was written by a certain Felix around the second quarter of the eighth century.[396] Less attention, however, has been paid to the verbal differences between these Anglo-Saxon versions and that in Numbers which (in so far as extant early manuscripts are a guide) was not prone to textual variants. Felix changed the verb form and altered the order of the words to suit the phrasing of the prophecy he put into the mouth of his eponymous subject ('… et fugient a facie tua qui te oderunt …'), while the copy on the reverse of the Staffordshire Hoard strip was augmented by the addition of the invocation 'adiuve nos deus' ('Help us, O God'). Given that these two versions were manifestly adjusted, it is worth considering whether the departures from the Vulgate text on the obverse of the strip may likewise reflect adaptation rather than inaccuracy. The words in question on the obverse are the verbs relating to the fate of God's enemies. Where the received biblical text reads 'dissipentur' (the present passive subjunctive of dissipo, dissipare, 'to spread, scatter, disperse') and 'fugiant' (the present subjunctive of fugio, fugere, 'to flee'), our text has 'disepentur' and 'fugent'. Were these, then, distortions of the Vulgate version, or might they rather represent a different word and a different tense altogether, namely 'dis[s]epientur' (the future passive of dissepio, dissepire, meaning 'to separate, tear apart') and 'fugient' (the future indicative of fugio)? Certainly, the spellings on the obverse are orthographically as close and closer respectively to these two words[397] – and, for what it is worth, we may note that the latter corresponds exactly to one of the alterations made by Felix in his rendering. Moreover, these alternatives would have only a modest effect on the import of the phrase, which would then mean: 'Arise, O Lord, and may your enemies *be torn apart* and those who hate you *will flee* from your face'. Now, there can be no doubt that the verse from Numbers was in the mind of whoever devised the inscription on the obverse; and it seems at least as likely that it was adapted or slightly misremembered as simply misspelled in the process of transmission to this new context.

A broader point here is that the two versions of the text on the strip are unlikely to have been copied from one and the same manuscript exemplar (nor, indeed, was one of them copied directly from the other). On the contrary, the variants in both versions, above all that on the obverse, might suggest that whoever drafted them worked from memory rather than from a book. Provision of the text presupposed knowledge of Numbers (at least of a short quotation therefrom); it did not necessarily require access to a Bible. The

connection between the strip and biblical manuscripts may have been indirect rather than direct – reflecting the education and experience of the clerics responsible for selecting and drafting the text, not the books that they had to hand at the time in question.

In itself the writing does little to help define the nature of the object from which the strip comes, as its content could be relevant to any number of artefacts. Conversely, if the object were indeed one arm of a cross, as seems most likely, then the other three arms may well have borne additional inscriptions. Accordingly, interpretation of the extant verse must be restrained by the probability that its precise meaning in its original setting may have been complemented, even completed, by other phrases whose nature is unknowable, with a contingent tempering, intensifying or amplifying as appropriate. That said, the fact that the extant phrase seems particularly well suited to a context in which conflict might be envisaged, above all conflict between a Christian force and a non-Christian one, remains worth noting.[398]

To sum up: the palaeography of the inscriptions is compatible with a date in the seventh century, making the strip a vital early witness to the creative use of a scriptural text to enhance the significance of a metalwork object in Anglo-Saxon England during the conversion period. The contrast between the styles of script on the two sides indicates drafting by different hands, one schooled in a manner of writing with stronger links to the Continent, the other working solidly within the Insular tradition. There is no shortage of known occasions in seventh-century England – and there were doubtless many more that are unrecorded – when individuals from contrasting cultural and hence scribal backgrounds were juxtaposed. One thinks, for instance, of Cedd (d. 664), who had trained at Lindisfarne, moving to an Essex whose earliest taste of Christian culture had come from the Roman mission in Kent; or of the Frankish cleric Agilbert (d. *c* 680) when he arrived at the Northumbrian court in 663/4. Similar contrasts might have obtained in places where clerics from Irish foundations could have encountered ones from a British background – as may conceivably have been the case at Lichfield with the arrival of the Lindisfarne-trained Chad in 669, if a British Christian community had indeed survived there into the seventh century.[399]

Both scribe-drafters whose writing is reflected on the strip deployed a biblical verse; one certainly, the other arguably, used it with a measure of freedom; one or both may have cited it from memory. If literate individuals trained in contrasting ecclesiastical traditions are most likely to have encountered (or to have succeeded) one another in a church setting, this in no way rules out an association with a court. The articulated wish for God to defeat his enemies is likewise compatible both with a primarily secular and with a primarily ecclesiastical setting. Given its context within the Staffordshire Hoard, an assemblage dominated by military items, the object from which the strip came, though Christian, evidently was – or came to be – connected to bellicose activity. If the strip was indeed from a cross, it might then be compared in general terms with that erected by King Oswald of Northumbria (d. 642) prior to his battle at Heavenfield, which was simultaneously a declaration of faith and a totem for victory.[400]

The circumstance that two attempts were made at rendering the inscription, with appreciable differences in spelling, content and layout, suggests that any or all of orthographical accuracy, shades of meaning and aesthetic effect could have been considerations for the makers and owners. What is unequivocal is that the writing dominates the strip and hence the viewer's perception of it. Whether or not the words were easy to read when the artefact was complete, they were unquestionably prominent, the presence and visibility of the text being arguably as important as its legibility. The product of one of the first generations in which there would have been any interest in applying Latin inscriptions to an Anglo-Saxon object, the strip thus proclaims the versatility of writing in contexts of limited literacy as a multivalent symbol whose potency was simultaneously linked to, yet independent of, its semantic value. The inclusion of an appropriate text could enhance the efficacy of the object, irrespective of how many people were able to read it for themselves.[401] More generally, the presence of the inscribed artefact amidst so much war gear in the Staffordshire Hoard advertises no less clearly than do Bede's narratives that, in embedding itself into Anglo-Saxon society, Christianity stood at the heart of the political and military, as well as the religious, struggles of seventh-century England.

Head-dress mount (cat. 541)

The sub-conical mount with a column-mounted apical disc (**541**) was the first discovery at the site (fig 2.79; cf fig 1.14) and Terry Herbert recalled that he first thought it had come off 'either a door or a small jewellery box'.[402] Remarkably, instead the object in garnet cloisonné with gold panels bearing incised animals and serpents is highly significant, as it may be a unique example from early medieval Europe of a type of head ornament worn by a priest or even a bishop.[403] It is also notable for the similarity of its Style II animal ornament to that of the great gold cross.[404] An exploded illustration of its final stage of assembly is shown in fig 2.80.

The three main parts – the large sub-conical mount, column and small apical disc – were pegged and riveted together. Further fixing-holes on the large mount's damaged reverse probably secured it to a leather or textile chin-strap. It is bent, but originally it formed a low-cone shape. Its triangular cloisonné panels and gold panels with incised Style II were made and inserted separately, with evidence for some form of assembly code on the detached parts.[405] The apical disc has a setting with a large *millefiori* glass stud.[406] The glass stud in its bezel became detached in conservation, showing that it had slotted into the top of the apical disc; four silver rivets in the bezel's base originally ran through holes in the small disc, fixing the assembly to the top of the column, from which a rectangular peg protrudes that was in turn received into the base of the disc with its stud. The gold column with rectangular and square garnets is heavy (20.73g) and it may have a solder core.[407] The wider base of the column was secured to the large sub-conical mount with a large silver washer and rivets; the washer was fixed into the column's core in some way (possibly with solder), and part of it has broken off and is embedded inside the column.

▼ **Fig 2.79.** (i) Head-dress mount **541** (scale 3/2). (ii) Enlarged detail of the prophet Ezra from the Codex Amiatinus (cf fig 2.87), showing how the mount may have been worn. *Photograph*: D. Rowan, © Birmingham Museums Trust. *Drawing*: Chris Fern, © Barbican Research Associates.

▶ **Fig 2.80.** Exploded illustration of head-dress mount **541** in the final stage of assembly (scale 1/1). *Image*: I. Dennis.

Cross-pendant (cat. 588)

The cross-pendant has one broken arm and another is bent, damage which was probably the result of a deliberate act against an object of personal faith.[408] Despite this, it is in a sense the only 'complete' object in the collection, not being a fitting. It is a high-quality piece made from gold sheet in the form of an equal-arm cross with expanded arms that are slightly concave at their ends and which emanate from a round centre with a flat-topped cabochon garnet (fig 2.81). The suspension loop on the top arm shows that it was worn round the neck, probably as a pectoral cross. The arms and loop are decorated with filigree scrollwork, with mainly volute scrolls on the arms and S-scrolls on the loop. Thick beaded wire frames the ornament, and the same wire type together with plain wire forms a collar to the plain bezel of the gem-setting. The reverse is plain except for a triangular filigree flourish at the back of the loop.

Fig 2.81. Cross-pendant **588** with a line drawing (i) of the cross from Thurnham (Kent); ii) a comparison of the outlines of cross **588** (red) and that from Thurnham (scale 1/2). *Photograph:* G. Evans. *Drawing:* C. Fern. © Barbican Research Associates.

The hollow but robust sheet box-construction is visible in section on the broken arm, and a sealed void space has been confirmed for the centre of the object by a computerised tomography (CT) scan, undertaken at Southampton University (fig 2.82i). As the garnet is not backed by a metal foil, it was possible to inspect the central void with a microscope, but this showed nothing of substance within the space.[409] Nevertheless, the void is of a similar size to that at the centre of the famous pectoral cross in gold and garnet from the coffin of St Cuthbert, which it has been suggested might have held a relic (fig 2.82ii).[410]

Fig 2.82. Drawing of a CT-section taken of the centre of the cross-pendant **588** (i), showing the plano-concave lens of the garnet and the void behind it. A deliberate space was also created at the centre of the cross of St Cuthbert (ii). *Drawing:* C. Fern; (ii) adapted after Bruce-Mitford 1974.

Given the relatively small number of cross-pendants of the period from England,[411] the resemblance to one in particular is noteworthy (fig 2.81i–ii). The Thurnham gold cross (Kent) found in 1967 is no longer available for research, but its near exact equivalence of form, scale and manufacture with a hollow structure raises the possibility that both crosses are from one workshop, or even that they were made by a single individual.[412] Only the additional garnets and a more limited use of filigree on the cross from Thurnham are notable differences.

The Christian objects: function and significance
Leslie Webster

One of the most striking aspects of this otherwise military assemblage is the presence of objects of specifically Christian function. They are small in number, but their presence in the Hoard is disproportionately significant, with important implications.[413] In the following overview, only objects which are considered to have had a specifically religious function are discussed; others which have embedded cross images or other possible Christian motifs, but were designed for lay use (for example, sword and saddle

fittings), are discussed separately.⁴¹⁴ At the end of this section, a few objects of uncertain meaning or function, but of possible religious significance, are also reviewed.

Eight objects can be identified as having a definite or plausible religious function. These are: a gold cross in sheet metal, one face from a standing cross (**539**); an inscribed gold arm, probably from a cross (**540**); a gilded silver base for a standing cross (**607/8**); an elaborate gold, garnet- and *millefiori*-inlaid sub-conical mount (**541**), here argued to be from an ecclesiastical head-dress; a gold and garnet cross-pendant (**588**); a gold and garnet applied cross (**482**); a small gold cruciform mount (**481**); and a garnet-inlaid cruciform mount (**526**).

These fall into two groups, discussed separately below: the first four are from objects of exceptional quality, which played a role in Christian ceremony and worship, and which are unique in seventh-century Anglo-Saxon England; the remaining four are personal crosses or cruciform mounts that could have belonged to either a lay person or a cleric; these were all either displayed on the body or on equipment, in a manifestation of the Christian faith. They can be directly compared to other contemporary Christian artefacts.

Objects associated with Christian ceremony and worship

The large gold cross (**539**), undecorated on one side, has attachment holes that presumably served to rivet it to a wooden support. If there was another metal cross covering the other side of the support, it has not survived; although the inscribed cross arm (**540**) is close to the lower arm of the great cross in estimated original length,⁴¹⁵ its significantly narrower width would not have made a good match on the corresponding side and, for other reasons,⁴¹⁶ it is unlikely to have been paired with the cross.

The form of the cross, its arms expanding slightly towards the terminals with their distinctive projections, is clearly derived from sixth-century Byzantine examples, such as the two standing silver crosses from Kurin (Syria), in the Walters Art Museum,⁴¹⁷ with typical lobed projections at the terminals (fig 2.83). Like them, it could have been carried in procession or fixed in a stand on an altar, or both. The Byzantine crosses are of solid metal, and have tangs at the bottom that secured them in a base when standing; it is possible that the wooden body of the Staffordshire cross had a similar projecting stem that could engage with a solid base,⁴¹⁸ allowing it to serve as both a processional cross and as an altar cross, in the Early Christian manner. A *c* AD 600 Visigothic chancel-screen panel from Narbonne indicates this dual function in its depiction of a similar cross being held up by a short stem on a base.⁴¹⁹

▲ **Fig 2.83.** A silver processional or altar cross from Kurin (Syria). The cross is 340mm tall (scale 1/4). *Image*: by kind permission of the Walters Art Museum, Baltimore.

These Byzantine silver crosses can be plain or inscribed, but are otherwise simple in their decoration. However, much more elaborate jewelled crosses of similar form occur in the contemporary tradition of the *crux gemmata*, the jewelled cross. Following the discovery of the True Cross at Golgotha, place of the Crucifixion, by Helena, mother of Constantine the Great, in whose reign Christianity became the established religion of the Roman Empire, the Emperor Theodosius (408–50) is said to have erected a great jewelled cross on the site at Jerusalem. This was much emulated; gem-studded crosses were represented in early medieval apse mosaics, for example, at Sant' Apollinare in Classe at Ravenna, and Santa Pudenziana in Rome (fig 2.84), while the emperor Justin II (565–74) and his wife presented a lavishly gilded and jewelled example containing a relic of the True Cross to Pope John III (561–74) (fig 7.2).⁴²⁰ This too served both as an altar and a processional cross. Along with other church equipment, crosses of Byzantine type and the concept of the jewelled cross were introduced into Anglo-Saxon England with the Roman missions, and by successive influxes of ecclesiastics from Rome and the East.⁴²¹ The continuing Anglo-Saxon veneration of the *crux gemmata* is signalled by its prominence in three Anglo-Saxon poems: *The Dream of the Rood*, Æthelwulf's *De Abbatibus* and Cynewulf's *Elene*.⁴²² In the first and greatest of these, the cross is described as 'covered with gold; fair gems were set at the earth's surface, likewise there were five upon the crossbeam'.⁴²³

▲ **Fig 2.84.** The *crux gemmata* from the apse mosaic of Santa Pudenziana, Rome, showing the cross standing on Golgotha. *Image*: © Andrea Jemola / Scala Florence.

The availability of high-quality large cabochon garnets in Anglo-Saxon England in the first half of the seventh century gave rise to a particular local variant, set with five prominent gems, one at the centre and one at each end of the arms; this appears in some pendant crosses, such as those from Thurnham (Kent) (fig 2.81i), and Catterick (North Yorkshire), as well as in the Staffordshire cross.[424] Through their deep red colour, the garnets symbolised the five wounds which Christ suffered on the Cross.[425] The idea may have been adapted from Merovingian examples, such as the famous jewelled cross of St Eligius, formerly at the royal abbey of Saint-Denis.[426] Given this distinctively Anglo-Saxon adaptation of the *crux gemmata*, could it be that the prominent animal ornament on the Staffordshire cross not only evokes an older, apotropaic tradition, but also acts as a local substitute for a Christian symbol, in this case, the vine-scroll motif?[427] That appears on a number of Byzantine crosses, including on the back of the jewelled Justin II cross. By the middle of the eighth century, the Anglo-Saxon zoomorphic tradition had become fully integrated into the vine-scrolls of stone crosses and ecclesiastical metalwork, suggesting that its earlier, plant-free, presence on the Staffordshire cross and in Early Insular manuscripts might be in some sense a precursor to the Insular vine-scroll.[428] The animals on the Staffordshire cross envelop the image of the cross, rather than dwell in the vine-scroll that adorns it in later Anglo-Saxon versions, but the idea of the wooden cross as the Tree of Life, nurturing the faithful, is inherent in both. Whether or not this explanation is correct, the visible links of the animal ornament on the cross with secular metalwork of the first half of the seventh century, and with the art of the earliest Insular manuscripts, show clearly that the cross is a transitional object, at the crossroads between two cultures. It has no contemporary parallels, and experiments freely with binding together 'pagan' tradition with Roman/Byzantine iconography, form and function; yet it is a marvellously accomplished and mature piece, suggesting that this was an already established iconography, created by a church which was confident in the message it wished to give to its Anglo-Saxon converts.

Although it is now unique, the cross was probably only one of many Anglo-Saxon crosses created within the first fifty years of the Conversion. Though the earliest liturgical equipment for use in churches and monasteries was imported, native versions were soon commissioned by kings and bishops; royal workshops would quite naturally begin by adapting their own traditions to the new objects. Bede, writing in the early years of the eighth century, gives a suggestive example. He rarely refers to contemporary artefacts, but was clearly impressed by the story of the great cross of gold and chalice of Edwin of Northumbria, which were rescued with other unnamed treasures by Bishop Paulinus after Edwin's calamitous

defeat and death at the battle of Hatfield Chase, near Doncaster, in 633. With the king's wife and family, they were taken back by sea to safety in Kent, and could still be seen there in Bede's day.[429] For Bede, writing in his monastery at Jarrow, these artefacts were associated with the first Northumbrian king to lead his people in converting to Christianity and, as such, they had special meaning. Presumably equally grand ecclesiastical equipment existed in other Anglo-Saxon kingdoms, but Bede does not mention it. Nor is it said whether Edwin's splendid artefacts were made in England, though as the pre-eminent king of his day, he would certainly have had the required resources and craftsmen to execute such things to fittingly glorify his new church, and is indeed recorded as having commissioned other metal objects for the public good.[430] Given that Edwin was converted in 627, only five years before his death, his gold cross must have been made quite close in time to the Staffordshire cross, which was also very probably made in a context of royal patronage.[431]

The equally exceptional inscribed gold or gold-sheeted arm (**540**) is similar in date to the processional/standing cross.[432] It probably formed the lower arm of a cross of Byzantine type, several of which also bear niello-inlaid inscriptions running along and down the arms (as was doubtless the case with the cross from which this fragment comes).[433] Like the large gold cross, it was attached to a wooden backing, which might have been a standing/processional cross of similar type. However, the content of the inscription suggests that the arm is more likely to have been part of a cross attached to a portable reliquary, specifically one carried into battle.[434] The following summarises the case for this, which has been argued more fully elsewhere.[435]

The fierce words of this inscription call on God to defeat his enemies.[436] They are taken from the Old Testament, Numbers 10:35, where the Israelites are on their long and dangerous passage through the wilderness. The words are spoken by Moses as the wooden Ark of the Covenant is raised up to advance before the Jews, protecting them through God's accompanying presence. A slightly different version appears in Vulgate Psalm 67:2, which resonates with references to the crossing of the wilderness, and concludes with the words 'Terrible is God as he comes from his sanctuary; he is Israel's own God, who gives to his people might and abundant power'. In other biblical passages the Ark is taken to the battlefield.[437] The force of these words would not have been lost on seventh-century Anglo-Saxon kings, busily engaged in enlarging and extending their territory; Bede and others emphasised the comparisons between Anglo-Saxon and victorious biblical leaders such as David.[438] The triple-tongued creatures that partially frame the inscriptions may have been intended in some way to reinforce the special power of the words. Sea-creatures with similar gaping mouths, eyes and triple foliate tongues occur in contemporary Merovingian sculpture at Poitiers, in the church of Saint Saturnin, and on the steps of the nearby mausoleum known as the Hypogée de Dunes.[439] It is striking that, in the latter case, the step with sea-creatures is immediately adjacent to a step carved with a motif of three interlacing snakes (fig 2.85), closely similar to those on the helmet-crest (**589–90**) and cheek-piece returns (**591–2**) (cf figs 5.15 and 5.17).[440] In the context of the mausoleum, on the liminal steps between the worlds of the living and the dead, these images carried special, apotropaic meaning, as they must also have done on the helmet and the inscribed strip from the Hoard.[441]

The Latin word *arca* was commonly used in the early medieval period not only for the biblical Ark itself, but for reliquaries and other types of containers; the conflation of the two makes it plausible that the cross arm, directly associated with the Ark of the Covenant by its inscription, came from such an object. No Anglo-Saxon reliquary survives from the seventh century, but contemporary Irish and continental examples show that the dominant tradition was for these to be a small, gabled or pitched-roofed type, loosely termed house-shaped.[442] Later examples, such as the probably eighth/ninth-century Anglo-Saxon example (*Arch Gwenfrewi*) from St Winifred's church, Gwytherin (North Wales),

▲ **Fig 2.85.** Sea-creatures (i) and serpent interlace (ii) from carved stone steps in the mausoleum of Hypogée de Dunes, Poitiers (France). The beast head from strip **550** can be compared with the sea-creature with the triple-foliate tongue (not to scale). *Drawing*: C. Fern.

and the early twelfth-century shrine of St Manchan at Boher (Co Offaly), Ireland, indicate that these could also be on a larger scale, with provision to be carried around on poles, like the Ark.[443] Some have allegedly been carried into battle, again, like the Ark.[444] The Irish shrine has a large metal cross attached to its principal face, and the inscribed cross arm is thus best explained as part of a cross mounted on a portable shrine evoking the biblical Ark; it would have contained holy relics that brought protection, and bore a biblical inscription that was linked to the Ark and its power to protect, and called on divine support against enemies. It is hard to resist the conclusion that this shrine was used in, and possibly made for, a battle context.

The gilded silver domed base and socket (**607/8**) has been reconstructed from a number of gilded silver fragments, which together form part of a stand for the shaft of an upright wooden object, most probably a cross, which might have been held in place by a dowel held by silver pins (fig 2.76).[445] This can be unpinned to release the wooden shaft, allowing the cross to be carried separately. Most probably it served as a stand for the processional/standing cross from the Hoard, something which is supported by the compatible dimensions of each.

The domed profile of the base suggests an allusion to Golgotha, the hill of Calvary on which the True Cross stood, something supported by Roman and contemporary Anglo-Saxon parallels. The great fifth-century apse mosaic at Santa Pudenziana in Rome has one of the earliest depictions of Golgotha, in which the jewelled True Cross stands on Golgotha, depicted as a rocky hill (fig 2.84). That a Golgotha iconography had become established in Anglo-Saxon England during the first half of the seventh century is illustrated by three early seventh-century Anglo-Saxon versions, in which the cross of Christ is flanked by those of the two thieves. Two of these, incised on relic containers from a female burial at Cuxton (Kent), show the three crosses standing on a hill, while the third is a garnet cloisonné version on a sword pommel from Dinham (Shropshire) (fig 2.86).[446] This new Christian iconography was thus evidently widely understood in Anglo-Saxon secular, as well as ecclesiastical, circles in the first half of the seventh century. During conservation, it was observed that the domed base might have had a deliberately contoured aspect.[447] Its damaged condition makes it impossible to be certain that this is so, but if, as with the mosaic cross in Santa Pudenziana, the base represents the rocky hill of Calvary, it would add further support to the identification of the cross and base ensemble as an image of Golgotha.

There appear to be no contemporary equivalents for this iconography elsewhere in Germanic Europe, or for a dismountable base; yet it is hard to imagine another purpose for this quite specific and complicated object, especially given its association in the assemblage with a unique standing cross.

The last in this group of objects specifically associated with Christian ceremony and worship (**541**) is perhaps the most speculative and certainly the most complicated (fig 2.79).[448] Its distinctive form and iconography, and the presence of holes for attachment to a textile or leather base, suggest that this is a head-dress of some sort, with an explicitly Christian function.

▲ **Fig 2.86.** The gold and garnet cloisonné pommel from Dinham (Shropshire) (scale 3/2). *Image*: © Friends of Ludlow Museum and Shropshire Museum Service.

First, as the analytical drawings make very clear (fig 5.14), the fitting is decorated with up to seven deliberate cross motifs, culminating in a cross within a cross in the *millefiori* inlay at its apex. This elaborate programme strongly accords with an overtly Christian purpose. Second, the object bears a striking resemblance to the head-dress worn by the prophet Ezra in the well-known image in the Codex Amiatinus (figs 2.79ii and 2.87), one of three great Bibles written, with Bede's participation, at the monastery of Jarrow-Wearmouth, probably not long before 716, when Abbot Ceolfrith set out for Rome to present it to the Pope.[449] In this image, probably adapted from the portrait of Cassiodorus in the great Italian Bible from which the text of the Codex Amiatinus is copied,[450] Ezra is portrayed in the regalia of the Jewish high-priest, a topic about which Bede wrote at some length.[451] His head-dress consists of a cloth, surmounted by a golden cap above the forehead, secured

with a ribbon. It is not known how early Bede developed his interest in such things, but the Ezra portrait, which he almost certainly devised, shows that these matters occupied his mind some years before the creation of the Codex Amiatinus, though the relevant texts in which his thoughts are preserved are believed to date to the 720s.[452] The Staffordshire head-dress, on the other hand, seems likely to date to the middle of the seventh century, perhaps a full fifty years before Bede began to think about the topic and to formulate something remarkably similar as a basis for the high-priest's head-dress in the Ezra portrait. How can this be explained?

A key source of information on the high-priest's head-dress which Bede drew upon in his writings is *Antiquitates Iudaice* by the Jewish author, Flavius Josephus.[453] His description of a golden tiered head-dress surmounted by a protruding calyx, is used by Bede to modify the Old Testament account.[454] Bede prefers Josephus's description of golden crowns as against the biblical linen ones, arguing that Josephus is likely to have been right, since he was of priestly descent and would have seen the head-dress in the Temple of his day.[455] Alan Thacker has pointed out (pers comm) that it is very unusual for Bede to offer exegesis on a non-biblical text, which may suggest that this issue had particular importance for him. Bede here envisages the head-dress as a cap over the brow, surmounted by a small three-tiered golden crown, culminating in a finial that resembled a plant, which he called an *achanus* (thistle). The fact that he replaces Josephus's plant-name, *hyoscyamus* (henbane), with that of a native plant known to him might suggest that he had an object with which he was familiar already in mind. In subsequently incorporating both the biblical linen and the Josephan gold versions into his figurative analysis, Bede may also indicate that, like Josephus, he was familiar with golden crowns and wished to justify them.

These hints that Bede himself had some first-hand knowledge of similar ceremonial headgear are further borne out in *De Tabernaclo*.[456] Here, Bede discusses the gold plate with the four-lettered name of God, which in both the Bible and in Josephus is described as sitting on the brow.[457] He links this symbolically to

▲ **Fig 2.87.** The Codex Amiatinus showing the prophet Ezra (cf fig 2.79ii). MS Amiatino I, fol Vr (not to scale). Florence, Biblioteca Laurenziana (Laurentian Library). *Image*: © DeAgostini Picture Library/Scala, Florence 2018.

the signing of the cross on the forehead of the newly baptised, and continues 'properly was the name of the Lord inscribed on the forehead of the High Priest with four letters, in order to signify the same number of the parts of the Lord's cross which we were going to bear on our foreheads'.[458] Since the faithful profess this sacred name on the brow, 'how much more necessary must it be for those chosen

for the leadership of the Lord's flock, having received the priesthood and the spiritual office of teaching, to exhibit in themselves an example of virtue for all?' This linking of God's name on the high-priest's gold head-plate with the sign of the cross made on the forehead at baptism finds a striking reflection in the Staffordshire gold head-dress, which, when seen from above, presents a seven-fold set of images of the cross, a literal embodiment of both the cross of baptism made on the forehead and an echo of the high-priest's plate worn in the same place – as in the Ezra portrait. Though in both Josephus's and Bede's accounts, the gold plaque is separate from the golden crown with the calyx, it is significant that Bede's Ezra image appears to have conflated the two, to create something surprisingly like the Staffordshire object.

As both DeGregorio and Thacker argue, for Bede the head-dress is symbolic not only of Old Testament high-priestly authority but also of contemporary ecclesiastical leadership.[459] Bede states that the high-priest's head-dress represented the 'dignity of the priesthood'[460] and might be seen as having connotations specifically of archiepiscopal authority – since Bede was probably writing this work in the expectation that the metropolitan/archiepiscopal status of the see of York was about to be revived.[461] If, as the evidence of the Ezra portrait and his writings suggests, Bede's portrayal of this is indeed underpinned by an *earlier* head-dress that he had seen, it seems plausible that it was worn by the bishop of the *gens*, signalling the highest ecclesiastical authority.

What, then, might have been the origin of such a head-dress? Like the large gold cross, with which it shares very similar small crouching animals (figs 5.12 and 5.14), the Staffordshire version probably dates to the middle of the seventh century, and it seems reasonable to assume that it was among the earliest of what must have been at best a very small number. There being no other evidence for similar head-dresses in the Anglo-Saxon period, or indeed in the early church elsewhere,[462] the most plausible explanation is that these head-dresses, including that which inspired Bede, were created – either directly, or through copying an existing exemplar – from Josephus's description of the high-priestly head-gear.

If the dating of the head-dress is correct, it implies that a copy of the *Antiquitates* was accessible in England by the middle of the seventh century. Although very little direct evidence survives for the contents of Anglo-Saxon libraries, the presence of individual books can be inferred from contemporary references.[463] We do not know when copies first came to England, but a copy of the Greek text probably existed in the monastic library at Canterbury in the time of the great scholar Archbishop Theodore (668–90),[464] and, given the interest of the text and the earlier reputation of Canterbury as a centre of learning, a copy of the Cassiodoran Latin translation, as used by Bede, might conceivably have been present much earlier.[465] Extraordinary as the hypothesis may seem, it accords well with the determination of the Anglo-Saxon church, in these formative years of the Conversion, to assure that their practices were grounded in biblical or exegetical authority; a head-dress symbolising spiritual leadership, as Bede envisaged, would be a powerful and necessary symbol of ecclesiastical authority. Significantly, in the case of the Staffordshire example, this is enhanced by the assumption of the visual vocabulary (Style II) and appearance (garnet and gold inlays) of insignia associated with contemporary secular authority, such as we see elsewhere in the Hoard.

Crosses worn on the body or on equipment

The four crosses in this small group share an iconography but differ in their usage. As noted above,[466] of these the most likely to have had an ecclesiastical role is the cross-pendant (**588**: fig 2.81), one of a well-known group of seventh-century garnet-inlaid pendant crosses that includes the pectoral cross found in St Cuthbert's coffin, presumed to be a sign of his episcopal status. Some of these belonged to secular owners, like the crosses from female burials at Trumpington (Cambridgeshire), Ixworth (Suffolk) and Desborough (Northamptonshire).[467] Many others, such as the recent very similar find from near Newark (Nottinghamshire), and those from Holderness (East Yorkshire) and Wilton (Norfolk), lack any context that might have clarified whether they were worn by lay or priestly owners.[468] However, given the specifically ecclesiastical nature of certain other objects in the Hoard, the possibility that the cross was worn as a priestly or episcopal pectoral cross seems plausible.

The other three crosses were attached in various ways to a base, for display on the body, or on equipment. The small gold sheet cross (**482**) with filigree and central cabochon garnet is of light construction and was attached by a single central rivet, which suggests that whatever base it was fixed to was not subject to particular stress or movement that could have dislodged the mount. In appearance it is similar to the pendant cross from the Hoard, and that from near Newark. The even smaller gold filigree cross (**481**) was attached by means of holes at the end of each arm and at its centre; it may have formed part of a group of similarly decorated appliqués, for example, **435** and **461**. Its small size and simple shape are matched by miniature copper-alloy applied and pendant crosses known from seventh-century burials, especially in Kent.[469] The small garnet and glass cloisonné cruciform mount (**526**) is more robust, and with six attachment holes, some containing gold rivets, was designed to fit very securely to its base. The garnet work has no close parallels among the other cloisonné in the Hoard, so it is unlikely to belong to any of the recognised suites of mounts.

Its small size makes the cruciform shape unlikely to reflect a practical function, such as a strap distributor, suggesting that it is intended as a cross. All three of these cross-shaped mounts could be seen as making a public affirmation of faith, and were perhaps also perceived to confer protection on the bearer, in the tradition of pagan amulets.

Objects of uncertain, but possibly religious, purpose

There remain a few objects for which religious functions might be mooted, but which lack conclusive diagnostic evidence. Three of these are discussed below and require no further explanation here:[470] gold filigree fragment **680**; silver and iron bar **684**; and silver socket **685**. The remaining two groups pose interesting questions that are explored in more detail below; these are the three gold and garnet edge-mounts (**562–4**, fig 2.64), the gold 'eye'-shaped mounts with garnet cloisonné (**542–3**) and their matching strip-mounts (**544–7**: figs 2.58 and 2.60).

At first sight, the L-shaped and linear edge-mounts (**562–4**) have a marked similarity to the jewelled mounts on early medieval treasure bindings from Gospel-books, notably the early seventh-century Byzantine style book-covers commissioned by the Lombardic queen, Theodelinda, in the cathedral treasury at Monza, Italy, and a book-cover depicted in a sixth-century icon of Christ Pantocrator in the Monastery of St Catherine, Sinai.[471] A sacred book would be a very plausible addition to the armoury of powerful and protective ecclesiastical symbols in the Hoard, and the case is argued by Fern (fig 2.64).[472] However, there remain several obstacles to this hypothesis.

The L-shaped mounts of the continental bindings are not edging mounts, but decorative appliqués, forming a broken frame around a central jewelled cross. The borders of the Monza covers are composed of four long garnet-inlaid strip-mounts, mitred at the corners. They are not slotted over the edges of the book-boards, but are nailed to the surface. The three Hoard edge-mounts, by contrast, are decorated on three sides and have an internal slot, approximately 2mm wide, containing fragments of wood. To provide effective protection to the edges of a book, these mounts would need to be continuous, as on other early medieval treasure bindings. Arranged in a continuous sequence, and allowing for the minimum number of missing components to complete a rectangular edging, the various possible configurations of the three mounts for one board imply a comparatively small book, perhaps in the region of 185–235mm × 135–40mm (the Monza covers, by contrast, each measure a substantial 341 × 265mm) (cf fig 2.64). If the Hoard mounts were indeed made for a precious text such as a small Gospel-book, a very bulky cover is implied, with external edges 8mm thick. Yet the 2mm width of the internal slots would be too narrow even to accommodate the edge of the unusually slender covers of the St Cuthbert Gospel (see below), which, at 137mm × 95mm, measure less than half the size of the Monza covers; the thickness of their wooden boards is 2.4mm, rising to 3.68mm with their goatskin covering.[473] The interesting suggestion above,[474] that the striking imitations of gold and garnet cellwork in several page borders of the c AD 800 Gospels of St Médard de Soissons[475] might imitate the framing of earlier treasure bindings, is of little help here, since even if they are intended to evoke edgings, they shed no light on their construction or mounting.

Nor does the admittedly very limited evidence for early Anglo-Saxon book-covers offer anything that can be compared to these splendid mounts. We know that, in the early eighth century, Bilfrith the anchorite made a magnificent jewelled and silver-gilt treasure binding for the Lindisfarne Gospels, long since vanished, and that in the 670s Bishop Wilfrid commissioned a sumptuous casing for a Gospel-book for his church at Ripon;[476] it too did not survive. They may well have emulated Byzantine-type treasure bindings similar to the Monza example, but we cannot be sure, and what little evidence survives for Anglo-Saxon bindings is actually very different. The earliest are the decorated leather bindings of the St Cuthbert Gospel of John, which was probably made in Wearmouth/Jarrow in the early eighth century, and the slightly later Cadmug Gospels now at Fulda.[477] These have no metal mounts, nor do the various book-covers depicted in contemporary manuscripts;[478] a set of eighth-century Anglo-Saxon copper-alloy edge and corner mounts survives on a continental binding at Fulda, but they are entirely different in shape and appearance.[479]

Although the balance of probability is against the mounts being from a book-cover, an alternative function remains elusive, as does their status – secular or religious? L-shaped seax-scabbard mounts, known from continental contexts, might be a possible explanation, but the fixings are different and the number of mounts would imply two such *en suite* scabbards, which do not accord with the evidence for seaxes in the Hoard; and, although the T-cell pattern on the side edges of these mounts matches that on the seax's upper hilt-fitting (**167**), it occurs elsewhere in the Hoard and cannot be regarded as diagnostic of a connection.[480]

The possible significance of the remarkable paired gold and garnet lentoid mounts (**542–3**), suggestive of a pair of eyes, and their *en suite* strip-mounts (**544–7**) became clear only at a late stage in this study. Although all six fittings contain an extensive programme of concealed crosses within their ornament, suggesting that they might display a Christian affiliation, there was nothing that initially suggested that they might have been specifically made for a religious

object. However, noting that two strips were originally attached, at oblique angles, at one end of each 'eye' (see fig 2.58), it has been possible to conclude from the different angles of their free ends that in the most plausible configuration (fig 2.60) the 'eyes' were indeed presented as a pair, and that the design was intended to fit onto a large, flat, house-shaped or trapezoidal wooden object similar in outline to reliquaries in early medieval western Europe.[481] While it cannot be proven that they were affixed to a shrine or other portable ecclesiastical object of this shape, in the absence of secular parallels for such an object, and given the repeated cross motifs in their decoration, this remains the most likely explanation. Whatever the object's function, the configuration of eye-shaped and strip-mounts is unique; but it is worth observing that decorated panelled frames reminiscent of such metalwork are widely used to construct elaborate designs in the display pages of Early Insular manuscripts, suggesting some influence from metalworking tradition.

It is not impossible that some of the other large cloisonné mounts from the Hoard were also attached to this object, or on other items of possible religious significance, but we have found no physical or other evidence to support this. One exception is the inscribed cross arm (**540**), which, as argued above, was probably attached to a reliquary of similar scale; it might even have been affixed to the other side of a shrine associated with the eye motifs. In terms of iconography, it is plausible that the 'eyes' were intended to represent eyes, and had meaning in a Christian context. The Augustinian concept of the eyes of the body and those of the mind, ultimately derived from Neoplatonism, was certainly known to the Anglo-Saxon church, and was later to be much promoted by King Alfred in his writings.[482] The Alfredian version of spiritual vision is embodied in the enlarged eyes of the personifications of Sight on the ninth-century Fuller Brooch and the Alfred Jewel.[483] There is no earlier Anglo-Saxon evidence for the depiction of the eyes as a conduit for spiritual knowledge, but there are hints that this was an iconography well understood in the seventh century, as Fern has pointed out in the case of the Merovingian Chelles chalice,[484] where a procession of similar garnet-inlaid 'eyes' around the rim appear to link the sacrament of the Mass to spiritual vision (fig 2.69).

More speculatively, there might be a connection with the depiction of pairs of eyes in *ex voto* images in shrines and sanctuaries, common in antiquity, and continuing into the early medieval period. A sixth-century gold *ex voto* with a pair of eyes was found near the tomb of St Peter in Rome,[485] and, much closer to home, by the fourth century there seems to have been a major shrine dedicated to healing diseases of the eye near the Roman town of Wroxeter. Over eighty plaster, gold and copper-alloy eye-shaped *ex votos* were found here, some with rivet holes for fixing to a board or a wall.[486] It is most unlikely that this nearby Roman shrine had any connection with the eye motifs in the Hoard, which, as probable war *spolia*, are unlikely to have come from Mercia; but whatever their provenance, it is striking that these powerful symbols appear nowhere else in Anglo-Saxon metalwork, perhaps indicating that their antecedents may lie in the late Roman world, rather than in Germanic tradition.

Conclusion

The significance of the Christian objects within the Hoard, as part of God's armoury on the battlefield, is discussed below, in its historical context.[487] As we have seen, the inscription on the cross arm alone implies a context of conflict, with its defiant call to scatter God's enemies, or even tear them apart.[488] If this belonged to a shrine, as proposed, that suggests that holy relics were another armament in the Christian cause, while the possible pectoral cross and episcopal head-dress suggest the presence of God's representative alongside the temporal power manifested in the king. Whether carried in procession, or standing erect upon its base, the large gold cross represents God's standard, equivalent to that carried before a king, as his Anglo-Saxon *thuuf* was carried before Edwin.[489] It is a portable symbol of Christian authority and of divine protection. In his account of the so-called 'Alleluia' victory, in which British forces led by the Gaulish bishops Germanus and Lupus defeated invading Saxons and Picts in the fifth century, Bede emphasises how these bishops, as apostolic leaders, brought Christ himself to fight on their side.[490] Germanus bore a standard on the battlefield.

Such a reading gains support from the absence of key liturgical items, such as a chalice, portable altar or paten – or (as argued above) vestiges of jewelled gospel covers – which shows that the items in the Hoard were not a haul of precious loot from a monastery or church, but chosen for a purpose.

The four ceremonial objects from the Hoard are the earliest surviving Anglo-Saxon ecclesiastical objects. Exotic as they seem in their uniqueness, the eclectic melding of traditions that they exhibit can now be fully understood as typical of the early Anglo-Saxon church; the assimilation of Germanic art to Mediterranean traditions has long been recognised as the dominant aspect of Insular manuscripts, but the Staffordshire Hoard allows us to see that this experimentation with old and new forms and styles occurs in ecclesiastical artefacts across all media, and at a relatively early date in the conversion programme. Shaping Roman and Byzantine iconographies within a pre-existing native tradition of symbolic ornament was a key element in reaching

out to newly converted Anglo-Saxons who were accustomed to reading messages in images, not words. What these objects so clearly reveal is how, by the middle years of the seventh century, the Anglo-Saxon church had already invented its own individual idiom, and laid the foundations for the distinctive Insular culture that developed in the decades that followed.

MISCELLANEA

Over 1,700 mainly small fragments remain unattributed by object-type or class (table 2.1), though by weight (370.42g) these account for only 6 per cent of the whole collection. While some were found without association, many came from soil-blocks (online table 2), and others were found attached to or trapped inside larger objects (fig 2.2; online table 3). Over 1,000 fragments (54.71g) are silver sheet (**690**); more than 250 are from bosses, rivets or nails (**616–75**); and assorted other remains are from gold, silver and copper-alloy objects (**605**, **677–89** and **691–5**). In addition, there are two other items: a curious bar of iron, wood, horn and silver (**684**); and a second socketed-base in silver (**685**).

The puzzling iron bar (**684**) is encased in silver, with thin layers of ash-wood (*Fraxinus excelsior*) and horn underneath the silver on one side (fig 2.88). One end is D-shaped, with a central hole, while the other end may be broken. In its proportions and size (L. 61.5mm) this object resembles a cross arm (cf **539** and **540**). While its core of corruptible iron could be said to compromise its identification as a sacred object, this metal was used similarly as a core for a number of later Byzantine processional crosses with silver coverings.[491]

Whether or not the sturdy silver socket (**685**) was associated with another cross can only be speculated, but the width measurement of the top of the socket is close to those of the lower arm of the great cross (**539**) and inscribed strip (**540**). Preserved inside the socket was a large fragment of hornbeam (*Carpinus betulus*), a wood often used for heavy duty work on account of its robustness.[492] Originally, it was secured to a base by means of four flanges with central rivet-holes; cut marks on it show it had suffered a chopping blow.

The small gold sheet remains (**682**) are probably mainly derived from torn hilt-plates, while the fragments of filigree (**681**), bits of cell-wall (**683**), gold foils (**694–5**) and garnets (**692–3**) must come from other gold objects.[493] Two strips with herringbone filigree and gold nails might be from hilt-fittings (**677–8**).

▲ **Fig 2.88.** Drawings of object **684**, its X-radiograph and section, with a tentative reconstruction of it as the arm of a cross. *Drawing*: C. Fern.

One other small gold fragment (**680**) with filigree herringbone ornament was found inside pommel **41**. It might have formed the arm of a cross-pendant, since it is of hollow box-construction, but it is much slenderer than the arms of cross-pendant **588**.[494] Inside the hollow arm is a fragment of wood (species unidentified). A similarly slight, garnet-inlaid fragment from the arm of a cross was found at a seventh-century Northumbrian royal centre at Dunbar, East Lothian (Scotland).[495]

Of the small silver remnants (**686–9**), most notable are: one fragment (**686**) with unusual punchwork;[496] remains (**687**) with Early Insular style;[497] and three fragments (**605**) with Style II animal ornament related to that on pommel **71** and hilt-fitting **189**. In addition, one small copper-alloy fragment (**691**) has interlace.[498]

The loose bosses, nails and other related parts are summarised in table 2.10. The bosses and boss-headed rivets in gold (**616–56**), silver (**661–2**, **664–71**) and brass (**663**) are similar to examples found with hilt-plates, and this is probably the origin of the majority (fig 2.89). A small number suggests sets with plates.[499] However, small gold bosses and small garnet bosses are also known on other types of object, including buckles.[500] Three larger gem-settings (**616–7**) are certainly not from hilt-plates. Pair (**616**) is of tall form, made of thick gold with filigree collars, and each setting has a rivet

▲ **Fig 2.89.** Selection of the loose bosses, rivets, nails and washers in silver and gold, and 'locking' pin **676** and the loop remaining from its pair. *Photographs*: © Birmingham Museums Trust; Cotswold Archaeology, © Barbican Research Associates, G. Evans; C. Fern.

piercing its base. One has remains of a calcite-wax paste, which presumably backed its stone. They can be compared with the gem-settings inside the famous Ormside bowl (from Cumbria) of the later eighth century, but this is by no means the only conceivable function for them.[501]

There are thirty-nine small nails and rivets in gold (**657–9**) and almost 140 in silver (**672–5**). Most have small domed heads and round-sectioned shanks. The nails have shanks tapered to a point; the rivets have blunt and often slightly expanded ends (incomplete examples are identified as 'nails/rivets'). Under magnification, the shanks typically appear facetted along their length, indicating they were made from round wire that was manufactured or finished by hammering. A single gold rivet (**657**: [*K406*]) has a seam down its length, showing it was made from wire that was rolled; and a few other nails and rivets have square-sectioned shanks, the unfinished form taken by the 'wire' before rolling or hammering. There are no fine striations on the shanks to indicate any of the wire was drawn through a drawplate.

Most of the gold rivets are like those with pommels and hilt-plates, but the more numerous silver rivets probably come from a greater variety of objects, including probably silver mounts **567–71** and the considerable quantity of reeded strip (**611** and **613**). The gold nails are all small (L. 3–8mm) and so are some silver examples, and these are like the nails found with some of the small mounts from hilts.[502] The 'nails' could not have withstood actual hammering, however, so it is likely they were fixed with some form of adhesive in pre-drilled holes. Two silver rivets (**672**) are larger (L. 36mm).

There are few surviving washers (**660** and **675**). Eight in gold (**660**) are double-washers from hilt-plates, including three possible pairs: these were used with rivets to secure the pommel to the upper guard (fig 2.18).

	Catalogue	Gemmed bosses	Bosses/Boss-headed rivets/ boss parts	Rivets	Nails	Nails/ rivets/ other	Washers
GOLD	**616–60**	9	47	16	16	7	8
SILVER	**661–2, 664–76**	-	15	55	24	57	3+?1
	Total:	9	62	71	40	64	12

▲**Table 2.10**. Boss-types, rivets, nails, washers and related fixings. '?': uncertain identification/quantity.

CHAPTER THREE

CHAPTER THREE
WORKSHOP PRACTICE

ELEANOR BLAKELOCK AND CHRIS FERN

There is a distinct lack of direct information concerning smiths and the culture of fine metalworking in the period. What understanding we have is largely derived from detailed examination of the surviving objects made by metalworkers. To this end, the Hoard, in the quantity and quality of its objects, contributes beyond any find before it to the search for the 'elusive' smith.[1] The metalwork presents almost the full Anglo-Saxon ornamental repertoire of the seventh century in the most prized materials of the day – silver, gold and garnet – with the bent and ruptured state of many of the finds allowing, furthermore, an appreciation of their manufacture that has rarely been possible previously.

Just a single smith's grave is known from Anglo-Saxon England, at Tattershall Thorpe (Lincolnshire), which contained tools and cut garnets among its many items.[2] The grave was located in isolation at the edge of fenland, a distance in death that perhaps mirrored an ambiguous status in life. The legendary Germanic smith, Weland, remembered on the Franks Casket, is portrayed as a mysterious figure of genius and magic, who ultimately takes a grisly revenge upon a royal master who had enslaved him.[3] In *Beowulf*, arms and armour are described as the 'work of Weland', though prestigious weapons are credited to 'giants'.[4] The specialist, transformational and sometimes hazardous processes of metalworking, along with knowledge of the cryptic ornament used in creating the artefacts, probably combined to make the smith a figure apart from ordinary society, regarded as skilled and essential, but also potentially dangerous.[5] Nevertheless, the regard and influence that such specialists could attain is shown by St Eligius (c 588–660), goldsmith and moneyer to the Merovingian royal court.[6] He is our best documented example of a real smith from this period, is known to have worked widely, and some surviving objects are even attributed to him. Equally, it is possible to imagine a master goldsmith behind many of the Hoard artefacts. Anglo-Saxon law codes of the seventh century indicate smiths in royal service, but it is unclear if they were free or bonded servants.[7] However, in an age when golden weapons were crucial to the fabric of society, the model of the enslaved Weland has an intrinsic logic, since it may ultimately have been the goldsmith that was the most prized and jealously guarded commodity of all.

In the figure of Weland, the smith is idealised as both a weapon-smith and goldsmith, capable of fabricating a whole sword from the blade to its hilt decoration.[8] The collection's many fittings show, however, how complex and multi-stage the hilt alone could be and, with manufacture increasingly centralised from the late sixth century onwards, we should perhaps consider the possibility of small teams of craftsmen: maybe a master goldsmith with apprentices.[9] The evidence for 'assembly' marks on some artefacts may support this,[10] as well as the fact that some production must have been regarded as low-skilled, such as the mixing of pastes or the rolling of beaded filigree wire. Master smiths are unlikely to have been common,[11] so with a collection like the Hoard there is the possibility that finds showing related manufacture and ornament could actually have been made in the same workshop, if not by the same individual.

What form the 'workshop' took is likewise largely unknown, except that a structure with an enclosed hearth would have been necessary.[12] Strict control of heat was required for hot working, indicated by changes in the colour of the metal, so the hearth needed to be in darkness.[13] However, the fine ornament of the objects would have required the opposite, natural light, so this work was probably undertaken in the open air. The tools of the Tattershall smith show that the apparatus was portable and small-scale, a fact that doubtless contributes to the archaeological invisibility of smithing, and means that a smith might have worked anywhere that had the basic requirements and a patron.[14] Two sites considered of royal status, Sutton Courtenay (Oxfordshire) and Rendlesham (Suffolk), now indicate non-ferrous metalworking, from the evidence of scraps of gold sheet and droplets, lead models and unfinished items.[15]

ANALYSING THE RESOURCE

A wide range of examinations undertaken between 2009 and 2016 by different specialists was aimed at realising as much as possible the tremendous potential of the treasure.[16] The results are a significant addition to scholarship, and in several instances are the most comprehensive studies of their kind to date. They show the varied daily activities of the workshop, from new evidence of a process of

surface-enrichment of gold alloys, to the ingredients mixed to make paste fillers for the fragile objects, and ultimately the sophistication of the miniature crafts of filigree and cloisonné. The evidence reveals that smiths could be conservative, shown by the dominant fashion for gold filigree pommels, but also capable of individual genius, as expressed by objects like pommel **57**, the cloisonné seax hilt-suite and great gold cross (figs 2.10, 3.80 and *frontispiece*). This chapter is separated into two sections: *Materials* and *Manufacture*. The first is concerned with the raw resources used and the second with their transformation by a range of sophisticated techniques.

As early as 2010, data on the gold, garnet and glass were collected from around fifty finds, work that was funded by The National Geographic and organised via the British Museum. This was done at Paris using the particle-induced X-ray emission (PIXE)/particle-induced gamma-ray emission (PIGE) technique. Critically, however, the results obtained for the gold alloys by this analysis largely represent the composition of the surface metal of the objects only. Subsequent analysis undertaken in Stage 1 of the Historic England project in 2013–14 revealed the alloy quality at the surface level of many gold objects to be substantially different from the sub-surface core metal, a difference that can only be due to deliberate manipulation, a process known as 'surface-enrichment'.[17] From the results of the gold analysis it is not possible to suggest any origin for the metal ore, but the findings of the 2013–14 study set the Hoard gold within the wider context of the metal economy of early medieval England, a time when gold was ever prized but fluctuating in its availability and alloy quality. Nevertheless, the data show that gold use in the Anglo-Saxon workshop was not simply a passive reflection of the availability of the metal, but that smiths were controlling and manipulating the resource to a hitherto unrecognised extent. Analyses of the silver and small quantities of copper alloy were also undertaken, to allow comparison with other metal studies.

The garnet analysis was undertaken with the aim of evidencing the exotic origins of the precious stones. The identification of minor and trace elements, and mineral inclusions, has narrowed the source possibilities, with regions in central Europe and South Asia suggested. The chemistry of the small amount of glass was also determined by PIXE/PIGE, with further inlays studied later at the British Museum by X-ray fluorescence (XRF). Most is probably reworked glass from Roman and Anglo-Saxon sources, with in some cases potash (plant ash) added, perhaps to extend dwindling supplies. A small number of further objects with corroded inlays were examined for the Historic England project by two separate studies at the British Museum and University College London (UCL) Institute of Archaeology. These have revealed the chemistry of the inlay, but the weathered and diminished material remains 'unidentified'.

The rare organic material was assessed and analysed jointly at the British Museum and Birmingham Museum and Art Gallery. Included is evidence for the perishable materials used for the hilts of swords, as well as of paste fillers, which together indicate the wider resource drawn upon in manufacture, including the produce of plants, animals and even insects. In addition, a single fragment of textile represents a tantalising shred of evidence for the Hoard's deposition.

The *Manufacture* section includes studies of all the techniques shown by the finds, with key examinations in particular of the principal crafts of filigree and cloisonné. These were all conducted during Stage 2 (2015–16) of the Historic England project and, while they are by no means exhaustive, each gives comprehensive coverage in the wider context of precious metalworking and lapidary work in early Anglo-Saxon England. The studies are well illustrated with photomicrographs and measurements taken with a Keyence microscope, significantly aiding an appreciation of the miniature nature of the crafts. For example, many of the wires used in the gold filigree are less than 0.5mm in diameter. Analytical methods, including XRF, metallography and scanning electron microscope-energy-dispersive X-ray (SEM-EDX), were employed to understand 'invisible' aspects of the metalwork, such as the metallic recipes and techniques used for gilding, niello and soldering, and an explanation was also sought for the 'surface-enrichment' revealed by the gold analysis. The last technique slightly enhanced the gold colour of the metal at the very surface and was possibly routinely carried out. Lastly, also not known before, are the 'assembly' marks on some objects, simple line marks that, although crude, help illuminate the mental process of the individuals responsible.

MATERIALS

Gold

There is no evidence that gold was mined in Britain or northern Europe in the period. Instead, the metal was probably derived largely from late Roman and imported Byzantine *solidi*, much of which left the eastern empire as tribute payments to Germanic and Asian tribes.[18] However, while Byzantine coin may have been used directly to make a small number of objects in the collection, most were probably produced from imported Merovingian coin or scrap objects that had themselves been alloyed from *solidi*.[19] For the later fifth and first half of the sixth centuries, gold finds are rare in England, but in the archaeological record objects in the metal occur more frequently from the final decades of the sixth century. This change may relate to a shift in the supply of gold to England, from an initial gold stream coming westward via south Scandinavia that was low yielding, to a more abundant supply centred on the near Continent that was fed by large

payments made to Merovingian rulers from Byzantium and the Visigoths.[20] This influx of gold did not last, however. The supply again reduced around the 630s/40s and the gradual debasement of gold coin in Europe resulted. Anglo-Saxon coinage shows a related gradual decline in gold fineness up to the 660s/70s when silver coinage effectively replaced the gold.[21] Past examinations of non-coin metalwork have attempted to identify this same pattern, with the aim that comparison of gold-alloy fineness against well-dated continental coinage might be used as an independent means of establishing the date of manufacture of jewellery.[22] However, there are considerable complications in linking coin fineness with the gold alloys of jewellery, not least that there is variation even within datable coin groups,[23] and, as already stated, high-fineness Roman/Byzantine coin and other recycled metal could offer alternative raw materials.

A pilot study of sixteen gold objects from the Hoard for the Historic England Project was carried out initially to investigate the effects of the burial environment on the metal alloys and to determine what further analysis was appropriate.[24] It revealed the first cases of significant 'surface-enrichment' (the deliberate alteration of the alloy quality at the surface level), emphasising the need to consider the composition of the sub-surface core metal of the objects to establish the alloys employed. In the subsequent fuller study of 114 finds, sub-surface analysis using SEM-EDX was therefore undertaken.[25] Comparison of the core-alloy data with that from the surface also allowed an appreciation of how widespread the surface-enrichment treatment was for the gold objects as a whole, and, for more complex pieces, how it varied across their different components.[26] In addition, the core-metal analysis was undertaken to help determine the potential sources of the gold, to identify possible object sets and workshop groups, and to provide comparison data for the chronological study of the gold alloys.

Silver and small quantities of copper occur naturally in gold deposits, but these metals could also be added by the craftsman to alter the colour or properties of alloys.[27] The analysis indicated an inverse relationship between the gold- and silver-alloy content; when the gold is lower, silver is correspondingly higher, but the copper content of the alloy remained consistently low, between c 0.5–4.5 per cent. This supports the suggestion that the gold was recycled. If ore-extracted metal had been used, it might have been expected that the copper would have increased proportionately with the silver, to economise on the gold used, while retaining the golden colour.

▲ **Fig 3.1.** Ternary diagram showing the range of gold-alloy compositions.

A ternary diagram shows the range of gold alloys from the core analysis (fig 3.1). The majority of the objects had a composition: Au c 66–88wt%; Ag c 10–31wt%; Cu c 1.5–3wt%. A small group comprised objects of high fineness (Au c 90–8wt%; Ag c 2–9wt%; Cu c 0–2.5wt%),[28] while two objects were of particularly low fineness (Au c 47–54wt%; Ag c 43–51wt%; Cu c 2–3wt%).[29] For comparison, the high-fineness objects are similar in composition to the famous shoulder-clasps of Sutton Hoo (fig 6.10).[30]

The alloy range confirms that Merovingian gold coin and scrap objects made from that coin were probably the materials predominantly used. The exception is the small group of objects of high fineness, which have compositions that suggest Late Roman or Byzantine coin (Au c 90–98wt%) was the source.[31] This is further supported by the presence of platinum group elements in the alloys, including for the cloisonné seax hilt-fittings (**55, 167–9** and **225**), as these tend to be removed by repeated recycling.[32] The use of Byzantine coin has likewise been suggested for gold bracteates manufactured earlier in Scandinavia in the fifth to sixth centuries,[33] and their example well illustrates how objects of high fineness might be of variable date.

The objects for analysis were selected to include examples from the whole chronological span of the collection.[34] However, the results did not show a consistent pattern of decline in gold alloy fineness over time, as might have been anticipated if Merovingian coin was the only source.[35] This can be illustrated with specific examples. Pommels **2** and **4** have core alloys (Au c 81–83wt%) that are in broad agreement with the late sixth- or early seventh-century date suggested by their early Style II ornament, and the two pommels demonstrate heavy wear.[36] In comparison, the set of pommel **5** and hilt-collars **89–90** is of the same stylistic horizon, but the core alloys of the two

Fig 3.2. Results from the sub-surface analysis of the great gold cross (**539**), showing the different compositions of the various parts.

parts tested (**5** and **90**) are of lower fineness (Au *c* 71–3wt%). Some later objects, pommel **56** (Au *c* 70–6wt%) and mount **460** (Au *c* 77–8wt%), probably of the second quarter of the seventh century, show similar levels of fineness; but contemporary with them are pommel **57** (Au *c* 82–95wt%), hilt-plate **370** (Au *c* 88wt%) and bird-fish mount **538** (Au *c* 86–90wt%) that have gold contents higher even than the late sixth-century material. All three are exceptional 'princely' objects, so their high fineness, achieved probably by adding Byzantine coin, possibly reflects the extraordinary status of their owners. Among the latest finds are examples of relatively high fineness also, including the mounts from silver pommels **76** (Au *c* 74–82wt%) and **77** (Au *c* 79wt%), the sheet body of cross **539** (Au *c* 81–3wt%) and inscribed strip **540** (Au *c* 75wt%). These can be compared with the purity of contemporary Anglo-Saxon coinage (Au *c* 50–75wt%) of the 'Substantive Gold phase' (*c* 630–50).[37] Overall, the results suggest that smiths were aware of the properties of different raw gold materials and that the metal chosen could be carefully selected.

For a few composite objects it was possible to demonstrate that their different parts were made from different alloys (fig 3.2). This was the case for the great gold cross (**539**): the core alloys of the gem-settings are lower in fineness (Au *c* 71–2wt%) than the sheet metal of the cross body (Au *c* 81–3wt%). Possibly this was done to create a colour contrast between the components, an effect that would have been enhanced, furthermore, by the process of surface-enrichment carried out on the sheet of the cross.[38] Another example is pommel **55** from the seax suite, which appears to have had silver added to its alloy (Au *c* 69–73wt%), compared with the other fittings of the set (**167–9** and **225**: Au *c* 82–5wt%). On this evidence, it is possible that the pommel represents a replacement, although there is no appreciable difference in the quality of its manufacture.

Silver, copper alloy and other metals

Writing in the early eighth century, Bede listed *argentum* among the mineral wealth of Anglo-Saxon England, indicating silver mining by at least this date, although there is little evidence otherwise for the exploitation of silver-bearing ores after the departure of the Romans until the twelfth century.[39] It has been suggested that the 'Anglian' colonisation of the Peak District in the seventh century was partially stimulated by the demand for silver,[40] and other sources that could have been exploited include the Welsh borders and Cheddar, documented in use from the ninth century.[41] However, probably the principal source in the sixth and seventh centuries was again imported wealth, including from the east, of which the clearest example is the Byzantine silver plate from Sutton Hoo mound 1.[42]

The silver metalwork in the Hoard was also alloyed. Elements such as tin, zinc, lead and gold, as well as traces of metals like bismuth, derive from the ore source or could be deliberately or accidentally incorporated during mixing or recycling. Copper especially could be added to lower the melting temperature, as well as to make the alloy

Fig 3.3. Binary plots showing the range of gold–silver compositions and the levels of lead, tin and copper within the silver alloys.

harder and more durable.⁴³ Sixty individual pieces of metalwork were subjected to sub-surface analysis using XRF to determine their core alloys, which would allow comparison between objects of differing date, style and function.⁴⁴ In addition, qualitative surface analysis was carried out on fifty-three silver die-impressed sheet fragments from the full range of panels and bands that were too delicate for sub-surface analysis.

The silver objects demonstrated a range of compositions of 75–98wt% silver with 0–20wt% copper (fig 3.3). Many had up to 4 per cent tin, 4 per cent lead and 4 per cent gold; some had traces of zinc up to 1.5 per cent. Overall, the silver is remarkable in its homogeneity compared to the gold objects, which had a much larger range of gold–silver compositions. However, the results suggest that the alloys are also the result of recycling and mixing, from scrap silver, silver gilt and probably copper alloy. For instance, the analysis showed a consistent presence of gold within the silver. There are two possible explanations for this: that auriferous silver was used that had not been parted after cupellation to remove the gold; or that the gold present was due to the recycling of silver objects with gilding.

There is an apparent relationship between lead and tin in the silver alloys, and both show a good correlation to copper. This suggests that the lead and tin may have entered as scrap leaded bronze (the most common copper-alloy type in the Hoard, see below). The presence of zinc in the silver suggests it also entered with copper, as any zinc present in the silver ore would have evaporated during smelting and cupellation due to its low boiling point. It is likely, therefore, that pieces of brass or gunmetal were also occasionally added, as has been observed in other silver alloys.⁴⁵ Two groups analysed show related alloys (fig 3.4): the niello mounts (**567** and **569–71**) and cast helmet parts (**589–91** and **593**). However, it was also shown that separate components from single objects could have varying compositions, for example, the different parts of pommels **75–7**, indicating different melts. It is possible that over time there was an increase in lead and tin with a related decrease in zinc. This is perhaps due to the gradual loss of zinc from successive recycling, although this is not entirely clear; technical choices might also have been a consideration. Objects that were cast tended to have more lead than those that were worked, like the die-impressed sheet. A number of the silver objects with niello inlay have a higher fineness, possibly to take advantage of the higher melting temperature of the silver, desirable given the high-temperature application of the inlay, although this was not strictly necessary.⁴⁶

Several groups can be suggested within the assemblage of silver die-impressed sheet, possibly representing different melts. The kneeling warrior band (**593**) and a lone fragment of a mailed figure (**606**: *[K7]*) have more zinc present than the panels of the marching warriors (**596–7**) and others with Style II (**594** and **601–2**), although all are similar overall to the cast helmet parts. In comparison, the alloy of the silver Style II panel of the neck-guard (**600**) and the forward-facing warrior fragments (**599**) revealed a different ratio

▼ **Fig 3.4.** Binary plot comparing the alloys of different silver objects: helmet parts (**589–91** and **593**; included is reeded strip **611** and **613**, and that from socket **607/8**); niello mounts (**567** and **569–71**); weapon-fittings (pommels **63–9**, **71–3** and **75–7**; sword-ring **82**; hilt-collars **182**, **184**, **186** and **188**; hilt-plates **371–2**, **375**, **379**, **381–2** and **385**; hilt-guard **409**; hilt-fittings **533** and **536**; and pyramid-fitting **580**); and other objects (buckle **587**, edging **614–5**, fragment **684** and socket **685**).

▶ **Fig 3.5.** Hoard copper alloys compared to data for early Anglo-Saxon and middle Saxon object alloys (Blades 1995). Note how the Hoard material forms two separate groups similar to the middle Saxon alloys.

of copper to lead relative to the other panels, while the analysis also confirmed these sheets had no gilding present.

Most of the copper alloy remains are fragments of cores or liners that supported the structures of the precious-metal objects. Qualitative surface XRF analysis was carried out on a selection to identify the range of different alloys and to provide comparison data with other Anglo-Saxon assemblages (fig. 3.5).[47] The majority were leaded tin bronzes (>3wt% tin), with less than 1 per cent zinc present,[48] including the gilded disc-mount (**698**) found apart from the rest of the collection. Only five objects included copper with no tin or zinc detected, and of these only the inner lining to gold mount **413** was leaded (>4wt% lead). A set of three bosses (**669**) had cores of pewter, a high-tin alloy with both copper and lead, as did the core inside one of the sword-rings of pommel **77**. Boss **663** is the only brass object, assuming the rivet-head is correctly identified to the period, and there were no examples of gunmetal. Overall, the sample fits best the range of alloys seen by Blades for the middle Saxon period.[49] The limited variety and general absence of zinc argues against random recycling, with instead the copper alloys being the product of more careful selection, perhaps with regard to the metallurgical characteristics desired.

There are only a few fragments of iron in the collection. The very end of a sword tang is snapped off inside the copper-alloy core of pommel **2**, and in two cases the metal was a core material for objects (**259** and **684**).

The analysis of the silver objects showed, in addition, that mercury had been used extensively for gilding.[50] Also the element might have been used by smiths in the period to recover gold from the surface of scrap gilded objects.[51] Mercury cannot be recycled, as it evaporates when heated or naturally overtime; therefore, it must have been regularly imported. There are a number of mercury sources known across Europe.[52] One is the Almadén mine in Spain, exploited from the Iron Age, where it is believed production increased during the fifth century.[53]

▲ **Fig 3.6.** Plot of CaO vs MgO (both as wt%) for the Staffordshire Hoard garnets (black diamonds) overlaid against the five garnet types identified by Calligaro and Périn (2013). The plot also indicates potential sources for the garnets proposed by Calligaro et al (2007).

Garnets

Janet Ambers[†] and Catherine Higgitt

The restricted incidence of gem-quality garnet, its relatively simple major element, but variable trace element composition, and the occurrence of mineral inclusions make the stone potentially suitable for sourcing studies. The scientific investigation of garnets used to decorate early medieval metalwork has been a subject of interest for many decades, therefore, and recently has been greatly aided by the development of non-destructive ion beam analytical methods such as PIXE analysis.[54] PIXE analysis of garnets from Merovingian and other European contexts allows them to be grouped on the basis of their chemical composition and, when combined with other archaeological evidence, to suggest possible geographical provenances for the garnets.[55] Using this approach, researchers have classified early medieval garnets into a number of distinct groups. Calligaro *et al* have identified five types of garnet (Types I–V),[56] and in a further refinement of this work, Gilg *et al* have published a slightly modified version of the groupings and suggest the existence of one additional group.[57] Determining garnet sources from their

Catalogue	K-number	Object	Garnets present*/analysed	Calligaro Type (no. of garnets)
36	[K352]	gold pommel with garnet cloisonné	45/21	Type I (10); Type II (11)
46	[K1160]	gold pommel with geometric garnet cloisonné	54/22	Type I (3); Type II (8); Type III?a (5); Type V (6)
48	[K715]	gold pommel with garnet cloisonné	65/17	Type V
51	[K452]	gold pommel with garnet cloisonné	117/22	Type I (4); Type II (5); Type V (13);
52	[K284]	gold pommel with garnet cloisonné	210/46	Type I (15); Type II (20); Type V (11)
158	[K570]	gold hilt-collar with beaded garnet cloisonné	13/8	Type II (7); Type IIIb (1)
167	[K370]	gold seax hilt-collar with Style II garnet cloisonné	140/22	Type I (3); Type II (1); Type V (18)
473	[K1000]	gold hilt-fitting with two small mounted cabochon garnets	2/2	Type I (1); Type II (1)
495	[K1226]	small gold fitting with glass and garnet cloisonné	16/3	Type V
517	[K980]	gold hilt-fitting with garnet cloisonné decoration in form of two eagles	44/20	Type I (9); Type II (10); Type IIIa (1)
521	[K1465]	gold hilt-fitting with garnet cloisonné	9/9	Type V
539	[K308]	large unmounted cabochon	1/1	Type V
539	[K659]	single mounted cabochon, broken into three pieces	1 (3 pieces)/3	Type II (2); Type IIIb (1)
539	[K1314]	single mounted D-shaped cabochon	1/1	Type III?a
542	[K270]	gold eye-shaped mount with garnet cloisonné	184/15	Type V
551	[K645]	fragment of gold strip-mount with garnet cloisonné (possible set 553)	5 (1 in 2 pieces)/6	Type I (4); Type II (2)
553	[K673]	gold strip-mount with garnet cloisonné (possible set 551)	65/22	Type I (4); Type II (10); Type IIIa (8)
558	[K275]	mount with gold and garnet cloisonné fitting (set 560)	181/26	Type V
560	[K677]	mount with gold and garnet cloisonné strip (set 558)	74/12	Type V
562	[K356]	gold edge-mount with garnet cloisonné (set 563)	288/18	Type V
563	[K357]	gold edge-mount with garnet cloisonné (set 562)	185/14	Type V
572	[K377]	gold pyramid-fitting with glass and garnet cloisonné	69/27	Type I (16); Type II (9); Type III?a (1); Type IIIb (1)
575	[K1201]	gold pyramid-fitting with garnet cloisonné	44/4	Type I (1, raised); Type V (3)
577	[K565]	gold pyramid-fitting with glass and garnet cloisonné	11/6	Type II (5); Type IIIa (1)
579	[K1166]	gold pyramid-fitting with glass and garnet cloisonné	47/16	Type I (1); Type II (6); Type IIIa (3); Type V (6)
581	[K382]	silver pyramid-fitting with attached gold panels, with garnet cloisonné and teardrop-shaped cabochon decoration	7/7	Type I (3); Type II (2); Type V (1); Other (1)
583	[K1425]	gold button-fitting with garnet cloisonné	14/10	Type V
588	[K303]	large mounted cabochon at centre of gold cross-pendant	1/1	Type IIIb
617	[K91]	single mounted cabochon (cracked)	1 (4 pieces)/1	Type I
692	[K695]	large flat-topped unmounted cabochon	1/1	Type IIIa
693	[K1565]	single loose elongate garnet	1/1	Type II

▲ Table 3.1. Details of the garnets from the Staffordshire Hoard, drawn from analysis of 384 garnets from thirty-one objects or fragments, with assigned groupings (based on types defined by Calligaro et al 2007). '*': some objects have lost garnets due to damage. '?': uncertain identification.

chemical composition is complicated, but drawing on a range of evidence, these researchers have suggested potential sources for the garnet groups that they have identified, including India, Sri Lanka and the Czech Republic, as indicated in fig 3.6.[58]

In late 2010, PIXE analysis of cloisonné and cabochon garnets associated with thirty-one objects or fragments from the Staffordshire Hoard was undertaken at the Accélérateur Grand Louvre d'Analyse Élémentaire (AGLAE) facility in Paris.[59] The results are summarised here and described in detail elsewhere.[60] The analysis indicates that the Hoard garnets also fall into a number of compositional groups, suggesting they originate from a number of distinct sources. The garnets have compositions close to those reported previously for early medieval garnets, with the exception of one garnet from pyramid-fitting **581** (see below). Figure 3.6 overlays the data for the Hoard garnets with that for early medieval garnets analysed by Calligaro *et al*. On the basis of these data, the assigned groupings for each of the garnets analysed are given in table 3.1.

Six large cabochon stones were examined and a number were found to be Type III pyraldines with compositions similar to garnets associated with Roman and Byzantine jewellery, perhaps suggesting the reuse of earlier stones or imported cut stones.[61] The repaired, mounted cabochon [*K659*] from cross **539** has an almandine-rich Type II composition, although the small piece of garnet inset as a repair at the edge (fig 4.1) appears to come from a completely different stone (a Type III pyraldine). The large unmounted cabochon [*K308*], possibly from the same cross, appears to be an unusually large pyrope garnet (Type V), although overall the pyrope-rich garnets tend to be the smaller stones in the Hoard.

While the garnet groups in the cloisonné objects from the Hoard are similar to those identified in continental material, there are differences in how the stones have been used. Some of the objects contain only almandine-rich stones (e.g. **36**, **473**, **551**, **517**, **553**, **572** and **577**), while others contain only pyrope-based stones of closely similar composition (e.g. **48**, **495**, **521**, <u>**542**</u>, <u>**558**</u>, <u>**560**</u>, <u>**562**–**3**</u> and **583**). Stylistically, it has been suggested that the five objects underlined are products of the same cloisonné workshop.[62] However, mounts **551** and **553** are also part of the same object group, although they contain only almandine-rich stones. A number of pieces contain both almandine- and pyrope-based garnets, a characteristic that is unusual in Merovingian cloisonné, in comparison. In some cases, the mixed almandine- and pyrope-based stones appear to have been colour-matched (pommel **52**: side with geometric design), but on other pieces the almandine-based stones are used for larger cells (e.g. pommels **46** and **52**: side with zoomorphic design: fig 3.7), while for seax collar **167** pink almandines are combined with deep red pyropes to pick out different elements in the zoomorphic decoration (figs 3.7 and 3.95). The deliberate use of stones of different types (and colours) has been noted previously on Anglo-Saxon objects; namely the gold scabbard button-fittings from Sutton Hoo, where almandine-rich garnets pick out the shape of a cross against a background of pyrope-based stones.[63] Pyramid-fitting **581**, one of the latest objects in the collection, has the most diverse range of stones, although close in colour: Types I and III almandines, Type V pyrope and the only non-pyralspite garnet (a grossular garnet, probably of the hessonite variety).

In early medieval continental Europe, garnet cloisonné was extensively used for the decoration of jewellery and weaponry in the fifth and sixth centuries. Analytical data from such cloisonné objects reveal a shift from the almost exclusive use of almandine-rich stones (Types I–III) in the fifth and sixth centuries to the almost exclusive use of pyrope-rich stones (Types IV–V) during the seventh century.[64] This has been linked to an interruption in the supply of almandine-based garnets coming from South-East Asia (India and Sri Lanka) around AD 570–80, although this remains an ongoing topic of research. Although pyrope-rich stones (likely of European origin) start to be used by the end of the sixth century, these are typically smaller garnets, less suited to the production of cloisonné. In Anglo-Saxon England and Scandinavia, the peak period of production of high-quality cloisonné occurs in the seventh century, precisely at the period when garnet supplies are dwindling and

▶ **Fig 3.7.** Garnet types identified for pommel **52** and seax collar **167**: I = Type I almandine-based garnets (Rajasthan); II = Type II almandine-based garnets (?India); V = Type V pyrope-based garnets (Czech Republic). *Photographs*: G. Evans.

52

167

cloisonné production is declining in central Europe.⁶⁵ In light of this chronological disconnect, the findings from the Staffordshire Hoard are of particular interest as there is very little analytical data about the types (and thus probable sources) of garnets used in cloisonné-decorated objects from elsewhere in Anglo-Saxon England. The fact that cloisonné work continued to be produced implies that large, high-quality garnets continued to be available in these regions in the early seventh century, raising interesting questions about how – and from where – garnets were reaching these areas. It is not until the third quarter of the seventh century that garnet supplies seem to decline in Anglo-Saxon England and Scandinavia.

The fact that some of the Hoard objects were decorated exclusively with almandine-rich or pyrope-based stones ostensibly might suggest that a similar chronological progression from the use of almandine-rich stones to the use of pyrope-based stones is being observed as for Merovingian cloisonné. It is notable that several of the group of large cloisonné mounts,⁶⁶ dated slightly later, to the second quarter of the century,⁶⁷ show only the use of Type v garnets (**542**, **558**, **560**, and **562–3**). However, within the sample overall there appears to be little chronological spread based on the dating, with a lack of definite sixth-century material with cloisonné, making it difficult to comment on whether there is evidence for a chronological shift in the garnet sources employed.

The use of mixtures of almandine-rich and pyrope-based garnets in the same object also differentiates the cloisonné of the Staffordshire Hoard from typical continental production. It is possible that many of the objects from the Hoard were produced at an intermediate period in the early seventh century when both types of stone were available. However, it is also possible that the combining of almandine- and pyrope-based stones – and particularly the deliberate use of almandine- and pyrope-based stones of different colours – within the same object may be typical of production in Anglo-Saxon England, perhaps reflecting the ongoing availability of stocks of stones from mixed sources in such workshops.

Ultimately, given the limited object sample, the conclusions drawn by the investigation can only be tentatively applied to the whole assemblage. Nonetheless, this study provides the first PIXE data for Anglo-Saxon garnets from a British archaeological context, and the suggested patterns within the data and the other features identified will help to provide a framework for future research. Additionally, and importantly, this work contributes the first evidence base for the discussion of the long-distance trade networks that brought garnet to the workshops of Anglo-Saxon England.

Glass

Chris Fern and Andrew Meek

Twenty-two objects have glass inlays, in most cases featuring as a rare element in cloisonné ornament.⁶⁸ In addition, harness-mount **698** from the same field as the Hoard has a central blue glass stud. Anglo-Saxon jewellery arguably shows less incorporation of glass than might be expected, given the evidence for broadly contemporary industries producing glass vessels and beads.⁶⁹

The chequered glass known as *millefiori* is seen on seven objects. Most of the inlays are small, thin and flat, but the stud on the apical disc of roundel **541** is a more unusual cabochon form (diam. 14mm). All these inlays would have been cut from glass canes that were possibly produced within the British Isles. Small fragments of *millefiori* cane have been found at Anglo-Saxon and Irish sites, including at the monastic site of Monkwearmouth-Jarrow (Tyne and Wear), where Cramp has suggested manufacture may have taken place.⁷⁰ There are four different patterns in the collection (e.g., figs 3.8–3.9): red and blue check (**53** and **494–5**); red, white and blue check (**541**); red and white check with small crosses (**578–9**); and a red cross on a blue background (**576**). Only on pyramid-fitting **576** was an inlay backed by a gold foil, as was standard with garnets.⁷¹ The red and blue check *millefiori* is especially interesting, in the light of the occurrence of similar glass at Sutton Hoo used for items of the mound 1 cloisonné regalia, including the shoulder-clasps (fig 6.10).⁷² However, a study (by

▲ **Fig 3.8.** Glass *millefiori* inlay on pommel **53**. The red and blue check pattern can be compared with similar examples used for the regalia from Sutton Hoo. *Photograph*: C. Fern.

CHAPTER THREE | WORKSHOP PRACTICE

▲ **Fig 3.9.** Glass *millefiori* inlay on pyramid-fitting **578** of red and white checks with red crosses. *Photograph*: C. Fern.

▲ **Fig 3.10.** Tiny red glass sphere used for the eye of bird mount **512**. *Photograph*: C. Fern (*inset* G. Evans).

Meek) for the project, comparing the glass chemistry of the Sutton Hoo and Hoard examples, has revealed differences, as will be discussed.[73]

Tiny glass eyes were used for the animals in garnet cloisonné on several objects: seax hilt-collars **167–8**, and bird-mounts **511–2** and **514–5**. The similar execution of this rare detail on these high-quality objects makes it possible that they represent the output of a single workshop, if not a single craftsman. Each eye is a sphere of dark red glass less than 1mm in diameter (fig 3.10). Pyramid-fittings **578–9** might also have had similar glass eyes, now lost; and one tiny sphere 'eye' was found loose.[74] A parallel for their use, but not in cloisonné, comes from Harford Farm (Norfolk), grave 18, in the form of a silver pin suite with animal-head terminals with small glass eyes.[75] Glass eyes of a different kind, of flat blue glass, can be seen on the cloisonné shoulder-clasps of Sutton Hoo (fig 6.10), and such detailing also occurs occasionally in Merovingian and other continental zoomorphic cloisonné.[76] Another item using dark red glass is cross **526**. The circular, flat inlay at its centre is very close to garnet in appearance, which presumably it was intended to imitate, but microscopic examination has revealed tiny bubbles within the setting, characteristic of glass.

The small triangular inlays of opaque blue glass on pyramid-fittings **572–3** (fig 3.11) can also be compared with the combination of blue glass with garnets on the Sutton Hoo shoulder-clasps (fig 6.10). This fashion was also a feature of Kentish cloisonné, as can be seen on the composite disc-brooch from Kingston Down (fig 6.9i).[77]

▲ **Fig 3.11.** Triangular blue glass inlays in the cloisonné on pyramid-fitting **572**. *Photograph*: C. Fern.

Decayed inlays on bird-mounts **516–7** were possibly originally of the same blue glass.

Translucent blue glass occurs with garnets on the cloisonné roundel on pommel **76**; the inlay framing the central cabochon garnet is white glass, but originally it would have been colourless.

Fig 3.12. Yellow-green glass in the gem-setting of hilt-plate **260**, probably reused vessel glass. *Photograph*: © Birmingham Museums Trust.

Yellow-green translucent glass was used for the one surviving inlay on pommel **75** and for the remaining boss on hilt-plate **260** (fig 3.12). Lastly, a different use of glass is seen on pommel **49**, in the form of two red inlays, which were possibly repairs for lost garnets (fig 4.12).

Six of the inlays (**49**, **53**, **167**, **495**, **572** and **579**) were analysed in Paris, in 2010, at the AGLAE, by particle-induced X-ray and gamma ray emission (PIXE and PIGE), to determine their chemical composition.[78] Further studies by XRF were undertaken at the British Museum of the inlays on pommels **75** and **76**.[79] All the glass was found to be soda-lime-silica based.

The blue glass inlays on pommel **76** and pyramid-fitting **572** are natron glass, coloured with the addition of cobalt and containing varying levels of antimony. The further presence of lead, as well as the antimony, suggests the source was reworked Roman glass or possibly imported cullet.[80] The same is also true of the blue parts of the *millefiori* inlays on pommel **53** and mount **495**.

The originally colourless glass on pommel **76** is also natron glass. It is antimony-decoloured glass, like that found in Britain during the Roman period,[81] and so its use in this context could also indicate reworked residual glass. The white part of the *millefiori* inlay on pyramid-fitting **579** is likewise antimony-opacified glass.

The translucent yellow-green glass on pommel **75**, coloured by the addition of iron, is probably also natron based.[82] It is very similar to Anglo-Saxon vessel glass, which is possibly its origin, and the same is likely for the inlay on hilt-plate **260**.

Vessel glass manufacture declined in Britain from the fifth century, though specific Anglo-Saxon vessel forms indicate the survival of some level of industry.[83] Supplies of natron-rich cullet from the east possibly remained available into the sixth century, but at some point glassworkers somewhere in north-west Europe, and possibly in the British Isles, started to adulterate glass by the addition of potassic wood ash-rich material, most likely in an attempt to extend supplies.[84] It is this glass type that is confirmed for the red inlays on pommel **49**, the tiny eyes on hilt-collar **167** and the red elements of the *millefiori* inlay on pyramid-fitting **579**. The glasses showed a natron base, but with elevated levels of potassium oxide and magnesium oxide, which would be consistent with the addition of ash. The identification of this type of glass in a *millefiori* inlay is particularly significant as it strengthens the long-held belief in the insular origin of the glass type.[85]

'Unidentified' inlay

Chris Fern and Marcos Martinón-Torres

Fourteen objects have cloisonné filled with remains of a heavily decayed inlay. The material is firm to powdery, green-tinged (copper-rich) and in most cases has expanded beyond the cell edges due to its corrosion (fig 3.13). However, there can be no doubt that it is the remains of a deliberate inlay, perhaps once as brilliant in its appearance as the garnet cloisonné. Objects with the material are pommels (**38–40**, **43–4** and **54**), hilt-collars (**165–6**, **170–1** and **177**) and pyramid-fittings (**578–9**). In most cases it was used without other inlays, but on the pyramid-fittings it was combined with garnet and glass. In addition, one hilt-plate (**363**) has just two cells with the material incorporated with its garnet ornament, which may indicate in this instance that the inlay formed a repair. Possibly, it was used mostly as a substitute for garnet, and accordingly was perhaps red in the majority of cases. However, its deliberate combination with garnets on pyramid-fittings **578–9**, where it was used only for the animal ornament, might suggest that in some cases the inlay was a different colour. A further observation of its use on these fittings is that those cells containing the decayed inlay also have evidence of backing paste, like that used for the garnet cloisonné (but there are no backing foils).[86] This could suggest that the corroded substance was some form of mineral stone, cut and set like garnet over a paste; although evidence on the other objects suggests that the inlay might have been vitreous, like enamel (see below; cf fig 3.14), and in no other instance was it associated with a paste.

A preliminary examination at the British Museum ruled out that the copper-rich content of the substance was a corrosion product from the alloys of the objects.[87] Neither is it consistent with remains of a backing paste (not least as no garnets, other inlays or gold

CHAPTER THREE | WORKSHOP PRACTICE

▲ **Fig 3.13.** 'Unidentified' decayed inlay, now a firm to powdery green substance, in the cloisonné of pommel **54**. Its expansion is due to corrosion. *Photograph*: © Birmingham Museums Trust.

backing foils were found associated). A subsequent, more detailed, examination at the UCL Institute of Archaeology identified possible spillage around the edges of the cellwork of the cloisonné, which would be consistent with a vitreous material applied in a molten state (fig 3.14).[88] Also, rare and very small reddish fragments of the inlay (<0.5mm in size) were found preserved (fig 3.15). A reasonable deduction from these observations, therefore, might be that the inlay in these instances was applied in a vitreous state, and cooled to form a red decoration.

Nevertheless, there are problems with this identification. Analysis by SEM-EDX showed the decayed inlay to be dominated by copper carbonates,[89] with only small amounts of lead, zinc and cobalt, which are the elements found in glass and enamel of the period.[90] In particular, the levels of silica and other light oxides are too low for corroded glass, even allowing for the severe weathering of the material (and samples analysed in cross-section showed virtually no silica, alkali or alkali earth oxides).[91] The microstructure of the material is also different from the typical layered arrangement of devitrified glass. Furthermore, in a red particle from pommel **44** (fig 3.15) the levels of iron are very high, compared to other glass of the period.[92] Iron-rich copper slag was used to colour glass red during the medieval period, but if this material had been added then diagnostic slag particles ought to have survived corrosion and been identifiable under microscopic examination, which was not the case.[93] It should also be noted that other glass in the collection was well preserved, despite its exposure to the same burial environment.[94] The alternative hypothesis, as already proposed, is that the material is a previously unknown type of stone inlay formed of a copper-rich mineral, like cuprite. Once oxidised this mineral presents as copper carbonates.

▲ **Fig 3.14.** Very small patch of red substance, possibly molten spillage, at the edge of the cloisonné on pommel **54**. *Photograph*: © Birmingham Museums Trust.

▲ **Fig 3.15.** Very small red fragment of inlay preserved in a cloisonné cell on pommel **44**. *Photograph*: © Birmingham Museums Trust.

Organics and pastes

Peter Mc Elhinney and Chris Fern

Remains of organics identified on the Hoard's metal fittings have provided information about what materials the objects were originally attached to. In addition, many were found to have the remains of pastes used as fillers, some being largely or entirely made of calcium carbonate. One organic sample contributes evidence for the deposition of the Hoard, in the form of a single scrap of textile, which is possibly the remains of a bag or wrapping. Its survival and that of other materials, including antler/bone, horn and wood, was due to interaction with silver and copper corrosion salts from the metal alloys of the objects. In all, material was examined from seventy-nine sources and characterised by a combination of micro Fourier transform infrared spectroscopy (micro-FTIR), SEM, SEM-EDX and optical microscopy.[95] The remains were mainly with finds, but some was loose material. In a few cases, material with hilt-plates and mounts indicated that the fittings must have been buried still attached to the organic guards of weapon-hilts (**243–4**, **258**, **412–3** and **451**). As well as the full study (by Mc Elhinney) that informs this section, the relevant findings of previous examinations at the British Museum undertaken earlier in the post-excavation process have been incorporated,[96] and where taxonomies are assigned, these were determined by those analyses.

Bone (or antler) was identified with three objects, discoloured to green by copper corrosion. This is likely to represent remains from hilt-guards in two cases, as the material was found within mounts from the tips of guards (**412–3**). The presence of both compact and cancellous tissue is possible, but, due to distortion of the organic structures, it is conceivable that antler and not bone was the source. Bone guards would be highly unusual, though cases of bone handles for seax knives are known, of mid or late seventh-century date.[97] Cloisonné mount **565** has a large inlay of bone, identified as mammalian by microscope examination.[98]

Horn was more commonly used in the construction of weapon-hilts in the period.[99] Three objects have evidence for its use for guards. Relatively substantial remains are sandwiched between one pair of gold hilt-plates (**243**) and survive on the underside of one other plate (**258**), but only traces were preserved on an in-situ nail with guard mount **451**. The remains with the hilt-plates have a blackened appearance and are fractured, delaminated and deformed, but the gold plates show no effects from burning, so heating is unlikely to have been the cause. The same effects can result from bio-deterioration, as observed in equine hoof disease, for example.[100]

The small textile fragment [*K1821*] (*c* 8 × 8mm) was found in soil within gold hilt-collar **126** (fig 3.16). This was studied by Caroline Cartwright, and, although its direct contemporaneity is not certain, she has concluded it would 'not be out of place for the seventh or eighth century'.[101] Parts of the textile were found to be mineralised by metal corrosion products, but some fibres survived with sufficient diagnostic features to enable them to be identified as processed and unprocessed flax (*Linum usitatissimum*). Examination using a VP-SEM revealed a plain weave structure with Z-twist yarns.

Fig 3.16. BSE image of the textile fragment from hilt-collar **126**, showing a plain weave and Z-twist yarns. *Photograph*: C. R. Cartwright, © Trustees of the British Museum.

A large piece of well-preserved hornbeam wood (*Carpinus betulus*) was found within silver socket **685**. It appears to be the base of a shaft with a square section and is bored with a hole that aligns with holes on the sides of the metal fitting. Wood remains were identified with an additional ten objects. Within the hollow interior of one of the ring-knobs of silver pommel **75** a dowel of ash (*Fraxinus excelsior*) survived, used to strengthen the join between the separately cast components, and presumably a corresponding dowel was used for the

Fig 3.17. Surviving ash dowel used to align and secure one of the ring-knobs on pommel **75**. *Photograph*: K. Fuller, © Birmingham Museums Trust. *Drawing*: C. Fern.

pommel's other ring-knob (fig 3.17). Ash was also identified with a layer of horn within the silver sheet casing of object **684** (fig 2.88).[102]

Four gold pommels (**17**, **19**, **29** and **51**) also included wood as part of their core structures. In all cases the material was found in the interior, close to the apex, and in three cases the remnants appeared indented. This indentation might be due to distortion from deterioration, or it could suggest the use of shaped cores, which in each case served to bed the tang of the weapon and prevent it from penetrating the delicate gold structure of the pommel (fig 3.18). In two cases, a paste filler made up the rest of the core (see below). It is also possible that horn traces identified at the British Museum within pommel **36** (but not detected later by FTIR analysis) relate to a lining of material that fulfilled a similar function.[103] Although not exact parallels, 'packing pieces'

Fig 3.19. Wax and glue paste remains on helmet-band **593**, showing a positive cast of a warrior figure. The paste had backed and adhered a warrior-decorated band of silver-gilt sheet originally set within the tray of the helmet-band. *Photograph*: C. Fern.

Fig 3.18. Wood and calcite core inside pommel **51** (scale 1/1). *Photograph*: P. Mc Elhinney, © Birmingham Museums Trust. *Drawing*: C. Fern. .

of wood have been suggested for two swords from the Dover Buckland II cemetery (Kent) and for one from Broadstairs (Kent), which were used to secure the grips and pommels.[104] Small wood remains were also associated with the paste filler of helmet-crest **589** (see below) and with three garnet cloisonné objects forming a set (**562–4**), while a larger fragment survives within the hollow structure of gold fragment **680**.

Beeswax associated in some cases with a protein component, most likely animal glue, was identified as a construction material for over twenty objects (fig 3.19): inside seven pommels (**4**, **29**, **32**, **36**, **47**, **76** and **77**); in both sections of helmet-crest (**589–90**); in the silver helmet-band (**593**);[105] as a filler for two bosses (**616**); as the backing paste for over a dozen cloisonné objects (**158–60**, **174**, **362**, **542–5** and **550–3**); and in the recess of one cloisonné strip-mount (**557**). In addition to these examples, several small balls (*c* diam. 5mm) of pure beeswax [*K1637*] were recovered from the sieving of soil block 17. It is possible these originated from an object, as a core or paste, but their pure, unmixed state might alternatively indicate that they represent a deposit of the material in a 'raw' unworked form.

The wax-glue paste was probably applied to these objects in a molten or softened state, which set when cooled. Egg white has been considered the protein component in wax-glue pastes in other studies.[106] However, since egg white coagulates at approximately the melting point of beeswax (65°C), the compatibility of such a mix is questionable. Animal glues produced by processing hides and connective tissues are primarily composed of collagen, while the processing of hooves and horn produces a keratin basis. FTIR spectra in this case demonstrated peaks that could indicate a keratin-derived glue.[107] In addition, samples from cloisonné cells on hilt-collar **159**, and large mounts **542** and **553**, were identified in a separate study as containing possible plant gum.[108]

The now separated wax-glue core from pommel **76** retains the shape of the upper interior of the object, showing that it once formed a solid fill. In the case of pommel **77**, the wax mix was found inside both the separated ring-knobs, and in at least one of these it appears to have been combined with a copper-alloy core.

The wax pastes inside two pommels (**29** and **47**) and other objects (**589**, **549** and **616**: [*K311*]) also contained calcium carbonate as an ingredient. This material was similarly used without wax as a core paste inside at least three other gold pommels (**10**, **24** and **51**),[109] and traces also remained inside pyramid-fitting **577**. In the interior of pommel **36** calcium carbonate was identified along with wax, but the two were not found to be mixed, and may instead have formed

separate layers. FTIR and SEM analyses of samples from two pommel cores (**10** and **36**) showed no preserved microfossils in the calcium carbonate and suggested that the material had been processed to produce a lime-plaster-like material. Processing limestone into lime plaster (i.e. quicklime) is a relatively complex process that involves heating to a high temperature so that the carbon dioxide begins to dissociate, around 825°C, before cooling and slaking.[110]

No exact parallels for the use of pastes within pommels are known, though 'chalk mixed with beeswax' was identified as a filler within the upper guard of a sword-hilt from Rostock-Dierkow (Germany), probably of eighth-century date.[111] It is likely that the use of such paste fillers was common and widespread, however, with Coatsworth and Pinder noting their use to fill void spaces within Anglo-Saxon, Merovingian and Lombardic brooches.[112] Examination of the calcite filler inside one of the helmet-crest pieces (**589**) also suggested residues of glue, as well as the fragments of wood already noted. The hard paste has a burnished appearance and perhaps it was a foundation for a wood or bone strip, into which bristles of hair or the quills of feathers were inserted to form a crest.[113]

The paste formed of a mix of beeswax and glue found in the cloisonné was set behind the gold foils and stones in the cells, probably to serve as a yielding filler.[114] It is possible that finely ground silicate was also a component in some pastes, but further analysis of these would be needed to confirm fully the quantity and range of the mineral ingredients. Overall, the pastes used appear similar, although it should be noted that this apparent homogeneity may be due to the fact that most of the examined objects (i.e. **542–5** and **550–3**) are from suites that could have been produced by a single workshop.[115] In comparison, Arrhenius's study of cloisonné characterised a considerable variety of paste types.[116] Calcium carbonate was a typical ingredient in many, which is lacking in the examined cloisonné of the Hoard, yet as noted calcite-wax pastes were clearly used in other types of manufacture in the collection (including behind the filigree panel on cloisonné mount **556**). She assigned pastes made predominantly of wax that are most similar to those used for the collection's cloisonné to her 'Organic' group, which included a few examples from England as well as others from Scandinavia, Hungary and further east.[117] Silicates were also common inclusions in many of her paste types.

The range of organic and inorganic materials that have been identified draws attention to some of the more rarely observed processes involved in the manufacture of fine metalwork. The collection and preparation of such materials as beeswax, horn, wood, glues and quicklime suggest a network of workers beyond the smith, but all ultimately in the service of the elite consumers of the prestige objects.

Other materials

The clear and colourless cabochon stone at the centre of the gold mount on pommel **77** has been confirmed as rock crystal quartz by Raman spectroscopy. The only other use of stone is the bead (**584**) that fits with scabbard button-fitting **582**. The opaque cream-coloured stone was drilled, lathe-turned and polished to a barrel form with concave ends. It is a microcrystalline/cryptocrystalline quartz,[118] and possibly magnesite. The same type of stone was used for a bead with a similar button-fitting from Niederstotzingen, grave 9 (Germany).[119]

Amber was used as a repair for a lost garnet on hilt-collar **157**, and other small pieces found loose in soil block 18 may be detached from the same object.[120] While commonly used for Anglo-Saxon beads,[121] examples of amber in metalworking are unusual, one such being the Ripon jewel (North Yorkshire).[122]

MANUFACTURE
Casting

Casting represents the primary stage of manufacture for all the metalwork, even for those objects that did not ultimately take cast form. The gold sheet that was used so extensively for the gold objects, as well as the Hoard's silver sheet, would have started as ingots or cooled globules, which would have required hammering to the desired thickness, and the wire used for nails, rivets, hilt-rings and filigree would also have been shaped ultimately from either ingots or sheet. The ingots could have been cast in open moulds, though the surface tension of molten gold (alloyed with silver and copper) makes it unlikely that this form of casting was used for the more ornate objects.[123]

Only two gold objects have decoration that was cast, pommel **57** and hilt-plate **370**, although it is possible the serpent mounts (**527–32**) were also cast, and other gold objects do have cast, non-ornamental parts that are integral to their mainly sheet structures.[124] By contrast, most of the silver weapon-fittings and the single silver buckle (**587**) were cast.

Both the rarity of ornamental casting in gold and its predominant application in silver are true of early Anglo-Saxon metalworking generally.[125] Casting gold objects seems to have required greater quantities of metal, which may explain its rarity compared to the more economical method of manufacture using sheet. Pommel **57** is the greatest by weight (44.23g) of all the gold pommels in the collection; serpent pair **531–32** have a similar combined weight (46.71g); and hilt-plate **370** also has a greater weight (21.44g)

relative to other fittings of the type. All of these objects are also unusual, and some were manufactured using high-fineness gold.[126] It is probable, therefore, that the casting of gold ornamental objects was an infrequent activity in the workshop, and maybe one reserved for patrons of especially high status who also desired more singular objects made of the finest gold. The best example of this beyond the Hoard is the great gold buckle (412.70g) of Sutton Hoo.[127]

Fig 3.20. Hilt-plate **370** showing the rounded edges of the cast ornament, evidence that a wax model was probably used. The eyes of the creatures were added with a punch. *Photograph and drawing*: C. Fern.

The soft edges of the ornament on pommel **57** and hilt-plate **370** (figs 2.10 and 3.20) suggests they were based on wax models from which a clay mould was made using the so-called lost-wax technique,[128] and the same can be said of the cast silver parts of the helmet (**589–92**; figs 2.45–2.46). Rare models of lead are also known from the period,[129] and even wood or antler models might have been used for simple forms like hilt-plates. Potentially such templates might be reused, although no objects have been identified in the collection as cast from the same model or mould, a fact that arguably reinforces the case for the prevalent use of wax models. Clay mould fragments have been found at sites of the period across northwest Europe, but early Anglo-Saxon examples are extremely scarce.[130] Once removed, the cast object would have required finishing, by filing clean sprues and flashing, and details would have been refined. A sprue scar is visible at one end of pommel **57** on the snout of the wolf head (fig 2.10), and another is visible in the interior of silver hilt-collar **182**. Also a few silver objects demonstrate filing marks on their edges (**72**, **183**, **186–7** and **380**).

Sheet and foil

Most of the gold objects have superstructures of sheet metal, in some cases with surviving evidence for inner cores or linings of metal, or paste fillers, which gave essential support to their fragile construction. Measurements from around 160 objects show that the gold sheet was mostly in the range of 0.2–0.4mm thickness, but some was as thin as 0.1–0.2mm (online table 5). Examples of thicker gold sheet (th. 0.8mm) include that used for pommel **55** and its associated fittings from the seax (cf fig 3.80), and thicker sheet was also used for vertical wall elements in some cloisonné (e.g. **541–66**). Even a small change in thickness could considerably increase the amount of gold used overall, as is illustrated by two pommels of sheet and filigree construction (without cores): pommel **31** has sheet of less than 0.2mm thickness and is 6.94g; pommel **16** used sheet of 0.3–0.4mm thickness and is 15.90g. Ordinarily the thrifty smith probably used the thinnest sheet possible that was necessary to meet the structural needs of the object, but exceptions to this rule include the small proportion of objects manufactured using a double-sheet thickness, mostly those with incised animal ornament (**459**, **538–9** and **541**).

To form the metal sheet, an ingot would have been beaten on an anvil until uniform in thickness, with regular annealing to reduce the risk of fracture and to retain the alloy's softness and ductility.[131] No hammer marks have been observed on any sheet or plate surfaces, though there is plentiful evidence for the further stages of production. Soldered joins are visible on many objects, especially

Fig 3.21. Sheet joins in the interior of pommel **11**. *Photograph*: © Birmingham Museums Trust.

in the interiors of gold pommels and hilt-collars, some of which appear to have been sprung apart by damage (figs 3.21–3.22; cf fig 2.74i). Lightly incised lines also occur on objects that appear to relate to the planning of form (fig 3.23), or to the laying out of decoration (figs 3.42 and 3.79).

▲ **Fig 3.22.** Sheet joins in the interior and around the bottom edge of hilt-collar **166**. Some of the seams are partly sprung. *Photograph*: C. Fern.

▲ **Fig 3.23.** The reverse of hilt-plate **292** showing fine incised lines (digitally enhanced) at the edge of the plate (arrow 1) and at the junction with the side-flange (arrow 2). Note also the stepped join in the flange (arrow 3). *Photograph*: © Birmingham Museums Trust.

Gold can be beaten very thin to form foil, as is demonstrated by the collection's loose foils (**694–5**) from cloisonné objects.[132] It was not possible to take thickness measurements from these, but they are likely to be of similar thinness to that established by other studies, of *c* 0.01–0.03mm.[133] Gold of high purity is necessary to achieve this, with the alloys probably less than 1wt% copper.[134]

Inscribed strip **540** (figs 2.78 and 3.47) has the appearance of being solid gold, but might in fact be formed of a silver bar with only a thin veneer of gold sheet. In the fracture at its fold is a brown tarnished metal that has the appearance of silver. Its alloy was investigated using XRF, but this analysis failed to confirm the character of the metal. It is the case that there are no visible seams on the object, which might have been expected, in line with what has been observed for other sheet-formed objects; although a skilled smith could perhaps have removed these by burnishing.

The collection's hundreds of silver sheet fragments come mainly from decorative coverings, including for a socketed base (**607/8**) and at least one helmet (**593–604** and **606**). By contrast, it appears only rarely to have been used to manufacture weapon-fittings.[135] Thick silver plate was used, however, for the large silver mounts with niello ornament (**567–71**).

The analysis of the silver of the die-impressed sheet revealed only small quantities of copper (typically <6wt%)),[136] with less lead than in the alloys of cast objects.[137] This lower copper content would have made the silver easier to hammer, while any lead present would have been detrimental to the die-impressing process. Once the sheet was of the desired thickness, it would have been annealed a final time to make it malleable enough to be worked with the die. The sheet is generally 0.15–0.25mm thick, with the two longest bands (**593–4**) an estimated 480–550mm in length (figs 2.49–2.50), each of which was possibly beaten out of a single ingot.

Soldering

Soldering was used extensively in the manufacture of the gold objects: to join sheet components; to set filigree ornament; and for the construction of cloisonné cellwork. Two main types of solder are described in classical and medieval historical sources: one was a metal alloy, applied to joins as finely cut fragments or as a metallic powder; the other was formed from copper oxides or salts in an organic compound (i.e. 'organic' soldering). In either case, when heat was applied, directed by a blow pipe or using the smith's own breath, the liquid solder would have flowed towards the heat source, to be drawn into joints and points of contact by capillary action.[138] In contrast, for the silver objects a soft solder would have been used, probably an alloy of silver with lead and tin, with a melt temperature below 450°C.[139]

Bonds formed by 'organic' soldering in goldsmithing typically leave little visible trace, yet they would have been strong enough to bear repeated heating of the metal, thus allowing repeated soldering of an object.[140] This could have made it most attractive for the manufacture of filigree and cloisonné objects, allowing parts to be completed in stages. It is also feasible that both the described soldering techniques were used together, as in modern jewellery production, with the solder with the highest melting temperature used first.[141] In organic soldering the copper starts diffusing into the gold at 900°C and at a critical concentration will melt,[142] while the historic recipes for metallic gold solders would have had melt temperatures of 938–75°C.[143]

Nevertheless, previous examinations of Anglo-Saxon gold objects have not revealed the characteristic blemishes near joints to indicate use of metallic gold solder, and it has been suggested, therefore, that organic soldering was favoured.[144] On most objects in the collection, solder is likewise invisible without the aid of a microscope (fig 3.24). However, a small number demonstrate an excess of solder (figs 3.25–3.26 and 3.58), and solder scarring can be seen on objects where filigree wires or cloisonné cell-walling are missing (figs 3.27–3.28). Joins are also visible on hilt-rings, where the thick filigree wire was soldered to form the ring (fig 3.29). In addition, some sheet backings on filigree objects have fine pitting that is visible under magnification. This could have been caused during soldering, although it might alternatively have resulted from the surface-enrichment of the sheet, a process described below.[145] The two solder methods are impossible to differentiate with certainty by surface analysis, so chemical analysis was undertaken of sections sampled at the damaged edges of

▲ **Fig 3.24.** Mount **447** showing solder around the beaded wire of a filigree scroll. *Photograph*: © Birmingham Museums Trust.

▲ **Fig 3.25.** Hilt-collar **133** showing filigree scrollwork flooded by solder. *Photograph*: © Birmingham Museums Trust.

▲ **Fig 3.26.** Hilt-ring **218** showing filigree wire flooded by solder. *Photograph*: © Birmingham Museums Trust.

▲ **Fig 3.27.** Hilt-plate **288** showing solder scarring (arrow) where a filigree collar of beaded wire has been lost from around a rivet-hole. *Photograph*: E. Blakelock, © Birmingham Museums Trust.

▲ **Fig 3.28.** Cloisonné strip-mount **547** showing solder scarring (arrow) where the gold sheet walls of the cellwork have been stripped away. *Photograph*: C. Fern.

▲ **Fig 3.29.** Hilt-ring **191** showing the solder join in the thick beaded wire of the ring. *Photograph*: © Birmingham Museums Trust.

Fig 3.30. Chemical analysis of sheet, wire and solder components of three hilt-collars (**101** and **105-6**) plotted on a liquidus gold-silver-copper diagram showing melting points for different alloy compositions.

three filigree hilt-collars (**101** and **105–6**).[146] The results showed elevations in copper, with corresponding decreases in gold and silver (fig 3.30). For two samples (**101** and **106**) there was an increase in copper, from c 2wt% in the sheet and filigree parts, to 8–9wt% at the join. This would have lowered the melting point by at least 60°C. The sample from collar **105** had a smaller proportion of copper at the join, with an increase of up to 2.5wt% in the metal, which would have lowered the melting point by only c 30°C. These results suggest a copper-rich organic solder in all three cases. Had a metallic solder with silver been used, only a decrease in the gold content would have occurred. The sections of the joints also showed the copper had diffused into the sheet and wire, creating a strong bond (fig 3.31). A metallic solder, by contrast, would have formed a film connecting the wire and sheet.[147]

Fig 3.31. BSE elemental map for hilt-collar **106**, showing a section through a filigree wire and its backing sheet, with the relative concentrations of metals in the copper-rich solder.

Surface-enrichment of gold

A significant finding from the gold analysis was that the alloy fineness of many objects had been deliberately increased at the surface of the metal. This surface-enrichment has not previously been recognised in early medieval metalworking, although it is known from historical sources for other periods and from analysis of the metalwork of other cultures.[148] Gold is very resistant to all forms of corrosion, including attack by acids and alkalis.[149] However, the levels of non-noble metals in an alloy can change. Copper is often leached naturally in burial environments, but silver is more resistant.[150] The removal of silver from a gold alloy usually requires deliberate chemical action, by methods such as cementation or, more recently, by parting using mineral acids.[151] Both processes result in a surface layer relatively enriched in gold, enhancing the colour of the metal once burnished.[152]

A pilot study undertaken of sixteen gold objects, mostly hilt-plates, showed multiple cases of significant but not consistent surface-enrichment.[153] Key to identifying this surface-enrichment was comparison of the alloy composition in deep scratches, made during the dismantling of the fittings before burial.[154] The metal within the scratches showed the expected loss of copper but little loss of silver had occurred in the burial environment; however, results from undamaged surfaces proved the removal of silver during manufacture. The subsequent larger study of 114 objects demonstrated surface-enrichment (i.e. reduction of silver) for over 100 of the total 221 object-parts tested. It occurred across the full object range examined (e.g. weapon-fittings and Christian objects) and across the full date-range of the collection, implying a routine and probably widespread practice.[155] Furthermore, the analysis showed a difference in the actual components treated: mostly the sheet parts of objects demonstrated enrichment, whereas filigree wires and cell-walls in cloisonné seem not to have been consistently treated (fig 3.32).

Pommel **31** is an example of an object with differential enrichment to its components (fig 3.33). The sub-surface core alloy of its various parts show a broadly consistent alloy (Au 57.9–62.9wt%). At the surface, however, the alloy of the pommel body forming the backing to the filigree recorded an increased gold fineness (Au 74.6wt%). This would have created an effective colour contrast against the duller overlying wires and apex cap that were not enriched. A similar contrast between gold components can be seen on pommel **25** (fig 1.18).

Sections prepared from samples taken from the torn edges of six objects showed the depth of the surface-enrichment was 2–4 microns thick.[156] Five of these demonstrated enrichment on the front of the sheet only (i.e. the surface that faced outwards on the object). This could indicate that the surface-enrichment was achieved using a paste, as immersing the sheet or object in a liquid in a cementation process would have resulted in the enrichment

◀ **Fig 3.32.** Frequency graph showing (*on the left*) the percentages of sheet and wire components surface-enriched, with a decrease of silver at the surface level (- value); *versus* (*on the right*) components that showed an increase in silver (+ value) at the surface level. This recorded increase in silver was possibly due to corrosion products from silver in the alloys; or could have been transferred in the burial environment by proximity to silver objects. Results determined by SEM-EDX analysis.

Fig 3.33. Plots of gold *versus* silver for the different components of pommel **31**, as determined by SEM-EDX analysis. *Left graph*: surface and sub-surface analyses of the cap sheet and filigree wires; *right graph*: surface and sub-surface analyses of the body/back-sheet, showing surface-enrichment. *Photograph*: C. Fern.

of both sides. Sulphur and chlorine were detected in the surface-enriched layers of four objects, occasionally alongside areas with phases of silver chloride or silver sulphides. This may suggest that the pastes used included both sulphur and salt as active ingredients.

Four different paste 'recipes' are given in late antique and medieval texts, in the third-century Leyden Papyrus, the seventh-/eighth-century Codex Lucensis 490 and the ninth-century Mappae Clavicula.[157] Significantly, all are described as used to colour gold. Ultimately, it is not possible to know what specific mixes Anglo-Saxon smiths employed, and different metalworkers probably used variations, but these sources prove the long tradition of surface-treating gold.[158]

Gilding

The majority of the silver objects were gilded. Especially rich coverings are preserved on some die-impressed sheet panels (**593–8** and **601–3**; figs 2.52–2.53) and on the cast helmet parts (**589–92**; fig 3.34; cf figs 2.45–2.46), while other finds have only traces (e.g. **68–9**). Some objects were only partly gilded (i.e. parcel-gilt), creating a bichrome contrast: pommels **64** and **66**, silver mounts **567–71** and sheet panel **600** have golden frames or borders; whereas on pommels **73** and **75–6** the ornament was parcel-gilded inside silver borders (figs 2.11 and 3.51). On some objects where gilding does not visually survive, it was proved by scientific (XRF) analysis, being indicated by the presence of mercury and a trace gold content.[159] In fact, mercury was detected in all examinations of the gilded metalwork, which agrees with the accepted view that the element was commonly used for gilding in the period.[160]

It is difficult to distinguish scientifically between cold and hot gilding with mercury.[161] Pliny, in AD 77–9, described a method of 'cold' gilding using gold leaf with an adhesive coating of mercury

Fig 3.34. Cheek-piece **591** showing the bonded layer of gilding (Th. 0.3mm) visible at a break-edge (arrow). *Photograph* (enhanced): © Birmingham Museums Trust.

Die-impressing on sheet and foil

George Speake

During the early medieval period cast copper-alloy dies were used to impress designs on thin sheets of metal, a technique known as die-impressing or *Pressblech*. The method was widely employed by craftsmen in Anglo-Saxon England, in Scandinavia and on the Continent, with the decorative sheets applied to enhance a range of objects. It is probable that dies could also have been made of other materials, such as bone or wood, which have not survived.[168] From the reassembled die-impressed silver sheet of the collection (**593–604**), designs from a minimum of twelve separate dies have been identified.

No actual helmet dies have been identified from Anglo-Saxon England, but the number of other dies now known has increased significantly as a result of metal-detector finds, adding to the preliminary corpus published in the 1970s.[169] It is unclear whether their distribution is the result of casual loss, reflecting the movement of craftsmen, or indicates the location of possible workshops. A full analysis of the more recent discoveries has not been undertaken, but the dies would all appear to be of cast copper alloy of 3–4 mm in thickness.[170] The majority from Anglo-Saxon and other Germanic contexts show a design in positive relief, referred to as 'patrix' dies. Where the design is in the negative, that is recessed or *intaglio* (as

that was left to evaporate without heating.[162] A second method, known as amalgam gilding, involved applying a paste of ground gold and mercury, with the mercury then driven off by heating (i.e. 'hot' gilding) to leave a firmly bonded and porous layer of gold that could be burnished.[163] This second technique is well documented in medieval sources, including in the Codex Lucensis 490 and Mappae Clavicula.[164]

The scientific analysis revealed, furthermore, that mercury was present at the sub-surface level on objects, indicating its bonding with the core metal.[165] This is only likely to have occurred if heating had taken place, thus confirming that amalgam gilding was probably the method used, as has been suggested was the norm in the period.[166] Other physical evidence that this was so, includes the finding of mortars for the mixing of amalgam pastes at the Anglo-Saxon settlement of *Hamwic* (Southampton, Hampshire).[167] The habitual use of mercury and its hazards may well have been one reason for the characterisation of the smith in the period as 'other' and belonging at the margins of society.

Fig 3.35. Fragment of zoomorphic band **594** in silver gilt. *Photograph*: E. G. Fregni, © Birmingham Museums Trust.

Fig 3.36. Both sides of one fragment from panel **596,** showing the head, arm and torso of a mailed warrior, gripping a spear and holding a shield. *Photographs*: C. Fern.

on some bracteate dies), they are referred to as 'matrix' dies. It is likely that all the impressions in the collection were made with patrix dies (figs 3.35–3.36).

Two methods have been suggested for how the dies were used, both with the die design facing upwards, but to what extent they replicate the working of Germanic craftsman is open to debate.[171] The thin sheet could have been worked down onto the die using a wooden burnisher.[172] The quality and clarity of the impression may well have been determined by the material of the die (whether bone, wood, stone or copper alloy), as well as by the thickness and malleability of the metal sheet to be impressed. However, the second method has been shown by experiment to be more reliable for achieving a distinct impression without loss of registration.[173] It involved placing a thick piece of leather on top of the sheet before hammering, which forces the sheet into the grooves and hollows of the die, producing a crisp and clear relief impression. This is a variant of the method proposed by Theophilus, where a thick piece of lead rather than leather is recommended.[174]

Examination of the period's copper-alloy dies has also found general agreement that the second method was used, including for the Swedish Torslunda helmet dies.[175] Bruce-Mitford mistakenly suggested that the Torslunda dies A and B had been hammered directly from the back, but in the case of dies C and D he stated: 'the backs of the dies were not hammered, as their roughness shows, but the bronze sheets were hammered or driven directly onto the front of the die, which carried the figures. This may in some degree account for their worn surface condition.'[176] In addition, of note is a die from Liebenau (Germany), which has a different design on each side and it cannot therefore have been directly hammered on its reverse.[177]

Examination of the reverse of the die-impressed fragments of the Hoard provides insight regarding the die design and how it was formed. From the front of panel **596** the mail appears as regular rounded protrusions (fig 3.36), but the reverse shows the effect was achieved by rows of upstanding trapezoidal impressions on the die.

The patterned gold foils used to back the garnets and glass of the cloisonné jewellery were also die-impressed (figs 3.90 and 3.98–3.103), and though their manufacture has been considerably debated, it is now recognised that small copper-alloy dies were used; although again the non-survival of bone, ivory or fine-grained hardwood dies does not necessarily preclude their use.[178] Five dies have been found in Denmark and one from Tjitsma (Wijnaldum, Netherlands) in Frisia.[179] Examples have yet to be discovered on Anglo-Saxon sites, but their existence in the equipment of smiths is implicit and manifest in the quantity and quality of the surviving cloisonné.[180]

All the Danish dies are negative dies, with the cross-hatched lines recessed below the surface of the die (*intaglio*). Two of the dies still had fragments of gold foil adhering to them. One, the die from Gudme, is fractionally larger than the others, being 19.9mm wide. The die from Tjitsma (Netherlands), by contrast, is a positive die (17.4mm × 16.1mm) with a 'boxed' pattern. The majority of its boxes contain sixteen squares, although some of the lines are slightly askew, creating some boxes with twenty squares.[181] Similar foils have been identified in the collection.[182]

Variation in the quality and precision of the foil patterns has led to a number of theories about how they were made. With reference to the foils from Sutton Hoo, East observed that the uniformity of line spacing, crossing angle and slope raised doubt as to whether the dies that made the patterns could have been cut by hand. In a

parallel study at the British Museum, Meeks and Holmes replicated the 'standard' and 'boxed' foils of the Sutton Hoo jewellery with an experimental die created using a mechanical jig.[183] This was used to impress the patterns on gold foil, rolled to a thickness of 0.025mm and annealed. The foil was then placed above a sheet of lead. Variations in the strength of the impression could be achieved by varying the backing surface on which the foil was placed. In this they concurred with the opinion of Avent and Leigh that 'the pattern could have been stamped on to foil laid on a firm but slightly plastic surface'.[184] It is also feasible that, given the malleability of gold, good impressions could be made using a wooden burnisher to work the foil onto the die. Yet, caution is needed in considering these interpretations. Modern attempts to replicate the methods and techniques used may both illuminate and mislead, not least since workshop procedures across the Germanic world probably varied.[185] The use of a mechanical jig may not be consistent with the evidence of the Tjitsma die, where the pattern does not align with the die edges. Likewise, in an innovative study, Adams has argued that the irregularity of lines and patterning on certain Merovingian disc-brooches would 'militate against the uniformity of a jig'.[186]

Reeded strip

George Speake

In the collection, the vast majority of the reeded strip is silver with gilding (**607/8–613**); there are just three instances of gold reeded strip (pommel **31**; hilt-collars **149–50**). The gold strip could have been hand shaped, but the longitudinal, parallel channels and ridges of the harder silver strip must have been manufactured by a mechanical method.[187] Chasing, swageing, carving and draw-swageing have all been suggested, but in experiments the most effective was the last method.[188] This technique involves the use of a clamp to pull a strip of metal through a narrow grooved opening, creating fine and even reeding. However, to date, the evidence for clamps and swages awaits discovery. An alternative proposed method was the use of a shaped steel scraper, which had the negative of the desired profile cut into its working edge. Reasonable results were produced in experimentation, but it was found to be very labour intensive and with the frequent need to sharpen the scraper. When examined microscopically, both methods show parallel scratching along the grooves,[189] marks also visible on the Hoard's silver reeded strip (figs 3.37–3.39). The various forms of the strip have been discussed in *Chapter 2*.[190]

▲**Fig 3.37.** Silver-gilt 5mm reeded strip (**611**). *Photograph*: C. Fern.

▲**Fig 3.38.** Silver-gilt 8mm reeded strip (**613**) with a deliberately flattened butt-end. Parallel striations from manufacture are visible beneath the gilding. *Photograph*: C. Fern.

▲**Fig 3.39.** Two fragments of silver-gilt 8mm reeded strip (**613**) with ends deliberately cut at angles. *Photographs*: C. Fern.

Incising and punching

Incised or carved decoration is not common in early Anglo-Saxon metalworking,[191] but a small number of objects in the Hoard prove the exception, including the incised animal ornament in gold on bird-fish mount **538** and great cross **539** (figs 2.66 and 2.73). In addition, channels were carved to hold black niello inlay on objects. On the suite of large silver nielloed mounts (**567–71**) they present at break edges as V-shaped or U-shaped in section (figs 3.40–3.41).

As well as the great cross and bird-fish mount, pommels **56–7**, mounts **459** and **485–7**, and head-dress mount **541** have similar carved animal ornament in gold. For almost all of these (except on pommel **57**) a double layer of gold sheet was used, with the ornament carved into the top layer, and sometimes through it (fig 3.42). This form of ornament and manufacture has only two parallels, both from Bamburgh (Northumberland): one is the published small rectangular mount with a single Style II creature,[192] and a second mount with serpents was recently added by the ongoing excavations at the site.[193] Marks left by cutting tools are visible under magnification on the Hoard objects, and layout marks for the animal design are faintly visible on the great gold cross (fig 3.42). In addition, small carved heads were used for the serpents of the filigree panels of mounts **556-61** (fig 3.43), and some of the creatures have carved tail-tips also.

Rare too is the incised animal ornament in silver on the set formed of pommel **71** and fragments **189** and **605**. Similar decoration on silver and copper-alloy objects includes the creatures inscribed on the silver back-plates of composite disc-brooches from

▲ **Fig 3.40.** Broken edge of eye-shaped mount **567**, together with a drawn section, showing channels carved for niello inlay. *Photograph*: E. Blakelock. © Birmingham Museums Trust.

▲ **Fig 3.41.** Three-dimensional image of mount **568**, showing the carved edges of an empty, flat-bottomed channel. *Photograph*: E. Blakelock. © Birmingham Museums Trust.

▼ **Fig 3.42.** Incised and punched ornament of the great gold cross (**539**). Tool marks can be seen in the carved channels and in places the top layer of sheet has been cut through, and, due to damage, has lifted (arrow 1). Faint layout marks for the design are visible at the ear of the creature (arrow 2). A circle punch was used for the eye and a narrow triangular punch for 'hair'. *Photograph*: C. Fern.

Fig 3.43. Carved serpent head on one filigree mount [K69] from cloisonné strip-mount **556**. *Photograph:* C. Fern.

Faversham (Kent) and Harford Farm (Norfolk), and the ornament on the buckle from Eccles (Kent).[194]

Punch ornament was used for two main purposes on the Hoard metalwork: to create patterned bands and borders that were sometimes inlaid with niello (fig 3.44); or to add eye and other detail in the animal ornament (fig 3.42). In contrast with the accuracy demonstrated in most cases, seemingly random punching occurs across one side and on the top of pommel **73**. This could be evidence that the object was utilised in a secondary capacity after dismantling, perhaps as a test piece (fig 2.11). The decoration appears to have been common in Anglo-Saxon metalworking during the sixth century with a range of geometric forms used,[195] but it seems to have been less popular in the seventh century.[196] Rare finds of iron punches show that the tools were similar in appearance to a chisel, although with the punch end tapered to a narrow, shaped point.[197] The punch-marks in the collection are illustrated in table 3.2. Most are basic forms and smaller than *c* 1mm in size.[198] One silver fragment (**686**) stands out, as it is decorated with pelta and fish-scale marks that are large (*c* 5mm) and without Anglo-Saxon parallels.

Hilt-collar pair **184–5** have zig-zag bands, originally inlaid with niello, interspersed by gilded bands with triangular and diamond punching (fig 3.44). Similar zig-zag bands are seen on other objects (**75**, **182–3**, **409** and **591–2**). On cheek-piece **592** layout marks to guide the positioning of the punch are visible with a microscope (fig 3.45). This particular niello-band decoration is quite common on sixth-century objects in England; for example, on the drinking-horns from Taplow (Buckinghamshire), and on a range of Kentish brooches.[199] However, due to wear and corrosion, it is not always possible to be certain that the punch ornament was applied to the metal body of the object, as opposed to the decoration having been impressed into a wax or lead model from which the object was cast. (This can be said, for instance, of the zig-zag bands on the rivet-housings of pommel **75** and on hilt-guard set **409**.)

Punch-mark type	No. objects	Catalogue
▲	13	68, 73, 75, 182–5, 390, 587, 590, 409, 688:[K870], 690:[K1520]
▲ (small)	1	539
▼ ◆	2	184–5
○	14	370, 485–7, 518–22, 529–30, 589–90, 538
●	7	68, 412, 531–2, 589–90, 540
⌣	1	590
▮	1	589
෴	1	686

Table 3.2. Punch-mark types.

Fig 3.44. Hilt-collar **184** showing worn punch ornament. The reconstruction illustrates the original design of four zig-zag bands with niello, spaced with three gilded and punched bands. *Photograph:* © Birmingham Museums Trust. *Drawing:* C. Fern.

Fig 3.45. Zig-zag punched and inlaid band on cheek-piece **592** with layout marks (arrow). *Photograph*: E. Blakelock. © Birmingham Museums Trust.

Simple circle or dot punches without inlay and of varying size were used to depict the eyes of creatures on many objects, a practice not seen before in seventh-century metalworking: on great cross **539** (fig 3.42); hilt-plate **370**; bird-fish mount **538**; inscribed strip **540**; helmet-crests **589–90**; tongue-shaped mounts **485–7** and **518–22**; and serpent mounts **529–30**. Also, on the great cross a narrow triangular punch was used to add 'hair' to the bodies of the creatures (fig 3.42). On the animal-head terminals of the helmet-crest (**589–90**) several different punches were used: a large circle punch on the muzzle of each creature; a solid punch for the jaws; and notch, triangular and half-circle forms were used variously on the bands of the neck and nasal.

Niello

The distinctive black inlay of niello is made from a mixture of one or more metal sulphides, worked at high temperature.[200] It was used throughout the Anglo-Saxon period, and twenty-one silver and six gold objects in the collection have remains, while a number of others have probably lost the ornament.[201]

On the suite of large silver mounts (**567–71**) the pattern of the inlay imitates the geometry of cloisonné cellwork (fig 3.46; cf fig 2.67). Incised or cast channels for *faux* cloisonné, probably originally inlaid, also feature at the ends of the rivet-housings of pommel **76**. Among the few parallels for this type of ornament from England are a pyramid-fitting from Heacham (Norfolk) and a pommel from Sarre (Kent).[202] On the Continent a similar imitation of cloisonné was achieved through a different technique, known as *Tauschierung*, by the inlaying of strips of silver or other wires into iron objects.[203]

Parallels for the use of niello with the Latin text on one side of inscribed strip **540** (fig 3.47; cf fig 2.78) are provided by inlaid inscriptions in Roman and contemporary Byzantine metalworking.[204] However, the Hoard's other gold objects with niello show that this choice of decoration, while rare, was not exceptional in the seventh century. On pommel **56** niello was used to contour the animal ornament (figs 3.63 and 4.28), and the animal head on strip **540** was similarly outlined; on pommel **57** the ornament forms lines (fig 2.10); and on serpent mounts **531–2** the punched eyes of the creatures are niello-filled. In contrast, on gold guard-tip **412** the inlay was used as a background for a serpent design, which must first have been carved in 'positive' relief (fig 2.25).

One set of silver hilt-fittings (**69**, **186–7** and **533–5**) and a pommel fragment (**78**) have remains of niello in channels along strands of cast interlace (fig 3.48). A good parallel for this technique is offered by a pyramid-fitting from Stanton St John (Oxfordshire).[205] These are quite different in style to the inlay on pommel **68** (fig 3.49), which included a niello-filled dot pattern for the hair and beard of the human head (fig 5.4).

Fig 3.46. Geometric inlay on mount **570**, showing overlapping niello stripwork (arrow). Note also the U-shaped and flat channels where inlay has been lost. *Photograph*: E. Blakelock. © Birmingham Museums Trust.

Silver hilt-fittings (**75–6** and **409**) demonstrate further applications. On pommel **75** silver teardrops are set against triangular niello backgrounds (fig 3.50); on pommel **76** silver animal ornament is again on a niello background (fig 3.51); and hilt-guard pair **409** have borders of zig-zag and leaf silver and niello (fig 2.24). In particular, the silver motif reserved against a niello background on pommel **76** can be compared with the technique of champlevé enamelling seen in Celtic metalworking.[206]

Combined analysis (XRD, SEM-EDX and XRF) was carried out on the Hoard niello.[207] Past examinations have found that silver-sulphide niello was most commonly applied to gold objects in the

Fig 3.47. Detail of the inscription on strip **540**, showing surviving niello within the flat-bottomed channel cut in the strip. *Photograph*: E. Blakelock. © Birmingham Museums Trust.

Fig 3.48. Niello remains on hilt-collar **187**. The U-shaped profiles of the channels are visible where the inlay is missing. *Photograph*: E. Blakelock. © Birmingham Museums Trust.

Fig 3.49. One of the boar heads on pommel **68**, (with a drawing inset), showing the remnants of the niello inlay in the eye, teeth and channels. *Photograph*: E. Blakelock. © Birmingham Museums Trust. *Drawing*: C. Fern.

Fig 3.50. Detail of one of the nielloed triangles with teardrops on pommel **75**, with a drawing inset. *Photograph*: E. Blakelock, © Birmingham Museums Trust. *Drawing*: C. Fern.

period, as was found to be the case for all six gold examples in the collection. The majority of the silver objects suggested the same niello type, with the possible exception of hilt-collars **184–5** and **188**, and pommel **68**, which instead indicated the potential use of a silver-copper sulphide niello. This latter niello type has previously been reported as more common for Anglo-Saxon silver metalwork.[208] Therefore, the dominance of silver-sulphide niello for the silver metalwork in this instance may be considered unusual.

The niello on the objects appears either slightly raised from the surface or flush. Since the silver-sulphide niello could not have been melted into place (as this would have caused it to decompose into metallic silver), it was perhaps instead first applied as a powder, before being softened, shaped and pushed into the channels at around 600°C.[209] There are some objects on which 'sections' of the inlay appear to overlap, suggesting its application in this manner in short strips (fig 3.46). Where the inlay is flush with an object surface, as on guard-tip **412**, this was probably achieved by grinding and polishing, a method described by Theophilus.[210] This may explain why on

pommel **57** (fig 2.10) the panels with niello lines were made and inserted separately, since it would have been problematic otherwise to polish the inlay flat without damaging the cast relief of the object. In contrast, the niello on gold pommel **56** and on inscribed strip **540** was left raised (figs 3.47 and 3.63). For the silver objects, the niello was most likely applied before any gilding, to avoid marks from residues or damage from heating and polishing.

Filigree

Chris Fern and Niamh Whitfield

Filigree is a form of decoration that uses fine wires and granules of precious metal to produce delicate patterns and textures. The term derives from the Italian *filigrana*, which in turn comes from the Latin *filum* (wire) and *granum* (grain). The craft is an extremely conservative one, with traditions and conventions transmitted from one culture to another over many centuries, drawn ultimately from a stock of techniques developed in the classical world. Most filigree from Europe around the time of the Hoard was manufactured in gold.

In Anglo-Saxon England, filigree was applied to much of the fine metalwork of the seventh century. Despite the shared heritage of early medieval filigree as a whole, distinctive repertoires of patterns

▲ **Fig 3.51.** 'Serpent' triquetra in silver against a triangular niello field on pommel **76**, with a drawing inset. *Photograph*: E. Blakelock. © Birmingham Museums Trust. *Drawing*: C. Fern.

▼ **Fig 3.52.** Hilt-collar **110** with Style II animal ornament in filigree. Inset is a drawing of the almost identical motif from its pair (**109**). The panel frame of collar **110** consists of *three-ply twisted-beaded wire* (arrow 1). The bodies of the creatures are formed from bands of *herringbone* (arrow 2), except for the neck of one creature (arrow 3), which is instead formed from *concertinaed wire* (this does not occur on collar **109**, see inset). *Triple-strand* pattern (with flanking *spiral-beaded wires*) forms the heads (arrow 4) and limbs (arrow 5). Single *granules* enclosed in beaded wire (i.e. *collared granules*) were used for the eyes (arrow 6), and clusters of *granules* fill the hips and shoulders (arrow 7). The back-sheet was repoussé worked to add depth to the design. *Photograph*: © Birmingham Museums Trust. *Drawing*: C. Fern.

and techniques arose at different periods in different regions. Particularly influential on Anglo-Saxon work was the style of Scandinavian and north-western European filigree, but also, to some extent, that of the Merovingian territories and perhaps Lombardic Italy.[211] The Hoard contains many examples that now rank among the finest Anglo-Saxon examples of the craft, chief among them the matching pair of hilt-collars **109–10** (fig 3.52). The filigree animal ornament on each collar uses more techniques than is found on any other object in the collection.

Filigree is the dominant mode of decoration in the Hoard. The ornament occurs on 401 objects or fragments, equal to around 60 per cent of the total.[212] Figure 3.53 shows the quantities of finds with filigree per category. However, use of the ornament varies from instances of total coverage on pommels (**1–35**) and hilt-collars (**85–156**) (e.g. figs 2.6 and 2.14), to more limited applications, for example, as trims on the large cloisonné mounts (**542–66**), or as collars for bosses and gem-settings (e.g. figs 2.58 and 2.89). Most is gold except for a small number of occurrences in silver: two pommels (**63** and **75**), one buckle (**587**), two bosses (**662** and **669**) and a number of very small silver filigree fragments (**689**). Pommel **63** (fig 2.9) is now a parallel to the silver pommel that was found at Gresford (Wales).[213]

Consideration of details and minor deviations from standard practice are extremely important in the study of filigree. The quantity and quality of the Hoard filigree contributes very substantially to the understanding of the craft. On its objects, as elsewhere, basic forms of filigree could be used singly, but in many cases more complex, composite forms occur, and elements were commonly juxtaposed to create what are here referred to as 'patterns'.[214] Popular wire types and such patterns, chiefly *triple-strand* and *herringbone*, were also frequently imitated on metalwork made by other techniques. Examples include the creatures with patterned bodies on objects **71**, **189** and **605**, and on die-impressed panel **600** (fig 2.54).

The use of different filigree wires, granules and patterns was recorded by object-type, summarised in tables 3.3–3.4. The majority conform to the known Anglo-Saxon corpus. However, some rarer elements are better represented in the collection than in material from elsewhere, and a number of novel types also occur (described below). Three pattern types dominate (*triple-strand*, *herringbone* and *scrollwork*), accounting for three-quarters of all incidences (table 3.4; fig 3.54). Since the pommels (77 per cent) and hilt-collars (70 per cent) show the most enthusiastic application of the ornament, table 3.5 further compares these object-types according to the frequency of their different techniques and patterns. Although up to five techniques (wires and granules) and five patterns can occur, most pommels and collars have only two techniques and two patterns. The hilt-collars of low form have the fewest patterns.

Fig 3.53. Number of objects with filigree per category.

155

Catalogue	Total with filigree	With cloisonné/gem-setting only	Silver filigree	Plain wire	Beaded wire	Spiral-beaded wire	Flattened-beaded wire	Two-ply twisted wire	Three-ply twisted wire	Two-ply twisted-beaded wire	Three-ply twisted-beaded wire	Four-ply twisted-beaded wire	Wrapped-beaded wire	Twisted square-section wire	Strip-twisted wire	Granulation	Strip-work	Platform-filigree	Flat back-sheet (unmodified)	Relief back-sheet (die-impressed)	Lattice backing	Repoussé back-sheet	Pierced back-sheet	Layout marks
Pommels 1–78	60	22/4	2	10	57	6	1	38	-	4	-	-	-	-	1	16	1	-	32	1+?2	7	6+?2	-	4
Hilt-collars 85–190	76	2/1+?1	-	13	71	10	-	34	2	16	4	5	3	2	-	14	-	-	56	3+?2	6	6+?3	2	5
Hilt-rings 191–242	34	-	-	-	24	-	-	-	-	-	8	-	6	-	-	-	-	-	-	-	-	-	-	-
Hilt-plates/guards 243–409	66	1/?1	-	-	65	4	-	4	-	1	-	-	-	-	-	-	-	1	3	-	-	2	-	-
Small mounts 410–537	73	-/?+?3	-	6	68	8	-	37	-	3	2	5	-	-	-	9	-	-	63	2	2	5	-	1
Large mounts 538–71	29	26/2	-	1	28	3	-	-	-	2	1	-	-	-	-	1	-	-	6	-	-	-	-	1
Pyramid/button-fittings 572–83	6	6/-	-	-	6	-	-	-	-	2	2	-	-	-	-	2	-	-	2	-	-	-	-	-
Buckles 585–7	2	-	1	-	2	-	-	1	-	-	-	-	-	-	-	-	-	-	-	-	-	-	-	-
Cross-pendant 588	1	-/1	-	1	1	-	-	-	-	-	-	-	-	-	-	-	-	-	1	-	-	-	-	-
Cheek-pieces 591–2	2	-	-	-	2	-	-	-	-	-	-	-	-	-	-	-	-	-	-	-	-	-	-	-
Bosses, boss-headed rivets etc. 616–76	48	-/9	2	3	48	1	-	1	-	-	-	-	-	-	-	-	-	-	-	-	-	-	-	-
Fragments 677–80	4	-	-	-	3	-	-	4	-	-	-	-	-	-	-	-	-	-	-	-	-	-	-	-
Total:	**401**	**57/49**	**5**	**34**	**375**	**32**	**1**	**119**	**2**	**28**	**17**	**5**	**9**	**2**	**1**	**42**	**1**	**1**	**163**	**10**	**15**	**22**	**2**	**11**

▲ Table 3.3. Incidence of filigree types: wires, granules, back-sheet forms, layout marks and other forms (per object or fragment; small fragments not included: **681** and **689**). '?': uncertain identification/quantity.

Filigree pattern	Incidence
Triple-strand	145
Herringbone	115
Scrollwork (incl. figure-of-eights)	63
Collared granules	35
Annulets	30
Herringbone-with-spine	22
Other pattern	8

Fig 3.54. Incidence of filigree patterns on 317 objects/fragments.

Wires and granules on a sample of objects were measured for the Hoard project using a Keyence VHX digital microscope and for thicker wires callipers were used (online table 5). In addition, a separate study was undertaken independently by Aude Mongiatti at the British Museum with measurements taken using an SEM.[215] The filigree measurements from both examinations agree generally and are also similar to those recorded for other Anglo-Saxon objects.[216] In the report that follows only measurements from the Hoard project are quoted.

The visual impact of the small-scale precision of the work is striking, but when examined under a microscope, variations in quality are nevertheless apparent. Occasionally, poorly manufactured wires occur, or elements appear not fully aligned, as on pommel **24** (fig 3.55) and hilt-collar **95**.

Wires, granules and patterns

Plain wire (or round wire) was not commonly used unmodified as an ornamental wire in Anglo-Saxon filigree, and usually the wire is worked further to create beaded- and twisted-wire forms. However, there are thirty-four instances of plain wire recorded in the Hoard (fig 3.56).

The round wire that was the basis of much of the ornament was probably produced mainly by block-twisting. This involved twisting a long thin metal rod on its own axis, until it attained a rounded, solid cross-section, which was subsequently rolled smooth between two flat surfaces.[217] Marks left from this process are visible under the microscope on some wires in the form of helical creases (fig 3.57), a detail also observed in filigree elsewhere.[218] Most of the

Fig 3.55. Poorly formed thin *beaded wires* (arrow 1) in *triple-strand* pattern on pommel **24**. The notches at the ends of the thick *beaded wires* (arrow 2) were possibly created in levering the ends of the wires forward, to increase the illusion of interlacing. Also, one small fragment seems to have been accidentally soldered (arrow 3). *Photograph*: C. Fern.

Object-type	Triple-strand	Herringbone	Collared granules	Herringbone-with-spine	Plaited wire	Scrollwork/figure-of-eights	Annulets	Conical spirals	Concertinaed wire
Pommels	46	38	12	1	-	10	6	-	-
Hilt-collars	44	34	10	16	2	7	7	-	4
Hilt-plates/guards	16	3	-	1	-	1	1	-	-
Small mounts	30	35	10	3	-	42	15	-	-
Large mounts	6	-	1	1	-	-	-	-	-
Pyramid/button-fittings	2	-	2	-	-	2	-	2	-
Cross-pendant 588	1	1	-	-	-	1	1	-	-
Fragments	-	4	-	-	-	-	-	-	-
Total:	145	115	35	22	2	63	30	2	4

▲ **Table 3.4.** Incidence of filigree patterns (per object or fragment; small fragments not included: **681** and **689**).

Object-type	No.	Types of wire/granule (cf. Tab. 3.3)					Types of pattern (cf. Tab. 3.4)					
		1	2	3	4	5	0	1	2	3	4	5
Pommels	55	9	**26**	15	5	-	4	15	**19**	12	3	1
High hilt-collars	34	2	**19**	10	1	2	-	8	**16**	7	3	-
Low hilt-collars	42	8	**23**	9	1	1	-	**34**	7	1	-	-

▲ **Table 3.5.** Frequency per pommel or hilt-collar of different filigree types (wires/granules only) and patterns.

wires produced by this means that were used in patterns on Hoard objects are *c* 0.2–0.9mm diameter, though the finest are as thin as *c* 0.15mm in diameter. The wires used to form the twisted wires commonly seen in *herringbone* pattern were routinely of *c* 0.20mm in diameter.[219]

An alternative method of manufacture for fine wire in antiquity was by strip-twisting. This involved coiling a thin strip of sheet metal to form a slender hollow tube. *Strip-twisted wires* occur in Merovingian filigree,[220] but their use in Anglo-Saxon metalworking is extremely rare. Instances are seen on pommel **54**, on the rivet-housings at each end (fig 3.58). These appear to represent a deliberate use of 'unfinished' *strip-twisted wires*, however, as normally the wires would have been rolled smooth. An example of a different 'unfinished' wire is seen on hilt-collar pair **123–4** (fig 3.59). They demonstrate short lengths of a *twisted square-section wire*, the form taken by wire early in the process of block-twisted manufacture. Just two filigree objects from England are known to the authors with wires of similar type. One is a gold finger-ring from Snape (Suffolk), which may be a Merovingian import, and the other is a pendant from Loftus (North Yorkshire).[221]

Some objects with much thicker wires were probably made differently, by hammering and rolling. The filigree collars from the helmet cheek-pieces **591–2** and gold hilt-rings **191–210** have beaded wires (shaped from plain round wire), respectively, of 3.2–3.4mm and 1.6–3.0mm diameter (fig 3.60), which suggests this method of manufacture. Many of the Hoard's gold rivets (**657**) were probably made in the same manner, as they have shanks with round sections (*c* 1–1.5mm) that show a facetted surface when viewed with a microscope.

Beaded wire is the most common wire type in Anglo-Saxon filigree generally, and it occurs in some form on over 90 per cent of the Hoard's filigree objects (table 3.3). The wires were probably manufactured using a 'beading file', a tool with two edges and a central groove; Theophilus described such a tool in the twelfth century, and an example was discovered among Roman Iron Age deposits at Illerup (Denmark).[222] It would have been rolled by hand over a plain wire at right angles, and for each repetition one tooth of the file was repositioned in the last furrow formed, thus maintaining a regular succession of beads.[223] Many objects in the collection use several thicknesses of beaded wire, with even but differently spaced 'beads', so assorted sizes of file would have been necessary.[224] For example, on pommel **30** four gauges of wire are recorded (*c* 0.3/0.5/0.9/1.1mm diameter).

A variation of beaded wire is *spiral-beaded wire*, produced by beading at an oblique angle (fig 3.62). This results in a wire with a continuous spiral groove, like a screw thread.[225] Although spiral-beaded wire is found in contemporary Merovingian and Lombardic filigree, previously it has been rarely observed in Anglo-Saxon filigree – but notably it was used, for example, on the related hilt-suite from

▲ **Fig 3.56.** Hilt-collar **111** decorated with looped-ribbon interlace formed from *beaded wires* in *triple-strand* pattern (arrow 1). The loops are infilled with *concertinaed wire* (arrow 2). The borders are formed from bands comprising *beaded wires* and thinner *plain wires* (arrow 3), and the back-sheet was repoussé worked from the front to add depth. Marks from the blunt-pointed tool used to depress the back-sheet can be seen between the wires (arrow 4). *Photograph*: © Birmingham Museums Trust.

▲ **Fig 3.57.** SEM image of one end of pommel **42**. The rivet-housing (on the right of the image) is covered by two-ply *twisted wires* laid in *herringbone* pattern (arrow 1). The creases seen on some of the wires are left from manufacture by block-twisting. The small part of the pommel side visible (on the left of the image) shows the interlace pattern formed from *beaded wires* in *triple-strand* (arrow 2). Note also the smooth surface of the vertical edge wire, the result of the beading having been flattened by wear. *Image*: A. Mongiatti, © Trustees of the British Museum.

▲ **Fig 3.58.** The rivet-housings at one end of pommel **54**. A range of different wire types were used, including *beaded wire*, a two-ply *twisted wire*, and 'unfinished' *strip-twisted wires* laid in *herringbone* pattern (arrow). Note also the solder inundating the herringbone. *Photograph*: © Birmingham Museums Trust.

▲ **Fig 3.59.** Hilt-collar **124** showing the use of an 'unfinished' *block-twisted wire* (arrow 1). Note also the thick *wrapped-beaded wire* at the edge (arrow 2). *Photograph*: © Birmingham Museums Trust.

Market Rasen (fig 2.41).[226] It may be considered significant, therefore, that the wire type occurs on thirty-two objects in the collection, including on the gem-settings of the great cross (**539**) and inscribed strip (**540**), but viewed overall it remains a less common type.[227] In addition, the wire is seen twice imitated in cast metalwork, in an exaggerated form, on pommel **57** and strip **540** (figs 2.10 and 2.78).

Another modified form of beaded wire is seen just once on pommel **56**. Framing both the pommel sides are wires that were deliberately flattened (fig 3.63). This is the first recorded instance of *flattened beaded wire* in Anglo-Saxon filigree, but it is a type seen on later Celtic artefacts, such as the Westness brooch, although there it does not lie flat, as on the pommel, but is placed on edge.[228] It is interesting that an Anglo-Saxon smith should choose to deliberately flatten the wire. One possibility is that it was done in an attempt to make the pommel appear older, as the wire closely resembles heavily worn beaded wire (figs 4.3ii and 4.4), since 'heirloom' weapons were highly prized in the society of the day.[229]

The most popular and enduring pattern created with beaded wire was *triple-strand* (figs 3.55–3.57, 3.61–3.62, 3.64 and 3.75; table 3.4).[230] It comprised a central, thick beaded wire with finer flanking wires (total width *c* 0.9–2.0mm). Around a third of the Hoard objects that have filigree patterns demonstrate triple-strand (fig 3.54), which was used primarily for zoomorphic and non-zoomorphic interlace, as seen on numerous pommels, hilt-collars and mounts.[231] The ancestry of this filigree form can be traced back at least to Migration period Scandinavia, where it was also used on weapon-fittings (cf fig 2.40), among other objects.[232] In the interlace designs the wires are not actually interwoven, but the

▲ **Fig 3.60.** Hilt-ring **207** formed from a thick *beaded wire*. *Photograph*: © Birmingham Museums Trust.

triple-strand bands were arranged to create this illusion (e.g. fig 3.75). In addition, visible only with a microscope are small nicks at the tips of some wires, where they meet crossing elements, a feature also recorded outside the Hoard (fig 3.55).[233] It is possible that these were caused in the process of levering the wire tips very slightly forward, to bring them into contact with the crossing wires, thus enhancing further the impression that the bands interweave.

In the vast majority of cases, the finer flanking wires are beaded, matching the thicker central wire, but other combinations occur on a small number of objects. In fifteen cases flanking spiral-beaded wires were combined with a central beaded wire (fig 3.62),[234] a variation that is also seen on the Market Rasen hilt-fittings (fig 2.41). A similar effect was achieved using two-ply twisted wires on a

small number of objects (fig 3.64).²³⁵ In two cases the flanking wires are plain: on the triple-strand axis of fish **462** and on the loop of cross-pendant **588**.

Some of the finest beaded wire (*c* 0.2mm diameter) was used to form *scrollwork*.²³⁶ This ornament is most popular on the collection's small mounts, many of which were probably hilt-mounts (table 3.4). The different scroll forms, including S-scrolls, C-scrolls, V-scrolls, volute scrolls and figure-of-eights, were usually made from single strands of beaded wire, and they could be combined in designs (figs 3.62 and 3.64–3.67). Volute scrolls are also known as 'oculus scrolls', and are equivalent to Avent's filigree type 3.4. All these forms have parallels outside the Hoard, including on Kentish brooches from southern England.²³⁷ Much rarer are the C-scrolls formed by a two-strand band of spiral-beaded wire on three mounts (**473–5**) and two collars (**130–1**). This scroll type is found on two brooches from Gilton (Kent),²³⁸ although the character of the face-mask decoration on mounts **473–4** can also be compared with ornament on objects of Merovingian manufacture, for example, that on the sixth- to seventh-century disc-brooches from Rosmeer (Limburg, Belgium), Baslieux (Meurthe-et-Moselle, France) and Saint-Moré (Yonne, France).²³⁹ Also of note are the scrolls at the tips of mounts **410–1** that, unusually, are joined with lengths of beaded wire.

Rare patterns in beaded wire include *plaited wire, concertinaed wire* and *conical spirals*. One pair of hilt-collars (**128–9**) has genuinely *plaited wire* interlace, the bands being actually interwoven from single strands of beaded wire (fig 3.68), making them the only exceptions to the false interlace that predominates on the other objects and in Anglo-Saxon filigree generally. It is a technique not previously recorded in Anglo-Saxon use before the eighth century.²⁴⁰ However, it is seen on contemporary objects from the Netherlands, including on the disc of a gold brooch from Hoogebeintum, which has been recently dated to the second quarter of the seventh century (although in this case, *two-ply, plain, twisted*, not *beaded, wire* was used).²⁴¹ Interlace formed in this way is also seen earlier in Roman filigree, including on a bracelet from Rhayader (Wales).²⁴²

Conical spirals (wires *c* 0.3mm, cones *c* 2.0mm) occur on the silver pair of pyramid-fittings (**580–1**), and they are likewise novel in Anglo-Saxon filigree (fig 3.67). Similar filigree cones are known from late Roman, Viking and Irish metalworking, including in the last case on the 'Tara' brooch (Co Meath), Ardagh chalice (Co Limerick) and Knoxspark disc-mount (Co Sligo).²⁴³

Concertinaed wire was used on three hilt-collars (**110–3**), which might all be of one workshop, given the rarity of the pattern in Anglo-Saxon filigree (figs 3.52 and 3.56). This filigree application was used in Scandinavia from the Roman Iron Age,²⁴⁴ and an

▲ **Fig 3.61.** Cabochon garnet boss on hilt-plate **245** with a collar formed of *beaded wires* in *triple-strand* pattern (arrow). *Photograph*: © Birmingham Museums Trust.

▲ **Fig 3.62.** SEM image of mount **474** showing *spiral-beaded wires* (with a 'screw thread'), including one formed into a figure-of-eight (arrow 1). The thinner *spiral-beaded wires* together with thicker standard *beaded wires* form a triple-strand (arrow 2). *Image*: A. Mongiatti, © Trustees of the British Museum.

▲ **Fig 3.63.** Pommel **56** showing *flattened-beaded wire* (arrow) used to frame the sides. *Photograph*: C. Fern.

example of a Migration period object with the pattern is the Ålleberg collar from Västergötland (Sweden).[245] It is also found in Merovingian filigree.[246]

Beaded wires could also be wound together to form two-, three- and four-ply composite *twisted-beaded wires* (figs 3.52 and 3.69).[247] These thicker wires, of *c* 0.5–1.7mm diameter, were used for edging and framing, especially on hilt-collars (but also on other objects), sometimes combined with thinner wires, and were also used to form hilt-rings. For example, the three-ply version of the wire was used to make hilt-rings **211–8** (fig 3.69).

A composite wire unique to the Hoard, representing very possibly an Anglo-Saxon innovation, was formed of a beaded wire tightly wrapped around a plain core wire (fig 3.70). This *wrapped-beaded wire* occurs as edging on three hilt-collars (**123–4** and **126**; *c* 1.3mm diameter) and was also used to form hilt-rings (**219–24**; *c* 2.0–3.1mm diameter). On several objects the core wire is visible where the wrapping wire has been damaged or has spread, which, along with evidence of solder flooding and effects from heating, indicates how the wires were made.

The most popular wire type after beaded wire is *two-ply twisted wire* (table 3.3), which was formed by winding together two thin plain wires. Most commonly this composite wire was used to form *herringbone*, a pattern of considerable antiquity.[248] The twisted wires were laid side by side in opposing directions of twist, with the resulting decoration forming variously bands, frames or coverings, as seen on hilt-collars (e.g. **97**, **114–5**), mounts (e.g. **448–9**) and the rivet-housings and shoulders of pommels (figs 3.52, 3.57 and 3.71).[249] The coverings especially give an impression of textile (e.g. fig 3.71). However, one instance of a two-ply twisted wire band is highly unusual in terms of the material used and the scale of the wires: running over the top of silver pommel **75** is a sunken channel in which was set a pair of thick, twisted wires in silver (individually *c* 0.7mm diameter).

Just two instances of *three-ply twisted wire* are seen on hilt-collar pair **114–5** (fig 3.71). This wire type is again known in Celtic filigree, but it is not known to occur elsewhere in Anglo-Saxon filigree.[250]

A pattern known as *herringbone-with-spine* combines a pair of twisted-beaded wires with a single plain or beaded wire set medially, with sometimes additional flanking wires. It was used on around twenty objects (fig 3.54).[251] A band of the ornament forms a collar to the bezel on the largest gem-setting from the great gold cross (fig 3.72), and a cross motif was formed using the pattern on silver pommel **63** (fig 2.9) and on mount **471** (fig 5.23). On fish mount **462** a different *herringbone* pattern was formed, comprising a central spine of triple-

▲ **Fig 3.64.** Pommel **8** showing a rare *triple-strand* pattern, comprising a thick *beaded wire* with flanking *two-ply twisted wires*. Note also the use of scroll fragments of fine *beaded wire*, which also form eyes to the zoomorphs hidden in the design (cf fig 5.6). *Photograph*: © Birmingham Museums Trust.

▲ **Fig 3.65.** Mount **447** with S-scrolls in fine *beaded wire* set on an angle. Note the wear to the beading on the frame and scrolls. *Photograph*: © Birmingham Museums Trust.

▲ **Fig 3.66.** Hilt-collar **130** with volute scrolls (arrow 1) and annulets (arrow 2) in *spiral-beaded wire*. *Photograph*: © Birmingham Museums Trust.

▲ **Fig 3.67.** Pyramid-fitting **580** with *conical spirals* of *beaded wire* (arrow 1) nestled between the arms of three teardrop garnets. The remaining space is filled with S-scrolls of fine beaded wire. The gold mount was edged with beaded wire and outermost with two-ply *twisted-beaded wire* (arrow 2). Note also the cast beaded edge of the silver fitting, and the gold foil with a cross-hatched pattern of 'standard' type exposed by the broken garnet. *Photograph*: © Birmingham Museums Trust.

▲ **Fig 3.68.** Hilt-collar **128** showing one of only two examples of *plaited wire* (with pair **129**). Note also the wear to the top of the wires. *Photograph*: © Birmingham Museums Trust.

▲ **Fig 3.69.** Detail of hilt-ring **211** formed from three strands of *beaded wire* (three-ply) twisted together. The end is cut, and the scrap of sheet is part of a patch that had covered the join in the ring. *Photograph*: © Birmingham Museums Trust.

▲ **Fig 3.70.** Detail of hilt-ring **224** formed from *wrapped-beaded wire*. Where the wrapping wire has spread apart, a plain core wire (c 1mm diameter) is clearly visible. *Photograph*: © Birmingham Museums Trust.

strand (with flanking plain wires) with alternating strands of beaded and plain wires arranged at 45 degrees to it.

Further rare filigree forms are seen on pommel **23** and hilt-plate **360**. On the pommel is *strip-work* formed of fillets of flat sheet (*c* 0.7–1.0mm) fringed with beaded wires, which were soldered to the sheet body of the object. Identical branching designs are on each side, and further strips frame the sides and shoulders. Only one other example of similar strip-work is known, on the filigree pommel from Ardleigh (Essex).[252] On the hilt-plate, single lengths of beaded wire were soldered on top of strips of gold laid flat, termed here *platform-filigree*.[253]

Granulation is not especially common in early Anglo-Saxon filigree, in comparison to wire-work, despite the fact that granules can be simply manufactured, by melting gold chips that cool as tiny spheres. Measured examples in the Hoard were *c* 0.4–0.9mm in diameter. Often small annulets of beaded wire were added, forming *collared granules*, like small rosettes. On mounts **467–8** and pyramid-fittings **574–5** these were arranged in lines (fig 2.44). Of note are the unusual double-collared examples on pommel **21** (fig 3.73). In a number of cases, collared or unmodified, the granules were used to form the eyes of creatures, as on pommels **1–2**, mounts **470–2** and hilt-collars **85–8**, **109–10** (fig 3.52) and **155**. More unusual was the application of clutches of granules to fill pear-shaped shoulders and hips, as on hilt-collar pair **109–10** (figs 3.52 and 3.74). Parallels for this can be found among the filigree of Sutton Hoo mound 1,[254]

but such granulation work is more common and widespread in Scandinavian filigree, including on weapon-fittings (fig 2.40) and neck-collars.[255] Later it is seen in Celtic filigree; for example, the granules used to fill the bodies of creatures on the Hunterston brooch and Derrynaflan paten.[256]

Small *annulets* of wire (without central granules) also occur as decoration.[257] On bird-headed mount **465** they were used as a fill (fig 2.35). Unusual examples formed of two beaded wires, forming a double ring, occur on pommel **76**, and hilt-collars **94** and **188**; and examples in spiral-beaded wire occur on mounts **473–4**.

Back-sheets

Mostly the filigree was soldered onto the flat gold (or silver) sheet that typically formed the body of the object (table 3.3). For the interlace and zoomorphic filigree in triple-strand this is somewhat unusual, at least in contrast with the majority of Anglo-Saxon filigree known previously, which comes largely from Kent and other regions of south-east England. The 'Kentish' designs, on objects including buckles and clasps with triangular plates, though similarly in triple-strand and related in style,[258] typically have their filigree wires soldered onto relief sheet backings,[259] which were modelled by impressing with a die.[260] Dies of copper alloy for shaping such back-sheets have been found

▲ **Fig 3.71.** Hilt-collar **114** showing *herringbone* decoration and *three-ply twisted wire* (arrow) framing at the edge of the mount. *Photograph*: © Birmingham Museums Trust.

▲ **Fig 3.73.** *Collared granules* on pommel **21**, unique for their double collars of beaded and plain wires. *Photograph*: C. Fern.

▲ **Fig 3.72.** Gem-setting from the centre of great gold cross **539**. It has a dog-tooth bezel of gold sheet with a filigree collar of *herringbone-with-spine*, comprising a pair of *two-ply twisted-beaded wires*, a central *plain wire* and flanking *beaded wires*. *Photograph*: C. Fern.

▲ **Fig 3.74.** Clutch of *granules* forming one animal shoulder on hilt-collar **110**. The largest granule was set at the centre, and the shoulder is delineated in *spiral-beaded wire*. *Photograph*: © Birmingham Museums Trust.

Fig 3.75. i) Back and ii) front views of mount **456**: the back-sheet was probably modelled with a die; the interlace is in *triple-strand* pattern; two- and three-ply *twisted-beaded wires* frame the edges. *Photographs*: © Birmingham Museums Trust.

Fig 3.76. Pommel **2** with a *lattice backing* (arrow), cut from thin sheet, behind worn and flattened wires. *Photograph*: © Birmingham Museums Trust.

on the Isle of Wight and in Hampshire, regions that were under Kentish influence in the late sixth to early seventh century.[261] By contrast, in the Hoard only a small number of objects have filigree designs mounted on *relief back-sheets* that were probably formed with a die (fig 3.75). Possibly the technique derives from Scandinavian metalworking, since objects with relief backings made in that region date from the early sixth century (fig 2.40), although they may not have been made in the exact same way.

Several other types of modelled back-sheet also occur (table 3.3). In fifteen cases the filigree was mounted on a flat *lattice back-sheet*, to raise it slightly from the body of the object.[262] Typically, the piercing on the lattice is incredibly precise, so it is nearly invisible behind the wires (fig 3.76), but on each side of pommel **35** the lattice is clearly apparent, forming a tier of sheet between the filigree and the pommel. The Hoard dramatically increases the number of known Anglo-Saxon examples of this technique. Hitherto it was identified on a pair of mounts from Faversham (Kent),[263] though most significant is the occurrence of this method of manufacture on the closely related hilt-fittings from Market Rasen (fig 2.41).[264]

More common on the objects was to work the back sheet (i.e. the sheet body of the object) in repoussé after the wires had been soldered. However, the direction of the working varies. Some *repoussé back-sheets* were modelled from the front to set the filigree in relief (e.g. hilt-collars **109–12**): the result is not dissimilar to the outcome achieved by die-impressing, although marks from the point of the tool used confirm the technique (figs 3.52 and 3.56). Probably the forming was done with a yielding material, such as leather, laid behind the gold sheet. In addition, a variation is seen on the set formed by pommel **5** and hilt-collars **89–90**: these have back-sheets that were either repoussé worked or die-impressed, but which were also lattice-cut.

True repoussé, working the back-sheet from the reverse, seems to have been done to emboss non-filigree details. This is most clear on the animal head of mount **460** (fig 3.77), but it was also done for the 'eye' mounts of pommel **77**. A parallel for this technique from Ireland, though not exactly alike, is the small repoussé-plumped Garryduff bird.[265] Examples of filigree panels repoussé worked from the front can be seen on the late composite disc-brooches from Milton (Oxfordshire) and Harford

Fig 3.77. 'Horse' head of mount **460**. The sheet of the mount has been embossed by repoussé working from the back. *Photograph*: © Birmingham Museums Trust.

Fig 3.78. Hilt-collar **125** showing the reverse of the pierced back-sheet on which the filigree was set. The incised 'X' is possibly an 'assembly' mark. *Photograph*: © Birmingham Museums Trust.

Farm (Norfolk), which at the earliest were made in the second quarter of the seventh century.²⁶⁶

One hilt-collar pair (**125–6**) demonstrates *pierced back-sheets* (fig 3.78). The filigree was mounted on separate sheet panels, as was the case for the lattice back-sheets, but small holes were instead drilled through the plates in the tight gaps between the triple-strand interlace. No parallels exist for this technique.

Lastly, there are multiple examples of *layout marks* on objects (fig 3.79), lines that were lightly incised onto back-sheets, which are overlaid and matched by the filigree designs. Probably these were made to guide the accurate placing of wires in complex designs when they were soldered.²⁶⁷

Conclusion

Overall the filigree of the Hoard fits generally with the existing Anglo-Saxon corpus in its range and occurrence of wires, granules and patterns. Style II animal ornament and interlace designs in *triple-strand* predominate, which were based on a style that was first widespread in Scandinavian metalworking in the sixth century. Arguably, the use of clusters of granules in the animal ornament of hilt-collars **109–10** points to at least some continued influence from this same region into the seventh century (figs 3.52 and 3.74). *Herringbone* pattern is also common, and *scrollwork* is well represented on the collection's small mounts. However, there are idiosyncrasies. These include the previously unrecorded filigree type of *wrapped-beaded wire*,

and seldom seen filigree types in an Anglo-Saxon context, such as *spiral-beaded wire*. In the currency of back-sheets, the Hoard metalwork demonstrates many more cases of *flat*, *lattice* and *repoussé* form. The occurrence of these and other filigree forms, and in some cases their novelty, could suggest that they are the result of manufacture in a region or regions outside of Kentish and East Anglian southern England, where most Anglo-Saxon filigree parallels have hitherto been found. Several of these rare traits do feature, however, on the hilt-fittings from Market Rasen (Lincolnshire) (fig 2.41), the most important match for the Hoard's filigree pommels and hilt-collars. Other elements, but particularly the *conical spirals* on two pyramid-fittings (**580–1**: fig 3.67), may represent a 'missing link' with Irish filigree, which probably developed its tradition chiefly, if not entirely, from Anglo-Saxon metalworking. Lastly, it is possible that the somewhat unusual character of the Hoard filigree might have a chronological explanation, since the use of 'rare' and 'novel' forms could represent techniques and fashions that arose later than the Kentish and East Anglian filigree traditions that were focused on the late sixth and early seventh centuries.

▲ **Fig 3.79.** *Layout marks* (digitally enhanced) on the back-sheet of hilt-collar **107**, which were probably a guide for the *triple-strand* interlace with serpent head. *Photograph*: © Birmingham Museums Trust.

Cloisonné and other lapidary work

Chris Fern

The cloisonné of the Hoard presents the ornamental form at its full flourish in early medieval north-west Europe, with mosaic-like coverings of mainly red garnets inlaid in gold cells or *cloisons*. Geometric designs predominate, a style with a long tradition reaching back to the Black Sea and Syrian regions in the early first millennium AD.[268] Its spread westward into Europe is marked by its popularity in the fourth and fifth centuries among Asian and Germanic tribes, including the Huns, but its appeal for Germanic rulers was probably increased further by its adoption by the elite of the Eastern Roman Empire. Weapon-fittings and harness that were probably made in east Roman workshops were included as a statement of royal power in the grave of the Frankish king Childeric (d. 481/2) at Tournai (Belgium).[269] Anglo-Saxon England adopted the metalworking style late, when it was already declining on the Continent,[270] yet its objects are among the finest known. They include the objects of regalia from 'royal' Sutton Hoo (fig 6.10),[271] with which the Hoard examples can be compared, both in their style and technique.

In the sixth century, imported garnets started to be used sparingly in England.[272] The triangular gem-setting on one side of silver pommel **64** is possibly an early example (fig 2.9). Cloisonné in the stepped-geometric style of the Continent was probably adopted by Kentish metalworkers, including its application, on buckles and disc-brooches, in the decades before 600.[273] The kingdoms of Kent and East Anglia have produced most evidence for the development of regional cloisonné styles, although the recent finds from a cemetery at Loftus (North Yorkshire), as well as the well-known pectoral cross of St Cuthbert, are suggestive of workshops also operating in the Northumbrian sphere.[274]

The Hoard has a total of 131 objects with cloisonné, mostly in gold, across the full range of object forms, and with both geometric and zoomorphic ornament represented. The assemblage is largely characteristic of early Anglo-Saxon manufacture, with the key features summarised in tables 3.6–3.8. The fittings of the 'princely' seax hilt (fig 3.80) stand out especially for their high-quality manufacture, as do zoomorphic mounts **511–5** and large mounts **542–66**. The seax fittings originally incorporated 441 garnets and eight tiny glass inlays. Sets **542–7** and **558–61** held around 1,500 garnets each, although damage prevents certain quantification for these and many other objects. For general comparison, the cloisonné assemblage from Sutton Hoo mound 1 included some 4,000 garnets in total, with the shoulder-clasps (920) and purse-lid (1,526) having the most.[275]

CHAPTER THREE | **WORKSHOP PRACTICE**

pin (missing)

reconstruction

55

169

225

167

scratched outline, dent and marks from pin

168

contact mark from blade

0 10 20 30 40mm

◀ **Fig 3.80.** Gold and garnet cloisonné fittings from the hilt of a seax or knife. A pin housed in the pommel was fastened through the tang to secure the hilt assembly, and possibly it was removable to allow repairs. *Photographs*: G. Evans. *Drawing*: C. Fern.

Catalogue	Total with cloisonné	Gem-setting(s) only	Garnet	Glass	Rock crystal	Bone	Amber	'Unidentified' inlay	Stone bead
Pommels 1–78	22	4	15	4	1	-	-	6	-
Hilt-collars 85–190	25	2	21	2	-	-	1	5	-
Hilt-plates/-guards 243–409	9	21	7	1	-	-	-	1	-
Small mounts 410–537	37	10	43	8+?1	-	-	-	-	-
Large mounts 538–71	26	2	27	1	-	1	-	-	-
Pyramid/button-fittings 572–84	12	-	12	5	-	-	-	2	1
Cross-pendant 588	-	1	1	-	-	-	-	-	-
Bosses 616–20	-	9	4	-	-	-	-	-	-
Totals:	131	49	130	22	2	2	1	28	2
Cell-wall fragments 683	5	-	-	-	-	-	-	-	-
Loose garnets 692–3	-	-	74	-	-	-	-	-	-
Loose foils 693–5	(44)	-	-	-	-	-	-	-	-
Harness-mount 698	-	1	-	1	-	-	-	-	-

▲ **Table 3.6.** Quantities of cloisonné, gem-settings and inlays. '?': uncertain identification/quantity.

Stones and manufacture

The small flat garnets that dominate are mostly less than 10mm in length and usually do not exceed 1mm in thickness, although stone thickness for the *in situ* cloisonné is only visible where damage allows (fig 3.81). The loose stones (**693**) in the collection have a greater range of thickness (0.4–1.6mm). Very fine striations on the surfaces of the stones, visible with magnification, suggest that they were probably shaped with some form of cutting wheel, as has been suggested in other studies.[276] Some 'flat' stones were finished with a slightly convex top surface (e.g. pommel **46**), while others were cut with angled or rounded surfaces to fit the edges of pommels and hilt-plates (e.g. **46**, **50**, **52** and **366–9**).

The flat stones with, mainly, neatly cut edges take a variety of shapes: many are stepped forms, familiar from other Anglo-Saxon cloisonné, but some were cut precisely to irregular shapes to serve in the animal ornament. None of the stones or cellwork is suggestive of 'crude' workmanship of the sort seen, for example, on the late composite disc-brooch from Boss Hall (Suffolk), which it has been suggested might indicate 'faltering' skills towards the end of the peak period of cloisonné in England, dating from the mid-seventh century.[277] A significant new discovery, however, is the 'unidentified' inlay on some objects, even if it remains to be fully understood.[278] Only occasionally do other inlays occur, of glass, amber and bone (table 3.6).[279]

The pyramid-fittings in particular display several types of rare cut stones. The top edges of pair **572–3** have triform garnets cut in three planes (fig 3.82), the only parallels for which are found on the pyramid-fittings from Sutton Hoo mound 1.[280] Pair **578–9** have bifid forms at their edges; pair **574–5** have at their apices square table-cut garnets with flat tops and angled sides; and small teardrop cabochon garnets were arranged as triforms on the sides of pair **580–1** (fig 3.67). These last stones might have been imported already cut as they have no parallels from England.

Also rare, and possibly representing the skilful reuse of antique, imported stones, are the garnets cut with beaded surfaces on hilt-collar pair **157–8** (fig 3.83). The only Anglo-Saxon parallels for these are the 'serrated' garnets decorating the bases of the button-fittings from Sutton Hoo mound 1.[281] Similar cut garnets are known from throughout

Europe, but on objects of fifth- to sixth-century date, including on a fitting in the shape of a bull's head from the grave of Childeric.[282] Of note, too, is a loose boat-shaped garnet (**693**: [*K1565*]), which does not fit any of the empty cellwork of the collection.

The largest stones are the garnet cabochons of round, oval and D-shaped form from gem-settings, including those of great cross **539** and cross-pendant **588**. They are only slightly smaller than the largest garnets known from England (*c* 30mm × *c* 20mm), including the pendants from Epsom (Surrey) and Milton Regis (Kent), and that on a buckle from Tostock (Suffolk).[283] The term 'gem-setting' is here used to describe lapidary work that is not cellwork; each stone was set instead in isolation in a sheet or cast bezel. While the small garnets that dominate in the cloisonné were undoubtedly shaped locally, these ostentatious cabochons might have a more distant source, as it has been argued that they were made in Byzantine workshops.[284] A large number are now known across north-west Europe, and some, like the Hoard examples, have flat tops that were most probably intended for *intaglio* engraving (a technique not seen in Germanic workshops). The concentric circles drilled on one of the cross garnets (fig 4.1) were probably added by an Anglo-Saxon jeweller, however, and they were possibly inlaid with gold originally.[285]

Garnet **692** is without any definite association, but possibly it came from the central setting of the great cross, perhaps being combined originally with a white surround of bone, paste or rock crystal

▲ **Fig 3.81.** Damaged edge of mount **551** showing in section the expertly cut flat garnets with gold foils beneath them. The stones have sunk in their cells and soil is where the backing paste would have been. Note the gold foils overlap the edge of each stone, helping to create a good fit. *Photograph*: C. Fern.

▲ **Fig 3.82.** Triform garnet cut in three planes at the corner of pyramid-fitting **573**. The different purple-pink hue of the stone was deliberately chosen to contrast with the orange-red garnets used for the flat sides of the fitting. *Photograph*: C. Fern.

(*frontispiece*). An example of a similar composite jewel, comprising an amethyst cabochon backed by a crystal disc, is the pendant known from Stretham (Cambridgeshire).[286] It is doubtful that a garnet big enough could have been found to otherwise fill the large central setting (45mm × 37mm) of the cross.

Cross-pendant **588** also has a flat-topped cabochon (figs 2.81–2.82i), and, in common with garnet **692** and the round garnet from the great cross (**539**: [*K308*]), it has been shown to have a shaped reverse, forming altogether a thick plano-concave lens. The basal concavity of each stone serves to expand the light as it enters, although the garnet from the cross-pendant is especially dark.

There are also many small gem-settings, some retaining miniature garnet cabochons (fig 3.61), on hilt-plates (**243–62** and **365**) and other objects (e.g. **436**, **465**, **473–4** and **482**). Further examples are detached (**616–20**). In addition, a cabochon rock crystal was used for the gem-setting on one side of pommel **77**.

Mainly, the bezels of the small and large gem-settings are plain with filigree collars. Rarer in Anglo-Saxon England are the dog-tooth bezels found on the great cross (**539**). Bruce-Mitford cited several examples in his discussion of the dog-tooth edging on the famous pectoral cross of St Cuthbert,[287] including the bezel gripping the large garnet on the Tostock buckle,[288] and that with a garnet

cabochon on a brooch from Sarre (Kent).[289] To these can now be added a pendant from Loftus (North Yorkshire),[290] as well as the dog-tooth edging seen on the collection's button-fittings (**582–3**). The dog-tooth bezel form is ultimately of far greater antiquity, however, its use dating back to at least the sixth century BC.[291] Examples from earlier Germanic contexts include gold finger-rings and brooches with flat-topped cabochon garnets of fourth-century date from Denmark.[292]

Most of the cloisonné appears to be of one type, although the techniques of manufacture used could only be confirmed beyond doubt where damage or loss allowed inspection. The *cloisons* were built up from short sections of vertical gold strip soldered in position on sheet back-plates (figs 3.28 and 3.84). This type of cloisonné is Adams' Class I, the main form used in Anglo-Saxon England.[293] The cellwork would have been completed first, with the stones then cut and cold fitted or any inlay applied.[294] In the case of the garnet cloisonné, each cell held a single stone, with a patterned gold foil usually placed behind. The stones were made level by the use of a backing paste set behind the foils that provided a firm but yielding foundation. To keep the stones in their cells, the tops of the cell-walls could be smoothed over by burnishing, as is especially evident on pommel **47** and matching collars **159–60** (fig 3.85). However, on the finer objects a remarkable accuracy of fit was achieved, which seems to have been sufficient to retain the inlays, assisted by the gripping effect of the gold foils that overlapped the bottom edge of each stone (fig 3.81), and very little smoothing over is discernible. In addition, from the evidence of fixing-holes within cells (i.e. under stones and foils), it appears some fittings must have been secured on their objects before all their stones were set.

Up to thirty-five objects may have so-called *gold lidded cells*, which were used in both zoomorphic and geometric cloisonné designs.[295] This technique employed small pieces of gold sheet instead of stones that were set horizontally to cap cells and create the illusion of a solid metal surface. When a precise finish was achieved, few signs of manufacture remain. Lidded cells have been recorded before, most notably with the animal ornament on the shoulder-clasps (fig 6.10) and purse-lid of Sutton Hoo,[296] but were previously unknown with (non-zoomorphic) geometric cloisonné. Clear examples of their use can be seen on pommels **49** and **53** (figs 3.86–3.87).

An examination of the Sutton Hoo shoulder-clasps was undertaken at the British Museum to enable comparison with the seax fittings (fig 3.88) as both have zoomorphic and geometric cloisonné of

▲ **Fig 3.83.** Garnets cut with a beaded surface on hilt-collar **158**. *Photograph*: © Birmingham Museums Trust.

the highest order.[297] In the complex zoomorphic designs on the Sutton Hoo clasps, slight joins remain around the gold lids that are visible even without magnification (fig 3.88iii).[298] However, very few joins are visible on the seax hilt-collars (**167–8**) around the animal ornament.[299] Based on microscope examination, it is proposed that each collar was manufactured by the following method (figs 3.88i–ii): the outlines of the zoomorphic pattern was first cut out of the gold sheet band that formed the body of the object; the vertical cellwork was then built within the outlines in the standard manner; a small number of lids were used to cap larger background areas, but for small gaps vertically inserted fragments probably sufficed; the paste, foils and garnets were added in the completed cellwork before final burnishing to hide the manufacture joins. In sum, it is argued that the collars of the seax manifest a variation of the technology used for the Sutton Hoo shoulder-clasps.

On one set of objects with zoomorphic cloisonné, pommel **54** and hilt-collars **165–6** (fig 3.89), the gaps around the cells appear to have been infilled completely with small sheet fragments (i.e. they are without lidded cells). The effect of this *fragment fill* in this case was a less expert finish. However, other objects from outside the Hoard also demonstrate the technique, including at least one minor application on the Sutton Hoo clasps,[300] and it was used in the cloisonné of an interlace frame on a coin pendant from Bacton (Norfolk).[301]

The seax hilt-collars (**167–8**) are not the only examples of cellwork cut out of sheet. Pyramid-fittings **576–7** were possibly made

Fig 3.84. Damaged cloisonné on mount **546** with stones probably lost due to movement of the cell-walling. The surviving garnets are sunken due to the shrinkage and part dissolution of the backing paste. The grey-coloured paste is visible in some cells without foils and stones, and one cell without its stone retains a gold foil. There is little, if any, smoothing over of the tops of the walls, in contrast with other objects (see fig 3.85). The accompanying drawing shows the essential structure of Class I cloisonné (after Adams 2000). *Photograph and drawing*: C. Fern.

Fig 3.85. Cloisonné of pommel **47** showing uneven cellwork and non-uniform stone cutting. The tops of the cells have been smoothed over to hold the garnets in place. The inexpert finish can be contrasted with that of edge-mount **564** (fig 3.91). *Photograph*: C. Fern.

similarly and certainly this method was used for hilt-plates **366–9**. A small number of foils and stones in the tangled remnants of the plates indicate that garnets were set along the slotted edges, but the cells were not constructed with walls of gold sheet; so instead the stones must have been set in recesses cut into the edges of the horn or wood hilt-guards. This is comparable with, but not exactly the same as, Adams' Class II cloisonné.[302]

It is also important to consider the absence from the collection of other types of cloisonné, of cast copper-alloy form, or using silver or copper-alloy sheet.[303] Copper-alloy manufacture in particular appears to have been a feature of some of the earliest and latest cloisonné. Objects of the late sixth- to early seventh century are the cast belt- and scabbard-fittings from Sutton Hoo mound 17;[304] whereas among the latest are several composite disc-brooches from southern England with *cloisons* in copper-alloy sheet that are probably of the middle third of the seventh century.[305] Of note, however, if not strictly an example of cloisonné, is the unusual arrangement of triangular gem-settings in cast silver on one side of silver pommel **75**, which originally held glass inlays.

Fig 3.86. Photomicrograph and drawing (scale 1/1) of the pattern of garnet crosses and gold *stepped rhomboids* on pommel **49**. The gold rhomboids are formed with 'lids' of gold sheet. *Photograph and drawing*: C. Fern.

Scientific analysis has confirmed that the garnets come from multiple sources, including potentially India, Sri Lanka and the Czech Republic (Bohemia), and that stones from these different origins were combined on certain objects.[306] While the Anglo-Saxons probably knew little or nothing of these actual origins, it is clear that they sometimes selected stones of differing hue to achieve contrast in their designs. On the seax hilt-collars (**167–8**) garnets of subtly different colours (and different chemical components) were used in conjunction with different gold foil types to pick out parts of the zoomorphic ornament (figs 3.88i and 3.95). Similarly, on mounts **516–7** darker garnets were used for the head-surround elements of the birds (fig 2.35); and on pyramid-fittings **572–3** and **578–9** the edge stones of rare shape are also a contrasting purple-pink (fig 3.82). At Sutton Hoo, a comparable deliberate use of different coloured garnets has been observed, highlighting the crosses on the button-fittings from the scabbard;[307] and the practice was also known on the Continent, for example, on a disc-brooch from Soest (Germany).[308]

Cell-forms and patterns

From among the many designs certain cell-forms and patterns can be isolated and discussed for their significance to Anglo-Saxon and early medieval cloisonné (tables 3.7–3.8). A form dating back to at least the fifth century and popular in continental cloisonné was the *stepped rhomboid* (figs 3.86 and 3.90).[309] Examples formed with gold lidded cells are on pommel **49**, with examples in garnet on guard-fittings **499–502**, and since these are the only use of the cell-form in the collection, it is possible these objects were a set (cf fig 2.29). It is a rare cell-form in Anglo-Saxon cloisonné generally,[310] but examples figure prominently on the shoulder-clasps from Sutton Hoo (fig 6.10), as well as on other objects from the mound 1 burial.[311] The arrangement on pommel **49** can be compared with the pattern on the shoulder-clasps, and both have been related to carpet-page ornament in manuscripts.[312]

Fig 3.87. Style II animal design on one side of pommel **53**. *Lidded gold cells* were used between the cellwork forming the body of each creature. Two different types of gold foil were set behind the stones (visible where garnets are missing), and a square of chequered *millefiori* glass was placed between the heads of the creatures. *Photograph and drawing*: C. Fern.

Fig 3.88. Detailed comparison of hilt-collar **168** and one Sutton Hoo shoulder-clasp.

i) Subtly different shades of garnet were used on hilt-collar **168** for the different body and leg elements, combined with two different types of patterned gold foils.

ii) The suggested method of construction: first the outline was cut out, then vertical and lidded (L) sheet elements were added, leaving only the animal cellwork. Burnishing has removed almost all trace of the joins.

iii) Tiny gaps betray the edges of the lidded cells used on the Sutton Hoo shoulder-clasps (scale 4/1). *Drawing*: C. Fern. *Photographs*: C. Fern (i) and A. Mongiatti (iii); *Photograph*: (iii) © Trustees of the British Museum.

Fig 3.89. Hilt-collar **165** showing fragments of sheet set vertically to infill spaces between cells. The cloisonné is filled with 'unidentified' inlay. *Photograph*: © Birmingham Museums Trust.

Especially conspicuous is the use of *mushroom* and *arrow* cellwork, as both whole and split forms.[313] The whole *mushroom* is notable in Anglo-Saxon cloisonné, in particular, for the prominence it was afforded in the designs on the early seventh-century regalia of Sutton Hoo, which led initially to it being claimed as 'the hall-mark of an Anglian cloisonné style'.[314] This statement has since been challenged on the basis of rare examples of *mushroom* cloisonné on the Continent and in Scandinavia.[315] The evidence includes its use on a disc-brooch from Täbingen (Germany) that pre-dates the metalwork of Sutton Hoo,[316] and on other objects of Frisian manufacture from Wijnaldum (Netherlands).[317] Also it occurs in other forms of continental metalworking, for example on the so-called *Christus-Schnallen* ('Christ buckles').[318] Possibly, therefore, as Arrhenius and Adams have argued, the cell-form did originate somewhere in Merovingian Europe.[319] However, perhaps most important to observe for England is that the *mushroom* form was afforded no real importance in Kentish cloisonné (contrasting with that at Sutton Hoo),[320] yet, as its proliferation in the Hoard now shows, it was clearly essential to and manifest in the character of cloisonné produced in other Anglo-Saxon territories.

Quatrefoil or cross patterns formed by the convergence of *mushroom* and *arrow* cell-forms are seen on multiple objects,[321] while on pommels **48–50** coverings are formed by the same two cell-forms. *Arrow* cell-forms also occur at Sutton Hoo, including in a mushroom-arrow cross, which appears again in Suffolk on the Wilton Cross (fig 6.4) and on a brooch from Sutton.[322] This same mushroom-arrow cross is seen on Hoard objects (fig 3.91).

Object-type	Split-mushroom	Mushroom	Split-arrow	Arrow	Stepped rhomboid	Cross	Lidded cell	Fragment fill
Pommels	5	12	2	6	1	3	5	1
Hilt-collars	6	10	17	4	-	3+?1	7	2
Hilt-plates/guards	-	-	-	-	-	-	3	-
Small mounts	9	7	5	3	4	1	16	-
Large mounts	9	18+1†	16	7	-	-	2	-
Pyramid/button-fittings	-	2	-	-	-	-	2	-
Total:	29	50	40	20	5	8	35	3

▲ **Table 3.7.** Selected cell-forms recorded for the cloisonné. '†': mushroom cells in niello inlay on silver mount **569**; '?': uncertain identification/quantity.

Just two objects on the Continent are known with mushroom-arrow crosses: a mount from Tongres (Belgium) and a disc incorporated into the shrine of St Egbert (Trier, Germany). Bruce-Mitford argued that both these objects were products of the 'Sutton Hoo workshop', and it remains true that their style is out of place on the Merovingian Continent.[323]

On six of the large garnet cloisonné mounts (**542–7**) three different cross motifs are embedded in a repeat pattern, and the same pattern occurs on pommel **47**, though with a clearly inferior finish (fig 3.92). Possibly the pommel was the later product, and it seems very likely all were made in the same workshop. Another connection seems likely between mounts **565–6** and pommels **50–1**, because of their use of similar 'fish-scale' patterns, formed of curved, stepped and arrow cells (fig 3.93). The design was probably derived from one seen commonly in Anglo-Saxon cloisonné,[324] of a stepped cell between curved elements, as occurs on pommels **36** and **52**.

Fish-scale decoration proper occurs on fish mount **513** (fig 3.94) and six other mounts (**41**, **496–7** and **521–3**). This relatively

▲ **Fig 3.90.** Exposed gold foils of *standard* type on mount **499** with two central *stepped rhomboid* cells. Note the foils have been placed with the same orientation, but some have been laid showing their cross-hatched pattern in the positive and some in the negative. *Photograph*: © Birmingham Museums Trust.

▶ Gold and garnet seax fitting **168** with animal interlace (not to scale). *Photograph*: D. Rowan; © Birmingham Museums Trust.

Fig 3.91. Cloisonné on edge-mount **564**, showing *mushroom* and *arrow* cellwork, forming two alternating quatrefoil or cross motifs, as illustrated in the drawing (scale 1/1). *Photograph and drawing:* C. Fern.

♣ *mushroom*
♣ *arrow*

uncommon form of cellwork is regarded as late in Anglo-Saxon usage, but it is seen on the Continent in the fifth century, where it was also used as feather ornament on bird-mounts.[325] The best known example of the cellwork in Anglo-Saxon cloisonné outside the Hoard is on the buckle from Crundale (Kent), an object usually dated to around the mid-seventh century.[326]

Cross cells are seen on seven objects (**49**, **52**, **54**, **165–6**, **178** and **525**) and possibly hilt-collar **164**. This is a rare form, too: other Anglo-Saxon parallels with the cell-form are the pommel from Dinham (Shropshire) (figs 2.86 and 5.23iv), a cross-pendant from Holderness (East Yorkshire), and objects from Sutton Hoo mound 1.[327] Once again, it does not figure within the cloisonné of the extensive Kentish disc-brooch series,[328] but a gold panel from Maidstone (Kent) does have a cross garnet centrally.[329]

Animal ornament exerted less influence in cloisonné manufacture in north-west Europe than on other forms of metalworking.[330] Nevertheless, the nineteen objects with zoomorphic cloisonné in the Hoard, including a number of sets, make a significant contribution to examples known previously.[331] As already discussed, the ornament of the seax collars (**167–8**) invites comparison especially with the interlaced creatures from the shoulder-clasps of Sutton Hoo mound 1 (figs 3.88 and 3.95).[332] The relationship suggested by the similar qualities of their zoomorphic cloisonné would seem to be reinforced, furthermore, by the fact that the choice of pattern for the geometric bands on both seax collars has an exact parallel in a band on one of the rectangular strap-mounts from mound 1 (fig 3.95).[333]

Fig 3.92. Cloisonné pattern on mount **543**, which is seen also on mounts **542** and **544–7**, and the derivative version on pommel **47** (scale 1/1). *Drawing:* C. Fern.

Fig 3.93. Similar cloisonné patterns on mount **565** and pommel **50**, and a related cell arrangement on pommel **36** (scale 1/1). *Drawing*: C. Fern.

The animal ornament that is set against gold backgrounds on the seax fittings and clasps stands in contrast to most zoomorphic cloisonné of the Continent and Scandinavia, which was generally set within geometric compositions or otherwise geometricised. An example of this geometric animal style is the pommel from Hög Edsten (Sweden) with boar-head ornament (fig 2.42i).[334] Bruce-Mitford suggested that the contrasting 'uniquely effective' form of the ornament at Sutton Hoo, achieved by the use of lidded cells, was another hallmark of a local Anglian master goldsmith.[335] However, rare finds with the lidded-cell technique from elsewhere in England, including a fitting with zoomorphic cloisonné from Thurnham (Kent), suggest the possibility of its use beyond East Anglia.[336]

The Hoard's bird and fish mounts (**511–15**) can also be compared with the cloisonné of Sutton Hoo, particularly the birds of the purse-mount from mound 1, even if they are not a match for their virtuoso achievement (cf figs 2.35, 3.94 and 5.11 esp. vi).[337] Like the Sutton Hoo birds, several have 'feathered' tails, but, more significantly, they share with them the signature attribute of a Y-shaped beak.[338]

Less obviously zoomorphic are the designs on seax pommel **55** and pommel **73**. The abstract motif on one side of pommel **73**, of a circular garnet between beak-shaped garnets, possibly intended with the gold filigree ornament as a bird-like creature (fig 5.22), has close parallels in the cloisonné on pyramid-fittings from Newark (Nottinghamshire) and Ezinge (Netherlands).[339] Pommel **55** (figs 3.80 and 5.8), in contrast with the sinuous and bold animal ornament of the seax collars (**167–8**) with which it forms a set (cf fig 3.95), has concealed geometricised beasts on its sides that are more in keeping with the zoomorphic cloisonné of Scandinavia and the Continent.

The cloisonné on a small group of filigree pommels is stylistically distinct and, in some cases, comparatively crude. The designs all occur on one side only and were filled either by garnets (**36–7**) or 'unidentified' inlay (**38–40**). Two (**37–8**) have applied panels with cellwork forming an 'X' or saltire; one (**36**) has a variation of this same motif centrally; and one (**39**) has a panel with a concealed cross of a different sort (fig 3.96). In addition, the same *X-cloisonné* motif, as on pommels **37–8**, is on the apices of pyramid-fittings **580–1**. It is tempting to suggest that these objects might represent the products of a region with a less developed cloisonné tradition, beyond Kent and East Anglia, and which experienced a fluctuating access to garnet (thus explaining perhaps the use of the 'unidentified' inlay). However, the occurrence of the same 'unidentified' inlay on other objects with full cloisonné,[340] and its use together with garnet,[341] prevents any straightforward interpretation of its application.[342] No objects outside the collection retain evidence of a comparable decayed inlay, but this is possibly not the first time it has been encountered. A disc-brooch from Sutton (Suffolk) has gold *cloisons* scoured of their contents, but when it

▲ **Fig 3.94.** Fish mount **513** with *fish-scale* cloisonné (scale 4/1). *Photograph*: C. Fern.

was found in 1835 it originally had inlays of red, blue, green and 'other colours'.³⁴³ Other objects found in previous centuries are also known with empty cloisonné that might originally have had inlays, including several brooches from Kent.³⁴⁴

A feature characteristic of the latest composite disc-brooches of southern England is so-called *honeycomb cloisonné* (fig 3.97).³⁴⁵ This pattern, which is actually formed of irregular pentagons, occurs only twice in the collection, as a cloisonné column at one end of hilt-collar **168** (figs 3.80 and 3.95), and as *faux* cloisonné 'scales' incised on the fish of mount **538**. A further parallel from Kent is the cabochon pendant from Milton Regis, dated by Hawkes to the mid-seventh century (broadly contemporary with the late composite disc-brooches), which has *honeycomb* cloisonné forming part of its frame.³⁴⁶ The upper part of the pendant frame has a different pattern with circles in blue glass between garnets.³⁴⁷ Versions of this rare *round* cellwork occur in bands at the ends of hilt-collar pair **159–60**, and in a variation using ovoid forms along the framework of mounts **558–61**.

▲ **Fig 3.95.** Style II animal ornament on seax hilt-collars **167-8**, compared with select patterns from Sutton Hoo mound 1 (enlargements scale 3/2). *Drawing*: C. Fern.

The latest cloisonné in England manifests a *rectilinear* style, sometimes alongside *honeycomb* cellwork, but it is associated with few if any stepped or other complex cell-forms. It has been considered 'characteristic of the decline of cloisonné', implying a period when lapidary skills were failing, preventing the manufacture of the range of stone forms and patterns seen previously.³⁴⁸ Its finest examples, nevertheless, are of high quality, including the pectoral cross of St Cuthbert,³⁴⁹ and more recent finds of a pendant from Loftus (North Yorkshire)³⁵⁰ and cross from Trumpington Meadows (Cambridgeshire).³⁵¹ *Rectilinear* cloisonné is not common in the collection, but the frame to the roundel on pommel **76** (fig 2.12) is one example that may be said to be in the style.³⁵²

Fig 3.96. Inexpert cloisonné on pommel **39** filled with 'unidentified' inlay. The geometric cellwork hides a cross with expanded arms. *Photograph*: © Birmingham Museums Trust.

Fig 3.97. *Honeycomb* and *round* cellwork on objects in the collection and on a pendant from Milton Regis (Kent) (scale 1/1). *Drawing*: C. Fern.

Backing foils

Gold backing foils with cross-hatched patterns occur on the majority of the intact objects with cloisonné, some of which are exposed by damage (fig 3.90), and others were found loose (**693–5**). The foils were designed when *in situ* beneath the stones to reflect back the light and thus improve the lustre. Very few objects were made without them, but they include cross-pendant **588**, which has no foil behind its central cabochon garnet.[353] The loose and exposed foils are of gold, with just one exception in silver gilt that was set behind the apex garnet on pommel **76**; it was backed by the wax core that filled the hollow interior of the pommel, the top of which bears an impression of the foil pattern.

The study of Anglo-Saxon foils by Avent and Leigh identified a conservative practice, with two main foil types termed *standard* and *boxed*.[354] The same types were identified in a separate study by East of the Sutton Hoo foils.[355] For the collection, 117 objects have *standard* foils with cross-hatched patterns (fig 3.90), which is equivalent to approximately 65 per cent of all the objects set with stones. *Boxed* foils were used on only fifteen objects.[356] Mostly these are composed of 3×3 grids arranged in boxes with thicker lines (fig 3.98), the pattern that is also the most common outside the collection. The loose foils (**693–5**) add another thirty-five *standard* and nine *boxed* foils. Avent and Leigh found that most *standard* foils have *c* 3–4 lines per mm.[357] No survey of line fineness was undertaken for the Hoard foils, but the *standard* foils of the seax suite were measured at *c* 4 lines per mm.

As already noted for hilt-collars **167–8**, some objects could have both *standard* and *boxed* foils (cf figs 3.88 and 3.95). Only a small number of Anglo-Saxon objects with both foil types have been previously identified.[358] In the Hoard further instances occur with both geometric and zoomorphic designs. Another application in a zoomorphic design is seen on damaged pommel **53** (fig 3.87). With geometric patterns (figs 3.90 and 3.99) foil combinations are recorded on six large mounts (**542–3** and **552–5**) and on one pair of pyramid-fittings (**576–7**). Large *boxed* 3×3 foils (fig 3.98) fill the central cell of each of the eye-shaped mounts (**542–3**), while the framing bands have *standard* foils. On only one pair of strip-mounts (**550–1**) and on pommel **64** were *boxed* foils used without accompanying *standard* foils.

There are a few *boxed* foils of more unusual type. The D-shaped garnet boss from the foot of the great gold cross (**539**) has a foil with a 4×4 pattern. Avent and Leigh termed this *special boxed*, and they recorded it on just seven Anglo-Saxon objects.[359] A significant detail of the Hoard boss foil is that one line of the pattern was misaligned, resulting in a row of 4×5 grids.[360] The largest (**694**)

Fig 3.98. *Boxed* 3×3 foil in the large 'eye-shaped' or vesical cell at the centre of mount **542**. *Photograph*: © Birmingham Museums Trust.

Fig. 3.99. Mount **552** showing the use of *standard* foils for the central line of *mushroom* cells, with *boxed* 3×3 foils used for the surrounding cells. *Photograph*: © Birmingham Museums Trust.

of the loose foils was possibly impressed from the same die, as it also has 4×4/4×5 boxes, and given its size (L. 15.5mm) it might also be from the cross (fig 3.100).[361] Both are among the largest foils known (together with those on mounts **542–3**), and at the limit of the maximum size that could be produced, based on the dimensions of the few dies that have been found.[362] Avent and Leigh identified a foil of the same rare character on two sixth-century Kentish objects, which they also considered could indicate foils produced from a single die.[363] Since their study, a die for making foils of 4×4/4×5 type has been found at Tjitsma (Netherlands).[364] However, Tulp's and Meeks' comparison of this die against known Anglo-Saxon foils found no match.[365] Nor were the *special boxed* 4×5 foils in the collection made by the Tjitsma die, since they show a different orientation to their irregular boxes. This proves, therefore, that more than one die must have existed in Europe with the irregular pattern, which raises the question whether the 'error' in the misalignment was deliberate or accidental.

Mistakes transferred from a die are also apparent in the cross-hatching on an exposed foil on mount **506** (fig 3.101). Rare foils and 'fingerprint' errors are the best means for identifying identical-die use between objects, with the hope of thus isolating objects of the same workshop. However, this did not prove possible from East's study of the Sutton Hoo cloisonné,[366] and nor has it so far proved possible to link any Hoard objects by this means. It is also the case that foils of the same type, but from different dies, could be used on single objects, but only one clear instance has so far been recorded on hilt-plate **363** (fig 3.102).

Surprisingly, given the quantity of the collection's cloisonné, only one pair of objects has foils of a type previously unrecorded for Anglo-Saxon England. Mounts **473–4** have foils with standard cross-hatching overlaid by a lozenge pattern: termed *boxed lozenge* (fig 3.103). Avent and Leigh recorded one instance of a lozenge-patterned foil on a brooch from Dover (Kent), but it is quite different.[367] A published brooch from Morrild, Hjorring (Denmark), has foils that are closer parallels.[368]

CHAPTER THREE | WORKSHOP PRACTICE

seax fittings (fig 3.80). They come closest to equalling the brilliance of the mound 1 shoulder-clasps, and a shared origin with them must be considered a distinct possibility. Conversely, there is little to indicate links with the productive workshops of 'Kentish' southern England. Furthermore, the inexpert and idiosyncratic nature of the ornament of one small group of pommels (i.e. **36–40**) may suggest the objects of a region with a poorer cloisonné tradition, which was less developed and not so well resourced. Lastly, while establishing the date-range of the cloisonné objects has not been the aim of this study, there are few that appear early (i.e. mid/late sixth century) or late (mid/late seventh century), and the majority, therefore, must date within the first half of the seventh century.

▲ **Fig 3.100.** Loose foil **694** of *special boxed* 4×4 type, with one line of 4×5 boxes. It is possible it came from one of the gem-settings of the great gold cross (**539**) or inscribed strip (**540**). *Photograph*: C. Fern.

Conclusion

The Hoard cloisonné is mostly of high quality and some is outstanding, confirming once again the impression of a peak period of expert manufacture in seventh-century England, when paradoxically the opposite was true of production on the Merovingian Continent, from where the craft had been imported but where cloisonné skills were then in decline. The seax hilt-fittings, zoomorphic mounts, large cloisonné fittings and the extravagant cabochons of the great cross all indicate a supreme and probably royal command of capital and skills. While the combined assemblage undoubtedly represents the output of more than one workshop, examination of the cell-forms and patterns suggests that much could be from one region, East Anglia. In particular, close links have been demonstrated with the regalia of Sutton Hoo mound 1, especially for the garnet cloisonné

▲ **Fig 3.102.** Two *standard foils* of different fineness (struck from different dies) on hilt-plate **363**. *Photograph*: © Birmingham Museums Trust. *Photograph*: © Birmingham Museums Trust.

▲ **Fig 3.103.** Unusual *boxed-lozenge foil* on one of the garnet cabochon settings on mount **474**. *Photograph and drawing*: C. Fern.

▲ **Fig 3.101.** *Standard foil* on small mount **506** showing line errors transferred from the die used. The line count is approximately 4 lines/mm. *Photograph*: © Birmingham Museums Trust.

'Assembly' marks and other marks

Chris Fern

A variety of incised marks (table 3.9) was recorded on thirty-eight gold objects and one silver pommel that are different from the 'layout' marks for sheet patterns and filigree ornament.[369] Most occur on reverses or in interiors, in places where they would not have been visible.

An exception is the rune-like mark on one side of silver pommel **72**, an object which is otherwise quite plain, though the mark is lightly incised and difficult to make out on the scratched surface (fig 3.104). It may be a ᚳ rune: the 'c' of the Anglo-Saxon *futhorc*.[370] Other objects showing the use of the rune form that are somewhat later in date, *c* 700, are the Whitby comb and Franks Casket.[371] One other rune-like 'inscription' occurs, together with an incised grid pattern, on hilt-collar **174** (fig 3.105). These would have been hidden when the collar was in position, but more importantly the line marks appear entirely indecipherable, so at best they might be considered pseudo-runic. Grid patterns occur on two other objects, which are less precisely executed: hilt-collar **175** (the pair to **174**) and hilt-plate **278**. The fact that these three objects are the only examples in the collection to share these similar patterns might indicate that they were part of a set; the grid motifs may relate to assembly, although there are no other grounds for linking the hilt-plate with the pair of collars.

The other marks are all scratched combinations of lines or crosses (fig 3.106). Where they occur on the reverse of mounts that were inserted into objects, it is possible that they were made simply to roughen the contact surface and help adhesion, regardless of whether solder or glue was used. For instance, rough lines were recorded within one of the panel recesses on pommel **57**, prior to the re-attachment of its loose gold panel with black niello lines.

However, that some of these marks were probably aids to assembly is suggested by their occurrence within groups. Hilt-plates **361** (X) and **362** (XX) are from the same sword-hilt (but different guards). Gold cloisonné mounts **503** (//) and **506** (#) were part of a suite of four guard-fittings (and they again come from the upper and lower guards). Cloisonné strip-mounts **556** (III, III) and **557** (X, XX) are a pair, with each made in two parts. Other examples with marks are: mounts **445** (//) and **446** (//); eye-shaped mounts **542** (—) and **543** (X); and mount **541** (fig 1.14).

▲ **Fig 3.104.** Pommel **72** with a possible ᚳ rune. *Drawing*: C. Fern.

▲ **Fig 3.105.** Photomicrograph and drawings of grid and rune-like markings on hilt-collar **174**. *Photograph*: © Birmingham Museums Trust. *Drawing*: C. Fern.

◀ Hilt-mount **473** with small cabochon garnet 'eyes' (not to scale). *Photograph*: D. Rowan; © Birmingham Museums Trust.

Object-type	Round	'Fish-scale' (with arrow)	Fish-scale	Honeycomb	Rectilinear*	Chevron	X-cellwork (saltire)	Mushroom/arrow quatrefoil or cross	Other cross	Zoomorphic
Pommels	-	2	1	-	1	-	3	4	2	5
Hilt-collars	2	-	-	1	2	1	-	4	1	5
Hilt-plates/ guards	-	-	-	-	7	2	-	-	-	-
Small mounts	-	-	6	-	2	-	-	-	1	7
Large mounts	4	2	-	1†	-	-	-	11	7	-
Pyramid/button-fittings	-	-	-	-	2	-	2	-	8	2
Total:	**6**	**4**	**7**	**2**	**14**	**3**	**5**	**19**	**19**	**19**

▲ **Table 3.8.** Selected patterns recorded for the cloisonné. '*': most examples, including those on hilt-plates, are not true instances of the late style, but feature the ornament as narrow bands or frames; '†': honeycomb pattern on bird-fish mount **538**.

The most complex assembly programmes are on the two large, curved cloisonné strip-mounts (**558–9**), and these appear to relate to the fitting of their rectangular gold filigree panels (fig 3.106). The marks are found mainly on the reverse of the filigree panels, with only a single instance on one of the strip-mounts. However, understanding of the system that the marks represent is hindered by several factors: not all the small filigree mounts survive; most were found *ex situ*; and the few that had remained in position could not be examined on their reverses. Reassignment was possible for many, nevertheless, and eventually it was established that a separate scheme of marks was most probably used for each strip (fig 2.63). These programmes may be related, furthermore, to those used for mounts **556–7**, which are stylistically cognate. Mount **558** used crosses (X, X, IXI); mount **559** used straight, angled and curved lines (I, III, \, I-I, U).

Assembly marks are not otherwise known in early Anglo-Saxon manufacture, but they have been identified on Irish objects of the late seventh or early eighth centuries. On the famous Derrynaflan paten (Co Tipperary), the marks include a series of letters, indicating a literate craftsman, which served to locate its many separate parts in manufacture,[372] and other examples are on the Ardagh chalice (Co Limerick).[373] Some Anglo-Saxon finds do bear comparable marks to those on the Hoard objects, but these do not appear related to assembly: a boxed cross was scratched on one side of the iron cap of the famous York helmet from Coppergate (fig 3.106i);[374] and similar incised markings accompanied animal ornament and a runic inscription on the reverse of a composite disc-brooch from Harford Farm (Norfolk) (fig 3.106ii).[375] While a literal meaning for the Hoard's marks of cross and line type seems unconvincing, in choosing to use forms (I, IX, IXI) that are relatable to runic characters, it is possible that the craftsmen were drawing on a common system, just as the maker of the Irish Derrynaflan paten sourced his forms from the half-uncial alphabet.

▲ **Fig 3.106.** Markings on the reverse of filigree panels from strip-mounts **558-9**, marks from other objects (**175, 278, 312** and **506**), and *comparanda*: i) Coppergate helmet (York); ii) Harford Farm (Norfolk) composite disc-brooch. *Photograph*: G. Evans. *Drawing*: C. Fern.

CHAPTER FOUR

CHAPTER FOUR

LIFE OF OBJECTS:
WEAR, MODIFICATION, REPAIR AND DAMAGE

CHRIS FERN

Details of wear, modification, repair and damage were recorded for all the objects, where condition allowed (fig 4.1). It has become current in archaeology to consider this information relating to the use and treatment of finds before they entered the archaeological record as constituting a sort of 'object biography'.[1] Central to this is the view that artefacts in the past were integral to the action of human societies, so by revealing their 'history' we are informed about the cultural context of their use. With so many of the mounts and fittings of the Hoard probably coming from swords, *the* weapon of the warrior elite, this examination has the potential to illuminate how power was actually exercised within the early Anglo-Saxon kingdoms. Also, wear and repair can be considered alongside aspects of typology and style to assist in determining the date of objects,[2] while evidence of damage, so abundant in the Hoard, ultimately reveals how the finds were treated before burial and gives insight into what the assemblage represents.

Fig 4.1. Repaired garnet boss from the great gold cross (**539**). Scientific analysis has shown that the small replacement garnet piece in its own gold collar is mineralogically different from the original stone (scale 2/1). *Photograph*: G. Evans.

old.[4] One is the famous mention of the eighth-century sword of King Offa, with a 'pitted hilt', in a will of the eleventh century.[5] Earlier examples of 'ancestral' blades are suggested by finds of swords from burials of the sixth to seventh centuries, which demonstrate fittings that were made and added over a considerable period, perhaps up to *c* 100 years.[6] Signs of wear and repair have also been observed before on sword-fittings, indicating weapon maintenance and curation, including most recently and systematically in a study of swords from England and north-west Europe by Sue Brunning.[7] An example of a sword-hilt with wear is that from the ship-burial in Sutton Hoo mound 1, the filigree wires at the edges of the sword pommel having been worn smooth.[8] More generally, evidence of wear is not uncommon on many types of find of the early Anglo-Saxon period, although this aspect of object biography was not consistently noted in older studies.[9]

WEAR

Wear and tear was not necessarily a bad thing in Anglo-Saxon society. Swords in particular could be long maintained and valued as 'heirloom' objects. Weapons that endured might even attain mythical reputations and be personified, at least according to the named blades of legend, such as *Hrunting* and *Nægling* in the Anglo-Saxon epic *Beowulf*.[3] Bequests of swords recorded in wills of the later Anglo-Saxon period very probably represent the continuation of a more ancient practice in relation to heirlooms, with weapons that are described not only as highly valuable but many generations

Three levels of wear were recorded for the finds in the collection: 'light', 'moderate' and 'heavy' (table 4.1). Wear may be caused by multiple factors, so the degree of surface attrition on an object is not necessarily a straightforward measure of age. While the continuous use of an item over time can be assumed to have contributed, the intensity of its use is also important to consider, together with the object's actual function and the hardness of its material. Furthermore, judging wear is subjective, and in the case of the collection it was additionally complicated by the fragmented and damaged state of much of the metalwork. It is considered, therefore, that the results of the study can only serve as an approximate guide to how long the material was in circulation. Table 4.2 summarises the results of the wear survey for the different weapon- and scabbard-fittings.

Level of wear	Characteristics of wear:
Light	Light smoothing of edges and relief decoration; minor flattening of filigree beading (visible under microscope).
Moderate	Extensive light scratches; moderate smoothing of edges, of relief and punch decoration, and filigree beading.
Heavy	Extensive light scratches; considerable loss of relief and punch decoration in areas; heavy erosion of filigree beading; loss of filigree wires; gold sheet worn through.

▲ Table 4.1. Criteria for judging wear.

Object-type	*Light*	*no.*	*Moderate*	*no.*	*Heavy*	*no.*	*Wear n/a*	*Polishing marks*
Pommels	32%	25	47%	37	21%	16	-	-
Hilt-collars	75%	80	21%	22	5%	5	1	1
Hilt-rings	79%	41	15%	8	-	-	3	-
Hilt-plates/guards	37%	63	36%	61	5%	9	34	20
Small mounts†	63%	81	23%	30	11%	14	3	-
Pyramid/button-fittings	77%	10	15%	2	-	-	1	-

▲ Table 4.2. Wear on weapon- and scabbard-fittings. '†': mainly hilt-fittings.

Fig 4.2. Heavy wear and damage to the apex of pommel **14**. The sheet cap has been partly worn away (arrow), and the filigree wires have been flattened from wear and by a tool, possibly a pair of tongs. *Photograph*: © Birmingham Museums Trust.

It was found that levels of wear were easiest to grade on the gold filigree finds with delicate beaded-wire ornament. This is because use of these objects has led to the gradual erosion of miniscule amounts of gold from surfaces, reducing the raised, patterned wires so that in extreme cases they appear flat (figs 4.2–4.4). Also, on some gold filigree pommels (**4**, **9** and **14–15**) the sheet cap that covered the apex has worn through and torn (fig 4.2), evidence that certainly suggests prolonged use. Heavy attrition is also seen on some silver items, for example, pommel **68** (fig 4.5). Its relief ornament is worn smooth at the apex and edges, and probably much of the original gilding and perhaps niello inlay had already been lost by the time it was deposited. The harder material properties of a silver alloy, compared to gold,[10] mean that the heavy wear on this silver pommel is suggestive of a longer period of use than for the gold filigree objects with equivalent wear. This is in keeping with the early date ascribed to pommel **68**,[11] though it is possible that the gold fittings with heavy wear also came from 'heirloom' swords.

In cases of light wear to filigree objects, the beading of the wires appears only slightly reduced, and such wear is sometimes detectable only with a microscope (fig 4.3). Notably, items with coverings of cloisonné often appeared to have less wear. This might have an explanation in chronology (i.e. the objects could be later in date than the majority with filigree), but also the hardness of the garnet inlays may have made these objects more resistant to abrasion. For instance, the filigree decorated ends and edges of pommel **49** show moderate wear, and its cloisonné on one side was repaired (see below), but the garnet-inlaid surfaces do not suggest the same degree of use (fig 4.12).

Fig 4.4. Heavy wear on one side of pommel **3**, including a missing wire at the apex (arrow). *Photograph*: © Birmingham Museums Trust.

Fig 4.3. Comparison of wear on two gold filigree pommels: i) light wear to pommel **5**; ii) heavy wear to pommel **2**. The wear is focused at the edges and apex, and one side of one rivet-housing has been eroded. *Photograph*: © Birmingham Museums Trust.

Fig 4.5. Heavy wear to the edges of the shoulders and apex of silver pommel **68**, which has removed details of the animal ornament and beaded framing (scale 2/1). *Photograph*: G. Evans.

England the sword was predominantly used as a key component of elite warrior costume, with its real force as an instrument for aggression a dormant prospect.

There are exceptions, of course, within the general patterns observed. Two sets of filigree pommels and hilt-collars (**1** and **87–8**; **5** and **89–90**) show only light to moderate wear, yet their early Style II animal ornament indicates that they must have adorned sword-hilts for at least half a century.[15] This poses the question of whether some ornate weapons might have been used only on ceremonial occasions, with their owners possessing more ordinary swords for battle. Or perhaps the arms in question were owned by individuals who avoided or neglected their duty. Conversely, pommel 77 shows heavy wear on its protruding ring-knobs, which is somewhat at odds with the later date of this object within the overall Hoard chronology.[16] Furthermore, the closely related group of silver pommels **64–6** display varying degrees of wear, even though they must have been made around the same time. This suggests that they had non-uniform 'biographies', with the swords they were attached to used differently.

Apart from the heavily worn ends observed on a small number of hilt-plates, mostly it was the filigree collars around bosses that allowed a determination of the level of wear on plates. However, a different form of wear was also seen repeatedly on bottom plates

It is interesting to consider how the wear to the weapon-fittings occurred, and what the levels and patterns of abrasion tell us about how the actual weapons might have been used. According to Brunning, most pictorial scenes and written sources from Anglo-Saxon England and north-west Europe describe or depict swords drawn and wielded.[12] However, some illustrate swords worn at the waist as part of aristocratic masculine dress, as on the Hoard's sheet panels (**596–7**: figs 2.52–2.53 and 5.18). These two different uses for the sword can be compared against the cumulative evidence from the weapon-fittings (table 4.2). Pommels show the most wear, which was typically at apices, at the edges of shoulders, and on the tops of rivets and their housings (fig 4.6; cf figs 4.2–4.5). This accords with Brunning's survey, which found similar wear on pommels.[13] It is tempting to suggest, as Brunning has done, that this wear was the result of the habit of resting a hand on the pommel of a weapon when it was worn scabbarded at the waist. However, some of the Hoard's hilt-plates also show heavy attrition at their tips (fig 4.6), as on plates **317** and **320**, where the gold sheet is completely worn through. The same pattern is seen for sets of filigree mounts that wrapped around the ends of guards (**439–45** and **451–3**). By contrast, less wear generally is seen on hilt-collars, hilt-rings and other small mounts from the grip (table 4.2), including examples dated to the sixth century, which must have been of some age when deposited (i.e. **85–90** and **182–7**). Rather than wear from handling, therefore, this combined evidence suggests wear that resulted from the action of clothing repeatedly brushing against a sword-hilt when it was worn scabbarded.[14] Hence, the wear patterns observed for the Hoard metalwork do not match the popular image in the early medieval sources of the drawn blade with violent purpose, but instead may be better explained as the result of casual but persistent abrasion that occurred while swords were worn 'peacefully' at the waist. This implies that in the early kingdoms of Anglo-Saxon

Fig 4.6. Schematic drawing showing points of most wear in red: on the apex and edges of pommels; and at the ends of fittings on guards. The line in blue represents polishing marks observed on hilt-plates of the lower guard. *Drawing*: C. Fern.

from the lower guard (fig 4.6). Scratches are common to every find in the collection, of course, but the character of the light abrasion in question is different from the random striations normally seen. The scratches are fine, longitudinal and parallel with the blade-slots on the plates; very possibly they are the result of polishing (figs 4.7–4.9). Examples include the scratches on hilt-collar **168** from the bottom of the cloisonné seax hilt (fig 4.8; cf fig 3.80), and those covering the relief animal ornament on hilt-plate **370** (fig 4.9). Sword and seax blades would have required regular maintenance, and if rust spots formed these would have had to be removed by rubbing, probably with an oil or fat containing a light abrasive. It is likely that the top of the blade was most prone to rust, due to the ingress of moisture (including rainwater) and air at the top of a scabbard.[17] Hence, it can be imagined how the hilt-plates of the lower guard, which were at the junction of the hilt and blade, were particularly exposed to this maintenance, and were scratched as a result. Furthermore, it proposes another means by which wear to all objects could have occurred, from deliberate polishing, though this could not have been carried out on objects with coverings of filigree ornament, as they would have been damaged by the rubbing action. The later Anglo-Saxon will of Æthelstan, already mentioned in relation to the bequest of the corrosion-pitted sword of Offa, also records the existence within the prince's household of a *swurdhwitan* ('sword-polisher or -furbisher'),[18] a specialist servant class that perhaps had its roots much earlier, based on the evidence here.

◀ Silver-gilt pommel **68** showing a bearded human head and animal legs (not to scale). *Photograph*: D. Rowan; © Birmingham Museums Trust.

▲ **Fig 4.7.** Hilt-plate **293** showing longitudinal scratches probably caused by polishing of the sword blade. *Photograph*: © Birmingham Museums Trust.

▲ **Fig 4.8.** Hilt-collar **168** showing polishing scratches aligned with the slot for the seax blade. *Photograph*: C. Fern.

◀ **Fig 4.9.** Hilt-plate **370** showing polishing scratches over relief animal ornament (overlaid by a larger scratch) and aligned with the blade-slot. *Photograph*: C. Fern.

▲ **Fig 4.10.** Hilt-plate **289** showing a mark (arrow) around the rivet-holes left by a pommel. The beaded wire collar at the tip is missing its boss-headed rivet. The filigree demonstrates moderate wear. *Photograph*: © Birmingham Museums Trust.

Also seen commonly on the hilt-plates are impressions and patinas left from contact with other fittings from the hilt (fig 2.18). Top plates of the upper guard often bear the outline impression from a pommel (fig 4.10); and marks are seen on other plates, from hilt-collars and hilt-rings, as on hilt-plate **244** (fig 2.19). Contact marks are rare on other objects, though some hilt-rings show flattening on the edges that contacted the grip and guards. Seax collar **168** has an impression surrounding its blade-slot from the actual iron blade (fig 3.80).

Certain key objects show little if any abrasion (except blade polishing), which has implications for their dating:[19] seax hilt-fittings **55**, **167–9** and **225**; pommel **57**; seax hilt-plate **370**; great cross **539**; head-dress mount **541**; cross-pendant **588**; and cast helmet-parts **589–92**. The large cloisonné mounts (**542–66**) also appear largely unworn, though some show repairs (**558–9**), as does one garnet boss from cross **539** (fig 4.1).[20] The filigree cross-pendant ought to have signs of casual abrasion from clothing in the same way as the weapon-fittings, but objects like the great cross and helmet would have been less exposed to such wear. However, it is worth noting that the York Coppergate helmet, which was perhaps 100 years old when it was buried in the ninth century, does show extensive wear to its raised crest parts and had been repaired.[21] In contrast, the near-pristine gilded surfaces of the Hoard helmet (that were not damaged by removal) suggest it was far from a relic when dismantled.

MODIFICATION AND REPAIR

Instances of modification and repair further demonstrate the use and upkeep of valued objects. Definite examples in the collection are few, although they make an important contribution to the growing evidence for curation and object adaptation in Anglo-Saxon England. Previous studies have observed cases of modification and maintenance to 'heirloom' swords,[22] including in relation to the sword-ring custom, with the 'rings' fitted to existing weapons as symbols of status and obligation.[23]

One pair of silver hilt-plates (**372–3**) might have been adapted for a sword-ring, as a single large hole was drilled through each plate (one end of the upper guard), and filing marks are visible around the holes (fig 4.11). One of the silver ring-rivets (**82**) in the collection is an approximate fit with the plates.

Fig 4.11. Hole (arrow) drilled at one end of hilt-plate **373** with filing marks. It was possibly done to fit a sword-ring. *Photograph*: © Birmingham Museums Trust.

One of the clearest examples of a repair is the garnet cabochon from the lower arm of the great cross (fig 4.1). At some point the stone was smashed and a chip from one side was lost. A garnet slice, with a different provenance from the original stone,[24] was shaped to replace the missing part and it was mounted in its own thin collar of gold.

There are several other possible repairs to cloisonné objects. Pommel **49** has two red glass inlays among its otherwise garnet stones (fig 4.12). This has a parallel in the small number of glass repairs for lost garnets on the St Cuthbert pectoral cross.[25] An alternative explanation, however, is that the glass was used in these instances in place of a full supply of garnets, or in the absence of enough stones of sufficient size.[26] On hilt-collar **157** a missing garnet was replaced instead with an amber setting, and hilt-plate **363** has two of its cloisonné cells filled with an 'unidentified' material that may likewise indicate some substitute inlay.[27] Mounts **558–9** have three filigree panels between them that are marked out by the fact that they have serpents with heads different from all the others (fig 2.63), which again could represent refurbishment after the loss of some original panels. A further type of repair may be indicated by multiple small perforations observed on the reverse of cloisonné mount **553**: these were perhaps made with a needle-like tool that was used to push outwards stones that had sunk in their cells, a method proposed by Bruce-Mitford in relation to perforations of similar character on the back of cloisonné mounts from Sutton Hoo mound 1.[28]

Fig 4.12. Two glass inlays on pommel **49**, replacements probably for lost garnets. *Photograph and (inset) drawing*: C. Fern.

Possible evidence that some swords had been dismantled for repair or refitting (perhaps with new blades) before their precious-metal parts became part of the Hoard comes from instances of hilt-plates with additional fixing-holes. However, it is also feasible that these could represent acts of misalignment during manufacture.[29] Extra fixing-holes were also noted on several small mounts (**422**, **481** and **486**), on the top of the column of mount **541** and on the gold mounts from hilt-collar remains **188**.

Instances of mismatched nails or rivets were also recorded, which might suggest replacements, including on pommel **14** and mount **451**. On small mount **486** a copper-alloy nail had been driven through the centre of the fitting, while the two others in the set of three have original gold pins. Similarly, a replacement small garnet boss is indicated by the non-uniform pair on the top plate of hilt-plate pair **243** (fig 2.19).

Along half of the length of helmet-band **593** the decorated sheet band had been penetrated by rivet-holes that did not respect the ornament. These possibly indicate another repair, perhaps to reinstate the sheet band, which appears originally only to have been glued in position.

Several final examples are worth noting, though none is certain: pommel **55** was made using a different gold alloy from the other parts of the seax hilt-suite, so it might be a replacement;[30] if the scratched mark on silver pommel **72** is a rune, then it could be considered a modification;[31] and the random stamping on pommel **73** may indicate it was used by a smith as a test piece after it was removed from its sword.[32]

DAMAGE

A prevailing feature of the Hoard is the damage done to its objects, which have been torn, cut, prised and folded, with a total disregard for their superbly ornate craftsmanship and high contemporary worth. The majority of the finds appear to have suffered some form of injury prior to deposition, although much of the silver metalwork had deteriorated further after burial. Only a small number of objects indicate damage that was probably caused by the plough that raised the collection: the clearest example is the large discoloured dent on one side of seax hilt-collar **168**. Table 4.3 summarises the different patterns of ancient damage seen for the different find types, suggesting that the fittings were removed from their original objects by various means.

Around a third of the objects have potential cut marks or scratches, most probably caused by knives. The marks generally look remarkably fresh, though their antiquity is proven by coverings of tarnish. Very few seem to relate to damage from use before dismantling, though one exception may be the deep scratch on bird-fish mount **538** (fig 2.66ii). Nor are the cut marks random; rather, they give the impression of having been controlled even when relatively severe (figs 4.13–4.16). A distinction can be drawn, therefore, with the very different slashing and chopping marks, from axes and swords, seen on the ritually destroyed war-gear of the great bog sacrifices of the early first millennium AD in north Germany and south Scandinavia.[33] Nor are the marks like the scars from actual battle seen on objects from the same deposits, in the form of notches on blades and puncture marks from spears and arrows. A few instances of more forceful cuts do stand out in the

Object-type	'Intact'†	Missing/damaged rivet-housings	DAMAGE INTERPRETATION					
			Torn	Cut marks & blade scratches	Tool marks	Levered	Folded	damaged fixing-holes
Pommels	33%	38%‡	4%	14%	32%	24%	-	-
Hilt-collars	17%	-	49%	41%	12%	7%	3%	-
Hilt-rings	15%	-	13%*	56%	19%	4%	-	-
Hilt-plates/guards	7%	-	57%	16%	6%	4%	5%	4%
Small mounts#	55%	-	48%	14%	6%	9%	<1%	12%
Large mounts	20%	-	34%	49%	-	3%	14%	23%
Pyramid/button-fittings	67%	-	17%	-	-	-	-	-
Helmet parts	-	-	●	●	-	●	-	-

▲ **Table 4.3.** Interpretation of damage on weapon- and scabbard-fittings. '*': hilt-rings 'broken apart' without signs of cutting; '†': includes fully intact objects, those with minor damage, and those slightly misshapen; '‡': includes end fragments; '#': mainly hilt-fittings.

collection, nevertheless. Chop marks on silver-socket **685** were perhaps the result of an attempt to truncate the hornbeam shaft it had secured, and some longer mounts (**545**, **547** and **564**) were crudely divided.

That more than one individual was tasked with the object breaking may be suggested by the patterns of damage on some pairs of hilt-collars and hilt-rings. Hilt-collars **85-6** were severed with angular cuts (figs 4.13–4.14) and so was collar **105**. Hilt-collar pair **114–5** present with vertical cuts, as does flattened collar **92** and mount **456** (fig 4.15). Other collars were cut open at the original soldered join in their circuit (**130–1**, **135–6**, **138**, **144**, **146** and **154**).

Some fittings and mounts seem simply to have been torn away from their hilts, like filigree guard-tip set **443**–**7**. Often, the collars and rings removed by this means had also broken at an original seam, where the structure was weakest.

Removal of the fittings by cutting or tearing could have left the grip and guards of some swords complete, if unadorned, and these weapons might have been immediately reusable. However, those hilt-collars and hilt-rings that are relatively intact must indicate that dismantling of the hilt was undertaken,[34] and this is indicated too by those hilt-plates (**243–4** and **258**) and mounts (**412–3** and **451**) that were deposited still attached to their horn or bone guards.

◀ **Fig 4.13.** Angled cut marks on hilt-collar **85** at two magnifications. *Photographs*: © Birmingham Museums Trust.

▲ **Fig 4.14.** Angled cut mark on hilt-collar **86**, suggesting controlled removal (cf the damage to its pair shown in fig 4.13). *Photograph*: © Birmingham Museums Trust.

▲ **Fig 4.15.** Vertical cut mark on mount **456**. *Photograph*: © Birmingham Museums Trust.

▲ **Fig 4.16.** Cut end of hilt-ring **222**. *Photograph*: C. Fern.

▲ **Fig 4.17.** Torn-open underside of pommel **55**, showing the pin-housing (arrow 1) and a levering mark (arrow 2). *Photograph*: C. Fern.

▲ **Fig 4.18.** Cut mark and a burr of metal on the edge of hilt-plate **387**. *Photograph*: C. Fern.

Fig 4.19. Cut marks from the point and edge of a blade inserted under hilt-plate **328**. *Photograph*: © Birmingham Museums Trust.

Damage on some pommels suggests levering. Pommel **57** has a slicing cut on its base, its rivets were severed and one end was torn and bent upwards (fig 2.10): probably a knife had been pushed under its base to lever it off its sword. Other pommels also have damaged basal edges (**4**, **38** and **46**) or cut rivets (**48**, **53**, **55**, **60–1** and **76**) and they could have been removed in the same manner. Pommel **55** from the seax hilt-suite is the clearest example. Its underside was torn open as it was levered, releasing a pin that had fastened the pommel to the tang and leaving a dent on the cap-fitting (**169**) on which it had sat (figs 3.80 and 4.17).

Slicing marks, which removed pieces of side flange, can also be seen on the reverse of some of the cloisonné strip-mounts (**547** and **559–61**). This damage again was presumably caused by a blade being slid horizontally under the mounts, and a similar action is indicated by the burr of metal on one edge of hilt-plate **387** (fig 4.18). Also notable are several cut marks on bird-headed mount **464** (fig 2.35).

Scratches caused by the sliding tip of a blade, and in a few cases puncture marks from the tip, occur on hilt-plates and other objects (figs 4.19–4.24). On several hilt-plates (**287**, **289** and **317**) they are associated with contact marks left by hilt-collars or pommels, again pointing to the use of knives to lever off these fittings. Others concentrate around rivet-holes, from the removal of washers and bosses. However, tearing is the most common damage for the gold hilt-plates, presumably as their thin, soft metal yielded with relative ease, allowing them to simply be peeled from the weapon guards. In many cases this also caused the fixing-holes to be distorted (fig 4.25) as the plates were pulled against their nails or rivets. This damage feature is also seen on some gold mounts.

Fig 4.20. Cut marks on hilt-plate **373**. *Photograph*: © Birmingham Museums Trust.

Fig 4.21. Blade scratches on hilt-plate **287**. *Photograph*: © Birmingham Museums Trust.

Around a third of the gold filigree pommels are missing their rivet-housings from one or both ends, and there is also the small group of detached end fragments (**59–62**). The rivet-housings were often added separately in manufacture and so the joins are a point of weakness. Other pommels have rivet-housings that are broken or distorted (**20**, **31**, **34**, **41**, **57**, **68** and **78**). Some of this damage was probably caused by levering, but there is additional evidence that around a third of the pommels were pulled from their weapons by another means.

Flattening of filigree ornament and dents on the sides of some pommels suggest the use of metalworking tongs for dismantling, of which a rare contemporary example is the pair from the seventh-century smith's grave at Tattershall Thorpe (fig 4.26).[35]

◀ **Fig 4.22.** Mark from the point of a knife on hilt-plate **314**. *Photograph*: © Birmingham Museums Trust.

▲ **Fig 4.24.** Cut marks on one side of mount **489** from the point of a knife used to lever the fitting out of its recess on a weapon-hilt. *Photograph*: © Birmingham Museums Trust.

▲ **Fig 4.23.** Blade scratches around rivet-holes on hilt-plate **320**, probably caused during the removal of a washer or boss. *Photograph*: © Birmingham Museums Trust.

▲ **Fig 4.25.** Stretched fixing-holes on the reverse of guard-tip mount **510**. *Photograph*: © Birmingham Museums Trust.

Close examination of the objects was necessary, however, to distinguish this type of damage from the similar effects of heavy wear or an impact. Original photographs were consulted: where mud had covered the damage and where the flattening is on both sides it was deemed more certain to be old. Also, in contrast with the smoothing of filigree ornament from wear that was due to the gradual erosion of the gold, the compressing effect of a tool has resulted in the displacement of the metal, not its loss, and the flattening can be further associated with micro-striations (fig 4.27). Moreover, in some cases slight horizontal dents or undulations were observed, indicating what may be impressions from the gripping 'teeth' of the tool that was used (fig 4.28). Other possible tool marks occurred on hilt-collars, hilt-rings and hilt-plates (fig 4.29), including two especially clear instances of 'teeth' patterns on gold hilt-plate fragments (fig 4.30–4.31), though it is uncertain if these were made by tongs or a different kind of tool.

The types of damage discussed so far appear incidental to dismantling, but a small number of objects exhibit injury or manipulation that appears more deliberate, and that in some cases might have been carried out for ideological reasons. The top arm of cross-pendant **588** was snapped off and another is bent (fig 2.81); it is of a robust construction and so considerable effort would have been needed to break it. Other Christian objects may suggest similar treatment, but are less certain examples: all three smaller cross mounts have damage to at least one arm (**481–2** and **526**); while two fragments (**680** and **684**) and the inscribed strip (**540**) are possibly single arms from crosses. Perhaps all were targeted with the intention of 'breaking' their power, by the act of fragmenting the cross form. However, as a caveat, it is notable that the famous pectoral cross of St Cuthbert had suffered a broken arm twice from ordinary use.[36]

▲ **Fig 4.26.** Iron smithing tongs from the Tattershall Thorpe grave (scale 1/2). *Drawing:* adapted by C. Fern, after Hinton 2000.

▶ **Fig 4.27.** Pommel **2** demonstrating considerable wear to its gold filigree (arrow 1), but its decoration was also flattened on both sides, probably by a tool (arrow 2), resulting in metal displacement and micro-striations. Soil had covered this evidence, confirming its antiquity. *Photograph:* © Birmingham Museums Trust.

Fig 4.28. Pommels **14** and **56** showing horizontal dents, in each case on both sides, probably from the 'teeth' of a tool. The missing ends of pommel **56** were probably torn off in the same process of removal (scale 3/2). *Photographs*: © Birmingham Museums Trust and G. Evans. *Drawing*: C. Fern.

The folding of the arms of the great cross (**539**) and that of the inscribed strip (**540**) might also be seen as iconoclastic acts in the context of the overtly religious nature of these objects (figs 2.73 and 2.78). However, as Leahy has suggested,[37] the manipulation of these large items might instead have been due to a need to fit them into a small bag or other container. Herbert's account that at discovery the detached bosses of the cross had been parcelled inside its folded arms may further support such an argument.[38] In addition, the longer cloisonné strip-mounts (**544–7** and **558–9**) were cut and bent to a similar maximum size (fig 2.58). Of course, it could be argued that these actions achieved both ends – annihilation of the sacred, and mundane storage.

Nevertheless, a clear act of sacrilege seems to be indicated by damage to bird-fish mount **538** (fig 2.66i), regardless of whether a Christian or 'pagan' meaning is proposed for the fish symbol.[39] The head of the fish that was made as a whole with the rest of the mount was found detached, and since the severing break is not near a point of weakness (such as a fixing-hole or sheet join) it appears to have been a considered decapitation.

Other smaller objects were neatly folded, including parts of hilt-collars **93** and **122**, and hilt-plate **325** (fig 4.32). These could simply represent casual acts, however, and perhaps they show a smith thinking ahead to how the objects would be melted down in one of the small crucibles typical of the period.[40]

The deconstruction of the helmet is also partly revealed from its various parts. Silver helmet-band **593** has repeated nicks along one edge, as well as blade scratches within the band, marks presumably made by a knife used to lever out its gilded sheet band showing a

Fig 4.29. Hilt-ring **221**, of wrapped-beaded gold wire, pinched on one edge by a tool. *Photograph*: © Birmingham Museums Trust.

procession of warriors (figs 2.49 and 4.33). Possibly this was done to expose the rivets that would have lain behind the decorated sheet. It appears that the rigid two-piece silver band was then pulled off the cap in chunks. The cheek-pieces (**591–2**) were found separated from their tabs, which had been cast as one with them, and one cheek-piece (**592**) is bent with its front edge torn off (fig 2.46); its poorer condition overall is possibly due to the extra seasons it spent in the plough-soil (it was not found until 2012). In both cases, the cheek-piece tabs had been bent until they eventually snapped, which may have resulted from forcing the inflexible fittings outwards against the solid edges of the cap. Breaking the cheek-pieces off would have freed the gold collars that surrounded the tabs, and this may have been the intention. The crest sections (**589–90**) were doubtless also levered off, before being bent (fig 2.45), probably again to make them small enough for a container. The decorated silver-gilt sheet that is argued to have covered the cap also has some evidence of cutting, but it is uncertain whether some or all of this relates to the trimming of the sheet to fit at manufacture. The sheet coverings would probably have been simple enough to remove once the framework of reeded strip (**613**) and any edging (**615**) was peeled off. Overall, the helmet's total destruction can be compared with the treatment of two other Anglo-Saxon helmets. That from Wollaston (Northamptonshire) had been rendered unusable, by forcing its nasal into the cap, before it was placed in a grave.[41] In contrast, great care was taken in the partial dismantling of the Coppergate helmet, found buried in a pit at York, suggesting that its reuse was intended.[42]

▲ **Fig 4.30.** Hilt-plate fragment **347** with tool 'teeth' marks (arrow). *Photograph*: © Birmingham Museums Trust.

▲ **Fig 4.31.** Hilt-plate fragment **355** with tool 'teeth' marks (arrow). *Photograph*: BMAG, © Birmingham Museums Trust.

▲ **Fig 4.32.** Hilt-plate **325**, neatly folded and with torn rivet-holes (scale 1/1). *Photograph*: C. Fern.

▲ **Fig 4.33.** Nicks from a blade along the edge of helmet-band **593**. Scratches in the interior were probably made by the tip of the same knife. *Photograph*: R. Altpeter, © Birmingham Museums Trust.

CONCLUSION

Few objects are without impairment and it is clear that the metalwork as a whole is the result of a process (or processes) of crude but systematic dismantling. Refitting was clearly not intended, since only a small number of items were left sufficiently intact. Nor was any concern shown for the high cultural worth of the objects; even the most outstanding were cut, bent and levered (e.g. pommel **57**; cross **539**; cloisonné seax set **55**, **167–9** and **225**; and large cloisonné mounts **542–66**). As was suggested soon after discovery, the stripped sword-blades may be absent from the collection because they were quickly re-hilted, albeit as plainer weapons, and put back into circulation,[43] whereas objects like the helmet and cross were utterly destroyed. While nothing in England compares exactly, it is notable that some of the related gold filigree pommels from outside of the Hoard, mostly single finds, do show levered edges or are missing ends, suggesting that they too could have been removed in a similar manner.[44] In the context of the battlefield, it is tempting to see the damage demonstrated as a form of vindictive ritual, directed against the personified swords and other equipment of hated enemies.[45]

Certain Christian objects (**539–40** and **588**) and the bird-fish mount (**538**), in particular, show injuries for which an ideological or even iconoclastic interpretation is possible. Nevertheless, the stripping and breaking was clearly followed by a process of sorting to remove as much base-metal as possible, and the remaining objects very much give the impression of a 'harvest' of bullion. The dismantling could have been a single event, perhaps as much a form of triumphant display as it was also an act of economic management. This theory gains some support from the apparent symbolic selectivity of the Hoard contents, although the considerable date-range and suggested diverse origins of the material must ultimately leave open the possibility that more than one phase of object breaking occurred.[46]

The identification of the likely use of metalworking tongs in the dismantling process makes it conceivable that the work was carried out by the same enigmatic social group responsible for manufacture – smiths. Finally, this makes attractive the idea that some relationship was possible between the Hoard and the nearby settlement of Hammerwich (fig 1.3), a place-name that probably indicates a metalworking site of the Anglo-Saxon period,[47] though its contemporaneity is uncertain and its origin might be considerably later.

◀ Gold bird-fish mount **538** (not to scale).
Photograph: D. Rowan; © Birmingham Museums Trust.

CHAPTER FIVE

CHAPTER FIVE

STYLES OF DISPLAY AND REVELATION

CHRIS FERN

Most of the weapon-fittings and other objects are fashioned with intricate ornament in different animal, geometric and scrollwork styles. These represent the period's high arts, which were worn, wielded or otherwise displayed by the elite. Especially enthralling are the miniature designs of beasts and birds that are executed in filigree wire, inlaid in cloisonné, incised or cast. The mystery of their possible meaning is increased in many cases by their deliberate concealment in complex and often ambiguous patterns, and there can be no doubt that the mainly small objects bearing the art were intended to be scrutinised. Revelation of their hidden zoomorphic forms could have offered not only intellectual fulfilment but also spiritual enlightenment.[1] Masks, crosses and other geometric symbols can also be discerned on some objects. The drawings and analyses in this and previous chapters 'decode' many of the designs. Each deciphered image allows an intimate glimpse into the early Anglo-Saxon mind – of both maker and user. They show how the smiths who created the objects were not only supreme metalworkers but also ingenious artists.

The sophistication of the ornament accords with the oft-cited observation of Gregory the Great (*c* 540–604) that the image served in the place of the book for the religious learning of the illiterate masses of the period.[2] The crosses, hidden and overt, that occur on some of the objects must thus have affirmed and displayed a Christian allegiance in the context of the early conversion in Anglo-Saxon England in the seventh century. However, the animal ornament of the Hoard might have had very different meaning, since the decoration had its roots in 'pagan' Scandinavia, where it was probably associated with the worship of Odin.[3] Related and complex pre-Christian beliefs were fundamental to Germanic cultures across north-west Europe, and even if these religious systems are now difficult to comprehend with the passage of time, it is very unlikely that the ideological shift necessitated by Christian conversion resulted in their quick eradication. In England in the sixth century, before Christianity became widespread, the adopted Scandinavian animal art might accordingly have been associated with Woden (i.e. Odin), or with other deities, heroes or legends of Germanic belief. One of the best indications that this pre-Christian ornament did continue to bear 'pagan' meaning into the long phase of Christianisation of the Anglo-Saxon kingdoms is the fact that specific motifs with long-established pedigrees remained in use. In addition, the valuable gold and the blood-red to purple garnets used for the high-status objects may have had additional sacred significance, as well as connotations of imperial power.[4]

The Hoard's magnificent gilded helmet combines animal ornament with bold warrior imagery that, in contrast, is unambiguous in its message of power. The reconstructed order of the cap's human figural ornament suggests a military or even supernatural hierarchy (figs 2.48 and 2.56): lowermost was a band of running or kneeling rank-and-file fighters; above them (separated by an animal band) and larger in size were groups of marching warrior aristocrats or perhaps ancestors in mail and helmets; and surmounting all were panels showing ritualistic spear warriors and a victorious rider that may denote a king or even a god (i.e. Odin/Woden).

The styles in the Hoard are summarised in table 5.1. While most are well-known forms of ornament, if unequally studied, the *Early Insular style* is argued to represent an aesthetic that has not previously been so clearly manifested in an Anglo-Saxon metalwork assemblage. It resulted from the coming together, somewhere in Britain, of Anglo-Saxon and Celtic ornamental traditions.

STYLE AND SUBSTANCE

Animal ornament, like that in the collection, represents a crucial remnant of the intellectual heritage of Germanic Europe, in the period from the end of the Western Roman Empire to the time of the arrival of Christianity and literate culture.[5] It is thought that the ornament functioned to encode social and religious beliefs, and that very probably its forms, made interactive by their characteristic concealment and ambiguity, were considered to have magical protective power.[6] Hence, the decoration may have been restricted largely to the costume and equipment of elites as a means for signalling and legitimising their

Catalogue	Animal ornament Style I	Animal ornament Style II	Interlace (non-animal)	Scrollwork	Geometric cloisonné	Early Insular style
Pommels	-	41	34	10	19	6
Hilt-collars	2	28	32	9*	23	2
Hilt-plates/guards	-	1	2	1	9	2
Small mounts	-	48	12	42	33	12
Mount 538	-	1	-	-	-	-
Christian objects 539–41	-	3	1	-	1	-
Large mounts 542–66	-	6†	2	-	25	-
Pyramid/button-fittings	-	2	-	2	12	2
Cross-pendant 588	-	-	-	1	-	-
Helmet parts 589–92	-	4	-	-	-	-
Die-impressed sheet 594, 600–3	-	5	-	-	-	1
Fragments 605	-	1	-	-	-	-
Fragments 686	-	-	1	1*	-	1
Fragments 687	-	-	1	-	-	-
Fragment 691:[K1284]	-	-	1	-	-	1
Harness-mount 698	-	-	-	-	-	-
Total:	**2**	**140**	**86**	**66**	**122**	**27**

▲ Table 5.1. Styles in the Hoard (objects can manifest more than one style). '*': scrolls in cast ornament; '†': a total of thirty-one serpent-interlace panels and two (non-animal) interlace panels survive with cloisonné mounts 556-61.

authority, by privileging their association with prevailing and potent 'pagan' beliefs and legends that in turn sanctioned the social order.[7] Furthermore, the hidden quality of the art could have served as another form of control, by deliberately limiting understanding of its content to those permitted to 'wear' and 'read' it – the ruling warrior class. However, while the recurrent animal and geometric forms seen in the Hoard's ornament can be considered as iconography, we largely lack the context-specific knowledge from pre-Christian England needed to unpick their meaning.

Germanic animal ornament had become widespread and dominant in many parts of north-west Europe by the sixth century.[8] It has long been studied since its first classification in 1904 by the Swedish archaeologist Bernhard Salin, who characterised the art into

▲ **Fig 5.1.** Decoding Style II (enlargements scale 2/1). Eight zoomorphs typical of early Style II decorate each side of hilt-collar **90**: they share body parts and have 'paperclip' jaws with angled head-surrounds; also contained in the writhing composition are quatrefoil motifs. More easily deciphered are the eight biting quadrupeds of late Style II on hilt-plate **370** that form a procession each side of the blade-slot. *Photographs*: G. Evans. *Drawing*: C. Fern.

Styles I, II and III.[9] Only the first two of these styles are found in Anglo-Saxon England and both occur in the Hoard, but in very unequal quantities: Style I (two objects) and Style II (140 objects) (table 5.1). Salin's classification allowed archaeologists to consider animal ornament as a means for relative dating, since the non-naturalistic forms that are manifested in the art change their style

over time. Stylistic differences in the Hoard's animal Style II are likewise considered significant for dating.[10]

It is accepted that Style I originated in south Scandinavia in the fifth century, where it was adapted from late Roman art into a style of contorted, often fragmented, animal and human forms.[11] Alongside it was developed a partly related iconography on gold bracteates (pendants), which has been argued to represent the religion of Odin and other gods.[12] The Style I produced in Anglo-Saxon England has also been shown to be a complex ornament that had significant, probably religious, meaning.[13] Across Europe, the style was transformed around the mid-sixth century by the influence of interlace art.[14] Its renewed popularity at this time was probably due to increased contact with the Byzantine Empire, the dominion of which extended to northern Italy. The result was a new ornament: Style II. In this style animal forms were instead made sinuous and interwoven in rhythmic patterns (fig 5.1).[15] Where this artistic transformation first occurred is debated, since a preceding phase of interlace with Style I can be found in several regions of Europe prior to the full appearance of Style II, including in Anglo-Saxon England.[16] Possibly it is wrong to look for a single point of genesis. Nevertheless, the flourishing of Style II in Scandinavia stands out in particular, as is demonstrated by ornament from the ship-burials of Vendel and Valsgärde (Sweden),[17] and it may have had its origin in the region like Style I before it.[18] Certainly, Scandinavian Style II appears to have been a key influence on the adoption and development of the art in England.[19] However, early examples of Style II also occur on the Continent among the Merovingians and Lombards, cultures that had close contact with the Byzantine Empire during the sixth century.[20]

The transition from Style I to Style II took place around the same time as significant social change in Europe and Scandinavia, which is reflected in the application of the ornament. Gilded objects with Style I are not especially uncommon, reflecting the fact that this ornament served the numerous petty hierarchies that then existed in the localised landscape of sixth-century England.[21] The take up of Style II from the later sixth century, however, coincided with the emergence of dynastic elites across Europe, so its objects are rarer, as the ornament by this time had become restricted to a smaller, paramount social class. Consequently, Style II objects are more often of precious metal and, when found in graves, the burials tend to be richly furnished and some have accompanying barrows.[22] Style II was used to decorate both masculine and feminine equipment, including military fittings, belt furniture, horse-harness and brooches. Also, around the same time, cloisonné in the stepped-geometric style of the Continent was adopted in southern England, an aesthetic that may have been considered ultimately 'Roman', just like the Mediterranean interlace that inspired Style II.[23]

Two regional versions of Anglo-Saxon Style II have been suggested previously – 'Kentish' and 'Anglian' – on the basis of the rich material culture of the kingdoms of Kent and East Anglia.[24] Both feature objects with filigree and cloisonné decoration, but the former technique is most associated with Kentish metalworking, while not even the finest objects of the Hoard surpass the excellence of the cloisonné of Sutton Hoo (Suffolk), in southern East Anglia. However, the genuineness of these two regional traditions is now challenged by the Style II of the Hoard. In *Chapter 6*, it is argued that they should be redefined as being chronological rather than regional in character: as 'early' Anglo-Saxon Style II (previously that known as 'Kentish') and 'late' Anglo-Saxon Style II (previously that known as 'Anglian'). The different distributions of early and late Anglo-Saxon Style II can instead be understood as due to trends over time: animal ornament had possibly already fallen out of favour with the ruling Kentish elite by the time that late Anglo-Saxon Style II production was at its peak in Anglian regions, in the early seventh century.[25] In addition, the ornament of the Hoard now raises the strong likelihood that Style II was being enthusiastically produced elsewhere in England, beyond Kent and East Anglia.

That elite metalworking was of great importance to the emerging kingdoms of early Anglo-Saxon England is beyond doubt. Finds of gold- and garnet-decorated buckles and brooches from burials in Kent and East Anglia suggest the development of distinctive metalworking traditions.[26] Now the massed fittings of the Hoard are evidence for the likely existence of 'kingdom styles' of hilt-furniture for swords and seaxes. While the detailed ornament on the fittings is miniature, the dominant overall styles of the sets would have been readily appreciable at a glance (figs 3.80 and 6.6). In sum, it was not the miniature animal ornament of Style II that was used to display regional identity, but object-form combined with ornamental technology.

The question of what religious meaning Style II had is not straightforward, as the ornament was used in both 'pagan' (i.e. Scandinavian) and Christian contexts. The state of flux of old and new beliefs that characterised the Anglo-Saxon conversion, contemporary with the Hoard metalwork, arguably makes such an enquiry even harder, yet more vital. The fact that many of the key animal forms and motifs of Style II were inherited from Style I means it is possible that 'pagan' narratives remained associated. Indeed, Høilund Nielsen has argued that Style II and its mythology was adopted from Scandinavia by elites across Europe from the late sixth century as a means of continuing to display their affinity to the powerful northern region and its gods, at a time when the spread of Christianity threatened change.[27] A foil to this argument, however, is the fact that Style II was also applied to ecclesiastical objects in England and on the Continent.[28] For instance, in the Hoard

Fig 5.2. Gold and garnet pommel **52** with syncretic art: one side is the Germanic 'pagan' motif of a pair of creatures, perhaps horses, together with beaks of birds at the ends; the other side is a Christian *Romanitas* image of rounded arches, triangular pediments and crosses, probably based on a basilica, like that depicted on the broadly contemporary Byzantine weight from the British Museum. *Photograph*: D. Rowan, © Birmingham Museums Trust. *Drawing*: C. Fern.

Sutton Hoo mound 1 burial (possibly the grave of King Rædwald) is well known for its mix of Germanic and Christian objects and rituals.[33] Lastly, that ornament like that found in the Hoard could encode religious meaning is further suggested by the description of the 'Grendel' sword in *Beowulf*, which is argued to have been based on a representation of a filigree-decorated hilt.[34] In the poem the hilt's decoration is described as communicating the story of the Flood, although this biblical episode cannot have been original to the oral 'pagan' verse on which the epic was based, so perhaps it replaced an earlier pre-Christian legend. (Many of the Hoard's filigree pommels and other objects bear repeated, possibly 'pagan' religious motifs, which are discussed and interpreted below.)

The state of intellectual negotiation between old and new beliefs necessitated by the Conversion is actually reflected on objects in the Hoard. The most obvious instance is the great gold cross (**539**), which represents a version of the Roman *crux gemmata* (jewelled cross), but with Germanic zoomorphic ornament.[35] However, such syncretism is also a feature of some of the military fittings. Pommel **52** is perhaps the most ingenious example (fig 5.2): one side has a motif of confronted beasts, common in Germanic animal ornament,[36] as well as bird beaks at the ends; the other side shows a *Romanitas* vision formed by an unusual arrangement of rounded and pointed arches, with crosses at the ends.[37] The essential elements of this second design can be found in Byzantine art, for instance, on the weight illustrated in fig 5.2: it depicts a basilica with triangular pediments and a rounded arcade that houses a cross, and is probably a rendering of the Church of the Holy Sepulchre.[38]

it was used on the great gold cross (**539**) and head-dress mount (**541**). Symbols can change their meaning between contexts, of course, with creatures like birds and serpents appropriate to serve both pre-Christian and Christian spiritual menageries.[29] Nevertheless, there is also considerable evidence that beliefs linked with traditional power were not immediately dispensed with at the conversion in England. There is the famous tale of King Rædwald maintaining altars to Christ and to 'gods whom he had previously served'.[30] Woden was retained as an ancestor in the royal genealogies of Anglo-Saxon Christian rulers.[31] And the origin myth of Hengist ('Stallion') and Horsa ('Horse') remained essential to the Anglo-Saxon *gens* (i.e. folk character), even though it probably had its roots in a horse cult.[32] Likewise, archaeology has demonstrated cases of syncretic practice. The

Warriors have always taken their gods to war, so the application of pre-Christian and Christian imagery to weaponry and other

objects should be no great surprise. Probably the motifs displayed or hidden were considered to offer spiritual protection on the battlefield. As Webster has argued, the great cross (**539**) was very likely the talisman of a Christian Anglo-Saxon king and his army.[39] Sacred iconography on weaponry, in contrast, perhaps provided a more personal defence, with the favour of ancient and new gods sought equally in some cases, as is indicated by the syncretic ornament of pommel **52**. Lastly, the aggressive beasts, birds of prey and venomous serpents of the animal ornament might have been believed to transfer bestial attributes to the war-gear or warrior.[40]

ANIMAL ORNAMENT IN THE HOARD

One hundred and forty-two objects carry depictions of creatures or take animal form (table 5.1). The ornament is overwhelmingly of Style II form, with the total quantity representing a very significant, approximate doubling of the previous corpus for England.[41] Across Europe the ornament was in use from *c* 550 to *c* 650/675.

Only one pair of silver hilt-collars (**182–3**) has the earlier Style I form of the art, and given their worn condition they may be the collection's oldest objects. The chopped-up patterns in panels on one side of each collar show little that is recognisably animal or human, as is typical of later Style I in England (fig 5.3).[42] It has been suggested that this disarticulation and the art's general ambiguity reflects the existence of 'pagan' beliefs in animal-human transformation.[43]

Pommel **68** arguably captures the early development of Style II somewhere in Scandinavia and it is the only certain import in the collection. It may originally have had a bichrome appearance in silver with parcel gilding, as well as black niello inlay, as reconstructed in fig 5.4. On one side of the pommel is a bearded godhead with staring eyes – Odin perhaps – set between two animal legs. The other side has boar heads in the pommel corners, while two zoomorphs are shown centrally in an affronted pose: each has a ribbon body, a single leg and a head turned backward. Its overall programme of human–animal–interlace and somewhat disarticulated parts can be compared with the Style II on the illustrated buckle from Zealand (Denmark) (fig 5.4i). However, the best parallel for the human head, with its niello-dotted hair and nose-bar, is the head on the well-known buckle from Åker (Norway) with bichrome and niello early Style II (fig 5.4ii).[44] The origin of the buckle has been much debated, though it is generally agreed it dates around the last quarter of the sixth century.[45] A further detail of pommel **68** points to an association with other Scandinavian Style II: the legs flanking the head have hips with a separate lappet and a central ring-and-dot.[46] This hip-form is related to that seen with the horses that decorate the rim of the boss of the Sutton Hoo shield that was manufactured possibly in Sweden (fig 5.5i).[47] The positioning of the boar heads in the corners of the pommel on one side is more widely paralleled, but includes several further Scandinavian examples (fig 2.42i–ii).[48] Also, pommel **23** may be another instance, as its pattern of gold strips on each side can be said to imitate the placement of cornered 'heads'.

Most of the creatures of Anglo-Saxon Style II are highly stylised and often contorted into interlacing patterns, although some are more recognisable. The types decorating objects in the assemblage are representative of the ornament in England generally:[49] most common are strange 'zoomorphs', then serpents, quadrupeds (four-legged creatures) and birds of prey with curved beaks (table 5.2). Rarer are fish and boars, the latter being identified by tusks and blunt snouts, while wolves and horses can also be suggested. Human imagery is rare, with the exception of the warrior decoration of the helmet, but a number of objects have stylised faces, masks or helmets, and some have possible eye motifs.

The zoomorphs that populate the filigree appear especially abstract (e.g. fig 5.1: hilt-collar **90**): they have serpent-like bodies with hind-parts only or are limbless, looping and biting jaws, sometimes with angled head-surrounds; and most are without eyes. The angled head-surround is a curious and abundant characteristic of early Style II, a *leitmotif* which also features commonly with birds. Possibly it had some significance, now lost. The zoomorphs with hind-parts suggest a creature that in origin at least was something else before it was stretched and altered by the filigree medium. This is suggested by the stylistically related creature in filigree on a scabbard-mount from Hou (Langeland, Denmark), which appears to be a quadruped with all four limbs formed by curls (fig 5.5iii).[50] It is an object of the mid-sixth century, at the latest, and possibly such early objects with what appears to be antecedent ornament

Fig 5.3. Style I animal ornament on hilt-collars **182–3**. *Drawing*: C. Fern.

Fig 5.4. Pommels **68-9** and hilt-collars **186-7** with *comparanda*: i) buckle from Zealand (Denmark); ii) head from the Åker buckle (Norway); iii) pommel from Beckum (Germany); iv) zoomorphic detail from a harness-mount from Sutton Hoo mound 17 (Suffolk). *Drawing*: C. Fern, (iii) after Evison 1976.

were a key influence on early Style II filigree, in England and on the Continent.[51] The many examples of limbless zoomorphs in filigree on Hoard objects might be argued to represent a final stage in the Hou creature's evolution; or they might alternatively be interpreted as serpents. It might be speculated that the fantastical form of the zoomorph reflects a supernatural meaning, and it is tempting in particular to relate the creatures to the *wyrmas* of *Beowulf* and other Old English texts, a word that could describe both 'serpents' and 'dragons', although these written sources are centuries later in date.

Silver pommel **69** has a mirrored pair of zoomorphs shown affronted (fig 5.4; cf figs 2.16 and 2.33). A similar design is found on the form-related silver pommel from Beckum II (Germany) (fig 5.4iii). Anglo-Saxon examples of kindred creatures in cast metalwork are also plentiful, including those on a gilded copper-alloy harness-mount from Sutton Hoo mound 17 (fig 5.4iv).[52] The creature illustrated from this mount has a recognisable hind-leg to its serpent-like body, in contrast to the creatures on both pommels, which terminate in curls or loops, like the 'limbs' of the quadrupeds on the Hou mount (cf fig 5.5iii). Nevertheless, almost certainly these and other examples of cast and gilded Style II were meant to imitate the more prestigious instances in filigree. The silver collars (**186-7**) that are suggested as forming a set with pommel **69** have other examples of beasts and serpents, as well as panels filled with interlaced animal legs (fig 5.4).

Prior to the finding of the Hoard, Style II filigree in England was considered chiefly characteristic of the metalwork of the kingdom of Kent and other parts of southern England. An example of 'Kentish'

Object-type	Zoomorphs	Serpents	Quadrupeds	Birds	Fish	Boars	Face/mask/helmet	'Eye'	Warriors
Pommels	24	13	9	4	-	3	5	2	-
Sword-rings	-	-	-	1	-	-	-	-	-
Hilt-collars	12	11	7	-	-	1	-	-	-
Hilt-plates	-	-	1	-	-	-	-	-	-
Small mounts	6	9	3	20	4	-	8	2	-
Mount 538	-	-	-	1	1	-	-	-	-
Christian objects 539, 540, 541	2	2	2	1	-	-	-	-	-
Cloisonné mounts 542–543, 556–561	-	8†	-	-	-	-	-	2	-
Silver mounts 567–568	-	-	-	-	-	-	-	2	-
Pyramid-fittings 578–579	2	2	-	-	-	-	2	-	-
Helmet parts 589–592	2	4	4	2	-	-	-	-	-
Die-impressed sheet 593–604	3	-	2	2	-	-	1	-	5*
Fragment 605	-	-	1	-	-	-	-	-	-
Total:	51	49	29	29	5	4	16	8	5

▲ **Table 5.2.** Incidence of Style II creatures and anthropomorphic imagery (mask, 'eye' and warrior). '†': a total of thirty-one serpent-interlace panels survive with cloisonné mounts **556–61**; '*': **569–7** suggest a minimum of twelve original panels.

Style II is that decorating the triangular plate of a buckle from Alton (Hampshire), grave 16, which is one of a series of similar buckles (fig 5.5iv; cf fig 2.39).[53] In the collection, similar ornament is most common on the sides and shoulders of pommels and on the wide bands of the hilt-collars of high form. Certain examples (**1–2**, **85**, **88** and **90**) are especially close to 'Kentish' zoomorphic forms (figs 2.6, 5.1 and 5.5). However, the evidence and conclusions of the studies undertaken for the Hoard provide cause for thinking the collection's objects were not made in southern England, but are potentially from a different region or regions. The distribution of related filigree pommels shows a total absence of examples from south of the River Thames (fig 6.7),[54] while idiosyncrasies of the Hoard filigree suggest the possibility, if not the likelihood, of the existence of filigree-manufacturing workshops in other kingdoms.[55] In particular, the hilt-suite from Market Rasen (Lincolnshire) is a robust parallel for the collection's sets of filigree pommels and collars (fig 2.41).

It is also the case that much of the Hoard's Style II filigree departs from the strong sense of order of 'Kentish' examples (e.g. fig 5.5iv). Irregular patterns and creatures with interchangeable body parts occur repeatedly, and some designs combine these two compositional principles.[56] Several examples can be demonstrated. On hilt-collar **90** the jaws and body-strands of the zoomorphs must be switched within the identical design on each side in order to count all eight creatures (fig 5.1). On pommels **4–5** and **36** quartets of creatures with interchangeable body parts form central quatrefoil knots (fig 5.7). Hilt-collar **92** has bands of creatures on each side that multiply as their U-shaped jaws and body-strands are swapped (fig 5.9). Related are the paired zoomorphs with conjoined, U-headed jaws on mounts **425–6** (fig 5.9). As already stated, such ambiguity was undoubtedly deliberate: it made intellectual engagement with the design necessary to decipher its forms, bringing a sense of animation and possibly enlightenment; and at the same time any meaning the pattern had was concealed from the unknowing. To the 'uneducated' eye, many of the creatures are all but invisible and some patterns seem entirely disordered. This first appears to be the case on pommels **7** and **16** (fig 5.6), yet even the designs on these two objects are developed from the familiar motif of a pair of zoomorphs. This tendency for ambiguity was long established, being a feature of preceding Style I,[57] and it can be seen also in the inaugural Style II of the Hou mount (fig 5.5iii). It has been compared, furthermore, with the use of kennings and riddles in later Anglo-Saxon poetry, with both traditions perhaps reflecting an enduring fascination within Germanic culture for mental puzzles.[58]

Pommel **1** is a rare example in the assemblage that is close to the 'Kentish' orthodoxy of regular Style II (fig 5.5). Each side shows an almost identical design of two creatures, but total symmetry was avoided: on one side the zoomorphs' jaws terminate in curls in the corners that point upwards, while on the other side they point downwards. A similar design principle was applied on the smaller shoulder zones of many pommels. In most cases a single creature or interlace design is repeated on each shoulder, but it was rotated through 180 degrees in each case to create a balanced asymmetrical composition. The Style II creatures on pommel **69** are a rare instance among the animal interlace of the Hoard of a design with total mirror symmetry (fig 5.4).

The zoomorphs in filigree display a range of head-forms (figs 2.6, 5.1 and 5.6–5.9). Some demonstrate the quintessential form with an angled head-surround and looping jaws (e.g. **1**, **2**, **7**, **85** and **88**); others have paperclip-shaped jaws and head-surrounds (e.g. **8**, **36** and **90**) like the creatures on the Hou mount (cf fig 5.5iii); some have U-shaped jaws without head-surrounds (e.g. **3–5**, **17–9**, **34**, **36** and **92**); and a few have small O-shaped heads (**4**, **20–1** and **34**). On some objects, or within sets of objects, these different head-forms were combined (single objects: **4**, **6**, **12**, **34**, **36** and **118**; sets: **1** and **87–8**). The small O-shaped heads have no parallel in Anglo-Saxon filigree, but rare instances can be found in other forms of Style II on metalwork from England and the Continent.[59] Zoomorphs with U-shaped heads can be found among the cast Style II of Sutton Hoo mound 17, as well as in the animal ornament on die-impressed sheet mounts decorating drinking-cups from the 'princely' burial at Prittlewell.[60] Most significant is the similarity of the design on pommel **18** to that on a filigree pommel from Earl Shilton (Leicestershire): both show two addorsed, limbless zoomorphs with long U-shaped jaws (cf figs 5.5v and 5.6).[61] It is inconceivable that the complex designs on these two objects can have been devised independently of one another, so it would seem very likely that they are products of a single workshop.

The Germanic motif of a pair of creatures was applied on many of the pommels and not only to those with filigree ornament (e.g. figs 2.6, 2.10, 5.2, 5.4, 5.6 and 5.8). In some designs the beasts bite their own bodies, while in others they attack their twin. Pairs of zoomorphs form the motif on sixteen gold filigree pommels (**1–3**, **6–10**, **12**, **16–18**, **20–1** and **34–5**) and on two silver pommels (**68–9**). Quadruped creatures were used on the sides of other pommels in gold (**52–7**) and silver (**70–1** and **73**). Round-back pommel **56** has one of the clearest examples (fig 5.8), which is closely related to that on the well-known Crundale pommel. Others vary considerably in their legibility (fig 5.8): it is possible to interpret an abstract version of the pommel **56** design on pommel **35**, although, perhaps deliberately, the filigree ornament of the latter can also be read as a pair of zoomorphs and similarly the design on pommel **53** can be compared with the clumsier version on pommel **54**.

CHAPTER FIVE | **STYLES OF DISPLAY AND REVELATION**

▲ **Fig 5.5.** Style II filigree on pommel **1** and hilt-collars **85** and **88** with *comparanda*: i) motif of a pair of horses from the shield-boss from Sutton Hoo mound 1; ii) pommel from Skurup (Sweden); iii) scabbard mount from Hou (Langeland, Denmark); iv) 'Kentish' Style II from the Alton buckle (Hampshire); v) pommel from Earl Shilton (Leicestershire). *Drawing*: C. Fern.

218 PART I | THE HOARD

Fig 5.6. Pairs of zoomorphs on filigree pommels. *Drawing*: C. Fern.

CHAPTER FIVE | **STYLES OF DISPLAY AND REVELATION**

▲ **Fig 5.7.** Quartets of zoomorphs on filigree pommels. *Drawing*: C. Fern.

▲ **Fig 5.8.** Pairs of zoomorphs and quadrupeds (the 'paired-beast' motif) on pommels. Pommel **35** has two possible readings of its ornament. *Comparanda*: i) The design on the pommel from Crundale (Kent) can be compared especially with pommel **56**. *Drawing*: C. Fern.

Fig 5.9. Zoomorphs and quadrupeds on pommels, hilt-collars and mounts. *Drawing*: C. Fern, except **460** by G. Speake.

However, most cryptic of all are the creatures in the geometric garnet cloisonné of pommel **55**.

Most examples of pommels with the paired-beast motif had been found in Scandinavia prior to the Hoard, including the sixth-century pommel from Skurup (fig 5.5ii; cf fig 2.40).[62] Pairs of creatures can also be found on other Style II objects, however, as well as earlier in Style I.[63] While attributing any specific meaning to the motifs of Germanic animal ornament is highly problematic, it has been argued previously that some instances of the paired-beast design were representations of horses.[64] A particularly clear example is the equine pair from Sutton Hoo that have manes portrayed (fig 5.5i).[65] Horse customs were long-established in Scandinavia, from the prehistoric period onwards, and alongside races and sacrifice they probably included stallion baiting.[66] It is not impossible, therefore, that the motif was meant to depict a ritual in which two horses fought. The horse was certainly a quadruped with special importance in Anglo-Saxon England,[67] and while there is no evidence for horse baiting, the animal was sometimes a prized offering in burials and cremations.[68] Moreover, as already noted, a horse cult probably lay at the heart of the principal Anglo-Saxon legend of Hengist and Horsa, warrior brothers whose names meant 'stallion' and 'horse'.[69] That this motif and myth of origin was fundamental to the ruling warrior class of seventh-century England is suggested further by the appearance of Hengist in royal genealogy, and according to Bede a *monumentum* to Horsa remained in Kent even into the eighth century.[70] Nevertheless, while the long-necked and long-headed quadrupeds on some pommels can be said to be horse-like (**52–3**, **56–7** and **70**), the same is not true of the serpent-like zoomorphs on the filigree pommels, and furthermore other pommels and objects bear designs with higher multiples of creatures (e.g. fig 5.7).

Gold mount **460**, a fitting probably from the grip of a sword, was possibly another example of the motif. It is incomplete, but almost certainly it was double-headed originally (fig 5.9).[71] Again, the head with its flaring nostril and long-neck can be said to be horse-like, and correspondingly the remaining projection at the back of the other neck is hoof-like. The head-form can be compared, moreover, with the heads of the equally equine creatures on the mounts from maplewood cups from Sutton Hoo mound 1 (fig 5.12i).

Pairs of quadruped creatures occur also on filigree collars **109–10**, but are instead arranged head-to-tail, and the same motif is seen in cloisonné on one side of collar **166** (and probably on **165**) (fig 5.9). Irregular zoomorphic interlace, inhabited by U-headed creatures, decorates the other side of collars **165–6**. The somewhat inexpert finish of these collars can be compared with the supreme execution of the quadrupeds with tiny, beady eyes on the cloisonné seax collars (figs 3.80 and 3.95). Collar **167** has two panels per side, each containing a single identical but mirrored creature, with a looping body that is wrapped by its front and hind limbs. The pair of non-identical quadrupeds on each side of collar **168** are joined in an affronted pose by the gripping hind-leg of one of the creatures. In total, twelve beasts populate the seax set, including the two concealed on each side of pommel **55**. The Style II cloisonné of the seax collars (**167–8**) has been likened to that on the shoulder-clasps of Sutton Hoo mound 1.[72] However, the study of the collars' manufacture against that of the clasps has identified differences,[73] and in stylistic terms the animal ornament of the seax is surely later. This is suggested by the wrapping limbs of the creatures of collar **168** that are very like that of the quadruped from the Book of Durrow (fig 6.3). Nevertheless, it is difficult to resist ultimately the notion that the clasps and seax might both represent creations of the same peerless master-smith, resident in an East Anglian royal workshop that served Sutton Hoo.

Pommel **57** is a similarly 'princely' and unparalleled object (fig 2.10).[74] Its sculpted, projecting animal heads and imitation wire framing are exceptional in Anglo-Saxon Style II. Fourteen creatures are arranged in almost perfect symmetry on the sides and at the ends, but with a stark asymmetry introduced to the object by the black niello lines in panels on each side.[75] Its use of a varied menagerie and the heads at the ends with jagged jaws find their best parallels in Scandinavian and continental Style II (e.g. fig 5.4i),[76] but the quadrupeds that are incised at the centre on each side are firmly in the repertoire of Anglo-Saxon late Style II.[77] They again occur in pairs with limbs that are entwined differently in each version, introducing a further subtle asymmetry. The heads with predatory jaws forming the pommel terminals might have been meant to stand for wolves,[78] although comparison can also be made with the maws of creatures of other species on the Scandinavian-style helmet from Sutton Hoo mound 1.[79] Flanking each of the 'wolf' heads, and visible only from above, are pairs of bird heads, while duck-billed heads form nasals to the 'wolf' heads. This helmet theme is continued by the boar head that projects below the apex on each side, as remarkably each wears a *Spangenhelm*. These boars in helmets were surely intended as a playful reference to the Germanic boar-crested helmet, as described in *Beowulf*, and that is attested by the actual examples from Benty Grange (Derbyshire) and Wollaston (Northamptonshire) (fig 7.3).[80] Speake has suggested that the boar may have been particularly associated with royal power,[81] and so the creature's prominent position on this pommel might

▶ Gold and garnet sword pyramid-fitting **578** (not to scale). Photograph: D. Rowan; © Birmingham Museums Trust.

not simply be due to its ferocious reputation. Viewed frontally, furthermore, each boar head acquires a more ambiguous quality and may instead be interpreted as a human head, with the tusks transformed into a moustache. Lastly, in looking down on the pommel, a zoomorphic cross can be suggested, although the object's otherwise over-bearing 'pagan' scheme might favour that this is an accident of composition.

An intriguing parallel for pommel **57** is offered by silver pommel **71** (fig 5.9). It has a similar moulded band with boar heads surmounting its rounded apex, which also forms a zoomorphic cross with the shoulder panels filled with interlaced serpents. Incised on one side of the pommel was a pair of quadrupeds with herringbone-filled bodies, while on the other side are further serpents. Similar quadrupeds occur on the other objects with which it forms a set: **189** and **605** (fig 5.9). The use of herringbone fill for the bodies of these creatures is seen also on the Sutton Hoo cup-motif (fig 5.12i), while real filigree herringbone pattern was used for the quadrupeds on hilt-collars **109–10** (fig 5.9; cf fig 3.52). The heads with splayed jaws, which feature on the quadrupeds and larger serpents of the set (**71**, **189** and **605**), can be compared with those of the quadrupeds from the transecting arms of the great cross (fig 5.12).

Hilt-plate **370** (fig 5.1) is another object that stands out, for its rare manufacture in cast gold and for the fact that it is the only hilt-plate with animal ornament, suggesting that it too may have been made for a significant patron. It features again the quadrupeds of Anglo-Saxon late Style II. Pairs of confronted creatures occur at each end, but they also form part of a procession with the other beasts along each side of the plate. Each bites the limb of the beast before it.

Serpent ornament is seen across the collection, including the six sculpted examples (**527–32**) cast in gold (fig 2.34). Early Style II examples include those on silver-gilt collar **186** (fig 5.4) and the quartet of snakes in filigree with looped bodies on one side of pommel **2** (fig 2.6iv). They are most popular in filigree, occurring on twelve pommels (**2**, **5**, **7**, **9**, **11–15**, **22** and **37–8**), nine hilt-collars (**85–6**, **104–5**, **107–8**, **123–4** and **151**) and eight mounts (**451**, **455** and **556–61**). On one side of pommel **38** there are mirror-identical designs that flank a central cloisonné triangulate motif with a saltire cross formed by the cell-walling: each includes a serpent, a double-headed serpent and an interlacing strand (fig 5.10). Quite a range of head-forms were used for the collection's filigree serpents, including 'semi-naturalistic' heads with gold granules for eyes (**2**, **85–6** and **151**), simple U-shaped heads (e.g. **11**, **15**, **123** and **455**) and other forms (**38**, **104–5** and **558**). There are also serpents in cloisonné (**163** and **578–9**) and one in niello (**412**) ornament (fig 5.10).

The head-forms of the filigree serpents can be compared with examples on other Anglo-Saxon objects: those on hilt-collar **151** are the same form as was used for the serpents on the well-known buckle from Crundale (fig 5.10i); those on pommel **2** and hilt-collars **85–6** are close to a head-form seen on the Sutton Hoo shoulder-clasps (figs 2.6iv and 5.5);[82] and the curled heads on pommel **38** and hilt-collars **104–5** can be compared with the heads of the creatures on a gold filigree pendant from Loftus (North Yorkshire) (fig 6.9ii).[83] Perhaps most striking, however, is the similarity of the serpent design on mount **455** (fig 5.10) with that on a filigree buckle from Faversham (Kent), objects that it is difficult to imagine on this evidence were made independently of one another.[84]

A total of thirty-one separate filigree serpent panels decorated one of the suites of cloisonné mounts (**556–61**). The majority have tiny heads carved in gold and are clearly by the same hand (fig 3.43), but the panels overall exhibit subtly different patterns (fig 5.10): some contain a serpent that interlaces with a separate loop, while the interlace pattern in other cases is formed entirely from the body of the creature. On mounts **558–9** the serpents were probably all positioned so that they ran in one direction (figs 2.63 and 5.10), and each mount also has a single curved panel at one end containing non-animal interlace, as well as what are probably replacement panels with serpents with different heads. A relationship is possible with hilt-collar **151**, since its filigree serpents are similarly interlaced (fig 5.10), and with the ornament of head-dress mount **541** (fig 5.14). The latter had at the centre of its sub-conical mount four curved panels with incised Style II, three containing comparable serpents and one of non-animal interlace.

It is impossible to be sure whether the adder (*Vipera berus*) was the inspiration for these serpent motifs, but its poisonous striking bite and common occurrence across Europe and Asia, including its presence in mainland Britain, must make it a distinct prospect.[85] The repeat application of nested serpents, poised to strike, in the panels on cloisonné mounts **556–61** might thus have created a sort of spiritual armour for the saddle which, it is argued, they decorated (fig 2.70).[86] Brown has similarly suggested that the beast heads with three-forked tongues on strip **540** were intended to fulfil an apotropaic role, being modelled on the 'brazen' serpent of Moses (fig 2.78),[87] and additionally a pair of serpents guard the D-shaped setting at one end of the piece. Considering in particular the inspiration for the unusual head-form on strip **540**, the Hendersons have drawn attention to a story in Adomnán's *Vita Columbae*, in which the saint triumphs on Iona over serpents with three-forked tongues, though the ultimate source for these creatures is traceable to a Virgilian text.[88] Indeed, it seems very likely that the heads were designed by the literate overseers responsible for the texts on the

CHAPTER FIVE | STYLES OF DISPLAY AND REVELATION 225

▲ **Fig 5.10.** Serpents on Hoard objects with *comparanda*: i) detail from the filigree serpent and Stafford knot interlace from the Crundale buckle (Kent); ii) incised serpent and Stafford knot interlace from the Eccles buckle (Kent); iii) serpents in garnet cloisonné from the Diss pendant. *Drawing*: C. Fern.

inscribed strip, since they certainly do not appear to represent the work of an Anglo-Saxon smith schooled in Style II.

Knotted serpents and zoomorphs decorate the sides of pyramid-fittings **578–9**. The zoomorphs are a confronted pair, but their motif can also be interpreted as a helmeted head, the form of which is not unlike the helmet from Sutton Hoo (fig 5.10).[89] Viewed from above, furthermore, a myriad of crosses on different alignments can be made out from the gold, garnet and glass design of each pyramid. The cloisonné creatures can be compared to those on the Diss pendant (Norfolk) found in 2015 (fig 5.10iii).[90]

The Hoard ornament includes many examples of birds of prey with curved beaks (fig 5.11). The eagle in particular might have been a symbol of power suited to the battlefield, as it had been the bringer of victory on the Roman *Aquila*.[91] However, as creatures of the air, in Germanic mythology birds were also transporters of human souls to the afterlife, as well as the specific familiars of gods.[92] In later Norse mythology, Odin is described as able to change shape into an eagle, an act which is redolent of the collection's bird-mask imagery (see below).[93] In addition, the use of hawks in the aristocratic pastime of falconry, by the time of the Hoard, might have added to the appeal of bird-of-prey motifs, but this also warns against attributing an 'eagle' identification to every instance.[94]

The striking gold-sheet plaque (**538**) showing a pair of birds flanking a fish had possibly adorned the front of a 'princely' – even 'royal' – saddle (figs 2.66 and 2.71i).[95] The most obvious parallel for it, at least in terms of scale and luxury, is the bird mount from the Sutton Hoo shield, although in contrast it was made of gilded copper alloy and wood with very thin coverings of gold sheet.[96] The large birds of mount **538** are also different, as they are without angled head-surrounds, and they have incised, semi-naturalistic neck and body plumage, which does not feature on the Sutton Hoo mount and its relations.[97] However, their curled, reeded wings and tails are stylised, and the fish has angular non-naturalistic scales, imitating 'honeycomb' cloisonné.[98] The birds' claws and beaks rip at the fish in a visceral motif of dominance. The composition is one of 'split-representation': the actual motif on which the design was based was that of a single bird catching a fish (fig 2.66v).[99] This artistic principle has been observed in many cultures, including previously in Germanic animal ornament.[100] In this case the split-representation is indicated by the fish's Janus-like head and the line that divides the creature (fig 2.66iii). The design is meant to be mentally folded in half along this division, with thus two sides of one bird and one fish represented, which creates a sense of three-dimensionality for the otherwise flat image. Possibly the bird was meant to be a white-tailed sea eagle, although ospreys (sometimes called 'fish eagles') equally take fish, and both species are indigenous to the British Isles. The line down the middle of the fish may also have been intended to reference the 'lateral line' that is faintly visible on the sides of fish and which marks a system of sense organs. In addition, two further small creatures crouch at the fish's tail, which are again birds or bird-headed (fig 2.66iv), and these do manifest the angled head-surrounds typical of Style II.

The device of a triumphant bird with a fish was known across Europe in the period, including the detail illustrated from a Scandinavian bracteate (fig 5.11i).[101] The scene evoked is also found in later Norse mythology: in the *Seeress's Prophecy* an eagle is described as hunting for fish among mountainous waters.[102] A number of parallels exist in early Anglo-Saxon metalwork.[103] Closest to the arrangement of mount **538** are the fish between birds on two horse-harness mounts from Gunthorpe (Norfolk) and Coddenham (Suffolk), with a loop on the Coddenham mount indicating that the correct orientation of the device was probably with the birds 'rampant' (figs 2.71i and 5.11ii).[104] A further, but more abstract, example in filigree comes from one of the Sutton Hoo shoulder-clasps (fig 5.11iii),[105] and another fitting from Springhead (Kent) shows a variation with two fish between two birds.[106] The motif is seen again in the collection in the form of mount **459** (figs 2.35 and 5.11), which, like mount **538**, has feather and fish-scale detail, as well as in the garnet cloisonné set of birds and fish (**511–3**) (figs 2.30, 2.35 and 3.94). However, the closest match for the wing and tail form of the birds on mount **538** is found on a much smaller mount from Asthall (Oxfordshire), although it is without a fish (fig 5.11iv; cf fig 2.66iii).

Bird or bird-head ornament is most common among the small hilt-fittings from guards and grips (**459, 463–5, 467–74, 511–2, 514–7** and **536–7**). The decoration is rarer on pommels (**52, 73** and **78**), and unusual bird heads were also incised on each side of sword-ring **82**. The filigree and cloisonné design on pommel **73** can be interpreted as a pair of confronted bird-headed zoomorphs (fig 5.22): the central roundel with beak appendages must be switched to form each creature. The confronted bird pair in filigree with small cabochon garnets for eyes on mounts **473–4** are also unusual in their tracery form. These designs can alternatively be interpreted as masks, with two readings possible for mount **474** (fig 5.11). A number of the other bird pairs can similarly be translated (figs 5.11).

The faces, masks and helmets on pommels **57** and **68**, and pyramid-fittings **578–9** have already been described, but further possible examples occur on several other pommels. Cloisonné pommel **46** has an identical design on each side, of a pair of eye-shaped cells with a central mushroom shape, which was possibly meant as a mask (fig 2.8), and another might have been

intended on pommel **55** (fig 5.8). At each end of the remaining ring-knob of pommel **76** are two visages, one being an interlace version of the other (fig 2.12). Human imagery is rare generally in Anglo-Saxon Style II, and was more common in Style I. Parallels for the abstract masks on pommels **46** and possibly **55** are those on the sixth-century pommels from Coombe and Lower Shorne (both Kent).[107]

A further two pommels have possible 'eye' motifs. Pommel **77** has two eye-shaped filigree gold mounts on its ring-knobs, and the larger central gold mount on the same side has a cabochon rock-crystal between 'lids' of filigree scrollwork (figs 5.22 and 6.6). The 'eye' on pommel **41** at the centre of one side, formed by a collared filigree granule within a filigree loop, is much less certain. Along with the cloudy crystal 'pupil' of pommel **77**, the most evocative examples in the collection are the large eye-shaped mounts (**542–3** and **567–8**) (figs 2.58, 2.60 and 2.72), but there is also a small pair of mounts in gold filigree (**478–9**). The vesical shape taken by most, including the eye-shaped garnets on pommel **46**, is the same as that used for animal eyes on several objects (**71**, **460** and **540**); the eye-form was also employed for beasts and human figures in early manuscript art.[108] Metalwork parallels are few, though two from Ireland are a small filigree mount from Lagore (Co Meath), which features an eye-shaped setting that probably had glass or garnet inlays originally,[109] and a very similar filigree mount from Lowpark (Co Mayo).[110] These are broadly similar in size to the filigree mounts attached to pommels in the Hoard, although they may not have served the same purpose. If this eye symbolism was intended, it need not have had the same meaning for all the objects, given the temporal range of the collection. In the 'pagan' context, depictions of eyes have been linked with Odin's sacrifice of one of his eyes for wisdom,[111] but this does not fit especially well with pairs of eyes; whereas for those objects made and used in the context of the Conversion, and in the case of the Irish instances, a Christian meaning may have pertained.[112]

The Christian meaning of the fish must have been introduced to the Anglo-Saxons at the Conversion, so it has been suggested that the creature only became popular late in Style II in England.[113] However, it was also a rare motif in 'pagan' Style I in the sixth century,[114] so a Christian meaning cannot be assumed for its use in all cases, especially when it was combined with other creatures, as on mounts **459** and **538**.[115] There are two, now unaccompanied, filigree fish mounts (**461–2**), but, as noted, the single cloisonné fish **513** was probably a set with two birds. The pike is often suggested as the species that was symbolised, since its predatory aggression is considered to have made it a suitable warrior motif, but most depictions are so stylised that no certain identification is possible.[116] A detail of mount **461** suggests an alternative species, as it appears to have a hooked 'kype' jaw (fig 5.11). Male salmonids (salmon and trout) develop a hook in the spawning season that they use to fend off or attack other males; some have more pronounced hooks than others, giving them a greater dominance. The fish from the hanging-bowl from Sutton Hoo mound 1 has also been suggested as being possibly modelled on a salmonid.[117]

Certain to be among the latest Style II of the collection, as well as generally within Anglo-Saxon England, is the carved animal ornament on the great gold cross (**539**).[118] In total, twenty-one animals or animal-parts inhabit the mount: fourteen are contained in panels on the arms; four bird heads with curlew-like beaks surround the centre; and pairs of proud ears terminate the three short arms (figs 2.74, 5.12 and *frontispiece*). The *top arm* is divided into two unequal panels: a single self-biting beast with an eyeless almond-shaped head fills the small bottom panel; in the larger frame two quadrupeds with the same head-form as the singleton are shown confronted, with interlocked bodies and entangled limbs, and each bites the other's forelimb. Close parallels for these almond-headed animals are rare: they include creatures that are scratched on the back of a composite disc-brooch from Harford Farm (Norfolk) (fig 5.12iii);[119] a pair that are on the reverse of a triangular buckle-plate from Littlebourne (Kent) (fig 5.12iv);[120] and the so-called 'Bamburgh beast' (Northumberland), which has a similar head but with an eye (fig 5.12ii).[121]

The two panels of the *bottom arm* show a parade of seven beasts, interrupted by the gem-setting (figs 2.74 and 5.12). Most are of one species, with S-form bodies and jawed heads like bent paper-clips with forward-drooping ears. The heads are back-turned, biting their own bodies and hind-quarters, and the creatures are connected by hooked tails, an unusual bestial attribute in Style II. They are also unusual in other ways. Several of the leading animals have back-curled rear claws on their hind-limbs, and all have punched 'hair' and eye detail. Also, the front creature in the short panel has a neck-ring (or possibly this is a lone jaw/head element), and the other in the same panel is backed by two interlace knots. An interloper in the procession, at the narrow bottom-end, has instead an almond-shaped head and simple looped body. Relations of the S-form creatures, which also have back-curled rear claws and combine with small knots, occur among the animal ornament of the helmet (**591–2**: bands 1 and 3, and panel 4) (cf figs 5.12 and 5.17).[122]

The motifs on the *transecting arms* are similar, but with the positions of the heads and hind-limbs of the creatures reversed in each version, and in another deliberate act of asymmetry one creature in the left-arm panel is missing its ear (figs 2.74 and 5.12). These horse-like animals, again with punched detail, are further examples of head-to-tail quadrupeds, like those on the hilt-collars already discussed

▲ **Fig 5.11.** Birds, fish and masks in the Hoard with *comparanda*: i) bird landing on a fish from a gold bracteate (IK-33 British Museum-C); ii) mount from Gunthorpe (Norfolk); iii) fish between birds in gold filigree from one of the Sutton Hoo shoulder-clasps; iv) mount from Asthall (Oxfordshire); v) bird head from the Sutton Hoo great gold buckle, with a Y-shape groove on the beak; vi) bird of prey with a smaller bird from the Sutton Hoo purse-lid, with Y-shape cell-walling on the curved beak of the larger bird. *Drawing*: C. Fern, except **461** by G. Speake, and (ii) by J. Gibbons, PAS CC Licence <https://finds.org.uk/database/artefacts/record/id/258779> (accessed 18 May 2017).

CHAPTER FIVE | **STYLES OF DISPLAY AND REVELATION**

▲ **Fig 5.12.** The art of the great gold cross with *comparanda*: i) motif from the maplewood cups, Sutton Hoo mound 1 (Suffolk); ii) the 'Bamburgh beast' (Northumberland); iii) Style II quadrupedal interlace etched on the reverse of a brooch from Harford Farm (Norfolk); iv) Style II quadrupeds on the reverse of a buckle from the Littlebourne (Kent); v) animal-head (folio 2) in Durham A.II.10. *Drawing*: C. Fern.

(**109–10** and **165–6**). A very significant parallel for them was identified soon after the Hoard's discovery, by Høilund Nielsen: the motif from the right *transecting arm* is identical to that on mounts that decorated the maplewood cups from Sutton Hoo mound 1 (fig 5.12i).[123] The design from the ship-burial, already considered regarding mount **460**, differs only in its manufacture by die-impressing on silver-gilt sheet and in small aspects of its style.[124] The die-impressing method of production indicates the Sutton Hoo motif could have had many reproductions and been widely disseminated,[125] any one of which might have been the inspiration for the version on the cross, or the die itself might have been copied. However, the goldsmith who made the cross further adapted the motif to create the non-identical design on the left arm. This rare example of copying is, of course, of the utmost importance for considering the date and origin of the cross, and by extension the Hoard,[126] with its implication *even* for a direct association with Sutton Hoo mound 1, the possible grave of King Rædwald (d. *c* 624).[127]

George Speake considered that the creatures of the Sutton Hoo cup-motif showed 'continuity' with the later animal ornament of the Book of Durrow, and the art of the cross can also be compared with that in the manuscript.[128] In particular, the affinities of the *top arm* beasts with the quadrupeds from Durrow folio 192v can be readily appreciated, and surely no great period of time can separate their creation (fig 5.13). The heads of the animals on the *transecting* and *bottom arms* can also be likened to that at the foot of the initial 'I' at the beginning of St John's Gospel (folio 2) in the Durham A.II.10 manuscript (fig 5.12v).[129] Its dot infill can be said to be similar as well to the punched 'hair' on the bodies of the cross creatures. Another parallel for the head-form of the *transecting arm* beasts is that used for the serpents on the 'late' Eccles buckle (fig 5.10ii).[130] It is clear, therefore, as will be argued in *Chapter 6*, that the production of the cross must date to the period between the manufacture of the Style II metalwork of Sutton Hoo mound 1 and the production of the Durham and Durrow gospel-books.[131] Such comparisons, furthermore, now renew the argument for a greater appreciation of the immediacy of the role of metalwork ornament in early manuscript illumination.[132]

The cross very much has the character of an early and experimental ecclesiastical object.[133] The placing of animal ears at the ends of the cross arms, proud like those of a horse, and its covering Style II ornament indicate it was fashioned by a goldsmith well-schooled in the traditions of Germanic ornament. Nevertheless, its overt form is that of a Roman *crux gemmata* (jewelled cross): the cross of victory of the new religion. An Anglo-Saxon depiction of a processional cross of around the same date is that on a gold finger-ring found in 2011 at Uttlesford (Essex).[134] It shows an almost naked human figure holding the cross, while in the other hand is gripped a bird, and over the figure flies another bird (fig 5.23iii). As with the great cross (**539**) of the Hoard, the Christian symbolism on the ring is balanced by the pair of birds and naked figure, which surely are non-Christian in intent.

The Style II ornament on object **541**, another early ecclesiastical object,[135] is very like that on the great cross in its incised manufacture and style (fig 5.14; cf fig 5.12). The beasts in the four larger panels on the sub-conical mount were probably originally arranged in opposed pairs – two zoomorphs and two quadrupeds. These can be compared especially with the single self-biting creatures on the cross: on the top arm and at the foot of the bottom arm (fig 5.12). Beyond the collection, only the small mounts from the Northumbrian royal fortress of Bamburgh offer good parallels for these incised animal panels (fig 5.12ii).[136] In the Hoard, there is the further link, noted above, between the panelled serpent and interlace ornament of mount **541** and the filigree panels of cloisonné mounts **556–61** (cf figs 5.10 and 5.14), and three gold-sheet mounts (**485–7**) with single carved quadrupeds are further relations (fig 5.9). Each of these last creatures has a contorted rear leg, threaded through a slit in its haunch, which is to an extent reminiscent of the treatment of the forelimb of the 'Bamburgh beast' (cf fig 5.12ii). In sum, these Hoard objects, including head-dress mount **541**, must be of the same late style horizon as cross **539**, and very possibly all were made within the same localised sphere of workshop influence.

▲ **Fig 5.13.** Quadrupeds from the Hoard and the Book of Durrow compared. *Drawing*: C. Fern.

pommel **56** (scale 3/2)

cross **539**: *top arm*

Book of Durrow

CHAPTER FIVE | **STYLES OF DISPLAY AND REVELATION**

Fig 5.14. Animal and cross ornament on head-dress mount **541**. *Drawing*: C. Fern.

Finally, a small detail in the animal ornament of several key objects is important for considering their origin.[137] The beaks of the birds on these objects are divided by a Y-shaped groove, a feature that mimics the play of light within the deep groove of bird beaks cast in relief.[138] In cast and incised metalwork the Y-shaped groove is seen with birds on pommel **57**, bird-fish mounts **459** and **538**, and great cross **539**. This detail was first discussed by Speake, who considered it a key feature of some of the artefacts from Sutton Hoo mound 1,[139] including the great gold buckle (fig 5.11v). A further deliberate contrivance, not noted previously, is the use of the same feature in the bird cloisonné of mound 1, with the Y-shape formed by the cell-walling of the beak (fig 5.11vi). This too is seen in the Hoard cloisonné on bird mounts **511–2** and **514–7**. Other finds of cast metalwork with the detail have also been found in eastern England, which may further support the case for it being a 'signature' of East Anglian metalworking,[140] including most recently a few examples from the royal settlement of Rendlesham (Suffolk).[141] However, a small number of brooches with the beak marking are also known from further afield, as far away as Wales; but they are inferior in quality and may therefore have acquired the trait second-hand.[142]

ORNAMENT OF THE HELMET AND DIE-IMPRESSED SHEET

George Speake

Even in its fragmentary state the helmet's art presents us with a dazzling and glittering arrangement of zoomorphic and figural depictions that have been a revelation. The cast silver-gilt designs of the cheek-pieces and the two sections of the helmet-crest indicate superb skills, craftsmanship and artistry (figs 2.45–2.46).[143] The harmonic interplay of beasts and serpents within their ornament suggests that they are a suite from the same helmet and the work of one craftsman. There is a diversity of style and imagery, however, on the die-impressed sheet fragments that implies a range of dies and the hands of several craftsmen (figs 2.49–2.55). As already noted, some uncertainty remains as to whether all the sheet fragments were associated with a single helmet. Possibly some were removed from other helmets or were originally mounted on different prestige items, such as drinking vessels (e.g. **598**) and shields.[144]

It is tempting to view the finely crafted helmet, which can be argued, was 'fit for a king',[145] as the product of a smith maintained by a royal court, as has been suggested for the helmet of Sutton Hoo. Although considered as the possession of an East Anglian king, the Sutton Hoo helmet was very possibly of Swedish origin, or at least the work of a craftsman very familiar with the skills of Scandinavian armourers.[146] There are strong stylistic and art-historical reasons, however, for seeing the Hoard helmet as being the product of an Anglo-Saxon workshop.

Animal ornament

As is argued above, the varied schemes of animal ornament enhancing the helmet can be considered as being more than just decoration. The various stylised birds, quadrupeds and serpents could have been protective emblematic symbols, intimately linked to religious beliefs.[147] Nevertheless, curiously absent is the depiction of the boar, a creature which appears on other helmets, either as a free-standing, crest fixture, or just its head with distinctive tusks, as on the eyebrows of the Sutton Hoo helmet. The boar is considered as an emblem of protection, linked to Odin/Woden, the god of death and battle, as well as the divine ancestor of almost every Anglo-Saxon royal dynasty.[148]

The crest (**589–90**), mounted longitudinally on the top of the helmet, has cast animal-head terminals at each end that have hybrid characteristics, part equine and part serpent-like (figs 2.45 and 2.47 and 5.15–5.16). In contrast to the aggressive bared teeth of the 'dragon' heads on the Sutton Hoo helmet-crest,[149] the heads that are similar but not identical appear tame and benign, with lentoid unblinking eyes and clenched mouths. While there are no distinguishing horse-like ears, the binding behind the mouth and head suggest the straps of a bridle.

Four distinct designs of animal interlace decorate the vertical sides of the two sections of the crest. There is order and clarity in these low relief cast designs, showing a sinuous sequence of intertwined serpents and quadrupeds. In total there are twenty-four creatures: four quadrupeds and twenty serpents. One side of each crest section shows four intertwined smooth-bodied serpents that interlace (fig 5.15). On the opposite side are more complicated schemes of animal interlace with a total of four quadrupeds and twelve serpents (fig 5.16). Within the ornament of the more complete section (**589**) can be identified three pairs of serpents with bodies of differing length and different head-forms. The upper section of the design has a pair of quadrupeds whose elongated limbs echo the undulations of their double-strand bodies.

The possible significance of this serpentine ornament demands some comment. Armed and helmeted warriors are depicted with snakes on a helmet panel from Valsgärde 7 (fig 5.18ii), but such a profusion of serpentine creatures, as on the crest and cheek-pieces (see below), do not appear on any other Anglo-Saxon or Germanic helmet. Similar designs can be found on other

CHAPTER FIVE | **STYLES OF DISPLAY AND REVELATION** 233

serpents

589

590 589

▲ **Fig 5.15.** Serpent interlace on one side of helmet-crest **589-90**. *Drawing*: C. Fern.

Fig 5.16. Serpent interlace and quadrupeds on the other side of helmet-crest **589–90**. *Drawing*: C. Fern.

objects, however. Incised on the front and back of a maplewood lyre from Trossingen (Germany), grave 58, is an even greater abundance of writhing, interlacing serpents, set out in a sequence of panels.[150] On the front of the lyre there is a clear relationship between serpents and warriors: serpentine interlace is positioned above the helmeted heads of twelve warriors, who are arranged in two confronted rows. One might argue that these schemes of interlace have the same symbolic protective significance as the serpentine crest-ornament. Serpent decoration can also be found on Roman helmets. Embossed snakes feature on several examples, datable to the late second to early third century AD, which also have raised central crests that terminate in an eagle's head.[151] The helmet from Iron Gates on the Danube has a writhing snake on each side, below the crest, with its head facing to the front.[152] The crest is embossed to represent close-set standing feathers and is hollowed as if to receive an additional crest of hair or real feathers. Snakes are also part of an embossed forehead-plate on a helmet from Guisborough (North Yorkshire), with their heads meeting on the border of the raised centre.[153] Four snakes can be identified on a similar helmet from the River Saône at Chalon (France). Two are coiled around the centre of the helmet, like a ribbon, and two others extend from the borders above the ears and curl forward with their heads above the helmet brow. Given the association of serpents in the iconography of these earlier Roman helmets, it is tempting to consider whether the Hoard's pairs of writhing snakes cast in gold (**527–32**) could once have been adornments to another helmet. Similar three-dimensional snake appliqués in copper alloy were attached to a Roman helmet recovered from the Thorsberg bog, in Schleswig (Germany).[154]

The iconographic meaning of serpent decoration is open to interpretation, as the significance of the serpent clearly differed in Christian and pre-Christian contexts.[155] The serpentine interlace schemes carved on the hafts of spears recovered from the fifth-century Scandinavian votive deposits of Kragehul and Nydam suggest a link with the protective power of Odin,[156] whose weapon was the spear. Serpents were potent in later Christian thinking, as embodiments of temptation and evil, while their ability to shed their skins made them also symbols of regeneration, akin to the Christian belief of resurrection.[157] Yet there is no overt Christian symbolism on the crest or cheek-pieces, unlike the cross on the nasal of the Benty Grange helmet (figs 2.75a and 7.3), or the inscription on the crest of the Coppergate helmet. In contrast to the Christian features on these two Anglo-Saxon helmets, it is suggested that as so many serpents are entangled in the crest ornamentation, for the wearer of the helmet an association with the protective power of Odin/Woden is more likely.

Visually the schemes of the crest complement the animal ornament on the cheek-pieces (**591–92**). The zoomorphic designs on the cast, silver-gilt cheek-pieces are mirrored versions of each other (fig 5.17; cf fig 2.46). Each cheek-piece has on the outside face three curving bands of sinuous Style II ornament and a corner panel containing a single, composite quadruped with serpent-headed appendages. All are framed by silver zig-zag borders with black niello inlay. In total, sixteen animals and ten serpents can be counted on each cheek-piece.

In *band 1*, four creatures are placed in a processional arrangement (fig 5.17). The creatures are linked by overlapping fore- and hind-limbs. Their backward-facing heads and long jaws grip their own S-shaped bodies. The angled head-surround of each creature is formed by a serpent: its open-jawed head projects forward, its body passes under the creature's broad-banded neck, and its tail fuses with the raised hind-quarter of the neighbouring creature. Two almost identical Style II animals inhabit *band 3*, although they are slightly larger in scale. The uppermost creatures in *bands 1* and *3* are distinctive in having an elongated upper jaw, which, after passing behind its own body, has its mid-section tied in a Stafford knot.[158] In the intervening *band 2*, nine creatures of a differing species with no identifiable head-surrounds are shown in procession, each with only a hind-leg, their ribbon bodies creating an undulating interlace. Seven ring-eyed heads with splayed jaws follow closely, but the two heads at the end are turned back: one belongs to a creature with a shorter body that nibbles its own foot. In the corner (*panel 4*) is a single creature composed of different animal elements. It has the beak of a bird, the body of a quadruped and a head-surround formed of an eyeless, open-jawed serpent. A second serpent rises from the elongated, back-turned claw of the hind-leg. On the front-facing edge of each cheek-piece is a less elaborate scheme of ornament, consisting of a tapering panel containing two entwined serpents.

A notable characteristic of this supreme Style II animal ornament is the fusion and interplay of beast and serpent. This also appears on opposing sides of the crest. Within the panels the versatile design of the interlinked zoomorphic elements, the warm-blooded and the cold-blooded, is clearly articulated with a carefully controlled rhythm and flow. In this, the animal ornament has a fluency that anticipates the calligraphic skills in the zoomorphic panels of fol. 192v in the Book of Durrow, but there are features, too, that betray links with earlier Germanic ornament. This provides a conundrum in attempting to establish the chronology of the ornament. In the corner panel, the body of the beak-headed quadruped has a genetic link to a crouched, equine-like quadruped in Style I, forming an animal brooch from grave 433, Dover Buckland (Kent).[159] It must date from the early part of the sixth century and is clearly related

Fig 5.17. Animal ornament of cheek-piece **591**. *Drawing*: C. Fern.

to quadrupeds on the foot-plates of silver square-headed brooches from Gummersmark and Vedstrup (Denmark).[160] An early date may also be indicated by the use on the cheek-pieces of enclosing borders of zig-zag niello (fig 2.46).[161]

Some similarities for the animal schemes can be found in Scandinavian and continental Style II, but closer analogies for the interlinked procession of animals on the cheek-pieces are manifest in Anglo-Saxon Style II.[162] Stafford knots in animal interlace, as in *bands 1* and *3*, are a feature of the serpentine borders of two Kentish buckles from Crundale and Eccles, objects of the second quarter of the seventh century (fig 5.10i–ii). Yet, *band 2* of the cheek-pieces echoes a similar scheme on the earlier die-impressed rim mounts of drinking vessels from the 'princely' chamber-grave at Prittlewell (Essex), which has been dated to shortly before 600.[163] The evidence is not conclusive, but it is tempting to argue for a comparable early dating for the ornament of the cheek-pieces.[164]

The design of the die that impressed zoomorphic band **594** consisted of five linked, closely spaced creatures, with a beaded border above and below (fig 5.18; cf fig 2.50). The eyed head of each is turned back, with an open mouth that nestles against the neck of the creature behind. The neck and undulating body are filled with evenly spaced billets. Each creature's forelimb passes under and over the body of the preceding creature like a tentacle. The body terminates in a pear-shaped hip, with a hind-leg with a trowel-like foot, bearing a curled rear toe.[165] The creature bears a passing resemblance to zoomorphs on several Scandinavian harness-

CHAPTER FIVE | STYLES OF DISPLAY AND REVELATION

▲ **Fig 5.18.** Animal and warrior ornament of die-impressed sheet **593–7** with *comparanda*: i) the 'rider and fallen warrior' panel from Sutton Hoo mound 1; ii) panel with marching warriors, serpents and bird from Valsgärde 7 (Sweden); iii) detail of boar-crested helmet from die C, Torslunda (Sweden). *Drawing*: G. Speake, except (i) and (iii) after Bruce-Mitford 1978 © Trustees of the British Museum; (ii) adapted by C. Fern.

mounts,[166] and the notion that the creatures are the 'Anglicised' offspring of Scandinavian parents does seem justified.

The medley of Style II creatures decorating the neck-guard (**600**: figs 2.54–2.55 and 5.19) provide a contrast to the ornament discussed so far, and being zoomorphic would have stood out on the helmet from the figural panels of the cap and helmet-band (see below). As reconstructed, from the small part that remains, it is argued that the arrangement was of multiple panels in an overall symmetrical composition. The long tapering panel of triple-strand interlace at one end (at the inner curve of the outer edge) may have terminated in a serpent head. Abutting one end of this panel, centrally positioned, was a panel containing two interlinked zoomorphs. The form of one is more distinctive, showing a long-jawed head with an angled head-surround, the creature back-turned and biting its own beaded body, which terminates with a pear-shaped hip and foot.

▼ **Fig 5.19.** Animal and warrior ornament of die-impressed sheet **598–603** with *comparanda*: i) the two fragments of sheet panel **599** superimposed on the 'dancing warrior' panel from Sutton Hoo mound 1. *Drawing*: G. Speake, except (i) adapted after Bruce-Mitford 1978.

Beneath the tapering panel of serpent interlace were two panels of differing size separated by a border of herringbone-with-spine. The smaller sub-triangular panel contains part of a back-turned Style II quadruped with a beaded body; enough survives to indicate it is biting its own body and that it also had an angled head-surround. The adjacent, incomplete larger trapezoidal panel showed part of a more complex zoomorphic arrangement of two herringbone-bodied creatures. A pear-shaped hip and part of a foot are in one corner, and in the other corner is a looped limb. Two other fragments, possibly from a mirrored panel, showed related interlinked creatures.[167]

One large trapezoidal panel survives from the lower part of the neck-guard. It has the remains of three further body-biting, interlinked creatures. Each creature had a beaded body with a pear-shaped hip from which extended a four-toed, fronded foot. The heads of two have the familiar angled head-surrounds, but the centrally placed head is different, the surround being looped and twisted. This skein-like feature is not closely paralleled in Anglo-Saxon ornament.[168] A suggested similarity occurs on the interlinked creatures, also die-impressed, on the tail decoration of the bird from the Sutton Hoo shield and on one of the panels of the shield's winged 'dragon', but here the loop extensions are in front of the eye, enclosing it.[169]

The gilded semi-circular frame at the back edge of the neck-guard (fig 2.55) might have been without ornament; or it could have had a separate panel (e.g. **603**) set within it, as reconstructed. Silver-gilt panel **603** shows part of a distinctive Style II creature (fig 5.19; cf fig 2.51). It has an S-shaped body that is split to allow the creature's elongated, narrow jaws to penetrate. The head is without a surround, in contrast with the creatures just discussed, and instead it is rounded with a lentoid eye. Its forelimb, extending from the body but without its foot, is interlinked with the probable limb of an adjoining, missing creature, which is evidenced by a curving section of body. Short sections of straight panel edges survive. There are several stylistic parallels for this Style II beast on a range of seventh-century Anglo-Saxon mounts and fittings, but none is die-impressed, being instead engraved or cast.[170]

The clipped shape of panel **601** has been suggested as possibly indicating its use as decoration for a helmet nasal (fig 5.19; cf fig 2.51).[171] The impressed elements of the design are indistinct, but the heads and incomplete body parts of four Style II creatures are discernible, all with bodies infilled with spaced beading. A central triangular section contains a back-turned creature whose jaws grip its triple-strand body. Projecting forward is a forelimb with a three-toed foot, and a backward-turned hind toe. The lower section of the panel shows parts of two further Style II creatures, while the upper section shows a very indistinct pairing. Like the creature on panel **603**, none of these creatures has an angled head-surround.

The nineteen silver-gilt fragments that make up group **602** with Style II need not all be from one panel (fig 5.19; cf fig 2.51). Some show tantalising parts of bodies, limbs and jaws. Included is a distinctive three-toed foot, with two forward-facing toes and a longer backward-looped hind toe or claw. One fragment includes a Stafford knot formed probably from a body part, paralleling the use of this motif on the cheek-pieces (see above). Alone, however, this is insufficient evidence to confirm that these impressed zoomorphic fragments were part of the same helmet.

Figural ornament

Parallels for the striking figural imagery of the die-impressed sheet in the Hoard come, in particular, from helmets from eastern Sweden, as well as from some other related items (table 5.3). They together provide a fascinating insight into the thought-world of warrior culture in Anglo-Saxon England and Scandinavia.

The silver-gilt sheet strip that decorated helmet-band **593** was impressed from a die that showed five warriors facing to the left (fig 5.18; cf fig 2.49). Each kneels on the left leg, which is thrust back, or possibly they were meant to appear as running. The warriors appear to be naked apart from the swords in scabbards that are belted at their midriffs. Held extended by the right hand in front of each warrior is an upright spear, and held in the left hand is a round shield with a boss. Unlike the warriors on panels **596–7** (see below), the warriors do not wear helmets; their profiled heads gaze upwards with swept-back hair reaching their shoulders. There are very slight differences between each warrior, including that the leading warrior, on the left of the die, holds his spear at an angle.

There are no close Anglo-Saxon or Germanic parallels for this die design. In the act of kneeling it is possible the warriors are paying homage and it may be a depiction, therefore, of the bond of loyalty between a lord and his warriors (as was manifested by the sword-ring custom).[172] In Germanic antiquity, kingship and military leadership were closely connected and certainly by the seventh century had merged. Furthermore, the location of this band of rank-and-file warriors on the helmet (fig 2.47) might have been intended to convey their relatively lowly rank, if the reconstruction is correct, as they are below the elite warriors depicted on panels **596–7** (fig 2.48).

An alternative view is that the apparent nakedness of the warriors might suggest the depiction of so-called 'berserker'. As Hilda Ellis Davidson has described them, the 'berserker' were warriors so full of the ecstasy of battle that they were impervious to wounds and danger, and it was believed that they derived their power

Description	Staffordshire Hoard	Valsgärde 7	Vendel XIV	Sutton Hoo 1	Vendel I	Valsgärde 8	Vendel XI	Gamla Uppsala, east mound	Caenby	Torslunda dies	Pliezhausen brooch
Kneeling warrior procession	X (593)										
Marching elite warriors (eagle-helmeted)	X (596–7)	X	X								
Marching elite warriors (boar-helmeted)		X		X	X					X (C)	
'Horned' warriors	X (599)	X		X							
Mounted elite warrior	X (593)	X			X	X		X	X		X
Fighting warriors			X								
Man with two beasts							X			X (A)	
Man with one beast										X (B)	
'Horned' warrior with two spears and warrior in wolfskin										X (D)	

▲ **Table 5.3.** Concordance of figural designs on Scandinavian-type helmets and related material (minor variations within examples of the same basic design are not distinguished, such as direction, the number of warriors, and subsidiary elements).

from Odin.¹⁷³ It is recorded that 'berserker' were in the bodyguard of Harald Fairhair, king of Norway, in the ninth century.¹⁷⁴ However, the essential characteristic of fighting in a state of wild frenzy is also recorded much earlier among Germanic peoples, in the time of Tacitus.¹⁷⁵

Panel **596** shows three armed and helmeted, marching warriors, moving to the right (fig 5.18; cf fig 2.52). Each warrior has a sword, spear and shield, and their helmets are eagle-crested with sub-triangular cheek-pieces, but with no evidence of a guard to protect the neck. The small round shields are held in the left hand, raised level with the shoulder. Their knee-length attire differs, showing two distinct designs: the central warrior wears a tunic of criss-cross textured material with a lower hem, while the other two figures wear dot-textured mail hauberks. The fingers and thumbs of the hands clutching the spears are defined, and the feet have prominent ankles. This last feature can be found on one of the die-impressed panels from the Sutton Hoo helmet (fig 5.18i), on the legs of the fallen warrior stabbing a horse, and it is seen too on panels on Swedish helmets and on the warriors of the Swedish Torslunda dies.¹⁷⁶ While these subjects are all male figures, it can also be found with several female figures on the Scandinavian gold sheet *guldgubber*.¹⁷⁷

One possible interpretation of the panel, and the detail of the shields held close to the chins of the warriors, might be that it reflects a battle-tactic employed by earlier Germanic warriors and recorded by Tacitus:

> They have also a different kind of chant. Its recital – *barritus*, to use their own name – serves to kindle their courage and helps them by its sound to forecast the issue of the coming battle. They inspire or feel terror according to which army roars the louder, and they regard the competition as one of valour rather than voice. What they aim at most is a harsh tone and a hoarse murmur, and so they put their shields before their mouths, in order to make the voice swell fuller and deeper as it echoes back.¹⁷⁸

Panel **597** shows three armed and helmeted warriors, marching in succession to the left (fig 5.18; cf fig 2.53). The figures have slightly different proportions from those marching right on panel **596**, with bulkier, squatter bodies and larger heads; but the helmets are the same, set on similar skyward gazing and beardless heads. Each warrior again holds in his left hand a round shield with a boss, though in this case they are at waist level and partially conceal the warriors' diagonally slung swords, as well as the downward-pointing spears clutched in the right hand. However, the attire of the warriors is reversed from that of panel **596**. Instead, the central warrior wears a knee-length mail tunic, belted at the waist, and the two flanking warriors wear textured tunics. The patterns of the tunics are different: the leading warrior's is formed of three short parallel lines that alternate in a repeating diagonal pattern, and there is no hem-line; the rear warrior at the right of the panel wears a tunic with a repeating pattern of chevrons that does have a defined hem. It is possible that these patterns depict a further form of armour, or they might simply indicate textiles. As on the panels of warriors marching right, the ankles are clearly marked. The rectangular die that produced warrior panel **597** is a very different design, therefore, from that which produced panel **596**. It is not simply a copy in reverse.

Based on the arrangements of panels on the well-preserved Scandinavian helmets from Vendel and Valsgärde (Sweden), it is suggested that panels **596**–**7** were positioned on the helmet-cap so that the warriors were shown marching forward, from the back of the helmet to the front (figs 2.48 and 2.56): the warriors marching left were on the left side of the cap; the warriors marching right were on the right side of the cap. This scheme would have presented the viewer with contrasting and opposing aspects of the warriors, since the weapons are retained in the same hand in each case. The shields are always on the left and the spears are always on the right. To own a sword, a mail tunic and a crested helmet implies wealth and status, suggesting the figures of panels **596**–**7** were meant to depict members of the warrior elite. Their portrayal complements, in particular, the warrior equipment vividly described by the *Beowulf* poet, but how accurate this was to the real warrior society of the seventh century is debatable. Furthermore, stylistic conventions and technical constraints would have been significant influences in the production of such dies.

No such die-impressed panels showing marching warriors occur in the decorative scheme of the Sutton Hoo helmet, nor on any other helmets from Anglo-Saxon England. Indeed, it should be stressed that actual figural depictions in Anglo-Saxon art of the sixth and seventh centuries are not common, in comparison with face masks and other abstract anthropomorphic imagery that do occur with some regularity, especially in Style I.¹⁷⁹

In comparison with figural depictions on Scandinavian bracteates of the fifth and sixth centuries, the scale and proportion of the warriors of panels **596**–**7** are more realistic. However, it is likely that some significant details were exaggerated for emphasis, such as the enlarged eagle-headed crests of the helmets. Oversized helmet-crests also appear on helmet-panel designs from Scandinavia: on the helmet from Vendel I the mounted rider on the left side wears a helmet with a large eagle crest (fig 5.20ii), while the rider on the right side wears a large boar-crest (fig 5.20i); similar crests are borne by marching warriors on the helmets from Valsgärde 7 and Vendel XIV, and Torslunda die C (figs 5.18ii–iii and 5.20iv–v).

Fig 5.20. Warrior ornament *comparanda*: i–ii) mounted warriors on opposed helmet panels from Vendel I (Sweden); iii) cast figurine of a warrior on horseback from Bradwell (Norfolk); iv) panel showing five warriors from the right side of the helmet from Vendel XIV; v) panel of warriors from left side of helmet from Vendel XIV; vi) warriors in combat from the front of the helmet from Vendel XIV. *Drawing* of i-ii) Vendel warriors after Stolpe and Arne 1927. *Drawing* of Bradwell mount courtesy of Steven Ashley.

The depictions of warriors on the east Swedish helmet panels provide comparative material, but none shows a design of three armed, marching warriors. As already stated, the Swedish panels were designed to depict warriors facing to the front of the helmet. Hence, it is likely that Torslunda die C, showing two warriors facing left, each with spear and sword but no shield, was intended to produce panels for the left side of a helmet.[180] On the helmet from Vendel XIV, two long rectangular panels each show five squat, mail-coated warriors with eagle-crested helmets, facing right (fig 5.20iv). They wear mail to below their knees, with each warrior holding a downward-pointing spear in the left hand, and in the

right hand is held upright a ring-pommelled sword in its scabbard (die size: W. 121mm × H. 42mm). The left side of the helmet has a sequence of four panels (W. 53mm × H. 47mm), each depicting two fierce-looking warriors wearing mail and eagle-crested helmets (fig 5.20v). They both have a cross-shoulder harness with a ring-pommelled sword, a studded shield in the left hand, and a downward-pointing spear in the right. A boar's tusk is attached to the haft of each spear. There are differences between the eagle-crested, helmeted heads: the leading warrior appears to have a face-guard with tusks, and though both helmets have neck-guards, the patterning is distinctive to each.[181]

The textile pattern showing a triple-band diagonal interweave on the tunics of the central warrior of panel **596** (figs 2.52 and 5.18) and the leading figure on panel **597** (figs 2.53 and 5.18) can be compared to similar patterns on the Swedish helmet panels and dies. The same textured detail is on the helmet of the rider from Vendel I (fig 5.20ii), and it is seen also on the Torslunda dies: on the helmets of the warriors on die C (fig 5.18iii), and on the tunic of the man between bears on die A.[182]

The armed warriors on the maplewood lyre from Trossingen (Germany), already discussed, may also be considered. Each long-skirted warrior carries a spear and two shields,[183] and wears a high-domed *Spangenhelm* with a mail neck-guard. There are two groups of six warriors, with a leading warrior in each case grasping the haft of a centrally positioned upright spear that separates the troops, with pennants hanging from the spearhead. The scene has been interpreted as an oath-swearing ceremony. Possibly, in this case, the elite warriors, like the processions on the helmets, were intended as an idealised image of the *comitatus* (aristocratic warband) whose loyalty the king commanded.

During conservation, a small number of silver sheet fragments (**599**) were grouped together because of their similar corrosion patina and their absence of gilding. The iconography of the three fragments, which depict figural elements similar to designs on other helmet panels, suggests that they were part of another image of warriors holding spears (fig 5.19; cf fig 2.51). However, the scene originally depicted was different from the other warrior panels. The warriors are shown frontally and they appear closely related to the so-called twin 'dancing warriors' with spears, swords and horned head-gear from the Sutton Hoo helmet, the horns being terminated by bird heads (fig 5.19i).[184] Fragments from four impressions survive for the Sutton Hoo helmet, the panels being placed at the front of the cap, either side of the crest, and at the front edge of each of the two cheek-pieces. Other related examples are also known from Anglo-Saxon England and Scandinavia. They include fragments of silver sheet from the Caenby barrow (Lincolnshire) that might have come from a similar impression, although there is no certainty that they derive from a helmet.[185]

On panel **599** the posture of the figures below the waist is uncertain. It is possible that the warriors were kneeling, with the left knee abutting the haft of the innermost spear. Alternatively, they could have had their knees bent forward, in the pose of the related warrior with a horned helmet on the well-known Finglesham buckle, grave 95 (Kent), who holds in each hand an upright spear.[186] More recent finds decorated with similar horned figures are a fragmentary plaque from Ayton (Scottish Borders), which is probably a buckle-plate but possibly a die,[187] and a triangular bronze die from Fen Drayton (Cambridgeshire).[188]

There are several Scandinavian versions with horn-helmeted figures, including on the helmet from Valsgärde 7,[189] and on die D from Torslunda.[190] It is probable too that a fragment of copper-alloy sheet from the East Mound at Gamla Uppsala (Sweden) depicted such a figure and is derived from a helmet.[191] Bruce-Mitford has claimed that, while the die design on the Gamla Uppsala fragment is not identical with the one used at Sutton Hoo, it 'was certainly cut by the same man'.[192] What is distinctive about the design on panel **599**, that on the Sutton Hoo helmet and those on the close counterparts from Gamla Uppsala and Valsgärde 7, is that the figures hold a pair of spears in one hand. These have not survived on the Caenby fragment, but on it and on the Sutton Hoo example the warrior also holds up a sword in his right hand. It is possible, therefore, that the original design of panel **599** likewise showed twin warriors holding pairs of spears and swords (fig 5.19i).

The Sutton Hoo, Caenby and Valsgärde 7 parallels show warriors wearing belted, kaftan-style coats with decorated facings, possibly depicting tablet-woven edgings. On one fragment of panel **599** a related costume is suggested, the edging having sections of beading sandwiched by horizontal bands. These are most closely matched on the Caenby fragment. The garments of the warriors on the Sutton Hoo helmet differ by having ribbed edging above a broad zig-zag pattern.

The similar kaftan-style costume depicted in all these instances contrasts with the armour and war-gear of the helmeted warriors of panels **596–7**, but it was not necessarily non-martial. Two front panels on the helmet from Vendel XIV show warriors in hand-to-hand combat (fig 5.20vi).[193] The figure on the left wears a bordered garment of the same type as that worn by the warrior of panel **599**, the lower section of which has been penetrated by a barbed spear. His opponent wears mail and in his left hand holds a shield weighed down by another embedded spear. The same type of dress is also worn by some male figures on the diminutive, die-impressed *guldgubber* from Scandinavia, the largest concentration of which

has been found on Bornholm at Sorte Muld (Denmark).[194] Some figures appear to carry a staff or 'sceptre' rather than a spear, and the significance of these images, whether secular or religious, is open to debate. The scene enacted on panel **599** and on the Sutton Hoo helmet has also been considered by Ellis Davidson as some form of ritual.[195] A leaping dance routine appears to be being performed by the horn-helmeted warrior on die D from Torslunda, while holding a spear in each hand,[196] and likewise the wearing of the bird-horned helmets or head-dresses and the clutching of pairs of spears on the other examples may suggest some form of choreographed ceremony.

Panel **595** shows a mounted warrior, the design again being incomplete (fig 5.18). On the Sutton Hoo helmet, an equestrian warrior panel has been identified as occurring eight times: six of these were on the left side of the helmet, with two surviving locations on the right side (fig 5.18i).[197] There are similarities as well as differences, however, between the Sutton Hoo and Hoard horseman motifs. In agreement, panel **595** shows the mounted warrior and horse moving to the left, in the act of riding down a foe. In both cases, too, the adversary strikes back, but the Hoard's retaliatory figure is much more diminutive, as well as naked. He plunges a sword or knife into the flank of the horse, while his right hand grips its left foreleg. In keeping also with the Sutton Hoo example, the horseman holds a spear above his head, in his right hand, the tip of which nestles below the top left corner of the panel. The horse's head is missing, but its harness is clearly defined, studded with a dotted pattern. Positioned centrally is the horseman's circular, bossed shield, and projecting downwards is his left leg and foot with a clearly defined ankle. Part of his patterned tunic is visible above the rim of the shield, but his chest section is missing. A significant difference with the rider on the Sutton Hoo helmet is that the horseman in this case is helmeted (cf fig 5.18i). The helmet has distinctive curved cheek-pieces that are comparable to those of helmets depicted on panels from Vendel XIV (fig 5.20iv–v), but they are quite different from the examples of the marching warriors of panels **596–7**. Much of the helmet is missing, however, and it is not possible to determine the form of the crest, whether it differed from the eagle crests of the marching warriors or was surmounted by a boar (cf fig 5.18iii). The face of the warrior is visible.

Positioned between the mane of the horse and the head of the horseman is a circular disc with nine dots around a central boss, a detail missing on the Sutton Hoo depiction. This has possible correspondence with a motif seen on some east Scandinavian C-bracteates, which has been interpreted as a sun symbol.[198] A further fragment in the collection with the same disc (**606**) is suggestive of at least one further impression of the horseman panel. The proportions of the horse and rider in panel **595** are quite different, however, from the enlarged heads and stylised horses typical of C-bracteates.[199]

A small additional fragment that does not join may be part of panel **595**.[200] It possibly shows the back view of a small figure that stylistically is comparable to the squat, stabbing warrior at the front of the horse. The figure also appears almost naked, except for a belt, and parts of both arms survive. This posture echoes that of a small figure perched on the rump of the horse on the helmet panel from Valsgärde 7;[201] likewise a small figure can be seen partially surviving at the rear of the Sutton Hoo rider (fig 5.18i); and others are on panels from Valsgärde 8.[202] In some cases these small characters appear to be grasping and guiding the butt-end of the horseman's spear.

The motif of the spear-wielding equestrian warrior on the helmets from Vendel, Valsgärde and Sutton Hoo suggests a shared cultural significance. In addition, a similar design is known on a die-impressed gold disc-brooch from Pliezhausen (Germany).[203] More abbreviated versions of the equestrian warrior, some with a spear, occur on Merovingian and Alemannic open-worked discs from purses.[204] From England, note should also be taken of the recent discovery of a cast copper-alloy figurine from Bradwell (Norfolk), which now provides a three-dimensional Anglo-Saxon parallel (fig 5.20iii).[205] The warrior sits astride his mount holding a circular shield, his pointed shoes or feet dangling below the belly of the horse, but there are no secondary figures. Nor does the rider have a spear or a helmet. The mount's function is uncertain, but it is tempting to consider whether it was once attached to the crest of a helmet, like the boar on the helmet from Benty Grange (cf fig 7.3).

Ultimately, the equestrian motif of the helmet panels represents the Germanic adoption and transformation of a Roman image, which occurs on a number of carved military tombstones in the Rhineland and in Britain, of the first and second centuries AD. The motif was of a cavalryman riding down a barbarian warrior. Its use on tombstones has been interpreted as symbolic of the victory of the deceased over death, but other interpretations are possible.[206] In practical terms, what may be depicted is a combat tactic described by the fourth-century Roman writer Ammianus Marcellinus, who described how Aleman warriors attacked cavalry:

> [the] infantry soldier in the very hottest of the fight … can creep about unseen, and by piercing a horse's side throw its unsuspecting rider headlong, whereupon he can be slain with little trouble.[207]

By the seventh century, in the Germanic context, the symbolism of the equestrian warrior motif was probably very different. As the spear was Odin's/Woden's battle weapon, the small spear-holding warriors may have had a particular meaning, affirming the helmet wearer's belief in the protective power of the pagan god. On the helmet from Vendel I, the left side panels show a mounted warrior

carrying a spear that is argued to represent Odin, accompanied by two birds. In front of the horse, instead of the depiction of a stabbing warrior, there is a coiled serpent, whose head rests against the lowered spearhead of the rider (fig 5.20ii). However, one example on the Continent comes undeniably from a Christian setting. On a carved stone from Hornhausen (Germany) an armed horseman with a downward-pointing spear is depicted above a stone panel that shows two interlinked, long-jawed creatures.[208] Once thought to be a tombstone, it is now considered to have been originally part of the choir screen of a church.[209]

It is much less certain whether the fragments of silver-gilt band with face masks (**598**) had any association with a helmet (fig 5.19). The largest surviving part shows three frontal male heads, beardless but with drooping, linked moustaches. They have prominent, round staring eyes in clearly defined sockets, and well-defined noses and opened mouths. Such die-impressed heads are not evident on any other Anglo-Saxon or Scandinavian helmet, but they closely resemble those on the rim and triangular mounts of a pair of maplewood bottles from the Taplow barrow.[210]

In conclusion, it can be stated confidently that the Hoard's figural panels fit with the iconography of Scandinavian helmets, and with that of the Scandinavian-style helmet from Sutton Hoo, though within this tradition individual expression is seen in terms of detail and combination of motifs (table 5.3). Bruce-Mitford believed that close cultural ties, resulting in shared craftworking technologies, gave rise to the Sutton Hoo helmet.[211] The reconstruction of the Hoard helmet with its silver-gilt panels would suggest it was one of the grandest yet known (figs 2.48 and 2.56). Although recovering the narratives that lay behind the images has not been attempted here (and would be highly contentious), they very probably complemented the myths and legends concerning heroes and gods found in Old English and Old Norse sources. Indeed, the marching warriors (and animal ornament) on the Trossingen lyre suggest a close link between the oral poetic tradition and such images.

INTERLACE AND KNOTS

In many cultures interlace and knot ornament has been believed to be apotropaic.[212] On weapons and armour, such decoration of unbroken loops and twisted strands might have been thought to possess an intrinsic protective power, which was perhaps reinforced by any animal content in the ornament. Although Byzantine art is considered to have been the major influence on the renewed appeal of interlace art by the mid-sixth century,[213] in fact the decoration never disappeared. Examples of interlace can be found on Anglo-Saxon pottery and brooches of fifth- to sixth-century date,[214] and the ornament in mosaic form probably remained visible in some locations within Romano-British ruins.[215] Present in a more everyday sense could have been instances observable within such crafts as textiles, basketry, leatherwork and ropework.

Interlace decoration that was free of animal ornament remained in use throughout the period of Style II usage. It could be applied on metalwork independently of the animal style, or in separate zones alongside it. In the collection, non-animal interlace occurs mainly on pommels, hilt-collars and small mounts (table 5.1).[216] Hilt-collars demonstrate most instances,[217] but there are also many cases of its use in combination with Style II. On some pommels with Style II, for example, it occurs as shoulder ornament or on one side of the pommel.[218] Similarly, on hilt-collars **109–10** it was applied on one side only, with Style II on the opposite side; and on cloisonné mounts **558–9** two filigree panels with non-animal interlace accompanied numerous serpent panels (fig 2.63).

The interlace is not all of one type. Regular interlace in the Roman style features on a number of objects, possibly all of which are early (fig 5.21). Significantly, the looping pattern repeated on each shoulder of pommel **68** is close to a Byzantine design illustrated by Haseloff.[219] Although there is an absence of direct evidence for how such stylistic borrowings might have occurred, one explanation that seems increasingly likely is that the ornament arrived in north-west Europe decorating Byzantine goods, such as textiles and metal vessels, making it conceivable that a model was copied for the pommel in its Scandinavian setting of manufacture.[220] Also probably early is the knot composed of three loops on mount **533** (probably a set with pommel **69** and its collars), and the pattern of the serpent ornament in the large panel on one side of hilt-collar **85** suggests a similar base pattern was copied (cf figs 5.5 and 5.21). Interlace of a similar basket-weave kind decorates hilt-collars **89** and **93–5**, and the same type is found on pommel **14** inhabited by serpents (fig 5.10).

Alongside the emergence of Style II, a different type of interlace, irregular and non-Roman in style, was developed and rapidly became popular.[221] Termed *Schlaufenornamentik* (loop ornament), it could again be with or without zoomorphic elements.[222] A good example from outside the collection is the enmeshed pair of serpents filling the round tongue-shield of the Sutton Hoo great gold buckle.[223] The irregular character of some of the Hoard's Style II filigree has already been noted, but it is also the case that there are many instances of irregular interlace without animal content. Tracing the strands on actual examples (fig 5.21) reveals that the irregular patterns are not random or careless, as they might first appear, but are complex and deliberate. On pommel **31** a looping pattern repeated each side is formed by a single strand. In the

246 PART I | THE HOARD

Fig 5.21. Interlace in the Hoard with *comparanda*: i) serpent interlace from the Trossingen lyre (Germany). *Drawing*: C. Fern.

CHAPTER FIVE | **STYLES OF DISPLAY AND REVELATION**

Fig 5.22. Early Insular style with *comparanda*: i) die from Lullingstone (Kent); ii) mount from the Benty Grange hanging bowl (Derbyshire); iii) detail from the foot of the Tassilo Chalice (Kremsmünster Abbey, Austria); iv) die-impressed sheet with a quadruped from Dunadd (Argyll and Bute, Scotland); v) interlace on a mould fragment from the Mote of Mark (Dumfries and Galloway, Scotland); vi) disc-mount from Cumbria. *Drawing*: C. Fern.

design on one side of pommel **29** are two unbroken elements that are densely tangled. On hilt-collar **100** the wider lower band of interlace is again formed of a single continuous strand; the top band incorporates one strand that is plaited with a loop. Pommel **33** has a complicated pattern of three strands, which at its centre form a quatrefoil knot. The extreme asymmetry and twisting in these designs can be said to give them a writhing quality (nevertheless, the lack of any zoomorphic elements means they are not strictly Style II). Similarly, the pattern on pommel **32** has a somewhat quasi-zoomorphic appearance, especially due to its use of filigree granules that hint at 'eyes'; though in contrast with the unbroken interlace patterns, just discussed, tracing the strands shows that they are disarticulated (nor are any cohesive animal forms present).

Pommel **30** presents a coiling interlace style that is also seen on the gold filigree mounts of the set formed by pommel **76**, hilt-collar pair **188** and hilt-guard pair **409** (cf figs 2.12, 2.24 and 5.21). These objects are further linked by their gold back-sheets that were repoussé worked between the filigree wires.[224] The same back-sheet treatment occurs on hilt-collars **109–10** with irregular interlace and late Style II animal ornament.[225]

There are further examples of shared patterns (fig 5.21). Pommels **2** and **9** have the same shoulder interlace, and pommel **22** has a miscopied version. The thick band of regular interlace on one side of collar **98** is very like that on collars **125–6**. Ring interlace occurs on nine objects, including most conspicuously as a 'chain' of rings on hilt-collar **98** and on the shoulders of pommel **40**. On other objects rings were incorporated within non-animal interlace designs (**76**, **113** and **121–2**), or occur with animal ornament (**15**, **34** and **118**). Interlocking-ring interlace, like that on objects **40** and **98**, though rare, is paralleled by instances on a drinking-horn terminal from Sutton Hoo mound 1 and on a mould fragment from the Mote of Mark (Scotland).[226] On hilt-collar **113** the rings are combined with two figure-of-eight ribbons infilled with concertinaed filigree wire. Similar 'ribbon' interlace is seen on collars **111–12** and mount **454**.

So-called 'Stafford knots' occur on twelve objects.[227] Examples include: the arrangement of a band of linked knots above a serpent that is repeated on each side of filigree pommel **11** (fig 5.10); the similar bands that decorate filigree hilt-collars **104** and **127**; in cloisonné the single instances that flourish from the ends of the bird heads on mounts **514–15** (fig 5.11); and in the cast decoration on cheek-pieces **591–2** the knots that are formed from the jaws of the quadruped creatures (fig 5.17). Outside the Hoard, Stafford knots can be seen on both early and late objects,[228] and the form was not limited to Anglo-Saxon England, as is shown by interlace with the knot on a gold-sheet cross from Andelfingen (Switzerland).[229] The ornament of pommel **11** can be compared in particular with the serpent interlace on the well-known buckles from Crundale and Eccles (fig 5.10i–ii).[230]

There is a further type of interlace (fig 5.22) on some of the silver objects that are considered examples of the Early Insular style (see below). It occurs as cast decoration and was gilded, being formed of double or triple strands, and is characteristically fine and densely woven.

SCROLLWORK

Filigree scrollwork was the most popular ornament on the small gold mounts (tables 2.4 and 5.1), many of which are argued to come from weapon-hilts.[231] The scrolls in panels on several sets can be closely compared (**410–11**, **439–42**, **443–7** and **471–2**). The impression they give of a distinctive hilt-furniture style is further reinforced by the fact that the ornament was not commonly combined with Style II or interlace, the styles that are characteristic of the gold pommels and high-form hilt-collars. However, there are exceptions: mounts **469–72** have scrollwork with quintessential Style II bird heads; gold filigree pommel **8** has single scrolls interspersed with zoomorphic filigree on its sides, as well as C-scrolls filling its shoulders (figs 3.64 and 5.6); and collar **116** is an example of the high-form type on which scrollwork is dominant. Also, scrollwork does fill a number of the animal-shaped mounts (**460**, **463–4** and **467–8**), though the bird-head forms of these mounts (as argued below) are not typical of Style II and, on account of their relationship with mounts **536–7**, they are considered of the Early Insular style. Several other silver hilt-fittings in the Early Insular style include filigree scrollwork on their gold mounts or use scrolls in their cast decoration. The ornament was chosen, too, to decorate the arms of cross-pendant **588**, and in this respect it can be compared with the sheet gold cross from Winster Moor (Derbyshire),[232] notwithstanding the Hoard cross is the far superior product.

The filigree scroll-forms used were selected from a long-established ornamental grammar,[233] with some forms having origins dating back at least to the sixth century BC and Hellenistic-Etruscan metalworking.[234] In the early medieval period, the ornament was widely, if periodically, employed in continental, Scandinavian, Anglo-Saxon and Irish metalworking.[235] Examples of its use on the Continent include the gold fittings on the Lombardic swords from Nocera Umbra (Italy).[236] In Anglo-Saxon England, the kingdom of Kent in particular demonstrates a tradition of

◀ Silver-gilt pommel **73** showing its inlaid mount decorated with garnet and filigree (not to scale).
Photograph: D. Rowan; © Birmingham Museums Trust.

filigree scrollwork broadly contemporary with the Hoard, most notably on plated and composite disc-brooches.[237] In this case, too, it seems the decoration was often used independently of animal ornament, despite the strong Kentish tradition of zoomorphic filigree. This suggests that certain associations and meanings could have governed its application, but again there are exceptions. One such is the scrollwork band with bird heads on the reverse of the composite disc-brooch from Kingston Down (Kent),[238] which can be compared with the Hoard's guard-tip mounts (**469–72**) with scrollwork and bird heads (fig 5.23: **471**). However, the key parallels for the collection's more than forty small mounts with the ornament remain the grip-mounts of the Sutton Hoo mound 1 sword and, above all, those of the Cumberland hilt (fig 2.26).[239]

EARLY INSULAR STYLE

A relatively small number of objects are suggested as coming from a metalworking tradition that was receptive to both Anglo-Saxon and Celtic influences, which shall be termed here the Early Insular style (table 5.1; figs 2.12, 2.24 and 5.22). It is argued that the aesthetic they manifest predates the 'full' Insular style that is expressed by, for example, the ornament of the Book of Durrow.[240] However, that the meeting of the two traditions in fact started earlier is shown by instances including the animal ornament in the Cathach of St Columba, of the later sixth century, or by the interlace and animal-headed swastika on one of the Celtic hanging-bowls from Sutton Hoo mound 1.[241] These bronze bowls were made in British territories, but have been found mainly in Anglo-Saxon graves and, while they must have been considered luxuries, they occur in such numbers that they surely indicate frequent high-level contact between the different cultures.[242] A different example of the Early Insular style, from south-west England, comes from Swallowcliffe Down barrow (Wiltshire), a seventh-century Anglo-Saxon burial at the border with the British west. A mount from the grave, suggested as from a satchel, shows interlace and scrollwork combined with Celtic whorls and trumpet-scrolls.[243] In the north, contact with the British west may have become increasingly frequent in the seventh century, due to the aggressive expansion of the Anglo-Saxon kingdom of Northumbria.[244] Ornamented metalwork at sites including the Mote of Mark (Dumfries and Galloway) and Dunadd (Argyll and Bute) indicates the influence and possibly the presence of Anglo-Saxon elites in south-west Scotland.[245] Also, the pyramid-fitting from Dalmeny (West Lothian) (fig 2.44) and a button-fitting from East Linton (East Lothian) suggest objects that relate to this period of Northumbrian conquest.[246] Cultural interaction at the Mercian border might have produced hybrid ornament, too, of which the hanging-bowl mounts from Benty Grange (Derbyshire) could be a resulting example (fig 5.22ii).[247]

The assemblage's objects of the Early Insular style include hilt-fittings, two pyramid-fittings and fragments.[248] They are related in their materials, manufacture and form, as well as by their ornament. Most are of cast silver with gilding and several feature gold panels with filigree and cloisonné ornament. On pommels and hilt-collars (**73–5**, **76–7** and **188**) the gold panels were mounted on one side only, but on hilt-guard pair **409** they were set on both sides (fig 2.24). It is suggested that these guards formed a suite with pommel **76** and collars **188** (*endpiece*). Another key trait of many is cast non-animal interlace (fig 5.22), which on several pommels and hilt-collars is on the opposite side to the gold panels. As well as being typically tightly woven, some of the interlace patterns feature pointed elements at their corners or vertices – known as 'box points' – of which the interlace on pommel **75** has the clearest examples.[249] Other instances of interlace with box points confirm its generally late character, including its appearance in silver-gilt on an iron cross-pendant from Standlake (Oxfordshire),[250] in the manuscripts of Durrow (folios 1v and 2) and Durham A.ii.10 (folio 3v)[251] and on the Bewcastle Cross (Cumbria).[252] However, closer parallels for the Hoard interlace are the patterns on mould fragments from the Mote of Mark (fig 5.22v), which would have decorated axe-shaped and disc-shaped mounts, in the manner of Anglo-Saxon horse-harness.[253]

Laing has argued that the Mote of Mark interlace could date from the later sixth century, in the context of the general renewed popularity of interlace in north-west Europe at this time.[254] However, Graham-Campbell and Speake have both opposed this early date, demonstrating that the interlace style is relatable to forms of late Style II on horse-harness mounts from Hardingstone (Northamptonshire) and Faversham (Kent).[255] A more likely historical context for its appearance in the British kingdom of Rheged, Graham-Campbell suggested, was the Northumbrian 'advance into Scotland around 638'.[256] A less well-known object with the same style of interlace is a disc-mount that was in the Crosthwaite Museum, Keswick (fig 5.22vi).[257] Its find location is not known exactly, but it is likely to have come from the north-west region, and its ornament is a strong parallel also for that on harness-mount **698** (fig 5.22), which was found a short distance from the Hoard (cf fig 1.25ii). Lastly, further examples of similar interlace can be found on objects from other Celtic regions, including on the bow of a brooch from Ardakillen Lough (Co Roscommon, Ireland),[258] on a pommel from Culbin Sands (Moray, Scotland)[259] and on disc-mounts from Dunadd (Kilmartin, Scotland) and Portmahomack (Easter Ross, Scotland).[260]

The animal ornament of the Early Insular style objects is also unusual. On one side of pommel 76 is a triquetra of three silver zoomorphs against a black niello background, raised on a subtriangular platform (figs 2.12 and 5.22). Each serpent-like creature has a fantail. This creature form and the triangulate motif are distinctive, but a few objects bear parallels. Three 'dolphinesque' creatures with fishtails occur on a small disc from Lullingstone (Kent) that was possibly a die (fig 5.22i).[261] It was found at the same time as a hanging-bowl that can be considered another example of the Early Insular style, since it has axe-shaped mounts with interlace, reminiscent of the Mote of Mark example (cf fig 5.22v), as well as animal appliqués, including stags with scrolled hips, and a bird with a fish.[262]

The whorl of creatures repeated on the three appliqués of the hanging-bowl from Benty Grange, from the same grave as the famous boar-crested helmet (cf fig 7.3), provide another version (fig 5.22ii).[263] Each beast bites the fishtail of that before it, the design set against a background of yellow enamel, with a triskelion formed at the centre. The enamel inlay in this case can be likened to the unusual use of niello as a background on pommel 76, which might perhaps indicate the hand of a British smith more familiar with the technique of *champlevé*. A triskelion with animal heads against an enamelled field on a 'latchet' dress-fastener in the National Museum of Ireland can also be compared, but it is not so close in its style.[264] However, the most intriguing and closest parallel for the motif on pommel 76 is that repeated around the foot of the Tassilo Chalice (fig 5.22iii), made for the abbey of Kremsmünster (Austria), between AD 777 and 788. Although manufactured on the Continent, its decoration is considered Anglo-Carolingian.[265] None of the Hoard's objects in Early Insular style can possibly be so late, and more than a century must separate the use of the designs, therefore.[266] A range of objects no doubt provided models for the chalice's ornament, so perhaps one was an Anglo-Saxon relic. That the motif of a fishtailed zoomorph or serpent was possibly more widely known is suggested by two further examples in stone carving, both from Northumbrian contexts. One is the pair of creatures guarding the entrance to St Peter's Church, Monkwearmouth (Tyne and Wear), the building of which began in 674; the other is on the seventh- or eighth-century stone sundial set in the wall of Escomb church (Co Durham) (fig 5.23ii).[267]

The animal heads from fragmentary hilt-collar pair 188 are hachure filled, have almond-shaped and pupiled eyes, and jaws that end in scrolls (fig 5.22). Similar creatures with scrolled snouts feature on the Tara and Hunterston brooches, in Durham manuscript A.II.17 (folio 1r) and on mounts from Oseberg (Norway), examples that are dated between the late seventh and eighth centuries.[268] Earlier, if less specific, parallels for animal ornament featuring scrolls can be found among the Evangelist beasts in the Book of Durrow (folios 191v and 124v), the stags of the Lullingstone bowl, and a Style II-like quadruped with scrolled hips from Dunadd (fig 5.22iv).[269] Fragment 687 also features scrolls at the ends of its strange tendrils (fig 5.22).

One side of pommel 75 has a triangulate composition that clearly echoes the form of the raised field on pommel 76 with the zoomorphic triquetra (fig 5.22). The reconstruction suggests the pattern was originally formed of six small, raised triangles, which are interspersed with bands of interlace and centrally a triquetra. The last can be compared with the interlace triquetras on folio 3v of the Durham A.II.10 manuscript.[270] On each raised triangle is a triform of silver teardrops with a niello background. Similar 'teardrop' ornament can be found on Celtic or Celtic-influenced objects, including in the openwork frame of the disc-mount from Swallowcliffe Down, and on the 'sprinkler' from the same grave.[271] On the possible Pictish pommel from Culbin Sands, mentioned already for its interlace, it occurs on one side.[272] In addition, the teardrop-shaped garnets arranged as triforms on the sides of pyramid-fittings 580–1 might be considered further examples (fig 3.67). Scrollwork filigree surrounds these garnets, and the same mode of filigree was used to decorate the gold mounts on pommels 74 and 77. Its use on pommels is unusual (see above), but the filigree interlace and garnet cloisonné on pommels 73 and 76 are more in keeping with the other pommels of the Hoard. The conical spirals of beaded wire nestling in the arms of the garnet triforms on the pyramids (fig 3.67) provide a further link with Celtic metalworking,[273] as does the triskelion with scrolled arms on the ring-knob of pommel 76.

Another ornamental form adopted into the Early Insular style was the pelta.[274] The pelta form of gold filigree mounts 476–7 is unparalleled in Anglo-Saxon metalworking, as is the punched pelta decoration on silver fragment 686.

The borders of niello with silver leaf forms on hilt-guard set 409 (fig 2.24) can be paralleled by leaf-shaped ornament on further mould fragments from the Mote of Mark, and the form occurs elsewhere too in Celtic metalworking.[275]

Bird-headed mounts 536–7 in cast silver with gilded interlace are related in their style and form to gold mounts 463–5 and 467–8.[276] The rounded heads of the birds on these mounts can be contrasted with the head-form typical of birds in Style II with an angled head-surround (e.g. 57, 469–72, 511–2 and 514–7), and in this regard they are more akin to the large birds of mount 538, and ultimately with birds depicted in early manuscript art (cf figs 2.10, 2.35, 2.66, 5.11 and 5.22–5.23). Examples are the circular heads used for the

▲ **Fig 5.23.** Symbols of belief on Hoard objects with *comparanda*: i) the heads of the zoomorphs on the portal stone at Monkwearmouth (they have serpent-like bodies with fishtails); ii) carved 'serpent' with a fishtail from Escomb church (Co Durham); iii) gold finger-ring from Uttlesford (Essex), showing a figure with a processional cross and two birds; iv) crucifixion scene on one side of the pommel from Dinham (Shropshire). *Drawing*: C. Fern.

two versions of the eagle of St John in the Book of Durrow (folios 2 and 84v).[277] The beaked roundel in garnet cloisonné on pommel **73** and the birds of mounts **473–4** can be considered further versions (figs 5.11 and 5.22).

GEOMETRIC ORNAMENT AND SYMBOLS

The vast majority of the cloisonné is geometric in style, with much in the stepped-geometric style of the Continent (table 5.1).[278] Many of the cell-forms can be paralleled on objects outside the collection, with, in particular, the use of mushroom- and arrow-shapes shown to have links with East Anglian metalworking.[279] The cellwork and gem-settings on a few objects instead place emphasis on triangular forms.[280] Triangular cell-forms can be found quite widely, including on 'Kentish' disc-brooches and buckles,[281] and illustrated are the examples on the pyramid-fitting from Dalmeny (fig 2.44) and a pendant from Loftus (fig 6.9ii). However, the small triangular mount on the Cumberland hilt (fig 2.26) is the best parallel for mounts **489–93** (fig 2.25).

A small number of non-cloisonné objects have unusual and notable geometric ornament. The honeycomb pattern cast or incised on one side of silver hilt-collar **182** has no parallel elsewhere in Anglo-Saxon ornament, and it is different from the incised 'honeycomb' on mount **538** that imitates Anglo-Saxon cloisonné.[282] It can be compared instead with examples of honeycomb cloisonné on the Continent, such as that on the scabbard mouthpiece of a probably sixth-century sword from Köln St Severin (Germany).[283] In filigree, trapezoidal mount **438** stands out for its unusual pattern formed in scrollwork and herringbone (fig 2.25). Triangular, stepped and mushroom forms were combined in the niello ornament imitating cloisonné on mounts **567–71** (fig 2.67). Without parallel is the stark juxtaposition of animal ornament and panels with black lines on gold pommel **57**: on one side are pairs of straight vertical lines; on the other side are pairs of curved lines set on an angle (fig 2.10). The niello patterns with animal ornament on silver-gilt pommels **68–9** (fig 5.4), while very different from one another and from the use of niello on pommel **57**, would nevertheless have been equally striking originally.

On many fittings are geometric motifs, concealed and unconcealed – some of which probably represent symbols of belief (table 5.4). Many are hidden cross forms that represent a contrast with the Hoard's overt examples (**481–2**, **526**, **539** and **588**). Their cryptic nature fits with the tradition of ambiguous imagery established in animal ornament (see above), so it seems unlikely that they were hidden against fear of persecution. However, the universality of the cross as a symbol, including its use in Anglo-Saxon England before the Conversion, means that it is a challenge to know how to interpret some instances. For example, simple cruciform stamps were used widely on 'pagan' pottery urns of fifth- to sixth-century date, and crosses also occur on cast brooches of similar date, sometimes alongside Style I animal ornament.[284] Nonetheless, against the backdrop of the growing influence of Christianity by the seventh century, the frequency with which crosses and quatrefoil motifs appear is notable. One undoubted contemporary use of the Christian symbol as a form of spiritual armour is the silver cross on the nasal of the helmet from Benty Grange (figs 2.75a and 7.3), a protection that was perhaps considered to be further enhanced by the boar on the top of the helmet.[285]

The earliest cross forms in the Hoard are the quatrefoil knots hidden in filigree ornament on pommels and hilt-collars (table 5.4).[286] The four 'leaf' shape of the quatrefoil was in most cases formed by the body parts of serpents (fig 2.6) or zoomorphs (figs 5.1, 5.5 and 5.7). On other objects, quatrefoil knots appear unencumbered (figs 2.24 and 5.23),[287] which is how the knot appears in Roman mosaics.[288] It remained in use in the Roman east, as is shown by a gold buckle from Hamas (Syria) in The Walters Art Museum (Baltimore).[289] In this Byzantine setting, the knot's use very probably had a Christian association, but its appearance also in Style II in 'pagan' Scandinavia complicates any straightforward explanation of its meaning in the Anglo-Saxon context, immediately prior to and during the early conversion.[290] In England, further examples in Style II can be seen on the gold clasps from Taplow (Buckinghamshire),[291] on the Alton buckle (fig 5.5iv), on the hilt-collars from Market Rasen (fig 2.41) and on folio 192b of the Book of Durrow.[292]

Different quatrefoil motifs using arrow and mushroom cell-forms are found in the cloisonné ornament of a range of fittings (figs 3.91–3.92 and 5.2; tables 3.8 and 5.4).[293] Again, the motif's meaning was probably not fixed across different contexts of use, with examples known from Scandinavia and from Christian regions of the Continent, as well as from Anglo-Saxon England.[294] However, on pommel **47** and on mounts **542–7**, mushroom quatrefoils were employed alongside other cross forms (figs 2.58, 3.92 and 8.2), which might make a Christian meaning more likely. The three on pommel **47** can also be compared with the similar positioning of the three crosses on the pommel from Dinham (Shropshire), which form a Calvary scene, along with two beast heads at the foot of the crucifixion (figs 2.86 and 5.23iv).[295]

Actual cross-shaped garnets, or shaped cellwork with some other inlay, also occur in the cloisonné, as on pommels **52–3** (figs 5.2 and 5.8; cf fig 3.86; table 3.7).[296] In addition, crosses may be detected in the cell-walling or cell-forms of further objects, including pommels **39** and **41**, and small mount **495** (fig 5.23).

Object-type	Filigree quatrefoil	Cloisonné quatrefoil	Incised/cast quatrefoil	Swastika	Cross-form object	Crosses in ornament	Stafford knot	Triform	Pelta
Pommels	7	4	2	3	-	11	4	3	-
Hilt-collars	4	4	-	-	-	1	3	?1	-
Hilt-plates/guards	2	-	-	-	-	1	-	-	-
Small mounts	-	-	-	1	3	8	2	-	2
Mount 538	-	-	-	-	1	-	-	-	-
Christian objects 539 and 541	-	-	-	-	-	1	-	-	-
Large mounts 542–66	-	11	-	-	-	6	-	-	-
Pyramid-fittings	-	-	-	-	-	10	-	2	-
Cross-pendant 588	-	-	-	-	1	-	-	-	-
Helmet parts 591–2	-	-	-	-	-	-	2	-	-
Die-impressed sheet 602	-	-	-	-	-	-	1	-	-
Fragment 686	-	-	-	-	-	-	-	-	1
Fragments 687	-	-	-	-	-	-	-	?1	-
Harness-mount 698	-	-	-	-	-	1	-	-	-
Total:	**13**	**19**	**2**	**4**	**5**	**39**	**12**	**7**	**3**

▲ **Table 5.4.** Incidence of symbols.

The bold equal-arm cross in filigree on one side of silver pommel **63** is surely a strong candidate for a Christian symbol (fig 5.23). But more ambivalent are the possible Latin crosses that can be suggested from the frames which divide the scrollwork on mounts **439–42** and **471** (fig 5.23).

A different X-form can be tentatively suggested on a small number of objects. Known either as a saltire or *crux decussata* in Christian use, the symbol was derived from the Greek letter Chi [χ] of the Chi-Rho, but again such a simple geometric form might have had alternative meanings. Examples in Style II that are questionable in intent are those on hilt-collar **90** and pommel **17** (figs 5.1 and 5.7), while versions can also be interpreted from the triangulate cellwork of several pommels (**36–8** and **47**), mounts (**542–7**) and pyramid-fittings (**580–1**) (fig 5.10: **38**).[297]

Further cryptic crosses are seen on a range of objects. On pommel **76** (fig 2.12) crosses can be read in the alternating glass, and garnet settings of its central roundel, which are reminiscent of examples formed in the geometric cloisonné of composite disc-brooches.[298] Crosses can also be interpreted from the geometry of pyramid-fittings **572–9**, when the objects are viewed from above (figs 5.10: **578** and 5.23: **574**). The Christian head-dress mount (**541**) presents an assortment, including those formed in the chequered pattern of its large glass *millefiori* stud (fig 5.14). It is possible this glass, used mainly for smaller inlays, which does not occur in Anglo-Saxon metalworking before the seventh century, and was possibly made at Christian sites,[299] was regarded as emblematically Christian, since the patterns in it naturally form crosses. On pommel **53** a small rectangle in it was placed between the heads of two Style II creatures on one side, with the pattern orientated in such a way as to form a cross (figs 3.87 and 5.8). This may represent another example, therefore, of the combination of Germanic 'pagan' animal and Christian symbolism. The multiple cross forms within the inlays at the apices of pyramid-fittings **578–9**, including the tiny forms within the white check, appear even more explicit (figs 3.9 and 5.10).

The quatrefoil knot on pommel **74** hides a swastika at its centre (fig 5.23), and another is hidden on pommel **53**, formed by the interlocking jaws of the fighting beasts in cloisonné (fig 5.8).[300] The same symbol can be found concealed in Style II elsewhere, for example, on the plates of a buckle from Saint-Denis (Paris),[301] and in England one is formed in the jaws of the creatures from Monkwearmouth, already mentioned (fig 5.23i).[302] The swastika was widespread in use in the fifth to sixth centuries, including on Anglo-Saxon pottery and brooches, and an instance is also seen on a sword pommel from Bifrons (Kent).[303] However, the only overt use of the motif in the collection is bird-headed mount **464** (fig 2.35). It is best paralleled by a pendant from Wieuwerd (Netherlands).[304]

It has been suggested the swastika was associated with the god Thunor/Thor,[305] but the symbol was also used in the Roman period, and it is unlikely to have had a 'pagan' meaning in the context of its use on the porch stones of Monkwearmouth. In this context, as in the case of the version on the Bifrons pommel, the symbol may have been considered to be protective.

Triforms are a final form of motif seen in the collection, such as the triskelion and triquetra examples of the Early Insular style (see above). These motifs are often regarded as unambiguously Celtic, since triform knots and whorls abound in British and Irish metalworking.[306] However, examples do occur on Anglo-Saxon, Merovingian and Scandinavian objects, such as the bird-headed triskelion in garnet cloisonné on a gold filigree pendant from Faversham (Kent).[307] Less obvious are the triquetras hidden in the filigree of pommel **8** (fig 5.6).

CONCLUSION

Beyond the ability of the Hoard's gold and garnet objects to beguile, their complex styles have tremendous potential for revealing new insights on the thought-world of the Anglo-Saxons, in a critical period that saw the creation of new identities and mentalities for social elites, as kingdoms were formed and converted. The swords, fighting knives and helmet bearing ornament were instruments for killing or armour for protection, but probably it was in the everyday and ceremonial contexts, as part of warrior costume, that the message of the animal, human and geometric imagery was mostly conveyed. The animal ornament, with its roots in Germanic 'pagan' belief and mythology, doubtless remained critical to the display of the legitimacy of the established social order, for nobles, princes and kings. Though we are not able to translate with certainty any of the 'pagan' motifs, their prominence throughout the assemblage suggests that their meaning and power was far from spent at the coming of the new Christian religion in the early seventh century. Significantly, a number of objects demonstrate a syncretic approach to the iconography of the ancient and new, indicating that pre-Christian and Christian symbols could be viewed as harmonious (e.g. fig 5.2). As Bede's famous account of Oswald's raising of a cross before the battle of 'Heavenfield' (*c* 634) shows,[308] the Christian sign was viewed foremost as a symbol of victory by the early Anglo-Saxons, but as such, for a time at least, it had to keep company with the battlefield talismans of Germanic art and religion: the zoomorph, eagle and stallion.

CHAPTER SIX

CHAPTER SIX

DATE AND ORIGIN

CHRIS FERN

The enquiries into the date and origin of the finds are inextricably linked, since the object parallels that inform the dating are spread throughout Anglo-Saxon England and beyond. Based on the evidence of this related material, and taking account of the character of the region in which the Hoard was found, there are good reasons for believing that many of the objects were made far from where they came to be deposited. The analysis also suggests that the accumulation process of the treasure was complex. The material overall has a considerable date-range and different provenances can be proposed for groups of style-related finds. Together these aspects imply that the collection did not necessarily result from a single episode, regardless of the mechanism(s) chosen to explain it, whether as tribute or battle loot, to name but two. Instead, it is argued, the metalwork could have accrued over a few decades. The latest object or group provides us with a *terminus post quem* for the actual burial of the assemblage. It is not considered likely that the collection was above ground long after its incorporation, since any prolonged period would very probably have resulted in the presence of further, later items. Table 6.1 summarises the dating and possible origins.

DATING THE HOARD

The Hoard presents significant challenges for dating, both for establishing the overall date-range of the material and for determining a *terminus post quem* for its deposition. The collection is without any coins and an independent chronology for its metalwork cannot be established by scientific means.[1] The rarity and in some cases the novelty of its object forms in precious metal, furthermore, mean that there is a considerable lack of *comparanda* for typological dating, from graves or other contexts. However, the ornamental filigree and cloisonné techniques of the assemblage are well paralleled on a variety of objects,[2] including brooches and buckles, and in particular the Style II animal ornament that occurs on 140 Hoard items can be compared with an external corpus.[3]

Shortly after discovery, emphasis was placed on the expert dating of the exceptional inscription of strip **540** (fig 2.78), a feature which clearly marks it out as one of the latest objects: Brown proffered a date for the script of *c* 670–*c* 700, but acknowledged it could be as early as *c* 650; Okasha believed it to be no earlier than *c* 700, and Klein has since reiterated a similar dating.[4] Gameson's new analysis in *Chapter 2* now reinforces the case that it is probably a work of the seventh century,[5] but given its 'unique nature' and the considerable temporal range of the potential parallels for the script, it cannot offer a secure *terminus post quem* for the Hoard. Instead, dating must be based on an appreciation of the assemblage as a whole.

The early Anglo-Saxon period is rich in objects due to the custom of placing possessions and symbolic items in burials (i.e. 'grave goods'),[6] but dating this material culture from graves is not straightforward. In general, weaponry (spears, shields and swords) was deposited as the costume of males, whilst brooches, beads and girdle-equipment constituted the costume of females. However, the complexity of the material record and variations in custom at the local and regional level, as well as the 'heirloom factor' (the placing of old objects in graves), mean that we cannot date grave goods with the close precision we would wish. Nevertheless, in 2013 a long-awaited chronological framework for Anglo-Saxon grave goods of the sixth to seventh centuries was published (hereafter the *AS Chronology*).[7] It is important because it provides a robust chronology, which, though broad in its periodisation, can be applied supra-regionally. It was established using the technique of correspondence analysis, in combination with high-precision radiocarbon dating of associated human remains, and modelling with Bayesian mathematics. Separate male (AS-M) and female (AS-F) phases were produced based on leading-artefact types, as well as a further male series (AS-Mp–AS-Mt) from the clustering of significant grave assemblages.[8] The majority of the forms of the Hoard's many hilt-fittings are unfortunately poorly served, due to the extreme scarcity of swords with ornate parts among weaponry placed in burials, but comparable filigree, cloisonné and Style II animal ornament does feature on many other objects from the

CHAPTER SIX | DATE AND ORIGIN

Hoard Phase (HP)	Styles typical of the phase	Summary	Objects definitely of the phase	Objects possibly of the phase	Possible origin of the metalwork
1 sixth century	Style I and early Style II; regular interlace	'Heirloom' silver weapon-fittings	HP1: 68–9; 79/84, 80/81/83; 182–7; 533–5	?HP1: 82 HP1–HP2: 64–7, 78, 372–4 HP1–?HP4: 226–42, 371, 374–408, 696–7	68 = Scandinavia; otherwise Anglo-Saxon
2 c 570–c 630	Early Style II; regular and irregular interlace; scrollwork; some cloisonné	Mainly gold. Some 'heirloom' fittings. Filigree zoomorphic and interlace style weapon-fittings; Cumberland-hilt style weapon-fittings;	HP2: 1–42, 58, 63, 85–108, 117–27, 243–62, 425–6, 450–3, 456–7, 469–472, 480, 483–4, 572–3, 582–4	?HP2: 114–6, 414–24, 427–49, 478–9, 489–93 HP2–?HP3: 128–50, 153–8, 190 HP2–HP3: 59–62, 191–224, 263–360, 410–11, 413, 458, 481–2, 488, 494–5, 524–6, 585–8, 677–8	?Greater Northumbria
3 c 610–c 650	Late Style II; cloisonné	Mainly gold. Cloisonné style weapon-fittings; other gold objects; cloisonné mounts; silver niello mounts; ecclesiastical objects; helmet	HP3: 47, 49–57, 70–1, 109–13, 151–2, 159–63, 165–70, 181, 189, 225, 370, 454–5, 459–61, 485–7, 499–502, 511–5, 538–66, 574–9, 589–97, 599–601, 603, 605, 607/8, 612–3, 615, 676	?HP2–HP3: 46, 171–80 ?HP3: 43–5, 48, 361–9, 412, 462, 496–8, 503–10, 516–23, 527–32, 567–71	East Anglia
4 c 630–c 660	Early Insular style; scrollwork	Silver with gold mounts. Early Insular style weapon-fittings	HP4: 72–77, 188, 409, 463–5, 467–8, 536–7, 580–1, 687, 698	HP3–HP4: 466 ?HP4: 473–7, 587, 686	?Greater Northumbria, ?Mercia

▲ **Table 6.1.** Summary of Hoard Phases 1–4. '?': possible.

550 AD

Hou, Langeland (Denmark), scabbard mount
(?mid-sixth century)

Gold filigree

Alton 16 (Hampshire), buckle
(AS-Mq 550/70 - 565/595)

Hilt-collar 88

Pommel 2

600 AD

Cast or sheet

Faversham (Kent), Keystone garnet
disc-brooches (Avent Class 7)

Broadstairs 59 (Kent), buckle
(AS-FB 510/45 - 555/85)

Prittlewell (Essex), drinking-horn
(cal AD 575–605 95% probability)

Pommel 69

Beckum II (Germany),
Lower Rhine phase 6 (c 570–c. 585).

Sutton Hoo 17 (Suffolk), harness-mount
(AS-Ms 585/615 - 610/45)

Sutton Hoo 2, mount

graves studied. All the date-ranges given below follow those at 95 per cent probability given in the *AS Chronology*.⁹

Particularly important are the dates in the *AS Chronology* for several graves regarded as 'princely', which provide many of the artefact parallels for the ornament of the Hoard objects: the burial at Taplow (AS-Mr 565/95–585/615), and Sutton Hoo mounds 1 and 17 (AS-Ms 585/615–610/45).¹⁰ In addition, as the subject of a separate study, the 'princely' burial at Prittlewell has a modelled-radiocarbon date of 575–605 cal AD (95% probability), as well as an independent *terminus post quem* of c 580 provided by coins.¹¹ The Sutton Hoo mound 1 ship-burial is also dated by coins from the grave to c 600–c 640.¹² It is considered by many probably to be the grave of King Rædwald (d. 624/5) of East Anglia.¹³ The *AS Chronology* statistically tested this proposition and found it showed good agreement with the scientific and typological dating of the grave,¹⁴ though the rapid succession of East Anglian kings in the second quarter of the seventh century must ultimately leave open

▲ **Fig 6.1.** Anglo-Saxon early Style II (c 570–c 600), showing zoomorphs with angled head-surrounds on objects from East Anglia (Sutton Hoo), southern England (Kent, Hampshire and Essex) and in the Hoard. All share a common ancestor in the Scandinavian quadruped from Hou (Langeland, Denmark), while that from Beckum II (Germany) is an instance from the Continent. The cast and sheet versions imitate those in gold triple-strand filigree (not to scale). *Drawing*: C. Fern.

the possibility that the grave is that of another of the kingdom's rulers.¹⁵ Although in the *AS Chronology* mounds 1 and 17 at Sutton Hoo have the same date-range, in Carver's publication of the cemetery mound 17 is considered earlier on the basis of the typology of the grave artefacts (phase 3: c 600–c 620).¹⁶

Høilund Nielsen has produced the only chronological study of the development of Anglo-Saxon Style II.¹⁷ She used correspondence analysis to compare the anatomical parts of the ornament's stylised creatures, largely as recorded in Speake's 1980 corpus, with the aim of tracing their evolution through time. She created separate phases

for 'Kentish' Style II (KA, KB and KC) and 'Anglian' Style II (SC, A1, A2 and MS) based on prior understanding that the then distribution of the material reflected regional styles.[18] In the Kentish sequence, her earliest phase KA (late sixth century) comprises mainly bird forms, with zoomorphs only truly appearing in phase KB, and full zoomorphic interlace in phase KC (seventh century). 'Anglian' Style II begins with Scandinavian influence in phase SC (mid sixth century) in the form of the ornament on the 'heirloom' shield and drinking horns from Sutton Hoo mound 1. In phases A1 and A2 (late sixth/early seventh century) are objects with zoomorphic interlace, including finds from Sutton Hoo mounds 1, 2 and 17. However, far from being distinctly 'Anglian', phases A1 and A2 are in fact populated by zoomorphs that are anatomically closely related to those seen on 'Kentish' objects, as is shown in fig 6.1 (cf zoomorphs of Essex/Kent/Hampshire with those of Sutton Hoo). Their slight differences are the consequence of their manufacture in different materials and workshops, and they should not therefore be considered a consciously different aesthetic. Høilund Nielsen's phase MS ('manuscript'), representing latest usage in England, includes examples of Style II's on metalwork and in early manuscript illumination, the start of which she dated from c 620.[19]

The substantial record of Style II in the Hoard, together with the new dating provided by the *AS Chronology*, now challenges Høilund Nielsen's model of the development of the elite style in England. It is argued in this chapter that the ornament, instead of taking 'Kentish' and 'Anglian' regional forms, should be understood as 'early' and 'late'. Anglo-Saxon early Style II corresponds with all of Høilund Nielsen's Kentish phases and her Anglian phases A1–2. Its key form, at least for dating, is the serpent-like zoomorph, which was known across Europe (fig 6.1). That early Style II was also well known in different parts of England is suggested not only by the Sutton Hoo (East Anglian) instances and those in the Hoard, but by further occurrences on recent and widespread metal-detected finds with the form of the art, like the pommel from Wellingore (Lincolnshire) (fig 6.2i).[20] In Anglo-Saxon late Style II the quadruped was the signature creature (fig 6.3). This version of the ornament, in contrast, does not seem to have been applied in the same manner in all regions, which may explain why it was previously considered distinctly 'Anglian': in particular, in most cases of its use on Kentish-type objects in precious metal it was confined to the reverse, or else it occurs on objects of base metal.[21] It is possible that this indicates that animal ornament had fallen out of favour with the Kentish ruling elite by the time of late Style II (the opening decades of the seventh century). By comparison, in the metalwork of the Hoard, as at Sutton Hoo, the quadrupeds of late Style II were given full prominence.

An approximate *terminus ante quem* for the Hoard's gold metalwork around the mid-seventh century seems likely on the evidence of the rarity of gold objects from the archaeological record in England after this time, and from an accompanying fall in gold fineness seen in the numismatic record, due very probably to the metal's growing scarcity.[22] From the 630s/40s a shortage of gold in north-west Europe is likely to have resulted from the cessation of imports of Byzantine coin during the reign of Heraclius (610–41).[23] Viewed generally, the gold-alloy fineness established for the Hoard metalwork fits best with the 'Early' (c 590–c 630) and 'Substantive' (c 630–c 650) phases of early Anglo-Saxon gold coinage.[24] In the following 'Pale gold' and 'Transitional' phases, the content of the metal in coins falls dramatically (Au <50wt%) and ultimately to a nominal level.[25] By the 670s silver coinage had replaced that in gold.

Two rare, late objects in gold and garnet from England are the pectoral cross of St Cuthbert and a cross found recently in a grave at Trumpington (Cambridgeshire). The latter also has granular filigree. A radiocarbon date for the Trumpington burial indicates that it took place around the time of the cessation of the Anglo-Saxon grave-good custom,[26] a date determined at c 670 by the *AS Chronology*.[27] The cross of St Cuthbert was probably buried with him in 687.[28] The Trumpington cross is not heavily worn, but the Cuthbert cross was twice repaired,[29] so both were probably made around, or soon after, the mid-seventh century.

▲ **Fig 6.2.** Gold filigree pommels from (i) Wellingore (Lincolnshire) and (ii) Middleham (North Yorkshire), and the 'York group' shilling (iii) found with the Middleham pommel. Note the damage to one edge of the Wellingore pommel, to its copper-alloy core and gold cap, which is similar to damage on Hoard examples, caused by removal by levering. *Photographs*: courtesy of the Portable Antiquities Scheme (www.finds.org); PAS: i) LIN-871CD5, ii–iii) BM-7C4457.

Fig 6.3. Anglo-Saxon late Style II (c 610–c 650), showing quadrupeds on objects from East Anglia (Sutton Hoo), Kent and in the Hoard (not to scale; some reversed). *Drawing*: C. Fern.

It is significant to note that the late cloisonné, rectilinear style they manifest is not common in the Hoard.[30] The *AS Chronology* also shows that gold filigree and garnet pendants, some with cross designs, continued to be buried late in female graves and, allowing for their use before burial, the latest among them were probably also made during the decades either side of c 650.[31] Nevertheless, a lack of gold, twinned with a growing demand for gold coinage, might have already reduced resources for non-coin metalworking in some regions prior to this date, a situation that could have given rise to the Hoard's latest silver objects with gold mounts of the Early Insular style.[32]

Initially it was hoped that the scientific analysis of the gold of the objects might prove a means of dating.[33] This is because contemporary Merovingian gold coinage, the most likely raw material for the majority of the metalwork, shows a decline in alloy fineness that can be linked with known dates of issues, moneyers and royal mints.[34] Comparison with the gold purity of (non-coin) artefacts, like those in the collection, has thus been used by past studies as an independent means for dating.[35] However, analysis of the gold-alloy fineness of the Hoard metalwork has shown a considerable overall range with no consistent pattern of decline corresponding with the chronology indicated for the objects by their typology and style. For instance, some gold objects with late Style II (e.g. **57**, **370** and **538**) exceed the purity (Au c 80wt%) of gold objects with early Style II (e.g. **2** and **4**). It has been concluded from this that Anglo-Saxon metalworkers must in some cases have been manipulating the alloys of objects, for example, by increasing their fineness using rare sources of purer gold to meet the demands of elite patrons.[36] Therefore, the analysis done for this project shows that gold-alloy fineness cannot be used as a means for dating individual non-numismatic objects with any precision; though the general alloy-range of a large collection such as the Hoard ought still to fit broadly with the situation prevailing in the wider metal economy.

The evidence of wear recorded on the objects also helps to corroborate the arguments for the dating established by typology and style.³⁷ It is the case that a number of the pommels with heavy wear are earlier by these criteria (**2–4**, **7–9**, **14–5**, **25**, **36**, **40**, **43–4**, **64** and **68**), while some that are later in date have only light wear (**16**, **32–3**, **52–7**, **70–3** and **76**). There are exceptions to this pattern, of course, but considered generally this evidence has enabled a narrower date-range for the accumulation of the collection to be suggested than the very broad date-range indicated by the typological and stylistic evidence alone.

Four phases (*Hoard Phases 1–4*) are proposed for the metalwork that relate approximately to date of manufacture, spanning from the sixth century to just after the middle of the seventh century. The bulk of the material is from *Hoard Phases 2–3*. The phases overlap at their limits, meaning that objects near the start and/or end of each phase are potentially contemporary. The system is presented as a structure for understanding the complexity of the Hoard; the phases should not be applied uncritically to other external material or treated as similar to the absolute date periods of the *AS Chronology*.

Hoard Phase 1: sixth-century silver fittings from weapons

A relatively small number of silver fittings are of this phase, some showing considerable wear: up to seven pommels, three pairs of hilt-collars and three sword-rings, together probably with accompanying hilt-plates and hilt-rings. They may represent parts stripped from just a few swords that were already old when dismantled, and that may be considered, therefore, to have been long maintained as antique or 'heirloom' weapons. Their manufacture in silver and the date of the diagnostic items agrees with the trend observed in the *AS Chronology*, for metalwork prior to the late sixth century to be predominantly in copper alloy or silver and often gilded.³⁸

The late Style I animal ornament on hilt-collar pair **182–3** suggests their manufacture around the middle of the sixth century. The *AS Chronology* shows that objects with Style I had largely stopped being buried in graves by around the century's third quarter.³⁹

The banded ornament of hilt-collar pair **184–5** is comparable to, and must be contemporary with, the similar zig-zag niello and gilded decoration on a scabbard mouth-piece from Gilton (Kent). The position of this object-type in the *AS Chronology* indicates the Gilton sword was buried during the middle two quarters of the sixth century.⁴⁰

Most of the silver (**63–70**) and gold pommels of the Hoard take Menghin's *Typ Beckum – Vallstenarum* form, of his phases D–F (*c* 570/80–*c* 680).⁴¹ Nørgård Jørgensen's chronology of Scandinavian war-gear suggests approximately the same start date for the pommel-form (types SP3–SP4), but it is argued to have remained in use longer in Scandinavia (phases II–V: *c* 560/70–*c* 750).⁴² The *Typ Beckum – Vallstenarum* form is not represented in the *AS Chronology*, though Menghin's earlier *Typ Bifrons – Gilton* pommel-form (SW2-b) is included, dated to its phase AS-MB (525/50–545/65),⁴³ which is relevant to the dating of a few objects (see below) as well as being notable for the general absence of the form from the Hoard.

Pommel **68** is perhaps the earliest pommel in the collection, as well as an import from Scandinavia. Its hybrid *Typ Bifrons – Gilton* / *Typ Beckum – Vallstenarum* form agrees with its early Style II ornament.⁴⁴ It can also be dated by the correspondence of its interlace pattern to serpent interlace on a wooden lyre found in grave 58 at Trossingen (Germany) (fig 5.21).⁴⁵ An oak coffin in the burial has been dated to *c* 580 using dendrochronology, although the lyre was old and repaired when buried. Sword-ring **82** is a possible fit with pommel **68**.

A late sixth-century date for pommel **69** (with fittings **186–7** and **533–5**) is suggested by its similarity to the German parallel from Beckum II (fig 5.4iii): the continental pommel is from a coin-dated burial of Siegmund's Lower Rhine phase 6 (*c* 570–*c* 585).⁴⁶ Pommel group **64–6**, plain pommel **67** and fragment **78** could all have been made in the late sixth century also,⁴⁷ but an early seventh-century date for them cannot be ruled out. Pommel **70** (*Hoard Phase 3*) with late Style II and probably pommel **63** (*Hoard Phase 2*) with a filigree cross show that the production of silver pommels of *Typ Beckum – Vallstenarum* form continued in England well into the first half of the seventh century.

The two other silver sword-rings (**79/84** and **80–1/83**) in the assemblage are like examples found with sixth-century *Typ Bifrons – Gilton* pommels.⁴⁸ Also, as silver hilt-plates and hilt-rings feature on swords with pommels of the same type in the *AS Chronology*,⁴⁹ it would seem very likely that some of the Hoard's silver hilt-plates and hilt-rings (**226–42**, **371–408** and **696–7**) formed sets with the silver pommels and collars of this phase. However, as the long-oval hilt-plate type was long-lived across north-west Europe, it cannot be discounted that some originated from sets with the later silver pommels of *Hoard Phases 2–4*.

Hoard Phase 2 (gold): Anglo-Saxon early Style II and contemporaneous styles and objects, c 570–c 630

Most of the gold filigree pommels, hilt-collars and small mounts, as well as gold hilt-rings and hilt-plates, were probably made and used within the period *c* 570–*c* 630. The majority cannot be closely dated within this chronological range, due to a lack of well-dated parallels; however, many exhibit a general correspondence of form and style. Diagnostic are twenty-seven gold pommels, fifteen hilt-collars and eight small mounts with forms of early Style II characterised by the use of zoomorphs and serpents.[50] The start date of *c* 570 for this phase follows that suggested by Høilund Nielsen for the beginning of Style II production in England.[51] In total, sixteen of the objects with the animal ornament have heavy wear: filigree pommels (**2–4, 7–9, 14–15** and **35–6**) and hilt-mounts (**425–6** and **450–3**). These gold fittings probably again came from swords that saw decades of use, like the 'heirloom' weapons of *Hoard Phase 1*.

The Style II on a few sets formed of gold filigree pommels and hilt-collars of high form (**1–2, 5** and **85–90**) can be closely compared with ornament on objects that come mainly, but not exclusively, from southern England (fig 6.1). Probably these instances represent an initial phase of early Style II in England of the late sixth century. An object of Høilund Nielsen phase KB is the buckle with a rectangular back-plate (BU4-c) decorated with a pair of zoomorphs from Broadstairs (Kent), grave 59, of phase AS-FB (510/545–555/585).[52] Another of the parallels is the Style II buckle with gold filigree (Høilund Nielsen phase KC) from Alton, grave 16, which was most likely buried towards the end of *AS Chronology* phase AS-Mq (550/70–565/95), given the triangular form of the buckle-plate and the fact that the object had been repaired more than once (cf figs 2.39 and 5.5iv).[53] The absolute date-range of the Taplow grave (see above), which produced a related triangular buckle and triangular clasps with Style II (phases KB–KC), allows for burial after *c* 600, but the cognate ornament of the objects could also be consistent with their manufacture earlier.[54] The clasps were made of gold sheet over copper alloy,[55] a technique with clear parallels among the collection, including for pommels **1** and **2**. Also probably of the late sixth century are the gilded Style II mounts from horse-harness from Sutton Hoo mound 17, but once more the repaired harness was used for some time before the burial took place, probably in the early seventh century.[56] From mound 2 at the cemetery is a pair of gilded disc-mounts with similar forms of zoomorph.[57] The Prittlewell grave, of the last two decades of the sixth century (see above), contained multiple objects with early Style II. The designs on gilded rectangular mounts from a pair of drinking horns (S39–S40) are comparable to those on hilt-collars **88** and **90**, and they can also be likened to the Style II on cup-mounts from Taplow.[58]

The Prittlewell drinking-horn pattern is akin, furthermore, to the Style II filigree on the hilt-collars from Market Rasen (fig 2.41), so there can be little doubt that these hilt-fittings and the others in the set were manufactured a decade or two prior to 600. The latter find and the closely related pommel from Wellingore (fig 6.2i) are two of the more recent objects to be found that show the distribution of early Style II outside of south-east England.[59] Lastly, within the assemblage the broad contemporaneity of the zoomorphic forms in gold filigree (**1–2, 88** and **90**) with the creatures on silver pommel **69** should be noted (fig 6.1).

The development from *c* 600 onwards of the tradition represented by the collection's filigree pommels and hilt-collars is harder to trace, but the many permutations of Style II and interlace ornament decorating them suggest that the fashion could have remained popular for a considerable period.[60] One of the latest objects of this filigree tradition might be the pommel from Middleham (North Yorkshire), which came probably from a ploughed-out grave that also included the sword to which it had been fitted and a gold shilling of the 'York group' (*c* 625–*c* 650) (fig 6.2ii–iii).[61] However, the pommel's elongated form, manner of construction and geometric filigree (without Style II or interlace) sets it apart from the pommels of the Hoard and others.

Various head-forms were used in the Style II animal ornament (e.g. figs 5.4–5.9). Fourteen pommels and collars have versions of the quintessential zoomorph with an angled head-surround (fig 6.1), as found in Kentish and continental early Style II:[62] five of these have heavy wear. Twenty-two objects have U-headed zoomorphs:[63] nine show heavy wear. Four pommels have O-headed creatures:[64] one has heavy wear. The early use of the U-headed creature form is shown by examples on silver hilt-collars **186–7** (fig 5.4). Further instances are on pommel **5** and hilt-collar **87**, and their Style II also includes zoomorphs with head-surrounds. Pommels **3** (U-headed zoomorphs) and **36** (U-headed and head-surround zoomorphs) are heavily worn, so could be of the late sixth century, but pommels **17–19** (U-headed zoomorphs) have only light or moderate wear, so perhaps are closer to *c* 600 or later. The O-headed creatures on the shoulders of pommel **4** (fig 5.7), which is heavily worn, can be traced back to the late sixth century on the Continent.[65] Nevertheless, round-back pommel **34** (O-headed and U-headed zoomorphs) is very probably of the early seventh century, contemporary with the other filigree round-back pommels (**35** and **37**), based on the date of this pommel-form on the Continent.[66] Pommel **35** has heavy wear also, however, which might be considered to contradict a later date.

It seems very likely that the archetype of the zoomorph with an angled head-surround was in use beyond the late sixth century, but this form's ultimate duration of use is difficult to establish.

Late versions may be represented by the irregular design based on a pair of creatures on the almost pristine pommel **16** (fig 5.6), and by the similarly tangled Style II on pommel **10** that is also lightly worn. This understanding rests on the logic that the Style II filigree on the pommels and collars developed from regular to irregular forms over time; however (as discussed below), there is evidence that shows regular interlace continued to feature on some filigree-decorated objects well into the seventh century. Atypical, but with angled head-surrounds, and possibly also late, are the back-biting zoomorphs on each side of filigree pommel **12**, which again is not overly worn (fig 5.8). The alloy of this pommel is the least pure of all the gold objects (Au *c* 52–4wt%), and if it had been made only from contemporary Merovingian or Anglo-Saxon coinage, this could suggest a date for manufacture as late as the second quarter of the seventh century.[67]

That serpent interlace started early and continued late in filigree Style II is shown by examples in the Hoard. Twenty objects of *Hoard Phase 2* have serpent ornament.[68] The four creatures on one side of pommel **2** and those matching on hilt-collars **85–6** are certainly early (see above), while the serpent-inhabited interlace on both sides of pommel **14** might also be of the late sixth century, given that the pommel is heavily worn and its basketwork pattern is not unlike that on the Alton buckle (cf figs 5.5iv and 5.10). The serpent and Stafford-knot interlace on pommels **9** and **11** have been compared with the designs on the 'late' Eccles and Crundale buckles (fig 5.10i–ii);[69] however, the knot form also occurs on sixth-century objects from Prittlewell.[70] Serpents with little ʊ-shaped heads, like those on pommels **9** and **11**, are seen also on other pommels (**12**, **15** and **37**) and mounts (**451** and **455**). Pommel **37** is of the later round-back form, and mount **455** has a pair (**454**) with a possibly late form of ribbon interlace (see below). In addition, the same head-form was used for the quadruped creatures on hilt-collars **109–10** (*Hoard Phase 3*). The evidence altogether, therefore, may suggest that the ʊ-shaped head-form was current only from the early seventh century. Of the same date or perhaps slightly later may be the curled head-forms on pommels **13** and **38**, and those on hilt-collars **104–5**, which are like examples seen in regular interlace on two late composite disc-brooches from Milton (Oxfordshire).[71] The latest filigree serpents in the collection, of *Hoard Phase* 3, are probably those in panels on hilt-collar **151** and cloisonné mounts **556–61**.[72]

Both regular and irregular (non-animal) interlace occurs on filigree pommels with Style II (e.g. **6**, **7** and **9**), and the two types of ornament are also found combined on sets of fittings (e.g. **89**). It seems both forms of interlace were in use early,[73] but of the fourteen pommels with only non-animal interlace (without Style II) only two show heavy wear.[74] This might suggest that the use of interlace without animal content (i.e. Style II) became more popular over time, and that perhaps these pommels mainly post-date *c* 600. However, it is also the case that on the hilt-collars (the bulk of which, it is reasonable to suggest, must be contemporary with the pommels) non-animal interlace was more popular than Style II (table 5.1). Nor does it simply appear that irregular interlace replaced the original Roman-style, regular interlace over time: the continued use of the latter into the second quarter of the seventh century in at least one region is demonstrated by the regular serpent designs on the brooches from Milton,[75] and this adds caveats, furthermore, to the early dating of pommel **14**, and to the later dating of pommels **10** and **16**.

Some filigree pommels (**29–33**) with irregular interlace and light wear might be as late as *c* 620–*c* 630. In the case of pommel **30** this can be proposed on the basis of the similarity of its coiling interlace with that on objects of the Early Insular style (**76**, **188** and **409**), though the latter stylistic group is itself difficult to date.[76] Pommel **31** has interlace that may also be contemporary. Outside the Hoard a composite disc-brooch from Monkton (Kent) has comparable coiling interlace, which is certainly a late example in the brooch series (even though Avent's dating of it to the 640s based on the object's gold fineness must now be accepted with caution).[77] Pommels **32–3** of exaggerated tallness with densely tangled interlace might be among the latest objects in the filigree tradition, if the observed tendency for the height of 'cocked-hat' pommels to increase over time is correct.[78] The irregular interlace on pommel **29** is similar.

The unusual style of ribbon interlace on hilt-collars **111–3** and mount **454** might be relatively late, as these objects share a rare filigree technique with collars **109–10** (*Hoard Phase 3*),[79] which have late Style II as well as irregular interlace. In addition, collars **109–10** show that the high form of hilt-collar continued late in use. Collar **151** (*Hoard Phase 3*) is an example of a later collar of low form. As well as its filigree serpent interlace, it also has herringbone filigree, so possibly the collection's other low collars with herringbone (**128–50** and **152–8**) should accordingly be dated late in *Hoard Phase 2* or even into *Hoard Phase 3*. The sword from Acklam Wold (North Yorkshire) with comparable gold collars with herringbone-with-spine filigree (cf **153–8**) has an iron sword pommel with silver inlays (SW3-b), which in the *AS Chronology* is mainly a pommel type of the seventh century.[80]

The cross in silver filigree on pommel **63** and the cruciform symbolism on filigree and cloisonné pommels **37–9** and **41**, accompanied in each case by serpent interlace or non-animal interlace, might be later in date within this phase also, viewed in the historical context of the Anglo-Saxon conversion. All have only

light or moderate wear. Possibly, therefore, they mark a fashion that was contemporary with the pommels with all-over cloisonné and cross iconography of *Hoard Phase 3*. However, note must also be taken of the occurrence of two gold crosses in the Prittlewell grave, which, on the basis of the scientific dating of the burial, show that Christian symbolism could have been known in south-east England at least a decade prior to 600.[81]

The Cumberland hilt (fig 2.26), the key parallel for the Hoard's small hilt-mounts with filigree scrollwork, is another important find with little contextual evidence, meaning it cannot assist with dating the style. Nor can the example of the small gold hilt-mount with filigree annulets on the sword from Chessell Down (Isle of Wight) be closely dated;[82] but the grip-fittings with filigree scrollwork on the sword from Sutton Hoo mound 1 must be of the late sixth or early seventh century, depending on whether they are contemporary with the garnet cloisonné pommel or later additions.[83] A similar style of filigree, combining scrollwork, annulets and herringbone, is also seen on 'Kentish' objects dated in the *AS Chronology* to phases AS-FD/E (580/640–660/85).[84] Despite this considerable date range (for the burial of the objects), however, it is likely that the majority of the plated (BR2-c) and composite disc-brooches (BR2-d) with the ornament were made just prior to or during the early seventh century. Coins struck before *c* 615 found with a composite disc-brooch from Sarre (Kent) provide an approximate date for its manufacture and for that of the other class 2 brooches with the style,[85] while the plated disc-brooch form is argued to be typologically earlier.[86] In addition, scrollwork was combined with early Style II on the triangular clasps from the Taplow burial and on the reverse of the disc-brooch (class 3.2) from Kingston Down (fig 6.9i), providing parallels for objects **8** and **469–72**.[87] Most of the Hoard's small mounts with scrollwork are therefore probably of similar date, but that the ornament did continue into the second quarter of the seventh century is shown by its application on the gold mounts of objects of the Early Insular style.[88]

The occurrence with the late sixth-century Market Rasen hilt-suite (fig 2.41) of gold hilt-plates with small garnet bosses means that plates **243–62** could be of similar date; and the gold hilt-plates with the sword from Sutton Hoo mound 1 would suggest that many of the Hoard's plain gold plates were once associated with the pommels and collars of this phase also.[89] However, seax plate **370** with its quadrupedal Style II is of *Hoard Phase 3* and almost certainly other plates must have formed sets with the pommels of this later phase, including probably those with cloisonné trims (**361–9**).

The late sixth-century Prittlewell burial is the only dated context for the Hoard's gold beaded hilt-rings (**191–210**), while the pair of twisted-beaded wire rings on the Sutton Hoo mound 1 sword provides the only context for the Hoard examples (**211–8**). However, such simple forms may well have continued long in use. The pair of garnet and glass cloisonné pyramid-fittings of low form (**572–3**) is also suggested as of this phase. In the *AS Chronology* the fittings (SW5-b) come mainly from graves of phase AS-ME (580/610–610/45),[90] with Sutton Hoo mounds 1 and 17 both demonstrating sets. Button-fittings **582–3** are probably contemporary. The only cloisonné button-fittings from Anglo-Saxon graves are those from Sutton Hoo mound 1 and Wickhambreaux (Kent), and the latter also included a triangular buckle with early Style II filigree.[91] Similar fittings also appear in continental graves at the same period and in the Lower Rhine chronology (Spa4) they occur in phases 5–6 (*c* 565–*c* 610/620).[92]

Hoard Phase 3 (gold): Anglo-Saxon late Style II and contemporaneous styles and objects, c 610–c 650

In particular, the regalia of Sutton Hoo mound 1 are important for dating the Style II and cloisonné objects of this phase. The clearest examples of Anglo-Saxon late Style II in the East Anglian 'royal' grave are the quadruped creatures on the purse-lid and on the mounts of the maplewood cups (fig 6.3). Høilund Nielsen assigned both objects to her phase A2, but the quadrupedal Style II that they represent mainly defines her phase MS, with the latest versions those in Insular manuscript art of the second half of the seventh century.[93] If the purse and maplewood cup-mounts were among the latest objects in mound 1, this could suggest the emergence *c* 620 of late Style II in England, especially if it is accepted that the grave was that of King Rædwald (d. 624/5). However, the absolute limits set by the coin-dating of the burial (*c* 600–*c* 640) mean that *c* 610–*c* 630 is a more cautious estimate. A considerable number of the objects of the Hoard are attributed to this phase, including the majority with cloisonné ornament and many of the most impressive (table 6.1). No objects of this phase have heavy wear, in comparison with those of *Hoard Phases 1–2*.

The quadruped-creature form could have been reintroduced into Anglo-Saxon Style II from Scandinavian animal ornament, in which it had remained, or its resurgence in England might have resulted from influence from Byzantine representational art, as Haseloff long ago suggested in relation to the ornament of Sutton Hoo.[94] Examples of late Style II quadrupeds occur on pommels **52–7** and **70–1**;[95] hilt-collars **109–10**, **165–8** and **189**; hilt-plate **370**; mounts **485–7**; great cross **539**; head-dress mount **541**; helmet parts **589–92**; die-impressed sheet **594** and **601**; and fragment **605**.

Their forms can be compared with examples outside the Hoard (fig 6.3). A few have semi-naturalistic qualities, such as ears, while other characteristics include: heads that are elongated or almond-shaped; eyes set to the back and top of the head; flexed or S-shaped bodies, often with contoured edges; and sometimes creatures with wrapping limbs. Very rarely are head-surrounds used with the quadrupeds (though they continued in use for birds), whilst punched eyes feature in the Hoard but not elsewhere.

The combination of 'honeycomb' cloisonné with quadrupedal Style II in cloisonné on hilt-collar **168** of the seax suite (**55**, **167**–**9** and **225**) has a parallel in the ornament of a composite disc-brooch from Faversham (Kent), which has the cloisonné form on its front and a procession of quadrupeds incised around its reverse. In the *AS Chronology* the brooch type is of phases AS-FD/FE (580/640–660/85).[96] There is scholarly consensus, however, that composite disc-brooches were largely produced during the first half of the seventh century,[97] and Avent concluded that the cloisonné ornament on the Faversham brooch indicated a date of manufacture no earlier than the 630s.[98] The seax set can also be dated by its typological relationship to the fittings (SX4-c) with the seax (fig 2.43) from Ford (Wiltshire), of *AS Chronology* phase AS-MF (610/45–660/85), and the grave has a modelled-radiocarbon date of 620–650 cal AD (95% probability).[99] It is most probably the case, therefore, that the seax fittings are later (but not that much later) than the Sutton Hoo shoulder-clasps with which they have been compared for their technical excellence.[100]

The quadrupeds on pommels **52**–**7** and **70**–**1** vary in their exact likeness to those on the celebrated Crundale pommel from Kent, but there is no doubt that they belong to the same style horizon (figs 2.10, 5.8–5.9). The Kentish pommel and the triangular buckle with which it was found have been considered to date around the middle of the seventh century, on the basis of the relationship of the pommel ornament with that in the Book of Durrow (fig 6.3),[101] and correspondingly the pommel features in Høilund Nielsen's phase MS.[102] A similar date for pommel **56** (fig 5.8), with the most Crundale-like design of the group (cf fig 5.8i), is suggested by its round-back shape, a pommel-form that is rare in England and that is not included in the *AS Chronology*. Menghin dated the occurrence of round-back pommels (*Typ Eisenach – Sontheim*) on the Continent to his phase E (*c* 620/30–*c* 650),[103] and the same approximate date has been corroborated by more recent chronological studies.[104]

The silver triangular buckle with a gold fish from Crundale has a quadruped scratched on its reverse, like the ornament on the back of the Faversham composite disc-brooch.[105] The gold fish with filigree detail on the buckle front can be considered to offer a general parallel for the Hoard's small fish mounts (**461**–**2**), as well as for the large gold fish of mount **538**. The large birds of the plaque (**538**), in contrast with most Style II forms, demonstrate a certain semi-naturalism,[106] and a later rather than earlier date can be suggested by two features in particular: the effect of its deeply incised neck plumage is similar to the shaded leg feathers on the eagle of St John (folio 1) in Corpus Christi College Manuscript 197;[107] and the imitation 'honeycomb' cloisonné of the fish-scales indicates its contemporaneity with seax collar **168** (see above). Fish-scales and feathers are also seen on the closely related mount **459**, and similar detail figures on mounts **461** and **513**. Also, cloisonné bird and fish mounts **511**–**5** are linked with the seax collars by their use of tiny glass eyes, and, like the seax fittings, they have been compared with the Style II cloisonné of Sutton Hoo.[108]

The motif of head-to-tail quadrupeds on the Sutton Hoo maplewood cups provides an approximate date for the versions on hilt-collars **109**–**10** and **165**–**6**, and the equine head of mount **460** also has been compared (cf figs 5.9 and 5.12i).[109] However, most important is the identification of the careful copying and then adaptation of the Sutton Hoo motif on the transecting arms of great cross **539**.[110] The motif on the cups was impressed using a die that could have remained in circulation and have been copied for decades after its creation (*c* 610–*c* 630). Indeed, that the cross was not made until considerably later is suggested by the other key metalwork parallels for its animal ornament: Hines has proposed a 'decade (or two) either side of 650' for the runic inscription on the back of the Harford Farm brooch that bears related Style II incised at the same time (fig 5.12iii);[111] and the Littlebourne buckle with Style II (fig 5.12iv), is dated to the same horizon by the object's close formal and stylistic relationship to the buckle from Crundale.[112] In sum, a date for the cross's manufacture in the second quarter of the seventh century can be argued from the related metalwork, but a date closer to 650 than to 625 is surely more likely, not least based on the further evidence of the relationship of the cross ornament to that in the Durham A.II.10 (fig 5.12v) and Durrow manuscripts (fig 5.13).[113] This would allow up to thirty years between the rendering of the matching Sutton Hoo and cross motifs, equivalent maybe to the full career of a master goldsmith, in whose possession the die remained, and arguably at the limit of what is plausible. Of course, if this dating is accepted, it is necessary to consider again the long-debated question of when (and where) the Book of Durrow was produced.[114]

The great cross is also of the utmost importance for dating inscribed strip **540** and head-dress mount **541**. The D-shaped boss on the cross and that on the strip are so similar that they have to be

contemporary, and they indicate in all probability a single workshop origin. The Style II of head-dress mount **541** has its closest parallels in the ornament of the cross (**539**) and gold hilt-fittings **485–7**. The use of niello on strip **540**, furthermore, is only a feature of gold objects of this phase (**56–7**, **412**, and **531–2**), which is also true of the practice of incising animal ornament in gold sheet.

One further, small piece of evidence for the date of the cross (**539**) is represented by the pair of 'locking' pins (**676**) that are tentatively suggested to come from a standing base for it.[115] Their wire rings are like rings (WR2) from necklaces that in the *AS Chronology* are of phase AS-FE (625/50–660/85).[116]

The ornament of the helmet presents a special case. In the opinion of this author, it was made in the seventh century, probably during its second quarter, though Speake has offered an alternative, earlier dating.[117] The helmet makes deliberate use of outmoded ornament, as was first identified by Høilund Nielsen.[118] The zig-zag niello framing on the cheek-pieces (**591–2**) is most typical of the sixth century (as on hilt-collars **184–5**), and some of the animal ornament also has early parallels. The procession of zoomorphs in *band 2* on each cheek-piece (fig 5.17) is very similar to an early Style II design on cup-mounts at Prittlewell,[119] so may again have been copied from a metalworking die (as is argued above for the great cross). Also retrospective in style are the angled head-surrounds of the quadrupeds in *bands 1* and *3*, and in *panel 4*. Some of the creatures from the neck-guard also appear to be in early Style II (fig 5.19: e.g. **600**). Nonetheless, the correct dating for the cheek-pieces is betrayed by the S-shaped and contoured body-forms of the quadrupeds (*bands 1* and *3*, and *panel 4*). Parallels for them include the creatures on the bottom arm of cross **539** (cf fig 5.12). Now the grandest of its rare kind, the Hoard helmet is justly considered equivalent to a warrior crown. This being so, its prestige might have been enhanced if it was perceived to be a relic. Thus, the goldsmith responsible perhaps deliberately composed an archaising scheme – including traditional Scandinavian figural scenes – thereby making it an instant 'heirloom' to support the mythology of its ornament.

Many of the objects with geometric cloisonné manifest a distinctive style of mushroom and arrow cellwork that is also a feature of the metalwork of Sutton Hoo and East Anglia.[120] The suite of buckles and sword-harness mounts with this cloisonné style from Sutton Hoo mound 1 makes use of object-types long established on the Continent (*AS Chronology*: BU3-c/BU4-c).[121] However, the elongated form of the set's triangular 'dummy' buckle, which seems to anticipate the Crundale-Littlebourne form, and the light wear to the parts overall, indicate it is very probably of the early seventh century.[122] Another well-dated East Anglian parallel with mushroom–arrow quatrefoils, very like those on edge-mounts **562–4**, is the gold and garnet pectoral cross from Wilton (Norfolk) (fig 6.4i).[123] At the centre of the cross is a Byzantine *solidus* of Heraclius and Heraclius Constantine that Archibald has argued dates *c* 616–*c* 625: it may have travelled to England via a tribute paid in 623 to the Avars (then in Hungary), and the cross-pendant was most likely manufactured, therefore, in the 620s–640s.[124]

Since mounts **542–66** are closely connected in their style and manufacture as a group,[125] all were probably made around the same time as the related Wilton cross-pendant. That this was so for mounts **556–61** is further suggested firstly by the stylistic relationship of the mounts' serpent and interlace panels with those at the centre of head-dress mount **541**,[126] and secondly by the dating in the *AS Chronology* of comparable filigree serpent interlace. Similar ornament occurs on a gold disc-pendant (PE1) from St Mary's Stadium, Southampton (Hampshire), of phase AS-FE (625/50–660/85).[127] Contemporary also must be the serpent ornament on hilt-collar **151** and perhaps the nielloed serpent decoration of guard-tip **412**.

Pommels **49–51** are linked by their geometric patterns, and like pommel **47** they are connected stylistically with the large cloisonné mounts (**542–66**), so a date in this phase for these objects and their associated hilt-collars and mounts (**159–69**, **163–4** and **499–502**) can be stated with confidence. However, the abstract mask formed in the cloisonné on both sides of pommel **46** has its best parallels on pommels of *Typ Bifrons – Gilton* (phase AS-MB 525/50–545/65)[128] hence, possibly it is closer to *c* 600 in its date of manufacture or even earlier.[129] As noted above, the hilt-plates with cloisonné trims may have been fitted together with these pommel and collar sets, and perhaps the gold and garnet guard-tip mounts (**496–8** and **503–10**) were also associated.

The use of faux mushroom cloisonné and eye-shaped mounts in the bichrome set of **567–71** links them with the large cloisonné mounts (**542–66**) and a date for them in this phase is also suggested.

Another coin-dated object that can be compared with the objects of this phase is a garnet cloisonné pendant with Style II and mushroom cloisonné, found in 2015 at Diss (Norfolk) in a grave with two coins of Sigebert III (636–659).[130] The pendant has heavy wear on its loop but is not otherwise overly worn,[131] so the date of the associated coins could suggest its manufacture from *c* 620/30, (though coins of the same ruler have been found in graves up to the late seventh century).[132] Its zoomorphic cloisonné can be compared with that on pyramid-fittings **578–9** and hilt-collar **163** (fig 5.10).[133] The pyramid-fittings share their tall form with pyramids

Fig 6.4. Wilton cross with mounts **562–4**, showing the close similarity in the quality and pattern of their cloisonné. *Photographs*: Wilton cross © Trustees of the British Museum; **562–4** by Cotswold Archaeology, © Barbican Research Associates.

574–7, and all may represent a development, with an increase in height, from the low pyramid form of the late sixth to early seventh centuries.[134]

The unique serpent mounts (**527–32**) of the Hoard are probably also of this phase. Serpents **529–30** are related by their similar cast animal-heads to one group of cloisonné mounts (**518–22**),[135] which in their quality fit generally with the cloisonné of *Hoard Phase 3*. Additionally, both sets exhibit the detail of punched eyes (**518–22** and **529–30**) and one pair of serpents has niello ornament (**531–2**), rare techniques in goldworking that link them further with other objects of the phase.

Hoard Phase 4 (silver objects with gold mounts): Early Insular style objects, c 630–c 660

The mainly silver metalwork of this phase in the Early Insular style has few parallels for its ornament, meaning that the chronology of this part of the collection is especially poorly understood. A number of features, however, do suggest continuity with the metalwork of preceding *Hoard Phases 2–3*: the use of coiling filigree interlace (**76** and **188**); filigree scrollwork (e.g. **74**, **76–7** and **580–1**); the combining of filigree and cloisonné (**73** and **76**); and the specific use of X-form cloisonné on pyramid-fittings **580–1**.

The interlace of the Mote of Mark, which is a strong parallel for the style of the cast interlace on many of the objects (fig 5.22v), has been debated in terms of its date,[136] but Graham-Campbell's opinion that it emerged in the 630s now has support from other evidence for the dating of the material of this phase.[137] As already noted,[138] the late composite disc-brooch from Monkton presents a parallel for the coiling filigree interlace on the central gold mount on one side of pommel **76**, the grandest of the three pommels with fixed double 'sword-rings' (with **75** and **77**). And the brooch also has a central cloisonné roundel that is not dissimilar to that on pommel **76**.[139] Therefore, it seems very likely that the set of pommel **76**, hilt-collar pair **188** and hilt-guard pair **409** (*endpiece*) are of the same style horizon as the brooch, dating to the second quarter of the seventh century.

The closest relations of pommels **75–7** are Scandinavian ring-pommels of Nørgård Jørgensen's Type SP4b with single fixed sword-rings.[140] Nørgård Jørgensen dated the type to her phase IV (*c* 680–*c* 740), but the pommels of this form from Kyndby (Denmark) and Valsgärde 7 (Sweden) have been dated earlier by others. Ljungkvist has most recently dated the Valsgärde 7 burial to his 'Vet' phase *c* 620/30–*c* 700/10,[141] and Arrhenius dated the grave even earlier to *c* 600–*c* 630/40.[142] Høilund Nielsen placed the Kyndby pommel in her phase VII-B (seventh century), based on its Style II ornament.[143] Round-back pommels **72–4** are also unlikely to be much earlier in

date than *c* 630, given their manufacturing affinities with pommels **75–7**, as well as on the evidence of their form.[144]

The pair of bird-headed mounts in silver-gilt with cast interlace (**536–7**) and those in gold with related bird heads (**463–5, 467–8** and **473–4**) can be dated by the stylistic comparisons for bird-swastika mount **464** (fig 2.35). The similar bird-headed swastika in cloisonné on a pendant from the Frisian Wieuwerd hoard (Netherlands) is dated to *c* 620–*c* 630s by associated coin-pendants that were made from *solidi* of Heraclius and Heraclius Constantine (613–41), and from *tremisses* of Chlothar II (613–29).[145] In addition, the Frisian pendant and bird-swastika **464** are both stylistically related to a disc-pendant from Faversham (Kent) that is decorated with a bird-headed triskelion in garnet cloisonné, has filigree scrollwork, and uses the same bird-head form (without a head-surround).[146] It is an example of *AS Chronology* pendant-type PE1, which come from graves of phase AS-FE (625/50–660/85).[147]

The loop of silver buckle **587** has been likened to the loops of triangular buckles with early Style II (BU3-c),[148] but given it is of silver with a gold filigree inlay, in the context of the collection at least, it fits best with the material of *Hoard Phase 4*.

Others in the future may argue for a later date for some of the metalwork of this phase. This is certainly possible, for example, on the basis of the Insular art parallels for the animal ornament of pommel **76** and hilt-collar pair **188**.[149] However, in particular the use of the techniques of filigree and cloisonné on the objects suggests continuity with earlier material, which is considered here to be stronger evidence that it represents a phase of production preceding the full Insular style of the second half of the seventh century.

Summary

Overall, the metalwork spans about 100 years, in terms of date of manufacture, from at least the mid-sixth century to probably a limit around the mid-seventh century. The extraordinary character of the majority, however, means that there are few parallels, including in particular for the latest objects of the Early Insular style. We are also unable to date with the precision we would wish. In the future, the chronology proposed above will no doubt be improved and revised, as more such objects are discovered and via the scrutiny of the wider academic community.

The four phases of metalwork proposed are summarised in table 6.1 and their quantities are presented graphically in fig 6.5. There is a pattern. The bulk of the collection's objects are of the middle two gold phases (*Hoard Phase 2–3*), dating from the late sixth to mid-seventh century. This material is book-ended by two phases with smaller numbers of fittings that are mainly of silver (*Hoard Phases 1* and *4*). Because the Hoard is very much a sorted assemblage of select object-types and materials,[150] it cannot be regarded as a true reflection of the precious-metal economy of the time in England. Nevertheless, this trend could fit with the prevailing situation as it is currently understood, of a sudden and considerable increase in the availability of gold, from perhaps as early as *c* 570/80, until the decades prior to *c* 650. The earliest objects in silver of *Hoard Phase 1* (sixth century), therefore, can be considered vestiges from before this 'golden age'. Equally, the more conservative use of gold (in the form of mounts) for the silver fittings of *Hoard Phase 4* contrasts with the dominance of the metal in *Hoard Phases 2–3*, and it is possible their manufacture reflects a setting in which there was later a growing shortage.

Parts from antique or 'heirloom' weapons are represented by the relatively small number of silver fittings of *Hoard Phase 1* (sixth century) and the earliest gold fittings of *Hoard Phase 2* (*c* 570–*c* 630). They have Style I and early Style II ornament, and some demonstrate heavy wear. The gold fittings, manufactured perhaps during the final two decades of the sixth century, represent the earliest examples of a tradition of gold filigree hilt-furniture that is demonstrated also by the contemporary hilt-suite from Market Rasen (cf figs 2.14 and 2.41 and 6.6). Many such sets of filigree fittings can be imagined from among the pommels and hilt-collars of *Hoard Phase 2*, although the onward stylistic development of the tradition is harder to discern into the opening decades of the seventh century. It possibly remained popular for half a century, with brief flirtations with other forms and styles shown by the small number of round-back pommels and those with limited use of cloisonné. The low collar form in filigree perhaps became popular only in the seventh century, but the high form continued in use also (e.g. **109–10**). A different style, represented by the many gold filigree mounts with scrollwork, (of 'Cumberland' hilt-type), was probably contemporary, but perhaps of a different region; again, a limited use of cloisonné is seen (e.g. **489–93**).

The weapon-fittings of *Hoard Phase 3* (*c* 610–*c* 650), typically in cloisonné and with Anglo-Saxon late Style II, suggest a different hilt-furniture style and, in contrast with those of *Hoard Phase 2*, they do not show signs of heavy wear. This last fact implies that the weapons from which the fittings came were in use for less time before their parts were dismantled and included in the assemblage. Other objects of *Hoard Phase 3* with little evidence of long-term use

Fig 6.5. Proportions of metalwork allocated to *Hoard Phases 1–4* (cf table 6.1).

include the cross (**539**) and helmet (**589–92**), though the former and possibly the latter do show evidence of repair. In sum, it can be suggested, from the combined evidence of the styles and wear on the metalwork, that the bulk of the collection of *Hoard Phases 2–3* was probably accumulated *c* 620–*c* 650.

It is possible that the forms and ornament of the Early Insular style of *Hoard Phase 4* (*c* 630–*c* 660) represent a development from the filigree and scrollwork traditions of *Hoard Phase 2*, as stylistic similarities have been observed. However, the indeterminate dating of the objects of this last phase in particular mean that it is not possible presently to confirm a secure *terminus post quem* for when exactly the Hoard was buried. Nevertheless, the chronology of the majority of the metalwork suggests that the collection ceased to be active and above ground at some time in the second half of the seventh century. Possibly it was deposited as early as *c* 650–*c* 675.

Finally, one important piece of evidence may suggest that there was little delay between the date of the Hoard's latest material and its deposition. The gilded copper-alloy harness-mount (**698**) from the same field (fig 2.68) has interlace like that on the objects of *Hoard Phase 4*. It is likely, therefore, that it represents a contemporary loss, and perhaps even one associated with the individual or group responsible for the Hoard's actual burial.

ORIGINS

Determining where the manufacture of high-status metalwork, like that in the Hoard, actually took place is difficult. Very few workshop sites have been identified for the period, and portable material culture could move great distances. Pommel **68**, for example, is argued to have been made in Scandinavia.[151] However, the technology and ornament of the majority of the collection's objects indicate that they are undoubtedly Anglo-Saxon. Deciding the provenance of this material relies on comparing it with related metalwork from the whole of the archaeological record in Great Britain. But the find locations of this *comparanda*, from graves, hoards or accidental losses, only tell us for certain where the objects finally left circulation. The aristocratic class that used high-status metalwork was highly mobile. The dispersal of finds related to military equipment in particular might be explained by many factors, including as equipment lost by far-travelled warriors on campaign, by returned warriors with battlefield spoil, or by princes gone into exile. In addition, in the period objects could be disseminated as diplomatic gifts, such as a grand sword or saddle.

In recent decades, the hobby of metal-detecting and the recording of the Portable Antiquities Scheme have transformed distribution maps of Anglo-Saxon metalwork, populating them with a mass of mainly single finds.[152] The result is that gold and garnet objects, some with animal ornament, have now been found across the whole area of Anglo-Saxon settlement and beyond. This distribution cannot be regarded uncritically, however, in view of all the possibilities for object movement. It is almost certainly mistaken to assume that it indicates manufacture of metalwork like that in the

Filigree zoomorphic and interlace style
(Hoard Phase 2, c 570–c 630)

Cloisonné style
(Hoard Phase 3, c 610–c 650)

Cumberland-hilt style
(Hoard Phase 2, c 570–c 630)

Early Insular style
(Hoard Phase 4, c 630–c 660)

◀ **Fig 6.6.** Styles of hilt-furniture in the Hoard. The fittings of the *filigree zoomorphic and interlace style* and those of the *cloisonné style* are sets; the fittings shown to represent the *Cumberland-hilt style* and the *Early Insular style* are not actual sets. Photographs: Cotswold Archaeology, © Barbican Research Associates.

Hoard was undertaken everywhere. In fact, the opposite may have been true: high-status gold and garnet material culture was possibly only produced in a small number of the most powerful and advanced kingdoms of early Anglo-Saxon England.

The Hoard's gold and garnet objects are the result of highly accomplished and centralised manufacture that was very probably controlled by kings. Secure rule over a core territory, from which overlordship might be exercised, would have been essential, and strong foreign links would have been a prerequisite for acquiring the gold coin and garnet. Kingly reputation perhaps attracted and retained the best master goldsmiths capable of transforming such wealth. Since the metalwork created would have been critical to the maintenance of the warrior class – the arm of royal power – it is very likely that rulers closely guarded both the precious raw materials and the artisans.

It is not the case, however, that the kingdoms of Anglo-Saxon England emerged simultaneously. Location in particular was probably crucial to the pace of their development. The considerable quantities of gold and garnet brooches, buckles and other items from cemeteries in south-east England show beyond doubt that the kingdoms of Kent and East Anglia must have had dedicated workshops producing elite metalwork in the decades around *c* 600.[153] Both territories were well placed for contact with other kingdoms around the North Sea, and the evidence of history and archaeology shows that each enjoyed close cultural links with continental and Scandinavian domains. Both Anglo-Saxon kingdoms appear to have had expertise in filigree, cloisonné and Style II, but critical study of the metalwork from each region suggests different workshop traditions, which we might consider as 'kingdom styles', such as the Style II filigree of Kent,[154] or the 'mushroom' and zoomorphic cloisonné of East Anglia.[155]

The sets of weapon-fittings in the Hoard (online table 4) now indicate that swords were made with suites of hilt-furniture that equally can be interpreted as representing distinctive 'kingdom styles' made in different regional workshops (fig 6.6). The styles identified, even if they represent a simplification, serve to show the immediate visual impact of and contrast between, in particular, the *filigree zoomorphic and interlace style* and the *cloisonné style*. The dating of the metalwork, however, shows that these styles as well as the *Early Insular style* were probably not immediately contemporary.[156] This might be said to diminish the case for them having been the specific styles of different competing territories, since they could instead be argued to represent changing fashions that enjoyed more widespread application. Nevertheless, it is the case that the parallels for the filigree, cloisonné and Early Insular style objects are suggestive of separate localised manufacture. Each different style of hilt-furniture could have played a role in maintaining social cohesion, as a tangible and distinctive manifestation of a shared sense of kingdom identity. The ornament-bearing sword was both an embodiment of the territory and the means of its defence, therefore, established by its gift from the ruler. Weapons with recognisable styles of hilt-fittings might have served, furthermore, not only to display the elite status of the weapon-bearer, but to signal to others the wealth and power of the kingdom and ruler (the weapon-giver) that the warrior served.

Mercia

How the Hoard relates to its setting depends to a considerable extent on whether its objects *were* made in Mercia for a *local* warrior society. To date, the evidence does not provide a strong case. Archaeological discoveries in the surroundings of the find location indicate only limited early Anglo-Saxon culture,[157] and the artefact record appears impoverished, in contrast with that of Anglo-Saxon kingdoms to the south and east, where the discovery of an outstanding gold and garnet treasure would have been less surprising. This need not imply the absence of a complex society in the Mercian region of the Hoard site, but the near invisibility of it in the sixth and seventh centuries is more typical of contemporary British culture.[158] A different, altogether simpler, reading of the record could be that it is a true reflection of a locally less-developed political structure and economy. It is the opinion of historians that Mercia was the last of the major Anglo-Saxon domains to develop,[159] as it was also one of the last to be converted to Christianity.[160] Certainly, it is not the case that Mercia in the early seventh century constituted the monolithic 'state' covering the whole of middle England that is sometimes outlined on maps,[161] which gives an altogether false impression of the nature and stability of territorial rule in this period generally.

The Hoard was deposited in a location that was liminal both culturally and territorially (fig 6.7). Viewed against the spread of early Anglo-Saxon cemeteries of the fifth to seventh centuries, it can be seen that the site is at the very edge of Anglo-Saxon influence from the east of England.[162] The people of this border setting were known as the *Mierce* ('dwellers of the March').[163] British territories lay to the west and almost certainly Britons contributed to the region's population. The archaeological 'invisibility' of the Britons is well attested and, as in neighbouring British regions, the area around the site seems to have been largely aceramic, as well

as having a paucity of other material evidence. Yet the landscape, rich in natural resources, probably remained well populated.[164] A rare example of a British population near the border, to the south, has been demonstrated at the cemetery of Wasperton in the Avon Valley (Warwickshire). Carver has suggested that the burial-ground first served an indigenous community, before Anglo-Saxon culture became dominant by the late fifth century, whether by migration or acculturation.[165] By contrast, the territory in which the Hoard was buried has limited evidence of Anglo-Saxon cultural influence only after this date.[166] Indeed, it is possible that a native Christian community survived into the seventh century close by, if an account in the *Marwnad Cynddylan* of 'book-holding' monks near Lichfield is to be believed.[167]

As Hooke has shown, in its immediate setting the Hoard was also on marginal land at a boundary between two folk groups, the *Pencersǣte* and *Tomsǣte*.[168] The latter territory is significant, as with Tamworth and Lichfield in its vicinity, it may have been the seat of early Mercian royal power (figs 7.1 and 8.6).[169] An Anglo-Saxon presence, from the late fifth century, is indicated to the north of the confluence of the Rivers Tame and Trent by cemeteries at Wychnor and Barton-under-Needwood. However, a settlement at Catholme (near Wychnor) has been argued to have served a British community up to *c* 600, after which time Anglo-Saxon dwelling forms were adopted.[170] It is uncertain, however, whether these sites were within the dominion of the *Tomsǣte* ('dwellers of the Tame'), whose lands are believed to have been focused to the south of the Trent.

Fig 6.7. Map showing the distribution of gold and silver pommels (and the approximate find location of the Cumberland hilt) in relation to the Hoard site, the major Anglo-Saxon kingdoms and the spread of Anglo-Saxon material culture as demonstrated by cemeteries up to the seventh century. *Drawing*: C. Fern.

Fig 6.8. Elite objects from Mercia (Staffordshire, Warwickshire and West Midlands): i) gold brooch with three-dimensional animals from Streethay, Lichfield; ii) gold and garnet pendant from Hammerwich; iii) gold disc-pendant with Style II animal heads from Solihull; iv) gold and garnet cloisonné pommel from Maxstoke Priory; v) disc-brooch with Style II and glass inlays from Wasperton. *Photographs*: (i–ii) © The Potteries Museum & Art Gallery, Stoke-on-Trent (STKMG 2007.LH.45; STKMG 2006.LH.67); (iii) courtesy of the Portable Antiquities Scheme (<www.finds.org>), PAS: WMID-4241F2; (iv) © Trustees of the British Museum; (v) © Warwickshire Museum.

No 'princely' graves or cemeteries rich in gold and garnet grave goods, such as occur in south-east England, have been found in the Mercian Upper Trent region. Also very few single finds of the fifth to sixth centuries have been recorded by the Portable Antiquities Scheme within a 10km radius of the Hoard site: just three Anglo-Saxon copper-alloy brooch fragments and a highly unusual gold brooch with three-dimensional animal ornament (figs 1.2 and 6.8i).[171] Nearby Hammerwich may have started as a site for metalworking at some point in the early medieval period,[172] but apart from the loss there of a single seventh-century gold and garnet pendant (fig 6.8ii),[173] there is no evidence that high-status material contemporary with the Hoard was being produced. Gold pendants are the most common and widely distributed elite object-type of the period reported to the Portable Antiquities Scheme, and it can be imagined how easily they were lost; so there can be no certainty it was made locally.[174] Staffordshire, Warwickshire and the West Midlands combined have produced only a thin scatter of other gold objects of the late sixth to seventh centuries.[175] They include: a coin-pendant from Forsbrook with a Style II garnet cloisonné frame;[176] a gold and garnet cloisonné pommel from Maxstoke Priory (figs 6.7, no. 12, and 6.8iv);[177] a cloisonné fragment from Acton Trussell;[178] and a gold disc-pendant from Solihull (fig 6.8iii).[179] This last find has a design with several animal heads, but it is clumsy in its manufacture and some of its elements appear cannibalised from other jewellery. Possibly, *it* was made locally for an emergent border elite, in imitation of the high-status metalwork of the kingdoms to the south and east. In contrast, the south-east region may very well have been the origin of all the other finds. Notably, the pommel from Maxstoke has mushroom and arrow cloisonné cellwork, linking it with many objects in the Hoard, as well as with finds from East Anglia.[180]

Another object made perhaps for a member of a local border elite comes from grave 198 at Wasperton (fig 6.8v).[181] The disc-brooch with blue glass settings has a thin gilded plate with Style II animal ornament; it apes Kentish composite disc-brooch fashion, but it is inferior in quality to the products of that kingdom, as well as a rare example of Style II so far west. In fact, the very thin distribution of Style II metalwork throughout the Midlands suggests that the elite aesthetic may not have been widely known or manufactured in the region.[182] However, the Midlands territory is not devoid of evidence for local elites. A grave with a sword and hanging-bowl was found at Barlaston (Staffordshire), and further north are the barrow graves of the Peak district, of the mid-seventh century, among which was the famous burial at Benty Grange (Derbyshire) with its hanging-bowl and helmet (fig 7.3).[183] In addition, a single hanging-bowl mount has been found at Hints (Staffordshire).[184] High-status residences are suggested by the hall sites known from crop-marks at Hatton Rock (Warwickshire), Frogmore (Shropshire) and possibly at Long Itchington, but none can be dated definitely to the sixth or seventh centuries.[185]

Therefore, while the rise of local aristocracies across the greater Mercian region during the seventh century is suggested, the archaeological evidence does not point to the production of prestige gold and garnet metalwork like that in the Hoard, beyond probably local imitations. Mercia's landlocked isolation for much of the

period could have been a crucial factor that resulted in its slower political and economic development. Into the early seventh century the region would have had poorer access to imports of gold and garnet from North Sea trade, as well as to the technologies needed to transform these raw materials into objects (at least until Mercia exercised overlordship over the coastal kingdom of Lindsey by the second quarter of the seventh century).[186] Nevertheless, a cultural mix of Britons and Anglo-Saxons at the border might have created by the 630s a context suitable for the manufacture of objects in the Early Insular style, although other settings can also be envisaged for their production.[187]

The total disregard for the contemporary cultural worth of the Hoard objects and their ornament might be considered further evidence that the dismantling and ultimately the burial of the collection took place far from where the majority of the metalwork was made. Equally, the ecclesiastical material does not fit well with the supposed paganism of the Mercian region in the rule of King Penda (r. *c* 626/32–655).[188] It appears an unlikely context for the manufacture of such great works as cross **539** or inscribed strip **540**, for example, even if there is evidence that Christianity was tolerated during Penda's reign.[189] Nonetheless, the treasure is important for the Midlands, for however it ended up in its pit overlooking Watling Street, it surely now locates with a new precision a pre-eminent power at the heart of the emergent Mercian kingdom by the middle third of the seventh century, a power that seems to have arisen from obscurity to dominance within just a few decades. The aristocratic and probably royal character of some of the objects indicates contact of one form or another with paramount elites from other parts of Anglo-Saxon England, which by association may suggest that the authority that accumulated and controlled the Hoard was of a similar status.

Kent, East Anglia or Greater Northumbria

Parallels from closed archaeological contexts for the filigree and cloisonné techniques of the Hoard objects, as well as the Style II animal ornament, come mainly from graves in cemeteries in southeast England. Indeed, if it had been possible to forecast the treasure, most experts would probably have predicted a find location within either the kingdom of Kent or East Anglia. Around the time that much of the collection's metalwork was being made, according to the written sources, the rulers of these territories were periodically overlords of much of southern England, at dates coincident with peaks of excellence in the manufacture of prestige objects. However, no swords with gold filigree pommels and hilt-collars matching those in the Hoard have come from graves in either region,[190] while the study of the assemblage's filigree also suggests the possibility that much of the metalwork with this ornament could have come from elsewhere.[191] It has long been suspected, in particular, that the powerful kingdom of Northumbria must also have been engaged in the production of high-status metalwork.[192]

The map in fig 6.7 shows all the gold pommels known from early Anglo-Saxon England, outside of the collection, as well as the related pommel in silver filigree from Gresford (no. 10).[193] It also shows approximately where the 'Cumberland' hilt (fig 2.26) must have been found, assuming its name truly relates to its discovery in the historic county that today lies in the northern half of Cumbria. This find location is worth emphasising, given the number of mounts in the Hoard related to those of the 'Cumberland' hilt,[194] since the region is within the British territory of Rheged and considerably beyond the archaeological spread of Anglo-Saxon culture.

Only two of the pommels plotted in fig 6.7 are certainly from graves: the gold and garnet cloisonné pommel from Sutton Hoo mound 1 (no. 11)[195] and the gold filigree pommel found more recently at Middleham (no. 1).[196] These contexts prove the use of the objects in the regions where they were buried, although not necessarily their manufacture locally. However, since it is highly unlikely that the other pommels and sword-related fittings were casually dislodged from their weapons, it remains to explain how they entered the archaeological record. The Market Rasen hilt-suite in gold filigree is complete except for two of its hilt-plates, assuming it had an original full complement of four plates when deposited (fig 2.41).[197] As parts of the iron sword tang are within its two hilt-collars, it is possible it was the sword and hilt were originally whole, though no evidence of a blade or burial was found at the find site. During examination of the fittings, it was further noted that damage to one edge of the pommel suggests it may have been levered.[198] The Wellingore gold pommel also has a similarly damaged edge (fig 6.2i),[199] while the missing ends of the Earl Shilton pommel could be consistent too with removal by levering or pulling (fig 5.5v). Possibly, therefore, some of these stray fittings may have been dismantled from their swords by methods related to those argued for the Hoard pommels.[200]

Leahy has suggested that some of the single pommel finds might have been deliberate deposits, though he could not identify a consistent pattern in their topographical settings.[201] Nonetheless, their general distribution remains of interest (fig 6.7). All the findspots occur north of the River Thames (not a single gold filigree or cloisonné pommel is known from Kent or the rest of southern England), though two gold filigree pommels, from Essex and Suffolk (nos 7–8), could be said to fall within the wider East Anglian sphere. In fact, this distribution in overall terms is the opposite of that seen for gold, garnet and Style II metalwork from

graves in south-east England. A number of the pommels form a distribution broadly on the axis of the Fosse Way and south of the River Trent (nos 2–6, 12 and 14), while two come from Wales (nos 10 and 13). One possible interpretation of this thin spread focused on middle Britain, but stretching northwards and into the British west, is that it reflects the historically contested landscape of the seventh century, traversed by the armies of Mercia, Northumbria and East Anglia, and by the British forces of Gwynedd. This still does not tell us, of course, exactly why the sword-fittings were buried or where they were made, but in some aspects, at least, they share common ground with the Hoard.[202]

The lack of gold or silver pommels with filigree or cloisonné ornament south of the Thames is remarkable, given the other metalwork from that region hallmarked with the decoration.[203] The supremacy of King Æthelbert of Kent (r. c 580–616),[204] who was for a period 'overking' in England south of the Humber, coincides with a phase of high-status and distinctive gold and garnet metalwork production in the kingdom that was unmatched elsewhere prior to the regalia of Sutton Hoo. The region's disc-brooches of keystone-garnet, plated and composite type (fig 6.9i), and triangular-plated buckles and clasps, can be considered to mark the local products of a kingdom style.[205] Many examples have come from the King's Field cemetery, Faversham, a place-name combining the Latin *faber* with *hām*, meaning 'the settlement of the smith', which very probably indicates that the workshop that made many of the elite objects was nearby.[206] However, the studies in previous chapters have shown that the Hoard metalwork displays important differences from that of 'Kentish' southern England, true for the filigree, cloisonné and Style II animal ornament.[207] Also telling may be the noted absence from the collection of *Typ Bifrons – Gilton* pommels, the sixth-century (SW2-b) form found in Kent and in Merovingian regions on the Continent,[208] since examples might have been expected if the Hoard metalwork had been drawn partly or largely from a Kentish source. It is further possible, as already argued,[209] that animal ornament had fallen out of favour in Kent by the time of late Style II, whereas it was clearly popular in the region that produced the Hoard's objects with the style (*Hoard Phase 3*). Despite this, there are a few notable links with objects from Kent: cross-pendant **588** is a close parallel for that from Thurnham (fig 2.81); pommel fragment **78** has been compared to a pommel from Sarre;[210] and mount **455** bears a pattern close to one on a buckle from Faversham.[211]

Of the ten instances of filigree pommels and related fittings known outside the Hoard (fig 6.7), perhaps the best examples for suggesting an origin for the filigree hilt-furniture tradition are those from Middleham (no. 1) and Market Rasen (no. 2). As, respectively, the only grave find and the only almost complete hilt-suite, they might be considered to support a manufacturing base for the style (fig 6.6) that is so prominent in the collection (*Hoard*

◀ **Fig 6.9.** i) Composite disc-brooch from Kingston Down (Kent), with garnet and blue glass stepped cloisonné and filigree early Style II animal ornament. ii) Disc-pendant from Street House, Loftus (North Yorkshire), with rectilinear and triangular cloisonné, and filigree Style II serpent interlace. *Photographs*: (i) © National Museums Liverpool (World Museum); (ii) by D. Currie, © Tees Archaeology.

Phase 2) either in the kingdom of Lindsey or perhaps more likely in greater Northumbria. Bruce-Mitford long ago argued for high-status metalworking in Northumbria in the seventh century on the evidence of the pectoral cross of St Cuthbert,[212] and more recent finds of high-status metalwork from the cemetery at Loftus (North Yorkshire), including gold cabochon pendants and disc-pendants with filigree ornament, can now be considered to strengthen the case.[213] One of the pendants has Style II serpent filigree (fig 6.9ii), the head-forms of which have been compared with Hoard objects (**38** and **104–5**).[214] It also features a garnet cloisonné cross formed by a central roundel, off which come triangular arms that terminate in small circular settings. The central roundel can be compared with that on pommel **76** (fig 2.12).

The pyramid-fitting from Dalmeny (West Lothian) that is such a close parallel for pyramid pair **574–5** (fig 2.44) might possibly represent a Northumbrian object lost in the Anglian frontier zone of the Scottish lowlands.[215] Another object of significance, in relation to the hilt-plates with garnet bosses in the Hoard and those with the hilt-suite from Market Rasen, is a small garnet boss with a gold filigree collar found at the hillfort of Dunadd in British Dál Riata, since it is perhaps also best explained as having become detached from an Anglo-Saxon object, if not from a hilt-plate.[216]

The style of hilt-furniture represented by the Cumberland hilt was possibly also a tradition of the greater Northumbrian region, with that kingdom's gradual takeover of the British territory of Rheged during the seventh century providing a possible context for how it came to be so far west.[217] However, the poor provenance of this antiquarian find, acquired by the British Museum in 1876, means that even less certainty can be attached to this suggestion.[218]

As has been argued, the use of gold filigree interlace and scrollwork on the fittings of the Early Insular style (*Hoard Phase 4*) can be seen as representing some continuity with the ornament of the earlier gold filigree hilt-fittings of *Hoard Phase 2*.[219] That the metalwork of *Hoard Phase 4* might also be from a Northumbrian milieu is hinted at by the discovery recently at Bamburgh (Northumberland) of a single small gold mount with filigree ornament, from a potential workshop context, which was possibly made to fit the side of a pommel like those in the collection.[220] Alternatively, on the strength of the connection with the Mote of Mark interlace and other parallels, manufacture might be possible after *c* 630 in a recently taken over northern British territory or frontier zone, in which both Anglo-Saxon and Celtic influences were present.[221] To date, however, there is almost no closely comparable material from the Mercian frontier or from British and Welsh territories to the west, whether as stray finds or as objects from high-status sites, such as Dinas Powys (Glamorgan) or Llangorse (Powys).[222]

The unique invention of the double ring-knobs of pommels **75–7**, of the Early Insular style, could further fit with a northern Anglo-Saxon origin. One possible reading of the symbolism of a pair of 'rings', in the context of the sword-ring tradition,[223] is of a duty owed to two lords or two kingdoms. Historical sources record the formation of the kingdom of Northumbria from the unification of Deira and Bernicia, but for a period the two territories again fragmented, and two kings ruled (642–51).[224] It is tempting to wonder if such a political circumstance, of two territories unified but with each retaining a sense of independent identity, could have given rise to the exceptional pommels. Similar situations also occurred in other kingdoms, however: in particular the southern and northern Mercians occupied lands on either side of the River Trent, and they were ruled separately following Penda's death in 655.[225]

Many of the objects of *Hoard Phase 3* demonstrate such close stylistic affinities with the Style II and garnet cloisonné metalwork of East Anglia that it is difficult to resist the conclusion that some might actually have been made in the region or even in the same workshop(s) that served the 'royal' cemetery of Sutton Hoo. This includes the many weapon-fittings and mounts with mushroom and arrow cloisonné,[226] as well as the Style II cloisonné of the seax suite (**55**, **167–9** and **225**) and zoomorphic hilt-fittings (**511–5**). They have been compared in particular with the gold and garnet regalia from Sutton Hoo mound 1: the shoulder-clasps (fig 6.10), purse-lid and fittings from the sword, its harness and scabbard.[227] Other gold objects from the region with related geometric and zoomorphic cloisonné include the Wilton cross (fig 6.4i), the Sutton brooch and Diss pendant.[228] The high-quality cloisonné that all these objects demonstrate was conceivably a kingdom style developed when East Anglia was at the height of its power, marked by the rule of Rædwald (d. 624/5), and in particular by his status as overking in England after the death of Æthelbert of Kent (d. 616).[229] Archaeological investigations in Suffolk at the 'royal' settlement of Rendlesham and in the burial-grounds of the *emporia* of Ipswich have provided insight into how the East Anglian kingdom operated, with evidence of high-status metalworking, and links with Merovingian and possibly even Byzantine traders.[230] The *cloisonné style* of the Hoard (fig 6.6) and East Anglia might first have been inspired by imports from the Continent or Scandinavia, with the cloisonné pommel from Sutton Hoo mound 1 being a possible example.[231] Some of its earliest products may be the belt- and scabbard-fittings from mound 17, of garnet and blue glass, but manufactured in gilded copper alloy.[232] In addition, an object from the Continent that Bruce-Mitford argued was an export from East Anglia is the cloisonné fitting from Tongres (Belgium).[233] It now shares its geometric and late Style II cloisonné forms, including its mushroom and arrow quatrefoils, with objects from mounds 1 and 17, and the Hoard, including edge mounts **562–4** (fig 6.4).

Fig 6.10. One of the Sutton Hoo mound 1 shoulder-clasps (scale approx. 1/1). *Photograph*: © Trustees of the British Museum.

It is possible, even likely, that some of the non-cloisonné objects with late Style II also came from East Anglian workshops. This is suggested above all by the application of the Sutton Hoo cup-motif on great gold cross **539**.[234] If the motif on the cross was copied from the original die, still in the Sutton Hoo workshop, then it might even have been the commission of one of Rædwald's successors, the Christian rulers Sigeberht (acc. 630/1) or Anna (d. 653/4). Also important is the appreciation of the shared detail of the Y-shaped groove seen on the beaks of birds decorating objects from East Anglia and in the Hoard (**57**, **459**, **511–12**, **514–17** and **538**).[235]

The association of the great gold cross **539** with the metalwork of Sutton Hoo also has very important implications for the two other significant ecclesiastical objects related to it: inscribed strip **540** (with its very similar gem-setting) and head-dress mount **541** (with its close Style II animal ornament).[236] All might have been made in the same workshop and, therefore, represent products of Felix's (d. 647/8) early East Anglian church, along with possibly some of the large cloisonné mounts (**542–66**) that might be from books and other apparatus.[237] Bede records that the bishop from Gaul was supposedly charged by King Sigeberht with establishing the teaching of letters, which might even accord with the possible 'continental hand' at work on strip **540**,[238] though foreign churchmen were of course equally present at other religious centres around the same time, such as Canterbury or York.

CONCLUSION

There appears to be a remarkable coincidence between the dating of the Hoard metalwork and the events of Bede's history. Continuous and bloody conflict across middle Britain characterised much of the first half of the seventh century, but it was also a formative time: by the raising of armies and successive victories, Penda (r. *c* 626/32–655) began the unification of the border region of Mercia. As much as we might wish to, we can never tie the treasure to any particular historical individual or event – none of the objects is stamped *Penda rex* – and ultimately the Hoard is perhaps too small to be a royal treasure. Nevertheless, the date-range proposed for the collection's accumulation, the second quarter of the seventh century, fits tantalisingly with the era of Mercian total war with its neighbours to the east. The Hoard surely represents a part of the proceeds of those wars.

The pursuit of wealth was undoubtedly a factor that fuelled much of the fighting. Treasure could be taken as tribute or loot, with gold valued above all else. However, as the precious metal had mostly to be imported, this raises the question of what it was that foreign merchants desired that Anglo-Saxon rulers possessed. The answer may be slaves, or rather captives of war, a human commodity that could easily be acquired from raiding into enemy territory.[239]

The bulk of the metalwork (*Hoard Phases 2–3*) can be seen as reflecting the brief half-century in which gold seems to have been in relative abundance – a 'golden age' of warrior society – that had probably ended by *c* 640/50. The collection's fittings come mainly from the weapons of warrior aristocrats, but royal leaders may be indicated by certain 'princely' items and sets (e.g. pommel **57**; cloisonné seax suite **55**, **167–9** and **225**; and hilt suite **76**, **188** and **409**), by parts possibly from saddles (e.g. **538** and **556–61**) and perhaps above all by the crown-like helmet (**589–97** and **599–601**). Equally, small contingents of churchmen and even bishops on battlefields can be suggested by the ecclesiastical objects. Warfare at the time certainly could be lethal. According to Bede, Mercian victories resulted in the slaying of Kings Edwin and Oswald of Northumbria in the 630/40s, and of Kings Sigeberht and Anna of East Anglia probably in the 640s/50s.[240]

Some of the metalwork (*Hoard Phase 3*) demonstrates strong links in particular with East Anglia, with the region's 'mushroom'-style cloisonné and late Style II animal ornament. The objects of *Hoard Phase 3* were certainly made and in use in the first half of the seventh century, with many probably of the second quarter. This is approximately the period of main conflict between Mercia and East Anglia recorded by Bede's history. Possibly, therefore, some of the fittings do indeed derive from the arms and ecclesiastical objects of the ruling elite of the latter kingdom.

It has proved harder to suggest origins for the different styles of hilt-furniture in gold filigree of *Hoard Phase 2* and the fittings of the Early Insular style of *Hoard Phase 4*. A small amount of inconclusive evidence points to regions within greater Northumbria, with the kingdom's expansion westward into British territories in the seventh century, including Rheged, providing one possible context for the mixing of Celtic and Anglo-Saxon styles seen in *Hoard Phase 4*.

The latest objects of *Hoard Phases 3–4* suggest that the Hoard may have been buried as early as *c* 650–*c* 675, a period that coincides with a time of considerable crisis for the Mercian royal dynasty.[241]

▶ Hilt-collar **87** in gold filigree with Style II animal ornament (not to scale). *Photograph*: D. Rowan; © Birmingham Museums Trust.

PART II

THE BROADER CONTEXT

CHAPTER SEVEN

CHAPTER SEVEN

THE HISTORICAL CONTEXT:
LOCAL, REGIONAL AND NATIONAL

HISTORICAL BACKGROUND

Barbara Yorke

Early medieval Britain in the seventh century

The seventh century is revealed through both written and archaeological evidence as a period that saw much change and significant development, including the spectacular growth of some kingdoms and the adoption of Christianity by Anglo-Saxon elites.[1] The earliest kingdoms had emerged before 600 in areas of the south and east where there had been settlement of Germanic-speakers from North Sea regions in the fifth century – namely, Kent, the West Saxons, South Saxons, East Saxons, East Angles and Lindsey (in Lincolnshire) (Map 1). But not all smaller groupings had coalesced into kingdoms, and lesser units – where control was perhaps shared between several elite families – co-existed with them. Those of the East Midlands might be referred to collectively as the Middle Angles. Frankish influence, if not overlordship, may have played a significant role in shaping the earliest kingdoms of the south east. Areas to the west and north remained longer under the control of leaders of the British, that is the descendants of the inhabitants of Roman Britain. Anglo-Saxon kingdoms may have emerged there slightly later, and from smaller groups of Anglo-Saxon settlers, but two kingdoms, Mercia and Northumbria, expanded rapidly in the seventh century from their British powerbases. The Bernician kings of northern Northumbria were also influenced in their operation of power by the Irish rulers of the Dál Riata based in the Argyll area of Scotland.

Important though the profits of agriculture and foreign trade might have been to some of the royal houses, it seems to have been warfare that paid the highest dividends and underpinned their regimes. The British author Gildas, writing around the middle of the sixth century, recorded that the Anglo-Saxons had come to Britain originally as federate troops hired by British authorities in the fifth century when the Roman Empire had withdrawn its military support.[2] Mercian and Bernician kings first appear in written sources in the late sixth or early seventh centuries as either allies or hired forces of British rulers. The scale of warfare escalated in the course of the seventh century as a means not only of incorporating new territory, but also of accessing moveable wealth as tribute. The most powerful kings (sometimes referred to as '*bretwaldas*' or 'overlords') were apparently able to exact tribute from all the other Anglo-Saxon kingdoms. A heroic glow is provided for these bloodthirsty exploits in Old English verse, especially the celebrated poem *Beowulf* which may have its origins in this period.[3] But many of the same features are discernible, albeit from a rather more critical perspective, in the main Latin historical source for the period, the *Ecclesiastical History* of the Northumbrian monk Bede, completed in 731.[4] Bede records not only incessant warfare in the seventh century, but the symbolism of the hall where the king entertained and rewarded his military followers (*comitatus*), and the importance of reputation and of the display of status through weapons that plays such a major role in *Beowulf*.

One of Bede's main concerns was to record the adoption of Christianity by the royal courts of the Anglo-Saxon kingdoms in the course of the seventh century. Christianity had come to Britain when it was part of the Roman Empire, but seems to have become much more firmly embedded in the British provinces of the west and north, and in Ireland, in the course of the fifth century. Anglo-Saxons in contact with these areas or with the Christian Franks could have become familiar with the religion, but Bede believed that conversion and a formal church structure was only achieved in Anglo-Saxon areas after the arrival in Kent in 597 of a mission despatched by Pope Gregory the Great and led by his monk Augustine, who became the first archbishop of Canterbury. In 635 the Bernician King Oswald invited Irish missionaries from the island of Iona in Argyll to Lindisfarne, and because of the military dominance of the northern Northumbrian kings this mission was very influential in other Anglo-Saxon provinces as well.

Although the advent of an organised Christian church brought changes with it for Anglo-Saxon society, the church also adapted itself to the expectations of the Anglo-Saxon elites, especially when its leaders were recruited from those same elite families. The profits of war funded church foundations, and the *Penitential of Archbishop Theodore* (669–90) records that a third of the *pecunia* ('tribute') taken from a conquered province should go to the church.[5]

The early Mercian kings

The material of the Staffordshire assemblage was therefore brought together in a very significant period in the early expansion of the kingdom of Mercia. While the assemblage itself seems to reflect Mercian interactions with Anglo-Saxon kingdoms to the north and east, the findspot is in an area of Staffordshire that lacks Anglo-Saxon cultural evidence for the fifth and sixth centuries and so is likely to have been controlled and occupied at that time by the descendants of the British people who had lived in the area in the Roman period.[6] The earliest archaeological evidence for an Anglo-Saxon presence in the vicinity is cemeteries of late fifth- or sixth-century date that cluster in the Middle Trent valley, as John Hines discusses in greater detail.[7] This area also contains the long-lived settlement of Catholme with its successive halls and sunken-featured buildings that were occupied from the sixth or seventh century into the later Saxon period (see Maps 1 and 2 for the locations of sites mentioned in this chapter).[8]

The material evidence from these sites suggests links with Anglian areas of the East Midlands and East Anglia from where it is presumed these people had migrated; but finds are less plentiful and generally more modest than those in eastern Anglian regions. It is often assumed that the Mercian royal house is likely to have had its origins in the Middle Trent valley settlements, as Tamworth and Repton in Derbyshire were places of major significance for the dynasty in the eighth century and nearby Lichfield was the seat of the Mercian bishopric,[9] but specific evidence is lacking for exactly when, how or where the family came to power, though the findspot of the assemblage may now reinforce the significance of the locality. As in the West Saxon royal house, many of the names of the earliest recorded Mercian kings or their relatives contain Brittonic elements,[10] or the term *wealh*, literally 'foreigner' but often used to mean a Briton (as in modern 'Welsh').[11] Examples may include Penda, his reputed son Merewalh and Penwalh, the father of St Guthlac. Such names may imply alliance and intermarriage with the families of British leaders, and fit with some of the earliest references to Mercian kings being in close association with rulers from Wales.

The first recorded Mercian king is Cearl, whom Bede describes as receiving Edwin of the southern Northumbrian province of Deira when he was in exile before his succession in 616 and whose daughter he married.[12] It is not clear how, or even if, Cearl was connected with the family of Pybba (or Pypba) whose descendants dominated Mercian kingship into the ninth century. Two sons of Pybba, Eowa and Penda, appear in different sources and with rather different spheres of influence in the second quarter of the seventh century. Eowa features only in the ninth-century Welsh source, the *Historia Brittonum*, which seems to draw upon an earlier, lost Northern British chronicle.[13] In the *Historia Brittonum*, Eowa seems to be in alliance with Northumbrian kings.[14] Bede is concerned only with his brother Penda, a major rival of successive Northumbrian rulers. Penda first appears as a support to the Welsh king Cadwallon of Gwynedd in Bede's account of the battle of Hatfield in 633 in which Edwin of Northumbria was killed.[15] Bede records that it was only after this battle that Penda became king and that up to that point he was 'a most energetic member of the royal house of Mercia'. The *Anglo-Saxon Chronicle*, on the other hand, placed Penda's accession in 626.[16] Possibly that was when he began to lead a *comitatus* in association with British princes from Wales, while the major success in 633 significantly enhanced his status. The *Historia Brittonum* presents a different view again and claims that Penda only became king after the battle of Cocboy (known as *Maserfelth* to Bede) in 642 in which King Oswald of Northumbria and Penda's own brother Eowa were slain.[17]

Penda was 'the first to separate the kingdom of the Mercians from the kingdom of the Northerners' declared the *Historia Brittonum* with reference to the 642 battle.[18] One explanation for the apparent clash of opinions in early sources about when Penda became king of the Mercians may be that he and his brother Eowa ruled different parts of Mercia. Bede wrote, with reference to events of 655, that Mercia was divided by the River Trent into northern and southern parts.[19] It may be that until 642 Penda ruled the southern Mercians (including the findspot of the Staffordshire assemblage) and was allied with Welsh kingdoms to the west, while Eowa controlled the northern Mercians and was allied with the Northumbrians.

Certainly after 642, Penda's career seems to have stepped up a gear and moved in new directions. He became increasingly involved with other Anglo-Saxon kingdoms and went head to head in rivalry with the new Northumbrian king Oswiu, the brother of Oswald, to be overlord of all the southern Anglo-Saxon kingdoms. War was waged on a number of different fronts – and what we have recorded may be only part of the aggression that took place as Penda and Oswiu sought to compel southern kings to recognise their authority. In 645 Penda drove King Cenwalh of the West Saxons from his kingdom (though Cenwalh resumed his reign three years later).[20]

Cenwalh went into exile at the court of King Anna of the East Angles, a natural ally for him as there was already a history of bad blood between Penda and the East Anglian kings. Penda had killed Sigeberht the previous king of the East Angles, and his co-ruler Ecgric; the exact date of the battle is not recorded, but Bede places it after the events of 642.[21] Bede was particularly interested in this battle because Sigeberht had abdicated to enter a monastery but was forced to be present at the battle to help rally the men. He refused to bear arms and carried only a staff (*virga*). Anna died in battle against Penda in 654, according to the *Anglo-Saxon Chronicle*,[22] and this came after various hostile raids led by Penda into East Anglia, which Bede knew about from the *Vita* of the Irish monk Fursey, who withdrew to Francia because of them.[23] The *Historia Brittonum* records that Anna had been slain by Penda 'through trickery' (*per dolum*).[24] It says the same of the death of King Oswald, but it may indicate no more than the superiority of Penda's battle tactics.

The East Anglian kings vied with Penda for control of the Middle Angles, a disparate group of small-sized, but economically active peoples of the East Midlands who lay between their core areas. In 653 Penda is said by Bede to have made his son Peada their ruler.[25] Possibly this was a period when it looked as if a *modus vivendi* had been established between Mercia and Northumbria, for Peada married King Oswiu's daughter Alhflæd, and her brother Alhfrith married Peada's sister Cyneburh. Oswiu's young son Ecgfrith went as a hostage to the Mercian court,[26] but the leit-motif of the relations of Penda and Oswiu was hostility. Some of it we are only informed about incidentally. Bede, for instance, records a raid by Penda on the Northumbrian royal centre of Bamburgh (sometime between 642 and 651) in which he attempted to set the settlement on fire (but it was saved by the prayers of Bishop Aidan who saw the smoke from Lindisfarne).[27] Although not ranked by Bede as one of the great Anglo-Saxon overlords, a case can be made for Penda exercising a comparable overlordship at times over much of central and southern Britain.[28]

We are particularly well-informed about Penda's overlordship in the accounts of the climax of hostilities between him and Oswiu in 655, the year of Penda's death. Bede and the *Historia Brittonum* both present accounts of what occurred from different perspectives.[29] Events began when Penda and his Anglo-Saxon and Welsh subject kings journeyed to *urbs Iudeu*, which seems likely to have lain on the Firth of the Forth in the very north of Oswiu's territory.[30] The intention was to force Oswiu to accept Penda's overlordship and to exact tribute from him which Penda would then share with the leaders who had supported him. Bede says that Oswiu offered 'an incalculable and incredible store of royal treasures and gifts as the price of peace' (*innumera et maiora quam credi potest ornamenta regia vel donaria in pretium pacis largiturum*), but that Penda refused the gifts as he wanted to destroy Northumbria utterly.[31] The *Historia Brittonum* records that Oswiu handed over all the 'riches' (*divitias*) that he had with him and Penda distributed them to the Welsh kings who had come with him (and presumably to the Anglo-Saxon ones as well).[32] In Welsh this was known as *Atbret Iudeu* 'the Restoration of *Iudeu*', with the implication that these treasures had been previously exacted by Oswiu from British areas – and by extension probably from Anglo-Saxon kingdoms as well. According to the *Historia Brittonum* version, when Penda had achieved his objectives, he withdrew south. Apparently, Oswiu did not feel himself bound by any promises made, and went in pursuit. The place where he overtook and attacked Penda's army was identified by Bede as 'near the River *Uinued*' (*Winwæd*).[33] It has been identified with the place near Pontefract (West Yorkshire) where the Roman road known as the Roman Ridge (the modern A639), crosses the River Went. This is likely to have been the route that Penda used to travel to and from the north.[34] The site is only a few miles west of Hatfield where Penda and Cadwallon had defeated Edwin in 633. It was a marcher zone which Northumbria and Mercia competed to control. At *Winwæd*, in spite of having a smaller army, Oswiu inflicted a major defeat, aided by the flooding of the river which trapped the Mercians. Penda was killed, as were most of the Anglo-Saxon and Welsh leaders who had gone to *Iudeu* with him. Bede says that there were thirty *duces regii* in Penda's army. Bede specifically mentions King Æthelhere of the East Angles, the brother of Anna, who was killed, and Oethelwald, Oswiu's nephew and ruler of the southern Northumbrian province of Deira, who withdrew from the battle.[35] The British tradition was that all the Welsh princes who had come with Penda were killed apart from Cadfael of Gwynedd (who may have separated from Penda's army to journey home before Oswiu overtook them).[36]

Bede says that Oswiu took northern Mercia under his direct control, and permitted Penda's son Peada to rule the southern Mercians.[37] But in Easter 656 Peada was murdered through the treachery, Bede had heard, of his Northumbrian wife, Alhflæd, a daughter of Oswiu.[38] Oswiu presumably then controlled all of Mercia, but in 658 three Mercian leaders expelled him and established Penda's young son Wulfhere, whom they had kept concealed (one wonders where), as king.

Wulfhere (658–75) seems to have reasserted his father's control over the southern kingdoms. As well as being ruler of the Middle Angles and Lindsey, he can be traced as overlord of the East Saxons, Surrey and the South Saxons, and vied with the West Saxons for control of the Jutish districts of southern Hampshire and the Isle of Wight.[39] Bishop Wilfrid's biographer Stephen depicts him leading a force drawn from all the southern kingdoms against Oswiu's son and successor King Ecgfrith of Northumbria in 674 with the intention

of exacting tribute from him.[40] The site of the battle is not known. Wulfhere was defeated and obliged to pay Ecgfrith tribute instead, as well as to surrender some subject provinces including Lindsey and Hatfield.[41] Possibly as part of peace arrangements, Wulfhere's brother Æthelred married Ecgfrith's sister Osthryth. Wulfhere died in 675. Æthelred, his successor (675–abdication 704), had his revenge with a major victory over Ecgfrith in 679 in a battle near the River Trent. This was probably another battle in the disputed area immediately south of the Northumbrian province of Deira, for the Trent separated Lindsey from the province of Hatfield.[42] Bede describes how Archbishop Theodore of Canterbury organised a significant truce between the rival kingdoms in the aftermath of the battle in which Ælfwine of Northumbria, the heir and brother of Ecgfrith and brother-in-law of Æthelred, was killed.[43] In spite of his victory, Æthelred agreed to pay Ecgfrith the *wergild*, a monetary compensation, for the death of Ælfwine, thus putting an end to a possible blood-feud. The battle seems to have marked an end to Northumbrian attempts to dominate the southern kingdoms, and initiated a more peaceful period, in which no one ruler was dominant. The murder of King Æthelred's Northumbrian wife Osthryth, sister of Ecgfrith, in 697[44] may mark a final stage of Mercian disengagement from the Northumbrian sphere of influence.

Wulfhere and Æthelred appear to have been less involved with the Welsh kingdoms than their father had been and more orientated towards the Anglo-Saxon kingdoms of southern England. Wulfhere's marriage to Eormenhild, daughter of King Eorcenberht of Kent (640–64) and his wife, the East Anglian princess Seaxburh, may have been important in bringing him into closer contact with the dominant royal houses of the south east.[45] Like their father, Wulfhere and Æthelred were collectors of tribute and might use force to ensure compliance, as Æthelred did when he ravaged Kent in 676,[46] but they also developed royal power in other ways. They sought to control trade in valuable commodities produced in their kingdom, such as the brine springs of Droitwich, and to develop their own ports of trade.[47] A concern with getting a share in valuable overseas trade may have lain behind Wulfhere's attempts to win control of the Solent and of London. He seems to have been more successful with the latter, and the trading *wic* along the Strand may have developed considerably during his period of overlordship.[48]

The next generation of Mercian kings, Cenred (704–9), the son of Wulfhere, and Ceolred (709–16), the son of Æthelred, do not seem to have been so involved in affairs outside their own kingdom. Such indicators as there are suggest continuing interaction with the southern kingdoms rather than with Northumbria. In 715 Ceolred fought with King Ine of Wessex in the Vale of Pewsey, a disputed border zone between Wessex and Mercia, but the outcome is not recorded (though a West Saxon victory may be implied).[49] There is no indication of major collapse, but the relative lack of success or military activity from Cenred and Ceolred may have facilitated a change of regime. There are signs of growing problems and unrest within Mercia: the murder of Queen Osthryth in 697; the exile of the Mercian princes Guthlac and Æthelbald;[50] the abdication of Æthelred in 704 and Cenred in 709. In 716 Ceolred died suddenly, having fallen into a frenzied fit 'while feasting in splendour among his companions' according to the West Saxon churchman Boniface.[51] A Mercian king-list records the accession of Ceolwold, perhaps a brother or other close relative of Ceolred,[52] but he was overthrown in the same year by the exiled Æthelbald, a descendant of Penda's brother Eowa. Ceolred and Ceolwold are the last recorded descendants of Penda to rule. The year 716 therefore marked a significant regime change within Mercia, and it has even been suggested that the Staffordshire assemblage could have resulted from the desire of the successful descendants of Eowa to obliterate traces of their rivals.[53] It was undoubtedly an uncertain period in Mercian politics, which could be a classic context for the deposition of hoards, but the same could be said of earlier periods, especially that between the death of Penda (655) and accession of Wulfhere (658). The eighth century was to belong to descendants of Eowa: Æthelbald (716–57), who staged the coup in 716, was himself assassinated in 757, and succeeded by his distant cousin Offa (757–96). This was a period of sustained dominance of southern England by the Mercian kings and of significant expansion of Mercian territory and royal power.[54]

Religion in early Mercia

Both Bede and the *Historia Brittonum* stress that Penda was not a Christian: Bede says that Penda and the whole Mercian race were idolaters and ignorant of Christ's name,[55] and the *Historia Brittonum* that 'he was victorious through the arts of the Devil'.[56] Pagan rituals may well have been an important element of bonds between Penda and his closest military followers. However, that did not have to mean that Penda was actively hostile to Christians and Christianity, and there are several indicators that the opposite was the case. Even Bede admits that Penda did not forbid the preaching of Christianity in his kingdom, and even, rather curiously, that it was insincere Christians 'who scorned to obey the God in whom they believed' to whom Penda objected.[57] Throughout his military career Penda fought in alliance with Welsh Christian rulers and their armies, and, if he drew his own personal forces from the districts he ruled, some of those would have been British Christians. Religious difference does not appear to have been an issue and caution should be exercised in interpreting some of Penda's actions

as fuelled by paganism. After the victory over Oswald at the battle of *Maserfelth*, Bede says that Penda removed Oswald's head and hands and displayed them on stakes (from which Oswiu retrieved them a year later).[58] Suggestions that this was a sacrifice to Woden go further than Bede's description warrants; if it had been a 'pagan' act, one might have expected him to say so.[59] This was an act of ritual humiliation inflicted on the body of a defeated enemy that can be paralleled in many cultures, including that of the Roman army. It is unlikely that Penda's behaviour was markedly different from that of contemporary British and Anglo-Saxon Christian rulers, and even Bede does little to disguise his rival Oswiu's treacherousness and violent ruthlessness.

Peada's marriage to Oswiu's daughter was the occasion of the first recorded mission to the Mercians. Peada was baptised by Bishop Finan in Northumbria and returned with four priests from Lindisfarne.[60] When Oswiu took over Mercia after his victory at the battle of the River *Winwæd*, one of the group, Diuma, was appointed the first bishop of the Mercians and Middle Angles. Continuity and the Lindisfarne link were maintained by Wulfhere. Lichfield became the Mercian see under the Northumbrian Chad, who was appointed in 669 and had an unbroken succession from that date.[61] His brother Cedd had been one of those who had been sent to Mercia from Lindisfarne in 653, and Chad also maintained strong links with his family's monastery at Lastingham in Deira (North Yorkshire).[62]

Lichfield lies only a few miles from the place where the Staffordshire assemblage was deposited. The deposition may well have been made before Lichfield became the centre of the Mercian see, but it could already have been a significant British religious centre, perhaps even the site of a British bishopric. Suppositions to this effect have been based on Welsh poetry of the late twelfth or thirteenth centuries, such as the *Marwnad Cynddylan*,[63] but the distance in time between composition and the period the poems purport to describe makes them a questionable source.[64] Recent excavation of an enigmatic two-celled stone structure dated to the fifth and sixth centuries in the centre of Lichfield has provided new support for the traditions.[65] More generally, it has been suggested for some time that the Anglo-Saxon church organisation in western Mercia was based on British foundations.[66] By 669 Mercia, like everywhere else in Anglo-Saxon England, was under the jurisdiction of Archbishop Theodore of Canterbury, who vigorously implemented papal policy to correct various practices of the British and Welsh churches that were considered borderline heretical.[67] In effect, this authorised the Anglo-Saxon take-over of British church sites. Ironically, the conversion of the Mercian leaders led to greater hostility towards the British and Welsh church than seems to have been the case when they could be described as pagans.

Adherence to Christianity and direction from Canterbury can be seen as part of the consolidation of royal power and a growing involvement with southern England that characterised the reigns of Penda's sons. Both Wulfhere and Æthelred were founders of religious houses, particularly in border areas that they wanted to draw more closely into their kingdom. The important monastery of *Medehamstede* (Peterborough) in the Middle Anglian territory of the *Gyrwe* claimed Peada and Wulfhere as its royal patrons. It is difficult to tell fact from fiction in the *Medehamstede* traditions, which were improved in later periods,[68] but Bede records it as the foundation of Seaxwulf before he became bishop of the Mercians at some point between 672 and 676.[69] Cyneswith and Cyneburh, said to be daughters of Penda, are associated with another possible early monastery at Castor near *Medehamstede*.[70] A major Mercian foundation in Lindsey was Bardney, of which King Æthelred and his wife Queen Osthryth were major patrons. It was perhaps founded after Æthelred's victory over Ecgfrith of Northumbria at the battle of the River Trent in 679. Osthryth had the body of her uncle Oswald moved there from the battlefield site of *Maserfelth*, which was an important stage in the development of his cult.[71] The promotion of St Oswald at Bardney can be seen in the context of Lindsey as a province that was disputed between Northumbria and Mercia, but it may not have endeared Osthryth to a section of the Mercian nobility who were apparently responsible for her murder in 697.

In Mercia itself royal family nunneries were founded which, like those founded in the late seventh century in other kingdoms, took special responsibility for the religious needs of the royal house.[72] Wulfhere founded Hanbury (Staffordshire) for his daughter Werburg,[73] but the most significant of these so-called double houses was Repton (Derbyshire) where Merewalh, a brother of Wulfhere and Æthelred who is said to have ruled the *Westerne* of Shropshire, was allegedly buried.[74] It was in this foundation that the Mercian prince Guthlac began his religious career, at a time, perhaps in the aftermath of Osthryth's murder, when the descendants of Penda were proceeding against rival princes.[75] The abbess of Repton was possibly a supporter of the opposition, and Repton was the chosen burial place of Æthelbald, who returned from his exile in the Middle Anglian fens (where he met up with Guthlac who had retreated there as a hermit) to take the throne in 716.[76] After the accession of Peada in 655, Mercian kings and their families appear to have fully embraced Christianity, sometimes to a notable extent. Æthelred abdicated in 704 so that he could become abbot of his monastery of Bardney (though on occasion he continued to intervene in the kingdom's affairs).[77] Cenred, his nephew and successor, gave up the throne to travel to Rome to become a monk, together with Offa, a subking of the East Saxons; both men died there.[78] Such ostentatious religious behaviour has been seen as contributing to

a reaction against the line of Penda in 716.[79] Alternatively, it may itself be an indicator of growing conflict within Mercia, for in the early Middle Ages apparent abdication for religious purposes could conceal a political coup and be a means of removing a king from the throne without actually killing him.

The findspot of the Staffordshire assemblage and the history of Mercia

The findspot of the Staffordshire assemblage on Cannock Chase can be categorised as one of those areas of western England that had apparently come under 'Mercian' control by *c* 600, but which had not produced evidence for an Anglo-Saxon presence before the seventh century. Within the vicinity were a number of places that were to be significant under the Mercian regime and were of British origin (fig 7.1).[80] They include Lichfield, whose name was recorded by Bede as *Licidfelth/Lyccitfeld*.[81] Its first element is generally believed (although the explanation is not without problems) to be ultimately derived from that of Roman *Letocetum*.[82] *Letocetum* may have been a district name and it has been suggested that the second element of Lichfield's name – *feld* – may have been applied by Anglo-Saxons to British districts when they came under Anglo-Saxon control.[83] *Maserfelth*, where Penda defeated Oswald, may be a comparable example, and a case has been made for Oswestry ('Oswald's tree') as marking the site of that battle.[84] Another district to the north and west of Lichfield can be postulated based on a Roman station on Watling Street called *Pennocrucium*. In a ninth-century charter this was the territory of the *Pencersǣte*, the name of whose central place, Penkridge (*Pencric*), was derived from the earlier name for the Roman station that lies two miles to the south.[85] To the south of Lichfield was another *feld*, *Wednesfeld* ('Woden's *feld*') that appears in the historical record as a major royal estate.[86] The 'Woden' first element could appear suggestive of early Mercian origins and engagement with Germanic paganism. However, the place name is not recorded before the tenth century, by which time Woden had come to be seen as a royal ancestor rather than a pagan god.[87]

The part of Cannock Chase where the Staffordshire assemblage was discovered might be considered marginal as farming land, but was nevertheless an important economic resource shared between bordering districts, but probably without distinct boundaries until much later in the Anglo-Saxon period.[88] Ninth-century charters suggest that it was at that time a marcher area between the territories of the *Pencersǣte* and the *Tomsǣte*.[89] In the seventh century the boundaries of the three smaller districts discussed above converged in the area; that is, the former Roman districts of *Pennocrucium* and *Letocetum*, and *Wednesfeld*, which may have been in origin a comparable district. The findspot was, as David Roffe has said, not so much marginal as liminal.[90] It was an intermediary zone between the districts settled by Anglians and those whose inhabitants were predominantly British in origin, though by the seventh century under Anglo-Saxon rule. The area can be seen as typical of 'neutral' territory where assemblies might be held, and the meeting-place of Offlow (which gave its name to the large Domesday Book hundred encompassing the area) lay a few miles to the south east of the Staffordshire assemblage findspot, near the junction of the Roman roads of Watling Street and Ryknild Street.[91] The proximity of the find to Watling Street must also be deemed a significant feature. It is suspected that Welsh and Anglo-Saxon armies used Roman roads to move swiftly through the countryside on their often impressively long-distance campaigns.[92] If *Maserfelth* was the district containing Oswestry, King Oswald may have passed through in 642, and his brother Oswiu a year later to retrieve his head and hands. Such a penetration deep into former British districts under Mercian control may have highlighted the need for control or observation of movement along Watling Street, if this had not happened before. Roman roads could, of course, be used for other purposes, and the movement of goods for trade or as part of royal exactions would be another reason to keep them under supervision. A detailed examination of antiquarian accounts has revealed a lost square-

▶ **Fig 7.1.** Local context of the Hoard in the seventh century. *Drawing*: H. E. M. Cool and C. Fern.

banked enclosure at Knaves Castle, three-quarters of a mile to the west of the findspot of the assemblage, which, it has been suggested, could have been a Roman signal station or watchtower,[93] and it is not inconceivable that it could have been brought back into use in the middle Saxon period as part of a wider system of surveillance.[94] One could also postulate that a site near the junction of two such major routeways as Watling Street and Ryknild Street would make an ideal mustering site,[95] and so presumably also a de-mustering one where the spoils of war might be shared out. The place-name Shire Oak, a short way south of the findspot, might also be an indicator of this poorly recorded class of site. Hammerwich, at a similar distance to the findspot's north east, could be interpreted as a smithying site where the kind of dismantling of metal objects that lies behind the assemblage material could possibly have taken place.[96]

Conclusion

The period around 650 was one of rapid change and varying fortune in the relatively newly formed kingdom of Mercia. Deposition of the Staffordshire assemblage could have occurred in somewhat different circumstances depending on at exactly what point it was deposited between, say, 650 and 700. If the deposition was made when Penda was still alive, its contents could be seen as a result of the type of sharing out among allies, perhaps at an established assembly site, of *regia ornamenta* as implied in accounts of the 'Restoration of *Iudeu*' (but it is presumably not what was handed over at *Iudeu* itself because that can be expected to have returned to Northumbria with the defeat and death of Penda). The very deliberate selection and burial of certain categories of material could be taken as suggesting a conscious decision to remove that material from circulation. Traditional practices, such as a sharing of the spoils of victory with the gods or an attempt to provide supernatural reinforcement for the defence of Watling Street, could be evoked, but the intention could also have been something less specific, such as remembering the dead.[97]

After the defeat at the battle of the *Winwæd* in 655, the context could have been rather different. This was a period when initially more might have had to be hidden away from Oswiu of Northumbria than just Prince Wulfhere. It would have been a period when Mercia would have been obliged to hand over tribute to the Northumbrians, perhaps leading to a division of what was in the royal treasury, but perhaps also a time in which supernatural support would have been sought to overturn the situation. Such a reversal did occur in 658 when Mercian ealdormen rose up against Oswiu to place Penda's son Wulfhere on the throne. There were mixed fortunes in the reigns of Wulfhere and his brother Æthelred,

but on the whole probably more successes and tribute-taking than tribute-paying, culminating in Æthelred's major victory at the battle of the River Trent in 679. The reigns of the two brothers saw important consolidations of royal power, including developments that fostered trade as a contribution to royal revenues, another potential context for the assemblage.

The increasing importance of Christianity to kings and the creation of an Anglo-Saxon bishopric at Lichfield in 669 is yet another prism through which the Staffordshire assemblage might be viewed. Destruction or adaptation of pagan places of worship was a feature of the phase of Christianisation, and the release of wealth in the form of former offerings to these shrines has been suggested.[98] On the other hand, once Christianity had been established the church apparently got its share of spoils,[99] but could the assemblage have been a rejection of this type of blood-money? Political insecurity within Mercia from the very end of the seventh century until the coup of Æthelbald in 716 could also have produced conditions for the temporary burial of wealth, when it may even have been uncertain at times who was king. The accession of Æthelbald marked the end of power for the descendants of Penda, and so provides a possible context for the slighting of monuments or objects that were associated with their achievements. However the assemblage is interpreted, it is bound up with a significant, fast-changing phase in the development of Mercia into the dominant kingdom over much of England in the eighth century.

The Staffordshire assemblage appears to reflect some aspects of the heroic culture presented in *Beowulf* and Bede's *Ecclesiastical History*, but also provides some challenges to the impression they can give. The find's sword-fittings seem worthy of the type of swords with gold fittings referred to in the poem *Beowulf*, as Chris Fern discusses.[100] The honour paid in heroic verse to swords and their personal biographies can make them seem akin to warriors themselves.[101] But the dismembered state of the sword-fittings in the Staffordshire assemblage may lead us into an area that the heroic verse does not dwell upon, namely, that which can bring honour can also be used to dishonour; that just as warriors can be killed so can their weapons. Do we see in the dishonour paid to the sword-hilts and pommels that have been roughly separated from their blades, and to the accoutrements of supporting religious leaders, a symbol of the defeat and humiliation of the enemies of Mercia, either achieved or desired?

THE CHURCH AND WARFARE: THE RELIGIOUS AND CULTURAL BACKGROUND TO THE HOARD

Alan Thacker

The Staffordshire Hoard contains at least eight objects thought to have a specifically Christian function, all discussed in detail elsewhere in this volume.[102] The significance of those that clearly had a ceremonial or liturgical function will be the primary focus of this section, but the implications of other objects with obvious Christian motifs[103] will also be considered.

All this material is of native manufacture and none of it is considered to date much later than 650. As such, it is of exceptional interest: the overtly Christian objects must belong to the earliest phase of the production of this kind of material by the English. We need therefore to consider how the assemblage affects our view of the world that created it as much as in what ways our current views of that world can help us to interpret it.

The contemporary context

We know little about the furnishings of English churches in the first half of the seventh century. In his *Ecclesiastical History*, Bede tells us that when Augustine approached Canterbury, to take possession of the '*mansio*' given him by King Æthelberht of Kent after their first meeting in Britain in 597, he was accompanied by a 'holy cross' ('*crux sancta*') and an image ('*imago*') of Christ, presumably a processional cross, perhaps with a relic cavity, and an icon.[104] In 601, when Pope Gregory sent more priests to England, they brought with them all that was necessary for the worship and ministry ('*ad cultum … ac ministrandum*') of the church, including sacred vessels and altar cloths, church ornaments, relics (presumably housed in portable reliquaries) and many books.[105] These would have included objects made of or encased in precious metal, constituting treasure commensurate with the ecclesiastical material in the Staffordshire Hoard, but unlike the latter they were imported.

By the 630s, Christian objects could form part of an English king's treasure. Bede records that a great golden cross ('*crux magna aurea*') and a golden chalice consecrated to the service of the altar ('*calix aureus consecratus ad ministerium altaris*') were among the numerous precious vessels ('*vasa pretiosa … perplura*') belonging to Edwin of Northumbria, which his bishop, Paulinus, brought with him to Kent after the king's defeat and death at Hatfield in 633. Bede also notes that they were still on display in a Kentish church ('*ecclesia Cantiae*'), presumably either the cathedral church of Canterbury or that of Rochester, where Paulinus took charge as bishop and where he was buried upon his death in 644.[106] Edwin's cross, then, was in existence only a little before the probable date of the manufacture of that in the Hoard. Whether it was imported or made in England is difficult to say, although there is evidence that Edwin commissioned other metal vessels (albeit of bronze) for the public good.[107]

By the 670s, when Northumbrian ecclesiastics such as Benedict Biscop and Bishop Wilfrid were furnishing their monasteries, we get a clearer picture of ecclesiastical treasure. Biscop collected sacred ornaments, vestments, icons, relics and books for the communities at Wearmouth and Jarrow.[108] But he seems to have imported both the objects and the craftsmen, presumably because the manufacture of such material was still relatively uncommon in England. Wilfrid also collected relics, purple and silk vestments and other ecclesiastical treasure in Rome and Gaul,[109] among which presumably was the portable reliquary taken from him in 680 by the Northumbrian queen Iurminburg to be carried about with her 'like the ark of God' ('*sicut arca Dei*').[110] Like Biscop, Wilfrid was very concerned with the adornment of his churches. One of his first acts as bishop of York was to restore his see church (669–71) and to embellish the interior and the altar with various kinds of vessels and furniture.[111] Shortly afterwards, in the 670s, he made the interior of his church at Ripon very sumptuous. His biographer Stephen tells us that he adorned it with gold, silver and 'varied purple' ('*purpura varia*')' while the altar was vested with '*purpura*' woven with gold; he also commissioned a sumptuous Gospel book, with illuminations, gold lettering and purple-stained parchment ('*membrana depurpurata*'), and what seems to be a casing for this ('*bibliotheca librorum eorum*') of gold set with precious stones.[112] So, while Wilfrid clearly imported ecclesiastical paraphernalia, by the 670s he was also in touch with craftsmen based in England. Later we learn that Acca, bishop of Hexham (710–31), furnished Wilfrid's church with 'splendid ornaments' ('*magnalia ornamenta*') of gold, silver and precious stones and that he adorned the altars with '*purpura*' and silk. Whether these treasures were imported or made locally is uncertain.[113]

The great processional/altar cross (**539**) with its late Style II ornament and its prominent cabochon garnets and possible small space for relics may be compared with the jewelled crosses and cross-reliquaries of Byzantium and Rome. One particularly important survivor is the reliquary cross, given by the Emperor Justin II (568–75) to St Peter's in Rome (fig 7.2; cf *frontispiece*).[114] A large jewelled cross of a rather different kind is illustrated in a mosaic in Santo Stefano Rotondo, donated by Pope Theodore I (642–9), surmounted by a roundel with the head of Christ and with St Primus and St Felicianus, whom Theodore translated to the

◀ **Fig 7.2.** Reliquary cross given by Justin II to St Peter's, Rome (the stand is a later addition): Vatican, St. Peter's Basilica (Treasury Museum). *Photograph*: © Scala, Florence, 2019.

church, on either side.[115] Jewelled crosses also appear on the book-covers given by the Lombard queen Theodelinda (d. 628) to the cathedral at Monza.[116]

The relative fragility of the putative base (**607/8**) suggests that any stave to which the cross was attached was quite short (fig 2.77), easily held in the hand. We have evidence of how it might have been used in the elaborate and highly Romanised ritual that characterised Abbot Ceolfrith's departure from Wearmouth after his resignation in 716. Accompanied by deacons, one of whom held 'the golden cross that he had made' ('*crux quam fecerat aurea*'), the abbot crossed the River Wear. He then venerated the cross (the phrase used is '*adorat ad crucem*') before mounting his horse and riding off.[117]

Contemporary Gaul provides parallels for the production of ecclesiastical treasure in England in the earlier seventh century. In Gaul, from the 620s/630s, there had been considerable investment in beautifying and enriching the major shrine churches. A leading player had been the royal jeweller Eligius (d. 660), bishop of Noyon from 641. He had been responsible for the production of jewelled shrine-reliquaries, altar fronts and crosses, *ciboria* (altar canopies), pulpits and sacred vessels. Little of this work survives, though a few objects were recorded before destruction in the French Revolution (fig 2.69).[118] The great gold and cloisonné-jewelled cross that Eligius made for Saint-Denis, even though it was much larger (*c* 6 feet [1.8m] high) and evidently intended to adorn an altar, may perhaps be compared to the Hoard's processional cross.[119]

Parallels for the substantial reliquary that the inscribed strip (**540**) might have adorned are less easy to find. Fragments of roughly contemporary gilded and jewelled reliquaries survive at Conques and Agaune.[120] Another example, only 133mm long and 112mm high, of wood encased in gilded copper, forms part of the treasure of Saint-Benoît-sur-Loire and was given by one Mumma, perhaps Mummolus, abbot in the mid-seventh century (651–679/85), to hold relics of the Virgin and St Peter.[121] Closer to the putative Hoard object may have been the gold and silver reliquaries created by Eligius, which at this early date may have provided English patrons and craftsmen with models. Little is known, however, of their size and appearance, though the Merovingian fragments from the front and back panels of the Egbert-shrine in Trier may be *spolia* from one such object.[122]

One early portable shrine, perhaps nearly contemporary with that associated with the inscribed strip, is the housing of the imperishable arm and hand of King Oswald of Northumbria. Having been displayed on the battlefield after Oswald's defeat and death at the hands of Penda in 642, these relics were retrieved by his brother King Oswiu before 655. They were placed in the church of St Peter at the royal vill of Bamburgh and, in the time of Bede, preserved for veneration in a silver reliquary.[123] That reliquary could evidently be opened; Alcuin, writing in the 790s, tells us that such was the state of the imperishable remains that the nails kept growing and clippings taken from them were distributed as relics.[124] The hair clippings of St Cuthbert kept in a reliquary within the church at Dacre in the early eighth century provide an analogy.[125]

The arm of St Denis provides an almost exactly contemporary Frankish parallel to the enshrinement of the Oswald relic. Shortly before his death in 657, the Merovingian king Clovis II, husband of the English Balthild, caused the shrine of St Denis to be opened, breaking off and seizing an arm-bone of the saint. According to the *Gesta Dagoberti*, Clovis lost his mind as a consequence of this outrage and when he had recovered his senses he had the bone that he had removed vested in gold and silver, 'wonderfully worked', and restored to the community from which he had taken it.[126] The silver reliquary that housed Oswald's arm may have been a comparable object.

The most problematic of the Hoard's Christian objects is that plausibly identified as part of an ecclesiastical head-dress (**541**). Too flimsy and complex to have been of practical use, it presumably functioned as a ceremonial object, clearly one of great importance, given its exceptional quality. As reconstructed, it evokes the pontifical mitre ('*mitra … pontificalis*') described by Bede in *De Tabernaculo* and depicted in the Ezra portrait of the Codex Amiatinus (figs 2.79 and 2.80).[127] Bede's description, with its slight but significant change to his Josephan source, suggests that he had an actual object in mind; so does the fact that the head-dress in the Ezra miniature differs significantly from high-priest-type head-gear depicted in the *Christian Topography* of Cosmas Indicopleustes, compiled in the early sixth century and known in England by the early eighth.[128] The nature of episcopal headbands or diadems (*infulae*) in the Latin West at this time is uncertain and may have been variable; an English example may be the golden fillet inlaid with minute precious stones that encircled the imperishable brow of Cuthbert of Lindisfarne.[129] If the Hoard's head-dress was indeed intended as the ceremonial regalia of a bishop or metropolitan, then it is a reminder of the highly experimental nature of seventh-century English Christianity. We are looking, it seems, at an object with unique Insular origins – perhaps even related to the crowns worn by British priests.[130]

Christian and pagan culture in the early seventh century

The ambivalent cultural world to which these objects belonged is well evoked by the great processional cross (**539**). Taking its form from the great Christian symbol, the emblem of Christ's sacrificial death, as a '*crux gemmata*' and perhaps a reliquary it sits securely in Christian tradition. Yet its jewels are the garnets esteemed in contemporary pagan and military culture, and it is adorned with animal ornament of a kind again associated with secular pagan taste. This intermixture of Christian and pagan motifs is replicated with much more ambivalence in the ornament of a number of sword pommels and other fittings in the Hoard and suggests that in early to mid seventh-century England the cross was a potent symbol, of talismanic power.[131] That, of course, is the world to which the inscribed cross arm (**540**) and the contemporary Benty Grange helmet with its boar-crest and its nasal cross dates also belong (fig 7.3).[132]

Unsurprisingly, there was clearly considerable interaction between pagan and Christian culture in the new and experimental world of the earlier seventh century. It seems likely that the influence could go either way; Christianity could have influenced English paganism and vice versa. Bede, despite his famous discretion, allows glimpses of the predictable experiments and compromises, in particular in his account of King Rædwald of East Anglia (d. before 627), who maintained both Christian and pagan altars in the same temple (*fanum*).[133] Rædwald's successors abandoned this ambivalence and eventually adopted Christianity, although not without encountering significant resistance. Mercia under Penda, however, in the 650s remained closer to the world of Rædwald. The king himself was still a pagan, but tolerated the preaching of Christianity in his own heartlands and allowed his son Peada, whom he had made king of the Middle Angles in 653, to take a Christian (Northumbrian) wife and to convert.[134]

In early seventh-century England, Christianity was one of a number of (not necessarily exclusive) options open to the ruling elite. It was part of an unstable world in which looting and violence were endemic and which provides the context for the inclusion of the Christian objects in the Hoard. Like much of the other material, these had been broken up, a process that may be simply the consequence of the way in which they were initially acquired or a convenient dismantling in the building up of the assemblage (for whatever purpose). While the possibility that their condition may represent ritual defacement – a deliberate act of iconoclasm – cannot entirely be ruled out, the fact that the great processional cross was originally all folded one way and made into a parcel points more to the idea that its condition was the product of practical requirements rather than ideological malice.

Fig 7.3. Helmet (i) from Benty Grange (Derbyshire) with boar crest and detail (ii) of the silver cross on the nasal. *Photographs*: © Museums Sheffield.

Consideration of both the manner of acquisition and the reasons for defacement will affect our assessment of the Christian objects. All the overtly Christian items in the Hoard can be interpreted as religious paraphernalia of relatively recent manufacture. Dedicated liturgical items such as the processional cross can scarcely have been discarded simply because they had become redundant; some act of violence or some ideological reason must have been responsible for their inclusion in the Hoard. The most likely circumstances are that they were either taken as loot *in situ* from a religious community or taken in battle from clerics accompanying an army. In the mid-seventh century, religious communities were undoubtedly subject to looting and attack in internecine warfare between the English kingdoms. Stephen's *Life of Wilfrid* says explicitly that at the consecration of the church of Ripon in the 670s the bishop stood before the altar and enumerated the lands given to him together with the holy places ('*loca sancta*') deserted by British clergy, fleeing the swords of the warriors of 'our people' ('*gens nostra*').[135] Clearly, in the 660s/670s the Northumbrians, although officially Christian, had no qualms about looting the churches of their enemies. And while the British may have taken portable treasure with them, much of value may have been left behind.

The activities of the Mercian king Penda, recorded in detail by Bede, show how much Christian treasure might be at risk. Bede tells us that because of his 'savage and insupportable attacks', King Oswiu of Northumbria was forced to offer Penda 'an incalculable and incredible store of royal treasures and gifts' ('*innumera et maiora quam credi potest ornamenta regia vel donaria*'),[136] but Christian as well as pagan kings like Penda might perform such acts of destruction. Bede relates (with intense disapproval) that, when Æthelred, the Christian king of Mercia (674?–704?), invaded Kent, his 'evil army' ('*exercitus malignus*') profaned Kentish churches and monasteries 'without respect for religion or fear of God' ('*sine respectu pietatis vel divini timoris*').[137] Objects in the Hoard could have come from such activity. Whether pagan or Christian, the victors may have treated their loot with similar lack of respect.

The judgements of Archbishop Theodore (669–90), as revealed in the text known as his Penitential, are also relevant here. Theodore envisaged the possibility of theft or looting from churches, ruling that '*pecunia*' (here probably meaning goods/treasure rather than money) thus obtained was to be restored fourfold.[138] Even more suggestively, he also ruled that a third of '*pecunia*' seized in a foreign province from a conquered alien king should be assigned to the church.[139] That an important element in such booty could have been treasure taken from churches may well have been one of the reasons for this demand, but it is also clear that in the seventh century the church sanctioned the looting of alien provinces and sought to benefit from such activities.

Arguably, however, the Hoard's ceremonial Christian material does not represent booty looted from a church, but has strong links with the paraphernalia of war.[140] To place it in this context we need to think about the role of the church in warfare in the seventh century. As Bede's unreserved admiration for that most Christian king, Oswald of Northumbria, indicates, the church certainly expected rulers to fight valiantly in defence of the faith. Clerics, however, were not to fight as armed soldiers. Bede, for example, suppresses all mention of St Cuthbert of Lindisfarne's military career, even though it occurred before he became a monk.[141] The East Anglian king Sigeberht (630/1–before 654?) had been a vigorous and distinguished leader of men, but after he had resigned his kingdom and entered religious life prowess on the battlefield was no longer appropriate. When brought out of his monastery to fight against the Mercians, Sigeberht refused to carry any weapon other than a staff.[142] Clerics could, nevertheless, form part of a warband and be present at the battlefield. That is clear from Bede's account of the battle of Chester (*c* 616) in which the Christian British were defeated by Æthelfrith, the pagan king of Northumbria. The British army, Bede says, was accompanied by their priests ('*sacerdotes*'), assembled there to pray for the soldiers participating in the fight. Bede offers quite a detailed account of their role; 'they stood apart in a safe place' ('*seorsum in tutiore loco consistere*'), protected by a '*defensor*' called Brocmail. They were also very numerous – they came mostly from the nearby monastery of Bangor, which, allegedly, comprised more than 2,000 inmates and had sent most of its monks to be with the British host after a three-day fast. Æthelfrith, having ascertained their role, took the view that, even though they were unarmed, they were combatants, 'assailing us, as they do, with prayers for our defeat' ('*contra nos pugnant, qui adversis nos imprecationibus persequuntur*') and ordered them to be attacked. Brocmail and his men fled, leaving the monks to their fate. According to Bede, some 1,200 monks were slain, only fifty escaping with their lives. Notoriously, he in no way condemns the king's actions, seeing them rather as a proper punishment for the Britons' obdurate heresy and failure to engage with the English.[143]

Stephen, in his *Life of Bishop Wilfrid*, shows a similar attitude to clerical participation in war. When Wilfrid, returning to England from consecration in Gaul, *c* 666, lands in Sussex and encounters a pagan leader ('*princeps sacerdotum idolatriae*') he is accompanied by 'well-armed' and 'brave-hearted' companions ('*sodales*'), presumably not in holy orders. While they, though few in number, fight the pagans, the holy bishop and his clergy on bended knees raise their hands to heaven and gain the help of the Lord. In this, says Stephen, Wilfrid was like Moses, who continually called on the Lord for help, with Hur and Aaron raising his arms in prayer while Joshua smote the Amalekites on behalf of the people of God.[144] Stephen's Wilfrid, then, although not actually a combatant, was clearly at

home on the battlefield. He and his clergy could be imagined as having with them opulent liturgical gear, like that in the Hoard: crosses, reliquaries and even perhaps an episcopal head-dress.

Stephen's own unabashed militarism emerges especially clearly in his celebration of Ecgfrith's victory over the rebellious Picts (671/673), defined as a '*populi bestiales*' even though they were Christian (albeit schismatic); Stephen gloats over the enormous slaughter, of both combatants and fugitives, and over the reduction of the defeated tribes to slavery.[145] A similar fierceness governs his account of Ecgfrith's defeat of the catholic Christian king Wulfhere of Mercia (673/675). Ecgfrith, 'ruling in righteousness and holiness with God's bishop [Wilfrid]',[146] was strong like the Biblical David in crushing his enemies, and Stephen rejoices in the countless number of the slain. Unlike Ecgfrith, the proud and insatiable Wulfhere was not guided by God and his subsequent death, 'for whatever cause', was clearly seen as a punishment for his hostility to the Northumbrian king.[147]

For the warrior, the most totemic element of Christian liturgical gear was the cross. Its talismanic qualities for the English military elite were rooted in a strong association with war, going back to Eusebius's account of Constantine's vision in 312 at the Milvian bridge – '*in hoc signo vinces*' ('in this sign thou shalt conquer') – and of the making of Constantine's standard, the *Labarum*.[148] The cross was a crucial element in processions, often tinged with militaristic imagery in the liturgy, its role expressed most notably in Fortunatus' sixth-century hymn, '*Vexilla regis prodeunt*' ('The banners/standards of the king go forth').[149] The association of the cross with victorious warfare received a considerable boost in the earlier seventh century when Heraclius (610–41) recovered the relics of the True Cross after his defeat of the Persians in 627. Their return into Christian hands was celebrated in a new and triumphal devotion, the Exaltation of the Cross (14 September), introduced into Constantinople *c* 630 and shortly afterwards into Rome.[150] In England, King Oswald exhibited a similar sense of the cross's victorious power; the wooden cross that he set up at *Hefenfelth* in his battle against the hated British king Caedwalla in 634 later became a focus of veneration.[151]

Anglian connections

Some at least of the Hoard's most striking and high quality Christian objects, in particular the processional cross, the related inscribed strip and the Christian head-dress, could, then, have been an assemblage taken on the field of battle. It is perhaps unwise to ascribe the presence of such material to a single known event, especially as we know so little about the military engagements of the period. Nevertheless, if the Christian objects were taken on the field of battle, their deployment would suggest a major engagement, such as the fatal defeats of the Christian kings Edwin in 633 and Oswald in 642, both at the hands of Penda.[152] Clearly, given the link between the processional cross and the Sutton Hoo drinking cups,[153] one plausible context for the acquisition of these items is a raid on East Anglia, like that in which the former king Sigeberht perished. The manufacture by the mid-seventh century of such items would, however, seem exceptionally precocious in a kingdom whose rulers appear to have accepted Christianity decisively only in the 630s, if not later.[154] The craftsman who made the cross could well have worked for other rulers.

Another possible source of these objects is the briefly extant kingdom of Middle Anglia. Bede records that Peada was set up as the Christian ruler of the Middle Angles by the Northumbrian king Oswiu in the wake of the latter's victory at the *Winwæd* (655), that he was murdered in the following spring (656?) and that in 658 three Mercian noblemen expelled the Northumbrians and set up Wulfhere.[155] Could the revolt of the ealdormen have been a pagan as well as an anti-Northumbrian reaction? We know that Wulfhere became patron of an English, though Irish-trained, bishop and in the 660s sought to suppress apostasy among the kings of the East Saxons.[156] But was the young prince installed in 658 a Christian? If these objects had indeed been imported from Northumbria or created under Northumbrian influence, they could well have been taken out of use by the regime succeeding Peada but retained as treasure for recycling, to end up as part of the Staffordshire Hoard.

Interestingly, a variant form of the inscription on the cross arm occurs in a strongly Middle Anglian and Mercian context. Felix's *Vita Guthlaci* ('Life of St Guthlac') was written in the earlier eighth century at the command of an East Anglian king and features a saint whose family, though of Mercian royal descent, was resident in Middle Anglia. The (inaccurate) text on the strip, which derives from Numbers 10, 35, also occurs in Psalm 67, 2–3, but there, instead of directly invoking God, addresses Him in the third person.[157] Felix alludes to the Psalm text several times and once also to Numbers. Both versions of the text occur in a warlike setting. That in Numbers is spoken by Moses at the elevation of the Ark of the Covenant, whenever it moved before the Israelites on their journey from Sinai to Edom; that in Psalms is pronounced by David in the persona of Moses, celebrating God's victorious presence among the Israelites. The unusual use of the Numbers version, when that in Psalms verse would have been much more familiar from recitation in the liturgy, looks like a deliberate evocation of the Ark of the Covenant travelling with the Jewish host. It would have been a particularly appropriate inscription for a reliquary (one term for which was '*arca*'[158]) borne to war.[159] That in England such an analogy could be applied to a portable reliquary is evident from

Stephen's comments on Queen Iurminburg's treatment of that taken from Bishop Wilfrid.[160]

Felix's use of the Psalm text accords with this militaristic context, and his repeated invocation of it suggests that he thought of it as invested with talismanic power.[161] Thus he quotes it in his account of how Guthlac put to flight a group of devils who sought to attack him in the guise of a British warband: '*Exsurgat Deus, et reliqua.*'[162] As in Evagrius's Latin rendering of Athanasius's *Life of Antony*, which was one of Felix's models, no sooner had the saint intoned the verse than the demonic host vanished like smoke from his presence ('*velut fumus a facie eius*'), a further allusion to the passage in Psalms and a phrase evidently associated in Felix's mind with a tag from Virgil.[163] The text was clearly thought to afford especial protection since Felix uses it again (in the Numbers version) when Guthlac prophesies to his protégé, the exiled Æthelbald, that he will gain the kingship of the Mercians.[164] He also deploys the Psalmic reference to vanishing like smoke on two further occasions.[165] The text might thus be thought to have especial resonance for Middle Anglian and Mercian royalty.[166] By contrast, there is no reference to it at all in the authentic works of Bede.

The *Vita Guthlaci* offers a particularly revealing account of the implications of war for early English Christianity. Felix is quite open about his hero's military background, which he describes in considerable detail. He depicts Guthlac both as a secular warrior before his entry into religion and as a soldier of Christ ('*miles Christi*') afterwards. Presumably a cleric well-educated in both hagiography and heroic classical literature (primarily Virgil), Felix took a positive view of the military virtues. It is easy to imagine the deployment of the Christian objects in the Hoard in his world.

Conclusion

The material under discussion is evidence that the manufacture of Christian ritual objects began remarkably soon after the arrival of the Gregorian mission. These items should not be regarded as particularly strange or exceptional inclusions in the Hoard. Men in clerical orders clearly had their place on the battlefield and their equipment could be regarded in some sense as war gear; the Christian objects in the Hoard were treated much as the other material. The church moreover evidently sanctioned the acquisition of treasure, whether obtained by looting, by render as tribute or as the spoils of the battlefield, though whether it was concerned about the inclusion of Christian objects in such material is not clear. If, as seems at least possible, the major pieces in the Hoard formed part of the equipment of a ruler's war band, in the unstable and experimental world of the earlier seventh century they may have been jettisoned by new leaders with different political affiliations, rather than acquired on the field of battle. But whatever the means by which it found its way into the Hoard, this material gives us a range of new insights into the early decades of English Christianity.

▼Gold and garnet cross-shaped small mount **526** (not to scale).
Photograph: D. Rowan; © Birmingham Museums Trust.

CHAPTER EIGHT

CHAPTER EIGHT

THE ARCHAEOLOGICAL CONTEXT:
MATTERS OF MATERIAL AND SOCIAL SIGNIFICANCE

JOHN HINES

We have to rely largely upon the archaeological study of material remains from the fifth, sixth and seventh centuries AD for knowledge of what was happening then in the area that would eventually become England. The relevant documentary sources that are the domain of the historian are extremely sparse, and formidably difficult to interpret.[1] In archaeological terms, however, the hoard of precious-metal artefacts that is the subject of this volume is quite unparalleled in composition and character for early Anglo-Saxon England. It demands we think quite fundamentally about how it can or should be correlated with our existing views of what was a dynamic phase, and a fundamental one in respect of the reconstitution of Britain, and much of the rest of Europe too, after the demise of the Roman Empire in the West.

We can at least confidently start from the premise that this unique assemblage is a major collection of items which in themselves were of especial value in their original contexts. Those contexts comprise where, when and how the component objects were manufactured; where, when and how these items were distributed, displayed and used; and, finally, the circumstances in which they came to form part of this hoarded collection. The analysis of the contents of the assemblage in Part One of this publication also shows that there are three distinct but mutually compatible fields of reference within which the function and value of the material should be considered. The assemblage represents a considerable quantity of precious materials: primarily gold, silver and garnet. It is composed of fragmented artefacts that are overwhelmingly military in character, even though not every identifiable item comes from a weapon or piece of armour. Beyond the functional character of the artefacts represented, the assemblage also comprises a large group of objects in which the valuable materials have been painstakingly and often skilfully formed as works of art.

The detailed evidence systematically reviewed above shows that meticulous analysis of the range of parallels in design and form to the artefacts within the assemblage – not only externally, comparing finds from other contexts, but also internally, among the contents of the assemblage itself – enables us to emphasise particular regions, such as East Anglia, in which close parallels are known, and also to recognise the distinctly elite social contexts such objects are associated with.[2] The probable date at which the assemblage was brought together can also be determined, and this logically indicates the date at which it came to be buried, unrecovered for some thirteen and a half centuries, close to an east–west routeway and not far from a major contemporary Mercian royal centre and yet still in a relatively marginal location.[3] The archaeological dating evidence points firmly to the third quarter of the seventh century for those events.

THE EARLY ANGLO-SAXON PERIOD: GRAVES AND GRAVE GOODS

Dating the assemblage makes it possible for us to correlate it with a broader historical context.[4] In archaeological terms, meanwhile, both by date and by character, the assemblage belongs to the concluding decades of the distinctive and well-defined early Anglo-Saxon period in Britain. This 'Early' period is characterised principally by the regular inclusion of artefacts in inhumation graves with some of the dead of the population.[5] There is a sharp dichotomy between male and female grave goods, with the provision of military equipment constituting the gender-specific male category in contrast to a predominance of conspicuous dress-accessories that characterises female grave-assemblages. An important point to note, and one of high significance for understanding the Hoard in contextual terms, is that, however deeply rooted and determinative a conventional pattern of sexual and gender difference was in early Anglo-Saxon England, the reflex of that social model in the burial record was far from unvarying. From the second half of the sixth century onwards, weapon graves became much fewer in number across the country than they had previously been, especially in the Midlands and the north.[6] In female graves, the provision of gender-typical practical

accessories, such as spindle-whorls and shears, becomes more frequent and there are examples of artefacts being collected and buried in a box with the deceased rather than upon and around the clothed body.[7] A progressive erosion of a marked contrast between child- and adult-related grave goods is also evident in the female sphere in the later sixth and seventh centuries.[8] Sometime in or around the 670s, according to the evidence of radiocarbon dates and our ability to use Bayesian modelling techniques to refine estimates of phase-boundaries, the tradition of including grave goods in

▲ **Fig 8.1.** Sword-related finds from the East Anglian centre of Rendlesham (Suffolk): i–ii) plain copper-alloy pommels; iii) gold and garnet pyramid-fitting; iv) lead model for the casting of a skeuomorphic sword-ring; v) pommel with skeuomorphic sword-ring from grave 3, Orsoy, Nordrhein-Westfalen (Germany) (scale 1:1). *Photographs*: (i–iv) © Suffolk County Council, reproduced with kind permission. *Drawing*: I. Dennis, after Bruce-Mitford 1978.

'furnished' burial came to an abrupt end, an event that may have been coordinated with the consolidation of the influence of the Church in England and its subsequent ability to control burial practices.[9] The ecclesiastical history of earlier Anglo-Saxon England is, of course, intimately intertwined with the social history of the population. The Staffordshire Hoard was collected and deposited at a time of considerable social and cultural change.

Items of weaponry similar in form and decoration to artefacts within the Staffordshire Hoard are known from quite a wide area around England. In the case of the sword-hilt fittings that predominate in the assemblage, however, the majority of the immediately comparable pieces are stray finds, usually made by metal-detectorists and not therefore from precisely describable archaeological contexts. Relatively few are from well-recorded burial contexts: the profusely furnished Sutton Hoo (Suffolk) mound 1 ship-grave is inevitably a primary point of reference, although a comparable *in situ* find is the gilt copper-alloy, cloisonné garnet-covered pyramid-fitting from mound 17 at that site.[10] Also to be noted are the imperfectly recorded graves unearthed in the nineteenth century at Coombe/Woodnesborough and Crundale Down in Kent, with cast and gilt copper-alloy and silver hilt-collars respectively, and a silver-gilt pommel with Style II decoration in the latter case.[11] The burial site at Sutton Hoo can be associated with the dynasty of the early kings of East Anglia, the Wuffingas; in all of these cases the ostentatious hilt-fittings have, even if imperfectly recorded, associated finds and contexts that reinforce the impression they themselves give of belonging to elite milieux, distinguished by rarity and special treatment in deposition, and characterised by the use of precious metals and by high-quality craftsmanship.

Among metal-detected finds at Rendlesham, close to Sutton Hoo in Suffolk (and a site identified by Bede as the location of a *vicus regius*, a royal settlement or estate centre of precisely the royal kindred that was burying at Sutton Hoo), are two plain, copper-alloy sword pommels that could have formed the cores of gold-covered pommels such as those in the Hoard, as well as a number of pyramid-fittings of both plain copper alloy and gold with garnet (fig 8.1i–iii).[12] Possibly the most significant sword-related find from Rendlesham, however, is the lead model for the casting of a metal false sword-ring of a size and shape identical to a known gilt copper-alloy specimen found at Orsoy (Rheinberg), Nordrhein-Westfalen, Germany (fig 8.1iv–v).[13] This object above all links the manufacture of exclusive sword-hilt fittings directly with an Anglo-Saxon royal context around the first half of the seventh century AD.

Counting the pommels, the contents of the assemblage represent a minimum of seventy-four sword-hilts, with just two certain examples of the distinct type of shorter one-edged sword known as the *seax*.[14] At least one helmet, but possibly more, is also represented in the pieces that make up the Hoard.[15] This profile is a highly skewed reflection of the arms and defensive armour and equipment known to be characteristic of seventh-century England.[16] The contrast between the composition of the Hoard and what is regularly found in burial contexts of the seventh century can be viewed as systematic and meaningful, and not merely a haphazard mismatch. The difference may, indeed, directly reflect the fact that the material present in these two distinct contexts was subject to separation and differential treatment.

Early Anglo-Saxon helmets are very rare finds. There are securely identified examples in just four Anglo-Saxon burials: Sutton Hoo mound 1; Shorwell (Isle of Wight); Benty Grange (Derbyshire); and Wollaston (Northamptonshire). Small fragments of possible helmet-plate decoration have been identified in a grave excavated at Caenby (Lincolnshire), and a moulded copper-alloy boar-figure from Guilden Morden (Cambridgeshire) is very similar in form and size to the forged iron boar-crests of the Benty Grange (fig 7.3) and Wollaston helmets.[17] All of the burials except those at Shorwell and Wollaston were barrow graves, of which Caenby and Benty Grange appear to have been both disturbed and robbed before their more scholarly excavation in the nineteenth century, so that the full contextual associations of the helmets have been lost. The Shorwell grave appears to have been disturbed by recent agriculture, and it is unclear whether a jewelled mount and a gold coin found close by had been deposited in this burial, although that seems likely.[18] The grave also contained a sword with a silver ring-pommel, a shield and the remains of a spear, a glass vessel and a copper-alloy hanging bowl. It is dated by the sword pommel to the first half of the sixth century. The Wollaston grave, excavated in 1997, also included a copper-alloy hanging bowl and a sword, the pommel of which had been broken off and removed from the tang before burial.[19] This grave assemblage also included three small, plain iron buckles, a knife and a hook-shaped copper-alloy fitting. The similarity of the helmet to the Benty Grange example, and the presence of the hanging bowl, suggest a seventh-century date for this burial. All of these interments again represent the more exclusive, elite range of grave goods regularly interred with men in the early Anglo-Saxon period. While we should not speculate further on how richly furnished the Benty Grange and Caenby graves may originally have been, the isolated grave at Wollaston contained nothing besides the helmet, which would imply that this deceased man enjoyed a status higher than that generally represented by the inclusion of a sword in Anglo-Saxon weapon graves.

Swords and seaxes appear in an effectively complementary chronological distribution in Anglo-Saxon furnished graves, with few two-edged swords still in evidence in the concluding phase of

furnished male graves defined by leading types, AS-MF (broadly in the middle two quarters of the seventh century),[20] while longer-bladed seaxes of Classes SX2 and SX3 are leading types of this phase. While the seax-fittings in the assemblage show the associated blades to have been relatively narrow, they do not reveal the length of the blade, a dimension required for chronological purposes.[21] It is noteworthy, though, that the splendid gold and cloisonné garnet seax-hilt mounts represented in the Hoard (**55**, **167–9** and **225**: fig 3.80) are considerably finer than anything that has been found with a seax, either hilt-fittings or scabbard-mounts, in an Anglo-Saxon grave.

Commonly found components of the dress and equipment of a fully armed male in the period are buckles. Male costume regularly included a belt around the waist, and characteristically male dress-accessories contrast with female ones from the later sixth century onwards in that men's belt-buckles could be large, highly decorated and ostentatious.[22] Buckles were also used for the adjustment of other straps, and not least on baldrics associated with the carrying of swords.[23] The one minor difference between the two small gold buckles (**585** and **586**) is the number of rivets that held the backplate clenched to the strap, two in the former case and three in the latter; nonetheless this detail means that only the latter is identifiable with buckle-type BU7 in the typology of the national chronological scheme.[24] This type appears in male graves from the middle of the sixth century onwards. The moulded plate at the base of the tongue of silver buckle **587** is comparable with shield- or mushroom-shaped tongue-bases familiar from the early sixth century into the seventh; however, the particular form represented by this buckle, suggested to have had a rectangular backplate, is unparalleled and the object is typologically unclassifiable. Altogether, the three buckles in the assemblage are of extremely high quality and material value, and quite different from what a random selection of the buckles in general use in contemporary England would show.

The association of possible saddle- and bridle-mounts along with the military equipment in the Hoard is of considerable interest.[25] The association of equestrianism with high male status, which was also directly expressed through fine and conspicuous military equipment, is both chronologically persistent and widely attested. Horses themselves could be sacrificed as grave goods: an outstanding example from the very end of the fifth or early sixth century is grave 323 at RAF Lakenheath, Eriswell (Suffolk), in which a young man of *c* 18–25 years at death was buried with a sword, spear and shield, enhanced with silver sheet on the boss, and a horse of some fourteen hands wearing full harness and an exceptionally richly-decorated bridle comprising many gilt copper-alloy mounts and pendants, also with extensive silver-sheet appliqués.[26] The war-booty votive hoards of Jutland and Fyn dating from the second to fourth centuries AD provide important *comparanda* indicating that an elite group consisting of around one in forty of the members of the army on campaign was not only mounted but would have entered the battlefield on richly harnessed horses.[27] The most fully equipped horse and human grave relatively close in date to the Staffordshire assemblage is that of Sutton Hoo mound 17, although a single roundel from the robbed mound 2 at this site indicates that this grave may also have included horse-gear.[28] There are fewer examples of horse graves from the seventh century than the later fifth and sixth centuries,[29] but in relation to the overall frequency of well-furnished burial within this date-range, the difference is of limited significance.

The presence of purely symbolic Christian objects in the assemblage is noteworthy: these comprise one, possibly two, pendant pectoral crosses (**588** and **680**), and one, maybe two, larger modelled and jewelled crosses that could have been borne in liturgical processions or displayed on an altar (**539** and **684**).[30] Jewelled pectoral crosses are almost exclusively found in female graves;[31] the significant exception known to archaeology is St Cuthbert's cross, which appears most likely to have been included in the shrouding or vestments close to the deceased bishop's body when he was first interred in AD 687 rather than to have been added when he was translated, incorrupt, eleven years later.[32] In the exclusively masculine context of the Hoard, therefore, it is conceivable that the pectoral crosses should be directly associable with churchmen, presumably of high ecclesiastical rank, whether monks or in the priesthood:[33] the collocation of these items with the military equipment in the assemblage is fully congruent with the familiar historical examples of the invocation of God's favour and support in battle, and with the prominent examples in Anglo-Saxon history of high-ranking men, such as Guthlac of Crowland or Benedict and Eosterwine at Monkwearmouth and Jarrow, withdrawing from active military careers in their early adulthood to become leading churchmen.[34]

The story of Constantine the Great's vision of the cross and effective conversion represents how, despite the explicit and radical pacifism of the Christian Gospels, when it transformed into a politically favoured and state-sponsored absolutist religion, Christianity was reconciled with the military necessities of secular power. The conversion of the Anglo-Saxon kingdoms, channelled through the kings and the aristocracy immediately around them, had to reflect the same realities. The Old Testament histories of the Israelites provided abundant examples of the God of the Old Covenant favouring his faithful people with victory in warfare, and Old English verse retellings of, for instance, the story of the Exodus, or that of Judith, reflect – just as the biblical quotation from Numbers on the gold strip (**540**) does – the ready adoption and promotion

of these religiously interpreted military ideals.[35] In this regard it is illuminating to reflect on how the great epic *Beowulf*, very probably an eighth-century composition,[36] adapted traditional Germanic heroic legend to a Christian scheme of values. The Grendel-kin are explicitly identified as the innately sinful and evil descendants of Cain the fratricide, and the man-eating monster Grendel, deprived of and hating the joys of human society, is quite explicitly *Godes andsaca*, ('God's enemy').[37]

A truly vital question in relation to the early to middle seventh century, then, when England was in the process of Christianisation, with sequences of conversion, apostasy and re-conversion experienced in several kingdoms, is how far it was possible for the warrior class of a Christian community to regard themselves as fighting on God's side – and thus risking their lives for God as the one supreme, divine Lord, as well as for their own king and patron – against God's enemies. The records of warfare involving the Anglo-Saxons in the period provided by Bede in his *Ecclesiastical History* understandably show how far a contemporary churchman could construe those struggles according to this model, be that as clashes between Christians and heathens within a kingdom, or warfare between good Christians and bad Christians.[38] It may be argued, however, that the symbolic decoration of the weaponry in the Hoard reflects such an accommodation between the values of a warrior elite and the relatively newly arrived Christian religion only to a limited degree.[39] There are cross motifs on pommels, hilt-collar and hilt-guard pieces and on pyramid-fittings, as well as in the designs of less specifically identifiable mounts. Cross motifs are particularly associated with cloisonné garnet decoration rather than filigree; one filigree pommel and several mounts do have cross-shaped frames of moulded ridges for filigree-decorated panels, but in several of these cases one may at least suggest that the direct Christian symbolism of the cross pattern is less certain. Pommel **47** has three crosses on each side in a configuration that strongly recalls the Golgotha archetype (fig 8.2; cf fig 3.92). It is nonetheless a minority of the weapon-fittings in the assemblage that are marked with identifiably Christian symbolism. Without making assumptions about how unitary a community the assemblage might represent, then, we can adjudge that while the aristocratic military culture this assemblage represents was visibly engaged with Christianity, it was in essence still predominantly secular.

While the contrasts between the known burial evidence and the contents of the Hoard may be noted and even emphasised, it is important also to stress the fact that no unduly normative status should be attributed to the grave finds. As noted in the comprehensive report on Anglo-Saxon graves and grave goods up to and including this period, the secure grave-assemblages that can be assigned to the concluding phases of regular burial of men with weaponry are concentrated in the south and east of England. The distribution map of phase AS-MF published and discussed there can be supplemented with further shield bosses of Class SB5 and seaxes of Classes SX2 and SX3 known to be from funerary contexts.[40] The inclusion of this material redresses the geographical balance a little (fig 8.3), specifically in that seventh-century weapon burials are not totally unknown in the north Midlands and north of the Humber. Stray finds closely comparable with the contents of the Hoard mostly fall within the same broad area delineated here, although there are a number of pieces that have been found significantly beyond its borders: most striking is the cloisonné-decorated pommel found at Dinham, Ludlow (Shropshire) (fig 2.86).[41] One would dearly like to know how and why these objects came to be deposited; to explain them all merely as casual losses hardly seems plausible.[42]

The burial evidence nevertheless confirms the especially elite character of the Hoard. The Hoard assemblage provides its own particularly informative insight into the equipment of a social and military high elite: how that elite made use of ostentatious display in the ornamentation of weaponry; how to some extent it was associated with Christianity, and also to a degree with equestrianism. While parallels to some items in the Hoard in East Anglia and Kent are impressively close, we cannot yet determine with certainty whether the material in the assemblage represented the military elite of a particular region or kingdom, or a military elite distributed across quite different parts of England – and maybe even beyond.[43]

SOCIAL HIERARCHY AND ITS VISIBILITY

We can combine the evidence provided by both archaeology and history to delve deeper into the growth and character of the social elite with which the objects in the Staffordshire Hoard can be associated. The changing composition of the burial evidence that forms the foundation of our understanding of early Anglo-Saxon

▲ **Fig 8.2.** Pommel **47**. *Photograph*: Cotswold Archaeology, © Barbican Research Associates.

▲ **Fig 8.3.** Weapon-graves of the seventh century in England
(*AS Chronology* phase AS-MF: 610/45–660/85).

England is itself to be interpreted in terms of changes within this 'aristocratic' level in society: particularly, increasing stratification in the social structure as a whole, leading to intense competition for position and power among the elite.

These uncontroversial propositions are fully consistent with the historical outline of the widespread emergence of the earliest Anglo-Saxon kingdoms by the end of the sixth century and their progressive coalescence and consolidation during the seventh century.[44] It is nevertheless important to be wary of over-stating – or even just implying – some concomitantly anarchic character to the area that was to become England back in the fifth and earlier sixth centuries. Gildas' account of the disastrous history of the Britons in this period clearly indicates that elements of the social hierarchy of Late Roman Britain had been inherited and transformed into new power structures, even if that power was ultimately collected into the hands of 'tyrants' ruling petty kingdoms, the names of which also imply continuity with and derivation from Roman-period territorial and administrative divisions.[45]

With the Anglo-Saxons, similarly, the title and concept of the king, pre-Old English *kuning, came into Britain as part of their Germanic language that would transform into Old English, and remained the designation used for the head of a politically unified group. Equally fundamental to the linguistic description of society within this language was the term *kerl, Old English ceorl – originally a freeman, but to decline in status and eligibility to end up as the medieval churl or peasant. Far more variable proves to be the terminology used for various ranks of aristocracy in the ever-changing space between the king and the ordinary freemen, the ceorlas.[46]

What is called an 'egalitarian' character of very early Anglo-Saxon society is often emphasised as an aspect of the archaeological record. This does not mean that there were not marked differences in terms of the quality and quantity of grave goods individuals may be buried with, and thus that there were no forms of difference of status among the members of that population. There was manifestly something special about the young man who was buried, almost certainly sometime between AD 490 and 535, alongside the elaborately harnessed horse in grave 323 at RAF Lakenheath (Suffolk). Buried close to him, also very probably within the first quarter of the sixth century, was a woman who had reached the age of 35–45 when she died, to be interred in a costume that stood out by including a great square-headed brooch.[47] Close to Eriswell, a much younger adult woman was buried with a remarkably rich collection of grave goods around the same date, in grave 11 of the cemetery of Holywell Row.[48] The postulated 'egalitarianism' of the communities involved is not one that denies or minimises social ranking, but rather one which suggests that social eminence was a more fluid and pragmatic matter: an individual quality that varied demonstrably with the age, sex and capacity of the individuals concerned at the point at which they died rather than being determined by the fortune of birth to parents with a heritable status. It was thus more evident and relevant within the basic social units of household and community than it was a feature of differences between such entities.[49]

A reduction in the number of individuals being buried with assemblages of datable grave goods had set in some time in the second quarter of the sixth century, and this frequency continued to fall until it reached a low point, probably around the 570s.[50] Among the furnished Anglo-Saxon graves datable to the last quarter of the sixth and the first quarter of the seventh centuries a special group of 'princely' burials stands out – at Prittlewell (Essex), Taplow (Buckinghamshire), Broomfield (Essex) and Sutton Hoo (Suffolk); possibly also at Asthall and Cuddesdon (Oxfordshire).[51] These both reflect and portray the presence of a high social elite which, in the case of Sutton Hoo mound 1 at least, we can confidently associate not just with kingship but even with an overkingship among the Anglo-Saxons. What is not the case, though, is that the lower frequency of well-furnished graves in this phase simply represents the restriction of this ostentatious form of burial and the conspicuous consumption it involved to a highly exclusive social elite.[52] The furnished graves at Eriswell from this phase and through to the middle of the seventh century do not appear in any way different in status from their predecessors among the earlier generations that buried here. Moreover, some DNA evidence from this cemetery is consistent with the inherently plausible situation of one person buried here around the year 600 being a descendant of people buried at the site in the earlier phases when many more furnished graves were being created.[53] In some cases, the maintenance of a burial practice over nearly two centuries from the fifth century to the seventh was very probably the product of minimal change in customs and identity.

Nevertheless, the circumstances of such continuity were changing radically and materially. The archaeological evidence of the built environment of earlier Anglo-Saxon England is also consistent with a pattern of gradual and progressive widening in social stratification from the fifth century to the seventh and eighth. In this respect too, though, we must be wary of over-schematic representations and interpretations. The more egalitarian appearance of an early Anglo-Saxon free farming population appears to be well represented by two extensively excavated settlement sites, at Mucking (Essex) and West Stow (Suffolk), both with their origins in the fifth century and traceable, through phases of change, to the seventh and eighth centuries respectively. These 'villages' are characterised by similarly sized farm- or household-units made up of post-built rectangular small 'hall'-type buildings together with a number of

associated hut-like sunken-featured buildings (SFBs). During the lifetime of these settlements these unitary groups of structures were progressively relocated, creating the diachronic view of a settlement moving across an area.[54]

While sharing exactly the same types of building, features and material culture as Mucking and West Stow, there are contemporary sites whose history and internal organisation appear rather different. The settlement on Bloodmoor Hill, Carlton Colville, in the north-eastern corner of Suffolk, for instance, can be described as showing elements of overall 'planning' from when it first appears, probably very early in the sixth century.[55] The layout comprises a central group of post-built rectangular structures, a surrounding zone of SFBs, and discrete activity zones for metalworking, butchery and textile-production. In a second phase a closer association between individual post-built and sunken-feature buildings is observable, before a marked contraction in the density of occupation in Phase 2b, in the second quarter of the seventh century, when a cemetery also came into use within the former settlement area. Grave goods associated with some of the female burials here include silver dress-accessories and one pendant with a gold frame. There was, however, no weaponry in the burials osteologically identified as male.

In absolute and contemporary terms, some of the female grave-assemblages from Bloodmoor Hill can be described as 'rich', although, as at Eriswell, not unambiguously those of an ostentatious aristocracy:[56] a telling contrast, indeed, may have been present in a barrow burial only some 250 metres from this burial ground that was excavated in 1758 revealing a female grave-assemblage richer in gold.[57] Records of many other finds, both female dress-accessories and male weaponry, suggest that this barrow burial was associated with a predecessor of the cemetery excavated within the settlement area, and that it may therefore have been created immediately before the inception of that burial ground, in which one young woman was buried wearing a necklace including a pair of simple silver pendant crosses. It is possible that the contraction and subsequent abandonment of the settlement in the late seventh century were stages in a process of social re-organisation within a larger estate, with the Bloodmoor Hill settlement being succeeded by a settlement at Carlton (later Carlton Colville), where the parish church eventually appeared. The name Carlton itself represents Old English *ceorla-tūn*, 'settlement of the *ceorlas*'; place-name scholars are confident that examples of this relatively common place-name usually represent components of large-scale, closely admininstered, often royal, estates.[58] None of this tells us for certain what rank was held by the inhabitants of Phase 2b at Bloodmoor Hill, settlement and cemetery alike, or where they went when the site was abandoned. That they could have been either rising or falling in status in a changing social landscape is the key point.

The archetypal reference site for the royal apex of the settlement hierarchy in the seventh century has long been that of Yeavering (Northumberland), identified by Bede as the *villa regalis* ('royal vill') of Northumbrian kings down to the reign of Edwin (d. 633), after which a successor was located at *Maelmin*, plausibly identifiable with a known site at Milfield, just four kilometres north.[59] Yeavering itself stands out with its great halls, ranging from 18 to 30 metres in length and 6 to 10 metres in width, together with special structures including a fan-shaped grandstand or amphitheatre and an apparent cult-house or pre-Christian temple that was succeeded by a Christian church (fig 8.4). Aerial photography has identified another large hall-type building within an enclosure at Milfield. Aerial photography supplemented by geophysical survey at Rendlesham in Suffolk can also cautiously be interpreted as indicating the presence of at least one central great hall there, and a hall measuring 21 metres by 8.5 metres appears to represent the last pre-monastic royal phase of a Kentish royal vill at Lyminge.[60]

An important 'type-site' illustrating the embedding of the processes of social change in the Anglo-Saxon settlement record of the sixth to seventh centuries is Cowdery's Down, near Basingstoke (Hampshire).[61] From a combination of the evidence of stratigraphy and the introduction of new building techniques, three main phases are identified (fig 8.5). The first phase involved a settlement of two fenced enclosures, each containing one main rectangular, post-built structure, all of very similar sizes, but with one additional rectangular building added to the outside of one of the fenced enclosures. The second phase saw further buildings established both within and even across the fences, and apparently also a new, separate, large rectangular building some 130 metres away along the same ridge of land. Phase 3 of the settlement complex again involves two enclosed areas, but quite different from the earlier ones, and a row of three large buildings along the ridge. One of these, Building C12, with dimensions of 22 metres by 9 metres, is regarded in terms of 'scale, sophistication and … central position' as a dominant focal point of the settlement.[62]

In respect of eighth-century Anglo-Saxon settlement evidence, determining whether a site is a high-status secular one or had the specifically ecclesiastical status of monastery or minster has long been a contentious issue, and the debate shows no signs of reaching resolution. Key sites in the debate are Flixborough (North Lincolnshire) and Brandon (Suffolk).[63] A fundamental problem is that of just how distinctive we could ever expect the home of an ecclesiastical or monastic community to be at this time, given the manifold attractions for the social elite of endowing and occupying minsters.[64] A high level of literacy, evidenced, for instance, by the presence of inscribed plaques and quantities of *styli* for writing with, was certainly introduced to England through the Church,

▲ **Fig 8.4.** Schematic plan of development of the Anglo-Saxon royal vill at Yeavering (Northumberland), phases IIIC and IV, showing Building D2(b), the putative temple and Building B, apparently a church, with adjacent burial areas shaded (scale 1/2000). *Drawing*: K. Harding, after Hope-Taylor 1977.

but how far and how long it remained primarily associable with the Church we do not know. At Brandon, *styli*, glass inkwells and objects inscribed in both runic and roman lettering have been found. The excavated cemetery within this site contained the burials of 152 individuals who clearly represent a normal, organic community of men, women and children. This burial ground was also situated adjacent to a distinctive, oriented building that was probably a church.

The settlement evidence from various parts of eastern England is valuable in the present context because it takes us beyond the chronological horizon to which the furnished burials of the early Anglo-Saxon cemeteries are limited. It confirms the growth and consolidation of hierarchies of power and lordship within the Anglo-Saxon kingdoms from the fifth to the eighth centuries. Far more than the artefactual and artistic evidence on their own can do, it emphasises how the accommodation reached between the Church and the secular society of this population in the seventh and eighth centuries resulted in a permeable and, in effect, essentially indefinable boundary or interface between the Christian religion and its institutions and practical, social and economic life. The Church made a range of new opportunities for status and influence available to the privileged, the ambitious and the able of the Anglo-Saxon population.

▲ **Fig 8.5.** Schematic plan of development of the Anglo-Saxon settlement at Cowdery's Down (Hampshire), periods 4A–C (scale 1/2000). *Drawing*: K. Harding, after Millett and James 1983.

RESOURCES AND THEIR USE: THE CONTEMPORARY VALUE OF THE HOARD

Essentially economic is the question of the availability of the resources used to produce the artefacts within the assemblage. It can be proposed, indeed, that the nested relationship between the materials represented in the Hoard and the artefacts in which they appear, and the overall composition of this remarkable collection of items, reflects a special economic sphere in a very direct way. The back-story of the assemblage includes the fact that all of the items within it have been removed from their original places, in most cases from dis-assembled artefacts. Many of the sword pommels have in fact very clearly been *torn* from the weapons to which they were once fitted.[65] The uniqueness of the Hoard suggests that this was not done in preparation for a ritual burial of the items, as we can expect rituals to be repeated, but rather as a stage in the process of recycling and re-use of the precious and semi-precious materials concerned: the gold, silver and garnets. The range of products of this period with which we are familiar tells us that those materials could have been used to produce new adornments for weaponry, armour or fine male costume, to make female dress-accessories – usually parts of the necklace – or to produce ecclesiastical treasures. Gold and silver might also be circulated as currency in the form of coin.

Exactly how and why this assemblage of material came together will probably never be known. It is possible that, like the military equipment sacrificed in the great Danish votive hoards a few centuries earlier, the assemblage comprises a forced tribute, or booty, precious war-gear stripped from the members of an army defeated, presumably by the Mercians. Considering the material in the context of a process of recycling does, however, enable us to affirm the credibility of one alternative hypothesis: that the Hoard comprises decommissioned items, the valuable materials of which were intended for re-use as part of a regular process. In that case the exceptional circumstance would be the secretion and non-retrieval of the assemblage, but not the fact that it was collected in the first place.

Such a perspective accommodates the identifiable artefactual range of the Hoard, with the significant exception of the possible priestly head-ornament, and the gold crosses (see below). The assemblage is dominated by sword-fittings (with which we may include the two seaxes), and it could simply be association as pieces of precious metal which governed a marginal admixture of most other items with these. In addition to the restricted distribution of swords in early Anglo-Saxon weapon graves, which unambiguously places the sword at the head of a ranked hierarchy of weaponry, seventh-century law-codes provide glimpses of aspects of royal control of the distribution of and access to such weaponry in light of the consequent social dangers. Æthelberht's Kentish law-code of the early seventh century contains a sequence of provisions penalising a man who supplies another man with weapons – even if no bad deed (*nænig yfel*) results, but with greater penalties if the weaponry is subsequently used in robbery or to kill.[66] An intriguing law in Ine's West Saxon code, probably of the end of the same century, provides a rising scale of penalties for a man who supplies an *esne* (a 'servant') with a sword, a spear or a horse, if that bondman subsequently flees.[67] It is King Alfred the Great's West Saxon law-code of the end of the ninth century that finally makes explicit a connection between a man surrendering his weapons, either temporarily or permanently, and the loss of social status.[68]

The evidence of poetry does not, of course, have the status of historical documentation; it nonetheless reliably reflects the value-system of the culture in which items of weaponry and armour could be very highly valued. *Beowulf* above all provides us with the dramatised portrayal of a warrior culture in which individual swords could be highly prized, bearing their own names, and with biographies of the battles in which they have been used.[69] This source additionally provides us with an insight into the exceptional potential importance of the helmet to any man who possessed one: when Beowulf and his men arrive at Hrothgar's hall Heorot to challenge Grendel their weapons are properly stored at the doorway, but Beowulf keeps his helmet on all the time until he finally, demonstratively, removes it to sleep and to grapple with Grendel unarmed and unprotected, hand-to-hand.[70]

The law-codes also direct our attention to a very different, pragmatic and materialistic, embodiment of social prestige. Social ranks are rigidly defined in the quantitative terms of the legal value of the individual of a particular rank: his, and in a more limited range of cases her, individual legal value in respect of compensation due for injuries or wrongs; weight and authority in determining legal procedures; and responsibility for providing redress when held responsible for some wrong. This concept is commonly referred to as '*wergild*', although the range of terminology actually used is highly variable, and in many cases the concept is used allusively.[71] The law-codes that we have from the seventh century relate directly to Kent and Wessex: these assign a consistent value to a nobleman of 6,000 pence or *sceattas*. The *wergild* of an ordinary freeman (*ceorl*) in Kent is one-third of this, at 2,000 *sceattas*. The West Saxon laws of King Ine imply sub-noble *wergilds* of 3,000 and 1,000 pence: respectively one-half of a higher nobleman, and then one-third of that. Other Old English law-codes include *wergild* tariffs ostensibly designated for the 'northern peoples' (*Norðleoda laga*) and Mercians (*Be Mircna lage*). These texts contain some features indicative of historically distinct origins, although they had clearly been collected around the early eleventh century, and adapted, primarily for the

purpose of creating a comprehensive, encyclopaedic body of Anglo-Saxon law.[72] The Laws of the Northern Peoples are in fact labelled as such only in one manuscript copy; the few other manuscript versions head the text *Be wergilde* or *Be werum* ('On *wergild*[s]'), and claim that it represents the *wergild* tariffs for the 'English' generally, not just the northern peoples. An interesting detail which the two codes share, after a manner, is that of specifying a *wergild* for a king at a figure of 30,000 units, those units being *þrymsas* in the case of the northern peoples' law and *sceattas* in the Mercian code. So inconsistent are the juridical implications of what actually stands in these two texts that the actual currency terms used here are plausibly to be identified as archaisms which can scarcely have been comprehensible or meaningful when the codes were copied in the forms we have them. The Mercian Law, for instance, uses the currency terms *scilling* and *pund* (shilling and pound) as well as *sceattas*. It offers a conversion of the 30,000 *sceattas* into pounds at 120 *punda*, which gives a pound of 250 *sceattas*. It also tells us that a thane's *wergild* is six times that of the *ceorl* – 1,200 shillings and 200 shillings respectively – and the king's *wergild* six times that of the thane, and thus 7,200 shillings. This gives us, then, a pound of sixty shillings, consistent with a Mercian shilling of four pence and 240 pence to the pound. The *sceatt* is thus in practical terms incommensurate with the other units.

When one, and maybe both, of the currency-units *sceattas* and *þrymsas* was current and meaningful, however, was in the seventh century. We can be confident that the Old English term *scilling* came to be used for a Roman/Byzantine coin, the gold *tremissis*, one-third of a *solidus*. The *solidus* had been a standard Roman gold coin since the very beginning of the fourth century, in the reign of the Emperor Diocletian, although the number of *solidi* to the Roman ounce was swiftly raised from five to six, and subsequently to seven in the Eastern Empire.[73] The word *tremissis* appears in early Old English texts in the expected form for its early borrowing from Latin, as nominative plural *trimsas* with a probable singular **trims*.[74] The putatively Northumbrian **þryms* would appear to have been derived from the same root, assimilated to the Old English numeral *þrīe*, 'three'. What it referred to, however, was not a third of a standard unit but rather a multiple of three: a form of three-penny 'shilling', recognised, if imperfectly, by the careful stipulation that the *ceorl*'s *wergild* in the northern peoples' law was 266 *þrymsas*, which was the equivalent of 200 *scillingas* in the Mercian Law.[75]

Below the *scilling* in the seventh-century law-codes was a unit called the *sceatt* in the Kentish laws and the *pæning* (later *pening*, the ancestor of the English 'penny') in the West Saxon ones. Despite the terminological difference, it has been demonstrated that these terms probably refer consistently to a common currency unit of silver rather than gold.[76] The fact that the *scilling* of the Kentish laws was the equivalent of twenty *sceattas* while that of the West Saxon laws was worth only five *pæningas* can be explained by the historical reduction in the gold content and thus the precious-metal value of the shilling from *tremisses* of around 90 per cent or more gold at the beginning of the seventh century to pale-gold coins containing as little as 15 per cent gold in the third quarter of that century. The later appearance of a Mercian shilling of just four pence can, indeed, readily be explained by a further currency reform of the later eighth century and the introduction of a heavier broad-flan silver penny.[77]

Despite the confused nature of the sources, it is certain that social status in the seventh century was equated with precise sums and weights in either gold or silver. It has been noted that the weight of the Sutton Hoo mound 1 great gold 'buckle' – which is not, in fact, a functional belt buckle at all – is very close indeed to the amount of gold that would, according to the Kentish and West Saxon law-codes of the seventh century, be the quantity of a contemporary nobleman's personal value or *wergild*.[78] Since this was the sum that would have been payable in compensation for the slaying of such a man, it is easy to perceive an implicit threat in the display of power by one who owned, or literally held, that sum in a single spectacular object. In a more constructive aspect of the lord–subordinate-follower relationship, however, the Old English poem *Widsith* succinctly narrates an episode in which a gold object of a specific *wergild* value (600 shillings) is given by a king, apparently to endow the recipient with the status associated with that value and/or in public recognition of his status.[79]

Despite the necessarily repeated warnings against treating poetic fiction as if it were an historical source, the types of exchange and relationship embedded in such tales are not too utterly unrealistic for us to consider the material evidence in that light. It is entirely credible that ostentatious military equipment – particularly swords, but possibly helmets and riding gear too – was given by a king to retainers within a close retinue, confirming the inter-dependent but hierarchical relationship between giver and receiver. It is also credible that such material could have been expected to return, either regularly or intermittently, to royal workshops for refashioning, re-use and re-issue. What, however, we cannot see in the Hoard is anything equivalent to the case made for the Sutton Hoo great gold buckle and the gold ring in *Widsith* where the actual amount of the precious metal in an artefact is directly concomitant with a particular social status. The material in the assemblage is highly fragmentary, and only in the case of the exceptional cloisonné seax-hilt can we confidently re-assemble a complete set of fittings. The amount of gold used in, for instance, complete sword pommels can vary greatly, from an exceptional 44.23 grams of distinctly high carat gold (Au *c* 82–95wt%) in **57** to

11.62 grams in **18**. It is possible that the amount of gold used altogether on the hilt of the sword represented by the former was close to the sum of an ordinary *ceorl*'s *wergild* as given in the West Saxon, northern peoples' and Mercian laws (65–6 grams Au), but that is not only a matter of speculation, but also an exceptional case within the assemblage.

The recovered Hoard assemblage contained just under 4kg of gold. There was also more than 1.5kg of silver.[80] There is no precise figure as it is impossible to separate the different materials for weighing; in any event, total recovery of the original assemblage is unlikely. These sums are equivalent to the *wergild*s of eight–nine noblemen, and less than half the compensation price for a king. The assemblage certainly was a valuable treasure at the time, but it does not contain more than the resources to be associated with – and possibly also required to maintain – the structured society of a moderately sized region.

We can also assess in quantitative terms the minimum figure of seventy-four swords represented in the assemblage. The evidence of weapon graves indicates that swords were carried by a relatively small elite group among the fighting men of the community, while the right and duty of possessing and bearing arms is in itself to be associated with the 'free' ranks.[81] There is no one figure available for the proportional size of the sword-bearing elite among the freemen as a whole, and the question is best approached from mass data rather than in terms of individual sites. Heinrich Härke's data for early Anglo-Saxon weapon burials as a whole gives a proportion of fractionally over 10 per cent of all weapon graves as having contained swords.[82] In Kent – where, we may recall, the law-codes give a much higher value for the ordinary freeman or *ceorl* than any other kingdom – and in Sussex the frequency of sword-graves is much higher than elsewhere, at 22–25 per cent. In East Anglia, and in the other Saxon areas of southern England, the figures are consistently in the range of 6–9 per cent. Sword-graves are practically unknown in the Midlands. If, outside of Kent, we refer to a proportion of sword-bearers to ordinary freemen of 1:10, and if we also accept that one hide was the unit of land designated to support one ordinary freeman, the number of swords in the assemblage would represent the elite to be expected to occupy a territory of at least 740 hides. As well as the fact that the figure of seventy-four swords is an absolute minimum, it may also be the case that the exceptional quality of the swords in the assemblage should presuppose a considerably higher multiplier in terms of hides. For comparison, however, the Tribal Hidage includes no fewer than eleven groups assessed at 600 hides, and one, the unlocated *Wigestan*, at 900 hides.[83] As already noted, we have no grounds for assuming that the assemblage represents a collection from some such unitary territory; this calculation is undertaken to assess what the material was effectively worth in contemporary terms. Its 'value' in terms of minimum sword-count is greater by a considerable order of magnitude than the social value represented by the quantity of precious metal in the assemblage alone. In military terms, however, it may still correlate with the armed power of only a modestly sized territory.

If the precious metals and controlled artefacts that make up the assemblage were circulating in regular, socially embedded transactions, they were circulating in what in economic terms was a closed and special system. The number of transactions involving gold was both low and controlled, and so, in terms of the price equations of classical economics, the fixed 'prices' or values of men to be reflected in key exchanges could be maintained. Overall, however, the archaeological record shows more gold being used and deposited in the early and middle seventh century, while the ecclesiastical crosses represent the increasing transfer of precious metals into ecclesiastical treasures that were not intended for circulation. There appears to have been an increased supply of gold coin from the Continent to England starting in the later sixth century, although we must also make allowance for changes in manufacturing organisation and priorities, and burial practice, which made the gold that was present even more visible. Study of seventh-century coinage on the Continent and in England shows a progressive reduction in gold content which is usually interpreted as reflecting a shortage of gold supply from the second quarter of the century;[84] again, however, the evidence could also represent a deliberate transition to a lower value currency allowing for an expansion in the monetised economy.[85]

The analytical results of levels of gold fineness in the sword pommels have concluded, conversely, that there is no regular pattern of chronological change in the gold content among these, implying that the standards maintained in this field of elite transactions were kept separate from (at least incipient) contemporary alterations to the coinage.[86] This does not help us to narrow the range of possibilities as to where the material is from, precisely because it belongs to the closed economic system just noted. One of the most startling aspects of the immediate area in which the assemblage was deposited, so close to the respectively ecclesiastical and royal Mercian centres of Lichfield and Tamworth, is the fact that both stray finds and coin hoards of the seventh and eighth centuries imply this was a practically unmonetised area. The numbers of *sceattas* and of Offa's pennies from this region in the *Corpus of Early Medieval Coin Finds* are low single figures.[87]

THE ARCHAEOLOGY OF EARLY MERCIA

The discovery of the Staffordshire Hoard transforms our archaeological perception of the early Mercian kingdom no less than it has added new dimensions to the overall picture of seventh-century Anglo-Saxon material culture and practice. Historically, the sequence of events leading to the suddenly powerful presence of Penda as King of Mercia in the mid-seventh century is extremely obscure. Archaeologically, however, we can at least confirm that the Mercian kingdom under Penda emerged with its centre in an area where a Germanic cultural presence can be traced back over some 150 years.

Topographically, the region in question is clearly defined by the major rivers, southwards from around the confluence of the Derwent and the Trent near the present city of Derby to the confluence of the Tame and the Trent close to Lichfield and Tamworth. Cremation burials are known in this area at Barton-under-Needwood and King's Newton, Melbourne (Derbyshire) and Stapenhill (Staffordshire) (fig 8.6). Although cremation was a more common funerary rite relatively early in the Anglo-Saxon period, in no case do the recorded forms of any of the few surviving or illustrated urns, or the associated finds, point us conclusively into the fifth century for these burials.[88] Inhumation burials and the grave goods from them are more informative in this respect. The Stapenhill cemetery produced considerably more inhumation graves than recorded cremations, and the known range of brooches from the female graves is consistent with a horizon in the last quarter of the fifth and first quarter of the sixth centuries for the origins of this cemetery. The same profile is implied by the large number of cruciform brooches recorded as metal-detector finds from Barton-under-Needwood.[89] Other significant burial grounds have been found at Duffield and Little Chester in the Derby area, and at Swarkestone (Derbyshire) and Wychnor (Staffordshire) on the northern side of the Middle Trent (fig 8.6).[90]

Precise details of the form and decoration of the artefacts from these sites which either survive or for which we have illustrations confirm the generally 'Anglian' character of the material culture, but otherwise give little away in terms of close material connections or origins. There are surprisingly few known examples of the wrist-clasps that were such a distinctive feature of Anglian women's dress within the broader Anglian region, although one relatively unusual example from Little Chester can be identified as a simplified derivative of an archetype represented by a much finer silver specimen known from a burial at the Empingham I cemetery in Rutland, 80km east of Lichfield.[91] Metal-detecting and the recording of finds under the PAS has added a considerable number of cruciform brooches from this region to the excavated examples,

almost certainly all from inhumation graves; again, however, these cruciform brooches are of forms with parallels all over Anglian England.[92] Fragments of great square-headed brooches, probably all of them originally gilded, have been recorded on the PAS database from Longden, Elford and Barrow-upon-Trent.[93] Small though these pieces are, it is again unusually difficult to align them with known examples from the remainder of the national corpus.[94] This suggests that the production of these relatively high-status brooches was a local matter in the Middle Trent zone; the visible designs and the products are not, however, of great quality.

There is virtually no evidence of continuity of furnished burial in the Middle Trent region beyond the third quarter of the sixth century. A single, plain, copper-alloy pyramid-fitting assigned to the Ingleby area could have come from a disturbed burial, but need not have done so.[95] We are, however, unusually fortunate in being able to trace a plausible sequence of continuity within the Middle Trent region from the earliest Anglo-Saxon phase, probably in the late fifth century, through to the seventh and eighth centuries and well beyond, at the settlement site of Catholme. Around 3.7 hectares of this site were excavated over several seasons starting in 1973. It sat upon the gravel terrace of the northern bank of the River Trent, close to the confluence of the Tame. The area excavated lay just north-east of the Wychnor early Anglo-Saxon cemetery, and it is inconceivable that the settlement does not represent later generations of the same community as buried their dead there. From the earliest published reports, Catholme has stood out for the apparent longevity of the settlement, as indicated by the range of radiocarbon dates from deposits in the settlement features (pits, ditches, post-holes and wall-trenches, and SFB fills).[96] A re-assessment of this dating evidence, together with the stratigraphical details of the features of the site, shows that it is plausible that, from the late sixth century to the late tenth or early eleventh, Catholme was a settlement with occupation and activity within the excavated area moving around in a manner comparable to that already noted at West Stow and Mucking, not the stable nucleated village the undated site-plan had seemed to suggest.[97]

Finds made within the settlement show that it was involved in animal husbandry, and textile-production, probably farming both sheep and cattle, and possibly pigs. Ironworking residues included both smelting slag and forging debris. The iron artefacts found were all functional items of everyday equipment, and only a few small fragments of non-ferrous metalwork (lead and copper-alloy) were left lying around or lost. There were no coins, nor any of the finer pottery available in the region in the tenth century. This looks, therefore, like a site that functioned either at a subsistence level, or as a base-level farming and ironworking site within a larger multiple estate.[98] In the Domesday Survey of 1086, the vill of *Wichnor* was

Fig 8.6. The Middle Trent, Derwent and Tame regions, showing sites and features referred to in this chapter. Distribution of the Peak District barrow burials is after Ozanne 1963. *Drawing*: K. Harding.

a minor one, with just six peasant households, although it did have a mill worth 18 pence per annum. Its neighbours to the west, however, were the royal estates of Alrewas and King's Bromley.[99] Whatever the fate or fortune of the individuals involved at any stage here, the long sequence, archaeological and historical, from the early Anglo-Saxon cemetery of Wychnor to the Domesday assessment 600 years later may perfectly reflect the eclipse of the free *ceorl* as a householder of eligible status and his reduction to the peasant churl of the High Middle Ages.

The apparent cessation of furnished burial in the areas along the principal river valleys in the sixth century sharpens the contrast with the Peak District to the north and west, where a remarkable density of seventh-century barrow burials has been found, both male and female graves, including the Benty Grange weapon grave noted above.[100] These burials must surely be those of the elite of the territory of the *Pēcsǣte*, assessed at 1,200 hides in the Tribal Hidage; the background to this group, however, can only be a matter of informed speculation. Economically, the great resource of the Peak District was the seams of lead ore, also producing some silver, which had been mined in the Roman period and which we know were in production again by the eighth century.[101] Interestingly, the context in which we know of huge demand for lead from the later seventh century onwards is the construction of stone churches, with lead used both for roofing and window cames. Christian symbolism is evident in grave goods of the Peak District, on the Benty Grange helmet, and in one pendant-cross found in the vicinity of White Low, Elton (Derbyshire). And even Penda accepted the conversion of his son Peada in order to marry Alhflæd, daughter of King Oswiu of Northumbria, and to create a short-lived Christian Middle Anglian kingdom in 652.[102] Nonetheless, it is implausible that the large number of barrow burials in this region could all be late enough to represent land-taking designed solely to meet the demand for lead created by church-building.[103]

Immediately after the Battle of the River *Winwæd*, at which Penda lost his life (655), there was a division of the Mercian kingdom between southern and northern Mercians, with the dividing line being formed by the River Trent. Implicitly, Oswiu of Northumbria sought to retain control of the northern Mercian area while he granted the southern Mercians, assessed at 5,000 hides, to his son-in-law Peada – who in fact lived only until the following Easter, when he was assassinated. The Peak District must have been within the territory of the northern Mercians, and its resources must equally have been of value to and coveted by Oswiu. The rule of the Northumbrian king had been extended to the northern border of the Peak District by the conquest and annexation of the British kingdom of Elmet by 616.[104] The sources are in fact silent on how soon the territory of the northern Mercians was restored to Mercian rule. Wulfhere was established as king of the Mercians in 658, and the territory contested between him and Ecgfrith of Northumbria in the 670s was the kingdom of Lindsey.[105] A major battle was fought between Wulfhere's successor, Æthelred, and Ecgfrith in 679 'alongside the River Trent'.[106] Even a short-term change of rule in the Peak District area will surely have encouraged clear declarations of who was in charge, and to whom the local governing elite owed allegiance. Barbara Yorke's suggestion that the southern and northern Mercians may once have been separately governed by Penda and his brother Eowa, respectively, would also provide relevant historical circumstances for the exceptional burial evidence of the Peak District.[107]

We are thus able to entertain explanations of the striking contrast in respect of the furnished burial evidence between the riverine area of the Middle Trent and the Peak District in terms of a complementary relationship between the two zones rather than of exceptional, externally imposed, circumstances in the latter alone. In essence, these two zones represent in a very stark form the changing profile of early Anglo-Saxon burial evidence generally: the widespread and common creation of furnished graves in a period from the later fifth century into the third quarter of the sixth century; then a period of up to fifty years in which it is difficult for us to identify many well-furnished burials; followed by a concluding phase in which richly-furnished female graves become much more frequent – alongside male graves broadly datable to the middle quarters of the seventh century in the Peak District area.

The construction of monumental and expensive elite funerary monuments directly asserted the presence of the current governing elite of an area in such a way as to imply, if not absolute insecurity, at least recognition of a potential challenge that needed to be answered. The Mercian power appears to have long passed beyond any such conditions in the kingdom's heartland along the Middle Trent, nor ever to have required the same conspicuous demonstration of its power and authority in the western territories of the *Magonsǣte/Westerna* and *Wreocensǣte*.[108] It is remarkable, although not incomprehensible, that the particular circumstance of being the contact zone between an expansive Northumbria and Mercia from the second decade of the seventh century onwards may have been sufficient for the Peak District to see the adoption of a politically motivated style of burial practice that was otherwise unknown in either kingdom.

Before the end of the seventh century, Lichfield had become the see of the Mercian bishopric and Tamworth an important royal vill. By the mid-eighth century, the church at Repton housed a special Mercian royal burial crypt. The cathedral of Lichfield and the churches of Repton and nearby Breedon-on-the-Hill have all

CHAPTER EIGHT | **THE ARCHAEOLOGICAL CONTEXT** 319

produced ornamental and decorative carved stonework datable to the eighth century, extensively so in the latter cases.[109] Excavations in Tamworth have uncovered both the remains of fortifications, probably datable to the reign of Offa in the second half of the eighth century, and a water mill datable to the late eighth or early ninth century; both representing innovations in terms of military strategy and control and technology and economy, respectively, that can be directly linked to forward-looking policies of the powerful kings of Mercia.[110]

Were we to take the known archaeological evidence from the late fifth and sixth centuries in the Middle Trent area and juxtapose it with that from the eighth and early ninth centuries, the progressive course of development between the two would appear straightforward and self-explanatory. The unanticipated appearance of the Peak District barrow burials in the seventh century and of the Hoard within the same phase do not force us to reconsider and revise our notions of the fundamental pattern of historical evolution and how material culture related to that. What they do show us very forcefully is how that course of events was marked by competition and struggle, and how much, materially, had to be invested by the successful parties in realising their ends. No less than the historical evidence, then, the archaeological context leaves both conceivable explanations of the collection of the assemblage open: that it was the product of a regular recirculation of prestige weaponry and armour, or that it was tribute or booty wrested in exceptional circumstances. Where a breakdown in control at the heart of the Mercian kingdom must be implicit is in the fact that this Hoard was taken, buried and never recovered. To explain that, we are free to use informed imagination.

◀ Hilt-collar **113** in gold filigree with interlace ornament (not to scale). *Photograph*: D. Rowan; © Birmingham Museums Trust.

CHAPTER NINE

CHAPTER NINE

HOARDS AND HOARDING

INTRODUCTION

Leslie Webster and Tania Dickinson

Many different factors – economic, social, political and religious – govern why particular objects are deliberately assembled and deposited together, though for convenience the term 'hoard' is often used to cover them all. A better understanding of the mindsets and intentions behind their construction and concealment may, however, be achieved by tracing patterns of hoarding behaviour over time and space; for example, in the particular combinations of objects and specific types of location. In the case of the Staffordshire Hoard this approach presents difficulties because its highly unusual assemblage is without parallel. Nonetheless, it was proposed from the outset of the research project that hoarding practices within areas chronologically and geographically adjacent to early Anglo-England should be explored: they were the most likely to afford appropriate insights into the motives behind assemblage and deposition, while significant differences between them might help to pinpoint critical underlying factors.[1]

For this chapter, three subject-areas within the period *c* AD 300–700 were selected for study: fourth- to fifth-century Britain, both before and after the official withdrawal of Roman authority in 410; the third to seventh centuries in mainland Europe, both inside the Empire during the period of transition from Roman rule to the Germanic successor states, and beyond its limits; and the same period in Scandinavia, which had never been part of the Roman Empire. In each subject-area, hoards are an important component of the archaeological record, and the surveys share a common agenda of exploring the composition, contents and contexts of hoards as key factors in determining the role(s) of treasure in a society, and why it came to be buried. The resulting essays vary significantly, however, in scope and approach. Partly this may be explained by inherent differences – in scale, geography, culture, economy and political composition, all of which have an impact on the available data – and partly by often consequential regional differences in contemporary scholarly approaches and in archaeological activity, including more recently the incidence of metal detecting. In this introduction we provide some necessary background and guidance, to give an overview of the surveys and to point to some implications that these might have for the Staffordshire Hoard.

First, as noted above, the three regions differed significantly in their cultural, economic and political relationships with the Roman Empire. In Britain – and most markedly in the agriculturally productive south and east of Britain – the cultural assimilation between Roman and native British culture, which had developed and been sustained for three centuries, was already showing signs of change during the fourth century, as Roman authority itself changed and weakened, eventually ceasing altogether in the early fifth century. However, the rate and nature of the transition to a different kind of society during the course of the fifth century is much debated: the year AD 410 did not mark an abrupt break with a Romanised way of life, and there was significant regional variation. Nevertheless, the erosion and eventual withdrawal of Roman authority gradually diminished any sense of continuity with the institutions of the Empire: the monetary economy collapsed; large estates and urban centres began to fall into disuse or to be used in different ways; and the Latin language lost traction in common use, giving way to Anglo-Saxon and British vernaculars. The volume and pattern of hoarding became rather different from that elsewhere within the Empire, reacting, it seems, to the general climate of isolation and uncertainty; and indeed, in some respects it resembles hoarding from beyond the *limes*.[2] As for the various incoming Anglo-Saxon groups, though they certainly had contact with Romans and Roman artefacts, and some had even served as federates in the Roman army, they had little knowledge or experience of Roman civil institutions, having lived beyond the frontier until they began settling in Britain, possibly from as early as the final years of the declining Roman administration. Until the later sixth century, the grave goods ritually buried with the Anglo-Saxon elite suggest that supplies of silver and gold were scarce, and derived mainly from recycled Roman material. Though some

gold reached Anglo-Saxon England from Scandinavia and even Byzantium, these imports are uncommon in graves, and very rarely occur in hoards.[3]

The vast region of Scandinavia, from nearby parts of which some of these Anglo-Saxon settlers had come, presents a very different case. Access to wealth and consequent hoarding patterns varied considerably across this geographically diverse region, and across time.[4] Though it lay far beyond the frontiers, some parts, such as Denmark and southern Sweden, intermittently had profitable contact with the Empire, as luxury Roman imports in burials and massive gold and silver hoards of imperial coins suggest. At the same time, it is also clear that patterns of settlement and social and economic organisation differed significantly across the region during this period, with evidence of competition between warring groups in areas that had greater access to wealth, such as southern Scandinavia in the fourth to sixth centuries. There, the distribution of wetland weapon deposits and treasure hoards, and of central places in which religious cults, the production of high-status objects and a degree of regional political authority were concentrated, points to a late Iron Age culture in which treasure deposits played an important symbolic and social role. These distinctive and changing patterns of wealth and power across Scandinavia present a contrasting picture to later Roman Britain and Anglo-Saxon England, and to continental Europe.

The survey of mainland Europe also deals with a vast area, in which many impressive treasure hoards and a variety of hoarding practice are observed, from both within and beyond the *limes*, the frontiers of the Empire. In the Migration period of the third to sixth centuries, mobile groups of Germanic and other 'barbarian' peoples, such as the Huns and Alans from the east, formed complex relationships with the western Empire. Some of these Germanic groups, including first the Ostrogoths and then the Longobards in northern Italy, the Merovingian Franks in France, the Burgundians in south-eastern France and what is now Switzerland, and the Visigoths in Spain, settled within the Empire's borders, eventually establishing 'successor states', replacing Rome's authority with their own kings but adapting many of the institutions and trappings of that authority as well as its official language, in stark contrast to the situation in Britain.[5] Others, such as the Saxons settled in what is now north Germany and the Thuringians to their east, emerged as independent Germanic polities outside the frontiers. Some of the continental treasures surveyed here come from within the *limes* and are wholly Roman in content and perhaps also in agency, like the Kaiseraugst (Switzerland) hoard, while the rest exhibit varying degrees and kinds of relationship with the Roman world; some from within the old *limes*, such as those from Szilágysomlyó (Romania) and Domagnano (Republic of San Marino), indicate Germanic owners who had become Romanised or who had very close contact with the Empire. Others outside the borders, in Poland and elsewhere in the east, exhibit responses to the reception of Roman wealth not dissimilar to those observed in parts of Scandinavia.[6] The same may be said of hoards from the North Sea coastal areas of the Netherlands and northern Germany, not considered here but covered in detail by the recent work of Johan Nicolay.[7]

If the marked cultural, political and economic differences between the areas constrain a common interpretation, so too does the degree to which contemporary and near-contemporary written sources survive to influence ideas. The extent to which written sources may lead, or mislead, archaeological explanation is exemplified by the discussion of accounts of the burial of treasure in contemporary texts such as saints' lives. These have tended to foster an interpretation of early medieval continental hoards as being deposited with the intention of recovery, rather than for symbolic purposes,[8] but it might be argued that they have also hampered the adoption of archaeological theories derived from sociology and anthropology. While written sources might give some degree of cultural and historical context to the deposits of late and post-Roman Britain and of continental Europe, these do not exist for Scandinavia in this period; as with Anglo-Saxon England, with its poetic legacy enshrining memory of traditional tales from northern and central Europe,[9] it is a much later literary tradition that casts an alternative (and arguably questionable) light on the region in the Migration and Merovingian periods.[10]

So it is no accident that in Scandinavia modern archaeological theory has played a much greater part in the examination of the function of treasure and hoards,[11] for in this period, lacking contemporary historical narrative, it was a *prehistoric* society. Its development is studied as part of a pre-Roman Iron Age continuum, albeit divided into a Roman and a Late Iron Age roughly cognate with the Roman and post-Roman (or early medieval) periods further south. Scandinavian archaeology has thus placed greater emphasis on exploring the critical role of individual find circumstances, the wider landscape context of hoarding, the way in which it is embedded in social structures and their underlying ideologies. More recently, studies on hoarding in late and post-Roman Britain have also begun to embrace such approaches, although some scholars still favour a more traditional perspective.[12]

As a consequence, on the Continent the overarching context of the literary records, the dominant focus on opposing cultures within and outside the *limes*, and a lack of detailed information

on the find circumstances of many of the older deposits have tended to encourage the persistence of a traditional interpretation of hoards as safekeeping mechanisms, buried in response to danger or adversity.[13] Conversely, for Scandinavia and in late and post-Roman Britain more open-ended examinations of hoarding, as presented here, suggest new ways of assessing the evidence; for example, through a much greater emphasis on the biographies of objects within a deposit, on the history of its assemblage and on the underlying mentality of those who concealed it.

It should be noted, however, that while the lack of contemporary written sources for Scandinavia in the third to seventh centuries liberates discussion from the seductive but dangerous tendency to associate deposits with historical individuals or events – a clear risk where the Staffordshire Hoard is concerned – it can also sometimes make it harder to characterise their social context. Although Nicolay's comparative analyses attempted to relate the fifth- to seventh-centuries hoards of the Netherlands and coastal northern Germany to the interplay of systems of socio-economic distribution and ritual practices and hence to phases of political development, this approach does not work comfortably for Scandinavia. Rather, as Fischer argues here, the different kinds of deposit and distinctively varied patterns of hoarding evident across this very large and geographically diverse region make it difficult to generalise about the social and political dynamics behind them, and equally to draw any implications for the Staffordshire Hoard.[14]

While none of the three studies presented here identifies a close parallel to the Staffordshire Hoard, each brings insights into relevant background factors. In particular, they help us to see more clearly just how varied hoarding practices were, and that contrasts in and between the subject-areas may be more valuable than consistency for exploring factors behind the carefully selected and dismantled nature of the Staffordshire Hoard. Possibilities raised by the contributors to this chapter are integrated into a final discussion of what the Hoard means in *Chapter 10*, and will not be rehearsed here, but some pertinent messages can be mentioned.

First, it now seems clear that the exceptional incidence of treasure hoards from late and post-Roman Britain, particularly of silver hoards, has more in common with hoarding practices beyond the Roman world than with, for example, Roman Gaul or Italy, collectively reflecting Britain's increasing isolation.[15] That such a different pattern of hoarding emerges in fifth-century post-Roman Britain has suggested that there was perhaps more in common between the world-view of the native population and the Anglo-Saxon incomers, who had developed their own ideas of a Roman past, and how it might be expressed – not least, in prestige artefacts and their decoration. Although the Staffordshire Hoard is much later, and from a somewhat different political and economic climate, such readings of the late and post-Roman hoard material suggest possible new approaches to its interpretation within the broader cultural context.

Second, it is only in southern Scandinavia and northern Germany, the regions from which significant elements of Anglo-Saxon origin myths and ancestral poetry were derived, that we encounter war booty deposits, made during the third to fifth centuries. Although the contents and depositional circumstances of these weapon offerings differ in significant ways from the much later Staffordshire Hoard, it is perhaps suggestive that it is the *only* other known deposit apparently comprised of battle booty. And as we also know from *Beowulf* and other literary survivals from a northern oral poetic tradition, the nature and symbolism of treasure that must be disposed of forever continued to resonate in Anglo-Saxon England. To what extent the deposit of this assemblage of partly dismantled battle spoils might reflect orally transmitted traditions of the consignment of weaponry to the earth is quite impossible to say, but it suggests an evident contribution to future debate. The archaeological evidence for near-contemporary ritualised hoarding behaviours from southern Scandinavia suggests that knowledge of such behaviours could also have reached Anglo-Saxon England, given the continuing ties between that region and England.

Finally, as already noted, the treasure hoards from mainland central Europe have mostly been represented as burial for safekeeping in time of danger, which of course remains one possible interpretation of the Staffordshire Hoard. But the example of the Staffordshire Hoard, reflected in the open-ended conclusions of *Chapter 10* below, reinforces Hardt's own conclusions that many of these finds deserve reassessment; some, like that from Pietroasa (Romania), contain elements which clearly suggest that they may have been put beyond use for religious reasons, precluding the idea of retrieval, but others are similarly worthy of re-evaluation. Even in the later Germanic and Norse literary sources cited here (including *Beowulf*, invoked in Guest's essay),[16] there are hints of alternative explanations for certain kinds of hoard, in which treasure that is considered tainted is consigned forever to water or the earth.[17]

As these authoritative surveys show, the evidence for hoards and hoarding in the late Roman and early medieval period is rich, complex and variable, and ripe for an ongoing debate in which the Staffordshire Hoard will provide as much an impetus to current and future research as it will gain from the results.

HOARDING IN LATER ROMAN BRITAIN AND BEYOND

Peter Guest

'This year the Romans collected all the hoards of gold that were in Britain; and some they hid in the earth, so that no man afterwards might find them, and some they carried away with them into Gaul.' These words were recorded for the year AD 418 in the *Anglo-Saxon Chronicle*, the collection of Old English annals recounting important events in the history of Britain that are believed to have been first compiled in Wessex under King Alfred. Although the *Chronicle* is an immensely rich source of material and one of only a handful of texts that tell us about Britain in the years after its separation from the Roman Empire, it was not intended to be read as we might read a modern historical account and it needs to be used cautiously.[18] Bearing this in mind, nonetheless it is striking that, while almost all of the *Chronicle's* many entries describe events involving kings and emperors, popes, bishops and martyrs, the commentary for 418 is unusual for not referring to any named individuals. Instead, it is the Romans in Britain whose general hoarding and exporting of gold were considered worthy of entering into the annals: an illustration of the significance of the Roman past in Anglo-Saxon England in explaining how the peoples of Britain came to be there.[19] Whether or not this had been the case when the Staffordshire Hoard was collected and buried is less certain, although gold, particularly old or exotic gold, is a common theme in contemporary Anglo-Saxon and Germanic literature.[20]

It is noteworthy, therefore, that gold hoards are a very rare archaeological find from the early Anglo-Saxon period, when it appears the possession of this most precious metal was restricted to the highest echelons of society who, rather than hoarding it, occasionally chose it to accompany their dead into the afterlife. The extraordinarily rich burials at Sutton Hoo confirm the importance of gold and silver in eastern England in the seventh century, where the deposition of valuable prestige objects demonstrated the wealth and sophistication of the Anglo-Saxon elites and emphasised their pre-eminent political, economic and social statuses.[21]

This is very different from the archaeological picture of the later fourth and fifth centuries, when Roman gold, silver, pewter and bronze objects were deposited in the ground far more often than had been the case throughout the previous 350-year history of Roman Britain. As will be described in the following sections, the hoarding of wealth in such conspicuous quantities almost certainly occurred in the years leading up to the formal secession of Britain from the Roman Empire not long after 400, as well as in the decades that followed this seismic political event. The reasons for this atypical behaviour by the owners of high-status portable wealth, and for how long into the post-Roman fifth century people continued to behave in this way, are also central themes of this essay, but the entry for 418 in the *Anglo-Saxon Chronicle* suggests that an echo of this archaeologically attested outbreak of mass hoarding certainly remained in the collective Anglo-Saxon memory for many centuries afterwards.[22]

The hoarding of Roman objects in Britain in the fourth and fifth centuries

Although the deposition of caches of valuable objects was a longstanding practice in Britain, extending far back into prehistory, more hoards of gold and silver have been recovered from the end of the Roman period than any other in British archaeology.[23] Some of these are among the most significant collections of precious metal objects from the entire late Roman world, most conspicuously the so-called 'treasure' hoards from Hoxne, Mildenhall and Water Newton. Yet these are just the best known among many other finds that, when taken together, produce such a significant hoarding 'event' or 'episode' at this time. In fact, some forty treasure hoards have been discovered and reported from Britain, usually containing a combination of gold jewellery, silver tableware and gold and silver coins, while many hundreds of hoards of late Roman bronze coins are also known.[24]

Hoarded coins include gold *solidi*, silver *miliarenses* and the smaller *siliquae*, though the vast majority are low-value copper issues. The latest coinage to circulate in Britain in any significant quantities was issued by the imperial mints in Gaul and Italy during the reigns of Theodosius, Arcadius and Honorius between 388 and 402, after which the supply of new coinage to Britain ceased very abruptly, as it did to all parts of the north-western Empire once the Gaulish mints' output was greatly reduced. From this time only a trickle of new gold and silver coins arrived in Britain during the rest of the fifth and sixth centuries – Roman as well as so-called 'pseudo-imperial' issues produced by various barbarian rulers in the post-Roman west.[25] Most of these are stray finds or were recovered during the excavation of sites and cemeteries (many of the latter had been converted into items of personal decoration such as necklaces), although there are a few significant hoards from this period of ultra-low coin supply too, notably the find from Patching in Sussex. Most hoards of late Roman objects are found in the lowland part of southern Britain, below an imaginary line between the Rivers Humber and Severn, although there are important variations between hoards found in different parts of this region (fig 9.1). The majority of treasure hoards, for example, come from

the East Anglian counties of England, including the gold jewellery and silver spoons from Thetford,[26] the great collection of silver table vessels from Mildenhall,[27] the early Christian liturgical silver vessels from Water Newton,[28] and the gold jewellery, silver tableware and 15,234 gold and silver coins from Hoxne (figs 9.2–9.3).[29] Elsewhere, gold jewellery and silver plate are far less common and hoards from south-western England, for instance, are more likely to contain coins alone, particularly copper coins and silver *siliquae*.[30]

The great late Roman hoarding episode in Britain has been explained by historians and archaeologists as a symptom of the violence and fear experienced by the indigenous population when threatened by various 'barbarian' raiders and invaders, particularly Angles, Saxons, Jutes, Picts and Irish, as well as home-grown gangs of bandits known as *bagaudae*. This was also the time that Roman rule in Britain came to an end, apparently after the poorly defended Roman Britons ejected the imperial administrators and tax collectors sometime around 410. The final straw seems to have been the usurpation of Constantine III in 407 and the withdrawal of the last remnants of the Roman army in Britain to the Continent in support of his claim to the imperial purple.[31] A small number of Constantine III's coins are present in British and Gaulish hoards, a reminder of this short last chapter in the history of Britain as a part of the ancient Mediterranean super-state.[32]

Archaeology is rarely quite this black and white, however, and another reading of the same evidence suggests that the Romano-British population's reaction to the consequences of their separation from the late Roman imperial political system is an equally good, if not better, fit.[33] The absence, for example, of similar levels of hoarding of Roman objects in other parts of the Empire, where the threats from beyond the frontiers were felt at least as keenly as in Britain (and probably more so given their proximity to the barbarians), is a problem that significantly undermines the 'hordes = hoards' interpretation. The years from the later fourth century to 450, the period including the British hoarding peak, witnessed numerous invasions into the Empire by Germanic and Hunnic groups often followed by large-scale devastation and disruption, including momentous catastrophes such as, for instance, the death of the emperor Valens and the destruction of the eastern Roman army at Adrianople in 378 and the sacking of Rome in 410. Although the imperial court had moved to the relative

▲ **Fig 9.1.** Late Roman coin and treasure hoards from Britain, showing coin hoards ending with issues of 378–411 (map (i) is based on coin data from Bland *et al* forthcoming; map (ii) shows significant treasure hoards of late Roman objects mentioned in the text). *Drawing*: H. E. M. Cool and C. Fern.

i

ii

▲ **Fig 9.2.** Mildenhall (i) and Water Newton (ii) treasures (not to scale). *Photographs:* © Trustees of the British Museum.

Fig 9.3. Selection of objects from the Hoxne hoard: (i) gold and silver coins; (ii) gold bracelets; (iii) silver spoons (not to scale). *Photographs*: © Trustees of the British Museum.

safety of Ravenna before then, there is no doubt that the political, social and economic situation was parlous for many people in the Roman Empire during these violent years, yet the provinces of Gaul, Germany, Italy and others produce only a fraction of the number of hoards recovered in Britain (the burial of silver coins is a particularly insular phenomenon). 'Hordes = hoards' is perhaps a valid interpretation of hoarding in other places or at other times, but the available archaeological evidence indicates that we should look elsewhere for a more reliable explanation of hoarding in late fourth- and fifth-century Britain.[34]

The status of gold and silver in the later Roman world (and beyond)

Gold, glitteringly pure and incorruptible, was highly prized in the later Roman Empire, becoming the preferred medium of emperors and their aristocracies for the conspicuous demonstration of the enormous wealth and political power they held. Admired and jealously coveted, gold was intimately associated with the sacred person of the emperor, and various imperial edicts issued during the fourth and fifth centuries proscribed the public giving of this most precious metal for anyone outside the imperial household and the consulate.[35] Later Roman society was rigidly structured, and precious metals, in particular gold, played a central role in the cultural practices and traditions that maintained the positions of wealthy and powerful individuals within the social system that characterised the Roman world in Late Antiquity. These included prestige gift-exchanges when the emperor distributed precious metals at formal ceremonies to his subjects, rewarding them for their loyal service and binding them to the self-sustaining imperial culture that ultimately defined them. Ensuring the act of gift-giving was as conspicuous as possible was important in the late Roman prestige-exchange system, and gold and silver in a variety of forms were presented to the emperor's men at public events to celebrate important occasions such as imperial accessions, anniversaries and birthdays. The aristocracy was the main beneficiary of imperial liberality and members of the various senatorial orders would have received their gifts from the emperor in person at ceremonies like that described by Corippus to celebrate New Year in Constantinople in 566:

> Then the names of the senators were read out from the sacred register, and the conscript fathers came up joyfully as they were summoned and approached the lofty steps of the throne; they held out their hands and took the gifts of the consul and ruler of the world, and proudly carried away silver vessels full of yellow gold.[36]

A small number of the silver ceremonial dishes presented by Roman emperors survive today, of which the large flat decorated plate known as the *Missorium* of Theodosius is the most magnificent (fig 9.4). Probably made for Theodosius I's *decennalia* anniversary in 388, the plate shows the emperor seated between his junior emperors, Valentinian II and Arcadius, handing a rolled document – perhaps a title to an imperial position or an award of some kind – to a smaller figure at his feet.[37] The favoured form for the giving of imperial gifts of gold was the *solidus* and it is likely that the fortunate recipient of Theodosius' bounteousness would have received the plate heaped with gold coins.

Other beneficiaries of imperial prestige gift-exchanges were the soldiers of the army, each of whom in the later fourth and fifth centuries would have received *donativa* (literally 'gifts') of five *solidi* plus a pound of silver on the accession of a new emperor, as well as further *donativa* of five *solidi* to celebrate every five-year period of imperial rule (*quinquennium*). Although we do not know the exact size of the later Roman army, if the often-quoted figure of 300,000 soldiers is a reasonable estimate then the celebration of each quinquennial anniversary would have required the distribution of something like 1.5 million *solidi*, or about 20,000 pounds of gold, to the military alone. Simply paying the military *donativa* required what seem to be huge quantities of gold, but it is worth bearing in mind that not all of the coins would have been freshly struck and also that it was not unusual for Roman senators in the fifth century to receive annual incomes equivalent to 1,000 to 4,000 pounds of gold (for

Fig 9.4. Missorium of Theodosius (not to scale). Madrid, Royal Academy of History. © 2018. Photo Scala, Florence.

comparison, the forty hoards from Britain that include late fourth- and fifth-century *solidi* contain fewer than 2,000 coins, together weighing less than 26 Roman pounds).[38]

It was impossible to obtain enough new gold and silver, whether from the imperial mines or taken as booty and tribute, to provide for *donativa* on such a huge scale. Therefore, in order to maintain the late Roman prestige-exchange economy and, specifically, the practice of patronage to the aristocracy and the army, the imperial court strove to recover as much of the distributed precious metals as possible. Responsibility for the retrieval of the emperors' generosity fell to the *Comes Sacrarum Largitionum* ('Count of the Sacred Largesses'), one of the most senior court officials whose many roles included oversight of the complicated taxation system whereby gold was brought back to the imperial treasury (the Count also controlled the *comitatus* ('court') mint where the *solidi* that played such an important role in fulfilling the emperor's redistributive obligations to his subjects were struck).[39]

Overall, the mechanisms devised to maintain the internal closed system of precious metal distribution and retrieval seem to have been remarkably effective, although we also know that Roman emperors regularly handed over large quantities of gold (presumably *solidi* and ingots) to 'barbarian' kings during the later fourth and fifth centuries. Alaric the Goth, for example, received a 'subsidy' from the Roman Senate in 408 to persuade him to lift his siege of Rome, payment that included 5,000 pounds of gold as well as 20,000 pounds of silver, 4,000 silk tunics, 3,000 scarlet-dyed skins and 3,000 pounds of pepper. Later, during the 430s and 440s, the eastern emperor signed various treaties with Attila the Hun that stipulated the annual payments of large quantities of Roman gold (supposed to be 2,100 pounds after 447, equivalent to half a quinquennial *donativa* for the entire Roman army), while from the 460s to the 480s annual payments of gold were supposed to be handed to various Gothic kings (all of whom also held senior posts in the Roman military), including the enormous sum of 10,000 pounds to Theoderic in the 470s.[40]

The *solidus* clearly played a critical role in the complicated relationship between the Roman emperors and their 'barbarian' neighbours, its messages and symbols of Roman imperial authority acting as a guarantee of purity. Numerous fourth- and fifth-century *solidi* have been discovered outside the Empire in central and eastern Europe, from Poland in the north to Romania and the Ukraine in the south, as well as a concentration of finds from southern Scandinavia.[41] In these areas, *solidi* are found together with Roman silver and 'barbarian' objects of precious metal, and these coins must have been familiar objects to Germanic, Hunnic and Gothic kings and their peoples. In many cases the *solidi* had been transformed by the addition of a hoop or the piercing of the coin so that they could be worn in groups on necklaces and perhaps bracelets, and there can be little doubt that Roman gold coins became highly desirable objects for the display of personal and collective wealth and power in the societies of Rome's 'barbarian' neighbours, albeit manifested differently to the practices observed within the Empire.[42]

Dating hoards of late Roman objects

The dating of hoards plays an obviously critical role in how they are interpreted, so it is unfortunate that the date when the latest object within a hoard was made is still regularly confused and conflated with the date of the hoard's burial. Roman coins in particular can be closely dated, often to short periods of time, and hoards containing these objects are invariably reported to have been deposited very close to the date when the latest coin was struck, invariably leading to the search for a historically attested event to explain its burial. However, the most recently manufactured object only provides the latest point in time after which a hoard must have been buried (referred to by archaeologists as the *terminus post quem* or *tpq*), and knowing when something was produced does not tell us for how long it remained in use and was therefore available to be hoarded. In fact, it is quite clear that an object, particularly one considered valuable, could have had a long history before being hoarded; when it was made may well have been only the beginning of a complicated lifecycle of use and reuse.

The concept of Object or Artefact Biography is a useful approach to take to the study of hoarding in the Roman world, reminding us that objects can perform different functions depending on the social context of when they are used and by whom. This idea distinguishes between connected phases of an object's life-history, which can be summarised in the following way:

- PRODUCTION → • SUPPLY → • USE / CONSUMPTION (circulation / reuse) → • DEPOSITION (loss / disposal) → • DISCOVERY → • ARCHAEOLOGICAL ARTEFACT

During the Use/Consumption phase, how an object is perceived and used can change, become adapted or be entirely transformed in new or altered contexts.[43] The burial of gold, silver and bronze objects in fourth- and fifth-century Britain is a good example of how objects' functions could become dramatically altered: gold, silver and copper coins bearing the Roman emperor's image were struck to serve as monetary and ceremonial objects, not to be hoarded in a far-flung province. The same is the case when we consider the gold jewellery and silver tableware found in treasure

hoards, which presumably were made to adorn the bodies and the dining tables of their wealthy owners rather than to be buried in holes in the ground.

The length of time between an object's manufacture and its incorporation in a hoard can be estimated from the other items deposited with it and this kind of study clearly shows that late Roman gold and silver coins (and jewellery and tableware too) circulated for many years. Almost 50 per cent of the 14,565 silver *siliquae* from the Hoxne treasure, for instance, were at least twenty years old when the most recent coin was struck, while the twenty *siliquae* from the Patching hoard were available to be hoarded for between fifty and 100 years before their burial on the English south coast together with twenty-three Roman and pseudo-imperial (Visigothic) *solidi*, three *miliarenses* and a Republican *denarius* struck in 49 BC (fig 9.5). The latest coin from Patching is a pseudo-imperial *solidus* struck in the name of Severus III (461–65), indicating that the hoard cannot have been buried earlier than 461.[44] Patching is the first, and so far only, hoard to combine old worn 'Romano-British' *siliquae* with coins from the second half of the fifth century and the inevitable conclusion, admittedly from this single source alone, is that late fourth-century Roman silver coins (and probably gold coins too) circulated during the period 450–60 plus. Most of the Patching *siliquae* are similar in many ways to silver coins in hoards that close with issues from 395–402, raising the distinct possibility that other apparently late Roman hoards containing coins also could have been deposited closer to 450 rather than in the years immediately before or after 410. How the Patching coins might have been used in the fifty-plus years after the end of Roman Britain is unclear, but it would seem prudent to assume that being outside the imperial monetary economy for half a century is likely to have had a considerable effect on the functions they performed.

Fragmentation of Roman gold and silver objects

The Patching hoard combines the coins described above with fifty-four pieces of 'hack silver' (derived from the German term *Hacksilber* for cut-up Roman silver sheet and bars), and two gold finger-rings.[45] Other hack silver hoards include the well-known finds from Traprain Law (fig 9.6) and Coleraine, in southern Scotland and Northern Ireland respectively, as well as numerous examples from southern Scandinavia, especially Denmark and the Baltic Sea region.[46] Some of the Danish hoards also include fourth- and fifth-century Roman gold *solidi* and it seems that the one-off find from Patching shares several important characteristics with hoards from places that had never been part of the Roman Empire (it is worth remembering that Britain in the 460s was no longer formally connected to the Roman imperial political infrastructure either). The vessels and other objects from these hoards had been cut up prior to their deposition and each clearly had had long and complicated histories. Made to be used in an exclusive dining setting, both to contain and display food but also to demonstrate their owners' wealth, the vessels' use-lives were transformed once they had been cut into small pieces. Although this feels like gratuitous cultural vandalism, we might bear in mind that an important consequence was that possession of the once-single vessel could now be shared among many people.

▲**Fig 9.5.** Selection of objects from the Patching hoard: gold *solidi*, silver *miliarenses* and *siliquae*, two gold finger-rings and fragments of hack silver (not to scale). *Photograph*: © Trustees of The British Museum.

▲**Fig 9.6.** Selection of objects from the Traprain treasure (not to scale). *Photograph*: © National Museums Scotland.

Fig 9.7. Clipped *siliquae* from the Hoxne hoard, showing progressive reduction in size (not to scale) *Image courtesy of Peter Guest.*

The old Roman *siliquae* from Patching had also been subjected to cutting, though in the case of these coins this involved clipping their edges with a shear-like tool, probably on multiple occasions. Many thousands of clipped *siliquae* are found in numerous hoards of late Roman coins and other objects from Britain and it is thought that this practice began in the later fourth century, probably to obtain silver metal for the manufacture of other silver objects (fig 9.7). That this included new copies of silver *siliquae* has been proved by the analysis of coins from the Hoxne treasure (where some 98.5 per cent of these coins were clipped), which demonstrated that the compositions of the *siliqua* copies were so similar to official coins that they were very likely produced from the same metals.[47] Even though the clipping of *siliquae* does not appear to have been as obviously destructive as the cutting up of silver dishes, flagons and platters, this act nonetheless confirms the transformation of these coins from monetary objects to what were effectively small pieces of portable silver bullion that could be re-used for a variety of new purposes.

Numerous die-links have been identified between *siliquae* copies from Hoxne and other British hoards and there is now little doubt that coin clipping and the production of copies were conspicuously British practices. The simplest explanation for this unusual behaviour is that it was a response to a period of demand for silver in Britain that was not being met by the supply of coins, new and old, from the imperial mints – a deficit that the relative scarcity of clipped *siliquae* from other parts of the Roman Empire suggests was not experienced in the same way elsewhere. It is significant, therefore, that clipped *siliquae* are found also in areas that had never been part of the Roman Empire's monetary economy: the hoards from Traprain in Scotland and Coleraine in Ireland, for instance, as well as an important cluster of finds from Denmark and southern Norway. Here, these 'British' coins have been recovered from several settlements and hoards in Jutland and Zealand (many of which also contain small fragments of late Roman silver vessels and native silverwork), while other examples also have been discovered on the Baltic island of Bornholm.[48]

The means by which cut-up and fragmented Roman objects, including clipped *siliquae*, arrived in southern Scandinavia remain uncertain, although the similarities between Danish hack silver hoards and the British hoards from Patching, Traprain and Coleraine point to the existence of shared traditions of silver deposition outside the Roman world after *c* 400 that extended from Ireland in the west to the Baltic in the east and which, significantly, included Britain. Furthermore, the presence of considerable quantities of fifth-century *solidi* found on sites and in hoards from the Baltic region (probably slightly later than the Danish hack silver hoards discussed above), and often associated with 'Germanic' gold objects such as arm-rings, bracteates, rings and pendants, as well as fragments of other precious metal items, suggests overlapping political and social networks in the fifth and sixth centuries connecting different parts of this 'North Atlantic–North Sea–Baltic' zone, firstly, internally with one another and, secondly, externally with the late Roman world to the south. We might speculate whether these exchanges indicate mainly political, social or trade links between these regions or if they were the result of raiding across the North Sea, but they are surely convincing evidence for the dramatic transformation of Britain's relationship with continental Europe – Roman and 'barbarian' – during the fifth century.[49]

The hoarding of late Roman objects in post-Roman Britain

The reassessment of the relevant archaeological material, together with a consideration of the role and functions performed by gold in the fourth and fifth centuries, suggests the mass hoarding of late Roman objects in Britain is probably better explained as a response to the formal separation of Britain from the Roman Empire *c* 410, rather than as a reaction to any immediate threats from 'barbarian' raiders and invaders. The burying of gold and silver in particular was not something that other parts of the Empire seem to have indulged in, while the great peak of 'late Roman' hoarding in Britain bears many similarities with the behaviour of peoples outside the Roman world. Although the dating of hoards of late Roman objects is a problem that remains to be fully resolved, the accumulated evidence is beginning to indicate that this episode of mass hoarding does not in fact belong to the archaeology of Roman Britain at all, but should instead be considered a part of the history of Britain in the fifth century: a consequence of its isolation from the political, economic and social structures of the Roman Empire.

These years must have been a period of intense uncertainty and anxiety for a great many people in Britain, caused in no small part by the unique manner of Britain's separation from Roman Europe. The important accounts by the Byzantine historian Zosimus and the British cleric Gildas (both notoriously unreliable but written close to the events they describe) agree that Roman Britain ceased to exist as a political entity following the expulsion of imperial officials at the beginning of the fifth century.[50] Precisely when and how this occurred are uncertain, but the separating of Britain from the rest of the Continent must have resulted in a sudden disconnection not just from imperial bureaucrats and tax collectors, but from other aspects of Roman cultural life as well. Once outside the Empire, Britain would no longer have been part of the imperial system of patronage and prestige gift-exchange, and the flow of new largesse from the emperor's court to the Romano-British elite must have ceased abruptly. With no new gold and silver, objects of these metals would have become increasingly scarce and it is very likely that how they were valued and used would have changed in light of the new post-Roman situation.

In other parts of the Western Roman Empire the established imperial administrative and political structures seem to have continued in remarkably good shape, despite the tumultuous events of the fifth century that would see them eventually overwhelmed. 'Barbarians' such as Burgundians, Franks, Goths, Vandals and Huns were able to penetrate deep into Roman territory, yet once there few of these invaders sought to destroy the infrastructure of imperial authority, instead preferring to assume the titles and instruments of Roman power. In Britain, however, the Angles, Saxons and other Germanic groups who arrived on the southern and eastern coasts in the fifth century must have encountered a situation where Roman *Britannia* was no more than a cherished memory and where new local power structures most likely filled the vacuum left after the secession of *c* 410. Only provincial trappings of Roman authority would have survived to be adopted or adapted and, after apparently rejecting these, Anglo-Saxon culture seems to have replaced existing Romano-British traditions and practices across much of southern England more quickly and more thoroughly than in Italy, Spain or Gaul.[51] The unique circumstances that brought about the ending of the Roman period in Britain produced an equally remarkable cultural response from some of the island's population in the mass deposition of valuable Roman objects.

In this explanation of the evidence, the hoards from Mildenhall, Hoxne, Thetford and Water Newton should not be seen as Roman hoards, but rather as collections of Roman objects buried in post-Roman Britain. How long after the end of Roman Britain these hoards could have been deposited is difficult to say at the moment, but the (so far unique) find from Patching indicates it is possible that Roman objects continued to be deposited in the ground into the second half of the fifth century, perhaps closer to 480 than 450. This suggests that rather than the immediate terror of raiding barbarians causing this phenomenon, we might imagine a widely held and deep anxiety about the unknown, mixed over time with feelings of loss in the years after Britain's isolation from the Roman world. At the same time, however, while the archaeological picture is highly complicated, and it is likely that there were many reasons why people buried Roman objects in fifth-century Britain, given the history of the period it is difficult to believe that fear was not somehow involved. Gildas' account of the letter sent by the Britons to the Roman commander 'Agitius' (almost certainly the general Aetius), asking for help against the Scots and Picts, conveys the feelings of this staunch Remainer long after the fifth-century Leavers had won the argument. The plea bore the title, 'The Groans of the Britons', and continued: 'The barbarians drive us to the sea, the sea drives us to the barbarians; between these two means of death, we are either killed or drowned.' Whether or not such a letter actually was ever sent is not known (Gildas was more concerned with conveying moral judgements than historical accuracy), but the impact of the story relied on its accurately reflecting the situation in Britain in the mid-fifth century as remembered during Gildas' lifetime.

If the prolonged uncertainty and anxiety of the fifth century directly or indirectly caused some of the population of post-Roman Britain to hoard their portable wealth in the manner described in this essay, we also need to ask whether the same people intended to recover their hoards or if these caches were meant to stay in the ground. The notion that high-status valuable objects could have been buried and deliberately left unrecovered has been problematic for many archaeologists and historians in the past, particularly those whose research focuses on the Roman period and for whom such actions appear irrational and, frankly, un-Roman. It is clear, however, that this is precisely the situation we are confronted with as far as the burial of late Roman objects in Britain is concerned: this behaviour has far more in common with the patterns of hoarding we see outside the boundaries of the Empire in the fourth and fifth centuries than within. As has been argued here, the burial and non-recovery of hoards in fifth-century Britain occurred within the context of an extended period of political and social upheaval and it would not be surprising if, in these circumstances, those people affected developed new cultural practices in response. Whether or not these practices were manifestations of widely held traditions and if they involved ritualised activities are questions to which we do not have answers at present. Yet, if there is one message that the study of late Roman hoards and hoarding can offer to the scholarship of the Staffordshire Hoard, it is that to understand the reasons for the burial and non-recovery of important hoards of

valuable objects requires us to put aside our preconceptions of how people in the past *should* have behaved and instead use the evidence to appreciate how people really *did* behave, no matter how odd this might seem to us today.

HOARDING IN CONTINENTAL GERMANIC EUROPE

Matthias Hardt [52]

The deposition of objects, overwhelmingly of metal but also in other materials, is a widespread phenomenon in Europe in prehistory and the early historic period.[53] The interpretation of Bronze Age hoards as being for safekeeping[54] or as gifts for the gods[55] has seen wide discussion[56] in which the question of whether the deposits were intended to be permanent or to be retrieved has played a great role.[57] The spatial positions of the deposits in their landscapes have also been considered.[58] By contrast, the hoards of the early Christian centuries on the Continent have not been discussed so intensively, either in comparison with the prehistoric ones or indeed contemporary deposits from Scandinavia[59] or the North Sea areas.[60] Two exceptions are Volker Bierbrauer's monograph, on the grave and hoard finds of the Ostrogothic period in Italy,[61] and that of his pupil Michael Schmauder, which considered the hoards of the fifth century from the Carpathian Basin in an examination of the graves of the elite there.[62] Many Migration period and early medieval hoards have indeed been displayed and appreciated in museum exhibitions,[63] but without any attempt to provide a 'history of hoarding'[64] or to 'investigate the places of deposition'[65] for this period. Given the frequent lapses of time since discovery and the consequent poor documentation relating to the circumstances of many hoards' recovery, these would be bold undertakings, not to be attempted lightly. The following contribution can only be a first step on the way to a comparative study of early historic hoarding and deposition practices in continental Europe that will, above all, allow comparisons with Scandinavian and North Sea area hoarding practices. This review of the evidence will also point to how the

▼ **Fig 9.8.** Map of hoards on the Continent.
Drawing: H. E. M. Cool and C. Fern.

★ Staffordshire Hoard
1. Berthouville
2. Graincourt-lès-Havrincourt
3. Weissenburg
4. Hagenbach
5. Neupotz
6. Kaiseraugst
7. Gross-Bodungen
8. Młoteczno
9. Lengerich
10. Dortmund
11. Szilágysomlyó I
12. Gross Köris
13. Cottbus
14. Pietroasa
15. Piotrowice
16. Szilágysomlyó II
17. Cluj-Someşeni
18. ?Sevso Treasure
19. Rülzheim
20. Rome (Esquiline Hill)
21. Regium
22. Desana
23. Domagnano
24. Galognano
25. Feltre
26. Isola Rizza
27. Gourdon
28. Valdonne
29. Fuente de Guarraz
30. Grüneck
31. Hildesheim
32. Parabiago

Staffordshire Hoard might be judged against the rather different background of continental hoards and hoarding practices, and accounts of hoards in continental early medieval texts.

Hoard finds and precious metal deposits dating between the fourth and eighth centuries are widely distributed in the central European area and, in some cases, show substantial differences in content. The following overview first of all describes the importance that treasure which was not hidden played in the exercise of power in early historic central Europe. This is the background for the hoards from Late Antiquity, the Migration and the Merovingian periods, which were deposited for a variety of reasons, mainly in the earth but also occasionally in water. As far as possible, the original owners and the events that may have brought about the depositions will be considered. Following on from this, selected hoards and deposition practices will be considered based on archaeological material from the Roman provinces, the barbarian regions beyond the imperial frontiers in the Roman and Hunnic periods, the post-Hunnic Balkans and mid-Danubian area, Ostrogothic and Lombardic Italy, the Burgundian realm and, finally, the Merovingian kingdom (fig 9.8). These are arranged according to chronological, functional and regional criteria. Finally, there is a short consideration of written and oral traditions about hiding treasure.

Royal treasure, gift exchange and tribute

The hoards of the fourth to seventh centuries AD in central Europe are the archaeological vestiges of a period when the giving away of precious metal was a prerequisite for exercising political power. The early medieval kings and princes accumulated quantities of gold, silver and precious stones in their treasuries just as the Roman emperors had before them. It came from Roman sources and from their barbarian neighbours as booty, annual payments, ransoms, tributes, gifts or dowries.[66]

The treasure of a king was an instrument in the wielding of his power. By means of presentations and gifts to his close associates he confirmed and secured his status.[67] Precious gifts from the king to his army and followers run as a recurring thread through the history of the early Middle Ages, from the fake golden arm-rings that the Frankish king Clovis gave to the followers of his rival, Regnarchar of Cambrai,[68] to the portions of the booty from the Avars that Charlemagne awarded to his victorious troops in 796.[69]

In times of crisis a well-filled treasury enabled disaster to be averted, and neighbours' intent on plunder to be held off – assuring that a complete military defeat, which naturally would have involved loss of one's treasure, was not sustained or had not really been the enemy's intention. In 566 the Frankish king Sigibert I found himself in this situation following the defeat of his army against an Avar assault that the khagan Bayan had personally led against the east of the Merovingian territory. Although Sigibert had already been captured and his army had abandoned him, the Frankish historian, Gregory of Tours, reported that eventually the king, through the *ars donandi*, his ability to give gifts, overcame those he could not defeat in battle.[70] The exchange of gifts, described in the sources as *dona* and *munera*, governed the relationships between people and were part of the rules of the game at this time.[71] There was scarcely ever an embassy that did not take gifts with it and likewise bring gifts back. So it was with the gold medallions that the Frankish king Chilperic I received from Byzantium,[72] or the water-clock that the Ostrogothic king, Theoderic the Great, sent to the Burgundian king Sigismund as a demonstration of his supremacy.[73] Kings also sought to influence their relationship with supernatural powers through gifts.[74]

A well-filled treasury made possible the generosity appropriate for the honour and status of a royal household.[75] The table services provided the setting for the feasts and drinking bouts that were so important in promoting peace, alliances and a sense of community.[76] Single vessels or whole services were especially associated with the memory of the heroic past and origins of the people. Probably they were the backdrop to special feasts that singers included in their poetry and songs.[77]

Treasure provided the gold and silver that Clovis, mounted on his horse, scattered among those present after his investiture as consul by Emperor Anastasius in Tours. And it was probably the Avar booty that made possible the inauguration of the emperor Charlemagne on Christmas Day 800, challenging the hitherto sole emperor in Byzantium. The role of royal treasure was thus to be the foundation of the gifts appropriate for royalty and the royal household, for the feasts where the tribe's tales of its past were related, and for provision for marriages. Marcel Mauss described this function when he wrote in 1925 in his *Essai sur le don*, describing exchange structures in archaic societies. 'Between vassals and chiefs, between vassals and their henchmen, the hierarchy is established by means of these gifts. To give is to show one's superiority, to show that one is something more and higher, that one is *magister*. To accept without returning or repaying more is to face subordination, to become a client and subservient, to become *minister*.'[78] The treasure of kings in the early Middle Ages was the instrument for determining royal rank and for the construction and maintenance of royal authority that had to be constantly produced and reproduced so that the economic capital won through the position of power was distributed, thereby binding other persons to the ruler, and thus symbolic capital was won.[79] Taking into account the circumstances described by Mauss and Bourdieu it is small wonder that in early medieval Europe not

only the king, but also other notables – dukes, military leaders and bishops – made use of, and disposed of, treasure. The treasure of the king was in this sense not an institution entirely bound to the kingship or the realm, although power over the realm guaranteed many revenues and the king had many items of regalia in his keeping. It represented, in the context of an archaic society, the peak of an economic system that a large part of the barbarian conquerors of Roman territories was still bound to. The almost unlimited means of the collapsing Roman state offered the barbarian princes a final flowering of this system. Only when the Roman gold ran dry and there was an increasing convergence with Roman legal processes was there a move to the feudalisation of medieval Europe. This resulted in the dominance of a type of royal gift that could not be preserved in a chest or bag and, in times of danger, could not be concealed in the ground: namely, land.[80]

Prior to this, the circulation of gold, silver and precious stones in formalised giving and taking was very important in the creation of political and social relationships. These materials could also be withdrawn from the system; sometimes they were deposited with permanent intent, sometimes temporarily. Many times, they were not recovered. The following section will provide selected examples from the range of fourth- to eighth-century hoards and deposits represented in the central European mainland.

Precious metal of provincial Roman origin

Numerous hoards were deposited in the Roman period, both beyond Roman territory and within the provinces. These contained silver vessels, such as in the Hildesheim silver treasure,[81] and Roman coinage, which, like the silver table services, could have come into barbarian possession as booty, gifts or soldiers' pay.[82] Already, before the collapse of the Roman military frontier in Germany, numerous deposits were made in the vicinity of many forts whose contents were presumably hidden in advance of German plunderers.[83] The hoards from Berthouville[84] and Graincourt-lès-Havrincourt (both France),[85] Weissenburg,[86] Hagenbach[87] and Neupotz[88] (all Germany) and Parabiago (Italy)[89] were associated with the booty-hunting raids of Alemannic, Frankish and Saxon groups in AD 260 that brought about the withdrawal from the Roman frontier on the Rhine and Danube.[90] In the course of this, not only money and precious metals but also household equipment and tools of less valuable materials were hidden.

An aggressive phase of Alemannic–Roman relations in the middle of the fourth century precipitated a rash of treasure finds at the fortress of Kaiseraugst (Switzerland). Thousands of coins were found there during the nineteenth and twentieth centuries, which had been hidden in AD 351–4 during the Alemannic raids.[91] But by far the most important treasure find of this period at Kaiseraugst (discovered in 1960–61) was not directly connected to this phase of Alemannic raiding on the upper Rhine.[92] It consists of silver tableware and a substantial quantity of silver coins and bullion. Its owner was an officer of the highest rank temporarily stationed there. Possibly it was the future *magister militum*, Romulus,[93] who, before setting off on secondment to the army of Magnentius in Africa in 350/51, had hidden it in a wooden chest without being able to recover it again.[94] These actions can only be connected with anxieties about the barbarians living north of the Rhine.

The contents of all these treasure finds show that forts, fort settlements, shrines and country estates were favoured goals for the raids in the Roman provinces. The golden bowl in the Pietroasa treasure (Romania; discussed below) had perhaps been stolen from a Roman shrine. The coins and the hack silver in the hoards at Gross-Bodungen (Germany)[95] and Hammersdorf (now Młoteczno in Poland)[96] could have come from a plundering raid within the Empire, or originated as gifts, tribute or soldiers' pay; they appear to have been assembled over a long period of time. In Lengerich (Germany) a 'safekeeping deposit' was discovered in 1847. This contained a silver bowl, an inscribed crossbow brooch, two gold *Kolben* arm-rings and other jewellery, as well as ten gold coins of the Constantinian period. Dating to 'before AD 364', it was perhaps hidden by a member of the army of Magnentius.[97] In Dortmund (Germany) a major hoard of Roman gold *solidi* found in 1907 contained, besides 430 *solidi* (struck between 335 and 441), thirteen barbarian copies and sixteen silver coins, and three gold neck-rings.[98]

Gold and silver: coins, ingots and rings in Migration period hoards in eastern central Europe

From the second half of the fourth century, ever larger barbarian groups pressed into the provinces of the Roman Empire and were frequently integrated as *foederati* in the army. They received subsidy payments in the form of *solidi*,[99] multiple *solidi*, and medallions. In the first hoard from Szilágysomlyó (found in 1797 in what was formerly Hungary, now Romania) there were originally fourteen heavy gold medallions of the emperors Maximian, Constantine I, Constantius, Valens, Valentinian I and Gratian.[100] It also contained heavy ingots, one or more pounds in weight, which were manufactured and distributed from the workshops of the *Comes Sacrarum Largitionum*,[101] and which by various routes reached barbarian rulers outside the Empire, for example as here, in the Carpathian Basin.[102]

The precious metal handed over in large amounts to the tribal groups was often re-worked into jewellery, which made visible the renown and prestige of the wearer.[103] Wealth could be especially manifested by gold and silver neck- and arm-rings, which are also frequently found in deposits. Recovered from a lake at Gross Köris (Germany), a silver neck-ring with hooked fastening and simple crossbow brooch formed part of an offering of the fourth or fifth centuries.[104] A treasure find from Cottbus (Germany) consists of three gold *Kolben* arm-rings, a gold neck-ring with a pear-shaped loop fastening and an elaborate spiral gold arm-ring.[105] The Pietroasa hoard of the mid-fifth century (see further below), contained, in addition to the much-discussed fragmentary gold neck-ring with a runic inscription, another gold looped neck-ring and further neck- and arm-rings set with precious stones, which were subsequently destroyed.[106] A single deposit of a sixth-century neck-ring weighing 1,880g was found at Piotrowice in Poland (formerly Peterfitz, Germany).[107]

Brooches from deposits in the Carpathian Basin

A picture of hoarded jewellery is presented by the second part of the Szilágysomlyó hoard (found in 1889 in what is now Şimleu Silvaniei, Romania). Both parts were found on the same piece of land and were probably hidden by the same owner. In addition to the imperial medallions already described, the first part also included a disc pendant and a gold chain with pendent amulets.[108]

In contrast, the so-called second treasure contained, alongside three gold bowls, ten pairs of brooches and a singleton, a gold ring and several, mostly related, jewellery fragments.[109] The garnet-decorated gold and gold-sheeted silver brooches are of various forms and date the deposition of the hoard to the first half[110] or middle of the fifth century.[111] Its components suggest accumulation over several generations, and, as the signs of wear show, they were worn by their owners to differing degrees. Above all, it is the unparalleled onyx brooch with its exceptionally carefully polished central precious stone, encircled by rock crystals and cornelians that is the highlight (fig 9.9).[112] It is considered to be a 'princely gem',[113] and 'a product of the imperial gold workshops in Constantinople'.[114]

▶ **Fig 9.9.** Gold brooch from the Szilágysomlyó II hoard. A central onyx cabochon is inset with garnets and framed with garnet and green glass cloisonné; the head and foot are ornamented with cabochon rock crystal, red carnelian and green glass (not to scale). *Photograph*: © Hungarian National Museum.

One in this form and size was also worn by the emperor himself. Thus, in the context of imperial regalia, the brooch could be seen as a presentation gift to a barbarian, possibly Gepid, prince in the Carpathian Basin.[115] After an indeterminate period in his treasury it joined the rest of the finds, whether directly or perhaps by a roundabout route involving other owners, to eventually be hidden in the earth.

The remarkable brooches from the Pietroasa (Romania) hoard can also be seen in this light.[116] This high-status hoard, which was retrieved in 1837, originally had two pairs of brooches and a singleton as well as table vessels (see below) and other jewellery. One brooch from the smaller pair was lost, while the other four, though severely damaged, were preserved.[117] All were profusely decorated with precious stones.[118] Of particular note here is the single oversized brooch depicting a falcon or eagle that seems to have the character of insignia.[119]

The connection between gold jewellery and precious stones can also be seen in other items in the Pietroasa hoard. As well as two lost arm-rings decorated with stones and two lost stone-inlaid neck-rings,[120] there is a broad oval neck-collar (fig 9.10). Recent research on the shapes of the densely packed cells and the polished flat garnets of this neck-collar, alongside other stylistic considerations, such as the differing forms of the polychrome style of the brooches, suggests that the concealment of the Pietroasa hoard can be dated to the middle of the fifth century.[121] Since the previously preferred dates for the hoard – a late fourth-century date based on an (assumed) association with the Visigothic *iudex* Athanaric[122] and a turn of the fifth century date based on a connection with the Goth Gainas, who was rising in Byzantine military service[123] – have been shown to be invalid, the chronological connections with the Szilágysomlyó hoard become all the clearer. Trying to connect the Pietroasa find with a known person is also therefore questionable. There need be no doubt, however, that this accumulation of jewellery in gold and precious stones, of neck- and arm-rings, of brooches as well as tableware (which will be discussed below), was at least part of the treasure of an East Germanic, very probably Gothic, ruler;[124] this unknown person concealed it on the south-east slope of the Carpathians at the earliest in the turbulent time at the end of the Hunnic Empire in the middle of the fifth century. The runic inscription with religious content on one of the gold rings in the hoard also allows at least the possibility that the motivation behind this deposit was not just one of 'safekeeping', but also had a sacred element.

The hoard from Cluj-Someșeni (Romania) was found not far from the princely graves of Apahida, with which it was perhaps connected. It contained a high quality pectoral ornament, along with other neck ornaments with beads and pendants, belt buckles, a gold neck-ring, two gold arm-rings and four finger-rings, one of which was set with an antique silver gem. Much of the jewellery, originally weighing about a kilogram and made exclusively from high grade gold, was decorated with garnets.[125]

▲ **Fig 9.10.** Gold neck-collar from the Pietroasa treasure with garnet cloisonné ornament (not to scale); Bucarest, Muzeul National de Istorie a Romaniei, © 2018. *Photograph*: DeAgostini Picture Library/Scala, Florence.

Tableware in hoards from the Danubian area

As in numerous hoards of the later Roman Empire in the western provinces, tableware of precious metal decorated with precious stones occurs in the Migration period hoards of the Danubian area, which were associated with the East Germanic kingdoms of the Goths and Gepids. The Szilágysomlyó treasure find contained only three small gold bowls, decorated on the interior with a few precious stones.[126] The treasure of Pietroasa, which, as we have seen, was probably hidden in the mid-fifth century, shows all the magnificence imaginable for gold tableware. Besides a sparingly decorated circular gold plate weighing almost eight kilograms,[127] there was also a gold bowl, probably made in the mid-fourth century. In the interior of this there is a female figure interpreted

▶ **Fig 9.11.** Gold bowl from the Pietroasa treasure with repoussé decoration and central female figure (not to scale); Bucarest, Muzeul National de Istorie a Romaniei, © 2019. *Photograph*: DeAgostini Picture Library/Scala, Florence.

CHAPTER NINE | **HOARDS AND HOARDING**

as a mother goddess, surrounded by the pantheon of the gods (fig 9.11).¹²⁸ Two polygonal drinking vessels, with handles representing panthers, have openwork sides inlaid with garnets and rock crystal.¹²⁹ In addition, the drinking service contained a gold ewer,¹³⁰ as well as a circular salver and a tall jug, both of which were melted down after discovery.¹³¹

The tableware in these treasures was possibly made in imperial workshops: the bowl with its representation of the gods, perhaps associated with the cult of Cybele, has been regarded as originally a gift of the Emperor Julian to the temple of Cybele in Antioch, restored by him in AD 362.¹³² What path it took from there, perhaps with the polygonal vessels, and how they came into the possession of a ruler in the Carpathian region eludes our precise knowledge, but in the broadest sense may be associated with war booty.¹³³

The find circumstances of these hoards make their East Germanic connections certain. In contrast, the findspot and detailed information about the circumstances of earlier ownership of the large, so-called 'Sevso' treasure, offered for sale by Sotheby's and now in the possession of the Hungarian state, was long unclear, although there were many indications of a Hungarian-Pannonian source.¹³⁴ The treasure, buried in a copper cauldron, contained fourteen late Roman silver vessels manufactured in different places in the Roman Empire in the century between AD 350 and 450. Repairs and wear show that they had been used over a long period before being concealed for unknown reasons.¹³⁵

When, in the summer or autumn of 2013, four detectorists located a precious metal hoard during illegal prospection around Rülzheim (Germany), destroying the archaeological record, the thought of the Treasure of the Nibelungs immediately sprang to mind. In the assemblage, which the looters may not have handed over in its entirety to the authorities, there was a massive silver dish with semi-precious stones mounted in the centre and round the rim. In the central medallion there was an onyx, similar to the one in the imperial brooch from the Szilágysomlyó hoard (fig 9.9). Another large silver plate, originally from Gaul or Britain, had been cut into three pieces in antiquity. Eighty-four gold appliqués probably belonged to a noble's cloak. Fragments of a folding chair with finials for the arm- and back-rests in the form of human figures completed this hoard. On the basis of stylistic links to the second Szilágysomlyó hoard, it can be dated to the mid-fifth century. The silver dish with semi-precious stones and the gold appliqués suggest nomadic horsemen, and thus the so-called 'Barbarian Treasure of Rülzheim' should be thought of, not in connection with the Nibelungs, but rather as evidence of the activity of groups of nomadic horsemen, whether Hunnic or Alanic, in the middle Rhine area in the mid-fifth century.¹³⁶

Hoard finds in Italy, Burgundia and Visigothic Spain

In 1793 a hoard was discovered on the slopes of the Esquiline Hill in Rome, consisting of twenty-five or twenty-seven silver vessels and other objects, among which were the Projecta and the Muse caskets, plates, jugs and a flask, fittings from furniture and elements of horse-trappings. Inscriptions show that some of the objects belonged to the Turcii family, who had accumulated the treasure since the second third of the fourth century and had concealed it, at the earliest, about AD 380, or conceivably in connection with the siege and capture of Rome by the Visigoth Alaric I in 410.¹³⁷

In 1957 a hoard found during scheduled excavations in the Late Antique town of Regium (Reggio Emilia, Italy) provided information about the time when Theoderic's Ostrogoths captured North Italy from Odoacer, the first barbarian king of Italy (476–93). In a lead pipe, which had been covered by an inverted silver bowl and sealed internally by another smaller silver vessel, fifty-nine newly minted Byzantine *solidi* of the period between Marcian (*c* AD 450) and Zeno (AD 493) were found, fifty-six of them from the mint at Constantinople. The pipe also contained a pair of gilded silver bow brooches, a gold onion-knobbed crossbow brooch, twelve gold earrings or ear-pendants, three gold necklaces, fifteen gold finger-rings, a gold pectoral cross, a silver spear-shaped strap-end, eighty-four beads, two gems and eleven pieces of hack silver, probably originally from a plate, with a total weight of 138.4g. The inscriptions on one of the finger-rings, ETTILA and STAFARA, are East Germanic, not Gothic, so one can see the owners of the hoard as being a Germanic couple in the entourage of Odoacer. Based on the coin dating, the burial of the hoard can be dated to the period of the conflict between Theoderic and Odoacer, though the bow brooches in particular could extend into the Ostrogothic period in Italy.¹³⁸

The total of fifty objects comprising the hoard from Desana (Piedmont, Italy), acquired by the municipal museum in Turin in 1938, included a pair of cloisonné bow brooches with bird heads on the semi-circular head plate and Mediterranean interlace decoration on the long foot, a knobbed bow brooch, a gold onion-knobbed crossbow brooch, and a wedding ring with the names STEFANIUS and VALTRUDA. The artefacts represented in the hoard date between the third and the sixth centuries. The hoard came from the neighbourhood of a large Roman villa, which continued in use into the sixth century and which had been provided with a chapel in the fifth century. The Christian character of many parts of the hoard was clearest on two gilded silver spoons with the cross symbol on the handles. Altogether in the hoard there were twelve *cochlearia* spoons from a set for special occasions, one of them inscribed with the Germanic name GUNDILA, and five *ligula* spoons for everyday

use. Two spoons carried the inscription *Vivas in Deo utere felix* ('live in God, good luck to the user'). It is not only the Romano-Germanic names on the wedding ring, but also the Roman as well as barbarian cultural influences which permeate the hoard, that show the coexistence of the immigrants with the indigenous population in north-west Italy in the time of the Ostrogothic king, Theoderic the Great (d. 526).[139]

The most significant items of jewellery yet known from the Ostrogothic period in Italy came from a hoard, or possibly from a grave.[140] They were allegedly discovered at Domagnano (Republic of San Marino) in 1893, and pieces were subsequently scattered across the world – to the British Museum in London, the Germanische Nationalmuseum in Nürnberg, the Parisian de Béarn collection and the Metropolitan Museum of Art in New York. The find consisted of a pair of eagle brooches, a pair of pendent ear-rings, an insect-shaped brooch, nine two-part necklace pendants, a two-part gold necklace, a garnet-inlaid disc-headed pin, a gold ring set with a garnet and three cloisonné fittings of unknown function.[141] The eagle brooches turn their heads to face each other and consist of elaborate cloisonné-work of rectangular, curved and round cells on solid gold sheet backings. The birds' breasts bear a clearly recognisable cross. Most cells contain light red flat garnets with facetted edges, set on stamped silver-gilt foil on a cement base. The wingtips are set with lapis lazuli, while the rectangular cloisons along the central axis and some cells at the tail tips are set with ivory. The brooches have a net gold weight of 128.44g.

From the same workshop as the brooches come the multi-part pendent ear-rings weighing 17.85g, the bee or cicada brooch weighing 9g, as well as the necklace pendants. Among the remaining finds, whose relationship to the brooches and necklace is not beyond doubt, two cloisonné gold mounts in the form of a helmeted head are noteworthy, especially in the context of the Staffordshire Hoard (fig 9.12). The cellwork is constructed on three levels, intended to be read in different ways. Flanking the nose are two fish, whose heads also form the eyes of the helmet-wearer, and the heads of two birds of prey with upward-pointing beaks; the nasal, brow-band and crest of the helmet also can be read as a Latin cross. Similar fish also appear on another cloisonné rectangular mount – fishes, birds of prey and crosses are frequent motifs in early Christian iconography. From the viewpoint of the wearer, the cellwork of the helmet mounts presents an image of a cicada with highlighted eyes, its wings arranged between the upturned bird heads. In this orientation, the rounded end, which forms the helmet cap seen frontally, forms a beast's head with a broad muzzle and two white inlays suggesting boar tusks – a motif that is found on numerous bow brooches. The symbolism is Christian, albeit combined with an originally pagan element in the cicada. These insects were singled

▲ **Fig 9.12.** Gold cloisonné mount depicting a helmeted head from the Domagno treasure (not to scale). *Photograph*: © Trustees of the British Museum.

out on account of 'their mysterious relationship with the earth, their apparently magical ability to appear in large numbers, as well as the ability, [...] to live on dew'.[142]

In any event, the high quality of the assemblage from Domagnano shows that it is very probably associated with a high-status Ostrogothic woman who, at some point in the last decade of the fifth century or in the first half of the sixth, buried her jewellery or took it with her to the grave.

The hoard from Galognano (Tuscany, Italy) shows that the Ostrogoths were also active donors of liturgical equipment to the Italian Church. The assemblage of silver Eucharistic vessels, found in 1963, consisted of four chalices and a paten. Two are inscribed with Gothic donor names: HIMNIGILDA on the third largest chalice, and SIVEGERNA on the paten. The hoard was probably hidden in the course of the Gothic war against Byzantium and never retrieved.[143] A silver dish from Feltre (near Belluno, Italy) may also be associated with the Byzantine reconquest[144] through its inscription,

Fig 9.13. Miniature chalice and paten set from Gourdon (not to scale). *Photograph*: © Bibliothèque nationale de France.

GEILAMIR REX VANDALORVM ET ALANORVM, identifying it as the property of the Vandal king, Gelimer (AD 530–34).[145] If it was not made in the household of the Vandal king, it could equally have taken different paths to the treasury of the Vandals, just as it later found its way from there to northern Italy.[146]

In 1872 a hoard was discovered in the vicinity of the parish church of Isola Rizza (Verona, Italy), within a Late Antique cemetery. It originally consisted of six silver spoons, two gold and silver disc brooches with filigree decoration, a belt clasp and three gold belt mounts, and a silver bowl. The basal medallion of the 40.5cm diameter bowl, recessed in an ornamental frame, is decorated in relief with a charging cavalryman equipped with a *Spangenhelm*, lamellar armour and spear. He spears a fallen foot-soldier armed with a sword and shield, and rides over a similarly equipped foot-soldier who has already fallen. Given the different equipment of the rider and the foot-soldiers, it is suggested that this depicts a battle of Byzantine cavalry against Longobard infantry. However, it could also be interpreted as a scene from the Gothic wars or more generally as the conflict of Roman against barbarian. The bowl can be dated to the late fifth or beginning of the sixth century.[147]

A hoard from Gourdon (France), now in the Cabinet des Médailles, Paris, was found before 1845.[148] It contained a chalice and paten (fig 9.13), as well as 104 Byzantine coins consisting of thirty-six *solidi* and sixty-eight *tremisses* from the time of Leo I to Justinian (AD 475–535). The chalice, which has a fluted foot and griffin-head handles inlaid with cabochon garnet eyes, is only 7.5cm high. It, together with the paten (19.5×12.5cm), could be interpreted as a liturgical set for use while travelling, though this remains debatable, on account of their small size.[149] The paten's raised rim is decorated with a band of stepped lozenge-shaped garnets between rows of garnet roundels, recalling the scabbard fittings from the Frankish king Childeric's grave at Tournai (AD 481/82). Four small inlaid crosses are set at each corner of the rim, and a larger garnet-inlaid cross appears at the centre of the paten. Both vessels were already quite old when hidden in the first half of the sixth century. The hoard has been associated with the Burgundian king Sigismund (d. AD 524) because his royal monograms appear on the *solidi*.[150]

Also, from the sphere of seventh-century Merovingian kings, are two silver plates from Valdonne (France). The larger one, weighing 408g, has five Byzantine-Greek monogram stamps, while the smaller, weighing 305g and probably modelled on the larger, also has five stamps, one of which has a Latin inscription, ARBALDO. This may signify a Merovingian official,[151] because of the similarity of this stamp to monograms on coins of Chlothar II, Dagobert I and Sigibert III. It must have been commissioned during the time of those Merovingian kings, who were also served by the renowned goldsmith, Saint Eligius.[152]

Strong Byzantine influence is evident in the manufacturing technique and subjects of the, originally eleven, circlet crowns

from a hoard discovered at Fuente de Guarraz (Spain).[153] Originally, they were probably hung above the altars of the cathedral of the Spanish Visigothic kingdom and were hidden in advance of the Arab conquest in AD 711. Individual letters hang by chains from each crown, spelling out the name of the commemorated donor. One such inscription, RECCESVINTHUS REX OFFERET, refers to the Visigothic king, Reccesvinth, who ruled from AD 649 to 672. Also noteworthy are the openwork crowns with multiple pendants and stone inlays, the crown of King Swinthila with an inscribed gold sheet cross, the horizontal arm of a processional cross, and a pair of gold sheet crosses with cabochon precious stone inlays. Such crowns were not only made as gifts for Christian churches, but were also worn ceremonially, in prestigious ceremonies. Thus, according to the *Historia Wambae Regis*, the usurper Paul stole a crown from the altar of the church in Gerona in the late seventh century in order to seize the kingship.[154]

This investigation of hoarding and depositional practices between the fourth and the eighth centuries concludes with the important coin hoard uncovered in 1906 during road building beneath the Grüneck castle near Ilanz (Canton Graubünden, Switzerland). It forms a bridge between the seventh-century and earlier gold hoards, and the Carolingian and Slavic silver denier and dirham hoards. Besides two gold ear-pendants, five small discs with suspension loops and two gold lumps weighing 7.413g and 4.864g, it contained eighty-three Lombardic *tremisses* and fifty-three silver coins, of which forty-eight were from Carolingian mints, two from Mercia, one from Kent and two were Arabic *dirhams*. One of these, a *dirham* of Harun al-Raschid of AD 789/90, provides a *terminus post quem* for the hoard. Its deposition can be linked with the monetary reforms of Charlemagne in AD 793, when the heavy silver *denier* was introduced and the *tremiss* was no longer accepted in early Lombardic Italy. The hoard is associated with the trade route from the North Sea to Italy via the Rhine and the Alpine passes.[155]

Hidden treasure in texts from the early medieval period

The historical and hagiographical Latin texts written during the early medieval period have handed down a large number of stories about treasures in the widest sense, which are usually referred to by the term *thesaurus*.[156] Occasionally, a *thesaurus absconditus* is mentioned, that is, a treasure that is hidden or found in the ground. The Treasure of the Nibelungs, submerged in the Rhine, is certainly the best known of the hidden treasures found in the textual tradition of the early Middle Ages.

The story of Kriemhild (Gudrun in the early Norse versions) demanding the return of the hoard in the *Nibelungenlied*,[157] which was written *c* 1200, is central to this tale of the revenge of a royal sister, who had her brother (Gunther/Gunnar) murdered in reprisal for the directly related murder of her husband (Siegfried/Sigurd); it appears in much older versions of the history of the Burgundians.[158] Originally, in the *Lay of Atli* in the Norse *Poetic Edda*, Attila, the king of the Huns, greedy for gold, demands the surrender of treasure from the Burgundian (Gothic in this version) king, Gunnar.[159] The Burgundians were already described as hiding their treasure in the waters of the Rhine in the earliest known versions, and Gunnar takes its secret location to his death.[160] Later variants of these tales also talk of concealment in solid ground.[161] In the case of the Nibelungs' hoard, which is an exclusively poetic subject, it is a royal treasure that must be hidden in as safe a place as possible, in anticipation of raids by enemy nomadic horsemen with a lust for gold. The manner in which the holders of the secret, Gunther/Gunnar and his trusted friend and brother Hagen/Hogni, deal with the knowledge of the place of concealment shows that, prior to the deposition, a future recovery of the treasure was not ruled out and indeed was expected.[162] However, it is also noteworthy that treasure, in these literary sources, sometimes seems to be imbued with special, even symbolic, meaning, which may reflect ways in which it might once have been regarded in practice. For example, although Gunther intends to retrieve the Nibelungs' treasure eventually, a telling alternative reading is given by his princely companion, Gernot, who says that 'rather than always be plagued by this gold, let us have it sunk in the Rhine *so that no one would have possession of it*'[163] – a suggestion that this tainted treasure should be put beyond reach for ever. It is also interesting to compare the casting of the Nibelung treasure into the waters of the Rhine with the watery sacrifices of some northern hoards, and to reflect on whether some older concepts of treasure offerings persisted into later times.

Numerous historical texts and saints' lives from the early medieval period also provide accounts of the concealment or discovery of treasure in the ground.[164] In these sources, it is clear that such deposits were made for the temporary safeguarding of precious metal. Most consisted of coins, ingots or jewellery, and often also silver tableware. All these texts imply that these valuable items were buried with the intention that one day, when the danger was past, they would be recovered and used. If these hoards were not deposited in response to the threat of war, their deposit is usually attributed to the avarice of their owners or the illegal acquisition of their contents. The recovery of ancient hidden treasures by lucky finders was, according to the clerical authors of these texts, generally connected with divine will and signs sent by God.

The character of the texts handed down, and their religious authorship, is probably the reason why the deposition of precious metal for pagan religious motives was at no point considered. Such a sacrifice of hidden treasure evidently plays no role in the thought of the Christian authors. Thus, it is not out of the question that such religious depositions might still have taken place in the early Middle Ages. In these written sources, however, we find only such treasures that in archaeological discussion are described as classical safekeeping finds.

Conclusion

The examination of hoard finds and the written sources for treasure between the fourth and eighth centuries in mainland Europe has shown, above all, the heterogenous composition of deposits of precious metal. Coins, ingots, jewellery and tableware were deployed in gift exchange and in the projection of power, but they were also concealed and not always recovered. Whether the deposits were made with the intention of recovery or were intended to be permanent is frequently unclear because of the recording of the finds. Scholars have usually regarded them as a safeguard against (competing) looters in times of war or crisis, and only rarely as an irreversible deposit connected to sacrificial rituals. For the contemporary Christian authors, religious activities outside of Christian sacred spaces were clearly unthinkable and archaeological scholarship has so far found little evidence for it. Future explorations need to investigate hoards through detailed analysis of their composition, the history of the assemblage and the intentions behind the deposition. The findspots should play a greater role in future research, especially with regard to landscape-forming elements such as the topography of settlement and communications. Burial, assembly and execution places, and land-use and water systems, also need to be taken into consideration. Small-scale microtopographic investigations will contribute to the outcome as well as multi-regional comparative studies.

Perhaps, as the last paragraph could imply, the discovery and analysis of the Staffordshire Hoard may suggest new ways of looking at some of the continental Germanic deposits. Although it appears very different in its composition from most of the hoards discussed in this survey, the range of circumstances under which the Hoard might have been assembled and buried (see *Chapter 10*) suggest that some of these continental deposits would repay re-examination.

SCANDINAVIAN HOARDING

Svante Fischer

From the late Roman Empire to the early Middle Ages, various Scandinavian regions, extending from West Jutland on the North Sea shore to the Baltic islands off eastern Sweden (fig 9.14), display a wide range of hoarding.[165] These can sometimes be integrated into a larger picture of Germanic successor kingdoms in the wake of the Roman Empire, but there are also exceptions that raise questions with regard to our knowledge of manifestations of power and glory in the past.

Imagining Scandinavia

At the time of the deposition of the Staffordshire Hoard, Scandinavia played a symbolic role in Anglo-Saxon society. It served as an important element in the ideological backdrop of Anglo-Saxon aristocratic culture; many competing royal dynasties in England traced their ancestry to Germanic gods such as Woden, but also to quasi-mythical Scandinavian leaders such as Offa of Angeln, Geat, and possibly Horsa and Hengist. This idea of Scandinavian ancestry was also widely expressed in the material culture; Anglo-Saxon goldsmiths emulated certain types of Scandinavian jewellery such as square-headed and cruciform brooches, bracteates and sleeve-clasps. Some Old English poems, such as *Beowulf* and *Widsith*, contain fragments of wondrous and spectacular tales of royal families and events that had supposedly taken place back in Scandinavia. The main characters in *Beowulf* were Danes from Zealand, Geats from Västergötland, and Swedes further north.[166] Legendary kings and heroes of Scandinavia were depicted as generous gold-givers, armed with the most precious of weapons. They bravely fought monsters and dragons, descending into the unknown realms of the underworld. The story-teller Widsith related how he had spent time with various Scandinavian tribes and rulers during his long wanderings among the tribes of Europe in days of old.

This fanciful vision of a heroic and opulent Scandinavia, a suitable Anglo-Saxon past, had at least partly to do with the fact that Scandinavia had never been part of the Roman Empire. Instead, this barbarian periphery had always enjoyed a complicated relationship with Roman culture and society, with brief stints of direct interaction and longer periods of isolation. As a result, some regions of Scandinavia appear to be extremely rich in finds of late Roman and early medieval gold treasures, while other regions seem to be almost devoid of precious metals. This uneven pattern can partially be explained by the fragile nature of the networks that organised the flow of precious metals, which were difficult to establish and almost impossible to maintain for more than one

CHAPTER NINE | HOARDS AND HOARDING 345

Fig 9.14. Maps showing the distribution of different types of hoards and deposits in Scandinavia mentioned in the text. *Drawing*: H. E. M. Cool and C. Fern.

● Major war-booty sacrifices in wetlands

1. Illerup
2. Porskjaer
3. Esjbøl
4. Nydam
5. Thorsberg
6. Kragehul
7. Vimose
8. Finnestorp
9. Snösbäck
10. Skedemosse

● Major war-booty sacrifices on dry land

11. Uppåkra
12. Fulltofta
13. Sösdala

▲ Major gold hoards

14. Gallehus
15. Broholm
16. Tureholm
17. Timboholm
18. Ålleberg
19. Möne
20. Färjestaden

■ Weapon-fitting hoards on dry land

21. Åker
22. Hög Edsten

● Central places

23. Gudme
24. Lejre
25. Uppåkra
26. Sorte Muld
27. Helgö

generation at a time. Recent research by Nicolay has argued for a direct link between the hoarding of precious metals and the process of state formation in the successor kingdoms along the North Sea. It seems that this model is not universally applicable, however. With the diverse and irregular background, the hoarding of precious metals in Scandinavia in the fourth to seventh centuries is not as easy to link to the early state formation process as in other parts of Western Europe.[167]

Ways of hoarding

The relative isolation of Scandinavia from the world of Late Antiquity meant that only certain features of the Roman world could have an impact on local society. Old Scandinavian traditions were confronted with new Roman influences. Hoards often contain a curious blend of barbarian and Roman ways of amassing wealth. Above all, there is a remarkable feature that can be observed in most Scandinavian war booty sacrifices and precious metal hoards: the process of 'premeditated deactivation'; the hoards bear witness to a past mentality, in which the conscious removal of objects from normal use or deliberately detaching them from certain fields of interaction played a fundamental part. 'Deactivation' could be achieved either by conscious destruction of the objects or by placing these within sites considered to be beyond reach. The sensed need to remove or destroy precious objects in the wake of armed conflict meant that wealth was not easy to accumulate, and that the Scandinavian elites were vulnerable to sudden changes along the import routes of precious metals from the outside world.

One of the largest gold hoards is the one from Tureholm in Södermanland in eastern Sweden (fig 9.15, cf fig 2.40).[168] When the hoard was discovered, during the construction of a barn in 1774, it consisted of an astounding amount of gold bullion, at least 12.5kg, more than three times the sum of the Staffordshire Hoard. Most of the gold in the Tureholm hoard was in the shape of spirals and bars, but there were also a number of neck-rings, and hilt-collars and scabbard-fittings with filigree ornament. The crescent-shaped stamped ornamentation on the largest neck-ring, which weighed as much as 985g, and the filigree work on the sword parts suggest a late fifth-century or early sixth-century date. Given the weight, size and condition of the different objects, this must have been a royal hoard and it is significant that it remained untouched in the ground even after gold had become scarce in Scandinavia.

War booty sacrifices

In the third and fourth centuries AD, there were many pitched battles in what is modern-day southern Denmark and northern Germany, the gateway between Scandinavia and the Roman Empire. Winning a battle in southern Scandinavia at this time meant that one also had to deal with the spoils of victory.[169] In many cases, the war booty was gathered from the battlefield and subsequently deposited after having been 'deactivated', usually by means of breaking spears and hacking shields to pieces. The known war booty sacrifices are concentrated in the period between the third and the fifth centuries and mainly found in wetlands in eastern Jutland (fig. 9.14i). As a rule, the bodies of the fallen warriors are absent in these sacrifices.

There are three basic types of war booty sacrifice: those that are connected to the sea, such as the three ships in Nydam in Jutland; those that mainly contain infantry equipment, such as Kragehul on Funen; and those that mostly contain cavalry equipment, notably Sösdala and Fulltofta in Scania in southern Sweden.[170] Some war booty sacrifices show a distinct hierarchy: in Illerup in Jutland and Vimose on Funen, the war leaders went into battle on horse-back and carried Roman equipment whereas the common warriors on foot used weapons of domestic origin.[171] In addition to these earlier war booty sacrifices there are a few later contexts from Västergötland in Western Sweden, whose extent are not fully known, especially Finnestorp and Snösbäck, which date from the late fifth century to the early seventh centuries.[172]

▲ **Fig 9.15.** Neck-collar and weapon-fittings from the Tureholm hoard. *Photograph*: C. Åhlin, © Statens Historiska Museum (SHM 29).

Some of the war booty sacrifices also include small, portable precious metal hoards that reflect their respective deposition periods, notably a group of die-identical imitations of *denarii* in Illerup (*c* 250), hack silver in Nydam (*c* 350–400), *denarii*, snake head bracelets and an *aureus* in Skedemosse on Öland (*c* 350–400) and a single gold bracelet in Snösbäck (*c* 600). These small hoards show that people went to battle carrying some of their most precious belongings, but also that the victors were not always interested in keeping such loot, perhaps considering this undignified behaviour or even dangerous blasphemy.

Precious metal hoards and central places[173]

The most important constraint on the hoarding of precious metals was the relative scarcity of gold and silver, which had to be brought in from the outside world. For Scandinavians, gold and silver could not just be acquired on an open market regulated by supply and demand. On the contrary, gold and silver carried immense social significance and any transfer of ownership was a complicated matter, especially in terms of wider supra-regional networks. On certain aristocratic sites, workshops were established so that precious metals and prestigious weapons could be hoarded, altered and redistributed.

Some of the most important aristocratic sites developed into central places (fig 9.14ii), especially Gudme on fourth-century Funen.[174] These can with some justification be regarded as early precursors to future trading networks and the first merchant settlements in Scandinavia. Gudme was followed in the late fifth and early sixth century by Helgö in Lake Mälaren in eastern Sweden and Sorte Muld on Bornholm in the Baltic, while Uppåkra in Scania became more prominent in the sixth and seventh centuries.[175] Central places seem to have played an important role in various forms of pre-Christian religion, and many of the figurative representations on precious metal objects produced in the workshops of certain central places have been connected to religious beliefs and aristocratic ideology emanating from local elites. In particular, the so-called '*Drei Götter*' (three gods) gold bracteates from Gudme are interesting in that they seek to transform a traditional fourth-century Roman imperial iconography found on the reverse sides of *solidus* coinage into a new world of Scandinavian imagery, typically the image of the standing emperor surrounded by two junior members of the imperial college.[176] In some cases, it cannot be ruled out that central places were linked to specific war booty sacrifices. Much of the material in Kragehul is certainly contemporary with Gudme, for instance. Uppåkra is exceptional in that it has a dryland war booty sacrifice of more than 200 spear heads close to the main settlement complex, where at least three people had died inside a burning house in the fifth century. In addition, there is a later distribution pattern of sixth- and seventh-century sword pommels that may well be the remains of a battlefield along the slopes of a ridge just south of the main settlement of Uppåkra.[177]

The composition of precious metal hoards changed over time and various Scandinavian regions differ widely from each other in terms of finds. Certain objects that are quite commonplace in one region are simply absent in others, suggesting that import, hoarding and trade were kept separate from each other. It is quite apparent that Norway and Finland were relatively poor and isolated when compared to certain parts of Denmark and Sweden.

Silver was the most important precious metal in Denmark up to the late fourth century, with some 5,000 known *denarii*.[178] When gold replaced silver as the dominant metal by the mid-fifth century, the older central places of Denmark were gradually replaced by new central places in other regions further north in Sweden and the Baltic islands. The many silver hoards in Denmark often contain hack silver made from Roman plate, and occasionally *siliquae*.[179] By contrast, there is only one known fragment of a Roman silver plate in Sweden from Öland, just as there is only one known *siliqua* from Scania.

The later silver hoards on Gotland generally contain quite worn Roman *denarii* that were imported in the fourth and fifth centuries from areas in central and eastern Europe under barbarian control (current Ukraine and Hungary). In fact, Gotland accounts for more than 7,000 *denarii* of the total 8,000 from southern and eastern Sweden, but it is also clear that the Gotlanders had a different source from their peers in Denmark.[180] As a comparison, there are only ten *denarii* known from Norway and two each from Bohuslän, Västergötland and Finland.[181]

The distribution pattern of gold hoards shows equally distinct regional differences, with parts of Denmark and Sweden displaying abundance, while Norway and Finland seem to have had little to offer in return for imported gold (fig 9.14ii). In Denmark, there were hoards of Roman gold coinage in the Gudme area on Funen already by the mid to late fourth century.[182] Then followed a general hiatus in the import of Roman gold coinage that lasted one or two generations.

Finds of mid to late fifth-century Roman *solidus* coinage imported from Italy are very frequent on the Swedish islands of Öland, Gotland and Helgö, and the Danish island of Bornholm.[183] This *solidus* horizon is particularly important because there is reciprocal evidence of Scandinavians fitting *solidus* coinage within gold filigree pendants and taking these to the Continent, as shown by the finds from Udovice, Serbia.[184] Öland, Gotland and Helgö account for *c* 800 *solidi* – compared to the mere seven *solidi* from Norway (most

of which date to the hiatus period of the late fourth century), four *solidi* from Finland and two from Latvia.[185] Gotland shows an unusual hoarding pattern with several hoards dating to the late fifth and early sixth century containing both *denarii* and *solidi*, which is also the case in the grave of the Frankish king Childeric (*c* 482) and the Vedrin hoard (*tpq* 491), both in Belgium. Gotland thus had a very different form of hoarding from other Scandinavian regions, which reflects the fact that Gotland briefly enjoyed a different source that was abruptly cut during the turbulent fifth century and replaced with a new source.[186]

Regions with very few coin finds, especially Norway and western Sweden, appear to have compensated for this dearth by hoarding gold bracteates, even if many of the gold bracteates could have been imported from more affluent areas in southern Scandinavia, especially Gudme. Once again, the regional contrasts are striking. There are *c* 900 known gold bracteates in Scandinavia, a figure quite comparable to the *c* 1,000 known *solidi* from all of Scandinavia, yet there are only fifteen recorded hoards that combine gold bracteates and *solidi*, none of which is in eastern Sweden or in Norway.[187] In addition, the common D-type bracteates typical of Norway and Västergötland have yet to be found in any significant number north of Södermanland in eastern Sweden. These patterns cannot be accidental. In some parts of Scandinavia most people who imported or hoarded Roman *solidi* were either unwilling or unable to exchange the *solidi* for gold bracteates because the latter came from other regions. It seems that various forms of gold could be considered unsuitable or unclean under certain circumstances.

Unminted, and thus essentially untraceable, gold is the norm for precious metal hoards in most regions, but the sizeable quantities found in Sweden (*c* 50–55kg) exceed by far the sum total of Denmark, Norway and Finland,[188] but also the Scandinavian North Sea regions. The two largest known gold hoards, Tureholm in Södermanland (*c* 12–15.5kg) and Timboholm in Västergötland (7.081kg) are remarkable assemblages. While Tureholm seems to contain important high-status items such as sword-fittings, the Timboholm hoard is testimony to something else: gold was carefully measured according to international standards. The Timboholm hoard consists of twenty-six interconnected rings (most weighing *c* 165–172g) and two ingots that all conform to carefully measured units of the East Roman *libra* (pound).[189] A survey of all gold finds in Uppland, Södermanland and Gästrikland in eastern Sweden, with a total weight of 16.4kg, revealed a proportional weight system for gold hoards with a distinct hierarchical distribution pattern in six weight groups located around minor central places, typically *Tuna* place-names and sites for legal assemblies around Lake Mälaren.[190]

The flow of Roman gold coinage to Scandinavia via Pannonia and Italy in the fifth and early sixth centuries appears to have been unrelated to the rise of the sixth- and seventh-century successor kingdoms in the North Sea region. There is only one die-link between the Low Countries and Scandinavia: a *solidus* type struck in Constantinople for Leo in the Midlum hoard matches a single find from Långlöt parish on Öland.[191] Between England and Scandinavia, there is also only one die-link, between a single detector find of an early sixth-century Merovingian *solidus* from Essex and the Endre hoard on Gotland, Sweden.[192] It is therefore not possible to equate Scandinavian hoarding patterns to a gradual process of early state formation, as has been recently suggested for the North Sea regions in western Europe.[193] However, it seems that the networks in which precious metal objects circulated were subject to yet another significant transformation that lasted from the early sixth to the late seventh century, with a growing contact network connecting southern Norway, Denmark and the southern and western parts of Sweden to the Merovingian and Anglo-Saxon kingdoms on the North Sea.

This new network replaced the late fifth- and early sixth-century links between the Baltic islands and east-central Sweden and the barbarian warlords of central and eastern Europe and Italy. This shift is also reflected in the composition of hoards and deposits. Post-Roman western Europe was less wealthy than the Mediterranean of the Late Empire. This caused gold to become increasingly scarce in Scandinavia as time progressed. By the mid-sixth century, there was little left of the past splendour in the halls of Gudme, and the workshops in Helgö had essentially ceased their production. By the late seventh century, a new type of hoard, such as Åker in the Oslo Fjord in Norway (fig 5.4ii) and Hög Edsten in western Sweden (fig 2.42), shows that the supra-regional networks of Western Europe had slowly begun to expand across the North Sea.[194] Still, in this period of decline in Scandinavia, there is no clear relationship between the growing Merovingian North Sea kingdoms and the decreasing number of recorded precious metal hoards in Scandinavia.

Early sixth-century *solidus* imitations struck in Merovingian Gaul appear only on Helgö and Gotland, but not elsewhere in Scandinavia. In the early to mid-sixth century, when the Merovingian kingdoms began to issue new forms of gold coinage, such as debased *tremisses*, to replace the old Roman coins and *solidus* imitations, the Scandinavians were unable to benefit from much of the accompanying economic upswing in the North Sea area. Later Merovingian period imitative coinage, such as the many derivatives of the Madelinus mint that are characteristic of gold hoards such as Dronrijp in the Netherlands, of *c* 640,

or Sutton Hoo in England, have yet to be found in Scandinavia.[195] This could be interpreted as some form of rupture in the relations with the North Sea, possibly a shift from direct contact with Merovingian Gaul to less affluent Anglo-Saxon and Frisian intermediaries.

The collective evidence suggests that the *c* 60kg of late Roman or Migration period gold found in Scandinavia had probably been removed from circulation by the mid-seventh century. The generous gold-giver Hrothgar in *Beowulf* was a figure of the past. While some 9kg of gold have been found in the Gudme area, the later central place of Uppåkra, contemporary with the Staffordshire Hoard, has yielded only a mere 200g. One ingenious solution to the new scarcity of gold was the creation of a miniature form of hoarding in the shape of *guldgubbar*, the Swedish term for tiny finger nail-sized gold foils weighing *c* 0.1g each.[196] Some 3,000 *guldgubbar* are known, of which some 2,500 have been found at Sorte Muld in Bornholm alone.[197] A patrix found in Uppåkra matches *guldgubbar* found in Sorte Muld. This irrefutable die-link shows that some of the central places that survived the general collapse of the late sixth century exchanged symbolic tokens of the past opulence.

Conclusion

This overview of the various forms of hoard in Scandinavia shows that the Scandinavian regions were quite unlike each other and that people were obliged to manage their wealth differently. Even if the emerging Anglo-Saxon polities of the seventh century were starting to shape a number of narrative stereotypes of an imagined ancestral past, Scandinavians did not share a single uniform ideology or religion, expressed in archetypical war booty sacrifices, precious metal hoards or central places. Rather, the various Scandinavian regions functioned as autonomous entities. There were no nation-states, fixed territorial borders or distinct ethnic forms of material culture at the time. The Scandinavian war booty sacrifices, precious metal hoards and central places rarely overlap, and the find categories are indicative of a number of practices and ideas that are sometimes hard for us to understand.

The separate phenomena of precious metal import and hoarding do not correspond to the process of early state formation and the creation of viable political structures within neatly designated spheres of power. This realisation means that one has to reconsider the uncertain role of the central places. It seems unlikely that there ever was a single dominant central place, nor was there an even flow of commercial goods between equal-sized nodes in a stable network. There is little evidence for any connection between central places such as Gudme, Helgö and Uppåkra. This has to do with the fact that the hoards are so different from each other; *siliquae* and *aurei* can be found in Gudme, *solidi* in Helgö, while mostly copper alloys, a handful of bracteates and some occasional imported brooches have been found in Uppåkra. The only material that would suggest direct links between these central places are the relatively late *guldgubbar*. Perhaps we should see the early Scandinavian central places as hostile competitors rather than as symbiotic team players in a mutually beneficial system. Both Helgö and Uppåkra were sacked by invaders on several occasions.[198] This understanding brings us to consider the even more uncertain role of some of the workshop hoards from Västergötland, especially the late sixth-century hoard from Djurgårdsäng. There is a lot of different silver in Djurgårdsäng, hack silver, silver rings and a series of nine matching ingots, and continental garnet jewellery matching a brooch found *in situ* in a female grave in the cemetery of Bulles (Oise) in northern France.[199] In addition, it includes both a D-type gold bracteate and nielloed silver sleeve-clasps.[200] But it will be very difficult to determine how many times the alloys of the ingots had been recast or what the original source was.

The main insight offered by this survey is that, as more pieces of evidence are gathered from the different parts of Scandinavia, the less one can generalise about the Staffordshire Hoard in a wider perspective. It is safe to claim, however, that the relationship between the Scandinavian elite and their most prized belongings was volatile and thus highly ritualised. It is also certain that this intricate world connecting people and prestigious weapons was expressed in a rapidly changing symbolic language that will probably remain impossible to decipher. The latter realisation should serve to caution against all too deterministic interpretations of what really caused the Staffordshire Hoard to be assembled and deposited.

CHAPTER TEN

CHAPTER TEN

WHAT DOES IT MEAN?

TANIA DICKINSON, CHRIS FERN AND LESLIE WEBSTER

In this final chapter we seek to answer the big questions about the Staffordshire Hoard: what sort of assemblage was it? How was it brought together? Why was it buried? Ever since its discovery these questions have tantalised scholars and the public alike, but as the preceding chapters demonstrate there is a wide range of possible explanations and many uncertainties. There are also quite divergent opinions about how deposits of valuables should be understood in general, and about criteria for discriminating between such finds in the archaeological record.[1]

Richard Bradley defines a hoard as a 'collection of artefacts which were deposited in a group on the same occasion'.[2] Although in theory this separates deliberate acts from accidental single losses – or, indeed, from refuse accumulation – in practice distinctions may not always be so clear-cut. Equally problematic is the distinction drawn between hoards that were intended to be recovered and those that were committed for ever, a concept central to the old English law of treasure trove (but not now to the Treasure Act 1996).[3] The former are most often equated with stores of economically valuable possessions, such as coin or workable materials, which were buried for safekeeping but not recovered because of personal or political circumstances. The latter are explained as ritualised or 'special' offerings, and include both one-off deposits and accumulations over time, whether of individual items or groups.[4] These may express religious and superstitious beliefs about interactions with the supernatural, but also social attitudes about relationships in this world between people (and artefacts), thus overlapping in kind and purpose with deposits placed with the dead.[5] 'Safekeeping' hoards also embody social values, however. Simple distinctions thus mask the multiplicity and complexity of actual hoarding practice, and really reflect differing approaches to the interpretation of cultural behaviour as a whole.[6]

Two ways of exploring hoards are currently much favoured. One is detailed analysis of the objects themselves, with a focus on establishing their life history ('object biography')[7] and the processes behind their assembly. This approach has been applied to the Staffordshire assemblage in *Part One*, as far as has been possible, though its exceptional character means that parallels for the object-types from well-established contexts are limited. The second approach is to focus on patterns of repeated behaviour, in object-combinations and especially in the locations in which they occur, to understand processes of deposition. Here interpretation of the Staffordshire Hoard is handicapped by a lack of closely comparable deposits and by the very limited information on the immediate context.

THE EXCEPTIONALITY OF THE ASSEMBLAGE

Key characteristics

Since its discovery, the striking character of the Hoard has been repeatedly noted. Set out at length in *Part One*, its main features are worth restatement. First, it consists almost entirely of fragments of precious material. The broken and distorted condition of the objects can be attributed partly to the fragile nature of the material, especially the silver, and to a more limited extent to disturbance by ploughing, but mainly to deliberate dismantling prior to deposition.[8] Second, the collection is the result of a very high degree of selectivity: only objects or fittings made of gold or silver were chosen for deposition, with almost all the base metals that originally would have been constituent components removed and excluded. Third, the artefacts from which the finds were removed carried particularly distinctive cultural associations. Overwhelmingly they belonged to a male, and specifically a martial, sphere of action, including those objects which were part of Christian religious ritual.[9] The complete absence of objects from the female sphere of life is remarkable, given that this is abundantly represented in contemporary early Anglo-Saxon furnished burials, as well as among stray finds recorded by the PAS.[10] The overall mass of the precious metal and garnets, but more especially the overall quality

of the finished products – their high level of artistry and symbolic complexity – places this treasure trove at the pinnacle of seventh-century Anglo-Saxon society. The superlative nature of some items, such as the helmet, sword pommel **57**, the gold and garnet seax fittings and head-dress mount **541**, has led to suggestions that they belonged to the uppermost social level, arguably to kings or princes in the case of the first three and a bishop in the case of the last.[11] While not all the sword-hilts suggested by the fittings in the assemblage quite match this standard, they are very far from typical of swords known from burials, which nonetheless represent men of select social standing.[12] The inferred sword-hilts must reflect the possessions of very highly placed men, associates and members of royal retinues.

Altogether the Hoard is symbolic at the highest level, representing the powers – secular and spiritual – on which a seventh-century Anglo-Saxon king might depend.

Comparable assemblages?

Although a number of the object-types present in the assemblage are new to archaeology, and the functions of some remain to be confidently identified, on the whole the manufacturing techniques and decoration of the objects are familiar, with parallels in a range of contemporary Anglo-Saxon artefacts that are expressive of wealth and power. None of these, however, stems from contexts that match overall the complexion of the Hoard. The 'princely' male burials of late sixth- and seventh-century England are a major source of comparison, for example. They demonstrate the same high importance attached to armaments for warfare (and hunting) as does the Hoard, but they also regularly contain equipment for entertainment and, especially in their multiple vessels, for lavish feasting, items which are conspicuously absent from the Hoard (unless silver-sheet band **598** came, as suggested, from a drinking cup).[13] Moreover, these elite graves are monuments to individuals, with never more than one sword each, and rarely more than one shield,[14] whereas the number of sword-hilts represented in the Hoard marks it as a communal assemblage of the elite.[15]

Depositions of valuables outside burial are widely attested across late Roman and early medieval Europe, as the contributors to *Chapter 9* describe, but none offers a close analogy to the Staffordshire assemblage in terms of composition and context. The war booty sacrifices of southern Scandinavia strike an obvious chord of similarity in their massed deposits of damaged and dismantled military equipment. The watery locations, the evidence for repeated episodes of destruction and deposition over a wide area, and the overwhelming presence of iron weaponry differ from the Hoard situation, however. At the elite settlement complex of Uppåkra (Sweden), various dryland deposits of weaponry, spread over an area c 600 × c 750m near and beyond a long-lived 'cult house', might seem to offer better analogies.[16] Damaged iron spearheads of the third to fifth centuries were mainly involved, the majority in a single deposit, but there was also a broad scatter of dismantled sixth- and seventh-century weapon-fittings, including copper-alloy sword pommels and a few really prestigious items, such as helmet parts. Clearly these deposits related to a number of different occasions and circumstances, though what these were – re-deposited war trophies, residues of a military settlement and its workshops, or the rejected spoils of a battle on the site – is a matter of debate.[17]

Hoards of precious metals, found extensively within and beyond the Roman imperial frontiers, are characteristically composed from coin, un-minted bullion, prestige tableware (very occasionally Christian liturgical vessels) and jewellery (imported and/or locally made), but variously as complete objects or scrap metal and in diverse combinations that reflect time/space differences. Weapon-fittings were rarely included. These object-types are thus categorically different from those in the Staffordshire Hoard, but, like it, many of the hoards contain objects made over a lengthy period of time, which complicates dating their deposition and also, without good contextual information, explanation of their purpose. In Scandinavia, clear associations with high-status and cult centres have encouraged interpretation in terms of ritual deposits, with wealth deliberately removed from circulation for religious and social reasons.[18] This may be true too of continental hoards, although traditional explanations, driven by historical texts and a functional outlook, have tended to associate them more with economic wealth concealed in times of aggression.[19] Reassessment of the late Roman metalwork 'hoarding event' in Britain suggests that in this case, however, deposition was a response to the social and economic upheaval that accompanied the end of Roman rule and that changed the ways by which these prestige possessions could be accessed, controlled and used.[20] The hoards from Patching (Sussex), c 470, and Oxborough (Norfolk), c 475, lie at the end of this series.[21]

By contrast, in the next two centuries in England deliberate deposition of valuables outside burial became remarkably rare. A dispersed hoard found at Binham, near the north coast of Norfolk, contained at least six late fifth- to early sixth-century gold bracteates, a probable silver brooch and one gold and one copper-alloy bracelet (total gold wt. >104g), all damaged before deposition. It fits a Scandinavian model of votive hoards linked to elite centres.[22] Until recently the only other certain hoard was the striking assemblage found at Crondall (Hampshire), datable

to *c* 645: it contained at least 101 gold coins (Anglo-Saxon and continental *tremisses* plus three blanks); two gold fasteners, probably garnet-inlaid and possibly from a purse; and a small stone (inlay?), now lost.[23] Over the last few years, however, a large dispersed gold hoard has been coming to light from 'West Norfolk' (also known as 'Near Swaffham'), though full details have yet to be made public. It consists mainly of late sixth- and early seventh-century Merovingian *tremisses*, but also a crushed bracteate, possibly included as a 'make-weight'.[24] The integrity of other cases of two or more coins found together (the numismatic definition of a 'hoard') is less assured: a nineteenth-century find of at least ten *tremisses* (deposited *c* 530?) from the bed of the Thames at Kingston-on-Thames (Surrey) is now lost, but might be a candidate for a ritual deposit; the contexts of four *solidi* from Horndean (Hampshire) and three to six pale gold shillings from York (*c* 660–80) are uncertain; but the four unmounted seventh-century *tremisses*, three Merovingian and one Anglo-Saxon, found recently on two separate occasions near Chipping Ongar (Essex) almost certainly represent a dispersed hoard dating from the second quarter of the seventh century.[25] The relative paucity of gold-coin hoards compared with the growing number of fifth- to seventh-century single coin-finds in southern and eastern Britain seems to support the presumption that the latter are accidental losses. But whether all need be, and whether single precious-metal object-finds, such as parts from sword-hilts, are also accidental losses should be queried. Differences in kind – at least for most swords, bracteates and coins – between single finds and those known from graves make it unlikely that the former had mainly come from disturbed graves and leave open the possibility that some might have been individual 'special deposits' of a ritualised nature.[26] Finally, it should be recognised that throughout the Anglo-Saxon period weaponry was deposited in rivers and occasionally beside prehistoric monuments in a manner resembling prehistoric and Scandinavian ritual offerings, though nearly all of it was iron and, before the eighth century, mostly involved spearheads.[27]

Thus, although the Staffordshire Hoard resonates with aspects of other high-status and ritual deposits, it remains unique overall. This exceptionality must reflect the circumstances surrounding its creation, but makes recovering the details that much the harder.

TOWARDS A BIOGRAPHY OF THE STAFFORDSHIRE HOARD

Assembly

Reconstructing the Hoard's biography must start with the arguments for date and origins.[28] Some of the objects were veritable heirlooms from the sixth century, including the single imported piece (pommel **68** from Scandinavia), but the majority was made between the late sixth and mid-seventh century, with the stylistically latest suggesting deposition somewhere between *c* 650 and *c* 675. The stock of material from which the Hoard was drawn had thus been in a process of development for at least 100 years. Further, this development had encompassed several regions of the country: although seventh-century material culture is remarkably uniform compared with the strongly regionalised styles of the preceding two centuries, the metalworking and stylistic details of the Hoard material have enabled the outline of regionalised elite ('kingdom') production to be identified.

Significantly, the styles and forms of the objects differ in specific ways from the filigree and cloisonné metalwork well known from the kingdom of Kent. This includes the fact that the predominant group of sword-fittings with gold filigree are paralleled only by finds made north of the Thames, which suggests the manufacture of such hilt-furniture in an Anglian area (or areas), somewhere in eastern, midland and northern England (fig 6.7). Discriminating between sources within this zone is barely yet possible, though the range of options must include the kingdom of Northumbria. Strong affinities between much of the finest material in the Hoard, especially the cloisonné work assigned to *Hoard Phase 3*, and objects found in East Anglia point to that region as probably a major source, with workshops under East Anglian royal patronage or influence responsible for much of the ceremonial display gear – the helmet, the cloisonné seax, a putative saddle mount (**538**), the processional cross (**539**), the head-dress mount (**541**) and arguably some of the other large cloisonné mounts, whatever they actually fitted.

The many filigree sword-fittings of Cumberland-hilt type and the smaller number of sword-hilts in Early Insular style might indicate a third area of origin, arguably in greater Northumbria or among neighbouring British kingdoms, such as Rheged, though an origin further south for the Early Insular material is also conceivable, including possibly Mercia itself. There is little otherwise, however, at this date in Mercia to substantiate the development of a regional workshop style there, neither in the Peak District barrow burials of northern Mercia nor in the sparse distribution of Anglo-Saxon precious-metal objects which reached southern Mercia.[29]

How the Staffordshire Hoard formed must therefore have been cumulative, complex and, given the phases of production now detected in the assemblage, episodic. Although the point at which each object, or group of objects, joined what might be envisaged as

▶ Half of strip-mount **558** with gold and garnet cloisonné and a filigree serpent panel (not to scale). *Photograph*: D. Rowan; © Birmingham Museums Trust.

the Hoard's 'parent population' cannot be precisely known, let alone the contexts in which they did so, general understandings about the nature of early medieval kingship and the role of valuables in the late Roman and early medieval world allow us to perceive some of the circumstances controlling the process.[30]

While the political power of seventh-century kings depended ultimately on immoveable wealth – land and its human resources – without a developed system of taxation and administration their ability to marshal and control its outputs at any distance was severely limited, thus circumscribing the size and permanence of territories. In contrast, moveable wealth – treasure – was both storable and easily exchangeable. According to contemporary historical texts, treasure typically comprised gold and silver, gemstones, weaponry, horses, plate or vessels and prestigious clothing, items which in one guise or another characterise archaeological hoards. Most importantly, giving and receiving treasure signalled social worth and relationship, constructing the political bonds within and between kingdoms. Status, affiliation, obligation and hierarchy were expressed in the material, form and decoration of prestige objects, in the ceremonials of their gifting and in the associations that they accumulated through their lifetimes.

Most of the swords in the Hoard had probably been commissioned by kings or magnates; given to those newly taking up service in their retinue or already well established, as well as to esteemed affiliates, they signified members of the warrior aristocracy. The antiquity of the 'heirloom' pieces of *Hoard Phase 1* and the level of wear on some *Hoard Phase 2* pieces even allows for the possibility that some might have been returned to the giver to be given out again, or had been passed to an heir. Sequential ownership is also sometimes revealed by refurbishment and remodelling of the sword's composite structure, most strikingly by the addition or removal of a sword-ring, a probable symbol of loyalty to a leader. In the Hoard, however, such a specific modification, rather than more general repairs, is possibly indicated only by silver hilt-plates **372–3** (fig 2.22).[31] Other Hoard objects, such as the large mounts from putative saddles and those of uncertain function, could originally have been gifts sent, for example, as part of building alliances between kingdoms – through high-status marriages or children sent for fosterage – or in support of the Christian mission. Some items might be so intimately tied with a person or institution, however, that they would never willingly be alienated, or were circulated only within a very circumscribed context. The helmet above all might fall into this category, if, as seems plausible, it was constructed to embody the authority and dynastic origin myths of a king.[32] Likewise, although treasures, and especially objects necessary for the practice of the Christian faith, were gifted to and between religious foundations, they were not expected to be regularly recirculated.[33]

A king's ability to gift treasure presupposed his capacity to acquire it. But, unlike the late Roman imperial system,[34] early Anglo-Saxon kings lacked a peaceable means of getting back what they had given out. Their ultimate source of precious materials was either what could still be recycled from late Roman stocks in Britain or imported from the Continent and the Byzantine Empire beyond.[35] Either way supply would have been limited and dependent on what could be given in exchange (political obligation, commodities, slaves). Yet, as competition for regional and inter-regional dominance in late sixth- and seventh-century England intensified, so did the need to acquire, display and redistribute treasure in return for political and military support. So raiding and warfare were a dominant aspect of life: prestige objects and slaves for trading overseas – the fruits of war – could be taken as trophies, booty, tribute, payments in compensation and with or as hostages.[36] Depending on the context, the meaning of treasure changed – from alliance and obligation on the one side, to subjection and humiliation on the other.[37]

A 'last gathering'

In principle, there came a point when all the objects represented by the Hoard had come into existence. The lack of any items of definitely local manufacture also presupposes that there came a point when all had been brought into Mercia. But which, and how many, of the general mechanisms outlined above actually accounted for their arrival is hard to assess. With neither an exact date for the Hoard's deposition nor sufficiently precise historical information, the temptation to align the Hoard with a specific historical context would lead to circular argument, and must be avoided. Nevertheless, there is a remarkable coincidence between the estimated period in which the majority of the material accumulated (*Hoard Phases 3* and *4*) and the turbulent reign of King Penda of Mercia (*c* 626–55), on which Bede opens a small, almost certainly partial, window.[38] At least, it raises some general models.

An initial and most obvious model is a single military engagement.[39] It might even be speculated that a battle could have taken place close to the Hoard site, its elevated situation overlooking a major road and perhaps at the fringe of thin woodland,[40] with marshy ground below, being a fairly classic location for an early medieval battle or ambush.[41] In this scenario, the Hoard represents spoils taken from a field of battle. If the sword-hilts reflect the leading warriors present, their number and diversity would suggest an army made up of many contingents and drawn from several regions, as was the case at the battle of the *Winwæd* in 655, where Penda was supported by thirty magnates (including King Æthelhere of East Anglia), each commanding a war band.[42] The Christian religious

and ceremonial items in the Hoard would indicate that clerics were also present at the battle to mediate divine assistance.[43] The probably episodic accumulation of the Hoard, however, would favour not a single battle, but a series, and either way there is no evidence on the objects of damage certainly caused by weapons,[44] while many items of equipment that might be expected on a battlefield are clearly missing from the Hoard.

Rather than being personal possessions of fighters, the Hoard could indicate capture of royal treasure that was travelling with a king and his army:[45] the very utility of moveable wealth exposed it to diversion and misappropriation, as exemplified by the extended tribulations of the treasure collected in 584 as dowry for Rigunth, daughter of Merovingian King Chilperic and Queen Fredegund.[46] Alternatively, instead of acquisition through a pitched battle, the Hoard could have come from successful raids on the seats and treasuries of political rivals, or even on religious foundations, activities well documented at the time among both pagan and Christian kings, including of Mercia.[47] A generic description of the taking of treasure occurs in Felix's *Life of St Guthlac*, written c 730–40:

> But when he had devastated the towns and residences of his foes, their villages and fortresses with fire and sword, and gathering together companions from various races and from all directions, had amassed immense booty, then, as if instructed by divine counsel, he would return to the owners a third part of the treasure collected.[48]

Although the purpose of this hagiographical account is to show Guthlac in transition from aristocratic warrior to a soldier for Christ, it illustrates at least two elements that we can recognise in the Hoard: namely, the presence of warriors from different regions, and the amassing of significant treasure through warfare.

The absence of liturgical vessels, however, and perhaps also the abundance of weaponry, makes an ecclesiastical origin, at least as a single source, unlikely.[49] Another possibility is that the assemblage represents all or part of a tribute or compensation payment, taken after a successful encounter against another, probably Anglian, kingdom. The treasure known as the 'Restitution of *Iudeu*', given in 655 by King Oswiu of Northumbria to Penda, provides a provocatively apposite model, but would require some imaginative special pleading to be equated with the Hoard itself.[50] Finally, the material might simply have accumulated in Mercia over time, stored in a treasury or displayed as trophies in a hall, the fruits of several episodes of successful warfare as well as of the exchange of prestige goods with allies.

Final selection and disassembly

If charting in detail the stages by which the objects formed a notional 'parent population' and then eventually arrived in Mercia is impossible, so too is determining the sequence that led to their final deposition. What is clear, though, is that this too involved several stages – of selectivity and deliberate dismantling – which are critical to understanding the Hoard's overall significance.

The disassembly of the objects was crude but comprehensive and systematic.[51] Knives were used to cut, slice and lever, and tongs to grip and pull off fittings; sword pommels show more evidence of being levered and pulled off, whereas other fittings from the sword grip (collars, plates and small mounts) were more frequently just torn off, with a few indicating that the whole hilt was dismantled (table 4.3). The consistency with which fittings were taken apart is more likely to be the result of smiths undertaking the task than, say, soldiery on the field of battle. A workshop context for the dismantling might even explain how small balls of pure beeswax (which, unlike its other occurrences in fillers and backing pastes, had not been worked with other material) came to be among the assemblage (in soil block 17).[52] The random stamping on pommel **73** might also be because, after dismantling, a smith had used it as a test piece.[53] At the end of the exercise, it was smiths who would have had the necessary expertise to discriminate gold and silver from any gilded copper alloy, which seems to have been excluded with some rigour from the final collection.[54] After dismantling, most of the fragments apparently remained as they were, varying from crumpled to more or less intact, but a few were folded up, perhaps to facilitate packing.

Plainly, very few of the fittings could have been reused as they were; there was little possibility, for example, of recirculating the gold pommels by attaching them to new sword blades. At best their value had been reduced to bullion. In some late Roman silver and Scandinavian gold hoards, pieces of scrap metal correspond to fixed weights, suggesting that objects were cut up in order to facilitate redistribution of treasure according to economic value by weight.[55] The famous incident of King Oswald of Northumbria breaking up a silver dish for distribution to the poor may contain an echo of the practice.[56] Unfortunately, the composite structure and extreme fragmentation of the objects in the Hoard precludes discovery of whether that was so in this case. Nor can it be certain that the dismantling was a single event and that some, or even most, of the material was not already disassembled when it entered the 'last gathering', for example, as part of a treasure store rather than possessions on the person. However, the heavy wear on some objects from *Hoard Phases 1* and *2* implies that they had remained in use for quite some time, while the freshness of cut-marks and of

the gilding on some of the helmet parts implies no significant gap between their disassembly and burial.[57]

The conclusion would seem to be that the dismantled fragments were destined for the melting pot, to be refashioned into new prestige objects, but if so they were not 'crucible ready'. Although some garnets were loose (at least by the time the Hoard was discovered), many of the inlays were still *in situ*, and other items retained cores or liners of base metal; a few hilt-plates were still sandwiched together with their organic fill, and button-fitting **582** was retained with its stone-bead collar. There is certainly no evidence that any of the metal had already been melted. On this argument, the Hoard is simply a collection of material *en route* between a decision to 'de-commission' the parent objects and their ultimate recycling.[58]

These arguments overlook, however, the levels of selectivity involved. Although the archaeological research has been able to recompose many of the objects into sets representing whole artefacts, it is obvious that a considerable number of bits are missing. Unless these are all still in the plough-soil, it must be assumed that after dismantling there was a further stage of selection, whether hasty and random or deliberate, with perhaps some pieces from the treasure retained to be given out later, either as a form of currency or refashioned into new objects of gold or silver.

In fact, the *c* 4kg of gold and *c* 1.7kg of silver in the Hoard make it fairly modest by comparison with other archaeological finds. While it exceeds the *c* 1.6kg gold and garnet regalia from Sutton Hoo mound 1, none of its objects can individually match the weight of the great gold buckle from that grave (*c* 400g). The Hoard is also substantially outweighed by some continental and Scandinavian early medieval hoards, notably the supposedly 12.5kg of gold from Turcholm (Sweden) (figs 2.40 and 9.15). All these hoards pale in comparison, however, to payments purportedly made by late Roman and early medieval rulers.[59] For example, in the early 580s the Merovingian king Childebert II received 50,000 *solidi* from the Byzantine emperor Maurice Tiberius for taking military action against the Longobards;[60] at 72 *solidi* to the Roman pound (23.5 carat [4.7g] average weight per *solidus*) this would have been equivalent to *c* 235kg.[61] In 631 the Merovingian king Dagobert I received in return for his military support 200,000 *solidi* (equivalent to 940kg of gold) from the Visigothic king Sisenand.[62] This sum might be an exaggeration, because it was in lieu of a promised 500-pound gold *missorium* (equivalent to 36,000 *solidi*), but the fact that the Gothic nobles had vetoed alienation of the *missorium*, which had been gifted 200 years earlier to the Gothic king Thorismund by the Roman general Aetius, suggests that its value was far more than its bullion equivalent.

And the same can be said of the Staffordshire Hoard. Although quantitative modelling of the contemporary value of the Hoard postulates an equivalence with the economic resources of a 'modestly sized territory',[63] what is really significant is the exceptionally high symbolic value of the objects chosen for disassembly in the first place. These objects are unlikely to be a representative sample of a seventh-century treasury, let alone of what was brought to a battlefield. They are equally unlikely to have been selected for decommissioning and recycling because they were 'out-of-date', in style or relevance, particularly not the recently made Christian devotional objects. Rather, the objects represented here – the very large number of prestige swords, the helmet, the episcopal headdress, the cross, the possible reliquary, saddles and other large-scale display items – are a portrayal of the size and powers of a royal court, comparable to a parade. Their selection for dismantling was not just for recycling; it was ideologically driven. This might have been simply to prevent further circulation of a competitor's political capital (the counterpoint to gift exchange).[64] But defeat or displacement of a competitor might have required more overt deactivation and destruction of his symbolic property, the embodiments of his identity, authority and agency. Fern detects some acts of deliberate damage in the dismantling process: for example, the removal of the fish's head from bird-fish mount **538**, the snapping off of one arm from cross-pendant **588** and the comprehensive deconstruction – almost literally defacement – of the helmet.[65] Resonances with Scandinavian weapon sacrifices do not mean such behaviour must be attributed only to pagans, since seventh-century kings, pagan or Christian, had little compunction about sacking ecclesiastical foundations, and defeated Christians could be dismissed as inadequate or schismatic in their faith and so deserving destruction.[66] Royal treasure held particular significance when power was being transferred or a new king succeeded,[67] and shifting political and religious loyalties, within as much as between kingdoms, might have occasioned disposal of a previous regime's regalia. Treasures might even have become regarded as tainted because of associations with dynastic disaster or their involvement in long-running conflict: like the dragon's hoard in *Beowulf*, the only solution to their intrinsic danger was destruction. Without prejudice to the date of deposition of the Hoard, the politics of Mercia between the circumstances leading up to the battle of the *Winwæd* in 655 and the beginnings of a Mercian recovery under Wulfhere (acceded 658) provide provocative examples of the kind of inter-dynastic tensions that might have been at stake.[68]

The preceding argument is constructed in such a way as to admit that the final destruction of the assemblage might yet have been accomplished via the crucible. Indeed, the power of smiths to transform metal might offer further layers of symbolic meaning – by renewing artefacts, social wellbeing could be restored.[69] But

were that the case, the trajectory was clearly interrupted: we would be forced to imagine some precipitate emergency that led to the assemblage being incompletely (and hastily?) bagged up and then disposed of. Such a scenario might accord with the observation that the Hoard would fit into a satchel or modern shoe box,[70] though that has not been explicitly modelled in theory, let alone (obviously) tested in practice, and might be an underestimate had whole hilts been present; still, a horse's saddle-bag or two would be a fair assessment of volume. However, the attitudes detected in the selectivity and dismantling open up the possibility that the intended final fate of the assemblage had only ever been burial. To investigate the alternatives further we must turn to the context of deposition.

Burial

Unfortunately, knowledge of the Hoard's immediate context is constrained by the limited amount of post-discovery fieldwork that has so far been possible, and by its modest results.[71] Negative evidence must always be treated cautiously, of course, especially given that barely 0.65 per cent of the field in which the Hoard lay has been opened to excavation.

The finds lay entirely within the *c* 0.30m deep plough-soil, with no associated cut features observed. Individual locations are known for only 13 per cent of the fragments and then only to the 1m squares used in the excavation, but these suggest that objects were spread by the plough within a maximal area of 16 × 14m, with a core area 3–4m square (fig 1.24i).[72] Larger objects tended to be spread the most, whereas silver fragments, which dominated the 'soil lumps' retrieved by the metal-detectorist, were reportedly concentrated within a two-metre square and possibly represent the filtrate at the base of a container or pit. But the ploughing had obliterated any other evidence for the nature of the deposit and what might have sealed it. Although some separation of finds by type and material is feasible, no consistent patterns have been discerned in the distribution of fragments from the same object or in the co-association of fragments from different objects. The degree of intermixing in the material (items of gold lying among the silver in the soil blocks, for example) strongly supports its having been deposited on a single occasion and all together, and not successively over a period of time. The single fragment of linen from hilt-collar **126** might indicate that some items had been placed separately in a bag or wrapped, but the only other hint of a container is the folding of some of the objects.

The Hoard findspot lies towards the northern end of a north-west to south-east ridge (fig 1.4). On four separate occasions aerial photography has captured cropmarks at this point. The largest is an amorphous oval, *c* 50 × *c* 40m, but within its area two other images picked out two concentric features: these are equated with anomalies detected by the geophysical surveys and identified in excavation as natural ice wedges (figs 1.9 and 1.10). The Hoard was centred between the two ice wedges, but spread over them both. Although the cropmark images vary, and have been given different specific interpretations (the large oval as a 'ditch' and the two concentric rings as 'banks'), they are perceived as reflecting the same underlying feature(s).[73] The different signals might be due to the variable soil geomorphology encountered here.[74] There is no evidence, however, that they constituted a natural 'mound',[75] and certainly not a man-made one, but the stiff clay soil that filled the inner ice wedge (fig 1.10) could have supported distinctive vegetation on the brow of the ridge.[76] It would also appear that these natural conditions influenced the alignment chosen for the internal field boundary (the long curving ditch on fig 1.4) when the land was enclosed in the nineteenth century.

The only other evidence for activity in the field contemporary with the Hoard is the horse-harness mount **698**, which is stylistically akin to the latest objects identifiable in the Hoard. The findspot of the largest fragment, found by the metal-detectorist in 2009, is not known precisely, but the other two fragments were found in 2012 some 40m apart and some 40–50m east of the Hoard focal point (fig 1.25ii). It is possible that they had been spread by the plough downhill from the main assemblage, but the rarity of gilded copper alloy in the Hoard and the dispersal pattern of the main assemblage argue against this. If the mount is an accidental loss, as is often assumed for the many PAS finds of horse-harness, it could still imply that a seventh-century horseman of some social standing had visited the site, whether involved in the deposition of the Hoard, in a putative battle at the site, or for some other reason. If it was a deliberate deposition in its own right, however, it would put the site in a new light – as a place for repeated 'special' or ritualised deposits. Otherwise there are no clear indications of human activity in the field until it was enclosed for agriculture.[77] There is no evidence of human burial or of structures that might be associated with settlement, let alone cult practices, although traces of such activities could easily have eluded the fieldwork methods deployed to date.

At present it seems that the significance of the Hoard's location lies not in any historic use but in its topography (see map 1 and figs 1.2, 1.3 and 7.1). The key features are its position on a brow of a hill, whose poor soils perhaps supported distinctive vegetation, and overlooking Watling Street, the major Roman road which ran from London into Wales. The site possibly lay close to Watling Street's intersection with a routeway coming north-east from the Wolverhampton area, and certainly not far from

the former's junction at Wall with Ryknild Street, *the* route from the west Midlands north to Northumbria, as well as south to the Cotswolds.[78]

In other respects, the Hoard location is peripheral, environmentally, culturally and politically. This part of Mercia lay at the edge of Cannock Chase, an area of heathland and woodland resources throughout the Middle Ages, and probably before.[79] It also falls outside the areas of England characterised by early and middle Anglo-Saxon material culture, especially as represented respectively by furnished burial and by middle Saxon settlement sites and *sceattas*.[80] Nearly all the few PAS finds datable to the late fifth to seventh centuries from the immediate locality fall on the eastern perimeter of the zone surveyed by Goodwin, a 10km radius from the site (fig 1.2),[81] and this part of Mercia also fails to register in the burgeoning distribution of fifth- to seventh-century coins.[82] These patterns underscore the landlocked nature of the kingdom of Mercia in the early seventh century, as well as the cultural interface between Anglo-Saxons and Britons out of which it grew. And, as has been emphasised several times in this book, the Hoard site also sits marginally between smaller folk units from which Mercia was composed (fig 7.1): the *Tomsǣte* to the east, focused round Lichfield and Tamworth, by the late seventh and eighth centuries respectively the episcopal seat and a major stronghold of southern Mercia; the *Pencersǣte* (around Penkridge) beyond Cannock Chase to the west; and the royal estate (district) of *Wednesfeld* to the south west.[83]

The Hoard site can thus be perceived as on the fringe; yet at the same time it was accessible and, potentially, readily identifiable. Had a precipitate and secret burial of ill-gotten or ambushed goods been at stake, a remote spot would have been ideal, but that was not necessarily on offer here, even by depositing the Hoard on the side of the ridge that faced away from Watling Street.[84] The place in general could have been known and obvious. In fact, it was exactly the kind of place – 'out in the landscape' – that was suitable both as a gathering or meeting place and for the consignment of 'special' or ritual deposits.[85]

CONCLUSION: MULTIPLE EXPLANATIONS AND NARRATIVES

In the end it is impossible to be sure how and why the Staffordshire Hoard came to be. What has been suggested here is simply what seems most plausible at this stage of research; debate will undoubtedly continue to flourish, while different perspectives and new information will almost certainly change conclusions. The painstaking work of conservation and archaeological analysis has revealed the Hoard's quite remarkable composition and character, giving new substance to our picture of early Anglo-Saxon political, religious and cultural practice. At the same time, scholarly knowledge of the wider world from which it came provides a general understanding of the attitudes and behaviours which could have given rise to such an assemblage, and the contexts in which these occurred. What cannot be decided is what sort of hoard it was.

Was it an 'assemblage in transition', one stage in a process of selection, disassembly and reworking of objects culled from a larger collection that for some reason was arrested, leading to burial away from any settlement and, subsequently, to non-recovery? While an affirmative answer to the first part of this question can be made rationally and based on evidence, an answer to the second part requires the services of an historical novelist not an archaeologist or historian.

Or were the objects deliberately removed from circulation for ideological reasons of a political, religious or superstitious nature? That the Hoard is so far unique might seem to preclude an explanation based on ritual, since 'ritual' should mean repeated actions.[86] But that might be to expect too much of the archaeological record; after all, until about twenty-five years ago the only seventh-century gold sword pommel known in England was that in Sutton Hoo mound 1; now there are at least another seventy (a minimum of fifty-eight in the Hoard plus twelve from Treasure and PAS reports: fig 6.7). Also, archaeologists now take a more nuanced approach to ritualised behaviours, into which it is possible to fit the Staffordshire Hoard.

Nor can the Hoard be tied to a specific historical event. Apart from the methodological impediments, that the Hoard cannot be dated precisely and that information on Mercian history is sparse (and very much filtered through the eyes of Bede), the extraordinary constitution of the assemblage defies its being given a definitive biography, let alone one that satisfies historical conditions. At best, its formation and demise can be seen as reflecting a critical stage in the fierce competition and ideological accommodations that established the kingdoms of seventh-century England.

▶ Garnet cloisonné button-fitting **583** (not to scale), with dog-tooth bezel and filigree collar. *Photograph*: D. Rowan; © Birmingham Museums Trust.

AFTERWORD

AFTERWORD

THE IMPACT OF THE HOARD

Tania Dickinson, Leslie Webster and Chris Fern

When the Staffordshire Hoard was dug out of the ground in 2009, a new chapter in its biography opened: as a source of academic research and wider public knowledge about our past, and as museum exhibits for the enjoyment and education of the public. In this *afterword*, we consider its impact on Anglo-Saxon studies and on public engagement with the past, and reflect on what the research project has taught us so far and what might yet be learnt.

Impact on knowledge of the Anglo-Saxon world

In the *Introduction* to this book, we set out the questions, aims and challenges that the Hoard posed as this project began its journey to its conclusion. Some of these have been straightforward to answer, others much less so, and some have proved impossible – at least within the scope of the project. Future researchers will ask new questions, and find different answers. But it has been our primary aim to present the data as fully as possible here, to identify and address the fundamental questions surrounding the Hoard and its wider context, and to provide a firm basis which will stimulate and encourage future work. A colloquium is planned in 2019, after the book's publication, and its outcomes may add further refinements to what follows.

Despite its lack of an established context, the richness of the material in the Staffordshire Hoard and the complexities which lie behind it make the Hoard a landmark for Anglo-Saxon studies, similar in a way to the impact of the Sutton Hoo ship burial, discovered eighty years previously. Because so many of its contents embody new types of object and of decoration, it invites new ways of thinking about the existing corpus of Anglo-Saxon material culture, and about the wider society in which it had meaning and function. The Hoard will be a point of reference, discussion and investigation for decades to come.

This exceptionality has been a timely reminder of how dependent interpretation is on what survives into the archaeological record. Since the advent of the PAS, differences in artefact types and distribution patterns have become increasingly apparent between burial evidence, which continues to dominate the study of the early Anglo-Saxon period, and chance finds made, mainly, by metal-detection.[1] The latter imply a range of activities and contexts not represented in graves; many are probably part of day-to-day life in and between settlements, but the concurrence of so many remarkable objects in the Hoard alerts us to the existence of yet other behaviours and potential data. The importance of immediate professional investigation following such chance discoveries, if their full value to knowledge is to be realised, hardly needs emphasis.

Of the three orders of research questions outlined in the *Introduction*, the primary group, addressing the intrinsic nature of the Hoard – the nature of its contents and of their manufacture, the date of its burial and its immediate physical context – has been in some ways the most straightforward to respond to (*Chapters 1–6*). The most problematic of these – why was it assembled, why buried, and by whom – have undergone forensic examination in *Chapter 10* to identify and critique the various options available, and we have suggested some fresh ways of thinking about these issues, both in the light of *comparanda* discussed in *Chapter 9*, and of current theoretical thinking.

The outcomes of the third group of questions, relating to how the Hoard has affected the management of cultural heritage and its presentation to the public, are discussed at the end of this *Afterword*. It is, however, the second group of research questions, addressing what the Hoard might reveal about contemporary life and society in seventh-century Anglo-Saxon England, which has generated some of the most interesting results. Despite (and in some cases perhaps because of) their damaged condition, the quantity and variety of the Hoard objects have allowed significant new insights into early Anglo-Saxon craft and manufacturing processes (*Chapter 3*). For example, gold analysis has revealed hitherto unsuspected evidence for the deliberate and sophisticated manipulation of the surface gold content of some objects to enhance appearance. This has been observed both on early and later material from the Hoard, as well as on other selected Anglo-Saxon objects, suggesting a more

nuanced set of implications for our understanding of how gold was managed in a context of declining gold availability. Other new lines of enquiry are offered by the results of the trial programme of garnet analysis, which has identified for the first time a specific range of sources of raw garnets used in Anglo-Saxon goldsmiths' work that differed from those used elsewhere in western Europe, while the 'unidentified' inlay of other cloisonné objects remains an enigma for further research.

The range of forms, styles and decorative techniques displayed by these artefacts, particularly the sword fittings, has prompted recognition of probably regionally based elite traditions, with attendant implications for the understanding of military and other elite identities (*Chapters 2* and *6*). Probably the most important among these has been the characterisation of a new phase of possibly northern Anglo-Saxon art, here termed the Early Insular style. Characteristic of the tradition are extraordinary silver hilts (*endpiece*), their pommels cast with double sword-rings and decorated with typically dense interlace and a range of zoomorphic and other elements that have parallels in later Insular metalwork and manuscripts. Another group, composed of superbly crafted gold and garnet cloisonné artefacts, bears distinctive signatures which place it firmly within the orbit of the workshop(s) serving the East Anglian dynasty, represented in the Sutton Hoo mound 1 ship burial. Other artefact groups within the Hoard prompt reconsideration of the origin of some forms of decoration; the presence of so many filigree-decorated pommels and hilt-collars, for instance, presents a challenge to the conventional view that the ornament they carry is essentially Kentish, not least because not a single sword with such fittings has yet been found in Kent. The gilded silver helmet, patiently reconstructed from a myriad of fragments, though still incomplete, has its own new and particular story to tell about elite military culture, ancestral myth-making and the brutality of warfare and its aftermath in ways not accessible to us from the documentary sources, or from the evidence of high-status burial.

Not just the regionalisation but also the dating of art styles within the Hoard suggest modifications to existing readings of the evidence; in particular, it is suggested on the basis of the sequences established for the Hoard that the differences between 'Kentish' and 'Anglian' forms of Style II animal ornament are likely to be chronologically rather than regionally significant (*Chapters 5* and *6*). And as an example of how the dating of decorated objects in the Hoard might have impact on other disciplines, we cite two examples that link to manuscript studies. The great gold cross (**539**) is linked by its animal ornament directly to the Sutton Hoo mound 1 burial, of the 620s or 630s, and to the Book of Durrow, one of the earliest Insular illuminated manuscripts, which cannot be dated on internal evidence or by association, but is currently thought by most art historians and palaeographers to date to *c* 680. However, the dating evidence supplied by the cross's close link to the coin-dated burial at Sutton Hoo suggests that the conventional date for the manuscript deserves rethinking. Equally, the inscribed strip (**540**), probably a cross arm, is a uniquely early witness to the use of biblical texts to enhance and empower the artefacts of the Anglo-Saxon church in the conversion period, and also provides new dating evidence for the early use of Insular and continental scripts in England.[2] In both these cases, it is the overall assessment of the Hoard's date that now more securely anchors the manuscript chronology, not the reverse.

The impact of the Hoard on understanding of Anglo-Saxon political, religious and cultural history is reviewed in the contributions to Part Two. It gives dramatic substance to the emergence of Anglo-Saxon kingdoms in an atmosphere of fierce competition and extravagant display, illuminating the picture given by Bede, by the 'princely' burial mounds of the late sixth and early seventh centuries, and by grand settlement complexes like Yeavering and Lyminge. In particular, the Hoard has drawn attention in a new way to the value of gold and silver in the seventh-century economy, and has critically posed the question about how much was actually in circulation: combined with the growing body of single coin losses, the Hoard suggests that there was far more moveable wealth available than would have been envisaged from burial and settlement data.

More specifically, the Hoard has focused thought on the ways in which Mercia rose to be a major power in the seventh century, a process that is patchily recorded by Bede and poorly represented archaeologically. The Hoard's location has highlighted the distinction between Northern and Southern Mercia, made by Bede, and its correspondence with the different cultural contexts of the Peak District barrow-burials, on the one hand, and the early Anglian settlement of the Middle Trent, on the other: these now look like formative distinctions in the emergence of Mercia.[3]

The interdependence of early Anglo-Saxon kings and the personnel and institutions of the early English church is another theme well known from the pages of Bede, but the Hoard has given it an arresting concreteness. Its mixture of military and religious objects should not be surprising, yet the degree is unparalleled archaeologically. It throws into relief how close and complex the underlying human relationships were, whether in royal courts, in patronage of churches and on battlefields.

The total number of ecclesiastical objects in the Hoard remains uncertain, but the quality of those that can be recognised so far

is extraordinary. The Hoard has provided a first glimpse of some of the earliest religious equipment of the conversion-period church, highlighting the apparently precocious development of a specifically Anglo-Saxon Christian material culture. These remarkable objects – jewelled crosses, ark-like shrines and episcopal head-dresses – illuminate a new church in the process of inventing its outward and visible signs in ways that accommodate the old to the new; just as in a famous letter where Pope Gregory the Great advised the Roman missionary Mellitus to adapt the old pagan festivals and places of worship for use in the new Christian observance.[4] The consummate integration of 'pagan' Germanic and Christian motifs and iconography in this material reinforces understanding of how and why animal ornament could be retained beyond the seventh century as a trademark of Anglo-Saxon art.[5]

Finally, the artistic amalgamations visible in the objects may be paralleled by the behaviours that arguably can be inferred from the final treatment and disposal of the Hoard as a whole, as detailed in *Chapters 4* and *10*. These confront us with the likelihood that during the conversion period there was a far greater range of ritualised activity and heterodox ideas than has generally been allowed: the Hoard invites their investigation.[6]

Future research

The research project was designed to set out the character of the Staffordshire Hoard and to explore leading questions about its origin, date and deposition, but with a short delivery date and closely targeted budget. Although this programme has achieved much, it was made plain from the outset that it could not address all questions as fully as might be desirable, especially when so much depended on a painstaking but slow process of piecing back together thousands of fragments. As noted in the *Introduction*, our intention has been to provide as comprehensive and fully resourced an account of the contents of the Hoard as possible, to facilitate the work of future researchers. The presentation of data and images in the digital archive is intended to enable such work at a detailed level, without researchers necessarily or in the first instance having to handle the objects themselves.

Among some of the obvious research topics demanding attention are detailed analyses of the garnet work. At a preliminary stage, funding from the National Geographic enabled the British Museum and the two owning museums to take advantage of concurrent major research being undertaken in Paris on the sourcing of garnets; but there is clearly scope for a much more extensive examination, integrating studies of the technology of garnet cutting and cloisonné design and set within the wider perspective of European garnet usage currently being developed by the 'International Framework' consortium based in Mainz, and through the work of the Musée d'Archéologie Nationale and Centre de Recherche et de Restauration des Musées de France (C2RMF) in Paris.[7]

A physical replica of the helmet is underway as we write and may yield more insights on its unique structure and appearance, but there is particular potential for exploring fully the helmet's overall iconographic programme and its wider meanings. Other potential avenues of future research include extracting more information about the context of the Hoard from manipulating the data about the location and co-associations of the object fragments in the ground, and possibly further metal analysis, within a wider investigative programme on the manufacture of gold and silver early Anglo-Saxon objects. In this context, any further analysis of the gold will be directly comparable to our results, as both curating museums hold certified gold standards for calibration. The rare organic remains from the collection, furthermore, might in the future provide a means of scientifically dating some of the finds. Some questions, however, must await quite new campaigns of research. An obvious need is to understand far better the local context of the Hoard. There is a debate about whether a more extensive exploration of the immediate field context would deliver useful results.[8] Certainly, any such programme would need to be carefully thought through, financially and professionally. More immediately, as indicated in our *Introduction*, there must be scope to gain not only a better understanding of the wider landscape of this region, but also of the political geography of early medieval Mercia as a whole, drawing on developments in landscape archaeology as well as more traditional methods of documentary history and place-name studies.

Such suggestions are of course only indicative of the Hoard's research potential. In all of this, we have been conscious of the inevitable limits not only of our resources, but of our vision and understanding; we know that future researchers will frame questions never thought of here, and find answers we could never have envisaged. The ongoing story of the Hoard will be as fascinating as the narrative we have constructed so far.

▶ Silver pommel **71** with incised Style II serpent and quadruped ornament (not to scale). *Photograph*: D. Rowan; © Birmingham Museums Trust.

IMPACT ON PUBLIC ENGAGEMENT WITH THE PAST

Jenni Butterworth

An estimated 2.2 million visits have been made to see the Staffordshire Hoard on display since 2009. While the collection has drawn significant audiences on loan, both nationally and internationally, overwhelmingly those visits (around 90 per cent) have been made to venues in the West Midlands – that is, to Birmingham Museum & Art Gallery, The Potteries Museum & Art Gallery Stoke-on-Trent, Tamworth Castle and Lichfield Cathedral.[9] That this large audience for the collection existed at all is due to the owners' commitment to exhibition during the research and conservation phase, one honoured continuously since the acquisition, with the exception of just a few weeks in 2014 and 2016 to facilitate collection management and research.

Since its discovery, the Hoard has generated a substantial impact beyond the academic archaeological sphere, and this commitment lies at the heart of that developing legacy. Achieving continuous public display of the Hoard while simultaneously undertaking a lengthy and ambitious research and conservation programme presented quite a challenge, especially given the involvement of multiple venues and exhibitions. The Prittlewell assemblage, discovered in 2003 and of similar Anglo-Saxon date to the Hoard, is perhaps a more 'standard' model, being displayed only in brief temporary exhibitions during the research programme.[10]

Being largely precious metal and therefore relatively stable chemically and physically, the Staffordshire Hoard, unlike Prittlewell, presented an opportunity to exhibit unconserved items safely, allowing audiences to see them in their excavated state (generally the larger and more robust items, with objects assessed as fragile or in uncertain condition not included). The disadvantages of choosing to display the subject of an active research project were obvious and practical: delivering a coherent exhibition strategy with a mutable reservoir of objects required considerable investment on the part of museum staff, while for the research project, studying a collection located across multiple venues likewise presented significant logistical challenges.

The two 'grouping exercises', during which the entire collection was brought together in the conservation studio, proved vital in mitigating negative impact on the research project, allowing short but intense periods of assessment to identify or confirm joins and sets. Flexible displays, with minimal fixed interpretation and mounting to accommodate the inevitable object rotations and alterations – both physical and interpretive – were delivered by the museums in the early years of the research project. Even the first permanent Staffordshire Hoard gallery, opened at Birmingham in October 2014, continued to incorporate cases in which large numbers of objects could be displayed in their crystal storage boxes, a solution which not only delivered flexibility, but also conveyed the number and variety of the artefacts, as well as a sense of the conservation practice being conducted behind the scenes.

A short tour of three West Midlands venues (Shire Hall, Stafford, Lichfield Cathedral and Tamworth Castle) in 2011 provided a pilot for the tailored use of volunteers in this context. The Potteries Museum & Art Gallery led the recruitment of 'Hoard Hosts' to provide a general support function for visitors, but also to deliver fluid interpretation to supplement the limited fixed information, with curatorial briefings and a 'buddying' system for newer recruits to ensure individuals were prepared for questions and informed about the research. A high level of engagement with the subject matter and enthusiasm for the dynamic nature of the collection created a positive volunteer ethos popular with visitors, who often praised this in their feedback, as well as a sustained legacy for both individuals and institutions: the Hoard volunteer programme continues, with participants continuing to report high levels of personal development, and several have joined museum friends' groups and committees at both Tamworth Castle and The Potteries Museum.[11]

The regional tour was very successful and provided the foundation for two long-term loans to Lichfield Cathedral and Tamworth Castle alongside the permanent exhibitions at Birmingham and Stoke-on-Trent. The 2.2 million visits attest to the degree to which the decision to maintain the exhibition programme despite the practical drawbacks met a genuine public appetite, and has ensured that the profile of the collection has remained high within the region and attracted visitors to the host venues. The Staffordshire Hoard is a key asset for all of its West Midlands locations (seen by more than 20 per cent of visitors at all venues in 2016), and thus of significant benefit to the museums and wider visitor economy.

The regional tour in 2011 alone garnered 36,214 visitors, increased retail spend by 100 per cent at all venues and is estimated to have delivered an economic impact of more than £1 million in just nine weeks.[12] Undoubtedly this was an exceptional response to a new, high-profile discovery, but each venue has continued to attract high numbers of visitors, especially when exhibitions have been refreshed or the research programme has generated media interest. The new gallery at Birmingham attracted capacity figures during its initial weeks in 2014 and almost 100,000 visitors in its first six months, despite the collection having been on display near-continuously in four West Midlands venues for the preceding four years, while the Potteries Museum won a regional tourism award for their well-attended *Dark Age Discovery* exhibition celebrating the Cultural Olympiad in 2013.

Beyond the museums, the Staffordshire Hoard has had a wider impact for the owning cities of Birmingham and Stoke-on-Trent. Not only has it brought tourism to these cities, but it has also delivered considerable positive national and international press and media coverage. The early partnership established with National Geographic, which included an exhibition in Washington DC,[13] coupled with well-managed media relations, led to a number of high-profile television documentaries about the Hoard and the collection still regularly features or is referenced in broadcast news and documentaries.[14] As well as providing a key visitor attraction, the collection has also become a recognised part of each city's wider brand and identity and a source of influence for both artists and architects. For instance, the architectural design for a new banking headquarters being built in Birmingham is directly inspired by the Hoard.[15]

A significant benefit of the high profile maintained by the collection was that the museums were able to cultivate public access to the research process itself, and in particular the conservation. Field archaeology has a strong tradition of engagement with active projects, but museum conservation less so, although by 2010 a growing number of international initiatives were challenging this situation.[16] The Staffordshire Hoard conservation programme, based at Birmingham, was initiated and led by members actively engaged in the promotion of conservation as a public-facing discipline and thus was designed to deliver regular and intensive outreach, both directly and online, to regional, national and global audiences throughout the duration of the programme.[17]

An integral programme of placements for conservation professionals and students, as well as cross-disciplinary opportunities, was built into the Hoard conservation schedule, while for the general public, a programme of open lectures and talks, publications, conservation studio tours and 'glass wall' conservation events, family days, and written and video blogs was launched to allow engagement both directly and remotely.[18] The success of the conservation team in driving public engagement with the wider project, rather than simply delivering the conservation of the objects themselves, was recognised by two awards: the Archaeological Institute of America's Conservation and Heritage Award 2013,[19] and The ICON/Pilgrim Trust Award for Conservation 2015. Described by the ICON judges as 'the pin-up poster project of the sector', the Staffordshire Hoard received praise for its work to raise the profile of the discipline.[20]

Each of the Hoard venues has developed popular outreach and educational programmes, both formal and informal, focusing on the Hoard and its Anglo-Saxon context. To choose two examples: in 2013/14, twenty-seven different schools used the Hoard Gallery at The Potteries Museum for educational visits, while Birmingham Museum and Art Gallery saw a six-fold increase in school children participating in Staffordshire Hoard education sessions during the opening six months of the Staffordshire Hoard Gallery, and it continues to remain highly popular with schools.[21] Another significant achievement was *Treasure! The Discovery of the Staffordshire Hoard*, a 'pop-up' exhibition of replicas and interactives developed by Staffordshire County Council with Heritage Lottery Funding, inspired by a similar travelling exhibition created for the Hallaton Iron Age hoard,[22] and designed to visit schools and community venues unsuitable to host a loan of the original artefacts. In three years, the exhibition visited twenty-four venues, received more than 102,000 visitors and received overwhelmingly positive feedback.[23]

The strong regional partnerships that emerged in the immediate aftermath of the discovery continued to form an important strand of the Staffordshire Hoard programme after the acquisition. Heritage partnerships and collaborations at regional and national level were, of course, not a new or unusual concept. Indeed, both Birmingham and The Potteries museums themselves had been members of the West Midlands Archaeological Collections Research Unit from the 1970s to the 1980s, and this longstanding regional network, interestingly in this context, had been revived in 1991 and was successful in its bid to host one of the first regional pilots for the Portable Antiquities Scheme in 1997.[24] In the East Midlands, the Hallaton Iron Age hoard, acquired by Leicester County Council in 2007, provided a recent best practice model for national and local professional, governmental, academic and community groups working in partnership to excavate, research and exhibit an important treasure discovery.[25]

At the heart of the Staffordshire Hoard programme was the joint ownership of the collection itself, and the collaborations between the owning museums and a range of national and international partners and specialists to deliver the research project, but beyond that a further group of stakeholders was created. In August 2010, the Mercian (later Staffordshire Hoard) Trail was formed, bringing together the owners of the collection with the regional partners who had supported the acquisition, with the aim of facilitating the initial tour of the objects to West Midlands venues, and then more broadly to develop 'a permanent Mercian Trail across the region to help bring the story of ancient Mercia to life for residents, school children, students and tourists alike'.[26]

Thus, two long-term exhibitions were established at Tamworth Castle and Lichfield Cathedral, which, combined with the museum displays at Birmingham and Stoke-on-Trent, allowed the development of a regional interpretative strategy that embraced different aspects of the Hoard relevant to each location within an

Anglo-Saxon context, respectively warfare and kingship, belief, international connections and craftsmanship, and Mercian life. Beyond this, the Trail continued to support coordinated marketing and a strategic approach to the visitor economy and local growth, including maintaining the Staffordshire Hoard website, which acts as a primary portal for audiences worldwide wishing to access information about or visit the collection and which received 575,814 visits to March 2018.[27] The community exhibition mentioned previously was developed under the aegis of the Trail, and indeed the group has proved a successful vehicle for garnering funding from national bodies such as Heritage Lottery Fund and Arts Council England, who have expressed a strong interest in the partnership working it delivers.

The multiple-venue approach to the collection was queried early on, the suggestion being that as a single assemblage, it should perhaps be displayed as such to avoid 'obscur[ing] its archaeological value'.[28] While the concept of display of the collection as a complete entity is appealing, not just to archaeologists but to the public, as demonstrated by media interest in the 'grouping exercise',[29] the interpretation of elements of the collection across multiple venues with differing but relevant characters has encouraged the broadest possible examination of its 'meaning', while the varied audience profiles of those venues has arguably enabled it to reach a larger and more diverse audience of regional, national and international visitors than a single venue could provide.

However, the programme that has developed around the Staffordshire Hoard collection is undoubtedly a complex one: it has embraced a wide range of different stakeholders and individual personnel, and there have thus, inevitably, been times when not all of those relationships have progressed smoothly. Varying institutional aims and cultural practices have meant occasional conflicts as differing approaches to the programme have arisen.[30] However, the resolution of all parties to deliver the best outcomes for the collection and the public who donated so generously to its acquisition has fostered a collegiate environment and a series of mechanisms for resolving differences. In a challenging financial environment with increasingly limited resources, the partnership also provides valuable critical friendship, joint fundraising and shared skills, expertise and resources.

The enormous popularity of the Staffordshire Hoard and the accompanying surge in interest in the wider Anglo-Saxon history of the region invites exploration. From the first announcement at the Coroner's Inquest, the public and media reaction to the find was high, with the acquisition fundraising benefiting materially from high levels of public donation. Indeed, as the first national campaign for an archaeological treasure led by the Art Fund, its success has had a specific impact on the way in which similar campaigns are approached, and thus the nature of public ownership of heritage.[31] Moreover, the regional 'ownership' of the collection felt during the acquisition phase has proved to be an enduring phenomenon. The Staffordshire Hoard represents a significant example of the public's deep interest and pride in local and regional history, one echoed in community responses to a number of other recent treasure and archaeological discoveries, such as the Galloway Viking hoard, the Hallaton hoard and the Oxford Westgate excavations.[32]

Although data gathered in 2016 for a UK tour of the Staffordshire Hoard suggests that nationally, the public awareness of the collection has ebbed and flowed since the discovery, this is not something reflected in the visitor numbers and evaluation at the West Midlands venues, where awareness of the collection remains high, even with non-users.[33] Examining visitor figures from Birmingham and Stoke-on-Trent suggests that, although visitor figures peak as new exhibitions or marketing campaigns are undertaken, there is a core loyal audience at both venues, who continue to visit – and revisit – the collection regardless of external initiatives.[34] The importance of historical continuity to post-industrial communities has been noted by a number of scholars, and Capper and Scully specifically suggest that the exquisite craftsmanship exhibited on the Hoard objects may have contributed towards their importance to a locality with a strong history of skilled trades.[35] Certainly, pride in a discovery of international significance within the region, with optimism about its potential to encourage positive local socio-economic change based on shared historic past, is documented.[36]

It can be argued that the decision to exhibit soil-covered objects amplified and sustained initial interest in the collection, by fostering a culture of 'archaeological transparency' and encouraging the audience to share in the academic discovery and museum collections process. Visitor evaluation in the early years clearly indicated that release of new information about the Hoard was strongly appealing, with return visits to the displays encouraged by the rotation and physical alteration of the objects, accompanied by the development of the interpretation. A sense of partnership with the collection and the research, rooted in a feeling of authenticity and identification with the objects, was a powerful draw.

The ability of the Hoard to generate impact beyond a core archaeological or heritage audience is notable, and it is impossible here to adequately convey the scope of responses to the collection across many spheres. Enabled by the high level of information and images in the public domain as well as the museum displays, the public in the widest sense – professional, commercial, individual, academic and otherwise – has been inspired to celebrate the collection in many different media: jewellery, ceramics, replicas,

sculpture, architecture, performance, broadcast, prose and poetry, to name but a few. The exceptional craft quality and the lavishness of the Hoard is clearly a factor in generating intellectual, artistic and emotional response: the ability of the Hoard to stimulate audiences to consider 'what they value most' and why, is significant.[37] But the unusual nature of the burial and its Anglo-Saxon context is also important: the perceived mysteries about the deposition and the absence of a single authoritative explanation for it has provided a creative space in which multiple narratives inspired by the collection have been able to flourish.

Finally, the Staffordshire Hoard is, among many other things, a metal-detected find of considerable archaeological significance, and as such has contributed to discussion of the role of dramatic and amateur discoveries in archaeology.[38] The collection is just one of the very high number of metal-detected finds that are reported to the PAS annually, and, like the vast majority (over 80 per cent), discovered on cultivated land.[39] The initial recovery of the collection did attract some early criticism, and it is clear that some loss of data was sustained by the finder not reporting his discovery sooner,[40] but, despite this, the Hoard remains a demonstrably successful case for the Portable Antiquities Scheme and for modern Treasure procedures, which enabled prompt archaeological attention to the site and successful processing and acquisition of the find.[41]

Only a tiny fraction of reported metal-detected finds is of an exceptional nature like the Hoard, but the scale of their impact is significant. Cases like these provide a clear illustration of the various pressures such unexpected discoveries place on the regional and national archaeological, governmental and museum bodies, whose responsibility it is to ensure that the finds are appropriately recovered, researched and acquired for public and academic benefit.

In terms of the archaeological recovery and research, the Staffordshire Hoard benefited from one important factor: strong relationships leading to positive action on the part of local museums, the PAS, the British Museum and county archaeological officers. This enabled a rapid assessment of the discovery, and the soliciting of Historic England support for the investigation of the site. For complex finds that merit archaeological intervention, the communication link from finder and PAS onwards to the wider archaeological network is vital, but its effectiveness can vary on a case by case basis due to a number of individual factors.[42] The Staffordshire Hoard provides not only a good example of an effective collective response to an unexpected discovery, but also strong support for the development of a strategy to guide such a response in every case that merits it, as recognised by the PAS.[43]

In conclusion, the very early decision to place the collection on display during the fundraising and acquisition process, and to maintain public access during the research phase, has had far-reaching effects, for the museums themselves, for heritage fundraising and for the millions of visitors who might in other circumstances only recently have had access to the Hoard. The raised profile of the museums and the accompanying benefits for the disciplines of conservation and archaeological research are significant, and the programme has enabled the museums to explore fluid and flexible methods of display and interpretation, to which the public have responded enthusiastically. The community and engagement impact of the collection, particularly at regional level, has been exceptional, and the national and regional collaborations it has generated have been significant, as well as increasing the public profile of the owning cities.

With the completion of the research project, the initial phase of practical challenges, such as the fundraising and the balancing of the research and exhibition pressures, are over. However, at the time of writing, a new chapter with fresh challenges might be said to be opening for the Staffordshire Hoard, its custodians and audiences. The completion of the research project means the collection may in some ways be considered to have become 'less dynamic': although the exceptional nature of the Hoard and the questions about its deposition are unlikely to diminish, and new research initiatives are highly likely, the mysterious and evolving narrative so popular with audiences will to some extent be superseded by the results of this research.[44] At a basic level, the oft-quoted and unknowable 4,000-plus fragments have become a thoroughly quantified catalogue of 698 entries, accompanied by authoritative, if not always concurrent, explanation. The museum engagement programme, previously fed by an active research and conservation project, will need to sustain audiences using a narrative that refreshes less often, while maintaining the sense of public partnership fostered with the collection.

National partnerships were created in the course of the research project, but at the heart of the museum programme is a series of local and regional partnerships – something very much lauded at their inception.[45] Those institutions and partnerships face increasing pressure brought about by a growing climate of austerity. However, the success of the Staffordshire Hoard programme so far provides a clear example of how a history of joint working by the museums has borne considerable fruit, and the benefit of such partnerships and projects to the sector more widely, and it is hoped that the strength of these relationships will continue to sustain and grow the profile of the collection and the Anglo-Saxon heritage of the region.

PART III

THE ABBREVIATED CATALOGUE

CATALOGUE IMAGES

PART III | THE ABBREVIATED CATALOGUE

1 2 3 4

5 6 7 8

9 10 11 12

13 14 15 16

0 10 20 30 40mm

CATALOGUE IMAGES | 1–32

17
18
19
20

21
22
23
24

25
26
27
28

29
30
31
32

0 10 20 30 40mm

PART III | THE ABBREVIATED CATALOGUE

33 34 35 36

37 38 39

40 Core 41 42

43 44 45 46

0 10 20 30 40mm

CATALOGUE IMAGES | 33–63

47 48 49 50

51 52 53

54 55 56 57

58 59 60 61 62 63

0 10 20 30 40mm

380 | PART III | THE ABBREVIATED CATALOGUE

64

65

66

67

68

69

70

71

72

73

74

75

76

Core

0 10 20 30 40mm

CATALOGUE IMAGES | 64–92

77

78

79, 84

80, 81, 83

82

85

86

87

88

89

90

91

92

0 10 20 30 40mm

382 PART III | THE ABBREVIATED CATALOGUE

93

94

95

96

97

98

99

100

101

102

103

104

105

106

0 10 20 30 40mm

CATALOGUE IMAGES | 93–121

107 108 109 110

111 112 113 114

115 116 117

118 119 120 121

0 10 20 30 40mm

122 123 124

125 126 127

128 129 130 131

132 133 134 135

0 10 20 30 40mm

CATALOGUE IMAGES | 122–48

136

137

138

139

140

141

142

143

144

145

146

147

148

0 10 20 30 40mm

385

386 PART III | THE ABBREVIATED CATALOGUE

149

150

151

152

153

154

155

156

157

158

159

160

161

162

0 10 20 30 40mm

CATALOGUE IMAGES | 149–80

163
164
165
166
167
168
169
170
171
172
173
174
175
176
177
178
179
180

| 181 | 182 | 183 | 184 |

| 185 | 186 | 187 | 188 |

| 189 | 191 | 192 | 193 |

| 194 | 195 | 196 |

0 10 20 30 40mm

CATALOGUE IMAGES | 181–210

197

198

199

200

201

202

203

204

205

206

207

208

209

210

PART III | THE ABBREVIATED CATALOGUE

211

212

213

214

215

216

217

218

219

220

221

222

223

224

0 10 20 30 40mm

CATALOGUE IMAGES | 211–46

225 226 227 228

229 230 231 234

235 236 243

244 245 246

0 10 20 30 40mm

392 PART III | THE ABBREVIATED CATALOGUE

247

248

249

250

251

252

253

254

255

256

0 10 20 30 40mm

CATALOGUE IMAGES | 247–68

257

258

259

260

261

262

263

264

265

266

267

268

0 10 20 30 40mm

394 PART III | THE ABBREVIATED CATALOGUE

269 270 271 272

273 274 275 276 277

278 279 280

281 282 283 284

0 10 20 30 40mm

CATALOGUE IMAGES | 269–96

285

286

287

288

289

290

291

292

293

294

295

296

396 PART III | THE ABBREVIATED CATALOGUE

297

298

299

300

301

302

303

304

305

306

307

308

309

310

311

312

0 10 20 30 40mm

CATALOGUE IMAGES | 297–326

397

313

314

315

316

317

318

319

320

321

322

323

324

325

326

0 10 20 30 40mm

398 PART III | THE ABBREVIATED CATALOGUE

327

328

329

330

331

332

333

334

335

0 10 20 30 40mm

CATALOGUE IMAGES | 327–51

336

337

338

339

340

341

342

343

344

345

346

347

348

349

350

351

0 10 20 30 40mm

400 PART III | THE ABBREVIATED CATALOGUE

352 353 354 355 356 357 358

359 360 361

362 363

364

365

366

0 10 20 30 40mm

CATALOGUE IMAGES | 352–77

367

368

369

370

371

372

373

374

375

376

377

402 PART III | THE ABBREVIATED CATALOGUE

378 379 380 381

382 383 384 385

386 387 388 389

390 391 392 393

0 10 20 30 40mm

CATALOGUE IMAGES | 378–421

Upper Guard **Lower Guard**

409

410 **411** **412** **413**

414 **415** **416** **417**

418 **419** **420** **421**

404 PART III | THE ABBREVIATED CATALOGUE

422 423 424 425 426 427

428 429 430 431 432

433 434 435 436 437

438 439 440 441

CATALOGUE IMAGES | 422-57

442

443

444

445

446

447

448

449

450

451

452

453

454

455

456

457

PART III | THE ABBREVIATED CATALOGUE

458 **459** **460** **461**

462 **463** **464** **465**

466 **467** **468** **469**

470 **471** **472** **473**

0 10 20 30 40mm

CATALOGUE IMAGES | 458–89

474
475
476
477
478
479
480
481
482
483
484
485
486
487
488
489

0 10 20 30 40mm

408 | PART III | THE ABBREVIATED CATALOGUE

490

491

492

493

494

495

496

497

498

499

500

501

502

503

504

505

0 10 20 30 40mm

CATALOGUE IMAGES | 490–526

506 507 508 509

510 511 512 513 514 515

516 517 518 519 520 521

522 523 524 525 526

0 10 20 30 40mm

410 PART III | THE ABBREVIATED CATALOGUE

527

528

529

530

531

532

533

534

535

536

537

538

CATALOGUE IMAGES | 527–49

539

540

541

542

543

544

545

546

547

548

549

0 20 40mm

412 | PART III | THE ABBREVIATED CATALOGUE

550

551

552

553

554

555

0 10 20 30 40mm

CATALOGUE IMAGES | 550–8

556

557

558

0 10 20 30 40mm

414 PART III | THE ABBREVIATED CATALOGUE

559

560　　**561**

562　　**563**　　**564**

565　　**566**

CATALOGUE IMAGES | 559–71

567

568

569

570

571

0 10 20 30 40mm

572 573 574 575

576 577 578 579

580 581 582/4 583

585 586 587 588

CATALOGUE IMAGES | 572–93

589

590

591

592

593

0 20 40mm

594

595

596

597

CATALOGUE IMAGES | 594–603

598

599

600

601

602

603

420 PART III | THE ABBREVIATED CATALOGUE

604

605

607/8

611

612

613

614

CATALOGUE IMAGES | 604–85

615

616 **617** **618** **621**

676 **677** **678** **679**

680 **681** **684** **685**

687 **688** **692**

696 **698**

Fragments not illustrated – (for images see online database):

190, **232-3**, **237-42**, **394-408**, **697**, **606**, **609-10**, **619-20**, **622-75**, **682-3**, **686**, **689-91**, **693-5** and **697**.

CATALOGUE ENTRIES

▼ Pommels in gold (1–20).

POMMELS IN GOLD

Cat.	(mm)	(mm)	(mm)	Wt (g)	AuWt%†	Objects	Description	Wear	Set	K-numbers	Grid
1	45	19	16.5	32.74	-	1	Cocked-hat form, filigree. Style II on sides/shoulders. Triple rivet-housings. Copper-alloy core.	M	87-8	280	-
2	42.5	14.5	15.5	15.33	81·3%	1	Cocked-hat form, filigree. Style II on sides/one shoulder, including quatrefoil; interlace on other shoulder. Copper-alloy core with iron tang fragment. ?Tool flattening.	H	85-6	457	-
3	29	23	13	8.14	-	1	Cocked-hat form, filigree. One half crushed. Style II on sides; shoulders have interlace.	H	-	1030	O10
4	40	16	17	14.49	81·3%	1	Cocked-hat form, filigree. One side spread (?levered, cut mark). Identical Style II on sides/shoulders, including quatrefoils. ?Tool flattening. Wax core-filler.	H	-	455	-
5	46	12.5	20	11.30	71·3%	1	Cocked-hat form, filigree. Missing one end. Style II on sides/shoulders, including quatrefoils.	M	89-90	309	-
6	44	13	17	14.19	-	1	Cocked-hat form, filigree. Style II one side with quatrefoil; interlace other side with stafford knot and on shoulders.	M	-	558	-
7	45	20.5	18	13.20	-	1	Cocked-hat form, filigree. Twisted. Style II one side/shoulders; interlace other side.	H	-	664	-
8	43	14	19.5	8.57	69-79%	1	Cocked-hat form, filigree. Sides pinched. Style II on sides; triquetras one side; scrollwork on shoulders. ?Tool flattening.	H	-	686	-
9	46	18	16	11.33	75·6%	1	Cocked-hat form, filigree. End flattened, misshapen. Style II and interlace on sides/shoulders.	H	-	375	-
10	39	13.5	19.5	10.37	-	1	Cocked-hat form, filigree. Missing one end, side pushed in (?levered). Style II on sides; stafford knots on shoulders. ?Tool flattening. Calcite core-filler.	M	-	359	-
11	38.5	10.5	19	9.04	80·3%	1	Cocked-hat form, filigree. Found in 3 fragments, twisted. Style II and stafford knots on sides; interlace on shoulders.	M	-	585, 714	-
12	46	12	16.5	10.85	52·4%	1	Cocked-hat form, filigree. Style II sides/shoulders. Impact/?tool flattening.	L	-	669	-
13	37.5	17	-	6.69	-	1	Cocked-hat form, filigree. Missing ends, sides torn. Style II one side, interlace (?Style II) the other side; herringbone banding on shoulders.	M	-	693	-
14	48	17.5	20.5	32.21	-	1	Cocked-hat form, filigree. Style II serpents on sides/shoulders. ?Tool flattening. Copper-alloy core.	H	-	353	-
15	42	13	15.5	7.84	-	1	Cocked-hat form, filigree. Style II serpent each side; collared granules on shoulders. Single rivet-housings at ends.	H	-	287	-
16	40	11	20	15.90	-	1	Cocked-hat form, filigree. Style II on sides; interlace on shoulders.	L	-	1200	J8
17	37.5	17	16.5	6.69	-	1	Cocked-hat form, filigree. Missing one end, sides/end misshapen. Style II on sides, saltire one side; herringbone fills shoulders. Wood in interior.	M	-	1097	L10
18	38.5	17.5	17	11.62	-	1	Cocked-hat form, filigree. Style II on sides; collared granules and herringbone banding on shoulders. ?Tool flattening.	M	-	393	-
19	40.5	20	18	16.06	-	1	Cocked-hat form, filigree. End pushed in, edge ragged (?levered). Style II on sides; herringbone pattern fills shoulders. Silver core.	L	-	710	I12
20	45.5	11	20	11.91	-	1	Cocked-hat form, filigree. Torn end, sides squashed. Style II on sides; herringbone banding on shoulders. Impact/?tool damage.	M	-	460	-

CATALOGUE ENTRIES | TABLES 1–38

▼ **Pommels in gold (21–38).** † — values from core metal, rounded-off (cf. Blakelock 2014); ? — possible/uncertain'; Wear — H (heavy), M (moderate), L (light)

Cat.	(mm)	(mm)	(mm)	Wt (g)	AuWt%†	Objects	POMMELS IN GOLD	Wear	Set	K-numbers	Grid
21	32.5	13	18	7.81	-	1	Cocked-hat form, filigree. Missing ends, side pushed in. Style II one side; arched herringbone band and bands of collared granules other side; herringbone fills shoulders.	M	-	1278	N12
22	39	19	18.5	12.93	64-72%	1	Cocked-hat form, filigree. Edge bowed out and ?tool flattened. Style II serpent each side; interlace on shoulders.	M	-	381	-
23	45	12.5	18	11.84	-	1	Cocked-hat form with filigree. Missing end, dented base. Strip work and herringbone banding on sides/shoulders (Style II cornered heads on sides).	M	-	293	-
24	44	12.5	14	11.75	-	1	Cocked-hat form, filigree. Sides dented. Interlace on sides. Herringbone band over the apex/shoulders. Calcite core-filler.	M	-	307	-
25	46	10	16.5	9.96	-	1	Cocked-hat form, filigree. Missing one end, one side dented (?levered). Interlace on sides, with collared granules one side; shoulders filled by figure-of-eights.	H	-	717	-
26	27	42	-	9.19	71-3%	1	Cocked-hat form, filigree. Missing one end and rolled. Interlace on sides/shoulders. Hilt-plate tip soldered to end.	M	-	276	-
27	52	15.5	20	25.08	-	1	Cocked-hat form, filigree. Interlace on sides/shoulders, with annulets and figure-of-eight. Apex has herringbone fill. ?Tool flattened. Copper-alloy core.	M	?105-?106	299	-
28	40	12	19	9.85	-	1	Cocked-hat form, filigree. Found in 3/?5 fragments; parts of sides and one end missing. Interlace on sides and shoulders.	M	-	650, 1252, 1255, ?1123	M6, N9, N10
29	47.5	12	18.5	7.97	-	1	Cocked-hat form, filigree. Missing ends, twisted. Interlace on sides; collared granules on shoulders. Calcite-wax core-filler.	L	-	701	-
30	43.5	10	19	15.36	78-9%	1	Cocked-hat form, filigree. One side pushed in (?recent/tool). Interlace on sides/shoulders.	M	-	1004	K10
31	41	12	15	6.94	58-63%	1	Cocked-hat form, filigree. Missing part of one end, side dented (?levered). Interlace on sides/shoulders.	M	-	88	K10
32	39	17	21	10.31	68-70%	1	Cocked-hat form, filigree. Quasi-zoomorphic interlace on sides/shoulders. Apex dented and flattening by ?tool. Wax core-filler.	L	-	458	-
33	44	7	26	15.42	70-8%	1	Cocked-hat form, filigree. Missing ends, twisted. Quasi-zoomorphic interlace on sides with quatrefoil; interlace on shoulders.	L	-	697	-
34	49	17	16	9.79	-	1	Round-back form, filigree. One end bent up (?levered), side pushed in. Style II on sides; collared granules on shoulders.	M	-	553	-
35	31	23	16	9.25	76-9%	1	Round-back form, filigree. Missing ends, sides spread. Style II on sides; interlace on shoulders.	H	-	1073	M10
36	40.5	22	14	10.45	80-2%	1	Cocked-hat form. Side dented, end twisted. Filigree Style II one side with quatrefoils, and on shoulders. Garnet cloisonné frame with filigree Style II in panels on other side. ?Tool flattening. Wax (with calcite) core.	H	-	352	-
37	44	13	14	6.90	-	1	Round-back form. Missing ends, sides spread. Filigree interlace one sides and Style II on shoulders; other side has a garnet cloisonné panel with saltires, and panels of filigree collared granules.	M	-	1228	M9
38	44	16	21	10.21	-	1	Cocked-hat form. One side pulled out (?levered, cut mark). Filigree Style II and cloisonné panel with saltire one side; filigree interlace on other side and shoulders.	L	-	666	-

▼ Pommels in gold (39-54).

Cat.	(mm)	(mm)	(mm)	Wt (g)	AuWt%†	Objects	POMMELS IN GOLD	Wear	Set	K-numbers	Grid
39	44	15	22	10.96	78-83%	1	Cocked-hat form. Missing ends. Filigree interlace both sides, a cloisonné panel with cross one side, and collared granules on shoulders.	M	-	349	-
40	50.5	21	17	21.58	75-6%	1	Cocked-hat form. Sides misshapen. Cloisonné one side; filigree interlace on other side and shoulders. Square gem-setting (empty) at apex. ?Tool flattening. Copper-alloy core (loose).	H	-	680	-
41	42.5	17.5	14	11.75	66-70%	1	Cocked-hat form. End torn, sides spread, with ?tool mark (?levered). Garnet cloisonné one side with cross, and on shoulders. Filigree interlace with collared granules on other side.	M	-	465	-
42	46	9.5	18	11.21	77%	1	Cocked-hat form, filigree. Interlace on sides/shoulders; an empty gem-setting one side, a quatrefoil on other side. Flattening from ?tool. ?Calcite core-filler.	M	-	554	-
43	38.5	19.5	16	9.51	70%	1	Cocked-hat form, cloisonné. Missing ends, sides spread. Geometric cellwork, shoulders have mushroom forms.	H	-	360	-
44	45	10	-	8.23	-	1	Cocked-hat form, cloisonné. Twisted, missing ends. Geometric cellwork, including mushroom and arrow forms.	H	-	572	-
45	50	13	24	15.82	-	1	Cocked-hat form, cloisonné. Missing sides, 3 joined fragments. Shoulders have stepped cellwork. ?Tool scratches.	?L	-	401, 1018, 1025	N7
46	42	17.5	20	24.02	81%	1	Cocked-hat form, garnet cloisonné. One end rejoined. Sides show abstract facemasks with central mushroom cells and eye-shaped stones; shoulders include mushroom forms also. Dents and cut mark one edge (levered?).	L	280-1, 629	1160, 1272	N12, O14
47	45	15.5	19.5	15.66	-	1	Cocked-hat form, garnet cloisonné. Twisted. Geometric cellwork, including mushroom quatrefoils and other hidden crosses. Calcite-wax core-filler.	L	159-60	1195	K13
48	36	12	16	9.40	-	1	Cocked-hat form, garnet cloisonné. Geometric cellwork, including mushroom quatrefoil. Filigree rivet-housings.	M	-	715	J12
49	45	20	17	20.97	70%	1	Cocked-hat form, garnet cloisonné (repair: 2 cells red glass). Geometric cellwork, including mushroom forms and crosses. Filigree rivet-housings.	M	499-502	674	-
50	45	14	18	16.00	77-85%	1	Cocked-hat form, garnet cloisonné. Missing one end. Geometric cellwork, including mushroom and fishscale patterns. Apex marked by ?tool. Edge damaged (?levered).	L	?163-?164	292	-
51	46	12	19	16.98	-	1	Cocked-hat form, garnet cloisonné. Fishscale cellwork on sides; mushroom cellwork on shoulders. Wood core, calcite-wax core-filler.	M	-	452	-
52	53	14	21	19.08	72%	1	Cocked-hat form, garnet cloisonné. One end twisted off (rejoined) Enclosed rivet-housings. Style II one side, beaks at ends. Arches other side, crosses at ends. Shoulders have mushroom cellwork.	L	-	284, 327	-
53	32.5	14	17.5	20.31	71-96%	1	Cocked-hat form, garnet cloisonné. Sides damaged, ends detached (3 fragments, joined). Style II one side with *millefiori* square. Mushroom ?quatrefoil on other side. Rivets cut.	?L	165-6	145, 808, 1167	O12
54	40.5	21	20	17.40	-	1	Cocked-hat form, cloisonné. One side spread (?levered). Different Style II each side. Shoulders include cross and mushroom cellwork. Filigree rivet-housings.	L	-	355	-

▼**Pommels in gold (55-62)** and **silver (63-70)**. † — values from core metal, rounded-off (cf. Blakelock 2014); ? — possible/uncertain'; Wear — H (heavy), M (moderate), L (light)

Cat.	(mm)	(mm)	(mm)	Wt (g)	AuWt%†	Objects	POMMELS IN GOLD	Wear	Set	K-numbers	Grid
55	29.5	12.5	11	9.74	70·3%	1	Miniature cocked-hat form, garnet cloisonné. Identical geometric cellwork each side with hidden Style II. Apex/shoulders have rectangular garnets. Base torn open, ?blade scratch (levered).	L	167-9, 225	376	-
56	32	7	17	6.90	70·6%	1	Round-back form. Missing ends. Identical incised Style II both sides with niello. Filigree herringbone band on shoulders. ?Tool marks on sides.	L	-	347	-
57	60	15	27	44.23	82·95%	1	Cocked-hat form. Torn end, sides pinched, cut mark to edge. Enclosed rivet-housings (one rivet cut). Cast, almost identical Style II animal decoration each side, framed by imitation wire, including: a boar head each side of the apex with a pair of Style II creatures incised centrally beneath; 'wolf' heads at the ends flanked by flat bird heads; further heads surmount the wolf heads. Two panels each side have nielloed lines.	L	-	27, 358	J12
58	18.5	7.5	-	2.06	-	1	Small part, 2 fragments: apex and shoulder only. Filigree interlace.	L	-	1430, 1466	-
59	17.5	8	10	1.07	-	1	End fragment and small part of side: paired rivet-housings. Filigree, scrollwork and interlace.	M	-	1093	M11
60	13	5	5	1.26	-	1	End fragment: paired rivet-housings. Filigree, herringbone pattern. 1 rivet, cut.	M	-	1401	-
61	10	4	4	0.83	-	1	End fragment: paired rivet-housings. Filigree, herringbone pattern. 2 rivets, cut.	L	-	1832	-
62	12	7.5	5	0.60	-	1	End fragment: paired rivet-housings. Filigree, herringbone pattern and scroll.	M	-	1833	-

Cat.	(mm)	(mm)	(mm)	Wt (g)	Au%Wt†	Objects	POMMELS IN SILVER	Wear	Set	K-numbers	Grid
63	56	16.5	19	27.77	-	1	Cocked-hat form, filigree. Sheet cap partly missing. Interlace with cross one side; interlace with round gem-setting (empty) the other. Figure-of-eights on shoulder. Filigree flattened by ?tool. Silver core.	M	-	306, 1826	-
64	39	13.5	16	10.81	-	1	Cocked-hat form, cast. Gilded double-line framing, triangular garnet setting one side. Cut mark on shoulder. Edge dented (?levered).	H	-	286	-
65	39.5	12	16	8.18	-	1	Cocked-hat form, cast. Small part of edge missing (?levered). Single-line framing. Gilding (from analysis).	M	-	827	-
66	48.5	13	19	17.27	-	1	Cocked-hat form, cast. Gilded single-line framing. Cut mark on shoulder.	M	-	456	-
67	43.5	14	19	19.35	-	1	Cocked-hat form, cast and plain. Dent each side below apex from ?tool.	L	-	559	-
68	49	16	18	19.87	-	1	Cocked-hat form, cast, gilded with niello. Triple rivet-housings one end, two the other end. Style II: bearded head with animal legs one side; zoomorphs and boar heads on other side. Shoulders have interlace.	H	?82	711	L12
69	47	10.5	15	9.37	-	1	Cocked-hat form, cast, gilded with niello. 2 fragments joined, missing one side, damaged edge (?levered). Style II on side and possibly shoulders. Flattening from ?tool.	M	?186-?187, ?533-	39, 1007	J12, M11
70	23	13	13	2.57	-	1	Fragment, apex and part of sides/shoulders. Cocked-hat form, cast, with Style II each side.	L	-	150	-

428 — PART III | THE ABBREVIATED CATALOGUE

▼ Pommels in silver (71–8).

Cat.	(mm)	(mm)	(mm)	Wt (g)	Au%Wt†	Objects	POMMELS IN SILVER	Wear	Set	K-numbers	Grid
71	31	22	15	10.43	-	1	Round-back form, cast. Band with boar heads and incised Style II decoration. 3 joined fragments. Gilded (from analysis). Dent to edge (?levered).	L	189, 605	514, 1684, 1901	-
72	48.5	14.5	21	17.12	-	1	Round-back form, cast and plain. Found in 4 fragments (3 joined), part of side and one end missing. Possible rune one side. ?Tool mark on shoulder.	L	-	240, 1447, 2092	-
73	52	14	14	22.35	69–71%	1	Round-back form, cast. Gilded interlace one side. Other side has a gold mount with a central garnet cloisonné 'beaked' roundel and flanking filigree interlace (?Style II).	L	-	294	-
74	40.5	15	15	8.30	-	1	Round-back form, cast. 6 joined fragments, missing parts of apex/side/shoulder. One side has an incised and gilded quatrefoil knot; other side and shoulder have gold filigree mounts, including scrollwork.	M	-	5, 596, 597, 604, 1347, 1968	-
75	50.5	12.5	30	30.16	-	1	Cocked-hat form, cast, with double sword-rings with single cylindrical rivet-housings each end. Found in 15 fragments, missing parts of both sides, one sword-ring and one end. Both sides have the same triangular arrangement and panels of gilded interlace. One side the triangles are decorated with silver tear-drops on niello backgrounds; the other side the triangles probably all had inlays; one of green glass remains. Band of silver herringbone filigree over pommel apex/shoulders and tops of sword-rings. Sword-rings have cast, gilded interlace. Rivet-housings have gilded herringbone bands. Niello frame to pommel body. Wooden dowel in one sword-ring.	M	-	20, 163, 290, 530, 744, 903, 904, 907, 942, 983, 1112, 1185, 1204, 1376, 1726	L12, M11, M14, N6, N11
76	48	20.5	27	37.40	67–82%	1	Cocked-hat form, cast, with double sword-rings with single cylindrical rivet-housings each end. Found in 26 fragments, missing part of one side, ends and most of one sword-ring. One side has cast and gilded interlace with centrally a silver Style II triquetra on a niello triangular field; the almost complete sword-ring has a central triskelion, interlace and mask motifs. Other side has 3 gold mounts with filigree interlace and scrollwork, and a cloisonné roundel of garnet and glass showing cross motifs. Garnet gem-setting at apex. Gilded quatrefoils on shoulders. Filigree herringbone bands on edges and ends. Wax core-filler. Rivet ?cut.	L	?188+	98, 291, 301, 807, 831, 964, 1384–5, 1445, 1483, 242, 1087, 1623, 1629, 1631, 1640–2, 1649, 5014, 5065	H9, K12, L9, L11, L12, M8
77	67	13	28	19.62	79%	1	Cocked-hat form, cast, with double sword-rings. Found in 17 fragments, missing much of one side and ends. One side has cast and gilded interlace with centrally remains of an empty gem-setting. Other side has 4 gold mounts with filigree scrollwork and centrally a gem-setting of rock crystal. Apex and tops of sword-rings have cast gilded interlace also. Pewter core in one sword-ring, and wax in both.	M	?409	136, 149, 189, 417, 536, 876, 908, 994, 1337, 1403, 1448, 1896, 2093, 2158, 5090	F10, L14
78	20	11	10.5	2.78	-	1	End fragment, cast. Enclosed rivet-housing, with gilded Style II bird head each side. Interlace with niello.	M	-	825	-

Sword-rings in silver (79–84) and **hilt-collars in gold (85–100)**. † – values from core metal, rounded-off (cf. Blakelock 2014); ? – possible/uncertain'; Wear – H (heavy), M (moderate), L (light)

SWORD-RINGS IN SILVER

Cat.	(mm)	(mm)	(mm)	Wt (g)	Objects		Wear	Set	K-numbers	Grid
79/84	-	11	14	3.15	1	Sword-ring, 2 parts: squat ring-rivet, broken, and D-shaped collar.	M	-	247, 1625	-
80/81/83	12.5	12	23	5.19	1	Sword-ring, 3 parts: squat ring-rivet, and U-shaped collar. Gilding traces.	-	-	531, 626-7	-
82	30	21	17	22.26	1	Sword-ring, fixed form, broken rivet. Incised bird head each side.	L	?68, ?372-3	543	-

HILT-COLLARS IN GOLD

Cat.	(mm)	(mm)	(mm)	Wt (g)	Au%Wt†	Objects		Wear	Set	K-numbers	Grid
85	68	-	12.5	7.77	-	1	High form, filigree; three panels each side with Style II. From upper grip. 3 rejoined fragments. Angled cut marks with flattening.	M	2, 86	152, 398, 726	M12
86	25/30	-	14.5	10.98	-	1	High form, filigree; three panels each side with Style II. From lower grip. 2 fragments. Angled cut marks.	L	2, 85	6, 854	I10, L12
87	59	-	20.5	19.64	-	1	High form, filigree; Style II each side. From upper grip. 2 rejoined, torn fragments.	L	1, 88	483, 879	K12
88	43	20	22	28.77	88-91%	1	High form, filigree; Style II with quatrefoil knot each side. From lower grip. Cut and torn open.	L	1, 87	300	-
89	32	23	14.5	9.62	-	1	High form, filigree; identical interlace each side. From upper grip. Torn open. Flattening from ?impact/tool.	L	5, 90	1613	-
90	80	-	17	12.84	71-3%	1	High form, filigree; identical Style II each side, forming quatrefoil knots and 'saltires'. From lower grip. Torn open.	L	5, 89	552	-
91	43	23	14	10.16	-	1	High form, filigree; bands of Style II and herringbone. From upper grip. Cut and torn open.	M	92	387	-
92	86	-	13.5	13.80	78%	1	High form, filigree; Style II with collared granules on side; bands of interlace and Style II the other. From lower grip. Cut open, flattened.	M	91	560	-
93	18/28	-	19	7.77	-	1	High form, filigree; interlace each side. From upper grip. 2 fragments, one folded.	L	94	17, 1052	M7, M12
94	47.5	-	20	11.81	-	1	High form, filigree; interlace in two panels each side. From lower grip. 2 joining fragments, cut and torn.	L	93	315, 555	-
95	54	-	19	11.94	-	1	High form, filigree; both sides decorated with semi-regular interlace. 3 torn, rejoined fragments.	L	-	684, 1909	-
96	28.5	18	15.5	8.08	-	1	High form, filigree; two bands of regular interlace each side. Indicates oval section of grip. Dented edge (?levered).	M	-	719	-
97	34	-	17	6.07	-	1	High form, filigree; two bands one side of interlace and scrollwork; herringbone pattern covers the other side. From upper grip. Edge dented (?levered).	L	98	2	L12
98	40	13	18	7.59	69%	1	High form, filigree; two bands each side with different interlace, separated by herringbone bands. From lower grip; indicates an oval section.	L	97	278	-
99	32.5	-	13	3.42	-	1	High form, filigree; two bands of interlace each side. From upper grip. 2 rejoined fragments, torn open.	L	100	321, 512	-
100	50/46.5	-	18	8.61	-	1	High form, filigree; two bands of interlace each side. Small gem-setting (empty) one side. From lower grip. 2 joining fragments, torn, misshapen.	L	99	105, 739	L11, M12

▼ Hilt-collars in gold (101–20).

Cat.	(mm)	(mm)	(mm)	Wt (g)	Au%Wt†	Objects	HILT-COLLARS IN GOLD	Wear	Set	K-numbers	Grid	
101	46	-	-	16.5	5.66	-	1	High form, filigree; looping interlace each side. Torn open. Flattening from ?tool.	L	102	698	-
102	45	-	-	17.5	9.17	-	1	High form, filigree; looping interlace each side. 2 fragments, torn and twisted. Flattening from ?tool. Cut marks.	L	101	372, 1121	P8
103	42	-	-	14	9.00	68%	1	High form, filigree; looping interlace each side. From upper grip. Torn open.	L	104	21	L12
104	55	-	-	16	14.75	-	1	High form, filigree; different Style II interlace each side, Stafford knots one side. From lower grip. Torn open.	L	103	386	-
105	74	-	-	15.5	10.90	-	1	High form, filigree; Style II interlace and collared granules each side. Cut and torn open. Flattening from tool.	L	?27, ?106	367	-
106	29	-	-	21	7.11	-	1	High form, filigree; interlace and collared granules. Incomplete, 6 torn fragments.	L	?27, ?105	126, 804, 857, 1367, 1874	J10, K11, L7, L9
107	30.5	13	-	14	7.67	-	1	High form, filigree; irregular interlace both sides, one side includes a serpent head (Style II). From upper grip; indicates an oval section. Flattening from ?impact/tool. Cut mark.	L	108	108	-
108	53	16	-	16	14.59	78%	1	High form, filigree; irregular interlace both sides, one side includes serpent heads (Style II). From lower grip; indicates an oval section. Flattening from ?impact (?recent).	L	107	699	-
109	45	-	-	14	3.47	-	1	High form, filigree; Style II quadrupeds one side; irregular interlace other side. 2 rejoined fragments. Flattening from ?tool.	L	110	1082, 1148	L16, M11
110	32.5	-	-	16.5	6.75	73.4%	1	High form, filigree; Style II quadrupeds one side; irregular interlace other side. Torn, crumpled.	L	109	1118	P13
111	25	17	-	12.5	4.98	-	1	High form, filigree; ribbon interlace each side. From upper grip. Torn open, rolled.	L	112	1144	P6
112	50	-	-	15	8.94	-	1	High form, filigree; identical ribbon interlace each side. From lower grip. Torn open.	L	111	688	-
113	33	17	-	13	5.01	77%	1	High form, filigree; identical figure-of-eight, ribbon and ring interlace each side. Torn open one end.	L	-	271	-
114	62	-	-	19	8.08	-	1	High form, filigree herringbone pattern. From upper grip. Cut open.	L	115	1258	N10
115	75	-	-	15	9.80	-	1	High form, filigree herringbone pattern. From lower grip. Cut open, twisted.	L	114	561	-
116	60	22	-	1	5.15	-	1	High form with triangular projections, filigree scrollwork each side. 2 torn, rejoined fragments, opened out.	L	-	403, 782	-
117	36.5	-	-	9	4.82	-	1	Low form, filigree; looping interlace each side. From upper grip. 2 rejoined fragments, torn apart.	L	118	582, 882	O18
118	54.5	-	-	10	6.98	-	1	Low form, filigree; Style II interlace one side; looping interlace other side. From lower grip. Torn open. Cut marks.	L	117	720	L12
119	25	-	-	7	2.48	-	1	Low form, filigree; five of ?six original panels, with interlace, including quatrefoils. Incomplete, cut ends.	L	120	1231	M9
120	36	10	-	8.5	2.58	-	1	Low form, filigree; four of ?six original panels, with Style II and interlace. Incomplete, torn ends. Cut marks.	L	119	1085	M11

▼ **Hilt-collars in gold (121–44).** † — values from core metal, rounded-off (cf. Blakelock 2014); ? — possible/uncertain'; Wear — H (heavy), M (moderate), L (light)

HILT-COLLARS IN GOLD

Cat.	(mm)	(mm)	(mm)	Wt (g)	Au%Wt†	Objects	Description	Wear	Set	K-numbers	Grid
121	44	-	8	4.32	-	1	Low form, filigree; six panels with interlace. From ?upper grip.	L	122	466	-
122	25.5	-	8	8.13	-	1	Low form, filigree; six panels with interlace. From ?lower grip. Tightly folded.	L	121	65	K10
123	28/35	-	6.5	3.17	-	1	Low form, filigree; Style II ?serpents each side. From upper grip. Incomplete, 2 joining fragments, cut and torn open.	L	124	1022, 1140	N7, Q9
124	95	-	9	5.87	-	1	Low form, filigree; Style II ?serpents each side. From lower grip. Incomplete, 2 joining fragments, torn open.	L	123	671, 965	K12
125	28/36	-	9.5	6.81	-	1	Low form, filigree; regular interlace each side. From upper grip. Incomplete, 2 joining fragments, cut and torn open.	L	126	798, 1239	-
126	56	17	12	11.80	69-70%	1	Low form, filigree; regular interlace each side. From lower grip; indicates an oval section. Cut and torn open. Textile fragment associated.	L	125	281	-
127	46	-	7.5	3.93	75%	1	Low form, filigree; band of interlaced stafford knots. Indicates an oval grip section. Lifted edge (?levered).	L	-	135	-
128	31	-	4	2.69	76-8%	1	Low form, filigree; band of plaited interlace. From ?upper grip. 2 torn, rejoined fragments.	M	129	76, 811	J11, M10
129	66.5	-	4	3.83	-	1	Low form, filigree; band of plaited interlace. From ?lower grip. Cut open.	M	128	856	I10
130	49	-	6	3.53	-	1	Low form, filigree; shaped to fit a raised band; filigree scrollwork. From upper grip. Torn/?cut open at butt-join, twisted.	L	131	8	M12
131	44	27	4	5.18	-	1	Low form, filigree; shaped to fit a raised band; filigree scrollwork. From lower grip. Cut open at butt-join.	M	130	1315	-
132	22	19	4	1.57	-	1	Low form, filigree; band of S-scrolls. From ?upper grip. Incomplete, torn, crushed ends (?tool).	H	133	1103	-
133	47	-	3	2.89	-	1	Low form, filigree; band of panelled S-scrolls. From ?lower grip. ?Complete, cut open, twisted.	H	132	925	-
134	29	-	5	2.46	-	1	Low form, filigree; band of collared granules. ?Complete, torn ends, coiled.	L	-	322	-
135	61	-	5	2.28	-	1	Low form, filigree; filigree herringbone band. From upper grip. Cut open at butt-join.	L	136	853	K10
136	44	26	5.5	3.99	-	1	Low form, filigree; filigree herringbone band. From lower grip. Cut open at butt-join.	M	135	566	-
137	73	-	6	3.97	-	1	Low form, filigree; filigree herringbone band. Incomplete, cut ends.	L	138	125	L11
138	25/26	-	6	2.71	-	1	Low form, filigree; filigree herringbone band. Incomplete, 2 joining fragments, cut at butt-join.	L	137	142, 927	-
139	55	-	6	3.89	-	1	Low form, filigree; filigree herringbone band. 2 rejoined fragments, folded and twisted. Ends angled; one flattened (?tool).	H	140	1188, 1323	M14
140	87	-	8	5.69	76%	1	Low form, filigree; filigree herringbone band. 2 rejoined fragments; one end folded and missing. Other end angled.	H	139	547, 1178	-
141	47	-	5	2.78	-	1	Low form, filigree; filigree herringbone bands. Incomplete, 2 rejoined fragments, one end cut. Cut marks.	L	-	5010, 5011	E8
142	56	-	4.5	1.87	-	1	Low form, filigree; filigree herringbone band. Folded end.	L	-	1164	-
143	31.5	12.5	4.5	2.30	-	1	Low form, filigree; filigree herringbone bands. Indicates an oval grip section. Flattened edge (?tool).	M	-	573	-
144	28	-	2.5	1.45	-	1	Low form, filigree. Cut open at butt-join, coiled. Herringbone band.	L	-	1537	-

▼Hilt-collars in gold (145–64).

HILT-COLLARS IN GOLD

Cat.	(mm)	(mm)	(mm)	Wt (g)	Au%Wt†	Objects		Wear	Set	K-numbers	Grid
145	26	16	3	1.51	-	1	Low form, filigree herringbone band. From upper grip; indicates an oval section.	L	146	122	K10
146	50	17	3	2.28	-	1	Low form, filigree herringbone band. From lower grip. Cut open at butt-join.	L	145	389	-
147	74	-	3.5	1.69	-	1	Low form, filigree herringbone band. Torn, opened out. 2 rejoined fragments.	L	-	364, 1470	-
148	55	-	5	3.98	-	1	Low form, filigree herringbone bands with plain centre. Incomplete, cut ends.	L	-	116	L10
149	43	17	4	2.13	-	1	Low form, filigree herringbone pattern and panels of reeded sheet. Incomplete.	L	150	569	-
150	35	5	5	1.03	-	1	Low form, filigree herringbone pattern and a panel of reeded sheet. Half fragment, one end cut.	L	149	1381	-
151	51	-	6	3.73	67-9%	1	Low form, filigree; panels with Style II serpents and sections of herringbone pattern. 2 joining fragments.	M	?152	855, 5034	I10, J5
152	33	-	5.5	1.10	-	1	Low form, filigree; includes herringbone pattern. Fragment, one end cut.	L	?151	1322	-
153	67.5	-	3	2.55	-	1	Low form, filigree band of herringbone-with-spine. Incomplete, ends ?cut.	L	154	990	M8
154	50.5	-	2	2.59	-	1	Low form, filigree band of herringbone-with-spine. Cut open at butt-join.	M	153	1276	N12
155	42	24	3	4.59	-	1	Low form, filigree band of herringbone-with-spine. From upper grip; indicates an ?hexagonal section. Cut open.	M	156	1074	M11
156	84	-	3	7.45	-	1	Low form, filigree band of herringbone-with-spine. From lower grip. 2 rejoined fragments, twisted, ends cut.	M	155	1032, 1369	L7
157	31	18.5	6.5	6.36	84-5%	1	Low form, filigree and cloisonné. Two joined bands: one of filigree herringbone-with-spine; one of beaded garnets (repaired). From upper grip; indicates an oval section.	M	158	679	-
158	46	23	7	10.91	-	1	Low form, filigree and cloisonné. Two joined bands: one of filigree herringbone-with-spine; one of beaded garnets. From lower grip; indicates an oval section.	M	157	570	-
159	29	16	14	8.31	79-81%	1	High form, garnet cloisonné; three panels each side, including arrow/mushroom quatrefoils; end panels have split circles. From upper grip; indicates an oval section. Crushed edge.	L	?47, 160	1155	O11
160	46.5	16	15	12.40	-	1	High form, garnet cloisonné; three panels each side, including arrow/mushroom quatrefoils; end panels have circles. From lower grip; indicates an oval section. Crushed end/edge.	L	?47, 159	850	J10
161	51.5	17	14	14.35	-	1	High form, garnet cloisonné; three panels each side, with stepped/arrow cellwork. Cut open.	L	?162, ?181	722	M12
162	36	17.5	18	10.53	-	1	High form, garnet cloisonné; six columns of mushroom shapes each side. 2 rejoined fragments, cut open. Dents one edge (?levered).	?M	?161	104, 324	L11
163	27	-	11.5	6.81	-	1	High form, garnet cloisonné; two bands each side: one with lines of arrow shapes; one of a Style II plaited serpent. From upper grip. Cut and torn open.	L	?50, 164	544	-
164	46	-	14	12.15	-	1	High form, garnet cloisonné; two matching bands each side, including arrow/mushroom quatrefoils. From lower grip. Cut open. ?Blade-tip mark in interior.	L	?50, 163	568	-

Hilt-collars in gold (165–81).

† – values from core metal, rounded-off (cf. Blakelock 2014); ? – possible/uncertain; Wear – H (heavy), M (moderate), L (light)

Cat.	(mm)	(mm)	(mm)	Wt (g)	Au%Wt†	Objects	HILT-COLLARS IN GOLD	Wear	Set	K-numbers	Grid
165	22	19	19.5	21.24	-	1	High form, cloisonné; one panel each side with Style II; end panels and borders include mushroom-shaped, stepped and cross cells. From upper grip. Ends flattened.	?L	54, 166	967	I10
166	40.5	17	19	19.95	90-1%	1	High form, cloisonné; one panel each side with Style II; end panels and borders include mushroom-shaped, stepped and cross cells. From lower grip. Edge dented (?levered).	?L	54, 165	660	-
167	30	18	16	18.94	82%	1	High form, garnet cloisonné; two panels each side with Style II creatures (glass eyes), framed by stepped and chevron bands. From upper grip of seax; indicates an egg-shaped section. Fits hilt-ring 225.	L	55, 168, 169.	370	-
168	31	16.5	22.5	29.95	82%	1	High form, garnet cloisonné; one panel each side with Style II creatures (glass eyes), framed by stepped, chevron and honeycomb bands. From lower grip of seax; indicates an egg-shaped section. Base has blade-slot and blade mark, and polishing scratches. Edge dented (recent).	M	55, 167, 169, 225	449	-
169	32.5	20	8.5	17.26	85%	1	Collar-cap, garnet cloisonné; bands of stepped pattern. From upper grip of seax, with tang-slot; indicates an egg-shaped section. Fits hilt-ring 225. Scratched outline of pommel 55. ?Blade scratch on cap.	M	55, 167, 168.	354	-
170	31	18.5	9.5	4.40	-	1	Low form, cloisonné; stepped pattern both sides. From upper grip; indicates an oval section.	M	171	469	-
171	81.5	-	9	9.48	-	1	Low form, cloisonné; one panel each side, different designs, including mushroom cellwork. From lower grip. Torn open.	L	170	682	-
172	38	13	5.5	4.38	-	1	Low form, garnet cloisonné; bands of mushroom and stepped pattern both sides, square cells at ends. Torn open.	L	173	1247	N9
173	42	-	6.5	2.56	-	1	Low form, garnet cloisonné; band of mushroom and stepped pattern, with square cells (?from ends). Fragment, torn ends.	L	172	326	-
174	30	20	6	6.15	-	1	Low form, garnet cloisonné stepped band. From upper grip; indicates an oval section. One end lifted (?levered). Cut mark. Fine ?assembly marks.	L	175	1003	M11
175	53	-	5.5	12.25	-	1	Low form, garnet cloisonné stepped band. From lower grip. 2 fragments, torn/?cut open. ?Blade mark (?levered). Fine ?assembly marks.	L	174	644, 1126	P11
176	34	-	4	4.61	-	1	Low form, garnet cloisonné; stepped pattern both sides, central empty square cell. From upper grip. Torn open.	L	177	383	-
177	37	-	5	6.93	-	1	Low form, garnet cloisonné; stepped pattern, central square cell. From lower grip. Fragment, cut end, sheet flanges.	L	176	583	-
178	56	33	6	8.96	-	1	Low form, garnet cloisonné; stepped pattern both sides, equal-arm cross centrally. From ?lower grip. Torn open.	L	-	380	-
179	48	-	4.5	3.37	-	1	Low form, garnet cloisonné stepped band. From ?upper grip. Torn open.	L	-	1275	N12
180	53	-	6	7.82	-	1	Low form, garnet cloisonné stepped pattern both sides/ends. From ?lower grip. Torn open, twisted, dented.	L	-	296	-
181	32	15	5	3.75	-	1	Low form, garnet cloisonné; panelled stepped pattern both sides. Cut open.	L	?161	1058	M8

▼ **Hilt-collars in silver (182–9)** and **copper alloy (190)**.

HILT-COLLARS IN SILVER (182–9) AND COPPER ALLOY (190)

Cat.	(mm)	(mm)	(mm)	Wt (g)	Objects	Description	Wear	Set	K-numbers	Grid
182	32.5	16	17	7.55	1	High form, cast, gilded. Style I one side; line, punch and honeycomb decoration other side. From upper grip. Incomplete, 7 rejoined fragments.	M	183	298, 1347, 1542	-
183	40.5	-	17	9.17	1	High form, cast, gilded. Style I one side; line and punch decoration other side. From lower grip. Incomplete, 10 rejoined fragments.	M	182	181, 187, 528, 743, 755, 936, 1152, 1210, 1253, 1306	J6, J13, J14
184	46	22	16	24.67	1	High form, cast. Horizontal gilded bands and silver bands with niello zig-zag pattern. Edge damaged (?levered). Indicates an oval section to grip. Copper-alloy core.	H	185	369	-
185	40	-	15	5.40	1	High form, cast. Horizontal gilded bands and silver bands with niello zig-zag pattern. Incomplete, 15 rejoined fragments.	M	184	19, 430, 537, 1446, 1570, 1589, 2090, 2091	-
186	41.5	14	10.5	7.65	1	High form, cast, gilded with niello. Three panels each side with different Style II. From upper grip; indicates an hexagonal section. ?Lever mark on edge.	L	?69, 187, ?533–?535	304	-
187	50	14	11	10.16	1	High form, cast, gilded with niello. Three panels each side with different Style II. From lower grip; indicates an hexagonal section. 5 rejoined fragments.	L	?69, 186, ?533–?535	160, 186, 595, 953, 1364	-
188	34	-	18	10.45	2	Possible pair of collars, 10 fragments. High form, cast, gilded with niello. Interlace and animal-head decoration one side; gold filigree mounts other side with quatrefoils and looping interlace. ?Tool damage.	L	?75, ?76, 409	34, 53, 180, 947, 993, 1026, 1169, 1189, 1238, 1248	M10, M14, N13, O10, O12
189	20	-	8.5	3.16	?1	Possible pair of collars, 4 fragments. Cast, incised Style II.	L	71, 605	205, 814, 1359, 2075	J11
190	12.5	-	3	0.84	?1	Low form, one or possibly a pair; 32 small copper-alloy fragments. Cast, gilded; imitates herringbone-with-spine filigree.	-	-	1454, 1461, 1607, 1618, 1657, 1659, 1660, 1696, 1873	L12

▼ **Hilt-rings in gold (191–216).** † – values from core metal, rounded-off (cf. Blakelock 2014); ? – possible/uncertain'; Wear – H (heavy), M (moderate), L (light)

Cat.	(mm)	(mm)	(mm)	Wt (g)	Au%Wt†	Objects	HILT-RINGS IN GOLD	Wear	Set	K-numbers	Grid
191	26	19.5	2	2.68	-	1	Beaded type. From ?upper grip; indicates an oval section. Matches mark on 318.	L	?192, ?318	392	-
192	50	22	2.5	4.96	-	1	Beaded type. From ?lower grip; indicates an oval section. Matches mark on 244.	L	?191, ?244	470	-
193	37.5	24	3	8.10	-	1	Beaded type. From ?upper grip; indicates an oval section. ?Broken at soldered join.	L	?194	56	L11
194	59	21	3	12.78	-	1	Beaded type. From ?lower grip. Broken at soldered join.	L	?193	812	J10
195	32	24	2	5.26	-	1	Beaded type. From ?upper grip; indicates an oval section. Cut open. ?Tool mark.	M	?196	574	-
196	75	-	2	5.44	-	1	Beaded type. From ?lower grip. Cut open, misshapen.	M	?195	692	-
197	27	16.5	2.5	4.65	-	1	Beaded type. From ?upper grip; indicates an oval section. Light ?cut/tool marks.	L	-	1426	-
198	26	20	2	2.79	96%	1	Beaded type. From ?upper grip; indicates an oval section. Cut mark.	L	-	140	-
199	28	21	2	2.43	-	1	Beaded type. From ?upper grip; indicates an oval section. ?Broken open.	L	-	391	-
200	36	23.5	2.5	6.46	-	1	Beaded type. From ?lower grip. Edge lifted, with cut mark (?levered).	L	-	289	-
201	36	35	2	2.38	-	1	Beaded type. Cut open.	L	-	1134	Q9
202	76	-	2	5.28	-	1	Beaded type. Misshapen. ?Broken at soldered join.	L	-	894	-
203	50	-	2	5.27	-	1	Beaded type. Misshapen. ?Broken at soldered join.	M	-	986	M8
204	47	-	2	2.83	-	1	Beaded type. Misshapen. Broken open. Cut mark.	L	-	1060	M8
205	79	-	2	5.17	-	1	Beaded type. Misshapen. Broken open, cut mark. Small area pinched by ?tool.	L	-	1076	M11
206	22/27	-	2	1.99	-	1	Beaded type. 2 fragments (not certainly one ring). Cut and ?tool marks.	L	-	729, 956	M12
207	57	-	2	2.77	-	1	Beaded type. Incomplete, one end cut.	L	-	28	L12
208	40.5	-	1.5	1.13	-	1	Beaded type. Not certainly a hilt-ring. ?Incomplete, cut ends.	L	-	1220	M8
209	22	-	2	1.37	-	1	Beaded type. Fragment, one end cut; another cut mark also.	L	-	926	-
210	42	-	2	2.06	-	1	Beaded type. Incomplete, one end cut, other possibly broken at join.	L	-	1120	P12
211	45	-	2	2.29	-	1	Twisted-beaded type. Ends cut. Patch over join (cut).	L	?212	784	-
212	70	-	2	3.12	-	1	Twisted-beaded type. Ends cut. Patch over join.	L	?211	471	-
213	27.5	22	2	2.08	-	1	Twisted-beaded type. From ?upper grip. Broken at soldered join. Patch over join (cut). Pinched by ?tool.	L	?214	1017	L7
214	71	-	2	2.42	-	1	Twisted-beaded type. From ?lower grip. Ends cut. Cut mark.	L	?213	971	M9
215	58	-	2	1.87	-	1	Twisted-beaded type. Incomplete, one end cut. Patch of sheet (fragment).	L	-	100	K11
216	61	-	2	4.21	-	1	Twisted-beaded type. Broken at soldered join. Patch one end, originally over join.	L	-	1045	M7

▼ **Hilt-rings in gold (217–25), silver (226–41)** and **copper alloy (242)**.

HILT-RINGS IN GOLD

Cat.	(mm)	(mm)	(mm)	Wt (g)	Au%Wt†	Objects	Description	Wear	Set	K-numbers	Grid
217	53	-	2	1.49	-	1	Twisted-beaded type. Beaded wire on one edge. Cut ends.	L	218	1280	M10
218	39	-	2.5	2.13	-	1	Twisted-beaded type. Incomplete, broken ends. Beaded wire on one edge. Cut mark.	L	217	1096	-
219	39	30	4	5.94	-	1	Wrapped-beaded type. From ?upper grip. Broken at soldered join. Beaded wire on edge.	L	220	129	-
220	56.5/41.5	-	4	10.00	-	1	Wrapped-beaded type. 2 fragments, cut ends. From ?lower grip. Beaded wire on edge.	L	219	1212, 1343	N8
221	30	23.5	2	2.71	-	1	Wrapped-beaded type. From ?upper grip; indicates an oval section. Pinched by ?tool.	L	?221-4	724	L12
222	65	-	2	2.46	-	1	Wrapped-beaded type. Cut ends, opened out.	L	?221-4	366	-
223	45	21	2	3.06	-	1	Wrapped-beaded type. From ?lower grip. Cut open, end pinched by ?tool.	L	?221-4	132	J10
224	42	24	2	4.20	-	1	Wrapped-beaded type. From ?lower grip; indicates an oval section. Pinched by ?tool.	L	?221-4	1059	M8
225	33	22	2.5	7.77	-	1	Cast, plain; indicates an egg-shaped section. From seax hilt; fits between hilt-collar **167** and cap-fitting **169**.	L	55, 167-9	690	-

HILT-RINGS IN SILVER (226–41) AND COPPER-ALLOY (242)

Cat.	(mm)	(mm)	(mm)	Wt (g)	Objects	Description	Wear	Set	K-numbers	Grid
226	34	29	3	4.05	1	Beaded type. Half only, 2 rejoined fragments, ends cut. From ?upper grip.	L	?227	1194	K13
227	45	21	3	3.65	1	Beaded type. Half only, end cut. From ?lower grip.	L	?226	1205	N8
228	23	20.5	3	1.68	1	Beaded type. Fragment, broken ends. Gilded.	L	?229	246	-
229	17	-	3	1.43	1	Beaded type. Fragment, one end cut. Gilded.	M	?228	1368	-
230	22	-	3	2.88	1	Beaded type. Half only, 2 rejoined fragments, end cut. Gilded.	L	-	902, 1227	L9
231	49	15	2.5	2.98	1	Beaded type. Incomplete, 2 fragments. From ?lower grip; indicates an oval section.	L	-	472	-
232	30	-	2	0.76	1	Beaded type. Half only, 5 joining fragments. Gilded.	M	?233	1498, 1840, 2156	-
233	13	-	2	0.20	1	Beaded type. 2 small joining fragments. Gilded. Flattened by ?tool.	-	?232	1481, 1746	-
234	19	-	2.5	0.60	1	Beaded type. Fragment, end cut.	M	-	183	-
235	35	-	2	0.99	1	Beaded type. Incomplete, ends broken. Cut marks.	L	-	396	-
236	39	-	2.5	1.68	1	Beaded type. 2 small joining fragments. Multiple cut marks.	M	-	1597, 1635	-
237	18	-	2	0.30	1	Beaded type. Fragment. Gilded.	L	-	1835	-
238	15.5	-	2	0.31	1	Beaded type. Small fragment. Gilded.	-	-	1935	-
239	13.5	-	2.5	0.41	1	Beaded type. Small fragment.	L	-	756	-
240	8	-	2	0.12	1	Beaded type. Small fragment.	L	-	267	-
241	15	-	2	0.18	1	Beaded type. 2 small fragments. Gilded.	M	-	511, 1705	-
242	10	-	2	0.12	?1	Beaded type. 4 small fragments. Gilded. Possibly more than one ring.	-	-	1571, 1695, 2018	-

CATALOGUE ENTRIES | TABLES 217-64

▼**Hilt-plates in gold (243-64)**. † – values from core metal, rounded-off (cf. Blakelock 2014); ? – possible/uncertain'; Wear – H (heavy), M (moderate), L (light)

Cat.	(mm)	(mm)	(mm)	Wt (g)	Au%Wt†	Objects	HILT-PLATES IN GOLD	Wear	Set	K-numbers	Grid
243	59.5	21.5	15.5	16.23	-	1	Pair of oval plates, garnet bosses; upper-guard. Pommel mark, and hilt-collar or grip mark. ?Tool/blade scratches. Copper-alloy liner.	M	244	283	-
244	86	23.5	14	21.96	-	1	Pair of oval plates, gemmed bosses (empty); lower-guard. Large blade-slot. Mark from hilt-ring. Copper-alloy liner. ?Tool mark.	M	243, ?192	563	-
245	19	15	<0.5	2.81	-	1	Garnet bosses; top plate, upper guard. Cut, folded. Pommel mark.	M	?246-8	863	K10
246	41	-	4	5.56	-	1	Gemmed bosses (one garnet); bottom plate, upper guard. Torn, misshapen. Hilt-collar/ring or grip mark. ?Tool mark.	L	?245, ?247-8	702	-
247	68	-	<0.5	3.98	-	1	Gemmed bosses (empty); top plate, lower guard. Torn, incomplete, 2 rejoined fragments. Hilt-collar mark.	L	?245-6, ?248	777, 1083	M11
248	99	36	4	9.73	-	1	Oval form, garnet boss; bottom plate, lower guard. Missing one end.	L	?245-7	667	-
249	40.5	14.5	<0.5	3.20	-	1	Oval form, gemmed bosses (one garnet); top plate, upper guard. Twisted.	M	250	836	L10
250	50	15	<0.5	4.81	-	1	Oval form, garnet bosses; top plate, lower guard. Twisted. Hilt-collar/ring or grp mark.	L	249	771	-
251	44	16.5	<0.5	1.97	-	1	Oval form, garnet bosses; top plate, upper guard. Incomplete, 2 torn joining fragments. Pommel mark.	L	252, ?253	58, 402	L11
252	29	-	3	3.91	-	1	Garnet bosses; bottom plate, upper guard. Incomplete, 2 rejoined fragments, bent and torn. Hilt-collar or grip and washer marks.	L	251, ?253	60, 143	K10
253	81	21	<0.5	5.04	-	1	Oval form, gemmed bosses (one garnet); top plate, lower guard.	L	?251-2	670	-
254	73	-	2	3.11	-	1	Side fragment, part of a gemmed boss (empty); bottom plate, lower guard. Ends torn. ?Polishing scratches.	?M	-	1202	N13
255	15	-	1.5	1.01	-	1	End fragment, garnet boss; upper guard.	L	256-7	33	-
256	13	-	1.5	0.60	-	1	End fragment, garnet boss.	L	255, 257	1474	-
257	51	-	<0.5	2.59	-	1	Oval form, garnet boss; bottom plate, upper guard. Missing tip, torn, folded.	H	255-6	1072	M11
258	51	19	3	2.48	-	1	Oval form, gemmed bosses (empty); bottom plate, upper guard. Damaged end. Washers and grip or hilt-collar marks. Horn guard remains and ?horn liner.	M	-	285	-
259	44	16	1.5	1.01	-	1	Oval form, gemmed bosses (empty); bottom plate, upper guard. End missing, torn. Hilt-collar or grip mark. Iron liner.	L	-	272	-
260	50	20	2.5	4.16	-	1	Oval form, glass boss; bottom plate, upper guard. End missing, torn. Hilt-collar/ring mark. Cut and tool marks.	L	-	37	M12
261	38	18	<0.5	3.22	77%	1	Gemmed bosses (empty); upper guard. Bent, 2 rejoined fragments.	H	-	12, 1234	M9, L12
262	81	20.5	<0.5	4.36	-	1	Oval form, gemmed bosses (one garnet); top plate, lower guard. Torn side, 3 rejoined fragments. Hilt-collar or grip mark. Cut mark.	H	-	481, 769, 860	K11
263	49	19	1	12.38	-	1	Oval form, bosses; bottom plate, lower guard. Torn, misshapen. Mark from hilt-collar/ring.	M	264	564	-
264	91	22.5	6	23.68	-	1	Oval form, bosses; bottom plate, lower guard. Large blade-slot. ?Polishing scratches.	L	263	282	-

▼ Hilt-plates in gold (265–88).

Cat.	(mm)	(mm)	(mm)	Wt (g)	Au%Wt†	Objects	HILT-PLATES IN GOLD	Wear	Set	K-numbers	Grid
265	47.5	16	2	5.40	-	1	Pair of oval plates; upper-guard. One incomplete, bent and torn. One intact boss. Pommel and hilt-collar/ring marks. ?Tool mark.	M	-	661	-
266	59.5	23.5	1	3.02	-	1	Oval form, boss; top plate, lower guard. 2 rejoined fragments, bent end. Hilt-collar/ring mark.	L	?267-9	317, 1236	L9
267	69	23	3.5	8.73	-	1	Oval form, bosses and filigree trim; bottom plate, lower guard.	H	?266, ?268-9	672	-
268	14.5	-	<0.5	0.84	-	1	Small fragment with filigree trim.	M	?266-7, ?269	1375	-
269	22	-	3	1.48	-	1	Small fragment with filigree trim.	M	?266-8	5083	E14/D14
270	54	22	3	5.87	-	1	Oval form, bosses; bottom plate, upper guard. Bent, torn. Hilt-collar/ring mark.	H	271	549	-
271	48	36	2.5	8.09	-	1	Oval form, bosses; top plate. Folded, torn. Hilt-collar/ring mark. ?Cut/tool marks.	H	270	117	K10
272	46	23	<0.5	5.65	-	1	Oval form, bosses; top plate, lower guard. Bent. Hilt-collar/ring mark.	L	-	551	-
273	50	-	3.5	2.84	-	1	Half fragment with boss; bottom plate, lower guard. Torn ends.	M	-	1230	M9
274	21	17	2	1.47	-	1	Half fragment with boss; upper guard. Torn, bent.	M	-	1046	M7
275	13	-	3.5	0.93	-	1	End fragment with boss and rivet. Torn edges.	L	-	177	-
276	12	-	1.5	0.74	-	1	End fragment with boss. Torn edges. ?Blade scratches.	L	-	1496	-
277	14	-	<0.5	0.75	-	1	End fragment with boss. Torn edges.	L	-	61	K10
278	42	21	<0.5	5.15	-	1	Oval form, bosses; top plate, lower guard. Bent ends.	M	279	459	-
279	73	19	3.5	8.25	-	1	Oval form, bosses; bottom plate, lower guard. Twisted, torn edges.	L	278	378	-
280	54	20	0.5	6.29	-	1	Oval form, one boss-headed rivet and filigree collars; top plate, upper guard. Mark from pommel **46**.	L	46, 281	562	-
281	57	-	0.5	8.43	-	1	Oval form, filigree collars; top plate, lower guard. Torn and twisted. Hilt-collar or grip mark.	L	280	461	-
282	31.5	-	<0.5	1.86	-	1	One boss-headed rivet; upper guard. Torn and twisted.	H	-	779	-
283	59	15	3	5.78	-	1	Oval form, filigree collars; upper guard. Sides lifted (?levered). Copper-alloy boss-core and liner.	M	-	708	-
284	43	19.5	1	9.25	-	1	Oval form, one boss-headed rivet; top plate, lower guard. Torn and folded. ?Blade scratches.	L	-	134	J10
285	75.5	25	<0.5	6.07	-	1	Oval form, one boss-headed rivet and filigree collars; top plate, lower guard. 3 rejoined fragments. Hilt-collar or grip mark.	L	-	646, 647, 991	M13
286	21	13	0.5	1.96	-	1	Half fragment, one boss-headed rivet; upper guard. Torn, bent.	L	-	766	-
287	47	17.5	2	5.25	-	1	Oval form, filigree collar; top plate, upper guard. Torn open, twisted. Pommel marks. Cut marks. Blade scratches.	M	-	1500	-
288	57	21	2	5.51	-	1	Oval form, filigree collar; bottom plate, upper guard. Cut open, 2 rejoined fragments. Hilt-collar/ring and washers marks.	M	-	584, 725	M12

▼ **Hilt-plates in gold (289–313).** † – values from core metal, rounded-off (cf. Blakelock 2014); ? – possible/uncertain'; Wear – H (heavy), M (moderate), L (light)

Cat.	(mm)	(mm)	(mm)	Wt (g)	Au%Wt†	Objects	HILT-PLATES IN GOLD	Wear	Set	K-numbers	Grid
289	56	22	2	10.48	-	1	Oval form, filigree collars; top plate, lower guard. Bent. Hilt-collar/ring mark with blade-point mark.	L	-	548	-
290	55	25	3	8.39	-	1	Filigree collars; bottom plate, lower guard. Bent, dented (?recent). ?Polishing scratches.	M	-	1011	M10
291	52	19	2.5	4.30	-	1	Oval form, filigree collars; bottom plate, lower guard. Folded, split one end.	M	-	955	K12
292	85	24.5	4	8.06	-	1	Oval form, filigree trim and filigree collar; bottom plate, lower guard. ?Polishing scratches.	M	-	557	-
293	61	16	2	5.80	-	1	Filigree collars; bottom plate, lower guard. 2 rejoined fragments, cut and torn. ?Polishing scratches.	L	-	780, 1137	Q9
294	84	-	3	7.89	-	1	Rivet-holes on sides with filigree collars; bottom plate, lower guard. Missing end, torn.	?L	-	313	-
295	28	-	1	0.83	-	1	Filigree collar; ?lower guard. Torn, missing one end.	M	-	1048	O8
296	26.5	12	4	0.67	-	1	Side fragment, filigree collar; upper guard. Torn, flattened. ?Blade scratches.	M	-	155	-
297	38	-	3	3.25	-	1	Filigree collar; upper guard. Torn, misshapen, missing one end. Cut marks.	L	-	846	L11
298	31.5	16.5	2	0.75	-	1	Half fragment, filigree collar; upper guard.	M	-	482	-
299	28	15.5	1	0.88	-	1	Half fragment, filigree collar; upper guard.	L	-	973	M10
300	24	13	2.5	0.82	-	1	End fragment, filigree collar; upper guard.	M	-	1199	K14
301	29	-	<0.5	1.45	-	1	Fragment, filigree collar; upper guard. Badly torn.	-	-	1237	-
302	39	23	2.5	2.20	-	1	Half fragment, filigree collar; bottom plate, lower guard.	L	-	319	-
303	58	-	1	0.99	-	1	Side fragment, filigree collar; ?lower guard. Edges torn. ?Blade scratch.	L	-	727	M12
304	17	22	3	0.74	-	1	End fragment, filigree collar; ?lower guard. Torn, flattened.	L	-	862	K11
305	35.5	12	3.5	0.73	-	1	Side fragment, fragment of filigree collar; bottom plate, lower guard. Torn, crumpled. ?polishing scratches.	-	-	835	L11
306	31	-	0.5	3.90	-	1	Top plate, upper guard. Ends folded, twisted. ?Cut rivets. Faint mark from pommel. ?Blade scratches.	L	?307-9	93	L11
307	45	17	0.5	3.85	-	1	Oval form; bottom plate, upper guard. End folded. Boss and hilt-collar/ring/grip marks.	L	?306, ?308-9	694	-
308	55.5	14	0.5	4.20	-	1	Oval form; top plate, lower guard. Misshapen.	L	?306-7, 309	571	-
309	62	17	1	5.26	-	1	Oval form; bottom plate, lower guard. Twisted. Marks from bosses.	L	?306-8	448	-
310	44	19	<0.5	5.39	-	1	Oval form; top plate, upper guard. Torn, bent. Marks from pommel and bosses. ?Blade scratches.	?M	-	62	L10
311	46	18	0.5	3.80	-	1	Oval form; top plate, upper guard. End bent. Pommel mark.	M	-	277	-
312	31	-	1	2.32	-	1	Top plate, upper guard. Missing ends, misshapen. Pommel mark.	M	-	477	-
313	44	26	1	5.46	-	1	Top plate, upper guard. Torn, bent. Marks from pommel and bosses. ?Tool marks reverse.	L	-	1221	N11

▼ Hilt-plates in gold (314–38).

HILT-PLATES IN GOLD

Cat.	(mm)	(mm)	(mm)	Wt (g)	Au%Wt†	Objects	HILT-PLATES IN GOLD	Wear	Set	K-numbers	Grid
314	58	20	<0.5	3.35	-	1	Top plate, upper guard. 2 rejoined fragments, Missing one end/side. Marks from pommel and boss. ?Blade scratches.	L	-	648, 1225	N9
315	24.5	14.5	<0.5	0.73	-	1	Half fragment; top plate, upper guard. Torn edges. Pommel mark.	?L	-	851	K10
316	26.5	13	<0.5	1.92	-	1	?Top plate, upper guard. Crumpled, torn edge. ?Pommel mark.	L	-	1071	M10
317	66	24	<0.5	4.84	-	1	Oval form; bottom plate, upper guard. Cut open. Marks from hilt-collar/grip (with blade-point mark), washers and bosses.	H	-	295	-
318	59	23	2	4.70	-	1	Oval form; bottom plate, upper guard. Flattened tip (?tool). Rivet cut. Marks from a hilt-collar/ring and bosses.	M	?191	351	-
319	22.5	19	2	3.28	-	1	Bottom plate, upper guard. Torn, twisted. Marks from a washer and boss.	L	-	57	M10
320	39	16.5	3	2.51	-	1	Half fragment; ?bottom plate, upper guard (?grip side). Torn, bent. Marks from ?hilt-collar/grip. Blade scratches.	H	-	318	-
321	14	20	3	0.55	-	1	End fragment; upper guard.	L	-	484	-
322	18	-	<0.5	1.23	-	1	End fragment; ?upper guard. Boss mark.	-	-	1839	-
323	26	23	3	0.53	-	1	End fragment; upper guard.	L	-	2077	L7
324	76	22	<0.5	5.51	-	1	Oval form; top plate, lower guard. Marks from hilt-collar/ring and bosses.	L	-	844	M9
325	24	22	<0.5	4.83	83%	1	Top plate, lower guard. Twice folded. Marks from bosses. Rivet-holes torn.	L	-	10	K12
326	43	-	1	5.08	-	1	Top plate, lower guard. Torn, twisted. Boss mark.	L	-	316	-
327	77	-	1	11.23	-	1	Top plate, lower guard. Torn open, misshapen. Mark from hilt-collar/ring and bosses. ?Blade scratches.	L	-	368	-
328	66	24	0.5	9.42	-	1	Oval form; top plate, lower guard. Torn/?cut open, bent. Marks from hilt-collar/grip and boss. ?Levered edge with cut marks.	M	638	446	-
329	30/39.5	23	<0.5	3.24	72%	1	Top plate, lower guard. 2 joining fragments, torn. Marks from bosses.	?M	-	79, 649	L10
330	41	-	4	1.55	-	1	Top plate, lower guard. Badly torn, missing one end/side.	?L	-	1143	K5
331	87	23	3	11.01	-	1	Oval form; bottom plate, lower guard. Dented edge. Marks from bosses. Copper-alloy liner. ?Polishing scratches.	M	-	1822	-
332	82.5	24	4	8.13	-	1	Oval form; bottom plate, lower guard. Dented edges. ?Polishing scratches.	L	-	395	-
333	85.5	21	3	9.55	-	1	Oval form; bottom plate, lower guard. Torn open one end. Marks from bosses. ?Polishing scratches.	M	-	723	M12
334	79.5	21	2.5	5.58	-	1	Oval form; bottom plate, lower guard. Torn, twisted. Marks from bosses. ?Polishing scratches.	M	-	880	K10
335	49.5	46.5	3	6.49	47%	1	Bottom plate, lower guard. Torn, folded. Copper-alloy liner.	M	-	133	J10
336	57.5	21	4	3.10	83%	1	Bottom plate, lower guard. 2 rejoined fragments, missing one end, flattened. Boss mark. Fragments copper-alloy liner.	L	-	3, 479	I9
337	53	8	4	2.12	-	1	Blade-slot insert from a plate from the lower guard.	L	-	1259	N10
338	44	-	3	4.95	-	1	Bottom plate, lower guard. Torn, twisted. Marks from bosses. ?Polishing scratches.	L	-	473	-

▼ **Hilt-plates in gold (339-63).** † – values from core metal, rounded-off (cf. Blakelock 2014); ? – possible/uncertain'; Wear – H (heavy), M (moderate), L (light)

Cat.	(mm)	(mm)	(mm)	Wt (g)	Au%Wt†	Objects	HILT-PLATES IN GOLD	Wear	Set	K-numbers	Grid
339	37	19	2.5	3.80	-	?1	Bottom plate, lower guard. 2 fragments (?same hilt-plate), torn and twisted together. ?polishing scratches.	L	-	5025	J14
340	41.5	-	2.5	0.56	-	1	Side fragment; bottom plate, lower guard. Torn, crumpled.	-	-	44	J10
341	62	10	2.5	2.40	-	1	Side fragment; bottom plate, lower guard. ?Polishing scratches.	L	-	581	-
342	61	11	3	0.88	-	1	Side fragment; bottom plate, lower guard. Torn, crumpled. Fragments copper-alloy liner. ?Polishing scratches.	-	-	911	-
343	40	10	3	1.43	-	1	Side fragment; bottom plate, lower guard. Ends torn, folded. ?Polishing scratches.	-	-	1163	O13
344	30	8	<0.5	1.02	-	1	Side fragment; bottom plate, lower guard. Ends torn.	?L	-	1216	N11
345	27	-	<0.5	0.51	-	1	Side fragment; ?bottom plate, lower guard. Ends torn.	-	-	59	L11
346	22	-	<0.5	0.52	-	1	Side fragment; ?bottom plate, lower guard. Ends torn. ?Blade scratches.	?M	-	1198	K13
347	13	17	<0.5	0.57	-	1	End fragment; ?lower guard. Boss mark. ?Tool mark at edge.	L	-	165	-
348	25	-	<0.5	0.69	-	1	End fragment; ?lower guard. Boss mark.	M	-	803	L9
349	18	-	3	0.88	-	1	End fragment.	M	-	1240	-
350	11	-	<0.5	0.17	-	1	End fragment.	-	-	1602	J10
351	49	-	1	0.39	-	1	Side fragment; one curved edge, other edges torn.	-	-	32	L12
352	9	-	3	0.20	-	1	Small side fragment.	-	-	114	M12
353	23	-	2	0.56	-	1	Small side fragment.	-	-	976	M10
354	28	-	<0.5	1.06	-	1	Side fragment; crumpled, edges torn.	-	-	1197	K13
355	21	-	<0.5	0.23	-	1	Side fragment; crumpled, edges torn. Tool mark.	-	-	1229	M9
356	28	-	<0.5	0.39	-	1	Side fragment; crumpled, edges torn. ?Polishing scratches.	M	-	1345	-
357	23	-	2.5	0.64	-	1	Side fragment; one edge cut.	-	-	1943	O10
358	24	-	<0.5	0.69	-	1	Side fragment.	-	-	1947	M8
359	62.5	-	<0.5	6.38	-	1	Plate fixed with hilt-collar with filigree scrollwork; top plate, lower guard. 2 rejoined fragments, missing parts of one end and side.	L	-	399, 881	Q10
360	22/30/32	22.5	1.5	6.07	-	?1	One plate or a set; 3 fragments, no joins. Crosses on tips with filigree. ?Blade scratch.	M	-	320, 1063, 1250	M8, M9
361	40	19	4	13.61	-	1	Oval form, garnet cloisonné trim; bottom plate, upper guard. Ends bent, torn. Marks from a hilt-collar or grip, and bosses. ?Blade scratches.	M	362	691	-
362	71	16.5	4.5	19.26	-	1	Oval form, garnet cloisonné trim; bottom plate, lower guard. Twisted, one end torn. ?Blade scratches. ?Polishing scratches.	L	361	1056	M8
363	60	12	2	3.63	-	1	Garnet cloisonné trim; two cells of decayed unidentified inlay (?repairs); bottom plate, upper guard. Torn, twisted; 3 rejoined fragments. Marks from boss and hilt-collar or grip. ?Organic remains of guard.	M	364	767, 1150	K16

▼ Hilt-plates in gold (364–70) and silver (371–82).

HILT-PLATES IN GOLD

Cat.	(mm)	(mm)	(mm)	Wt (g)	Au%Wt†	Objects	HILT-PLATES IN GOLD	Wear	Set	K-numbers	Grid
364	80	21	2.5	8.22	-	1	Oval form, garnet cloisonné trim; bottom plate, lower guard. Twisted, torn. ?Cut mark. Marks from bosses.	L	363	374	-
365	76.5	-	3.5	9.33	-	1	Garnet cloisonné trim and gemmed boss; bottom plate, lower guard. Twisted, torn. ?Polishing scratches.	L	-	1136	M5
366	50	-	2.5	3.72	-	1	Garnet cloisonné trim; ?top plate, upper guard. Twisted, torn.	-	367-368-9	774	-
367	30/38	-	2.5	4.78	-	1	Cloisonné trim; upper guard, ?bottom plate. 2 fragments, twisted and torn.	-	366, 368-9	87, 806	J10
368	55	18	3	7.57	-	1	Garnet cloisonné trim; ?top plate, lower guard. Misshapen, torn.	-	366-7, 369	736, 778	M12
369	64	30.5	3	9.78	-	1	Cloisonné trim; bottom plate, lower guard. Misshapen, torn.	L	366-8	5091	-
370	74	23	3	21.44	88%	1	Cast, Style II ornament, filigree collars; bottom plate, lower guard of seax. Bent end. ?Cut mark.	L	-	567	-

HILT-PLATES IN SILVER

Cat.	(mm)	(mm)	(mm)	Wt (g)	Objects	HILT-PLATES IN SILVER	Wear	Set	K-numbers	Grid
371	91.5	21	4	14.42	1	Bottom plate, lower guard, gilded. 5 rejoined fragments. Cut mark to edge.	M	-	138, 419, 593, 761, 799	-
372	70	19	6	10.89	1	?Top plate, upper guard. 4 rejoined fragments. Large hole for ?sword-ring. ?Blade/tool scratches.	M	373, ?82	159, 239, 1029, 5084	K13
373	73	22	6	14.94	1	Bottom plate, upper guard. Large hole for ?sword-ring. Cut/tool marks (?levered).	M	372, ?82	279	-
374	24	17	4	1.48	1	End fragment, side-flange has line decoration; top plate from upper guard. Bent (?levered). Marks from pommel.	M	375-7, ?378	26	M12
375	31	21	4	5.46	1	Side-flange has line decoration; bottom plate from upper guard. 4 rejoined fragments, bent U-shape, missing part, dented and cut edges (?levered). Mark from hilt-collar or grip, washers and bosses.	?M	374, 376-7, ?378	179, 522, 837, 2082	J10
376	32.5	9	4	1.20	1	Side fragment, side-flange has line decoration. 2 rejoined fragments.	-	374-5, 377, ?378	1170, 1269	N12, O9
377	23	-	4.5	0.49	1	Side-flange fragment, line decoration.	-	374-6, ?378	1154	O9
378	12	-	-	0.31	1	Side fragment, line decoration.	-	?374-7	1268	M15
379	35	20	3	5.36	1	Half fragment, gilded; upper guard. 2 rejoined fragments. Flattened. ?Tool marks.	M	?380	13, 995	M8
380	26	19	4	2.85	1	End fragment, gilded; upper guard. 3 rejoined fragments. Flattened.	?M	?379	1141, 1180, 1217	N8, N9, Q11
381	23.5	-	3	2.1	1	End fragment, gilded; upper guard. 2 rejoined fragments. Rivets 666 are an approximate fit.	?M	?382, ?666	1823, 2083	-
382	28.5	20	3	3.34	1	End fragment; upper guard. Rivets 666 are an approximate fit.	?M	?381, ?666	1534	-

▼ **Hilt-plates in silver (383-408 and 696-7)**. ? – possible/uncertain'; Wear – H (heavy), M (moderate), L (light)

Cat.	(mm)	(mm)	(mm)	Wt (g)	Objects	HILT-PLATES IN SILVER	Wear	Set	K-numbers	Grid
383	32.5	-	4	3.34	1	End fragment, gilded; bottom plate, lower guard. 3 rejoined fragments. Mark from boss.	M	?384	198, 944, 1335	K12
384	51	-	3	5.44	1	Half fragment, gilded; bottom plate, lower guard. 3 rejoined fragments, bent.	M	?383	979, 1209, 1338	I11, K8
385	60	-	6.5	3.10	1	Side fragment, gilded; bottom plate, lower guard. 3 rejoined pieces. Cut ends.	M	-	248, 2085	-
386	48	-	4	1.62	1	Side fragment; bottom plate, lower guard. 2 rejoined pieces. ?Polishing scratches.	?L	-	1975, 2084	-
387	23	-	3.5	1.70	1	End fragment, ?gilded; ?top plate, ?lower guard. Cut mark.	M	-	741	-
388	20	-	4	0.85	1	End fragment; ?top plate, ?lower guard. Cut mark.	-	-	1942	K13
389	16	-	4	1.10	1	End fragment, side-flange, part of one rivet-hole.	M	-	2028	-
390	14	-	1	0.88	1	End fragment, punch decoration; ?top plate, ?lower guard. 3 rejoined pieces.	L	-	1453	-
391	12	-	0.5	0.27	1	End fragment, ?gilded. Mark from boss.	-	-	2087	-
392	19	-	4	1.01	1	End fragment, ?gilded.	M	-	864	-
393	19	-	0.5	1.81	1	End fragment, rivet with washer; ?top plate, ?lower guard. 2 joined fragments.	-	-	1462	-
394	14	-	-	0.40	1	Small side fragment; bottom plate, ?lower guard.	-	-	935	-
395	15.5	-	4	0.99	1	Small side fragment, gilded; bottom plate, ?lower guard. ?Polishing scratches.	L	-	938	-
396	12	-	4	0.51	1	Small side fragment.	-	-	90	K10
397	20	-	4.5	1.03	1	Small side fragment.	-	-	167	-
398	12	-	4	0.64	1	Small side fragment, gilded. Cut marks.	-	-	200	-
399	25.5	-	3	1.40	1	Small side fragment, gilded. Cut marks.	M	-	422	-
400	15	-	3.5	0.76	1	Small side fragment, ?gilded.	-	-	609	-
401	17	-	6	0.55	1	Small side fragment.	M	-	901	-
402	17	-	3.5	0.88	1	Small side fragment, ?gilded.	M	-	941	-
403	16	-	3	0.72	1	Small side fragment. Cut marks.	M	-	1057	M9
404	32	-	5	1.55	1	Side fragment, ?gilded. Rejoined from 4 smaller fragments.	-	-	1999	-
405	20	-	3.5	0.68	1	Small side fragment. Mark from hilt-collar or grip.	-	-	253	-
406	12	-	4	0.27	1	Small side fragment.	-	-	2071	-
407	19	-	4	0.68	1	Small side fragment.	-	-	2030	-
408	11.5	-	3.5	0.51	1	Small side fragment.	-	-	1926	-
696	38	22	0.5	1.79	1	Top plate, ?lower guard; gilded. Missing ends, rejoined from 7 fragments. Mark from hilt-collar/ring. ?Cut end.	-	-	2189, 2190	-
697	21	17	5	1.84	1	End fragment, ?gilded; ?lower guard. Rejoined from 14 fragments.	-	-	1712	-

▼ Hilt-guard set in silver (409) and small mounts in gold (410-25).

HILT-GUARD SET 409

Cat.	(mm)	(mm)	(mm)	Wt (g)	Au%Wt†	Objects	HILT-GUARD SET 409	Wear	Set	K-numbers	Grid
409	27.5/99	25	13/14.5	37.55	73·4%	2	Pair of cast silver hilt-guards; incomplete, reconstructed from 37 fragments; 5 gold mounts with filigree interlace and one garnet setting. The mounts were set on the sides of the guards, combined with panels of cast and gilded interlace, with borders with niello zig-zag and leaf-shape patterns. Punchwork decorates the flat top and bottom silver surfaces of the plates. ?Polishing scratches.	M	?776, 188	38, 41, 63, 94, 137, 151, 231-2, 244, 379, 425, 529, 642, 826, 931, 1242, 1334, 1387, 1449-50, 1531, 1562, 1567, 1569, 1582-4, 1667, 1924, 1929, 1969, 1979, 5026, 5037, 5061	G8, 110, K11, L11, M10

SMALL MOUNTS IN GOLD

Cat.	(mm)	(mm)	(mm)	Wt (g)	Au%Wt†	Objects	SMALL MOUNTS IN GOLD	Wear	Set	K-numbers	Grid
410	28.5	13.5	1	5.57	-	1	Guard-tip mount; filigree scrollwork and herringbone banding. Filigree flattened by ?impact/tool.	L	411	689	-
411	32	27.5	1	5.47	-	1	Guard-tip mount; filigree scrollwork and herringbone banding. Flattened, torn.	L	410	1028	L7
412	22	9	<0.5	6.42	-	1	Guard-tip mount; Style II serpent in niello. Sheet gold over copper-alloy core-liner; ?bone/horn guard *in situ*. Torn.	M	-	972	L8
413	14	9.5	-	2.58	-	1	Guard-tip mount; undecorated. Sheet gold over copper alloy core-liner; ?bone/horn guard *in situ*. Torn.	-	-	1079	-
414	15	10	0.5	0.49	-	1	Sub-triangular form; filigree herringbone frame and scrollwork. Torn end.	L	-	30	M12
415	20	10	0.5	0.82	-	1	Sub-triangular form; filigree herringbone frame and scrollwork.	M	-	119	K9
416	20.5	9.5	0.5	0.76	-	1	Sub-triangular form; filigree herringbone frame and scrollwork. Flattening from ?tool.	?M	-	45	-
417	10	8	<0.5	0.19	-	1	Triangular form; filigree herringbone frame and scrollwork. One point torn.	L	?418-9, ?478-9	2072	N8
418	19.5	19	0.5	0.42	-	1	Triangular form; filigree herringbone frame and scrollwork. Fixing-holes at ends torn.	L	?417, ?419, ?478-9	1487	-
419	17	-	0.5	0.67	-	?1	Three fragments, torn, misshapen, possibly same mount. Triangular form; filigree scrollwork with herringbone frame.	M	?417-8, ?478-9	1033, 1061, 1946	O10, M10
420	21.5	19	0.5	1.43	-	1	Triangular form; filigree scrollwork and herringbone framing. Bent, torn, edge dented (?levered).	H	?478-9	878	K10
421	25	19	0.5	1.21	-	1	Triangular form; filigree scrollwork and herringbone framing. Torn holes.	L	?478-9	978	I10
422	28	13.5	0.5	1.46	-	1	Triangular form; filigree scrollwork and herringbone framing. One fixing-hole repaired, one torn.	L	-	1102	J8
423	15	15	1	1.06	-	1	Triangular form; filigree scrollwork and herringbone band. Folded.	L	-	1187	L14
424	12	15	0.5	0.41	-	1	Triangular form; plain with filigree edging.	L	-	802	J11
425	13.5	13	1	1.19	-	1	Triangular form; filigree Style II. Cut edge, ?blade-point mark (?levered), and flattening from ?tool.	H	426	9	K12

▼**Small mounts in gold (426–49)**. † – values from core metal, rounded-off (cf. Blakelock 2014); ? – possible/uncertain'; Wear – H (heavy), M (moderate), L (light)

Cat.	(mm)	(mm)	(mm)	Wt (g)	Au%Wt†	Objects	SMALL MOUNTS IN GOLD	Wear	Set	K-numbers	Grid
426	14	14	1	1.33	-	1	Triangular form; filigree Style II. ?Blade-point mark (?levered), torn fixing-hole and flattening from ?tool.	H	425	485	-
427	23.5	9	1	0.60	-	1	Rectangular form, triangular projection (torn apex); filigree scrollwork.	L	-	1428	-
428	19	5	1	0.50	-	1	Rectangular form; filigree scrollwork.	M	429	1429	-
429	18	4	1	0.35	-	1	Rectangular form; filigree scrollwork.	M	428	1591	-
430	14	4	0.5	0.15	-	1	Fragment, torn, ?rectangular form; filigree scrollwork.	L	-	340	-
431	20	5	0.5	0.51	-	1	Sub-rectangular form; filigree scrollwork and herringbone banding.	L	-	334	-
432	21.5	4.5	1	0.45	-	1	Rectangular form, slotted ends; filigree herringbone band.	L	-	157	-
433	16.5	4	1	0.33	-	1	Sub-rectangular form; filigree herringbone band. One fixing-hole torn.	M	-	5063	F8
434	17	2	1	0.27	-	1	Strip with return ends; filigree herringbone band. Damage from ?impact/tool.	L	-	768	-
435	20	5.5	1	0.63	-	1	Rectangular form; filigree collared granules in a herringbone frame. Damage from ?impact/tool.	L	-	1558	-
436	11	5	0.5	0.27	-	1	In 2 fragments, incomplete. ?Rectangular form; garnet boss at end, filigree collared granules.	L	-	2157	-
437	18.5	4	0.5	1.05	-	1	Sub-rectangular form; plain sheet.	L	-	1181	N9
438	58	18	1	3.50	-	1	Trapezoidal form; filigree, geometric arrangement of herringbone bands with scrollwork. Torn ends.	M	-	833	-
439	33	11	0.5	1.60	-	1	Rectangular form; filigree with cross, scrollwork and herringbone. Torn end.	H	440-2	480	-
440	29	12	0.5	1.86	-	1	Rectangular form; filigree with cross, scrollwork and herringbone. Torn edge.	H	439, 441-2	992	M8
441	23	10	0.5	1.46	-	1	Rejoined from 2 fragments. Rectangular form; filigree with cross, scrollwork and herringbone. Torn, one fragment curled and holed.	H	439-40, 442	1380, 1687	-
442	29.5	9	0.5	1.41	-	1	Rejoined from 2 fragments. Rectangular form; filigree with cross, scrollwork and herringbone. Torn end.	H	439-41	1386, 1685	-
443	39	9	1	2.91	-	1	Strip-mount; filigree with cross and scrollwork. Torn, missing ends.	H	444-7	478	-
444	30.5	11	1	2.85	-	1	Strip-mount; filigree with cross and scrollwork. Torn fixing-holes.	H	443, 445-7	1256	N10
445	39.5	12	1	5.13	-	1	Strip-mount; filigree with cross and scrollwork. Torn fixing-holes.	H	443-4, 446-7	687	-
446	21	12	1	1.65	-	1	Missing one end, torn; filigree scrollwork.	M	443-5,	325	-
447	12	11.5/1	1	1.03	-	?1	Two fragments, torn; filigree scrollwork.	M	443-6	951, 1440	K12
448	56	10	1	2.59	-	1	Strip-mount, stepped end; filigree herringbone fill.	M	449	800	J10
449	32.5	8	1	1.39	-	1	Strip-mount, stepped end; filigree herringbone fill.	M	448	1427	-

▼ Small mounts in gold (450–73).

Cat.	(mm)	(mm)	(mm)	Wt (g)	Au%Wt†	Objects	SMALL MOUNTS IN GOLD	Wear	Set	K-numbers	Grid
450	19	7.5	1	0.97	-	1	Rectangular form; filigree interlace (?Style II). Cut marks to edge.	H	451-3	810	J10
451	18	10	1	2.60	-	1	Strip-mount; filigree Style II serpents. Horn guard remains.	H	450, 452-3	305	-
452	46	11	1	3.53	-	1	Strip-mount; filigree interlace (?Style II). Ends bent outwards.	H	450-1, 453	464	-
453	50	10.5	1	3.26	-	1	Strip-mount; filigree interlace (?Style II). Flattened.	H	450-2	721	M12
454	32	14	1	2.51	-	1	Rectangular form; filigree interlace and annulets. Cut marks. Damage from ?impact/tool.	L	455	735	-
455	27	14.5	1	1.83	-	1	?Rectangular form; filigree Style II serpents and annulets. Torn, end missing.	L	454	958	-
456	56	12	1.5	4.91	-	1	Trapezoidal form; filigree, regular interlace. One end cut, one torn.	L	457	314	-
457	38	15	1.5	4.98	-	1	Trapezoidal form; filigree, regular interlace and herringbone banding. Torn end.	M	456	1034	O7
458	15	10.5	4	1.56	-	1	Rectangular form; filigree interlace. Copper-alloy plate on reverse.	M	?494-5	1042	M7
459	24	11.5	1	2.13	-	1	Bird and fish mount (Style II), incised on sheet metal. Bent head-end.	M	-	42	-
460	40	19	0.5	1.49	77-8%	1	Zoomorphic form, horse-like head (Style II); filigree scrollwork. Torn, missing its second, mirrored head.	M	-	1497	-
461	23	5	0.5	0.93	-	1	Fish form; filigree, fish-scale pattern and annulets. Bent. Cut mark.	M	-	796	J11
462	30	12	0.5	1.42	-	1	Fish form; filigree herringbone pattern.	M	-	1663	-
463	21.5	11	0.5	1.02	-	1	Bird head each end, one crumpled; filigree scrollwork. Cut marks.	M	-	1538	-
464	38	33	1	3.55	76-8%	1	Swastika form with bird heads; filigree scrollwork; ?gem-settings. Cut marks.	M	-	297	-
465	22	20	0.5	1.21	75%	1	Bird-headed form; filigree annulets and collared granules; three gem-settings, one with garnet boss. ?Blade scratches.	M	-	468	-
466	12.5	11	0.5	0.37	-	1	Zoomorphic-head form, head torn; filigree herringbone band.	L	-	5057	L11
467	21	20	0.5	2.84	-	1	Bird-headed form, one of two heads remains, other torn off, filigree scrollwork and collared granules. From ?upper grip.	M	468	390	-
468	39.5	24	0.5	4.36	-	1	Bird-headed form (pair of mirrored heads); filigree scrollwork and collared granules. From ?lower grip.	M	467	475	-
469	16.5	-	0.5	0.73	-	1	Half fragment, rolled, torn; Style II bird-headed form; filigree herringbone, scrollwork and collared granules.	-	470	52	N12
470	22	18	0.5	1.79	69-73%	1	Bird-headed (Style II) form; filigree herringbone, scrollwork and collared granules. Bent, torn.	L	469	365	K10
471	21.5	9	1	1.31	-	1	Bird-headed (Style II) form; filigree cross and scrollwork. 2 fragments (rejoined), torn at join. Flattening from ?tool.	M	472	113, 923	-
472	23	11	1	1.05	-	1	Half fragment, ?torn at join; bird-headed (Style II) form; filigree scrollwork.	L	471	1321	-
473	26.5	25	1	4.54	-	1	Style II birds/face-mask; filigree scrollwork; garnet gem-settings as eyes. From ?upper grip.	L	474-5	1000	M13

Small mounts in gold (474-97).
† – values from core metal, rounded-off (cf. Blakelock 2014); ? – possible/uncertain'; Wear – H (heavy), M (moderate), L (light)

SMALL MOUNTS IN GOLD

Cat.	(mm)	(mm)	(mm)	Wt (g)	Au%Wt†	Objects	SMALL MOUNTS IN GOLD	Wear	Set	K-numbers	Grid
474	35	21	1	6.52	89-91%	1	Style II birds/face-mask; filigree scrollwork; garnet gem-settings as eyes. From ?lower grip. Misshapen, one fixing-hole torn.	M	473, 475	454	-
475	34	18	1	6.58	-	1	Misshapen and torn, 2 rejoined fragments; filigree interlace, collared granules and scrollwork.	M	473-4	71, 1010	K11, L11
476	13	10	0.5	0.39	-	1	Pelta form; filigree herringbone banding. Cut edge.	L	477	738	M12
477	14	7.5	1	0.34	-	1	Pelta form; filigree herringbone banding. Cut, missing upper part.	L	476	865	-
478	18	9	0.5	0.78	-	1	Eye-shaped form; filigree herringbone band and scrollwork. Fixing-holes torn. Flattening damage.	L	479, ?417-21	40	L12
479	23.5	9	0.5	0.73	-	1	Eye-shaped form; filigree herringbone band and scrollwork. Fixing-holes torn. Flattening damage.	L	478, ?417-21	1273	N12
480	24.5	7	1	1.42	-	1	L-shaped form; filigree Style II with herringbone banding.	L	-	974	M10
481	19.5	15	0.5	0.64	-	1	Cross form, one arm missing; filigree annulets and herringbone banding.	M	-	920	-
482	20.5	15.5	1	1.32	-	1	Cross form, one arm torn and bent; filigree scrollwork, central garnet boss.	L	-	5018	M11
483	13	10.5	1	1.09	-	1	Tongue-shaped form; filigree interlace. ?Blade scratch, reverse. Torn basal edge.	L	484	487	-
484	13	10	1	1.04	-	1	Tongue-shaped form; filigree interlace.	L	483	1579	-
485	13	8	<0.5	1.33	-	1	Tongue-shaped form; incised Style II creature.	L	486-7	1165	-
486	10	7	<0.5	0.25	-	1	Tongue-shaped form; incised Style II creature. Torn head. Pierced by rivet (repair)	L	485, 487	409	-
487	9.5	7	0.5	0.22	-	1	Tongue-shaped form; incised Style II creature. Torn, missing head.	L	485-6	587	-
488	35	10	1	4.41	98%	1	Strip with forked end; plain.	M	-	95	K10
489	12	12	2	1.13	-	1	Triangular form; garnet cloisonné, stepped cellwork. Fixing-holes torn, cut marks (?levered).	L	490	22	-
490	12.5	12	2	1.08	-	1	Triangular form; garnet cloisonné, stepped cellwork with mushroom-shape. Cut marks (?levered).	L	489	783	-
491	15	14	2.5	1.05	-	1	Triangular form; garnet cloisonné, rectilinear cellwork. Fixing-holes torn. Cut one edge (?levered).	L	-	1868	-
492	15.5	9.5	2	1.11	-	1	Triangular form; garnet cloisonné, triangular and rectilinear cellwork.	L	-	331	-
493	14.5	12	2.5	0.98	-	1	Triangular form; triangular garnet gem-setting, filigree scrollwork frame.	M	-	718	-
494	13.5	7	3	0.95	-	1	Rectangular form; garnet and glass cloisonné, geometric cellwork.	?L	?458, ?495	1184	L14
495	14.5	11	2.5	1.59	-	1	Rectangular form; garnet and glass cloisonné with concealed crosses.	?L	?458, ?494	1226	J9
496	25	8	2	2.79	-	1	Guard-tip mount; garnet cloisonné, fish-scale cellwork. Torn, 2 rejoined fragments.	L	497	737, 788	M12
497	30	7.5	2	2.61	-	1	Guard-tip mount; garnet cloisonné, fish-scale cellwork. Ends bent outwards.	L	496	1316	-

▼ Small mounts in gold (498–519).

SMALL MOUNTS IN GOLD

Cat.	(mm)	(mm)	(mm)	Wt (g)	Au%Wt†	Objects	Description	Wear	Set	K-numbers	Grid
498	34	8	2.5	5.40	-	1	Guard-tip mount; garnet cloisonné, stepped cellwork. Folded, torn.	L	-	474	-
499	29	8	3	4.27	-	1	Guard-tip mount; garnet cloisonné, split/half-mushroom and stepped-rhomboid cellwork. From upper guard.	L	500-2	323	-
500	24	8.5	4	4.69	-	1	Guard-tip mount; garnet cloisonné, split/half-mushroom and stepped-rhomboid cellwork. From upper guard.	L	499, 501-2	373	-
501	30	10	4	7.19	-	1	Guard-tip mount; garnet cloisonné, split/half-mushroom and stepped-rhomboid cellwork. From upper guard.	L	499-500, 502	773	-
502	28	10	4	6.77	-	1	Guard-tip mount; garnet cloisonné, split/half-mushroom and stepped-rhomboid cellwork. From lower guard.	L	499-501	348	-
503	24.5	6	2.5	3.13	-	1	Guard-tip mount; garnet cloisonné, arrow-shaped and stepped cellwork. From upper guard. Twisted.	L	504-6	969	L8
504	28	6	2	3.81	-	1	Guard-tip mount; garnet cloisonné, arrow-shaped and stepped cellwork. From upper guard.	L	503, 505-6	1147	K16
505	34.5	7	3	4.79	-	1	Guard-tip mount; garnet cloisonné, stepped cellwork. From lower guard. Twisted.	L	503-4, 506	118	L10
506	62.5	8	3	5.54	-	1	Guard-tip mount; garnet cloisonné, stepped cellwork. From lower guard. Sides bent. Damage from ?impact/tool.	L	503-5	1246	N9
507	17.5/23	8	1.5	2.17	-	1	Guard-tip mount, in 2 torn fragments; garnet cloisonné, mushroom and stepped cellwork. From ?upper guard.	L	508	106, 5031	L9, M11
508	44.5	8.5	2	3.35	-	1	Guard-tip mount; garnet cloisonné, mushroom-, arrow-shaped and stepped cellwork. From ?lower guard. Splayed sides, torn ends.	L	507	476	-
509	22.5	9	1.5	2.98	-	1	Guard-tip mount; garnet cloisonné, stepped cellwork.	L	510	1001	K12
510	21	9	1.5	2.75	-	1	Guard-tip mount; garnet cloisonné, stepped cellwork. Damaged one side/end.	L	509	1366	-
511	22	9.5	2	2.31	79%	1	Style II bird form; garnet cloisonné. Bent head.	L	512, ?513	16	K12
512	22	9	2	2.45	-	1	Style II bird form; garnet cloisonné. ?Blade scratch.	L	511, ?511-2	1084	J12
513	24.5	10	2	1.50	-	1	Fish form; garnet cloisonné.	L	?511-2	328	-
514	15	9	1	1.40	-	1	Style II bird-headed form; garnet cloisonné with stafford knot.	L	515	575	F10
515	15	10	2	1.44	-	1	Style II bird-headed form; garnet cloisonné with stafford knot.	L	514	5009	-
516	25	21	2	3.99	-	1	Pair of Style II birds, garnet cloisonné. From ?upper grip.	L	517	72	L11
517	34	21	1.5	4.82	-	1	Pair of Style II birds; garnet cloisonné. From ?lower grip. Flattened.	L	516	980	I10
518	19	9	2	1.35	-	1	Tongue-shaped form with animal head; garnet cloisonné, mushroom- and arrow-shaped cellwork.	L	519-20	78	K11
519	19	8	2	1.52	-	1	Tongue-shaped form with animal head; garnet cloisonné, mushroom- and arrow-shaped cellwork.	L	518, 520	728	M12

▼**Small mounts in gold (520-32)** and **silver (533-7)**, and **large mounts in gold (538-9)**. † – values from core metal, rounded-off (cf. Blakelock 2014); ? – possible/uncertain'; Wear – H (heavy), M (moderate), L (light)

Cat.	(mm)	(mm)	(mm)	Wt (g)	Au%Wt†	Objects	SMALL MOUNTS IN GOLD	Wear	Set	K-numbers	Grid
520	18	9.5	2	1.37	-	1	Tongue-shaped form with animal head; garnet cloisonné, mushroom-shaped cellwork.	L	518-9	1555	-
521	18	8	2	1.39	-	1	Tongue-shaped form with animal head; garnet cloisonné, fish-scale pattern.	L	522	1465	-
522	16	8.5	2	1.28	-	1	Tongue-shaped form with animal head; garnet cloisonné, fish-scale pattern.	L	521	1838	-
523	20	8	2	1.42	-	1	Tongue-shaped form; garnet cloisonné, fish-scale pattern.	-	-	1424	-
524	25	6.5	2	1.06	-	1	Oval form; garnet cloisonné. Long dent, ?impact/tool.	?M	-	148	-
525	25	8	2	2.24	-	1	Oval form; garnet cloisonné, cross and mushroom cellwork. Cut marks.	L	-	388	-
526	23	-	1.5	2.46	-	1	Cross form; garnet and glass cloisonné, geometric cellwork. Arms bent.	?L	-	820	J10
527	58	5.5	2	5.13	94%	1	Cast, serpent form, flat-round head with pitchfork jaws. ?Cut mark, tail.	L	528	128	L11
528	108	5	3	10.74	-	1	Cast, serpent form, flat-round head with pitchfork jaws.	L	527	943	L8
529	37.5	-	2.5	3.26	98%	1	Cast, serpent form, semi-naturalistic with punched eyes.	L	530	816	L9
530	54	-	3	4.47	-	1	Cast, serpent form, semi-naturalistic with punched eyes. Twisted. Cut marks, underside.	L	529	1014	L10
531	93.5/13	5	4.5	25.61	-	1	Cast, serpent form, semi-naturalistic with nilloed eyes. Twisted, head detached.	L	532	700, 1365	-
532	80/13	4.5	4	21.10	-	1	Cast, serpent form, semi-naturalistic with nilloed eyes. Head detached, missing tail.	L	531	731, 883	M12, Q10

Cat.	(mm)	(mm)	(mm)	Wt (g)	Au%Wt†	Objects	SMALL MOUNTS IN SILVER	Wear	Set	K-numbers	Grid
533	14	13.5	1	1.36		1	Tongue-shaped form; gilded interlace with niello. Flattening from ?impact.	-	?69, ?186-?187, ?534-?535	577	-
534	12	10.5	1	0.75		1	Tongue-shaped form; gilded interlace with niello.	L	?69, ?186-?187, ?533, ?535	1106	-
535	13.5	9	1.5	0.74		1	Grip edge-mount; interlace. Missing one side.	L	?69, ?186-?187, ?533-?534	1277	N12
536	20	20	1	2.38		1	Bird-headed form; gilded interlace.	L	537	791	-
537	28	25	1	2.41		1	Bird-headed form, 2 rejoined fragments; gilded interlace.	L	536	1525, 1603	-

Cat.	(mm)	(mm)	(mm)	Wt (g)	Au%Wt†	Objects	LARGE MOUNTS IN GOLD	Wear	Set	K-numbers	Grid
538	120	55	2	62.20	86-90%	1	Mount of a fish between birds; fish-head detached. Incised feather and fish-scale detail on gold sheet; Style II creatures at fish tail. Cut mark.	L	-	652, 1249	N13
539	114	-	1	175.25	59-83%	1	Great cross; folded arms. 6 gem-settings, one *in situ*; three garnet cabochons (one repaired). Style II on arms; four bird heads surround the centre; animal ears project from the arms.		-	308, 655-9, 1314	-

▼ Large mounts in gold (540–53).

Cat.	(mm)	(mm)	(mm)	Wt (g)	Au%Wt†	Objects	LARGE MOUNTS IN GOLD	Wear	Set	K-numbers	Grid
540	89.5	16	2	79.69	75%	1	Strip with Latin inscriptions, front and back, and animal heads; folded in half. Text is niello inlaid one side. Gem-setting one end (flattened, ?tool) with cast surround with serpent heads.	L	-	550	-
541	63	-	3	70.66	70-89%	1	Sub-conical mount with column and small apical disc; misshapen, found in 9 parts; garnet cloisonné, including mushroom cellwork, with Style II incised gold panels and a large *millefiori* stud on the small disc. Multiple cryptic crosses.	L	-	54, 112, 130, 467, 545, 1055, 1324, 1510	J10, K10, M10
542	74	52	3	38.20	-	1	Eye-shaped, damaged edge; garnet cloisonné (wax-glue paste), including mushroom cellwork, with central empty 'eye' cell; multiple cryptic crosses; filigree trim. ?Blade scratches on reverse. ?Cut nail/rivet.	L	543-7	270	-
543	73	53	3	36.98	-	1	Eye-shaped. Garnet cloisonné (wax-glue paste), including mushroom cellwork, with central empty 'eye' cell; multiple cryptic crosses; filigree trim. Blade scratches on reverse.	L	542, 544-7	843	K11
544	35/38	15	3.5	31.31	-	1	Strip with angled ends; folded, snapped, found in two fragments; garnet cloisonné (wax-glue paste), including mushroom cellwork; multiple cryptic crosses; filigree trim. Blade scratches on reverse.	L	542-3, 545-7	1, 5005	J12
545	44/78	15	4	29.88	-	1	Strip with angled ends; bent, cut in two; garnet cloisonné (wax-glue paste), including mushroom cellwork; multiple cryptic crosses; filigree trim.	L	542-4, 546-7	463, 712	-
546	40/78	15.5	3.5	45.68	-	1	Strip with angled ends; folded, in two fragments; garnet cloisonné, including mushroom cellwork; multiple cryptic crosses; filigree trim. Blade scratches on reverse.	L	542-5, 547	127, 643	O20
547	171	15	3	34.43	-	1	Strip with angled ends, ?cut in two, garnets scoured from one end; cloisonné, including mushroom cellwork, and multiple cryptic crosses; filigree trim. Blade scratches and cut on reverse.	L	542-6	681, 1313	-
548	70.5	12.5	4	15.61	-	1	Strip, curved; garnet cloisonné, including a line of mushroom cells; filigree trim.	L	549	447	-
549	60.5	12.5	4	16.31	-	1	Strip, misshapen from curved; garnet cloisonné, including a line of mushroom cells; filigree trim.	L	548	1050	O8
550	119	21	3.5	35.86	81%	1	Strip with garnet cloisonné (wax-glue paste), including a line of arrow-shaped cells; filigree trim.	L	551, ?552-5	273	-
551	60	20.5	4	24.07	-	1	Four fragments of a strip with garnet cloisonné (wax-glue paste); incomplete, originally probably identical to **553**.	L	550, ?552-5	384, 400, 645, 1139	Q17
552	86.5	18	3	23.57	-	1	Strip with pointed end, bent; garnet cloisonné (wax-glue paste), including a line of mushroom cells; filigree trim. Cut mark and Blade scratches on reverse.	L	553-5, ?550-1	362	-
553	85	18	3	21.06	-	1	Strip with pointed end, bent; garnet cloisonné (wax-glue paste), including a line of mushroom cells; filigree trim.	L	552, 554-5, ?550-1	673	-

CATALOGUE ENTRIES | TABLES 540-66

▼ **Large mounts in gold (554-66)**. † – values from core metal, rounded-off (cf. Blakelock 2014); ? – possible/uncertain'; Wear – H (heavy), M (moderate), L (light)

Cat.	(mm)	(mm)	Wt (g)	Au%Wt†	Objects	LARGE MOUNTS IN GOLD	Wear	Set	K-numbers	Grid	
554	62	18.5	3	16.10	-	1	Strip with pointed end, bent; garnet cloisonné, including a line of mushroom cells; filigree trim.	L	552-3, 555, ?550-1	663	-
555	69	17	3	13.00	-	1	Strip with pointed end, bent; garnet cloisonné, including a line of mushroom cells; filigree trim.	L	552-4, ?550-1	668	-
556	81/83.5	12	4	26.24	-	1	Strip, curved, with garnet cloisonné and two Style II filigree serpent panels (one missing); misshapen, torn; cloisonné includes mushroom quatrefoils (crosses); filigree trim. Wax-calcite filler in one recess.	L	557, ?558-61	69, 445, 1062, 1948	K10, M10
557	39/81.5	11	3.5	26.76	-	1	Strip, curved, one end damaged; garnet cloisonné and three Style II filigree serpent panels; cloisonné includes mushroom quatrefoil (crosses); filigree trim. Cut nail/rivet.	L	556, ?558-61	158, 556, 662, 716, 1402	K10, M10
558	96/107	19.5	3	80.79	65-78%	1	Crook-shaped strip, misshapen, found in eleven parts; garnet cloisonné framing, of oval and stepped forms; filigree trim; rectangular filigree panels (one missing) inset the whole length, most with Style II serpents. Cut mark on one filigree mount. Two replacement mounts.	L	559, 560-1	89, 154, 169, 275, 312, 513, 797, 1439, 1741-2, 5008	J10, N7
559	85/105	19	3	82.50	-	1	Crook-shaped strip, misshapen, found in twelve parts; garnet cloisonné framing, of oval and stepped forms; filigree trim; rectangular filigree panels (one missing) inset the whole length, most with Style II serpents. Cut mark on edge. One replacement mount.	L	558, 560-1	67, 109, 131, 371, 438, 789, 847, 885, 1317, 1456, 1544, 5066	I12, K10
560	40.5	19.5	3	11.72	-	1	Rectangular, damaged ends, cut marks; garnet cloisonné framing, of oval and stepped forms; filigree trim; two rectangular filigree panels inset with Style II serpents.	L	558-9, 561	677	M11
561	40.5	19.5	3	10.54	-	1	Rectangular, twisted end; garnet cloisonné framing, of oval and stepped forms; filigree trim; two rectangular filigree panels, found separately, inset with Style II serpents. Cut marks	L	558-60	68, 696, 952	L8, L10
562	79	29.5	8	27.91	80-83%	1	L-shaped edge-mount, with niche, twisted; garnet cloisonné, mushroom and arrow cellwork with quatrefoils (crosses); filigree trim.	L	562-4	356	-
563	48	-	8	19.42	-	1	Edge-mount, with niche, folded from straight; garnet cloisonné, mushroom and arrow cellwork with quatrefoils (crosses); filigree trim.	L	562, 564	357	-
564	40/35	32	9	26.13	-	1	L-shaped edge-mount, with niche, torn, two fragments; garnet cloisonné, mushroom and arrow cellwork with quatrefoils (crosses); filigree trim.	L	562-3	665, 1145	L16
565	57	56	3	29.96	69%	1	Wing-shaped; garnet cloisonné, fish-scale pattern; bone inlay; filigree trim.	L	566	653	-
566	57	50	3	26.90	-	1	Wing-shaped, edge bent; garnet cloisonné, fish-scale pattern; filigree trim.	L	565	654	-

▼ **Large mounts in silver (567-71)**, and **pyramid-fittings in gold (572-77)**.

LARGE MOUNTS IN SILVER

Cat.	(mm)	(mm)	(mm)	Wt (g)	Objects	Description	Wear	Set	K-numbers	Grid
567	48	28	1	9.51	1	Eye-shaped, damaged end and edge; niello triangle pattern; filigree trim around cut-out 'eye'.	?L	568-71	310	-
568	20	-	1	3.33	1	Three fragments, incomplete; pair to **567**.	?L	567, 569-71	620, 638, 1021	N7
569	212	33	1	67.87	1	Tapered mount with fantail, found in 27 fragments, some bent; niello imitating cloisonné with a line of mushroom 'cells'; gilded edges. Cut marks and blade scratches, tail ?levered.	?L	567-8, 570-1	82-83, 168, 182, 251, 350, 421, 431, 538, 619, 867, 929, 975, 982, 1005, 1098, 1111, 1285, 1296, 1615, 1630, 1669, 1700, 2170, 5044, 5051	G11, K10, M10, M11, M12
570	78	14	1	29.68	?2	Possibly two strip-mounts, incomplete, 15 fragments; niello imitating cloisonné; gilded edges. ?Blade scratches on reverse.	?L	567-9, 571	161, 241, 713, 823, 1036, 1069, 1182, 1196, 1233, 1716	K9, L9, M9, M11, O10
571	55	15	1	48.05	1	Possibly a single strip with two turning, pointed ends; incomplete, 27 fragments; niello interlocking triangles; gilded edge. Cut mark.	?L	567-70	64, 592, 641, 747, 895, 932, 946, 954, 968, 988, 1002, 1039, 1114, 1142, 1149, 1168, 1191-2, 1219, 1235, 1287, 1528, 1599, 5046, 5085	E12, I10, K5, K10, L8, L12, L16, M7, M9, M12, M14, M16, N7

PYRAMID-FITTINGS IN GOLD

Cat.	(mm)	(mm)	(mm)	Wt (g)	Au%Wt†	Objects	Description	Wear	Set	K-numbers	Grid
572	21	21	13.5	13.27	87%	1	Pyramid-fitting, low form; garnet cloisonné and small blue glass inlays. Slightly twisted.	L	573	377	-
573	21	21	13.5	13.11	86-8%	1	Pyramid-fitting, low form; garnet cloisonné and small blue glass inlays.	L	572	462	-
574	18.5	18	18	9.27	66-8%	1	Pyramid-fitting, tall form; filigree and garnet cloisonné. Copper-alloy core. Loop missing.	M	575	107	-
575	18	20	18	8.92	-	1	Pyramid-fitting, tall form; filigree and garnet cloisonné. Copper-alloy core. Loop at base. Squashed.	M	574	1201	N8
576	20	20	21.5	15.26	-	1	Pyramid-fitting, tall form; garnet cloisonné; *millefiori* inlay, loose from apex.	L	577	450	-
577	20	18	21.5	15.30	-	1	Pyramid-fitting, tall form; garnet cloisonné.	L	576	565	-

CATALOGUE ENTRIES | TABLES 567–81

▼ **Pyramid-/button-fittings in gold (578-9 and 582-3)** with **stone bead (584)**, and **silver pyramid-fittings (580-1)**. † – values from core metal, rounded-off (cf. Blakelock 2014); ? – possible/uncertain'; Wear – H (heavy), M (moderate), L (light)

PYRAMID-/BUTTON-FITTINGS IN GOLD AND BEAD 584

Cat.	(mm)	(mm)	(mm)	Wt (g)	Au%Wt†	Objects	Description	Wear	Set	K-numbers	Grid
578	23.5	-	21	16.51	74-8%	1	Pyramid-fitting, tall form; garnet cloisonné and 'unidentified' inlay; *millefiori* inlay at apex; Style II each side.	L	579	451	-
579	23.5	-	21	16.52	-	1	Pyramid-fitting, tall form; garnet cloisonné and 'unidentified' inlay; *millefiori* inlay at apex; Style II each side. Slightly squashed.	L	578	1166	K7
582	14	-	17	3.27	-	1	Button-fitting; garnet cloisonné. Dog-tooth bezel, filigree collar. Fits bead **584**.	L	583-4	675	-
583	14	-	15	3.19	-	1	Button-fitting; garnet cloisonné. Dog-tooth bezel, filigree collar.	L	582	1425	-
584	19	-	10	5.30	-	1	Barrel-shaped quartz bead. Fits fitting **582**.	-	582	764	-

PYRAMID-FITTINGS IN SILVER

Cat.	(mm)	(mm)	(mm)	Wt (g)	Au%Wt†	Objects	Description	Wear	Set	K-numbers	Grid
580	24	24	19	18.07	75%	1	Pyramid-fitting, tall form; cast silver body with gold mounts; mounts have filigree scrollwork and spiral conicals, and tear-drop garnet triforms; garnet cloisonné 'X' at apex.	L	581	302	-
581	21	-	19	11.24	-	1	Incomplete, 5 fragments; identical pair to **580**.	L	580	382, 676, 849, 999, 1254	M14, N10

▼ **Buckles in gold (585-6)** and **silver (587)**, **cross pendant in gold (588)**, and **helmet parts in silver (589-90)**.

Cat.	(mm)	(mm)	(mm)	Wt (g)	Au%Wt†	Objects	BUCKLES IN GOLD	Wear	Set	K-numbers	Grid
585	16	12	4	2.03	-	1	Small, oval loop, rectangular back-plate. Lines on tongue one end.	L	-	144	-
586	21	17	5	5.40	-	1	Small, oval loop, rectangular back-plate. Three filigree-collared bosses and a lightly incised band on plate.	L	-	685	-

Cat.	(mm)	(mm)	(mm)	Wt (g)	Objects	BUCKLE IN SILVER	Wear	Set	K-numbers	Grid
587	16.5	29	2.5	6.06	1	Oval loop, oval tongue-shield, rectangular back-plate. Gold herringbone filigree on loop.	L	-	957, 959	K12

Cat.	(mm)	(mm)	(mm)	Wt (g)	Au%Wt†	Objects	CROSS-PENDANT IN GOLD	Wear	Set	K-numbers	Grid
588	64.5	50	9.5	24.38	84-7%	1	Equal arms with flared ends, round cabochon garnet at centre; one arm broken, one bent. Filigree scrollwork on arms and loop. ?Cut mark on loop.	L	-	303	-

Cat.	(mm)	(mm)	(mm)	Wt (g)	Au%Wt†	Objects	HELMET PARTS IN SILVER	Wear	Set	K-numbers	Grid
589	128	12	9.5	74.58	-	1	Curved helmet-crest part in silver-gilt, tapered to animal-head terminal, with Style II interlace. Bent, fractured, head found detached. Cut marks. Calcite-wax paste and wood in channel.	L	590-2	47, 678, 546	M12
590	175	11.5	9.5	55.18	-	1	Curved helmet-crest part in silver-gilt, tapered to animal-head terminal, with Style II interlace. Found in 25 fragments, some torn and bent. ?Cut mark. Calcite-wax paste in channel.	L	589, 591-2	31, 49, 73, 139, 363, 397, 519, 535, 541, 616, 629, 868, 950, 1012, 1158, 1177, 1257, 1261, 1652, 1882, 1973, 5019, 5033	E10, F7, F9, G10, K15, L12, M12, N10, N10

CATALOGUE ENTRIES | TABLES 585–98

▼ **Helmet parts in silver and gold (591–8).** † – values from core metal, rounded-off (cf. Blakelock 2014); ? – possible/uncertain'; Wear – H (heavy), M (moderate), L (light)

Cat.	(mm)	(mm)	(mm)	Wt (g)	Au%Wt†	Objects	HELMET PARTS IN SILVER AND GOLD	Wear	Set	K-numbers	Grid
591	96	79.5	20	122.28	73%	1	Silver-gilt cheek-piece with Style II and a gold filigree collar. Attachment tabs bent and broken off.	L	589-90, 592	288, 453, 740, 1509	-
592	89.5	55	2	116.07	-	1	Silver-gilt cheek-piece with Style II and a gold filigree collar. Rolled with torn edges (?recent); attachment tabs, and front edge, bent and broken off.	L	589-91	97, 594, 772, 1223, 5004	M9, M20, R6
593	125	17	4	55.32	-	1	Helmet-band, found in 112 fragments; comprising a rigid, originally curved, silver-gilt band with a silver-gilt sheet band insert, showing a die-impressed procession of kneeling warriors. Evidence for wax-glue. Many cut marks indicate levering of the sheet band.	?L	-	48, 51, 96, 228, 234-5, 237, 243, 250, 255, 523, 794, 834, 970, 1031, 1432, 1437, 1515, 1529, 1541, 1551, 1556, 1561-2, 1574, 1577, 1608, 1627, 1634, 1643, 1650, 1676, 1692, 1734, 1778, 1801, 2000, 2031, 2098, 2131-5, 2137	L7, L10, L12, M9, M12, N12
594	150	25	<0.5	24.57	-	1	Silver-gilt sheet band, found in 118 fragments, die-impressed with a procession of Style II creatures.	?L	-	171, 207, 209, 598, 795, 905, 966, 1113, 1115, 1171-2, 1179, 1203, 1363, 1392-3, 1406, 1412, 1416-9, 1473, 1495, 1517, 1519, 1532, 1550, 1593, 1664, 1690, 1931, 1944, 2128-30, 2145, 2174, 2175-76	H11, I7, K8, K16, P14
595	52	-	<0.5	3.19	-	1	Silver-gilt sheet panel, found in 22 fragments, die-impressed with a mounted warrior and two naked figures.	?L	-	156, 166, 1218, 1333, 1363, 1373, 1392, 1397, 1400, 1409, 1437, 1615, 1621, 1624, 2011	E8, N13
596	44	-	<0.5	7.40	-	6	Remains of six identical silver-gilt sheet panels, found in 82 fragments, each die-impressed with three warriors marching right. Cut at ?manufacture or ?removal.	?L	597	55, 201, 237, 429, 493, 506, 748, 819, 829, 961, 1013, 1109, 1328, 1361, 1412, 1423, 1437, 1476, 1495, 1503, 1562, 1574, 1577, 1593, 1596, 1621, 1664, 1667, 1690, 1694, 1772-3, 1847, 2181-2, 5017, 5039, 5067	I10, J10, K8, K10, L10
597	52	-	<0.5	8.64	-	6	Remains of six identical silver-gilt sheet panels, found in 74 fragments, each die-impressed with three warriors marching left. Cut at ?manufacture or ?removal.	?L	596	237, 435-6, 813, 828, 933, 1290, 1319, 1332, 1373, 1382-3, 1392, 1400, 1405, 1407, 1416-7, 1420, 1423, 1480, 1495, 1503, 1556, 1562, 1596, 1636, 1664, 1690, 1694, 1770-1, 1774, 2012	J10
598	25	-	<0.5	1.07	-	1	Silver-gilt sheet band, found in 9 fragments, die-impressed with moustached heads.	?L	-	795, 1146, 1621, 1701, 1769, 1775, 2138, 2152	J7

▼ **Helmet parts in silver (599–604‡ and 606), and silver coverings for a stand (607/8)**. ‡ — sheet **605** (not die-impressed) is below, 'Fragments in silver'

Cat.	(mm)	(mm)	Wt (g)	Au%Wt†	Objects	HELMET PARTS IN SILVER ‡	Wear	Set	K-numbers	Grid
599	36	-	0.80	-	?1	Originally 3 fragments (2 joined), corroded, from a silver sheet panel, die-impressed, probably showing dancing warriors with spears.	-	-	621, 793, 1008	J9
600	107	-	9.77	-	?1	Silver sheet, found as 96 fragments, die-impressed with panels with Style II. Gilded borders.	L	-	24, 75, 120, 146, 153, 191, 195, 210, 226, 229, 502, 510, 518, 520, 521, 527, 540, 542, 600, 601, 606, 613, 640, 746, 757, 763, 785, 795, 830, 838-40, 910, 934, 960, 1023, 1057, 1070, 1081, 1088, 1095, 1099, 1117, 1161, 1176, 1271, 1291, 1303, 1326, 1350, 1363, 1473, 1533, 1577, 1596, 1670, 1677, 1690, 1714, 1778, 1865, 1906, 1912, 1952, 2057, 2191, 2150, 5030, 5077	I8, I12, J10, K9-K12, K15, L10, L12, M9-M10, M14, N7, N12, P16
601	34	14	0.52	-	1	Silver-gilt, possibly leaf-shaped sheet panel, found in 4 fragments, with die-impressed Style II.	L	-	858, 905	H9
602	24	-	1.91	-	?1	One or more silver-gilt die-impressed sheet panels, found in 19 fragments, with Style II and stafford knots.	L	-	4, 185, 542, 760, 1023, 1340, 1416, 1493, 1495, 1664, 5020, 5052, 5054, 5079	F9, M12-M13, N7
603	38.5	-	0.70	-	1	Silver-gilt sheet panel, found in 9 fragments, with die-impressed Style II.	L	-	216, 1332, 1353, 1690, 5055	N9
604	34	-	2.46	-	?1	Silver sheet fragments, 9 fragments total, of die-impressed herringbone border.	L	-	15, 170, 212, 218, 790, 795, 1186, 1574, 1779	L12, L14
606	<15	-	11.74	-	-	Three-hundred and ninety small fragments of non-associated sheet with die-impressed decoration.	-	-	See full online catalogue	

Cat.	(mm)	(mm)	Wt (g)	Objects	SILVER-GILT COVERING FOR STAND	Wear	Set	K-numbers	Grid
607/8	115	81	90.38	1	Silver-gilt sheet covering for an oval base with socket (i.e. a stand), trimmed with two bands of silver strip (W. 11mm/14mm); found in 112 fragments. ?Blade scratches,/?tools marks; crumpled base from ?levering	?L	?539	35-6, 43, 99, 147, 162, 164, 166, 171, 190, 193-4, 196-7, 206, 222, 252, 258, 526, 611, 628, 630-2, 745, 750, 776, 794, 818, 822, 841, 889, 906, 917, 922, 924, 937, 1065, 1090, 1100, 1130, 1151, 1208, 1211, 1213, 1326, 1331, 1350, 1409, 1411, 1413, 1458-9, 1504, 1516, 1524, 1548, 1553, 1576, 1594, 1596, 1626, 1628, 1678, 1689, 1718, 1792-3, 1978, 2121-2, 2136, 2166, 2188, 5062, 5070-1, 5081	G7, J8, K8, K11, L9, L11-12, L16, M11-12, N8, O12, P11

CATALOGUE ENTRIES | TABLES 599-627

▼ **Reeded strip and edging in silver (609-15)**, and **bosses, nails, rivets and washers in gold (616-27)**. ? – possible/uncertain';
Wear – H (heavy), M (moderate), L (light)

REEDED STRIP AND EDGING IN SILVER

Cat.	(mm)	(mm)	(mm)	Wt (g)	Frags	Description	Wear	K-numbers	Grid
609	11	4.5	1	0.29	2	Small length of reeded strip (4mm), two reeds. One rivet.	?L	1719	-
610	22	4	1	0.22	1	Small length of reeded strip (4mm), four reeds. One nail.	?M	5015	N6
611	<116.5	5-6	1	15.18	17	Gilded reeded strip (5mm), four reeds; three long sections, some curved; total surviving length c. 600mm.	L	85, 123-4, 385, 507, 517, 683, 707, 1124, 1232, 1274, 1327, 2123-5, 2127, 5076	E8, K10, K12, L9, M9, N12
612	19	7	1	2.77	3	Two clips of reeded strip (7mm), four reeds. One gilded.	?L	525, 2126	-
613	<93	7-9	1	132.18	674	Gilded reeded strip (8mm), eight reeds; most straight lengths, some curved; total surviving length of c 3100–400mm. Fragments curled and folded from removal. One length attached to a silver-gilt sheet fragment.	L	See full online catalogue	
614	<148	7	6-8	104.93	43	Gilded edging with a U-section; six parts, straight and curved; total surviving length c 800mm; not all one object. Wood in one section.	?L	11, 23, 77, 81, 173, 176, 233, 238, 249, 418, 420, 515, 517, 622, 635, 824, 842, 945, 1086, 1159, 1190, 1243, 1332, 1344, 1363, 1475, 1577, 1761, 1780, 1782, 1974, 2029, 2192-3	J7, J10, L9, L11, L12, M11, N12
615	<83	5.5-6	5	29.33	25	Edging with a U-section, curved, with few joining lengths due to damage; total surviving length c 400mm.	?L	46, 236, 618, 623, 742, 948, 963, 984, 996, 1024, 1067, 1089, 1119, 1132, 1263, 1266-7, 1311, 1332, 1633, 1806, 5073	F13, I12, M11, M13, M15, N7, N10, P8, P9

BOSSES, NAILS, RIVETS AND WASHERS IN GOLD

Cat.	(mm)	(mm)	Wt (g)	Frags/objects	Description	Wear	Set	K-numbers	Grid	
616	17	10-1	-	12.19	2	Pair of bosses, probably gem-settings, filigree collars. Calcite-wax filler in one. Both dented, by ?tool.	L	pair	311, 394	-
617	11	5.5	-	1.32	1	Garnet boss, filigree collar.	L	-	91	M9
618	4.5	2-2.5	-	0.30	3	Set of small garnet bosses, filigree collars.	L	set	1560, 1800, 1851	-
619	6-7	2.5	-	0.79	2	Pair of small gem-settings, missing stones, filigree collars. One flattened.	L	pair	1753, 1886	-
620	7	-	-	0.20	1	Small gem-setting, missing stone, filigree collar.	H	-	1377	-
621	20	13	5-5.5	4.56	2	Pair of bosses, filigree collars, one with rivet. One ?tool dented. Wax filler in other.	L	pair	1536, 1686	-
622	20	10	-	1.33	1	Boss-headed rivet, filigree collar.	L	-	29	-
623	26	10	-	0.98	1	Boss-headed rivet, filigree collar.	M	-	66	K10
624	17	8.5	2.5	0.50	1	Boss-headed rivet, filigree collar.	M	-	172	-
625	8	3	-	0.63	1	Boss-headed rivet, filigree collar. ?Cut rivet.	L	-	1554	-
626	15	5.5	-	0.63	1	Small boss-headed rivet, filigree collar.	L	-	753	-
627	24	11	5	1.64	1	Boss-headed rivet (pierced type), filigree collar. ?wax filler.	M	-	332	-

▼ Bosses, nails, rivets and washers in gold (628–55).

Cat.	(mm)	(mm)	(mm)	Wt (g)	Frags/objects	BOSSES, NAILS, RIVETS AND WASHERS IN GOLD	Wear	Set	K-numbers	Grid
628	16	10	3	1.04	1	Boss-headed rivet (pierced type), filigree collar.	L	-	792	-
629	16-22	8	4.5	4.63	3	Set of boss-headed rivets, no collars.	?L	set; 281	486, 488, 1897	-
630	19-19.5	6	2.5	2.36	2	Pair of boss-headed rivets, missing collars.	?L	pair; ?289, ?300	14, 490	-
631	13	7	3	0.69	1	Boss-headed rivet, missing collar.	?L	-	335	-
632	20	6	3	0.75	1	Boss-headed rivet, missing collar.	?L	-	489	-
633	13	4.5	-	0.42	1	Small boss-headed rivet.	?L	-	1564	-
634	10.5	3	-	0.23	1	Small boss-headed rivet. Fragment of sheet gold attached.	?L	-	1724	-
635	12.5	-	-	2.33	1	Half-boss with rivet.	L	-	404	-
636	10	4	-	0.58	1	Boss, filigree collar.	L	-	1620	-
637	9	3.5-4	-	3.2	4	Set of bosses, filigree collars, pierced for rivets. ?Paste filler in one.	L	set	586, 1546, 1831, 5028	K7
638	11-2	4.5	-	2.44	2	Pair of bosses, filigree collars, pierced for rivets.	L	pair; ?328	18, 1241	-
639	9	3	-	0.5	1	Boss, filigree collar, pierced for rivet.	L	-	1388	-
640	8	-	-	0.41	1	Boss, filigree collar, pierced for rivet.	L	-	1318	-
641	7.5	3	-	0.50	1	Boss, filigree collar, pierced for rivet. ?Paste filler.	L	-	1688	-
642	7.5	3	-	0.34	1	Boss, filigree collar, pierced for rivet. ?Tool dented.	L	-	5003	N3
643	10	-	-	0.86	1	Boss, filigree collar, pierced for rivet.	L	-	1540	-
644	8.5	2	-	0.29	1	Boss, filigree collar, pierced for rivet. Flattened.	L	-	202	-
645	7	2.5	-	0.34	1	Boss, filigree collar, pierced for rivet. Silver core. Fragment of ?hilt-plate.	L	-	1754	-
646	10	-	-	0.71	1	Boss, filigree collar, pierced for rivet. Misshapen. Fragment of ?hilt-plate.	L	-	1105	-
647	-	7	-	0.18	1	Half a boss, filigree collar, pierced for rivet. Fragment ?hilt-plate.	L	-	1693	-
648	9	-	-	0.33	1	Boss, filigree collar, pierced for rivet. Flattened and torn.	?L	-	1933	-
649	5	4.5	-	0.77	1	Boss, pierced for rivet, no collar.	?L	?292	175	-
650	8	-	-	0.33	1	Boss, filigree collar. Torn and boss partly missing. Cut marks on collar.	L	-	1174	-
651	5.5-6	-	-	0.38	2	Pair of boss-washers, filigree collars.	M	pair	411, 1441	-
652	9	-	-	0.21	1	Boss-washer, filigree collar. Hole torn.	L	-	1378	-
653	3	-	-	0.02	1	Boss-washer, filigree collar. Torn and folded.	L	-	1302	-
654	3.5-4	-	-	0.09	3	Set of small filligree collars. One torn open.	?L	set	1442, 1499, 1600	-
655	8	-	-	0.07	1	Boss fragment, filigree collar.	-	-	1391	-

Bosses, nails, rivets, pins and washers in gold (656-60) and silver (661-72). ? – possible/uncertain'; Wear – H (heavy), M (moderate), L (light)

BOSSES, NAILS, RIVETS AND WASHERS IN GOLD

Cat.	(mm)	(mm)	Wt (g)	Frags/objects	BOSSES, NAILS, RIVETS AND WASHERS IN GOLD	Wear	Set	K-numbers	Grid	
656	14.5	-	0.28	1	Boss fragment (pierced type), no collar.	-	-	1325	-	
657	12-22	1-1.5	4.98	16	Small rivets. Several cut.	-	-	336, 338, 343, 405-6, 427, 491, 651, 1549, 1595, 1828, 1921, 2023	-	
658	3-8	1-2	1.00	16	Small nails. One cut.	-	-	414, 498-9, 1308, 1394, 1415, 1434, 1530, 1616, 1647, 1673, 1691, 1786, 1819, 1918, 2044	F9	
659	6.5-12	1-1.5	-	0.78	7	Small nails/rivets. All incomplete. Several cut. One pierces a sheet tab.	-	-	1605, 1706, 1751, 1828, 2049	-
660	7.5-12	2.5-4	-	2.19	8	Double-washers from hilt-plates. Three possible pairs. One set ?levered.	-	3 pairs	412, 496, 588, 1281, 1444, 1547, 1619, 1638	-

BOSSES, NAILS, RIVETS, PINS AND WASHERS IN SILVER

Cat.	(mm)	(mm)	Wt (g)	Frags/objects	BOSSES, NAILS, RIVETS, PINS AND WASHERS IN SILVER	Wear	Set	K-numbers	Grid	
661	11-2	-	0.73	2	Remains of a pair of silver bosses, with gold washers with filigree collars, and a silver rivet.	M	pair	1535, 2088	-	
662	6	-	0.04	1	Boss-washer, filigree collar.	-	-	1748	-	
663	8.5	3.5	0.50	1	Plain boss, part of rivet shank.	-	-	949	-	
664	17	7	3	0.91	1	Boss-headed rivet. Gilded. ?Cut marks.	-	-	1330	-
665	2.5	3	-	0.08	1	Boss-headed nail/rivet. Gilded. Shank cut.	-	-	1644	-
666	5.5	2	-	0.7	2	Pair of boss-headed nails/rivets. Gilded. Shanks cut.	-	pair	1703, 1767	-
667	10	5	-	0.46	1	Boss-headed rivet. Shank broken/?cut.	-	-	1730	-
668	14.5	5.5	-	0.92	1	Boss-headed rivet. Gilded. Cut marks.	-	-	2180	R6
669	6-7	3-6	-	0.76	3	Set of bosses, pierced for rivets. One has filigree collar. Pewter cores. Fragment of ?hilt-plate with one.	H	set	1543, 1702, 1704	-
670	8	3.5	-	0.11	1	Boss, pierced for rivet, no collar. Gilded.	-	-	1404	-
671	6	2	-	0.12	1	Boss, pierced for rivet, no collar. Gilded. Cut marks.	-	-	1472	-
672	11/36	6	-	2.71	2	Pair of larger silver rivets, rectangular heads. Gilding on one. Cut marks.	L	pair	1265, 1651	M15

▼ **Bosses, nails, rivets, pins and washers in silver (673-6)**, and **fragments in gold (677-80)**.

BOSSES, NAILS, RIVETS, PINS AND WASHERS IN SILVER

Cat.	(mm)	(mm)	Wt (g)	Frags/objects	Description	Wear	Set	K-numbers	Grid
673	5–22	1–4	8.06	53	Small rivets. Some have gilded heads. A few are cut.	-	-	266, 434, 610, 751-2, 1020, 1457, 1489, 1527, 1552, 1674, 1834, 1914, 1922, 1981, 1996, 2015, 2024, 2033, 2035, 2045, 2050-1, 2058, 2064, 2164	N7
674	3–18.5	1.5–2	3.24	24	Small nails. Some have gilded heads. One pierces a sheet tab. A few are cut.	-	-	178, 264-5, 997, 1414, 1467, 1501, 1521, 1563, 1573, 1588, 1612, 1675, 1757, 1857, 1936, 1980, 2009, 2041	-
675	2–16	6.5	6.56	61	Small nail/rivet fragments. Some gilded. Three washer fragments.	-	-	223, 614, 1356, 1452, 1493, 1559, 1653, 1723, 1749, 1807, 1815, 1829-30, 1862, 1885, 1891, 1900, 1982, 1988, 1995, 1998, 2001, 2010, 2016, 2019, 2025, 2032, 2034, 2046, 2052, 2055-6, 2063, 2171, 2187	-
676	24	-	1.68	2	Pin with wire ring, gilded, and remains of a second ring.	-	pair	428, 786	-

FRAGMENTS IN GOLD

Cat.	(mm)	(mm)	Wt (g)	Frags/objects	Description	Wear	Set	K-numbers	Grid
677	30	6	1.53	1	Strip with herringbone filigree, loop one end, like jaws. Rejoined from 2 fragments. Cut other end. Possibly from a hilt-collar.	M	-	70	-
678	22	4	0.57	1	Strip with herringbone filigree. Possibly from a hilt-collar.	M	-	765	-
679	26	3.5	1	0.58	Strip with herringbone filigree. Possibly an inlay.	L	-	1051	M7
680	20	4	1.12	1	'Arm' of box-construction with herringbone filigree. Possibly part of a cross pendant. Wood inside.	L	-	1898	-

CATALOGUE ENTRIES | TABLES 673-90

▼ **Fragments in gold (681-3)** and **silver (605 and 684-90)**. ? – possible/uncertain'; Wear – H (heavy), M (moderate), L (light)

Cat.	(mm)	(mm)	Wt (g)	Frags/ objects	FRAGMENTS IN GOLD	Wear	Set	K-numbers	Grid
681	<31	-	4.70	25	Twenty-five fragments with filigree decoration.	-	-	262, 408, 341, 423, 733, 1006, 1282, 1346, 1358, 1469, 1482, 1485, 1522, 1539, 1639, 1655, 1671-2, 1787, 1872, 1920, 1959, 1989, 2183, 5035	K13, L11, M12, M10
682	<33	-	10.19	35	Thirty-five fragments. One annulet, the rest sheet metal, probably mostly from hilt-plates.	-	-	86, 103 111, 141, 225, 329-330, 337, 339, 344, 410, 589-590, 775, 845, 1064, 1131, 1206, 1224, 1245, 1251, 1379, 1471, 1486, 1667, 1820, 1845, 1848, 1953, 1958, 1977, 2026, 2097, 5032, 5086	J10, L10, M8-M9, M11, N9, N13, P11
683	<19	-	1.55	5	Five fragments of cloisonné cell walling.	-	-	121, 500, 734, 2027, 2076	M12

Cat.	(mm)	(mm)	Wt (g)	Frags/ objects	FRAGMENTS IN SILVER	Wear	Set	K-numbers	Grid	
605	44	9	<0.5	1.22	Silver strip, 3 torn fragments, with Style II and twisted border.	-	71, 189	213, 1027, 1068	M11, O10	
684	61.5	19	6.5	12.68	1	Silver bar with semi-circular terminal, in 2 fragments; ?broken other end. Possibly a cross arm. Core of iron, wood and horn.	-	-	274	-
685	35	47	2	44.67	1	Silver socketed-bracket with wood remains; four-lobed base; found in 9 fragments. Cut mark.	?L	-	516, 787, 794, 997, 1128-9, 5058	-
686	28	13	1	1.33	1	Silver sheet, 2 fragments rejoined. Pelta and fish-scale punch decoration. Possibly hilt-plate.	?L	-	754, 1925	-
687	<23	1	-	8.36	12	Bent, broken silver fragments, possibly multiple objects but related ornament. Gilded cast interlace and scrolls.	L	-	805, 815, 1080, 1113, 1122, 1138, 1260, 1755, 1972, 5027, 5056, 5069	L9, M10, N10, P11, P14, Q15
688	<16	-	-	6.82	24	Silver fragments, some decorated.	-	-	184, 219, 639, 754, 870, 887, 1041, 1047, 1193, 1286, 1292, 1355, 1443, 1533, 1720, 1971, 1990, 2005, 2039, 2048, 2086, 2168-9	K9, L8, L10, M14, O7, O8
689	<10	-	-	0.29	19	Small fragments of silver filigree; some/all probably from pommel **63**.	-	-	257, 504, 1408, 1604, 1606, 1610, 1654, 1697, 1750, 1785, 1805, 1870, 1993, 2060	K10
690	<35	-	-	25.22	1070	Small fragments of non-associated silver sheet, many gilded. Most are thin; a few are thicker plate.	-	-	See full online catalogue	-

461

▼ **Fragments in copper alloy (691), loose garnets and gold foils (692–5), and harness-mount in copper alloy (698).**
‡ — **696-7** are above, 'Hilt-plates in silver'

FRAGMENTS IN COPPER ALLOY

Cat.	(mm)	(mm)	Wt (g)	Frags/objects		Wear	Set	K-numbers	Grid
691	<13.5	-	5.41	107	Small fragments of copper-alloy; probably mostly from liners or cores; a few are decorated, one with cast interlace.	-	-	204, 211, 214, 259, 263, 493, 495, 497, 509, 709, 754, 900, 1100, 1135, 1279, 1284, 1395, 1418, 1438, 1455, 1488, 1490, 1511, 1518, 1526, 1551, 1557, 1575, 1581, 1609, 1645, 1863-4, 1880, 1887, 1965, 1994, 2054, 2068, 2074	D10, J5, J7, K10

LOOSE GARNETS AND GOLD FOILS

Cat.	(mm)	(mm)	Wt (g)	Frags/objects		Wear	Set	K-numbers	Grid
692	23	18	6.88	1	Large oval garnet cabochon, flat top, concave base (plano-concave).	-	-	695	-
693	<12.5	0.5–1.5	1.68	73	Small cut garnets (with 5 gold foils), various forms.	-	-	439-44, 503, 579, 875, 1298, 1307, 1389, 1398, 1422, 1435, 1463, 1477, 1492, 1507, 1512, 1523, 1565, 1578, 1580, 1587, 1614, 1646, 1656, 1681-2, 1709-11, 1722, 1725, 1727-9, 1731-3, 1735-40, 1758-60, 1762-6, 1768, 1788, 1798, 1844, 1874, 1962, 1984, 2079, 2094-5, 2184-6	J10, K11, L10
694	15.5	-	0.13	1	Cross-hatched gold foil of 'special boxed' type.	-	-	1078	K9
695 ‡	<6.5	-	0.19	38	Cross-hatched gold foils, including 'standard', 'boxed' and 'special boxed' types.	-	-	413, 1222, 1283, 1299, 1390, 1399, 1421, 1436, 1464, 1484, 1508, 1551, 1568, 1572, 1585, 1601, 1665, 1698, 1707, 1776, 1791, 1849, 1893-4, 1963-4, 1986	L9, N9, N10

HARNESS MOUNT IN COPPER ALLOY

Cat.	(mm)	(mm)	Wt (g)	Objects		Wear	Acc. no.
698	45.5	4.5	15.04	1	Disc-mount, 3 fragments. Cast, gilded interlace and pelleted cross, with central blue glass cabochon. (Not part of Hoard: see fig 1.25 for location of fragments).	-	(PMAG) 2013.LH.59.1, 5001, 5007

SELECT SETS OF HILT-FITTINGS

SELECT SETS OF HILT-FITTINGS

Cat: 1/87-8 | **Objects:** 1 pommel/2 hilt-collars | **Confidence:** certain /probable | **Material:** gold | **Technique:** filigree

The pommel (**1**) and hilt-collars (**87-8**) share the feature of lattice back-sheets, and Style II zoomorphs with eyes formed of collared granules. The collars are also linked by their use of vertical bands, formed by beaded wires that uniquely are spaced and set on a strip of gold, which separate the panels of Style II filigree each side. They are *certain* to be a pair; the pommel is considered *probably* a set with them.

Cat: 2/85-6 | **Objects:** 1 pommel/2 hilt-collars | **Confidence:** certain/probable | **Material:** gold | **Technique:** filigree

The pommel (**2**) and hilt-collars (**85-6**) share the feature of lattice back-sheets. The forms of the serpent heads on the pommel and collars are also alike, and the collars are further linked by their use of vertical bands that separate the panels of Style II filigree each side. In their form and ornament they are *certain* to be a pair; the pommel is considered *probably* a set with them.

Cat: 5/89-90 | **Objects:** 1 pommel/2 hilt-collars | **Confidence:** probable | **Materials:** gold | **Technique:** filigree

The pommel (**5**) and hilt-collars (**89-90**) share a rare back-sheet form, the only examples in the collection, the sheets being die-impressed/repoussé formed and cut to form lattices. The collars are also linked by their use of vertical bands formed of filigree herringbone-with-spine. The core alloys of the pommel and one collar (**5, 90**) are also similar (Au *c.* 71–3 wt%). The objects are considered *probably* a set, since there is some variation in their Style II filigree and interlace ornament.

Cat: 27/105-6 | **Objects:** 1 pommel/2 hilt-collars | **Confidence:** possible | **Materials:** gold | **Technique:** filigree

The objects are considered *possibly* a set on the basis of their similar filigree interlace ornament.

Cat: 46/280-1/629 | **Objects:** 1 pommel/2 hilt-plates/3 boss-headed rivets | **Confidence:** certain/probable
Materials: gold/garnet | **Technique:** filigree/cloisonné

The pommel (**46**) outline, with spaced rivet-housings, matches an impression on hilt-plate **280**; the hilt-plate is a *certain* set with plate **281**; rivets **629** fit the filigree collars on the plates and so are *probably* a set.

Cat: 47/159-160 | **Objects:** 1 pommel/2 hilt-collars | **Confidence:** certain/possible | **Material:** gold/garnet | **Technique:** cloisonné

The pommel (**47**) and collars (**159-60**) share the use of 'mushroom' and 'arrow' cloisonné, which also shows similar execution, the tops of the cells having been smoothed over to hold the garnets in place. The vertical bands at the end of each collar are also related, showing bands of full circles or split circles. In their form and ornament they are *certain* to be a pair; the pommel is considered *possibly* a set with them.

Cat: 49/499-502 | **Objects:** 1 pommel/4 mounts | **Confidence:** certain/possible | **Material:** gold/garnet/glass | **Technique:** cloisonné/filigree

The pommel (**49**) and guard-tip mounts (**499-502**) are the only cloisonné objects in the collection that use the 'stepped rhomboid' cell form. They are considered *possibly* a set. The guard-tip mounts are a *certain* set, based on their matching form and ornament.

Cat: 50/163-4 | **Objects:** 1 pommel/2 hilt-collars | **Confidence:** certain/possible | **Material:** gold/garnet | **Technique:** cloisonné

The collars (**163-4**) are a certain pair based on their use of an identical cloisonné pattern formed of a central row of 'arrow' cells with flanking 'split-arrow' forms. Both collars also use 'mushroom' forms and one edge of each has a lip. They are *possibly* a set with the pommel (**50**) based on the similar quality of their cloisonné.

Cat: 54/165-6 | **Objects:** 1 pommel/2 hilt-collars | **Confidence:** certain/probable
Material: gold/unidentified inlay/filigree | **Technique:** cloisonné

The pommel (**54**) and collars (**165-6**) have cloisonné with an 'unidentified' inlay. Each design includes zoomorphic, equal-arm cross and 'mushroom' forms, and the cloisonné work is of similar quality. The collars are considered a *certain* pair; the pommel is considered *probably* a set with them.

Cat: 55/167-9/225 | **Objects:** 1 pommel/2 hilt-collars/cap-fitting/hilt-ring | **Confidence:** certain
Material: gold/garnet/glass | **Technique:** cloisonné

The cap-fitting (**169**), ring (**225**) and one hilt-collar (**167**) fit neatly together. The small pommel (**55**) fitted on top of the cap-fitting (**169**), the arrangement confirmed by a scratched outline of the pommel on the top of the fitting. The second hilt-collar (**168**) has matching ornament. Several of the fittings have similar core alloys (**167-9, 225**: Au *c.* 82–5wt%). Pommel **55** is different (Au *c* 69–73wt%). The set is *certain*.

SELECT SETS OF HILT-FITTINGS

Cat: 69/186-7/533-5 | **Objects:** 1 pommel/2 hilt-collars/3 mounts | **Confidence:** certain/possible
Material: silver | **Technique:** cast, niello

The silver collars (**186-7**) are a *certain* pair, based on their form and Style II. The silver pommel (**69**) and mounts (**533-5**) also have cast Style II or interlace. All of the objects have the same style of niello inlay, set in channels along the strands of interlace. The mounts are *possibly* a set, and the pommel is *possibly* a set with the collars and mounts.

Cat: 76/188/409 | **Objects:** 1 pommel/2 hilt-collars/2 hilt-guards | **Confidence:** probable
Material: silver/gold/garnet/glass | **Technique:** cast/gilding/filigree/cloisonné/ niello

The pommel (**76**), hilt-collars (**188**) and hilt-guards (**409**) have gold mounts with a similar style of filigree interlace, and some of the mounts have repoussé-worked back-sheets. The objects also all have cast interlace and niello inlay. The surviving edge of the bottom collar fits approximately into an oval slot on the lower hilt-guard. The objects are considered a *probable* set.

GUIDE TO THE DIGITAL COMPONENT OF THE PUBLICATION

H E M COOL

This book is only one of the outcomes of the research project. The full publication includes an extensive digital component (<doi.org/10.5284/1041576>) that is hosted by the Archaeological Data Service (<http://archaeologydataservice.ac.uk/>). The publication there started in 2017.

The digital component consists of two main strands. The full catalogue is presented in two forms. There is a set of pdf files with catalogue entries and scaled multiple views of most pieces. There is also a database that contains the catalogue entries and the photographs, but also provides additional information. From the database, the condition reports can be accessed, which describe the conservation and joining work, as well as individual reports for the pieces that describe the scientific analysis that has been conducted on them. All of the fragments are recorded on the database. Where a catalogue entry consists of several fragments with different *K* numbers, the main catalogue entry is the first *K* number in the sequence. Individual condition reports and analytical reports can be accessed via the individual *K* numbers. Where possible the database also shows a view of the fragment prior to any conservation work. The X-radiograph plates created by the Lincolnshire Archives in Stage 1 of the project are also available.

The second strand consists of the specialist research reports that the project has commissioned, and which underpin the text in this book. There are thirty of these reports, as listed below. The majority relate to the programme of scientific analysis that was undertaken during both stages of the project (nos 2–16, 18–23 and 25–6). There are also reports on aspects of the recovery and the Hoard site itself, including a survey of the air photograph coverage for the area (no. 1), a survey of contemporary activity recorded within 10km of the Hoard site (no. 24) and the reports relating to the recovery in 2009 and 2012 (nos 27–9). An overview of the development of the project is provided in no. 30. The programme of work undertaken on the die-impressed sheets in Stage 1 of the project is described in no. 17.

The digital component also contains a series of online tables, which provide supplementary information referred to in the chapters of this book, the project designs and the newsletters that tracked the progress of the project.

STAFFORDSHIRE HOARD RESEARCH REPORTS

1. Deegan, A 2013. *Air Photo Mapping and Interpretation for Contextualising Metal-Detected Discoveries: Staffordshire Anglo-Saxon Hoard*

2. Meek, A 2012. *The PIXE and PIGE Analysis of Glass Inlays from the Staffordshire Hoard*

3. Cartwright, C R 2013. *Macro-organic Materials from the Staffordshire Hoard*

4. La Niece, S 2013. *The Scientific Analysis of Niello Inlays from the Staffordshire Hoard*

5. Steele, V and Hacke, M 2013. *FTIR and GC-MS Analysis of Pastes and Soils from the Staffordshire Hoard*

6. Blakelock, E S 2013. *Pilot Study of Surface Enrichment in a Selection of Gold Objects from the Staffordshire Hoard*

7. Blakelock, E S 2014. *Analysis of a Multi-Component Garnet, Gold and* Millefiori *Object from the Staffordshire Hoard*

8. Blakelock, E S 2014. *XRF Analysis of Silver Foils from the Staffordshire Hoard*

9. Blakelock, E S 2014. *Phase 2 of the Analysis of Selected Items from the Staffordshire Hoard and of Contemporary Anglo-Saxon Objects from the British Museum and Stoke-on-Trent Potteries Museum & Art Gallery: a study of gold compositions and surface enrichment*

10. Blakelock, E S 2014. *Scientific Analysis of the Staffordshire Hoard Seax Set*

11. Stacey, R J 2014. *FTIR, Raman and GC-MS Analysis of Possible Organic Pastes and Associated Foils (K234 and K235) from the Staffordshire Hoard*

12. Blakelock, E S 2014. *Analysis of the Staffordshire Hoard Great Cross (K655, K657, K658, and K659), Gem setting (K1314) and Inscribed Strip (K550)*

13. Cartwright, C 2013. *Identification of Fibres of Textile Fragments Found Inside Silver Gilt Collar K281 from the Staffordshire Hoard*

14. Meek, A 2013. *XRF Analysis of Triangular Green Inlay in Staffordshire Hoard Object K744*

15. Meek, A 2013. *XRF Analysis of Inlays in Staffordshire Hoard Object K301*

16. Blakelock, E S 2014. *A Comparative Study XRF and SEM-EDX Analysis of Gold / Silver / Copper Alloys at the Birmingham Museum Trust and the British Museum Laboratories*

17. Shearman, F, Camurcuoglu, D, Hockey, M and McArthur, G 2014. *Investigative Conservation of the Die-impressed Sheet from the Staffordshire Hoard*

18. Blakelock, E S 2015. *Pilot XRF Study of the Silver Hilt-plates from the Staffordshire Hoard*

19. Blakelock, E S 2015. *XRF Study of Silver Objects from the Staffordshire Hoard*

20. Blakelock, E S 2015. *The XRF Analysis of the Copper Alloy Objects and Fragments in the Staffordshire Hoard*

21. Blakelock, E S 2016. *The Analysis and Documentation of Niello Objects in the Staffordshire Hoard*

22. Blakelock, E S 2015. *Examination of Cross Sections through a Selection of Gold Objects from the Staffordshire Hoard*

23. Martinón-Torres, M 2016. *Analysis of Weathered Green Inlays in the Staffordshire Hoard*

24. Goodwin, J 2016. *A Survey of the Sources for Possible Contemporary Activity in the Vicinity of the Hoard Find Spot*

25. Mc Elhinney, P 2015. *Analysis and Characterisation of the Staffordshire Hoard Organic Material*

26. Mongiatti, A 2016. *Scientific Investigation of Filigree Decoration on 37 Artefacts from the Staffordshire Hoard*

27. Jones, A and Baldwin, B 2017. *The Staffordshire Hoard Fieldwork 2009–2010*

28. Cool, H E M 2017. *Discoveries on the Hoard Site in 2012*

29. Chapman, H 2017. *The Staffordshire Hoard Surveys: an assessment*

30. Cool H E M 2017. *The Development and Progress of the Staffordshire Hoard Research Project*

GLOSSARY

addorsed
A pair of creatures back to back.

affronted
A pair of creatures with bodies facing, heads turned away.

Bayesian mathematics/modelling techniques
A statistical approach, based on Bayes' theorem (1763), which analyses new data in the context of existing data and prior assumptions in order to quantify explicitly the probability of a given interpretation. In archaeology it has been especially used to refine radiocarbon dating.

BSE (back scattered electron)
See under SEM (scanning electron microscopy).

cabochon
Gemstone or glass inlays cut to a round or oval outline, domed in profile and with a flat or concave base.

champlevé
A technique for applying enamel to recessed areas produced by casting, chasing or engraving.

cloisonné
A technique in which individual metal cells (*cloisons*) are inlaid with gemstones, glass or other materials, such as enamel.

cochlearia
Small spoons with shallow bowls and long, tapering handles with a pointed end that was used to pierce eggs and spear small pieces of food.

cocked-hat
The typical form taken by sword pommels in the early medieval period, named after the bicorne hat of the eighteenth century.

confronted
A pair of creatures with bodies and heads facing.

correspondence analysis
A statistical method for exploring relationships within large and complex sets of data, presented as rows and columns in a table. In early medieval archaeology it is used to sort or seriate (put in sequence) artefact-types on the basis of nominated intrinsic attributes, and burials on the basis of the artefact-types within them.

early medieval period
The fifth to eleventh centuries AD in Europe.

foederati
Barbarian troops engaged under a formal treaty (*foedus*) to provide military support to a late or sub-Roman authority but under their own leadership.

hack silver
Fragments of silver artefacts that have been cut up and sometimes folded into smaller pieces, usually found in bullion hoards. These smaller units were more convenient for transporting, distribution or melting down.

Half-uncial
The standard formal book-hand of Late Antiquity and the early Middle Ages; a calligraphic script based around curvilinear forms, it is well-suited to being written with a pen.

hilt
The handle of a weapon, including the grip, pommel and guards.

Insular art style
A term used to signify the close interaction of Anglo-Saxon, British and Irish artistic and intellectual cultures during the period *c* 550–800, when differentiating between areas of production can be difficult.

***Kolben* arm-ring**
Cast penannular arm-ring with abutted and expanded terminals, current in Scandinavia and mainland Europe from the third to sixth centuries; a sign of status.

ligula
Long-handled spoons whose bowls can be a variety of sizes and shapes. Thought to have been used to eat with, to act as 'scoops' and to apply medications.

Merovingian (period)
The dynasty of the Frankish kings *c* 450–752, named after their supposed founder Merovech.

micro-FTIR (micro Fourier transform infrared spectroscopy)
This technique subjects small areas of a sample to a broad frequency spectrum of infrared light. The bonds between the atoms in a molecule absorb the infrared energy at specific frequencies, relative to the arrangement and distribution of the elements present. The resulting spectrum showing the absorption peaks for the unknown sample can be compared to spectra for known materials to identify the molecules present.

Migration period
Late fourth to sixth centuries in Europe, characterised by long distance population movements.

millefiori
A glass-working technique that fuses canes of different colours arranged in a decorative pattern. Transverse slices of the resulting rod show the pattern. These can be used to form inlay. The term is Italian and can be translated as 'a thousand flowers'.

natron
Natural deposits of sodium compounds found in dried lake beds; sources in Egypt were exploited throughout antiquity to provide an essential component in the manufacture of glass.

niello
A soft black sulphide inlay, usually of copper or silver.

PIXE (particle-induced X-ray emission) / PIGE (particle-induced gamma emission)
These complementary techniques use particles such as protons to bombard samples, and are often used together to determine elemental composition. PIXE uses the emitted X-ray fluorescence to identify the elements present. The protons produce lower background noise than XRF, so this method has very good accuracy and high analytical sensitivity. PIGE is used to detect light elements in samples by using the gamma rays emitted, thus making it an ideal technique for the analysis of glass and garnets.

pommel
Fitting from the end of a sword-hilt that caps the iron tang.

Portable Antiquities Scheme (PAS)
An organisation that records archaeological objects found by the public in England and Wales in order to advance understanding of the past. It is run by the British Museum and the National Museum of Wales: <https://finds.org.uk/>.

quadruped
Four-legged creature, commonly depicted in profile and typical of Anglo-Saxon late Style II animal ornament.

quatrefoil
Four-lobed interlace knot or cell arrangement in cloisonné; the term means 'four-leafed'.

Raman spectroscopy
This uses the scattering of light from a laser source to determine the compounds present in a sample. It is often used to identify semi-precious stones and corrosion products.

repoussé
A technique used to model sheet metal in relief (from the front or back), by impressing into the sheet with a tool or die.

saltire
Cross formed of diagonal elements (also known as St Andrew's cross or *crux decussata*).

scrollwork
Decoration formed from scroll patterns.

seax
A single-edged long knife or dagger, sometimes with a distinctive angled back to the blade.

SEM (scanning electron microscopy)
Scanning electron microscopy (SEM) uses a beam of electrons to interact with the atoms in a sample

and is a method for producing high resolution and high magnification images. Two imaging modes are used: **secondary electron (SE),** which gives topographic information, and **back scattered electron (BSE)**, which provides compositional information. SEM can be combined with **energy dispersive X-ray spectroscopy (SEM-EDX)** to characterise the type and distribution of elements present within a sample. **Variable pressure SEM (VP-SEM)** is used for delicate samples that would be unable to withstand the high-pressure vacuum associated with conventional SEM techniques.

SFB (sunken-featured building)
A building type common on the Continent during the late Roman and Migration periods (German: *Grubenhaus*) and in early Anglo-Saxon settlements; it is characterised by a central pit, which in many, though not certainly all, cases was covered by suspended flooring.

siliqua
A late Roman silver coin. Those struck after the reforms of AD 355 had a weight of *c* 2g, but after AD 388 the weight varied between the different mints.

solidus
The standard late Roman gold coin struck at 72 to the Roman pound at a theoretical weight of 4.48g.

Square capitals
The highest grade formal lettering of Roman Antiquity, frequent in inscriptions, occasionally used as a book-hand; an epigraphic script juxtaposing upright, angular and circular forms, it is better suited to the chisel than the pen.

Stafford knot
An interlace pattern – see fig 5.10.

Style I
Animal ornament current in parts of northern Europe from the late fifth to late sixth centuries. Animal and human elements can be combined and are often disjointed, to create ambiguous images.

Style II
Animal ornament widely current in northern and western Europe from the mid-sixth to mid-seventh centuries. Animal forms are typically combined or transformed into interlace designs.

suite
A set of objects in the same style.

syncretism (syncretic)
The fusion or reconciliation of different traditions or beliefs, for example, in the context of a ceremony or as displayed in ornament.

tang
The shank of iron at the end of a sword- or knife-blade to which the hilt was attached.

terminus ante quem (*taq*)
(Latin) 'date before which'.

terminus post quem (*tpq*)
(Latin) 'date after which'.

tremissis
A late Roman gold coin that was the equivalent of one-third of a *solidus*. Its use continued in a number of Roman successor states, including Merovingian France, whence examples were imported into Anglo-Saxon England, and used as models for the earliest Anglo-Saxon coinage.

triform
Any symbol with three arms, such as a triskelion.

triquetra
Interlace motif with three joined arcs stemming from a common centre.

triskelion
Motif with three curved lines stemming from a common centre.

Vendel period
The period between the Migration period and Viking period in Sweden, *c* 550–*c* 800, named after the major ship-grave cemetery at Vendel; it is characterised especially by the currency of Style II animal art.

VP-SEM (variable pressure SEM)
See under SEM.

wic
A modern term for the coastal and riverine trading centres of seventh- to ninth-century England; it is borrowed from the Old English element, *wīc*, found in many place-names, some of which have had this function confirmed by excavation (e.g. Ipswich).

XRD (X-ray diffraction)
This technique is used to identify crystalline materials, such as niello inlay. The atoms in a sample cause the beam of X-rays generated by the instrument to diffract in different directions. By measuring the angles and intensities of the beams, the instrument can identify the crystalline structure and chemical bonds.

XRF (X-ray fluorescence)
This is one of the most common methods used for precious metal analysis, because of its non-destructive nature. X-rays are used to bombard the sample, which release energy in the form of X-ray fluorescence that can be detected and measured to determine the elements present. The intensity of the energy is proportional to the amount of an element present; therefore, quantification is possible. XRF will penetrate deeper into a sample than SEM-EDX; however, the results will mostly derive from the surface rather than the deeper core regions.

zoomorph(ic)
Animal-like form or part used as ornament. Style II zoomorphs can have few or no limbs, like serpents. They are typical in Anglo-Saxon early Style II.

INTRODUCTION

ENDNOTES

1 Especially Bede, *HE* (Colgrave and Mynors 1969).

2 Of particular relevance is Felix, *Vita sancti Guthlaci* (Colgrave 1956).

3 Most obviously *Beowulf* (Mitchell and Robinson 1998; Donoghue and Heaney 2019), though it is a matter of debate how far the *c* 1000 AD text embodies the world of the seventh or eighth century, when it was probably composed, let alone the world of the fifth and early sixth centuries to which it purports to refer; see Mitchell and Robinson 1998, 8–13, and Webster 2019.

4 For an overview, see Hamerow *et al* 2011.

5 Yorke 1990; see this volume, chapter 7, 286–99.

6 Geake 2010 contains a selection of the papers presented.

7 On the successive advisory panels to the Project, the Research Advisory Panel [RAP] and the Conservation Advisory Panel [CAP], subsequently combined as the Research Project Advisory Panel [RPAP], see this volume, chapter 1, *Acquisition, funding and project organisation*, 16, and *Cool 2017a.

8 *Cool 2013, sections 6 and 7.1; *Cool 2015, sections 4, 5 and 6. Historic England was created on 1 April 2015 from a division of functions within English Heritage; throughout this volume we refer to Historic England, regardless of the date in question.

9 See this volume, chapter 1, *The reliability of the finds context*, 24, and Chapter 2, 30–121.

10 See this volume, chapter 1, *Die-impressed silver-sheet*, 24, and *The reliability of the finds contex*t, 24-6.

11 See this volume, chapter 1, *Acquisition, funding and project organisation*, 16.

12 See this volume, chapter 1, *Fieldwork of 2009 and 2010*, 12, and chapter 7, *The findspot of the Staffordshire assemblage and the history of Mercia*, 291; Parsons 2010; Hooke 2011; *Goodwin 2016.

13 <https://doi.org/10.5284/1041576>.

14 See this volume, Part III The Abbreviated Catalogue, 373–469.

15 Accession number 2010.LH.10.

16 Accession number 2010.0138.

CHAPTER ONE
FROM DISCOVERY TO CONSERVATION
ENDNOTES

1 Centred on NGR SK 406328/306396.

2 For a discussion of the precise numbers discovered by Herbert, see this volume, chapter 1, *The reliability of the finds context*, 24–7.

3 <https://finds.org.uk/> (accessed 14 May 2019).

4 See this volume, chapter 1, *Acquisition, funding and project organisation*, 13–14.

5 Funded under the SHAPE sub-programme 32144.110.

6 *Jones and Baldwin 2017; *Cool 2017b.

7 British Geological Survey n.d.

8 LandIS n.d.

9 Powell *et al* 2008.

10 *Jones and Baldwin 2017.

11 Staffordshire County Council 2009, para. 3.3 and risk register.

12 That is the remains of biological material that float to the surface; the heavier mineral material sinks to the bottom of the tank.

13 Vista 2009.

14 The 1,381 'finds' subsequently proved higher in number because during conservation it was found that this figure included fragments and objects stuck together by mud that had been lifted and recorded together.

15 Simmonds 2008, fig 52.

16 *Deegan 2017.

17 See discussion in this volume, chapter 1, *The reliability of the finds context*, 26 and fig 1.25.

18 Simmonds 2008, fig 52.

19 Champness 2008, 57.

20 Hooke 2011, 1.

21 Ibid.

22 *Goodwin 2016, where further details of the sites identified by HER numbers will be found.

23 Staffordshire HER 07472.

24 Staffordshire HER 58252.

25 Staffordshire HER 53870.

26 Greenslade and Kettle 1984, 338.

27 Hooke 2011, 6.

28 A map of the county of Staffordshire by William Yates (surveyed 1769–75, published 1775), Staffordshire Record Office, D590/410.

29 Greenslade 1990, 266.

30 *Cool 2017b.

31 *Cool 2017a, 6.

32 This figure is five short of the actual number of gold and silver pieces found (86), which became apparent only after conservation.

33 Palmer 2013, sect. 9.10, fig 10.

34 *Chapman 2017.

35 *Cool 2017b, fig 1.

36 Department for Culture, Media and Sport 2008, 5.

37 Ibid, 6.

38 PAS n.d. 'The Treasure Act'.

39 Leahy *et al* 2011, 204.

40 PAS n.d. 'Writing to the Coroner'.

41 Leahy and Bland 2009, 8.

42 The West Midlands NUTS1 level region comprises several English counties (NUTS2 level), including the West Midlands and Staffordshire: Medland 2011, 2.

43 Culture, Media and Sport Committee, House of Commons 2007, 184 and 418.

44 Jackson 2012, 41.

45 Williams and Ager 2010, 11.

46 PAS 2009a, 1.

47 This arrangement dates to the period 1974–97 when Stoke-on-Trent was part of the county rather than a unitary authority.

48 Leahy and Bland 2009, 8, and see this volume, chapter 1, *Investigative conservation methodology*, 17.

49 PAS 2009b, 2; press statement by Norman Palmer, Chairman of the TVC, 26 November 2009.

50 Bland and Johns 1994, 7; Williams and Ager 2010, 11.

51 PAS n.d. 'When your finds are declared treasure'.

52 Medland 2011, 21.

53 Williams and Ager 2010, 11.

54 PAS 2009a, 1.

55 BBC News 2009; Reuters 2009; Capper and Scully 2016, 188.

56 National Heritage Memorial Fund 2010, 29; Capper and Scully 2016, 185.

57 Art Fund 2010.

58 Leahy and Bland 2009, front matter.

59 Finds highlighted at annual launches of the Treasure Report being the exception; Treasure Registrar, pers comm 10 May 2016.

60 Birmingham Museum & Art Gallery n.d.; The Potteries Museum & Art Gallery Friends n.d.

61 *The Art Newspaper* 2011, 25.

62 Treasure Registrar, pers comm 10 May 2016.

63 Director of Development Art Fund, pers comm 28 November 2016.

64 Art Fund n.d.

65 See this volume, chapter 1, *Fieldwork in 2012*, 13.

66 PAS 2013, 5.

67 BBC News 2013.

68 Accession numbers 2013.LH.39, 2013.LH.59.

69 *Cool 2017a.

70 Cane et al 2014.

71 PAS 2009a, 1.

72 See this volume, chapter 1, *The reliability of the finds context*, 26.

73 Cane 2010.

74 Ibid, 2.

75 See *Cool 2017a for its memberships.

76 Greaves and Cane 2015, 70.

77 ICON 2014; ECCO n.d.

78 See *Cool 2017a for the progress of the project and the normal dispersal of the fragments during it.

79 Although currently deemed not analytically significant, all soil was retained by the conservation team for possible future research.

80 In this volume catalogue numbers are indicated in bold. The *K*-number of an individual fragment (which forms part of the accession number in both museums) is shown in italics.

81 *Mc Elhinny 2015.

82 See this volume, chapter 3, *Cloisonné and other lapidary work*, 166–81.

83 See this volume, chapter 3, *'Assembly' marks and other marks*, 183–5.

84 *Meek 2012. See this volume, chapter 3, *Glass*, 134.

85 *Blakelock 2013. See this volume, chapter 3, *Gold*, 125–7.

86 See this volume, chapter 3, *Soldering*, 141–3.

87 See this volume, chapter 3, *Gold*, 125–7.

88 See this volume, chapter 2, *Christian objects: Socketed-base and pins (cat. **607/8** and **676**)*, 102; also, see this volume, chapter 2, *Objects associated with Christian ceremony and worship*, 111.

89 *Shearman et al 2014.

90 Butterworth et al 2016; also, see this volume, chapter 2, *Helmet parts, decorated silver sheet, reeded strip and edge binding*, 70–9.

91 This does not include the soil blocks.

92 Birmingham Archaeology 2010; Jones 2010.

93 For examples, see Birmingham Archaeology 2010, figs 14–23; Jones 2010, tab. 1.

94 Soil blocks [*K438*], [*K512*] and [*K795*]. In online table 3 some 'finds groups' also have the character of soil blocks (e.g. BA0203, BA1037, BA1038, BA1049 and BA1051).

95 Their discovery is described in a recorded interview between PAS Finds Liaison Officer Duncan Slarke and Terry Herbert, made in late Summer/Autumn 2009.

96 Geake 2010, 36. Geake cites Leahy (2010) as her source. This article contains no such reference, but Leahy suggested a 'shoe box' in an answer to questions at the British Museum Symposium (Tania Dickinson, pers comm) and the suggestion is repeated in Leahy et al 2011, 215.

97 *Cartwright 2013a; see also this volume, chapter 3, *Organics and pastes*, 136.

98 Palmer 2013; *Chapman 2017; *Cool 2017b.

CHAPTER TWO
CHARACTERISING THE OBJECTS
ENDNOTES

1 Leahy and Bland 2009; Leahy 2010.

2 For a discussion of Mercian coinage, see Williams 2001.

3 Leahy and Bland 2009; Leahy 2010.

4 Leahy 2010: an original 3,490 fragments were quoted from the 2009 excavation.

5 Palmer 2013; *Cool 2017b.

6 The 'K' prefix of the K-numbering comes from 'Kevin' (Leahy). The final index ran from [K1–K2193] for the 2009 finds and additions, with [K5001–K5091] for the 2012 finds.

7 The late recognition of certain objects, as well as changes of interpretation, has resulted in a small number of objects being numbered out of sequence.

8 Where a part or parts of an object in different materials were found detached (e.g. a gold mount on a silver pommel), these were considered separately when calculating the weights of the assemblage.

9 Leahy 2010: the original figures were 5.1kg of gold and 1.4kg of silver.

10 *Pace* Fischer and Soulat 2010: several pommels were originally thought to be copper alloy, but are in fact silver.

11 Wanhill 2002.

12 See this volume, chapter 2, *Hilt-mounts and other small mounts (cat. **410–537**)*, 50–5.

13 Ellis Davidson 1962; Menghin 1983.

14 Cameron 2000, app. 1.

15 Leahy 2010. Ninety-two pommels were originally recorded.

16 Evison 1967.

17 *Pace* Fischer and Soulat 2010.

18 See this volume, chapter 3, *Filigree*, 163–5.

19 The use of calcite and wax fillers is also seen for other objects in the collection. See this volume, chapter 3, *Organics and pastes*, 137–8.

20 See this volume, chapter 5, 207–55.

21 Gold pommel with garnet cloisonné: **36–7**, **41**, **46–53** and **55**. Gold pommel with cloisonné, without garnet: **38–40**, **43–4**,?**45** and **54**. Gold pommel with empty gem-setting: **42**. Silver pommel with garnet gem-setting: **64**. Silver pommel with garnet cloisonné: **73** and **76**. Silver pommel with cloisonné with glass inlays: **75**. Silver pommel with rock crystal setting: **77**.

22 See this volume, chapter 3, *Cloisonné and other lapidary work*, 166–78, especially 177–8.

23 See this volume, chapter 3, 'Unidentified' inlay, 134–5.

24 See this volume, chapter 3, *Cloisonné and other lapidary work*, 173–4.

25 See this volume, chapter 3, *Cloisonné and other lapidary work*, 174.

26 See this volume, chapter 3, *Cloisonné and other lapidary work*, 172–8; also, this volume, chapter 5, *Geometric ornament and symbols*, 253–5.

27 See this volume, chapter 3, *Gold*, 126–7, table 3.7.

28 See this volume, chapter 3, 'Assembly' marks and other marks, 183.

29 Blakelock 2015a, table 5.

30 Hilt-rings **206** and **241** may each be two rings, and **208** is not certainly a ring. Additionally, several gold fragments with filigree (**677–8** and **681**) might be parts of further collars.

31 See this volume, chapter 3, *Hilt-plates and hilt-guards (cat. **243–409** and **696–7**)*, 44–8.

32 The Market Rasen hilt-suite was examined by the author at the British Museum in 2012; the copper-alloy liners are not described in the published report: *TAR* 2002, no. **58**, **68–70**.

33 See this volume, chapter 2, *Hilt-mounts and other small mounts (cat. **410–537**)*, 50.

34 See this volume, chapter 6, *Hoard Phase 2 (gold): Anglo-Saxon late style II, contemporaneous objects, c 570– c 630*, 264.

35 Hilt-collars: **100**, **116**, **121–2**, **149** and **151–2**.

36 See this volume, chapter 3, *Back sheets*, 163–5.

37 See this volume, chapter 5, *Animal ornament in the Hoard*, 222, fig 5.9; also, chapter 6, *Dating the Hoard*, 260–1, fig 6.3.

38 See this volume, chapter 3, *Wires, granules and patterns*, 160, fig 3.68.

39 See this volume, chapter 3, *Wires, granules and patterns*, 161–2, table 3.4.

40 Bruce-Mitford 1978, pl 22a.

41 See this volume, chapter 2, *Hilt-mounts and other small mounts (cat. **410–537**)*, 55.

42 See this volume, chapter 5, *Animal ornament in the Hoard*, 222, fig 5.9; also chapter 3, fig 3.95, and chapter 6, *Dating the Hoard*, 260–1, fig 6.3.

43 See this volume, chapter 3, '*Unidentified*' *inlay*, 134–5.

44 See this volume, chapter 6, *Hoard Phase 4 (silver objects with gold mounts): Early Insular style objects, c 630–c 660*, 269–70.

45 See this volume, chapter 6, *Hoard Phase 1: sixth century silver fittings from weapons*, 263.

46 Hilt-rings: **226–7**, **231**, **234–6** and **239–40**.

47 See this volume, chapter 3, *Wires, granules and patterns*, 161, figs 3.69–3.70.

48 Hilt-plates **696–7** were discovered late in the cataloguing process, in 2016, and hence had to be numbered out of sequence.

49 Three examples have two riveted plates each (**243–4** and **265**), which have been counted as six individual plates for the purpose of the 'object' total in table 2.1.

50 Hilt-plates: **243–53**, **255–7**, **263–4**, **266–71**, **278–9**, **306–9**, **362–4**, **366–9** and **372–84**.

51 Menghin 1983, 331–2, Karte 10, *Typ Faversham – Endrebacke*.

52 Hilt-plates: **244**, **264**, **292**, **331–5**, **337** and **371**.

53 Based on a sample of over 100 plates measured with callipers.

54 For other filigree collar forms with bosses: **299**, **618** and **628**.

55 Sheet boss with hilt-plate (gold): **280**; loose (gold): **621–6**, **629** and **631–2**. Cast boss with hilt-plate (gold): **286**; loose (gold): **630** and **633–5**; loose (silver): **663–8**.

56 Hilt-plates (gold): **278–9**.

57 Hilt-plates (gold): **263–7** and **270–7**; loose (gold): **627–8**, **637–49** and **656**; loose (silver): **669–71**.

58 Loose (gold): **651–3**; loose (silver): **661–2**.

59 Hilt-plates (gold): **243–59** and **261–2**; loose (gold): **618–9**.

60 Loose (gold): **621**, **627**, **637** and **641**.

61 Indicated by the absence of gold and mercury: Blakelock 2015b.

62 The author examined the object (Acc. 1876,0717.1) in 2012, with further analysis carried out by the British Museum (Blakelock et al 2013).

63 See this volume, chapter 3, *Organics and pastes*, 136.

64 Mount **498** is the only singleton. The other fittings of the type all form sets.

65 See this volume, chapter 3, *Stones and manufacture*, 172, table 3.7.

66 The example on the Cumberland hilt, most like mount **427**, is on the side not shown in fig 2.26.

67 Arwidsson 1954, Taf. 19–21; Evison 1967, pl 13b; Nerman 1969/1975, no. 523, Taf. 53; Menghin 1983, 252–3, no. 103; Nørgård Jørgensen 1999, 274, no. 333, Taf. 139.

68 Webster and Backhouse 1991, 26, no. 9; Nicolay 2014, 69, fig 4.10, no. 4.

69 See this volume, chapter 2, *Crosses worn on the body or on equipment*, 116–7.

70 See this volume, chapter 6, *Hoard Phase 2 (gold): Anglo-Saxon Early Style II: contemporaneous objects, c 610–c 650*, 264–6.

71 Nicolay 2014, 76–7, fig 4.17.

72 See this volume, chapter 3, *Gold*, 126–7, n. 28.

73 Ibid.

74 For a further suggestion of their possible use as helmet decoration, see this volume, chapter 5, *Animal ornament*, 234.

75 Bruce-Mitford 1978, 564–81, fig 421; Menghin 1983, 150–1 (NB his reconstruction of the Sutton Hoo mound 1 harness is incorrect); Carver 2005, fig 101.4.

76 Bruce-Mitford 1978, fig 416b.

77 Ibid, 294–7, 300–6, 564–81, fig 425.

78 Menghin 1983, 363–5.

79 Leahy 2015, 119–20. For a new gazetteer of single instances from graves and stray finds, see Mortimer and Bunker 2019.

80 Menghin 1983, 142–3.

81 Bruce-Mitford 1978, 273–82, 294–7, figs 208, 210, 224; Evison 1976, 312; Menghin 1983, fig 64.

82 See this volume, chapter 2, *The typological and functional significance of the weapon-fittings*, 64.

83 See this volume, chapter 3, *Glass*, 132–4.

84 See this volume, chapter 3, '*Unidentified*' *inlay*, 134–5.

85 See this volume, chapter 6, *Hoard Phase 4 (silver objects with gold mounts): Early Insular style objects, c 630–c 660*, 269–70.

86 Marzinzik 2003, 59.

87 Cramp 1957; Wormald 1978; Newton 1993; Mitchell and Robinson 1998, 8–13; Webster 2018.

88 *Beowulf* lines 1,687–98; see also Cramp 1957, 63–7.

89 Bosworth and Toller <http://bosworth.ff.cuni.cz/036669> (accessed 5 Feb 2017); *A Thesaurus of Old English* 2017, s.v., '13.02.08.04.03.01.01|02.02 (adj.) Hilt of sword :: Provided with a hilt, hilted :: With twisted hilt,' <http://oldenglishthesaurus.arts.gla.ac.uk/category/?id=19021> (accessed 5 Feb 2017).

90 Cramp 1957, 63, 67.

91 Ibid.

92 See this volume, chapter 5, *Style and substance*, 212.

93 Härke 1992b; 2004b.

94 Bruce-Mitford 1978, 273–309, pls 21–2a.

95 Halsall 2003, 57–8.

96 Härke 1992b, 162, fig 29.

97 See this volume, chapter 2, *Hilt-mounts and other small mounts (cat. **410–537**)*, 50–2.

98 Menghin 1983, 69–70, 315–317, Abb. 32–3, Karte 3. Hoard pommels: **1–3**, ?**4**, **5–13**, ?**14**, **15–25**, **27–33**, **36**, **38–9**, ?**40**, ?**41**, **42**, **45–8**, ?**49**, **50–1**, **53–4**, ?**55**, **63–9** and ?**70**.

99 For example, pommels: **4**, **14**, **40–41**, **43**, **49**.

100 Menghin 1983, Karte 3.

101 Fern 2017; see this volume, chapter 5, *Animal ornament in the Hoard*, 213.

102 Menghin 1983, 312–5; Fern 2017.

103 Stolpe and Arne 1927, Taf. 34.4.

104 Evison 1976, fig 1. See this volume, chapter 5, *Animal ornament in the Hoard*, 214.

105 PAS: LEIC-E45DE0 <https://finds.org.uk/database/artefacts/record/id/778653> (accessed 30 Jan 2018).

106 Fischer and Soulat 2009; *pace* Fischer and Soulat 2010. See this volume, chapter 6, *Kent, East Anglia or Greater Northumbria*, 276–7.

107 Evison 1967, no. 31, fig 14c; Menghin 1983, 317, no. F.111.

108 Evison 1967, fig 14e.

109 Menghin 1983, 199–200, cat. 25.

110 Fern 2017, fig 3g.

111 Menghin 1983, 321–8, Abb. 7, Karten 5–6.

112 Norfolk Museum: NMS-BE3EB3. The author is grateful to Tim Pestell for providing information on the find.

113 Boyle *et al* 1998, grave 178, fig 5.101, no. 1.

114 NIS <http://inventorium.arch.ox.ac.uk/gravegood.php?site_ID=Sib&grave_ID=Sib177&objectID=M6532&g=yes&sortclasscode=&search=search> (accessed 14 Aug 2016); *TAR* 2003, 83, no. 114.

115 Bayliss *et al* 2013, 185, e-fig 5.6.

116 Haseloff 1981, 241–5, Taf. 35; Menghin 1983, 312, no. C.41.

117 Haseloff 1981, 241–5, Taf. 34; Menghin 1983, 310, no. B.19.

118 Haseloff 1981, 241–59, Taf. 34–38; Jørgensen and Vang Petersen 1998, figs 162–3, 183; Speake 1980, fig 5c–f, h. The Tureholm collars are in the Swedish History Museum, Stockholm, SHM 29.2. <http://mis.historiska.se/mis/sok/resultat_bild.asp?invnr=28&typ=fotografi&searchmode=&qmode=&qtype=bild&sort=&orderby=upptagning.namn&sm=&pagesize=6&page> (accessed 15 Jan 2017).

119 Speake 1980, 52–3.

120 Pasqui 1918, figs 4–5, 71; Menghin 1983, 258–60, cat. 112–3.

121 Scott 2013.

122 McDonald 2006.

123 Sumnall 2014.

124 Market Rasen: *TAR* 2002, 68–70, no. 58. British Museum Acc: BM.2006,1001.1. Wellingore: TAR 2003, 85, no. 117; Daubney 2004.

125 *TAR* 2003, 84, no. 115.

126 Hinds 2010.

127 Aldbrough: *TAR* 1998/9, 34. Middleham: Parol 2014.

128 *TAR* 2005/6, 223–4, no. 1226.

129 See this volume, chapter 5, *Animal ornament in the Hoard*, 216.

130 The group was examined by the author at the British Museum in 2012; *TAR* 2002, nos 58, 68–70.

131 Pers comm, Caroline Cartwright, Senior Scientist and Wood Anatomist, Department of Scientific Research, British Museum. Date assessed: 8 Apr 2003.

132 Härke 2004a, 557.

133 Gannon 2013, 91–2, fig 2; Williams and Hooke 2013, 61.

134 Bruce-Mitford 1978, 303–4, pls 21a, 22a; Webster 2012a, 31; BM 1995, 0501.1 <http://www.britishmuseum.org/research/collection_online/collection_object_details.aspx?objectId=84836&partId=1> (accessed 12 Jan 2017).

135 Bruce-Mitford 1972, 80–3.

136 Arrhenius 1985, 141–6.

137 Ljungkvist and Frölund 2015, 22.

138 See this volume, chapter 2, *Pommels and sword-rings (cat. **1–84**)*, 38; also, this volume, chapter 3, *Cell-forms and patterns,* 172–7, and *Organics and pastes*, 137–8.

139 Fischer and Soulat 2010, 140; Fern 2017.

141 Stolpe and Arne 1927, pl 43: fig 13; Nerman 1969/1975; Nørgård Jørgensen 1991, 221.

142 Musty 1969.

143 Nerman 1969/1975, Taf. 204: no. 1688, Taf. 205: no. 1694.

144 Evison 1967; Fischer *et al* 2008.

145 Evison 1967.

146 Gold examples are known from Gudme (Denmark): Jørgensen and Vang Petersen 1998, 216, fig 161.

147 The silver fittings are pommel **68** (see this volume, chapter 2, *Pommels and sword-rings (cat. 1–84)*, 4, 40–1; for hilt-plate pair **372–3**, 47, fig 2.21, and chapter 4, *Modification and repair*, 194, fig 4.11.

148 Montelius 1924.

149 Evison 1967, nos 17, 89, fig 10d; Fischer *et al* 2008, nos 18, 90–3, fig 49.

150 Montelius 1924.

151 Ibid, fig 42; Evison 1967, 97, pl xiv; Jørgensen and Vang Petersen 1998, 282, fig 204; Nørgård Jørgensen 1999, fig 51.2.

152 Pers comm, G. Youngs; Bamburgh Research Project n.d: the so-called 'Bamburgh beauty' (L. 14mm).

153 Menghin 1983.

154 Ellis Davidson and Webster 1967, 17–18, figs 3–4; Evison 1987, 22, grave 98, fig 46.1b; Evison 1988, 5, grave 16, fig 27.1a.

155 Menghin 1983, no. 28, 204.

156 Ibid, 136, 330, Karte 9 (NB the types on the map are reversed in error).

157 Arwidsson 1954, Abb. 82, Taf. 20–1.

158 Barton 2011. The author owes this reference to his colleague, Niamh Whitfield.

159 Ager and Gilmore 1988.

160 <http://www.britishmuseum.org/research/collection_online/collection_object_details.aspx?objectId=90982&partId=1&searchText=Crundale&page=2> (accessed 15 Aug 2016). The pictures show only a single collar, but a pair survives.

161 Menghin (1983) does not publish any examples outside of England, and no others are known to the author.

162 Evison 1967, nos 8, 12; Evison 1987, grave C.

163 Pers comm, C. Scull; Blackmore *et al* 2019.

164 Bruce-Mitford 1978, fig 217a–b, pl 21d.

165 Menghin 1983, 331–2, Karte 10.

166 For example, Grave C Buckland I, Dover, and Coombe (Evison 1987, 21–2, figs 1a–e; Ellis Davidson and Webster 1967, 17, fig 3).

167 Nørgård Jørgensen 1999, 71, Abb. 49–50.

168 See this volume, chapter 2, *Hilt-mounts and other small mounts (cat. 410–537)*, 50–5, fig 2.25.

169 Evison 1967, 75–6, 88, fig 11a; Bruce-Mitford 1978, 298–9, pl 22a.

170 Pasqui 1918, fig 71; Menghin 1983, nos 112, 258–9; Nicolay 2014, 77, fig 4.18.

171 Menghin 1983, 312, no. 42; Arrhenius 1985, fig 166.

172 Pirling 2015, 28.

173 Leahy 2015, 119–20. The total number of pyramid-fittings recorded is now approximately 170: pers comm, P. Mortimer; Mortimer and Bunker 2019.

174 Menghin 1983, 150–1, 363–5, Karte 22. For a Scandinavian example see <http://www.uppsalatidningen.se/aktuellt/guld-och-granater-i-stormannagraven-4245934.aspx> (accessed 11 Sept 2018).

175 Bruce-Mitford 1978, 300–2, fig 227, pl 22e.

176 Webster and Backhouse 1991, 50–1, no. 32a.

177 Carver 2005, fig 105, nos 5a–b.

178 Darch 2006.

179 Bruce-Mitford 1974, 268, pls 86e and 87; A. Blackwell pers. comm. The Dalmeny pyramid was found in the nineteenth century and the full facts of its discovery are not known.

180 Bruce-Mitford 1974, 268.

181 Webster 2001, 272, fig 18.6(b); BM 2000,0102.1 <http://www.britishmuseum.org/research/collection_online/collection_object_details.aspx?assetId=740630001&objectId=63039&partId=1> (accessed 12 May 2017).

182 BM 1974,0201.1 <http://www.britishmuseum.org/research/collection_online/collection_object_details.aspx?objectId=94203&partId=1&searchText=maidstone&images=true&from=ad&fromDate=400&to=ad&toDate=700&page=1> (accessed 4 Oct 2016).

183 Speake 1980, pl 14e; Geake 2001.

184 Menghin 1983, 144; Müssemeier *et al* 2003, 43, Abbs 7–8.

185 Dowker 1887; Evison 1976, 314, pl lxvia–b.

186 Bruce-Mitford 1978, 294–7, 304.

187 Record unavailable at time of research, but can now be accessed at Anon PAS 2010.

188 Burrill 2010.

189 Evison 1976, 314, pl lxvic–d.

190 Lowe 1999, 31.

191 Marzinzik 2003, 59.

192 Ibid, 76–7.

193 Musty 1969, figs 5h1–6h1.

194 Marzinzik 2003, 51–2, map 28; see also Geake 1997, 79, fig 4.27, map 44.

195 Speake 1980, pl 6b; Evison 1988, 18–9, fig 27: 16.2.

196 Bayliss *et al* 2013, 190–201.

197 Musty 1969, 114–6.

198 Hilt-plates **244**, **264**, **292**, **331–2**, **337** and **370–1**.

199 Cameron 2000, 45, app. 1.

200 Bruce-Mitford 1978, figs 211, 217c, 218m; Cameron in Blackmore *et al* 2019.

201 Examples from England include the swords from Coombe (Ellis Davidson and Webster 1967), Sutton Hoo mound 1 (Bruce-Mitford 1978) and the Cumberland hilt (see this volume, chapter 2, fig 2.26). See also Ellis Davidson 1962, pls vii–x. For examples from Europe, see Menghin 1983.

202 For example, hilt-collars: **97–8**, **107–8**, **157–8**, **174–5** and **184–5**.

203 Hilt-collars: **182–3**, **186–7**. Possibly hilt-collars: **85–6** and **155–6**.

204 Halsall 2010.

205 In addition, swords with only wooden or horn hilts are known, like that preserved from Snape (Suffolk): Cameron and Filmer-Sankey 1993.

206 Ager and Gilmore 1988.

207 Bede, *HE* III.24 (McClure and Collins 1994, 150).

208 See this volume, chapter 9, *Scandinavian hoarding*, 346–7.

209 Hedeager 1992, 162–70; Jensen *et al* 2003.

210 Hedeager 1992, 169; Lau 2014, 271–3.

211 See this volume, chapter 2, *Discussion of the large mounts and harness-mount (cat.* **698***)*, 94–6.

212 For a detailed discussion of early medieval warfare, see Halsall 2003.

213 See this volume, chapter 5, 257–80.

214 Ellis Davidson 1962, 52; Brunning 2013, 120, 136–41; Fischer *et al* 2008, 24, 26.

215 See this volume, chapter 3, *Die-impressing on sheet and foil*, 146–8.

216 Bruce-Mitford 1978, 82–90; 1983, Vol 1, 316–295; Quast 1997, fig 502.

217 Oddy *et al* 1978.

218 Bruce-Mitford 1983, Vol 1, 316–95; Pinder 2001; Coatsworth and Pinder 2002, 118–25; Cook 2004, 36.

219 Bruce-Mitford 1978, 146, figs 103–6 and 136–8; Oddy *et al* 1978.

220 See this volume, chapter 2, *The social context, form and date of the helmet*, 79–85.

221 See this volume, chapter 3, *Organics and pastes*, 138.

222 Tweddle 1992; Meadows 1997; 2004.

223 See this volume, chapter 5, *Ornament of the helmet and die-impressed sheet*, 244, table 5.3.

224 See this volume, chapter 5, *Ornament of the helmet and die-impressed sheet*, 239–44, table 5.3.

225 See this volume, chapter 2, *The social context, form and date of the helmet*, 83.

226 Tweddle 1992. See this volume, chapter 2, *The social context, form and date of the helmet*, 81, cf fig 7.3.

227 Meadows 1997; 2004.

228 Giovanna Fregni, pers comm.

229 There is some discrepancy between the fragment quantities of reeded strip **613** calculated from original records (**674**) and in final conservation (**642**). Around thirty fragments could not be located at the end of conservation in 2016 (from six of 227 contexts). However, two possibilities seem most likely: that the 'missing' fragments were joined at some point without record to other fragments with different *K*-numbers; or that they are the result of incorrect fragment counts made prior to conservation.

230 See this volume, chapter 2, *Socketed-base and pins (cat.* **607/8** *and* **676***)*, 102, fig 2.76.

231 Tweddle 1992, figs 530–2, 537, 543–5 and 549–53.

232 Fragments [*K1566*, *K1592* and *K5080*].

233 Fragments [*K245*, *K533*, *K1413*, *K1478*, *K1553*, *K1678* and *K1679*].

234 Fragments [*K1413* and *K1678*].

235 See this volume, chapter 3, *Reeded strip*, 148.

236 Ninety-degree edge [e.g. *K532*, *K930*, *K1173*, *K1305* and *K1433*]; forty-five-degree edge [e.g. *K1091* and *K1433*]; twenty-degree edge [*K1680*].

237 Fragments [*K1348*, *K1491* and *K1493*–*K1494*].

238 Bruce-Mitford 1983, Vol 1, fig 260.

239 Bruce-Mitford 1983, Vol 1, fig 267; Cook 2004, 36.

240 Bruce-Mitford 1978, 146; Oddy *et al* 1978.

241 Cameron 2000, 45–6, figs 25–6.

242 Bruce-Mitford 1978, 146, figs 103–6, 136–8; Oddy *et al* 1978.

243 Steuer 1987, 192; Marzinzik (2007, 42–3) has suggested that the helmets should be referred to as the 'Nordic crested group'.

244 Tweddle 1992, 1,082–132.

245 Ibid, 1,095.

246 Hood *et al* 2012.

247 Bruce-Mitford 1978, 138–225.

248 Bruce-Mitford 1974, 223–52.

249 Meadows 1997; 2004.

250 Tweddle 1992.

251 Bruce-Mitford 1978, fig 153. The grave was robbed and badly excavated in the nineteenth century. No other helmet parts have been identified.

252 Tweddle 1992, fig 522; Underwood 1999, 102; Marzinzik 2007, 42.

253 Bruce-Mitford 1978, 220.

254 Lindqvist 1925. See also Alföldi 1934.

255 Almgren 1948; 1983.

256 Arwidsson 1977, 29.

257 Tweddle 1992, figs 407 and 590.

258 See this volume, chapter 2, *Cast helmet parts with animal ornament (cat. **589–92**)*, 71, fig 2.47.

259 Meadows 1997; 2004.

260 Bruce-Mitford 1978, 152. It was noted in the report on the reconstruction of the helmet that 'the Tower of London replica was made deliberately slightly smaller in brow-level circumference and length from front to back at rim level to discount a slight inflation of dimensions in the original which was due to corrosion'.

261 Bruce-Mitford 1978, 138.

262 See this volume, chapter 5, *Figural ornament*, 239–45.

263 Alkemade 1991, 290.

264 Arrhenius 1983, fig 6.

265 Stolpe and Arne 1927, pl xli; Bruce-Mitford 1978, fig 158; Tweddle 1992, fig 537.

266 Alexander 1978, cat no. 42; Tweddle 1992, fig 534.

267 Bruce-Mitford 1974, pl 59b.

268 Stolpe and Arne 1927, pl xli; Arwidsson 1977, Abb. 65.

269 Webster 2012b, figs 25–6.

270 Tweddle 1992, fig 533.

271 Bruce-Mitford 1974, ch 9; 1978, 158; the translation is from Heaney 1999.

272 Russell Robinson 1975, 142–3, figs 154 and 156–7.

273 It has been suggested that the Benty Grange boar had a dorsal ridge, possibly of hair, fixed along its back.

274 Russell Robinson 1975, 129, fig 376.

275 Tweddle 1992, fig 502.

276 Klumbach 1973, 51–61, Taf. 19–21 (see also the two helmets from Berkasovo (Yugoslavia), Taf. 1–9); Bruce-Mitford 1978, fig 166; Tweddle 1992, fig. 527a–c.

277 Bruce-Mitford 1978, 171. This is solely based on internal evidence of fragments of the right cheek-piece, which preserve almost the entire outer edge with the exception of the upper edge, which is largely provided by a substantial fragment of the left cheek-piece.

278 Tweddle 1992, 989. It is noted that the term 'cheek-piece' is something of a misnomer. They actually served to protect the areas behind the lower jaw, where the major blood vessels to the brain pass up the neck and are vulnerable to attack.

279 See this volume, chapter 2, *Helmet parts, decorated silver sheet: reeded strip and edge binding*, 71, fig 2.47.

280 It is possible that any uncertainty about the attachment of the securing tabs may be resolved in the process of fabricating an actual reconstruction, something planned by the owning museums, but not yet begun at the time of writing.

281 Bruce-Mitford 1974, pl 72c.

282 There remains the possibility that the iron 'staining' is secondary, due possibly to the iron-rich soil at the site.

283 It is suggested that the Sutton Hoo shoulder-clasps were mounted on leather, in apparent imitation of Roman imperial armour. Bruce-Mitford (1978, fig 394) draws a comparison with the breastplate of the muscle-cuirass from the statue of the Emperor Augustus at Prima Porta (Vatican Museum).

284 Siddorn 2003, 129–30.

285 Werner 1949, 249. In a fourth-century chieftain's grave in the cemetery at Monceau-le-Neuf (France) were found two boar tusks of exceptional size joined together with sheet silver to form a crescent shape, which Werner deduced had been riveted on to a helmet of leather.

286 Underwood 1999, 79. The archaeological evidence for covers of cow-hide is corroborated by the Laws of Aethelstan (926–30), which stipulate that sheepskin should not be used in the making of shields.

287 Oddy *et al* 1978.

288 Arwidsson 1977, 24.

289 Axboe 1987, 19. In making dies C and D the craftsman had detached two panels from a helmet with the underlying leather still attached and made two casts of them, producing two dies no thicker than 2.5mm. In contrast, the other pair of dies (A and B) are 4.4mm and 3.5mm thick.

290 Bruce-Mitford 1978, 185.

291 Siddorn 2003, 129.

292 Bruce-Mitford 1978, 146. On the Sutton Hoo helmet, the brass edging of the neck-guard, cheek-pieces and cap was held in place by reeded bronze clips.

293 Tweddle (1992, 960–5) identifies four different types of edge binding, which had been secured with brass rivets. The neck-guard on the Coppergate helmet consists of a mail curtain.

294 Bruce-Mitford 1978, figs 156–7.

295 Tweddle 1992, 1,123. It is noted that while mail and cheek-pieces both occur separately among the different groups of Scandinavian helmets, they have not, so far, been found together, as on the later Coppergate helmet. Tweddle suggests that this combination of mail and cheek-pieces may have been drawn directly from the *Spangenhelm* tradition and the Coppergate helmet is merely the first and only surviving evidence for this usage.

296 Bruce-Mitford 1978, 185, fig 139.

297 Meadows 1997; 2004.

298 Meadows 2004, 8–9.

299 Bruce-Mitford 1978. The helmet from Sutton Hoo is described as being 'richer and of higher quality than any other helmet yet found and closer to the late Roman prototypes that lay behind the Vendel Type'.

300 Chaney 1970, 137. The transition between helmets and crowns, as items of kingship, has been stressed by Alföldi (1934) and Almgren (1983).

301 Chaney 1970, 139. The kennings quoted by Chaney are collected in Marquardt 1938, 253.

302 Chaney 1970, 140.

303 Tweddle 1992, 1,170.

304 Ibid, 1,191.

305 Ambrosiani 1983, 21–2.

306 Jørgensen and Vang Petersen 1998, 223.

307 Dodwell 1982, 30.

308 Sawyer 1968, 1488.

309 Tweddle 1992, 1,095.

310 Ibid, 1,170.

311 Bruce-Mitford 1974, 242.

312 Meadows 1997; 2004.

313 Marzinzik 2007, 54–5.

314 See this volume, chapter 5, *Figural ornament*, 239–45.

315 Bruce-Mitford 1974, 258; 1978, 225.

316 Bruce-Mitford 1978, 224. Recent work on the Sutton Hoo coinage by Gareth Williams (2011, 40–1) has questioned the precision of this dating: 'It seems unlikely that the latest coins in the hoard could date from any earlier than c 610, or much later than c 635. Since imported coins were still coming into East Anglia after that date, and local coins began to be produced soon after, it is likely that the burial falls between those dates.'

317 See this volume, chapter 5, *Ornament of the helmet and die-impressed sheet*, 232–45.

318 Webster 2012a, figs 34 and 39.

319 Niello-inlaid zig-zag borders do not occur on the Sutton Hoo regalia, although triangular punchwork producing zig-zag patterns without niello as an infill is evident on the magnificent Swedish shield (Bruce-Mitford 1978, fig 89a, c, f and i). However, set against this evidence of an early date is the fact that similar zig-zag decoration is seen on some of the latest objects in the Hoard, like pommel **76** and hilt-guard set **409**.

320 See this volume, chapter 5, *Figural ornament*, 239–45.

321 Bruce-Mitford 1974, 224.

322 For a later dating, see this volume, chapter 6, *Hoard Phase 3 (gold): Anglo-Saxon late Style II and contemporaneous objects, c 610–c 650*, 268.

323 Fern 2005; 2007; 2010.

324 See this volume, chapter 3, *Garnets*, 129–32, and *Organics and pastes*, 136-8.

325 Filigree panels [*K109, K1439*].

326 See this volume, chapter 5, *Animal ornament in the Hoard*, 224.

327 See this volume, chapter 3, '*Assembly' marks and other marks*', 183–5.

328 Filigree panels [*K154, K438*] and one in situ.

329 For a discussion of its art, see this volume, chapter 5, *Animal ornament in the Hoard*, 226.

330 It can be compared chiefly with inlaid ornament on iron buckles from Kent: see Hawkes 1981.

331 See this volume, chapter 3, *Silver, copper alloy and other metals*, 127–9.

332 See this volume, chapter 3, *Cell-forms and patterns*, 173–4, table 3.7

333 See this volume, chapter 6, *Summary*, 271.

334 Gaborit-Chopin 1991, 56–9; Roth 1996, Band 2, 631, Abb. 495; Bardiès-Fronty *et al* 2016, 39–41, 130–1, no. 83, fig 21.

335 de Linas 1864, 5; Vierck 1985, 404–6; Roth 1996, 631, Abb. 496; Bardiès-Fronty *et al* 2016, 211, fig 50.

336 Webster 2015, 68–9.

337 <http://gallica.bnf.fr/ark:/12148/btv1b8452550p/f72.zoom> (accessed 27 Sept 2016). The author owes this observation to Joanna Story.

338 See this volume, chapter 2, *Objects of uncertain, but possibly religious, purpose*, 117–18.

339 Ibid.

340 Ibid.

341 Webster and Backhouse 1991, 121, no. 86. For a discussion of the binding and its date, see Pickwoad 2015, 45–6; Webster 2015, 79–80.

342 Evans 2004, 24–6, pl 9; Pirling 2015, 22–3.

343 Lines 1,035–45; trans. Bradley 1995, 438–9; Mitchell and Robinson 1998, 82–3; Webster 2018.

344 Avent 1975, pl 68, no. 179; Bruce-Mitford 1978, fig 435.

345 Ryan 1993; Whitfield 1993.

346 See this volume, chapter 6, *Hoard Phase 3 (gold): Anglo-Saxon late Style II and contemporaneous objects c 610–c 650*, 268.

347 Bruce-Mitford 1978, 55–63, fig 44; Leahy and Bland 2009, 40; Leahy 2010.

348 Dickinson 2005.

349 Pasqui 1918, figs 14–17; Oexle 1992, Taf. 172; Fern 2017.

350 Kelly 2001; Evans 2004, 24–9; Fern 2005, 57–61.

351 Dickinson 2005, figs 10, 11c–d and 13b, e.

352 Carver 2005, 230; Dickinson *et al* 2011, 47.

353 Lau 2014.

354 Dixon and Southern 1992, 67. Blinkers were used much earlier, in the Bronze Age in the Middle East and by the Assyrians in the ninth to eighth centuries BC: Curtis and Tallis 2012, 118–9.

355 Fern 2005; Carver 2005, 221–38, figs 109–13, 115 and 117.

356 Fern 2005, fig 5.17.2; Carver 2005, fig 115.

357 See this volume, chapter 2, *Objects associated with Christian ceremony and worship*, 114–16.

358 See this volume, chapter 2, *Hilt-mounts and other small mounts (cat. **410–537**)*, 50–5, and *Large mounts not from weaponry and harness-mount (cat. **698**)*, 85–96.

359 Edited transcript of an interview with Terry Herbert, January 2010, by Fulcrum Television for the National Geographic.

360 See this volume, chapter 3, *Stones and manufacture*, 169.

361 Bruce-Mitford and Luscomb 1974, 234, fig 40b, pl 70c; Webster and Backhouse 1991, 170–3, no. 133.

362 Cotsonis 1994.

363 See this volume, chapter 5, *Style and substance*, 212, and *Animal ornament in the Hoard*, 229–30.

364 XRF undertaken by E Blakelock, Birmingham Museum and Art Gallery, 17 Feb 2016.

365 See this volume, chapter 6, *Dating the Hoard*, 258, and *Hoard Phase 3 (gold): Anglo-Saxon late Style II and contemporaneous styles and objects, c 610– c 650*, 267–8.

366 The related silver-gilt material was originally considered to be two objects and hence was given two catalogue numbers (**607** and **608**).

367 Cotsonis 1994.

368 See this volume, chapter 2, *Objects associated with Christian ceremony and worship*, 113, and chapter 7, *The Church and warfare: the religious and cultural background to the Hoard*, 295.

369 See this volume, chapter 3, *Sheet and foil*, 140.

370 See this volume, chapter 2, *Great gold cross (cat. **539**)*, 100-1.

371 A scarred area immediately to the left of the first upright of the 'u' could be an erased otiose stroke or guide line.

372 Contracted letters implied by the *tilde* (an abbreviation mark taking the form of a straight line).

373 Largely concealed by the fold.

374 The consistent form of the 'i's and the 't's elsewhere leave little doubt that this is indeed what was written.

375 Contracted letter implied by the *tilde*.

376 A character of unorthodox, ambiguous form, impossible to show typographically, hence here represented by an asterisk.

377 Short straight line of ambiguous purpose.

378 Character formed by a straight line crossed at the bottom with a diagonal, most probably representing a 'v', just conceivably a 't'.

379 Notwithstanding obliteration via cancel lines, these are clearly a 'd' and an 's' with a *tilde* for the contracted 'e' and 'u'.

380 See this volume, chapter 2, *The palaeography of the inscriptions*, 107.

381 For previous discussions, see Brown 2010 and 2013; Ganz 2010; Okasha 2010.

382 Suggested by Brown 2010, 5; 2013, 52.

383 On the reverse, serifs were only applied to the first 'd' of line 1, to the penultimate 'i' of line 1, ?to the first 'i' of line 2, and to the final 'd' of line 2.

384 Respectively, those of: 'disepentur' and 'tui'; 'surge'; 'oderunt'; 'fugent'; and 'tua'.

385 In 'a facie tua'.

386 The final letter of 'fugiun[t]'; also 'inimictiui'.

387 To cite just one continental example at random: Milan, Biblioteca Ambrosiana, H 78 sup.: CLA III, no. 347, where dated s. vi. Relevant Irish writing appears in the hard point glosses added to Codex Usserianus Primus (Dublin, Trinity College, 55: CLA II, no. 271, where the original stratum is dated s. VII[in]). The most relevant manuscript example of Anglo-Saxon provenance and (presumptively) origin is Bodleian Library, Douce 140: CLA II no. 237; Parkes 1976; Barker-Benfield in Brown, 2006, no. 55.

388 An arguably early instance of the use of Half-Uncial alongside Capital forms appears, for example, on a stone at Gelli-Gaer in Glamorgan: Redknap and Lewis 2007, G28M, pp 305–8, where ascribed to s. v–vi. Crude Half-Uncials appear on a cross-shaft at Llantwit Major, also Glamorgan (ibid, G 65, pp. 377–82, where tentatively ascribed to s. viii).

389 Brown 1982; 2012, 148–54.

390 Bodleian Library, Douce 140: CLA II no. 237; Parkes 1976; Barker-Benfield in Brown, 2006, no. 55.

391 Durham Cathedral Library, A.II.10, fols 2–5, 338 and 339 + C.III.13, fols 192–5 + C.III.20, fols 1–2: CLA II, no. 147; Mynors 1939, no. 6; Gameson 2010 no. 2. See also this volume, chapter 5, *Animal ornament in the Hoard*, 227-30.

392 For example, Durham Cathedral Library, A.II.16; CLA II no. 148a–c; Trier, Domschatz, 61 (134): CLA IX, no. 1,364.

393 See also this volume, chapter 2, *The Christian objects: function and significance*, fig 2.74.

394 Edinburgh, National Museum of Scotland, inv. FC 282; Small *et al* 1973, i (no. 15), pp 64–5; ii, pl xxix; Youngs 1989, no. 102. York Museums, CA 665: Webster and Backhouse 1991 nos 47 and 178a; Tweddle 1992.

395 'Dissipentur' could be understood in the more specifically military sense of 'may they be routed' or to have the more comprehensive meaning of 'may they be destroyed'. Although an analogue for the text appears in Psalm 67.2 ('Exsurgat deus et dissipentur inimici eius et fugiant qui oderunt eum a facie eius'), the change in person from second to third and in mood from imperative to subjunctive, with a corresponding suite of verbal differences ('Surge domine' rather than 'Exsurgat deus', 'inimici tui' not 'inimici eius' and 'oderunt te a facie tua' rather than 'oderunt eum a facie eius'), leave no doubt that the version from Numbers was the source here.

396 Felix, *Vita sancti Guthlaci*, 49 (Colgrave 1956, 148–50).

397 'Disepentur' is one letter distant from both 'dis[s]ipentur' and 'dis[s]epentur'. 'Fugent' is one letter distant from 'fugient', but two from 'fugiant'.

398 See also this volume, chapter 2, *The Christian objects: function and significance*, 110–19, and chapter 7, *The Church and warfare: the religious and cultural background to the Hoard*, 293–9.

399 The presence of a bishop and 'book-holding monks', who are likely to have been British, relies upon the uncertain testimony of the verse epic Marwnad Cynddylan (Williams 1935, no. xiii; Clancy 1970, 87–9). Its formal features are seen as compatible with a seventh-century date by Roland (1990, 181). The case that the lines in question refer to a British community is put by Kirby (1977, 36–7) and Bassett (1992, 34).

400 Bede, *HE* III.2 (Colgrave and Mynors 1969).

401 See also Webster 2005, esp. 36–8, on this topic.

402 From the edited transcript of an interview with Terry Herbert, January 2010, with Fulcrum Television for *National Geographic*.

403 See this volume, chapter 2, *Objects associated with Christian ceremony and worship*, 114–16.

404 See this volume, chapter 5, *Animal ornament in the Hoard*, 227–32.

405 See this volume, chapter 3, *'Assembly' marks and other marks*, 183–5.

406 See this volume, chapter 3, *Glass*, 132–4.

407 The dull metal of the interior is visible, but XRF analysis of it was unsuccessful due to covering corrosion (Blakelock pers comm).

408 See this volume, chapter 4, *Damage*, 201.

409 A Keyence microscope was used at maximum magnification (×200). Only a fine mould-like material was visible.

410 Bruce-Mitford 1974, 282–3, fig 48a.

411 See this volume, chapter 2, *Crosses worn on the body or on equipment*, 116–17.

412 Bruce-Mitford 1967; 1974, pl 5b. The cross was not declared Treasure Trove and was sold by Sotheby's: <http://www.alamy.com/stock-photo-1300-year-old-anglo-saxon-gold-cross-found-by-farm-worker-basil-wright-84103416.html> (accessed 1 Mar 2016).

413 See this volume, chapter 7, *Christian and pagan culture in the early seventh century*, 297–8; Webster 2016, originating in a paper given in 2011, gives an initial appreciation of the major religious items in the Hoard.

414 See this volume, chapter 5, *Geometric ornament and symbols*, 252–5.

415 The length of the cross is estimated as 165–85mm, that of the inscribed strip 168mm.

416 See this volume, chapter 2, *Great gold cross (cat. 539)*, 100–1, and *Objects associated with Christian ceremony and worship*, 111–16.

417 Accession numbers 57.641 and 57.632.

418 See this volume, *Great gold cross (cat. 539)*, 101, *Socketed-base and pins (cat. 607/8, 676)*, 99, and *Objects associated with Christian ceremony and worship*, 114.

419 Bardiès-Fronty *et al* 2016, cat. no. 208.

420 See also this volume, chapter 7, *The Church and warfare: the religious and cultural background to the Hoard*, 293–5. Sant' Apollinare in Classe was consecrated in 549, while the mosaic of the Cross in Majesty in Santa Pudenziana dates to the late fourth or early fifth century. The cross of Justin II is in the Vatican Museum.

421 See, for example, the silver cross that was carried as a standard when Augustine first encountered Æthelbert of Kent, and the list of liturgical equipment and books that were subsequently brought by Mellitus, Justus, Paulinus and Rufinianus in 601; Bede, *HE* I.25, I.29 (Colgrave and Mynors 1969).

422 *The Dream of the Rood* and *Elene* are translated in Bradley 1995, *De Abbatibus* in Campbell 1967. The earliest version of *The Dream of the Rood* appears on the eighth-century Ruthwell cross; the other two poems can be dated to the ninth century. See also Wood 2006.

423 *Dream of the Rood*, lines 7–11: 'Eall þæt beacen wæs begoten mid golde; gimmas stodon fægere æt foldan sceatum, swylce þær fife wæron uppe on þæm eaxlegespanne.'

424 Cramp 2013, 74–5.

425 Anglo-Saxon exegesis of Christ's wounds goes back at least to Bede; see Homily II.9 in Luke 24:36–47: Martin and Hurst 1991, 78–87; Brown 2009.

426 Bardiès-Fronty *et al* 2016, cat. no. 83; Gaborit-Chopin 1991, 41–3 and cat. no. 1 and figs 1–1a and 2. The early seventh-century cross was almost entirely destroyed in 1792,

but a small surviving fragment and earlier depictions show that it was lavishly set with flat and cabochon gems. See also this volume, chapter 7, *The Church and warfare: the religious and cultural background to the Hoard*, 295.

427 The use of plant ornament, common in classicising art, is not seen in Anglo-Saxon metalwork or manuscripts before the early eighth century. For discussion of the vine-scroll in Anglo-Saxon England, see Webster 2012a, 18, 38.

428 Like other Germanic peoples, the Anglo-Saxons had traditionally used animal motifs to symbolise aspects of man's relationship with the natural and supernatural world, something readily adaptable to Christian iconography.

429 '*Attulit quoque secum uasa pretiosa Eduini regis perplura, in quibus et crucem magnam auream, et calicem aureum consecratum ad ministerium altaris, quae hactenus in ecclesia Cantiae conseruata monstrantur*'; Bede, *HE* II.20 (Colgrave and Mynors 1969).

430 'He commanded brass bowls to be set up at springs along the highways, to enable travellers to refresh themselves.' Bede, *HE* II.16 (Colgrave and Mynors 1969).

431 See this volume, chapter 7, *The contemporary context*, 293–5.

432 See this volume, chapter 2, *The palaeography of the inscriptions*, 103–8.

433 For a Syrian sixth-century inscribed example, see Stiegemann *et al* 2013, cat. no. 76.

434 See this volume, chapter 7, *Christian and pagan culture in the early seventh century*, 296–9.

435 Webster 2016, 40–4.

436 See this volume, chapter 2, *The palaeography of the inscriptions*, 103–8.

437 Joshua 6:4–15; 1 Samuel 4:3–11; 2 Samuel 11:11.

438 See this volume, chapter 7, *Christian and pagan culture in the early seventh century*, 296–9.

439 La Croix 1883, pl vii, step P; Flammin 1999. The heads of these creatures are not depicted as seen from above, as on the inscribed strip, but share a similar well-defined shape and features.

440 La Croix 1883, pl vii, step Q.

441 See this volume, chapter 5, *Ornament of the helmet and die-impressed sheet*, 232–9.

442 For a useful overview, see Quast 2012.

443 Butler and Graham-Campbell 1990; Edwards 1992; Webster 2016. Bourke 2009 proposes an Irish twelfth-century origin for the *Arch Gwenfrewi*, comparing it to St Manchan's shrine, but the date and origin of its decorated fittings, known only from a crude seventeenth-century drawing, remain debatable.

444 For example, the Breccbennach of St Columba, traditionally identified with the eighth-century Monymusk reliquary, in the National Museum of Scotland – though this association is now considered doubtful; see Caldwell 2001.

445 See this volume, chapter 2, *Socketed-base and pins (cat. **607/8**, **676**)*, 102.

446 Cuxton: Blackmore 2006, 3.13.1 and 2; Dinham: Webster 2005, 32, figs 7a–b.

447 Pers comm Pieta Greaves.

448 See this volume, chapter 2, *Head-dress mount (cat. **541**)*, 109, and *Objects associated with Christian ceremony and worship*, 114–16. An earlier presentation of this case was first argued in 2011, and published in Webster 2016; that account has been extended here.

449 Alexander 1978, cat. no. 7; Meyvaert 2005.

450 Codex Grandior; for reference to the immense discussion on this topic, see Meyvaert 2005.

451 *De Tabernaclo*, 3–10; Holder 1994; *In Ezram et Neemiam*, 2.1886–89; DeGregorio 2006, 149, and App. 2.

452 DeGregorio 2006, xxxix–xliii.

453 Josephus (*Antiquitates Judaicae* 3.172-8; Feldmann 1999). This influential text was translated from the Greek into Latin by Cassiodorus, which was much used by Bede (Lapidge 2006, 218).

454 *De Tabernaclo* 3.7, 3.8: Holder 1994; for the Old Testament account, see Exodus 28:36–9.

455 *De Tabernaclo* 3.8; Holder 1994.

456 *De Tabernaclo* 2.7; Holder 1994, 130–2.

457 Exodus 28:36–8; Josephus (*Antiquitates Judaicae* 3.178 : Feldman 1999). This distinctive aspect of the head-dress is also discussed in the sixth-century *Christian Topography* of the Greek monk Cosmas Indicopleustes, Book v (McCrindle 1897/2010, 155, 157), which is presumably based in part on Josephus. An eighth/ninth-century manuscript of this text in the Vatican depicts two views of Aaron as high-priest, wearing such a head-dress (Biblioteca Apostolica, Vat. gr.669, f. 50r).

458 *De Tabernaclo* 2.7; Holder 1994, 130–2.

459 DeGregorio 2006, App. 2, 232–3.

460 *In Ezram et Neemiam* 2.1886–89: DeGregorio 2006, 149, App. 2.

461 The author is grateful to Alan Thacker for drawing this to her attention.

462 The bishop's mitre as we know it does not seem to have appeared before the tenth century, and its origins are uncertain. It does seem, however, that it may have ultimately derived from a conical cap. A first-century Romano-British bronze head-dress known as the Hockcliffe (Norfolk) 'crown' has a small finial at its apex; it is, however, improbable that any tradition or memory of such presumed ritual gear could have been transmitted down to the seventh century.

463 Lapidge 2006, 31–52.

464 Bischoff and Lapidge 1994, 216–7; Lapidge 2006, 32–3, 177–8, 218. Interestingly, a copy of Cosmas Indicopleustes (see endnote 457) also existed in the Canterbury library of Theodore and Hadrian; Lapidge 2006, 32, 177.

465 When Sigeberht of East Anglia established a monastic school in the early 630s, his Frankish bishop, Felix, sent to Canterbury for teachers from the school set up by Augustine; Bede *HE* III.18 (Colgrave and Mynors 1969). A copy of the Cassiodoran translation of *Antiquitates* is also listed in an eleventh-century Anglo-Saxon inventory, possibly from Peterborough Abbey (Medehamstede), though the date of the manuscript is not known, nor when it might have arrived there.

466 See this volume, chapter 2, *Cross-pendant (cat. 588)*, 110.

467 Trumpington: <https://www.flickr.com/photos/cambridgeuniversity/sets/72157629525838627/> (accessed 29 May 2017); this cross, though clearly part of this group, was not worn as a pendant, but sewn onto a garment at the chest, to similar effect. Ixworth and Desborough: Webster and Backhouse 1991, cat. nos 11 and 13.

468 Newark: Rohde 2007; Holderness: Paynton 1999; Wilton: Archibald 2013.

469 For example, the specimens from Breach Down, Kent (British Museum, BEP 1879,0524.62–64).

470 See this volume, chapter 2, *Miscellanea*, 119.

471 Monza: Menis 1990, ix.24; the icon is illustrated in Stiegemann *et al* 2013, 1, pl 15.

472 See this volume, chapter 2, *Large mounts not from weaponry and harness-mount (cat. 698)*, 90–1.

473 Pickwoad 2015, 6, 49–50, 52.

474 See this volume, chapter 2, *Large mounts not from weaponry and harness-mount (cat. 698)*, 94–5.

475 For example, fols 30v and 31v; Paris, Bibl. Nat. Lat.8850.

476 See this volume, chapter 7, *The contemporary context*, 293.

477 Pickwoad 2015; Webster 2015.

478 Webster 2015, 68–9.

479 Wilson 1961, 201–5, pls 35–6.

480 For example, the copper-alloy Style II decorated example from a seventh-century grave in the Marne region (British Museum, BEP ML 4140), which is identical in shape and size (L. 72mm) to the L-shaped mounts <http://www.britishmuseum.org/research/collection_online/collection_object_details.aspx?assetId=477352001&objectId=84866&partId=1> (accessed 29 May 2017).

481 See this volume, chapter 2, *Sets of mounts in garnet cloisonné (cat. 542–66)*, 88, 90, 95.

482 For St Augustine on this subject, see Miles 1983; for Anglo-Saxon reception of this idea, see Pratt 2003.

483 Pratt 2003, 209–20.

484 See this volume, chapter 2, *Discussion of the large mounts and harness-mount (cat. 698)*, 94.

485 Stiegemann *et al* 2013, 2, cat. no. 62.

486 Barker *et al* 1997, 212–6, figs 312–313.

487 See chapter 7, this volume, chapter 7, *Christian and pagan culture in the early seventh century*, 296–9. See also Webster 2016.

488 See this volume, chapter 2, *The palaeography of the inscriptions*, 107.

489 Bede, *HE* II.16 (Colgrave and Mynors 1969).

490 Bede, *HE* I.20 (Colgrave and Mynors 1969).

491 Cotsonis 1994, 56–64.

492 See this volume, chapter 3, *Organics and pastes*, 136.

493 See this volume, chapter 3, *Cloisonné and other lapidary work*, table 3.6.

494 See this volume, chapter 2, *Cross-pendant (cat. 588)*, 110.

495 Perry 2000, 113–4, fig 94.1; Blackwell 2010, fig 39.

496 See this volume, chapter 3, *Incising and punching*, 150, table 3.2; also, chapter 6, *Dating the Hoard*, table 6.1.

497 See this volume, chapter 6, *Dating the Hoard*, table 6.1.

498 Fragment [*K1284*].

499 See this volume, chapter 2, *Hilt-plates and hilt-guards (cat. 242–409, 696–7)*, 47–8.

500 Webster and Backhouse 1991, 24–5, 31, nos 6 and 15, fig 2.

501 Ibid, 172–3, no. 134.

502 See this volume, chapter 2, *Hilt-mounts and other small mounts (cat. 410–537)*, 50–5. Small mounts: **431**, **435**, **441–2**, **451–2**, **480** and **536**.

CHAPTER THREE

WORKSHOP PRACTICE

ENDNOTES

1 Wicker 2012.

2 Hinton 2000; Coatsworth and Pinder 2002.

3 Dronke 1997, 255–84; Webster 2012b, 16–7, fig 4.

4 *Beowulf*, lines 455, 1,558, 1,562 and 2,616.

5 For the legend of Weland as depicted on the Franks Casket, see Webster 2012b, 16–7.

6 Vierck 1974.

7 Coatsworth and Pinder 2002, 214–5.

8 Ibid, 229.

9 Ibid, 228–34.

10 See this volume, chapter 3, *'Assembly' marks and other marks*, 183–5.

11 Coatsworth and Pinder 2002, 5, 229.

12 Ibid, 21–9.

13 Untracht 1982, 407; Perea and Armbruster 2011; Aufderhaar 2012.

14 Coatsworth and Pinder 2002, 41–63.

15 Hamerow 2010, 63, fig 5; Scull *et al* 2016, 1,602–3, fig 8.

16 The original reports for all the studies undertaken as part of the Historic England Project are available in the ADS digital archive: <https://doi.org/10.5284/1041576>.

17 See this volume, chapter 3, *Gold*, 126–7, and *Surface-enrichment of gold*, 144–6.

18 Jørgensen and Vang Petersen 1998, 181; Nicolay 2014, 210–5.

19 Hawkes *et al* 1966; Brown and Schweizer 1973; Hawkes and Pollard 1981.

20 Nicolay 2014, 210–32, 238–44 and 250–7; see this volume, chapter 9, *Scandinavian hoarding*, 344–9.

21 Williams and Hook 2013, 51–70.

22 For example, Brown and Schweizer 1973.

23 Williams and Hook 2013, 67.

24 Blakelock 2013.

25 Blakelock 2014; Blakelock *et al* 2016.

26 See this volume, chapter 3, *Surface-enrichment of gold*, 144–6.

27 Pingel 1995, 394–7; Raub 1995, 245.

28 Pommels: **53** and **57**; hilt-collars: **88** and **166**; hilt-ring: **198**; small mounts: **488**, **527** and **529**.

29 Pommel **12**; hilt-plate **335**.

30 Hughes *et al* 1978; Blakelock 2014.

31 Hughes *et al* 1978; Oddy and La Niece 1986; Blakelock 2014.

32 Ogden 1977; Meeks and Tite 1980.

33 Arrhenius 1977.

34 For dating, see this volume, chapter 6, 257–81.

35 Blakelock *et al* 2016.

36 Cf Brown and Schweizer 1973.

37 Williams and Hook 2013, 54–70.

38 See this volume, chapter 3, *Surface-enrichment of gold*, 144–6.

39 Bede, *HE* I.1 (McClure and Collins 1994, 9–12).

40 Ozanne 1963, 35.

41 Pers comm Peter Claughton.

42 Bruce-Mitford 1983.

43 Grimwade 2009.

44 Blakelock 2015a; 2015b.

45 Mortimer 1986.

46 See this volume, chapter 3, *Niello*, 151–3.

47 Blakelock 2016b.

48 Terminology here follows Bayley 1989.

49 Blades 1995.

50 See this volume, chapter 3, *Gilding*, 145–6.

51 Smith and Gnudi 1990, 383.

52 Maras *et al* 2013.

53 Edmondson 1989, 94; Martínez-Cortizas *et al* 1999.

54 Calligaro *et al* 2000.

55 Calligaro *et al* 2007; Gilg *et al* 2010.

56 Calligaro *et al* 2007; Périn *et al* 2007.

57 Gilg *et al* 2010.

58 Ibid; Calligaro and Périn 2013.

59 Beam time at the AGLAE (Accélérateur Grand Louvre d'Analyse Elémentaire) facility in the C2RMF (Centre de Recherché et de Restauration des Musées de France) laboratories was made possible under the FIXLAB Transnational Access programme of the CHARISMA project. Financial support by the Access to Research Infrastructures activity in the 7th Framework Programme of the EU (CHARISMA Grant Agreement no. 228330) is gratefully acknowledged.

60 Higgitt *et al* in preparation.

61 Calligaro *et al* 2007; Périn *et al* 2007.

62 See this volume, chapter 2, *Large mounts not from weaponry and harness-mount (cat. 698)*, 85–93.

63 Unpublished Raman analysis conducted at the British Museum by Janet Ambers (BM registration number: 1939, 1010.26).

64 Calligaro *et al* 2007; Gilg *et al* 2010.

65 *International Framework* collaborative project, <http://zellwerk.hypotheses.org/> and papers and posters presented at the associated Gemstones in the first Millennium ad: Mines, Trade, Workshops and Symbolism conference, 20–22 October 2015, Mainz <https://zellwerk.hypotheses.org/conference> (accessed 30 May 2017).

66 See this volume, chapter 2, *Large mounts not from weaponry and harness-mount (cat. 698)*, 85–93.

67 For the dating of the mounts, see this volume, chapter 6, *Hoard Phase 3 (gold): Anglo-Saxon late Style II and contemporaneous objects, c 610–c 650*, 268, table 6.1.

68 Pommels: **49**, **53** and **75–6**; hilt-collars: **167–8**; hilt-plate: **260**; small mounts: **494–5**, **511–2**, **514–7** and **526**; large mount: **541**; pyramid-fittings: **572–3**, **576** and **578–9**.

69 Brugmann 2004; Evison 2008, 1.

70 Youngs 1989, 199–202, 204; Coatsworth and Pinder 2002, 150–3; Cramp *et al* 2006, 263–6.

71 See this volume, chapter 3, *Stones and manufacture*, 170, fig 3.84, and *Backing foils*, 179–80.

72 Bruce-Mitford 1978, 582–97, pls 13–7 and 24a.

73 Meek 2012; 2016.

74 Object [*K580*].

75 Penn 2000, 53–4, pl XXIII.

76 Bruce-Mitford 1978, pl 17; Pirling 2015, 32.

77 Kendrick 1933, 429; Webster and Backhouse 1991, no. 32.

78 Meek 2012; 2016.

79 Meek 2013a; 2013b.

80 Meek 2012; 2013a.

81 Foster and Jackson 2010, 3,074.

82 Meek 2013b.

83 Evison 2008, 1, 7–8.

84 Freestone *et al* 2008, 40–1.

85 Bruce-Mitford 1978, 583; Meek 2012 and 2016.

86 See this volume, chapter 3, *Organics and pastes*, 137–8.

87 La Niece 2013.

88 The full analysis is in Martinón-Torres 2016.

89 Ibid.

90 For example, see Stapleton *et al* 1999; Peake and Freestone 2014.

91 Freestone 2001.

92 Freestone *et al* 2008

93 Stapleton *et al* 1999; Peake and Freestone 2014.

94 See this volume, chapter 3, *Glass*, 132–4.

95 *Mc Elhinney 2015.

96 O'Connor 2011; Cartwright 2013a and 2013b; Steele and Hacke 2013; Stacey 2014.

97 Cameron in Caruth and Hines forthcoming.

98 O'Connor 2011.

99 Cameron and Filmer-Sankey 1993, 103.

100 Radostits *et al* 2006.

101 Cartwright 2013a.

102 The organics with objects **75** and **684** were identified by Cartwright (2013b).

103 Cartwright 2013b.

104 Ager 2012, 51; pers comm Ager.

105 Stacey 2014.

106 For example, Giostra *et al* 2008.

107 See also Stacey 2014.

108 Mounts: **542** and **553**; Steele and Hacke 2013.

109 Pommel **42** also has possible traces of calcite in its interior (not analysed).

110 Spiropoulos 1985.

111 Biborski *et al* 2010, 40.

112 Coatsworth and Pinder 2002, 138.

113 See this volume, chapter 2, *Helmet parts, decorated silver sheet, reeded strip and edge binding*, 71, figs 2.47 and 2.56.

114 Coatsworth and Pinder 2002, 137–8.

115 See this volume, chapter 2, *Large mounts not from weaponry and harness-mount (cat. 698)*, 85–93.

116 Arrhenius 1985.

117 Ibid, 204, table xi, v.i.

118 The identification of the stone as rock crystal quartz was made by Don Steward, Curator of Natural History, The Potteries Museum & Art Gallery, Stoke-on-Trent.

119 Menghin 1983, 253.

120 Find [*K1395*].

121 Lucy 2000, 42.

122 Hall *et al* 1999.

123 Coatsworth and Pinder 2002, 70.

124 Pommels: **45**, **48** and **50–4**; seax parts: **169** and **225**; small mounts: **518–22**; pyramid-fittings: **572–3** and **576–9**.

125 Coatsworth and Pinder 2002, 69–86.

126 The gold alloys of serpent pair **531–2** are unknown, but serpents **527** and **529** are among the most gold rich objects. See this volume, chapter 3, *Gold*, 126–7, n. 28.

127 Bruce-Mitford 1978, 536–64; Coatsworth and Pinder 2002, 66.

128 Dickinson 1982, 32; Coatsworth and Pinder 2002, 76–7.

129 Mortimer 1994.

130 Coatsworth and Pinder 2002, 69–73.

131 Ibid, 86–8; Grimwade 2009, 87.

132 Oddy 2000, 3. See this volume, chapter 3, *Backing foils*, 179–80.

133 Meeks and Holmes 1985.

134 Ibid; Grimwade 2009.

135 Pommel: **63**; hilt-plates: **385–6**, **391–3**, **404–8** and **696–7**; objects: **684** and **686**.

136 See this volume, chapter 3, *Silver, copper alloy and other metals*, 127–9.

137 Blakelock 2015b.

138 Untracht 1975, 176; Ogden 1982, 64; Coatsworth and Pinder 2002, 95–100; Perea and Armbruster 2011.

139 Coatsworth and Pinder 2002, 96.

140 Wolters 1981, 127.

141 Untracht 1975, 392.

142 Raub 1996.

143 Blakelock 2016a; Wolters 2006, 73.

144 Coatsworth and Pinder 2002, 99.

145 See this volume, chapter 3, *Surface-enrichment of gold*, 144–6.

146 Blakelock 2016a.

147 Scrivano *et al* 2013.

148 Blakelock *et al* 2016.

149 Wise 1964, 180.

150 Tate 1986; Voute 1995, 333.

151 Craddock 2000.

152 Lehrberger and Raub 1995.

153 Blakelock 2013.

154 See this volume, chapter 4, *Damage*, 195–203.

155 Blakelock 2014; Blakelock, *et al* 2016.

156 Blakelock 2016a. The objects sampled were three hilt-plates (**261**, **293** and **343**), one cloisonné edge-mount (**563**) and two hilt-collars (**101** and **106**).

157 Burnam 1920, 102–3; Smith and Hawthorne 1974, 42; Caley and Jensen 2008, 69.

158 Ashbee 1967, 102.

159 Blakelock 2015b, 6.

160 Northover and Anheuser 2000, 113; Coatsworth and Pinder 2002, 129–30.

161 For an overview, see Oddy 2000.

162 Pliny, *NH* xxxiii.20.65 (Rackham 2003); Oddy 2000, 5.

163 Northover and Anheuser 2000; Oddy 2000.

164 Burnam 1920, 127–8; Hawthorne and Smith 1979, 36.

165 Blakelock 2015b, 7.

166 Coatsworth and Pinder 2002, 129.

167 Bayley and Russel 2008.

168 Hawkes *et al* 1979, 389; Coatsworth and Pinder 2002, 114.

169 Capelle and Vierck 1971; Hawkes *et al* 1979.

170 Twenty-five dies, of assorted scale, which range from the fifth to eighth centuries in date, are listed on the PAS database (pers comm Helen Geake 13 May 2013). In addition, two rectangular dies (unpublished) have been identified by George Speake among the collection of Leicester Museum.

171 Hawkes *et al* 1979, 389; Coatsworth and Pinder 2002 109–14.

172 Hawkes *et al* 1979, 389; O'Meadhra 1987, 142–50, 171.

173 Coatsworth and Pinder 2002 114.

174 Hawthorne and Smith 1963, 153.

175 Foltz 1975, 12; Axboe 1987, 19.

176 Bruce-Mitford 1974, 216.

177 Capelle and Vierck 1971, 115, figs 4.1 and 5.1.

178 Avent and Leigh 1977, 3; Arrhenius 1985; East 1985; Meeks and Holmes 1985; Adams 2006.

179 Vang Petersen 1991, 53, fig 4a; 1994; Høilund Nielsen and Vang Petersen 1993, 225; Nijboer and Van Reekum 1999, 210; Tulp and Meeks 2000, 14; Lund Hansen 2009, 83.

180 Bruce-Mitford 1978.

181 Gerrets 1999, fig 4.

182 See this volume, chapter 3, *Backing foils*, 179–80.

183 Meeks and Holmes 1985, 152–4.

184 Avent and Leigh 1977, 4.

185 Capelle 2012.

186 Adams 2006, 21.

187 Pinder 2001; Coatsworth and Pinder 2002, 118–25. They note 'the widespread use of reeded strips, even for seemingly mundane purposes, would suggest that they were not terribly difficult to produce'.

188 Pinder 2001, 136–8; Coatsworth and Pinder 2002, 120–5.

189 Pinder 2001, fig 12.10; Coatsworth and Pinder 2002, pls 25–6.

190 See chapter 2, *Reeded strip (cat. 609–13)*, 78–9.

191 Coatsworth and Pinder 2002, 102–3.

192 Webster and Backhouse 1991, 58–9, no. 45.

193 Pers comm Graeme Young.

194 Hawkes and Detsicas 1973; Avent 1975, Vol 2, pl 72; Penn 2000, pl iv, fig 84.2.

195 Mortimer 1997; Martin 2015, 151–4.

196 A notable exception is the punched and niello-inlaid patterning on the Sutton Hoo great gold buckle (Bruce-Mitford 1978, fig 409).

197 Coatsworth and Pinder 2002, 46–50.

198 Cf Martin 2015, fig 44.

199 Avent 1975, Vol 1, fig 4, rim forms 4.1, 4.3–4.9; Leigh 1990, 108–9; Webster 2012a, fig 34.

200 La Niece 1983; Coatsworth and Pinder 2002, 116–8; Northover and La Niece 2009.

201 Objects with niello are pommels: **56–7, 68–9** and **75**; hilt-collars: **184–8**; hilt-guard set: **409** (lower guard); mounts: **412, 531–2, 534, 540, 567–71** and **591–2**; fragments: **688**. Objects with lost inlay are hilt-collars: **182–3**; hilt-guard set: **409** (upper guard); mounts: **533** and **535**; and possibly fragments **687** and pommel **74**.

202 Evison 1967, 79, fig 14e; Rogerson 2013. See also Sumnall 2006.

203 Hawkes 1981; Aufleger 1996, Band 2, Abb. 486; Adams 2011a, esp. 25–7, fig 11.

204 For example, Weitzmann 1979, 603, no. 537; Johns and Potter 1983, 133, no. 66.

205 Williams 2012.

206 Coatsworth and Pinder 2002, 153–6. See this volume, chapter 5, *Early Insular style*, 250–3.

207 Blakelock 2016c.

208 La Niece 1983; 1988.

209 La Niece 1983.

210 Hawthorne and Smith 1979, 115.

211 Whitfield 2007.

212 This figure does not include the small remains included in fragment-groups **681** and **689**.

213 *TAR* 2005/6, 223–4, 403, no. 1226.

214 Such compound units are sometimes referred to as 'standard combinations of wires and granules' (Whitfield 2007, 19) or 'combined filigree forms' (Whitfield 2009, fig 5).

215 Mongiatti 2016.

216 As recorded in previous research by Niamh Whitfield.

217 Whitfield 1990, 14–8.

218 For example, Whitfield 1990, figs 3–4.

219 Cf Mongiatti 2016.

220 For example, Whitfield 1990, fig 7.

221 Bruce-Mitford 1974, 131, pl 21; Sherlock 2012, pl. 3.2. The Loftus pendant, based on the published image in Sherlock (2012), uses wire of strip-twisted form.

222 Hawthorne and Smith 1979, 90; Carnap-Bornheim and Ilkjær 1996, 81, fig 58a.

223 Multi-edged swages were also possibly used, but they would have been more difficult to manufacture than ones with two edges and are unproven (Whitfield 1998, 60–6).

224 Cf Mongiatti 2016.

225 Whitfield 1998, 76–9.

226 *TAR* 2002, nos 58, 68–70.

227 Objects with spiral-beaded wire: pommels **12, 27, 29, 32** and **40–1**; hilt-collars **101–2, 105–6, 109–10, 116, 130–1** and **134**; hilt-plates **255–7** and **359**; small mounts **414, 424, 427, 431, 473–5** and **482**, large mounts **539–40** and **558**; boss **654**.

228 Whitfield 1987, pl iib.

229 Härke 2000.

230 The pattern is referred to in other studies as 'three-strand band', e.g. Whitfield 2009.

231 The sample of 317 objects, on which this figure is based, does not include the categories of hilt-rings or boss parts, objects without any of the pattern types listed in table 3.4.

232 Whitfield 2007, figs 8b, 8c, 9a, 10a–c, 11i.

233 Whitfield 1987, pl iif.

234 Pommels **12, 27, 29** and **40–1**; hilt-collars **101–2, 105–6** and **109–10**; small mounts **473–5**; one serpent mount on **558**.

235 Pommels **8** and **12**; small mounts **439–42** and **461**.

236 Whitfield 2007, 19.

237 For Avent's filigree type 3.4, see Avent 1977, Vol 1, fig 2.6. For parallels outside the Hoard, see Avent 1975.

238 Ibid, Vol 2, pls 52 (no. 153) and 78 (no. 192).

239 Bardiès-Fronty et al 2016, 216–18, nos 170–1, fig 51.

240 Webster and Backhouse 1991, no. 181.

241 Nicolay 2014, fig 4.20.

242 Bruce-Mitford 1974, pl 84a. See also a pendant from Lundeborg (Denmark), in Jørgensen and Vang Petersen 1998, 206, fig 154.

243 Duczko 1985, 88, figs 114–5; Whitfield 1993, fig 14.8g; 2009, fig 5g; 2010, fig 1, pls 1–2.

244 Andersson 1995, fig 101.

245 Whitfield 2007, fig 7c.

246 For example, on a griffin brooch now in the Walters Art Museum, no. 57.571.

247 Objects with two-ply twisted-beaded wire: pommels **15, 41, 63, 73** and **77**; hilt-collars **89–90, 109–10, 113, 117–20, 132–6** and **157–8**; hilt-plate **359**; small mounts **456** and **471–2**; large mounts **539–40**; pyramid-fittings **580–1**. Objects with three-ply twisted-beaded wire: hilt-collars **103–4, 153–4**; hilt-rings **211–8**; small mounts **456–7**; great cross **539**; button-fittings **582–3**; fragments **681**: [*K733*, *K1959*]. Objects with four-ply twisted-beaded wire: hilt-collars **87–8, 125** and **155–6**. Twisted-beaded wire is referred to in other studies as 'twisted wire rope', e.g. Whitfield 2009.

248 Ogden 1982, 52. The pattern is referred to in other studies as 'pseudo-plait'.

249 These coverings are referred to in other studies as 'carpets', e.g. Whitfield 2007, 23, fig 4d.

250 Whitfield 1993, fig 14.7f.

251 Pommel **63**; hilt-collars **88–90, 103–4, 116–20** and **153–8**; hilt-plate **359**; small mounts **462** and **471–2**; great cross **539**.

252 McDonald 2006.

253 No correspondence is intended between the term 'platform-filigree' used here and the technique known as 'hollow platform' that has been used in other studies to refer to relief back-sheets. The technique is also different from the platform-mounted wires on a filigree mount from Lagore (Ireland) (Whitfield 2001, 143–4, figs 13.1e, 13.3).

254 Bruce-Mitford 1978, fig 435.

255 Danish finds in Jørgensen and Vang Petersen 1998, 191–3, 230–2 (figs 143–4, 172). Swedish finds from Tureholm (Acc: SHM 29) (Södermanland) at: <http://mis.historiska.se/mis/sok/resultat_bild.asp?invnr=28&typ=fotografi&searchmode=&qmode=&qtype=bild&sort=&orderby=upptagning.namn&sm=&pagesize=6&page> (accessed 27 Jul 2016).

256 Whitfield 1993, figs 14.1, 14.12; 2007, 29–3, fig 7–8.

257 The definition 'annulet' does not include the use of wires as collars for bosses or around holes for nails/rivets, such as the examples in triple-strand beaded wire on mounts **476–7**.

258 See this volume, chapter 5, *Animal ornament in the Hoard*, 214–16.

259 Speake 1980, pls 6–7; see also Coatsworth and Pinder 2002, 111–4. However, the back-sheets on the Crundale buckle are flat (Mongiatti 2016).

260 See this volume, chapter 3, *Die-impressing on sheet and foil*, 146–8.

261 Basford 2007; Webley 2007.

262 Pommels: **1–3, 5, 17–8** and **35**; hilt-collars: **85–90**; small mounts: **483–4**.

263 Whitfield 1997, pls 11.1b–c.

264 See this volume, chapter 2, *The typological and functional significance of the weapon-fittings*, 61.

265 Whitfield 2001, 147–51, fig 13.11.

266 Avent 1975, Vol 2, pl 73 (no. 182); Penn 2000, 46.

267 Pommels: **7, 9, 13** and **21**; hilt-collars: **98, 107, 120, 123** and **151**; mount: **558** (on one serpent panel).

268 Adams 1991; 2000.

269 Périn and Kazanski 1996; Quast 2015a; 2015b.

270 Pers comm Alex Hilgner. The use of cloisonné on the Continent will be dealt with in full in the publication of the International Framework project (Quast et al forthcoming). A short summary in English can be found in Hilgner 2016, 2–3.

271 Bruce-Mitford 1975; 1978; 1983.

272 Webster 2012a, 58–60.

273 Avent 1975; Speake 1980, pls 6–7; Bayliss et al 2013, object-types BR2-c and BU3-c, leading type phases AS-F D–E and AS-M C–E, 140, 222, table 10.1, fig 8.16.

274 Bruce-Mitford 1974, 281–302; Sherlock 2012, pls 3.6–3.7.

275 Bruce-Mitford 1978, app. B, table 34.

276 Coatsworth and Pinder 2002, 143–8.

277 Evans cited in Scull 2009a, 88–91.

278 See this volume, chapter 3, '*Unidentified*' *inlay*, 134–5.

279 See this volume, chapter 3, *Glass*, 132, *Other materials*, 138, and *Organics and pastes*, 136.

280 Bruce-Mitford 1978, 'stone 1', 306, pl 21b.

281 Ibid, 297, fig 222g.

282 Quast 2015b, Taf. 20. Other examples are illustrated in: Arrhenius 1985, 46–52, fig 145; Bardiès-Fronty et al 2016, 162, 164, no. 115; Akhmedov 2007, no. i.38.1, fig 2.

283 Hawkes and Grove 1963; Webster and Backhouse 1991, no. 35, 54; West 1998, fig 128.10.

284 Geake 1997, 39–40; Adams 2011b.

285 Coatsworth and Pinder 2002, 146–7.

286 Lethbridge 1953. The round, flat-topped cabochon has been recently proven scientifically to be amethyst (Hilgner forthcoming).

287 Bruce-Mitford 1974, 291–2.

288 West 1998, fig 128.10.

289 Avent 1975, Vol 1, 56; Vol 2, 177, pl 66.

290 Sherlock 2012, pl 3.2.

291 Oddy 1982, 114, no. 24.

292 Jørgensen and Vang Petersen 1998, figs 108 and 133.

293 Adams 2000, fig 2.

294 Pinder 1995.

295 Objects with zoomorphic cloisonné: pommels: **52–3**; hilt-collars: **167–8**; small mounts: **511–7**; pyramid-fittings: **578–9**. Objects with geometric cloisonné: pommels: **47**, **49** and **51**; hilt-collars: **161–2**, **170–1** and **181**; hilt-plates: **363–5**; small mounts: **496–502** and **507–8**; large mounts: **541** and **562**.

296 Bruce-Mitford 1978, 503–5, 512–4, 523–32, 597–9, figs 367, 369, 377, 386, pls 13–7.

297 The examination was undertaken at the British Museum in 2014. A series of photomicrographs was also taken of the clasps by Aude Mongiatti and Eleanor Blakelock.

298 Bruce-Mitford 1978, pl 17.

299 X-radiographs of the seax collars were also produced, but unfortunately these do not assist in understanding their manufacture.

300 On a photomicrograph taken by E. Blakelock (pers comm) at the British Museum, a small area on one clasp near a Style II design is filled with fragments.

301 Speake 1970, 3–4, pl 1a.

302 Adams 2000, fig 2.

303 Coatsworth and Pinder 2002, 134–6.

304 Carver 2005, 241–2, figs 102.5a–c and 103.6.

305 Avent 1975, Vol 1, 63; Vol 2, nos 170–2, pls 60–2; Pinder 1995; Scull 2009a, 88–91; Hamerow et al 2015, fig 4.

306 See this volume, chapter 3, *Garnets*, 129–32.

307 Bruce-Mitford 1978, 304–5.

308 Pers comm Alex Hilgner. The brooch is published by Bleicher (2000).

309 Adams 1991, 211–3; 2010, 85–7.

310 Recent finds are a scabbard button-fitting from Griston (Norfolk) and buckle-tongue from Cold Ashton (Gloucestershire). Both have the cell-form centrally (Anon PAS 2010: NMS-Z32B24; Adams 2014: PAS GLO-51DC59).

311 Bruce-Mitford 1978, figs 327–30, 331a, 347, pls 15, 17–18.

312 Henderson 1987, 32; Brown 2010.

313 Objects with whole mushroom cells: **41**, **43–4**, **46–54**, **159–60**, **162–6**, **171–3**, **490**, **507–8**, **518–20**, **525**, **541–9**, **552–7**, **562–4** and **572–3**. Objects with split-mushroom cells: **41**, **44**, **48**, **50**, **55**, **159–60**, **167–8**, **178**, **499–502**, **507**, **518–20**, **525**, **542–3** and **558–64**. Objects with whole arrow cells: **44**, **47**, **49–52**, **159–60**, **163–4**, **503–4**, **508**, **550–1** and **562–6**. Objects with split-arrow cells: **49–50**, **159–62**, **164–5**, **167–9**, **172–8**, **181**, **503–6**, **508**, **541–7** and **556–64**.

314 Kendrick et al 1939, 134; Kendrick 1940, 36, fig 3; Bruce-Mitford 1974, 29, 262–80, fig 6a–f; 1978.

315 Fischer and Soulat 2010 (i.e. the pommel from Skrävsta); Ljungkvist and Frölund 2015, fig 16.

316 Adams 2011a, fig 14.3.

317 Schoneveld and Zijlstra 1999 (*contra* Bruce-Mitford 1974, 262–80); Nicolay 2014, fig 438.

318 Kühn 1973, Taf. 43, nos 71–4; Menghin 1983, no. 40, 323; Aufleger 1996, band 2, Abb. 486; Müssemeier et al 2003, type Gür4.11, 21, Abb. 8.

319 Arrhenius 1985, 73; Adams 2011a, 27–8.

320 Avent 1975, Vol 2, pl 53.155, pl 65.175. Bruce-Mitford (1974, 262 3, pls 85c–d, 86a) noted two further occurrences, from Forest Gate (Essex) and Dorchester-on-Thames (Oxfordshire).

321 Objects with *mushroom quatrefoil*: **47–8**, **53**, **159–60**, **166**, **542–74**, **556–7** and **562–4**. Objects with *mushroom and arrow quatrefoil*: **159–60**, **164** and **562–4**. Object with *arrow quatrefoil*: pommel **52**.

322 Bruce-Mitford 1974, 29–32, fig 6a–f; Avent 1975, Vol 1, fig 25, Type 19 group.

323 Bruce-Mitford 1974, 29–32, 273–5, fig 6.

324 Avent 1975, Vol 2, pls 55–6, 68.

325 Adams 2006, 16, figs 12–3. See also its use on the regalia of Childeric: Périn and Kazanski 1996, Abb. 122.

326 Webster and Backhouse 1991, no. 6, 24–5.

327 Bruce-Mitford 1978, figs 323, 324a–b, 327a, 327c; MacGregor 2000; Webster 2012a, 31, fig 12.

328 Avent 1975. The author is also not aware of any cross garnets on buckles or pendants from Kent or 'Kentish' southern England.

329 BM1974,0201.1 <http://www.britishmuseum.org/research/collection_online/collection_object_details.aspx?objectId=94203&partId=1&searchText=maidstone&images=true&from=ad&fromDate=400&to=ad&toDate=700&page=1> (accessed 4 Oct 2016).

330 For examples, see Speake 1980, figs 2–3; Arrhenius 1985, figs 161–3, 169, 170, 173.

331 Objects with Zoomorphic cloisonné: **52–5**, **73**, **163**, **165–8**, **511–7** and **578–9**.

332 Bruce-Mitford 1978, pls 15, 17.

333 Ibid, inv. 17, fig 328c.

334 The pommel from Vallstenarum (Sweden) is another example. Speake 1980, fig 3e–f.

335 Bruce-Mitford 1978, 597–9.

336 Bruce-Mitford 1974, 273–5, pl 91; Webster and Backhouse 1991, no. 41; A F Richardson 2005; Adams 2010, fig 6. Adams illustrates a fitting from Kerč (Crimea) with cloisonné interlace, marking an important parallel with Anglo-Saxon interlace and zoomorphic cloisonné, but an important distinction is that it does not use the lidded-cell technique.

337 Bruce-Mitford 1978, pls 13a, 14a.

338 See this volume, chapter 5, *Animal ornament*, 232.

339 *TAR* 1998/9, 36–7, no. 62; Nicolay 2014, fig 4.37.

340 Pommels: **43–4**, **54**; hilt-collars: **165–6**.

341 Hilt-collar: **177**; pyramid-fittings: **578–9**.

342 See this volume, chapter 3, '*Unidentified* inlay, 134–5.

343 Bruce-Mitford 1974, 262–6, pl 85a.

344 Avent 1975, Vol 2, pls 60.169, 64.173, 70.180.

345 Avent 1975, Vol 1, 63.

346 Hawkes and Grove 1963. For a recent comparable dating for the object form, see Bayliss *et al* 2013, type PE-9f, 214, table 10.1.

347 Hawkes and Grove 1963, 26–8.

348 Bruce-Mitford 1974, 290.

349 Ibid, 281–302, pl 85a.

350 Sherlock 2012, pl 3.7.

351 <http://www.cam.ac.uk/research/news/mystery-of-anglo-saxon-teen-buried-in-bed-with-gold-cross> (accessed 1 Feb 2017).

352 Objects with *rectilinear* cloisonné: pommel: **76**; hilt-plates: **363–9**; hilt-collars: **157–8**; small mounts: **491–2**; pyramid-fittings: **574–5**.

353 Objects without foils: hilt-plates: **243**, **245–6**, **248** and **251–2**; small mount: **368**; boss: **617**.

354 Avent and Leigh 1977.

355 East 1985.

356 Objects with *boxed* foils: **53**, **64**, **167–8**, **539**, **542–3**, **550–5**, **576–7**.

357 Avent and Leigh 1977.

358 Ibid, 27; East 1985.

359 Avent and Leigh 1977, 2, 15.

360 The boxes adjacent are possibly 3×4, although the distortion created by viewing the foil through the cabochon stone means that this is not certain. Foil **694** has no 3×4 boxes.

361 In addition, one further small fragment **695** [*K1299*] has 4×5/5×5 boxes.

362 Tulp and Meeks 2000. See this volume, chapter 3, *Die-impressing on sheet and foil*, 146–8.

363 Avent and Leigh 1977, nos 162–3, 15; Evison 1987, 38, pl 6a; Hawkes 2000, fig 21.9.

364 Tulp and Meeks 2000.

365 Ibid, appendix.

366 East 1985.

367 Avent and Leigh 1977, 28; Evison 1987, 44, pl iie.

368 East 1985, fig 18.

369 See this volume, chapter 3, *Sheet and foil*, 140, fig 3.23; also, *Back-sheets*, 165, fig 3.79.

370 Findell 2014, 35.

371 Waxenberger 2017, table 8.

372 Brown 1993.

373 Ibid.

374 Tweddle 1992, 947, figs 407, 412.

375 Penn 2000, fig 84.

CHAPTER FOUR

LIFE OF OBJECTS

ENDNOTES

1 Appadurai 1986.

2 See this volume, chapter 6, *Dating the Hoard*, 263.

3 Ellis Davidson 1962, 129–52; Brunning 2013, 37–43; 2017. See also Brunning 2019, published just prior to this volume.

4 Tollerton 2011, 195–6.

5 Whitelock 1979, no. 130; the will is also available online in Keynes 2010.

6 Härke 2000. An 'heirloom' sword from Chessell Down cemetery (Isle of Wight), grave 76, has a scabbard mount with Style I animal ornament of late fifth- to sixth-century date, as well as a gold parallelogram mount with filigree on its grip of late sixth- to seventh-century date. See also this volume, chapter 6, n. 82.

7 Brunning 2013; 2017; 2019.

8 Bruce-Mitford 1978, fig 433d.

9 For an example of a recent study that does record object use, adaptation and repair (on cruciform brooches), see Martin 2015, especially 132–40.

10 For the relative hardness values for silver and gold alloys, see Grimwade 2009, tables 2.1, 9.3.

11 See this volume, chapter 6, *Hoard Phase 1: sixth-century silver fittings from weapons*, 263.

12 Brunning 2013, 84–5, 225.

13 Brunning 2013, 123–34; 2017.

14 Brunning also suggests this as an explanation for the asymmetrical wear seen on pommels (2017, 412, 414).

15 See this volume, chapter 6, *Hoard Phase 2 (gold): Anglo-Saxon early Style II and contemporaneous styles and objects, c 570 – c 630*, 264–5.

16 See this volume, chapter 6, *Hoard Phase 4 (silver objects with gold mounts): Early Insular style objects, c 630–c 660*, 269–70.

17 Pers comm Henry Yallop. In the thirteenth/fourteenth centuries, some swords were fitted with 'rain guards' to prevent moisture getting into their scabbards, and in the nineteenth/twentieth centuries langets fulfilled the same function.

18 See this volume, chapter 4, n. 5. Tollerton 2011, 196.

19 See this volume, chapter 6, *Hoard Phase 3 (gold): Anglo-Saxon late Style II and contemporaneous objects, c 610–c 650*, 266–9.

20 See this volume, chapter 6, *Hoard Phase 3 (gold): Anglo-Saxon late Style II and contemporaneous objects, c 610–c 650*, 266–9.

21 Tweddle 1992, 1,026–9, 1,165.

22 Härke 2000; Brunning 2013, 117–8, 136–41; 2017. Other objects too could be repaired, from brooches to shields: Dickinson and Härke 1992, 56–9; Penn 2000; Martin 2015, 132–46.

23 Evison 1967; Fischer *et al* 2007; Fischer and Soulat 2009.

24 See this volume, chapter 3, *Garnets*, 129–32.

25 Organ 1974, 281.

26 The central red glass setting of cross-mount **526** may be similarly explained as used in the absence of a garnet of sufficient size, since it is almost indistinguishable from the mount's garnet inlays.

27 See this volume, chapter 3, *'Unidentified' inlay*, 134–5.

28 Bruce-Mitford 1978, 600, fig 375b.

29 Hilt-plates: **249**, **261**, **271**, **284**, **311**, **313**, **317–19**, **328**, **331**, **333** and **364**.

30 See this volume, chapter 3, *Gold*, 125–7.

31 See this volume, chapter 3, *'Assembly' marks and other marks*, 183–5.

32 See this volume, chapter 3, *Incising and punching*, 149–51.

33 See this volume, chapter 9, *Scandinavian hoarding*, 346–7.

34 Hilt-collars: **96–8**, **107–8**, **157–8**, **167–9**, **184** and **186**. Hilt-rings: **191–2**, **197–8**, **200**, **221** and **224–5**.

35 Hinton 2000, 24–6.

36 Bruce-Mitford 1974, 286–7.

37 Leahy and Bland 2009, 36–7; Brown 2010.

38 See this volume, chapter 2, *Great gold cross (cat. **539**)*, n. 359, 100–1

39 See this volume, chapter 5, *Animal ornament in the Hoard*, 226–7.

40 Coatsworth and Pinder 2002, 66–9.

41 Meadows 2004; Read 2006, 39.

42 Tweddle 1992, 1,033–4, 1,165–7.

43 Leahy and Bland 2009, 12.

44 See this volume, chapter 2, *The typological and functional significance of the weapon-fittings,* 60-1.

45 Brunning 2017, 414–5.

46 See this volume, chapter 6, 258–81.

47 Parsons 2010.

CHAPTER FIVE
STYLES OF DISPLAY AND REVELATION
ENDNOTES

1 Lindstrøm and Kristoffersen 2001; Webster 2003.

2 *Unde et praecipue gentibus pro lectione pictura est.* Extract from epistle 13 in *Pat. Lat.* Letters LXXVII, col. 1,128. Cited in Hawkes 1997, 312.

3 Gaimster 1998; Pesch 2009. For the importance of Odin worship in Scandinavia, see Gunnell 2013.

4 Behr 2010; Webster 2012a, 25.

5 Pesch 2009, 214.

6 For anthropological studies of the uses of style, see Morphy 1989; Conkey and Hastorf 1990.

7 Earle 1990. For arguments that Anglo-Saxon animal ornament (Styles I and II) functioned in this way see Dickinson 2005; 2009; Høilund Nielsen 1999.

8 Haseloff 1974; 1981; Speake 1980; Leigh 1984; Dickinson 2009; Webster 2012a, 43–67.

9 Salin 1904.

10 See this volume, chapter 6, *Dating the Hoard*, 258–63.

11 Haseloff 1974; 1981.

12 Hauck 1985; Gaimster 1998; Dickinson 2005, 111–12.

13 Dickinson 2002; Martin 2015.

14 Haseloff 1981, 591–2, 596, 709.

15 Speake 1980.

16 For example, Ellis Davidson and Webster 1967, 26–32; Dickinson *et al* 2011, 47–9.

17 Stolpe and Arne 1927; Arwidsson 1942; 1954; 1977.

18 Høilund Nielsen 1991; 1998.

19 Høilund Nielsen 1999.

20 Haseloff 1981, 586–673. For a recent discussion favouring a continental origin, see Wamers 2009.

21 Dickinson 2009; Martin 2015.

22 Speake 1980; Høilund Nielsen 1999.

23 See this volume, chapter 3, *Cloisonné and other lapidary work*, 163.

24 Speake 1980; Høilund Nielsen 1999.

25 See this volume, chapter 6, *Dating the Hoard*, 260–1.

26 See this volume, chapter 6, *Origins*, 271–81.

27 Høilund Nielsen 1998.

28 For the use of Style II on Christian objects on the Continent, see Wamers 2009.

29 Hawkes 1997.

30 Bede, *HE* II.15 (McClure and Collins 1994, 98–9); Hoggett 2010, 29.

31 Moisl 1981; Yorke 2015.

32 Turville-Petre 1957; Yorke 1993.

33 Carver 2005.

34 See this volume, chapter 2, *Fittings from weaponry*, 58.

35 Fern forthcoming.

36 See this volume, chapter 5, *Animal ornament in the Hoard*, 216–22.

37 Fern and Speake 2014, 30–1.

38 Entwistle 2002, 613 fig 7.

39 Webster *et al* 2011, 221–5.

40 Speake 1980, 77–92; Pluskowski 2010.

41 Speake 1980; Høilund Nielsen 1999, fig 11.

42 Dickinson 2002, esp. 177, fig 9.

43 Leigh 1984; Williams 2001; Dickinson 2002, esp. 178–80, fig 9.

44 Fern 2017, 420–3, fig 2 [*K711*]. Other images of the buckle can be found in: Roth 1986, Abb.11; Gaimster 1998, fig 66.

45 Fern 2017, 423. Some favour a continental origin for the buckle: Roth 1986, 123. Others have argued it is Scandinavian: Cleve 1943, 22; Fett 1947, 12. For a discussion of the find's context, see Nybruget 1992.

46 Høilund Nielsen 1999, 187.

47 Bruce-Mitford 1978, 48–9.

48 Further examples include the pommels from Vallstenarum (Speake 1980, fig 3f), Endreback (Menghin 1983, no. 68, 315) and Dinham (Webster 2012a, fig 12).

49 Speake 1980.

50 Haseloff 1981, 256–60, Abbs. 171–7; Speake 1980, fig 4p.

51 Speake 1980, 53. See this volume, chapter 2, *The typological and functional significance of the weapon-fittings*, 59–60, fig 2.40.

52 Carver 2005, 247, fig 25ai.

53 Speake 1980, 54–5, pls 6–7; Evison 1988, 18–20, frontispiece, fig 27.2.

54 See chapter 2, this volume, chapter 2, *The typological and functional significance of the weapon-fittings*, 60–1 and chapter 6, *Kent, East Anglia or Greater Northumbria*, 276–9.

55 See chapter 3, this volume, chapter 3, *Filigree*, 165–6.

56 Objects with ambiguous patterns containing zoomorphs include pommels: **4–5**, **7**, **16** and **34–6**; hilt-collars: **90–2**; mounts: **425–6** and **480**.

57 Leigh 1984.

58 Hawkes 1997, 333.

59 Haseloff 1981, Klepsau grave 4; Speake 1980, fig 13s.

60 Blackmore *et al* 2019, Finds (S41–4).

61 Scott 2013.

62 Speake 1980, figs 3g–i; Menghin 1983, nos 41, 65–7, 70, 73, 79, 88.

63 For example, Fern 2010, 137, fig 7.5.

64 Roth 1986; Fern 2010, fig 7.6; Fern and Speake 2014, 30–1.

65 Bruce-Mitford 1978, 48–9.

66 Hagberg 1967, 81; Müller-Wille 1970/71, Abb. 43.

67 Fern 2010.

68 Fern 2007.

69 Bede, *HE* I.15: II.5 (McClure and Collins 1994, 26–8, 77–80); Turville-Petre 1957.

70 Bede, *HE* I.15 (McClure and Collins 1994, 26–8); Brooks 1989, 58–64; Fern 2010, 143–4.

71 It was not, therefore, ever intended to be a 'seahorse', as it became known soon after discovery: <http://www.staffordshirehoard.org.uk/staritems/stylised-horse> (accessed 24 Feb 2017).

72 Webster 2012a, 123–4.

73 See this volume, chapter 3, *Cloisonné and other lapidary work*, 170.

74 Fern 2017, 423–5 [*K358*], fig 3a–f.

75 See this volume, chapter 5, *Geometric ornament and symbols*, 253.

76 Høilund Nielsen 2001, 473–6.

77 See this volume, chapter 6, *Dating the Hoard*, 260–1, fig 6.3.

78 Høilund Nielsen 2001.

79 Bruce-Mitford 1978, 159–63, figs 117–8.

80 Bruce-Mitford and Luscombe 1974; Meadows 1997; 2004.

81 Speake 1980, 78–81.

82 Bruce-Mitford 1978, fig 435.

83 Sherlock 2012, 46–8, pl 3.6.

84 Speake 1980, pl 2h.

85 For more on serpent symbolism, see this volume, chapter 5, *Ornament of the helmet and die-impressed sheet*, 232–6.

86 See this volume, chapter 2, *Large mounts not from weaponry and harness-mount (cat. **698**)*, 95.

87 Brown 2010; see also this volume, chapter 2, *The Christian objects: function and significance*, 110–19. The serpent appears in the Old Testament, Numbers 21:8–9.

88 Henderson and Henderson 2010.

89 Bruce-Mitford 1978, pl 8; Fern and Speake 2014, 28–9.

90 Geake 2015. Concerning the Diss pendant, see this volume, chapter 6, *Hoard Phase 3 (gold): Anglo-Saxon late Style II, and contemporaneous styles and objects, c 610–c 650*, 268.

91 Dickinson 2005, 158.

92 Speake 1980, 81–5.

93 Dickinson 2005, 158, n. 124.

94 Hicks 1986.

95 See this volume, chapter 2, *Mount with fish and birds (cat. **538**)*, 92, and *Large mounts not from weaponry and harness-mount (cat **698**)*, 95.

96 Bruce-Mitford 1978, 55–63, fig 44.

97 Mount **459** has similar semi-naturalistic detail. For other examples of bird mounts, see Speake 1980, fig 17.

98 See this volume, chapter 3, *Cloisonné and other lapidary work*, 178.

99 Lévi-Strauss 1963; Fern 2017, 425–7 [*K652*], fig 4.

100 Kristoffersen 1995.

101 Ciglenečki 1994; Dickinson 2005, 154–60, fig 150f. Another example is that on the helmet from Krefeld-Gellep (Germany): Pirling 2015, 22–3.

102 Larrington 1996, 12.

103 Geake 2014.

104 Gunthorpe mount: Darch 2009; Coddenham mount: Martin *et al* 2000, 500, fig 154c.

105 Bruce-Mitford 1978, pl 16b; Ciglenečki 1994, Abb.1.2.

106 <http://www.wessexarch.co.uk/reports/54924/springhead-quarter-ebbsfleet> (accessed 2 Sep 2016).

107 Ellis Davidson and Webster 1967, 25, fig 3; Evison 1967, 86, fig 6d; Menghin 1983, nos 47 and 59, 313–14, Abb. 31.

108 For example, in the Durham A.II.10 and Durrow manuscripts: Henderson 1987, figs 20, 41–2; Meehan 1996, 34–5, 56, 62.

109 Whitfield 2001, 143–7, figs 13.2–13.3.

110 Whitfield, in Gillespie and Kerrigan 2010, 296–303, figs 4.57–4.59, 4.81, 4.83–4.85.

111 Williams 2011; Price and Mortimer 2014.

112 See this volume, chapter 2, *The Christian objects: function and significance*, 110–19.

113 Speake 1980, 80.

114 For examples on shield-mounts, see Dickinson 2005; for examples of fish-shaped pin-catches on great square-headed brooches, see Hines 1997a, 97.

115 Fern 2017, 427.

116 For examples, see Dickinson 2005, 154–6.

117 Bruce-Mitford 1983, 224–8.

118 Fern forthcoming.

119 Penn 2000, 45–9, 81–2, fig 84.2, pl iv.

120 *TAR* 1998/9, 35–6, no. 61.

121 Webster and Backhouse 1991, no. 45, 59.

122 The detail of the back-curled rear claw is also seen on an object from Salmonby (Lincolnshire): Speake 1980, fig 8l.

123 Høilund Nielsen 2010; Fern and Speake 2014, 38–9.

124 Bruce-Mitford 1983, Vol 1, 347–59, fig 261a.

125 See this volume, chapter 3, *Die-impressing on sheet and foil*, 146–8.

126 See chapter 6, *Kent, East Anglia or Greater Northumbria*, 278–9.

127 Chadwick 1940; Carver 2005, 503; Hoggett 2010, 28–9.

128 Speake 1980, 76.

129 Webster and Backhouse 1991, 111–12, no. 79; Webster 2012a, fig. 50.

130 Webster and Backhouse 1991, 25, no. 7.

131 For opinions of the manuscript's date, see Haseloff 1987, 46; Brown 2010; Henderson and Henderson 2010.

132 Henderson and Henderson 2010.

133 See this volume, chapter 2, *Great gold cross (cat. 539)*, 100–1, and *The Christian objects: function and significance*, 111–13; see also Fern forthcoming.

134 McLean 2011.

135 See this volume, chapter 2, *Head-dress mount (cat. 541)*, 109, and *The Christian objects: function and significance*, 114–16.

136 Webster and Backhouse 1991, 59, no. 45; see also this volume, chapter 3, *Incising and punching*, 149.

137 Fern 2017, 433.

138 Examples include the cast and gilded bird heads on the Sutton Hoo shield-grip: Bruce-Mitford 1978, pl 6.

139 Speake 1980, 42.

140 From Barham (Suffolk): Webster and Backhouse 1991, 56, no. 39; West 1998, 8, fig 7.70. From Burwell (Cambridgeshire): Speake 1980, fig 60.

141 Based on personal examination, at least two finds from Rendlesham have the detail.

142 The objects are annular/penannular brooches with bird-head terminals, from East and North Yorkshire, and Wales; Hirst 1985, 56–7, fig 41; Drinkall and Foreman 1998, 256, fig 84; Hinton 2005, fig 2.2.

143 See this volume, chapter 2, *Helmet parts, decorated silver sheet, reeded strip and edge binding*, 71.

144 Bruce-Mitford 1978, 82–90. On the elaborate Sutton Hoo shield from mound 1, which has no less than twenty Style II designs, there are multiple examples of die-impressed gilded sheet.

145 See this volume, chapter 2, *Origin, social significance and date*, 84–5.

146 Bruce-Mitford 1978, 225.

147 Speake 1980, 77–92; Fern and Speake 2014, 10–3.

148 Speake 1980, 79.

149 Bruce-Mitford 1978, figs 117–18.

150 Theune-Grosskopf 2006, Abb 1.

151 Russell Robinson 1975, 129, pls 376–83.

152 National Museum of Budapest, MNM. 54.5. 68.

153 Russell Robinson 1975, pls 391–3.

154 Engelhardt 1863, pls 5, 2; Matešić 2015, Taf. 100–1.

155 Speake 1980, 85–92.

156 Engelhardt 1867, pl 2, fig 9; Salin 1904, figs 559–60.

157 Speake 1980, 86.

158 For more discussion of the Stafford-knot form, see this volume, chapter 5, *Interlace and knots*, 249.

159 BM 1995.0102.865; Høilund Nielsen dates it even earlier to the late fifth century: Parfitt and Anderson 2012, 77–8.

160 Salin 1904, 62, 226.

161 See this volume, chapter 2, *Helmet parts, decorated silver sheet, reeded strip and edge binding*, 70–85.

162 Speake 1980, fig 8.

163 Blackmore *et al* 2019.

164 For an alternative, later dating, see this volume, chapter 6, *Hoard Phase 3 (gold): Anglo-Saxon late Style II and contemporaneous objects, c 610–c 650*, 266–9.

165 The shape of the foot is a variant of the examples in Scandinavian Style II listed by Salin 1904, fig 544.

166 Høilund Nielsen 2010. The similarity to certain Scandinavian beasts, to which Høilund Nielsen draws attention, is valid up to a point, but there are also marked differences. The species on the Danish mount has fierce teeth and the arrangement of the limbs and feet differ, and the creature is not part of a sequence but self-contained in its panel.

167 Fragments [*K24*] and [*K90*].

168 Salin (1904, fig 542a) illustrates a partially looped head-surround on a buckle from Vallstenarum, Gotland.

169 Bruce-Mitford 1978, figs 49–50.

170 Speake 1980, figs 8c–h.

171 See this volume, chapter 2, *Helmet parts, decorated silver sheet, reeded strip and edge binding*, 70–85.

172 Evison 1967; 1976; Steuer 1987, 203. See this volume, chapter 2, *Fittings from weaponry*, 33–70.

173 Ellis Davidson 1994, 66.

174 Ibid, 67.

175 Tacitus, (*Germania* 43 (Mattingley 1948).

176 Bruce-Mitford 1978, fig 156.

177 Watt 1999, 176, figs 4c–d, 6.

178 Tacitus, *Germania* 3 (Mattingley 1948).

179 Speake 1980, figs 2j, 6p, 12j, 13s; Leigh 1984; Dickinson 2005, 166–76; Brundle 2017. For instances in the Hoard, see this volume, chapter 5, *Animal ornament in the Hoard*, 213–32.

180 Bruce-Mitford 1978, fig 156b.

181 Stolpe and Arne 1927, pl. XLI.

182 Bruce-Mitford 1978, figs 156b–d.

183 Theune-Grosskopf 2006, 93–142, Abb. 18.

184 Bruce-Mitford 1978, 149, fig 110.

185 Ibid, 206, fig 153; see this volume, chapter 2, *Helmet parts, decorated silver sheet, reeded strip and edge binding*, 70–85.

186 Hawkes *et al* 1965; Hawkes and Grainger 2006, 413, pl XIV A.

187 Blackwell 2007, 166.

188 Leahy 2006, 279–80. There are a few other examples of this motif on the PAS database: West Ilsley (Berkshire) (Levick 2006) and Cambridgeshire (Geake 2009).

189 Bruce-Mitford 1978, fig 164c.

190 Ibid, fig 156a.

191 Ibid, fig155.

192 Ibid, 208. It is misleading to think of the helmet dies as having been 'cut'. The evidence of the Swedish helmet dies from Torslunda, Öland, would indicate that such dies were cast.

193 Walton Rogers 2007, 210–16. Reference is made to these kaftan-style garments as 'warrior coats'.

194 Watt 1999, fig 4.

195 Ellis Davidson 1965a, 26.

196 Holmqvist 1960, 101.

197 Bruce-Mitford 1978, figs 144, 190.

198 Speake 2015, 9–11. Initial interpretations of the sheet fragments considered this to be a depiction of a shield boss. The Swedish C-bracteate referred to with the solar symbol was found on the island of Öland: Hauck 1985, 45, Taf. 51–2; IK number 223.

199 On many C-bracteates the body of the rider is not indicated beneath the enlarged head, as evident on the C-bracteate with the solar disc referred to above: Hauck 1985, 45.

200 Fragment [K1333].

201 Arwidsson 1977, Abb. 128; Bruce-Mitford 1978, fig 164a.

202 Arwidsson 1977, Abb. 65.

203 Böhner and Quast 1994, 388. It is suggested that originally the embossed disc was part of a phalera and only later cut down and reused as a brooch.

204 Renner 1970.

205 Hills and Ashley 2017. As the Bradwell mount was unpublished at the time of writing, the author is grateful to Steven Ashley, Finds Archaeologist of Norfolk County Council, for providing him with a drawing and description of the object. An object broadly similar in form, but of much cruder workmanship and lacking in any fine detail, has been reported by Chester-Kadwell (2013) from Warham (Norfolk).

206 For example, Marzinzik 2007, 49.

207 Ammianus Marcellinus, *Res Gestae* XVI.12.22; (Rolfe 1986).

208 Quast 2009, 337.

209 Böhner 1976/77.

210 Speake 1980, fig 7m; Bruce-Mitford 1983, figs 281a–b.

211 Bruce-Mitford 1978, 205–20.

212 Kitzinger 1993.

213 Wamers 2009, 178–92.

214 Wylie 1852, pl iii.4; Hills 1977, fig 84 (urn 1456); Hills and Penn 1981, fig 109 (urn 2107); Hills *et al* 1987, fig 20 (urn 2359), fig 75 (urn 2642b); Hines 1997a, pls 51–60.

215 Neal 1981.

216 Pommels: **24–31**, **?32–?33**, **39–42**, **63**, **74–5** and **77**; hilt-collars: **89**, **92–103**, **106**, **109–13**, **117–22**, **125–9** and **188**; small mounts: **454**, **456–8**, **475**, **483–4** and **533–7**; Fragments: **687** and **691**: [K1284].

217 Hilt-collars: **93–103**, **106**, **111–13**, **117**, **119**, **121–2** and **125–9**.

218 Pommels: **2**, **6–7**, **9–11**, **13**, **16**, **22**, **35**, **37–8**, **86** and **73**.

219 Haseloff 1981, 645, fig 452c.

220 Ljungkvist (2009a) has demonstrated that elites in Scandinavia had access to a range of Byzantine goods in the period, and Scull *et al* (2016) have shown that some parts at least of Anglo-Saxon England may have enjoyed 'direct mercantile contacts with the Mediterranean', in the sixth and seventh centuries, based on recent evidence from Rendlesham (Suffolk).

221 Roth 1987, 26.

222 Roth 1975.

223 Bruce-Mitford 1978, fig 405; Speake 1980, fig 1a–b, d.

224 See this volume, chapter 3, *Filigree*, 163–5.

225 See this volume, chapter 6, *Hoard Phase 3 (gold): Anglo-Saxon late Style II and contemporaneous objects, c 610–c 650*, 266.

226 Bruce-Mitford 1983, figs 245c, 247a–c; Laing and Longley 2006, fig 56 (mould fragment 2273).

227 Pommels: **6**, **10–11** and **25**; hilt-collars: **88**, **104** and **127**; small mounts: **514–15**; cheek-pieces: **591–2**; die-impressed sheet: **602**.

228 See this volume, chapter 6, *Hoard Phase 2 (gold): Anglo-Saxon early Style II contemporaneous styles and objects*, c 570–c 630, 265.

229 Haseloff 1975, Abb. 7a, Taf. 38.1.

230 Webster and Backhouse 1991, 24–5, nos 6–7.

231 Small mounts: **410–11, 414–23, 427–31, 438–47, 460, 463–4, 467–8, 470–5, 478–9, 482** and **493**. See this volume, chapter 2, *Hilt-mounts and other small mounts (cat. 410–537)*, 50–5.

232 Ozanne 1963, 26–8, fig iia, pl ive.

233 See this volume, chapter 3, *Filigree*, 160. A selection of the scroll-forms is illustrated in figs 3.65–3.67.

234 Ogden 1982, 114, 118, pl 24.

235 Koch and Koch 1996, Abbs 218–20; Jørgensen and Vang Petersen 1998, 179, 191–3, 241–4, figs 135, 143–5 and 177; Whitfield 1993; 2001, 147–51; Bardiès-Fronty et al 2016, 216–21.

236 Pasqui 1918, figs 4–5, 71; Menghin 1983, 258–60, cat. 112–13.

237 Avent 1975.

238 Avent 1975, Vol 2, pls 68–9, no. 179; Speake 1980, fig 11q.

239 Bruce-Mitford 1978, 298–9.

240 Henderson 1987, 19–55; Meehan 1996; Webster 2012a, 76–8; Goldberg 2015.

241 Bruce-Mitford 1983, Vol 1, 244–56, 282–6; Henderson 1987, 26–8, fig 17.

242 Geake 1999; Bruce-Mitford and Raven 2005; Youngs 2009.

243 Speake 1989, 75–80; Youngs 1989, 54–5, no. 41.

244 Yorke 1990, 83–6.

245 Campbell and Lane 1993; Laing and Longley 2006.

246 Lowe 1999, 31.

247 See this volume, chapter 6, *Mercia*, 273–6.

248 Pommels: **72–7**; hilt-collar pair: **188**; hilt-guard pair: **409**; small mounts: **463–5, 467–8, 473–7** and **536–7**; buckle: **587**; fragments: **686–7**.

249 Cramp 1991, xxix.

250 Dickinson 1973, 249; Speake 1989, fig 68.

251 Henderson 1987, figs 2, 21, 42; Webster and Backhouse 1991, 111, no. 79.

252 Webster 2012a, fig 61.

253 Fern 2005; Laing and Longley 2006, 148–53; figs 56–7.

254 Laing 1975; Laing and Longley 2006, 148–53. See this volume, chapter 5, *Interlace and knots*, 245.

255 Graham-Campbell 1976; Speake 1989, 75–80, fig 68.

256 Graham-Campbell 1976, 50.

257 O'Sullivan 1990. The mount is now in the British Museum.

258 Youngs 1989, 39, 63, no. 58.

259 Pers comm Fraser Hunter.

260 Carver *et al* 2016, 90–2, fig 4.23.

261 Roach Smith 1860, pl 1; Speake 1980, 68, 71, fig 13l; Bruce-Mitford and Raven 2005, 428.

262 Bruce-Mitford and Raven 2005, 175–9, no. 43. The vessel is a band bowl with a C-rim. The bowl and weight cannot be said for certain to have been found together.

263 Ibid, no. 14, fig 42; Speake 1980, fig 11c.

264 Youngs 1989, 18–9, 43, no. 22.

265 Webster and Backhouse 1991, no. 131, 168.

266 See this volume, chapter 6, *Hoard Phase 4 (silver objects with gold mounts): Early Insular style objects, c 630–c 660*, 269–70.

267 Speake 1980, 89–90, fig. 12e; Henderson 1987, 38, figs 38–9; Webster and Backhouse 1991, 147–8; Hawkes 1997, 325, fig 10.6.

268 Haseloff 1987, figs 3 and 10–2; Whitfield 1993.

269 Henderson 1987, 52, figs 63–5; Campbell and Lane 1993, fig 6.6a; Bruce-Mitford and Raven 2005, 175–9, no. 43.

270 Henderson 1987, fig 21; Webster and Backhouse 1991, 111–2, no. 79.

271 Speake 1989, 30–43, 59–62, figs 29–32 and 57.

272 Pers comm Fraser Hunter.

273 See this volume, chapter 3, *Filigree*, 160, 166, fig 3.67.

274 For example, Youngs 1989, 23, 32, 34, 43, 50, nos 1, 17, 22, 34.

275 Ibid, 31–2, e.g. nos 16, 18; Laing and Longley 2006, fig 57: fragments 1115, 2745.

276 See this volume, chapter 2, *Hilt-mounts and other small mounts*, 52.

277 Henderson 1987, 42, 52, figs 42 and 61; Meehan 1996, 42. See also the eagle in Corpus Christi College MS197B: Webster and Backhouse 1991, 117–8, no. 83b.

278 Pommels: **36, 39–41** and **43–55**; hilt-collars: **159–81**; hilt-plates: **361–9**; small mounts: **489–92, 494–510, 513** and **516–26**; head-dress mount: **541**; large mounts: **542–66**.

279 See this volume, chapter 3, *Cloisonné and other lapidary work*, 173–4.

280 Pommels **36–38, 64**; pyramid-fittings **580–1**; small mounts **489–93**.

281 Avent 1975; Speake 1980, fig 6b.

282 See this volume, chapter 3, *Cloisonné and other lapidary work*, 178.

283 Menghin 1983, 241, no. 85.

284 Briscoe 1983; Dickinson 2002, figs 2, 8d–f, 11b and 12.

285 Bruce-Mitford and Luscombe 1974; Hawkes 1997, 326.

286 Pommels **2, 4–6, 33** and **36**; hilt-collars **88–90**.

287 Pommels **42, 74** and **76**; hilt-collar **188**; hilt-plate **409**.

288 Neal 1981, pls 39, 42, 68, 78, 87a, 88.

289 <http://art.thewalters.org/detail/24626/belt-buckle/> (accessed 7 Sep 2016).

290 Gaimster (1998, 84–91, figs 20–1, 45, 56, 79–81, 83, 108–9 and 111) discusses and illustrates their use on brooches, buckles, bracteates, horse-equipment, weapon- and shield-fittings.

291 Speake 1980, fig 4o; Webster and Backhouse 1991, 55–6, no. 38.

292 Speake 1980, fig 14c; Roth 1987, figs 2 and 4.

293 Pommels: **47–8** and **52–3**; hilt-collars: **159–60**, **164** and **166**; mounts: **542–7**, **556–7** and **562–4**. See this volume, chapter 3, *Cloisonné and other lapidary work*, 173–4.

294 For continental examples: Kühn 1973, Taf. 43, nos 71–4; Bruce-Mitford 1974, 273–5, pl 91; Menghin 1983, 323, no. 40; Aufleger 1996, Band 2, Abb. 486. For Scandinavian examples: Fischer and Soulat 2010 (pommel from Skrävsta); Ljungkvist and Frölund 2015, fig 16.

295 Webster 2012a, 31–2, fig 12. For an interpretation of the Dinham cross imagery, see this volume, chapter 2, *The Christian objects: function and significance*, 114.

296 Pommels: **49**, **52** and **54**; hilt-collar: **164–6** and **178**; small mount: **525**.

297 See this volume, chapter 3, *Cloisonné and other lapidary work*, 177.

298 Avent 1975, Vol 2, pls 61–74.

299 See this volume, chapter 3, *Glass*, 132–4.

300 The symbol can also be made out on pommel **54**, but it is less clear, bringing the total number to four uses.

301 Roth 1987, Pl 1.1; Bardiès-Fronty *et al* 2016, 230–1, no. 187.

302 Speake 1980, 89–90, fig 12e; Henderson 1987, 38, figs 38–9; Webster and Backhouse 1991, 147–8; Hawkes 1997, 325, fig 10.6.

303 Evison 1967, fig 7b; Briscoe 1983; Lucy 2000, 37, fig 2.9b; Briscoe 2011.

304 Nicolay 2014, 68–72, fig 410, no. 4.

305 Ellis Davidson 1965b, 83.

306 Multiple examples are illustrated in Youngs 1989. A triquetra also occurs on the hanging-bowl mount from Hints (Staffordshire): Slarke 2008.

307 Speake 1980, fig 13j–k; Webster and Backhouse 1991, 26, no. 9; Gaimster 1998, figs 94a–b, 96a, 98a, 98d, 104a–b, 106b, 107a.

308 Bede, *HE* III.2 (McClure and Collins 1994).

CHAPTER SIX
DATE AND ORIGIN
ENDNOTES

1 Cool 2015/6. The small amount of organic material from the Hoard represents a finite and potentially highly valuable resource that might be used for dating in the future. Currently, the samples have been deemed either too contaminated or too small for analysis.

2 See this volume, chapter 3, *Filigree*, 153–66, and *Cloisonné and other lapidary work*, 166–81.

3 See this volume, chapter 3, *Animal ornament in the Hoard*, 213–32.

4 Brown 2010; Okasha 2010; Klein 2013.

5 See this volume, chapter 2, *The palaeography of the inscriptions*, 103–8.

6 See this volume, chapter 8, *The early Anglo-Saxon period: graves and grave goods,* 302–6.

7 Bayliss *et al* 2013.

8 Ibid, 459–62.

9 Ibid, fig 8.16, table 8.2.

10 Ibid, e-fig 6.6.

11 Hirst *et al* 2004; Blackmore *et al* 2019.

12 Williams 2006, 177–80.

13 Chadwick 1940; Bruce-Mitford 1975; 1978; 1983; Carver 2005, 503; Hoggett 2010, 28–9.

14 Bayliss *et al* 2013, 319, 502.

15 Hoggett 2010, 27–33, fig 5.

16 Carver 2005, 242–3, 309–12.

17 Høilund Nielsen 1999.

18 Speake 1980.

19 Høilund Nielsen 1999, 187–8, fig 8.

20 See this volume, chapter 2, *The typological and functional significance of the weapon-fittings*, 60.

21 Hawkes and Detsicas 1973; Avent 1975, Vol 2, pl 72; Speake 1980, figs 6h–i, 8c, g, pls 7d–e, 8d, 9e; Webster and Backhouse 1991, no. 7, 25; Høilund Nielsen 1999, 195.

22 Williams and Hook 2013. A corresponding decrease in the quantity of gold and garnet objects is also seen on the Continent in the second half of the seventh century: pers comm Alex Hilger.

23 Williams and Hook 2013, 62–3.

24 Ibid, fig 2; cf this volume, chapter 3, *Gold*, 126–7.

25 Williams and Hook 2013, fig 6.

26 Pers comm Sam Lucy.

27 Bayliss *et al* 2013, 464–73.

28 Bruce-Mitford 1974, 282.

29 Ibid, 288.

30 See this volume, chapter 3, *Cloisonné and other lapidary work*, 178.

31 Bayliss *et al* 2013, 211, fig 8.16, table 10.1, object-type PE1, Phase AS-FE 625/650–60/685.

32 See this volume, chapter 5, *Early Insular style*, 250–3, and chapter 6, *Hoard Phase 4 (silver objects with gold mounts) Early Insular style objects, c 630–c 660*, 269–70.

33 See this volume, chapter 3, *Gold,* 126–7.

34 Kent 1975.

35 Hawkes *et al* 1966; Brown and Schweizer 1973; Hawkes and Pollard 1981.

36 See this volume, chapter 3, *Gold,* 126–7.

37 See this volume, chapter 4, *Wear,* 188–94.

38 Bayliss *et al* 2013, 546.

39 Ibid, fig 8.16, table 10.1: phases AS-Mp (525/50–550/70); AS-MB (525/50–545/65); AS-FB (510/45–555/85).

40 Evison 1967, no. 11, fig 9d; Menghin 1983, *Typ Kempston – Mitcham*, no. 26, 336–7; Bayliss *et al* 2013, 187, table 10.1, fig 8.16: object-type SW6-e: phases AS-Mp (525/50–550/70); AS-MB (525/50–545/65).

41 Menghin 1983, 315–17; Bayliss *et al* 2013, fig 5.1.

42 Nørgård Jørgensen 1999, 71–3, Abb. 111, types SP3–4, phases NJ-II–III.

43 Bayliss *et al* 2013, 184, fig 8.16, table 10.1.

44 Fern 2017, 420–3, pommel 'K711'; see this volume, chapter 2, *The typological and functional significance of the weapon-fittings*, 58–9. and chapter 5, *Animal ornament in the Hoard*, 213.

45 Theune-Grosskopf 2006; 2008. For more on the lyre from Trossingen, this volume, chapter 5, *Ornament of the helmet and the die-impressed sheet*, 235, 243.

46 Menghin 1983, 252–3; Siegmund 1998, 204, 526.

47 See this volume, chapter 2, *The typological and functional significance of the weapon-fittings*, 59. and chapter 3, *Cloisonné and other lapidary work*, 166.

48 For parallels, see Evison 1967, no. 17, 89, fig 10d; Fischer *et al* 2008, no. 18, 90–3, fig 49.

49 Bayliss *et al* 2013, e-fig 5.6. Examples are the sword from Bifrons (Kent), grave 39 (Hawkes 2000, 24–5 fig 16) and the sword from Buckland Dover (Kent), grave C (Evison 1987, 214, fig 1).

50 Pommels: **1–12**, **?13**, **14–21**, **?22**, **34–7** and **?38**. Hilt-collars: **85–8**, **90–2**, **?104–?105**, **107–8**, **118**, **120** and **123–4**. Small mounts: **425–6**, **?450**, **451**, **?452–?453**, **455** and **480**.

51 Høilund Nielsen 1999, 194, fig 10.

52 Speake 1980, fig 4m.

53 Ibid, pl 6b; Evison 1988, 18–20 75–6, figs 5, 27–8, frontispiece; Bayliss *et al* 2013, e-fig 6.6. The author is grateful to John Hines and Chris Scull for discussions concerning the date of Alton 16.

54 Speake 1980, fig 7f, pl 7f.

55 Webster and Backhouse 1991, 55–6, no. 38.

56 Carver 2005, 242–3, 309–12, figs 110.21a, 111.25ai–ii, 112.25cii.

57 Speake 1980, fig 10h; Carver 2005, 258, fig 122.22.

58 Speake 1980, fig 7j.

59 See this volume, chapter 2, *The typological and functional significance of the weapon-fittings*, 60.

60 See this volume, chapter 5, *Animal ornament in the Hoard*, 213–24, and *Interlace and knots*, 245–9.

61 BM-7C4457 <https://finds.org.uk/database/artefacts/record/id/643932> (accessed 11 Aug 2016); Gannon 2013, 91–2, fig 2; Williams and Hook 2013, 61.

62 Pommels: **1–2**, **6–10**, **12**, **16** and **36**. Hilt-collars: **85**, **88**, **90** and **118**.

63 Pommels: **3–5**, **17–19** and **34–6**. Hilt-collars: **87**, **91–2**, **118**, **120** and **123–4**. Small mounts: **425–6**, **?450**, **?452–?453** and **480**.

64 Pommels: **4**, **20–1** and **34**.

65 Haseloff 1981, 598 Abb. 406.

66 See this volume, chapter 6, *Hoard Phase 3 (gold): Anglo-Saxon late Style II, and contemporaneous styles and objects, c 610 – c 650*, 267.

67 But for problems with this method of dating, see this volume, chapter 3, *Gold,* 125–7.

68 Pommels: **2**, **5**, **7**, **9**, **11**, **?13**, **14–5**, **17**, **?22**, **37** and **?38**. Hilt-collars: **85–6**, **?104–?105** and **107–8**. Small mounts: **451** and **455**.

69 See this volume, chapter 5, *Animal ornament in the Hoard*, 249.

70 Hirst *et al* 2004; pers comm. D. Bowsher.

71 Avent 1975, Vol 1, nos 182–3, 63; Vol 2, pls 73–4; Bayliss *et al* 2013, fig 8.16, table 10.1 (object-type BR2-d, phases AS-FD/FE 580/640–660/85).

72 See this volume, chapter 6, *Hoard Phase 3 (gold): Anglo-Saxon late Style II and contemporaneous objects, c 610–c 650*, 268.

73 See this volume, chapter 5, *Interlace and knots*, 245–9.

74 Pommels **24–33** and **39–42**.

75 Avent 1975, Vol 1, nos 182–3, 63; Vol 2, pls 73–4.

76 See this volume, chapter 6, *Hoard Phase 4 (silver objects with gold mounts): Early Insular Style objects, c 630 – c 660,* 269–70.

77 Avent 1975, Vol 1, 63, no. 172; Vol 2, pl 62.

78 See this volume, chapter 2, *Pommels and sword-rings (cat. **1–84**)*, 36.

79 See this volume, chapter 3, *Filigree*, 160–1.

80 Bayliss *et al* 2013, 185, 488, fig 8.16, e-fig 5.6, table 10.1, (AS-MD/E/F 565/95–660/85).

81 Hirst *et al* 2004, 10.

82 The Chessell Down sword also has a Menghin *Typ Högom – Selmeston* scabbard mount of *AS Chronology* phase AS-MA (?–525/50), but the filigree mount is very probably a later addition: Evison 1967, fig 11; Arnold 1982, 62–3, fig 17; Menghin 1983, 334; Bayliss *et al* 2013, 187, object-type SW6-c, fig 8.16, table 10.1.

83 The Sutton Hoo mound 1 sword has a Menghin *Typ Beckum – Vallstenarum* pommel (phases D–F: c 570/80– c 680), but it must be an early example given its relationship to pommels from Väsby and Stora Sandviken of Menghin *Typ Krefeld-Gellep – Stora Sandviken* (phase C: c 520/30–c 570/80): Menghin 1983, 311–12, 315–17.

84 Avent 1975, Vol 1, 41–56; Bayliss *et al* 2013, 222, fig 8.16, table 10.1.

85 Avent 1975, Vol 1, 52, 63, 71–2; Vol 2, pl 66, no. 177.

86 Ibid, Vol 1, 62.

87 See this volume, chapter 5, *Scrollwork*, 249–50; Avent 1975, Vol 2, pl 69, no. 179; Webster and Backhouse 1991, 55–6, no. 38.

88 See this volume, chapter 6, *Hoard Phase 4 (silver objects with gold mounts): Early Insular Style objects, c 630–c 660,* 269–70.

89 Bruce-Mitford 1978, 288–94.

90 Bayliss *et al* 2013, 186, 488, e-fig 5.6, fig 8.16, table 10.1.

91 Dowker 1887, 6–9; Evison 1976, 312, pl lxvia; Bruce-Mitford 1978, 294–7.

92 Müssemeier *et al* 2003, 43, Abb. 7.

93 Høilund Nielsen 1999, 188, figs 3 and 10.

94 Haseloff 1952.

95 The preliminary date of the eighth century for pommel **57**, suggested by Fischer and Soulat (2010), was given before cleaning revealed its Style II ornament.

96 Bayliss *et al* 2013, 222, fig 8.16, table 10.1, object-type BR2-d.

97 Avent 1975, Vol 1, 63–4; Penn 2000, 45–6, Scull 2009a, 88–91; Hamerow *et al* 2015, 9–10.

98 Avent 1975, Vol 1, 63–4; Scull 2009a, 88–91.

99 Bayliss *et al* 2013, figs 6.1, 8.7.

100 See this volume, chapter 3, *Cloisonné and other lapidary work*, 170, and chapter 5, *Animal ornament in the Hoard*, 222.

101 Speake 1980, 45; Webster and Backhouse 1991, 24–5, no. 6.

102 Høilund Nielsen 1999, 187–8, fig 8.

103 Menghin 1983, 77–84, 321–7, Abb. 77; Bayliss *et al* 2013, fig 5.1.

104 Nieveler and Siegmund 1999, fig 1.11, Type Spa7D, phase 8 (c 610–c 640); Müssemeier *et al* 2003, 43–4, Abb. 9, Type Spa7D, phase 7 (c 610/20–c 640/50).

105 Speake 1980, fig 8g.

106 See this volume, chapter 5, *Animal ornament in the Hoard*, 226.

107 Webster and Backhouse 1991, 117–9, no. 83b.

108 See this volume, chapter 3, *Cloisonné and other lapidary work*, 177, and chapter 5, *Animal ornament in the Hoard*, 232.

109 See this volume, chapter 5, *Animal ornament in the Hoard*, 222.

110 See this volume, chapter 5, *Animal ornament in the Hoard*, 227–30.

111 Hines in Penn 2000, 81.

112 *TAR* 1998/9, 35–6; Webster and Backhouse 1991, 24–5, no. 6.

113 Durham A.II.10: Webster and Backhouse 1991, 111–2, no. 79; Webster 2012a, fig 50. Book of Durrow: Haseloff 1987, 46; Brown 2010.

114 Henderson and Henderson 2010; see further in this volume, *Afterword*, 363.

115 See this volume, chapter 2, *Socketed-base and pins (cat. 607/8 and 676)*, 102.

116 Bayliss *et al* 2013, 217, fig 8.16, table 10.1.

117 See this volume, chapter 2, *Origin, social significance and date*, 84–5.

118 Høilund Nielsen 2010.

119 Hirst *et al* 2004; pers comm D Bowsher Blackmore *et al* forthcoming; see this volume, chapter 5, *Ornament of the helmet and die-impressed sheet*, 236.

120 See this volume, chapter 3, *Cell-forms and patterns*, 173–4.

121 Bruce-Mitford 1978, 456–85; Adams 2011a; Bayliss *et al* 2013, 140, 143, e-fig 5.1.

122 Bruce-Mitford 1978, 572. Adams (2011a) argues for a potentially earlier date for the belt-suite.

123 Webster and Backhouse 1991, 27–8, no. 12; Archibald 2013.

124 Archibald 2013.

125 See this volume, chapter 2, *Large mounts not from weaponry and harness-mount (cat. 698)*, 85–93.

126 See this volume, chapter 5, *Animal ornament in the Hoard*, 224, 230.

127 Birbeck *et al* 2005, 45–6 and fig 26; Bayliss *et al* 2013, 211, e-figs 5.10, 7.3.

128 Bayliss *et al* 2013, 184, fig 8.16, table 10.1.

129 See this volume, chapter 5, *Animal ornament in the Hoard*, 227.

130 Geake 2015.

131 The pendant was examined by the author at the British Museum in April 2016.

132 Naylor 2016, 360–2.

133 See this volume, chapter 5, *Animal ornament in the Hoard*, 226.

134 See this volume, chapter 2, *The typological and functional significance of the weapon-fittings*, 64.

135 See this volume, chapter 2, *Hilt-mounts and other small mounts (cat. 410–537)*, 53.

136 See this volume, chapter 5, *Early Insular style*, 250.

137 Graham-Campbell 1976, 50.

138 See this volume, chapter 6, *Hoard Phase 2 (gold): Anglo-Saxon early Style II and contemporaneous styles and objects, c 570– c 630*, 265.

139 Avent 1975, Vol 1, 63, no. 172; Vol 2, pl 62.

140 Nørgård Jørgensen 1999, 71, Abb. 51, 111. See this volume, chapter 2, *The typological and functional significance of the weapon-fittings*, 62.

141 Ljungkvist 2009b, tables 1a, 4, 6.

142 Arrhenius 1983, fig 6.

143 Høilund Nielsen 1991, 130, 142.

144 See this volume, chapter 6, *Hoard Phase 3 (gold): Anglo-Saxon late Style II and contemporaneous objects, c 610–c 650*, 267.

145 Nicolay 2014, 68–72, fig 4.10.4.

146 Webster and Backhouse 1991, 26, no. 9.

147 Bayliss *et al* 2013, 211, fig 8.16, table 10.1.

148 Ibid, 140, fig 8.16, table 10.1, object-type BU3-c: phases AS-MC/MD/MF (545/65–610/45).

149 See this volume, chapter 5, *Early Insular style*, 251.

150 See this volume, chapter 2, 30–2.

151 See this volume, chapter 6, n. 44: see this volume, chapter 2, *The typological and functional significance of the weapon-fittings*, 59 and chapter 5, *Animal ornament in the Hoard*, 213.

152 Geake 2010; Leahy 2015.

153 For the objects, see: Avent 1975, both vols; Speake 1980; Bruce-Mitford 1978; 1983. Recent evidence of actual high-status production comes from Rendlesham (Suffolk) and possibly Lyminge (Kent): Scull *et al* 2016; Thomas 2017.

154 See this volume, chapter 3, *Filigree*, 163–6, and chapter 5, *Animal ornament in the Hoard*, 214–16.

155 See this volume, chapter 3, *Cell-forms and patterns*, 173–4.

156 See this volume, chapter 6, *Dating the Hoard*, 258–71.

157 See this volume, chapter 8, *The archaeology of early Mercia*, 315–19.

158 Bassett 2000.

159 Dumville 1989a, 140.

160 See this volume, chapter 7, 285–99.

161 For example, Leahy and Bland 2009, 14.

162 Härke 2011, fig 2a.

163 Brooks 1989, 160.

164 Bassett 2002.

165 Carver *et al* 2009.

166 See this volume, chapter 8, *The archaeology of early Mercia*, 315–9.

167 Brooks 1989, 168–70; Gelling 1992, 72–6.

168 Dean *et al* 2010, 148; Hooke 2010.

169 Yorke 1990, 101–2. See this volume, chapter 7, *Historical background*, 286–92.

170 Hamerow in Losco-Bradley and Kinsley 2002, 123–9.

171 *Goodwin 2016, appendix 1c: fragment of a great square-headed brooch from Longdon (Gilmore 2014b); a small square-headed brooch from Swinfern and Packington (Slarke 2009a); a small-long brooch from Fisherwick (Slarke 2009b).

172 Parsons 2010.

173 *TAR* 2004, 82, fig 115.

174 Leahy 2015, 121, fig 6.

175 Ibid, 121–2, fig 3.

176 Speake 1970, 6–7.

177 BM 1995, 0501.1 <http://www.britishmuseum.org/research/collection_online/collection_object_details.aspx?objectId=84836&partId=1> (accessed 12 Jan 2017).

178 Brindle 2011.

179 Gilmore 2012.

180 See this volume, chapter 3, *Cloisonné and other lapidary work*, 173–4, table 3.7.

181 Carver *et al* 2009, fig 4.11, no. 198.1, 334.

182 Høilund Nielsen 1998, fig 15; Leahy 2015, 122, fig 8.

183 Ozanne 1963, 20–1, figs 7 and 8a; Bruce-Mitford and Luscomb 1974; see this volume, chapter 8, *The archaeology of early Mercia*, 315–19.

184 Slarke 2008.

185 Hirst and Rahtz 1973; Palmer 1999, 118–9: Frogmore: <https://heritagerecords.nationaltrust.org.uk/HBSMR/MonRecord.aspx?uid=MNA143115>.

186 Green 2012, 150.

187 See this volume, chapter 6, *Kent, East Anglia or Greater Northumbria*, 278.

188 Yorke 1990, 103–5. See this volume, chapter 7, *Religion in early Mercia*, 289–91.

189 See this volume, chapter 7, *The Church and warfare: the religious and cultural background to the Hoard*, 296.

190 See this volume, chapter 2, *The typological and functional significance of the weapon-fittings*, 58–62.

191 See this volume, chapter 3, *Filigree*, 165–6.

192 Bruce-Mitford 1956, 316–25.

193 *TAR* 2005/06, 223–4, no. 1226.

194 See this volume, chapter 2, *Hilt-mounts and other small mounts (cat. **410–537**)*, 50–5, fig 2.25.

195 Bruce-Mitford 1978, 303–4, pls 21a, 22a.

196 Parol 2014.

197 *TAR* 2002, 68–70, no. 58. British Museum Acc: BM.2006,1001.1.

198 The Market Rasen hilt-fittings were examined by the author at the British Museum in 2012.

199 *TAR* 2003, 85, no. 117; Daubney 2004.

200 See this volume, chapter 4, *Damage*, 195–203.

201 Leahy 2015, 122–3.

202 Ibid.

203 See this volume, chapter 5, *Animal ornament in the Hoard*, 216–22.

204 Bede, *HE* II.5 (McClure and Collins 1994, 77–80); Yorke 1990, 28.

205 Avent 1975; Speake 1980, 52–8, pls 6–7.

206 Coatsworth and Pinder 2002, 218–19.

207 See this volume, chapter 3, *Filigree*, 165–6, and *Cloisonné and other lapidary work*, 181, and chapter 5, *Animal ornament in the Hoard*, 213–32.

208 Menghin 1983, 311–5; Fischer *et al* 2008; Fischer and Soulat 2009; Bayliss *et al* 2013, 184, fig 8.16, table 10.1. The early identification of this pommel-form in the Hoard was incorrect: *pace* Fischer and Soulat 2010; Bayliss *et al* 2013, 184, fig 8.16, table 10.1.

209 See this volume, chapter 6, *Dating the Hoard*, 261.

210 See this volume, chapter 2, *The typological and functional significance of the weapon-fittings*, 59.

211 See this volume, chapter 5, *Animal ornament in the Hoard*, 224.

212 Bruce-Mitford 1956, 316–25.

213 Sherlock 2012, 45–50.

214 Ibid, pl 3.6; see this volume, chapter 5, *Animal ornament in the Hoard*, 224.

215 Lowe 1999, 30–2.

216 Campbell and Lane 1993, fig 6.6b.

217 Laing and Longley 2006, 160–4, 166–7.

218 <http://www.britishmuseum.org/research/collection_online/collection_object_details.aspx?objectId=95583&partId=1> (accessed 18 Apr 2017).

219 See this volume, chapter 6, *Hoard Phase 4 (silver objects with gold mounts): Early Insular style objects c 630–c 660*, 269–70.

220 See this volume, chapter 2, *The typological and functional significance of the weapon-fittings*, 62.

221 See this volume, chapter 5, *Early Insular style*, 250–3.

222 Alcock 1963; Redknap and Lane 1994; Seaman 2013.

223 Evison 1967.

224 Yorke 1990, 74–81.

225 Bede, *HE* III.24 (McClure and Collins 1994, 149–52); Yorke 1990, 102; see this volume, chapter 7, *The early Mercian kings*, 287–9.

226 See this volume, chapter 3, *Cloisonné and other lapidary work*, 173–4, 181.

227 Bruce-Mitford 1978.

228 See this volume, chapter 3, *Cloisonné and other lapidary work*, 173–4, 177–8.

229 Bede, *HE* II.5 (McClure and Collins 1994, 77–80).

230 Scull 2002; Scull *et al* 2016.

231 Bruce-Mitford 1978, 291, figs 218a–e, 219–20, pls 21a and 22a.

232 Carver 2005, 241–2, figs 102.5a–c and 103.6.

233 Bruce-Mitford 1974, 273–5, pls 90a–c and 91; Speake 1980, pl 3e.

234 Carver 2005, 241–2.

235 See this volume, chapter 5, *Animal ornament in the Hoard*, 227–30.

236 See this volume, chapter 5, *Animal ornament in the Hoard*, 232.

237 See this volume, chapter 2, *Christian objects*, 99–101, 109, and chapter 5, *Animal ornament in the Hoard*, 227–31.

238 See this volume, chapter 2, *Large mounts not from weaponry and harness-mount (cat. 698)*, 85–96.

239 Bede, *HE* III.18 (McClure and Collins 1994, 138–9); Hoggett 2010, 31, 35. See this volume, chapter 2, *The palaeography of the inscriptions*, 103–8.

240 Pelteret 1980; Carver 2015, 17.

241 Yorke 1990, 62–3, 78.

242 See this volume, chapter 7, *Historical background*, 286–92.

CHAPTER SEVEN
THE HISTORICAL CONTEXT
ENDNOTES

1 For a recent overview, Higham and Ryan 2013, 20–178.

2 Winterbottom 1978, 25–9, 96–9.

3 Wrenn 1972; Heaney 1999.

4 Colgrave and Mynors 1969.

5 McNeill and Gamer 1938, 190.

6 Gelling 1992, 59–62.

7 Brooks 1989, 161–2; Welch 2001, 148–55; see this volume, chapter 8, *The archaeology of early Mercia*, 315–19.

8 Losco-Bradley and Kinsley 2002; see this volume, chapter 8, *The archaeology of early Mercia*, 315–19.

9 Brooks 1989, 160–2.

10 Jones 1998.

11 Faull 1975.

12 Bede, *HE* II.14; (Colgrave and Mynors 1969).

13 Charles-Edwards 2013, 346–7, 387–96, 437–52.

14 Bede, *HB* 65 (Morris 1980).

15 Bede, *HE* II.20 (Colgrave and Mynors 1969).

16 Whitelock 1961, 17.

17 Bede, *HB* 65 (Morris 1980).

18 Ibid.

19 Bede, *HE* III.24 (Colgrave and Mynors 1969).

20 Bede, *HE* III, 7 (Colgrave and Mynors 1969); Whitelock 1961, 17.

21 Bede, *HE* III.18 (Colgrave and Mynors 1969).

22 Whitelock 1961, 20.

23 Plummer 1896, 2, 169–74; Bede, *HE* III.19 (Colgrave and Mynors 1969); Rackham 2007.

24 Bede, *HB* 65 (Morris 1980).

25 Bede, *HE* III.21 (Colgrave and Mynors 1969).

26 Bede, *HE* III.24 (Colgrave and Mynors 1969).

27 Bede, *HE* III.16 (Colgrave and Mynors 1969).

28 Tyler 2005.

29 Bede, *HE* III.24 (Colgrave and Mynors 1969); Bede *HB* 65 (Morris 1980).

30 Fraser 2008.

31 Bede, *HE* III.24 (Colgrave and Mynors 1969).

32 Bede, *HB* 65 (Morris 1980).

33 Bede, *HE* III.24 (Colgrave and Mynors 1969).

34 Higham 2015, 10, 101–2.

35 Bede, *HE* III.24 (Colgrave and Mynors 1969).

36 Charles-Edwards 2013, 294.

37 Bede, *HE* III.24 (Colgrave and Mynors 1969).

38 Ibid.

39 Bede, *HE* III.39; IV.3; IV.13 (Colgrave and Mynors 1969); Stenton 1971, 84–5.

40 Stephen, *Vita Wilfridi* cap 20 (Colgrave 1927).

41 Higham 2015, 157–8.

42 Ibid, 180–2.

43 Bede, *HE* IV. 21 (Colgrave and Mynors 1969).

44 Whitelock 1961, 25.

45 Rollason 1982.

46 Bede, *HE* IV. 22 (Colgrave and Mynors 1969).

47 Maddicott 2005.

48 Cowie and Blackmore 2012, 16–17, 202.

49 Whitelock 1961, 26.

50 Meaney 2005.

51 Whitelock 1979, 820.

52 Yorke 1990, 111.

53 Kleinschmidt 2014.

54 Yorke 1990, 100–27; Hill and Worthington 2005.

55 Bede, *HE* II. 20 (Colgrave and Mynors 1969).

56 Bede, *HB* 65 (Morris 1980).

57 Bede, *HE* III. 21 (Colgrave and Mynors 1969).

58 Bede, *HE* III. 12 (Colgrave and Mynors 1969).

59 Chaney 1970, 115–19; Thacker 1995.

60 Bede, *HE* III. 21 (Colgrave and Mynors 1969).

61 Bede, *HE* IV. 3 (Colgrave and Mynors 1969).

62 Morris 2015.

63 Brooks 1989, 168–70; Gelling 1992, 72–6.

64 Charles-Edwards 2013, 651 79.

65 Sargent 2013.

66 Gelling 1992, 86–94; Bassett 2000.

67 Charles-Edwards 2013, 396–410.

68 Kelly 2009, 2–8, 131–60.

69 Bede, *HE* IV.6 (Colgrave and Mynors 1969).

70 Kelly 2009, 5.

71 Bede, *HE* III. 11 (Colgrave and Mynors 1969); Thacker 1995, 104–7.

72 Yorke 2003, 105–27.

73 Thacker 1985, 4.

74 Rollason 1982, 81; Kelly 2009, 183–5.

75 Felix, *Vita sancti Guthlaci*; (Colgrave 1956, 84–7); and see this volume, chapter 7, *The Church and warfare: the religious and cultural background to the Hoard*, 293–9, especially *Anglian connections*, 298–9.

76 Yorke 2003, 165–7.

77 Bede, *HE* v.24 (Colgrave and Mynors 1969).

78 Bede, *HE* v.19 (Colgrave and Mynors 1969); Stancliffe 1983.

79 Kleinschmidt 2014, 174–8.

80 Gelling 1992, 59–62.

81 Bede, *HE* IV.3, v.23 (Colgrave and Mynors 1969).

82 Gelling 1978, 100; Sargent 2013, 3–4.

83 Lewis 2007.

84 Stancliffe 1995.

85 Gelling 1992, 59.

86 Roffe 2014.

87 Reynolds and Langlands 2006.

88 Hooke 2011.

89 Ibid; Roffe 2014.

90 Roffe 2014, 1.

91 Ibid.

92 Baker and Brookes 2013, 140–52.

93 Horovitz 2013.

94 Baker and Brookes 2013, 179–92.

95 Baker and Brookes 2016.

96 Parsons 2010.

97 For an alternative position, see this volume, chapter 9, *Hoarding in continental Germanic Europe*, 334–44, where, following the traditional interpretation, most early medieval continental hoards are presented as safekeeping hoards.

98 Campbell 2007.

99 McNeill and Gamer 1938, 190.

100 See this volume, chapter 2, *The typological and functional significance of the weapon-fittings*, 58.

101 Ellis Davidson 1962; Brunning 2013.

102 See this volume, chapter 2, *Christian objects*, 99–119.

103 See, for example, this volume, chapter 5, *Geometric ornament and symbols*, 253–5.

104 Bede, *HE* I.25 (Colgrave and Mynors 1969).

105 Bede, *HE* I.29 (Colgrave and Mynors 1969).

106 Bede, *HE* II.20; III.14 (Colgrave and Mynors 1969).

107 Bede, *HE* II.16 (Colgrave and Mynors 1969).

108 Bede, *HA* caps 4–6 (Plummer 1896).

109 Stephen, *Vita Wilfridi* caps 5, 33, 55; (Levison 1913).

110 Stephen, *Vita Wilfridi* cap 39 (Levison 1913).

111 Stephen, *Vita Wilfridi* cap 16 (Levison 1913).

112 Stephen, *Vita Wilfridi* cap 17 (Levison 1913).

113 Stephen, *Vita Wilfridi* cap 22 (Levison 1913).

114 *Pace* 2009.

115 Brandenburg 2005, 213.

116 Nees 2002, 106–7.

117 *Vita Ceolfridi* 2 caps 26–7 (Grocock and Wood 2013).

118 *Vita Eligii* 1.32 (Krusch 1902); Vierck 1974; 1985, 404–9; Crook 2000, 72–3.

119 Vierck 1985, 404–6; Périn and Feffer 1985, 125.

120 Vierck 1974, 316, 360–4.

121 Périn and Feffer 1985, 142; Wieczorek *et al* 1996, ii, 929.

122 Vierck 1974, 359–67.

123 Bede, *HE* III.6 (Colgrave and Mynors 1969).

124 Alcuin *Bishops, Kings and Saints of York*, lines 308–9 (Godman 1982).

125 Bede, *HE* IV.32 (Colgrave and Mynors 1969).

126 *Liber Historiae Francorum* cap 44 (Krusch 1888); *Gesta Dagoberti* 1.52 (Krusch 1888); Wood forthcoming.

127 See this volume, chapter 2, *Christian objects associated with ceremony and worship*, 114–16.

128 Rome, Bibliotheca Apostolica Vaticana, MS gr 699; Chazelle forthcoming. The author is grateful to Celia Chazelle for much help with this manuscript.

129 Leclercq 1934, cols 1,554–7; Reginald Libellus cap 41 (Raine 1835).

130 See this volume, chapter 2, n. 461.

131 See this volume, chapter 5, *Geometric ornament and symbols*, 253–5. See also the gold foil crosses placed over the eyes of the Prittlewell Prince (probably buried c 575–605): Blackmore *et al* 2019, 290–5, 332–7, 334–8, 372.

132 Webster and Backhouse 1991, no. 46; cf the Christian inscription on the Coppergate helmet (later eighth century): ibid, no. 47.

133 Bede, *HE* II.15 (Colgrave and Mynors 1969).

134 Bede, *HE* III.21 (Colgrave and Mynors 1969).

135 Stephen, *Vita Wilfridi* cap 17 (Levison 1913).

136 Bede, *HE* III.24 (Colgrave and Mynors 1969).

137 Bede, *HE* IV.12 (Colgrave and Mynors 1969).

138 *Poenitentiale Theodori* 1. III.2 (Haddan and Stubbs 1871).

139 *Poenitentiale Theodori* I.VII.2 (Haddan and Stubbs 1871).

140 Webster 2016.

141 Anon, *Vita Cuthberti* 1.7 (Colgrave 1940); cf Bede, *Vita Cuthberti prosaica* caps 5–6 (Colgrave, 1940).

142 Bede, *HE* III.18 (Colgrave and Mynors 1969).

143 Bede, *HE* II.2 (Colgrave and Mynors 1969).

144 Stephen, *Vita Wilfridi* cap 13 (Levison 1913).

145 Stephen, *Vita Wilfridi* cap 19 (Levison 1913).

146 'cum pontifice Dei, iustus et sanctus regens populos'.

147 Stephen, *Vita Wilfridi* cap 20 (Levison 1913).

148 Cameron and Hall 1999, 80–2.

149 Leclercq 1914, cols 3,102–3.

150 Kaegi 2003, 156–91, 205–7; Ó Carragáin 2005, 189–95.

151 Bede, *HE* III.1–2 (Colgrave and Mynors 1969).

152 Bede, *HE* II.20; III.9 (Colgrave and Mynors 1969).

153 See this volume, chapter 5, *Animal ornament*, 227–30.

154 Bede, *HE* II.15; III.18 (Colgrave and Mynors 1969).

155 Bede, *HE* III.21, 24 (Colgrave and Mynors 1969).

156 Bede, *HE* III.21, 24, 29 (Colgrave and Mynors 1969).

157 For discussion of the texts, see this volume, chapter 2, *The palaeography of the inscriptions*, 103–8.

158 For example, Bede, *Vita Cuthberti prosaica* cap 42 (Colgrave 1940).

159 Significantly, the Ark was actually recorded as having been taken to the battlefield by the Israelites in their war against the Philistines, though we may note that on that occasion it brought not victory but defeat – a circumstance that Bede in his commentary struggled to explain: Hurst 1962, 42–5; and see also Webster 2016, 40–2.

160 Stephen, *Vita Wilfridi* cap 39 (Levison 1913); see this volume, chapter 7, *The contemporary context*, 293.

161 For patristic exegesis of this text as having especial power in the defeat of devils, see Ganz 2010.

162 Felix, *Vita sancti Guthlaci* cap 34 (Colgrave 1956).

163 *Vita Antonii* cap 13 (Migne 1857): 'Exsurgat Deus, et dissipentur inimici eius, et fugiant qui oderunt eum a facie eius, ut fumus minuitur deficient'.

164 Felix, *Vita sancti Guthlaci* cap 49 (Colgrave 1956).

165 Felix, *Vita sancti Guthlaci* caps 30, 33, 34 (Colgrave 1956).

166 Felix, *Vita sancti Guthlaci* cap 49 (Colgrave 1956).

CHAPTER EIGHT

THE ARCHAEOLOGICAL CONTEXT

ENDNOTES

1 See this volume, chapter 7, especially *Historical background*, 286–92.

2 See this volume, chapter 6, especially 271–80.

3 See this volume, chapter 1, *Discovery*, 4–5, and *Discussion*, 12–13; also, chapter 6, *Mercia*, 273–5.

4 See this volume, chapter 7, 285–99.

5 Bayliss *et al* 2013, esp. 13–32.

6 Ibid, 532–42.

7 Geake 1997, 81–2; Scull 2009b, 406–8.

8 Härke 1992, 182–90; Crawford 1998, 14–32; Stoodley 1999, 105–18.

9 Bayliss *et al* 2013, 459–73 and 548–54; see this volume, chapter 7, *The Church and warfare: the religious and cultural background to the Hoard*, 293.

10 Bruce-Mitford 1978; Carver 2005, fig 102.

11 Smith 1923, fig 6; Ellis Davidson and Webster 1967; A F Richardson 2005 Vol II, 21–2.

12 Scull *et al* 2016.

13 Bruce-Mitford 1978, 129–37. In this publication the pommel has apparently been misascribed to Orsay in France: cf Menghin 1983, 250 no. 101.

14 See this volume, chapter 2, *Fittings from weaponry*, 33–70. Fern stresses that the number of swords actually represented could have been considerably higher.

15 See this volume, chapter 2, *Helmet parts, decorated silver sheet: reeded strip and edge binding*, 70–9, and *The social context, form and date of the helmet*, 79–85.

16 Härke 1992b, 104–13.

17 Jarvis 1850; Bateman 1861, 28–33; Foster 1977; Bruce-Mitford 1978, esp. 205–20; Meadows 1997; see this volume, chapter 2, 80–5; also, chapter 6, *Dating the Hoard*, 262–3.

18 Hood *et al* 2012.

19 Meadows 1997; 2004.

20 Bayliss *et al* 2013, 459–62.

21 Ibid, 190–201.

22 Walton Rogers 2007, 123–5, 133–8; Bayliss *et al* 2013, 135–47.

23 Ellis Davidson 1994, 93–6; Menghin 1983, 142–51; see this volume, chapter 2, *Fittings from weapon-harness (cat. 572–87)*, 56–7.

24 Bayliss *et al* 2013, 146.

25 See this volume, chapter 2, *Large mounts not from weaponry and harness-mount (cat. 698)*, 85–98, and *Discussion of the large mounts and harness-mount (cat. 698)*, 94–8, Note also the unearthing of a contemporary copper-alloy harness-mount (**698**) in the same field as the Hoard, but apparently not as part of the assemblage.

26 Caruth and Anderson 1999; Caruth and Hines forthcoming.

27 Carnap-Bornheim and Ilkjær 1996, 247–77.

28 Carver 2005, 261 and fig 122 (cf ibid, figs 111–12).

29 Geake 1997, 101; Fern 2007.

30 See this volume, chapter 2, *Christian objects*, 110–19.

31 Bayliss *et al* 2013, 213.

32 Bede, *Vita Cuthberti*, ch. 13 (Webb 1975, 88); Coatsworth 1989.

33 The relationship between the military secular order and the Church in seventh-century England is more fully discussed by Alan Thacker: see this volume, chapter 7, *The Church and warfare: the religious and cultural background of the Hoard*, 296–9.

34 See this volume, chapter 7, *Religion in early Mercia*, 290, and *The contemporary context*, 293.

35 Zacher 2013, especially 130–49.

36 Neidorf 2014.

37 *Beowulf*, lines 99–114 and 783–8 (Mitchell and Robinson 1998).

38 Bede, *HE* II.2, II.20 and III.1–2 (Colgrave and Mynors 1969); see this volume, chapter 7, *The Church and warfare: the religious and cultural background of the Hoard*, 296–9.

39 For further discussion, see this volume chapter 5, 207–55, especially 253–5.

40 Bayliss *et al* 2013, 531–6.

41 See this volume, chapter 2, *Fittings from weaponry*, 33–70; cf also PAS finds from Humshaugh (Northumberland) (Collins 2013),

from near Gainford (Co Durham) (Proctor 2013), Hinton St Mary (Dorset) (Hayward Trevarthen 2012), Dorchester (Dorset) (Payne 2005).

42 cf Leahy 2015; Webster 2017.

43 See this volume, chapter 6, *Origins*, 271–80.

44 See this volume, chapter 7, *Historical background*, 286–92, especially 286–7.

45 Winterbottom 1978; Charles-Edwards 2013, 202–19.

46 Hines 2013.

47 cf Hines 1997a, 294–304.

48 Lethbridge 1931, 4–9; Hines 1997a, 48–58.

49 Scull 2011.

50 Hines 2017.

51 Nicolay 2014, 170–86.

52 cf Arnold 1988, 191–210; Hodges 1989, 38–42.

53 D Harrison in Caruth and Hines forthcoming.

54 West 1985; Hamerow 1993; 2012, 67–72.

55 Lucy *et al* 2009. The site at West Heslerton (North Yorkshire), on which interim reports have appeared (e.g. Powlesland 1997), has also been described as showing a 'planned' and functionally segregated layout.

56 Scull 2009b, 422–6.

57 Lucy *et al* 2009, 10–12.

58 Gelling 1978, 185.

59 Hope-Taylor 1977; Gates and O'Brien 1988; Hamerow 2002, 102–9.

60 Knox 2013; Scull *et al* 2016, fig 5; cf Chadwick Hawkes 1982, esp. 74–6.

61 Millett and James 1983.

62 Ibid, 215.

63 Pestell 2004, 21–64; Loveluck 2007; Blair 2011; Tester *et al* 2014.

64 Demonstrated in Bede's letter to Egbert, Archbishop of York: Whitelock 1968, 735–45.

65 See especially this volume, chapter 4, *Damage*, 195–205.

66 Liebermann 1903–16, i, 4: Ab 18–20.

67 Ibid, i, 102–3: Ine 29.

68 Ibid, i, 48–9: Af 1.2 and 1.4.

69 Ellis Davidson 1994, 129–52; Brunning 2013.

70 Hines 2008, esp. 93–7.

71 On the social structure of Anglo-Saxon England generally, see Stenton (1947, 274–314) and John (1996, 3–21).

72 Liebermann 1903–16, i, 458–63; Wormald 1999, esp. 391–4.

73 Grierson and Blackburn 1986, 102–7.

74 Sweet 1885, 38, 43 and 113; Bosworth and Toller 1898/1921, sv. TRIMES. The word þrymsa is recorded only in this, which is the genitive plural form, variably spelt þrymsa. The singular nominative and accusative forms should have been *þryms/þrims. Unfortunately, numismatists have erroneously indicated that there was an Old English base term þrymsa, and that it was a variant term for the shilling of four pence (Metcalf 1993–4, 29 no. 4; Grierson and Blackburn 1986, 157).

75 A copy of this law-code which survives only in a printed sixteenth-century edition offers an arithmetically slightly closer figure of 267 þrimsas: Liebermann 1903–16, i, 460, Ld 6.

76 Hines 2011.

77 Grierson and Blackburn 1986, 107 and 270–1; cf Naismith 2012, 96–106.

78 Hines 2011.

79 Hines 2014.

80 See this volume, chapter 2, 30–2.

81 Härke 1997, 141–8.

82 Härke 1992b, 112, Taf. 10.

83 Dumville 1989b.

84 Chadwick Hawkes *et al* 1966; Williams and Hooke 2013.

85 Blackburn 2003.

86 See this volume, chapter 3, *Gold*, 125–7.

87 <www.fitzmuseum.cam.ac.uk/emc/> (accessed 1 Dec 2016).

88 Brooks 1989, 161–2; Welch 2001. Meaney (1964, 222) suggests that cremation urns found at Stretton (Derbyshire) in the nineteenth century might represent a further cremation cemetery.

89 Martin 2015, 298, List of find-places: Derbyshire.

90 Meaney 1964, 72–82, 220–3; Kinsley 2002, 84–121.

91 Hines 1984, 35–109; 1993, 71 no. 2.

92 See especially Martin 2015: 298, 306 for an index of sites and brooches, and fig 36 for a representative distribution map.

93 Gilmore 2014a and 2014b; Atherton 2006.

94 Hines 1997a.

95 Atherton 2009.

96 Garton and Kinsley 2002; cf Losco-Bradley 1979.

97 Hines 2018.

98 Losco-Bradley and Kinsley 2002, 100–15.

99 Hawkins and Rumble 1976, 11.49 (Wychnor) and 1.11–2 (Alrewas and King's Bromley).

100 Bateman 1861; Jewitt 1870; Ozanne 1963.

101 Loveluck 1995.

102 Bede, HE III.21 (Colgrave and Mynors 1969).

103 The dating of the burials is assumed not to differ from the parameters of the chronological framework published in Bayliss *et al* 2013.

104 Yorke 1990, 83–6; Kirby 1991, 69–73.

105 Bede, *HE* IV.12 (Colgrave and Mynors 1969).

106 Bede, *HE* IV.21 (Colgrave and Mynors 1969).

107 See this volume, chapter 7, *Historical background*, especially 287.

108 Gelling 1992.

109 Jewell 1986; Rodwell *et al* 2008; Hawkes and Sidebottom forthcoming.

110 Rahtz and Meeson 1992; Bassett 2008; Hamerow 2012, 153.

CHAPTER NINE

HOARDS AND HOARDING

ENDNOTES

1 Cool 2013, 6.2 and 15.11v. The original proposal (that it should also include a survey of prehistoric special deposits) was eventually revised because of limitations on the scope of the volume. See also Anon 2016, a report of the conference held in 2016 as part of the research project led by Roger Bland, 'Crisis or continuity. Hoarding in Iron Age and Roman Britain with special reference to the 3rd century AD'.

2 See this volume, chapter 9, *The hoarding of late Roman objects in post-Roman Britain*, 332–3.

3 See this volume, chapter 10, *Comparable assemblages?*, 353–4.

4 See this volume, chapter 9, *Scandinavian Hoarding*, 348-9.

5 See this volume, chapter 9, *Hoarding in later Roman Britain and beyond*, 325, and *The hoarding of late Roman objects in post-Roman Britain*, 332–3.

6 See this volume, chapter 9, *Hoarding in continental Germanic Europe*, 336–7.

7 Nicolay 2014.

8 See this volume, chapter 9, *Hoarding in continental Germanic Europe*, 334–5; also, *Hidden treasure in texts from the early medieval period*, 343–4.

9 See this volume, chapter 9, *Imagining Scandinavia*, 344.

10 See this volume, chapter 9, *Hidden treasure in texts in the early medieval period*, 343.

11 For a broad introduction to the development of theories that underpin archaeological interpretation, see Johnson 2010.

12 Cool 2013, 6.2; cf, for example, Guest 2015 and Painter 2015.

13 See this volume, chapter 9, *Hoarding in continental Germanic Europe*, 336, and *Conclusion*, 344.

14 See this volume, chapter 9, *Conclusion*, 349.

15 See this volume, chapter 9, *Hoarding in later Roman Britain and beyond*, 325–6, and *The hoarding of late Roman objects in post-Roman Britain*, 332–4.

16 See this volume, chapter 9, *Hoarding in later Roman Britain and beyond*, n 20, and *Hidden treasure in texts in the early medieval period*, 343.

17 See this volume, chapter 9, *Hoarding in continental Germanic Europe*, especially 343.

18 For the *Anglo-Saxon Chronicle*, see Swanton 1996 and Howorth 1908. For literary sources for the fourth to sixth centuries generally, see Dumville 1977; Winterbottom 1978; Blockley 1983; Wood 1987; Woods 2009.

19 Howe 2004.

20 See this volume, chapter 9, *Hidden treasure in texts from the early medieval period*, 343–4. Gold is a recurring leitmotif in the Old English epic-poem *Beowulf*.

21 See this volume, chapter 7, *Historical background*, 286, and *The early Mercian kings*, 288; also, chapter 8, *The early Anglo-Saxon period: graves and grave goods*, 304, and *Resources and their use: the contemporary value of the Hoard*, 312–14.

22 The attribution of the entry to this specific year should be taken with a pinch of historical salt.

23 Bland 2015.

24 For gold and silver finds, see Hobbs 2006, 51–9 and 86–94. For coin hoards, see Robertson 2000, LVIII–LX and 353–410, and Abdy 2002, 56–66. Beagrie 1989 describes the deposition of late Roman pewter objects, including several hoards.

25 Abdy and Williams 2006; Bland and Loriot 2010.

26 Johns and Potter 1983.

27 Painter 1977a; Hobbs 2016.

28 Painter 1977b; Kent and Painter 1977.

29 Guest 2005; Johns 2010.

30 Hobbs 2006, 55–8.

31 Among others, see Collingwood and Myres 1936, 295–301; Frere 1967, 362–4; Robertson 1974, 33–4; Archer 1979, 29–31; Salway 1981, 458; Burnett 1984, 168; Esmonde Cleary 1989, 96–9 and 139–40; Kent 1994, LXXXII; Dark 2000, 143–4; Mattingly 2006, 538.

32 Bistuer 1984; Berdeaux-Le Brazidec and Hollard 2008; Abdy 2013.

33 Guest 2014.

34 For instances of the 'hordes = hoards' interpretative model, see this volume, chapter

9, *Hoarding in continental Germanic Europe*, 336, 344.

35 Jones 1964, 427–35; Hendy 1985, 386–95.

36 Cameron 1992, 179.

37 Strong 1966, 200; Reece 1999, 42–3. See Leader-Newby 2004 for a discussion of the surviving *missoria*.

38 Jones 1964, 435 and 527–56; Hendy 1985, 177–88 and 201–3.

39 Jones 1964, 427–35; Hendy 1985, 386–95; Delmaire 1989.

40 Jones 1964, 185–6; Blockley 1983, fr 9.3, 1–10; Hendy 1985, 261.

41 See this volume, chapter 9, *Hoarding in continental Germanic Europe*, 336, and *Scandinavian hoarding*, 347–9. See also, Gaul 1984; Hobbs 2006, 58–71; Komnick 2008; Ciołek 2009.

42 See, for example, Bursche 2001; Guest 2008; articles in Hunter and Painter 2013.

43 Appadurai 1986; Gilchrist 2000; Hurcombe 2007.

44 White *et al* 1999; Orna-Ornstein 2009; Abdy 2013.

45 The silver items include a complete later fifth-century Germanic sword scabbard chape-fitting.

46 See this volume, chapter 9, *Scandinavian hoarding*, 347. See also Hunter and Painter 2013, especially Rau 2013a.

47 Guest 2005, 110–15.

48 Horsnæs 2009, 2010 and 2013; Rau 2013a.

49 See this volume, chapter 9, *Scandinavian hoarding*, 347–8. Grane 2013; Guest 2014, 122–4.

50 For example, the discussions in Esmonde Cleary 1989; Higham 1992; Dark 2000. Also see references in this volume, chapter 9, note 18 for the *Anglo-Saxon Chronicle*.

51 Wickham 2005, 303–33; Esmonde Cleary 2013, 338–94; Gerrard 2013.

52 Translated from the German by Hilary Cool, Peter Guest, Leslie Webster and Tania Dickinson.

53 Geißlinger 1984; Hardt 2011; Eggert 2012, 78–83.

54 Huth 1997.

55 Hänsel and Hänsel 1997; Krenn-Leeb 2006.

56 Hansen 2002.

57 Geisslinger 1984; 2002.

58 Ballmer 2010; Hansen 2012; Neumann 2012.

59 Geisslinger 1967; Rau 2013a; 2013b.

60 Hauck 1970; Quast 2009; Nicolay 2014.

61 Bierbrauer 1975.

62 Schmauder 2002.

63 Bierbrauer *et al* 1994; Stadt Frankfurt am Main 1994; Wieczorek *et al* 1996;; Seipel 1999; Wieczorek and Périn 2001; Historisches Museum der Pfalz Speyer 2006; Menghin 2007; Aillagon 2008.

64 Hansen 2012, 28–29, 'Geschichte des Deponierens'.

65 Ibid, 39, 'die Orte der Deponierung [zu] erforschen'.

66 Hardt 2004; see this volume, chapter 9, *The status of gold in the later Roman world (and beyond)*, 329–30.

67 Hardt 2004, 236–48.

68 Gregory of Tours, *HF* II/42, 92 (Krusch and Levison 1951).

69 *Annales regni Francorum* ad a. 796, 98; Kurze 1950.

70 Gregory of Tours *HF* IV/29, 130; (Krusch and Levison 1951); Hannig 1986.

71 Hardt 2004, 196–9, 235–78.

72 Gregory of Tours, *HF* V/2, 266–7 (Krusch and Levison 1951).

73 Hardt 2004, 249.

74 Ibid, 264–78.

75 Ibid, 278–91.

76 Althoff 1987.

77 Hardt 2016.

78 Mauss 1925 (trans. 1954), 72.

79 Pohl 1999, 454, citing Bourdieu 1980 (trans. 1993), 236.

80 Hardt 2004, 303.

81 Gehrig 1980; Antikenmuseum Berlin 1988, 330–43; Heilmeyer 1988, no. 403–7, 576–80 with further references, Hardt 2004, 108–9; 2009.

82 Böhme 1995, 174.

83 Roeren 1960; Okamura 1990, 45–54.

84 Lestocquoy 1958, 56; Lapatin 2017.

85 Lestocquoy 1958, 58.

86 Kellner and Zahlhaas 1993, 139–46; Künzl 1996, 473.

87 Bernhard *et al* 1990.

88 Künzl 1993; Künzl and Künzl 1993; Historisches Museum der Pfalz Speyer 2006.

89 Toynbee and Painter 1986, 17, 29–30, no. 20.

90 Lund Hansen 1995, 398–402. Note, however, that Bradley 2017, 13–16, explicitly challenges the assumption that deposits in the Rhine at Neupotz were the result of hiding treasures.

91 Wrede and Cahn 1984, 405–6.

92 Guggisberg 2003.

93 Wrede and Cahn 1984, 409.

94 Ibid; Toynbee and Painter 1986, 17, 30–1, no. 22, 43–4, nos 54 and 55.

95 Grünhagen 1954, 2–49, 71–7; Rau 2013a, 342–3; 2013b, 192.

96 Bott 1976/77, 152–3; Rau 2013a, 341.

97 Berger 1991; Schmauder 1999, 104–5.

98 Berghaus 1986; Wieczorek et al 1996, cat. no. III.1.15, 822–4; Quast 2009, 218–20.

99 Biró-Sey 1970/71; 1988; Iluk 1985, 85; Martin 1987, 235; 1988, 216–21.

100 Fettich 1932, 45–53; Kiss 1986, 129; Dembski 1999, 31–7; Seipel 1999, 178–88; Schmauder 2002, ii 73–7 and pls 143–52.

101 Martin 1988, 212–13; see this volume, chapter 9, *The status of gold in the later Roman world (and beyond)*, 330, for discussion of *Comes Sacrarum Largitionum*.

102 Horedt 1984a; Iluk 1985, 85; Overbeck and Overbeck 1985, 210; Curta 1990.

103 Hardt 2003.

104 Gustavs 1987, 215–16, 219–28, 230–2.

105 Menghin 2007, cat. no. 0.4, 39, 277–8; Quast 2017, 109-13.

106 Dunareanu-Vulpe 1967, 38–40; Capelle 1968; Odobescu 1976, 301–557; Rusu 1986, 187–8; Stadt Frankfurt am Main 1994, no. 98.5–98.6, 232.

107 Kossinna 1919.

108 For this, see Capelle 1994; 1999.

109 Fettich 1932, 9–44, pl 1; Kiss, 1986, 129; Seipel 1999; Schmauder 2002, 41–43, ii, 80–8, pl 163–86.

110 Kossinna 1919.

111 Kiss 1982–4, 415; Harhoiu 1997, 154.

112 Fettich 1932, 56–8; Bóna 1991, 267; Seipel 1999, 139–59.

113 Harhoiu 1997, pl XLVII; Seipel 1999, cat. no. 45, 198, and figs 7, 198–9; 'fürstliches Kleinod'.

114 Horedt 1979, 134 and 136 with explanations to fig 46a; Bóna 1991, 267, 'ein Erzeugnis der kaiserlichen Goldschmiedewerkstatt in Konstantinopel'.

115 Fettich 1932, 59–62; Bóna 1991, 267; Kiss 1999a, 164–7.

116 Schmauder 2003, 84–8.

117 Odobescu 1889–1900, 1–58 (83–150), III (1900), 1–58 (737–94); Dunareanu-Vulpe 1967, 7–13; Rusu 1986, 181, 184.

118 Harhoiu 1977, 19–20.

119 Odobescu 1896, 67–75 (663–71) pl V; Dunareanu-Vulpe 1967, 33–4; Harhoiu 1977, 17–18; 1997, pl XXVI–XXVII; Stadt Frankfurt am Main 1994, no. 98.9, 234; Schmauder 2002, II, 54, pl 101–2; 2003, pl 5.

120 Harhoiu 1977, 10–11; 1997, 64; Rusu 1986, 181.

121 Horedt 1969, 552; 1971, 711; 1972, 114–16; Harhoiu 1977, 20–2, 27–8, 3.5.

122 Bock 1868, 120–4; Odobescu 1900, 15–26 (723–34); Harhoiu 1977, 3–5.

123 Rusu 1986, 194–6.

124 Brown 1972, 115.

125 Horedt and Protase 1970, 85–98, especially 86–9 and pls 21–5; Horedt 1984b, 36–7; Kiss 1986, 122; Harhoiu 1997, 82–3 and no. 30, 171 and pl LXX; Wieczorek and Périn 2001, cat. no. 4.11.1.2, 162–5; Schmauder 2002, 128–31, II, 28, pl 47.

126 Fettich 1932, 40–44, 55; Harhoiu 1997, 129 and pl LVII; Kiss 1999b; Schmauder 2002, 87–8 and pls 183–5.

127 Odobescu 1976, 89–218; Dunareanu-Vulpe 1967, 26–8; Harhoiu 1977, 7; 1997, 120–1 and pl XXVIII; Rusu 1986, 184; Stadt Frankfurt am Main 1994, no. 98.2, 231; Schmauder 2002, 191–3, II, 51 and pl 90.

128 Dunareanu-Vulpe 1967, 16–26; Heland 1973, 11–74; Odobescu 1976, 627–54; Harhoiu 1977, 9–11; 1997, 121–2 and pls XXXI–XXXII; Roth 1979, 135, 137–8 and fig. 47; Rusu 1986, 184–5; Toynbee and Painter 1986, 20 and 46–7, no. 59; Schwarz 1992, 168–84 and pls 9–11; Stadt Frankfurt am Main 1994, no. 98.3, 231; Schmauder 2002, 193–6, II, 51–2 and pls 91–7.

129 Dunareanu-Vulpe 1967, 30–2; Odobescu 1976, 687–704; Harhoiu 1977, 11; 1997, 127–9 and pls. XXXIII–XXXVI; Rusu 1986, 185; Stadt Frankfurt am Main 1994, no. 98.7–8, 233; Schmauder 2002, 196–8, II, 52–4 and pls 98–100; 2003, pl 7.

130 Dunareanu-Vulpe 1967, 28–30; Odobescu 1976, 601–26; Harhoiu 1977, 8–9; 1997, 124–5 and pls. XXIX–XXX; Rusu, 1986, 185–6; Stadt Frankfurt am Main, no. 98.1, 230; Schmauder 2002, 186–91, II, 50–1 and pls 88–9; 2003, pl 3.

131 Rusu 1986, 181.

132 Heland 1973, 96–103, especially 99–100; Rusu 1986, 184–5; Schwarz 1992, 183–4.

133 Schwarz 1992, 184.

134 Mundell Mango and Bennett 1994, 9–11; Visy and Mráv 2012; Heinrich-Tamáska 2014.

135 Mundell Mango and Bennett 1994, 11.

136 Himmelmann 2015.

137 Poglayen-Neuwall 1930; Shelton 1981; 1985; Cameron 1985; Painter 2000.

138 Bierbrauer 1975, 198–204; Bierbrauer *et al* 1994, 202–7.

139 Bierbrauer 1975, 204–7; Bierbrauer *et al* 1994, 208–12; Aimone 2008.

140 Bierbrauer 1975, 207.

141 Menghin *et al* 1987, 419–27; Bierbrauer *et al* 1994, 194–202; Périn 2008.

142 Kidd 1987, 429: 'ihrer geheimnisvollen Beziehung zur Erde, ihrem scheinbar magisch bedingten zahlreichen Erscheinen sowie der Fähigkeit, […] vom Tau zu leben'.

143 Bierbrauer *et al* 1994, 212–13.

144 Morrisson *et al* 1988, 125–7, 130.

145 Longpérier 1879/1884, 53–9; Calvi 1980; Morrisson *et al* 1988, 125–7.

146 Toynbee and Painter 1986, 18, 33, no. 27; Morrisson *et al* 1988, 126–7.

147 Bolla 2008; Landschaftsverband Rheinland 2008, cat. no. 173, 362.

148 Bardiès-Fronty *et al* 2016, cat. nos 64–5.

149 Elbern 1963, 23–5; 1964, 72, no. 23.

150 Lafaurie 1975, 75-6.

151 Werner 1980.

152 Hardt 2013, 334–6.

153 See Schramm 1954, 134–5; Roth 1979, 150–1, no. 64–5, pls 64–5; Palol and Ripoll 1990, 260–72 and pl 208, 214–16; Bardiès-Fronty 2008.

154 Julian of Toledo, (*Historia Wambae Regis*, 26 (Martínez Pizarro 2005).

155 Grierson 1953; Berghaus 2000.

156 Hardt 2001.

157 *Nibelungenlied* (v. 2367–8, 370; Boor 1979); *The Nibelungenlied* (Hatto 2004, 290).

158 Heinzle 1994, 66–9.

159 Larrington 1996, 210–16.

160 See *et al* 2012, 294, 297.

161 Grimm 1957, 18.

162 *Nibelungenlied* v. 1137, 186 (Boor 1979); *The Nibelungenlied* (Hatto 2004), 149; Heinzle 1994, 68–9.

163 The *Nibelungenlied* (Hatto 2004), chapter 19, 148–9 (authors' emphasis).

164 Hardt 2001.

165 See, for example, Fagerlie 1967; Lind 1981; Pesch 2007; Nicolay 2014.

166 Klaeber 1936.

167 Nicolay 2014.

168 Lamm 2005.

169 Jørgensen and Storgaard 2003.

170 Birch Iversen 2010; Rau 2010.

171 Ilkjaer 2006.

172 Nordquist 2004; Fischer *et al* 2008; 2013.

173 The term 'central place' is a key concept in Scandinavian archaeology as this was a pre-urban region of Europe at the time, with no Roman urban tradition. Central places can be seen as nodal points in various peer-polity networks and the exchange of prestigious import goods.

174 Nielsen *et al* 1994.

175 Kyhlberg 1986; Larsson and Hårdh 1998; Adamsen *et al* 2008; Arrhenius and O'Meadhra 2011.

176 Pesch 2007.

177 Herschend 2009; Andersson 2012; see also, this volume, chapter 10, *Comparable assemblages?*, 353.

178 Horsnaes 2010; 2013.

179 Rau 2013a; 2013b.

180 Lind 1981.

181 Skaare 1976, 33; Talvio 1980, 48; Hellgren 2001; Kjellgren 2004.

182 Horsnaes 2010.

183 Fagerlie 1967; Herschend 1980; 1991; Kyhlberg 1986; Fischer 2005, 253, table 3; Metcalf 2010; Fischer *et al* 2011.

184 Fischer 2008.

185 Kyhlberg 1986.

186 Fischer and Lind 2015, table 4.

187 Axboe 2004.

188 Fischer 2005, 253–5.

189 Herschend 2001; Lamm 2005.

190 The *Tuna* place-names are thought to be indicative of legal assembly sites and manors associated with the early monarchy in this region: Fischer 2005, 254–6, table 6.

191 Fagerlie 1967.

192 Westermark 1983.

193 Nicolay 2014, 292–3.

194 Slomann and Christensen 1984; Lamm 2006.

195 Nicolay 2014, 65, table 4.1 and 73, fig 4.13.

196 Lamm 2006.

197 Watt 2008.

198 Herschend 2009; Fischer *et al* 2013.

199 Legoux 2011.

200 Hines 1993.

CHAPTER TEN
WHAT DOES IT MEAN?
ENDNOTES

1 Bradley 2017; Naylor and Bland 2015 showcase current debate, mainly with reference to Britain; differences of approach are also reflected in the contributions to this volume, chapter 9, 321–49.

2 Bradley 2017, 81.

3 Bruce-Mitford 1975, 718–19, 726–9.

4 Bradley 2017, 8–16.

5 For current approaches to interpreting Anglo-Saxon burials, see Dickinson 2011.

6 For an introductory overview of theories that underpin archaeological interpretation, see Johnson 2010.

7 See this volume, chapter 9, *Dating hoards of late Roman objects*, 330.

8 See this volume, chapter 2 *Characterising the Objects*, 32; also, chapter 4, *Damage*, 195.

9 See this volume, chapter 2, *Conclusion*, 118–19; also, chapter 7, *The contemporary context*, 293–5.

10 See this volume, chapter 8, *The early Anglo-Saxon period: graves and grave goods*, 302–6; Leahy 2015.

11 See this volume, chapter 2, *The social context, form and date of the helmet*, 84–5; *Objects associated with Christian worship and ceremony*, 116; also chapter 6, *Conclusion*, 280.

12 See this volume, chapter 8, *The early Anglo-Saxon period: graves and grave goods*, 304, and *Resources and their use: the contemporary value of the Hoard*, 314.

13 See this volume, chapter 5, *Figural ornament*, 245.

14 Härke 1992b, 97–121; Ager et al 2006, 19–20.

15 See this volume, chapter 2, *The typological and functional significance of the weapon-fittings*, 65; a minimum of 74 swords from the number of pommels, but over 100 on the basis of all the different hilt-fittings.

16 Hills in Webster et al 2011, 226–7.

17 Helgesson 2004; 2010, especially 111–12 and fig 11; Herschend 2009, 369–77; Fischer et al 2013, 115–19; see also this volume, chapter 9, *Precious metal hoards and central places*, 347.

18 See this volume, chapter 9, *Scandinavian hoarding*, 346.

19 See this volume, chapter 9, *Hoarding in continental Germanic Europe*, 344.

20 See this volume, chapter 9, *Hoarding in later Roman Britain and beyond*, 333.

21 See this volume, chapter 9, *Hoarding in later Roman Britain and beyond*, 331; Abdy 2006, 94; Abdy and Williams 2006, 13–14.

22 Behr and Pestell 2014; Charlotte Behr, pers comm, 14 Feb 2017.

23 Akerman 1855, pl xxxiii; Sutherland 1948; Abdy and Williams 2006, 18–19; Williams 2006, 173–6.

24 TAR 2015, 27 (T231); Pestell 2017, 208; Tim Pestell, pers comm, reported that by October 2018 the coin-finds had over 100.

25 Abdy and Williams 2006, 14, 17, 20–1; Williams 2006, 181–4; *TAR* 2017 (T1154); Gareth Williams and Ian Richardson, pers comm, 10 May 2018.

26 For swords: Leahy 2015, 122; and see this volume, chapter 2, *The typological and functional significance of the weapon-fittings*, 65; also, chapter 8, *The early Anglo-Saxon period: graves and grave goods*, 304; for bracteates: Behr and Pestell 2014, 68–71; for coins: Williams 2006, 161–4; Scull and Naylor 2016. As Fern observes (see this volume, chapter 6, *Kent, East Anglia and Greater Northumbria*, 276), the context of the Market Rasen hilt is particularly ambiguous: it is complete or nearly complete, but its pommel might have been levered off, and it was found right beside a river.

27 Naylor 2015.

28 See this volume, chapter 6, 257–79.

29 Leahy 2015.

30 See this volume, chapter 8, *Social hierarchy and its visibility*, 306–11, and *Resources and their use: the contemporary value of the Hoard*, 312–14; see also, chapter 9, *The status of gold in the later Roman world (and beyond)*, 329–30, and *Royal treasure, gift exchange and tribute*, 335–6; Reuter 2000; Stafford 2000; Scull 2011; Nicolay 2014, 2–11.

31 See this volume, chapter 2, *Hilt-plates and hilt-guards (cat. **243–409**, **696–7**)*, 47; also, chapter 4, *Modification and repair*, 194.

32 See this volume, chapter 5, *Ornament of the helmet and die-impressed sheet*, 245, and chapter 6, *Hoard Phase 3 (gold): Anglo-Saxon late Style II and contemporaneous objects, c 610– c 650*, 268.

33 See this volume, chapter 7, *Christian and pagan culture in the early seventh century*, 297; also, chapter 8, *Resources and their uses: the contemporary value of the Hoard*, 312.

34 See this volume, chapter 9, *The status of gold in later Roman Britain and beyond*, 330.

35 New evidence for Byzantine trade with East Anglia, arguably direct, comes from coin-finds at Rendlesham: Scull *et al* 2016, 1,603–4; the number of east Mediterranean objects in Sutton Hoo mound 1 has been increased by identification of Levantine bitumen: Burger *et al* 2016.

36 For example, in 655 Ecgfrith, son of Oswiu of Northumbria, was held as a hostage in Mercia; his cousin, Oethelwald, was also in Penda's retinue at this time: Bede, *HE* III.24 (Colgrave and Mynors 1969).

37 Stafford 2000, 64.

38 See this volume, chapter 6, *Conclusion*, 279–80; also, chapter 7, *The early Mercian kings*, 288–9.

39 Nicolay 2014, 376.

40 Hooke 2010.

41 Halsall 2003, 157–8, 190–1.

42 Ibid; see also this volume, chapter 7, *The early Mercian kings*, 288.

43 See this volume, chapter 7, *Christian and pagan culture in the early seventh century*, 297–8.

44 The best candidate is bird-fish mount **538**: see this volume, chapter 4, *Damage*, 202.

45 Halsall 2003, 161.

46 Gregory of Tours, *HF* v1.45 (Thorpe 1974); Stafford 2000, 61–6.

47 See this volume, chapter 7, *The early Mercian kings*, 288–9, and *Christian and pagan culture in the early seventh century*, 297–8.

48 Felix, *Vita sancti Guthlaci*, chapter 17; (Colgrave 1956): 'Et cum adversantium sibi urbes et villas, vicos et castella igne ferroque vastaret, conrasis undique diversarum gentium sociis, inmensas praedas gregasset, tunc velut ex divino consilio edoctus tertiam partem adgregatae gazae possidentibus remitttebat …'.

49 See this volume, chapter 2, *The Christian objects: function and significance*, 117–18.

50 See this volume, chapter 7, *The early Mercian kings*, 288, and *Conclusion*, 292.

51 See this volume, chapter 4, *Damage*, 195–203.

52 See this volume, chapter 3, *Organics and pastes*, 137.

53 See this volume, chapter 3, *Incising and punching*, 150.

54 Only two fragments are listed in the catalogue (**691**).

55 Painter 2013; see this volume, chapter 9, *Precious metal hoards and central places*, 348.

56 Bede, *HE* III.6 (Colgrave and Mynors 1969).

57 See this volume, chapter 4, *Wear*, 194, and *Damage*, 202–3.

58 Thus Hines in this volume, chapter 9, *Resources and their uses: the contemporary value of the Hoard*, 312.

59 See this volume, chapter 9, *The status of gold in the later Roman world (and beyond)*, 329–30.

60 Gregory of Tours, *HF* vi.42 (Thorpe 1974).

61 Harl 1996, 196.

62 Fredegar, *Chronicle* IV. 73 (Wallace-Hadrill 1960).

63 See this volume, chapter 8, *Resources and their use: the contemporary value of the Hoard*, 314.

64 Fischer *et al* 2013, 111.

65 See this volume, chapter 2, *The social context, form and date of the helmet*, 79; also, chapter 4, *Damage*, 202.

66 See this volume, chapter 7, *Christian and pagan culture in the early seventh century*, 297–8.

67 Stafford 2000, 65.

68 See this volume, chapter 7, *The early Mercian kings*, 288, and *Anglian connections*, 298. Kleinschmidt 2014 considers a similar rationale, but his detailed explanations are far-fetched and rely on a much later dating of the Staffordshire Hoard than is advanced in this volume.

69 Bradley 2017, 124–41.

70 Leahy *et al* 2011, 215; Kevin Leahy has been photographed holding a leather satchel as an example.

71 See this volume, chapter 1, *Fieldwork of 2009 and 2010*, 7–13; *Jones and Baldwin 2017.

72 See this volume, chapter 1, *The reliability of the finds context*, 24–7.

73 See this volume, chapter 1, *Aerial photography assessment*, 12; *Deegan 2013, 9 (paragraphs 3.3.9–10), app 3 APN and fig 2.

74 *Jones and Baldwin 2017, section 8.2; Gearey 2010.

75 *Pace* *Jones and Baldwin 2017, section 10.2.

76 Gearey 2010.

77 See this volume, chapter 1, *Fieldwork of 2009 and 2010*, 13; and *Jones and Baldwin 2017, sections 9.3 and 10.2. Note, however, that the single struck prehistoric flint in the fill of shallow gully [*4005*] and a single late medieval sherd in the lower fill [*4403*] of the field boundary ditch are insufficient to date those features. The former could have reached its findspot at any time, the latter as part of later manuring, like the small number of post-medieval sherds and the slag-like material: cf *Cool 2017b, 3–4.

78 Margary 1967, especially 291 (Watling Street, road 1h) and 305 (Ryknild Street, road 18c); see also, this volume, chapter 7, *The early Mercian kings*, 288, and *The findspot of the Staffordshire assemblage and the history of Mercia*, 291.

79 See this volume, chapter 1, *Fieldwork of 2009 and 2010*, 12–13; also, chapter 7, *The findspot of the Staffordshire assemblage and the history of Mercia*, 291; Hooke 2010; Leahy *et al* 2011, 205–8.

80 Blair 2013, especially figs 3 and 9, now much elaborated in Blair 2018; see this volume, chapter 6, *Mercia*, 273–6, and chapter 8, *The archaeology of early Mercia*, 315–19.

81 *Goodwin 2016, app 1c.

82 Abdy and Williams 2006: while most of the coins in their catalogue reflect English Channel and North Sea contacts as far north as the Shetlands, some, especially Byzantine copper issues, relate to Atlantic/Irish Sea exchange; south-west Mercia seems to have had access to neither.

83 See this volume, chapter 1, *Fieldwork of 2009 and 2010*, 12–13; chapter 7, *The findspot of the Staffordshire assemblage and the history of Mercia*, 291; also chapter 8, *The archaeology of early Mercia*, 317; Hooke 2010; Blair 2013; Roffe 2014.

84 As suggested by *Jones and Baldwin 2017, section 10.1. Of course, the extent to which light woodland, a characteristic of the area in general, existed on the ridge, obscuring or enhancing vegetation at the Hoard findspot itself, is not known.

85 Semple 2010; Haselgrove 2015, especially 36–7; Bradley 2017, 160–98.

86 Thus, Hines in this volume, chapter 8, *Resources and their use: the contemporary value of the Hoard*, 312.

AFTERWORD
ENDNOTES

1 For example, McLean and Richardson 2010.

2 See this volume, chapter 2, *The palaeography of the inscriptions*, 103–8.

3 See this volume, chapter 7, *The early Mercian kings*, 287, and chapter 8, *The archaeology of early Mercia*, 315–19.

4 Bede, *HE* 1.30 (Colgrave and Mynors 1969).

5 For previous analyses, see especially Hawkes 1997; Webster 2012a, especially 29–41.

6 Carver 2010 expresses similar sentiments from a pre-Staffordshire Hoard, but wider, perspective.

7 For an overview of these research programmes, see: *Weltweites Zellwerk / International Framework*, *Römisch-Germanisches Zentralmuseum*, Mainz n.d.; Calligaro and Périn 2013; *L'origine des grenats du haut moyen âge* (The Origin of Early Middle Age Garnets) 2017; see this volume, chapter 3, *Garnets*, 129–31.

8 See this volume, chapter 1, *Fieldwork of 2009 and 2010*, 7–13, and *Fieldwork of 2012*, 13; *Cool 2017b; cf Carver 2011.

9 To October 2016. Hoard-specific visitor figures available for all venues 2009–16, with two exceptions: a conservative estimate for Litchfield Cathedral is included based on visitor evaluation; the 2009 display at the British Museum is excluded because there is no reliable method for estimating Hoard-specific visits. All visitor data in this section compiled by the author from museums' internal data, not individually referenced.

10 Museum of London 2005, 49; Southend on Sea Borough Council 2013.

11 Shingler 2013 and pers comm 20 Sep 2016; Capper and Scully 2016, 188.

12 The Mercian Trail Partnership 2011a, 2 (internal report prepared in November 2011).

13 Alexander 2011a; 2011b; exhibition: *Anglo-Saxon Hoard: Gold from England's Dark Ages* (National Geographic Museum, Washington DC, October 2011– March 2012).

14 For example, TV documentaries: *Lost Gold of the Dark Ages* (National Geographic 2010); *Finding the Staffordshire Hoard* (BBC 2011); *Secrets of the Saxon Gold* (Channel 4 2012).

15 2 Arena Central, Birmingham City Council Planning Application 2015/01113/PA (now renamed 1 Centenary Square).

16 For example, the Lunder Conservation Centre, Washington DC, opened in 2006 and providing the first ever permanent 'glass wall' public access to fine art conservation; see also Brooks 2008.

17 See Brooks and Cane 1994; Cane *et al* 2014.

18 Ibid.

19 Archaeological Institute of America 2013.

20 Anon 2015, 11.

21 Birmingham Museums Trust 2015; Potteries Museum education officer pers comm 21 Jan 2017.

22 *The Hallaton Treasure*: travelling exhibition Harborough Museum, Leicestershire County Council.

23 Senior Museums Officer, Staffordshire County Council pers comm 9 Dec 2016.

24 Bland 2008, 69.

25 Score 2011, 165.

26 The Mercian Trail Partnership 2011b, 1.

27 Staffordshire Hoard n.d. Note these are visits (not hits, which would be far greater).

28 James 2011, 1071.

29 BBC News 2014.

30 *Cool 2017a.

31 Director of Development, Art Fund, pers comm 30 Nov 2016.

32 Peacock 2016; *Daily Record* 2017; University of Leicester n.d.

33 Visitor evaluation data gathered during production of the exhibition 'Warrior Treasures: Saxon Gold from the Staffordshire Hoard' 2016, and Tamworth Castle redevelopment project 2015.

34 Staffordshire Hoard was the highest specific reason for visiting BMAG in summer/winter surveys 2016: *Birmingham Museums Trust Audience Research 2016* (internal report prepared by Bluegrass Research for Birmingham Museums Trust); PMAG figures show a slight drop since 2014 due to the opening of BMAG's permanent gallery, but the museum will address this with their own gallery redevelopment: PMAG Museums Manager, pers comm, 17 Feb 2017.

35 Capper and Scully (2016, 184) discuss the ceramic industry in the Potteries; Birmingham's metalworking trades might deliver a similar context.

36 For example, *The Sentinel* 2011.

37 For one example (of many) of cross-disciplinary responses to the collection, see Overbey and Williams 2016.

38 Indeed, it seems to have played some part in inspiring the very popular and well-reviewed BBC Four series, *Detectorists*, in which the search for a gold hoard is a recurrent theme.

39 Lewis 2012, 5.

40 Carver 2011, 230; Lewis 2016, 133; see this volume, chapter 1, *The reliability of the finds context*, 24–6.

41 See this volume, chapter 1, *Acquisition, funding and project organisation*, 13–16.

42 Lewis 2016, 133; and author's personal observation.

43 Lewis 2016, 133.

44 See this volume, *Afterword, The impact of the Hoard*, 364–6.

45 For example, Wakefield 2014.

BIBLIOGRAPHY

ABBREVIATIONS

BAR British Archaeological Reports

CLA Lowe, E A (ed) 1934–72. *Codices Latini Antiquiores: a palaeographical guide to Latin manuscripts prior to the ninth century*, The Clarendon Press, Oxford (eleven volumes plus *Supplement* with second edition of volume II)

HE Bede, *Historia Ecclesiastica*

HF Gregory of Tours, *Historia Francorum*

NH Pliny, *Natural History*

NIS 2007. *Novum Inventorium Sepulchrale: Kentish Anglo-Saxon graves and grave goods in the Sonia Hawkes Archive*, <http://inventorium.arch.ox.ac.uk/gravegood.php> (accessed 30 May 2017)

PAS Portable Antiquities Scheme

RGA Beck, H, Geunich, D and Steuer, H (eds) 1972–2008. *Reallexikon der Germanischen Altertumskunde*, De Gruyter, Berlin and New York (thirty-five volumes).

TAR *Treasure Annual Report*, Department for Culture, Media and Sport, London

1998/1999 *Treasure Annual Report* (published 2000)

2002 *Treasure Annual Report 2002* (published 2004)

2003 *Treasure Annual Report 2003* (published 2004)

2004 *Treasure Annual Report 2003* (published 2007)

2005/6 *Treasure Annual Report 2005/6* (published 2008)

2015 *Treasure Annual Report 2015* (published 2017)

2017 *Treasure Annual Report 2017* (forthcoming)

A

Abdy, R 2002. *Romano-British Coin Hoards*, Shire Archaeology, Princes Risborough

Abdy, R 2006. 'After Patching: imported and recycled coinage in fifth- and sixth-century Britain', in Cook and Williams 2006, 75–95

Abdy, R 2013. 'The Patching hoard', in Hunter and Painter 2013, 107–15

Abdy, R and Williams, G 2006. 'A catalogue of hoards and single finds from the British Isles *c* 410–675', in Cook and Williams 2006, 11–74

Adams, K 2014. 'GLO-51DC59: an early medieval buckle', <https://finds.org.uk/database/artefacts/record/id/641070> (accessed 30 May 2017)

Adams, N 1991. 'Late Antique, Migration period and early Byzantine garnet cloisonné ornaments: origins, styles and workshop production', unpublished PhD thesis, University College London

Adams, N 2000. 'The development of early garnet inlaid ornaments', in C Bálint (ed), *Kontakte zwischen Iran, Byzanz und der Steppe im 6–7 Jahrhundert*, 13–70, Varia Archaeologica Hungarica 10, Budapest

Adams, N 2006. 'Back to front: observations on the development and production of decorated backing foils for garnet cloisonné', *Hist Metall*, **40** (1), 12–26

Adams, N 2010. 'Rethinking the Sutton Hoo shoulder clasps and armour', in C Entwistle and N Adams (eds), *'Intelligible Beauty': recent research on Byzantine jewellery*, 83–112, British Museum Research Publication 178, London

Adams, N 2011a. 'Earlier or later? The rectangular cloisonné buckle from Sutton Hoo mound 1 in context', in Brookes *et al* 2011, 20–32

Adams, N 2011b. 'The garnet millennium: the role of seal stones in garnet studies', in C Entwistle and N Adams (eds), *'Gems of Heaven': recent research on engraved gemstones in late Antiquity, AD 200–600*, 10–24, British Museum Research Publication 177, London

Adamsen, C, Lund Hansen, U, Nielsen, F O and Watt, M (eds) 2008. *Sorte Muld: wealth, power and religion at an Iron Age central settlement on Bornholm*, Bornholms Museum, Rønne

Ager, B 2012. 'Swords', in Parfitt and Anderson 2012, 49–56

Ager, B and Gilmore, B 1988. 'A pattern-welded Anglo-Saxon sword from Acklam Wold, North Yorkshire', *Yorkshire Archaeol J*, **60**, 13–23

Ager, B, Cameron, E, Spain, S and Riddler, I 2006. *Early Anglo-Saxon Weaponry from Saltwood Tunnel, Kent*, CTRL Specialist Report Series, Archaeological Data Service, York, <doi.org/10.5284/1000230>

Aillagon, J-J (ed) 2008. *Rome and the Barbarians: the birth of a new world*, Skira, Milan

Aimone, M 2008. 'The treasure of Desana (Italy)', in Aillagon 2008, 378–9

Akerman, J Y 1855. *Remains of Pagan Saxondom,* John Russell Smith, London

Akhmedov, I R 2007. 'The S. V. Karakovskiy collection', in W Menghin (ed), *The Merovingian Period: Europe with borders: archaeology and history of the 5th to 8th centuries*, 78–82, Minerva, Berlin

Alcock, L 1963. *Dinas Powys: an Iron Age, Dark Age and early medieval settlement in Glamorgan*, University of Wales Press, Cardiff

Alexander, C 2011a. 'Magical mystery hoard', in *Natl Geogr,* **220** (5), 38–61

Alexander, C 2011b. 'Lost Gold of the Dark Ages: war, treasure and the mystery of the Saxons', *National Geographic*, Washington DC

Alexander, J 1978. *Insular Manuscripts, Sixth to the Ninth Century: a survey of manuscripts illuminated in the British Isles. Volume 1*, Harvey Miller, London and New York

Alföldi, A 1934. 'Eine spätrömische Helmform und ihre Schicksale im Germanisch Romanischer Mittelalter', *Acta Archaeol*, **5**, 99–144

Alkemade, M 1991. 'A history of Vendel period archaeology: observations on the relationship between written sources and archaeological interpretation', in A Roymans and F Theuws (eds), *Images of the Past,* 267–97, Amsterdam University Press, Amsterdam

Almgren, B 1948. 'Romerska drag i nordisk figurkonst från folkvandringstiden', *Tor,* **1**, 81–3

Almgren, B 1983. 'Helmets, crowns and warriors' dress: from the Roman emperors to the chieftains of Uppland', in Lamm and Nordström 1983, 11–16

Althoff, G 1987. 'Der frieden-, bündnis- und gemeinschaftsstiftende Charakter des Mahles im früheren Mittelalter', in I Bitsch (ed), *Essen und Trinken in Mittelalter und Neuzeit,* 13–25, Thorbecke, Sigmaringen

Ambrosiani, B 1983. 'Regalia and symbols in the boat-graves', in Lamm and Nordström 1983, 23–9

Andersson, K 1995. *Romartida Guldsmide i Norden. III: Övriga Smycken, Teknisk Analys och Verkstadsgrupper*, Uppsala University, Stockholm

Andersson, O 2012. 'Spjuten från Uppåkra – ritualförstörda eller förbrukade?', *Fornvännen,* **107**, 80–8

Anon 2015. 'The conservation awards', *Icon News: the Magazine of the Journal of the Institute of Conservation,* **61**, 8–13

Anon 2016. 'Crisis or continuity? Hoarding and deposition in Iron Age and Roman Britain and beyond: report on the "Hoarding and Deposition in Iron Age and Roman Britain, and Beyond" international conference, British Museum, 11–12 March 2016', <https://www2.le.ac.uk/departments/archaeology/research/previous-research-projects/hoarding-in-iron-age-and-roman-britain/crisis-or-continuity-hoarding-and-deposition-in-iron-age-and-roman-britain-and-beyond> (accessed 28 March 2018)

Anon PAS 2010. 'NMS-Z32B24: an early medieval scabbard', <https://finds.org.uk/database/artefacts/record/id/399208> (accessed 29 May 2017)

Antikenmuseum Berlin 1988. *Die ausgestellten Werke*, Staatliche Museen Preussischer Kulturbesitz, Berlin

Appadurai, A (ed) 1986. *The Social Life of Things: commodities in cultural perspective,* Cambridge University Press, Cambridge

Archaeological Institute of America 2013. 'AIA names 2014 Conservation and Heritage Management Award recipient', <https://www.archaeological.org/news/aianews/14276> (accessed 16 March 2018)

Archer, S 1979. 'Late Roman gold and silver coin hoards in Britain: a gazetteer', in P J Casey (ed), *The End of Roman Britain,* 29–62, BAR Brit Ser 71, Archaeopress, Oxford

Archibald, M 2013. 'The Wilton cross coin pendant: numismatic aspects and implications', in Reynolds and Webster 2013, 51–71

Arnold, C J 1982. *The Anglo-Saxon Cemeteries of the Isle of Wight,* British Museum Publications, London

Arnold, C J 1988. *An Archaeology of the Early Anglo-Saxon Kingdoms*, Routledge, London

Arrhenius, B 1977. 'Metallanalysen von Goldbrakteaten: Vorbericht über ein laufendes Forschungsprojekt', *Frühmittelalterliche Studien,* **11**, 74–84

Arrhenius, B 1983. 'The chronology of the Vendel graves', in Lamm and Nordström 1983, 39–70

Arrhenius, B 1985. *Merovingian Garnet Jewellery: emergence and social implications,* Almqvist & Wiksell International, Stockholm

Arrhenius, B and O'Meadhra, U (eds) 2011. *Excavations at Helgö XVIII: conclusions and new aspects,* Kungliga Vitterhets, Historie och Antikvitets Akademien, Stockholm

Art Fund n.d. 'The Staffordshire Hoard', <http://www.artfund.org/supporting-museums/art-weve-helped-buy/artwork/11078/staffordshire-hoard-anglo-saxon> (accessed 16 April 2016)

Art Fund 2010. 'The battle to save the Staffordshire Hoard', 3 June, <http://www.artfund.org/staffordshire_hoard/news_and_events/39/celebrities_gather_to_celebrate_staffordshire_hoard_acquisition> (accessed 16 April 2016)

Arwidsson, G 1942. *Die Gräberfunde von Valsgärde. I: Valsgärde 6*, Almqvist & Wiksell, Uppsala

Arwidsson, G 1954. *Die Gräberfunde von Valsgärde. II: Valsgärde 8*, Almqvist & Wiksell, Uppsala

Arwidsson, G 1977. *Die Gräberfunde von Valsgärde. III: Valsgärde 7*, Almqvist & Wiksell, Uppsala

Ashbee, C R 1967. *The Treatises of Benvenuto Cellini on Goldsmithing and Sculpture*, Dover Publications, New York

Ashley, S 2015. 'NMS-40A7A7: an early medieval mount', <https://finds.org.uk/database/artefacts/record/id/732160> (accessed 31 May 2017)

Atherton, R 2006. 'DENO-A99037: an early medieval brooch', <https://finds.org.uk/database/artefacts/record/id/135694> (accessed 5 May 2017)

Atherton, R 2009. 'DENO-08BD33: an early medieval scabbard', <https://finds.org.uk/database/artefacts/record/id/263461> (accessed 3 May 2017)

Aufderhaar, I 2012. 'What would a goldsmith's workshop look like in theory?', in Pesch and Blankenfeldt 2012, 87–100

Aufleger, M 1996. 'Metalarbeiten und Metallverarbeitung', in Wieczorek *et al* 1996, 618–28

Avent, R 1975. *Anglo-Saxon Disc and Composite Brooches*, 2 vols, BAR Brit Ser 11, Archaeopress, Oxford

Avent, R and Leigh, D 1977. 'A study of cross-hatched gold foils in Anglo-Saxon jewellery', *Mediev Archaeol*, **21**, 1–46

Axboe, M 1987. 'Copying in Antiquity: the Torslunda plates', *Studien zur Sachsenforschung*, **6**, 13–21

Axboe, M 2004. *Die Goldbrakteaten der Völkerwanderungszeit: Herstellungsprobleme und Chronologie*, Ergänzungsbände zum Reallexikon der germanischen Altertumskunde 38, De Gruyter, Berlin and New York

B

Baker, J and Brookes, S 2013. *Beyond the Burghal Hidage: Anglo-Saxon civil defence in the Viking Age*, History of Warfare 84, Brill, Leiden and Boston

Baker, J and Brookes, S 2016. 'Explaining Anglo-Saxon military efficiency: the landscape of mobilisation', *Anglo-Saxon England*, **44**, 221–58

Ballmer, A 2010. 'Zur Topologie des bronzezeitlichen Deponierens: von der Handlungstheorie zur Raumanalyse', *Praehistorische Zeitschrift*, **85**, 120–31

Bamburgh Research Project n.d. <http://bamburghresearchproject.co.uk/?page_id=608> (accessed 14 August 2016)

Baratte, F (ed) 1988. *Argenterie Romaine et Byzantine,* De Boccard, Paris

Bardiès-Fronty, I 2008. 'The cross of Guarrazar (Spain)', in Aillagon 2008, 368–9

Bardiès-Fronty, I, Denoël, C and Villela-Petit, I 2016. *Les Temps Merovingiens : trois siècles d'art et de culture*, Musée de Cluny, Paris

Barker, P, White, R, Pretty, K, Bird, H and Corbishley, M 1997. *The Baths Basilica Wroxeter Excavations: 1966–90,* English Heritage Archaeol Rep 8, English Heritage, London

Barton, C 2011. 'PAS-742D06: an early medieval unidentified object', <https://finds.org.uk/database/artefacts/record/id/463043> (accessed 29 May 2017)

Basford, F 2007. 'IOW-3AB946: an early medieval die stamp', <https://finds.org.uk/database/artefacts/record/id/196070> (accessed 30 May 2017)

Bassett, S (ed) 1989. *The Origins of Anglo-Saxon Kingdoms,* Leicester University Press, London

Bassett, S 1992. 'Church and diocese in the West Midlands: the transition from British to Anglo-Saxon control', in J Blair and R Sharpe (eds), *Pastoral Care before the Parish,* 13–40, Leicester University Press, Leicester

Bassett, S 2000. 'How the west was won: the Anglo-Saxon takeover of the West Midlands', *Anglo-Saxon Stud Archaeol Hist*, **11**, 107–18

Bassett, S 2008. 'The Middle and Late Saxon defences of western Mercian towns', *Anglo-Saxon Stud Archaeol Hist*, **15**, 180–23

Bateman, T 1861. *Ten Years' Diggings in Celtic and Saxon Grave Hills in the Counties of Derby, Stafford and York, from 1848–1858,* J R Smith, London

Bayley, J 1989. *A Suggested Nomenclature for Copper Alloys*, Ancient Monuments Lab Rep 80/89, English Heritage, Fort Cumberland

Bayley, J and Russel, A 2008. 'Making gold-mercury amalgam: the evidence for gilding from Southampton', *Antiq J* **88**, 37–42

Bayliss, A, Hines, J, Høilund Nielsen, K, McCormac, G and Scull, C 2013. *Anglo-Saxon Graves and Grave Goods of the 6th and 7th centuries AD: a chronological framework,* Soc Medieval Archaeol Monogr 33, Society for Medieval Archaeology, London

BBC News 2009. 'Huge Anglo-Saxon gold hoard found', 24 September, <http://news.bbc.co.uk/1/hi/england/staffordshire/8272058.stm> (accessed 4 May 2016)

BBC News 2013. 'Staffordshire Hoard inquest rules most new items treasure', 4 January 2013, <http://www.bbc.co.uk/news/uk-england-stoke-staffordshire-20903152> (accessed 4 May 2016)

BBC News 2014. 'Staffordshire Hoard finds together for the first time', 12 March 2014, <http://www.bbc.co.uk/news/uk-england-stoke-staffordshire-26545511> (accessed 18 May 2018).

Beagrie, N 1989. 'The Romano-British pewter industry', *Britannia*, **20**, 169–200

Behr, C 2010. 'The symbolic nature of gold in magical and religious contexts', in Geake 2010, <https://finds.org.uk/staffshoardsymposium/papers/charlottebehr> (accessed 20 March 2012)

Behr, C and Pestell, T 2014. 'The bracteate hoard from Binham: an early Anglo-Saxon central place?', *Medieval Archaeol,* **58**, 44–77

Berdeaux-Le Brazidec, M-L and Hollard, D 2008. 'Le depot de siliques à Bedeilhac-et-Aynat (Ariege) : un temoin de la presence des troupes de Constantin III (407–411) dans les Pyrenees?', *Cahiers Numismatiques*, **177**, 21–34

Berger, F 1991. 'Artikel Freren: Lohe (Lengerich) EL', in H-J Hässler (ed), *Ur- und Frühgeschichte in Niedersachsen*, 424, Konrad Theiss Verlag, Stuttgart

Berghaus, P 1986. 'Dortmund', *RGA*, **6**, 124–7

Berghaus, P 2000. 'Ilanz', *RGA*, **15**, 340–3

Bernhard, H, Engels, H-J, Engels, R and Petrovszky, R 1990. *Der römische Schatzfund von Hagenbach*, Römisch-Germanisches Zentralmuseum, Mainz

Besteman, J C, Bos, J M, Gerrets, D A, Heidinga, H A and de Koning, J (eds), 1999. *The Excavations at Wijnaldum. Vol 1: reports on Frisia in Roman and medieval times*, Balkema, Rotterdam

Biborski, M, Jagodziński, M F, Pudło, P, Stępiński, J and Żabiński, G 2010. 'Sword parts from a Viking Age emporium of Truso in Prussia', *Waffen- und Kostümkunde: Zeitschrift für Waffen- und Kleidungsgeschichte*, **52**(1), 19–70

Bierbrauer, V 1975. *Die ostgotischen Grab- und Schatzfunde in Italien*, Biblioteca degli Studi Medievali 7, Centro Italiano di Studi Sull'alto Medioevo, Spoleto

Bierbrauer, V, Hessen, O v, Arslan, E A (eds) 1994, *I Goti*, Electa Lombardia, Milan

Birbeck, V, Smith, R J C, Andrews, P and Stoodley, N 2005. *The Origins of Mid-Saxon Southampton: excavations at the Friends Provident St Mary's Stadium 1998–2000*, Wessex Archaeology Report 20, Wessex Archaeology, Salisbury

Birch Iversen, R 2010. *Kragehul Mose*. Jysk Arkæologisk Selskab, Aarhus University Press, Aarhus

Birmingham Archaeology 2010. *Staffordshire Hoard: Archaeological Recovery 2009*, Birmingham Archaeology Report Project 1971

Birmingham Museum & Art Gallery n.d. 'Visitor figures 2009–2010', BMAG, Birmingham (internal report prepared for museum use)

Birmingham Museums Trust 2015. 'Staffordshire Hoard Gallery: final evaluation report, June 2015 (internal report prepared by Birmingham Museums Trust for Heritage Lottery Fund)

Biró-Sey, K 1970/71. 'Der frühbyzantinische Solidus-Fund von Szikáncs', *Jahrbuch der Staatlichen Kunstsammlungen in Dresden*, 177–86

Biró-Sey, K 1988. 'Beziehungen der Hunnen zu Byzanz im Spiegel der Funde von Münzen des 5. Jahrhunderts in Ungarn', in *Popoli delle Steppe: Unni, Avari, Ungari = Settimane di Studio del Centro italiano di studi sull'alto medioevo*, **35**, 413–31, Presso la Sede del Centro, Spoleto

Bischoff, B and Lapidge, M 1994. *Biblical Commentaries from the Canterbury School of Theodore and Hadrian*, Cambridge Stud Anglo-Saxon England 10, Cambridge University Press, Cambridge

Bistuer, F 1984. 'Estudi sobre un tresoret de siliques dels emperadors Honori, Gracia I Maxim Tira', *Acta Numismàt*, **14**, 135–8

Blackburn, M 2003. '"Productive sites" and the pattern of coin loss in England, 600–1180', in T Pestell and K Ulmschneider (eds), *Markets in Early Medieval Europe: trading and 'productive' sites, 650–850*, 20–36, Windgather Press, Macclesfield

Blackmore, L 2006. *The Small Finds from Cuxton Anglo-Saxon Cemetery, Kent (ARC CXT98) Channel Tunnel Rail Link Section 1* (data-set). Archaeology Data Service, York, <doi.org/10.5284/1000230> (direct link: <http://archaeologydataservice.ac.uk/catalogue/adsdata/arch-335-1/dissemination/pdf/PT2_Spec_Reps/03_Small_finds/B_SFS_research_reports/SFS_SmallFinds_Text/SFS_CXT_text.pdf> (accessed 20 June 2018)

Blackmore, L, Blair, I, Hirst, S and Scull, C 2019. *The Prittlewell Princely Burial: excavations at Priory Crescent, Southend-on-Sea, Essex, 2003*, MOLA Monogr Ser 73, Museum of London Archaeology, London

Blackwell, A 2007. 'An Anglo-Saxon figure-decorated plaque from Ayton (Scottish Borders), its parallels and implications', *Medieval Archaeol*, **51**, 165–72

Blackwell, A 2010. 'Anglo-Saxon Dunbar, East Lothian: a brief reassessment of the archaeological evidence and some chronological implications', *Medieval Archaeol*, **54**, 361–71

Blades, N W 1995. 'Copper alloys from English archaeological sites 400–1600 AD: an analytical study using ICP-AES', unpublished PhD thesis, Royal Holloway University of London

Blair, J 2011. 'Flixborough revisited', *Anglo-Saxon Stud Archaeol Hist*, **17**, 101–7

Blair, J 2013. *The British Culture of Anglo-Saxon Settlement*, H M Chadwick Memorial Lectures 24, Department of Anglo-Saxon, Norse and Celtic, University of Cambridge, Cambridge

Blair, J 2018. *Building Anglo-Saxon England*, Princeton University Press, Princeton and Oxford

Blakelock, E S 2013. *Pilot Study of Surface Enrichment in a Selection of Gold Objects from the Staffordshire Hoard*, Staffordshire Hoard Res Rep 6, Archaeological Data Service, York, <doi.org/10.5284/1041576>

Blakelock, E S 2014. *Phase 2 of the Analysis of Selected Items from the Staffordshire Hoard and of Contemporary Anglo-Saxon Objects from the British Museum and Stoke-on-Trent Potteries Museum and Art Gallery: a study of gold compositions and surface enrichment*, Staffordshire Hoard Res Rep 9, Archaeological Data Service, York, <doi.org/10.5284/1041576>

Blakelock, E S 2015a. *XRF Study of the Silver Objects from the Staffordshire Hoard*, Staffordshire Hoard Res Rep 19, Archaeological Data Service, York, <doi.org/10.5284/1041576>

Blakelock, E S 2015b. *Pilot XRF Study of the Silver Hilt-plates from the Staffordshire Hoard*, Staffordshire Hoard Res Rep 18, Archaeological Data Service, York, <doi.org/10.5284/1041576>

Blakelock, E S 2015c. *Examination of Cross Sections through a Selection of Gold Objects from the Staffordshire Hoard*, Staffordshire Hoard Res Rep 22, Archaeological Data Service, York, <doi.org/10.5284/1041576>

Blakelock, E S 2016a. 'Never judge a gold object by its surface analysis: a study of surface phenomena in a selection of gold objects from the Staffordshire Hoard', *Archaeometry*, **58** (6), 912–29

Blakelock, E S 2016b. *The XRF Analysis of the Copper Alloy Objects and Fragments in the Staffordshire Hoard*, Staffordshire Hoard Res Rep 20, Archaeological Data Service, York, <doi.org/10.5284/1041576>

Blakelock, E S 2016c. *The Analysis and Documentation of Niello Objects in the Staffordshire Hoard*, Staffordshire Hoard Res Rep 21, Archaeological Data Service, York, <doi.org/10.5284/1041576>

Blakelock, E S, Fern, C and La Niece, S 2016. 'Secrets of the Anglo-Saxon goldsmiths: analysis of gold objects from the Staffordshire Hoard', *J Archaeol Sci*, **72**, 44–56

Blakelock, E S, Mongiatti, A and La Niece, S. 2013. 'Scientific investigation of an Anglo-Saxon sword hilt from Cumberland (1876,0717.1)', British Museum Sci Rep AR2012-211, Department of Conservation and Scientific Research, British Museum, London

Bland, R 2008. 'The development and future of the *Treasure Act* and Portable Antiquities Scheme', in S Thomas and P Stone (eds), *Metal Detecting and Archaeology*, 63–85, The Boydell Press, Woodbridge

Bland, R 2015. 'Hoarding in Britain from the Bronze Age to the 20th century', in Naylor and Bland 2015, 1–20

Bland, R and Johns, C 1994. *The Hoxne Treasure: an illustrated introduction*, British Museum Press, London

Bland, R and Loriot, X 2010. *Roman and Early Byzantine Gold Coins found in Britain and Ireland*, Royal Numismatic Society, London

Bland, R, Bryant, S, Chadwick, A, Garland, N, Ghey, E, Haselgrove, C, Mattingly, D, Moorhead, S, Robbins, K, Rogers, A and Taylor, J (forthcoming). *Iron Age and Roman Coin Hoards in Britain*, Oxbow Books, Oxford

Bleicher, W 2000. 'Über die Scheibenfibel des Grabes 106 vom merowingerzeitlichen Gräberfeld am „Lübecker Ring" in Soest', *Hohenlimburger Heimatblätter*, **61**, 81–95

Blockley, R C 1983. *The Fragmentary Classicising Historians of the Later Roman Empire: Eunapius, Olympiodorus, Priscus and Malchus. Part 2: text, translation and historiographical notes*, Francis Cairns, Liverpool

Bock, F 1868. 'Der Schatz des Westgothenkönigs Athanarich, gefunden im Jahr 1837 zu Petreosa in der Grossen Walachei', *Mittheilungen der Central Commission Vienna*, **13**, 105–24

Böhme, H W 1995. 'Archäologische Zeugnisse zur Geschichte der Markomannenkriege (166–180 n. Chr.)', in Kollegium des Römisch Germanischen Zentralmuseums (ed), *Festschrift für Hans-Jürgen Hundt zum 65. Geburtstag, Volume 2: Römerzeit (= Jahrbuch des Römisch Germanischen Zentralmuseums Mainz*, **22**), 153–217, Rudolf Habelt, Bonn

Böhner, K 1976/77. 'Die Reliefplatten von Hornhausen', *Jahrbuch des Römisch-Germanischen Zentralmuseums Mainz*, **23/24**, 89–138

Böhner, K and Quast, D 1994. 'Die merowingerzeitlichen Grabfunde aus Pliezhausen, Kreis Reutlingen', *Fundberichte aus Baden-Württemberg*, **19** (1), 383–419

Bolla, M 2008. 'The treasure of Isola Rizza (Italy)', in Aillagon 2008, 392–3

Bóna, I 1991. *Das Hunnenreich*, Theiss, Stuttgart

Boor, H de 1979. *Das Nibelungenlied*, nach der Ausgabe von K Bartsch, Deutsche Klassiker des Mittelalters 21, F A Brockhaus, Wiesbaden

Bosworth, J and Toller, T N 1898/1921. *An Anglo-Saxon Dictionary*, 2 vols, Oxford University Press, Oxford

Bott, H 1976/77. 'Zur Datierung der Funde aus Hammersdorf, Ostpreussen', *Jahrbuch des Römisch Germanischen Zentralmuseums Mainz*, **23/24**, 139–53

Bourdieu, P 1980 (trans 1993). *Sozialer Sinn: Kritik der theoretischen Vernunft*, trans G Seib, Suhrkamp, Frankfurt am Main

Bourke C, 2009. 'The shrine of St Gwenfrewi from Gwytherin, Denbighshire: an alternative interpretation', in N Edwards (ed), *The Archaeology of the Early Medieval Celtic Churches*, 375–88, Soc Medieval Archaeology Monogr 29, Maney, Leeds

Boyle, A, Jennings, D, Miles, D and Palmer, S 1998. *The Anglo-Saxon Cemetery at Butler's Field, Lechlade, Gloucestershire. Volume 1: prehistoric and Roman activity and Anglo-Saxon grave catalogue*, Thames Valley Landscapes Monogr 1, Oxford Archaeology Unit, Oxford

Bradley, R 2017. *A Geography of Offerings: deposits of valuables in the landscape of ancient Europe*, Oxbow Books, Oxford and Philadelphia

Bradley, S A J (trans and ed) 1995. *Anglo-Saxon Poetry*, The Everyman Library, Dent, London

Brandenburg, H 2005. *Ancient Churches of Rome*, Brepols, Turnhout

Breay, C and Meehan, B (eds) 2015. *The St Cuthbert Gospel: studies on the Insular manuscript of the Gospel of John*, The British Library, London

Brindle, T 2011. 'WMID-599B28: an early medieval unidentified object',<https://finds.org.uk/database/artefacts/record/id/425131> (accessed 1 June 2017)

Briscoe, D 2011. 'Continuity in Cambridge? Pot-stamp evidence for continuity from the fourth to fifth centuries AD', in Brookes *et al* 2011, 7–13

Briscoe, T 1983. 'A classification of Anglo-Saxon pot stamp motifs and proposed terminology', *Studien zur Sachsenforschung*, **4**, 57–71

British Geological Survey nd. 'Natural Environment Research Council', <http://www.bgs.ac.uk/> (accessed 15 March 2017)

Brookes, S, Harrington, S and Reynolds, A (eds) 2011. *Studies in Early Anglo-Saxon Art and Archaeology: papers in honour of Martin G. Welch*, BAR Brit Ser 527, Archaeopress, Oxford

Brooks, M M 2008. 'Talking to ourselves: why do conservators find it so hard to convince others of the significance of conservation?', in J Bridgland (ed), *15th Triennial Conference, New Delhi, 22–26 September 2008: preprints*, 1135–40, ICOM-CC, International Council of Museums, Paris

Brooks, M M and Cane, S 1994. 'Stop the rot, York Castle Museum: creating an exhibition on museum conservation', in J Sage (ed), *Exhibitions and Conservation: preprints of the SSCR conference held in Edinburgh 21 and 22 April 1994*, 35–44, Scottish Society for Conservation and Restoration, Edinburgh

Brooks, N 1989. 'The formation of the Mercian kingdom', in Bassett 1989, 159–70

Brown, D 1972. 'The brooches in the Pietroasa Treasure', *Antiquity*, **46**, 111–16

Brown, G H 2009. 'From the wound in Christ's side to the wound in his heart: progression from male exegesis to female mysticism', in C Karkov (ed), *Poetry, Place and Gender: studies in medieval culture in honor of Helen Damico*, 252–74, Medieval Institute Publications, Western Michigan University, Kalamazoo, Michigan

Brown, M P 1993. '"Paten and purpose": the Derrynaflan paten inscriptions', in Spearman and Higgitt 1993, 162–7

Brown, M P 2006. *In the Beginning: bibles before the year 1000*, Smithsonian Books, Washington

Brown, M P 2010. 'The manuscript context for the inscription', in Geake 2010, <https://finds.org.uk/staffshoardsymposium/papers/michellebrown> (accessed 4 May 2017)

Brown, M P 2012. 'Writing in the Insular world', in R Gameson (ed), *The Cambridge History of the Book in Britain. Vol I: c 400-1100*, 121–66, Cambridge University Press, Cambridge

Brown, M P 2013. 'Mercian manuscripts: the implications of the Staffordshire Hoard, other recent discoveries, and the "New Materiality"', in E Kwakkel (ed), *Writing in Context: Insular manuscript culture 500–1200*, 23–64, Leiden University Press, Leiden

Brown, M P and Farr, C (eds) 2001. *Mercia: an Anglo-Saxon kingdom in Europe*, Leicester University Press, London

Brown, P D C and Schweizer, F 1973. 'X-ray fluorescent analysis of Anglo-Saxon jewellery', *Archaeometry*, **15**, 175–92

Brown, T J 1982. 'The Irish element in the Insular system of scripts to circa AD 850', in H Löwe (ed), *Die Iren und Europa im frühen Mittelalter. Vol I*, 101–19, Klett-Cotta, Stuttgart (reprinted 1993 in J Bately, M P Brown and J Roberts (eds), *A Palaeographer's View: selected papers of Julian Brown*, 221–41, Harvey Miller Publishers, London)

Bruce-Mitford, R L S 1956. 'The pectoral cross', in C F Battiscombe (ed), *The Relics of St Cuthbert: studies by various authors*, 308–25, Oxford University Press for the Dean and Chapter of Durham Cathedral, Oxford

Bruce-Mitford, R L S 1967. 'The gold cross from Thurnham, Kent', *Antiq J*, **47** (2), 290–91

Bruce-Mitford, R L S 1972. *The Sutton-Hoo Ship-burial: a handbook*, 2nd edn, Trustees of the British Museum, London

Bruce-Mitford, R L S 1974. *Aspects of Anglo-Saxon Archaeology: Sutton Hoo and other discoveries*, Victor Gollancz, London

Bruce-Mitford, R L S 1975. *The Sutton Hoo Ship-Burial. Volume 1: excavations, background, the ship, dating and inventory*, British Museum Press, London

Bruce-Mitford, R L S 1978. *The Sutton Hoo Ship-Burial. Volume 2: arms, armour and regalia*, British Museum Press, London

Bruce-Mitford, R L S 1983. *The Sutton Hoo Ship-Burial. Volume 3: late Roman and Byzantine silver, hanging-bowls, drinking vessels, cauldrons and other containers, textiles, the lyre, pottery bottle and other items*, 2 vols, British Museum Press, London

Bruce-Mitford, R L S and Luscombe, M R 1974. 'The Benty Grange helmet', in Bruce-Mitford 1974, 223–52

Bruce-Mitford, R and Raven, S 2005. *The Corpus of Late Celtic Hanging-Bowls with an Account of the Bowls found in Scandinavia*, Oxford University Press, Oxford

Brugmann, B 2004. *Glass Beads from Early Anglo-Saxon Graves*, Oxbow, Oxford

Brundle, L 2017. 'The Taplow drinking horn: gripping-arm gestures and female performance in the Migration period', in Semple *et al* 2017, 373–81

Brunning, S E 2013. 'The "living" sword in early medieval northern Europe: an interdisciplinary study', unpublished PhD thesis, University College London

Brunning, S E 2017. 'Crossing edges? "Person-like" swords in Anglo-Saxon England', in Semple *et al* 2017, 409–17

Brunning, S 2019. *The sword in early medieval northern Europe: experience, identity, representation*, Boydell Press, Woodbridge

Burger P, Stacey, R J, Bowden, S A, Hacke, M and Parnell, J 2016. 'Identification, geochemical characterisation and significance of bitumen among the grave goods of the 7th century mound 1 ship-burial at Sutton Hoo (Suffolk, UK)', *PLoS ONE*, **11** (12), <doi:10.1371/journal.pone.0166276>

Burnam, J M 1920. *A Classical Technology: edited from Codex Lucensis, 490,* The Gorham Press, Boston

Burnett, A 1984. 'Clipped siliquae and the end of Roman Britain', *Britannia,* **15**, 163–8

Burrill, C 2010. 'DENO-2A0601: an early medieval scabbard', <https://finds.org.uk/database/artefacts/record/id/415993> (accessed 29 May 2017)

Bursche, A 2001. 'Roman gold medallions as power symbols of the Germanic elite', in B Magnus (ed), *Roman Gold and the Development of the Early Germanic Kingdoms: aspects of technical, socio-political, socio-economic, artistic and intellectual development,* AD *1–550,* 83–102, KVHAA Konferenser 51, Stockholm

Butler, L and Graham-Campbell, J 1990. 'A lost reliquary casket from Gwytherin, North Wales', *Antiq J,* **70**, 40–8

Butterworth, J, Fregni, G, Fuller, K and Greaves, P 2016. 'The importance of multidisciplinary work within archaeological conservation projects: assembly of the Staffordshire Hoard die-impressed sheets', *J Inst Conservation,* **39**, 29–43

C

Caldwell D, 2001. 'The Monymusk reliquary: the Breccbennach of St Columba?', *Proc Soc Antiq Scotland,* **131**, 267–82

Caley, E R and Jensen, W B 2008. *The Leyden and Stockholm Papyri: Greco-Egyptian chemical documents from the early 4th century* AD, The Oesper Collections, Cincinnati

Calligaro, T and Périn, P 2013. 'Note sur l'origine géologique des grenats utilisés par les orfèvres du haut Moyen Âge occidental', *Bulletin de liaison de l'Association française d'Archéologie mérovingienne,* **37**, 125–31

Calligaro T, Dran J-C, Ioannidou E, Moigrand B, Pichon L and Salomon J 2000. 'Development of an external beam nuclear microprobe on the AGLAE facility of the Louvre museum', *Nuclear Instr Meth Phys Res B,* **161–163**, 328–33

Calligaro, T, Périn, P, Vallet, F and Poirot, J-P 2007. 'Contribution à l'étude des grenats mérovingiens (Basilique de Saint-Denis et autres collections du Musée d'Archéologie Nationale, diverses collections publiques et objets de fouilles récentes)', *Antiquités Nationales,* **38**, 111–44

Calvi, C C 1980. 'I tesori bizantini', in B Forlati Tamaro (ed), *Da Aquileia a Venezia: Una mediazione tra l'Europa e l'Oriente dal* II *secolo a.C. al* VI *secolo d.C.*, 491–505, Libri Scheiwiller, Milan

Cameron, A 1985. 'The date and the owners of the Esquiline Treasure', *Amer J Archaeol,* **89**, 135–45

Cameron, A 1992. 'Observations on the distribution and ownership of late Roman silver plate', *J Roman Archaeol,* **5**, 178–85

Cameron, A and Hall, S G (eds and trans) 1999. *Eusebius, Life of Constantine,* Clarendon Press, Oxford

Cameron, E 2000. *Sheaths and Scabbards in England* AD *400–1100,* BAR Brit Ser 301, Archaeopress, Oxford

Cameron, E and Filmer-Sankey, W 1993. 'A sword hilt of horn from the Snape Anglo-Saxon cemetery', *Anglo-Saxon Stud Archaeol Hist,* **6**, 103–5

Campbell, A (ed) 1967. *Æthelwulf: De Abbatibus,* Clarendon Press, Oxford

Campbell, E and Lane, A 1993. 'Celtic and Germanic interaction in Dalriada: the 7th-century metalworking site at Dunadd', in Spearman and Higgitt 1993, 52–63

Campbell, J 2007. 'Some considerations of religion in early England', in M Henig and T J Smith (eds), *Collectanea Antiqua: essays in memory of Sonia Chadwick Hawkes,* 67–73, BAR Int Ser 1673, Archaeopress, Oxford

Cane, D, Cane, S and Greaves, P 2014. 'After the goldrush: creating and sustaining communities of interest around the Staffordshire Hoard', in J Bridgland (ed), *17th Triennial Conference, Melbourne, 15–19 September 2014: preprints 2001–2009,* ICOM-CC, International Council of Museums, Paris

Cane, S 2010. 'The Staffordshire Hoard conservation plan', in Geake 2010, <https://finds.org.uk/staffshoardsymposium/papers/simoncane> (accessed 23 March 2018)

Capelle, T 1968. 'Zum Runenring von Pietroassa', *Frühmittelalterliche Studien,* **2**, 228–32

Capelle, T 1994. *Die Miniaturenkette von Szilágysomlyó (Simleul Silvanei),* Universitätsforschungen zur Prähistorischen Archäologie 22, Rudolf Habelt, Bonn

Capelle, T 1999. 'Die Bedeutung der goldenen Miniaturenkette von Szilágysomlyó', in Seipel 1999, 55–61

Capelle, T 2012. 'An insight into the goldsmith's workshop', in Pesch and Blankenfeldt 2012, 17–27

Capelle, T and Vierck, H 1971. 'Modeln der Mcrovinger- und Wikingerzeit', *Frühmittelalterliche Studien,* **5**, 42–101

Capelle T, and Vierck, H, 1975. 'Weitere Modeln der Merovinger - und Wikingerzeit', *Frühmittelalterliche Studien,* **9**, 110–37

Capper, M and Scully, M 2016. 'Ancient objects with modern meanings: museums, volunteers, and the Anglo-Saxon "Staffordshire Hoard" as a marker of twenty-first century regional identity', *Ethnic Racial Stud,* **39** (2), 18–203

Carnap-Bornheim, C V and Ilkjær, J 1996. *Illerup Ådal. Volume 5: Die Prachtausrüstungen,* Jutland Archaeol Soc Pubs 25, Aarhus

Cartwright, C 2013a. *Identification of Fibres of Textile Fragments Found inside Silver Gilt Collar K281 from the Staffordshire Hoard,* Staffordshire Hoard Res Rep 13, Archaeological Data Service, York, <doi.org/10.5284/1041576>

Cartwright, C R 2013b. *Macro-organic Materials from the Staffordshire Hoard,* Staffordshire Hoard Res Rep 3, Archaeological Data Service, York, <doi.org/10.5284/1041576>

Caruth, J and Anderson, S 1999. 'RAF Lakenheath Anglo-Saxon cemetery', *Current Archaeol,* **163**, 244–50

Caruth, J and Hines, J forthcoming. *The Anglo-Saxon Cemeteries at RAF Lakenheath, Eriswell, Suffolk,* East Anglian Archaeology

Carver, M 2005. *Sutton Hoo: a seventh-century princely burial ground and its context*, Soc Antiq Lond Res Rep 69, British Museum Press, London

Carver, M 2010. 'Agency, intellect and the archaeological agenda', in Carver *et al* 2010, 1–20

Carver, M 2011. 'The best we can do?', *Antiquity,* **85**, 230–4

Carver, M 2015. 'Commerce and cult: confronted ideologies in 6th–9th-century Europe', *Medieval Archaeol,* **59**, 1–23

Carver, M, Garner-Lahire, J and Spall, C 2016. *Portmahomack on Tarbat Ness: changing ideologies in north-east Scotland, sixth to sixteenth century AD*, Society of Antiquaries of Scotland, Edinburgh

Carver, M, Hills, C and Scheschkewitz, J 2009. *Wasperton: a Roman, British and Anglo-Saxon community in central England,* Boydell and Brewer, Woodbridge

Carver, M, Sanmark, A and Semple, S (eds) 2010. *Signals of Belief in Early England: Anglo-Saxon paganism revisited,* Oxbow, Oxford

Chadwick, H M 1940. 'Who was he?', *Antiquity,* **53**, 76–87

Chadwick Hawkes, S 1982. 'Anglo-Saxon Kent, c 425–725', in P E Leach (ed), *Archaeology in Kent to AD 1500,* 64–78, CBA Res Rep 48, Council for British Archaeology, London

Chadwick Hawkes, S, Merrick, J M and Metcalf, D M 1966. 'X-ray fluorescent analysis of some Dark Age coins and jewellery', *Archaeometry,* **9**, 98–138

Champness, C 2008. 'Watling Street, Hammerwich', in Powell *et al* 2008, 57–9

Chaney, W 1970. *The Cult of Kingship in Anglo-Saxon England,* Manchester, University Press, Manchester

Chapman, H 2017. *The Staffordshire Hoard Surveys: an assessment,* Staffordshire Hoard Res Rep 29, Archaeological Data Service, York, <doi.org/10.5284/1041576>

Charles-Edwards, T M 2013. *Wales and the Britons 350–1064,* Oxford University Press, Oxford

Chazelle, C 2019. 'The illustrations of the Codex Amiatinus and of Cosmas Indicopleustes' Christian Topography', in J Hawkes and M Boulton (eds), *All roads lead to Rome. The creation, context and transmission of the Codex Amiatinus,* Brepols, Turnhout

Chester-Kadwell, M 2013. 'NMS-32FEA3: an early medieval figurine', <https://finds.org.uk/database/artefacts/record/id/573665> (accessed 31 May 2017)

Ciglenećki, S 1994. 'Bemerkungen zu den Schulterschliessen aus dem Königsgrab von Sutton Hoo', *Germania,* **72**, 314–23

Ciołek, R 2009. 'Der Zufluss von Solidi in die südlichen Ostseegebiet', in Wołoszyn 2009,

Clancy, J P 1970. *The Earliest Welsh Poetry,* Macmillan, London

Cleve, N 1943. 'Det stämpelornerade remgarnityret i fyndet från Åker i Norge', *Finkst Museum,* **49**, 13–23

Coatsworth, E 1989. 'The pectoral cross and portable altar from the tomb of St Cuthbert', in G Bonner, D Rollason and C Stancliffe (eds), *St Cuthbert, His Cult and His Community to AD 1200,* 287–301, Boydell & Brewer, Woodbridge

Coatsworth, E and Pinder, M 2002. *The Art of the Anglo-Saxon Goldsmith,* Boydell & Brewer, Woodbridge

Colgrave, B 1927. *The Life of Bishop Wilfrid by Eddius Stephanus,* Cambridge University Press, Cambridge

Colgrave, B (ed and trans) 1940. *Two Lives of St Cuthbert: a life by an anonymous monk of Lindisfarne and Bede's prose life*, Cambridge University Press, Cambridge

Colgrave, B 1956. *Felix's Life of Saint Guthlac,* Cambridge University Press, Cambridge

Colgrave, B and Mynors, R B M 1969. *Bede's Ecclesiastical History of the English People,* Clarendon Press, Oxford

Collingwood, R G and Myres, J N L 1936. *Roman Britain and the English Settlements,* Clarendon Press, Oxford

Collins, R 2013. 'NCL-925284: an early medieval scabbard', <https://finds.org.uk/database/artefacts/record/id/584446> (accessed 3 May 2017)

Conkey, M and Hastorf, C (eds) 1990. *The Uses of Style in Archaeology,* Cambridge University Press, Cambridge

Cook, B and Williams, G (eds) 2006. *Coinage and History in the North Sea World c 500–1250: essays in honour of Marion Archibald,* Brill, Leiden

Cook, J M (ed B Brugmann) 2004. *Early Anglo-Saxon Buckets: a corpus of copper alloy- and iron-bound, stave built vessels,* Oxford University School of Archaeology Monogr 60, Oxford University, Oxford

Cool, H E M 2013. *Contextualising Metal-Detected Discoveries: the Staffordshire Anglo-Saxon Hoard: revised project design*, Archaeological Data Service, York, <doi.org/10.5284/1041576>

Cool, H E M 2015. *Contextualising Metal-Detected Discoveries: the Staffordshire Anglo-Saxon Hoard: Stage 2 project design*, Archaeological Data Service, York, <doi.org/10.5284/1041576>

Cool, H E M 2015/6. 'The Staffordshire Hoard', *Hist England Res,* **2**, 3–7

Cool, H E M 2017a. *The Development and Progress of the Staffordshire Hoard Research Project,* Staffordshire Hoard Res Rep 30, Archaeological Data Service, York, <doi.org/10.5284/1041576>

Cool, H E M 2017b. *Discoveries on the Hoard Site in 2012,* Staffordshire Hoard Res Rep 28, Archaeological Data Service, York, <doi.org/10.5284/1041576>

Cotsonis, J A 1994. *Byzantine Figural Processional Crosses,* Dumbarton Oaks Byzantine Collection pubs 10, Dumbarton Oaks, Washington DC

Cowie, R and Blackmore, L 2012. *Lundenwic: excavations in Middle Saxon London, 1987–2000,* MOLA Monogr 63, Museum of London, London

Craddock, P T 2000. 'Historical survey of gold refining: surface treatments and refining worldwide, and in Europe prior to AD 1500', in A Ramage and P T Craddock (eds), *King Croesus' Gold: excavations at Sardis and the history of gold refining,* 27–53, British Museum Press, London

Cramp, R J 1957. 'Beowulf and archaeology', *Medieval Archaeol,* **1**, 57–77

Cramp, R 1991. *Grammar of Anglo-Saxon Ornament: general introduction to the corpus of Anglo-Saxon stone sculpture,* The British Academy and Oxford University Press, Oxford

Cramp, R J 2013. 'A lost pendant cross from near Catterick Bridge, Yorkshire', in Reynolds and Webster 2013, 73–86

Cramp, R J, Bettess, G and Bettess, F 2006. *Wearmouth and Jarrow Monastic Sites. Vol II,* English Heritage, Swindon

Crawford, S 1998. *Childhood in Anglo-Saxon England,* Sutton, Stroud

Crook, J 2000. *The Architectural Setting of the Cult of the Saints in the Early Christian West,* c 300–c 1200, Clarendon Press, Oxford

Culture Media and Sport Committee, House of Commons 2007. *Caring for our Collections: sixth report of session 2006–07. Vol II: oral and written evidence,* HMSO, London

Curta, F 1990. 'Zu den chronologischen Problemen der römischen Goldbarrenschätze aus Crasna (Kr. Covasna) und Feldiora (Kr. Brașov)', *Dacia,* Nouvelle Série, **34**, 269–84

Curtis, J and Tallis, N 2012. *The Horse: from Arabia to Royal Ascot,* British Museum Press, London

D

Daily Record 2017. 'Efforts to keep "extraordinary" Viking hoard in Dumfries & Galloway increase', 23 February, <http://www.dailyrecord.co.uk/news/local-news/efforts-keep-extraordinary-viking-hoard-9904323> (accessed 23 February 2017)

Darch, E 2006. 'NMS-A61494: an early medieval scabbard', <https://finds.org.uk/database/artefacts/record/id/128656> (accessed 29 May 2017)

Darch, E 2009. 'NMS-7B86F1: an early medieval mount', <https://finds.org.uk/database/artefacts/record/id/258779> (accessed 31 May 2017)

Dark, K 2000. *Britannia and the End of the Roman Empire,* Tempus, Stroud

Daubney, A 2004. 'LIN-871CD5: an early medieval sword', <https://finds.org.uk/database/artefacts/record/id/68081> (accessed 29 May 2017)

Dean, S, Hooke, D and Jones, A E 2010. 'The "Staffordshire Hoard": the fieldwork', *Antiq J,* **90**, 139–52

Deegan, A 2013. *Air Mapping and Interpretation for Contextualising Metal-Detected Discoveries: Staffordshire Anglo-Saxon Hoard,* Staffordshire Hoard Res Rep 1, Archaeological Data Service, York, <doi.org/10.5284/1041576>

DeGregorio, S (ed) 2006. *Bede, On Ezra and Nehemiah,* Liverpool University Press, Liverpool

de Linas, C 1864. *Orfèvrerie Mérovingienne : Les œuvres de Saint Eloi et la verroterie cloisonné,* Didron/Demichelis Libraire, Paris

Delmaire, R 1989. *Largesses Sacrées et Res Privata : l'Aerarium Impérial et son Administration de IVe au VIe siècle,* École française de Rome, Paris

Dembski, G 1999. 'Die Goldmedaillone aus dem Schatzfund von Szilágysomlyó', in Seipel 1999, 31–7

Department for Culture Media and Sport 2008. *Treasure Act 1996: code of practice (2nd revision) England and Wales,* HMSO, London, <https://www.gov.uk/government/publications/treasure-act-1996-code-of-practice-2nd-revision-england-and-wales> (accessed 5 September 2018)

Dickinson, T M 1973. 'Excavations at Standlake Down in 1954: the Anglo-Saxon graves', *Oxoniensia,* **38**, 239–57

Dickinson, T M 1982. 'Ornament variation in pairs of cast saucer brooches: a case study from the upper Thames region', in L E Webster (ed), *Aspects of Production and Style in Dark Age Metalwork: selected papers given to the British Museum seminar on jewellery AD 500–600,* 21–50, British Museum Occasional Paper 34, London

Dickinson, T M 2002. 'Translating animal art: Salin's Style I and Anglo-Saxon cast saucer brooches', *Hikuin,* **29**, 163–86

Dickinson, T M 2005. 'Symbols of protection: the significance of animal-ornamented shields in Early Anglo-Saxon England', *Medieval Archaeol,* **49**, 109–63

Dickinson, T M 2009. 'Medium and message: some observations on the contexts of Salin's Style I in England', *Anglo-Saxon Stud Archaeol Hist,* **16**, 1–12

Dickinson, T M 2011. 'Overview: mortuary ritual', in Hamerow *et al* 2011, 221–37

Dickinson, T M and Härke, H 1992. *Early Anglo-Saxon Shields* (= *Archaeologia* 110), Society of Antiquaries of London, London

Dickinson, T M, Fern, C J R and Richardson, A F 2011. 'Early Anglo-Saxon Eastry: archaeological evidence for the beginnings of a district centre in the kingdom of Kent', *Anglo-Saxon Stud Archaeol Hist,* **17**, 1–86

Dixon, K R and Southern, P 1992. *The Roman Cavalry: from the first to the third century* AD, Routledge, London

Dodwell, C R 1982. *Anglo-Saxon Art: a new perspective,* Manchester University Press, Manchester

Donoghue, D (ed) and Heaney S (trans) 2019. *Beowulf: a verse translation,* 2nd edn, Norton Critical Edition, W W Norton, New York and London

Dowker, G 1887. 'A Saxon cemetery at Wickhambreaux', *Archaeologia Cantiana,* **17**, 6–9

Drinkall, G and Foreman, M 1998. *The Anglo-Saxon Cemetery at Castledyke South, Barton-on-Humber,* Sheffield Excavation Rep 6, Sheffield Academic Press Ltd, Sheffield

Dronke, U 1997. *The Poetic Edda. Vol II: mythological poems,* Oxford University Press, Oxford

Duczko, W 1985. *Birka. Vol V: the filigree and granulation work of the Viking period, an analysis of the material from Björkö,* Almqvist & Wiksell International, Stockholm

Dumville, D 1977. 'Sub-Roman Britain: history and legend', *History,* **62**, 173–92

Dumville, D 1989a. 'Essex, Middle Anglia and the expansion of Mercia in the South-East Midlands', in Bassett 1989, 123–40

Dumville, D N 1989b. 'The Tribal Hidage: an introduction to its texts and their history', in Bassett 1989, 225–30

Dunareanu-Vulpe, E 1967. *Der Schatz von Pietroasa,* Verl. Meridiane, Bucharest

E

Earle, T 1990. 'Style and iconography as legitimation in complex chiefdoms', in Conkey and Hastorf 1990, 73–81

East, K 1985. 'A study of the cross-hatched gold foils from Sutton Hoo', *Anglo-Saxon Stud Archaeol Hist,* **4**, 129–42

ECCO (European Confederation of Conservator-Restorers' Organisations) n.d. 'E.C.C.O. professional guidelines', <http://www.ecco-eu.org/documents/> (accessed 16 March 2017)

Edmondson, J C 1989. 'Mining in the later Roman Empire and beyond: continuity or disruption?', *J Roman Stud,* **79**, 84–102

Edwards, N 1992. 'A fragment of a reliquary casket from Gwytherin, North Wales', *Antiq J,* **72**, 91–101

Eggert, M K H 2012. *Prähistorische Archäologie: Konzepte und Methoden,* Francke, Tübingen, Basel

Elbern, V H 1963. 'Der eucharistische Kelch im frühen Mittelalter', *Zeitschrift für Kunstwissenschaft,* **17**, 1–76, 117–88

Elbern, V H 1964. *Der eucharistische Kelch im frühen Mittelalter,* Deutscher Verein für Kunstwissenschaft, Berlin

Ellis Davidson, H 1962. *The Sword in Anglo-Saxon England: its archaeology and literature,* Clarendon Press, Oxford

Ellis Davidson, H R 1965a. 'The significance of the man in the horned helmet', *Antiquity,* **39**, 23–7

Ellis Davidson, H R 1965b. *Gods and Myths of Northern Europe,* Penguin Books, Harmondsworth

Ellis Davidson, H 1994 (repr. with corrections). *The Sword in Anglo-Saxon England: its archaeology and literature,* Boydell & Brewer, Woodbridge

Ellis Davidson, H R and Webster, L 1967. 'The Anglo-Saxon burial at Coombe (Woodnesborough), Kent', *Medieval Archaeol,* **11**, 1–41

Engelhardt, C 1863. *Thorsbjerg Mosefund,* Copenhagen

Engelhardt, C 1867. *Kragehul Mosefund,* Copenhagen

Entwistle, C 2002. 'Byzantine weights', in A E Laiou, *The Economic History of Byzantium: from the seventh through the fifteenth century,* 611–14, Dumbarton Oaks, Washington DC

Esmonde Cleary, S 1989. *The Ending of Roman Britain,* Batsford, London

Esmonde Cleary, S 2013. *The Roman West,* AD *200–500: an archaeological study,* Cambridge University Press, Cambridge

Evans, A C 2004. 'The saddle in Anglo-Saxon England and its European background', in L Gilmore (ed), *In the Saddle: an exploration of the saddle through history,* 21–30, Archetype Publications, London

Evison, V I 1967. 'The Dover ring-sword and other sword-rings and beads', *Archaeologia,* **101**, 63–118

Evison, V I 1976. 'Sword rings and beads', *Archaeologia,* **105**, 303–15

Evison, V I 1987. *Dover: the Buckland Anglo-Saxon cemetery,* Historic Buildings and Monuments Commission for England Archaeological Report, London

Evison, V I 1988. *An Anglo-Saxon Cemetery at Alton, Hampshire,* Hampshire Field Club Monogr 4, Alan Sutton, Gloucester

Evison, V I 2008. *Catalogue of Anglo-Saxon Glass in the British Museum* (ed S Marzinzik), British Museum Res Pub 167, British Museum, London

F

Fagerlie, J M 1967. *Late Roman and Byzantine* Solidi *found in Sweden and Denmark,* Numis Notes Monogr 157, The American Numismatic Society, New York

Faull, M 1975. 'The semantic development of Old English *wealh*', *Leeds Stud English,* **8**, 20–44

Feldmann, L (ed) 1999. *Flavius Josephus: translation and commentary. Vol 3: Judean antiquities, books 1–4,* Brill, Leiden and Boston

Fern, C J R 2005. 'The archaeological evidence for equestrianism in early Anglo-Saxon England, *c* 450–700', in A Pluskowski (ed), *Just Skin and Bones? New perspectives on human–animal relations in the historic past,* 43–71, BAR Int Ser 1410, Archaeopress, Oxford

Fern, C J R 2007. 'Early Anglo-Saxon horse burial of the fifth to seventh centuries AD', in S Semple and H Williams (eds), *Early Medieval Mortuary Practices,* 92–109 (= Anglo-Saxon Stud Archaeol Hist, **14**), Oxford University School of Archaeology, Oxford

Fern, C J R 2010. 'Horses in mind', in Carver *et al* 2010, 128–57

Fern, C J R 2017. 'Treasure at the frontier: key artefacts from the Staffordshire Hoard', in Semple *et al* 2017, 419–39

Fern, C J R forthcoming. 'Magnificent was the Cross of Victory: the great gold cross from the Staffordshire Hoard', in T Martin and W Morrison (eds), *Barbaric Splendour: the use of image before and after Rome*

Fern, C J R and Speake, G 2014. *Beasts, Birds and Gods: interpreting the Staffordshire Hoard,* West Midlands History Limited, Alcester

Fett, E N 1947. 'Åkerfunnet', *Bergen Museum Årbok* (for 1945), 3–18

Fettich, N 1932. 'Der zweite Schatz von Szilágy-Somlyó', *Archaeologia Hungarica* 8, Budapest

Findell M 2014. *Runes,* British Museum Press, London

Fischer, S 2005. *Roman Imperialism and Runic Literacy: The Westernization of northern Europe (150–800 AD)*, Aun 33, Uppsala

Fischer, S 2008. 'The Udovice solidus pendants: 5th century evidence of South Scandinavian mercenaries in the Balkans', *Fornvännen,* **103**, 81–9

Fischer, S 2011. 'Forskningsprojektet LEO – en presentation', in P Bratt and R Grönwall (eds), *Makt, Kult och Plats: Två Seminarier arrangerade av Stockholms Läns Museum under 2009 och 2010, 39–47,* Stockholms Läns Museum, Stockholm

Fischer, S and Soulat, J 2009. 'Runic swords and raw materials: Anglo-Saxon interaction with Northern Gaul: a presentation of two research projects at the Musée d'Archéologie Nationale', in *The 58th International Sachsensymposium, 1–5 September 2007 (= Vitark,* **7**), 72–9, NTNU Museum of Natural History and Archaeology and Tapir Academic Press, Trondheim

Fischer, S and Soulat, J 2010. 'The typochronology of sword pommels from the Staffordshire Hoard', in Geake 2010, <https://finds.org.uk/staffshoardsymposium/papers/svantefischerandjeansoulat> (accessed 2 May 2011)

Fischer, S, López Sánchez, F and Victor, H 2011. 'A result from the LEO-project: the 5th century hoard of Theodosian *solidi* from Stora Brunneby, Öland, Sweden', *Fornvännen,* **106**, 189–204

Fischer, S, Soulat, J, Fischer, L, Truc, M-C, Lemant, J-P and Victor, H 2008. *Les Seigneurs des Anneaux,* Bulletin de liaison de l'Association française d'Archéologie mérovingienne, Hors série 2 (Inscriptions runiques de France, 1), deuxième édition corrigée et revue, Condé-sur-Noireau

Fischer, S, Soulat, J and Linton Fischer, T 2013. 'Sword parts and their depositional contexts: symbols' in 'Migration and Merovingian period martial society', *Fornvännen,* **108**, 109–22

Flammin, A 1999. 'La sculpture du VIème au Xème siècle entre Loire et Gironde', unpublished doctoral thesis, Université de Poitiers

Foltz, E 1975. 'Technische Beobachtungen an Goldblattkreuzen', in Hübener 1975, 11–21

Foster, H E and Jackson, C M 2010. 'The composition of Late Romano-British colourless vessel glass: glass production and consumption', *J Archaeol Sci,* **37**, 3068–80

Foster, J 1997. 'A boar figure from Guilden Morden, Cambridgeshire', *Medieval Archaeol,* **21**, 166–7

Fraser, J E 2008. 'Bede, the Firth of Forth, and the location of *Urbs Iudeu*', *Scottish Hist Rev,* **87**, 1–25

Freestone, I C 2001. 'Post-depositional changes in archaeological ceramics and glasses', in D R Brothwell and A M Pollard (eds), *Handbook of Archaeological Sciences,* 615–25, John Wiley, Chichester

Freestone, I C, Hughes, M J and Stapleton, C P 2008. 'The composition and production of Anglo-Saxon glass', in Evison 2008, 29–46

Frere, S 1967. *Britannia: a history of Roman Britain,* Routledge, London

G

Gaborit-Chopin, D 1991. *Le Trésor de Saint-Denis*, Réunion des Musées Nationaux, Paris

Gaimster, M 1998. *Vendel Period Bracteates on Gotland: on the significance of Germanic art*, Acta Archaeologica Lundensia Series in 8º 27, Almqvist & Wiksell International, Lund

Gameson, R 2010. *Manuscript Treasures of Durham Cathedral*, Third Millennium, London

Gannon, A 2013. *Sylloge of Coins of the British Isles, 63. British Museum. Anglo-Saxon Coins. Part I. Early Anglo-Saxon Coins and Continental Silver Coins of the North Sea, c. 600–760*, British Museum Publications, British Museum Press, London

Ganz, D 2010. 'The text of the inscription', in Geake 2010, <https://finds.org.uk/staffshoardsymposium/papers/davidganz> (accessed 4 May 2017)

Garton, D and Kinsley, G 2002. 'Absolute chronology: radiocarbon dates', in Losco-Bradley and Kinsley 2002, 120–3

Gates, T and O'Brien, C 1988. 'Cropmarks at Milfield and New Bewick and the recognition of Grubenhäuser in Northumberland', *Archaeologia Aeliana*, series 5, **16**, 1–9

Gaul, J 1984. 'The circulation of monetary and non-monetary currency in the west Baltic zone in the 5th and 6th centuries AD', *Archaeologia Polona*, **23**, 87–105

Geake, H 1997. *The Use of Grave Goods in Conversion-period England, c 600–c 850*, BAR Brit Ser 261, Archaeopress, Oxford

Geake, H 1999. 'Why were hanging bowls deposited in Anglo-Saxon graves?', *Medieval Archaeol*, **43**, 1–18

Geake, H 2001. 'SF5196: an early medieval scabbard', < https://finds.org.uk/database/artefacts/record/id/19879> (accessed 29 May 2017)

Geake, H 2009. 'FAHG-8EAAA3: an early medieval mount', <https://finds.org.uk/database/artefacts/record/id/258876> (accessed 31 May 2017)

Geake, H (ed) 2010. *Papers from the Staffordshire Hoard Symposium*, <https://finds.org.uk/staffshoardsymposium> (accessed 16 June 2017)

Geake, H 2011. 'Accidental losses, plough-damaged cemeteries and the occasional hoard: the Portable Antiquities Scheme and early Anglo-Saxon archaeology', in Brookes *et al* 2011, 33–9

Geake, H 2014. 'The complete Anglo-Saxonist: some new and neglected early Anglo-Saxon fish for Andrew Rogerson', in S Ashley and A Marsden (eds), *Landscapes and Artefacts: studies in East Anglian archaeology presented to Andrew Rogerson*, 113–21, Archaeopress, Oxford.

Geake, H 2015. 'Why was a wealthy Anglo-Saxon woman buried in a remote part of Norfolk?', *British Archaeol*, **142**, 36–41

Gearey, B 2010. 'The potential of environmental archaeology and geoarchaeology at the site of the Staffordshire Hoard', in Geake 2010, <https://finds.org.uk/staffshoardsymposium/papers/benjamingearey> (accessed 16 February 2017)

Gehrig, U 1980. *Hildesheimer Silberschatz*, Bilderhefte der Staatlichen Museen Preussischer Kulturbesitz 4, Staatliche Museen Preussischer Kulturbesitz, Berlin

Geisslinger, H 1967. *Horte als Geschichtsquelle dargestellt an den völkerwanderungs- und merowingerzeitlichen Funden des südwestlichen Ostseeraumes*, Offa-Bücher 19, Wachholtz, Neumünster

Geisslinger, H 1984. 'Depotfund, Hortfund', in *RGA*, **5**, 320–38

Geisslinger, H 2002. 'Odysseus in der Höhle der Najaden – Opfer oder Schatzversteck?', *Das Altertum*, **47**, 127–47, 221–38

Gelling, M 1978. *Signposts to the Past: place-names and the history of England*, Dent, London

Gelling, M 1992. *The West Midlands in the Early Middle Ages*, Leicester University Press, London

Gerrard, J 2013. *The Ruin of Roman Britain*, Cambridge University Press, Cambridge

Gerrets, D 1999. 'Evidence of political centralization in Westergo: the excavations at Wijnaldum', in *Anglo-Saxon Stud Archaeol Hist*, **10**, 119–26

Gilchrist, R 2000. 'Archaeological biographies: realizing human lifecycles, -courses and -histories', *World Archaeol*, **31** (3), 325–8

Gilg, A, Gast N and Calligaro, T 2010. 'Vom Karfunkelstein', in L Wamser (ed), *Karfunkelstein und Seide: Neue Schätze aus Bayerns Frühzeit, Ausstellungskataloge der archäologischen Staatssammlung, 37* Verlag, 87–100, Friedrich Pustet, Munich

Gillespie R F 2010. 'A multi-period archaeological complex at Lowpark', in R F Gillespie and A Kerrigan (eds), *Of Troughs and Tuyères: the archaeology of the N5 Charlestown bypass*, NRA Scheme Monogr, 6, 155–317, National Roads Authority of Ireland, Dublin

Gilmore, T 2012. 'WMID-4241F2: an early medieval pendant', <https://finds.org.uk/database/artefacts/record/id/523861> (accessed 1 June 2017)

Gilmore, T 2014a. 'WMID-8D2884: an early medieval brooch', <https://finds.org.uk/database/artefacts/record/id/598077> (accessed 3 May 2017)

Gilmore, T 2014b. 'WMID-28BE76: an early medieval brooch', <https://finds.org.uk/database/artefacts/record/id/610237> (accessed 3 May 2017)

Giostra, C, Bruni, S, Guglielmi, V, Rottoli, M and Rettore, E 2008. 'The Ostrogothic buckle with cloisonné decoration from Tortona (Italy)', *Archäologisches Korrespondenzblatt*, **38** (4), 577–95

Godman, P (ed) 1982. *Alcuin: the bishops, kings and saints of York*, Clarendon Press, Oxford

Goldberg, M 2015. 'At the western edge of the Christian World, *c* AD 600–900', in J Farley and F Hunter (eds), *Celts: art and identity*, 170–205, British Museum Press, London

Goodwin, J 2016. *A Survey of the Sources for Possible Contemporary Activity in the Vicinity of the Hoard Find Spot*, Staffordshire Hoard Res Rep 24, Archaeological Data Service, York, <doi.org/10.5284/1041576>

Graham-Campbell, J 1976. 'The Mote of Mark and Celtic interlace', *Antiquity*, **50**, 48–50

Graham-Campbell, J and Ryan, M (eds) 2009. *Anglo-Saxon/Irish Relations before the Vikings*, Proc Brit Acad 157, Oxford University Press, Oxford

Grane, T 2013. 'Roman relations with southern Scandinavia in Late Antiquity', in Hunter and Painter 2013, 359–71

Greaves, P and Cane, D 2015. 'Appendix 1: conservation programme', in Cool 2015, 70–85

Green, T 2012. *Britons and Anglo-Saxons: Lincolnshire AD 400–650*, The History of Lincolnshire Committee, Lincoln

Greenslade, M W (ed) 1990. *A History of the County of Stafford. Vol XIV: Lichfield*, Oxford University Press, Oxford

Greenslade, M W and Kettle, A J 1984. *A History of Forests in Staffordshire*, Staffordshire County Library, Stafford (re-printed from Greenslade, M W and Jenkins, J G (eds) 1967. *Victoria County History of the County of Stafford. Vol II*)

Grierson, P 1953. 'La trouvaille monétaire d'Ilanz', *Schweizerische Münzblätter*, **4**, 46–8

Grierson, P and Blackburn, M 1986. *Medieval European Coinage, with Catalogue of the Coins in the Fitzwilliam Museum, Cambridge. I: the early Middle Ages (5th to 10th centuries)*, Cambridge University Press, Cambridge

Grimm, W 1957. *Die deutsche Heldensage*, Gentner, Darmstadt

Grimwade, M 2009. *Introduction to Precious Metals: metallurgy for jewellers and silversmiths*, A&C Black Publishers Limited, London

Grocock, C and Wood, I N (eds and trans) 2013. *Abbots of Wearmouth and Jarrow*, Oxford Medieval Texts, Clarendon Press, Oxford

Grünhagen, W 1954. *Der Schatzfund von Gross Bodungen*, Römisch-Germanische Forschungen 21, De Gruyter, Berlin

Guest, P 2005. *The Late Roman Gold and Silver Coins from the Hoxne Treasure*, British Museum Press, London

Guest, P 2014. 'The hoarding of Roman gold and silver in fifth century Britain', in F Haarer (ed), *AD 410: the history and archaeology of late and post-Roman Britain*, 117–29, Society for the Promotion of Roman Studies, London

Guest, P 2015. 'The burial, loss and recovery of Roman coin hoards in Britain and beyond: past, present and future', in Naylor and Bland 2015, 101–16

Guggisberg, M A (ed) 2003. *Der spätrömische Silberschatz von Kaiseraugst – die neuen Funde: Silber im Spannungsfeld von Geschichte, Politik und Gesellschaft der Spätantike*, Forschungen in Augst 34, Römermuseum Augst, Augst

Gunnell, T 2013. 'From one High-One to another: the acceptance of Óðinn as preparation for the acceptance of God', in R Simek (ed), *Conversions: looking for ideological change in the early Middle Ages*, 153–78, Fassbaender, Vienna

Gustavs, S 1987. 'Silberschmuck, Waffen und Siedlungsfunde des 3. bis 5. Jh. u. Z. aus einem See bei Gross Köris, Kr. Königs Wusterhausen', *Veröffentlichungen des Museums für Ur- und Frühgeschichte Potsdam*, **21**, 215–36

H

Haddan, A W and Stubbs, W (eds) 1871. *Poenitentiale Theodori*, in *Councils and Ecclesiastical Documents Relating to Great Britain and Ireland. Vol III: the English Church 595–1066*, 173–213, Clarendon Press, Oxford,

Hagberg, U E 1967. *The Archaeology of Skedemosse. Vol II: the votive deposits in the Skedemosse Fen and their relation to the Iron Age settlement on Öland, Sweden*, Almqvist & Wiksell, Stockholm

Hall, R, Paterson, E, Mortimer, C and Whitfield, N 1999. 'The Ripon jewel', in J Hawkes and S Mills (eds), *Northumbria's Golden Age*, 268–80, Sutton Publishing, Stroud

Halsall, G 2003. *Warfare and Society in the Barbarian West, 450–900*, Routledge, London/New York

Halsall, G 2010. 'The Staffordshire Hoard: warfare, aggression and the use of trophies', *Historian on the Edge*, 31 May, <https://600transformer.blogspot.co.uk/2010/05/the-staffordshire-hoard-warfare.html> (accessed 17 June 2017)

Hamerow, H 1993. *Excavations at Mucking. Vol 2: the Anglo-Saxon settlement*, English Heritage, London

Hamerow, H 2002. *Early Medieval Settlements: the archaeology of rural communities in north-west Europe 400–900*, Oxford University Press, Oxford

Hamerow, H 2010. 'Herrenhöfe in Anglo-Saxon England', *Siedlungs- und Küstenforschung im Südlichen Nordseegebiet*, **33**, 59–67

Hamerow, H 2012. *Rural Settlements and Society in Anglo-Saxon England*, Oxford University Press, Oxford

Hamerow, H, Hinton, D A and Crawford, S (eds) 2011. *The Oxford Handbook of Anglo-Saxon Archaeology*, Oxford University Press, Oxford

Hamerow, H, Byard, A, Cameron, E, Düring, A, Levick, P, Marquez-Grant, N and Shortland A 2015. 'A high-status seventh-century female burial from West Hanney, Oxfordshire', *Antiq J*, **95**, 91–118

Hannig, J 1986. 'Ars donandi: zur Ökonomie des Schenkens im früheren Mittelalter', *Geschichte in Wissenschaft und Unterricht*, **37**, 149–63 (reprinted in: Dülmen, R V (ed), *Armut, Liebe, Ehre: Studien zur historischen Kulturforschung*, 11–37, Fischer, Frankfurt/Main)

Hänsel, A and Hänsel B (eds) 1997. *Gaben an die Götter – Schätze der Bronzezeit Europas: Ausstellung der Freien Universität Berlin in Verbindung mit dem Museum für Ur- und Frühgeschichte*, Staatliche Museen zu Berlin – Preussischer Kulturbesitz, Bestandskataloge 4, Staatliche Museen Preussischer Kulturbesitz, Berlin

Hansen, S 2002. 'Über bronzezeitliche Depots, Horte und Einzelfunde: brauchen wir neue Begriffe?', *Archäologische Informationen*, **25**, 91–7

Hansen, S 2012. 'Bronzezeitliche Horte: zeitliche und räumliche Rekontextualisierungen', in Hansen *et al* 2012, 23–48

Hansen, S, Neumann, D and Vachta, T (eds) 2012. *Hort und Raum: Aktuelle Forschungen zu bronzezeitlichen Deponierungen in Mitteleuropa*, Topoi – Berlin Studies of the Ancient World 10, De Gruyter, Berlin

Hardt, M 2001. 'Verborgene Schätze nach schriftlichen Quellen der Völkerwanderungszeit und des frühen Mittelalters', in Pohl *et al* 2001, 255–66

Hardt, M 2003. 'Prestigegüter', *RGA*, **23**, 415–20

Hardt, M 2004. *Gold und Herrschaft: Die Schätze europäischer Könige und Fürsten im ersten Jahrtausend*, Europa im Mittelalter: Abhandlungen und Beiträge zur historischen Komparatistik 6, Akademie-Verlag, Berlin

Hardt, M 2009. 'Siegfried der Drachentöter: Otto Höfler und der Hildesheimer Silberschatz', in Landesverband Lippe (ed), *2000 Jahre Varusschlacht - Mythos*, 229–33, Theiss, Stuttgart

Hardt, M 2011. 'Hort', in A Cordes, H Lück, D Werkmüller (eds), *Handwörterbuch zur deutschen Rechtsgeschichte*, 1131–3, Schmidt, Berlin

Hardt, M 2013. 'Was übernahmen die Merowinger von der spätantiken römisch-byzantinischen Finanzverwaltung?', in J Jarnut and J Strothmann (eds), *Die merowingischen Monetarmünzen als Quelle zum Verständnis des 7. Jahrhunderts in Gallien*, 323–36, Mittelalter Studien 27, Fink, Paderborn

Hardt, M 2016. 'Tafelgeschirr und gentile Überlieferung', in A Mühlherr, H Sahm, M Schausten and B Quast (eds), *Dingkulturen: Objekte in Literatur, Kunst und Gesellschaft der Vormoderne*, 51–65, Literatur – Theorie – Geschichte 9, De Gruyter, Berlin

Harhoiu, R 1977. *The Fifth-century AD Treasure from Pietroasa, Romania, in the Light of Recent Research,* BAR Supp Ser 24, British Archaeological Reports, Oxford

Harhoiu, R 1997. *Die frühe Völkerwanderungszeit in Rumänien*, Archaeologia Romanica 1, Editura Enciclopedică, Bucharest

Härke, H 1992. *Angelsächsische Waffengräber des 5. bis 7. Jahrhunderts*, Rheinland-Verlag, Cologne

Härke, H 1997. 'Early Anglo-Saxon social structure', in Hines 1997b, 125–70

Härke, H 2000. 'The circulation of weapons in Anglo-Saxon society', in F Theuws and J L Nelson (eds), *Rituals of Power from Late Antiquity to the Early Middle Ages,* 377–99, The Transformation of the Roman World 8, Leiden, Brill

Härke, H 2004a. 'Swords, warrior graves and Anglo-Saxon warfare', *Current Archaeol*, 192, 556–61

Härke, H 2004b. 'The Anglo-Saxon weapon burial rite: an interdisciplinary analysis', *Opus,* **3**, 197–207

Härke, H 2011. 'Anglo-Saxon immigration and ethnogenesis', *Medieval Archaeol*, **55**, 1–28

Harl, K W 1996. *Coinage in the Roman Economy 300 BC to AD 700*, John Hopkins University Press, Baltimore

Haselgrove, C 2015. 'Hoarding and other forms of metalwork deposition in Iron Age Britain', in Naylor and Bland 2015, 27–4

Haseloff, G 1952. 'Zu den Darstellungen auf den Börse von Sutton Hoo', *Nordelbingen*, **20**, 9–20

Haseloff, G 1974. 'Salin's Style I', *Medieval Archaeol*, **18**, 1–15

Haseloff, G 1975. 'Zu den Goldblattkreuzen aus dem Raum nördlich der Alpen', in Hübener 1975, 37–70

Haseloff, G 1981. *Die germanische Tierornamentik der Völkerwanderungszeit*, Walter de Gruyter, Berlin/New York

Haseloff, G 1987. 'Insular animal styles with special reference to Irish art in the early medieval period', in Ryan 1987, 44–55

Hatto, A H 2004. *The Nibelungenlied,* Penguin Books, London

Hauck, K 1970. *Goldbrakteaten aus Sievern: Spätantike Amulett-Bilder der 'Dania Saxonica' und die Sachsen-Origo' bei Widukind von Corvey*, Münstersche Mittelalter-Schriften 1, Fink, Munich

Hauck, K 1985. *Die Goldbrakteaten der Völkerwanderungszeit. 1,3: Ikonographischer Katalog*, Münstersche Mittelalter-Schriften 24, Fink, Munich

Hawkes, J 1997. 'Symbolic lives: the visual evidence', in Hines 1997b, 311–44

Hawkes, J and Sidebottom, P forthcoming. *Corpus of Anglo-Saxon Stone Sculpture. Vol 13: Derbyshire and Staffordshire*, British Academy and Oxford University Press, Oxford

Hawkes, S C 1981. 'Recent finds of inlaid iron buckles and belt-plates from seventh century Kent', *Anglo-Saxon Stud Archaeol Hist*, **2**, 49–70

Hawkes, S C 2000. 'The Anglo-Saxon cemetery of Bifrons, in the parish of Patrixbourne, East Kent', *Anglo-Saxon Stud Archaeol Hist*, **11**, 1–94

Hawkes, S C and Detsicas, A P 1973. 'Finds from the Anglo-Saxon cemetery at Eccles, Kent', *Antiq J*, **53**, 281–6

Hawkes, S C and Grainger, G 2006. *The Anglo-Saxon Cemetery at Finglesham, Kent,* Oxford University School of Archaeology Monogr 64, Oxford University School of Archaeology, Oxford

Hawkes, S C and Grove, L R A 1963. 'Finds from a seventh century Anglo-Saxon cemetery at Milton Regis', *Archaeologia Cantiana,* **78**, 22–38

Hawkes S C and Pollard, M 1981. 'The gold bracteates from sixth-century Anglo-Saxon graves in Kent, in the light of a new find from Finglesham', *Frühmittelalterliche Studien,* **15**, 316–70

Hawkes, S C, Davidson, H R and Hawkes C 1965. 'The Finglesham Man', *Antiquity,* **29**, 17–32

Hawkes, S C, Merrick, J M and Metcalf, D M 1966. 'X-ray fluorescent analysis of some dark age coins and jewellery', *Archaeometry,* **9**, 98–138

Hawkes, S C, Speake, G and Northover, P 1979. 'A seventh-century bronze metalworker's die from Rochester, Kent', *Frühmittelalterliche Studien,* **13**, 382–92

Hawkins, A and Rumble, A 1976. *Domesday Book. Vol 24: Staffordshire,* Phillimore, Chichester

Hawthorne, J G and Smith, C S 1979. *Theophilus, On Divers Arts: the foremost medieval treatise on painting, glassmaking and metalwork,* Dover Publications, New York

Hayward Trevarthen, C 2012. 'DOR-A7E806: an early medieval scabbard', <https://finds.org.uk/database/artefacts/record/id/488762> (accessed 3 May 2017)

Heaney, S 1999. *Beowulf: a new translation,* Faber and Faber, London

Hedeager, L 1992. *Iron-Age Societies,* Blackwell, Oxford

Heilmeyer, W-D (ed) 1988. *Kaiser Augustus und die verlorene Republik,* Eine Ausstellung im Martin-Gropius-Bau, Berlin, 7. Juni–14. August 1988, Staatliche Museen Preussischer Kulturbesitz, Berlin

Heinrich-Tamáska, O 2014. 'Ungarns neues „Familiensilber": Der Seuso-Schatz', *Mitropa. Jahresheft des Geisteswissenschaftlichen Zentrums Geschichte und Kultur Ostmitteleuropas (GWZO),* **2014**, 8–12

Heinzle, J 1994. *Das Nibelungenlied: Eine Einführung,* Fischer, Frankfurt/Main

Heland, M V 1973. *The Golden Bowl from Pietroasa,* Acta Universitatis Stockholmiensis, Stockholm Stud Hist Art 24, Almqvist & Wiksell, Stockholm

Helgesson, B 2004. 'Tributes to be spoken of: sacrifice and warriors at Uppåkra', in L Larssen (ed), *Continuity for Centuries: a ceremonial building and its context at Uppåkra, Southern Sweden,* 223–39, Uppåkrastudier 10, Lund

Helgesson, B 2010. 'Krigarna från Uppåkra: 1000 år i järnålderssamhällets tjänst', in B Hårdh (ed), *Från romartida skalpellertill senvikingatida urnnesspännen,* 83–126, Uppåkrastudier 11, Lund

Hellgren, M 2001. 'Denaren från Vittene – ett bevis för romerskt falskmynteri', *Populär Arkeologi,* **2001:3**, 16–17

Henderson, G 1987. *From Durrow to Kells: the Insular gospel books 650–800,* Thames and Hudson, London

Henderson, G and Henderson, I 2010. 'The implications of the Staffordshire Hoard for the understanding of the origins and development of the Insular art style as it appears in manuscripts and sculpture', in Geake 2010, <https://finds.org.uk/staffshoardsymposium/papers/georgeandisabelhenderson> (accessed 1 March 2015)

Hendy, M 1985. *Studies in the Byzantine Monetary Economy, c 300–1450,* Cambridge University Press, Cambridge

Herschend, F 1980. *Två studier i öländska guldfynd. I: Det myntade guldet; II: Det omyntade guldet,* Tor 18, Uppsala.

Herschend, F 1991. 'Om öländsk metallekonomi i första hälften av första årtusendet e.Kr', in C Fabech and J Ringtved, (eds), *Samfundsorganisation og Regional Variation: Norden i Romersk Jernalder og Folkevandringstid,* 33–46, Aarhus Universitetsforlag, Aarhus

Herschend, F 2001. 'Two "West-Geatish" Greeks: the gold from Vittene and Timboholm', in Magnus, B (ed), *Roman Gold and the Development of the Early Germanic Kingdoms,* 103-18 Konferenser 51, Kungliga Vitterhets, Historie och Antikvitets Akademien, Stockholm

Herschend, F 2009. *The Early Iron Age in South Scandinavia: social order in settlement and landscape,* Occasional Papers in Archaeology, Societas Archaeologica Upsaliensis 46, Uppsala Universitet, Uppsala

Hicks, C 1986. 'The birds on the Sutton Hoo purse', *Anglo-Saxon England,* **15**, 153–65

Higgitt, C, Ambers, J and Calligaro, T forthcoming. 'Analysis of garnets from the Staffordshire Anglo-Saxon Hoard', *Journal of Archaeological Science*

Higham, N 1992. *Rome, Britain and the Anglo-Saxons,* Seaby, London

Higham, N 2015. *Ecgfrith: King of the Northumbrians, High-King of Britain,* Shaun Tyas, Donington

Higham, N and Ryan, M 2013. *The Anglo-Saxon World,* Yale University Press, New Haven and London

Hilgner, A 2016. 'The gold and garnet chain from Isenbüttel, Germany: a possible pin suite with Anglo-Saxon parallels', *Antiq J,* **96**, 1–22

Hilgner, A forthcoming. 'Garnet in Anglo-Saxon England: the meaning, provenance and distribution of garnet decorated objects from the late 5th to the early 8th century', unpublished PhD thesis, University of Mainz

Hill, D and Worthington, M (eds) 2005. *Æthelbald and Offa: two eighth-century kings of Mercia,* BAR Brit Ser 283, Archaeopress, Oxford

Hills, C 1977. *The Anglo-Saxon Cemetery at Spong Hill, North Elmham. Part I,* East Anglian Archaeology 6, Gressenhall

Hills, C and Ashley, S 2017. 'Horse and rider figure from Bradwell, Norfolk: a new early Anglo-Saxon equestrian image?', in B V Eriksen, A Abegg-Wigg, R Bleile and U Ickerodt (eds), *Interaction without Borders: exemplary archaeological research at the beginning of the 21st century. Vol 1,* 515–24, Wachholtz Verlag, Keil/Hamburg

Hills, C and Penn, K 1981. *The Anglo-Saxon Cemetery at Spong Hill, North Elmham. Part II,* East Anglian Archaeology 11, Gressenhall

Hills, C, Penn, K and Rickett, R 1987. *The Anglo-Saxon Cemetery at Spong Hill, North Elmham. Part IV: catalogue of cremations,* East Anglian Archaeology, 34, Gressenhall

Himmelmann, U 2015. 'Seiner Geschichte beraubt – der spätantike Schatzfund von Rülzheim', in P Diehl (ed), *Wissensgesellschaft Pfalz – 90 Jahre Pfälzische Gesellschaft zur Förderung der Wissenschaften,* 165–74, Veröffentlichung der Pfälzischen Gesellschaft zur Förderung der Wissenschaften 116, Ulbstadt-Weiher, Heidelberg, Neustadt a. d. W., Basel

Hinds, K 2010. 'WILT-B5EE27: an early medieval sword', <https://finds.org.uk/database/artefacts/record/id/407577> (accessed 29 May 2017)

Hines, J 1984. *The Scandinavian Character of Anglian England in the pre-Viking Period,* BAR Brit Ser 124, Archaeopress, Oxford

Hines, J 1993. *Clasps–Hektespenner–Agraffen: Typology, Function and Diffusion,* Kungliga Vitterhets Historie- och Antikvitets Akademien, Stockholm

Hines, J 1997a. *A New Corpus of Anglo-Saxon Great Square-Headed Brooches,* Boydell Press, Bury St Edmunds

Hines J (ed) 1997b. *The Anglo-Saxons from the Migration Period to the Eighth Century: an ethnographic perspective,* Boydell & Brewer, Woodbridge.

Hines, J 2008. '*Beowulf* and archaeology – revisited', in C E Karkov and H Damico (eds), *Aedificia Nova: studies in honor of Rosemary Cramp,* 89–105, Medieval Institute Publications, Kalamazoo

Hines, J 2011. 'Units of account in gold and silver in seventh-century England: *scillingas, sceattas* and *pæningas*', *Antiq J,* **90**, 183–215

Hines, J 2013. 'Social structures and social change in seventh-century England: the law-codes and complementary sources', *Hist Rev,* **86**, 394–407

Hines, J 2014. 'The hunting of the *sceatt*', in T Abrams (ed), *Studies in Early Medieval Coinage. Vol 3: sifting the evidence,* 7–17, Spink, London

Hines, J 2017. 'A new chronology and new agenda: the problematic sixth century', in C Insley and G R Owen-Crocker (eds), *Transformation in Anglo-Saxon Culture,* 1–21, Oxbow, Oxford

Hines, J 2018 'The Anglo-Saxon settlement at Catholme, Staffordshire: a re-assessment of the chronological evidence and possible re-interpretation', *Anglo-Saxon Studies in Archaeology and History* **21**, 47–59

Hinton, D A 2000. *A Smith in Lindsey: the Anglo-Saxon grave at Tattershall Thorpe, Lincolnshire,* Society for Medieval Archaeology Monogr 16, London

Hinton, D A 2005. *Gold and Gilt, Pots and Pins: possessions and people in medieval Britain,* Oxford University Press, Oxford

Hirst, S 1985. *An Anglo-Saxon Inhumation Cemetery at Sewerby, East Yorkshire,* York University Archaeol Pub 4, Maney and Son, Leeds

Hirst, S and Rahtz, P 1973. 'Hatton Rock 1970', *Trans Birmingham Warwickshire Archaeol Soc,* **85**, 161–77

Hirst, S, Nixon, T, Rowsome, P and Wright, S 2004. *The Prittlewell Prince: the discovery of a rich Anglo-Saxon burial in Essex,* Museum of London Archaeology Service, London

Historisches Museum der Pfalz Speyer (ed) 2006. *Geraubt und im Rhein versunken: Der Barbarenschatz,* Theiss, Speyer, Stuttgart

Hobbs, R 2006. *Late Roman Precious Metal Deposits, AD 200–700: changes over time and space,* BAR Int Ser 1504, Archaeopress, Oxford

Hobbs, R 2016. *The Mildenhall Treasure: late Roman silver plate from East Anglia,* British Museum Press, London.

Hodges, R 1989. *The Anglo-Saxon Achievement: archaeology and the beginnings of English society,* Cornell University Press, Ithaca, NY

Hoggett, R 2010. *The Archaeology of the East Anglian Conversion,* Boydell and Brewer, Woodbridge

Høilund Nielsen, K 1991. 'Centrum og periferi i 6.–8. årh.: Territoriale studier af dyrestil og kvindesmykker I yngre germansk jernalder I Syd- og Østskandinavien', in P Mortensen and B M Rasmussen (eds), *Fra Stamme til Stat i Danmark. Vol 2: Høvdingessmfund og Kongemagt,* 127–54, Jysk Arkæologisk Selkabs Skrifter 22.2, Højbjerg/Aarhus

Høilund Nielsen, K 1998. 'Animal style: a symbol of might and myth: Salin's Style II in a European context', *Acta Archaeol,* **69**, 1–52

Høilund Nielsen, K 1999. 'Style II and the Anglo-Saxon elite', *Anglo-Saxon Stud Archaeol Hist,* **10**, 185–202

Høilund Nielsen, K 2001 'The wolf-warrior: animal symbolism on weaponry of the 6th to 7th centuries', in Pohl *et al* 2001, 471–81

Høilund Nielsen, K 2010. 'Style II and all that: the potential of the hoard for statistical study of chronology and geographical distributions', in Geake 2010, <https://finds.org.uk/staffshoard symposium/papers/karenhoilundnielsen> (accessed 18 April 2011)

Høilund Nielsen, K and Vang Petersen, P 1993. 'Detector finds', in S Hvass and B Storgaard (eds), *Digging into the Past: 25 years of archaeology in Denmark,* 223–8, Aarhus Universitetsforlag

Holder, A (ed) 1994. *Bede, On the Tabernacle,* Liverpool University Press, Liverpool

Holmqvist, W 1960. 'The dancing gods', *Acta Archaeol,* **31**, 101–27

Hood, J, Ager, B, Williams, C, Harrington, S and Cartwright, C 2012. 'Investigating and interpreting an early-to-mid sixth-century Frankish style helmet', *British Museum Technical Research Bulletin,* **6**, 83–9

Hooke, D 2010. 'The landscape of the Staffordshire Hoard', in Geake 2010, <https://finds.org.uk/staffshoardsymposium/papers/dellahooke> (accessed 5 May 2014)

Hooke, D 2011. 'The landscape of the Staffordshire Hoard', *Trans Staffordshire Archaeol Soc,* **45**, 1–12

Hope-Taylor, B 1977. *Yeavering: an Anglo-British centre of early Northumbria,* HMSO, London

Horedt, K 1969. 'Die Datierung des Schatzfundes von Pietroasa', *Acta Musei Napocensis,* **6**, 549–51

Horedt, K 1971. 'Zur Geschichte der frühen Gepiden im Karpatenbecken', *Apulum,* **9**, 705–12

Horedt, K 1972. 'Neue Goldschätze des fünften Jahrhunderts aus Rumänien: ein Beitrag zur Geschichte der Ostgoten und Gepiden', in U E Hagberg (ed), *Studia Gotica: Die eisenzeitlichen Verbindungen zwischen Schweden und Südosteuropa,* 105–16, Almqvist & Wiksell, Stockholm

Horedt, K 1979. 'Die Ostgermanen im Karpatenbecken und an der unteren Donau', in Roth 1979, 133–5

Horedt, K 1984a. 'Crasna', *RGA,* **5**, 100–1

Horedt, K 1984b. 'Cluj-Someşeni', *RGA,* **5**, 36–7

Horedt, K and Protase, D 1970. 'Ein völkerwanderungszeitlicher Schatzfund aus Cluj-Someşeni (Siebenbürgen)', *Germania,* **48**, 85–98

Horovitz, D 2013. 'Knaves Castle; a lost monument on Ogley Hay near the site of the Staffordshire Hoard', *Staffordshire Archaeol Hist Soc Trans,* **46**, 33–71

Horsnæs, H W 2009. 'Late Roman and Byzantine coins found in Denmark', in Wołoszyn 2009, 231–70

Horsnæs, H W 2010. *Crossing Boundaries: an analysis of Roman coins in Danish contexts. Vol 1: finds from Sealand, Funen and Jutland,* National Museum of Denmark, Copenhagen

Horsnæs, H W 2013. *Crossing Boundaries: an analysis of Roman coins in Danish Contexts. Vol 2: finds from Bornholm,* National Museum of Denmark, Copenhagen

Howe, N 2004. 'Rome: capital of Anglo-Saxon England', *J Medieval Early Mod Stud,* **34** (1), 147–72

Howorth, H 1908. 'The Anglo-Saxon Chronicle: its origin and history', *Archaeol J,* **65**, 141–204

Hübener, W (ed) 1975. *Die Goldblattkreuze des frühen Mittelalters,* Verlag Koncordia, Bühl/Baden

Hughes, M J, Cowell, M R, Oddy, W A and Werner, A E A 1978. 'Report on the analysis of the gold of the Sutton Hoo jewellery and some comparative material', in Bruce-Mitford 1978, 618–25

Hunter, F and Painter, K (eds) 2013. *Late Roman Silver: the Traprain Treasure in context,* 339–57, Society of Antiquaries of Scotland, Edinburgh

Hurcombe, L 2007. *Archaeological Artefacts as Material Culture,* Routledge, London

Hurst, D (ed) 1962. *Bede, In Primam Partem Samuelis,* Corpus Christianorum Series Latina 119, Brepols, Turnhout

Huth, C 1997. *Westeuropäische Horte der Spätbronzezeit: Fundbild und Funktion,* Regensburger Beiträge zur prähistorischen Archäologie 3, Universitäts-Verlag, Regensburg

I

ICON 2014. *The Institute of Conservation's Professional Standards,* <https://icon.org.uk/system/files/documents/professional-standards-2016.pdf> (accessed 1 March 2017)

Ilkjaer, J 2006. 'Vimose, § 2–§ 5', *RGA,* **32**, 402–10

Iluk, J 1985. 'The export of gold from the Roman Empire to barbarian countries from the 4th to the 6th centuries', *Münstersche Beiträge zur antiken Handelsgeschichte,* **4** (1), 79–102

J

Jackson, R 2012. 'The Ilam pan', in D Breeze (ed), *The First Souvenirs: enamelled vessels from Hadrian's Wall,* 41–60, Cumberland and Westmorland Antiquarian and Archaeological Society, Kendal

James, N 2011. 'People's finds: context and control', *Antiquity,* **85**, 1068–72

Jarvis, E 1850. 'Account of the discovery of ornaments and remains, supposed to be of Danish origin, in the parish of Caenby, Lincolnshire', *Archaeol J,* **7**, 36–44

Jensen, X P, Jørgensen, L and Lund Hansen, U 2003. 'The Germanic army: warriors, soldiers and officers', in L Jørgensen, B Storgaard and L G Thomsen (eds), *The Spoils of Victory: the north in the shadow of the Roman Empire,* 310–28, Danish National Museum, Copenhagen

Jewell, R H I 1986. 'The Anglo-Saxon friezes at Breedon on the Hill, Leicestershire', *Archaeologia,* **108**, 95–115

Jewitt, L I 1870. *Grave-mounds and their Contents: a manual of archaeology, as exemplified in the burials of Celtic, the Romano-British, and the Anglo-Saxon periods,* Groombridge, London

John, E 1996. *Reassessing Anglo-Saxon England,* Manchester University Press, Manchester

Johns, C 2010. *The Hoxne Late Roman Treasure: gold jewellery and silver plate*, British Museum Press, London

Johns, C and Potter, T 1983. *The Thetford Treasure: Roman jewellery and silver,* British Museum Press, London

Johnson, M 2010. *Archaeological Theory: an introduction,* 2nd edn, Wiley-Blackwell, Chichester

Jones, A 2010. 'The Staffordshire Hoard fieldwork, 2009–2010', in Geake 2010, <https://finds.org.uk/staffshoardsymposium/papers/alexjones> (accessed 15 May 15)

Jones, A and Baldwin, E 2017. *The Staffordshire Hoard Fieldwork 2009–2010,* Staffordshire Hoard Res Rep 27, Archaeological Data Service, York, <doi.org/10.5284/1041576>

Jones, A H M 1964. *The Later Roman Empire, 284–602: a social, economic and administrative survey,* Blackwell, Oxford

Jones, G 1998. 'Penda's footprint? Place-names containing personal names associated with those of early Mercian kings', *Nomina,* **21**, 29–62

Jørgensen, L and Storgaard, B 2003. *Sejrens Triumf,* Nationalmuseet, Copenhagen

Jørgensen L and Vang Petersen, P 1998. *Guld, Magt og Tro: Danske Skattefund fra Oldtid og Middelalder,* Thaning and Appel, Danish National Museum

K

Kaegi, Walter E 2003. *Heraclius, Emperor of Byzantium,* Cambridge University Press, Cambridge

Kellner, H-J and Zahlhaas, K 1993. *Der römische Tempelschatz von Weissenburg in Bayern,* Philip von Zabern, Mainz

Kelly, E P 2001. 'The Hillquarter, Co. Westmeath mounts: an early medieval saddle from Ireland', in M Redknap, N Edwards, S Youngs, A Lane and J Knight (eds), *Pattern and Purpose in Insular Art,* 261–74, Oxbow Books, Oxford

Kelly, S 2009. *Charters of Peterborough Abbey,* Anglo-Saxon Charters 14, British Academy, Oxford

Kendrick, T D 1933. 'Polychrome jewellery in Kent', *Antiquity,* **7**, 429–52

Kendrick, T D 1940. 'The Sutton Hoo ship-burial: the archaeology of the jewellery', *Antiquity,* **14**, 34–9

Kendrick, T D, Kitzinger, E and Allen, D 1939. 'The Sutton Hoo finds', *British Museum Q,* **13**, 111–36

Kent J P C 1975. 'The coins and the date of the burial', in Bruce-Mitford 1975, 578–677

Kent, J P C 1994. *The Roman Imperial Coinage. Vol X: the divided empire and the fall of the western parts AD 395–491,* Spink, London

Kent, J and Painter, K S (eds) 1977. *Wealth of the Roman World: gold and silver, AD 300–700,* British Museum Press, London

Keynes, S 2010. 'The Staffordshire Hoard and Mercian power', in Geake 2010, <https://finds.org.uk/staffshoardsymposium/papers/simonkeynes> (accessed 06 April 2016)

Kidd, D S W 1987. 'Kommentar zum Fund von Domagnano', in Menghin *et al* 1987, 428–29

Kinsley, G 2002. 'The Anglo-Saxon', in Sparey-Green, C *et al* 2002. 'Excavations on the South-eastern defences and extramural settlement of Little Chester, Derby 1971–2', *Derbyshire Archaeol J,* **122**, 84-121

Kirby, D P 1977. 'Welsh bards and the border', in A Dormer (ed), *Mercian Studies,* 31–42, Leicester University Press, Leicester

Kirby, D P 1991. *The Earliest English Kings,* Unwin Hyman, London

Kiss, A 1982–4. 'Der Zeitpunkt der Verbergung der Schatzfunde I und II von Szilágysomlyó', *Acta Antiqua Academiae Scientiarum Hungarica,* **30**, 401–16

Kiss, A 1986. 'Die Goldfunde des Karpatenbeckens vom 5. bis zum 10. Jh.: Angaben zu den Vergleichsmöglichkeiten der schriftlichen und archäologischen Quellen', *Acta Archaeologica Academiae Scientiarum Hungarica,* **38**, 105–45

Kiss, A 1999a. 'Historische Auswertung', in Seipel 1999, 163–8

Kiss, A 1999b. 'Die Schalen', in Seipel 1999, 161–2

Kitzinger, E 1993. 'Interlace and icons: form and function in early Insular art', in Spearman and Higgitt 1993, 3–15

Kjellgren, R 2004. *Myntfynd från Bohuslän,* Sveriges Mynthistoria, Landskapsinventeringen 11, Kungliga Myntkabinettet, Stockholm

Klaeber, F 1936. *Beowulf,* 3rd edn, D C Heath and Company, Lexington, MA

Klein, T 2013. 'The inscribed gold strip in the Staffordshire Hoard: the text and script of an early Anglo-Saxon biblical inscription', *Anglo-Saxon Stud Archaeol Hist,* **18**, 62–74

Kleinschmidt, H 2014. 'Der Fund von Staffordshire und die Krise der merzischen Königsherrschaft um 700: ein Beitrag zur Kritik der Debatte um den Staatsbegriff des frühen Mittelalters und zur Kooperation zwischen Geschichtswissenschaft und Archäologie', *Frühmittelalterliche Studien,* **48**, 155–206

Klumbach, H 1973. *Spätrömische Gardehelme,* Münchner Beiträge zur Vor- und Frühgeschichte 15, C.H.Beck'sche, Munich

Knox, A 2013. 'Discovering an Anglo-Saxon royal hall', *Current Archaeol,* **284**, 20–5

Koch, R and Koch, U 1996. 'Die fränkische Expansion ins Mains- und Neckargebiet', in Wieczorek *et al* 1996, 270–84

Komnick, H 2008. 'Römerzeitliche Münzfunde in Nordostdeutschland zwischen Elbe und Oder', in A Bursche, R Ciolek and R Wolters (eds), *Roman Coins Outside the Empire: ways and phases, contexts and functions*, 113–33, Moneta, Wetteren

Kossinna, G 1919. 'Der goldene Halsring von Peterfitz bei Kolberg in Hinterpommern', *Mannus,* **9**, 97–104

Krenn-Leeb, A 2006. 'Gaben an die Götter? Depotfunde der Frühbronzezeit in Österreich', *Archäologie Österreichs,* **17** (1), 4–17

Kristoffersen, S 1995. 'Transformation in Migration period animal art', *Norwegian Archaeol Rev,* **28** (1), 1–17

Krusch, B (ed) 1888. *Gesta Dagoberti*, Monumenta Germaniae Historica, Scriptores Rerum Merovingicarum II, 215–328 and 396–425, Hahn, Hanover

Krusch, B (ed) 1902. *Vita Eligii episcopi Noviomagensis*, Monumenta Germaniae Historica, Scriptores Rerum Merovingicarum IV, 634–761, Hahn, Hanover and Leipzig,

Krusch, B and Levison W (eds) 1951. *Gregorii episcopi Turonensis. Libri historiarum X*, Monumenta Germaniae Historica SS rerum Merovingicarum 1.1, Impensis Bibliopolii Hahniani, Hanover

Kühn, H 1973. 'Die Christus-Schnallen der Völkerwanderungszeit', *Jahrbuch für Prähistorische und Ethnographische Kunst,* **23**, 51–76

Künzl, E (ed) 1993. *Die Alamannenbeute aus dem Rhein bei Neupotz: Plünderungsgut aus dem römischen Gallien. Vol 1: Untersuchungen*, Römisch Germanisches Zentralmuseum zu Mainz, Forschungsinstitut für Vor- und Frühgeschichte, Monographien 34,1, Rudolf Habelt, Bonn

Künzl, E 1996. 'Anmerkungen zum Hortfund von Weissenburg', *Germania,* **74**, 453–76

Künzl, S 1993. 'Das Tafelgeschirr', in Künzl E 1993, 113–227

Künzl, S and Künzl, E 1993. 'Der Fund von Neupotz – die historische Momentaufnahme der Plünderung einer römischen Domäne in Gallien', in Künzl E 1993, 473–504

Kurze, F 1950. *Annales regni Francorum et Annales qui dicuntur Einhardi*, Monumenta Germaniae Historica SS rerum Germanicarum in usum scholarum, Hanover

Kyhlberg, O 1986. 'Late Roman and Byzantine *solidi*: an archaeological analysis of coins and hoards', in B Hovén (ed), *Excavations at Helgö. X: coins, iron and gold*, 13–126, Kungliga Vitterhets, Historie och Antikvitets Akademien, Stockholm

L

La Croix, C 1883. *Monographie de l'Hypogée-Martyrium de Poitiers, décrit et dessiné par l'Inventeur*, Firmin-Didot, Paris

Lafaurie, J 1975. 'Le trésor de Gourdon', *Bulletin de la Societé nationale des Antiquités de France,* **19** (3), 61–76

Laing, L 1975. 'The Mote of Mark and the origins of Celtic interlace', *Antiquity,* **49**, 98–108

Laing, L and Longley, D 2006. *The Mote of Mark: a Dark Age hillfort in south-west Scotland*, Oxbow Books, Oxford

Lamm, J-P 2005. 'Timboholm', *RGA,* **30**, 612–13

Lamm, J-P 2006. 'Tureholm', *RGA,* **31**, 338–40

Lamm, J-P and Nordström, H (eds)1983. *Vendel Period Studies*, Museum of National Antiquities, Stockholm

LandIS n.d. 'Land Information System', Cranfield University, <http://www.landis.org.uk/index.cfm> (accessed 15 March 2017)

Landschaftsverband Rheinland 2008. *Die Langobarden: Das Ende der Völkerwanderung*, Wissenschaftliche Buchgesellschaft, Bonn, Darmstadt

La Niece, S 1983. 'Niello: an historical and technological survey', *Antiq J,* **63**, 279–97

La Niece, S 1988. 'White inlays in Anglo-Saxon jewellery', in E A Slater and J O Tate (eds), *Science and Archaeology Glasgow 1987*, 235–41, BAR Brit Ser 196, British Archaeological Reports, Oxford

La Niece, S 2013. *The Scientific Analysis of Niello Inlays from the Staffordshire Hoard*, Staffordshire Hoard Res Rep 4, Archaeological Data Service, York, <doi.org/10.5284/1041576>

Lapatin, K (ed) 2017. *Heiliger Luxus: Der römische Silberschatz von Berthouville*, Wissenschaftliche Buchgesellschaft, Darmstadt

Lapidge, M 2006. *The Anglo-Saxon Library*, Oxford University Press, Oxford

Larrington, C 1996. *The Poetic Edda,* Oxford University Press, Oxford

Larsson, L and Hårdh, B (eds) 1998. *Centrala Platser, Centrala Frågor: Samhällsstrukturen under Järnåldern : en Vänbok till Berta Stjernquist*, Uppåkrastudier 1, Almqvist & Wiksell International, Stockholm

Lau, N 2014. *Das Thorsberger Moor. Band 1: Die Pferdegeschirre*, Schleswig-Holsteinische Landesmuseen Schloss Gottorf, Schleswig

Leader-Newby, R E 2004. *Silver and Society in Late Antiquity: functions and meanings of silver plate in the fourth to seventh centuries*, Ashgate, Aldershot

Leahy, K. 2006. 'Fen Drayton', *Medieval Archaeol,* **50**, 278–80

Leahy, K 2010. 'The contents of the hoard', in Geake 2010, <https://finds.org.uk/staffshoardsymposium/papers/kevinleahy> (accessed 15 May 2014)

Leahy, K 2015. 'The Staffordshire Hoard in context', in Naylor and Bland 2015, 117–24

Leahy, K and Bland, R 2009. *The Staffordshire Hoard,* British Museum Press, London

Leahy, K, Bland, R, Hooke, D, Jones, A and Okasha, E 2011. 'The Staffordshire (Ogley Hay) hoard: recovery of a treasure', *Antiquity,* **85**, 202–20

Leclercq, H 1934. 'Mitre', in Cabrol, F and Leclercq, H (eds), *Dictionnaire d'Archéologie et Liturgie* XI, cols 1554–7, Librairie Letouzey et Ané, Paris

Legoux, R 2011. *La nécropole mérovingienne de Bulles (Oise)*, Mémoires de l'Association française d'archéologie mérovingienne 24, Association française d'archéologie mérovingienne, Condé-sur-Noireau

Lehrberger, G and Raub, C J 1995. 'A look into the interior of Celtic gold coins', in Morteani and Northover 1995, 341–55

Leigh, D 1984. 'Ambiguity in Anglo-Saxon Style I', *Antiq J,* **64**, 34–42

Leigh, D 1990. 'Aspects of early brooch design and production', in E Southworth (ed), *Anglo-Saxon Cemeteries: a reappraisal,* 107–24, Alan Sutton, Stroud

Lestocquoy, J 1958. 'Le trésor d'argenterie découvert à Graincourt-lès-Havrincourt (Pas-de-Calais)', *Bulletin de la société nationale des antiquaires de France,* **12** (3), 55–61

Lethbridge, T C 1931. *Recent Excavations in Anglo-Saxon Cemeteries in Cambridgeshire and Suffolk,* Cambridge Antiq Soc Quarto Pubs, New Ser 5, Cambridge Antiquarian Society, Cambridge

Lethbridge, T C 1953. 'Jewelled Saxon pendant from the Isle of Ely', *Proc Cambridge Antiq Soc,* **46**, 1–3

Levick, P 2006. 'BERK-4F2E17: an early medieval mount', <https://finds.org.uk/database/artefacts/record/id/118652> (accessed 31 May 2017)

Levison, W (ed) 1913. *Stephen, Vita Wilfridi I, episcopi Eboracensis,* Monumenta Germaniae Historica, Scriptores Rerum Merovingicarum VI, Hahn, Hanover and Leipzig

Lévi-Strauss, C 1963. *Structural Anthropology,* Basic Books, New York

Lewis, C P 2007. 'Welsh territories and Welsh identities in late Anglo-Saxon England', in N J Higham (ed), *Britons in Anglo-Saxon England,* 130–43, Pub Manchester Centre Anglo-Saxon Stud 7, Boydell Press, Woodbridge

Lewis, M 2012. 'The PAS – a rather British solution: the mandatory reporting and voluntary reporting of archaeological objects in England and Wales', *Europae Archaeologiae Consil Occas Papr,* **8**, 1–5

Lewis, M 2016. 'A detectorist's utopia? Archaeology and metal-detecting in England and Wales', *Open Archaeol,* **2**, 127–39

Liebermann, F 1903–16. *Die Gesetze der Angelsachsen,* 3 vols, Max Niemeyer, Halle a.S.

Lind, L 1981. *Roman Denarii found in Sweden. Vol 2: catalogue text,* Almqvist & Wiksell International, Stockholm

Lindqvist, S 1925. 'Vendelhjälmarnas ursprung', *Fornvännen,* **186**, 181–207

Lindstrøm, T C and Kristoffersen, S 2001. '"Figure it out!" Psychological perspectives on perception of Migration period animal art', *Norwegian Archaeol Rev,* **34** (2), 65–84

Ljungkvist, J 2009a. 'Continental imports to Scandinavia: patterns and changes between AD 400 and 800', in D Quast (ed), *Foreigners in Early Medieval Europe: thirteen international studies on early medieval mobility,* 27–47, Verlag des Römisch-Germanischen Zentralmuseums, Mainz

Ljungkvist, J 2009b. 'Valsgärde: development and change of a burial ground over 1300 years', in S Norr (ed), *Valsgärde Studies: the place and its people, past and present,* 13–55, Occ Papr Archaeol 42, Uppsala

Ljungkvist, J and Frölund, P 2015. 'Gamla Uppsala: the emergence of a centre and a magnate complex', *J Archaeol Ancient Hist,* **16**, 3–29

Longpérier, A de 1879. 'Le missorium de Geilamir roi des Vandales et les monuments analogues', *Gazette Archéologique,* **5**, 53–9 (reprinted in Longpérier, A de 1884, *Oeuvres. Vol 6,* 255–63, Paris)

L'Origine des Grenats du Haut Moyen Âge / The Origin of Early Middle Age Garnets 2017 <http://c2rmf.fr/evenement/lorigine-des-grenats-du-haut-moyen-age-origin-early-middle-ages-garnets> (accessed 25 May 2018)

Losco-Bradley, S 1979. 'Catholme', *Current Archaeol,* **59**, 358–64

Losco-Bradley, S and Kinsley, G 2002. *Catholme: an Anglo-Saxon settlement on the Trent gravels in Staffordshire,* Nottingham Stud Archaeol 3, University of Nottingham, Nottingham

Loveluck, C 1995. 'Acculturation, migration and exchange: the formation of Anglo-Saxon society in the Peak District, AD 400–700', in J Bintliff and H Hamerow (eds), *Europe between Late Antiquity and the Middle Ages: recent archaeological and historical research in western and southern Europe,* 84–98, BAR Int Ser 617, Archaeopress, Oxford

Loveluck, C 2007. *Rural Settlement, Lifestyles and Social Change in the Later First Millennium AD: Anglo-Saxon Flixborough in its wider context,* Excavations at Flixborough 4, Oxbow, Oxford

Lowe, C 1999. *Angels, Fools and Tyrants: Britons and Anglo-Saxons in southern Scotland,* Canongate Books and Historic Scotland, Edinburgh

Lucy, S 2000. *The Anglo-Saxon Way of Death,* Sutton Publishing, Stroud

Lucy, S, Tipper, J and Dickens, A 2009. *The Anglo-Saxon Settlement and Cemetery at Bloodmoor Hill, Carlton Colville, Suffolk,* East Anglian Archaeol 131, Cambridge

Lund Hansen, U 1995. *Himlingøje – Seeland – Europa. Ein Gräberfeld der jüngeren römischen Kaiserzeit auf Seeland, seine Bedeutung und internationalen Beziehungen, Det Kongelige* Nordiske Oldskriftselskab, Copenhagen

Lund Hansen, U 2008. 'Among the elite of Europe', in Adamsen *et al* 2008, 82–9

M

McClure J and Collins R (eds and trans) 1994. *The Ecclesiastical History of the English People. The greater chronicle: Bede's letter to Egbert*, Oxford University Press, Oxford/New York

McCrindle, J W 1897 (reprinted 2010). *The Christian Topography of Cosmas, an Egyptian Monk*, The Hakluyt Society and Cambridge University Press, Cambridge

McDonald, C 2006 'ESS-27D367: an early medieval sword', < https://finds.org.uk/database/artefacts/record/id/144896> (accessed 29 May 2017)

Mc Elhinney, P 2015. *Analysis and Characterisation of Staffordshire Hoard Organic Material*, Staffordshire Hoard Res Rep 25, Archaeological Data Service, York <doi.org/10.5284/1041576>

MacGregor, A 2000. 'A seventh-century pectoral cross from Holderness, East Yorkshire', *Medieval Archaeol,* **44**, 217–22

McLean, L 2011. 'ESS-E396B1: an early medieval finger ring', <https://finds.org.uk/database/artefacts/record/id/476309> (accessed 31 May 2017)

McLean, L and Richardson, A 2010. 'Early Anglo-Saxon brooches in southern England: the contribution of the Portable Antiquities Scheme', in S Worrell, G Egan, J Naylor, K Leahy and M Lewis (eds), *A Decade of Discovery: proceedings of the Portable Antiquities Scheme conference 2007,* 161–71, BAR Brit Ser 520, Archaeopress, Oxford

McNeill, J T and Gamer, H M 1938. *Medieval Handbooks of Penance,* Columbia University Press, New York

Maddicott, J S 2005. 'London and Droitwich, *c* 650–750: trade, industry and the rise of Mercia', *Anglo-Saxon England,* **34**, 7–58

Maras, A, Botticelli, M and Ballirano, P 2013. 'Archaeometric investigations on cinnabar provenance and origin by x-ray powder diffraction: preliminary data', *Intl J Conserv Sci,* **4**, 685–92

Margary, I D 1967. *Roman Roads in Britain,* rev edn, John Baker, London

Marquardt, H 1938. *Die Altenglischen Kenningar*, Niemeyer, Halle

Martin, E, Pendleton, C and Plouviez, J 2000. 'Archaeology in Suffolk 1999', *Proc Suffolk Inst Archaeol Hist,* **29**, 2000, 495–531

Martin, L and Hurst, D (eds) 1991. *Bede the Venerable, Homilies on the Gospels,* 2 vols, Cistercian Stud Ser 110 and 111, Cistercian Publications, Kalamazoo, Michigan

Martin, M 1987. 'Redwalds Börse: Gewicht und Gewichtskategorien völkerwanderungszeitlicher Objekte aus Edelmetall', *Frühmittelalterliche Studien*, **21**, 206–38

Martin, M 1988. 'Zum Gewicht des römischen Pfundes', in Baratte 1988, 211–25

Martin, T F 2015. *The Cruciform Brooch and Anglo-Saxon England,* Boydell & Brewer, Woodbridge

Martínez-Cortizas, A, Pontevedra-Pombal, X, García-Rodeja, E, Nóvoa-Muñoz, J C and Shotyk, W 1999. 'Mercury in a Spanish peat bog: archive of climate change and atmospheric metal deposition', *Science,* **284**, 939–42

Martínez Pizarro, J 2005. *The Story of Wamba: Julian of Toledo's Historia Wambae regis,* Catholic University of America Press, Washington, DC

Martinón-Torres, M 2016. *Analysis of Weathered Green Inlays in the Staffordshire Hoard,* Staffordshire Hoard Res Rep 23, Archaeological Data Service, York, <doi.org/10.5284/1041576>

Marzinzik, S 2003. *Early Anglo-Saxon Belt Buckles (late 5th to early 8th centuries AD)*: their classification and context, BAR Brit Ser 357, Archaeopress, Oxford

Marzinzik, S 2007. *The Sutton Hoo Helmet,* British Museum Press, London

Matešić, S 2015. *Das Thorsberger Moor. Vol 3: Die militärischen Ausrüstungen,* Verein zur Förderung des Archäologischen Landesmuseums, Schleswig

Mattingley, H 1948. *Tacitus on Britain and Germany,* Penguin, Harmondsworth

Mattingly, D 2006. *An Imperial Possession: Britain in the Roman Empire, 54 BC–AD 409*, Penguin, London

Mauss, M 1925 (trans 1954). *The Gift: forms and functions of exchange in archaic societies (trans. I. Cunnison),* Routledge & Keegan Paul, London and Henley (reprinted with corrections 1969)

Meadows, I 1997. 'Wollaston: the "Pioneer" burial', *Current Archaeol,* **154**, 391–5

Meadows, I 2004. 'An Anglian warrior burial from Wollaston, Northamptonshire', unpublished report, Northamptonshire Archaeology and Northamptonshire County Council

Meaney, A 1964. *Gazetteer of Early Anglo-Saxon Burial Sites,* George Allen and Unwin, London

Meaney, A 2005. 'Felix's *Life of Guthlac*: history or hagiography?', in Hill and Worthington 2005, 75–84

Medland, A 2011. *Regional Trends: portrait of the West Midlands,* Office for National Statistics, London

Meehan, B 1996. *The Book of Durrow: a medieval masterpiece at Trinity College Dublin*, Town House, Dublin

Meek, A 2012. *The PIXE and PIGE Analysis of Glass Inlays from the Staffordshire Hoard*, Staffordshire Hoard Res Rep 2, Archaeological Data Service, York, <doi.org/10.5284/1041576>

Meek, A. 2013a. *XRF Analysis of Inlays in Staffordshire Hoard Object K301*, Staffordshire Hoard Res Rep15, Archaeological Data Service, York, <doi.org/10.5284/1041576>

Meek, A. 2013b. *XRF Analysis of Triangular Green Inlay in Staffordshire Hoard Object K744*, Staffordshire Hoard Res Rep 14, Archaeological Data Service, York, <doi.org/10.5284/1041576>

Meek, A 2016. 'Ion beam analysis of glass inlays from the Staffordshire Hoard', *J Archaeol Sci: Reports*, **7**, 324–9

Meeks, N D and Holmes, R 1985. 'The Sutton Hoo garnet jewellery: an examination of some gold backing foils and a study of their possible manufacturing techniques', *Anglo-Saxon Stud Archaeol Hist*, **4**, 143–57

Meeks, N D and Tite, M S 1980. 'The analysis of platinum group element inclusions in gold antiquities', *J Archaeol Sci*, **7**, 267–75

Menghin, W 1983. *Das Schwert im frühen Mittelalter*, Konrad Theiss Verlag, Stuttgart

Menghin, W (ed) 2007. *Merowingerzeit - Europa ohne Grenzen: Archäologie und Geschichte des 5. bis 8. Jahrhunderts = Epocha merovingov - Evropa bez granic: archeologija i istorija V-VIII vv. = The Merovingian period - Europe without Borders: archaeology and history of the 5th to 8th centuries*, Moscow, St Petersburg

Menghin, W, Springer, T and Wamers, E (eds) 1987. *Germanen, Hunnen und Awaren: Schätze der Völkerwanderungszeit*, Germanisches Nationalmuseum, Nuremburg

Menis, G C (ed) 1990. *I Longobardi*, Electa, Milan

Metcalf, D M 1993–4. *Thrymsas and Sceattas in the Ashmolean Museum, Oxford*, 3 vols, Royal Numismatic Society and the Ashmolean Museum, London and Oxford

Metcalf, D M 2010. '"First to Öland, then to Gotland": the arrival of Late Roman and Byzantine *solidi* in Sweden and Denmark', *Travaux et Mémoires*, **16**, 561–76 (= Mélanges Cécile Morrisson), Association des Amis du Centre d'Historic et Civilisation de Byzance, Paris

Meyvaert, P 2005. 'The date of Bede's *In Ezram* and his image of Ezra in the Codex Amiatinus', *Speculum*, **80**, 1087–133

Migne, J-P (ed) 1857. *Athanasius, Vita S. Antonii, Versio Evagrii*, cols 857–976, Patrologia Graeca, Migne, Paris

Miles, M 1983. 'Vision: the eye of the body and the eye of the mind in Saint Augustine's *De trinitate* and *Confessions*', *J Religion*, **63** (2), 125–42

Millett, M and James, S 1983. 'Excavations at Cowdery's Down, Basingstoke, 1978–1981', *Archaeol J*, **140**, 151–279

Mitchell, B and Robinson, F (eds) 1998. *Beowulf: an edition with relevant shorter texts*, Blackwell, Oxford

Moisl, H 1981. 'Anglo-Saxon royal genealogies and Germanic oral tradition', *J Medieval Hist*, **7**, 215–48

Mongiatti, A 2016. *Scientific Investigation of Filigree Decoration on 37 Artefacts from the Staffordshire Hoard*, Staffordshire Hoard Res Rep 26, Archaeological Data Service, York, <doi.org/10.5284/1041576>

Montelius, O 1924. 'Ringsvärd och närstående typer', *Antikvarisk Tidskrift för Sverige*, **22** (5), 1–60

Morphy, H (ed) 1989. *Animals into Art*, Routledge, London and New York

Morris, J 1980. *Nennius, British History and the Welsh Annals*, Arthurian Period Sources 8, Phillimore, Chichester

Morris, R 2015. 'Landscapes of conversion among the Deirans: Lastingham and its neighbours in the seventh and eighth centuries', in P. Barnwell (ed), *Places of Worship in Britain and Ireland, 300–950*, 119–50, Shaun Tyas, Donington

Morrisson, C, Brenot, C and Barrandon, J-N 1988. 'L'argent chez les Vandales : Plats et Monnaies', in Baratte 1988, 123–31

Morteani, G and Northover, J P (eds) 1995. *Prehistoric Gold in Europe: mines, metallurgy and manufacture*, Kluwer Academic Publishers, Dordrecht

Mortimer, C 1986. 'Early use of brass in silver alloys', *Oxford J Archaeol*, **5**, 233–42

Mortimer, C 1994. 'Lead-alloy models for three early Anglo-Saxon brooches', *Anglo-Saxon Stud Archaeol Hist*, **7**, 27–33

Mortimer, C 1997. 'Punching and stamping on Anglo-Saxon artefacts', in G Boe and F Verhaeghe (eds), *Material Culture in Medieval Europe*, 77–85, Papers of the Medieval Europe Brugge 1997 Conference 7, Zellik

Mortimer, P and Bunker, M 2019. 'The sword in Anglo-Saxon England; the fifth to seventh centuries', Anglo-Saxon Books, Ely

Müller-Wille, M 1970/71. 'Pferdegrab und Pferdeopfer im frühen Mittelalter', *Berichten van de Rijksdienst voor het Oudheidkundig Bodemonderzoek*, **20/21**, 119–248

Mundell Mango, M and Bennett, A 1994. *The Sevso Treasure. Vol I: art historical description and inscriptions and methods of manufacture and scientific analyses*, Journal of Roman Archaeology Supplementary Series 12.1, Ann Arbor

Museum of London 2005. *Inspiring London: Museum of London annual report 2004/2005*, Museum of London, London, <https://www.museumoflondon.org.uk/application/files/9814/6796/7730/MOLAnnualReport200405.pdf> (accessed 23 February 2017)

Müssemeier, U, Nieveler, E, Plum, R and Pöppelmann, H 2003. *Chronologie der merowingerzeitlichen Grabfunde vom linken Niederrhein bis zur nördlichen Eifel*, Rheinland-Verlag GmbH, Bonn/Köln

Musty, J 1969. 'The excavation of two barrows, one of Saxon date, at Ford, Laverstock, near Salisbury, Winchester', *Antiq J*, **49**, 98–117

Mynors, R A B 1939. *Durham Cathedral Manuscripts to the end of the Twelfth Century*, Oxford University Press, Oxford

N

Naismith, R 2012. *Money and power in Anglo-Saxon England: the southern English kingdoms, 757–865*, Cambridge University Press, Cambridge

National Heritage Memorial Fund *2010. Report and Accounts 2009–2010*, <https://assets.publishing.service.gov.uk/government/uploads/system/uploads/attachment_data/file/247761/0107.pdf> (accessed 5 September 2018)

Naylor, J 2015. 'The deposition and hoarding of non-precious metals in early medieval England', in Naylor and Bland 2015, 125–46

Naylor, J 2016. 'Medieval Britain and Ireland in 2015', *Medieval Archaeol*, **60** (2), 349–67

Naylor, J and Bland, R 2015. *Hoards and the Deposition of Metalwork from the Bronze Age to the 20th Century: a British perspective*, BAR Brit Ser 615, Archaeopress, Oxford

Neal, D S 1981. *Roman Mosaics in Britain*, Alan Sutton, Gloucester

Nees, L 2002. *Early Medieval Art*, Oxford History of Art, Oxford University Press, Oxford

Neidorf L 2014. *The Dating of Beowulf*, Boydell & Brewer, Woodbridge

Nerman, B 1969/1975. *Die Vendelzeit Gotlands*, 2 vols, Almqvist & Wiksell, Stockholm

Neumann, D 2012. 'Hort und Raum: Grundlagen und Perspektiven der Interpretation', in Hansen *et al* 2012, 5–21

Newton, S 1993. *The Origins of Beowulf and the Pre-Viking Kingdom of East Anglia*, D S Brewer, Cambridge

Nicolay, J 2014. *The Splendour of Power: early medieval kingship and the use of gold and silver in the southern North Sea area (5th to 7th century AD)*, Groningen Archaeol Stud 28, Barkhuis Publishing and University of Groningen Library, Groningen

Nielsen, P O, Randsborg, K and Thrane, H (eds) 1994. *The Archaeology of Gudme and Lundeborg: papers presented at a conference at Svendborg, October 1991*, Arkæologiske Studier x, Copenhagen

Nieveler, E and Siegmund, F 1999. 'Merovingian chronology of the Lower Rhine area: results and problems', in J Hines, K Høilund Nielsen and F Siegmund (eds), *The Pace of Change: studies in early medieval chronology*, 3–22, Oxbow Books, Oxford

Nijboer, A J and Van Reekum, J E 1999. 'Scientific analysis of the gold disc-on-bow brooch', in Besteman *et al* 1999, 203–15

Nordquist, B 2004. 'Der Kriegsbeuteopferplatz von Finnestorp in Schweden', *Offa*, **61/62**, 221–38

Nørgård Jørgensen, A 1991. 'Kobbeå Grab 1 – ein reich ausgestattetes Grab der jüngeren germanischen Eisenzeit von Bornholm', *Studien zur Sachsenforschung*, **7**, 203–39

Nørgård Jørgensen, A 1999. *Waffen und Gräber: Typologische und chronologische Studien zu skandinavischen Waffengräbern, 520/30 bis 900 n.Chr*, Det Kongelige Nordiske Oldskriftselskab, Copenhagen

Northover, P and Anheuser, K 2000. 'Gilding in Britain: Celtic, Roman and Saxon', in T Drayman-Weisser (ed), *Gilded Metals: history, technology and conservation*, 109–22, Archetype Publications, London

Northover, P and La Niece, S 2009. 'New thoughts on niello', in A J Shortland, I C Freestone and T Rehren (eds), *From Mine to Microscope: advances in the study of ancient technology*, 145–54, Oxbow Books, Oxford

Nybruget, P O 1992. 'Åkerfunnet. Grav eller depot?', in E Mikkelsen and J H Larsen (eds), *Økonomiske og politiske sentra i Norden c 400–1000 e. Kr. : Åkerseminaret, Hamar 1990*, 23–39, Oslo

O

Ó Carragáin, E 2005. *Ritual and the Rood: Liturgical Images and the Old English Poems of the Dream of the Rood Tradition*, British Library Studies in Medieval Culture, University of Toronto Press, London and Toronto

O'Connor, S 2011. 'Staffordshire Hoard osseous materials ID: possible osseous materials on K546 and K653', independent unpublished technical report, Department of Archaeological Science, University of Bradford

Oddy, A 2000. 'A history of gilding with particular reference to statuary', in T Drayman-Weisser (ed), *Gilded Metals: History, Technology and Conservation*, 1–20, Archetype Publications, London

Oddy, J 1982. *Jewellery of the Ancient World*, Trefoil Books, London

Oddy, W A and La Niece, S 1986. 'Byzantine gold coins and jewellery: a study of gold contents', *Gold Bull*, **1**, 19–27

Oddy, W A, Bimson, M and Werner, A E 1978. 'Report on the scientific examination of the Sutton Hoo helmet', in Bruce-Mitford 1978, 226–31

Odobescu, A 1889–1900. *Le Trésor de Pétrossa : Étude sur l'Orfèvrerie antique. Vol 2 : Historique-Déscription*, P J Rothschild, Paris

Odobescu, A 1896. *Le Trésor de Pétrossa : Étude sur l'Orfèvrerie antique. Vol 3: Historique-Déscription*, J Rothschild, Paris

Odobescu, A 1900. *Le Trésor de Pétrossa : Étude sur l'Orfèvrerie antique. Vol 1*, J Rothschild, Paris

Odobescu, A 1976. *Opere IV. Tezaurul de la Pietroasa : Editie ingrijita*, Introducere Comentarii si Note de Mircea Babes, Studii arheologice de R. Harhoiu si Gh. Diaconu, Editura Academiei Republicii Socialiste Romania, Bucharest

Oexle, J 1992. *Studien zu merowingerzeitlichem Pferdegeschirr am Beispiel der Trensen*, Germanische Denkmäler der Völkerwanderungszeit Serie A 16, 2 vols, Verlag Philipp von Zabern, Mainz

Ogden, J 1977. 'Platinum group metal inclusions in ancient gold artefacts', *Historical Metallurgy J*, **11**, 53–72

Ogden, J 1982. *Jewellery of the Ancient World*, Trefoil Books, London

Okamura, L 1990. 'Coin hoards and frontier forts: problems of interpretation', in H Vetters and M Kandler (eds), *Akten des 14. Internationalen Limeskongresses 1986 in Carnuntum*, Der römische Limes in Österreich 36(1), 45–54, Verlag der Österreichischen Akademie der Wissenschaften, Vienna

Okasha, E 2010. 'The Staffordshire Hoard inscription', in Geake 2010, <https://finds.org.uk/staffshoardsymposium/papers/elisabethokasha> (accessed 4 May 2017)

O'Meadhra, U 1987. *Early Christian, Viking and Romanesque Art: motif pieces from Ireland. 2: a discussion on aspects of find context and function*, Theses and Papers in North European Archaeology 17, Almquist & Wiksell, Stockholm

Organ, R 1974. 'Examination of the gem-stones in the Cuthbert Cross', in Bruce-Mitford 1974, 296–9

Orna-Ornstein, J 2009. 'Patching, West Sussex, 23 AV and 27 AR (mixed Roman and pseudo-Roman) to c AD 465', in R Abdy, E Ghey, C Hughes and I Leins (eds), *Coin Hoards from Roman Britain: vol XII*, 389–92, Moneta, Wetteren

O'Sullivan, D 1990. 'Two early medieval mounts from the Crosthwaite Museum, Keswick', *Medieval Archaeol*, **34**, 145–47

Overbeck, B and Overbeck M 1985. 'Zur Datierung und Interpretation der spätantiken Goldbarren aus Siebenbürgen anhand eines unpublizierten Fundes aus Feldiora', *Chiron*, **15**, 199–210

Overbey, K E and Williams, M M (eds) 2016. 'Hoarders and hordes: responses to the Staffordshire Hoard', *Postmedieval*, **7 (3)**, 339–45

Ozanne, A 1963. 'The Peak dwellers', *Medieval Archaeol*, **6/7**, 15–52

P

Pace, V 2009. *La Crux Vaticana o Croce di Giustino Ii*, Bolletino d'Archvium Sancti Petri 4–5, Edizioni Capitolo Vaticano, Vatican City

Painter, K S 1977a. *The Mildenhall Treasure: Roman silver from East Anglia*, British Museum Press, London

Painter, K S 1977b. *The Water Newton Early Christian Silver*, British Museum Press, London

Painter, K S 2000. 'Il tesoro dell' Esquilino', in S Ensoli and E la Rocca (eds), *Aurea Roma: dalla città pagana alla città cristiana*, 140–6, Bretschneider, Rome

Painter, K S 2013. 'Hacksilber: a means of exchange?', in Hunter and Painter 2013, 215–42

Painter, K S 2015. 'Emergency or votive? Two groups of late-Roman gold and silver hoards', in Naylor and Bland 2015, 67–91

Palmer, S 1999. 'Archaeological excavations in the Arrow Valley, Warwickshire', *Trans Birmingham Warwickshire Archaeol Soc*, **103**, 1–230

Palmer, S 2013. 'Further archaeological survey at Semi-Bungalow Farm, Barracks Lane, Hammerwich, Staffordshire, 2012', unpublished Archaeology Warwickshire Report 1313

Palol, P de and Ripoll, G 1990. *Die Goten: Geschichte und Kunst in Westeuropa*, Belser, Stuttgart, Zürich

Parfitt, K and Anderson, T 2012. *Buckland Anglo-Saxon Cemetery Dover Excavations 1994*, The Archaeology of Canterbury New Ser 6, Canterbury Archaeological Trust, Ashford

Parkes, M B 1976. 'The handwriting of St Boniface: a reassessment of the problems', *Beiträge zur Geschichte der deutschen Sprache und Literatur* **98**,161–71 (reprinted in Parkes, M B 1991, *Scribes, Scripts and Readers: studies in the communication, presentation and dissemination of medieval texts*, Hambledon Press, London and Rio Grande)

Parol, J 2014. 'BM-7C4457: an early medieval assemblage', < https://finds.org.uk/database/artefacts/record/id/643932> (accessed 29 May 2017)

Parsons, D 2010. 'The name "Hammerwich"', in Geake 2010, <https://finds.org.uk/staffshoardsymposium/papers/davidparsons> (accessed 2 November 2016)

PAS n.d. 'The Treasure Act', <https://finds.org.uk/treasure> (accessed 16 April 2016)

PAS n.d. 'Writing to the Coroner', <https://finds.org.uk/treasure/advice/writing-to-coroner> (accessed 16 April 2016)

PAS n.d. 'When your finds are declared treasure', <https://finds.org.uk/treasure/advice/finders> (accessed 16 April 2016)

PAS 2009a. 'Minutes of the Treasure Valuation Committee meeting 30 September 2009', <https://finds.org.uk/treasure/minutes> (accessed 4 May 2016)

PAS 2009b. 'Minutes of the Treasure Valuation Committee meeting 25 November 2009', <https://finds.org.uk/treasure/minutes> (accessed 4 May 2016)

PAS 2013. 'Minutes of the Treasure Valuation Committee meeting 27 March 2013', <https://finds.org.uk/treasure/minutes> (accessed 4 May 2016)

Pasqui, A 1918. 'Necropoli barbarica di Nocera umbra', *Monumenti Antichi*, **25**, 137–352

Payne, N 2005. 'SOMDOR-F381A4: an early medieval scabbard', <https://finds.org.uk/database/artefacts/record/id/112570> (accessed 3 May 2017)

Paynton, C 1999. 'YORYM214: an early medieval pendant', <https://finds.org.uk/database/artefacts/record/id/28631> (accessed 29 May 2017)

Peacock, B 2016. 'Westgate Oxford pop-up museum: taking archaeology out into the city', *Museum Archaeologist Newsletter,* Summer 2016, 9–11

Peake, J R N and Freestone, I C 2014. 'Opaque yellow glass production in the early medieval period: new evidence', in D Keller, J Price and C Jackson (eds), *Neighbours and Successors of Rome: traditions of glass production and use in Europe and the Middle East in the later 1st millennium AD,* 15–21, Oxbow, Oxford

Pelteret, D 1980. 'Slave raiding and slave trading in early England', *Anglo-Saxon England,* **9**, 99–114

Penn, K 2000. *Norwich Southern Bypass. Part II: Anglo-Saxon cemetery at Harford Farm, Caistor St Edmund,* East Anglian Archaeology 92, Gressenhall

Perea, A and Armbruster, B 2011. 'Tomb 100 at Cabezo Lucero: new light on goldworking in fourth-century BC Iberia', *Antiquity,* **85**, 158–71

Périn, P 2008. 'The treasure of Domagnano (Republic of San Marino)', in Aillagon 2008, 302–5

Périn, P and Feffer, L-C (eds) 1985. *La Neustrie : Les pays du nord de la Loire de Dagobert à Charles le Chauve,* Musées et Monuments Départementaux de Seine-Maritime, Créteuil

Périn, P and Kazanski, M 1996. 'Das Grab Childerichs I', in Wieczorek *et al* 1996, 173–82

Périn, P, Calligaro, T, Vallet Poirot, J-P and Bagault, D 2007. 'Provenancing Merovingian garnets by PIXE and μ-Raman spectrometry', in J Henning (ed), *Post-Roman Towns: trade and settlement in Europe and Byzantium. Vol 1: the heirs of the Roman West,* 69–75, Walter de Gruyter GmbH & Co, Berlin and New York

Perry, D R 2000. *Castle Park, Dunbar: two thousand years on a fortified headland,* Soc Antiq Scotland Monogr Ser 16, Society of Antiquaries of Scotland, Edinburgh

Pesch, A 2007. *Die Goldbrakteaten der Völkerwanderungszeit: Thema und Variation,* RGA Ergänzungsbände 36, De Gruyter, Berlin, New York

Pesch, A 2009. 'Iconologia Sacra: zur Entwicklung und Bedeutung der germanischen Bildersprache in 1. Jahrtausend', in U van Freeden, H Freisinger and E Wamers (eds), *Glaube, Kunst und Herrschaft: Phänomene des Religiösen im 1. Jahrtausend n. Chr. in Mittel- und Nordeuropa,* 203–17, 59th Internationalen Saschensymposions, Dr Rudolph Habelt GmbH, Bonn

Pesch, A and Blankenfeldt, R (eds) 2012. *Goldsmith Mysteries: archaeological, pictorial and documentary evidence from the 1st Millennium AD in northern Europe,* Wachholtz Verlag, Neumünster

Pestell, T 2004. *Landscapes of Monastic Foundation: the establishment of religious houses in East Anglia, c 650–1200,* Boydell & Brewer, Woodbridge

Pestell, T 2017. 'The kingdom of East Anglia, Frisia and continental connections, c AD 600–900', in J Hines and N Ijssennagger (eds), *Frisians and their North Sea Neighbours,* 193–222, The Boydell Press, Woodbridge

Pickwoad, N 2015. 'The binding', in Breay and Meehan 2015, 41–63

Pinder, M 1995. 'Anglo-Saxon garnet cloisonné composite disc brooches: some aspects of their construction', *J Brit Archaeol Ass,* **148**, 6–28

Pinder, M 2001. 'An aspect of seventh–century Anglo-Saxon goldsmithing', in M Redknap, N Edwards and S Youngs (eds), *Pattern and Purpose in Insular Art: proceedings of the fourth international conference on Insular art,* 133–9, Oxbow Books, Oxford

Pingel, V 1995. 'Technical aspects of prehistoric gold objects on the basis of material analysis', in Morteani and Northover 1995, 385–98

Pirling, R 2015. *Gräber erzahlen Geschichte. Krefeld-Gellep: 6000 Gräber von Römern und Franken,* Droste Verlag, Düsseldorf

Plummer, C 1896. *Venerabilis Baedae Opera Historica,* 2 vols, Oxford University Press, Oxford

Pluskowski, A 2010. 'Animal magic', in Carver *et al* 2010, 103–27

Poglayen-Neuwall, S 1930. 'Über die ursprünglichen Besitzer des spätantiken Silberfundes vom Esquilin und seine Datierung', *Mitteilungen des Deutschen Archäologischen Instituts, Römische Abteilung,* **45**, 124–36

Pohl, E, Recker, U and Theune, C (eds) 2001. *Archäologisches Zellwerk: Beiträge zur Kulturgeschichte in Europe und Asien,* Verlag Marie Leidorf GmbH, Rahden/Westf

Pohl, W 1999 'Herrschaft', *RGA,* **14**, 443–57

Powell, A, Booth, P, Fitzpatrick, A P and Crockett, A D 2008. *The Archaeology of the M6 Toll 2000–2003,* Oxford Wessex Archaeology Monogr 2, Wessex Archaeology, Salisbury

Powlesland, D 1997. 'Anglo-Saxon settlements, structures, forms and layouts', in Hines 1997b, 101–16

Pratt, D 2003. 'Persuasion and invention at the court of King Alfred the Great', in C Cubitt (ed), *Court Culture in the early Middle Ages: proceedings of the first Alcuin conference,* 189–222, Brepols, Turnhout

Price, N and Mortimer, P 2014. 'An eye for Odin? Divine role-playing in the age of Sutton Hoo', *European J Archaeol,* **17** (3), 517–38

Proctor, L 2013. 'DUR-BA5975: an early medieval scabbard', <https://finds.org.uk/database/artefacts/record/id/584834> (accessed 3 May 2017)

Q

Quast, D 1997. 'Opferplätz und heidnische Götter: Vorchristlicher Kult', in K Fuchs (ed), *Die Alamannen: Katalog zur Ausstellung „Die Alamannen", 1997 /1998 hrsg. vom Archäologischen Landesmuseum Baden-Württemberg*, 433–40, Theiss, Stuttgart

Quast, D 2009. 'Velp und verwandte Schatzfunde des frühen 5. Jahrhunderts', *Acta praehistorica et archaeologica*, **41**, 207–30

Quast, D 2012. *Das merowingerzeitliche Reliquienkästchen aus Ennabeuren: eine Studie zu den frühmittelalterlichen Reisereliquiaren und Chrismalia*, Römisch-Germanisches Zentralmuseum, Kataloge Vor- und Frühgeschichtlicher Altertümer 43, Mainz

Quast, D (ed) 2015a. *Das Grab des fränkischen Königs Childerich in Tournai und die Anastasis Childerici von Jean-Jaques Chifflet aus dem jahre 1655*, Verlag des Römisch-Germanischen Zentralmuseums, Mainz

Quast, D 2015b. 'Die Grabbeigaben – ein Kommentierter Fundkatalog', in Quast 2015a 165–208

Quast, D 2017. 'Biesenbrow und Cottbus: eine kurze Anmerkung zu zwei frühgeschichtlichen Schatzfunden aus dem heutigen Brandenburg', *Archäologisches Korrespondenzblatt*, **47**, 107–16

Quast, D, Hilgner, A and Greiff, S (eds) forthcoming. *Simply Gold, Simply Red: results of an international project on early medieval garnet jewellery*, Monographien des Römisch-Germanischen Zentralmuseums, Mainz

R

Rackham, H (trans) 2003. *Pliny Natural History: books 33–35*, Loeb Classical Library, Harvard University Press, Cambridge MA and London

Rackham, O 2007. *Transitus Beati Fursei: a translation of the 8th century manuscript 'Life of Saint Fursey'*, Fursey Pilgrims, East Harling

Radostits, O M, Gay, C C, Hinchcliff, K W and Constable, P D 2006. *Veterinary Medicine: a textbook of the diseases of cattle, horses, sheep, pigs and goats*, 10th edn, Saunders Elsevier, Philadelphia PA

Rahtz, P and Meeson, R (eds) 1992. *An Anglo-Saxon Watermill at Tamworth: excavations in the Bolebridge Street area of Tamworth, Staffordshire in 1971 and 1978*, Council for British Archaeology Res Rep 83, York

Raine, J (ed) 1835. *Reginald of Durham: Libellus de admirandis beati Cuthberti virtutibus*, Surtees Society 1

Rau, A 2010. *Nydam mose: Die personengebundenen Gegenstande: Grabungen 1989–1999*, Jysk Arkæologisk Selskab, Aarhus University Press, Aarhus.

Rau, A 2013a. 'Where did the late empire end? Hacksilber and coins in continental and northern Barbaricum c AD 340–500', in Hunter and Painter 2013, 339–57

Rau, A 2013b. 'Some observations on Migration Period "Hacksilber" hoards with Roman components', in B Ludowici (ed), *Individual and Individuality? Approaches towards an archaeology of personhood in the first millenium AD*, 189–203, Neue Studien zur Sachsenforschung 4, Theiss, Stuttgart

Raub, C J 1995. 'Metallurgy of gold and silver in prehistoric times', in Morteani and Northover 1995, 243–59

Raub, C J 1996. 'Reaction soldering with copper on an early medieval disc brooch from Germany', *Gold Bull*, **29**, 27–30

Read, A 2006. 'The conservation of the Wollaston Anglian helmet', in R D Smith (ed), *Make all Sure: the conservation and restoration of arms and armour*, 38–43, Basiliscoe Press, Leeds

Redknap, M and Lane, A 1994. 'The early medieval crannog at Llangorse, Powys: an interim statement on the 1989–1993 seasons', *Int J Nautical Archaeol*, **23** (3), 190–205

Redknap, M and Lewis, J M 2007. *A Corpus of Early Medieval Inscribed Stones and Stone Sculpture in Wales. Vol I: south-east Wales and the English border*, University of Wales Press, Cardiff

Reece, R 1999. *The Later Roman Empire: an archaeology, AD 150–600*, Tempus, Stroud

Renner, D 1970. *Die Durchbrochenen Zierscheiben der Merowingerzeit*, Römisch-Germanischen Zentralmuseums Bonn and R Habelt, Mainz

Reuter, T 2000. '"You can't take it with you": testaments, hoards and moveable wealth', in Tyler 2000, 11–24

Reuters 2009. 'Huge gold discovery is "unprecedented"', 24 September, <http://uk.reuters.com/article/uk-britain-treasure-idUKTRE58N2VJ20090924> (accessed 4 May 2016)

Reynolds, A and Langlands, A 2006. 'Social identities on the macro scale: a maximum view of Wansdyke', in W Davies, G Halsall and A Reynolds (eds), *People and Space in the Middle Ages 300–1300*, 13–44, Brepols, Turnhout

Reynolds, A and Webster, L (eds) 2013. *Early Medieval Art and Archaeology in the Northern World: studies in honour of James Graham-Campbell*, Early Medieval Art and Archaeology in the Northern World 58, Brill, Leiden and Boston

Richardson, A 2005. 'KENT-AC1CE6: an early medieval buckle', <https://finds.org.uk/database/artefacts/record/id/90628> (accessed 30 May 2017)

Richardson, A F 2005. *The Anglo-Saxon Cemeteries of Kent*, 2 vol, BAR Brit Ser 391, Archaeopress, Oxford

Roach Smith, C 1860. 'On Anglo-Saxon remains discovered recently in various places in Kent', *Archaeologia Cantiana*, **3**, 35–46

Robertson, A S 1974. 'Romano-British coin hoards; their numismatic, archaeological and historical significance', in P J Casey and R Reece (eds), *Coins and the Archaeologist*, 12–36, BAR 4, Archaeopress, Oxford

Robertson, A S 2000. *An Inventory of Romano-British Coin Hoards,* Royal Numismatic Society, London

Rodwell, W, Hawkes, J, Howe, E and Cramp, R 2008. 'The Lichfield angel: a spectacular Anglo-Saxon painted sculpture', *Antiq J,* **88**, 48–108

Roeren, R 1960. 'Zur Archäologie und Geschichte Südwestdeutschlands im 3. bis 5. Jahrhundert nach Christus', in *Jahrbuch des Römisch-Germanischen Zentralmuseums Mainz (RGZM)* 1960, 214–94.

Roffe, D 2014. 'Sitting on the fence: the Staffordshire hoard findspot in context', <http://www.roffe.co.uk/Carleton.htm> (accessed 3 May 2017)

Rogerson, A 2013. 'NMS-043037: an early medieval scabbard', <https://finds.org.uk/database/artefacts/record/id/538684> (accessed 30 May 2017)

Rohde, A 2007. 'DENO-89E427: an early medieval pendant', <https://finds.org.uk/database/artefacts/record/id/197535> (accessed 29 May, 2017).

Roland, J 1990. *Early Welsh Saga Poetry: a study and edition of the Englynion,* D S Brewer, Cambridge

Rolfe, J C (trans) 1986. *Ammianus Marcellinus,* Loeb Classical Library, Heinemann, London / Harvard University Press, Cambridge MA

Rollason D, 1982. *The Mildrith Legend: a study in early medieval hagiography in England,* Leicester University Press, Leicester

Roth, H 1975. 'Die langobardischen Goldblattkreuze: Bemerkungen zur Schlaufenornamentik und zum Stil II', in Hübener 1975, 31–5

Roth, H (ed) 1979. *Die Kunst der Völkerwanderungszeit,* Propyläen Verlag, Berlin, Frankfurt/Main, Vienna

Roth, H 1986. 'Stil II – Deutungsprobleme: Skizzen zu Pferdemotiven und zur Motivkoppelung', in H Roth (ed), *Zum Problem der Deutung frühmittelalterlicher Bildinhalte,* 111–27, Thorbecke Verlag, Sigmaringen

Roth, H 1996. 'Kunst der Merowingerzeit', in Wieczorek *et al* 1996, 629–39

Roth, U 1987. 'Early Insular manuscripts: ornament and archaeology, with special reference to the dating of the Book of Durrow', in Ryan 1987, 23–9

Russell Robinson, H R 1975. *The Armour of Imperial Rome,* Arms and Armour Press, London

Rusu, M 1986. 'Der Schatz von Pietroasele und der zeitgenössische historische Kontext', *Zeitschrift für Archäologie,* **20**, 181–200

Ryan, M (ed) 1987. *Ireland and Insular Art AD 500–1200: proceedings of a conference at University College Cork, 31 October – 3 November 1985,* Royal Irish Academy, Dublin.

Ryan, M 1993. 'The menagerie of the Derrynaflan chalice', in Spearman and Higgitt 1993, 151–61

Rynne, E forthcoming. 'The Ardagh chalice: a description', in N Whitfield (ed), *Papers on the Ardagh Chalice,* National Museum of Ireland, Dublin

S

Salin, B 1904. *Die Altgermanische Thierornamentik,* Beckman, Stockholm

Salway, P 1981. *Roman Britain,* Oxford University Press, Oxford

Sargent, A 2013. 'Early medieval Lichfield: a reassessment', *Staffordshire Archaeol Hist Soc Trans,* **46**, 1–37

Sawyer, P H 1968. *Anglo-Saxon Charters: an annotated list and bibliography,* Royal Society Guides and Handbooks 8, Royal Society, London

Schmauder, M 1999. 'Der Verwahrfund von Lengerich, Ldkr. Emsland: Spiegel innerrömischer Kämpfe?', *Die Kunde N F,* **50**, 91–118

Schmauder, M 2002. *Oberschichtgräber und Verwahrfunde in Südosteuropa im 4. und 5. Jahrhundert: Zum Verhältnis zwischen dem spätantiken Reich und der barbarischen Oberschicht aufgrund der archäologischen Quellen. Vol 1: text; Vol 2: Katalog und Tafeln,* Archaeologia Romanica 3, Ed Acad Române, Bucharest

Schmauder, M 2003. 'The "gold hoards" of the early Migration period in south-eastern Europe and the late Roman empire', in R Corradini, M Diesenberger, H Reimitz (eds), *The Construction of Communities in the Early Middle Ages: texts, resources and artefacts,* 81–94, The Transformation of the Roman World 12, Brill, Leiden/Boston

Schoneveld, J and Zijlstra, J 1999. 'The Wijnaldum brooch', in Besteman *et al* 1999, 191–201

Schramm, P E 1954. *Herrschaftszeichen und Staatssymbolik: Beiträge zu ihrer Geschichte vom 3. bis zum 16. Jahrhundert, Vols 1–3* (1954–1956), Schriften der Monumenta Germaniae Historica 13, Hiersemann, Stuttgart

Schwarz, G 1992. 'Der Götterfries auf der antiken Goldschale von Pietroasa', *Jahrbuch für Antike und Christentum,* **35**, 168–84

Score, V 2011. *Hoards, Hounds and Helmets,* Leicester Archaeology Monogr 21, University of Leicester Archaeological Services, Leicester

Scott, W 2013. 'LEIC-62B043: an early medieval sword', < https://finds.org.uk/database/artefacts/record/id/546271> (accessed 29 May 2017)

Scrivano, S, Gómez-Tubío, B, Ortega-Feliu, I, Ager, F J, Moreno-Suárez, A I, Respaldiza, M A, de la Banderae, M L and Marmolejof, A 2013. 'Identification of soldering and welding processes in ancient gold jewellery by micro-XRF spectroscopy', *X-Ray Spect,* **42**, 251–5

Scull, C 2002. 'Ipswich: development and contexts of an urban precursor in the seventh century', in B Hårdh and L Larsson (eds),

Central Places in the Migration and Medieval Periods, 303–16, Uppåkrastudier 6, Almqvist & Wiksell International, Stockholm

Scull, C 2009a. *Early Medieval (late 5th–early 8th centuries AD) Cemeteries at Boss Hall and Buttermarket, Ipswich, Suffolk,* Soc Medieval Archaeol Monogr 27, Maney, Leeds

Scull, C 2009b. 'The human burials', in Lucy *et al* 2009, 385–426

Scull, C 2011. 'Social transactions, gift exchange and power in the archaeology of the fifth to seventh centuries', in Hamerow *et al* 2011, 848–64

Scull, C and Naylor, J 2016. 'Sceattas in Anglo-Saxon graves', *Medieval Archaeol,* **60**, 205–41

Scull, C, Minter, F and Plouviez, J 2016. 'Social and economic complexity in early medieval England: a central place complex of the East Anglian kingdom at Rendlesham, Suffolk', *Antiquity,* **90**, 1594–612

Seaman, A 2013. 'Dinas Powys in context: settlement and society in post-Roman Wales', *Studia Celtica,* **47**, 1–23

See, K v, La Farge, B, Horst, S and Schulz, K 2012. *Kommentar zu den Liedern der Edda. Band 7: Heldenlieder,* Winter, Heidelberg

Seipel, W (ed) 1999. *Barbarenschmuck und Römergold: Der Schatz von Szilágysomlyó,* Eine Ausstellung des Kunsthistorischen Museums Vienna und des Magyar Nemzeti Múzeum Budapest, Kunsthistorisches Museum Vienna 2, März bis 2. Mai 1999, Skira, Milan

Semple, S J 2010. 'In the open air', in Carver *et al* 2010, 21–48

Semple, S, Orsini, C and Mui, S (eds) 2017. *Life on the Edge: social, political and religious frontiers in early medieval Europe,* Proc 63rd Sachsensymposion, Durham, Neue Studien zur Sachsenforschung 6, Braunschweigisches Landesmuseum with the Internationales Sachsensymposion, Wendeburg

Shearman, F, Camurcuoglu, D, Hockey, M and McArthur, G 2014. *Investigative Conservation of the Die-impressed Sheet from the Staffordshire Hoard,* Staffordshire Hoard Res Rep 25, Archaeological Data Service, York, <doi.org/10.5284/1041576>

Sherlock, S 2012. *A Royal Anglo-Saxon Cemetery at Street House, Loftus, North-east Yorkshire,* Tees Archaeol Monogr Ser 6, Hartlepool

Shelton, K J 1981. *The Esquiline Treasure,* British Museum Press, London

Shelton, K J 1985. 'The Esquiline Treasure: the nature of evidence', *Amer J Archaeol,* **89**, 147–155

Shingler, C 2013. 'Flexible friends: volunteer hosts and the Staffordshire Hoard', in *Group for Education in Museums Conference, People Power: realising the potential of volunteers, communities and partners, 2–5 September,* University of Leeds School of Music and Leeds City Museum, Leeds

Siddorn, K J 2003. *Viking Weapons and Warfare,* Tempus, Stroud

Siegmund, F 1998. *Merowingerzeit am Niederrhein: Die frühmittelalterlichen Funde aus dem Regierungsbezirk Düsseldorf und dem Kreis Heinsberg,* Rheinische Ausgrabungen 34, Dr Rudolf Habelt and Rheinland Verlag Bonn and Cologne

Simmonds, A 2008. 'West of Crane Brook Cottage, Hammerwich (Site 34)', in Powell *et al* 2008, 62–79

Skaare, T 1976. *Coins and Coinage in Viking-Age Norway,* Universitetsforlaget, Oslo

Slarke, D 2008. 'WMID-1EFF72: an early medieval vessel', <https://finds.org.uk/database/artefacts/record/id/237172> (accessed 31 May 2017)

Slarke, D 2009a. 'WMID-BE11E7: an early medieval brooch', <https://finds.org.uk/database/artefacts/record/id/252112> (accessed 1 June 2017)

Slarke, D 2009b. 'WMID-66D3E0: an early medieval brooch', <https://finds.org.uk/database/artefacts/record/id/251724> (accessed 1 June 2017)

Slomann, W and Christensen, A E 1984. 'The Åker find: facts, theories and speculation', in M Larsen, J Henning, E Straume and B Weber (eds), *Festskrift till Thorleif Sjøvold på 70-årsdagen,* 173–190. Universitetets Oldsaksamling, Oslo

Small, A, Thomas, C and Wilson, D M 1973. *St Ninian's Isle and its Treasure,* Oxford University Press, Oxford

Smith, C S and Gnudi, M T 1990. *The Pirotechnia of Vannoccio Biringuccio: the classic sixteenth-century treatise on metals and metallurgy,* Dover Publications Inc, New York

Smith, C S and Hawthorne, J G 1974. 'Mappae Clavicula', *Trans Amer Philos Soc,* **64**, 3–76

Smith, R A 1923. *British Museum Guide to Anglo-Saxon Antiquities,* British Museum, London

Southend on Sea Borough Council 2013. 'See the Prittlewell Prince's top treasures!', <http://www.southend.gov.uk/news/article/7/see_the_prittlewell_prince_s_top_treasures> (accessed 16 March 2018)

Speake, G 1970. 'A seventh-century coin pendant from Bacton, Norfolk, and its ornament', *Medieval Archaeol,* **14**, 1–16

Speake, G 1980. *Anglo-Saxon Animal Art and its Germanic Background,* Clarendon Press, Oxford

Speake, G 1989. *A Saxon Bed Burial on Swallowcliffe Down: excavations by F de M Vatcher,* English Heritage, London

Speake, G 2015. 'Exploring an equestrian warrior', in *Contextualising Metal-Detected Discoveries: the Staffordshire Anglo-Saxon Hoard (Staffordshire Hoard Newsletter,* **9**), 9–11, <http://www.barbicanra.co.uk/assets/staffordhire-hoard-newsletter-9-december-2015.pdf> (accessed 30 May, 2018)

Spearman, R M and Higgitt, J (eds) 1993. *The Age of Migrating Ideas: early medieval art in northern Britain and Ireland,* Alan Sutton Publishing, Edinburgh/Stroud

Spiropoulos, J 1985. *Small Scale Production of Lime for Building,* Deutsches Zentrum für Entwicklungstechnologien – GATE, Deutsche Gesellschaft für Technische Zusammenarbeit (GTZ) GmbH, Eschborn

Stacey, R J 2014. *FTIR, Raman and GC-MS Analysis of possible Organic Pastes and Associated Foils (K234 & 235) from the Staffordshire Hoard,* Staffordshire Hoard Res Rep 11, Archaeological Data Service, York, <doi.org/10.5284/1041576>

Stadt Frankfurt am Main, Dezernat Kultur und Freizeit (ed) 1994. *Goldhelm, Schwert und Silberschätze: Reichtümer aus 6000 Jahren rumänischer Vergangenheit,* Eine Ausstellung des Dezernats Kultur und Freizeit, Museum für Vor- und Frühgeschichte, Archäologisches Museum der Stadt Frankfurt am Main in und unter Mitwirkung der Schirn-Kunsthalle vom 29. Januar bis 17. April 1994/Museum für Vor- und Frühgeschichte, Archäologisches Museum, Schirn-Kunsthalle, Frankfurt/Main

Stafford, P 2000. 'Queens and treasure in the Early Middle Ages', in Tyler 2000, 61–82

Staffordshire County Council 2009. 'Project design: the archaeological investigation and recording of the South Staffordshire Hoard', Stafford

Staffordshire Hoard n.d.<http://www.staffordshirehoard.org.uk/> (accessed 28 November 2016)

Stancliffe, C 1983. 'Kings who opted out', in P Wormald (ed), *Ideal and Reality in Frankish and Anglo-Saxon Society,* 154–76, Basil Blackwell, Oxford

Stancliffe, C 1995. 'Where was Oswald killed?', in Stancliffe and Cambridge 1995, 84–96

Stancliffe, C and E Cambridge (eds) 1995. *Oswald: Northumbrian king to European saint,* 84–96, Paul Watkins, Stamford

Stapleton, C P, Freestone, I C and Bowman, S G E 1999. 'Composition and origin of early medieval opaque red enamel from Britain and Ireland', *J Archaeol Sci,* **26**, 913–21

Steele, V and Hacke, M 2013. *FTIR and GC-MS Analysis of Pastes and Soils from the Staffordshire Hoard,* Staffordshire Hoard Res Rep5, Archaeological Data Service, York, <doi.org/10.5284/1041576>

Stenton, F M 1947. *Anglo-Saxon England,* 2nd edn, Oxford History of England 2, Clarendon Press, Oxford

Stenton, F 1971. *Anglo-Saxon England,* 3rd edn, Clarendon Press, Oxford

Steuer, H 1987. 'Helm und Ringschwert', *Studien zur Sachsenforschung,* **6**, 189–236

Stiegemann, C, Kroker, M and Walter, W (eds) 2013. *CREDO: Christianisierung Europas im Mittelalter,* 2 vols, Michael Imhof Verlag, Petersburg

Stolpe, H and Arne, T J 1927. *La Nécropole de Vendel,* Kungliga Vitterhets Historie och Antikvitets Akademien, Stockholm

Stoodley, N 1999. *The Spindle and the Spear: a critical inquiry into the construction and meaning of gender in the early Anglo-Saxon burial rite,* BAR Brit Ser 288, Archaeopress, Oxford

Strong, D 1966. *Greek and Roman Silver Plate,* Methuen, London

Sumnall, K 2006.' BERK-1DF3D2: an early medieval scabbard', <https://finds.org.uk/database/artefacts/record/id/131120> (accessed 30 May 2017)

Sumnall, K 2014. 'LON-F73775: an early medieval sword', <https://finds.org.uk/database/artefacts/record/id/599068> (accessed 29 May 2017)

Sutherland, C H V 1948. *Anglo-Saxon Gold Coinage in the Light of the Crondall Hoard,* Oxford University Press, Oxford

Swanton, M 1996. *The Anglo-Saxon Chronicles,* Dent, London

Sweet, H 1885. *The Oldest English Texts,* Early English Text Soc Orig Ser 83, Early English Texts Society, Oxford

T

Talvio, T 1980. 'Romerska myntfynd i Finland', *Nordisk Numismatisk Årsskrift,* **1979/80**, 36–54

Tate, J 1986. 'Some problems in analysing museum material by non-destructive surface sensitive techniques', *Nuclear Instru Meth Phys Res,* **14**, 20–3

Tester, A, Anderson, S, Riddler, I and Carr, R 2014. *Staunch Meadow, Brandon, Suffolk: a high status middle Saxon settlement on the Fen Edge,* East Anglian Archaeol 151, Bury St Edmunds

Thacker, A 1985. 'Kings, saints and monasteries in pre-Viking Mercia', *Midland Hist,* **10**, 1–25

Thacker, A 1995. '*Membra Disjecta:* the division of the body and diffusion of the cult', in Stancliffe and Cambridge 1995, 97–127

The Art Newspaper 2011. 'Exhibition and museum attendance figures 2010', **223** (April), 25

The Potteries Museum & Art Gallery Friends n.d. 'Newsletter May–August 2010', PMAG, Stoke-on-Trent (internal report prepared by Friends of The Potteries Museum & Art Gallery)

The Mercian Trail Partnership 2011a. 'Staffordshire Hoard on tour 2011: economic and community impact assessment' (internal report prepared for The Mercian Trail Partnership November)

The Mercian Trail Partnership 2011b. 'Staffordshire Hoard: Mercian Trail – strategy, November 2011' (internal report prepared for The Mercian Trail Partnership)

The Sentinel 2011. 'Hoard heads abroad to promote region', <http://www.stokesentinel.co.uk/hoard-heads-abroad-promote-region/story-13482028-detail/story.html> (accessed 28 November 2016)

Theune-Grosskopf, B 2006. 'Die vollstandig erhaltene Leier des 6 Jahrhunderts aus Grab 58 von Trossingen, Baden-Württemberg, Kreis Tuttlingen,' *Germania*, **84**, 93–142

Theune-Grosskopf, B 2008. 'Warrior and musician: the lyre from grave 58 at Trossingen and its owner', in A A Both, R Eichmann, E Hickmann and L-C Koch (eds), *Challenges and Objectives in Music Archaeology*, 217–27, Studien zur Musikarchäologie vi, Orient-Archäologie 22, Rahden, Westfalen

Thomas, G 2017. 'Monasteries and places of power in pre-Viking England: trajectories, relationships and interactions', *Anglo-Saxon Stud Archaeol Hist*, **20**, 97–116

Thorpe, L 1974. *Gregory of Tours: the history of the Franks*, Penguin Books, Harmondsworth

Tollerton, L 2011. *Wills and Will-Making in Anglo-Saxon England*, York Medieval Press, York

Toynbee, J M C and Painter, K S 1986. 'Silver picture plates of Late Antiquity: AD 300 to 700', *Archaeologia*, **108**, 15–65

Tulp, C and Meeks, N 2000. 'The Tjitsma (Wijnaldum) die: a 7th century tool for making a cross-hatched pattern on gold foil, or a master template?', *Historical Metall*, **34** (1), 13–24

Turville-Petre, J E 1957. 'Hengist and Horsa', *Saga Book*, **14**, 273–90

Tweddle, D 1992. *The Anglian Helmet from Coppergate*, Archaeology of York 17/8, Council for British Archaeology, London

Tyler, D 2005. 'An early Mercian hegemony: Penda and overkingship in the seventh century', *Midland Hist*, **30**, 1–19

Tyler, E M (ed) 2000. *Treasure in the Medieval West*, York Medieval Press, York

U

Underwood, R 1999. *Anglo-Saxon Weapons and Warfare*, Tempus, Stroud

University of Glasgow 2017. 'A Thesaurus of Old English'. <http://oldenglishthesaurus.arts.gla.ac.uk> (accessed 11 October 2018)

University of Leicester n.d. 'Coins, hoards and helmets: Iron Age treasure boosts tourism, underpins museum expansion and inspires new sense of community pride', Research Excellence Framework 2014 Impact Case Studies, <http://impact.ref.ac.uk/CaseStudies/CaseStudy.aspx?Id=37326> (accessed 24 January 2017)

Untracht, O 1975. *Metal Techniques for Craftsmen: a basic manual on the methods of forming and decorating metals*, Doubleday and Co, New York

Untracht, O 1982. *Jewellery Concepts and Technology*, Robert Hale, London

V

Vang Petersen, P 1991. 'Nye fund af metalsager fra yngre germansk jernalder', in P Mortensen and B Rasmussen (eds), *Fra Stamme til Stat I Danmark. Vol 2: Høvdingesamfund og Kongemagt*, 49–66, Jysk Arkaeologisk Selskabs Skrifter 22:2, Aarhus Universitetsforlag, Aarhus

Vang Petersen, P 1994. 'Excavations on Gudme-sites with treasure finds 1984–91', in P Nielsen, K Randsborg and H Thrane (eds), *The Archaeology of Gudme and Lundeborg*, 30–40, University of Copenhagen, Copenhagen

Vierck, H 1974. 'Werke des Eligius', in G Kossack and G Ulbert (eds), *Studien zur vor-und frügeschlichten Archäologie: Festschrift für Joachim Werner zum 65 Gebürtstag*, 309–80, Verlag C H Beck, Munich

Vierck, H 1985. 'L'oeuvre de saint Eloi, orfèvre, et son rayonnement', in Périn and Feffer 1985, 403–9

Vista 2009. *Report on Geophysical Survey at Staffordshire Hoard Site*, Vista Report 1971, Visual & Spatial Technology Centre, University of Birmingham, Birmingham

Visy, Z and Mráv, Z (eds) 2012. *A Seuso-kincs és Pannonia / The Sevso Treasure and Pannonia*, Magyar-országi tanulmányok a Seuso-kincsro 1, PTE Régészet Tanszék, Pécs

Voute, A 1995. 'Some experiences with the analysis of gold objects', in Morteani and Northover 1995, 329–40

W

Wakefield, J 2014. 'Inquiry: hard times for the UK's regional museums?', *Apollo: the international art magazine*, 3 September, <https://www.apollo-magazine.com/inquiry-hard-times-uks-regional-museums/> (accessed 24 January 2017)

Wallace-Hadrill, J M 1960. *The Fourth Book of the Chronicle of Fredegar*, Thomas Nelson and Sons, London

Walton Rogers, P 2007. *Cloth and Clothing in Early Anglo-Saxon England: AD 450–700*, CBA Res Rep 145, Council for British Archaeology, York

Wamers, E 2009. 'Behind animals, plants and interlace: Salin's Style II on Christian objects', in Graham-Campbell and Ryan 2009, 151–204

Wanhill, R J H 2002. *Archaeological Silver Embrittlement: a metallurgical inquiry,* National Aerospace Laboratory NLR, <http://reports.nlr.nl:8080/xmlui/bitstream/handle/10921/680/TP-2002-224.pdf?sequence=1> (accessed 17 August 2016)

Watt, M 1999. 'Kings or gods? Iconographic evidence from Scandinavian gold foil figures', *Anglo-Saxon Stud Archaeol Hist,* **10**, 173–83

Watt, M 2008. 'Guldgubber', in Adamsen *et al* 2008, 43–54

Waxenberger, G 2017. 'Date and provenance of the Auzon or Franks Casket', in Semple *et al* 2017, 121–33

Webb J F (trans) 1975. *Lives of the Saints,* Penguin, Harmondsworth

Webley, R 2007. 'HAMP-BAA204: an early medieval die stamp', <https://finds.org.uk/database/artefacts/record/id/185643> (accessed 30 May 2017)

Webster, L 2001. 'Metalwork of the Mercian supremacy', in Brown and Farr 2001, 263–78

Webster, L 2003. 'Encrypted visions: style and sense in the Anglo-Saxon minor arts', in C Karkov and G H Brown (eds), *Anglo-Saxon Styles,* 11–30, State University of New York Press, Albany

Webster, L 2005. 'Visual literacy in a protoliterate age', in P Hermann (ed), *Literacy in Medieval and Early Modern Scandinavian Culture,* 21–46, Stud Northern Civilization 16, The Viking Collection, Viborg

Webster, L 2012a. *Anglo-Saxon Art,* British Museum Press, London

Webster, L 2012b. *The Franks Casket,* British Museum Press, London

Webster, L 2015. 'The decoration of the binding', in Breay and Meehan 2015, 65–82

Webster, L 2016. 'Imagining identities: the case of the Staffordshire hoard', in J D Niles, Stacey S Klein and J Wilcox (eds), *Anglo-Saxon England and the Visual Imagination,* 24–48, Arizona Center for Medieval and Renaissance Studies, Tempe Arizona

Webster, L 2017. '*Wundorsmiþa geweorc*: a Mercian sword-pommel from the Beckley area, Oxfordshire', in J Hawkes and E Cambridge (eds), *Crossing Boundaries: interdisciplinary approaches to the art, material culture, language and literature of the early medieval world,* 97–111, Oxbow, Oxford

Webster, L 2019. 'Archaeology and Beowulf', in Donoghue and Heaney 2019, 212–23

Webster, L and Backhouse, J (eds) 1991. *The Making of England: Anglo-Saxon art and culture AD 600–900,* British Museum Press, London

Webster, L, Sparey-Green, C, Périn, P and Hills C 2011. 'The Staffordshire (Ogley Hay) hoard: problems of interpretation', *Antiquity,* **85**, 221–9

Weitzmann, K (ed) 1979. *Age of Spirituality: late Antique and early Christian art, third to seventh century,* Catalogue of the exhibition at The Metropolitan Museum of Art, 19 November 1977–12 February 1978, The Metropolitan Museum of Art, New York

Welch, M G 2001. 'The archaeology of Mercia', in Brown and Farr 2001, 149–59

Weltweites Zellwerk / International Framework, *Römisch-Germanisches Zentralmuseum, Mainz* n.d. <http://web.rgzm.de/en/research/research-emphases-and-projects/a/article/weltweites-zellwerk.html> (accessed 18 April 2017)

Werner, J 1949. 'Eberzier von Monceau-le-Neuf (Dep. Aisne): ein Beitrag zur Enstehung der völkerwanderungzeitlichen Eberhelme', *Acta Archaeologica,* **20**, 248–57

Werner, J 1980. 'Arbaldo (Haribaldus): ein merowingischer *vir inluster* aus der Provence? (Bemerkungen zu den Silbertellern von Valdonne, Dép. Bouches du Rhone)', in P Bastien (ed), *Mélanges de Numismatique, d'Archéologie et d'Histoire offerts à Jean Lafaurie,* 257–63, Société Française de Numismatique, Paris

West, S E 1985. *West Stow: the Anglo-Saxon village,* 2 vols, East Anglian Archaeol 24, Ipswich

West, S E 1998. *A Corpus of Anglo-Saxon Material from Suffolk,* East Anglian Archaeol 84, Ipswich

Westermark, U 1983. '*Solidi* found in Sweden and Denmark after 1967', *Numismatiska Meddelanden,* **33**, 32–40

White, S, Manley, J, Jones, R, Orna-Ornstein, J, Johns, C and Webster, L 1999. 'A mid-fifth century hoard of Roman and pseudo-Roman material from Patching, West Sussex', *Britannia,* **30**, 301–14

Whitelock, D (ed) 1961. *The Anglo-Saxon Chronicle: a revised translation,* Eyre and Spottiswoode, London

Whitelock, D (trans) 1968. *English Historical Documents. Vol I: c 500–1042,* Eyre & Spottiswoode, London

Whitelock, D (ed) 1979. *English Historical Documents. Vol I: c 500–1042, 2nd edn,* Eyre Methuen, London

Whitfield, N 1987. 'Motifs and techniques of Celtic filigree: are they original?', in Ryan 1987, 75–84

Whitfield, N 1990. 'Round wire in the early Middle Ages', *Jewellery Stud,* **4**, 13–28

Whitfield, N 1993. 'The filigree of the Hunterston and "Tara" brooches', in Spearman and Higgitt 1993, 118–27

Whitfield, N 1997. 'Filigree animal ornament from Ireland and Scotland of the late-seventh to ninth centuries', in C E Karkov, R T Farrell and M Ryan (eds), *The Insular Tradition,* 211–43, State University of New York Press, New York

Whitfield, N 1998. 'The manufacture of ancient beaded wire: experiments and observations', *Jewellery Stud,* **8**, 57–86

Whitfield, N 2001. 'The earliest filigree in Ireland', in M Redknap, N Edwards, S Youngs, A Lane and J Knight (eds), *Pattern and Purpose in Insular Art: proceedings of the fourth international Insular art conference*, 141–54, Oxbow Books, Oxford

Whitfield, N 2007. 'Motifs and techniques in early medieval Celtic filigree: their ultimate origin', in R Moss (ed), *Making and Meaning in Insular Art: proceedings of the fifth international conference on Insular art held at Trinity College Dublin*, 25–28 August 2005, 18–39, Four Courts Press, Dublin

Whitfield, N 2009. '"More like the work of fairies than of human beings": the filigree on the "Tara" brooch, a masterpiece of late Celtic metalwork', *ArchéoSciences, Revue d'Archéométrie,* **33**, 235–42

Whitfield, N 2010. 'Appendix 14.2: The gold roundel', in C Mount, 'Excavations of an early medieval promontory fort and enclosed cemetery at Knoxpark, Co. Sligo', in C Corlett and M Potterton (eds), *Death and Burial in Early Medieval Ireland in the Light of Recent Archaeological Excavations from Knoxpark, Co. Sligo*, Research papers in Irish Archaeology, no. 2, 214-16, Wordwell, Dublin

Wicker, N L 2012. 'The elusive smith', in Pesch and Blankenfeldt 2012, 29–36

Wickham, C 2005. *Framing the Early Middle Ages: Europe and the Mediterranean 400–800*, Oxford University Press, Oxford

Wieczorek, A and Périn, P (eds) 2001. *Das Gold der Barbarenfürsten: Schätze aus Prunkgräbern des 5. Jahrhunderts n. Chr. Zwischen Kaukasus und Gallien*, Theiss, Stuttgart

Wieczorek, A, Périn, P v, Weick, K and Menghin, W (eds) 1996. *Die Franken. Wegbereiter Europas. Vor 1500 Jahren: König Chlodwig und seine Erben*, Reiss-Museum Mannheim, Verlag Philipp von Zabern, Mannheim

Williams, D 2012. 'SUR-E6B3B4: an early medieval scabbard', <https://finds.org.uk/database/artefacts/record/id/526846> (accessed 30 May 2017)

Williams, G 2001. 'Mercian coinage and authority', in Brown and Farr 2001, 210–28

Williams, G 2006. 'The circulation and function of coinage in Conversion-period England, c AD 580–675', in Cook and Williams 2006, 145–92

Williams, G 2011. *Treasures from Sutton Hoo,* British Museum Press, London

Williams, G and Ager, B 2010. *The Vale of York Hoard,* British Museum Press, London

Williams, G and Hooke, D 2013. 'Analysis of gold content and its implications for the chronology of the early Anglo-Saxon coinage', in Gannon 2013, 55–70

Williams, H 2011. 'The sense of being seen: ocular effects at Sutton Hoo', *J Social Archaeol,* **11** (1), 99–121

Williams, I 1935. *Canu Lywarch Hen,* Gwasg Prifysgol Cymru, Caerdydd

Wilson, D 1961. 'An Anglo-Saxon bookbinding at Fulda (Codex Bonifatianus I)', *Antiq J, 51…',* 199–217

Winterbottom, M 1978. *Gildas: The Ruin of Britain and other works,* Phillimore, Chichester

Wise, E M 1964. *Gold: recovery, properties and applications,* Van Nostrand Co Ltd, London

Wołoszyn, M (ed) 2009. *Byzantine Coins in Central Europe between the 5th and 10th Century,* Polish Academy of Arts and Sciences, Cracow

Wolters, J 1981. 'The ancient craft of granulation: a re-assessment of established concepts', *Gold Bull,* **14**, 119–29

Wolters, J 2006. 'On the noble and illustrious art of the goldsmith: an 11th century text', *Hist Metall J,* **40**, 68–88

Wood, I 1987. 'The fall of the western empire and the end of Roman Britain', *Britannia,* **18**, 251–60

Wood, I 2006. 'Constantinian crosses in Northumbria', in C Karkov, S Larratt Keefer and K Jolly (eds), *The Place of the Cross in Anglo-Saxon England,* 3–13, Manchester Centre Anglo-Saxon Stud 4, Boydell Press, Woodbridge

Wood, I forthcoming. *Fursey and his Brothers,* Fursey Lecture 2016

Woods, D 2009. 'Late Antique historiography: a brief history of time', in P Rousseau (ed), *A Companion to Late Antiquity,* 357–71, Wiley-Blackwell, Chichester

Wormald, P 1978 'Bede, *Beowulf* and the conversion of the Anglo-Saxon aristocracy', in R T Farrell (ed), *Bede and Anglo-Saxon England,* 32–95, BAR Brit Ser 46, Archaeopress, Oxford

Wormald, P 1999. *The Making of English Law: King Alfred to the twelfth century,* Blackwell, Oxford

Wrede, H and Cahn, II A 1984. 'Vermutungen über Funktion und Besitzes des Silberschatzes', in H A Cahn and A Kaufmann-Heinimann (eds), *Der spätrömische Silberschatz von Kaiseraugst,* 405–9, Basler Beitr Ur- und Frühgesch 9, Habegger, Derendingen

Wrenn, C L (ed) 1972. *Beowulf with the Finnsberg Fragment,* Harrap, London

Wylie, W M 1852. *Fairford Graves: a record of researches in an Anglo-Saxon burial-place in Gloucestershire,* John Henry Parker, Oxford

Y

Yorke, B 1990. *Kings and Kingdoms of Early Anglo-Saxon England*, Seaby, London

Yorke, B 1993. 'Fact or fiction? The written evidence for the fifth and sixth centuries AD', *Anglo-Saxon Stud Archaeol Hist*, **6**, 45–50

Yorke, B 2003. *Nunneries and the Anglo-Saxon Royal Houses*, Continuum, London and New York

Yorke, B 2015. 'The fate of the otherworldly beings after the conversion of the Anglo-Saxons', in C Ruhman and V Brieske (eds), *Dying Gods: religious beliefs in in northern and eastern Europe in the time of Christianisation*, 167–75, Neue Studien zur Sachsenforschung Band 5, Niedersächsisches Landesmuseum Hannover, Hannover

Youngs, S (ed) 1989. *The Work of Angels: masterpieces of Celtic metalwork 6th–9th centuries AD*, British Museum Publications, London

Youngs, S 2009. 'Anglo-Saxon, Irish and British relations: hanging bowls reconsidered', in Graham-Campbell and Ryan 2009, 205–30

Z

Zacher, S 2013. *Rewriting the Old Testament in Anglo-Saxon Verse: becoming the chosen people*, Bloomsbury, London

INDEX

Key - Illustrations are indicated by page numbers in *italics* or by *illus* where figures are scattered throughout the text. Catalogue numbers are in **bold**.

Aberlemno (Angus), sculpture 81
Acca, Bishop of Hexham 293
Acklam Wold (N Yorks), sword 63, 65, 265
Acton Trussell (Staffs), cloisonné fragment 275
Aelfric, Archbishop of Canterbury 84
Ælfwine, King of Deira 289
Æthelbald, King of Mercia 289, 290, 292, 299
Æthelbert, King of Kent 277, 278, 293, 312
Æthelfrith, King of Northumbria 297
Æthelhere, King of East Angles 288, 356
Æthelred, King of Mercia 289, 290, 292, 297, 317
Æthelstan, will of 193
Æthelwulf, *De Abbatibus* 111
Aetius 333, 358
Agaune (France), Abbey of Saint-Maurice, reliquary 295
Agilbert 108
Agitius 333
Aidan, Bishop of Lindisfarne 288
Åker (Norway), hoard 213, *214*, 348
Alaric I, King of the Visigoths 330, 340
Alcuin 295
Aldbrough (E Yorks), pommel 60
Alemanni 336
Alfred the Great 118, 312
Alfred Jewel 118
Alhflæd of Northumbria 288, 317
Alhfrith of Northumbria 288
Ålleberg (Sweden) collar 161
Almadén (Spain), mine 129
Alrewas (Staffs), royal estate 317
Alton (Hants)
 buckle 65, 216, *217*, 253, *260*, 264
 sword *59*, 62, 63
amber 138
Ammianus Marcellinus 244
Anastasius, Emperor 335

Andelfingen (Switzerland), cross 249
Angles 333
Anglo-Saxon Chronicle 287, 288, 325
animal ornament
 date and origin 260–2, *260*, *262*
 description (*illus*)
 Christian objects 227–31
 helmet 232–9
 sword fittings 213–27
 research agenda xxxii, 366
 style and substance 208–13, *210*, *212*
 see also animal ornament Style I; animal ornament Style II
animal ornament Style I
 date 263, 270
 incidence 44, 209, 210, 213, *213*
 origins 211
animal ornament Style II
 character
 great gold cross 100
 head-dress mount 109, 116
 helmet 70, 71, 76, 79, 236–9
 hilt-collars 41, *41*, 42, *42*, 44, 58, 63
 hilt-plates 48
 miscellanea 119
 mounts 50, 55
 pommels (*illus*) 36, 37, 38, 39, 58–9, 62
 pyramid-fittings 56, 57, 64
 classification and chronology 211, 260–1, 273
 date 258–63, *260*, *262*, 264–9, 270, 365
 description (*illus*) 213–32
 incidence 209, 210–11, 213
 interlace and knots 245, 249
 manufacturing techniques *153*, 165, *172*, *178*, 191, 273
 origins 273, 276, 277, 278–9, 280, 365
 religious meaning 211–13, 253–5
 scrollwork 249
Anna, King of East Angles 279, 280, 288
Antiquitates Iudaice 115, 116
antler 136
Apahida (Romania), princely graves 338
archaeological context 302
 early Mercia 315–19, *316*
 future research 366

graves and grave goods 302–6, *307*
reliability of 24–6, *26*, *27*
resources and their use 312–14
social hierarchy, visibility of 306–11, *310*, *311*
Archaeology Warwickshire 6, 13, 26
Ardagh (Ireland), chalice 160, 185
Ardakillen Lough (Ireland), brooch 250
Ardleigh (Essex), pommel 60, 162
armies, Anglo-Saxon 65–70
Art Fund 14, 15–16, 370
ash (*Fraxinus excelsior*) 136–7
assembly/other marks 18–19, *19*, 183–5, *183*, *185*
Asthall (Oxon)
 mount 226, *228*
 princely burial 308
Athanaric, Visigothic *iudex* 338
Attila the Hun 330, 343
Augustine, St 286, 293
Avars 335
Ayton (Borders), plaque 243

Bacton (Norfolk), pendant 170
Balthild 295
Bamburgh (Northumbria)
 'Bamburgh beast' 227, *229*, 230
 mounts 62, 149, 230, 278
 raid 288
 relics 295
Bandhelm 80, 84
bands **593/4**
 catalogue *417–18*, 455
 damage 202–3, *203*
 date and origin 266
 description (*illus*) 70, 71, 74–5, 82
 manufacturing techniques 140, 145, 146–7, *146*
 organics 137, *137*
 ornament style 236–8, *237*, 239
 repair 195
 silver analysis 128
Bangor (Gwynedd), monastery 297
bar, iron, **684**
 catalogue *421*, 461

context 305
damage 201
description 119, *119*
materials 129, 137
Bardney (Lincs), monastery 290
Barlaston (Staffs), burial 275
Barrow-upon-Trent (Derbys), brooch 315
Barton-under-Needwood (Staffs), cemetery 274, 315
Baslieux (France), brooch 160
Bawtry (Notts), pyramid-fitting 64
Bayan 335
Bayeux Tapestry 81
bead (stone) **584** 56, *56*, 64, 138, 453
Beckum II (Germany), pommel 59, 214, *214*, *260*, 263
Bede, on
 Christian conversion 286, 289–90, 296, 298
 conflict in 7th century 286, 287–8, 297, 298, 306, 365
 ecclesiastical equipment 112–13, 118, 255, 293, 295
 Ezra's head-dress 114–16, 295
 Horsa 222
 Lichfield 291
 literacy 279
 Penda's army 65
 Rendlesham 304
 silver 127
 Yeavering 309
beeswax 74, 137–8, *137*, 357
Benedict Biscop 293, 305
Benty Grange (Derbys), burial 275, 304
 hanging-bowl mounts *247*, 250, 251, 275
 helmet
 boar 80, 222, *296*, 304
 cross 100, *100*, 235, 253, 296, *296*, 317
 date 80, 85, 304
 form and reconstruction 82
Beowulf
 heroic culture 286, 292, 306
 Scandinavia 344, 349
 smiths 124
 treasure 324, 358
 warrior equipment 241, 312
 helmet 81, 84, 222, 312
 saddle 95
 swords 58, 188, 212, 292, 312
 wyrmas 214
Bernicia 278, 286
berserker 239–41
Berthouville (France), hoard 336

Bewcastle Cross (Cumbria) 250
Bifrons (Kent), sword 63, 255
Bilfrith 94, 117
Binham (Norfolk), hoard 353
bird motifs
 character
 hilt-mounts/mounts 52, 55, 64, *92*, 93, 95
 pommels *38*, 39, 40, 59
 date and origin 261, 267, 270, 279
 incidence 215
 manufacturing techniques 133, *133*, 149, 151, 172, 177
 style and meaning
 general discussion 208, 212, 213, 226, *228*, 341
 great cross 227, *229*, 232
 mounts 226, *228*, 232, 249, 251–3, *252*
 pommels *212*, 222, 226, *228*, 232
 sword-ring 226
Birmingham Archaeology 4–6, 14
Birmingham Museum and Art Gallery 4, 14–16, *15*, 368–71
Bloodmoor Hill (Suffolk), settlement 309
boar motifs *38*, *62*, 213, 215, 222–4, 232
Boher (Ireland), shrine 114
Bohuslän (Sweden), coins 347
bone
 identification 136
 inlay 20, *20*, 93, 136
Book of Durrow, Trinity College, Dublin MS 57 267
 cross forms 230, 253, 267
 Evangelist beasts 251, 253
 ornament 250, 365
 quadrupeds 222, 230, *230*, 235, *262*, 267
book-fittings 85, 94–5, 117
Bornholm (Denmark), hoards 244, 332, 347, 349
bosses 47–8, 119, 121
 brass, boss **663** 119, 129, 459
 gold
 boss **616** 119–20, 137, 169, *421*, 457
 boss **617** 119, *120*, 139, 169, *421*, 457
 boss **618** *120*, 169, *421*, 457
 boss **621** *120*, *421*, 457
 bosses **635–6** 458
 boss **637** *120*, 458
 boss **638** 47, 458
 bosses **639–50** 458
 boss **655** 458
 boss **656** 459

silver
 boss **661** 459
 boss **669** 48, *120*, 129, 154, 459
 boss **670** 459
 boss **671** 48, 459
bracteates
 gold 126, 332, 348, 349
 iconography 211, 226, *228*, 241, 244, 347
Bradwell (Norfolk), figurine *242*, 244
Brandon (Suffolk), settlement 309–11
brass 129
Breedon-on-the-Hill (Leics), church 317–19
British Museum xxxi, 14, 15, 366, 371
Broadstairs (Kent)
 buckle *260*, 264
 sword 137
Broomfield (Essex), princely burial 308
Buckland (Kent)
 brooch 235
 swords 137
buckles 30
 buckle **585**
 catalogue *416*, 454
 description 56, *56*, 57, 65, 305
 buckle **586**
 catalogue *416*, 454
 description 56, *56*, 57, 65, 305
 buckle **587**
 catalogue *416*, 454
 date 270
 description 56, *56*, 57, 65, 305
 manufacturing techniques 138, 154
 Christ buckles (*Christus-Schnallen*) 173
Bulles (France), brooch 349
Burgundians 323, 333
Bury St Edmunds (Suffolk), pyramid-fitting 64
button-fittings
 button-fitting **582**
 bead 56, *56*, 64, 138
 catalogue *416*, 453
 date 266
 description 56, *56*, *57*, 64–5
 garnets 170
 button-fitting **583**
 catalogue *416*, 453
 date 266
 description 56, *56*, *57*, 64–5, *361*
 garnets 130, 131, 170
Byzantium, metalwork influences/parallels
 animal ornament Style II 211, 212, 245, 266
 cabochons 131, 169

Christian objects 118–19, 293
 binding 117
 great gold cross 100, 111, 112, 293
 inscribed strip 113
 geometric ornament
 niello 151
 see also solidi

cabochons
 garnets 130, 131, *160*, 169, *181*
 glass 132, 133
 rock crystal 138, 169
Cadfael of Gwynedd 288
Cadmug Gospels 117
Cadwallon of Gwynedd 287, 288
Caedwalla of Gwynedd 298
Caenby (Lincs), helmet fragment 80, 243, 254, 304
Cannock Chase (Staffs) 291, *291*, 360
Canons Ashby (Northants), pommel 60
Canterbury (Kent)
 cathedral church 293
 monastic library 116
Carlton Colville (Suffolk), settlement 309
Cassiodorus 114, 116
casting 138–9, *139*
Castor (Cambs), monastery 290
Cathach of St Columba 250
Catholme (Staffs), settlement 274, 287, 315
Catterick (N Yorks), cross 112
Cearl, King of Mercia 287
Cedd, St 108, 290
cell-wall fragments **683** 119, 461
Cenred, King of Mercia 289, 290
Cenwalh, King of Wessex 287–8
Ceolfrith, Abbot 114, 295
Ceolred, King of Mercia 289
Ceolwold, King of Mercia 289
ceorl 308
Chad, St 108, 290
Chalon-sur-Saône (France), helmet 235
Charlemagne 335, 343
cheek-pieces **591/2**
 catalogue *417*, 455
 date and origin *262*, 268
 description *69*, 70, *70*, 71, 82
 manufacturing techniques 139, 145, *146*, 150, *151*, 158
 organics 137, 138
 ornament style 113, 227, 235–6, *236*, 249
 silver analysis 128
 wear and damage 194, 203

Chelles (France) chalice 94, *94*, 118
Chessell Down (Isle of Wight), mount 64, 266
Chester (Cheshire), battle of 297
Childebert II, King of Franks 358
Childeric, King of Franks, burial of 166, 169, 342, 348
Chilperic I, King of Franks 335, 357
Chipping Ongar (Essex), hoard 354
Christian objects
 assemblage 97
 biography 356–7, 358
 context
 archaeological 305–6, 311
 historical 293–9
 damage 201–2, 205
 description and character (*illus*) 99–110
 exceptionality 352–3
 function and significance 110–19
 impact of discovery 365–6
 see also cross-pendant; great gold cross; head-dress mount; inscribed strip; pins; silver-gilt coverings
Christianity, conversion to 286–7, 289–91, 292, 296–8
cloisonné/lapidary work
 assemblage 166, *167*, 168
 backing foils 179–80, *180*, *181*
 cell-forms and patterns (*illus*) 172–8, 184
 conservation 18–20, *19*, *20*
 date and origin 131–2, 181, 271–3, *272*, 365
 stones and manufacture 168–72, *169*, *170*, *171*
Clovis I, King of the Franks 335
Clovis II, King of the Franks 295
Cluj-Someşeni (Romania), hoard 338
Coddenham (Suffolk), harness mount 226
Codex Amiatinus 114, 115, *115*, 295
Codex Lucensis 490 145, 146
Coleraine (Ireland), hoard 331, 332
Colomba, St 224
comitatus 243
Conques (France), reliquary 295
conservation
 Berberis thorns 18, 20
 die-impressed silver sheet 24, *24*
 filigree decorated objects 20–2, *20*, *21*
 garnet cloisonné objects 19–20, *19*, *20*
 methodology 17–18, *17*
 programme 16, 24, 369
 rejoining and reconstruction 22–3, *22*, *23*
Constantine, Emperor 298, 305

Constantinople, imperial gifts 329
context *see* archaeological context; historical context
Coombe (Kent), sword 62–3, 227, 304
copper alloy 129
copper-alloy fragment **691** 50, 119, 462
Corippus 329
Corpus Christi College MS 197 267
Cosmas Indicopleustes 295
Cotgrave (Notts), button-fitting 64
Cottbus (Germany), hoard 337
Cowdery's Down (Hants), settlement 309, *311*
crest sections **589/90**
 catalogue *417*, 454
 description *68*, 70, 71, *78*, 80, 113
 identification 32
 manufacturing techniques 139, 145, 151
 organics 137
 ornament style 232–5, *233–4*
 silver analysis 128
 wear and damage 194, 203
Cricklade (Wilts), pommel 60
Crondall (Hants), hoard 353–4
cross *see* cross motifs; cross-pendant; great gold cross
cross motifs, incidence and meaning 208, 215, 306
 head-dress mount 230, *231*
 hilt-mounts *252*, 253–5
 pommels *38*, *179*, *221*, 224, *252*, 253–5
 pyramid-fitting *225*, 226
cross-pendant **588**
 catalogue *416*, 454
 condition 32
 context 305
 damage 201, 205, 358
 description 110, *110*, 111, 116
 manufacturing techniques 130, 160, 169, 179
 origins 277
 ornament style 249
 wear 194
Crundale (Kent)
 buckle
 cloisonné 176
 date and origin 265, 267
 ornament style 224, *225*, 236, 249
 sword 63, 216, *220*, *262*, 267, 304
crux gemmata 111–12, *112*, 212, 230, 296
Cuddesdon (Oxon), princely burial 308
cuir bouilli 82–3
Culbin Sands (Moray), pommel 250, 251

'Cumberland' sword-hilt
 date and origin 266, *272*, *274*, 276, 278
 description 70
 mounts 50, *50*, 52, *52*, 55, 64
 pommel 65
 style 250, 253
Cuthbert, St
 headband 295
 military career 297
 pectoral cross
 date 261, 278
 ornament 166, 169, 178
 relic 110
 repairs 194, 201
 usage 116, 305
 relics 295
Cuxton (Kent), reliquary 114
Cyneburh 288, 290
Cyneswith 290
Cynewulf, *Elene* 111

Dacre (Cumbria), relics 295
Dagobert I 94, 358
Dál Riata 278, 286
Dalmeny (W Loth), pyramid-fitting 64, *64*, 250, 253, 278
damage 195–203, *197–202*, 358
dating evidence 258–63, *260*, *261*, *262*, 365
 Hoard Phase 1 263
 Hoard Phase 2 264–6
 Hoard Phase 3 266–9, *269*
 Hoard Phase 4 269–70
 summary 270–1, *271*
'deactivation' of objects 346
decorated silver sheet
 description 70–1, *71*, *73*, 74–5
 manufacturing techniques 140, 145, 146–7, *146*, *147*
 silver sheet **595**
 catalogue *418*, 455
 conservation 24, *24*
 description 70, *71*, *73*, 75, 77
 ornament style *237*, 244
 silver sheet **596**
 catalogue *418*, 455
 description 70, *71*, 74, 76, 81
 manufacturing techniques 147, *147*
 ornament style *237*, 239, 241–3
 silver analysis 128
 silver sheet **597**
 catalogue *418*, 455
 conservation 24, *24*

 description 70, *71*, *75*, 76, 81
 ornament style *237*, 239, 241–3
 silver analysis 128
 silver sheet **598**
 catalogue *419*, 455
 description 70, *73*
 origins 76, 353
 ornament style *238*, 245
 silver sheet **599**
 catalogue 456
 description 70, *71*, *73*, 76
 ornament style *238*, 243–4
 silver analysis 128
 silver sheet **600**
 catalogue *419*, 456
 description 70, *71*, 76, *76*, 77, 83
 manufacturing techniques 145, 154
 ornament style *238*, 258–9
 silver analysis 128
 silver sheet **601**
 catalogue *419*, 456
 date 266
 description 70, *71*, *73*, 77, 81
 manufacturing techniques 145
 ornament style *238*, 239
 silver analysis 128
 silver sheet **602**
 catalogue *419*, 456
 description 70, *73*, 76
 ornament style *238*, 239
 silver analysis 128
 silver sheet **603**
 catalogue *419*, 456
 description 70, *73*, 76
 ornament style *238*, 239
 silver sheet **604** 70, *73*, 76, *420*, 456
 silver sheet **605** 44, 149, 266, *420*, 461
 silver sheet **606**
 attribution 32
 catalogue 456
 description 71, *73*, 75, 77
 ornament style 244
 silver analysis 128
Deira 278, 287, 288, 290
Denis, St, relic 295
Derrynaflan (Ireland), chalice and paten 95, 163, 185
Derwent, River 315
Desana (Italy), hoard 340–1
Desborough (Northants), cross 116
Deurne (Netherlands), helmet 82
die-impressing 146–8, *146*, *147*
dies 146–7

digital archives 472
Dinas Powys (Glam), metalwork 278
Dinham (Shrops), pommel
 origins 306
 ornament 61, 114, *114*, 176, *252*, 253
Diss (Norfolk), pendant *225*, 226, 268, 278
ditch 11
Diuma, Bishop 290
Djurgårdsäng (Sweden), hoard 349
Domagnano (San Marino), hoard 323, 341, *341*
Domesday Survey 13, 291, 315–17
donativa 329–30
Dortmund (Germany), hoard 336
Dover (Kent)
 brooch 180
 sword 62, 63
The Dream of the Rood 111
Droitwich (Worcs), springs 289
Dronrijp (Netherlands), hoard 348–9
Duffield (Derbys), cemetery 315
Dunadd (Argyll & Bute), metalwork *247*, 250, 251, 278
Dunbar (Lothian), cross 119
Durham (Co Durham), Gospel-book 105
Durham Cathedral manuscript MS A.II.10 *229*, 230, 250, 251, 267

eagles 226
Earl Shilton (Leics), pommel 60, 216, *217*, 276
Early Insular Style 209, *247*, 250–3, 269–70, 271, 365
East Anglia, kingdom of
 7th century history 286, 287, 288, 296
 metalwork
 context 298–9
 date 259, 261, 268, 273, 276–9, 280
 manufacturing techniques 166, 181
 style 211, 222, 232, 253, 273, 354
 workshops 222, 273, 278, 279, 365
 sword-graves *303*, 304, 314
 Wuffingas royal house 85, 304
East Linton (Lothian), button-fitting 64, 250
East Saxons 286, 288
Eccles (Kent), buckle 150, *225*, 230, 236, 249, 265
ecclesiastical objects *see* Christian objects
Ecgfrith, King of Northumbria 288–9, 298, 317
Ecgric, King of East Angles 288
edge binding **614/15**

catalogue *420–1*, 457
damage 203
description 71, *77, 78*, 79, 83
Edwin, King of Northumbria
 cross and chalice 112–13, 118, 293
 death of 113, 280, 287, 288, 298
 received by Cearl 287
 villa regalis 309
Elford (Staffs), brooch 315
Eligius, St 94, 112, 124, 295, 342
Elmet 317
Empingham (Rutland), wrist-clasps 315
enclosures 12
Endre (Sweden), hoard 348
Eorcenberht, King of Kent 289
Eormenhild, St 289
Eosterwine, Abbot 305
Eowa of Mercia 287, 289, 317
Epsom (Surrey), pendant 169
Eriswell (Suffolk), burials 308, 309
Escomb church (Co Durham), sundial 251, *252*
eye motifs
 character 52, 85, *86, 88*, 90, 93, 96
 date and origin 268
 incidence 215
 manufacturing techniques 179, *180*, 183
 style and meaning 117–18, 226–7
Ezinge (Netherlands), pyramid-fitting 177
Ezra, portrayal of 114–15, *115*, 116, 295

face/helmet/mask motifs
 incidence 215
 style and meaning
 mounts *228*
 pommels *192*, 213, *214*, 226–7
 pyramid-fittings *225*, 226
 silver sheet *238*, 245
Faversham (Kent)
 brooches 150, *260, 262*, 267, 277
 buckle 224, 277
 mounts 164, 250
 pendant 255, 270
 sword 63
Felix 107, 279, 298–9, 357
Feltre (Italy), dish 341–2
Fen Drayton (Cambs), die 243
filigree
 conservation 20–2, *20, 21*
 description/discussion (*illus*) 153–6, 165–6
 back-sheets 163–5
 wires, granules and patterns 156–63

impact of Hoard's discovery 365
 style 214–16, *217–19*
filigree fragments 119, 154, *421*, 460–1
Finan, Bishop 290
Fincham (Norfolk), pyramid-fitting 64
Finglesham (Kent), buckle 243
Finnestorp (Sweden), war booty sacrifice 346
fish and bird mount *see* mount **538**
fish motifs
 character *92*, 93, 95, *96*
 damage 195, 202, 205, 358
 date and origin 267
 incidence 215
 manufacturing techniques 149, 151, 178
 style and meaning 213, 226, 227, *228*
flax 136
flint, prehistoric 11, 12
Flixborough (Lincs), monastery 309
Florence of Worcester 84
foil *see* sheet and foil
Ford (Wilts), seax 62, *63*, 65, 267
Forsbrook (Staffs), pendant 275
Franks 323, 333, 336
Franks Casket 81, 124, 183
Fredegund, Queen of Franks 357
Frogmore (Shrops), hall site 275
Fuente de Guarraz (Spain), hoard 343
Fulda (Germany), Cadmug Gospels 117
Fuller Brooch 118
Fulltofta (Sweden), war booty sacrifice 346
Fursey, St 288

Gainas, Goth in Byzantine service 338
Galloway (Scotland), Viking hoard 370
Galognano (Italy), hoard 341
Gamla Uppsala (Sweden)
 garnet workshop 61
 helmet fragment 243, 254
garnets
 discussion
 analysis 125, 129–32, *129, 131*, 365
 future research 366
 size and form 168–72, *169, 170, 171, 172*
 garnet **692** 100, 119, 169, *422*, 462
 garnet **693** 119, 168, 169, 462
 see also cloisonné/lapidary work
Garryduff (Ireland) bird 164
Geat 344
Gelimer, King of Vandals 342
gem settings **619/620** 169, 457
geometric ornament 209, *252*, 253–5

Gepids 338
Germanus, Bishop 118
Gerona (Spain), church 343
Gildas 286, 308, 333
gilding 145–6, *146*
Gilton (Kent)
 brooches 160
 scabbard mouth-piece 263
glass
 analysis 125
 use of 132–4, *132, 133*
glue 137, *137*, 138
gold
 analysis 125, 126–7, *126, 127*
 fragmentation of objects 331–2
 future research 366
 hoards 336–40, *337, 338, 339*, 347
 raw material 125–7
 status in later Roman world 329–30, 332, 365
 surface-enrichment 126, 144–5, *144, 145*, 364–5
 value 313–14, 365
 see also gold fragments; *guldgubber*; sheet and foil, gold; *solidi*
gold fragments
 catalogue *421*, 460–1
 fragment **680** 119, 137, 201, 305, *421*, 460
 fragment **682** 119, 461
Golgotha 111, 114
Gospels of St Médard de Soissons, Paris, Bibliothèque Nationale, MS lat. 8850 95, 117
Goths 333, 338, 341, 342; *see also* Ostrogoths; Visigoths
Gotland (Sweden)
 hoards 347, 348
 seax fittings 62, *63*
Gourdon (France), hoard 342, *342*
Graincourt-lès-Havrincourt (France), hoard 336
grave goods
 early Anglo-Saxon 302–6, *307*, 315, 317
 social hierarchy 306–8, 309, 314
 weapon burials 314
great gold cross **539**
 base *see* pins; silver-gilt coverings
 catalogue *411*, 449
 context 293–5, 296–7, 298, 305
 damage 202, 205
 date and origin *262*, 266, 267–8, 271, 279, 354

description 98, 99, 99, 100–1, *100*
function and significance 111, 118, 212, 213
garnets 130, 131, 169, 179
gold analysis 127, *127*
impact of discovery 365, 366
manufacturing techniques
 filigree 159, *163*
 incising and punching 149, *149*, 151
 sheet and foil 139
ornament style 227–30, *229*, *230*, 232, *262*
wear and repair *188*, 194
Gregory the Great, St 208, 286, 293, 366
Gregory of Tours, Bishop 335
Grenay (France), sword-ring 62
Gresford (Wrexham), pommel 60, 154
Griston (Norfolk), button-fitting 64
Gross-Bodungen (Germany), hoard 336
Gross Köris (Germany), hoard 337
Grüneck castle (Switzerland), hoard 343
Gudme (Denmark)
 die 147
 hoards 347
 settlement 348, 349
Guilden Morden (Cambs), helmet fragment 80, 304
Guisborough (N Yorks), helmet 235
guldgubber (*guldgubbar*) 241, 243–4, 349
gullies 11, *11*, 12, 13
Gummersmark (Denmark), brooch 236
Gunnar 343
Gunthorpe (Norfolk), harness mount 226, *228*
Guthlac, St 287, 289, 290, 298–9, 305, 357
Gwytherin (Conwy), reliquary 113
Gyrwe 290

Hacheston (Suffolk), pommel 60
hack silver 331–2, *331*
Hagenbach (Germany), hoard 336
Haigh, Andrew 4, 14
Hallaton (Leics), hoard 369, 370
Halsall, Guy 65, 70
Hamas (Syria), buckle 253
Hammersdorf (Młoteczno, Poland), hoard 336
Hammerwich (Staffs)
 metal-detector finds 12
 metalworking 205, 275, 292
 parish 4
 pendant 275, *275*
Hanbury (Staffs), nunnery 290

Harald Fairhair, King of Norway 241
Hardingstone (Northants), mounts 250
Harford Farm (Norfolk)
 brooch
 date 267
 manufacturing techniques 150, 164–5, 185, *185*
 style 227, *229*
 pin suite 133
harness-mount **698**
 catalogue *422*, 462
 context 305
 date 271
 description 85, 94, *94*, 96
 discovery and deposition 13, 359
 glass 132
 metal analysis 129
 ornament style *247*, 250
Harthacnut, King 84
Hatfield, province of 289
Hatfield Chase (Yorks/Lincs), battle of 113, 287, 288, 293
Hatton Rock (Warks), hall site 275
Heacham (Norfolk), pyramid-fitting 151
head-dress mount **541**
 assembly marks 18–19, *19*, 183
 catalogue *411*, 450
 conservation and reconstruction 18–19, *19*
 context 295, 298
 date and origin 266, 267–8, 354
 description 99, 109, *109*
 function and significance 111, 114–16, 118, 212, 255
 impact of discovery 366
 manufacturing techniques 132, 139, 149
 modification 195
 ornament style 224, 230, *231*
 wear 194
Heavenfield, battle of 108, 255
Heddernheim (Germany), helmet 82
heirloom factor
 fittings 190, 259, 263, 264, 270, 354, 356
 grave goods 258
 helmet 268
 swords 159, 188, 194
Helena, St 111
Helgö (Sweden), hoards 347, 348, 349
helmet
 biography 354, 356, 358
 conservation 24
 context 80, 304, 313
 deconstruction 202–3, *203*, 358
 form and reconstruction *78*, 79–80, 80–3

impact of discovery 365
origin, social significance and date 84–5, 266, 268, 271, 280, 356
ornament style (*illus*)
 animal 208, 232–9
 warrior 208, 232, 239–45, 254
parts, description (*illus*) 67, 70–9; *see also* bands; cheek-pieces; crest sections; decorated
 silver sheet; edge binding
reconstruction 78, 79
replica 366
wear 194
helmet motifs *see* face/helmet/mask motifs
Hengist and Horsa 212, 222, 344
Heraclius 298
Herbert, Terry 4, 8, 9, 24–6
Hildesheim treasure 336
hilt-collars
 catalogue *381–8*, 429–34
 general discussion
 character 33, *34*, 41–4, *41*, *42*
 impact of discovery 365
 typology and function 58, 59–61, *60*, *61*, 65
 hilt-collar **85**
 associations 464, *464*
 catalogue *381*, 429
 date and origin 264, 265
 description 41, 42
 manufacturing techniques 162
 ornament style 216, *217*, 224, 245
 wear and damage 191, 197, *197*
 hilt-collar **86**
 associations 464, *464*
 catalogue *381*, 429
 date and origin 264, 265
 description 41, 42
 manufacturing techniques 162
 ornament style 224
 wear and damage 191, 197, *198*
 hilt-collar **87**
 associations 464, *464*
 catalogue *381*, 429
 date and origin 264
 description 41–2, *41*
 manufacturing techniques 162
 ornament style 216, *281*
 wear 191
 hilt-collar **88**
 associations 464, *464*
 catalogue *381*, 429
 date and origin *260*, 264

description 41–2, *41*
manufacturing techniques 162
ornament style 216, *217*, *260*
wear 191
hilt-collar **89**
 associations 465, *465*
 catalogue *381*, 429
 date and origin 264, 265
 description 41, 42
 gold analysis 126–7
 manufacturing techniques 164
 ornament style 245, *272*
 wear 191
hilt-collar **90**
 associations 465, *465*
 catalogue *381*, 429
 date and origin 264
 description 41, 42
 gold analysis 126–7
 manufacturing techniques 164
 ornament style *210*, 213, 216, 255, *272*
 wear 191
hilt-collar **91** 41, 42, *381*, 429
hilt-collar **92**
 catalogue *381*, 429
 damage 197
 description 41, 42
 ornament style 216, *221*
hilt-collar **93** 41, 42, 202, 245, *382*, 429
hilt-collar **94**
 catalogue *382*, 429
 description 41, 42
 manufacturing techniques 163
 ornament style 245, *246*
hilt-collar **95** 41, 42, 156, 245, *382*, 429
hilt-collar **96** 41, 42, *382*, 429
hilt-collar **97** 41, 42, 161, *382*, 429
hilt-collar **98** 41, 42, *246*, 249, *382*, 429
hilt-collar **99** 41, 42, *382*, 429
hilt-collar **100** *20*, 41, 42, *246*, *382*, 429
hilt-collar **101** 41, 42, 143, *143*, *382*, 430
hilt-collars **102–3** 41, 42, *382*, 430
hilt-collar **104**
 catalogue *382*, 430
 date and origin 265
 description 41, 42
 ornament style 224, 249, 278
hilt-collar **105**
 associations 465, *465*
 catalogue *382*, 430
 damage 197
 date and origin 265
 description 41, 42

manufacturing techniques 143, *143*
ornament style 224, 278
hilt-collar **106**
 associations 465, *465*
 catalogue *382*, 430
 description 41, 42
 manufacturing techniques 143, *143*
hilt-collar **107** 41, 42, *166*, 224, *383*, 430
hilt-collar **108** 41, 42, 224, *383*, 430
hilt-collar **109**
 catalogue *383*, 430
 date and origin 265, 266, 267, 270
 description 41, 42, 63
 manufacturing techniques *153*, 154, 162–3, 164, 165
 ornament style *221*, 222, 224, 245, 249
hilt-collar **110**
 catalogue *383*, 430
 date and origin 265, 266, 267, 270
 description 41, 42, 63
 manufacturing techniques *153*, 154, 160–1, 162–3, *163*, 164, 165
 ornament style 222, 224, 245, 249
hilt-collar **111**
 catalogue *383*, 430
 date and origin 265
 description 41, 42
 manufacturing techniques *158*, 160–1, 164
 ornament style 249
hilt-collar **112**
 catalogue *383*, 430
 date and origin 265
 description 41, 42
 manufacturing techniques 160–1, 164
 ornament style *246*, 249
hilt-collar **113**
 catalogue *383*, 430
 date and origin 265
 description 41, 42, *318*
 manufacturing techniques 160–1
 ornament style *246*, 249, *318*
hilt-collar **114**
 catalogue *383*, 430
 damage 197
 description 41, 42
 manufacturing techniques 161, *163*
hilt-collar **115** 41, 42, 161, 197, *383*, 430
hilt-collar **116** 41, 44, 249, *383*, 430
hilt-collar **117** 41, 42, *383*, 430
hilt-collar **118**
 catalogue *383*, 430
 description 41, 42

ornament style 216, *221*, 249
hilt-collars **119–20** 41, 42, *383*, 430
hilt-collar **121** 41, 42, *246*, 249, *383*, 431
hilt-collar **122** 41, 42, 202, 249, *384*, 431
hilt-collar **123**
 catalogue *384*, 431
 description 41, 42
 manufacturing techniques 158, 161
 ornament style 224, *225*
hilt-collar **124**
 catalogue *384*, 431
 description 41, 42
 manufacturing techniques 158, *159*, 161
 ornament style 224
hilt-collar **125**
 catalogue *384*, 431
 description 41, *41*, 42
 manufacturing techniques 165, *165*
 ornament style 249
hilt-collar **126**
 catalogue *384*, 431
 description 41, *41*, 42
 manufacturing techniques 161, 165
 ornament style 249
 textile 136, *136*
hilt-collar **127** 41, 42, 249, *384*, 431
hilt-collar **128**
 catalogue *384*, 431
 description 41, 42, 63
 manufacturing techniques 160, *162*
hilt-collar **129** 41, 42, 63, 160, *384*, 431
hilt-collar **130**
 catalogue *384*, 431
 damage 197
 description 41, 44, 65
 manufacturing techniques 160, *161*
hilt-collar **131**
 catalogue *384*, 431
 damage 197
 description 41, 44, 65
 manufacturing techniques 160
hilt-collar **132** 41, 44, *384*, 431
hilt-collar **133** 41, 44, *141*, *384*, 431
hilt-collar **134** 41, *384*, 431
hilt-collar **135** 41, 42, 197, *384*, 431
hilt-collar **136** 41, 42, 197, *385*, 431
hilt-collar **137** 41, 42, *385*, 431
hilt-collar **138** 41, 42, 197, *385*, 431
hilt-collars **139–43** 41, 42, *385*, 431
hilt-collar **144** 41, 42, 197, *385*, 431
hilt-collar **145** 41, 42, *385*, 432
hilt-collar **146** 41, 42, 197, *385*, 432
hilt-collars **147–8** 41, 42, *385*, 432

hilt-collars **149–50** 41, 42, 148, *386*, 432
hilt-collar **151**
 catalogue *386*, 432
 date 265, 268
 description 41, 42
 ornament style 224, *225*
hilt-collar **152** 41, 42, *386*, 432
hilt-collar **153** 41, 42, 63, 165, *386*, 432
hilt-collar **154**
 catalogue *386*, 432
 damage 197
 description 41, 42, 63
 manufacturing techniques 165
hilt-collar **155**
 catalogue *386*, 432
 date and origin 165
 description 41, 42, 63
 manufacturing techniques 162
hilt-collar **156** 41, 42, 63, 165, *386*, 432
hilt-collar **157**
 amber 138
 catalogue *386*, 432
 date and origin 165
 description 41, *41*, 42
 garnets 168
 repair 194
hilt-collar **158**
 catalogue *386*, 432
 date and origin 165
 description 41, *41*, 42
 garnets 130, 168, *170*
 organics 137
hilt-collar **159**
 associations 466, *466*
 catalogue *386*, 432
 date and origin 268, *272*
 description 42, 44
 manufacturing techniques 170, 178
 organics 137
hilt-collar **160**
 associations 466, *466*
 catalogue *386*, 432
 date and origin 268, *272*
 description 42, 44
 manufacturing techniques 170, 178
 organics 137
hilt-collars **161–2** 42, 268, *386*, 432
hilt-collar **163**
 associations 467, *467*
 catalogue *387*, 432
 date and origin 268
 description 42, 44
 ornament style 224, *225*

hilt-collar **164**
 associations 467, *467*
 catalogue *387*, 432
 date and origin 268
 description 42, 44
 manufacturing techniques 176
hilt-collar **165**
 associations 468, *468*
 catalogue *387*, 433
 date and origin 266, 267, 268
 description 42, 44
 manufacturing techniques 134, 170, *173*, 176
 ornament style 222
hilt-collar **166**
 associations 468, *468*
 catalogue *387*, 433
 date and origin *262*, 266, 267, 268
 description 42, 44
 manufacturing techniques 134, *140*, 170, 176
 ornament style *221*, 222
hilt-collar **167**
 associations 468, *468*
 catalogue *387*, 433
 date and origin 266, 268, 278, 280
 description 42, 44, 62, *63*, 117, *167*
 gold analysis 126, 127
 manufacturing techniques
 animal ornament *178*
 backing foils 179
 cellwork 170, 176
 garnets 130, 131, *131*, 172
 glass 133, 134
 ornament style 222
 wear and damage 194, 205
hilt-collar **168**
 associations 468, *468*
 catalogue *387*, 433
 date and origin *262*, 266, 267, 268, 278, 280
 description 42, 44, 62, *63*, 65, *167*
 gold analysis 126, 127
 manufacturing techniques
 animal ornament *175*, 178, *178*
 backing foils 179
 cellwork 170, 176
 garnets 172, *173*
 glass 133
 ornament style 222
 wear and damage 193, *193*, 194, 195, 205
hilt-collar **169**

associations 468, *468*
 catalogue *387*, 433
 date and origin 268, 278, 280
 description 42, 44, 62, *63*, *167*
 gold analysis 126, 127
 wear and damage 194, 199, 205
hilt-collar **170** 42, 134, *387*, 433
hilt-collar **171** 42, 44, 134, *387*, 433
hilt-collars **172–3** 42, 44, *387*, 433
hilt-collar **174** 42, 137, 183, *183*, *387*, 433
hilt-collar **175** 42, 183, *185*, *387*, 433
hilt-collar **176** 42, *387*, 433
hilt-collar **177** 42, 44, 134, *387*, 433
hilt-collar **178** 42, 44, 176, *387*, 433
hilt-collars **179–80** 42, *387*, 433
hilt-collar **181** 42, *388*, 433
hilt-collar **182**
 catalogue *388*, 434
 date and origin 263
 description 41, 44, 62, 65
 manufacturing techniques 139, 150
 ornament style 213, *213*, 253
 wear 191
hilt-collar **183**
 catalogue *388*, 434
 date and origin 263
 description 41, 44, 62, 65
 manufacturing techniques 139, 150
 ornament style 213, *213*
 wear 191
hilt-collar **184**
 catalogue *388*, 434
 date and origin 263
 description 41, 44, 62–3
 manufacturing techniques 150, *150*, 152
 wear 191
hilt-collar **185**
 catalogue *388*, 434
 date and origin 263
 description 41, 44, 62–3
 manufacturing techniques 150, 152
 wear 191
hilt-collar **186**
 associations 469, *469*
 catalogue *388*, 434
 date and origin 263, 264
 description 39, 41, *42*, 44, 52, *54*, 62–3
 manufacturing techniques 139, 151
 ornament style 214, *214*, 224
 wear 191
hilt-collar **187**
 associations 469, *469*
 catalogue *388*, 434

date and origin 263, 264
description 39, 41, *42*, 44, 52, *54*, 62–3
manufacturing techniques 139, 151, *152*
ornament style 214, *214*
wear 191
hilt-collar **188**
associations 469, *469*
catalogue *388*, 434
date and origin 265, 269, 270, 280
description 41, 44, 62–3
manufacturing techniques 152, 163
modification 195
ornament style *247*, 249, 250, 251
hilt-collar **189**
catalogue *388*, 434
date and origin 266
description 39, 44
manufacturing techniques 149, 154
ornament style *221*, 224
hilt-collar **190** 41, *42*, 434
hilt-guards **409**
associations 469, *469*
catalogue *403*, 444
conservation and reconstruction 23, 32
date and origin 265, 269, 280
description 44, 48, *48*, 62, 63
manufacturing techniques 150, 151
ornament style 249, 250, 251
hilt-mounts
general discussion
character *49*, 50–5, *53*, *54*, 55
typology and function 58, 64, 65, 70
hilt-mounts **410–11** 50, 160, 249, *403*, 444
hilt-mount **412**
catalogue *403*, 444
damage 197
date and origin 268
description *49*, 50, *53*, 55
manufacturing techniques 151, 152
organics 136
ornament style 224, *225*
hilt-mount **413** 50, 129, 136, 197, *403*, 444
hilt-mount **414** *49*, 50, *403*, 444
hilt-mount **415** 50, *403*, 444
hilt-mount **416** *49*, 50, *403*, 444
hilt-mounts **417–19** 50, *403*, 444
hilt-mount **420** *49*, 50, *403*, 444
hilt-mount **421** 50, *403*, 444
hilt-mount **422** 50, 195, *404*, 444
hilt-mounts **423–4** 50, *404*, 444
hilt-mount **425**

catalogue *404*, 444
date and origin 264
description *49*, 50, 55
ornament style 216
hilt-mount **426**
catalogue *404*, 445
date and origin 264
description *49*, 50, 55
ornament style 216, *221*
hilt-mounts **427–9** *49*, 50, *404*, 445
hilt-mount **430** 50, *404*, 445
hilt-mount **431** 50, *272*, *404*, 445
hilt-mounts **432–4** 55, *404*, 445
hilt-mount **435** 116, *272*, *404*, 445
hilt-mount **436** 55, 169, *404*, 445
hilt-mount **437** *404*, 445
hilt-mount **438** *49*, 52, 253, *404*, 445
hilt-mount **439**
catalogue *404*, 445
description *49*, 50
ornament style 249, 255
wear 191
hilt-mount **440**
catalogue *404*, 445
description *49*, 50
ornament style 249, *252*, 255
wear 191
hilt-mount **441**
catalogue *404*, 445
description *49*, 50
ornament style 249, 255
wear 191
hilt-mount **442**
catalogue *405*, 445
description *49*, 50
ornament style 249, 255
wear 191
hilt-mounts **443–4** 50, 191, 197, 249, *405*, 445
hilt-mount **445**
assembly marks 183
catalogue *405*, 445
description 50
ornament style 249
wear and damage 191, 197
hilt-mount **446** 50, 183, 197, 249, *405*, 445
hilt-mount **447**
catalogue *405*, 445
damage 197
description 50
manufacturing techniques *141*, *161*
ornament style 249

hilt-mounts **448–9** 50, 55, 161, *272*, *405*, 445
hilt-mount **450** 50, 55, 264, *405*, 446
hilt-mount **451**
catalogue *405*, 446
date and origin 264, 265
description 50, 55
organics 136
ornament style 224
wear, damage and repair 191, 195, 197
hilt-mounts **452–3** 50, 55, 191, 264, *405*, 446
hilt-mount **454** 52, 55, 249, 265, *405*, 446
hilt-mount **455**
catalogue *405*, 446
date and origin 265, 277
description 52, 55
ornament style 224
hilt-mount **456**
catalogue *405*, 446
damage 197, *198*
description 52, 55
manufacturing techniques *164*
hilt-mount **457** 52, 55, *405*, 446
hilt-mount **458** 52, 55, 99, *406*, 446
hilt-mount **459**
catalogue *406*, 446
date and origin 267
description 55, *55*
manufacturing techniques 139, 149
ornament style 226, 227, *228*, 232
hilt-mount **460**
catalogue *406*, 446
date and origin 267
gold analysis 127
manufacturing techniques 164
ornament style 55, *221*, 222, 227, 230, 249
hilt-mount **461**
catalogue *406*, 446
date and origin 267
description 55, *55*, 116
ornament style *228*
hilt-mount **462** 55, 160, 161–2, 267, *406*, 446
hilt-mount **463**
catalogue *406*, 446
date and origin 270
description 52, *55*
ornament style 226, 249, 251
hilt-mount **464**
catalogue *406*, 446
damage 199

date and origin 270
description 52, *55*
ornament style 226, 249, 251, 255
hilt-mount **465**
 catalogue *406*, 446
 date and origin 270
 description 52, 55, *55*, 64
 manufacturing techniques 163, 169
 ornament style 226, 251
hilt-mount **466** 64, *406*, 446
hilt-mount **467**
 catalogue *406*, 446
 date and origin 270
 description 52
 manufacturing techniques 162
 ornament style 226, 249, 251
hilt-mount **468**
 catalogue *406*, 446
 date and origin 270
 description 52
 manufacturing techniques 162
 ornament style 226, 249, 251
hilt-mount **469**
 catalogue *406*, 446
 date and origin 266
 ornament style 226, 249, 250, 251
hilt-mount **470**
 catalogue *406*, 446
 date and origin 266
 manufacturing techniques 162
 ornament style 226, *228*, 249, 250, 251
hilt-mount **471**
 catalogue *406*, 446
 date and origin 266
 description 50
 manufacturing techniques 161, 162
 ornament style 226, 249, 250, 251, *252*, 255
hilt-mount **472**
 catalogue *406*, 446
 date and origin 266
 description 50
 ornament style 162, 226, 249, 250, 251
hilt-mount **473**
 catalogue *406*, 446
 date and origin 270
 description 52, 55, *55*
 garnets 130, 131, *182*
 manufacturing techniques 163, 169, 180
 ornament style 160, 226, 253
hilt-mount **474**
 catalogue *407*, 447
 date and origin 270

description 52, 55, *55*
 manufacturing techniques 160, *160*, 163, 169, 180, *181*
 ornament style 226, *228*, 253
hilt-mount **475** 52, 55, 160, *407*, 447
hilt-mounts **476–7** *49*, 52, 251, *407*, 447
hilt-mounts **478–9** 52, 227, *407*, 447
hilt-mount **480** 52, 55, *407*, 447
hilt-mount **481**
 catalogue *407*, 447
 description *49*, 52, 99, 111, 116, 117
 modification and damage 195, 201
hilt-mount **482**
 catalogue *407*, 447
 damage 201
 description *49*, 52, 55, 99, 111, 116, 117
 garnets 169
hilt-mounts **483–4** 52, 55, *407*, 447
hilt-mount **485**
 catalogue *407*, 447
 date and origin 266, 268
 description 52, 55
 manufacturing techniques 149, 151
 ornament style *221*, 230
hilt-mount **486**
 catalogue *407*, 447
 date and origin 266, 268
 description 52, 55
 manufacturing techniques 149, 151
 modification 195
 ornament style 230
hilt-mount **487**
 catalogue *407*, 447
 date and origin 266, 268
 description 52, 55
 manufacturing techniques 149, 151
 ornament style 230
hilt-mount **488** 52, *407*, 447
hilt-mount **489**
 catalogue *407*, 447
 damage *200*
 date and origin 270
 description *49*, 50
 ornament style 253
hilt-mount **490** *49*, 50, 253, 270, *408*, 447
hilt-mount **491** 50, 52, 253, 270, *408*, 447
hilt-mount **492**
 catalogue *408*, 447
 date and origin 270, *272*
 description 50, 52
 ornament style 253
hilt-mount **493** 50, 55, 253, 270, *408*, 447
hilt-mount **494** 52, 99, 132, *408*, 447

hilt-mount **495**
 catalogue *408*, 447
 description 52, 99
 garnets 130, 131
 glass 132, 134
 ornament style *252*, 253
hilt-mount **496**
 catalogue *408*, 447
 date and origin 268
 description 50, 55, 64
 manufacturing techniques 174
hilt-mount **497**
 catalogue *408*, 447
 date and origin 268
 description 50, 55, 64
 manufacturing techniques 174
hilt-mount **498** 50, 64, 268, *408*, 448
hilt-mount **499**
 associations 467, *467*
 catalogue *408*, 448
 date and origin 268
 description 50, *53*, 64
 manufacturing techniques 172, *174*
hilt-mounts **500–2**
 associations 467, *467*
 catalogue *408*, 448
 date and origin 268
 description 50, *53*, 64
 manufacturing techniques 172
hilt-mount **503**
 assembly marks 183
 catalogue *408*, 448
 date and origin 268
 description *49*, 50, 64
hilt-mounts **504–5** *49*, 50, 64, 268, *408*, 448
hilt-mount **506**
 assembly marks 183, *185*
 catalogue *409*, 448
 date and origin 268
 description *49*, 50, 64
 manufacturing techniques 180, *181*
hilt-mounts **507–9** 50, 64, 268, *409*, 448
hilt-mount **510** 50, 64, *200*, 268, *409*, 448
hilt-mount **511**
 catalogue *409*, 448
 date and origin 267, 278
 description 52, *55*, 64
 manufacturing techniques 133, 166, 177
 ornament style 226, 232, 251
hilt-mount **512**
 catalogue *409*, 448
 date and origin 267, 278

description 52, *54*, *55*, 64
manufacturing techniques 133, *133*, 166, 177
ornament style 226, *228*, 232, 251
hilt-mount **513**
 catalogue *409*, 448
 date and origin 267, 278
 description 52, 55, *55*, 64
 manufacturing techniques 166, 174, 177, *177*
 ornament style 226, 227, *228*
hilt-mount **514**
 catalogue *409*, 448
 date and origin 267, 278
 description 52, 64
 manufacturing techniques 133, 166, 177
 ornament style 226, *228*, 232, 249, 251
hilt-mount **515**
 catalogue *409*, 448
 date and origin 267, 278
 description 52, 64
 manufacturing techniques 133, 166, 177
 ornament style 226, 232, 249, 251
hilt-mount **516**
 catalogue *409*, 448
 description 52, *55*, 64
 garnets 172
 ornament style 226, 232, 251
hilt-mount **517**
 catalogue *409*, 448
 description 52, *55*, 64
 garnets 130, 131, 172
 ornament style 226, *228*, 232, 251
hilt-mount **518** 52, 53, 151, *409*, 448
hilt-mount **519** 52, 53, *54*, 151, *409*, 448
hilt-mount **520** 52, 53, 151, *409*, 449
hilt-mount **521**
 catalogue *409*, 449
 description 52, 53, 55, *55*
 garnets 130, 131
 manufacturing techniques 151, 174
hilt-mount **522**
 catalogue *409*, 449
 description 52, 53, 55, *55*
 manufacturing techniques 151, 174
hilt-mount **523** 52, 55, 174, *409*, 449
hilt-mount **524** 52, *409*, 449
hilt-mount **525** 52, 176, *409*, 449
hilt-mount **526**
 catalogue *409*, 449
 damage 201
 description *49*, 52, 99, 111, 116–17, *299*
 glass 133

hilt-mount **527**
 catalogue *410*, 449
 date and origin 269
 description 50, 53, 64
 manufacturing techniques 138
 ornament style 224, 235
hilt-mount **528**
 catalogue *410*, 449
 date and origin 269
 description 50, 53, 64
 manufacturing techniques 138
 ornament style 224, 235
hilt-mount **529**
 catalogue *410*, 449
 date and origin 269
 description 50, 53, *55*, 64
 manufacturing techniques 138, 151
 ornament style 224, 235
hilt-mount **530**
 catalogue *410*, 449
 date and origin 269
 description 50, 53, *55*, 64
 manufacturing techniques 138, 151
 ornament style 224, 235
hilt-mount **531**
 catalogue *410*, 449
 date and origin 269
 description 50, 53, 64
 manufacturing techniques 138, 151
 ornament style 224, 235
hilt-mount **532**
 catalogue *410*, 449
 date and origin 269
 description 50, 53, 64
 manufacturing techniques 138, 151
 ornament style 224, 235
hilt-mount **533**
 associations 469, *469*
 catalogue *410*, 449
 date and origin 263
 description 39, 52, *54*, 55
 manufacturing techniques 151
 ornament style 245, *246*
hilt-mount **534**
 associations 469, *469*
 catalogue *410*, 449
 date and origin 263
 description 39, *42*, 50, 52, *54*, 55
 manufacturing techniques 151
 ornament style *246*
hilt-mount **535**
 associations 469, *469*
 catalogue *410*, 449

 date and origin 263
 description 39, *42*, 50, 52, *54*, 55
 manufacturing techniques 151
 ornament style *246*
hilt-mount **536**
 catalogue *410*, 449
 date and origin 270, *272*
 description 50, 52, *54*, 55, 64
 ornament style 226, *247*, 251
hilt-mount **537**
 catalogue *410*, 449
 date and origin 270, *272*
 description 50, 52, 55, 64
 ornament style 226, 251
hilt-plates
 catalogue *391–402*, *422*, 437–43
 general discussion
 character 33, *34*, 44–8, *45*, *46*, *47*
 typology and function 58, *61*, 63, 65
hilt-plate **243**
 catalogue *391*, 437
 damage and repair 195, 197
 description 44, 45, *45*, 46, *46*, 47
 garnets 169
 organics 136
hilt-plate **244**
 catalogue *391*, 437
 description 45, *45*, 47, 65
 garnets 169
 organics 136
 wear and damage 194, 197
hilt-plate **245** 47, *160*, 169, *391*, 437
hilt-plate **246** 169, *391*, 437
hilt-plates **247–56** 169, *392*, 437
hilt-plate **257** 169, *393*, 437
hilt-plate **258**
 catalogue *393*, 437
 damage 197
 description 44, 47
 manufacturing techniques 136, 169
hilt-plate **259** 47, 129, *393*, 437
hilt-plate **260** 134, *134*, 169, *393*, 437
hilt-plate **261** 169, *393*, 437
hilt-plate **262** 47, 169, *393*, 437
hilt-plate **263** 47, 48, *393*, 437
hilt-plate **264** 47, 48, 65, *393*, 437
hilt-plate **265** 45, *393*, 438
hilt-plates **266–8** *393*, 438
hilt-plates **269–72** *394*, 438
hilt-plate **273** 47, *394*, 438
hilt-plates **274–7** *394*, 438
hilt-plate **278** 183, *185*, *394*, 438
hilt-plate **279** *394*, 438

hilt-plate **280**
 associations 466, *466*
 catalogue *394*, 438
 description 46, 47, 63
hilt-plate **281**
 associations 466, *466*
 catalogue *394*, 438
 description 46, 47, 63
hilt-plate **282** *394*, 438
hilt-plate **283** 47, 48, *394*, 438
hilt-plate **284** *394*, 438
hilt-plates **285–6** *395*, 438
hilt-plate **287** 199, *199*, *395*, 438
hilt-plate **288** *142*, *395*, 438
hilt-plate **289** 47, *193*, 199, *395*, 439
hilt-plate **290** *395*, 4390
hilt-plate **291** 47, *395*, 439
hilt-plate **292** *140*, *395*, 439
hilt-plate **293** *193*, *395*, 439
hilt-plate **294** 47, *395*, 439
hilt-plates **295–6** *395*, 439
hilt-plates **297–9** *396*, 439
hilt-plate **300** 47, *396*, 439
hilt-plates **301–2** *396*, 439
hilt-plate **303** 47, *396*, 439
hilt-plates **304–5** *396*, 439
hilt-plates **306–9** 47, *396*, 439
hilt-plates **310–11** *396*, 439
hilt-plate **312** *185*, *396*, 439
hilt-plate **313** *397*, 439
hilt-plate **314** *200*, *397*, 440
hilt-plate **315** *397*, 440
hilt-plate **316** 47, *397*, 440
hilt-plate **317** 191, 199, *397*, 440
hilt-plates **318–19** 47, *397*, 440
hilt-plate **320** 47, 191, *200*, *397*, 440
hilt-plates **321–4** *397*, 440
hilt-plate **325** 202, *203*, *397*, 440
hilt-plate **326** *397*, 440
hilt-plate **327** 47, *398*, 440
hilt-plate **328** 47, *199*, *398*, 440
hilt-plate **329** *398*, 440
hilt-plates **330–1** 47, *398*, 440
hilt-plate **332** *398*, 440
hilt-plate **333** 47, *398*, 440
hilt-plate **334** *398*, 440
hilt-plate **335** 47, *398*, 440
hilt-plate **336** 47, *399*, 440
hilt-plates **337–8** *399*, 440
hilt-plates **339–41** *399*, 441
hilt-plate **342** 47, *399*, 441
hilt-plates **343–6** *399*, 441
hilt-plate **347** *203*, *399*, 441

hilt-plates **348–50** *399*, 441
hilt-plate **351** 47, *399*, 441
hilt-plates **352–4** *400*, 441
hilt-plate **355** *203*, *400*, 441
hilt-plates **356–8** *400*, 441
hilt-plate **359** 41, 44, 48, *400*, 441
hilt-plate **360** 48, 162, *400*, 441
hilt-plate **361**
 assembly marks 183
 catalogue *400*, 441
 date and origin 266
 description 47, *47*, 48, 63
hilt-plate **362**
 assembly marks 183
 catalogue *400*, 441
 date and origin 266
 description *47*, 48, 63
 organics 137
hilt-plate **363**
 catalogue *400*, 441
 date and origin 266
 description 47, 48, 63
 manufacturing techniques 134, 180, *181*
 repair 194
hilt-plate **364** 47, 48, 63, 266, *400*, 442
hilt-plate **365**
 catalogue *400*, 442
 date and origin 266
 description 47, 48, 63
 manufacturing techniques 169
hilt-plate **366**
 catalogue *400*, 442
 date and origin 266
 description 48, 63
 manufacturing techniques 168, 171
hilt-plate **367**
 catalogue *401*, 442
 date and origin 266
 description 48, 63
 manufacturing techniques 168, 171
hilt-plate **368**
 catalogue *401*, 442
 date and origin 266
 description 48, 63
 manufacturing techniques 168, 171
hilt-plate **369**
 catalogue *401*, 442
 cloisonné 168, 171
 date and origin 266
 description 48, 63
hilt-plate **370**
 catalogue *401*, 442
 date and origin 262, 266

 description 44, 46, 47, 48, 65
 gold analysis 127
 manufacturing techniques 138–9, *139*, 151
 ornament style *210*, 224
 wear 193, *193*, 194
hilt-plate **371** 47, *401*, 442
hilt-plate **372** *46*, 47, 194, 356, *401*, 442
hilt-plate **373**
 catalogue *401*, 442
 damage *199*
 description *46*, 47
 modification 194, *194*, 356
hilt-plate **374** 48, *401*, 442
hilt-plate **375** 47, 48, *401*, 442
hilt-plates **376–7** 48, *401*, 442
hilt-plate **378** 48, *402*, 442
hilt-plate **379** *402*, 442
hilt-plate **380** 139, *402*, 442
hilt-plates **381–2** 47, *402*, 442
hilt-plates **383–6** *402*, 443
hilt-plate **387** *198*, 199, *402*, 443
hilt-plates **388–93** *402*, 443
hilt-plates **404–7** 47, 443
hilt-plate **696** 47, 263, *422*, 443
hilt-plate **697** 47, 263, 443
hilt-rings
 catalogue *388–91*, 435–6
 general discussion
 character 33, 41, 42–4, *42*
 typology and function 58, 63, 65
hilt-ring **191** 44, 63, *142*, 158, *388*, 435
hilt-rings **192–6** 44, 63, *388*, 435
hilt-ring **197** *42*, 44, 63, *389*, 435
hilt-rings **198–206** 44, 63, *389*, 435
hilt-ring **207** 44, 63, *159*, *389*, 435
hilt-rings **208–10** 44, 63, *389*, 435
hilt-ring **211** 44, 63, 161, *162*, *390*, 435
hilt-ring **212** 44, 63, 161, *390*, 435
hilt-ring **213** *42*, 44, 63, 161, *390*, 435
hilt-rings **214–16** 44, 63, 161, *390*, 435
hilt-ring **217** 44, 63, 161, *390*, 436
hilt-ring **218** 44, 63, *142*, 161, *390*, 436
hilt-rings **219–20** 44, 161, *390*, 436
hilt-ring **221** *42*, 44, 161, 202, *390*, 436
hilt-ring **222** 44, 161, *198*, *390*, 436
hilt-ring **223** 44, 161, *390*, 436
hilt-ring **224** 44, 161, *162*, *390*, 436
hilt-ring **225**
 associations 468, *468*
 catalogue *391*, 436
 description 44, 62, *63*, *167*
 gold analysis 126, 127

origins 278, 280
wear and damage 194, 205
hilt-rings **226–7** 44, 63, 263, *391*, 436
hilt-ring **228** *42*, 44, 63, 263, *391*, 436
hilt-rings **229–31** 44, 63, 263, *391*, 436
hilt-rings **232–3** 44, 63, 263, 436
hilt-rings **234–6** 44, 63, 263, *391*, 436
hilt-rings **237–41** 44, 63, 263, 436
hilt-ring **242** 41, 44, 263, 436
Hints (Staffs), hanging-bowl mount 275
Historia Brittonum 287, 288, 289
Historic England xxxi, xxxii, 16, 371
historical context
 background
 7th century Britain 286–7, 292
 early Mercian kings 287–9
 Hoard findspot 291–2, *291*
 religious and cultural background 293
 Anglian connections 298–9
 Christian and pagan culture in 7th century 296–8
 contemporary context 293–5
 religion in early Mercia 289–91
Hoard
 acquisition, funding and project organisation 13–16
 character *see* Hoard character
 context, research agenda xxxii; *see also* archaeological context; historical context
 date *see* dating evidence
 discovery and location 4–6, *4*, *5*, *6*
 fieldwork, 2009 and 2010 7
 aerial photography assessment 12–13
 methodology *7*, 8–9, *8*, *9*
 results *10*, 11, *11*
 fieldwork, 2012 13
 future research 366
 impact
 on knowledge of Anglo-Saxon world xxxii, 364–6
 public engagement with past 368–71
 interpretation and discussion 352–60; *see also* Hoard biography
 origins 271–9, *274*
 research agenda xxxi–xxxiii, 364–5
 terminology xxxi
 see also conservation; manufacturing
Hoard biography
 assembly 354–6
 last gathering 356–7
 selection and disassembly 357–9
 burial 359–60
Hoard character (*illus*) 30–3

Christian objects
 description 97, 99–110
 function and significance 110–19
 helmet 71–85
 large mounts not from weaponry 85–96
 research agenda xxxi–xxxii 364
 weapon fittings
 description 33–57
 typological and functional significance 58–70
 miscellanea 119–21
hoarding 322–4
 Continental Germanic Europe 334–5, *334*, 344
 brooches in Carpathian Basin 337–8, *337*, *338*
 gold and silver 336–7
 hidden treasure in texts 343–4
 Italy, Burgundia and Visigothic Spain 340–2, *341*, *342*
 precious metal of Roman origin 336
 royal treasure, gift exchange and tribute 335–6
 tableware from Danubian area 338–40, *339*
 later Roman Britain and beyond 325
 4th–5th centuries 325–9, *326*, *327*, *328*
 dating 330–1, *331*
 fragmentation of objects 331–2, *331*, *332*
 post-Roman period 332–4
 status of gold and silver 329–30, *329*
 Scandinavia 344–6, *345*, 349
 precious metal and central places 347–9
 war booty sacrifices 346–7
 ways of hoarding 346, *346*
Hodneland (Norway), pommel 59
Hög Edsten (Sweden), hoard 62, *62*, 177, 348
Högom (Sweden), hilt-collar 63
Holderness (E Yorks), cross-pendant 116, 176
Holy Sepulchre Church, Jerusalem 212
Holywell Row (Suffolk), burial 308
Hoogebeintum (Netherlands), brooch 160
horn *46*, 136, 137
hornbeam (*Carpinus betulus*) 136
Horncastle (Lincs), helmet fragment 80
Horndean (Hants), hoard 354
Hornhausen (Germany), carved stone 245
Horsa *see* Hengist and Horsa
horse equipment 305, 306
horse motifs *165*, *212*, 213, *217*, 222
Hou (Denmark), scabbard mount 213–14, 216, *217*, 260

Hoxne hoard (Suffolk)
 context 325, 326, *328*, 333
 dating 331
 object fragmentation 332, *332*
 valuation and fundraising 15, 16
Huns 333, 338, 340
Hunterston (Ayrshire), brooch 95, 163, 251

ice-wedges 11, *11*, 12, 359
Icklingham (Suffolk), helmet fragment 80
iconoclasm 201, 202, 205, 296
iconography 118–19, 366
Illerup Ådal (Denmark)
 beading file 158
 war booty sacrifice 70, 346, 347
incising and punching 149–51, *149*, *150*, *151*
India, garnets 129, 131, 172
Ine, King of Wessex 289, 312
Ingleby (Derbys), pyramid-fitting 315
ingots 336–7
inlay
 bone 20, *20*, 93, 136
 glass 132–4, *132*, *133*
 unidentified 134–5, *135*, 365
 see also niello
inscribed strip **540**
 catalogue *411*, 450
 context 295, 296, 298, 305
 damage 201, 202, 205
 date and origin 258, 267, 268, 279
 description 99, 101, 102, *103*, *106*
 function and significance 111, 113, 118
 gold analysis 127
 impact of discovery 365
 inscription palaeography 103–8, *103*
 manufacturing techniques 140, 151, *152*, 153, 159
 ornament style 224–6, 227
interlace and knots 209, 245–9, *246–7*, 365; *see also* Stafford knots
Ipswich (Suffolk)
 Boss Hall, brooch 168
 emporium 278
iron 129
Iron Gates (Serbia/Romania), helmet 235
Isola Rizza (Italy), hoard 342
Iudeu 288, 292, 357
Iurminburg, Queen 293, 299
Ixworth (Suffolk), cross 116

Jarrow *see* Monkwearmouth-Jarrow monastery
Jerusalem *see* Golgotha
John III (Pope) 111
Johnson, Fred 4
Josephus 115, 116
Julian, Emperor 340
Justin II, cross 111, 112, 293, *294*

Kaiseraugst (Switzerland), hoard 323, 336
Kent, kingdom of
 7th century history 286, 289, 293, 297
 law-codes 312, 313, 314
 metalwork
 date 261, 264, 266, 273, 276–7
 manufacturing techniques 163–4, 166, 173, 177–8, 181
 style 211, 214–16, 249–50, 354, 365
Keswick (Cumbria), Crosthwaite Museum disc-mount *247*, 250
King's Bromley (Staffs), royal estate 317
King's Newton (Derbys), burials 315
Kingston Down (Kent), brooch 64, 95, 133, 250, 266, *277*
Kingston-on-Thames (Surrey), hoard 354
Knaves Castle (Staffs), enclosure 292
knots *see* interlace and knots; Stafford knots
Knoxspark (Ireland), disc-mount 160
Köln St Severin (Germany), sword 253
Kragehul (Denmark), hoard 235, 346, 347
Krassum (Netherlands), mounts 52
Krefeld-Gellep (Germany)
 knife-grips 64
 saddle mounts 95
Kurin (Syria), crosses 111, *111*
Kyndby (Denmark), pommel 62, 269

Lagore (Ireland), mount 227
Lakenheath (Suffolk), horse burial 305, 308
Lamellenhelm 80, 84
Länglöt (Sweden), coin 348
lapidary work *see* cloisonné/lapidary work
Lastingham (N Yorks), monastery 290
law-codes 312–13, 314
layout marks 165, *166*, 183
lead ore 317
Leahy, Kevin 5, 14, 16
Lechlade (Glos), pommel 59
Lengerich (Germany), hoard 336
Letocetum see Wall
Lex Ribuaria 84
Leyden Papyrus 145
Lichfield (Staffs)
 Cathedral 12, 368, 369–70
 cemetery, Anglo-Saxon 12
 Christianity 108, 274, 290
 see 287, 290, 292, 317
 settlement, Anglo-Saxon 12, 291
 shrine of St Chad 12
Lichfield District Council 14, 15
Liebenau (Germany), die 147
Lindisfarne (Northumbria) 286, 288, 290
Lindisfarne Gospels, British Library Cotton MS Nero D IV 94, 117
Lindsey, kingdom of
 in 7th century 286, 288, 289, 290, 317
 metalworking 278
Little Chester (Derbys), cemetery 315
Littlebourne (Kent), buckle-plate 227, *229*, 267
Llangorse (Powys), metalwork 278
Loftus (N Yorks), pendant *277*, 278
 bezel 170
 cloisonné 166, 178, 253
 filigree 158, 224
London, Mercian control of 289
Long Itchington (Warks), hall site 275
Longdon (Staffs), brooch 315
Longobards 323, 342, 358
Lower Shorne (Kent), pommel 227
Lowpark (Ireland), mount 227
Lullingstone (Kent)
 bowl 251
 die *247*, 251
Lupus, Bishop 118
Lyminge (Kent), royal vill 309, 365

Maidstone (Kent), gold panel 64, 176
manufacturing
 Hoard's impact on knowledge of 364–5
 raw materials *see* amber; copper alloy; garnets; glass; gold; inlay; iron; organics and paste;
 rock crystal; silver
 research agenda xxxii, 364–5
 resource analysis 124–5
 techniques *see* assembly/other marks; casting; cloisonné/lapidary work; die-impressing;
 filigree; gilding; incising and punching; niello; reeded strip; sheet and foil; soldering; surface-enrichment
Mappae Clavicula 145, 146
Market Rasen (Lincs), hilt-suite
 character 61, *61*, 70
 hilt-collars 41, 60, *61*, 63
 hilt-plates 60, *61*
 pommel 60, 61, *61*, 65
 date and origin 264, 266, 270, 276, 277
 filigree 158–9, 164, 166, 216, 253
Marwnad Cynddylan 274, 290
Maserfelth 287, 290, 291
mask motifs *see* face/helmet/mask motifs
Maurice Tiberius, Emperor 358
Maxstoke Priory (Warks), pommel 61, 275, *275*
Mellitus, Bishop 366
Menghin, O 58, 59, 63
Mercia, kingdom of
 in 7th century 286, 292, 299, 365
 archaeology of 315–19, *316*
 early kings 287–9
 future research 366
 Hoard findspot in relation to 291–2, *291*, 356, 357, 358, 360
 law-codes 312, 313, 314
 metalwork 259, 273–6, *274–5*, 279, 280, 354
 religion 289–91, 296, 297
mercury 129, 145–6
Merewalh 287, 290
metalworking *see* manufacturing
Middle Anglia 286, 288, 290, 296, 298, 317
Middleham (N Yorks)
 pommel
 character 60, 61, 65
 date and origin *261*, 264, 276, 277
 shilling *261*, 264
Midlum (Netherlands), hoard 348
Mildenhall (Suffolk), hoard 325, 326, *327*, 333
Mileham (Norfolk), pommel 59
Milfield (Northumbria), settlement 309
Milton (Oxon), brooches 164–5, 265
Milton Regis (Kent), pendant 169, 178, *179*
Missorium of Theodosius 329, *329*
modification and repair 188, 194–5, *194*, *195*
monasteries 309–11
Monkton (Kent), brooch 265, 269
Monkwearmouth (Tyne & Wear), sculpture 251, *252*, 255
Monkwearmouth-Jarrow monastery (Tyne & Wear) 114, 117, 132, 293, 295, 305
Monza (Italy), book-covers 94–5, 117, 295
Morrild Hjorring (Denmark), brooch 180
Mote of Mark (Dumfries & Galloway), mould fragment *247*, 249, 250, 251, 269, 278

mounts
 catalogue *403–15*, 444–52
 general discussion
 character 85, 94–6
 garnet cloisonné **542–66** 85–93, *86*, *88–9*, *90*, *91*
 silver with niello **567–71** 93, *93*
 Christian affiliation 99
 damage 205
 date and origin 268, 279
 identification 32
 manufacturing techniques 140, 145, 149, 151, 166
 wear and repair 194
 see also harness-mount; hilt-mounts;
 saddle mounts
 mount **538**
 catalogue *410*, 449
 damage 195, 202, 205, 358
 date and origin 262, 267, 354
 description 85, *92*, 93, 95, *96*
 gold analysis 127
 manufacturing techniques 139, 149, 151, 178
 ornament style *204–5*, 226, 227, 232, 251, 253
 mount **541** *see* head-dress mount
 mount **542**
 assembly marks 183
 catalogue *411*, 450
 Christian affiliation 117–18, 227
 description 38, 85, *86*, *88*, 90, 94, 95
 garnets 130, 131, 132
 manufacturing techniques 174, 179, 180, *180*
 organics and paste 137, 138
 ornament style 253, 255
 mount **543**
 assembly marks 183
 catalogue *411*, 450
 Christian affiliation 117–18, 227
 description 38, 85, *86*, *88*, 90, 94, 95
 manufacturing techniques 174, *176*, 179, 180
 organics and paste 137, 138
 ornament style 253, 255
 mount **544**
 catalogue *411*, 450
 Christian affiliation 117–18
 damage 202
 description 38, 85, *86*, 88, *88*, 90, 95
 manufacturing techniques 174
 organics and paste 137, 138

 ornament style 253, 255
 mount **545**
 catalogue *411*, 450
 Christian affiliation 117–18
 damage 197, 202
 description 38, 85, *86*, 88, *88*, 90, 95
 manufacturing techniques 174
 organics and paste 137, 138
 ornament style 253, 255
 mount **546**
 catalogue *411*, 450
 Christian affiliation 117–18
 damage 202
 description 38, 85, *86*, 88, *88*, 90, 95
 manufacturing techniques *171*, 174
 ornament style 253, 255
 mount **547**
 catalogue *411*, 450
 Christian affiliation 117–18
 damage 197, 199, 202
 description 38, 85, *86*, 88, *88*, 90, 95
 manufacturing techniques *142*, *171*, 174
 ornament style 253, 255
 mount **548** 85, *88*, 90, *411*, 450
 mount **549** 85, *88*, 90, 137, *411*, 450
 mount **550**
 catalogue *412*, 450
 description 85, 90, *90*, 95, *113*
 manufacturing techniques 179
 organics 137, 138
 mount **551**
 catalogue *412*, 450
 description 85, 90, *90*, 95
 garnets 130, 131, *169*
 manufacturing techniques 179
 organics 137, 138
 mount **552**
 catalogue *412*, 450
 description 85, 90, *90*, 95
 manufacturing techniques 179, *180*
 organics 137
 mount **553**
 catalogue *412*, 450
 description 85, 90, *90*, 95
 garnets 130, 131
 manufacturing techniques 179
 organics 137, 138
 repair 194
 mounts **554–5** 85, 90, 95, 179, *412*, 451
 mount **556**
 assembly marks 183, 185
 catalogue *413*, 451
 date and origin 265, 280

 description 85, 90, 95, *95*
 manufacturing techniques 149, *150*
 ornament style 224, *225*, 230
 paste 138
 mount **557**
 assembly marks 183, 185
 catalogue *413*, 451
 date and origin 265, 280
 description 85, 90, 95, *95*
 manufacturing techniques 149
 organics 137
 ornament style 224, *225*, 230
 mount **558**
 assembly marks 185, *185*
 catalogue *413*, 451
 conservation 19, *19*
 damage 202
 date and origin 265, 280
 description 85, 90, *91*, 95, *95*, 355
 garnets 130, 131, 132
 manufacturing techniques 149, 178
 ornament style 224, *225*, 230, 245
 repair 194
 mount **559**
 assembly marks 185, *185*
 catalogue *414*, 451
 conservation 19
 date and origin 265, 280
 description 85, 90, *91*, 95, *95*
 manufacturing techniques 149, 178
 ornament style 224, *225*, 230, 245
 repair and damage 194, 199, 202
 mount **560**
 catalogue *414*, 451
 damage 199
 date and origin 265, 280
 description 85, 90, 95, *95*
 garnets 130, 131, 132
 manufacturing techniques 149, 178
 ornament style 224, *225*, 230
 mount **561**
 catalogue *414*, 451
 damage 199
 date and origin 265, 280
 description 85, 90, 95, *95*
 manufacturing techniques 149, 178
 ornament style 224, 230
 mount **562**
 catalogue *414*, 451
 Christian affiliations 117
 date and origin 268, *269*, 278
 description 85, 90, *91*, 95
 garnets 130, 131, 132

organics 137
mount **563**
 catalogue *414*, 451
 Christian affiliations 117
 date and origin 268, *269*, 278
 description 85, 90, *91*, 95
 garnets 130, 131, 132
 organics 137
mount **564**
 catalogue *414*, 451
 Christian affiliations 117
 damage 197
 date and origin 268, *269*, 278
 description 85, 90, *91*, 95
 manufacturing techniques *176*
 organics 137
mount **565**
 catalogue *414*, 451
 conservation 20, *20*
 description 38, 85, *92*, 93
 manufacturing techniques 174, *177*
 organics 136
mount **566**
 catalogue *414*, 451
 description 38, 85, *92*, 93
 manufacturing techniques 174
mount **567**
 catalogue *415*, 452
 Christian affiliation 227
 description 93, 95–6, *96*
 manufacturing techniques 149, *149*
 ornament style 253
 silver analysis 128
mount **568**
 catalogue *415*, 452
 Christian affiliation 227
 description 93, 95–6, *96*
 manufacturing techniques 149, *149*
 ornament style 253
mount **569**
 catalogue *415*, 452
 conservation and reconstruction 23
 description *69*, 93, *93*, 95–6
 ornament style 253
 silver analysis 128
mount **570**
 catalogue *415*, 452
 description 93, 95–6, *96*
 manufacturing techniques *151*
 ornament style 253
 silver analysis 128
mount **571**
 catalogue *415*, 452

 description 93, 95–6, *96*
 ornament style 253
 silver analysis 128
Mucking (Essex), settlement 308–9, 315
Mumma 295

nails/rivets
 catalogue 657–60
 description 119, 120, *120*, 121
 gold
 nails/rivets **622–7** 457
 nail/rivet **628** 458
 nail/rivet **629** 47, *120*, 458, 466, *466*
 nails/rivets **630–4** 458
 nails/rivets **657–9** 120, *120*, 459
 silver
 nails/rivets **664–8** 459
 nails/rivets **672–5** 120, *120*, 459–60
Narbonne (France), chancel-screen panel 111
National Geographic xxxii, 366, 369
National Heritage Memorial Fund 14, 15
Neoplatonism 118
Neupotz (Germany), hoard 336
Newark (Notts)
 cross 116
 pyramid-fitting 177
Nibelungs, treasure of 340, 343
Niederstotzingen (Germany), bead 138
niello 151–3, *151*, *152*, *153*
Nielsen, Høilund 260–1
Nocera Umbra (Italy), swords 60, 64, 249
Northumbria, kingdom of
 7th century history 278, 286, 287–9, 292, 297, 317
 metalwork
 date 259, 276, 277–8, 280
 style 166, 250, 354
Nydam (Denmark), war booty sacrifice 70, 235, 346, 347

Ödeberg (Norway), pommel 59
Odin (Woden)
 animal ornament, association with 208, 211, 226, 232, 235
 berserker power derived from 241
 depictions of 208, 213, 244–5
 eyes 227
 in genealogies 212, 344
 in place-name 291
 sacrifice to 290
Odoacer, King 340

Oethelwald of Deira 288
Offa (of the East Saxons) 290
Offa (of Mercia) 188, 193, 289, 314, 319
Offa of Angeln 344
Offlow (Staffs) 291
Ogley Hay (Staffs) 12, 13
Öland (Sweden), hoards 347, 348; *see also* Torslunda
organics and paste
 analysis 125
 conservation 18, 22
 description 136–8, *136*, *137*
 future research 366
Ormside (Cumbria) bowl 120
ornament style
 dating 258–63
 Phase 1 263
 Phase 2 264–6
 Phase 3 266–9
 Phase 4 269–70
 summary 270–1
 description/discussion 208–9, 255; *see also* animal ornament; animal ornament Style I; animal ornament Style II; Early Insular Style; geometric ornament; interlace and knots;
 Romanitas style decoration; scrollwork; warrior ornament
 impact of Hoard 365
Orsoy (Germany), pommel *303*, 304
Oseberg (Norway), mounts 251
Osthryth, Queen 289, 290
Ostrogoths 323, 334, 340, 341
Oswald, St
 Christian warfare 297
 cross erected by 108, 255, 298
 cult 290
 death 280, 287, 288, 290, 291, 298
 distributes silver dish to poor 357
 and Irish missionaries 286
 relics 295
Oswiu, King of Northumbria
 Middle Anglia 298, 317
 Oswald's head and hands retrieved by 290, 291, 295
 treasure given by 288, 297, 357
 warfare 287, 288, 290, 292
Oxborough (Norfolk), hoard 353
Oxford (Oxon), Westgate excavations 370

Pappilanmäki (Finland), pommel 62
Parabiago (Italy), hoard 336

Paris (France), Saint-Denis 94, 112, 255, 295
paste *see* organics and paste
Patching (Sussex), hoard 325, 331, *331*, 332, 333, 353
Paulinus, Bishop 112, 293
Paulinus of Nola, manuscript of 81
Peada of Mercia 288, 290, 296, 298, 317
Peak District
 Anglian colonisation 127, 317
 barrow graves 275, *316*, 317, 319, 354, 365
Pēcsǣte 317
Pencersǣte 12, 274, 291, 360
Penda, King of Mercia
 army of 65
 Mercia under 276–8, 279, 298, 315, 356
 paganism 276, 289–90, 296, 297, 317
pendant *see* cross-pendant
Penkridge (Staffs) 291
Pennocrucium 291
Penwalh 287
Peterborough (*Medehamstede*) (Cambs), monastery 290
Pietroasa (Romania), hoard 324, 336, 337, 338, *338*, *339*
pike 227
pins **676**
 catalogue *421*, 460
 date 268
 description 99, *101*, 102, *120*
Piotrowice (Poland), hoard 337
Plastazote 22–3, 24
Pliezhausen (Germany), brooch 244, 254
Pliny 145
Poitiers (France)
 church of St Saturnin 113
 Hypogée de Dunes 113, *113*
pommels
 catalogue *376–81*, *424–8*
 general discussion
 character (*illus*) 33, 34–40
 distribution in England 274, 276–7
 impact of discovery 365
 typology and function 58–62, *61*, 65, 70
 value 357
 pommel **1**
 associations 464, *464*
 catalogue *376*, 424
 date and origin 264
 description 36, 37, 41
 manufacturing techniques 162
 ornament style 216, *217*
 wear 191

pommel **2**
 associations 464, *464*
 catalogue *376*, 424
 damage *201*
 date and origin *260*, 263, 264
 description 36, *36*, 37
 gold analysis 126
 manufacturing techniques 129, 162, *164*
 ornament style 216, 224, 249
 wear *190*
pommel **3**
 catalogue *376*, 424
 date and origin 263, 264
 description 37, 38
 ornament style 216, *218*
 wear *190*
pommel **4**
 catalogue *376*, 424
 damage 199
 date and origin 263, 264
 description 36, 37
 gold analysis 126
 organics 137
 ornament style 216, *219*
 wear 190
pommel **5**
 associations 465, *465*
 catalogue *376*, 424
 date and origin 264, *272*
 description 36, 37
 gold analysis 126–7
 manufacturing techniques 164
 ornament style 216, *219*, 224
 wear *190*, 191
pommel **6** 37, 216, 265, *376*, 424
pommel **7**
 catalogue *376*, 424
 date and origin 263, 264, 265
 description 37
 ornament style 216, *218*, 224
pommel **8**
 catalogue *376*, 424
 conservation 22
 date and origin 263, 264, 266
 description 37, 38
 manufacturing techniques *161*
 ornament style 216, *218*, 249, 255
pommel **9**
 catalogue *376*, 424
 date and origin 263, 264, 265
 description 37, 38
 ornament style 216, 224, 249
 wear 190

pommel **10**
 catalogue *376*, 424
 date and origin 264, 265
 description 37
 organics 137, 138
 ornament style 216
pommel **11**
 catalogue *376*, 424
 date and origin 265
 description 37
 manufacturing techniques *139*
 ornament style 224, *225*, 249
pommel **12**
 catalogue *376*, 424
 date and origin 264, 265
 description 37
 ornament style 216, *220*, 224
pommel **13** 37, 224, 265, *376*, 424
pommel **14**
 catalogue *376*, 424
 damage *202*
 date and origin 263, 264, 265
 description 36, 37, 38
 ornament style 224, *225*, 245
 wear and repair 190, *190*, 195
pommel **15**
 catalogue *376*, 424
 date and origin 263, 264, 265
 description 37
 ornament style 224, *225*, 249
 wear 190
pommel **16**
 catalogue *376*, 424
 date and origin 263, 264, 265
 description 37, 38
 manufacturing techniques 139
 ornament style 216, *218*
pommel **17**
 catalogue *377*, 424
 date and origin 264
 description 37, 60
 ornament style 216, *219*, 255
 wood 137
pommel **18**
 catalogue *377*, 424
 date and origin 264
 description 37, 38, 60
 ornament style 216, *218*
 weight 38, 314
pommel **19**
 catalogue *377*, 424
 date and origin 264
 description 37, 60

manufacturing techniques 137
ornament style 216, *218*
pommel **20**
 catalogue *377*, 424
 damage 200
 description 37, 38
 ornament style 216, *218*
pommel **21**
 catalogue *377*, 425
 manufacturing techniques 162, *163*
 description 37, 60
 ornament style 216, *218*
pommel **22** 37, 224, 249, *377*, 425
pommel **23** 37, 60, 162, 213, *377*, 425
pommel **24** 37, 137, 156, *156*, *377*, 425
pommel **25**
 catalogue *377*, 425
 date and origin 263
 description *21*, 37, 60
 gold analysis 144
pommel **26** 37, *377*, 425
pommel **27** 37, *377*, 425, 465, *465*
pommel **28** 37, *377*, 425
pommel **29**
 catalogue *377*, 425
 date and origin 265
 description 37
 manufacturing techniques 137
 ornament style 245–9, *246*
pommel **30**
 catalogue *377*, 425
 date and origin 265
 description 37, 38
 manufacturing techniques 158
 ornament style *246*, 249
pommel **31**
 catalogue *377*, 425
 damage 200
 date and origin 265
 description 37
 manufacturing techniques 139, 144, *145*, 148
 ornament style 245, *246*
pommel **32**
 catalogue *377*, 425
 date and origin 263, 265
 description 36, *36*, 37
 organics 137
 ornament style *246*, 249
pommel **33**
 catalogue *378*, 425
 date and origin 263, 265
 description 36, 37

ornament style *246*, 249
pommel **34**
 catalogue *378*, 425
 damage 200
 date and origin 264
 description 36, 37, 59
 ornament style 216, 249
pommel **35**
 catalogue *378*, 425
 date and origin 264
 description 36, 37, 59
 manufacturing techniques 164
 ornament style 216, *220*
pommel **36**
 catalogue *378*, 425
 date and origin 263, 264
 description 37, *37*, 38, 57, 60
 garnets 130, 131
 manufacturing techniques 174, 177, *177*, 181
 organics 137, 138
 ornament style 216, *219*, 255
pommel **37**
 catalogue *378*, 425
 date and origin 264, 265–6
 description 36, 37, 38, 57, 59, 60
 manufacturing techniques 177, 181
 ornament style 224, 255
pommel **38**
 catalogue *378*, 425
 damage 199
 date and origin 265–6, 278
 description 36, 37, 38, 57, 60
 inlay 134
 manufacturing techniques 177, 181
 ornament style 224, *225*, 255
pommel **39**
 catalogue *378*, 426
 date and origin 265–6
 description 36, 37, 38, 57, 60
 inlay 134
 manufacturing techniques 177, *179*, 181
 ornament style *252*, 253
pommel **40**
 catalogue *378*, 426
 date and origin 263
 description 37, 38, 57, 60
 inlay 134
 manufacturing techniques 177, 181
 ornament style 249
pommel **41**
 catalogue *378*, 426
 damage 200

date and origin 265–6
 description 37, 57, 60
 manufacturing techniques 174
 ornament style 227, *252*, 253
pommel **42** 37, *158*, *378*, 426
pommel **43** 38, 134, 263, *378*, 426
pommel **44**
 catalogue *378*, 426
 date and origin 263
 description 38
 manufacturing techniques 134, 135, *135*
pommel **45** 38, *378*, 426
pommel **46**
 associations 466, *466*
 catalogue *378*, 426
 damage 199
 date and origin 268
 description *37*, 38, 46, 63
 garnets 130, 131, 168
 ornament style 226–7
pommel **47**
 associations 466, *466*
 catalogue *379*, 426
 date and origin 268, *272*
 description 38
 manufacturing techniques 170, *171*, 174, *176*
 organics 137
 ornament style 253, 255, 306, *306*
pommel **48**
 catalogue *379*, 426
 damage 199
 description 38
 manufacturing techniques 130, 131, 173
pommel **49**
 associations 467, *467*
 catalogue *379*, 426
 conservation 20
 date and origin 268
 description 38, 50, *53*
 glass 134
 manufacturing techniques 170, 172, *172*, 173, 176
 wear and repair 190, 194, *195*
pommel **50**
 associations 467, *467*
 catalogue *379*, 426
 date and origin 268
 description 38, *62*
 garnets 168
 manufacturing techniques 173, 174, *177*
pommel **51**
 catalogue *379*, 426

date and origin 268
description 38
garnets 130
manufacturing techniques 137, *137*, 174
pommel **52**
 catalogue *379*, 426
 date and origin 263, 266, 267
 description 36, 38, 59
 garnets 130, 131, *131*, 168
 manufacturing techniques 174, 176
 ornament style 212, *212*, 213, 216, 222, 226, 253
pommel **53**
 catalogue *379*, 426
 damage 199
 date and origin 263, 266, 267
 description 38
 glass 132, *132*, 133
 manufacturing techniques 170, *172*, 179
 ornament style 216, *220*, 222, 253, 255
pommel **54**
 associations 468, *468*
 catalogue *379*, 426
 date and origin 263, 266, 267
 description 38
 manufacturing techniques 134, *135*, 158, *159*, 170, 176
 ornament style 216, *220*
pommel **55**
 associations 468, *468*
 catalogue *379*, 427
 damage 198, 199, 205
 date and origin 263, 266, 267, 278, 280
 description 36, 38, 44, 62, *63*
 gold analysis 126, 127
 manufacturing techniques 139, *167*, 177
 ornament style 216, *220*, 222, 227
 wear and repair 194, 195
pommel **56**
 catalogue *379*, 427
 damage *202*
 date and origin *262*, 263, 266, 267
 description 36, *36*, 37, 39, 59
 gold analysis 127
 manufacturing techniques 149, 151, 153, 159, *160*
 ornament style 216, *220*, 222, *230*, *262*
pommel **57**
 catalogue *379*, 427
 damage 199, 200, 205
 date and origin 262, *262*, 263, 266, 267, 280
 description 36, *38*, 39, 59

gold analysis 127, 313
 manufacturing techniques 138, 139, 149, 151, 153, 159
 marks 183
 ornament style 216, 222–4, 232, 251, 253, *262*
 wear 194
pommel **58** *379*, 427
pommel **59** 200, *379*, 427
pommels **60–1** 198, 199, 200, *379*, 427
pommel **62** 200, *379*, 427
pommel **63**
 catalogue *379*, 427
 date and origin 263, 265
 description 37, *37*, 39, 47
 manufacturing techniques 154, 161
 ornament style *252*, 255
pommel **64**
 catalogue *380*, 427
 date and origin 263
 description *37*, 39, 47
 manufacturing techniques 145, 179
 wear 191
pommel **65** 39, 47, 191, 263, *380*, 427
pommel **66**
 catalogue *380*, 427
 date and origin 263
 description 39, 47
 manufacturing techniques 145, 166
 wear 191
pommel **67** 47, 59, 263, *380*, 427
pommel **68**
 catalogue *380*, 427
 damage 200
 date and origin 263, 271, 354
 description 36, 39, 40, 47, 59
 interlace 245, *246*
 manufacturing techniques 145, 151, 152, *152*
 ornament style *192*, 213, *214*, 216, 253
 wear 190, *191*
pommel **69**
 associations 469, *469*
 catalogue *380*, 427
 date and origin 260, 263, 264
 description 36, 39, *42*, 47, 52, *54*, 59
 manufacturing techniques 145, 151
 ornament style 214, *214*, 216, 253, *260*
pommel **70**
 catalogue *380*, 427
 date and origin 263, 266, 267
 description 39, 47
 ornament style 216, *220*, 222

pommel **71** *367*
 catalogue *380*, 428
 date and origin *262*, 263, 266, 267
 description 36, 39, 44, 59
 manufacturing techniques 149, 154
 ornament style 216, *221*, 224, 227, *262*
pommel **72**
 catalogue *380*, 428
 date and origin 263, 269–70
 description 36, 39, 40, 59
 manufacturing techniques 139
 modification 195
 rune 183, *183*, 195
pommel **73**
 catalogue *380*, 428
 date and origin 263, 269–70
 description 36, *36*, 39, *39*, 40, 59, 62
 manufacturing techniques 145, 150, 177
 modification 195, 357
 ornament style 216, 226, *247–8*, 250, 251, 253
pommel **74**
 catalogue *380*, 428
 date and origin 269–70
 description 36, *36*, 39, 40, 59, 62
 ornament style 250, *252*, 255
pommel **75**
 catalogue *380*, 428
 date and origin 269, 270, 278
 description 32, 36, 39, 40, 57, 62
 glass 134
 manufacturing techniques 145, 150, 151, *152*, 154, 161, 171
 ornament style *247*, 250, 251
 silver analysis 128
 wood 136–7, *136*
pommel **76**
 associations 469, *469*
 catalogue *380*, 428
 conservation and reconstruction 23, 32
 damage 198, 199
 date and origin 263, 265, 269, 270, 278, 280
 description (*illus*) 36, 39, 40, 44, 57, 62
 glass 133, 134
 gold analysis 127
 manufacturing techniques 145, 151, *153*, 163, 178, 179
 organics 137
 ornament style 227, *247*, 249, 250, 251, 255
 silver analysis 128
pommel **77**

cabochon stone 138, 169
catalogue *381*, 428
conservation and reconstruction 22–3, *22*
date and origin 269, 270, *272*, 278
description 32, 36, 39–40, 57, 62
manufacturing techniques 164
metal analysis 127, 129
organics 137
ornament style 227, *247*, 250, 251
silver analysis 128
wear 191
pommel **78**
catalogue *381*, 428
damage 200
date and origin 263, 277
description 39, 59
manufacturing techniques 151
ornament style 226, *228*
Portable Antiquities Scheme (PAS) xxxi, 4, 13–14, 364, 369, 371
Portmahomack (Highld), mount 250
post-holes 11
Potteries Museum and Art Gallery 4, 14–16, 368–71
Pressblech 146
Primasius, *In Apocalypsin* 105
princely burials xxxii, 260, 275, 308, 353, 365; *see also* Broomfield; Cuddesdon; Prittlewell; Sutton Hoo; Taplow
princely objects
helmet 84, 280
metal analysis 127
saddle 95, 226, 280
seax fittings 62, 166, 222, 280
sword fittings 59, 222, 280
Prittlewell (Essex), princely burial 308
crosses 266
cup mounts 216, 236, 268
date 260, 264
drinking horn mounts 260, 264
public engagement 368
sword 63, 65
punching *see* incising and punching
Pybba (Pypba), family of 287
pyramid-fittings 56–7, *56*, *57*, 64, *64*
pyramid-fitting **572**
catalogue *416*, 452
date and origin 266
description 56–7, *57*, 64
garnets 130, 131, 168, 172
glass 133, *133*, 134
ornament style 255
pyramid-fitting **573**

catalogue *416*, 452
date and origin 266
description 56–7, *57*, 64
garnets 168, *169*, 172
glass 133
ornament style 255
pyramid-fitting **574**
catalogue *416*, 452
date and origin 269, 278
description 56–7, *57*, 64, *64*
garnets 168
manufacturing techniques 162
ornament style *252*, 255
pyramid-fitting **575**
catalogue *416*, 452
date and origin 269, 278
description 56–7, *57*, 64, *64*
garnets 130, 168
manufacturing techniques 162
ornament style 255
pyramid-fitting **576**
catalogue *416*, 452
date and origin 269
description 56–7, *57*, 64
glass 132
manufacturing techniques 170–1, 179
ornament style 255
pyramid-fitting **577**
catalogue *416*, 452
date and origin 269
description 56–7, *57*, 64
garnets 130, 131
manufacturing techniques 170–1, 179
organics 137
ornament style 255
pyramid-fitting **578**
catalogue *416*, 453
date and origin 268–9
description 56–7, *56*, *57*, 64
garnets 168, 172
glass 132, 133, *133*
inlay 134
ornament style *223*, 224, *225*, 226, 255
pyramid-fitting **579**
catalogue *416*, 453
date and origin 268–9
description 56–7, *56*, *57*, 64
garnets 130, 168, 172
glass 132, 133, 134
inlay 134
ornament style 224, 226, 255
pyramid-fitting **580**
catalogue *416*, 453

description 56, 57, *57*, 62, 64, *66*
garnets 168
manufacturing techniques 160, *162*, 166, 177
ornament style 250, 251, 255
pyramid-fitting **581**
catalogue *416*, 453
description 56, 57, *57*, 62, 64
garnets 130, 131, 168
manufacturing techniques 160, 166, 177
ornament style 250, 251, 255

quadruped motifs
character *38*, 42, 55
date and origin 261, *262*, 265, 266–7, 268
incidence 215
style and meaning 213–14
great gold cross 227–30, *229*, *230*
head-dress mount 230, *231*
helmet 232, *234*, 235–6, *236*, 239, 249
hilt-collar 213, *221*, 222, 224
hilt-plate *210*, 224
pommels 216–22, *220*, 224, *230*, *367*
quartz 138

Rædwald, King of East Angles 85, 212, 260, 278, 296
Ravenna (Italy), Sant' Apollinare in Classe 111
Reccesvinth, King 343
recycling
Hoard 298, 312, 356, 358
metals 126, 127, 128, 129
reeded strip **609–13**
catalogue *420*, 457
damage 203
description and function 71, *71*, 78–9, 83
manufacturing techniques 148, *148*
Regium (Italy), hoard 340
religious objects *see* Christian objects
reliquaries 113–14, 295, 296, 298–9
Rempstone (Notts), helmet fragment 80
Rendlesham (Suffolk), *vicus regius*
great hall 309
metalworking 124, 232, 278, 304
sword-related finds *303*, 304
repair *see* modification and repair
Repton (Derbys)
double-house 290
royal crypt 317–19
settlement 287

Rhayader (Powys), bracelet 160
Rheged, kingdom of 250, 276, 278, 280, 354
Ripon (N Yorks)
 church 117, 293, 297
 Ripon jewel 138
Rippingale (Lincs), pommel 59
rivets *see* nails/rivets
roads 12; *see also* Ryknild Street; Watling Street
Rochester (Kent), church 293
rock crystal 138, 169
Romanitas style decoration 212, *212*
Rome (Italy)
 Esquiline Hill, hoard 340
 St Peter
 cross 293, *294*
 ex voto 118
 Santa Pudenziana 111, *112*, 114
 Santo Stefano Rotondo 293
Romulus 336
Rosmeer (Belgium), brooch 160
Rostock-Dierkow (Germany), sword 138
Royal Forest 13
royal treasure 358
Rülzheim (Germany), hoard 340
runes 183, *183*, 185
Rupertus cross 100, *100*
Ryknild Street 291–2, *291*, 360

saddle mounts 94, 95, *95*, *96*, 280
St Cuthbert Gospel 95, 117
St Ninian's Isle (Shetland), scabbard chape 107
Saint-Benoît-sur-Loire (France), treasure 295
Saint-Moré (France), brooch 160
Salin, Bernhard 210–11
Sarre (Kent)
 brooch 170, 266
 sword parts 59, 62, 151, 277
Saxons 323, 333, 336
scabbard-fittings 30, 33
Scalford (Leics), pommel 59
Scandinavia
 gold supply 125–6, 323
 hoards 323–4
 context 344–6
 damage and fragmentation 195, 331, 332, 357
 distribution *345*
 precious metals and central places 330, 347–9
 war booty sacrifices 346–7
 ways of hoarding 346

metalwork/metalworking
 date 261, 263, 266, 271
 helmets 79–80, 81, 82, 84
 manufacturing techniques
 cloisonné 70, 131–2, 173, 177
 die-impressing 146
 filigree 60–1, 70, 154, 159, 163, 164, 165
 garnet workshops 61–2
 style 211
 animal ornament 213, 222, 235, 236–8
 figural ornament 239, 241–5, 254
 geometric 253
 scrollwork 249
 pommel from 59, 263, 354
Schlaufenornamentik 245
scrollwork 209, 249–50
seax fittings
 assemblage 33
 biography 354
 character 62, *63*, 65
 context 304–5
 identification 32
 manufacturing techniques 166, *167*
 typology and function 58
 value 312, 313
Seaxburh 289
Seaxwulf, Bishop 290
Seeress's Prophecy 226
Selsey (Sussex), pyramid-fitting 64
serpent motifs
 character
 head-dress mount 109
 hilt-mounts 50, 53, 55, *55*, 64
 inscribed strip 102, *103*
 mounts 90, 95
 pommels *36*, *37*, *367*
 date and origin 264, 265, 268, 269
 incidence 215
 manufacturing techniques 149, *150*, 151, *153*, *166*
 style and meaning 212, 213, 224–6
 head-dress mount 224
 helmet 232–5, *233–4*, *236*, 238
 hilt-collars *217*, 224, *225*
 inscribed strip 224–6
 mounts 224, *225*
 pommels *218–21*, 224, *225*
 pyramid-fittings *225*, 226
'Sevso' treasure 340
sheet and foil
 gold
 cloisonné backing foils 179–80, *180*, *181*

 die-impressing 146–8, *146*, *147*
 fragments **694–5** 119, 140, 179–80, *181*, 462
 manufacturing techniques 139–40, *139*, *140*
 silver **690** 32, 119, 461
 see also decorated silver sheet; silver-gilt coverings
Shire Oak (Staffs) 292
Shorwell (Isle of Wight), helmet 80, 304
Sibertswold (Kent), pommel 59
Sigeberht of East Anglia 279, 280, 288, 297, 298
Sigibert I, King of Austrasia 335
Sigismund of Burgundy 335, 342
siliquae, in hoards
 Britain 325, 326, 331, *331*, 332, *332*
 Scandinavia 347, 349
silver
 in Hoard
 analysis *127*, 128–9, *128*
 raw material 127–9
 weight 314
 in later Roman world
 fragmentation 331–2, *331*, *332*
 hoards 336–7, 347
 status 329–30, 365
 see also hack silver; sheet and foil, silver; silver fragments; silver-gilt coverings
silver fragments
 catalogue 461
 identification 44, 119
 silver fragment **687** *247*, 251, *422*, 461
silver-gilt coverings **607/8**
 catalogue *420*, 456
 conservation and reconstruction 23, *23*
 description 32, 99, *101*, 102, *102*
 function and significance 111, 114, 295
 manufacturing techniques 140
Sinai (Egypt), monastery of St Catherine 117
Sisenand, King of the Visigoths 358
Skedemosse (Sweden), war booty sacrifice 70, 347
Skrävsta (Sweden), pommel 62
Skurup (Sweden), pommel 59, *60*, *217*, 222
Slarke, Duncan 4
smiths
 Hoard disassembly 205, 357, 358
 role of 124, 125, 127, 146
 royal patronage 222, 273
Snape (Suffolk), finger-ring 158
Snartemo (Norway), pommel 59
Snösbäck (Sweden), war booty sacrifice 346, 347

socket (silver) **685** 119, 136, 197, *421*, 461;
 see also silver-gilt coverings
Soest (Germany), brooch 172
soldering 141–3, *141*, *142*, *143*
solidi
 donativa 329–30, 336, 358
 fragmentation 331, 332
 as gold source 125–6, 261–2, 313
 hoards
 Britain 325, *328*, 330, *331*, 354
 Germanic Europe 336, 340, 342
 Scandinavia 347–8, 349
 iconography 347
 pendants 268, *269*, 270
 weapon prices 84
Solihull (W Mids), pendant 275, *275*
Sorte Muld (Denmark)
 guldgubber 244, 349
 settlement 347
Sösdala (Sweden), war booty sacrifice 346
South Saxons 286, 288, 314
Southampton (Hants)
 Hamwic 146
 pendant 268
Spangenhelm 80, 84, 222, 243
Springhead (Kent), fitting 226
Sri Lanka, garnets 129, 131, 172
Stafford (Staffs), Shire Hall 368
Stafford knots *225*, 235, 236, 239, 249, 265
Staffordshire County Council 14, 15
Staffordshire Hoard Symposium xxxi, 65
Staffordshire Moorlands Pan 14
Standlake (Oxon), pendant cross 250
Stanton St John (Oxon), pyramid-fitting 151
Stapenhill (Staffs), cremation 315
Stephen of Ripon 297–8, 299
Stora Sandviken (Sweden), sword 64
Streethay (Staffs), brooch 275, *275*
Stretham (Cambs), pendant 169
strip (silver) **605** *420*, 461; see also inscribed
 strip; reeded strip
Sturkö (Sweden), pommel 61
sun symbols 244
surface-enrichment 126, 144–5, *144*, *145*,
 364–5
Sutton (Suffolk), brooch 173, 177–8, 278
Sutton Courtenay (Oxon), metalworking 124
Sutton Hoo (Suffolk), princely burials xxxii,
 260, 278–9, 304, 308, 325
Sutton Hoo mound 1
 buckle 139, *228*, 232, 245, 313
 button-fittings 56, 64–5, 131, 168, 266
 cloisonné 173, 176, 180, 181, 365

cup mounts
 animal ornament 222, 224, *229*, 230,
 262
 date 266, 267
 reeded strip 79
die-impressed foils 147–8
drinking horns 249, 261
filigree 162
hanging-bowls 227, 250
helmet 304
 animal ornament 222, 226, 232
 brass edging 83
 cheek-pieces 82
 clips 79
 conservation 24, 81
 copper-alloy panels 71, 84
 crest 81
 date 80, 85
 face-mask 80–1
 figural ornament *237*, *238*, 241, 243–4,
 245, 254
 royal association 85, 232
 weight 83
purse-lid
 animal ornament *228*, *262*
 cloisonné 170, 177, 278
 date 266
 garnets 166
pyramid-fittings 64, 168
shield
 animal ornament 95, 213, *217*, 222, 226,
 239
 date 261
shoulder-clasps
 animal ornament *178*, 222, 224, 226, *228*
 cloisonné 166, 170, 172, *173*, 176, 181
 date 278, *279*
 filigree 95
 garnets 166
 glass 132–3
 gold 126
silver plate 127
strap mount *178*
sword
 blade width 65
 button-fittings 64
 cloisonné 278
 date 266
 grip-mounts 44, 64, 250
 hilt-rings 44, 63, 250
 pommel 61, 276, 278
 status 58
 wear 188

Sutton Hoo mound 2 *260*, 264, 305
Sutton Hoo mound 17
 animal ornament 216
 belt and scabbard-fittings 171, 278
 harness-mount 96, 214, *214*, *260*, 264
 horse equipment 305
 pyramid-fittings 64, 304
Swaffham (near) (Norfolk), hoard 354
Swallowcliffe Down barrow (Wilts), mount
 250, 251
Swarkestone (Derbys), cemetery 315
swastika motifs 52, 240, *252*, 255, 270
Swinthila, King 343
sword-rings
 catalogue *381*, 429
 general discussion
 character 33, 34, 40, *40*, 62
 impact of discovery 365
 sword-rings **79–81** 40, *40*, 62, 263, *381*,
 429
 sword-ring **82**
 catalogue *381*, 429
 date and origin 263
 description 40, *40*, 62
 modification 194
 ornament style 226
 sword-rings **83–4** 40, 62, 263, *381*, 429
swords
 biography 354, 356, 357, 358
 context 292, *303*, 304–5, 312, 313–14
 damage 195–203, *197–9*, *200*, *201–3*
 exceptionality of assemblage 352–3
 hilt-fitting sets
 catalogue 464–9, *464–9*
 date 263, 264, 265, 266, 268, 270
 description 41, 42, 44, 45, 50
 identification 32
 origins 273
 typology and function 58, 63, 64, 70
 wear 190
 modification and repairs 194–5, *194*, *195*
 parts see hilt-collars; hilt-guards; hilt-
 mounts; hilt-plates; hilt-rings; pommels;
 sword-rings
 typology 58–65, 67, 70
 wear 188–94, *190*, *191*, *193*
swurdhwitan 193
Szilágysomlyó (Romania), hoard 323, 336,
 337–40, *337*
Täbingen (Germany), brooch 173
Tacitus 241
Tame, River 315
Tamworth (Staffs)

settlement 287, 317, 319
Tamworth Castle 368, 369–70
Tamworth Borough Council 14, 15
Taplow (Bucks), princely burial 308
 bottle mounts 245
 clasps 253, 266
 cup mounts 264
 date 260, 264
 horn mounts 85, 150
Tara (Ireland), brooch 95, 160, 251
Tassilo Chalice (Austria) *247*, 251
Tattershall Thorpe (Lincs), tools 124, 200, *201*
Tauschierung 151
textile fragment 125, 136, *136*, 359
Theodelinda, Queen 94, 117, 295
Theoderic the Great, King of the Ostrogoths 330, 335, 340, 341
Theodore I (Pope) 293–5
Theodore, Archbishop of Canterbury 116, 289, 290, 297
Theodosius, Emperor 111
Theophilus 147, 152, 158
Thetford (Norfolk), hoard 326, 333
Thor/Thunor 255
Thorismund, King of the Goths 358
Thorsberg (Germany), weapons 70, *93*, 235
Thunor *see* Thor/Thunor
Thuringians 323
Thurnham (Kent)
 cross-pendant 110, *110*, 112, 277
 fitting 177
Timboholm (Sweden), hoard 348
Tjitsma (Netherlands), die 147, 148, 180
Tomsǣte 12, 274, 291, 360
Tongres (Belgium), mount 174, 278
Torslunda (Sweden), dies
 images 81, *237*, 241, 242–3, 244, 254
 manufacture and use of 83, 147
Tostock (Suffolk), buckle 169
Tournai (Belgium), Childeric's grave 166, 342
Traprain Law (E Loth), treasure 331, *331*, 332
Treasure Act 1996 4, 13–14, 16
Trent, River
 battle of 289, 290, 292, 317
 as boundary 315, 317
tribute
 Anglo-Saxon Britain 286, 287, 288, 289, 292
 Continental Europe 125, 268, 335–6
 Hoard as 258, 279, 299, 312, 319, 356, 357

Trier (Germany), shrine 174, 295
triquetras *153*, *218*, 251, 255
Trossingen (Germany), lyre 235, 243, 245, *246*, 263
Trumpington (Cambs), cross 116, 178, 261
Turcii family 340
Tureholm (Sweden), hoard 346, *346*, 348, 358
 hilt-collars 59, *60*, 63
Tuxford (Notts), hilt-collar 63

Udovice (Serbia), pendants 347
Uppåkra (Sweden), hoards 347, 349, 353
Uttlesford (Essex), finger-ring 230, *252*

Valdonne (France), hoard 342
Vale of York hoard 14, 15, 16
Vallstenarum (Sweden), pommel 62
Valsgärde (Sweden)
 animal ornament 211
 helmets
 form 80, 81, 83
 ornament 232, *237*, 241–2, 243, 244, 254
 social significance 84
 hilt-collars 63
 pommel 62, 269–70
Vandals 333, 342
Väsby (Sweden), pommel 61
Västergötland (Sweden), hoards 344, 346, 347, 348, 349; *see also* Ålleberg collar
Vedrin (Belgium), hoard 348
Vedstrup (Denmark), brooch 236
Vendel (Sweden)
 animal ornament 211
 helmets
 form 81, 83, 84
 inspiration 80
 ornament 56, 241–3, *242*, 244–5, 254
 knife 63
 pommel 59, 62
Vimose (Denmark), war booty sacrifice 346
Visigoths 323, 338, 343

Wall (*Letocetum*) (Staffs) 12, 291, 360
war booty
 Christian objects 297
 Hoard as 312, 319, 353, 356, 357
 hoards
 Continental Europe 335–6, 340

 Scandinavia 305, 324, 346–7, 349, 353
warrior ornament 215, *237*, *238*, 239–45, *242*
Wartski 16
washers
 gold 120, 121
 washers **651–4** 458
 washer **660** 46, 120, 459
 silver 120, 121
 washer **662** 154, 459
 washer **675** 120, 460
Washington DC (USA), exhibition 369
Wasperton (Warks)
 brooch 275, *275*
 cemetery 274
Water Newton (Cambs), hoard 325, 326, *327*, 333
Watling Street 4, 12, 291–2, *291*, 359–60
wax-glue paste 74, 137–8, *137*
weapon fittings
 assemblage 33, *33*
 typological and functional significance 58–70
 see also hilt-collars; hilt-guards; hilt-mounts; hilt-plates; hilt-rings; pommels; sword-rings; weapon-harness fittings
weapon-harness fittings 56–7, *56*, *57*
wear 188–94, *190*, *191*, *193*
Wednesfeld 291, 360
weight, Byzantine 212, *212*
Weissenburg (Germany), hoard 336
Weland 124
Wellingore (Lincs), pommel 60, 261, *261*, 264, 276
wergild 312–14
Wesel Bislich (Germany), mount 95, *96*
West Midlands Archaeological Collections Research Unit 369
West Saxons
 in 7th century 286, 287–8, 289
 law-codes 312, 313, 314
West Stow (Suffolk), settlement 308–9, 315
Westerne 290
Westness (Orkney), brooch 159
Whitby (N Yorks), comb 183
White Low (Derbys), pendant cross 317
Wibtoft (Leics), button-fitting 64
Wickhambreaux (Kent), button-fitting 64, 266
Widsith 313, 344
Wieuwerd (Netherlands), pendant 255, 270

Wigestan 314
Wijnaldum (Netherlands)
 cloisonné 173
 mount 64
Wilfrid, Bishop 117, 293, 297–8, 299
Wilton Cross 116, 173, 268, *269*, 278
wing motifs 85, *92*, 93
Winster Moor (Derbys), cross 249
Winwæd, river, battle of 288, 290, 292, 298, 317, 356, 358
Woden *see* Odin
wolf motifs *38*, 59, 139, 213, 222
Wolfson Foundation 15
Wollaston (Northants), helmet 304
 damage 203
 date 80, 85
 form 77, 80, 82, 83
 ornament 222
Wolverhampton (W Mids), minster charter 12
wood 136–7, *136*, *137*
Wroxeter (Shrops), shrine 118
Wuffingas 85, 304
Wulfhere, King of Mercia 288–9, 290, 292, 298, 317, 358
Wychnor (Staffs)
 cemetery 274, 315, 317
 Domesday survey 315–17

Yeavering (Northumbria), settlement 309, *310*, 365
York (Yorks)
 church 293
 Coppergate helmet
 assembly marks 185, *185*
 date 80
 form 80, 81, 82, 83
 inscription 107, 235
 royal association 84, 85
 wear and damage 194, 203
 hoard 354

Zealand (Denmark), buckle 213, *214*
zoomorphs
 character *36*, 37, 55, *55*
 date and origin *260*, 261, 264–5, 268
 incidence 215
 style and meaning 208, 255
 head-dress mount 230, *231*
 helmet 236, *236*, 238
 hilt-collars *210*, 213–14, *221*, 253
 mounts 216, *221*
 pommels (*illus*) 213, 214, 216–22, 250, 253
 pyramid-fittings 226
Zosimus 333

PICTURE CREDITS

Page numbers are in italics; catalogue numbers are in **bold**. All illustrations and images are credited throughout except for the following:

Front cover: A selection of highlight pieces from the Staffordshire Hoard. From top left to bottom right the items are:

(*left*) part of helmet cheek-piece **591**; (*above and right of cheek-piece* **591**) 'fish and bird' mount **538**; (*right of cheek-piece* **591**) hilt-piece **370**; (*top right*) folded great gold cross **539**; (*on left, below folded great gold cross* **539**) hilt-collar **168**; (*centre, to bottom left of great gold cross* **539**) apical disc with *millefiori* stud from mount **541**; (*bottom right*) animal-head terminal of helmet crest **590**; (*bottom*) inscribed strip **540**; (*centre left, above inscribed strip* **540**) head-dress mount **541**; (*centre right, above inscribed strip* **540**) pyramid-fitting mount **573**; (*between pyramid-fitting mount* **573** *and animal-head terminal from helmet crest* **590**) button-fitting **583**.

Spine (also page xxxvi): Mount **512**. Bird of prey. Gold and garnet fitting. One of a pair.

Back cover (also page 372): Mount **566**. Gold and garnet fitting.

1, 283, 373, 527, 561: Mount **538**. Illustration of the mount reconstructed. The design is a 'split representation' of a bird of prey landing on a fish. *Drawing*: C. Fern.

3: Mount **460**. Stylised seahorse with filigree decoration.

29: Cross-pendant **588**. Gold with filigree decoration and a cabochon garnet.

123: Apical disc with *millefiori* stud from mount **541**.

187: Pommel **14**. Gold filigree pommel cap with interlace decoration.

207: Hilt-plate **370**. Gold seax hilt plate with zoomorphic decoration.

257: Pommel **16**. Gold filigree pommel cap with interlace.

282: Half of strip-mount **558**. Gold and garnet.

285: Hilt-mount **411** with hilt-plate **323** embedded in it (as it was found).

301: Lower part of mount **541**. Gold and garnet with interlace animal panels.

321: Hilt-collar **115**. Gold hilt collar with filigree decoration.

351: Serpent mount **530**. Gold snake fitting.

363: Strip-mount **554**. Gold and garnet.

375: Seax-fitting **167**. Gold seax hilt fitting with zoomorphic interlace worked in garnets, single animals in panels.

423: Silver-gilt sheet **598**. Fragment stamped with two facing male heads.

463: Hilt-ring **197**. Gold wire hilt collar.

470–1: Strip-mount **550**. Gold and garnet.

(*Opposite page*) *586*: Cheek-piece **591**. Detail. Gold and niello panel with Anglo-Saxon animal interlace.

588: *Endpiece*: Reconstruction of a sword-hilt in Early Insular style, from the proposed set of pommel **76**, hilt-collar pair **188** and hilt-guard pair **409**. The silver objects with gold and garnet mounts were reassembled from a combined total of seventy-three fragments (scale 1/1). Image I. Dennis.

CW01238522

Encounters
A j o u r n e y t h r o u g h t h e w i l d

Gehan Rajapakse . Namal Kamalgoda . Palitha Antony . Sarinda Unamboowe

Leopard. Yala

Through Ravi, news reached Namal and me that the Kotabendi Wewa cubs were at a kill close to the road. We travelled through the night to reach Yala before the park opened. At Kotabendi Wewa we saw the cubs draped on a Malittan tree. We then watched the cubs drinking from a small pool of water in the thicket whilst shafts of sunlight fell on them. **GR**

Misty Morning. Yala

Moderagala Wewa, was a rarely visited part of the park, and as such one of my favourite places. This photograph was taken during a very dry spell. What greeted me took my breath away. A scene straight out of a Sherlock Holmes novel. The time was 7.30 am and the sun was high in the sky. A pair of Whistling Teal completed the picture. **NK**

Angled Pierrot. Morapitiya Forest Reserve
There was no wind that afternoon and this male Angled Pierrot was extremely still on the leaf. **PA**

Grey Heron. Yala

The soft morning light on this bird made a wonderful contrast against the darkness of the water and jungle. The heron ruffled it's feathers making a pleasing image. I dropped the exposure by a third of a stop to give it more impact. **SU**

ISBN 955-1115-00-7

Published by:
Zero3 Images
Vision House, 6th Floor,
52 Galle Road,
Colombo 4, Sri Lanka.
www.zero3images.com

1st Publication November 2004
2nd Publication February 2005

© All rights reserved. No portion of this book can be reproduced or utilized in any form or by any electronic, mechanical or other means without the prior written permission of the publisher.

Designed by Nelun Harasgama Nadaraja

Digital Artwork by Spot Digital Graphics

Printed by Gunaratne Offset Ltd.

GR	Gehan Rajapakse
NK	Namal Kamalgoda
PA	Palitha Antony
SU	Sarinda Unamboowe

None of the images in this book have been digitally or otherwise, altered or modified.

Cover:

Grey Partridge. Nawadankulama

The early morning tranquility at Nawadankulama was punctuated by the incessant calling of Grey Partridge, but the birds remained elusive. Sunlight was just breaking over the tree tops and an Indian Roller perched on a high branch presented a lovely photo opportunity. As we headed towards a clump of bushes close to the Indian Roller, we were overjoyed to see Grey Partridge preening themselves and calling loudly. **GR**

Frontispiece:

White Ibis. Kumana

On a low lit afternoon at Thunmulla in Kumana, I stopped to observe water birds. As I had anticipated the feeding Ibis flew off giving me the effect I wanted. **PA**

Back Page:

Road to Haputale

On my way to Haputale I needed to stretch my legs. Sensing a photo opportunity I parked at a convenient spot and waited for the sun to set. Forty five minutes later I was rewarded with the most pleasing play of light. **NK**

Endpaper:

Grass at Mana Wila. Wilpattu

I was on my first trip to Wilpattu. The park had just been reopened and as expected, we had not seen much. Despite this, the beauty of the park fascinated me. The setting around the villus was stunning, leaving me envious of the generation that had enjoyed Wilpattu at its best. **NK**

Back Cover:

Leopard. Yala

It was an overcast day and we were returning after a midday trip for fuel. We came across this leopard seated on a rock at eye level a dozen feet from the road. I have never been more relieved to have all my equipment with me and made full use of this great opportunity. **SU**

Encounters

A journey through the wild

Gehan Rajapakse . Namal Kamalgoda . Palitha Antony . Sarinda Unamboowe

Published by Zero3 Images

Foreword

A talented quartet of keen and enthusiastic photographers has combined their skills to produce a superb collection of nature photographs within the covers of one spectacular volume.

These four young men have undoubtedly exploited to the full, the latest photograph technology now available – of course at a price! The range of styles of all four are rather similar but their combined effort is an evocative tribute to our wildlife. They have accurately represented the wealth of colours used so lavishly in nature's palette.

This book is a delight to thumb through and will undoubtedly be enjoyed by anyone who values the green and unspoiled corners of our little island. Further, the images in the book, 170 in all, speak eloquently of the biological diversity in our country.

I know the photographers personally and have often seen and admired their work. Our confrontations are of course limited to those occasions when we run into each other at our favourite wildlife haunts. I must of course make special mention of Gehan Rajapakse whom I have known since childhood. Quite often while still a kid, he used to be found along with my two sons, perched on the baggage heaped up at the rear of my jeep – like stowaways. In those good old days, we used to be in

and out of Yala, Wilpattu, Kumana, Mannar and all those lagoons around Hambantota. I hope those early beginings made an impression on him and inspired him to take up wildlife photography.

The images in this book are of very high quality and some of them (especially among the birds) have never been photographed before. In nature not all is giant in scale, so I was very pleased to find that the photographers have paid special attention to the smaller fry like lizards, insects and butterflies, and even included a sprinkling of our flora. There are some stunning images in the book, but my own favourites are Gehan Rajapakse's juvenile Black-winged Kite, Painted Stork and baby Crocodile, and small elephant herd quenching its thirst at a fast drying waterhole. Palitha Antony's Angled Pierrot is a beauty; also his Centipede and the Iora at the nest. The bachelor of Borupan and the mating tree nymphs have been well taken by Namal Kamalgoda. Among Sarinda's contribution I was impressed by the Little Tern feeding the chick, the Sanderlings and the Hoopoe in flight.

I have no doubt that **"Encounters"** *A journey through the wild* will find a prominent place in the library of every outdoor enthusiast.

Dr. T. S. U. de Zylva

Introduction

Although not a member of the team of photographers collaborating on this project, as a fellow wildlife photographer I am pleased to have been invited to write an introduction to this book. I am only too familiar with the joys and frustrations of their chosen hobby and know each of them and their photography individually.

Contained within the covers of this book is more than a collection of wildlife photographs. It is in fact a fair representation of the rich and varied bio-diversity of our island home. None of these four individuals is a professional wildlife photographer nor have they the time to pursue photography as a full time or even part time occupation. Common to all of them however, is a driving passion to spend most of their limited free time in wilderness areas, immersed in their chosen hobby. Through this book they have chosen to share the results of their efforts with a wider public.

Among this collection of photos you will see distinct styles and favourite subjects. Wildlife photography requires patience, effort and timing. All photographs are an unique moment frozen in time. Some wildlife photos capture action too quick for the human eye to see. Wildlife photographers make their own luck by being out there when something unusual happens. In the absence of creative control over your animal subjects, the act of translating what you observe into a good photograph, takes mental and physical preparation, knowledge and skill.

The thoughts and comments of the photographers that accompany each photograph convey their enthusiasm and give a sense of immediacy to many of the photographs, making them interesting to read.

This book is a result of thousands of kilometers of collective travel through the remaining wilderness areas of Sri Lanka and hundreds of hours of observing wild animals in their natural habitat. Photographs taken in both protected and unprotected areas are included. Especially poignant are the many excellent photos of waders and other birds from Mannar and the north-west of the island; areas that were, for too many years, part of a war zone. Ironically because of that same tragic conflict, many birds may have been spared hostile human interest in them.

Photographs record, educate, inspire and entertain. While serving all these functions, wildlife photography can be an important means of promoting the conservation of species and their natural habitats.

Sri Lanka is a bio-diversity hotspot of global significance, especially in regard to its avian, amphibian, reptilian and insect diversity. Extra-ordinarily for an island of modest size, Sri Lanka, can also boast of several spectacular large mammals, among them Elephants, Leopards, and Bears.

The challenge for Sri Lankans in the 21st century is to protect this island's amazing bio-diversity, side by side with carefully planned economic development. Indeed, Sri Lanka's bio-diversity has to be recognized as one of its key natural resources. As a species whose very existence has an adverse impact on all other species, we humans now have a serious responsibility to conserve other species that share our planet. By increasing awareness and appreciation of nature, books such as this will contribute towards achieving that difficult objective.

Rukshan Jayewardene

Tree Bark. Yala PA

Acknowledgements

We would like to thank a number of people without whose help this "journey" would never have been possible.

Nelun for her excellent book design and commitment to our cause from the very first meeting. Shehan for taking on the roll of 'Project Manager' and for the tough job printing the final product and guiding us every step of the way. Prem for his patience and skill in laying out the pages. Your combined enthusiasm and support helped us overcome the many occasions when we felt a little out of control. Rukshan and Dr. T. S. U. de Zylva for the introduction and foreword respectively - you have no idea how much this means to us.

Sarath Perera and Jagath of Sarath Perera Photography for processing every single shot taken and patiently meeting our demands of 'can I have it by evening'.

Asoka Jayatilake and Chaminda of Chithral Colour for handling our never-ending and always urgent requests for prints. Kithsiri for helping with identification, Tara, Romi and Ruri for editing the text.

Wasantha Pushpananda the Warden of Wilpattu, for his dedication, commitment and drive to reclaim a lost paradise. The staff members of the DWC who are out in the field, for their dedication to protecting our wild places. Brigadier Sarath Fernando, Commanding Officer Mannar and the army officers who have accommodated our numerous requests to photograph birds in close proximity to the Talladi camp.

We hope you enjoy this journey with us.

Gehan

I would like to thank my mother for so admirably guiding the family through some tough times and never depriving me of an opportunity to visit the jungles from a very young age. My sisters and brothers-in-law Asitha and Niranjan for the wonderful support and encouragement extended to an important venture such as this. Nihal mama and Upen mama for holding my hand and guiding me through the first few steps on this journey and taking the time to teach me the ways of the jungle. Harshi for being there for me, for the love, affection and wonderful company and Thiranya and Ashwini for the constant enthusiasm shown by a standard query "Did you get any great pictures". Thanks Namal for always volunteering to look for camera specifications and bringing for me the first set of equipment and yours and Jackie's company on so many of the early trips when we spent many nights camping in the jungle. Sari and Palitha for joining in and making this journey so enjoyable and for the many nights spent under the stars listening to the silence. I would like to thank Mr. Chandra Jayaratne my CEO for his quiet encouragement, often inquiring on the success of our trips and for fostering and showing the way of leading a balanced life.

Namal

I would like to thank my mother who instilled in me, the love for wildlife from an early age and my father who, despite an allergy to dust, took us far and wide in search of wildlife. Jackie, initially a reluctant fan, is now my biggest. Jackie is also my able assistant who has handled my demands for lens, cameras, film and converters. She has been by my side for almost all my photographs. Lal, Rukshan, Ravi, Deepal, Kithsiri, US, Amila, Lester, Sarath, Gehan DS and the late Roshan for allowing me to hang out with them and the opportunity to learn from them. To Wasantha Pushpananda for reopening Wilpattu. To the likes of the late Kumarasinghe, who are at the forefront of the battle we cannot afford to lose. Dr. T. S. U. de Zylva for agreeing to write the foreword; your work has been a source of inspiration. Sari for carrying my equipment half way across the world. Gehan, Palitha and Sari for tolerating me and taking this wonderful journey with me. A man will be remembered not by his wealth or his title but by the quality of his friends. Finally to God for his wonderful creations which man seems determined to destroy.

Palitha

I would like to thank the following individuals for their support and guidance. Dr. Ravi Samarasinha for all his expert advice on wildlife photography, providing me with excellent information on the various subjects and accompanying me on most of my jungle trips. Ranjith Sisirakumara of Yala and the late Nihal Premasiri for being such great hosts and guides on my numerous trips to Yala. Kithsiri Gunawardena for introducing me to the world of reptiles and locating them for me to photograph with a sense of safety. Udaya Sirivardana of the Ceylon Bird Club for his valuable information on various birding locations, especially finding the Three-toed Kingfisher at Gilimale. Bird guide Sunil of Sinharaja for locating for me the Spurfowl nest and the Black-naped Monarch. Bird guide Thandula Jayaratne and Martin Wijesinghe for the accommodation and information on fauna and flora of Sinharaja. Special thanks to Lt. Colonel Jagath Pakshaweera of Mannar for arranging for us to freely travel and photograph in Mannar. Jeewaka Maddumage of Kumana for his constant updates of happenings in Kumana and Siasinghe for locating the crossed-tusker in Kumana and Mendis Wickremasinghe of IUCN, the reptile man with whom I had the confidence to get close to snakes. I would like to thank my beloved wife Kumari and the kids for tolerating all my jungle trips and days of absence from home and my brother Merril for most of the driving done in the early years of my photography.

Sarinda

I would like to thank my parents for the opportunities and buying me my first camera… my sister, for the unquestioning support and putting up with the madness for so long. Uncle Nihal, Aunty Dodo, Anu and Yohan, thank you for the second home. It's all the time spent in your company, and being a part of those memorable 'jungle' trips that started it all. Rukshan, thank you for your friendship, through good times and bad, and for all the encouragement and advice. To my dear friend, travelling companion, mentor and critique, Ravi… you have no idea how much I value your support. Thank you my fellow travellers… Gehan, Namal, Palitha, you have kept me on the path… even when I faltered. I look forward to the journey ahead. To my wonderful wife Ashani, it was you who re-ignited the fire. Thank you for the patience, the sharing, the encouragement, the support, your company… and above all for your love. And my two boys, Sharya and Sachin, my friends, my heroes; you make the sun shine a little brighter every day.

Heuglin's Gull. Talaimannar Beach

The fishing wadiya on the Talaimannar beach is a good place to watch gulls. Sarinda and I got to the beach early and made use of the soft morning light to take some pictures of the gulls as they flew in expectantly when the fishing nets were drawn in. **GR**

Leopard. Yala

An uneventful trip was drawing to an end. The Heenwewa cubs had remained elusive during our stay and when our guide suggested we try again, we were skeptical. Rounding a corner, we saw a vehicle that signaled us to approach quietly. The cubs were out in the open playing and we spent the whole morning with them. The spirit of the cubs seemed to have a dramatic influence on the dispirited inmates of the vehicle who on the journey back were as animated as the leopard cubs. **GR**

Leopard. Yala

An action filled morning spent with the Heenwewa cubs was drawing to a close. They walked into the reeds close to a nearby pool, disappearing from our view. A sudden alarm call from a peacock indicated that the mother maybe nearby and one cub sat back on its hind legs and peered in the direction from which the peacock was calling. **GR**

Grey Partridge. Nawadankulama

To see a Grey Partridge bathed in the morning light, feeding leisurely out in the open and not hurrying for cover is a great piece of luck. Not wishing to disturb such a tranquil scene, I stopped the vehicle at a fair distance and waited patiently for the bird to approach me. My viewfinder was illuminated by a fiery red hue as sunlight reflected off the reddish brown colors of this bird. **GR**

Openbill Stork. Yala

During a late evening drive back to the New Buttuwa bungalow, this Openbill was resting on a dead branch near Karawgaswala. The shutter released so slowly that it gave the bird sufficient time to change its position giving me a fascinating picture. **GR**

Black-winged Kite. Nawadankulama

Driving along the dried tank bed at Nawadankulama, we came upon a family of Black-winged Kites roosting on a dead tree. Often they would take flight and hover in mid air, waiting to strike at some unsuspecting prey. This juvenile bird perched momentarily on a bush swaying in a strong wind, allowing me an opportunity to take this picture at eye level, highlighting the cobwebs on the tree as well. **GR**

Gulls. Talaimannar

The morning hours bring the beach at Talaimannar to life as lots of gulls congregate here. The wet sand, gently breaking waves and the blue-green sea are a perfect setting for some quiet photography. **GR**

Gulls. Talaimannar

Mannar during the season, is a birder's paradise. The Talaimannar beach with its Fishing Wadiya, attracts large concentrations of gulls, terns and many shorebirds. Mornings are a hive of activity as the fishing nets are pulled in and the catch auctioned. The otherwise docile gulls go into a frenzy, skimming the gently breaking waves as they feed on the small fish that escape the nets. **GR**

Hoopoe. Yala

I was on a mission to photograph a Hoopoe with its crest open to satisfy the desire of a close friend. On a morning drive towards Karawgaswala from the Buttuwa plains, luck came my way with this sighting of a Hoopoe with its crest open, set against a dark background that highlights the colours of the bird. **GR**

Ceylon Lorikeet. Namunukula

Sarinda, Namal and I, together with our families, were on holiday in Namunukula hoping to spend a few quiet days reviewing the pictures we had taken during the year and doing a preliminary selection for this book. We were so glad we had brought our camera equipment along, as the garden of the bungalow was full of Layard's Parakeet, Ceylon Lorikeet, barbets, minivets and many other species of birds. We observed that some lorikeets kept returning to a particular tree where the unusual light play offered us some excellent photo opportunities. **GR**

Great Black-headed Gull. Mannar

Reports of a sighting of Crab Plover took Palitha and me in haste to Mannar. Dejected by the absence of Crab Plovers near the causeway, we proceeded to Kora Kulam and were treated to a sighting of hundreds of gulls feeding in the shallow water. Over a period of two hours, we inched our way closer to them and were rewarded with some close ups in the soft evening light. **GR**

Caspian Tern. Talaimannar

Palitha and I came across a large gathering of terns on the beach, as they rested in the morning sun. We were able to get close to the birds and had hours of pleasure photographing them. **GR**

Buffalo. Yala

As the dry season takes hold, one gets used to seeing Buffalo wallowing in drying puddles of water. The wet season transforms the park into a lush green forest and a time of plenty for all. It was the height of the wet season and driving past the waterhole at the junction of Gonalabba Meda Para and Akasachetiya, I saw this buffalo bathed in vegetation. **GR**

Lesser Black-headed Gull. Talaimannar

When fishing nets are drawn in during the morning hours, the beach is engulfed in a hive of activity as many hundreds of gulls land on the water's edge waiting to pick up fish discarded from the nets. The gently breaking waves make a great backdrop to watch and photograph this activity. **GR**

Leopard. Yala

The morning at Kotabendi Wewa was quiet with no signs of leopard. Having spent an hour listening for some jungle sign of their presence, we decided to head back to Pathanangala. At the Talgasmankada Meda Para junction, a jeep driver informed us that some deer had called towards the start of the open area but that he had seen nothing. Promising to keep an eye out, we proceeded for around 200 yards and saw one of the cubs on this tree. Three hours later it descended and disappeared into the forest. **GR**

Leopard Cub. Yala

Namal and I were taking an early morning drive from Heenwewa towards Gonagala, when we passed a small leopard seated at the edge of the forest waiting to cross the road. We stopped the vehicle, reversed and watched the cub for a few minutes before it disappeared into the thicket. We drove back towards Heenwewa and returned slowly. Around the corner saw to our great delight, the cub seated comfortably on the road. **GR**

Leopard. Yala

The Kotabendi Wewa cubs were on the move again and we came across a couple of vehicles parked, awaiting their arrival. A few seconds later many animated hands were pointing to the right of our vehicle where I saw some movement. The male cub unconcerned as usual strode through the Thora plants and crossed the road. **GR**

Painted Stork and Baby Crocodile. Yala

Driving through the Buttuwa plains, I saw this Painted Stork feeding and drove past it until the guide clutched my hand. Looking back I saw this amazing sight of nature's roles reversed as the stork hurriedly gulped down a baby crocodile and picked out another. With sweaty hands I took two pictures before a Brahminy Kite mobbed the stork and spoilt the show.
GR

Rays of Sunshine. Wilpattu

The morning air in Wilpattu is refreshing. To drive through the white sands of Mahapatessa is an exhilarating experience. A right turn towards Demata Wila and the road winds itself through some patches of heavily wooded forest. Here I came upon this lovely sight of the morning sun breaking through the tree canopy. **GR**

Grey Langur. Bundala

Namal, Sarinda and I were on a leisurely visit when we came across a family of Langur quenching their thirst. This individual was seated close to us and its expression was so laid back that I had to take a picture. **GR**

Turnstone. Talaimannar

The beach is a great place to photograph shorebirds as the sea provides an excellent backdrop. Sarinda, and I were on the beach looking for suitable subjects and the next moment he was belly crawling on the wet sand towards some Sanderlings. I followed and made my way towards this Turnstone as ground level shots of these small birds are always spectacular.
GR

Sanderling. Talaimannar

Any attempt to approach these little birds resulted in high levels of frustration as they continuously took wing. To remain stationary and wait for them to approach was the best strategy. A group of four scurried around the beach and fifteen minutes later, a single bird filled my frame. **GR**

Garganey. Wilpattu

We were parked in the shadows, silently waiting for a leopard to come for water at Mana Wila. The long evening shadows cast a deep hue on the scene as the few remaining ducks stayed perfectly still. **GR**

Terek Sandpiper. Talaimannar

A hint of excitement in Palitha's voice told me that he had seen something unusual. As I joined him on the beach, he pointed in the direction of a few Terek Sandpipers busily feeding amongst a gathering of Turnstones and Sanderlings. We spent the morning hidden amongst the boats taking pictures. **GR**

Grey Plover. Talaimannar

Early morning sunlight cast a golden hue on the tide swept beach. I was lying on the ground watching the many waders busily feeding at the water's edge and saw this plover making a hurried run towards me. **GR**

Pintail. Mannar

The Vankalai water body was covered with thousands of Pintail, Garganey and Wigeon in full breeding plumage, when Palitha and I made our way towards them for an evening of photography. Resting on the edge of the mudflats, the birds were very tolerant of our presence and offered some great photo opportunities. **GR**

Elephants. Yala

It was late evening and we were hurrying back to the Pathanangala bungalow, when we came across this family of elephants quenching their thirst. **GR**

Grey Partridge. Nawadankulama

On one of many visits to Nawadankulama, I came across a covey of Grey Partridge out in the open. A low level picture set the birds against a blue sky background. **GR**

Sunset. Talaimannar

The flurry of activity as the many hundreds of gulls perched on the beach take flight and dot the evening sky, makes this beautiful scene. The fire-red of the evening sky and the blurred wings of the birds in flight tempted me to use my camera. **GR**

Cattle Egret. Mannar

The paddy in Mannar had been planted and the open fields were awash with shades of green. The clean white egrets with their yellow beaks contrasted beautifully with the deep green background. **GR**

Rainbow Reflection. Wilpattu

Dark rain clouds were gathering over the skies as we made a quick visit to Mana Wila, seeking a leopard seated out in the open white sand. With no leopard in sight, we were just about to leave when I saw the rainbow in the sky. I drove round the Wila till I saw its reflection in the water and managed to frame a Wood Sandpiper as well. **GR**

Crab Plover. Talaimannar

We journeyed to Mannar with great expectation, as there had been a sighting of Crab Plover, a bird I had never seen, near the causeway. Many drives along the causeway at different times of the tide drew a blank. Upon returning to our lodge a friend casually mentioned that he had seen four Crab Plovers at the Talaimannar mud flats. The next morning I drove there with a sense of anxiety and was overjoyed to see the birds feeding on the edge of the mud flats. A single bird flew in and started feeding hurriedly at a pool of water against the backdrop of a turquoise blue ocean. **GR**

Grey Partridge. Nawadankulama

The early morning tranquility at Nawadankulama was punctuated by the incessant calling of Grey Partridge, but the birds remained elusive. Sunlight was just breaking over the tree tops and an Indian Roller perched on a high branch presented a lovely photo opportunity. As we headed towards a clump of bushes close to the Indian Roller, we were overjoyed to see Grey Partridge preening themselves and calling loudly. **GR**

Ceylon Junglefowl. Yala

The call of the junglefowl is unmistakable. A busy and shy bird who more often than not walks into the thick bush when approached, poses a challenge to any photographer. An early morning drive with Namal brought us upon three beautiful male birds foraging near Meynert Wewa. The morning sunlight and the green background were the perfect touch. **GR**

Indian Plaintive Cuckoo. Yala

A midday drive to the waterholes brought us to Rukwila. My guide spotted a pair of Plaintive Cuckoos hopping around the branches of a dead tree. The green vegetation at full aperture set a lovely background for the picture. **GR**

Spot-billed Ducks. Mannar

The water body opposite the Talladi army camp has been a favourite place to see this beautiful duck. We had heard that the birds had nested and were keen to see the little chicks. We spent some time watching this family swimming through the reeds and foraging for food. **GR**

Northern Shoveller. Mannar

A severe drought resulted in many of the migrant birds moving out of their locations much earlier than usual. A visit to Vankalai in Mannar was disappointing. Moving on, we approached the water body near the Talladi army camp and were excited to see a Shoveller swimming in the shallow water close to the road. **GR**

Egret. Mannar

Sunset in Mannar is always spectacular. To watch the sunset from the causeway with many waders busily feeding into the late evening, allows great opportunity for use of colour and light variation. I positioned my vehicle to silhouette a lone egret against a shaft of golden light.**GR**

Little Egret. Vankalai

On an evening drive to Vankalai, the sun was low in the sky and cast a beautiful light on the shorebirds feeding at the water's edge. This Little Egret was busily pursuing the numerous fish in the shallow waters. **GR**

Striated Weaver. Wasgamuwa

The long drive over a weekend was worth the effort just to photograph the beautiful colours of this little bird with a yellow head. We watched a large colony of these busy little birds weaving their nests, amidst a great degree of chatter. **GR**

Collared Scops Owl. Bundala

I was making plans to visit Yala when a close friend told me of the roosting spot of these little owls. I was lucky to see the whole family at the roost with the inquisitive youngsters determined to peep over the others to watch this stranger, a camera and tripod. **GR**

Leopard. Wilpattu

In March of 2003 the unimaginable happened; Wilpattu National Park was reopened. I ventured into Wilpattu to test some new equipment. This battle scarred male gave me the perfect opportunity to christen the new camera and lens. Gehan calls him the "Bachelor of Borupan". This leopard was first photographed at Borupan Wila, but has been seen at Kumbuk Wila, Welikanda and at Mahapatessa. **NK**

Snails. Bodhinagala

Sri Lanka is home to many species of endemic snails. This *Acavus superbus* was photographed at the Forest Hermitage. At one time this was one of the best places to see Green-billed Coucal. The bird has eluded me, but the location fascinates me. **NK**

Blue Mist. Yala

The dry zone forests of Sri Lanka are amazing places. In the midst of a parched environment, bloom such wonders as the Blue Mist. This particular plant was photographed at the Heenwewa bungalow. **NK**

Lunu Warana. Yala

A gem that blooms in the dry zone forest is the Lunu Warana flower. In their pursuit of big game, most visitors have no time for these that constantly surprise us and make our jungles a special place to be in. **NK**

Glory Lily. Uda Walawe

"Gloriosa Superba" or "Niangala" as its locally known, is a very beautiful plant that is commonly found in the jungles of Sri Lanka. Despite its beauty and wonderful name, it is treated with much respect and fear as it is poisonous. **NK**

Crested Hawk-Eagle. Yala

Diganwala was where I found this handsome specimen. It had just finished a bath and was preening itself on a tree. The proximity and the light were simply begging for a photograph. I was happy to oblige and was even happier when I saw the result. **NK**

Indian Pond Heron. Attidiya

The Indian Pond Heron is one of the most common and overlooked birds in Sri Lanka. Because of this, it tends to be very tolerant of humans.**NK**

Little Green Heron. Mannar

This beautiful but elusive bird is a very difficult subject to photograph. However, this particular individual is a 'regular' at the causeway. Accustomed to the movement of vehicles, it approaches to within touching distance. Soon after the cessation of hostilities I was in Mannar as part of the Ceylon Bird Club annual water bird census. Since, Mannar has been a happy hunting ground for Gehan, Palitha Sarinda and I, and we hope it will continue to be so. **NK**

Leopard. Yala

We followed this leopard from the Gonalabba Meda Para junction to Diganwala. For half an hour it played hide and seek with us and was constantly stopping to make its characteristic sawing noise. The movement of the leopard was also notified to us by the alarm calls of the other creatures of the jungle. At the end, this wily leopard gave me only one opportunity to take a photograph. **NK**

Leopard. Yala

On a Monday morning we received a call from Ravi who was in the park, to tell us of a sighting of three leopard at a kill. Since there was a lull at work, Jackie, Gehan and I drove into the night. Sure enough, the leopard were there. We spent the whole day with them. Thirst finally brought out one of the cubs to drink from a pool of water by the road. We were very tired but it was a totally satisfying 24-hour trip to Yala. **NK**

Leopard. Wilpattu

Only Wilpattu National Park can give you the opportunity to see leopard on white sand. Ever since I saw Dr. T. S. U. de Zylva's photograph of a leopard on the white sand of Welikanda in his book "Jungle Profiles", I have wanted to emulate it. But I will need many more photo opportunities before I can even match the great photographer. **NK**

Leopard. Yala

For most of 2003 and part of 2004, Kotabendi Wewa was the happening place for leopard. After nearly an hour's wait, listening to the alarm calls of deer, this sub adult male broke cover to cross the road. This was the only photograph I was able to take as he came too close to my camera and passed in front of Gehan's double cab. **NK**

Crested Serpent Eagle. Yala

This adult bird was seated on a low branch by the side of the Talgasmankada Road. It was so focused on its intended prey, that it ignored my slow approach. We never did find out it's intended victim - maybe it was simply enjoying the last rays of sunlight for the day. **NK**

Forest Eagle Owl. Anamaduwa

This is the dreaded "Ulama" the source of the frightening screams that are supposed to be the fore bearer of death. This particular juvenile owl had been raised by a village family whose simple house borders the forest. The owl has never been kept in a cage and was always free to come and go as it chose. When I saw the owl, it was already making kills and was very independent. I returned about two months later to see the adult plumage only to be informed it had flown away. **NK**

Adam's Peak. Maskeliya

I was at Mocha Estate in Maskeliya to relax with my friends. This was meant to be a real holiday where we could catch up on our sleep. Luckily I had my camera in hand as the sun set and the unmistakable profile of Adam's Peak stood out. A scene too good to ignore. **NK**

Indian Pipit. Horton Plains

Horton Plains is one of the most important watersheds in Sri Lanka. Its importance to Sri Lanka is immeasurable both from a bio-diversity and water management point of view. Cold wet and misty it is not always ideal for a nature photographer. Despite this, I'm drawn to this misty location in search of nature's bounty. **NK**

The Sentinel. Yala

This lone Grey Langur monkey was seated on a rock watching the darkness approach. I was fascinated by it's almost philosophical pose. Within seconds of this photograph, the rest of the troop climbed up and the serenity of the image was lost. **NK**

Ceylon Frogmouth. Sinharaja

A few friends wanted to start the year on a quiet note and we found ourselves at Martin's Lodge. We had been watching a butterfly when Rukshan spotted this nesting frogmouth. Nocturnal habits and excellent camouflage make this a rarely seen bird. Nests are even rarer. Despite the tag "Ceylon" this is not an endemic bird and is also found in South India. **NK**

Black-tailed Godwit. Wilpattu

Dressed up in its finest breeding plumage, this winter visitor was biding its time to return to it's breeding grounds. We in Sri Lanka rarely get to see the waders in their breeding plumage. This bird was photographed in late April and must have been one of the last to leave our shores. **NK**

White Ibis. Yala

The White Ibis is a common bird in Sri Lanka and often found in paddy fields. Koma Wewa was no exception. This Ibis seemed to have had a busy day and was just about to start preening itself. **NK**

Black-winged Stilts. Yala

Returning from my last round at the Palatupana Salterns, I happened to notice some unusual behaviour between two stilts. I barely had time to get the lens ready to capture this intimate moment. The ritual of courtship before and after mating was very tender. I felt privileged to have observed them. **NK**

Spotted Deer. Yala

For part of 1996 Yala was an unofficial "no go" zone. During that time those foolhardy enough, found the park to themselves. On the last day of our visit, Jackie, Gehan and I did one last round of the waterholes. At Siyambalagaswala, we witnessed this battle. In their eagerness for supremacy, they were oblivious to our presence. **NK**

Spotted Deer. Yala

The Park in the dry season is a wildlife photographer's dream. Driven by the desire to quench their thirst, these weary animals permitted close approach. **NK**

Peahen. Yala

In comparison with the extravagantly dressed male, the peahen is drab, but on its own, is a wonderfully pretty bird. Early morning near Vepandeniya, I came across this late riser perched on a tree, where it had sought refuge the night before. **NK**

Indian Roller. Minneriya

The open grasslands that are seasonally formed are an ideal location to view these colourful characters. Famous for it's elephants, I have also found that this is an excellent place for bird watching. The Indian Roller is also called "smoke inhaler" by villagers for its reputation of darting in and out of wild fires, picking up fleeing insects. **NK**

Ceylon Tree Nymphs. Sinharaja

The Tree Nymph is one of the most beautiful and graceful butterflies in Sri Lanka. I saw this pair attempting to mate. Desperate to make the most out of the low light conditions, I had to deliberately use a slow shutter speed to capture the effect. **NK**

Painted Storks. Minneriya

Minneriya is probably one of the best places to see the Asian Elephant. During the dry months this man made tank is a Mecca for elephants. It is also a time of plenty for the fish eating birds, as the fish are trapped in shallow and shrinking pools of water. The concentration of birds can number many hundreds and include many species. **NK**

Grass in the early morning. Yala

I had just started my morning round, when Jackie brought to my notice the play of early morning light on the grass. The colour of the grass highlighted with golden morning rays, combined to give me this pleasing picture. **NK**

Water Buffalo. Yala

Truly wild specimens of Water Buffalo are rare in Sri Lanka. I came across a herd wallowing in an algae covered mud hole. Hearing my vehicle, the herd snorted alarm calls and immediately challenged my presence. Once the females and the young had stampeded in retreat, the males followed. This proud and magnificent individual challenged my vehicle. **NK**

Elephants. Yala

Like Oliver Twist, this baby elephant always wanted more. It went to every member of it's herd looking for milk. Strangely enough, this was not it's mother but probably an elder sister. Subsequently to pacify the baby, the elder sister gave it the tip of her trunk to suckle on. **NK**

Pintail Snipe. Yala

To me all snipe look the same. Despite many years of serious birding, I still need to run to an expert to confirm identification. This particular winter visitor was on the side of the road just below the Vepandeniya rocks. I was parked and waiting for a possible leopard crossing, when I spotted this snipe. **NK**

Adam's Bridge. Mannar

I was among the first birders to visit Mannar as part of the annual CBC waterfowl census team. The next year I was back in Mannar with better information on where the birds were. These birds were roosting on an adjacent island. This flock comprised mainly of Greater Black-headed Gulls, Heuglin's Gulls and Caspian Terns. **NK**

Stork-billed Kingfisher. Talangama

On the rare occasion that I am in Colombo on a weekend, I make my way to Talangama to try my luck. It was an overcast day and I had given up and was about to head home when Jackie spotted this unusually tolerant kingfisher. I was able to photograph it for over half an hour. In the low light this was the best of over 20 shots. Despite many subsequent visits I have been unable to find my obliging friend again. **NK**

Leaf Litter. Morapitiya

I was in the Forest Reserve to observe birds but heavy rains had driven them all away. I was attracted by the colours of these leaves in various stages of decay. **NK**

An Elephant's Tale

This is the first tail full of hair I have seen on an elephant. Supposed to bring luck to the wearer, I am yet to see it bring luck to the elephant that owns it. In many parts of Sri Lanka, the "unlucky" owners of the hair are making their last stand against a never-ending wave of humanity. **NK**

Road to Horton Plains. Ohiya

On my way to Horton Plains I felt compelled to stop as I had been on the look out for a photo opportunity such as this. This was just before the climb to Ohiya. **NK**

Tender Leaves. Sinharaja

It is said that the majority of trees in the Sinharaja are endemic. Most species of endemic birds are also to be found here. Numerous endemic lizards, snakes and unidentified frogs make this their home. Wet weather, low light and leeches make this a photographer's nightmare, but one does the best one can. **NK**

Leopard. Wilpattu

As we approached Ilandai Motai, pugmarks told us a leopard was around. On our third pass we finally spotted this young male. This meant a four hour test of patience in the hot sun. He found himself a nice cool shady spot and went to sleep, leaving us roasting in the sun. We suspected he was hungry and was waiting in ambush. A Barking Deer approached, and the leopard began to stalk. Unfortunately at this time, an eager visitor moved his vehicle to get a better view and startled the deer, which fled for its life. **NK**

Crossed-Tusker. Yala

We were excited by the news that a crossed tusker had been sighted and made our way towards Suduwelimulla. Fresh tracks and broken branches indicated that an elephant had passed by recently. Further down the road we came across this magnificent tusker which looked at us briefly before disappearing into the thick shrub. PA

Centipede. Wilpattu

This centipede was seen close to the Kokmotai bungalow. I grabbed my camera and macro to get this shot. When I looked through the lens, I was amazed by it's colour against the background. **PA**

Juvenile Black-winged Kite. Nawadankulama

Gehan and I were photographing these birds from our vehicle. As they often do, one started to hover right above us. I was in the driving seat and had to crouch to get this shot. **PA**

Hump Nose Lizard. Kuruwita

This lizard was spotted on the path to Batadombalena. The genus Lyriocephalus is endemic to our country and confined to the dense lowland forests. It is a slow moving lizard. **PA**

Kangaroo Lizard. Sinharaja

We located this male Otocryptis at Kudawa. This is another genus with only one species in Sri Lanka. Males have a large and colourful gular sac. When we located this specimen, it was about to display but the unpredictable weather conditions allowed me to take only this photograph. **PA**

Seba's Bronzeback. Morapitiya

This photograph of the snake's head was taken on a footpath in the forest reserve. The close-up was possible because this species is non-venomous. **PA**

Leopard. Wilpattu

A great photographic opportunity. I entered the park at 4 pm with Senanayake the guide and took the Menikrala Uraniya road. As we approached Kuruttupandi Villu, we saw this totally relaxed leopard yawning and rolling about in the sand at the edge of the villu. **PA**

Leopard. Wilpattu

On alert after spotting a Barking Deer drinking at the waterhole at Iriyakulama Pooval villu, this leopard used my vehicle as cover and stalked the Barking Deer but did not make a kill. We left the leopard hidden amongst the dry reeds at Iriyakulama Pooval. **PA**

Leopard. Wilpattu

This particular visit to the park was very productive as we found this leopard completely relaxed. Despite my close presence, it kept rolling over in a playful mood. **PA**

Leopard. Wilpattu

The leopard looked at us over his shoulder. This photograph was taken after the park reopened in May 2003 after being closed for nearly 17 years. **PA**

Flamingo. Bundala

This line of flamingos in flight was photographed at Bundala in the morning hours. During the migrant season, flamingos are often seen in Bundala but making a close approach is difficult as they are easily disturbed. Early mornings and late evenings are the best times to take pictures of these birds in flight. **PA**

Crossed Tusker. Yala East

This is one of the few remaining Crossed-tuskers in our country. I was informed by game rangers Siasinghe and Jeewaka, that it visits a particular waterhole during the evenings and I decided to give it a try. Shortly before sunset, this majestic animal turned up at the plains. The beautiful background and the evening light highlighted the glint in the eye of this magnificent tusker. **PA**

Southern Purple-faced Leaf Monkey. Sinharaja

These monkeys are confined to the low-country wet zone, from the south bank of the Kalu Ganga to Ranna. This photograph was taken at Kudawa. **PA**

Black-naped Monarch. Sinharaja

Bird guide Sunil of Sinharaja showed me the nest of this beautiful bird on the road that leads to the research station. We observed the birds' feeding habits and photographed them without causing any disturbance. Two days later Sunil informed me that the nest had been broken and removed. **PA**

Leopard. Wilpattu

The excellent eyes of our guide S. M. Senanayake spotted this leopard on the far side of the Manikkapola Uttu Wewa. Two hours later it came out into the open and walked along the road, so close to my vehicle, that focusing was difficult. **PA**

Tusker. Yala

I encountered this tusker close to Andunoruwa. Judging from it's expression I knew it would drink or cool itself with mud. I photographed the tusker late in the evening and later, as expected, it got to the waterhole but there was insufficient light for photography. **PA**

Black-naped Hare. Yala

Incessant deer calls suggested that Leopard were on the move at Talgasmankada. Whilst I was waiting for the leopard to show themselves, this hare emerged from a bush and stood on its hind legs. I managed to grab a few shots and within minutes the leopard emerged at that exact spot. **PA**

Three-toed Kingfisher. Kegalle

A close friend informed me that he had seen a Three-toed Kingfisher at Kegalle. A great degree of patience was rewarded when the bird alighted on a little tree close to me and I thankfully took the shots I had always wanted. **PA**

Brown-headed Gull. Talaimannar

Sarinda and I decided to get to the beach before sunrise and wait for the gulls to arrive. Around 6.45 am the gulls started to come in and soon the whole beach was full of these birds. This particular bird fascinated me by stretching it's head. **PA**

Eurasian Spoonbill. Yala

We were watching their feeding behaviour at Koma Wewa, and a hungry chick was performing a dance while feeding. **PA**

Indian Reef Heron. Chilaw

On our annual bird count for CBC we spotted an unusual bird. As I had not brought my camera with me, I visited the lagoon the next day and went out on a fishing boat. We saw the bird on the far side and got as close as the boat would allow. I then waded through waist deep water to get this photograph. **PA**

Northern Shoveller. Mannar

Gehan and I spent several hours watching these birds close to the Talladi Army camp. **PA**

Leopard. Yala

It was the first time I had seen three leopard together. As we got closer, the mother and female cub left the rock. This cub was bold enough to stay for nearly two hours, giving me a sharp look each time I clicked. **PA**

Jackal. Yala

On our arrival this jackal stood up, stretched, walked and dipped itself in the mud pool by the side of the road. **PA**

Indian Plaintive Cuckoo. Udawalawe

Ravi and I were staying at Sinnuggala and decided to forego the usual park round for this photo opportunity. **PA**

Yellow Damselfly. Yala

A midday rest on a Yala trip becomes impossible when one has a macro lens, which can be put to use on small subjects. While my friends retired for their afternoon rest at Heenwewa, I was looking for little insects to photograph when I came across this amorous pair of dragonflies. The excellent lighting and lush green background completed the picture for me. **PA**

Leopard. Yala

Ravi and I drove up and down the Kotabendi Wewa road and midway saw fresh pug marks on our tyre tracks. The cubs were playing by the side of the road and then crossed over. I angled the vehicle to get a better view, but the leopard were disturbed by the alarm calls of the langur and melted into the jungle. **PA**

Leopard. Yala

A morning drive invariably takes you towards Kotabendi Wewa to see if the cubs were out. On this occasion, the cubs were out playing and one looked straight at the camera as the bright morning light fell on it's face. The dry grass in the background gives an interesting feel to the photograph. **PA**

Juvenile Crested Hawk-Eagle. Yala
The morning light added a glint to it's eyes as this bird perched on a dead branch, calling loudly. **PA**

Spot-winged Thrush. Sinharaja
This ground dwelling endemic bird was photographed on a path to the research station at Kudawa. **PA**

Common Iora. Yala

A male Iora was preparing for nesting on a Ranawara bush close to the Mahaseelawa bungalow. I photographed this bird at eye level by resting my lens on the vehicle. **PA**

Terek Sandpiper. Talaimannar

The beach offers excellent wader watching opportunities. Here the birds come so close to you, that even focusing on them is difficult. This Terek Sandpiper was busy digging in the sand looking for food particles, when I captured him on film. **PA**

Grey-headed Fishing Eagle. Yala

Grey-headed Fishing Eagles are generally considered shy birds. This bird was photographed from my vehicle at Karawgaswala. **PA**

Red-wattled Lapwing. Kumana

Whilst driving past Siyabalagaswala in Kumana, I found this Red Wattled Lapwing feeding at the water's edge set against this unusual background of red algae. The play of light during midday turned the colour of the algae into a dark red. It looked as if the bird was standing in a pool of blood. **PA**

Elephants. Yala

Gonalabba Meda para is not only famous for its leopard sightings but also for elephants and other wildlife. The heavy traffic on this road means that even elephants must make a hasty crossing. **PA**

Elephants. Kaudulla

During the dry months of the year, Kaudulla is the ideal location to see large herds of elephant. On this day we saw more than 80 elephants gathering near the water's edge. They formed themselves into small clusters and charged into the water to cool off the heat and quench their thirst. **PA**

Unidentified Frog Species. Sinharaja

One of Sri Lanka's premier reptile experts, Mendis Wickremasinghe and I were out under the lush green canopy in Sinharaja when he spotted this frog. The striking shades of yellow warranted a photograph and I inched myself forward and took some pleasing photographs without disturbing it. **PA**

Spotted Deer. Yala

A herd of deer were running through open grassland. I had always wanted to take a picture of movement and considered this an excellent opportunity. Stopping my lens down at f/16 to get a slow shutter speed, I took several frames as the deer passed by. I was happy to see that my efforts had created a stream of motion. **PA**

Ceylon Spurfowl. Sinharaja

I was informed by Sunil, a bird guide at Sinharaja that there was a nest on the path to the Moulawella trail. The light was low and I had to use very slow shutter speeds to record this extremely rare find. **PA**

Cobra. Sinharaja

Cobras are commonly found in Sinharaja and throughout most of the country. However, finding one at daytime is difficult but my friend came to my rescue and found me this specimen. **PA**

Little Terns. Yala

I was watching this bird at Palatupana, as it kept leaving the nest and flying back at short intervals. I was surprised by the arrival of a second bird with a fish for the chick. I had spent three and a half hours lying prone in stagnant mud, but this is one of my most satisfying images. **SU**

Grey Partridge. Talaimannar

Palitha and I had spent the morning trying to photograph gulls on the beach. We were heading back when we came upon these two birds, totally absorbed in grooming each other. The last of the soft morning light, combined with the blissful expression of the birds gave the picture a 'romantic quality'. **SU**

Leopard. Wilpattu

We saw this Leopard from across Thimbiri Wila, crouched in the tree line, close to the tank. While we worked our way into position, it walked to the water, drank its fill and sat down to groom itself. The light was poor and fading fast, but as it decided to move into the jungle, the clouds lifted just enough to give me a couple of shots. **SU**

Grey Herons Mating. Yala

This sequence at Mahaseelawa Wewa captures the mating ritual of these elegant birds. **SU**

Crested Hawk-Eagle. Yala

Ashani and I were returning to the bungalow after a long day, when we saw this bird, contrasted against the deep shades of the setting sun on the Buttuwa Plains. **SU**

Brown Shrike. Yala

I was photographing this bird feeding on ants, when it suddenly stopped, as if surprised by my presence and gave me a careful inspection. Convinced I posed no threat, it returned to it's feeding. **SU**

Spotted Dove. Anawilundawa Wewa

I had taken many pictures of this common bird, but on this rainy morning I liked the angle the bird gave me. The clear morning light lit it's 'spots' and red eye. **SU**

Great Stone-Plover. Yala

I belly crawled for over a hundred meters and this bird made it all worthwhile when it gave me a series of wing stretches. The evening sun was low in the sky, lighting the bird up and softening the background colour. **SU**

Little Tern. Yala

While photographing terns at their nest at Palatupana, this bird surprised me by landing a few feet in front of me. The birds had got comfortable with my prone form, and I was able to be in close proximity without disturbing their natural behaviour. **SU**

Common Redshank. Talaimannar

I was on the beach photographing gulls when this bird walked into my frame. I liked the effect the wind created, by blowing the top layer of sand and the contrast made by the blue of the sea. This bird is particularly elegant as it is streaked in its breeding plumage. **SU**

Lesser Sand Plover. Talaimannar

I was lying on the beach, when this plover got so comfortable with my presence that it almost stepped into my lens. I flapped my hands to keep it at bay till I captured this image. **SU**

Rufous-winged Bushlark. Wilpattu

This bushlark seemed unperturbed by my presence at Thimbiriwila and continued its high pitched call. Wilpattu has a healthy population of these active birds, and you can regularly see them making a sharp climbing flight and then 'parachuting' to the ground. SU

Leopard. Yala

We were following this leopard along the Talgasmankada road when it entered the jungle. When we pulled up alongside, I saw it entering a well lit clearing framed by the thick leaves. I took this image not expecting this unusual expression. **SU**

Purple Coot, Nawadankulama

I had never quite realized just how big a Purple Coot's feet were. The early morning light gave the picture a nice hue, and put a catch light in the eye of the bird. I was particularly pleased to catch the water droplets flying off it's toe. **SU**

Little Cormorant. Talangama

This attractive bird, appears to be getting off to a slow start as it warmed itself in the morning sun. **SU**

Spot-billed Pelican. Diyawanna Oya

Ashani insisted that I take this image on a chilly morning in Colombo. Having reluctantly done so, I now admit that the posture of the bird and the stillness of the water makes this a handsome portrait. **SU**

Juvenile Heuglin's Gull. Talaimannar

This is a great location to photograph a variety of gulls and waders. The presence of the fishing boats provide cover allowing close proximity and interesting angles. **SU**

Large Egret. Wilpattu

This bird was fishing in the Kanjuran Villu when it was disturbed by an approaching vehicle. **SU**

Female Pied Bush Chat. Horton Plains

The temperature at 6.00 a.m. was zero degrees Celsius. The frost on the leaves and the posture of the bird fluffed up against the cold, tells the story.
SU

Blue-tailed Bee-eater. Yala

This bird's striking colours against the green background drew me to capture this image. These birds are difficult to photograph as they are voracious feeders and rarely remain perched for long. **SU**

Purple-rumped Sunbird. Habarana

This female bird was building its nest on a Kumbuk tree, overhanging a pool of water. I spent a whole morning attempting to capture the image I had in mind. Having shot 56 frames of film, I was overjoyed with the result. The morning sun and the green background created this image, which is one of my favourites. **SU**

Terns. Yala

I watched these birds for some time, before attempting to approach them over wide open ground. The lack of cover made this impossible and every attempt I made resulted in them flying off. Finally, resigned to my fate, I used a long lens to photograph them from a distance as they took off. **SU**

Sanderlings. Talaimannar

This small flock of Sanderlings was feeding at the receding tide line, when I lay in their path to try and photograph them as they approached. They seemed oblivious to my presence, when all of a sudden they took off in formation to settle elsewhere along the beach. **SU**

Large Egret. Wilpattu

During the rains, these pretty flowers bloom at most of the Villu's, creating a beautiful splash of colour. At Borupanwila, the purple streak was punctuated by feeding egrets. This bird was disturbed by my approach resulting in an interesting image. **SU**

Sunrise. Horton Plains

You cannot do justice to the magnificent display that nature puts on at dawn and dusk. The flaming sky brings promise of another beautiful day at one of my favourite locations. **SU**

Chestnut-headed Bee-eater. Yala

We watched a pair of these colourful birds at Kohombagas Wala, diligently dig out a nesting hole, while keeping a watchful eye for any threat. They were skittish at first, then appeared to get comfortable with the proximity and presence of my vehicle, and continued their work undisturbed. **SU**

Peacock. Yala

I was keen on taking a section of the tail feathers of a Peacock, to depict the richness of colour and intricacy of detail. This bird at Heenwewa, distracted by his desire, continued to dance unabated. **SU**

Grey Langur, Yala

Early morning light at Wilapala Wewa and a thoughtful expression on it's face was what attracted me to make this image. The colours of the background add an interesting aspect. **SU**

Lesser Whistling Teal. Nawadankulama

The Nawadankulama Tank was bathed in morning light. I had been watching this bird for some time, waiting for it to flap its wings in characteristic fashion. **SU**

Golden Plover. Wilpattu

Ashani and I were at Kalivillu, when we spotted this shy bird feeding in the grass. We took over an hour to approach the bird giving it a chance to get comfortable with our presence. **SU**

Common Kingfisher. Talangama

This amazingly tolerant bird settled a few feet away from me; so close that I had to re-position my vehicle to be able to focus. The vivid colours of it's feathers appeared to vary with every change of angle. **SU**

Ceylon Lorikeet. Namunukula

This little gem of a bird was a part of a flock that kept visiting this broken branch and feeding off the gum oozing out of the tree trunk. I used a flash to enhance the available light, which gave a surreal feel to this image. **SU**

Openbill Storks. Bundala

These birds were in a dispute over their feeding ground, acting very aggressively towards any intruder. Commonly found throughout the country, the Openbill show variance in colour from grey to white. **SU**

Hoopoe. Yala

Frustrated by my futile attempts at capturing a portrait of this handsome bird, I just 'pointed and shot' as it left yet another perch. To say I was thrilled by the outcome would be a mild understatement. My joy was enhanced when I saw the ill fated caterpillar, captured in the frame as well. **SU**

Crested Tree-Swift. Yala

While on a morning drive in the park, the acrobatic flight of this swift caught my eye. I was pleasantly surprised when I followed the bird as it switched position with its mate, on a nest beside the road. **SU**

Tusker. Yala

We watched this tusker for most of the afternoon as it attempted to mate with a young, uncooperative female. Finally giving up it walked a short distance and appeared to sulk next to a Palu tree. **SU**

Purple-faced Leaf Monkey. Talangama

One of my favourite photo locations in Colombo is the Talangama tank. One morning while watching roosting Night Herons, I noticed a pair of eyes peering at me from the foliage. Although dwindling in numbers, these beautiful monkeys are still found in suburban gardens. **SU**

Brown-headed Gulls. Talaimannar

Mannar is a bird watcher's paradise. Made inaccessible for many years due to the security situation, it is now my favourite photo location. These gulls are some of the many uncommon species readily found on and around Mannar Island. **SU**

Leopard. Yala

This is the famous Kota Bendi Wewa female cub. This cub and its brother gave photographers and visitors spectacular sightings for over a year. On reaching maturity they separated and moved to other territories. This image was captured as she rested near a roadside puddle. **SU**

Leopard. Yala

We were on a 'fuel run' one gloomy afternoon, when we spotted this young male on a roadside rock, a few meters off the road and at eye level. I have never been more thankful for carrying all my equipment, even when going on a menial errand. The gloomy conditions permitted us to 'shoot our fill' at midday while this Leopard rested, undisturbed by three ecstatic photographers. **SU**

Gehan Rajapakse
Nikon F5/F80
Sigma 800 mm F 5.6,
Sigma 70 – 200 mm Zoom F 2.8
Sigma 170 – 500 mm F 6.7
Fuji Velvia 50, Provia 100 F

Namal Kamalgoda
Canon EOS 3
Minolta 7000xi
Canon 600 mm F4,
Minolta 200 mm F 2.8
Sigma 170 – 500 mm F 6.7
Canon 1.4 x and 2 x Teleconverters
Fuji Velvia 50, Provia 100 F, Provia 400 F

Palitha Antony
Canon EOS 3
Sigma 500 mm F 4.5
Sigma 180 mm F 3.5 Macro
Sigma 400 mm F 5.6
Canon 1.4 x Teleconverter
Fuji Velvia 50, Provia 100 F

Sarinda Unamboowe
Canon EOS 3
Canon Elan 7
Canon 600 mm F4
Canon 100 – 400 mm F 5.6
Canon 1.4 x and 2 x Teleconverters
Fuji Velvia 50, Provia 100 F